THE ROYAL ACADEMY OF ARTS

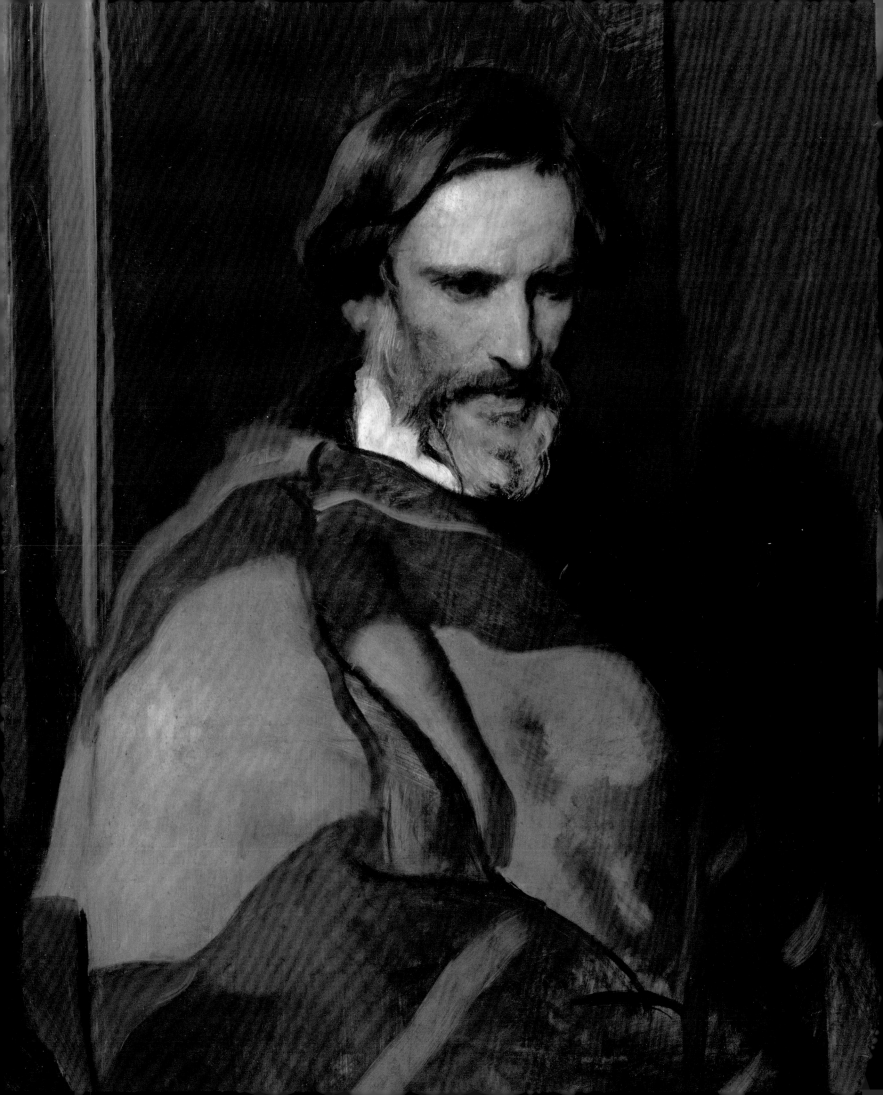

THE ROYAL ACADEMY OF ARTS

History and Collections

Edited by

ROBIN SIMON

with

MARYANNE STEVENS

PUBLISHED FOR
THE PAUL MELLON CENTRE FOR STUDIES IN BRITISH ART
BY YALE UNIVERSITY PRESS · NEW HAVEN AND LONDON
IN ASSOCIATION WITH THE ROYAL ACADEMY OF ARTS, LONDON

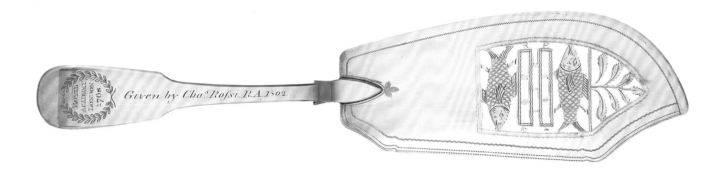

RA250

1768-2018

The Royal Academy of Arts is exceptionally grateful to
THE GABRIELLE JUNGELS-WINKLER CHARITABLE FOUNDATION
whose generosity made possible the conservation, cataloguing, photography and digitisation
of the RA Collections, enabling the creation of this publication.

ISBN 978-0-300-232073 HB
Library of Congress Control Number: 2017954640

Designed by Emily Lees
Printed in China

Frontispiece Sir Edwin Landseer RA, *John Gibson RA*, *c.*1850 (detail of fig. 128).
p. iii Ticket to the Antique School, 1824 (see fig. 391).
p. iv Robert Eley, fish slices, 1798–9 (see fig. 371).
p. v Sir James Gunn RA, *Pauline Waiting*, 1939 (detail of fig. 313).

FSC
www.fsc.org

MIX
Paper from
responsible sources
FSC® C008047

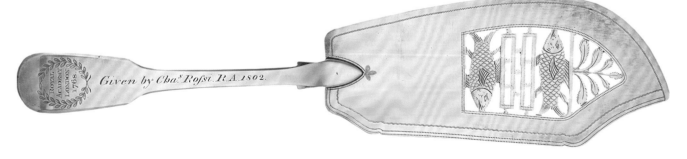

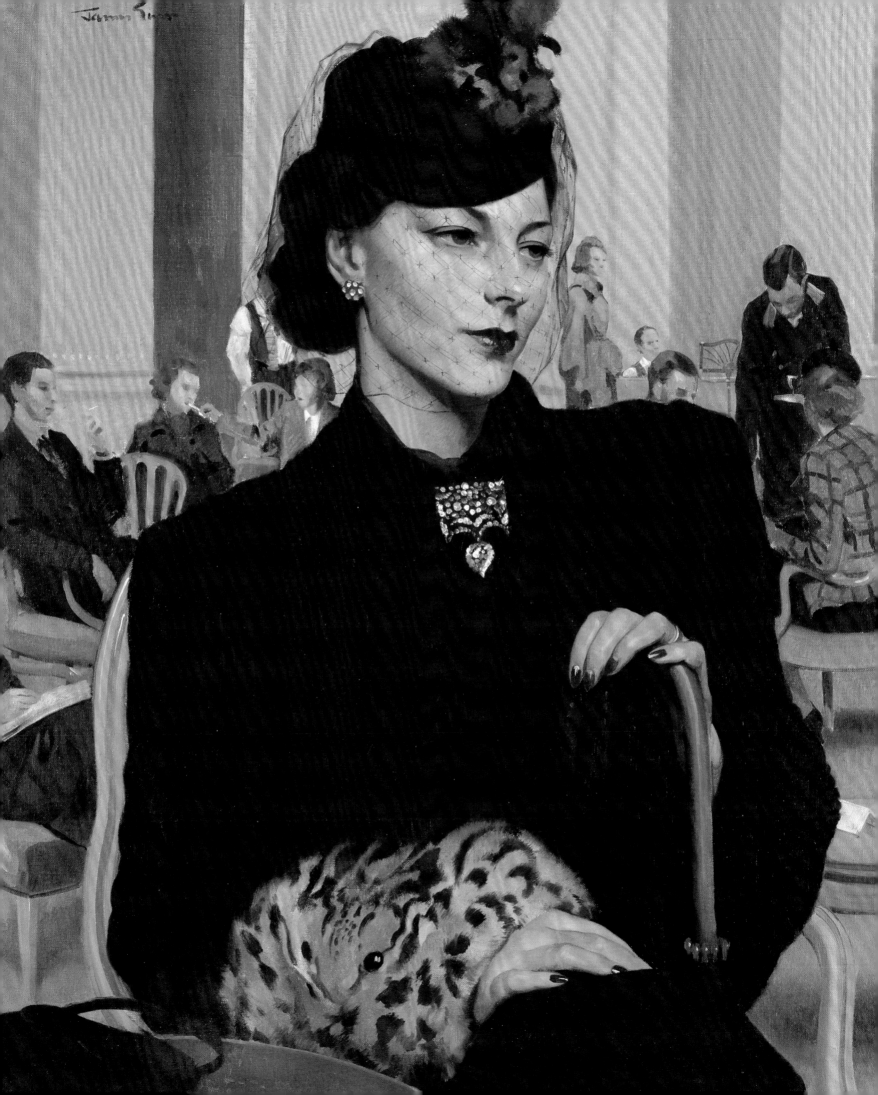

CONTENTS

CONTENTS

A CLOSER LOOK

FOREWORD

CHRISTOPHER LE BRUN
PRESIDENT OF THE ROYAL ACADEMY

This book is published in 2018 at a momentous time for the Royal Academy and its collection. It is the 250th anniversary of our founding, marked by the opening of the most significant development since we moved to Burlington House 150 years ago. Our enlarged campus includes grand spaces for displaying works from the collection finally in the way they deserve. Thus the gallery on the north-west side formerly known merely as number 8 is now transformed to become the Collection Gallery and home to Michelangelo's *Taddei Tondo*. It is displayed as a centrepiece surrounded by many of the key treasures of the Academy. These great works are in effect those also of the nation, and one of our primary purposes has been to share them more widely. The present generation of Academicians continues to sustain our eighteenth-century forebears' belief in art's power to enlighten, inspire and console.

The RA is very well known for its exhibitions, somewhat known for the Royal Academicians and a little known for the RA Schools. It is not yet at all well known for the very particular and very special collection that sits at its heart. Although first established with exemplary paintings, prints, casts and sculpture primarily for teaching following the example of Reynolds, soon it was established that each newly elected member should donate a work. These Diploma Works precede the granting of a diploma of membership signed by the Monarch. Some are great and created specially, some are modest, but in each case there is a story. They are selected by the artists themselves and approved by their peers. Together they form an unbroken and unique record of British art.

My predecessors will have shared my experience of considering the proposals: like all things where imaginative and driven individuals are concerned, it can be a far from straightforward process; it is above all personal, characterful and specific. Everything in the RA collection casts light on the life of an Academician, or of an incident in the Academy's

colourful history. Amongst the rich gathering of art we also find Turner's fishing rod and his own inscribed copy of Michelangelo's sonnets, a palette of Millais, the throne of Benjamin West, the death mask of John Constable and a letter of elegant refusal from Francis Bacon.

Academicians have always regarded it as axiomatic that a mind informed by scholarship and knowledge will more likely possess the necessary hinterland for full or true appreciation of the visual arts. Therefore they set out from the very beginning to equip the Academy by gift and purchase with the most comprehensive and magnificent library. It is certainly not the least of the many destinations for this book, and thus the imagination's circle is happily completed.

It is clear to me that this is a work of profound and valuable scholarship, but beyond that I recognise in our contributors, some of whom have devoted many years of their lives to this extraordinary place, their regard and (I dare say) even love for the Royal Academy. On behalf of my fellow members I would like to express my gratitude and thank most warmly all those whose have worked to bring this book to fruition. As we say in the traditional Academy toast, to them: 'Honour and Glory!'

FOREWORD

MARK HALLETT

DIRECTOR OF STUDIES, THE PAUL MELLON CENTRE FOR STUDIES IN BRITISH ART

The Paul Mellon Centre for Studies in British Art, and its sister institution the Yale Center for British Art, have enjoyed a close and highly collaborative relationship with the Royal Academy over many decades. We are delighted to have worked together once again in the development and publication of *The Royal Academy of Arts: History and Collections*. This richly informative book, published to coincide with the celebrations that are marking the Academy's 250-year history, owes its beginnings to conversations that took place a decade ago between the then director of the Paul Mellon Centre, Dr Brian Allen, and numerous colleagues at the Royal Academy, including MaryAnne Stevens, the then head of research. These discussions were prompted by a recognition that the Academy's remarkable archive and art collection – both of which were in the process of being digitally catalogued – deserved to be explored and appreciated anew. They were also stimulated by a sense that this same collection and archive could provide the basis for a new kind of history of the Royal Academy: one that told the institution's story through the prism provided by the fascinating material objects it had accumulated and been associated with over its 250-year history – objects, it was agreed, that also included the actual buildings in which the Academy has lived and breathed throughout its long life.

Recognising the potential of such a project, the distinguished art historian Robin Simon was commissioned by the Centre to edit a book that offered this kind of history, on which he would work closely with MaryAnne Stevens. Over the past ten years, the two of them have transformed this kernel of an idea into a truly monumental work. Collaborating with a wide range of authors from inside and outside the Academy, all of whom are specialists in their field, Robin and MaryAnne have constructed a book that looks at the history of the Academy and its collections from a rich array of perspectives, and that surprises and instructs at every turn. They and their large team of authors, and the editorial committee

they assembled to oversee the project, deserve heartfelt thanks. I would also like to record my special appreciation not only to Brian Allen himself, but also to Amy Meyers, Director of the Yale Center for British Art, Charles Saumarez Smith, Secretary and Chief Executive of the Royal Academy, and Christopher Le Brun, President of the Royal Academy, all of whom have given this project their support throughout its gestation. I would also like to thank all those colleagues at both the Paul Mellon Centre and the Royal Academy who have contributed to the scholarly research that has underpinned this project. Thanks, too, to the experienced and generous publishers who have given so much of their time and energy to this publication, most notably Gillian Malpass, formerly of Yale University Press, who shaped the book in important ways from its beginnings; Mark Eastment, who has helped steer the project through its final stages; and Nick Tite and Peter Sawbridge at Royal Academy Publishing, who have offered such constructive comments on the book's content and appearance. I wish to record my particular gratitude to Emily Lees, Editor at the Paul Mellon Centre, for transforming Robin and MaryAnne's multi-authored manuscript, and their long list of illustrations, into this elegantly edited and handsomely designed publication. In this task, she has been helped enormously by Jennifer Camilleri at the Royal Academy, who has supervised the collection of the images. Finally, we would like to record our thanks to Clare Davis at Yale University Press, who oversaw the printing of this book with her customary thoughtfulness and efficiency.

In 2007, the Yale Center for British Art and the Royal Academy hosted the great exhibition *Paul Mellon's Legacy: A Passion for British Art*, which showcased some of the most precious works of British art that had been acquired over many years by the American art-lover and philanthropist Paul Mellon. As well as founding the Yale Center and the London-based research centre that bears his name, Paul Mellon was a good friend of the Royal Academy during his lifetime. He lent works from his collection to many exhibitions at Burlington House, and in 1977 was granted the privilege of being named an Honorary Corresponding Fellow at the Academy. *The Royal Academy of Arts: History and Collections* has been published in the same spirit of friendship and collaboration that marked Paul Mellon's own relationship with the Royal Academy, and it has the aim – like all the scholarship he sponsored – of offering readers an account of this remarkable institution, and its collections, that is deeply researched, highly original and constantly stimulating.

PREFACE

ROBIN SIMON AND MARYANNE STEVENS

This book has its origins in the Royal Academy's Cataloguing Project, launched in 2000. By 2008, most of the Cataloguing Project was online at a site (www.royalacademy.org.uk/collection) that is still in progress as more objects are added and entries are developed and refined. The Cataloguing Project led to two decisions. In the first place, it was decided not to publish a set of hard-copy catalogues. Secondly, it opened the way for the Academy's works of art and other collections, together with its buildings past and present, to be exploited as never before in the creation of a new history: this book.

The role of architects and architecture within the Royal Academy is touched upon in many places in the book, but, given that it is the subject of recent and forthcoming volumes, it is not fully addressed here (see Introduction, note 2).

Contributions were invited from experts in their fields, both inside and outside the Academy. External authors familiarized themselves with the Royal Academy material in close consultation with its specialist curators, and progress was monitored by an editorial committee that, in addition to ourselves, included Paul Moorhouse, Martin Postle, Nick Savage, Helen Valentine and Annette Wickham, to whom our heartfelt gratitude is due. Those thanks extend to Mark Pomeroy, the Archivist of the Royal Academy, who has been of inestimable help to all concerned, and to the many members of staff who have also assisted.

Both the Cataloguing Project and this book were supported by generous grants from the Paul Mellon Centre for Studies in British Art under its then director, Dr Brian Allen, who also gave invaluable advice on the shape and content of the book, a relationship that has happily continued under his successor, Professor Mark Hallett. We are especially grateful to Emily Lees, our editor and designer at the Paul Mellon Centre; Jennifer Camilleri, of the Royal Academy picture library; Nancy Marten, our copy editor; Jacquie Meredith, our proofreader; Jane Horton, our indexer; and, for her support at an early stage of the project, Gillian Malpass.

INTRODUCTION

ROBIN SIMON

The Royal Academy of Arts was founded in 1768; ever since, it has played a crucial and often controversial role in the British art world. This book tells the rich history of the institution as it emerges from an unprecedented study of its remarkable collections: thousands of paintings, sculptures, drawings and engravings as well as silver, furniture, medals and historical photographs. There is also an archive of more than half a million institutional and private documents, dating from the Academy's foundation until the present day, as well as the first library in Great Britain dedicated to the fine arts, compiled as part of the Academy's self-defined role as Britain's premier teaching institution for artists. For that same pedagogic reason, there is an extensive collection of historic plaster casts after great works of sculpture and architecture, as well as copies of canonical works of art from the past. Among them is a still vibrant copy of Leonardo da Vinci's *Last Supper*, the original of which can now only faintly be discerned on the wall of the refectory of Santa Maria delle Grazie in Milan.

The basis for the Academy's art collection was established by the institution's Instrument of Foundation, which laid down that, upon election to the status of full Academician, every artist had to present a Diploma Work, 'a Picture, Bas relief or other Specimen of his Abilities' to be approved by Council.[1] There are now some 600 such works at the Academy, forming the core of its holdings. To them, however, have been added other works of art of all kinds, many of which have been acquired through donations by members, their families, friends and admirers. Among the Academy's original works of art, for example, is Michelangelo's Taddei Tondo, which is probably the greatest Italian Renaissance sculpture in Britain; yet, like the Leonardo cartoon, which was sold by the Academy to the National Gallery in 1962, this masterpiece was donated as an aid to instruction in the Royal Academy Schools. Altogether, the collections of the Royal Academy are comparable to those of any European academy. Crucially, they have survived remarkably intact, and so they

offer a unique resource for the study and appreciation not only of the Academy itself but also of the wider world of British art and architecture.

Responding to the fact that this material is so rich and diverse, this book has been organized into distinct sections, each of which focuses on a particular aspect of its history and collections. The first part deals in detail with the history of the institution and its buildings, the latter of which are as much part of its historical fabric as the objects they have housed. Prompted by the examination of two small objects in the Academy collection, a book and a manuscript, this book opens by reviewing the long struggle to establish a royal academy in Britain. The story reaches back to the late seventeenth century and forward through periods of considerable turmoil within the artistic community, until the Royal Academy was finally established on 10 December 1768. There then follows an account of the Academy's various homes until its arrival at Burlington House in 1867. Wherever it went, the Academy ensured that its precious and ever-growing collections went too. Indeed, parts of the collections were actually incorporated into the fabric of these various structures, as is the case with the stone that stands over the entrance to Burlington House inscribed 'Royal Academy of Arts'. Similarly, the paintings by Angelica Kauffman and Benjamin West that decorate the present entrance hall ceiling were originally painted for its earlier home in Sir William Chambers's New Somerset House.

The second part of this book focuses on the works of art that make up such an important part of the collections. In this section, paintings are discussed within chapters that themselves are devoted to particular topics or themes. Landscape painting, for example, has a chapter to itself, as does genre painting, which, adapting and superseding history painting, rose to a position of extraordinary dominance in the nineteenth century. Portrait painting, on the other hand, needs to be understood alongside the collection of sculpted and drawn portraits, since together they make up such a high proportion of the works of art in the collections. They are discussed within the context of 'pantheons', those arrays of portraits both public and private that, in the nineteenth century especially, became such a feature both of individual institutions and of national life. Abstract painting and sculpture, however, need to be understood within the framework of the Academy's fraught relationship with what are usually understood as avant-garde forms of art, especially during a notoriously difficult period either side of the Second World War. Having established itself at the centre of national life in the nineteenth century, the Academy struggled at times to find its way amid the rapidly changing aesthetics of the twentieth century and could appear reactionary and failing in nerve. Sculpture, too, forms a major part of this section, reflecting its position as the dominant public art form in Britain from the eighteenth century to the twentieth. In addition, this section of the book explores the embellishment of the Academy through the acquisition of associated artworks, in the form of silver and furniture, which often alert us to its priorities and preoccupations during different moments in its history.

The book's third section uses the Academy's holdings to investigate its long-standing role as a place of teaching and learning. It is worth stressing that teaching in its Schools has always been at the heart of the Academy. That activity has generated many works of art and other objects, not least the gold and silver medals (many designed by distinguished Academicians) with which the achievements of students were rewarded. The presence of Michelangelo's Taddei Tondo is only the most prestigious manifestation of the importance of artistic instruction within the Academy, and the reader will also find here separate chapters on the great plaster cast collection, on the copies of Old Masters, and on the historic écorchés and skeletons through which students have learned about anatomy, both human and animal. Indeed, one of the glories of the collection is a group of incomparable drawings by George Stubbs ARA for his *Anatomy of the Horse* (1766), some of which suffered precisely because they were handled and studied by students as well as Academicians. The Library takes its place within this section, too, since its purpose was to provide a resource for students needing to refer not only to the art of the past but also to such topics as classical literature, historic and foreign dress, classical and Renaissance architecture, natural history and aesthetics.

Finally, a fourth section takes us into the histories that lie in wait in the Academy's capacious archive. In his chapter, Mark Pomeroy fittingly describes this archive as 'the memory of the Royal Academy'. It contains not only the detailed records of the institution's activities since its inception, but also the papers and correspondence of many individual artists whose own archives have been bequeathed or presented to

the Academy over time. These materials, many of which have been newly catalogued and made available in digitized form, provide an often intimate insight into the relationships of Academicians, with one another and with the wider world.

The essays in each of these sections have been written by a wide range of experts, and are designed to provide illuminating and accessible entries into the Academy's collections and history. At the end of each chapter, furthermore, the reader will find a feature called 'A Closer Look', made up of shorter essays focused upon specific objects in the collections. This variety of content and flexibility of structure are meant to reflect and express the diversity of the Academy's collections, shaping a book that, just like those collections, is open to being enjoyed in a variety of ways. It can be read in sequence from start to finish, but it is also designed to encourage individual adventures of exploration and investigation on the reader's part, whether extended or brief, across its many pages.

The material evidence provided by the Academy's buildings and by the thousands of intriguing, revelatory and often startling objects in its collections has always been our starting point and our guide, and we hope that readers, too, will enjoy tracing the stories these buildings and objects continue to tell. In this respect it differs from, although it draws upon, earlier accounts, notably the history of the Academy by Sidney Hutchison first published in 1968, the year in which he became its Secretary.[2] Moreover, the stories told here do not only concern the Academy itself; they also encourage fresh reflections on the contribution that the institution has made to the history of British art and architecture over the past 250 years. Significantly, the Royal Academy – and particularly the twentieth-century Royal Academy – has at times suffered from what can be termed a proleptic fallacy: the institution and its members are sometimes not so much admired for what they have done but condemned for failing to accomplish what they never set out to do. The contributors to this book redirect attention to what the Royal Academicians have created and what their Academy has collected, not least in the modern period, offering what we believe is a rewarding and often surprising story.

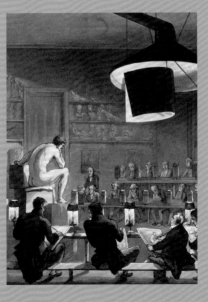

PART
ONE

THE INSTITUTION AND
THE BUILDINGS

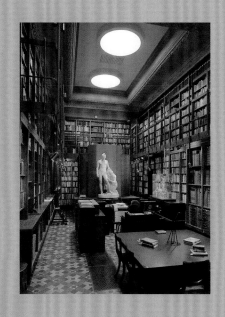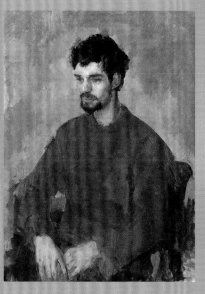

1

IN SEARCH OF A ROYAL ACADEMY

ROBIN SIMON

The fact that it took so long for an academy along European lines to be established in Britain is brought into focus by two objects in the Royal Academy collections. The first is Sir Robert Strange's *Inquiry into the Rise and Establishment of the Royal Academy of Arts* (fig. 1), an embittered tirade against the Academy by an artist who was ineligible for membership under a rule that excluded engravers. The second is the 'Roll of Obligation' of the Society of Artists, many of whose members seceded in order to found the Royal Academy (fig. 2). It was discovered in the stores of the Academy as recently as 2015 (it was in the sculpture store in a container labelled 'Artists' Memorabilia') and is a list of its members, including those who left to found the Royal Academy. As dramatic evidence of the rancour generated by that initiative, the names of the members of the Society who seceded are struck through and marked 'expelled'. Between them, the book and the manuscript shine a light upon the origins of the Royal Academy and

the convoluted circumstances of its birth, but they also point us further back in time to the many efforts, lasting for the best part of a century, at establishing a professional academy for artists in Great Britain.

When the Royal Academy of Arts was finally established in 1768, it happened, remarkably, within a matter of a few days, following an appeal to King George III by a group of artists on 28 November that year, leading to the Instrument of Foundation of 10 December (see fig. 5). It was one of the last of the royal academies to be created in Europe. The Académie royale de peinture et de sculpture in Paris, for example, had been created as long ago as 1648 and was reformed in 1663–4.[1] More recently, the Real Accademia de Bellas Artes de San Fernando had been founded in Madrid in 1744, the Kongelige Danske Kunstakademi in Copenhagen in 1754, and the Reale Accademia delle belle Arti di Parma was founded in 1752 and opened in 1757. In Italy, indeed, several academies were more venerable: Florence's

A N

INQUIRY

INTO THE

RISE and ESTABLISHMENT

OF THE

Royal Academy of Arts.

TO WHICH IS PREFIXED,

A Letter to the Earl of *Bute.*

By ROBERT STRANGE,

Member of the Royal Academy of Painting at Paris,
of the Academies of Rome, Florence, Bologna;
Profeſſor of the Royal Academy at Parma, &c.

✻✣✻
✣✻✣

LONDON:

PRINTED FOR E. AND C. DILLY, IN THE POUL-
TRY; J. ROBSON, NEW BOND STREET, AND
J. WALTER, CHARING CROSS.

M.DCC.LXXV.

1 Title page to Sir Robert Strange, *An Inquiry into the Rise and Establishment of the Royal Academy of Arts*, London 1775 (RA 06/1840).

Accademia del Disegno dates back to 1563, the Accademia di San Luca in Rome to the 1570s, and the Accademia Clementina in Bologna to 1710–11.

It is within this European context that the history of the Royal Academy demands to be understood, as Robert Strange clearly appreciated. The title page of his *Inquiry* (fig. 1) mentions his affiliations with academies in Europe, 'Member of the Royal Academy of Painting at Paris, of the Academies of Rome, Florence, Bologna; Professor of the Royal Academy at Parma, &c', while at the back of the book

(it was his personal copy) are attached original letters and diplomas relating to Strange's membership of the Parma and Bologna academies (fig. 3).

Strange must have thought he was holding a strong hand. It did him no good, not so much because these things were hardly worth the paper they were written on (although that is true of several), but because the founding of the Royal Academy had been the work of a close group of professional allies, personal friends and family relations, almost all of whom Strange had contrived to alienate. Seventeen had been, like Strange, members of the Society of Artists and those marked as 'expelled' on its Roll of Obligation include Joshua Reynolds and William Chambers (the first President and Treasurer of the Royal Academy, respectively), Francis Hayman, Richard Wilson, Paul Sandby, Joseph Wilton and Thomas Gainsborough. Strange helped to expel them and then became a director of what was left of the Society of Artists.[2] It was only one among many occasions when Strange demonstrated his remarkable talent for choosing the wrong side.

Like the Académie française in Paris (founded in 1635, not to be confused with the Académie royale), membership of the Royal Academy was officially limited to 40. Only 34 Foundation Members were initially assembled, but it was soon brought up to the right number. It was a rather hotchpotch collection and included, for example, two sets of brothers, Thomas and Paul Sandby and George and Nathaniel Dance, as well as a father and daughter, George and Mary Moser. Engravers might have been excluded under the high-minded terms of the Instrument of Foundation, but no one could claim that the membership, at this stage, was exclusively confined to the highest reaches of the fine arts. There was, for example, a painter of coats-of-arms on furniture and coaches, Charles Catton; a painter of flowers on coaches, John Baker; a coin and medal engraver, Richard Yeo; and a drapery painter, Peter Toms, to whom Joshua Reynolds, Francis Cotes and Benjamin West among the Foundation Members were indebted for assistance in the completion of their figures. There were also some glaring absentees, notably the architect Robert Adam, who may have been kept out by his fellow architect William Chambers.

Strange's family papers and letters were gathered together and published as *Memoirs of Sir Robert Strange, Knt., Engraver* ... in 1855. In these personal records Strange claimed that the exclusion of engravers from the Royal Academy was simply

2 Roll of Obligation of the Society of Artists, 25 January 1765, detail showing struck-out names (temporary accession no. 2015/7).

a ruse to keep him out. He was quite right; and he was also justified in pointing out that the engraver Francesco Bartolozzi should not, on the same grounds, have been a Foundation Member, an obstacle that had been circumvented by simply asserting that Bartolozzi was a painter. Although, like Strange, he had initially trained as a painter, Bartolozzi seems never, at least professionally, to have painted a picture.[3] Both were certainly brilliant engravers, but they could hardly have been more different, in character and as artists. Strange was ambitious and prickly, and wedded to the highest standards of traditional copper-plate engraving. Bartolozzi was charming and laid back, and famously innovative as an engraver and etcher.[4] He perfected the technique of stipple engraving, which imitated the softer effects of pencil or pastel to a

remarkable degree, collaborating in hundreds of such prints with his fellow Foundation Member Giovanni Cipriani, a lifelong friend from student days in Florence (another example of the accidents of friendship and kinship that tied the miscellaneous founders of the Academy together).

Strange had made an enemy of Bartolozzi in Bologna in 1763, together with the king's librarian Richard Dalton, in whose premises in Pall Mall the new Academy was to be based. The two men were in the city on a mission for the king and had pre-empted Strange in booking access to churches and collections in order for Bartolozzi to make drawings with a view to engraving. Strange partially dealt with the problem by calling upon the intervention, of all people, of Henry, Cardinal York, the brother of the Stuart

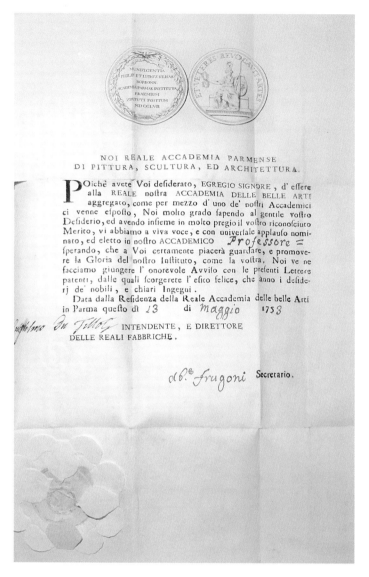

3 Diploma of the Reale Accademia delle belle Arti di Parma awarded to Robert Strange, tipped into back of his *Inquiry into the Rise and Establishment of the Royal Academy of Arts* (RA 06/1840).

Bute had not been in power for more than a decade. It was a full 15 years since the row over the royal portrait and seven since the foundation of the Royal Academy, from which Strange had done everything possible to ensure that he would be excluded. In contrast, Bartolozzi had actually been invited to England by Dalton with a promise of employment by the king (he arrived in 1764), and with Dalton intimately involved in the machinations that established the Royal Academy, Bartolozzi was certain to become a member.[5]

The exclusion of engravers aimed at Strange was, in fact, a marked departure from the model that the Royal Academy had deliberately taken, the Académie royale in Paris, where engravers had always been welcomed. But the choice of the French academy as the principal model is a reflection of the seriousness with which the founders of the Royal Academy approached their task. The Académie royale was an institution to which membership was only open after the most rigorous training and examination, and however much it may seem to have been thrown together in haste, the Royal Academy was determined to be an institution to which future admission would be without favour and upon merit. This was in contrast with some of the Italian academies, including those to which Strange drew attention on the title page of his book.

The Royal Academy was especially anxious to follow the example of the French academy in several important respects: annual lectures were to be given, and it would be a teaching institution. In one way it went further in pledging itself from the very start to hold an annual exhibition, in contrast with the Salon in Paris held under the auspices of the Académie royale, which for many decades was an irregular event that, once it had become established, was usually biennial. All this was in marked contrast with the most alluring Italian academy, the Accademia di San Luca in Rome, a city to which no fewer than 14 of the Foundation Members had travelled, which conducted no teaching (although lectures might be given) and held no regular exhibitions. Indeed, for all that Strange might vaunt his membership of this particular academy, his *Memoirs* reveal that in contriving to be elected to it he simply followed a well-worn and cynical procedure.

Theoretically, there was an objection in the rules of the Accademia di San Luca to the admittance of merely reproductive engravers such as Strange, but this was easily dealt

Pretender to the throne of George III. In fact, Strange had already annoyed the king when he was Prince of Wales by refusing to engrave his portrait, a furore that had earned Strange the antagonism also of the painter Allan Ramsay and of William Chambers. The row revolved around a request from the prince's favourite, Lord Bute, and Strange's *Inquiry* of 1775 is cast in the form of a complaining letter to Bute, which in itself was curiously maladroit, since by that date

with on the advice of the Principe Altieri, who said that another 10 crowns (in effect, a bribe) on top of the customary fee of 50 crowns would do the trick, and so Strange duly paid 60. He was put up for what was called an election, with black balls excluding and white balls admitting in the usual way, having been proposed for membership by its president, the artist Mauro Fontana. The election proceeded, with the engraver Giovanni Battista Piranesi in the chair. There were no black balls, but that was not surprising since there were only two votes cast, both white, out of a membership of 90, even though the rules technically demanded a two-thirds majority for admittance. Nor did Strange ever bother to present the miniature that he offered as a *morceau de réception* (in place of what would have been an unacceptable engraving).

Strange actually boasted about how clever he had been in 'overruling the laws of the institution' of the Rome academy. No such stratagems were necessary at the academies in Parma or Bologna, where he was ushered in, while in Florence election to the Accademia del Disegno was, if anything, even more of a formality for foreign artists, who were generously added to the class of membership termed 'd'onore'. Many such were elected to the Florentine academy without visiting the city or even the Italian peninsula; Stephen Slaughter (1697–1765) contrived to be elected when he was already dead.[6]

Not content with these resonant if hollow honours, Strange now planned a similar attack upon the more serious French academy in Paris. He was supposed to submit two portrait engravings, that is to say, original works rather than reproductions after other artists: 'As an engraver [he wrote to his brother-in-law] I never shall [be admitted to the Paris academy] as every such must present then two portraits engraved, which would never turn to my account. I shall endeavour to be received amongst the class of painters and consequently present the Accademy [sic] with some drawing.'[7] As a Roman Catholic and a Jacobite (he had been at Culloden in 1745), Strange was in a good position to be welcomed into the French academy, and he was its first British member (he had also worked in Paris in 1749–50 with the Anglophile French engraver and academician Jacques Philippe Le Bas). Strange presented some engravings to the French academy and also, more to the point, as he had planned, drawings that he had made in Italy.

The Royal Academy's founders set themselves against perpetuating these kinds of machinations, with which many of them were familiar, especially in Italy, and which came so naturally to Strange. The Foundation Members formed a remarkably cosmopolitan group: English, Welsh, Irish, Italian, Swiss, German, French, Austrian, American. Nine had been born on the Continent and several had trained there, including the English sculptor Joseph Wilton (first in Belgium, then in Paris, Florence and Rome). Fourteen of them had been associated with a more significant precedent for the Royal Academy than the Society of Artists (which was chiefly an exhibiting body): the St Martin's Lane Academy.[8] It had been founded by William Hogarth in 1735, endured until 1767, was very much a place of instruction and, more informally, of discussion, and was run co-operatively by its artist members. Its appearance is recorded in a painting by Johan Zoffany (see fig. 425), and features several involved in the earliest days of the Royal Academy. Near the centre facing the viewer is George Moser, who was to become the Keeper at the Royal Academy; directly behind him is Giuseppe Marchi, Reynolds's studio assistant; at the extreme left is John Hamilton Mortimer ARA, with Zoffany himself immediately behind. Leaning over in the back right row, near the model, is the gem engraver Edward Burch RA. Many of the fittings we see in Zoffany's painting, including the plaster casts from the Antique, were removed in 1767 and placed in store in preparation for what became the new Royal Academy. The conspirators also took with them the man in the red coat at the back of the painting, John Malin, who continued in his role of porter and occasional model in the new Academy.

The line that connects St Martin's Lane, the Society of Artists and the Royal Academy can be traced back through several attempts at establishing an academy for the training of artists in London. Throughout, a recurring theme is the need to emulate France and its Académie royale. Within a few years of that foundation, the French capital contained academies of all kinds, including those for architecture, literature and dance. In the latter part of the seventeenth century and the first part of the eighteenth, as Britain grew in economic might and in military power, the perceived cultural gulf that existed between the two countries became a matter of national embarrassment. Even as late as 14 years after the Royal Academy had been established, the engraver Valentine

Green ARA wrote a review of what little had been accomplished in the sphere of public art in terms of a prolonged and disappointed comparison with France: *Review of the Polite Arts of France, at the Time of Establishment under Louis the XIVth, compared with their Present State in England* (1782). The year before that, in 1781, Henry Emlyn had published his proposal for 'a new order in Architecture', the rather quaint-seeming 'Britannic Order' made up of lions' heads, roses, the Garter and the Prince of Wales feathers, that he devised in the form of a capital;[9] but Emlyn's suggestion needs to be understood in this same context, as a nationalistic blow against France, because he was offering a direct British equivalent of the 'French Order' (featuring cockerels and the fleur-de-lys) that Charles Le Brun had designed for the capitals of the Galerie des Glaces at Versailles 100 years earlier.

Writing from Naples about academies in his 'Letter concerning Design' in 1712 (it was first published in the 1732 edition of the *Characteristics*), Lord Shaftesbury had not referred to those at Rome, say, or Bologna, and indeed he barely mentioned Italy. Instead, his point of reference throughout was France ('our rival nation'), its academies, and the French academy in Rome. Talking of the way in which Britain lagged behind France in the visual arts, Shaftesbury remarked: 'As for other Academys, such as those for Painting, Sculpture or Architecture, we have not so much as heard of the Proposal; whilst the prince of our rival nation [Louis XIV of France] raises Academys, breeds youth, and sends rewards and pensions in to foreign countrys, to advance the interest and credit of his own.'[10]

Shaftesbury's 'Letter' states that he is unaware even of any proposal for an academy in England of painting, sculpture or architecture. Of course, when he wrote this he was in Naples, and so, wilfully or not, he professes himself ignorant of the academy that actually had established itself in London shortly after his departure for the south: the Great Queen Street Academy under the direction of Sir Godfrey Kneller that opened in October 1711 (Shaftesbury had left for Italy in early July of that year). Again, whether purely for effect one cannot say, Shaftesbury avows himself to be unaware of an earlier proposal for a royal academy in 1698, an intriguing initiative recorded in the diary of Narcissus Luttrell on 12 February 1698: 'His majestie is resolved to settle an academy to encourage the art of painting, where there are to be 12 masters and all persons that please may come and practice gratis.'[11]

'Twelve masters' indicates that this academy was designed upon the lines of the Académie royale, which featured a monthly rotation of twelve professors. It cannot be a coincidence either that the project should be mentioned in relation to a monarch, William III, who had been intent upon relocating the monarchy, in the manner of the French king, to a palace outside the capital, and recreating at Hampton Court, where French artists and craftsmen were currently hard at work, the nearest thing in England to Versailles. William III's plans gained impetus in 1698 during the negotiations following the Treaty of Ryswick (1697), in which the key figure was King William's companion, William Bentinck, Earl of Portland, who was actually provided by the French crown with Mansart's plans for Versailles, the Trianon and Marly.[12]

The interest in establishing an English royal academy along French lines at this time was serious, and a reflection of it was the restoration and hanging of the Raphael Cartoons (Royal Collection, on loan to the Victoria and Albert Museum, London) in the last decade of the seventeenth century. As the eighteenth century progressed, it became habitual to trumpet the Raphael Cartoons at Hampton Court as a resource in the training of artists to match anything outside Italy and certainly in Paris. It explains why Sir James Thornhill devoted the latter part of his life to copying the cartoons, and why his set of full-size copies was eagerly accepted by the Royal Academy as a gift from the Duke of Bedford in 1800.[13] Thornhill also made over 160 details from the cartoons of the kind that might be useful in artistic instruction, and some 200 tracings, in addition to his three sets of painted copies of varying scale (most of his drawings and tracings are in the Victoria and Albert Museum).

To the academic way of thinking, Raphael was the supreme artist, whose greatest paintings should be copied by students as part of their essential training. In practice, this meant especially at the satellite of the French academy, the Académie de France in Rome, where students could work directly from Raphael's frescoes in the Loggie and Stanze of the Vatican. England, Jonathan Richardson argued, was uniquely fortunate to own the cartoons because, he asserted, they were superior even to the frescoes in the Stanze. This claim was developed by Richardson in his *Account of Some of the Statues, Bas-Reliefs, Drawings, and Pictures in Italy* of 1722, to the subsequent annoyance of Nicolas Vleughels, the director of the Académie de France in Rome, who in 1735 wrote

an attack on Richardson's assertions. In fact, at the time that Richardson wrote, he struck an especially raw nerve, because from 1705 to 1725 the Académie de France was denied access to the Vatican, which undermined a fundamental tenet of its training. The students in Rome were reduced to copying Raphael from existing copies of Raphael, which was the position when Vleughels arrived in 1724.[14]

Richardson's assertion of the superiority of the cartoons had been anticipated in his *Theory of Painting* as early as 1715, during a period that witnessed several related developments: the reconstruction of the cartoons, then the first proposal for a royal academy, then the first engravings after the cartoons, and then the opening of the Great Queen Street Academy. Indeed, Richardson's resounding affirmation of the superiority of the cartoons in 1722 appeared in the year that also saw the publication of engravings of 90 heads in the cartoons after drawings by Nicolas Dorigny, whose complete engravings of the cartoons had been published in 1719.

Until the 1690s, the cartoons were still cut up in strips (an essential procedure in the manufacture of the tapestries) and in store, although they were temporarily on view on a couple of occasions, notably when William had them unrolled on the floor of the Banqueting House early in 1689, at which point he decided to relocate them to Hampton Court. They were then repaired by Parry Walton, who received payments totalling £200 in 1691 and July 1693, when they were glued on to large sheets and put on stretchers at Hampton Court. On 2 September 1697 Sir Christopher Wren, who supervised all Walton's restoration work for the Crown, reported that the cartoons had been reconstructed and hung up at Hampton Court for copying. This was in the shell of the new King's Gallery, where they were 'copying for my Lord Sunderland' according to Christopher Hatton in November 1697, perhaps by Charles Jervas, who had certainly made copies by May 1698.[15]

The year 1698 was a lucky one for the cartoons. They could so easily have been in Whitehall at the time of the fire in January that year that destroyed the ancient palace. Instead, in February we hear of plans for a royal academy, and also the earliest project to engrave the cartoons. This involved a visit to Paris by Charles Jervas, who was able to travel there early in 1698 because of the Treaty of Ryswick. Jervas went to see the greatest living engraver, Girard Audran. After Jervas had come to an agreement with Audran, he went on to Italy,

leaving his friend, Dr George Clarke of All Souls, Oxford, to forward Jervas's copies of the cartoons to Audran to work from. Unfortunately, war broke out again in 1702. Worse, Audran died in 1703, having completed only two of the prints, which, in any case, were a little approximate, given that they were based upon copies by Jervas. A slightly shady engraver called Simon Gribelin now moved in to take on the engraving, and his 'little set' – almost pocket-reference size – of prints was published in 1707 (and reissued in 1720).

In 1709, in an attempt to improve upon Gribelin's prints, John Talman, who was in Rome, requested the English envoy there to write to the ruling Whig trio in England of Lord Sunderland, Lord Somers and Lord Halifax to suggest that the more accomplished Nicolas Dorigny should engrave the cartoons, which he duly did after his arrival in England two years later, although he finally presented them to the king only in 1719. Dorigny had been given to understand that the Crown would pay for the engravings, but nothing of the sort happened, although Queen Anne did give him an apartment at Hampton Court, firewood and a daily bottle of wine, and he was ultimately rewarded with 400 guineas and a knighthood in 1720. In the absence of initial financial support, Dorigny was forced to invite subscriptions, and advertised a 'Proposal for Graving and Printing the Gallery of Raphael at Hampton Court' on 25 October 1711, precisely one week after the opening on 18 October, St Luke's Day, of Kneller's Great Queen Street Academy, of which Dorigny had been elected one of the first directors, having only just set foot in the country (which in itself is revealing). St Luke's Day was the occasion of the annual feast of the artists' club, the Virtuosi of St Luke, the significance of which diminished after the foundation of the Great Queen Street Academy. Again, one dimly perceives, if not a pattern, then repeated and interrelated initiatives.

Nothing came of William III's 1697–8 plan for a royal academy of painting, although we might note that just at this time the academies in Paris and Rome first felt the pinch of royal economies, owing to the vast expense of the perpetual warfare in which France was engaged, as a result of which subsidies to send prize-winning artists to Rome were suspended. Academies were not entirely unknown in England before this time, although none of them had been supported by the Crown.[16] William Gandy's 'Notes on Painting' in Ozias Humphry's *Memorandum Book* in the

British Museum record that in about 1673 Sir Peter Lely supervised drawing after the live model, both male and female, in an anticipation of an enduring feature of academies in England (in France only male models were seen in the academy). In 1692 students are reported to have attended life classes and 'diligently studied Nuditys at the Academy', although it is not now clear where this academy might have been. In 1681 Peter d'Agar had opened a school in the Savoy (the centre of Huguenot life in London), which, intriguingly, he advertised as 'Royal Academy of Painting, Designing, Mathematics etc in the Savoy'. If the inclusion of mathematics sounds an odd note, it would have had a very different resonance at the time, because the Académie royale insisted upon artists taking lessons in arithmetic, geometry, astronomy, anatomy, history and philosophy, as part of its aim at elevating training in the fine arts from a mechanical to a liberal education. In his *Science of a Connoisseur* of 1719 Richardson's plea for an academy is cast in precisely the same educational terms, as is the pamphlet of 1736 by a certain Thomas Atkinson that argued in favour of an official academy, a pamphlet pointedly given a title that echoed the 'Conférences' of the French academy, *Conference between a Painter and an Engraver*.

Whichever academies arose in England over the years, the French academies, funded by the monarch, were an ever-present reminder of national shortcomings in the polite and liberal arts. And so the idea of establishing a royal academy refused to go away. Sir James Thornhill put forward a plan to Lord Halifax, the new First Lord of the Treasury (which is to say, prime minister), on 11 October 1714, after the return of the Whigs on the death of Queen Anne (1 August 1714). It was for a purpose-built institution 'at the upper end of the [Royal] Mews', which, curiously enough, was the very site where the Royal Academy was to be housed from 1837 to 1868, in the National Gallery building on the north side of Trafalgar Square. It was to consist of 'many apartments convenient for such a purpose' and the total cost was no less than £3,139. What is not usually noticed is that the appearance of this proposal coincided with the abandonment by the new Whig ministry of an advanced plan for a royal academy of literature upon the lines of that in Paris.[17] It had been devised by Jonathan Swift, as Voltaire recorded in his *Letters concerning the English Nation* of 1733. Voltaire knew personally all the individuals involved in the project and

stated that it foundered because it had been promoted by the previous Tory government, and so was distasteful to the Whigs. In this context, Thornhill's characteristic manoeuvring may have proved just a bit too sharp, and his substitution at this moment of an art academy for the abandoned academy of literature may have been too hasty a move, as well as seriously expensive. Nothing came of Thornhill's scheme, perhaps because Halifax, a noted lover of the arts, died very soon after the proposal was put to him, although Thornhill took over the running of the Great Queen Street Academy on 29 October 1716.[18]

The middle years of the eighteenth century are marked by prolonged controversy over the establishment of an official academy. It revolved, especially in the mind of William Hogarth, around memories of how things had been done in earlier times, especially by Thornhill. And so it is that Hogarth, in his *Apology for Painters* in the 1760s, refers to the Great Queen Street Academy: 'It was begun by some gentlemen-painters of the first rank, who in their general forms imitated the plan of that in France, but conducted their business with far less fuss and solemnity; yet the little that there was, in a short time became the object of ridicule.'[19]

Here is mention of France again. There is an inner consistency in Hogarth's approach. He was not against academies as such: he hardly could have been, since he founded one himself and argued in their favour in writings of the 1750s and 1760s. Indeed, Hogarth at one point argued, if not straightforwardly, in favour of a royal academy, or at least around the idea. It is often forgotten that his papers include a fairly developed draft, or rather several drafts, of a letter *c*.1761, probably addressed to Lord Bute, on the topic of a 'royal academy', a title that he altered in draft to read 'Public academy', although his revolutionary proposal is never articulated.[20] He always was, however, in a phrase that has been used as evidence that he would have been opposed to the Royal Academy, against what he called 'the foolish parade of a French academy'.

Hogarth was particularly annoyed about the plans drawn up by colleagues in his own St Martin's Lane Academy for an official academy. He viewed them as evidence of dissatisfaction with his own academy, which, he said, had been conducted 'in as perfect a manner as other [either] that in France or Italy'. His fellow artists were, he noted, 'like to have destroyed' all they had accomplished 'by a vain attempt (the

whole body of artists meeting) of addressing the lords and commons'. He hoped that it would all 'blow over' and that it would rest with the king whether he wished merely to add to what Thornhill had long since succeeded in doing (running an academy), but with 'the addition of salary for professors', as in France. Hogarth tells us that he has been represented as 'an enemy … to the artist' because he made fun of the French academy where the professors were given salaries for 'telling … the younger ones when an arm or leg was too long or too short'.

The principal proposal to which Hogarth objected was formulated by a 26-man committee chaired by Francis Hayman, *The Plan of an Academy for the better Cultivation, Improvement and Encouragement of Painting, Sculpture, Architecture, and the Arts of Design in General* of 1755. The Academy Library contains a copy of John Evelyn's *Sculptura* … published that same year by John Payne and inscribed by him 'To the Gentlemen of the Academy for the Improvement of Painting, Sculpture, & Architecture …' (fig. 4). Payne was over-hasty in implying that this academy had actually come into existence, but many of the artists associated in this project went on to become Foundation Members of the Royal Academy, including Francis Hayman, Francis Milner Newton, George Moser, William Hoare, Joshua Reynolds, Samuel Wale, Thomas Sandby and Richard Yeo.

Another was John Gwynn RA, who was probably the author of a proposal anonymously published in 1755, *An Essay in Two Parts, On the Necessity and Form of a Royal Academy for Painting, Sculpture and Architecture*; the copy in the Royal Academy Library is inscribed with his name. In 1766 Gwynn prefixed his *London and Westminster Improved* with 'A Discourse on Publick Magnificence; With Observations on the State of Arts and Artists in this Kingdom, wherein the study of the Polite Arts is recommended as necessary to a liberal Education'. The argument, as so often, was shaped by way of reference to France, and we find the usual uncomfortable sense of a contrast between British military superiority and cultural inferiority: 'It is entirely owing to the encouragement of works of this sort [public artistic enterprises] that the kingdom of France has obtained a superiority over the rest of the world in the polite arts, and it is by the encouragement of these alone that this nation, to the full as ingenious as the French, can ever hope to make a figure in the arts equal to what they now make in arms' (p. 21).

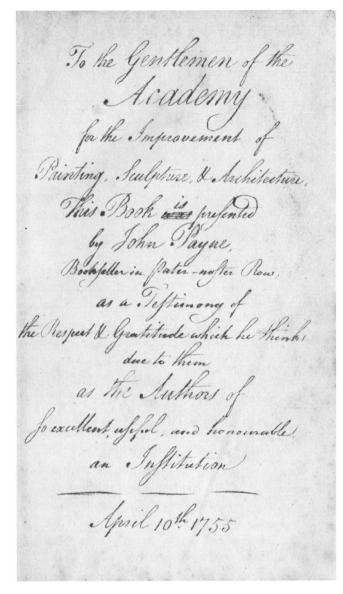

4 John Payne inscription on John Evelyn, *Sculptura; or, The History and Art of Chalcography, and Engraving in Copper*, London 1755: 'To the Gentlemen of the Academy for the Improvement of Painting, Sculpture, & Architecture …' (RA 03/2254).

As early as 1749 Gwynn had published *An Essay On Design: Including Proposals for Erecting a Public Academy*, which formed a key part of discussions between a group of professional artists and the Society of Dilettanti, the club of patrons of the arts that had been indicating its interest in founding an academy, even to the extent of having plans drawn up

by several different architects. 'Dilettanti', as a matter of fact, was a term in use in several Italian academies, referring to a class of membership open to individuals, usually of high social status and wealth, who took an interest in the arts and wished to signal as much by joining the local academy. One of the more striking features of the new Royal Academy was its careful avoidance of this kind of thing, with membership restricted to professionals.

As we have seen, at every stage during the many discussions and proposals for an official academy in England, the point of reference was not the Italian academies (with their 'dilettanti') but the French academy, with its high seriousness of professional purpose. This was the case with the detailed memoranda made by George Vertue in 1749 about the setting up of not just one but three academies (in Oxford, Cambridge and London) that he appears to have been discussing with Frederick, Prince of Wales.[21] Neither that nor the plans of the Dilettanti came to anything, but in the 1760s the momentum in favour of an official academy, however

funded, whether by subscription, the state or the Crown, was becoming unstoppable, and it fed into the violent disagreements within the Society of Artists in the 1760s that led directly to the foundation of the Royal Academy.

In fact, the Society of Artists had been torn apart by faction right from the start, following the meeting in November 1759 that led to its formation. In 1767, as one way out of the squabbles, George III had offered his patronage to the St Martin's Lane Academy, which would therefore have become the 'Royal Academy'. What Hogarth would have made of that is anyone's guess, but the intervention of the monarch provoked the removal that year to a warehouse off Pall Mall of much of the St Martin's Lane Academy equipment ('anatomical figures, bustoes, statues, lamps and other effects'),[22] some of which survive to this day in the Royal Academy.[23] The hasty establishment, therefore, of the Royal Academy during those few days in 1768, between the artists' appeal to the king on 28 November and his signing the Instrument of Foundation on 10 December, was less improvisatory than it appears.

A CLOSER LOOK

The Instrument of Foundation, 1768

MARYANNE STEVENS

The Instrument of Foundation (fig. 5 and see Appendix) of 10 December 1768 allowed for 40 full Academicians. They were to be painters, sculptors and architects, 'Men of fair moral Characters, of high Reputation in their several Professions, at least five and twenty Years of Age, resident in Great Britain', and, most importantly, could not belong to any other professional artists' society in London.[1] There were initially 34 'Foundation Members' who were appointed by royal command. In November 1769 a further two members were nominated by the monarch ('Nominated Members'). Sir Joshua Reynolds became first President, Sir William Chambers took the office of Treasurer, Francis Newton the post of Secretary and George Michael Moser that of Keeper of the Schools. The Librarian, an elected post established in 1770, was Francis Hayman. There were two female 'Foundation Members', Angelica Kauffman and Mary Moser. The first artist to be elected, as such, to full Membership was the sculptor Joseph Nollekens in 1771.

The Royal Academy was born when George III scribbled 'I approve of this Plan, let it be put into execution' at the foot of a large, though unshowy, document of four pages subsequently known as the Instrument of Foundation. It consists of a preamble and 27 clauses laying out the Academy's constitution and core purpose. An official account of the events leading up to the signing of the Instrument is written into the minutes of the Academy's General Assembly. Here it is claimed that the architect William Chambers tested the temperature of the king's opinion 'towards the end of November' in 1768. Having received some encouragement, a small group of artists submitted a formal memorandum on 28 November. This, too, was received graciously and the king asked for a 'fuller exposition', which was duly provided on 7 December. The Instrument as it now exists is the fair copy of this exposition, signed three days later. The minutes also make it clear that Chambers wished to take credit for the majority of the text of the Instrument, even if he did show the draft to 'as many of the Gentlemen concerned as the shortness of time would permit'.

As a self-governing body of professional artists, it was to the 40 full Academicians that the responsibility of conducting the affairs of the institution fell. Regular business was conducted by the Council, appointed in rotation rather than through election, chaired by the President. Council had control of the institution's agenda, but was dependent for ratification upon General Assembly, which met more irregularly and consisted of all full Academicians. Here the President, officers, new members, professors and visitors in the Schools would be elected by ballot, and changes to membership rules, reforms in the Schools and new laws ratified, all requiring majority assent.

Whereas Sundry Persons Resident in this Metropolis, Eminent Professors of Painting, Sculpture, and Architecture, have most humbly represented by Memorial unto the King, that they are desirous of Establishing a Society for promoting the Arts of Design, and earnestly soliciting his Majesty's Patronage and Assistance in carrying this their Plan into Execution, and Whereas its great Utility hath been fully and clearly demonstrated, his Majesty therefore, desirous of Encouraging every useful Undertaking, doth hereby Institute and Establish the said Society under the Name & Title of the *Royal Academy of Arts in London*, Graciously declaring himself the Patron, Protector, and Supporter thereof, and Commanding that it be Established under the Forms and Regulations herein after mentioned, which have been most humbly laid before his Majesty and received his Royal Approbation and Assent.

1mo

The said Society shall consist of Forty Members only, who shall be called Academicians of the Royal Academy, they shall all of them be Artists by Profession at the Time of their Admission, that is to say, Painters, Sculptors, or Architects, Men of fair moral Characters, of high Reputation in their several Professions, at least five and twenty Years of Age, resident in Great Britain, and not Members of any other Society of Artists established in London.

2do

It is his Majesty's Pleasure that the following Forty Persons be the Original Members of the said Society, Vizt.

Joshua Reynolds	J Baptist Cipriani	Nathaniel Dance	Wm Chambers	Francis Zuccharelli
Benjamin West	Jeremiah Meyer	Richard Wilson	Joseph Wilton	George Dance
Thomas Sandby	Francis Milner Newton	G. Michael Moser	George Barret	William Hoare
Francis Cotes	Paul Sandby	Samuel Wale	Edward Penny	Johan Zoffany
John Baker	Francesco Bartolozzi	Peter Toms	Augustino Carlini	
Mason Chamberlain	Charles Catton	Angelica Kauffman	Francis Hayman	
John Gwynn	Nathaniel Hone	Richard Yeo	Dominic Serres	
Thomas Gainsborough	William Tyler	Mary Moser	John Richards	

3o

After the first Institution, all Vacancies of Academicians shall be filled by Election from amongst the Exhibitors in the Royal Academy, the Names of the Candidates for Admission, shall be put up in the Academy, three Months before the Day of Election, of which Day, timely Notice shall be given in Writing to all the Academicians, each Candidate shall on the Day of Election have at least, thirty Suffrages in his Favour, to be duly elected, and he shall not receive his Letter of Admission, till he hath deposited in the Royal Academy, to remain there, a Picture, Bas relief or other Specimen of his Abilities approved of by the then sitting Council of the Academy.

5 Royal Academy Instrument of Foundation, 10 December 1768, p. 1 (RAA/IF).

Tension between these two bodies has intermittently erupted over the years, as questions of where the seat of ultimate authority lay: with the President and Council or with the membership as a whole. In addition, it was from the body of full Academicians that the officers of the Royal Academy were to be drawn – the President, Treasurer, Secretary (until 1873), Keeper and Librarian (until 1920) as well as the professorships of Painting, Sculpture, Architecture and Perspective. The number of full Academicians remained at 40 until, in 1853, two Academician Engravers were admitted, and it remained fixed at 42 until the number was raised to 50 in 1972. Furthermore, the rule to maintain open membership to all classes was abandoned in 1917, when quotas were introduced, the painters taking the lion's share, followed in descending order by the sculptors, architects and engravers. External pressure from the rapidly expanding number of professionally trained artists led the Royal Academy to lift its ceiling of Associate Members in 1866 from 20 to 30. It remained at this level, albeit with some significant modifications, until 1991. On 26 June 1991, under the presidency of Roger de Grey, Associate Membership was abolished, with all current Associates automatically accorded full Academician status. The membership of the Royal Academy is now held at 80.

As a fast-expanding institution functioning within a changing cultural and commercial climate, the Royal Academy recently recognized the need to undertake a governance review under the presidency of Nicholas Grimshaw. This included a radical proposal to draft specific non-artistic expertise into its deliberations, and in 2008 two non-Academicians were incorporated into Council. The Royal Academy also made provision for new categories of membership. In 1861 the 'Honorary Retired Class of Academicians' was introduced, to relieve ailing Academicians of their administrative duties and to make possible the election of a new member. In 1868 a class of 'Foreign Honorary Academicians' was instated, the first six being elected in December 1869, and in 1918 the Honorary Retired Class was superseded by that of 'Senior Academician' which a member became at the age of 75. None within these new classes was able to participate in the regular running of the administration or the Schools, although, with the exception of the honorary foreign members, they retained their right to vote for new members and attend General Assembly. They were all entitled to exhibit at the Annual (subsequently Summer) Exhibition.

The Instrument of Foundation obliged the Royal Academy to hold an annual exhibition of contemporary art (renamed Summer Exhibition in 1870), the first of which opened in the Academy's temporary accommodation at 125 Pall Mall on 11 April 1769. Based on the Paris Salon, the exhibition consisted of works by Academicians, who were permitted to exhibit by right, and those submitted by non-Academicians that had been approved by the Academy. The processes of selection and hanging were tightly controlled by the President and Council, who transformed themselves into a 'Management Committee', later adopting the terms 'Selection Committee' and 'Hanging Committee'. The installation was frame to frame and on strictly hierarchical principles: works deemed the best or of greatest iconographic significance were hung 'on the line', while the others were relegated to upper and lower levels (fig. 6). Entry was by ticket (one shilling) and the catalogue cost sixpence. The Royal Academy felt obliged to excuse itself for imposing this charge. Although, as the catalogue explained, 'being the beneficiary of royal munificence' might suggest that the exhibition should be free to all, the Academy wished to 'prevent the Room from being filled by improper persons to the entire exclusion of those for whom the Exhibition is apparently intended'. Works for sale were indicated with an asterisk in the catalogue, which also gave the address of each exhibitor; but the Academy was anxious not to make this commercial aspect of the exhibition too overt, and any transaction was to be conducted strictly between the artist and the potential purchaser.

Despite the existence of other exhibiting bodies in London, the Annual Exhibition swiftly became the nation's premier platform for contemporary art. The history of the Annual Exhibition's fortunes was the product of the ever-larger exhibition spaces at each of the buildings that the Royal Academy was to inhabit, the almost exponential growth in the number of professionally trained artists (to which the Academy's Schools had contributed), and the never-ending expansion of a wealthy, educated middle class bent on cultural pursuits and improvement, which included exhibition-going and collecting. The first Annual Exhibition attracted a very respectable 14,000 visitors over four weeks, but four times as many came when the exhibition opened in 1780 for a five-

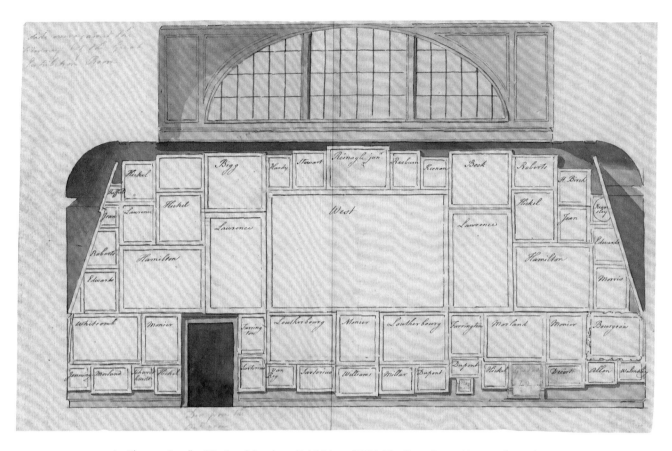

6 Thomas Sandby RA, *Royal Academy Exhibition of 1792: The Great Room, West Wall, April 1792*,
pen and ink with wash, 22.1 × 35.3 cm (RA 08/2007).

week run in the Academy's new accommodation at Somerset House. Subsequently, the significant increases in space offered by the east wing of the National Gallery building in Trafalgar Square and the purpose-built galleries of Burlington House saw attendance soar to 105,800 and 314,800 in 1837 and 1869 respectively. Thereafter it averaged 277,400 until 1911, when the number of visitors dropped to below 200,000, a position that has been maintained to this day.

From its inception, George III, the Royal Academy's 'patron, protector and supporter', took a personal interest in its affairs. Significantly, in view of the discord within the Society of Artists, which had been in essence an exhibiting body, the monarch declared his singular allegiance by refusing to attend any annual exhibition mounted by other artists' societies in London save that presented by his Academy.[2] The most important provision of the Instrument may, in fact, have been its ensuring of a personal relationship with the sovereign, which has consistently provided just enough protection for the Royal Academy to ward off attempts by the government to exert greater control over the institution.

'An Account of the Income and Expenses of the Royal Academy'

MARYANNE STEVENS

The Royal Academy received no state funding, and so from its inception it had to be a commercially successful enterprise. It depended upon income generated by the Annual Exhibition that was established as one of its duties in the Instrument of Foundation. The income generated had to cover many substantial costs: free tuition in the Schools as well as expenditure on the professors, visitors, models, servants and materials, the officers, allowances for attendance at Council, and charitable donations. It is all laid out in the elegantly penned pages of 'An Account of the Income and Expenses of the Royal Academy from its First Institution...delivered...to Council July 10th 1795' (fig. 7), which was based upon Sir William Chambers's personal reports on daily attendance and takings at the Annual Exhibition.[1] These accounts were delivered to Council four times a year on the quarter days: Lady Day, Midsummer, Michaelmas and Christmas.

Until 1780 the income from exhibitions was simply not enough, and in order to enable it to continue, the Academy received an annual subvention from George III's Privy Purse, cumulatively worth £5,116. In 1780 it all changed with the move to the more capacious spaces offered by New Somerset House, where the income generated by the Annual Exhibition (£3,069) not only covered the admittedly increased expenditure occasioned by the bigger premises but also provided a balance in hand of £1,235. Over the course of the next 100 years, ever-growing income from the Annual Exhibition ensured important surpluses that, from 1838, were in part astutely invested in income-yielding bonds, exchequer-bills and stocks. Indeed, in 1869, the first full year of residence in Burlington House, the net income stood at £9,086, even allowing for expenditure of £74,810 on the alterations and additions involved in turning the building into the Academy's new headquarters. The introduction of the winter loan exhibitions the following year initially contributed positively to the Academy's finances. Falling attendances in the 1890s, however, were accompanied by a similar decline in visitors to the Summer Exhibition, which fell below 300,000 annually from 1896. As a result, in 1902 the Royal Academy was in deficit for the first time. Between the two world wars the Royal Academy's financial model was forced to change, and at the same time the winter loan exhibitions began once more to make a positive contribution to the annual accounts.

Dr. The Cash of the Royal Academy Pr. Contra Cr.

7 An Account of the Income and Expenses of the Royal Academy from its First Institution…delivered…to Council
July 10th 1795 (RAA/TRE/1/1).

Diploma works:
The case of Sir John Everett Millais

ANNETTE WICKHAM

Although it was not explicitly stated, there was clearly an expectation that a Diploma Work, which every newly elected Academician had to present for approval by the President and Council, should be 'representative', and several instances are recorded of artists being requested to present a different work from that offered.[1] The choice was up to the individual artist and was inevitably influenced by many competing considerations, ranging from an artist's interest in posterity to more prosaic factors such as the number of unsold works in the studio. The definition of what was 'representative' could be at odds with the opinion of the Academy, as the case of John Everett Millais' Diploma Work reveals.

Millais' *A Souvenir of Velázquez* seems, on the face of it, an obvious choice for his Diploma Work, since it is a broadly painted portrait of a young girl very much characteristic of the style and subject matter that the artist adopted from the mid-1860s (fig. 8). But its presence in the Academy collection conceals an earlier and more controversial tale, because *A Souvenir of Velázquez*, which was only presented to the Academy in 1868, five years after Millais became an RA, was actually the second picture that Millais offered: the first, in 1865, was the *Parable of the Tares* (fig. 9), but it had been rejected. In its message of refusal Council gave the new

Academician a stern reminder that this latter painting had only been a 'temporary Deposit': that is to say, it had been given on the understanding that it would eventually be replaced by another work.[2]

Millais had been promising his Diploma painting since July the previous year, 1864, and by November that year he had already been reminded by Council to send it in as soon as possible.[3] The artist's apparently casual attitude towards the institution's regulations may, of course, have irritated members of Council, but there seems to have been more to the issue than mere pedantry, because the hanging committee of the 1865 Annual Exhibition was also said to have been on the verge of rejecting the same painting.[4]

The *Parable of the Tares* depicts a story from Matthew 13:24–30, in which a man plants wheat in his field but at night his 'enemy' secretly sows tares among the seeds, and the composition, focusing on the figure of the sower, is closely based on a woodcut that Millais had already published in the Dalziel brothers' *Parables of Our Lord* (1864) (fig. 10). Although the print did not elicit any particular criticism, contemporary press reports indicate that Millais' painting of the same scene was considered to be an unusual, even unsettling, treatment of the story. It was dubbed an 'antagonistic picture' by F. T.

18

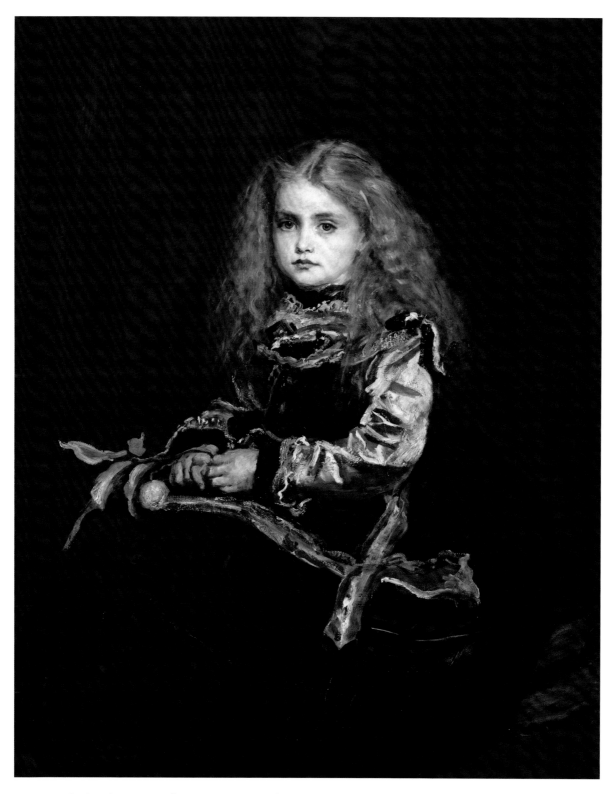

8 Sir John Everett Millais PRA, *A Souvenir of Velázquez*, 1868, oil on canvas, 102.7 × 82.4 cm (RA 03/721).

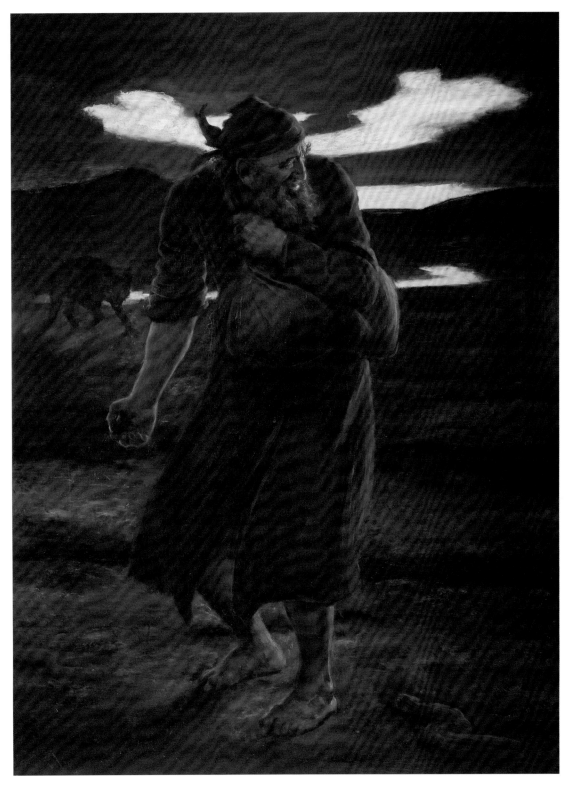

9 Sir John Everett Millais PRA, *Parable of the Tares*, 1865, oil on canvas, 111.8 × 86 cm.
Birmingham Museums and Art Gallery.

10 Sir John Everett Millais PRA, *The Tares*, woodcut, illustration to *The Parables of Our Lord…with Pictures by John Everett Millais; engraved by the Brothers Dalziel*, London 1864. Private collection.

Palgrave, who was referring to the fact that Millais' explicit representation of the sower as the Devil could be perceived as deliberately challenging, and had several critics tying themselves in knots over 'quasi-metaphysical difficulties'.[5] Some years later Walter Sickert suggested that the problem was of a more personal nature, however, stating that Millais' Devil was in fact a caricature of a 'handsome old Jewish RA (was it Solomon Hart?)'.[6] Whatever the truth (and it must be admitted that there is a resemblance to Hart's features as they appear in a portrait photograph in the collection), it seems possible that the Academy's Council and hanging committee simply considered the *Parable of the Tares* to be an inferior work that was not representative of the paintings that had secured Millais' membership.

In fact, Millais' earlier Pre-Raphaelite exhibits had themselves provoked accusations of perversity and blasphemy. His startling technical ability was, however, hard to deny, and Millais soon found favour with paintings that combined the perceived Pre-Raphaelite values of 'precision, truth and individuality' with more sentimental subject matter: for example, *A Huguenot on St Bartholomew's Day* (1852, private collection) and the *Black Brunswicker* (1860; Lady Lever Art Gallery, Port Sunlight).[7] Rather than sticking with this winning formula, Millais continued to experiment during the mid-1850s–1860s, and a specific criticism at this time was that he rejected the painstaking detail that had once been his trademark in favour of a looser, apparently effortless, painterly style, of which the *Parable of the Tares* is an example. Palgrave suggested that the problem lay in the translation of the composition from print to painting, arguing that the latter required more naturalistic detail in order to be convincing. Other critics called the painting 'superficial', characterizing it as a rejection of the tangible skill and dedication previously so evident in Millais' brand of Pre-Raphaelitism.[8] Given this context, it is easy to see how Council could have dismissed the *Parable of the Tares* as an eccentric experiment that did not have a place in the collection. After its rejection, Millais waited several years to comply, perhaps tactfully, and sent the Academy his new Diploma Work. *A Souvenir of Velázquez* can, however, be read as something of a retort. Instead of an obedient return to detailed finish, Millais offered the Academy a more brilliant example of his new approach.

THE BUILDINGS

CAROLINE KNIGHT

On the north side of Piccadilly in the heart of London a gateway opens on to the courtyard of Burlington House, home of the Royal Academy of Arts (fig. 11). The Academy is on the far side, in Burlington House proper, which is framed at either hand by three-storey palazzo-style blocks occupied by learned institutions including the Royal Society of Chemistry, the Geological Society and the Society of Antiquaries of London. The modern visitor to the Academy, crossing the granite paving, must avoid the jets of the fountain installed in 2002, laid out flush with the ground in front of the bronze statue of 1931 of Sir Joshua Reynolds, first President of the Royal Academy (fig. 12). The fountain, with a nod to the Royal Astronomical Society that overlooks it, is designed to reflect the positions of the stars and planets on the night of Sir Joshua's birth in 1723.[1] The entrance to Burlington House itself is through a rusticated portico on top of which is perched, a little awkwardly, a weathered stone inscribed 'Royal Academy of Arts' (fig. 13) brought

here along with other treasures from one of the Academy's earlier homes, which in itself may come as something of a surprise. The Royal Academy has become such a fixture of the London landscape that it seems as though it must always have been where we see it now. Nothing could be farther from the truth.

For the first century of its existence the Royal Academy led a distinctly peripatetic existence. At its foundation in 1768 under the patronage of King George III, it was initially offered part use of a building on Pall Mall that had formerly been a print warehouse, where the display space was able to house the first Annual Exhibition, which ran from 25 April to 27 May 1769. In 1771 much of its activity was moved into an old royal palace, Somerset House on the Strand, which was replaced by a new Somerset House, purpose-built government offices with a new home for the Academy in the north block on the Strand, into which the Academy moved in 1780. Its exhibitions were now held here, having until this

11 Burlington House seen from the courtyard.

date remained in Pall Mall. In 1836 the Academy was on its travels again, to a new building on the north side of Trafalgar Square that it shared with the National Gallery. Finally, in 1867, it came to Burlington House.

The Strand, linking the City and Westminster and running parallel to the River Thames, was one of the most desirable addresses in London in the sixteenth and seventeenth centuries, when it was lined with town palaces. By the mid-eighteenth century, fashionable London had moved to the West End, the great houses along the Strand were becoming obsolete, and their sites were being redeveloped. Old Somerset House was one of the few to survive, but it had seen better days when the Royal Academy transferred some of its key activities to a small part of this rambling palace in January 1771.

The building was begun in about 1547 by Edward Seymour, 1st Duke of Somerset, when he was at the height of his power as Regent or 'Protector' to his nephew Edward VI,

12 Alfred Drury RA, *Sir Joshua Reynolds*, 1931, bronze.

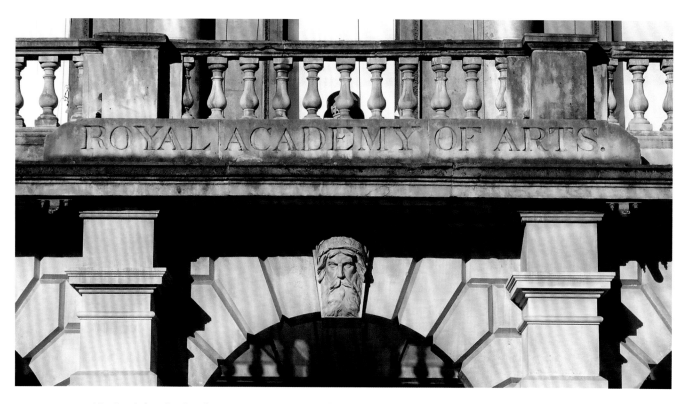

13 South façade of Burlington House with detail of stone inscribed 'Royal Academy of Arts' of uncertain date (but possibly first half of the nineteenth century) over entrance to Burlington House.

although it was not quite completed when he fell from power and was executed in 1552. On the north side Somerset House faced the Strand, with a surprisingly narrow street frontage of only 135 feet (41 metres). The large gardens opened on to the Thames and had two water gates, reflecting the fact that the river was the main transport artery for London. The Strand front was architecturally the most dramatic composition of the new palace, strongly influenced by Italian and French developments and by Sebastiano Serlio's books of designs. At a time when most London buildings were timber-framed or of brick, it was even more exceptional because it was faced in stone (fig. 14).

After Somerset's execution in 1552 his palace was forfeit to the Crown, and its later royal owners made significant changes. On James VI of Scotland's accession to the English throne in 1603, his wife, Anne of Denmark, was accorded Somerset House (renamed Denmark House in her honour) as her London palace on the understanding that it became her dower house should she outlive the king (although she

predeceased him in 1619). In 1609 she commissioned major building works at Somerset House under Simon Basil, the Surveyor of the King's Works. At a cost of around £45,000,[2] this exercise was more expensive than any other building

14 Kenton Couse, *Elevation of Strand Front of Old Somerset House, London*. National Archives (PRO 30/263).

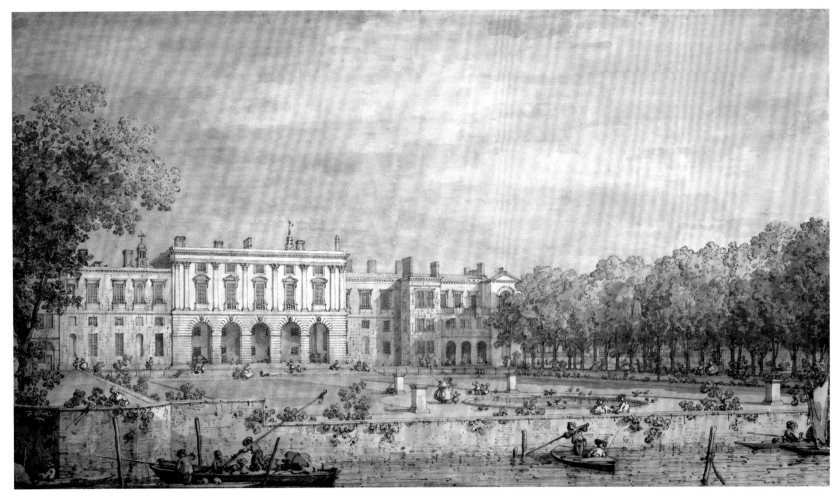

15 Antonio Canaletto, *View of Old Somerset House from the Thames, c.*1750, pen and brown ink, watercolour and wash, 41.3 × 73.3 cm.
Yale Center for British Art, New Haven, Paul Mellon Collection.

project of her husband's reign,[3] and included the creation of a suite of rooms on the *piano nobile* facing the river and backing on to Inner Court: her privy chamber, withdrawing room and state bedchamber.[4] These rooms were later to be used by the Royal Academy (fig. 15). Beyond lay the long gallery, reconstructed for the queen and overlooking a new garden on the east side.

Henrietta Maria, Charles I's consort, was given Somerset House as her dower house in February 1626.[5] Before the Civil War, she commissioned Inigo Jones to make internal alterations, replacing chimney pieces, replastering ceilings and altering panelling.[6] After she went into exile in France the building was used as an army headquarters, while various

apartments were given to state officials. The public had some access for important occasions. One was the dispersal of Charles I's art collection, when viewing and sales took place in the great hall and other rooms; another was the lying-in-state of Oliver Cromwell in 1658, when all the state rooms were draped in black and the body lay in the state bedchamber.[7] At the Restoration in 1660 the palace was reclaimed by the Crown and duly returned to Henrietta Maria, the Queen Dowager, who embarked on further alterations.

Henrietta Maria died in 1669, and although Somerset House officially remained the dower house of successive queens, it was never again in use as a royal residence after the departure to Portugal of Catherine of Braganza, widow

of Charles II, in 1692. Although much of the palace was used as grace-and-favour apartments, it became increasingly dilapidated and was described in 1773 as 'so far neglected as to be permitted to fall into ruin in some of the back parts'. Joseph Moser, who knew the building well since his uncle, George Michael Moser RA, was the first Keeper of the Royal Academy and had official lodgings in some of the queen's rooms overlooking the Thames, vividly described the state rooms, admittedly after the Academy had moved in, on the occasion of a tour of inspection of the eastern part of Somerset House undertaken by Sir William Chambers RA and others:

This old part of the mansion had long been shut up (it was haunted of course) when Sir William Chambers, wishing or being directed to survey it, the folding doors of the Royal bedchamber (the Keeper's drawing room) were opened, and a number of persons entered with the Surveyor. The first of the apartments, the long gallery, was observed to be lined with oak, in small panels; the heights of their mouldings had been touched with gold; it had an oaken floor and stuccoed ceiling…

It was extremely curious to observe thrown together in the utmost confusion various articles… In one part were the vestiges of a throne and canopy of state; in another curtains for the audience chamber, which had once been crimson velvet, fringed with gold… With respect to the gold and silver which were worked in the borders of the tapestries with which the royal apartments were, even within my remembrance, hung, it had been carefully picked out while those rooms had been used as barracks…

Treading in dust that had been for ages accumulating, we passed through the collection of ruined furniture to the suite of apartments… which fronted the Thames. In these rooms, which had been adorned in a style of splendour and magnificence creditable to the taste of the age of Edward the Sixth, part of the ancient furniture remained… the audience chamber had been hung with silk, which was in tatters, as were the curtains, gilt leather covers, and painted screens.[8]

The king soon gave permission for the Academy to move its Schools from its premises in Pall Mall, together with its Keeper, into the state rooms on the river front of Old Somerset House, which took place in 1770, and in January 1771

the *Morning Post* announced: 'notice is hereby given to the members and students that the Academy is removed to Somerset House.'[9]

Approaching from the Strand, visitors to the Academy entered through Protector Somerset's gatehouse and crossed a sloping courtyard that was much smaller than the present expanse. Passing under the arcade added by Anne of Denmark, they first entered the guard chamber, from which they could reach the *piano nobile* rooms facing the river. The Academy's rooms began directly above the arcade shown in Canaletto's drawing, with the 1662 presence chamber (53 × 27 ft, 16 × 8 m), which was used as the main teaching room, and the privy chamber (45 × 28 ft, 13 × 8 m), which became the lecture room. The withdrawing room (32 × 23 ft, 9 × 7 m) immediately to the east (to the viewer's right in Canaletto's drawing) became the library (figs 16 and 17), and what had been the dressing room to its side (E) with the state bedchamber (D) next to it towards the east were the Keeper's rooms. The long gallery (inscribed 'Gallery') farther to the east and running north–south was not part of the Academy's rooms, but the three small rooms behind it (A, B, C), which faced west on to Inner Court and had been used by Anne of Denmark's attendants, were intended for its use.[10] The Academy only claimed them with some difficulty, however, after pressure was applied to Sir James Wright, the courtier, diplomat and art collector whose lodgings they had been. By early 1772 he had surrendered them all to the Academy.[11]

The Academy's tenure of its rooms in Old Somerset House turned out to be short-lived. The Office of Works had reported to the Treasury in 1774 that major work would be required at Old Somerset House, and in May the king agreed that demolition should go ahead. In 1775 an Act of Parliament confirmed that Buckingham House would become the dower house of the queens of England, and that New Somerset House would provide government offices.[12] Government offices had hitherto been scattered through London, usually in ordinary domestic spaces, but these were now to be contained within a specially designed building that would combine many functions on one site. An impressive building would be required in order to reflect the growing power of the state, but who was to design it? In the first instance, the task fell to the Clerk of the Works at Old Somerset House, William Robinson, which did not suit the Academy's Treasurer, Chambers, who had also been Comptroller of the

16 *Plan of Royal Academy Rooms at Old Somerset House*, 1772, inscribed by Sir Joshua Reynolds 'The Academy Library'. Derbyshire Record Office (D3155M/C5263).

17 Kenton Couse, *Plan of Old Somerset House*, detail of river terrace side. National Archives (PRO 30/261).

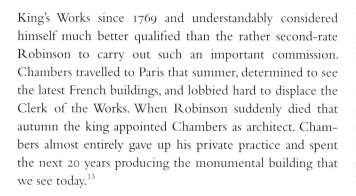

(above) 18 After Thomas Girtin, *Front of the Royal Academy, Strand*, line engraving, diameter 12.5 cm (RA 06/5155).

(right) 19 Thomas Malton the Younger, 'Somerset Terrace', in *A Picturesque Tour through the Cities of London & Westminster*, 2 vols, London 1792–1801 (RA 03/2656).

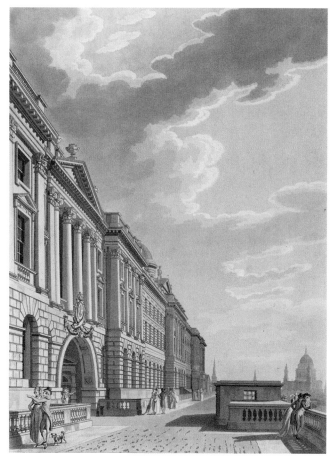

King's Works since 1769 and understandably considered himself much better qualified than the rather second-rate Robinson to carry out such an important commission. Chambers travelled to Paris that summer, determined to see the latest French buildings, and lobbied hard to displace the Clerk of the Works. When Robinson suddenly died that autumn the king appointed Chambers as architect. Chambers almost entirely gave up his private practice and spent the next 20 years producing the monumental building that we see today.[13]

NEW SOMERSET HOUSE

The second Somerset House (often referred to at the time as Somerset Place) occupies exactly the same site as Protector Somerset's house and grounds. Chambers's building was both larger and more symmetrical, however, and designed to provide as much office space as possible. The narrow north frontage now made an imposing addition to the Strand (fig. 18) and opened into a large courtyard, on three sides of which were the main office blocks for the Navy Board and other government agencies.[14] The Thames was to be expensively embanked, with a water gate for river access for the Navy Board's own official barge. The long south front had a spacious terrace (fig. 19) with views across the river that, before the subsequent nineteenth-century embankment, was much wider than it is now.

It was always understood that the Royal Academy would have space in the new building and that, while the gradual demolition of the old palace proceeded, it would remain on site until the new rooms were ready. The Academy was to be in the Strand, or north, block although other societies were now pressing for rooms in the same building, and the Royal

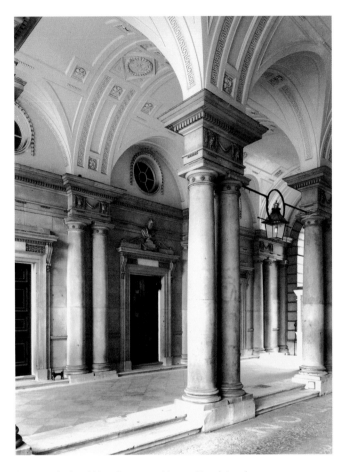

20 Vestibule of New Somerset House, Royal Academy entrance on west side, looking towards Strand on north.

21 Agostino Carlini RA or Joseph Wilton RA, head of Pan and rural group, east side, courtyard of New Somerset House c.1788.

Society and the Society of Antiquaries were duly accommodated. The design of the Strand block is the most ostentatious of the entire ensemble since it faced the public thoroughfare, reflecting eighteenth-century notions of decorum and proclaiming both royal patronage and the high-minded aims of the various societies it housed. The central vestibule (fig. 20), loosely based on the Farnese Palace in Rome of Antonio da Sangallo the Younger (1485–1546), makes a splendid public entrance. The central carriageway is separated from the pedestrian walkways by crisply carved pairs of Roman Doric columns, and the pedestrian flooring is of contrasting grey and purple marbles imported from Sweden.[15]

The courtyard opens up as the visitor moves from the dark vestibule into light, while the view from the courtyard back to the Strand block with its projecting wings presents a grand composition, distinguished by rusticated stonework and fine detailing. The Great Room, or exhibition gallery, in the attic is the centrepiece of this view. It is almost invisible from the street but is much more prominent when seen from the courtyard, with its three blank oval windows draped in festoons amid standing figures of the (then) four continents (by Joseph Wilton RA) and surmounted by the royal coat-of-arms, with Diocletian windows above and behind (fig. 22). Demarcating the Strand block from the offices is a bronze statue of George III accompanied below by an allegorical figure of the River Thames, both by John Bacon the Elder RA, a favourite of the king. It was only the most visible example of an extensive programme of sculpture with which Chambers embellished the building (fig. 21), commissioning work from various Academicians in addition

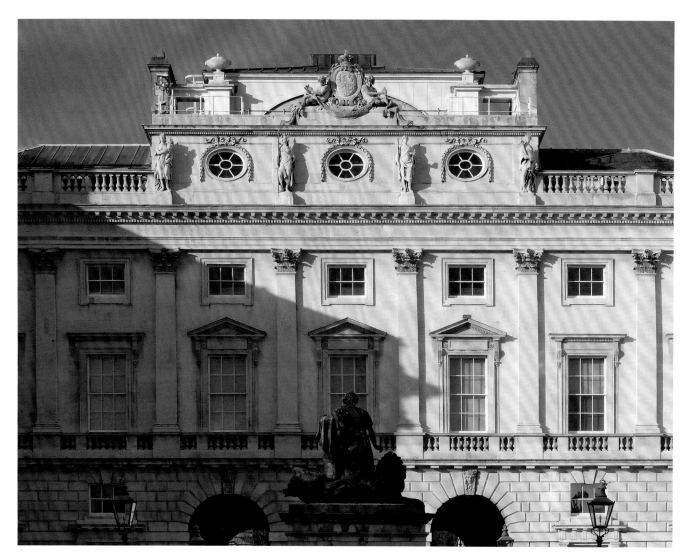

22 North block of New Somerset House with bronze statue of George III by John Bacon the Elder RA in foreground.

to Wilton and Bacon, including Agostino Carlini RA and Joseph Nollekens RA.

The offices ranged round the courtyard were plainer than the Strand block, as befitted their use, but they too were faced in Portland stone, setting a precedent for most subsequent government buildings. The river, still the main transportation artery in London, demanded that the south front of Somerset House seen from the Thames also be a prominent feature. It is, nonetheless, the least impressive part of Chambers's design. Its extreme length and the relatively small dome fail to create a sufficiently forceful composition,

and the effect was further weakened by the 1868–74 construction of the Victoria Embankment, which raised the ground level and cut off part of the basement, damaging the proportions of the elevation (fig. 23).

The Strand block housed the three societies engaged in 'useful learning and the applied arts' in rooms that interlocked and that from the exterior were indistinguishable. The Royal Society and the Society of Antiquaries shared the entrance on the eastern side of the vestibule, while the Royal Academy had its own entrance opposite. (Today these entrances are respectively those of the Courtauld Institute

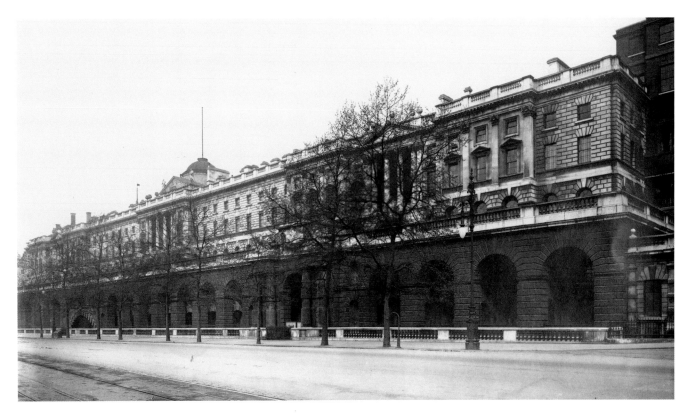

23 South (river) front of New Somerset House, c.1905.

and the Courtauld Gallery.) Accommodation was similar for each institution, although Chambers ensured that the Academy enjoyed slightly finer detailing. For example, although both sides of the block were provided with top-lit D-shaped staircases with ironwork balustrades, that of the Academy was more elaborate. The Academy also had much more space, since it required both teaching and exhibition rooms, in addition to the library and meeting room required by all three societies. Furthermore, while the Society of Antiquaries and the Royal Society shared the first-floor anteroom, the Academy had its own, which doubled as the library.

The Academy's apartments were created by Chambers to enable the institution to fulfil its key functions. The entrance hall was lined with casts after antique figures in togas, and the columnar screen in front of the staircase was flanked by casts of the *Furietti Centaurs* (fig. 24). Narrow stairs wind obscurely from the entrance hall down to the deep basement, where the Keeper had his subterranean rooms. Chambers rather wittily conceived them as a house within a house, with its

own façade and 'front door', perhaps (ultimately) a reference to such ingenious conceptions as the Dwarves' Apartments in the Palazzo Ducale, Mantua. In contrast with the Keeper's airy quarters on the river front of Old Somerset House, these new rooms were so gloomy that Moser soon moved out. On the ground floor was the 'Academy of the Living Model' (fig. 25), a utilitarian room for the life class, well proportioned but plain, containing small casts, reliefs and terracottas. On the *piano nobile* the Anteroom or Library, facing into the court-

(facing page, top) 24 George Johann Scharf, entrance hall of New Somerset House, 1836, watercolour, 45.7 × 68.6 cm. British Museum, London (1900,0725.12).

(facing page, bottom) 25 Thomas Rowlandson and Augustus Charles Pugin, 'Drawing from Life at the Royal Academy, Somerset House', in Rudolph Ackermann, *Microcosm of London*, London 1808–10, vol. I, pl. 1, etching aquatint and watercolour, 19.7 × 26 cm (RA 03/6172).

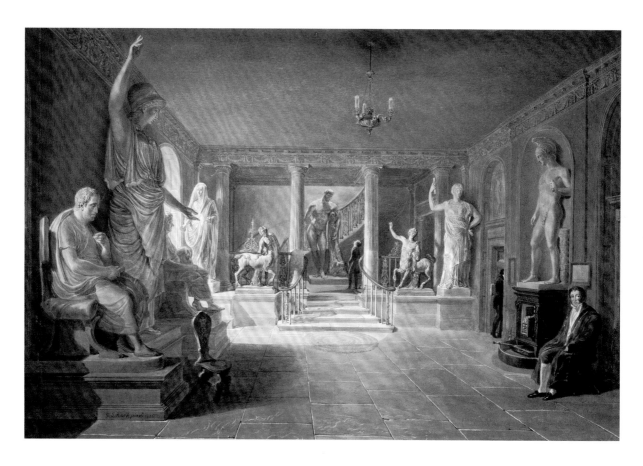

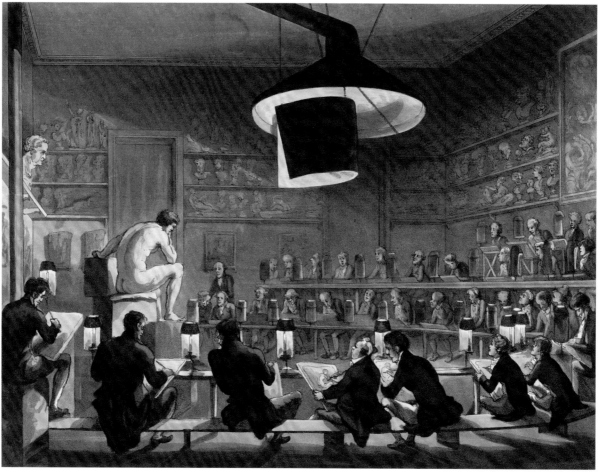

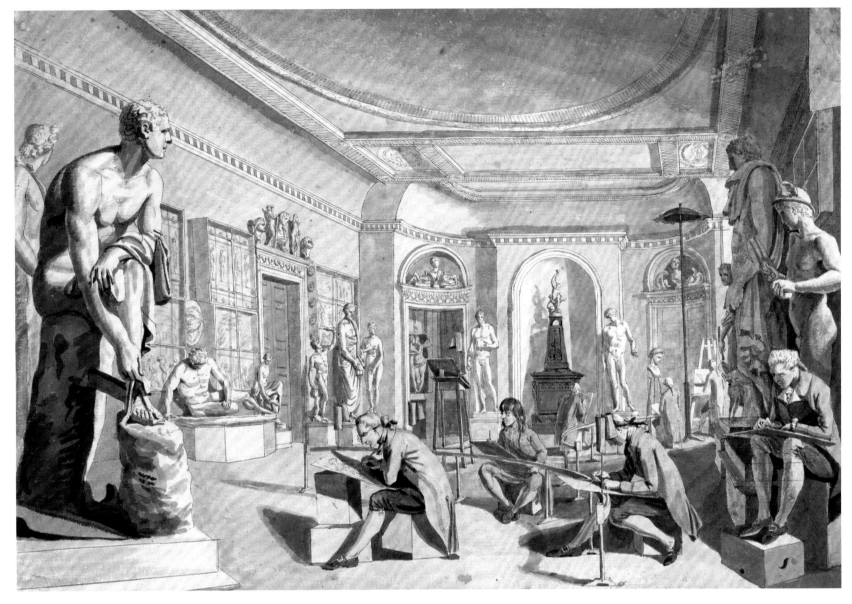

26 Edward Francesco Burney, *Antique School at New Somerset House*, c.1780, pencil and watercolour, 33.5 × 48.5 cm (RA 03/7484).

yard, was small but elegant, fitted up for books and with cases for the modest collection of prints. To the left, towards the Strand side, it gave on to the 'Academy of the Antique' (the terms 'School' and 'Academy' were used interchangeably when referring to the two classes, which were also often referred to as 'the Antique' or 'the Life'). Here the students drew from casts in a large room that was given an elaborate architectural treatment including an apsidal west wall with

doors in niches (fig. 26). Next, towards the east, still on the Strand side, was the second room of the Academy of the Antique, also lined with casts, which also functioned as the Council Room. Since it was the focal point for the governance of the institution, it was the most splendidly decorated room of all. Joseph Wilton carved the chimney pieces on the end walls, and the elaborate plasterwork of the ceiling, designed by Chambers in his rather heavy version of the

neoclassical style, provided the setting for paintings by Benjamin West PRA and Angelica Kauffman RA that are now in the entrance hall at Burlington House, having been transported to each of the Academy's homes (see fig. 53).

Other Academicians provided paintings to decorate these elaborate rooms. Joshua Reynolds, for example, created the central panel for the ceiling of the Library, the *Theory of Art* (now in the Academy's Library at Burlington House), while Giovanni Cipriani painted the allegories in the coving, '*Nature, History, Allegory* and *Fable*, the sources from which the chizzel [*sic*] and the pencil gather subjects for representation',[16] and the stairs were also decorated with panels by Cipriani. We might have expected the Academicians to have donated their work, but in fact they were paid quite generous sums by the Treasury: another instance, perhaps, of Chambers looking after the interests of his fellow members.[17]

Joseph (Giuseppe) Baretti, in his invaluable *Guide through the Royal Academy* of 1781, glosses over the problems of the staircase, saying merely that 'the stair, though winding, is easy and convenient',[18] which was simply not true, and its vertiginous ascent became notorious. Exhibitions took place in the Great Room in the attic storey, and so the public had to struggle up what is a very steep and quite narrow cantilevered staircase, past the high-ceilinged main and second floors, before arriving at their goal. The stair rail was worryingly low, the risers steep and the treads too narrow for either comfort or safety. Rowlandson brilliantly captured the travails of smartly dressed and not-so-young ladies negotiating the stairs in his well-known satirical drawing *The Stare-case* (fig. 27), which was much reproduced as a print. Once reached, however, the Great Room was undeniably a major achievement and rightly described by Baretti as 'the largest, and certainly the best of that sort in London, as the light is everywhere good and equal…Its length is 53 feet, its width 43, and its height 32.'[19] It was lit from above by four Diocletian windows that cast an even light over the walls. The upper part of the walls, as in subsequent exhibitions, was temporarily canted outwards and densely hung with paintings at the Annual Exhibition (fig. 28).

Chambers's New Somerset House, despite some shortcomings, was capable of impressing even the waspish Horace Walpole. Naturally, he attended the first Annual Exhibition to be held in the new building in 1780 and reported: 'You

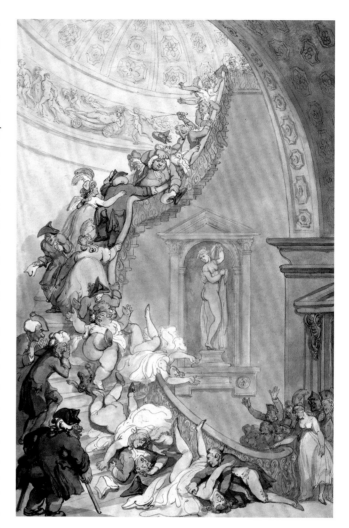

27 Thomas Rowlandson, *The Stare-case*, c.1800, watercolour and pen and ink, 44.5 × 29.7 cm. Yale Center for British Art, New Haven, Paul Mellon Collection.

know, I suppose, that the Royal Academy at Somerset House is opened. It is quite a Roman palace, and finished in perfect taste as well as boundless expense.'[20]

THE ROYAL ACADEMY AND THE NATIONAL GALLERY IN TRAFALGAR SQUARE

The first half of the nineteenth century saw the establishment of public art galleries across Europe. What had often formerly been royal collections were now being housed in

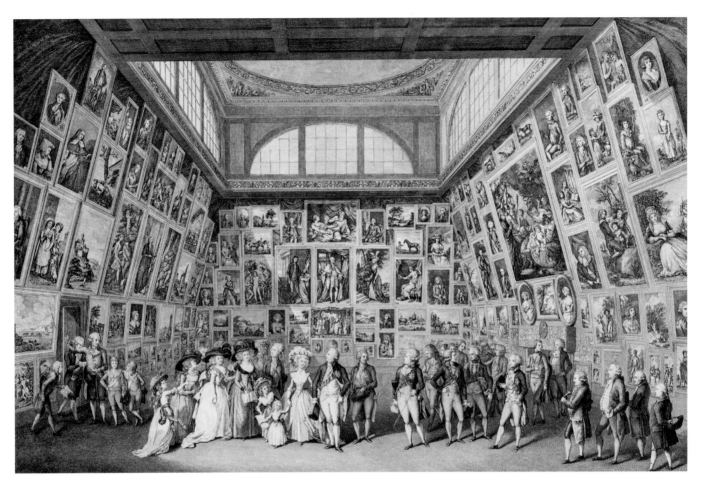

28 Pietro Antonio Martini after Johann Heinrich Ramberg, *Exhibition of the Royal Academy, 1787*, engraving, 32 × 49.1 cm (RA 06/5356).

purpose-built structures. The United Kingdom was exceptional in that the Royal Collection remained determinedly private. There was therefore an increasing demand for the creation of a separate national gallery of art, which was initiated by the government's acquisition of 38 Old Master paintings from the collection of Sir John Julius Angerstein after his death in 1823. It was followed by the bequest of other major works by Sir George Beaumont four years later. The nucleus of a national public collection thus formed meant that there was a need to provide more capacious accommodation than that afforded by Angerstein's town house on Pall Mall. It was a time of large-scale planning projects in London, and so the government determined to construct a new building capable of housing both the National Gallery and the Royal Academy of Arts.[21] The site

selected was on part of what had once been the extensive Whitehall Palace, Crown land that extended all the way from Parliament Square to Trafalgar Square. In 1731 William Kent had designed the Royal Mews, which filled the northern part of what is now Trafalgar Square. In the following century the royal family now used not only St James's Palace but also Buckingham House yet further to the west. Kent's stables had become redundant and were demolished in 1830, at which point Trafalgar Square was given its name. It had been formed as part of a vast urban planning scheme devised by John Nash that replaced Carlton House and its gardens with Carlton House Terrace and created Lower Regent Street and Regent Street. Trafalgar Square, as it became, was an open space along Nash's new street running from Charing Cross all the way via Regent Street to Portland Place, con-

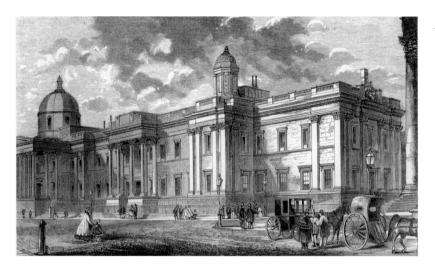

29 Attributed to Edmund Evans, 'East Wing of the National Gallery', woodcut, frontispiece to vol. I of William Sandby, *The History of the Royal Academy of Arts*, London 1862 (RA 06/5154).

necting the heart of London with Nash's newly laid out Regent's Park. It was decided to house the National Gallery and Royal Academy in a new building on the north side of the square (fig. 29).

The Academy was delighted to be part of the National Gallery building, as it would have more room there than in Somerset House, and it would give both the Academicians and the students ready access to the collection. The Council was, however, concerned that its tenure of the new premises might be less secure than at Somerset House. The Secretary, Henry Howard RA, was summoned before a committee of the House of Commons, and 'examined as to the apartments occupied by the Royal Academy, and the nature of their tenure'.[22] Council was assured that the Academy would be as secure in Trafalgar Square as at Somerset House, and the Prime Minister added: 'in the very distant and not very probable event of the space now assigned to the National Gallery becoming insufficient, I should hope that means might be found for making such additions as might become necessary without interfering with the Royal Academy.'[23] Unfortunately for the Academy this was not to be the case, and three decades later it was once again negotiating with the government for new premises.

No public competition was held for the new building on Trafalgar Square, and although schemes were submitted by

John Nash and C. R. Cockerell, in 1832 William Wilkins RA, who had already designed Downing College, Cambridge, and University College London, was awarded the commission. Indeed, Wilkins claimed to have identified the site for the gallery: 'The site was about to be converted into shops, and seeing a very magnificent site, I took the liberty of calling at Lord Dover's and Lord Aberdeen's, and suggested there would be the site for the National Gallery, if one was to be erected.'[24] It did, however, have some disadvantages. A barracks had already been built behind the proposed gallery/academy, and the Duke of Wellington insisted that Trafalgar Square (as it came to be known) would have to be easily accessed by the army in case of civil unrest. This was the period just before the Reform Bill was passed in 1832, when mob violence was a real possibility, and so provision was made for a passage to pass beneath the west wing, connecting the barracks and the square. The east wing in turn had a right of way through it leading to St Martin's Workhouse. These passageways can be seen behind the smaller porticoes to either side on the main entrance on Wilkins's plan (fig. 30).[25] Another problem was the adjacent church of St Martin-in-the-Fields. Thomas Gibbs's 1722 church in St Martin's Lane has a magnificent portico that, at the time, could only be seen at an angle, owing to the narrowness of the street upon which it sat. If an impressive new public space were to be created, it was felt that the west front of the church should be part of it, which led to the National Gallery building's being 'thrust back fifty feet' towards the barracks, consequently reducing the light from the north. Wilkins railed against this and 'the gentlemen amateurs [who] chose to thrust us up into a corner where we could get no light'.[26] But it was in vain, and so the building had to be long but shallow, filling the whole of the northern side of the square, the National Gallery to the west and the Royal Academy to the east, with a shared portico in the middle.[27]

The National Gallery was Wilkins's last major work, and not one of his most successful. In 1832 the Treasury agreed that a Portland stone building costing up to £50,000 should be constructed, providing that the portico consisted of columns that had been rescued from the demolition of the Prince Regent's Carlton House in 1827.[28] The requirement to use these columns, which were of a domestic proportion, on a much larger public building was to cause Wilkins many problems, and in the end only the capitals and bases were

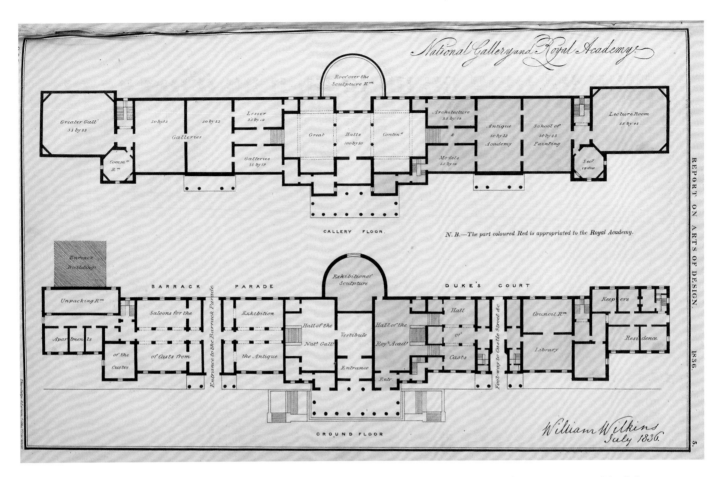

30 Coloured plan by William Wilkins RA of the National Gallery and Royal Academy building July 1836, in *Report of the Select Committee on Arts & their Connexion with Manufactures*, London 1836, facing p. 98.

used (and only in the side openings), while new columns were carved for the portico. The length of the building (461 feet or 140 metres) was also hard to handle, especially when it was only two storeys high, and so it was raised 12 feet in order to lend it more presence on the square. There were windows on the ground floor with narrower blank windows above, since these were on the walls of galleries that were designed to be lit only from above. The only vertical elements breaking the long, low roofline were the small 'pepper-pot' towers over each wing and the rather small central dome, all with fish-scale ornament in stone and lead respectively. These were not dominant enough to hold the length of the building – a similar problem to that encountered by Chambers in the river front of Somerset House. As a Greek Revival architect, Wilkins's style was austere, and money was

also tight, so there is not even any of the rich sculptural ornament we see at Somerset House. Instead, the design relies for its effect on the projections and recessions of the façade and the fine quality of the ashlar.[29]

The final cost, £75,883, was half as much again as the original Treasury forecast.[30] The Royal Academy, a private body, was in effect gaining its building out of public funds, and Wilkins and others, including the President, Sir Martin Archer Shee, were summoned before a select committee to defend themselves. The questioning by a group of radical Members of Parliament was hostile, with art academies generally being described as 'injurious to the arts' and the Royal Academy in particular having 'a baneful influence'.[31] William Ewart, the chairman, was unhappy about public funds being used for a private organization that only admit-

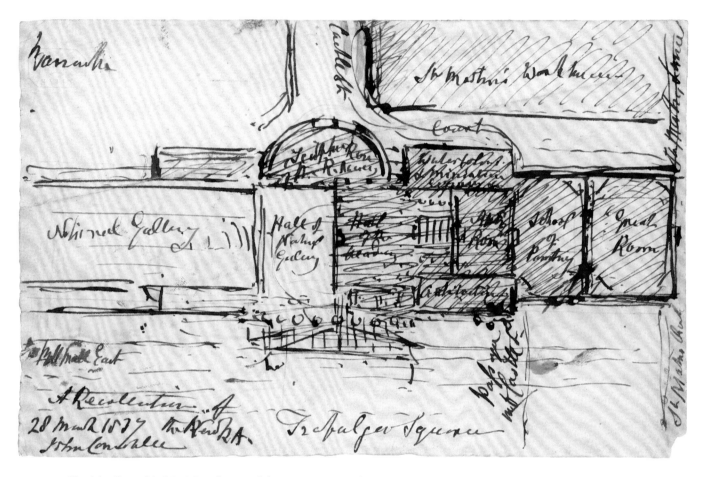

31 John Constable RA, *A Recollection of the New RA, 28 March 1837*, pen and brown ink sketch plan of part of ground floor, 34 × 25.4 cm. Yale Center for British Art, New Haven, Paul Mellon Collection.

ted the public to paying exhibitions – unlike the National Gallery. Nor did he approve of the provision of residential space for the Keeper, at the expense of possible gallery space. He pressed Wilkins as to how the Academy spaces could be converted into public spaces if required. Wilkins did not come well out of this: he was in late middle age and irascible, and indeed died three years later, still unhappy about his treatment over the National Gallery project.

The Royal Academy now had significantly more space although, as in Somerset House, not much of it was dedicated to teaching. Its entrance was on the east side within the portico, while the National Gallery had the main door in the centre. The entry lobby of the Academy opened into the large staircase hall that contained a cast of the massive Farnese Hercules, offering access to a large semicircular room to the

north, where sculpture was displayed. To the east, the main teaching room on the ground floor was the Hall of Casts, filling the whole depth of the building and lit from both sides. Here the Royal Academy's large cast collection was displayed. John Constable RA, who visited the new building in March 1837, three days before his death, made a quick sketch from memory of the interiors, marking on it the teaching rooms, which he gave to a friend (fig. 31).

Further towards the east was the public right of way running through the building, with beyond it the north-facing Council Chamber and south-facing Library, which were more private and better-furnished rooms for the use of Academicians.[32] In the eastern pavilion was the Keeper's apartment, six good-sized rooms on the ground floor with service rooms in a rather dark basement.[33] The lodging had

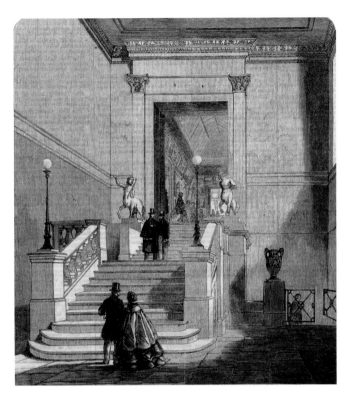

32 Stairs to exhibition rooms of the Royal Academy in Trafalgar Square, *Illustrated London News*, 18 May 1861 (RA 08/2650).

a wide central corridor and its own private entrance on the east side of the building, which is presently the entrance to the National Gallery café. It was much better accommodation for the Keeper than had been provided by Chambers in Somerset House.

The upper floor was designed primarily as exhibition space (fig. 32), but for much of the year it was also used for teaching, as the ground floor had only two good-sized rooms for the students to work in. It was much more convenient than Somerset House for the display of pictures and the comfort of visitors. Instead of the top-floor Great Room at Somerset House, five rectangular rooms of various sizes, reached by a wide staircase, exactly mirrored the space provided for the National Gallery in the west wing. These upper rooms were, as noted above, all windowless but were illuminated by cast-iron skylights, following current ideas on the best form of lighting for the display of art. The first two of these spaces were the Architecture and Medal Rooms, set above the Hall of Casts, with the much larger Antique

Academy and School of Painting lying beyond, rather pleasingly reflecting the approved progression of a student from drawing to painting. The Lecture Room was in the east pavilion, above the Keeper's lodgings, while the nearby octagonal room facing over Trafalgar Square was originally intended for the use of the Secretary but was later added to the exhibition space, although access to it was awkward.

The Academy also had use of the space in the central dome. This may appear insignificant in relation to the whole building, but the dome contains a surprisingly large room, known as 'the pepper-box', which allowed life classes to continue to be held in the summer despite the presence of the Annual Exhibition.[34] It is one of the very few interiors in the whole building not to have been drastically changed, and is still a circular space open into the dome, with unplastered walls showing the brick construction of the walls behind their ashlar facing, and with iron supports visible inside the dome. The three large north-facing windows, which are invisible from the surrounding streets, still have their original cast-iron frames, and two of the grilles to the other openings were left unglazed so that fresh air could circulate. About 25 students could have worked here, in addition to the model, albeit in fairly spartan conditions. Far below, the whole of the basement of the building was for staff and storage: the housekeeper had a small apartment opening on to the north area; an internal bedroom was for the 'Men-Servants' with another, larger, for the 'Women-Servants'; there was a large kitchen and several cellars, three for wine and beer, a coal cellar and a large storage cellar, all of them on the windowless south front.[35]

The move to Trafalgar Square witnessed the first transfer of those ceiling paintings (usefully on canvas) by Benjamin West and Angelica Kauffman referred to above. West's was set in the ceiling of the new Council Chamber, Kauffman's in the Library. The great Michelangelo tondo bequeathed to the Academy by one of the National Gallery's principal benefactors, Sir George Beaumont, was also installed in the Library, on the wall above the fireplace.[36] There was new-fangled gas lighting throughout, with a large lamp in the staircase hall, and extra lighting was ordered for the Life Academy and Antique School,[37] all of which must have provided some warmth at least in these otherwise unheated rooms.

The Royal Academy held a final dinner in Somerset House on 17 December 1836, just before moving into its

new building.[38] William IV attended the opening of the first Annual Exhibition in the new galleries on 28 April 1837, accompanied by the Duchess of Kent and the young Princess Victoria. It was one of Victoria's last public appearances as heir to the throne, as her uncle died just a few weeks later. The public opening was on 1 May.

ON THE MOVE AGAIN

The new spaces soon proved inadequate for both the Academy and the National Gallery. In 1844 the Academy asked James Pennethorne to open up the back of the central block so that there was more space for the display of sculpture, and in 1847 the National Gallery asked him for additional exhibition space above that on the first floor. It was not built until 1860, when the Academy also gained two interconnecting spaces flanking the semicircular Sculpture Room at the back, a modest increase in space.[39] In the 1880s major alterations designed by Sir John Taylor – after the departure of the Academy for Burlington House – meant that Pennethorne's rooms were demolished. They had lasted barely 20 years.

As the collections of the National Gallery increased, it had become clear to the Academicians that their tenure of half of the Wilkins building was unlikely to last, an appreciation aided by the fact that their President since 1850, Sir Charles Eastlake, had since 1855 also been the National Gallery's first director. In 1865 the Academy was given notice that it must leave the Trafalgar Square building, and a letter from the First Commissioner of Works, confirming that 'it was necessary to terminate as soon as possible the joint occupation of that building', also enquired: 'I wish to ascertain whether the members of the Royal Academy desire a site at Burlington House, on which they may build out of their own funds.'[40] At first, however, nothing happened. Eastlake was away in Italy and instead of dealing with the situation became too ill to return and died there later that year. It was his successor as President of the Academy, Sir Francis Grant, who was to deal tactfully and efficiently with the move to Burlington House, which took place gradually from 1869. The National Gallery, having also been threatened with a move, instead now took over the whole of the Trafalgar Square building, enlarging its gallery space and public areas.[41]

BURLINGTON HOUSE

Visitors to the Royal Academy today may be unaware that they are entering one of the oldest palaces in London's West End. Burlington House was begun in 1665 as a private house, altered in the early eighteenth century by the 3rd Earl of Burlington, rendered more symmetrical from 1815 to 1818 by Samuel Ware for Lord George Cavendish, then fairly radically transformed for the Royal Academy between 1868 and 1874, when the wandering Academicians were finally able to set up home on a sufficiently large and permanent site. The entrance hall, however, is noticeably low and wide, a reflection of the building's domestic origins in the seventeenth century. Set into the ceiling are the allegorical paintings by the Academicians Benjamin West and Angelica Kauffman (fig. 33) painted for the Academy's first purpose-built home, New Somerset House on the Strand. A wide central staircase invites visitors to rise to the exhibition rooms beyond. At the half-landing are two large early eighteenth-century mythological paintings by the Venetian artist Sebastiano Ricci, while at the top of the stairs on either side are over-life-size bronze statues of Thomas Gainsborough RA and J. M. W. Turner RA. A large vestibule leads into a grand suite of beaux-arts inspired, top-lit exhibition rooms designed by Sydney Smirke RA in 1866–7 (see fig. 51). They were first used for what became known as the Summer Exhibition in 1870 and provide one of the largest purpose-built spaces in London for the display of art, attracting around one million visitors every year. Beneath the northern suite of galleries lie, hidden from public view, the Royal Academy Schools with Cast Corridor, Life Room and studios, while countless offices are tucked into basements, mezzanines and attics, with much space previously given over to workshops and storerooms. The Library and Print Room sit on the third floor next to what were the Diploma Galleries, now the Sackler Wing of Galleries.

THE STORY OF BURLINGTON HOUSE

When St James's Square and its surrounding streets were developed as a fashionable residential area after the Restoration in 1660, its northern boundary was a new street called Piccadilly. The developer, Henry Jermyn, Earl of St Albans, realized that a new church would give the area a sense of

33 Angelica Kauffman RA, *Colour*, 1778–80, oil on canvas, 130 × 150.3 cm (RA 03/1130).

identity, and so he asked his friend Christopher Wren to sketch out a design for what was to become St James's, Piccadilly. With the transformation of an area that had previously been orchards and grazing, plots on the north side of Piccadilly became attractive potential sites for large town houses for the aristocracy. The diarist Samuel Pepys, always alert to developments in London, remarked in February 1665 on the three substantial free-standing houses which were then going up: 'Then we back again [from Whitehall] and rode into the beginnings of my Lord Chancellor's new house near St James's and very noble I believe it will be. Near that is my Lord Berkely [*sic*] beginning another on one side, and Sir J. Denham on the other.'[42] These three houses were Clarendon House, designed by Roger Pratt for the 1st Earl of Clarendon and demolished only 20 years later; Berkeley House, designed by Hugh May for the 1st Lord Berkeley of Stratton and demolished in 1733; and Sir John Denham's house, the only one to survive, now the home of the Royal Academy.

As a competent government administrator but not an architect, Denham probably asked someone in the Office of

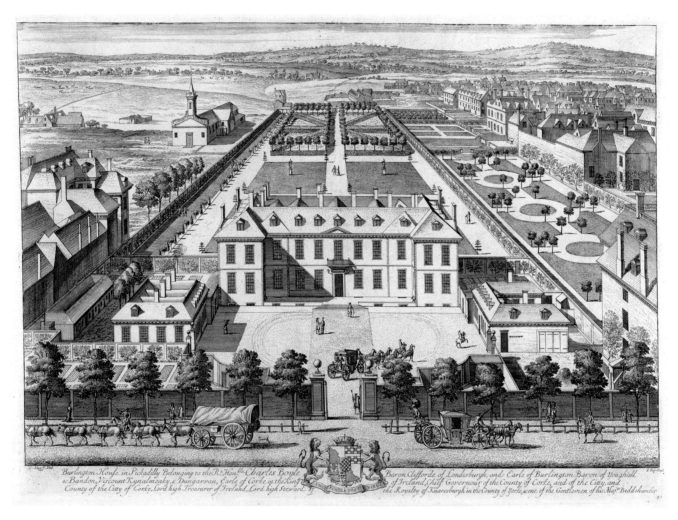

34 Johannes Kip after Leonard Knyff, 'Burlington House in Pickadilly', *c.*1700, in *Britannica Illustrata*, London 1707, etching, 32.5 × 47.8 cm (RA 05/3704).

Works to design his new house. Kip and Knyff's bird's-eye view (fig. 34) shows us the high wall hiding the house from Piccadilly, the south front, the forecourt flanked by two pavilions with small service areas behind them, and formal gardens to the north.[43] It was a typical Restoration house, similar to many going up in the country and suburbs: indeed, it was on the edge of London in Denham's time, with views of open country at the back, and its 3½ acre (1.2 hectare) site was comparable to many suburban houses. Denham's house still forms the core of Burlington House, although its brick walls are hidden by later stone facings, and the forecourt has been completely rebuilt. The entrance hall today is made up

from two front rooms of Denham's house and its staircase compartment knocked into one, hence its slightly uncomfortable proportions: long and low.[44]

 The house was built of brick with stone quoins, a truncated H-plan 11 bays wide. The north front, similar but not identical to the entrance front, overlooked large gardens reaching up to the present Conduit Street. A drawing by Samuel Ware records this front *c.*1812, and shows the stone steps and ironwork railings from the anteroom into the garden (fig. 35). At this date few changes had been made to this side: only the lowering of the tall chimneys and a small addition on the east side.

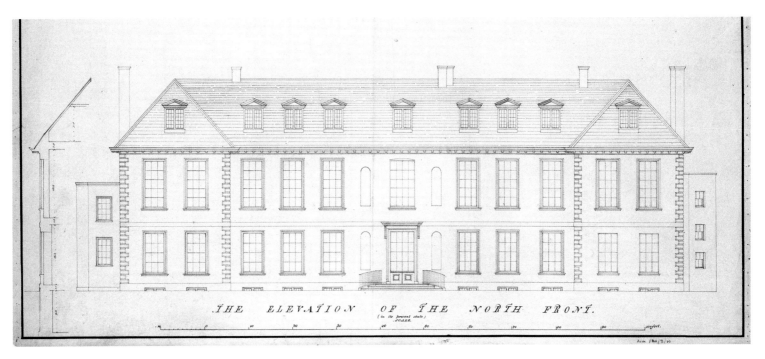

THE ELEVATION OF THE NORTH FRONT.

35 Samuel Ware, survey of north front of Burlington House, c.1812, pen with black ink, 47 × 70.5 cm (RA 06/5831).

Denham did not complete the house, and he sold it only days after his wife's death in 1667 (theirs had been a troubled marriage). The buyer was Richard Boyle, 2nd Earl of Cork, who had substantial estates in Ireland and Yorkshire. In 1664 he had been created 1st Earl of Burlington, and as he now possessed an English title in addition to his Irish peerage, and therefore a seat in the House of Lords, he required a large London house. Burlington House, as it has been called from that time to this, was to remain in his family until the mid-nineteenth century. Hugh May was appointed to finish the house, which seems to have been only a carcase when sold, and with the two single-storey pavilions in the forecourt still not built.

Burlington's building works were hampered by the difficulty of getting materials and workmen at a time when the City was being rebuilt after the Fire of 1666, and it was spring 1668 before he could move into his new house. Soon afterwards it was rated at 41 hearths, making it one of the largest houses in Westminster.[45] A complete set of plans belonging to the Royal Academy shows the layout of his house. It was a double-pile house, the entrance hall leading directly to an anteroom, which was a rather dark room lit only by the glazed door to the garden. This was flanked by two reception rooms on the garden front, with lodgings in the north-west and north-east cross-wings. In the former, still on the ground floor, were the Burlingtons' apartments, destroyed when Norman Shaw RA's staircase was inserted (1881–5). In the south-east angle was a double-height chapel (consecrated in 1668), with a family gallery that could be approached on the first floor (the household would have used the ground-floor entrance).[46] The main staircase, which was to the east of the entrance hall, led up to a first-floor saloon or 'great dining room' overlooking the forecourt, while on the opposite side an enfilade of reception rooms overlooking the gardens reflected the lay-out of the rooms below. The state bedroom was at this level in the north-west, above the Burlingtons' room, and again overlooking the gardens. The top floor was for servants, with some large spaces and smaller rooms lit by dormer windows.[47] Although the spine wall running east–west is substantial, many of the rooms have only thin partition walls, suggesting that Burlington wanted to finish the house as quickly as possible; and it is a surprisingly irregular plan for its date. We know very little about the appearance of these rooms, except that they

were panelled. There may have been elaborate plaster ceilings, because John Grove, Master Plasterer at the Office of Works, was employed, but none has survived and there are no contemporary descriptions of the interiors. Needless to say, Pepys was an early visitor, but he tells us frustratingly little about it, except that his wig caught fire there.[48]

BURLINGTON HOUSE 1710–1854

Major changes were made to the Restoration house in the early eighteenth century by the 2nd Countess Burlington and her son, the 1st Earl's grandson, Richard Boyle, 3rd Earl of Burlington. He inherited his titles as a boy, and grew up to be a noted amateur architect and an effective promoter of the Palladian revival.[49] Outside, the forecourt was the first area to be tackled, in about 1714–16, with the pavilions provided with an upper storey and refaced in stone by the Scottish architect James Gibbs, who had trained in Rome (and may already have worked on the interior of the house). The other major change to the forecourt was the replacement of the brick quadrant walls that linked the main gate with the pavilions. These now became a magnificent stone colonnade with Roman Doric columns and a balustraded parapet, inspired by Bernini's great curved colonnade at St Peter's in Rome. It was almost certainly also designed by James Gibbs, although there is no documentary proof. Horace Walpole described it: 'Soon after my return from Italy I was invited to a ball at Burlington House. As I passed under the gate, by night, it could not strike me. At day-break, looking out of the window to see the sun rise, I was surprised with the vision of the colonnade that fronted me. It seemed one of those edifices in fairy tales that are raised by genii in a night's time.'[50]

When these new buildings round the forecourt had been completed, the brick front of the main house must have appeared somewhat homely, and so the young Lord Burlington, back from his first Grand Tour in Italy and full of enthusiasm for Palladio, invited Colen Campbell to reface the south front of the house in stone. This was done 1717–20 and Campbell was also commissioned to redesign the 'Great Gate' or entrance from Piccadilly. Campbell, another Scot, was a rival of Gibbs and was promoting the Palladian Revival through the three volumes of his *Vitruvius Britannicus*, published in 1715, 1717 and 1725 respectively. These handsome

folios included plans, elevations and sometimes bird's-eye views of various great houses in Britain, preferably those built in the new Palladian style, some of them designed by Campbell himself. He managed to omit any mention of Gibbs's work at Burlington House, although he recorded its plan (including the colonnade) and the front of Burlington House in his 1715 (first) volume, and his own designs for the refaced front and the 'Great Gate' in the 1725 (third) volume (figs 37–9).

A print of 1732, *Of Taste*, made fun of Burlington's pretensions and showed William Kent, his protégé (discussed below), crowning the pediment while Raphael and Michelangelo look up towards him. It was derived from William Hogarth's print *Masquerades and Operas* (1724). According to Hogarth in in the *Daily Courant* of 24 February 1724, his print satirized the 'bad taste of the town' and also showed William Kent on top of the pediment of the new Burlington Gate, lording it over Michelangelo and Raphael, who look up admiringly towards him. Remarkably, Hogarth also inscribed the entrance 'Accademy [sic] of Arts' (fig. 36).

36 William Hogarth, *Bad Taste of the Town (Masquerades and Operas)*, 1724, engraving, 15.5 × 17.7 cm (RA 08/1354).

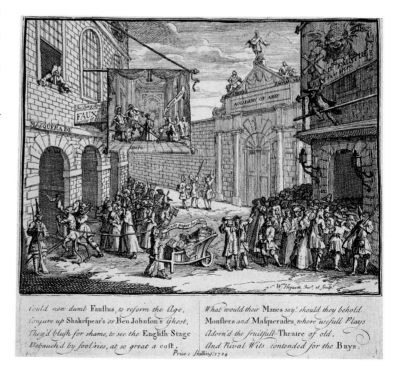

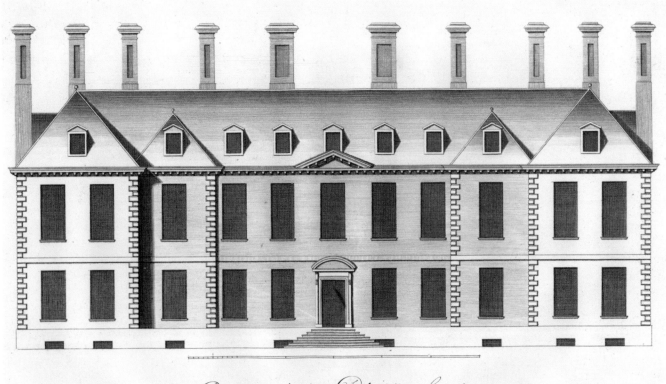

Burlington house in Pickadilly London

To the Right Hon.ble Richard Boyle Earl of Burlington and Cork &c.
Hereditary Lord High Treasurer of the Kingdom of Ireland

37　Henry Hulsbergh after Colen Campbell, 'Burlington House in Pickadilly London', 1715, in *Vitruvius Britannicus*, London 1715, vol. 1, pl. 32, line engraving, 25 × 37.6 cm (RA 08/1362).

38　Henry Hulsbergh after Colen Campbell, 'Burlington House in Pickadilly' (elevation of south front), 1715, in *Vitruvius Britannicus*, London 1725, vol. 3, pls 23–4, line engraving, 25.1 × 50.3 cm (RA 07/3235).

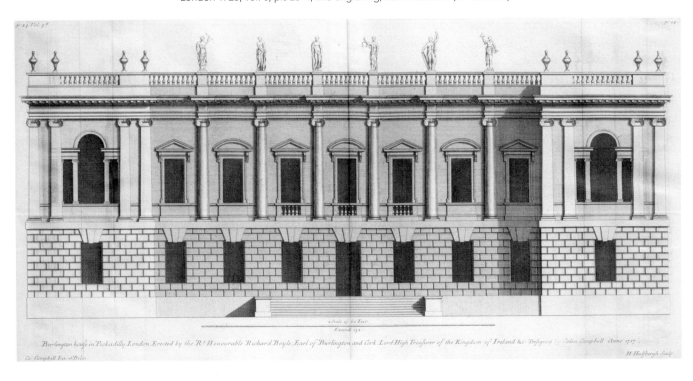

Burlington house in Pickadilly London. Erected by the R.t Honourable Richard Boyle Earl of Burlington and Cork Lord High Treasurer of the Kingdom of Ireland &c. Designed by Colen Campbell Anno 1717.

Co: Campbell Inv. et Delin:

H. Hulsbergh Sculp.

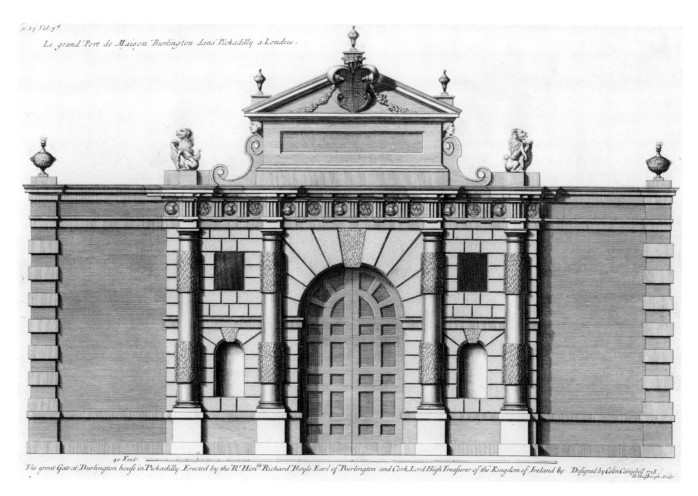

p. 25. Vol. 3.ᵈ

Le grand Port de Maison Burlington dans Pickadilly a Londres.

The great Gate at Burlington house in Pickadilly Erected by the Rᵗ Honᵇˡᵉ Richard Boyle Earl of Burlington and Cork Lord High Treasurer of the Kingdom of Ireland &c: Designed by Colen Campbell 1718.

39 Henry Hulsbergh after Colen Campbell, 'The Great Gate of Burlington House in Pickadilly, 1718', in *Vitruvius Britannicus*, London 1725, vol. 3, pl. 25, line engraving, 25 × 37.6 cm (RA 08/1354).

Some of the interiors were also refashioned by the 2nd Countess and her son, and three Venetian artists, Giovanni Antonio Pellegrini and Marco and Sebastiano Ricci, provided decorative paintings to adorn the interiors. Pellegrini was in London from 1709 to 1713, and his paintings, created in collaboration with Marco Ricci, may have been for a ground-floor room (possibly the 'garden room'). In the late 1720s Lord Burlington gave them to his friend Sir Andrew Fountaine, who installed them in his country house, Narford Hall in Norfolk, where they still hang.[51] Sebastiano Ricci, who arrived in London in 1711, was commissioned by the 2nd Countess to provide paintings for the staircase compartment then being redesigned, possibly by James Gibbs. These were the *Triumph of Galatea* (fig. 40) and *Diana and her Nymphs*,

which are now to be seen on the main staircase in the centre of the present building, and also the *Meeting of Bacchus and Ariadne*, subsequently inserted into the ceiling of the General Assembly Room (previously the state dining room). The ensemble was crowned by a ceiling painting, *Cupid before Jupiter*, which is still *in situ* in what is now the first-floor Council Room, a space fashioned out of the upper part of the former staircase.[52]

Some first-floor rooms on the south front, known as the Fine Rooms, were also remodelled: the work of William Kent, who lived in the house (and at Burlington's Chiswick House) as Burlington's guest after they both returned from Rome at the end of 1719. As the splendid Saloon shows, they took their inspiration from both Roman baroque and Pal-

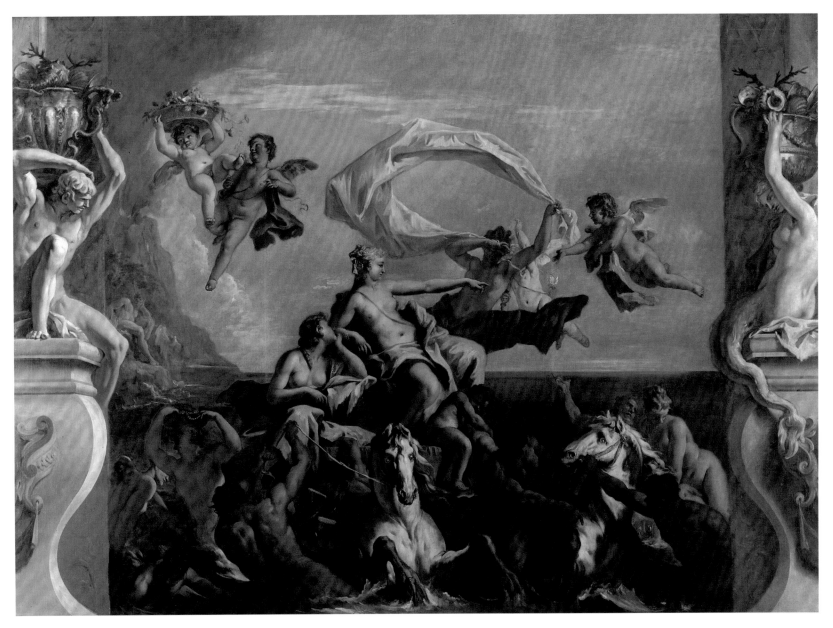

40 Sebastiano Ricci, *Triumph of Galatea*, 1713–15, oil on canvas, 347 × 482 cm (RA 03/188).

ladian interiors, with architectural cornices and pedimented doorcases topped by exuberant putti carved by Giovanni Battista Guelfi ('Guelphi') (fig. 41), an Italian sculptor who had been encountered in Rome by Kent and/or Burlington. A white-and-gold colour scheme, inspired by the interiors of Inigo Jones, replaced the dark wainscot. Kent had begun his career as a painter (in Rome he painted the ceiling of San Giuliano dei Fiamminghi, still *in situ*) although his career developed in the direction of architecture, interior design and garden design, notably at Chiswick House, occupations for which he was much more fitted. Kent made ceiling paintings for some of the ceilings in Burlington House in about 1720, although only two of them are still visible. The first, which Kent mentioned as early as January 1720, was in the Saloon,

a canvas of the *Banquet of the Gods*, where his oil-on-plaster decoration of the coving was painted over in the later eighteenth century. Fragments of Kent's painted decoration on the coving in the Saloon have recently been uncovered, as well as traces of a later scheme that had been superimposed upon it by the well-known firm of J. D. Crace in the 1890s.[53] The adjoining Secretary's room (now the Slaughter Room) has a Kent ceiling painting on plaster, *Assembly of the Gods*, while another, *The Glorification of Inigo Jones*, has been reset over the main staircase. All are far less accomplished than the paintings by the Ricci and Pellegrini.[54] Meanwhile, in spite of these internal and external changes to Burlington House, the garden front remained unaltered.

The Burlingtons' daughter, Charlotte, married William Cavendish, Marquess of Hartington, heir to the Duke of Devonshire (he became 4th Duke of Devonshire in 1755). With the deaths of Lord Burlington in 1753 and then of his widow in 1758, Burlington House and their estates passed via Charlotte, the sole heir (who had died), to the Devonshires, who already owned Devonshire House on Piccadilly, built for them by William Kent in 1734. They hardly needed another substantial London house, and from this time onwards Burlington House was let, while ideas for demolition and redevelopment were considered from time to time. From 1770 to 1782 William Cavendish-Bentinck, 3rd Duke of Portland, brother-in-law of the 5th Duke of Devonshire (who had succeeded to the title in 1764), took the house. John Carr of York converted the upper part of the chapel into an elegant oval library for him, which projected on the east side of the house; it was removed in 1815. Portland lived in the house again from 1785 until his death in 1809. During the intervening years, 1782–5, the house was taken by Lord George Cavendish, the Duke of Devonshire's younger brother, who was later to buy the house and so save it from almost certain demolition.

After Portland's death in 1809, various ideas for redevelopment of the valuable site were put forward. In the meantime, the house and its grounds lay empty, prompting Lord Elgin to ask Devonshire if he could store the marbles there that he had bought in Athens while he negotiated their sale. Some drawings show the scruffy shed behind the colonnade where these precious fragments from the Acropolis were kept, with the overflow heaped unceremoniously in a corner behind the shed: a broken urn, fragments of Ionic

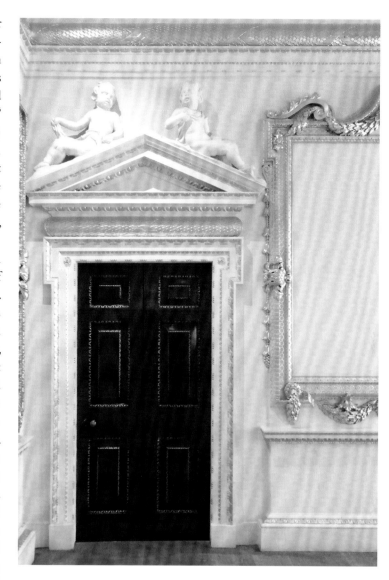

41 Doorcase in the Saloon, Burlington House, designed by William Kent, 1719–20, with putti by Giovanni Battista Guelfi ('Guelphi').

columns, a sarcophagus and lid, metopes and parts of the famous frieze of horsemen from the Parthenon. There they remained for five years, with occasional visitors coming to see them.[55]

In 1811 Samuel Ware prepared three plans for the 6th Duke of Devonshire and although they were not accepted, Ware was the architect of the major changes carried out soon afterwards. Lord George Cavendish, the 6th Duke's uncle, had recently inherited a fortune, and wished to buy

the house that he had previously rented. In 1815 he bought it from his nephew for £70,000, and employed Ware to make major alterations in an early instance of the Kentian revival style, a campaign that included developing a strip of land at the west side as Burlington Arcade.

BURLINGTON HOUSE AND THE ROYAL ACADEMY

After the death of the former Lord George Cavendish in 1834 (he had been made 1st Earl of Burlington of the second creation in 1831), the future of the house was again uncertain, and various schemes were put forward. James Pennethorne advised the government to buy the house and grounds, imaginatively suggesting that a domestic site in the West End could be used for public buildings housing the learned societies that were being squeezed out of Somerset House by the need for more office space. The newly founded University of London (1836) had as a matter of fact been promised accommodation at Burlington House, and there was urgent discussion about the need to enlarge the National Gallery, which was, of course, still sharing its building on Trafalgar Square with the Royal Academy. Wilkins's building had never been entirely satisfactory, and one idea was to build a completely new National Gallery on the site of Burlington House and what remained of its gardens. In October 1854 the Hon. Charles Cavendish (a younger son of the late Lord Burlington)[56] was paid £140,000 for the freehold, and, as a start, the Royal Society immediately moved from Somerset House into rooms in the main block of Burlington House. In June 1865 Sir Charles Eastlake, President of the Royal Academy and Director of the National Gallery, read out a letter from the Office of Works to the Council of the Academy which has already been quoted in part:

> Sir, the inadequacy of the building in Trafalgar Square for the requirements of the National Gallery and of the Royal Academy renders it necessary to terminate as soon as possible the joint occupation of the building by the two institutions, and I wish to ascertain whether the members of the Royal Academy desire a site at Burlington House on which they may build out of their own funds. They may have for that purpose either the southern side of the courtyard fronting Piccadilly, or the northern side of the garden fronting the street called Burlington Gardens.[57]

The lease would run for 99 years at a nominal rent, and designs would have to be approved by the First Commissioner of Her Majesty's Works. A committee was immediately set up to consider it consisting of three architect Academicians, Sydney Smirke, Philip Hardwick and George Gilbert Scott. There were various disadvantages in both the spaces they were offered, and certainly a building fronting on to Burlington Gardens would be a much less prominent site than any that the Royal Academy had so far occupied. At this tense time Eastlake was in Italy and died there at the end of the year. His successor, Sir Francis Grant, was a 'gentleman painter' whose social accomplishments were to prove invaluable. It was he who steered the Academy through the difficult negotiations with resounding success. It ended up with a much longer lease than had been offered and also the whole of Burlington House, together with half of the garden behind it on which to build new exhibition galleries. This achievement was also partly due to the vision of Sydney Smirke, who 'had submitted … a plan of the site on the Burlington property, including the house and a portion of the grounds at the back, not allocated to the London University or other purpose, which offered such important advantages … as had induced him at once to lay the matter before the Government'.[58]

In order for Smirke's vision to be carried out, it was necessary to remove the Royal Society from the main house. The Academy offered it £20,000, which was accepted in the summer of 1866.[59] The Academy then negotiated a very favourable lease on Burlington House of 999 years, with an annual rent of just £1. It so happened that Lord John Manners, the First Commissioner of Works, was related to Sir Francis Grant through his second wife and had twice sat to him for his portrait, which naturally helped to smooth the negotiations. In February 1867 the draft lease of the building and grounds was approved, and the next month Smirke was instructed to 'commence operations without delay'.[60]

Sydney Smirke was the younger brother of Sir Robert Smirke RA, architect of the British Museum, and had worked both with his brother and independently. He had been made Treasurer of the Academy and been appointed Professor of Architecture in 1861, and so seemed the natural choice as architect. He had recently designed the round Reading Room of the British Museum and several London clubs, but this was to be his last major commission. It was not a straightforward project, as government committees with

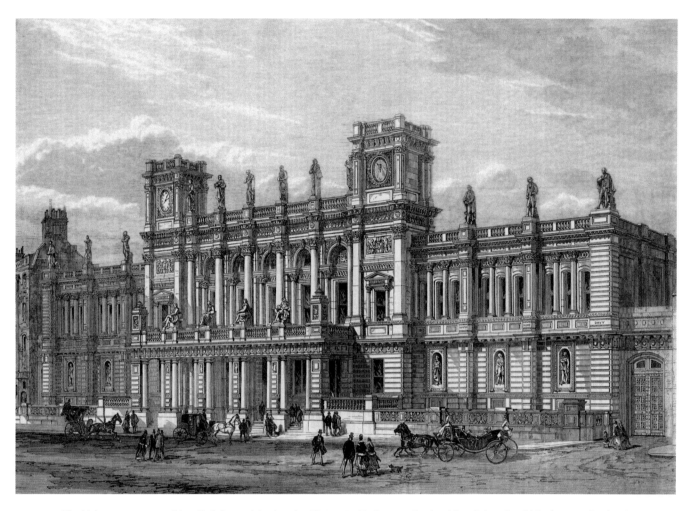

42 Unknown engraver, 'New Buildings of the London University, Burlington Gardens' (north façade of 6 Burlington Gardens),
wood engraving, 24 × 34.8 cm, *Illustrated London News*, May 1870 (RA 06/2567).

their inevitable delays were involved, and various architects were designing other buildings on the site. But Smirke and Grant proved to be an effective team in pushing through the project, always helped by Grant's contacts.

The main block of Burlington House, it was decided, would remain. The northern half of the garden, opening on to Burlington Gardens, was to have a new building designed by James Pennethorne as the Senate House of London University, a fine building that, after many incarnations, has now also been taken over by the Academy (fig. 42). The forecourt of Burlington House, with its colonnade and pavilions, was to be completely demolished, and the partnership of Robert Richardson Banks and Charles Barry Junior was to design a new

Piccadilly front and wings to either side of the forecourt for the use of the various learned societies: the Royal Society and the Society of Antiquaries (which, like the Academy, had had rooms in the Strand block of Chambers's Somerset House), the Royal Astronomical Society, the Geological Society and the Linnaean Society. They were subsequently joined initially by the British Academy and then, in its place, by the Royal Society of Chemistry. All of them, with the exception of the Royal Society, are still at Burlington House today.

Letters from Sir Francis Grant to Barry in 1866–7 show him driving the project forward with a mixture of firmness and diplomacy, first in order to get the lease signed and then to get agreement with the architects of the other buildings.

Grant did not like some aspects of the plans drawn up by Banks and Barry, in particular the narrowness of the archway from Piccadilly, 'which would make ladies and old gentlemen very nervous'.[61] He suggested a wider arch (20 instead of 18 feet wide) with pedestrian arches on each side – the arrangement we see today – amending the architects' designs by proposing a 'single and lofty archway for the ingress and egress of carriages and two smaller archways for foot passengers'.[62] Grant not only influenced this final design but also ensured the approval of Lord John Manners, Parliament, the prime minister and Queen Victoria. Indeed, Grant himself took the designs to the queen – the Academy's royal patron – but not until Banks and Barry had altered them according to his wishes. And so the four-storey entrance with its 32 foot (9.2 metre) high arch, which is such a striking feature of the north side of Piccadilly, is the work not just of Banks and Barry but also of the resourceful painter-President of the Royal Academy.[63]

Where the main building was concerned, Smirke's brief was to add an upper storey and to provide a link to the new galleries and the Schools, which were to be built on the garden.[64] As Mordaunt Crook says, Smirke was 'a first-rate second-rate architect'[65] and fulfilled his brief admirably: the Academy today still holds its main exhibitions in his galleries, and the Royal Academy Schools still use his studios and cast corridor underneath. His upper storey to the entrance front, described by Pevsner as 'High Victorian cruelty',[66] is dignified and appropriate, if somewhat top-heavy, and continues Colen Campbell's ashlar facing, using Corinthian columns with pilasters in the end bays. These echo Campbell's first-floor Venetian windows, here enlivened by red granite columns: Smirke was enthusiastic about introducing colour into his buildings. There are no windows in the central bays. Instead, there are niches filled with a series of full-length sculptures of great artists and architects from the past, a feature that can be seen on his originally proposed, somewhat lighter, treatment without the end bays (fig. 43).[67]

On the ground floor, Smirke made a more welcoming and accessible entrance for the public. A screen of rusticated stonework linked the two projecting wings of the house, its arches allowing light into the rooms behind while providing a covered space just at the entrance to the building. Inside, the entrance hall as we now see it was remodelled by T. G. Jackson RA. From here visitors to the galleries ascended

Samuel Ware's great staircase to the first floor, where the north wall was broken through in the centre to provide a route into Smirke's new galleries behind. Unlike the exhibition rooms in Trafalgar Square, these were dedicated public rooms that did not double as teaching rooms, another marked improvement upon the Trafalgar Square building. This new freedom made it possible for the Academy to consider, in 1869, instituting winter loan exhibitions (see Chapter 3), when they could again make use of all the public rooms, rather than just for the Annual (Summer) Exhibition. The new exhibition area was a triple-pile space, a series of interconnecting top-lit rooms,[68] with a glass-domed Octagon Room in the centre. To the west of the Octagon was the largest gallery and to the east a lecture room, which doubled as gallery space when required. This was the only room upstairs for the occasional use of the students, and it was soon decided to move the lecture room downstairs to the teaching area, completing the total separation of the teaching and exhibition functions. Excluding the vestibule leading from the stairs to the Octagon, there are now twelve galleries of various sizes, as the Architecture Room and the Large and Small Weston Rooms were added in 1885.

Smirke's rooms were spacious and high, with wide doorways framed in marble that permitted a much freer circulation of visitors than had been the case with the spaces designed by Wilkins for the Academy in Trafalgar Square. The additional storey on top of the old house was designed as additional gallery space, and approached by a new staircase in the north-east corner that has since been removed. Here, his Diploma Galleries for the display of works by Academicians were swept away in the creation of the Sackler Galleries that opened in 1991, and in the east cross-wing was the Gibson Gallery for the display of his bequest, a space now occupied by the new Library.[69]

On the *piano nobile* of Burlington House the Fine Rooms provided impressive offices for the Academicians. The main entry was into the Saloon in the centre, from the top landing of the main stairs. The room immediately to the west was the Secretary's room, with the larger General Assembly Room at the end inhabiting what had been the state dining room in Ware's reconfiguration of Burlington House of 1815–18. On the east side was the Council Room, with a marble chimney piece made by Joseph Wilton in 1780 that, like the West and Kauffman paintings, had moved with the Academy from

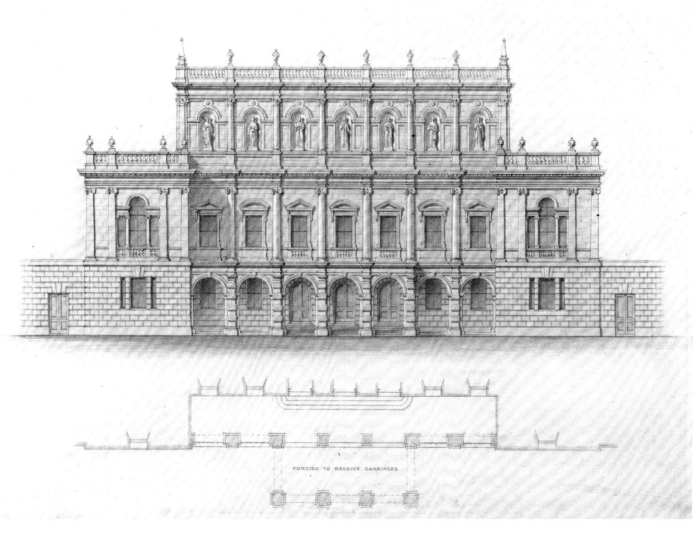

43 Sydney Smirke RA, *Design for Alterations and Additions to Burlington House*, March 1867, pencil, pen, wash and gouache, 39 × 45 cm (RA 05/2111).

Somerset House and Trafalgar Square to Burlington House. Beyond was, eventually, the Library, in a much larger room than in any previous building, inhabiting what had been the ballroom in Ware's remodelling.

These were the main public spaces, but where did the teaching take place? The cliff-like exterior north wall of the gallery block was given minimal decoration: just some polychrome brickwork and blank roundels. On the lower floor were the teaching spaces (completely separated from the public areas) which students entered, then as now, from Bur-

lington Gardens down a narrow, scruffy access lane between Burlington House and the side wall of Burlington Arcade. At basement level they went into the stone-flagged Schools, or Cast, Corridor (fig. 44), a vaulted passage that runs the whole width of the site and is lit only by borrowed natural light from the studios. Off the Corridor were the north-facing teaching rooms: the Life School with its distinctive semicircular seating, which is still there; Painting School; Sculpture School; and Antique School. In the south-east corner there was a lecture room, converted into the Architecture School

after 1945. The inner spaces of the basement were used for storage. There was access to the main house below the grand staircase, and here the basement was very little altered and provided cellars, storage space and rooms for the housekeeper. A new kitchen was built out at the side with access from the lane.

Before any work began at Burlington House, photographs were taken on behalf of the government while another set was made by Stephen Ayling, whose images are in the Academy collection, some of them showing the colonnade just before it was demolished (fig. 45). Battersea Park had recently been laid out by James Pennethorne, and there were plans to re-erect the colonnade at the end of the lake there, but, as so often, these plans came to nothing. The government kept back the colonnade when the rest of the building materials were auctioned in May 1868, but 'after lying for many years on the Embankment the stones [were] carted away'[70] and broken up for use as hardcore for roads.

The National Gallery was eager to take over the Academy's rooms in Trafalgar Square, and so work on the new quarters in Burlington House began as soon as possible. It

(left) 44 Cast Corridor in Royal Academy Schools, 2010 (RA 10/4569).

(below) 45 Stephen Ayling, Burlington House, Piccadilly, gateway and east colonnade, c.1860s (RA 04/53).

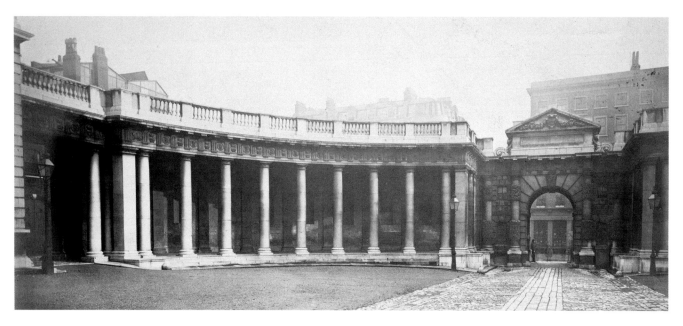

was completed remarkably quickly, considering the scale of the new building and the sensitive alterations that had to be made to the existing house. It was also expensive: the final cost was about £81,000 for the new building and about £40,000 for the conversion of Burlington House. Fortunately, when the sculptor John Gibson RA died in 1866 he bequeathed £32,000 to the Academy, which he hoped would be used to make a display of his works for students to study. A room was indeed made on the top floor for this purpose, but the residue made a handsome contribution to the building works.[71] The foundations for the new building behind Burlington House were laid in the summer of 1867,[72] and by the summer of 1870 Smirke told the Council that they had spent £77,243 5s 9d.[73] To the relief of the National Gallery, some space in the Trafalgar Square building had already been freed up by 1869, because the Council was by this date holding some meetings in Burlington House, where a covered passage was erected from Piccadilly to the entrance so that its members could reach the building safely while the forecourt pavilions and the colonnade were demolished.[74] Work on the main house was delayed by the need to rehouse the Royal Society in part of the new Banks and Barry ranges in the courtyard, and the need to evict the University of London, which had also taken up residence in Burlington House in 1856. Then the upper storey was added: the Gibson Gallery opened in 1876 and the two Diploma Galleries in 1878. Some alterations have been made over the years, but Smirke's additions and alterations have provided the Academy with fine galleries and extensive teaching space, much of it still in use today for its original purposes.

A CLOSER LOOK

The Great Exhibition Rooms

WILLIAM HAUPTMAN

The appearance of the Great Room on the top floor of the Royal Academy's home in New Somerset House, where its exhibitions were held, is well known from a print after Johann Heinrich Ramberg, an example of which, showing the future George IV visiting the Annual Exhibition, was presented to the Academy by its publisher in 1787 (see fig. 28). What is less well known is that this famous space was inspired by the 'Great Exhibition Room' in the Academy's first home at 125 Pall Mall, situated on the south side opposite Market Lane (now Royal Opera Arcade). It was drawn by the first Treasurer of the Royal Academy, the architect of New Somerset House, Sir William Chambers (fig. 46).[1] Chambers's drawing bears no date but must have been made at the time that he was planning the rooms at Somerset House, and he recorded the Pall Mall space in some detail. At the top, Chambers labelled the almost square area of this room as '39f' by '34.5 ' (presumably 34 feet 5 inches or 10.5 metres). The skylight, shown as the square area within, is indicated as measuring 23 feet 7 inches by 28½ feet (7.2 × 8.7 metres); the distance of the wall to the skylight was indicated as 5½ feet (1.7 metres). There was but one entrance to the room, seen at the left, a door measured by Chambers as 4 feet (1.2 metres). At the bottom, the section shows the height of the exhibition wall as 21 feet (6.4 metres) with the skylight windows above as 6 feet 7 inches (2 metres).

These measurements indicate that the overall exhibition space was about 1,300 square feet (121 square metres), less than the space available to James Christie at 83–84 Pall Mall when he completed his new auction rooms in late 1768, the dimensions of which Chambers recorded in ink at the bottom. When Chambers finished the Great Room at Somerset House for the first exhibition in 1780, it contained an exhibition space almost three times as large.

The appearance of the Academy's first Great Exhibition Room is known from a watercolour by Michel-Vincent Brandoin (fig. 47), an Anglo-Swiss caricaturist. He shows the exhibition of 1771, and the picture was engraved, with variations, by Richard Earlom and published by Robert Sayer. Brandoin selected a viewpoint showing the door ajar at the left opening into the main room where about 50 works are hung, including on the temporary wall divider at the right. This is but a fraction of the 276 numbers in the exhibition catalogue, with the additional works exhibited on the other side of the divider, in the space beyond it, and on the wall cut away from where Brandoin stood. Brandoin's depiction largely fits with Chambers's drawing, showing dark baize walls, the extended cornice, the skylight, and how the pictures at the sides were hung inclined slightly inward for better viewing in order to avoid glare from the top lighting and perhaps to

46 Sir William Chambers RA, *Exhibition Room of the Royal Academy in Pall Mall*, undated, pencil and ink on paper, 38.7 × 24.7 cm. Sir John Soane's Museum, London.

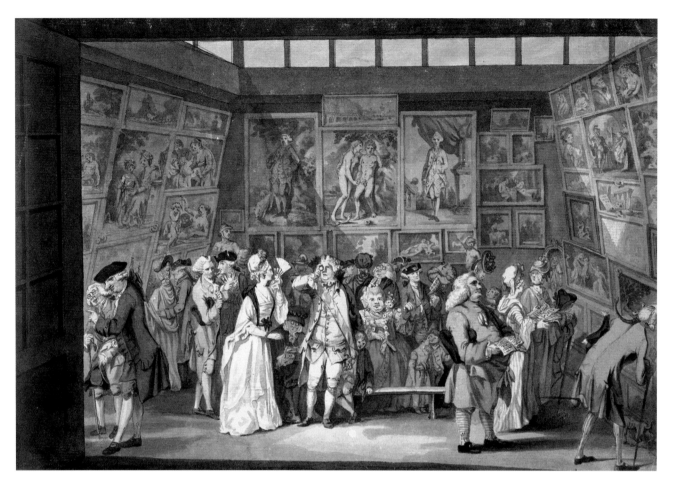

47　Michel-Vincent Brandoin, *Royal Academy Exhibition*, 1771, pen and watercolour, 23.8 × 34.9 cm,
Huntington Library, Art Collections and Botanical Gardens, San Marino, Sir Bruce Ingram Collection (63.52.23).

assist viewing in more shadowy areas of the room. As the only image known of the interior of the Academy's first Great Exhibition Room, Brandoin's watercolour serves as a valuable document of the interior of 125 Pall Mall, illustrating how the room was austerely disposed with only a crude bench for comfort, how pictures were hung frame to frame without labels – identification came from numbers in the catalogue – and how they were examined by a diverse but paying public before the grander Exhibition Room at Somerset House was made available nine years later.

Reynolds's 11th Discourse and the Turk's Head Club

CHARLES SAUMAREZ SMITH

The Academy owns an autograph manuscript of one of Sir Joshua Reynolds PRA's *Discourses on Art* that contains an emendation in Dr Johnson's hand (fig. 48). Horace Walpole suspected Edmund Burke of having contributed substantially to the writing of Reynolds's famous *Discourses*, and others have wondered the same, although the truth is probably, in Edmund Malone's carefully worded judgement, 'I have no doubt that some were submitted to Dr. Johnson, and some to Mr. Burke, for their examination and revision; and probably each of those persons suggested to their author some minute verbal improvements.'[1] Johnson's emendation – where he crossed out 'partiality to' and replaced it with 'disposition' in a superscript, and thus the phrase 'disposition to favour' – is indeed 'minute' but does confirm that Johnson examined Reynolds's text. The relevant passage in the 11th Discourse reads as follows: 'Vasari who seems to have no great partiality to disposition to favour the Venetian Painters, yet he everywhere he justly commends il modo di fare, la maniera la bella pratica that is the admirable manner and practice of that School, on Titian in particular he bestows the epithets of giudicioso, bello, e stupendo.'

Reynolds was unusual as a painter in being decidedly intellectual, liking to think as much as to look, employing his mind at least as much as his eyes, and enjoying the company of writers and men of ideas.[2] This characteristic of Reynolds, to be influenced as much by what he read as by what he saw, was evident from an early age. According to Samuel Johnson (fig. 49), his interest in art was first inspired not by drawing or by seeing paintings, but by his reading of Jonathan Richardson's *Essay of the Theory of Painting*.

Reynolds first read the works of Samuel Johnson when he was staying with his family after returning from Italy in autumn 1752. According to Boswell, Reynolds and Johnson met not long afterwards at the home of the daughters of Admiral Cotterell, when Johnson so admired a sardonic comment of Reynolds that he 'went home with Reynolds and supped with him'. To begin with, Reynolds found Johnson a bore, since Johnson hated being on his own, needing company to keep him free of the demons of depression, and so rather preyed upon Reynolds, taking up his evenings, staying late drinking tea, when Reynolds wanted to be out and about meeting new friends who might be useful to him in his career. In spite of these unpromising beginnings, Reynolds and Johnson became bosom friends. In 1759 Johnson asked Reynolds to contribute three essays to a much longer series of articles he was writing under the title 'The Idler' for the weekly paper

distance or in whatever light it 1.ᵗ
is placed, can be shewn

It is in vain to attend to the variation
of tint, if in that attention the general
hue of flesh is lost, or to finish ever
so minutely the parts, if the masses
are not observed, or the whole not
well put together.

Vasari seems to have no great
disposition to favour
partiality to the Venetian Painters,
he
yet, every where he justly com-
mends il modo di fare, la maniera,

la bella pratica that is the

admirable manner and practice of
that school, on Titian in particular
he bestows the epithets of giudicioso,

bello, e stupendo.

48 Emendation by Samuel Johnson in manuscript of 11th Discourse (delivered 10 December
1782) of Sir Joshua Reynolds PRA (REY/3/51).

49 John Watson, after Sir Joshua Reynolds PRA, *Samuel Johnson*, 1770, mezzotint, 40.6 × 33 cm (RA 06/1626).

decided to establish a weekly informal club that was to meet every Monday evening, upstairs in the Turk's Head tavern in Gerrard Street, a hostelry much favoured by artists (it was, for example, where plans had been made for the Society of Artists, inaugurated in 1761) and conveniently close to Reynolds's house in Leicester Square. This club, known in its early days as the Turk's Head Club, but later as the Literary Club ('Gentlemen of the Literary Club' had a special coach at Garrick's funeral in 1779) or simply The Club, included not only Reynolds and Johnson but also Edmund Burke.[3]

The nature of the relationship between Burke and Reynolds during the early days of the club is opaque, although the two were to become close friends, Reynolds often staying with the Burkes at their house in Beaconsfield. Reynolds was one of the first to read in draft and enjoy Burke's *Reflections on the Revolution in France* (1790) while Burke was to act as Reynolds's executor. Moreover, Burke, unlike Johnson, had a developed interest in aesthetics. He had published *A Philosophical Enquiry into the Origin of our Ideas of the Sublime and Beautiful* in 1757 and supported the young Irish painter and future Academician James Barry in Rome. It may have been Burke who encouraged Reynolds to think more deeply about his ideas on art and to acknowledge the complexities of the issues surrounding them.

The club may have influenced the thinking behind the establishment of the Royal Academy, but Reynolds certainly used members of the club as a sounding board, as he did when he was first invited to become President.[4] They provided him with his closest social circle, and it was with them that he celebrated his knighthood on 27 April 1769. He also ensured that members of the club received appointments to the Royal Academy. Samuel Johnson was elected Professor of Ancient Literature and Oliver Goldsmith Professor of Ancient History. Bennet Langton, another of the early members of the club, succeeded Goldsmith as Professor of Ancient Literature. Boswell, a later member, succeeded Joseph Baretti as Secretary for Foreign Languages. Throughout the rest of Reynolds's life, members of the club remained his closest friends, allies and confidants.

The Universal Chronicle: Reynolds's first experience of putting his aesthetic ideas on paper. The articles were based on jottings that Reynolds had made in a commonplace book in which he developed his ideas about art, and the finished essays were regarded as sufficiently striking to be published separately from the 'Idler' series, first as a duodecimo pamphlet under the title 'Three Letters to the Idler' and again in the *London Chronicle* (12–14 May 1761).

In summer 1762 the two friends travelled to Devon together, visiting country houses on the way. They stayed with Reynolds's family and, especially in the case of Johnson, were entertained as celebrities. It was probably on this trip that they

The Great Staircase of Samuel Ware

ROBIN SIMON

The central staircase that meets the visitor in the entrance hall of the RA is the work of the architect Samuel Ware, who completed it in 1818 as part of his three-year rebuilding of Burlington House for its new owner, Lord George Cavendish.[1] Ware presented his solution for the final element of his remodelling in an architectural drawing that is the finest of the more than 235 examples of his designs in the Academy's collections (fig. 50). In this elevational section, the view is through the whole compartment, looking west. The staircase has large, foliated cast-iron panels, the doors are copies of examples by William Kent, and the architrave frame is ready to receive a flanking painting by Sebastiano Ricci. Ware did not sign or date any of his drawings in the Academy's collections with the exception of this masterpiece, which he proudly inscribed 'March 27, 1817'.

In the staircase ceiling, Ware installed a roundel of about 1720 painted by William Kent for another part of the house, showing the bare-breasted goddess of Architecture holding a set-square and compasses. She is accompanied by Sculpture and Painting, who present her with an oval portrait of Inigo Jones, while a cherub holds a drawing showing the courtyard elevation of Burlington House. The positioning of the roundel in such a prominent place reflects Ware's sympathy with Palladian architecture, of which Jones was the legendary exponent in Britain, a taste that was unusual in the Regency period. Indeed, Ware made the plan of the house more Palladian by making it more symmetrical. The chief problem, as he saw it, lay in the position of the original staircase, which was to the right of where we see it now, and Ware placed his new staircase strictly in the centre, reusing, at either side, two of the canvases by Sebastiano Ricci that had decorated Lord Burlington's staircase of 1719–20. (The third of the paintings by Ricci from Burlington's staircase is now set into the ceiling of the General Assembly Room. Ricci's original circular ceiling painting over the old staircase is in the Council Room, very much in the position that it had always occupied.)

The garden façade of Burlington House designed by Ware still exists and can be viewed, strikingly, from the glass staircase and lift between the original house and the purpose-built building created by Sydney Smirke RA upon the garden of Burlington House.

Burlington House turned out to be Ware's largest commission, his second largest also being for Cavendish: the Burlington Arcade, with its 70 shops, next door to the west along Piccadilly, built in 1818–19.

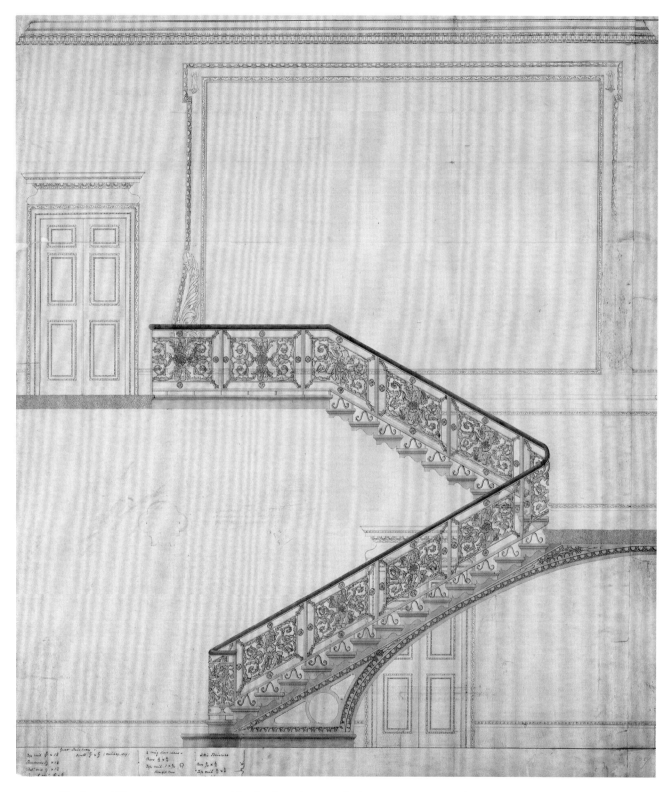

50 Samuel Ware, design as executed for the Great Staircase, Burlington House, 27 March 1817, pencil, pen and black ink, and grey, light brown and dark brown washes, 77.5 × 68.5 cm (RA 06/4835).

3

BURLINGTON HOUSE

Architecture for Exhibitions

MARYANNE STEVENS

Exhibitions have always been central to the role of the Academy, and the need to provide sufficient and appropriate space to house them was the main reason for most of the Academy's architectural developments at Burlington House. The two things therefore need to be considered together. In 1867, immediately after its arrival, the Academy began, at its own expense, the construction of very large new galleries designed by Sydney Smirke RA, as discussed in Chapter 1, including the expansive Gallery III (fig. 51). Initially, these galleries only had to house the Annual Exhibition, upon which the Academy relied for its funding, but, as we shall see, within a couple of years it embraced the opportunity to mount an annual loan exhibition, which meant that the main galleries might no longer remain empty for a large part of each year. The Annual Exhibition now became known as the Summer Exhibition and the annual loan exhibition as the Winter Exhibition. Very soon, further alterations took place

in order to provide yet more exhibition space in the form of three more galleries, together with a refreshment room, a secondary staircase and an extension to the studios in Smirke's Schools (1867–70), all completed to the designs of Richard Norman Shaw RA in 1885 (fig. 52).[1] At the same time, Shaw adapted what had been Lord Burlington's bedroom, subsequently a state dining room and then a refreshment room, into the General Assembly Room.

Subsequently, although the number of loan exhibitions at the Academy developed to an extent that no one in the nineteenth century could have foreseen, no major architectural changes were necessary at Burlington House until the late 1980s. Again, exhibitions prompted them, as the Academy realized that it had to respond to requests from lenders of works for the provision of more up-to-date spaces with, for example, proper climate controls. This was accompanied by an increased awareness on the part of the Academy of the

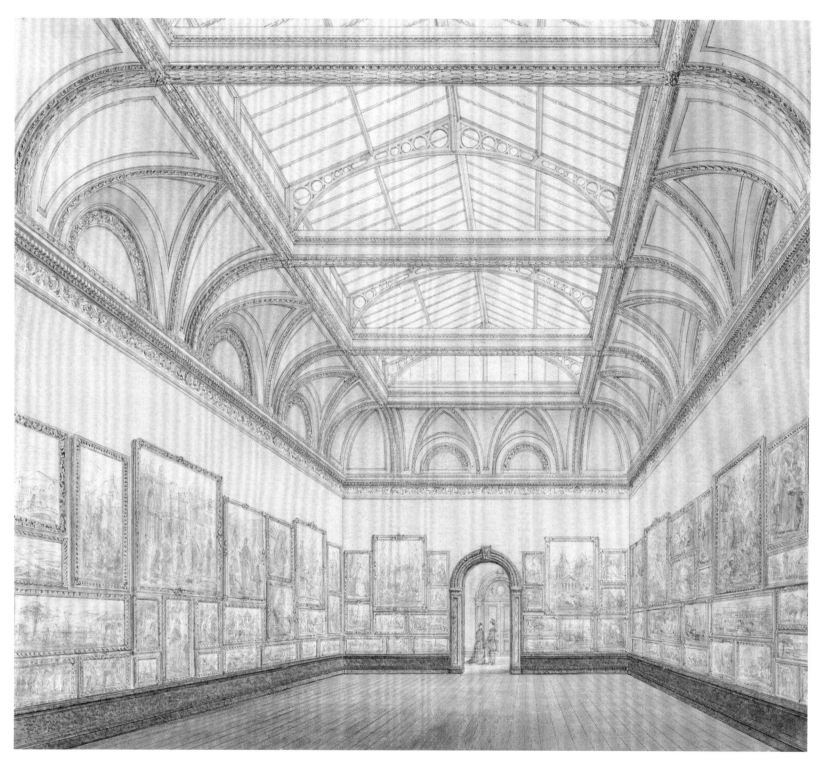

51 Sydney Smirke RA, design for Gallery III, c.1866–7, pencil and pen with coloured wash and gouache, 29 × 32.5 cm (RA 05/2123).

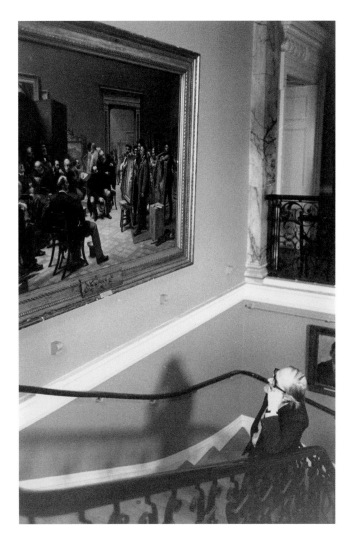

52 Anne James, *Sir Hugh Casson PRA on the Norman Shaw Staircase, Burlington House*, c.1980, photograph, 21.8 × 16.6 cm (RA 11/936).

need to conserve its own collections, including its library and archive.

Almost the only exceptions to this quiet period of some 75 years involved changes to the entrance hall, which, reflecting its origins in a private house, was simply too constrained to deal with the numbers visiting the exhibitions. First, the volume of the hall was tripled by T. G. Jackson RA in 1899–1900. He opened up the whole central area, inserted two additional front doors into what had been window frames, encasing them on the interior with small 'lobbies', reset the floor with black and white marble slabs, and pan-

elled the interior walls (fig. 53).[2] This arrangement echoed his penchant for Jacobean architecture, as did the plasterwork compartments created in the ceiling to accommodate the four oval paintings by Angelica Kauffman RA and five by Benjamin West PRA originally made for Somerset House in 1780. It was a pleasing composite style that Jackson employed to great effect at Oxford where both he and it earned the sobriquet 'Anglo-Jackson'. In addition, he inserted two arches to either side of the main staircase at ground-floor level at the southern side, the eastern one permitting more visible access to the Diploma Galleries. In 1962 Jackson's arrangement was significantly simplified by Raymond Erith RA when the panelling was swept away, the plasterwork streamlined, and the walls painted a deep Egyptian buff.

When the Academy had found itself having to move from Trafalgar Square, a possible home at 'Albertopolis' in South Kensington had been mooted, but as we have seen, Sir Francis Grant, President from 1866, favoured Burlington House. During the course of his campaigning, Grant noted the advantages of Burlington House, with exhibitions at the forefront of his arguments. Piccadilly was a central location that would attract the scale of visitors to ensure the Academy's future prosperity.[3] The 'faultless and beautiful' Burlington House, he asserted, would provide the most appropriate setting for what had become, over the last century, 'a National Institution'.[4] Furthermore, despite proposing to increase its accommodation from 12,600 to 29,600 square feet (1,170 to 2,750 square metres), the cost of construction at Burlington House, chiefly for exhibitions but also for teaching space, was estimated to be at least £30,000 cheaper than the provision of an entirely new building in South Kensington.[5]

In 1868 the Royal Academy was able to celebrate its centenary at Burlington House, having just endured almost ten years of uncertain tenure of the east wing of the National Gallery on Trafalgar Square. At this date, the Academy's governance lay with the Council made up, as originally prescribed, of eight full Academicians meeting with great regularity, and the more irregularly convened General Assembly, consisting of all 40 full Academicians and a significantly smaller number of Associate Members.[6] While the membership could be considered to encompass most successful artists within the mainstream of contemporary British art, from Edwin Landseer, Richard Redgrave and William Powell Frith to two recent recruits, Frederic Leighton and

53 Russell Westwood, *Cleaning Staff in the Entrance Hall, Burlington House, March 1953,*
photograph, 6 × 5.7 cm (RA 10/3374).

G. F. Watts, it did not allow for representatives of the more radical manifestations in British art, such as James McNeill Whistler or the Pre-Raphaelites, although this had been partially rectified by the election of John Everett Millais as RA some five years earlier. Financially, its funds were sufficiently robust to underwrite the costs of the construction of

Smirke's new galleries and teaching studios and still, as of March 1869, to record £157,505 in its reserves.[7]

A Private View at the Royal Academy, 1881 by William Powell Frith RA (fig. 54) exhibited at the Royal Academy in 1883, reflects the success of the move to Burlington House and the consolidation of the Academy's central position in the cultural

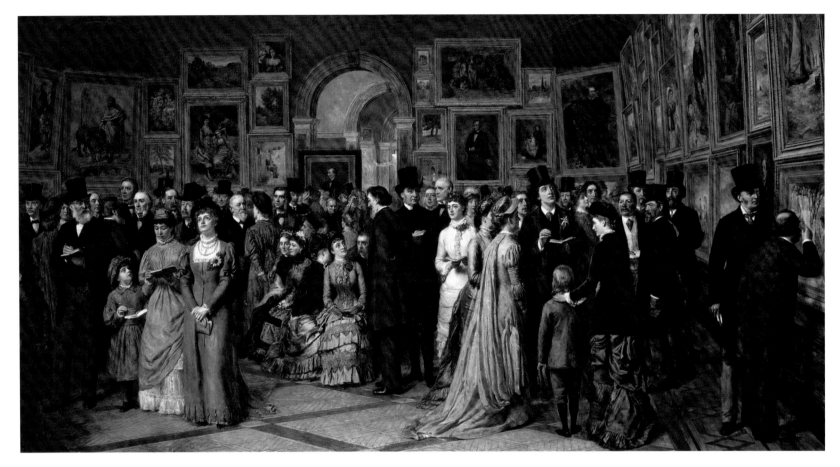

54 William Powell Frith RA, *A Private View at the Royal Academy, 1881*, 1883, oil on canvas, 60 × 114 cm. Private collection.

life of the nation. There was an element of gentle mockery intended by Frith in the direction of the passing fashion for 'aesthetic' dress and in the presence of Oscar Wilde, whom Frith referred to in his autobiography as a 'well-known apostle of the beautiful',[8] but the composition was essentially realistic in showing gathered together in Gallery III representatives of so many aspects of contemporary British society. The Established Church is embodied in the perhaps unexpected figure of the Archbishop of York at the centre, but he was chaplain of the Academy. To either side are distinguished members of the stage, letters, politics (including Prime Minister Gladstone, himself the Academy's Professor of Ancient History), painting, sculpture, surgery, finance and more.

The Academy's new home was 'officially' opened with the 101st Annual Exhibition on 12 May 1869 by Queen Victoria and was very soon followed by the first of the annual loan exhibitions, an 'Exhibition of the Works of the Old Masters, associated with A Collection from the Works of Charles Robert Leslie, R.A., and Clarkson Stanfield, R.A.' on 3 January 1870. Both, of course, were held in Smirke's new galleries, which were designed upon beaux-arts principles of major and minor axes to afford elegant vistas and to ensure logical and effective visitor flow, and provided with a sophisticated system of diffused natural top lighting.

The spacious and imposing galleries of Smirke and Shaw served the Academy well until, towards the end of the 1970s, lenders of works to exhibitions were asking for better climate- and light-controlled spaces, while the proliferation of modernized or new-build museums and galleries around the world raised uncomfortable comparisons with the Academy's own visitor facilities. Within the Academy, there was also mounting concern for the provision of purpose-designed

spaces that would ensure safe access to, and long-term care of, the institution's collections of works of art, books and archives. These considerations led to yet more alterations and additions to the structure and, indeed, the acquisition of another building, 6 Burlington Gardens, immediately behind Burlington House.

The Academy's archive reveals that there was a growing anxiety about the condition and use of the Diploma Galleries on the third floor of Burlington House. In May 1981 the then Surveyor of the Fabric, Denis Sarjeant, presented a report to Council, 'Proposed Reconstruction of the Diploma Galleries',[9] in which he advised the rebuilding of the galleries within their existing external envelope, thereby achieving climate and light level controls, flexible gallery space and consistent floor levels throughout.[10] The cost of this new facility for accommodating modern loan exhibitions at May 1982 prices was estimated to be £720,000. Funds were scarce, however, and any sums available were swiftly channelled towards the rehousing of the Library, the home of which had suffered significant structural damage. The scheme was shelved but calls for the improvement of the Diploma Galleries persisted, fuelled by an emerging discussion about the appropriate use to which the Private (now the Fine) Rooms should be put: their distinct historic architecture, domestic scale and confined points of access made them less than satisfactory for many types of exhibition, and the ever-growing need to raise revenue through corporate rentals was an argument in favour of moving exhibitions to other dedicated spaces within the building.

In order to readdress the redevelopment of the Diploma Galleries two things were needed: a compelling scheme and funds. The two processes appear to have proceeded more or less in tandem. In the early 1980s the then President, Sir Hugh Casson, met Arthur and Jillian Sackler. Arthur Sackler, a major American collector and philanthropist who had underwritten gallery extensions in Cambridge, Massachusetts, and Washington, DC, was persuaded by Casson's successor, Roger de Grey, to provide what was intended to be 50 per cent of the cost of a far more ambitious scheme initiated through conversations between de Grey and the newly elected architect member Norman Foster. Indeed, in response to a letter from de Grey in early 1985, Foster replied on 22 February: 'I was delighted to hear about your plans for the Diploma Galleries and would like to confirm

our enthusiasm to be involved in the project. When we have received the existing documentation I will attempt to set down a programme with appropriate course of action as the basis for our next meeting.'[11]

The 'appropriate course of action' was set out in June 1985, in the wake of a detailed analysis of the qualities of the existing Diploma Galleries and their potential for adaptation to modern standards. Tellingly for the realized scheme, Foster annotated a sketch dated 5 June about the provision of natural top lighting – 'quality of light vital!' – and noted the need for a void beneath the floor into which all the services could be placed, meanwhile creating a dialogue between the old and the new.[12] The option that essentially followed Sarjeant's 1981 proposition was swiftly eclipsed by a far more ambitious design generated by the identification of the brown-field, 14-foot (4.3-metre) wide site that contained the public lavatories between the garden façade of Burlington House and the southern wall of the main galleries. This gap would be able to accommodate vertical access to the third-floor galleries from a new reception area and provide, on ascending by lift or stair, new and exciting perspectives on to an architecturally compelling space within the heart of the Burlington House site (fig. 55). It also necessitated a radical reworking of the Diploma Galleries and their replacement by three barrel-vaulted, naturally top-lit galleries.[13]

The insertion of a light, contemporary glass and steel construction, set against façades dating from the eighteenth and nineteenth centuries, caused alarm in the conservation lobby, exemplified by a letter from the Victorian Society of 16 October 1988 addressed to Westminster's Director of Planning and Transportation. Having both railed against the loss of the historically significant Diploma Galleries roof and the Barry-designed staircase, and also castigated the vertical circulation proposal, the society concluded that 'the design failed to respect the building's historic character' and urged 'in the strongest possible terms that [the scheme] be rejected'.[14]

This opposition was eventually overcome, not least through the involvement of the conservation architect Julian Harrap, who advocated the restoration of both Samuel Ware's garden façade of Burlington House and Sydney Smirke's richly articulated, polychrome brick south façade of the main galleries, all to be fully revealed to the public for the first time since 1868. Foster's commitment to create a dialogue between

55 Stair (opened 1991) designed by Foster Associates inserted between the former garden front by Samuel Ware at rear of Burlington House and southern wall of the Main Galleries designed by Sydney Smirke RA.

the old and the new was to be carried out through the demarcation of the new floor levels inserted in the 14-foot (4.3-metre) gap by narrow strips of glass floor that vertically revealed the older fabric. Completion was, however, delayed by escalating costs and lack of money, which required a further capital campaign launched in 1988, and the difficulty in securing firm commitment from the Sacklers. These in turn generated internal disquiet that led, for example, to the resignation of the chairman of the Diploma Galleries Development Committee, Leonard Manasseh RA, in February 1987, and considerable unease on the part of the Treasurer, Sir Philip Powell RA, and the Comptroller, Ken Tanner, over a lack of control over the architect's evolving design and consequent increase in costs.[15]

The Sackler Galleries were opened by Queen Elizabeth II on 11 June 1991, their development having involved the relocation of the public lavatories to the ground floor of Burlington House and the installation of the Michelangelo Tondo at the western end of the Sackler reception area.[16] This transformation of the Academy's spaces on a concentrated, discreet scale won international acclaim. The architect and critic Robert Maxwell wrote: 'One cannot but admire the way in which Foster has renovated the Royal Academy, not only by the ingenuity of his spatial planning, but by its psychology. It makes a utopia out of a lost space, and it makes a modern gallery out of an old familiar one.'[17]

During this period there were three other important architectural interventions in Burlington House: the reloca-

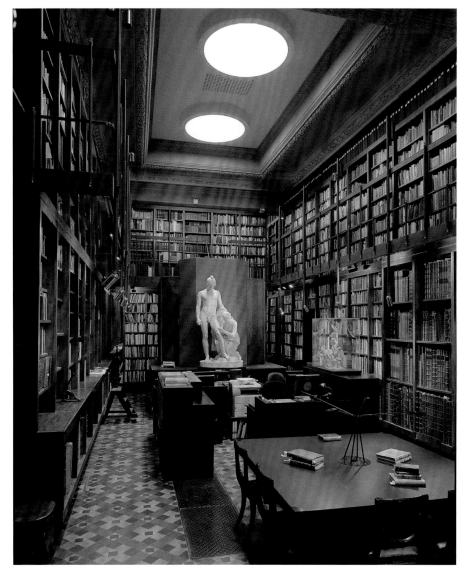

(left) 56 Frances Ware, *Royal Academy of Arts Library, 19 December 2011*, photograph (RA 12/656).

(right, top) 57 H. T. Cadbury-Brown RA, preliminary design for the Print Room, Royal Academy Library, perspective looking south, *c*.1990, pen and black ink with wash, 20.9 × 29.7 cm (RA 09/3253).

(right, bottom) 58 Leonard Rosoman RA, *Sir Hugh Casson PRA in the Library Print Room of the Royal Academy*, May 1992, pencil and watercolour, 80 × 112 cm (RA 04/2397).

tion of the Library to the Gibson Gallery (fig. 56) and the creation of a new RA Friends' Room and of a Print Room, all devised by another Academician architect, Professor H.T. (Jim) Cadbury-Brown (figs 57, 58). The Royal Academy's Library is the oldest fine arts library in the UK. Having been housed in what had been the ballroom on the first floor of Burlington House, it was relocated to the space immediately below it in 1927, when two rooms and a lobby articulated by a columnar screen were integrated into a single space by W. Curtis Green RA (fig. 59). The Library had been compro-

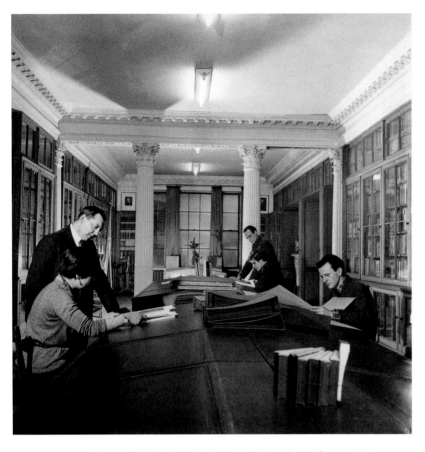

59 Russell Westwood, *Library, Royal Academy of Arts, 1953*,
March 1953, photograph (RA 10/3316).

mised since the opening of a Friends' Room in the Keeper's House in 1977, and it became unusable following the collapse of the columnar screen in 1984. It was decided to relocate the Library to the Gibson Gallery, one of the suite of Diploma Galleries, thus freeing up the ground-floor space for a new and more capacious Friends' Room.[18]

Cadbury-Brown was invited to undertake the design of both the Friends' Room and the Library. Design work on the Library was under way in the autumn of 1984, and the range of work and schedule of construction established at a meeting on 27 March 1985. The project was completed in September 1986 at a cost of £229,852.[19] The brief was not simple: the extensive holdings ranged from exceptionally rare and often outsized volumes to the normal fare of an art-school library of the 1980s. Access to the holdings had to be open, while the room also had to provide space for con-

sultation by readers and desks for the library staff. Faced with a tall, somewhat narrow, top-lit gallery, Cadbury-Brown's design first maximized shelving capacity by capitalizing on the height of the original gallery, adopting the traditional college library solution of a balcony above the reading room. Then, in order to break out of the constraint of the relatively narrow gallery, he borrowed Sir John Soane RA's conceit of creating an illusion of expanding space through the use of mirrors, placed horizontally under the balcony and vertically at the end of each wall: bookshelves appeared to march to infinity beyond the confining walls, and the balcony was seemingly eradicated in favour of serried vertical ranks of books. With the Library rehoused, its previous location was now allocated to the increasingly numerous Friends of the Royal Academy, with supplementary space provided for the Academicians in what had been the Library Annexe. Cadbury-Brown worked on the designs between October and December 1986,[20] and although the project had initially been costed at £48,000, it was delivered for the drastically reduced sum of £21,000. The Annexe conversion for the Academicians was completed two years later, while the Friends' Room underwent a refurbishment in late 1995.[21]

Cadbury-Brown's third intervention in Burlington House was the creation of the Print Room. This space, next to the new Library, emerged as a result of design decisions about the other two third-floor projects: the construction of the new Library at the nineteenth-century floor level and the raising of the new Sackler reception area (and hence the new galleries) to a level 5 feet (1.5 metres) higher in order to align it with the base of the cornice of the main galleries' southern façade. With the entrance to the new Library seriously compromised, a gallery running parallel to it was identified as a way of providing access to the Library, and in 1990 Cadbury-Brown and his wife, Betty, embarked on the design of a much-needed dedicated prints and drawings gallery for storage, study and display. In January 1990 the architects summarized what was an exceptionally challenging brief.[22] Drawings were completed by April, with furniture and other details being worked out over the course of the ensuing year. The room brilliantly managed to provide a small display area at the raised north end, a southern section for study and storage for around 25,000 works on paper, and a lower mezzanine devoted to architectural drawings and the maintenance of the collections. The room opened in 1992, having

60 Doorway to Keeper's House, Royal Academy, Burlington House, reopened 2013, with, over the door, *Keep me Safe*, neon, by Tracey Emin RA, 2006.

house some 600,000 institutional and personal records, was constructed on another found space, a flat roof immediately to the east of the new Library. It was designed by the Academy's in-house architecture team headed by Peter Schmitt and opened on 28 May 2002.[25] The Keeper's House at the east end of Burlington House was reconfigured by a collaboration between Long and Kentish and David Chipperfield RA, aimed at providing greatly enhanced space and facilities for Friends, Patrons and Academicians. It opened in September 2013 (fig. 60).

6 BURLINGTON GARDENS

In 2001 the Royal Academy acquired 6 Burlington Gardens, the building immediately behind Burlington House. This structure was erected on the northern half of the garden of Burlington House between 1867 and 1870 and had been designed by Sir James Pennethorne to serve as the headquarters of the University of London. Both its architectural history and its subsequent uses have been complex. Its street façade on Burlington Gardens was initially proposed to be in a Venetian Gothic style, but it was redesigned in a rich, grandiloquent Italian cinquecento palazzo manner, complete with niches and pedestals to accommodate a pantheon of sculptures representing the great intellectual figures of the past.[26] Like so many Victorian public buildings, the interiors were designed with specific functions in mind: a great 800-seat lecture theatre rising through three floors, examination halls, a library, and a senate chamber on the first floor flanked by attendant offices. All were accessed by a central staircase lit by a clerestory. The removal of the University of London administration to South Kensington in 1899 meant that the building was put to a series of different uses during the twentieth century, from the Civil Service Commission to the British Museum's Department of Ethnography (when the building became known as the Museum of Mankind). When this department retreated back to Bloomsbury in 1997, the opportunity for the Royal Academy to acquire the property was immediately grasped as a means of resolving increasing pressures upon the facilities of Burlington House. These included, as usual with the Academy, the provision of more exhibition space. In addition, there was a need to increase the number of studios in

cost £108,571, which was raised from a Wolfson Foundation challenge grant matched by the government.[23] On its completion, Sir Hugh Casson sent a handwritten note to Cadbury-Brown: 'Jim, Your room next to the Library is totally stunning and the view through the door into the Main Library is a huge success. Congratulations.'[24]

The history of architectural interventions in Burlington House continued into the new century. A fully climate-controlled, dust-free Dame Jillian Sackler Archive Room, to

61 David Chipperfield Architects, cross-section through 6 Burlington Gardens and Burlington House, 2008.

the RA Schools and also the accommodation of the now-extensive public education programmes, which to date had been hampered by the absence of a dedicated lecture hall and practical workshop facilities.

Although the Pennethorne building turns its back on the northern side of Burlington House, with its main galleries and line of studios, it is, fortunately, aligned to the south–north central axis of Burlington House. The challenge in integrating it into the already established public and academic life of the Royal Academy in Burlington House lay in finding the most elegant and least architecturally damaging physical link between the two buildings, and converting the somewhat degraded nineteenth-century interior spaces into something appropriate to twenty-first-century museum conditions.

The first decade of the twenty-first century saw three proposals being presented for consideration, all provided by Royal Academician architects. Between 1999 and 2002 Michael Hopkins RA (Hopkins Architects) proposed an ambitious scheme that linked the two buildings along the north–south axis with a large central atrium created across the open space between the back façades of the two buildings.[27] It was considered too expensive, and the proposal was superseded four years later by a more modest scheme developed as part of a masterplan for the entire 'Burlington Estate' by Colin St John Wilson RA. He sought to minimize the

impact of the link on the architecture of both buildings, and proposed a separation of vehicular and pedestrian access, as well as a discrete route from Burlington House to 6 Burlington Gardens on the east side of Burlington House via a 'piazza' that provided a public entrance to the newly expanded Royal Academy Schools. St John Wilson died in 2007, and a competition was held the following year that was won by David Chipperfield RA (David Chipperfield Architects).

Chipperfield reinstated the Hopkins axial link, taking the visitor from the entrance hall of Burlington House through new spaces created by sweeping away the public lavatories that had been relocated as part of Foster's Sackler Wing project, continuing down steps into the main vault under Smirke's main galleries, and then cutting through the Schools' Cast Corridor and two studios before rising by a grand staircase to enter 6 Burlington Gardens at the back of its main hall (fig. 61). This approach to the interior spaces was informed by Chipperfield's restoration and reconstruction of the Neues Museum, Berlin, where the ghosts of the original spaces cohabit with new, contemporary structures. Thus, at the Academy, a 300-seater lecture theatre has been reinstated within the footprint and shell of the original, although reduced by one level; the late baroque revival British Academy Room is retained; and the profile of the ceilings of the science examination rooms are used to allow natural daylight into the new temporary exhibition galleries.

On the other hand, additional facilities for the Schools and a learning studio and offices to accommodate an expanded administration were inserted as more robustly contemporary statements.

This most recent example of architectural change and expansion at the Royal Academy is scheduled to open in 2018, the 250th anniversary of the Royal Academy's foundation. For the completion of the 'Burlington Estate' the Academy again drew, as it had done in all but one case from 1780 onwards, upon one of its own architect members.

LOAN EXHIBITIONS

Henry Jamyn Brooks, inspired by the example of Frith's *Private View at the Royal Academy, 1881* (see fig. 54), took upon himself to create, apparently at the suggestion of Thomas Brock RA, its 'pendant', *Private View of the Old Masters Exhibition, Royal Academy, 1888* (National Portrait Gallery, London). It shows 66 individuals in British cultural life in Gallery III, including a dozen or so members of the Royal Academy, most prominently the President, Frederic, Lord Leighton. Fifteen were lenders of works to that year's exhibition, and others were members of the aristocracy, the plutocracy and the wealthy middle class. The walls are hung with paintings, all of them in the Winter Exhibition of 1888, by great Old Masters, including Rubens, Van Dyck and Hals, and by eminent representatives of the British School such as Reynolds, West and Gainsborough.

The Royal Academy's loan exhibitions[28] owed their existence and initial format to the British Institution, which had launched the first consistent programme of loan exhibitions in London in 1806 at what had been Boydell's Shakespeare Gallery at 52 Pall Mall.[29] The British Institution had been founded the previous year by a group of subscribers dominated by aristocrats, collectors and connoisseurs and had two purposes: to hold an annual exhibition of works by living artists and a loan exhibition of works by Old Masters and artists of the British School.[30] The former, held in the spring of each year, was intended to supplement rather than compete with the Royal Academy's Annual Exhibition. The British Institution's Old Master exhibition was held in the summer, and its aim, in the absence at that time of a national gallery or access to any examples of the work of the Old Masters in

the Royal Academy, was primarily educational: to enable professional and amateur artists and students to study great works of the past in the belief that it would raise the quality of the work that would be presented in the spring exhibitions. Sketches and studies after the works were encouraged, as well as the making of 'companion' pieces to works on display. Direct copying on a one-to-one scale was prohibited, not least in order to prevent forgeries (fig. 62).

The British Institution's initial years were marked by rather haphazardly created loan exhibitions and a growing antipathy between itself and the Academy. In 1813, however, there was a change in approach related to the Academy's own activities in this field. As a gesture of rapprochement, and a declaration that the British School was indeed the legitimate heir to the Old Masters, the British Institution mounted an important exhibition, properly organized, of the work of the Academy's first President. This celebration of Joshua Reynolds, who had laboured to establish the British School through his art, his *Discourses* and the establishment of the pedagogic programme of the Royal Academy Schools, was followed in 1814 by an equally carefully planned exhibition devoted to four other significant members of the British School: William Hogarth, Thomas Gainsborough RA, Richard Wilson RA and Johan Zoffany RA.

After considerable initial success, attendances at the British Institution's spring exhibition eventually declined, from about 20,000 visitors in the 1830s to between 7,000 and 10,000 a decade later, but its summer loan exhibitions established new levels of professionalism and supported important developments in the art world of nineteenth-century London as well as providing models for the Academy.[31] At precisely the time that the Academy was moving to Burlington House, 1867, the British Institution reached the end of its life, a demise brought about by the expiry of the 62-year lease on its building. If the renewal of the lease could not be funded, the spring and summer exhibitions were threatened with extinction. The general view of artists and critics was that the spring exhibitions – of works by living artists – could be dispensed with since, as the *Illustrated London News* noted on 8 January 1869, they had been 'so notoriously mismanaged that in recent years they became of little service to British art'. The prospect of the demise of the summer exhibitions of Old Masters caused considerable consternation, however, not least within the Royal Academy: despite the impressive

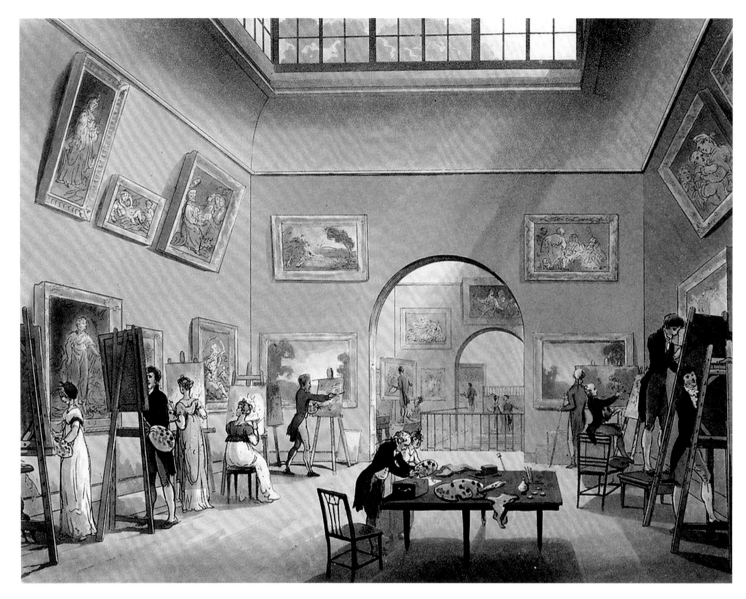

62 After Thomas Rowlandson, 'Artists copying at the British Institution', in Rudolph Ackermann, *Microcosm of London*,
London 1808–10, vol. I, pl. 13, coloured engraving. Private collection.

growth of the National Gallery's collections, these exhibitions had undeniably established a central position within the cultural life of London. Indeed, the Academy's Council sent a letter in 1866 to the British Institution expressing its concern at the loss this would pose for students, the 'matured artist' and the 'accomplished Amateur'. It reassured the Institution that, should a request for funds be made, it would put this to the Academy's General Assembly. This letter elicited

an expression of gratitude from the British Institution's secretary, George Nicol: 'should [the British Institution] find it advisable to appeal to the public for aid to enable them to provide some suitable gallery for the continuance of their exhibitions, they will gladly avail themselves of the proffered co-operation of the Members of the Royal Academy towards that object.'[32] No such appeal was made, and despite a proposal from the City of Leeds to the British Institution's

directors to continue the summer loan exhibitions there, starting in 1868 with an exhibition to rival that of the Manchester 'Art Treasures of Great Britain' of 1857,[33] the British Institution declined the offer and ceased to exist, and its building was turned into a billiard club.

Over the next three years, the initiative to ensure the continuity of the summer loan exhibitions passed to the Burlington Fine Arts Club, which had been founded by amateurs, collectors and artists to meet informally in order to discuss art and study works of art.[34] First housed at 177 Piccadilly, it moved to 17 Savile Row (just behind the Royal Academy) in 1869 into accommodation that also afforded space for exhibitions. In spring 1869, it approached the Royal Academy to rent two or three galleries during 'certain months of the year' in order to reinstate the British Institution summer loan exhibitions. Although this request gained the support of Council, where the intention to revive the exhibitions was received with sympathy, such was the Academy's continual concern to retain its independence from association with any other institution that the request was dismissed by the General Assembly on 19 June. At a special meeting of the General Assembly held on 19 July, the Royal Academy concluded that, given that the demise of the exhibitions presented 'great deprivation to all lovers of Art' and 'a serious loss to students in the prosecution of their Art studies', it should demonstrate its public responsibility as 'the chief Art-teaching Institution in the Kingdom' and fulfil the intentions of the Burlington Fine Arts Club by taking responsibility for the British Institution's summer loan exhibitions.[35] An exhibitions committee was therefore formed to create the first Academy loan exhibition, which should consist of the 'best works attainable' of the Old Masters and also – a key development – 'specimens of works of deceased British artists', in this case Clarkson Stanfield RA and C. R. Leslie RA. It was grandly assumed that, in contrast to the Burlington Fine Arts Club, the 'preeminent position of the Royal Academy in the country' would inevitably ensure the loan of 'the finest specimens of ancient Art that could be enjoyed by any private Society'.[36]

What were the Royal Academy's motivations for taking over the British Institution's loan exhibitions? In the first instance, it was now the proud owner of Smirke's suite of top-lit galleries (fig. 63), which had been fulsomely lauded by the reviewer in *The Times* of 1 May 1869: 'No European

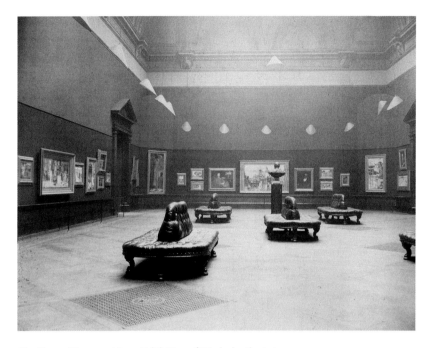

63 Henry Dixon and Son, *Exhibition of Works by the Late Sir Lawrence Alma-Tadema R.A., O.M.* (Gallery III, Royal Academy), 1913, photograph, 23.4 × 29 cm (RA 08/3039).

capital can now boast a more commodious and noble suite of rooms for its yearly display of painting and sculpture than London now possesses. The means of access and intercommunication are ample; the … rooms … are excellent in proportion [and] soberly eloquent in decoration.' That remained true, and with the Schools housed in separate accommodation below and to the north of the galleries, these grand spaces risked lying empty outside the five months or so each year of the Annual Exhibition. Second, as the self-styled 'chief art-teaching institution in the Kingdom' the Academy had, in the words of *The Times* (2 January 1885), 'the duty of endeavouring to supply the want' of access to great works of art that would further the training of students and the careers of artists. Third, the Academy saw such exhibitions as an extension of its founding principle, laid down by Reynolds in his first Discourse, to develop the taste of the connoisseur and the public. It must, however, also have had in view a possible increase in its funds through revenue from these additional exhibitions.

There were some elements of the project that could have argued against this seemingly bold move, which the Acad-

emy cautiously announced as being an 'experiment'. In the first instance, given that the loan exhibitions would have to be self-financing and that those of the British Institution had been relatively precarious because of poor attendances, the Academy could be seen to be taking on a financially risky enterprise. Moreover, for the first 100 years of its existence, the Academy, as an institution of living artists, had been committed to contemporary art, as demonstrated in its Annual Exhibitions, its Schools, and its resolve to eschew the creation of a collection of Old Masters. This apparent aversion to an association with the Old Masters might have led the Academy to dismiss any engagement with the British Institution loan exhibitions, but it was precisely that institution's precedent of showing the British School within the context of the Old Masters that gave the Academy the freedom to embrace, without embarrassment, the great art of the past. It could thus validate the rationale of its own foundation and its continuing existence, a point that was made in the opening pages of the 1869 Annual Report.[37] To be sure, there was dissent on the part of some Academicians, including Thomas Webster RA, who felt that loan exhibitions might be a waste of the institution's funds and a betrayal of its founding principles.[38] Equally, it was felt by some that there was a danger that the brilliance and perceived stature of the Old Master loan exhibitions might overshadow the Annual Exhibitions of work by living artists – as had indeed been the case at the British Institution.

1870–1914

The Academy's first loan exhibition, as noted above, opened to the public on 3 January 1870.[39] Its organization involved a steep learning curve: institutional structures and procedures for keeping track of works of art had to be established as well as systems for sourcing and selecting the works themselves. On 19 July 1869 the General Assembly had sanctioned the establishment of the exhibitions committee, which consisted of Sir Francis Grant (the President), William Boxall (director of the National Portrait Gallery), Charles West Cope, John Callcott Horsley, Frederic Leighton, Richard Redgrave (joined at the committee's third meeting by his brother, Samuel) and G. F. Watts, with S. P. Hart serving as secretary, and the first of fifteen meetings was held on 26 October.[40]

The committee took responsibility for finding loans, selecting works, eliminating those thought to be of poor quality or dubious attribution and installing the exhibition.

Loans were obtained using a combination of direct approaches and advertisement inviting offers. Major lenders, such as the queen, the Marquess of Westminster and the Marquess of Bute, had been approached during the course of the summer of 1869. An advertisement was placed in *The Times* on 22 November announcing the forthcoming exhibition and inviting works for the consideration of the exhibitions committee. While some offers of loans were received positively, such as that from Earl Spencer of four works by Rubens from the ballroom of Spencer House,[41] others were politely but firmly refused.[42] In the case of the recently deceased Academicians, Clarkson Stanfield and C. R. Leslie, members of the artists' families and the dealer Thomas Agnew[43] were invited to identify where important works by the artists were to be found, although the Academy did have their Diploma Works as a starting point (fig. 64). Similarly, for Old Masters the Academy could at that time still supply the Leonardo cartoon and also Giampietrino's copy of Leonardo's *Last Supper*. It amply made its point about the position of the British School in this company by mixing in works by the likes of Reynolds, Wilson and Cotman alongside the Old Masters. Reynolds's *Self-portrait* and full-lengths of *King George III* and *Queen Charlotte*, together with the *Self-portrait* by Sir Thomas Lawrence (see fig. 520) and Henry Singleton's *Royal Academicians in General Assembly* (see fig. 146) were hung in the vestibule as the first works to greet the visitor. The Leonardo cartoon was alone in the Octagon Room, while Gallery I set the bar high with two paintings by Velázquez, a Holbein, Rembrandt and Rubens mingling with British pictures such as the monumental *View of Wynnstay* and *View of Llangollen* by Richard Wilson RA (fig. 65) and Reynolds's *Earl of Suffolk*, while nearby was Leonardo's *Virgin of the Rocks* lent by the then Lord Suffolk.

It would appear that the Academy had hoped that the Burlington Fine Arts Club, with its connoisseur members, might have been of assistance in obtaining Old Masters. The secretaries of the Club, however, Ralph Wornum and J. Benington, possibly smarting from having had their proposal to reinstate the loan exhibitions hijacked by the Academy, declared that they could not undertake this 'in their co-operative capacity', although individual members might be

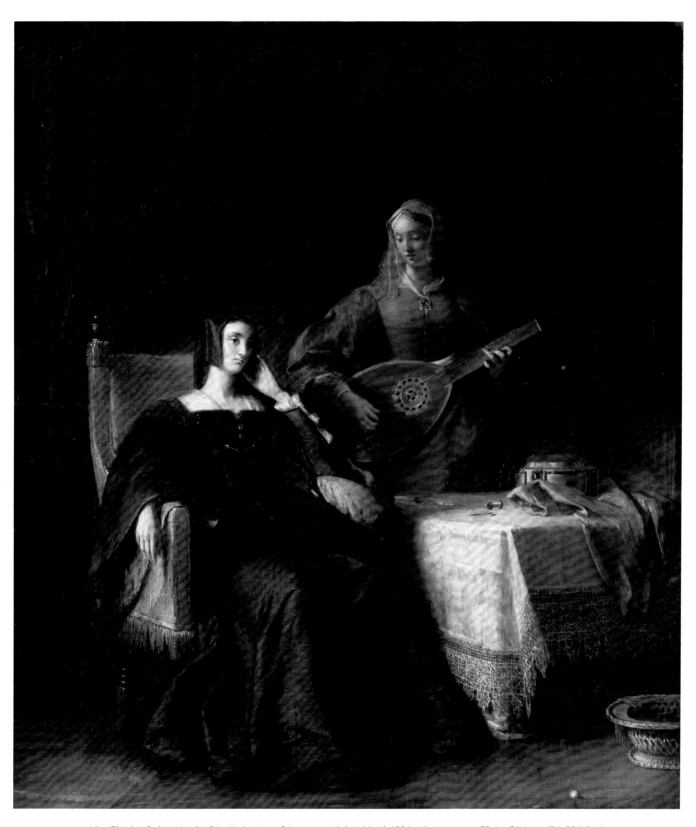

64 Charles Robert Leslie RA, *Katherine of Aragon with her Maid*, 1826, oil on canvas, 59.6 × 51.1 cm (RA 03/1361).

65 Richard Wilson RA, *View of Llangollen with Dinas Brân*, oil on canvas, 180.3 × 244.8 cm.
Yale Center for British Art, New Haven, Paul Mellon Collection.

willing to render 'co-operation in carrying out the scheme for the proposed exhibition'.[44]

The Old Masters and older works from the British School were hung in the first four galleries (I–IV), while those by Clarkson Stanfield and C. R. Leslie were in Galleries V and VI.[45] A total of 235 works were shown, of which 161 were by Old Masters and the British School of the past, and 74 by Clarkson Stanfield and C. R. Leslie.[46] There were 84 lenders, nine of whom lent more than six works, the four most gen-

erous being Thomas Baring (9), the queen (13), the Marquess of Bute (14) and the Marquess of Westminster (24).

Entry to the exhibition was set at one shilling, with the accompanying catalogue priced at sixpence. There were season tickets and free admission for 'discerning students' as well as for members of certain art societies and artists who had exhibited at the 1869 Annual Exhibition. The exhibition attracted some 52,660 visitors, assuring a net profit of £1,884. The Royal Academy had declared that it would not

make any financial gain from the enterprise, since it wished to be seen to be undertaking the exhibition 'solely in the interest of Art'.[47] Yet, although it distributed monies to three charities, it retained in its own coffers a net balance of £1,174.[48] The response of the press was generally favourable, praising the Academy not only for taking on the responsibility of the British Institution's exhibition but also for delivering loans of distinction, with 'the result now before the public in the shape of a far finer collection of Old Masters, foreign and English, than we ever remember to have seen in Pall Mall [i.e. the British Institution]'.[49] Some concern was expressed as to whether the reputations of either of the two recently deceased Academicians had been enhanced: 'the result of viewing so many of their respective works together was not favourable to the increase of either artist's reputation. It is, indeed, a test which few modern artists can stand, for are not the failures of a painter more numerous than the successes?'[50]

The Winter Exhibition ran for eight weeks, closing on 26 February, by which time the Academy had already decided to stage another the following year.[51] It considered that 'the result most fully satisfied the anticipation,[52] and loan exhibitions were now firmly established as a central feature in its life. Of those mounted between 1871 and 1913, 13 followed the model established by the inaugural show. Earlier on they were occasionally accompanied by 'sub-exhibitions' devoted to a theme or individual artist, including those on the Norwich School (1878) and Holbein and his German contemporaries (1880); and after 1886 the 'sub-exhibition' became a regular feature. The profits from the loan exhibitions, however, with a few notable exceptions, declined during this period and, apart from three, all went into deficit after 1893. While costs rose slightly, it was primarily the relentless decline in visitor numbers that was the chief factor. This may be attributed to emerging competition from other exhibition-making institutions, which brought with it issues of the availability of quality loans and the potential for clashes in exhibition programming.

In the wake of the highly successful Manchester 'Art Treasures of Great Britain' exhibition of 1857, and three major national loan exhibitions devoted to British portraiture held in the South Kensington Museum in 1866, 1867 and 1868, several institutions in London entered the loan exhibition 'market'. The Burlington Fine Arts Club presented

its first, admittedly semi-private, exhibition of drawings by Dürer and Michelangelo in 1869. The Grosvenor Gallery, founded in 1877 by Sir Coutts Lindsay, held the first of its annual winter loan exhibitions in 1878 ('Drawings by the Old Masters and Watercolour Drawings by Deceased Artists of the British School'). The Grosvenor Gallery was conceived on a grand scale (Blanche, Lady Lindsay, was a Rothschild and her money underwrote the venture) with an impressive suite of galleries.[53] Together with the annual group exhibitions of living artists which included those such as James McNeill Whistler, who had chosen to eschew the Academy, it also presented several solo exhibitions between 1882 and 1887.[54] The New Gallery, created in 1888 after a schism between Coutts Lindsay and his two erstwhile collaborators, James Comyns Carr and Charles Hallé, mounted its first winter exhibition in 1889 ('House of the Stuarts') together with solo shows.[55] Then the Guildhall Art Gallery, which introduced loan exhibitions in 1890, started to include Old Masters in 1894 (Flemish and Dutch works, including Rembrandt).[56] Additionally, loan exhibitions were appearing in the commercial galleries as well as in the form of national promotional exhibitions such as those mounted in West Kensington by the United States, Italy, France and Germany in 1887, 1888, 1890 and 1891 respectively.[57] Further pressure came from public institutions on the Continent, which also began to mount major loan exhibitions.[58] There was also the risk of duplication. *The Times*, for example, deplored the fact that in 1879 both the Royal Academy and the Grosvenor Gallery presented very large Old Master drawings exhibitions: 'Two such exhibitions … should never coincide … The two together constituted an excessive drain on private collections, and spread too abundant a banquet of various art for even Gargantuan stomachs.'[59]

Maintaining the flow of high-quality loans became a concern for the Royal Academy, and threatened its ability to offer a convincing representation of Old Masters and members of the British School. Permission to 'begin at the top of the list again' was therefore granted to the exhibitions committee by the Academy in 1891 when it was decided that, in order to maintain quality, it would permit the inclusion of works that had been displayed in previous exhibitions.[60] Reviewers, however, remained amazed at the willingness of major collectors to allow their masterpieces to be shown year after year with relatively few repetitions,

66 Charles Sims RA, assisted by Florence Asher, Margaret Brown, Rosalie Emslie and Veronica Martindale
(names just visible on the shield bottom right), *Crafts*, 1916, oil on canvas, approx. 518 × 1,067 cm.
Mural for the Civics Room of 'Arts and Crafts' exhibition at the Royal Academy, 1916.

a point forcefully made by *The Times* in 1893 when it reported that only 25 per cent of the works shown at Burlington House that year had been seen there before.[61] To some degree the threat of the stock of quality work becoming exhausted in the older, established collections was mitigated by the appearance of new, plutocratic collectors such as Pierpont Morgan, Asher Wertheimer, Frederick Richards Leyland and Constantine Alexander Ionides, and by borrowing from recently established public collections that were entitled to lend from their collections.[62]

1914–1939

The outbreak of the First World War did not halt the regularity of the Academy's Summer Exhibition. The winter exhibitions, however, underwent significant changes that were to have a lasting impact on the ethos of exhibitions

and their financial model both during the inter-war years and after 1945. Between 1914 and 1918, the main galleries of Burlington House were episodically rented out to specific institutions, such as the Arts and Crafts Exhibition Society in 1916. This exhibition was notable for its extraordinarily lavish setting, which included specially painted canvases on a very large scale, all so elaborate indeed that the opening was delayed by two weeks, none of it helped by the need to stop work at dusk because of wartime light restrictions. Remarkably, the painting representing *Crafts*, by Charles Sims RA (fig. 66), believed lost by the artist himself, was found in 2015 rolled up in the vaults of the Academy in an area used by art handlers, together with another canvas, equally large, by Doris Clare Zinkheisen, the subject of which is *People of London* (fig. 67).[63] Otherwise, exhibitions were chiefly in aid of patriotic causes, such as the 'War Relief Exhibition' in aid of the Red Cross and St John Ambulance Society in 1915, and the 'War Relief Exhibition Belgian Section', presented

two years later. And in the years immediately following the cessation of hostilities, the galleries gave space for exhibitions reflecting the war, with material ranging from officially commissioned and camouflage art to war memorials.[64]

In 1920 the Royal Academy introduced a new pattern of loan exhibitions that was generally to be maintained: the number held annually rose from one to at least three, and their subject matter became more focused, their catalogues more substantial and their financial arrangements more diversified. Up until 1939, on the one hand, the Academy hosted exhibitions mounted wholly by external organizations, such as the British School at Rome, the Royal Institute of British Architects and the International Society of Sculptors, Painters and Gravers, all of whom paid rent for the use of the galleries.[65] On the other hand, there were exhibitions over which it either continued to have sole charge or collaborated with another agent.

As had been the case before 1914, exhibitions dedicated to individual deceased Academicians or groups of them continued to be held: for example, that in 1922 presenting the work of 36 members who had died between 1899 and 1921. Solo or shared memorial shows also had their place, such as the

John Singer Sargent exhibition of 1926 (fig. 68) and the Sir Hamo Thornycroft and F. Derwent Wood memorial shows of the following year.[66] Of much greater significance, however, was the initiation of a series of loan exhibitions devoted to schools or specific nations that were mounted under the aegis of foreign governments or other agencies, with the Royal Academy as a collaborator rather than sole creator.

Exhibitions with a national agenda had been mounted in London and on the Continent before 1914. Germany marked the formation of the German Empire in 1871 by claiming ownership of the great European master, Holbein, in an exhibition mounted in Dresden, and the accession of Queen Wilhelmina of the Netherlands was heralded by the 1898 Rembrandt exhibition in Amsterdam. Likewise, the achievements of specific national schools were celebrated in the exhibitions mounted at the Guildhall Art Gallery and the New Gallery from the 1890s,[67] and such exhibitions could also become the vehicle for an assertion of a sense of nationhood and patriotic pride, as was the case with the exhibition of Flemish painters held in Bruges in 1902: 'To show the past richness and power of Flanders, does that not stimulate national sentiment? Our legitimate pride … has made us

67 Doris Clare Zinkheisen, *People of London*, 1916, oil on canvas, 198 × 533.4 cm. Mural for the vestibule of 'Arts and Crafts' exhibition at the Royal Academy, 1916.

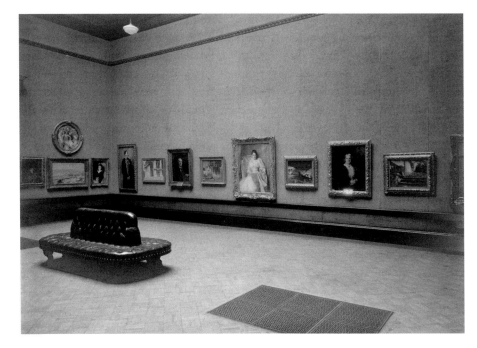

(left) 68 Grove, Son and Boulton, installation photograph of Gallery IV, Royal Academy, during the John Singer Sargent exhibition of 1926 (RA 08/2563).

(right) 69 Cover of *Exhibition of Flemish and Belgian Art – 1300 to 1900*, 1927, after poster by Sir Frank Brangwyn RA (RA 14/3750).

prouder of our quality of Flemings, prouder of our name as Belgians.'[68] But the inter-war years saw new, more nationally self-conscious, ambitious – and competitive – exhibitions devoted to specific schools of art in whose presentation the Royal Academy played a decisive role. Although, somewhat idealistically, these exhibitions could be perceived, as they were by Robert Witt in the introduction to the catalogue of the 'Exhibition of Flemish and Belgian Art 1300 to 1900' (1927) (fig. 69), as expressions of 'the new spirit of friendship and understanding in international relations', exerting influence in the 'direction of neighbourliness and sympathy',[69] they were as much the product of the darker rise of nationalism and the clamour for national identity that marked the 1920s and 1930s.

With the exception of the Persian and Chinese exhibitions of 1931 and 1935–6 respectively, and those devoted to Australian and Swedish art (1923 and 1924), which focused on recent or contemporary national art, the great sweep of Royal Academy loan exhibitions that celebrated national schools – those devoted to Spain (1920–21), Flanders and Belgium (1927), the Netherlands (1929), Italy (1930) and France (1932) – were survey shows, often incorporating new scholarship and attributions, and covering both old and modern (nineteenth-century) art. Within this programme, the Royal Academy did not shy away from sounding a British nationalistic note. It mounted important surveys devoted to 'British Primitive' painting from the twelfth century to the early sixteenth (1923)[70] and to 'British Art c.1000–1860' (1934) as well as a Sir Joshua Reynolds bicentennial exhibition in 1923.

All of these exhibitions were conceived on a grand scale, encompassing many hundreds of objects, sometimes thousands: 1,000 in 'Italian Art 1200–1900' (1930) and 3,000 in 'International Exhibition of Chinese Art' (1935–6), the latter a collaboration between two imperial powers in which the Royal Navy's warships were employed as a means of swift and secure transport (fig. 70). The exhibits ranged from the miniature to the monumental in size, such as a colossal 20-foot (6-metre) marble statue of the Buddha (fig. 71). They often embraced the full panoply of the fine and decorative arts and might cover a wide chronological range. 'Dutch Art

70 Topical Press Agency, the crew of *HMS Hood* unloading cases at Portsmouth, July 1935, silver gelatin print, 25 × 19.5 cm (RA 05/3489).

71 Topical Press Agency, installing the Amitabha Buddha in the Central Hall, 'International Exhibition of Chinese Art', 1935, silver gelatin print, 25.4 × 19.7 cm (RA 03/3479).

1450–1900' had major works by Rembrandt, de Hooch and Vermeer as well as Joseph Breitner and Vincent van Gogh, while 'French Art 1200–1900' presented Philippe de Champagne, Poussin and Claude together with Watteau, David, Ingres, Monet and Cézanne.[71] Such riches drove an eager public to crowd the galleries of Burlington House, where the art treasures were presented systematically by chronological period and/or by medium, often in elaborate architectural settings. Five of the nine exhibitions devoted to foreign schools brought attendances in excess of 200,000 (usually for an 8- to 12-week run), the top three being 'French Art 1200–1900' (350,000), 'International Exhibition of Chinese Art' (402,000) and 'Italian Art 1200–1900' (600,000).[72] These exceptional attendances were greatly welcomed by

the Academy because by this time the Summer Exhibition no longer provided sufficient income to cover its expenses and it relied on the income from loan exhibitions, which included new arrangements to cover what were often very significant costs (see p. 91 below, 'Sponsorship').

Before the First World War, the Academy had shouldered the financial risk of mounting its Winter Exhibition. From 1920 this situation was to change. While it continued to retain full responsibility for loan exhibitions on British art, a combination of different models to ensure that the institution did not suffer repeated financial losses was adopted for those devoted to foreign schools. These ranged from straight rental of the galleries (as for 'Spanish Painting' and 'Flemish and Belgian Art 1300 to 1900'), to rental and a share of the

gate ('Dutch Art 1450–1900' and 'Italian Art 1200–1900') to which could be added the retention of all income generated by the sale of catalogues and related merchandise ('French Art 1200–1900'). For those exhibitions where the UK government became directly involved, as in the case of the Chinese exhibition, the Royal Academy enjoyed a direct guarantee of funding. When comparison is made between the fortunes of the British and foreign school exhibitions, it is clear that those financial arrangements that involved subvention from external bodies were advantageous to the Academy. Although 'British Art c.1000–1860' returned a profit of £6,900, the show devoted to recently deceased British artists of 1922 produced a deficit of £505, whereas 'Italian Art 1200–1900', the 'International Exhibition of Chinese Art' (1935–6) and 'Exhibition of Seventeenth Century Art in Europe' (1938) produced surpluses of £6,625, £10,700 and £2,834 respectively, and this despite the inevitable increase in the costs of such large inclusive exhibitions and the marked decline in the value of sterling in the wake of the 1929 stock market crash. The hybrid financial arrangements for loan exhibitions over this period meant that, over this 20-year period, the Royal Academy registered only eight years of overall deficit. It appeared that the model of the loan exhibition as the revenue driver of the institution had now been established.

1939–1972

In 1938 three major survey exhibitions devoted to German, Indian and American art were under consideration by the Academy. With the outbreak of hostilities, winter exhibitions were once again suspended. The main galleries were made available to support the war effort, which included, at the request of the government, exhibitions mounted for propaganda purposes such as 'Greek Art 3000 BC–AD 1938' in 1942, presented through photographs and opened by the temporarily exiled King of the Hellenes. 'Modern Brazilian Paintings' was shown in 1944 and 'Soviet Graphic Art' in the following year. The Academy also made a foray into touring exhibitions in 1942, sending a selection of 65 works by Academicians to the regions, in association with the Council for the Encouragement of Music and the Arts. And it contributed to the debate about the rebuilding of bomb-torn

London through an exhibition of designs emanating from the Royal Academy Planning Committee under the chairmanship of Sir Edwin Lutyens PRA.[73]

The next phase in the history of the loan exhibition at the Royal Academy is bracketed by 'The King's Pictures', held over the winter of 1946–7, and the expansive Council of Europe exhibition, 'The Age of Neoclassicism', presented in 1972, the scale of which demanded that it should be presented in both the main and Diploma Galleries of Burlington House and also at the Victoria and Albert Museum. Patterns of exhibition, financial arrangements and the range of subjects reveal an institution during this period not entirely secure in its rationale for loan exhibitions. First, the number of exhibitions increased per annum from an average of three to five to seven from 1958. This was in part due to the reopening of the Diploma Galleries in 1952 as a temporary exhibition space rather than for the display of the Academy's permanent collection. Second, certain major loan exhibitions, such as 'Works by Holbein and other Masters of the 16th and 17th century' (1950–51) and the 'Age of Charles I' (1960–61), were extended beyond the normal three-month run in order to increase visitor numbers and maximize revenue.

The established pre-war practice of reviewing national schools or specific periods in the history of art continued. Surveys of Indian and Pakistani, Portuguese and Polish art were mounted in 1947–8, 1955–6 and 1970 as well as 'The Age of Louis XIV' (1958), 'Goya and his Times' (1963), 'France in the Eighteenth Century' (1968) and '50 Years Bauhaus' (1968). Equally, the Academy maintained its commitment to British art with exhibitions ranging from surveys of British portraiture (1956–7) and English taste in the eighteenth century (1955–6) to solo exhibitions devoted either to Academicians of historic significance, such as David Wilkie (1958), Thomas Lawrence (1961) and Edwin Landseer (1961), or to recently deceased members who stylistically spanned the contemporary British art scene, from the conventional offerings of Sir Alfred Munnings (1956) and Sir Frank Brangwyn (1953) to the slightly more adventurous art of Augustus John (1954), Dame Laura Knight (1956) and John Nash (1967). Most important for the institution, however, was the 'Royal Academy of Arts Bicentenary Exhibition', held over the winter of 1968–9.

New sources for exhibitions also introduced new elements into the programme, while changes of attitude within

the Royal Academy towards the more advanced manifestations of twentieth-century art made possible the inclusion of more avant-garde modern and contemporary subjects. The new sources for exhibitions were primarily the availability of individual private collections and the establishment of the Arts Council of Great Britain as an exhibition maker and broker on the national and international scene. In the period 1870–1939 there had been few instances of single collection exhibitions. The Academy had presented George McCulloch's collection of nineteenth-century British and European paintings, sculpture and works on paper as the Winter Exhibition of 1909, while the Iveagh Bequest to Kenwood dominated the loan exhibition of 1928. But from the later 1950s there were private collection exhibitions, beginning with a selection from that of Paul Oppé shown in 1958,[74] followed four years later by a selection of works by Thomas Girtin and his contemporaries from the collection of his descendant, Tom Girtin, and, rather daringly, contemporary American painting from the Johnson Collection in 1963. Paul Mellon's collection of British painting was presented in the following year and the Armand Hammer Collection in 1972.

The Arts Council of Great Britain, formed out of the wartime Council for the Encouragement of Music and the Arts, was to provide exhibitions, international partners and funding for a series of exhibitions shown at Burlington House from as early as 1949. The essential pattern was established with 'Landscape in French Art' (from the sixteenth century to the nineteenth). The Arts Council brought to this enterprise a French co-organizing and funding partner, the Directions des Relations Culturelles de France, while providing additional funds for all shipping and insurance for British loans. The Academy, while reluctantly having to forego the making of the catalogue, retained the income from the gate, the net profit from which was shared with the French organization. Thenceforth, the range of exhibitions presented in partnership with the Arts Council ranged from the sublime to the arcane and the 'edgy', from 'Delacroix' (1964) and 'Derain' (1967) to 'Hittite Art and the Art of Anatolia' (1964) and 'British Sculptors '72' (1972).

The exhibition that heralded a move towards the inclusion of the more progressive aspects of international twentieth-century art was that devoted to the École de Paris held in the spring of 1951. Responsibility for this initiative lay

with the relatively recently elected President, Sir Gerald Kelly, a portrait painter of exquisite taste with an appealing broadcasting personality, whose adherence to a polished, almost hyperrealist form of art belied his early years in Paris where he had consorted with members of Paul Gauguin's circle and had known Matisse. Together with Edward Le Bas RA, Kelly worked with a team of French specialists, Jean Cassou, director of the Musée d'Art Moderne, and Georges Salles, director of the Musées de France, and was supported organizationally by Frank McEwen, Fine Arts Officer at the British Council in Paris. The intention of the exhibition was to provide an overview of the achievements of the École de Paris since 1900. In all, 89 artists – including Bonnard, Vuillard, Matisse and Derain, Braque, Juan Gris, Léger, Max Ernst, Tanguy and Kandinsky – were represented by 163 works. The only 'absentee' from the roll of honour was Pablo Picasso, whose 'Communistic sympathies', it was recorded in the Annual Report, 'caused him to forbid the inclusion of any of his work'.[75]

Kelly only held the position of President for a further three years, and it was to be another eight before the exhibition programme opened up to other foreign twentieth-century subjects. Although Picasso finally entered the institution in the 1962 exhibition 'Primitives to Picasso', and American contemporary painting made between 1959 and 1962 was shown in 'Art USA Now' the following year, the Academy still chose not to embrace the more radical manifestations of twentieth-century art, a task already being fulfilled since the 1950s by the progressive exhibitions programme at the Whitechapel Art Gallery under Bryan Robertson. Nonetheless, while it settled for less challenging subjects such as 'Bonnard' (1966), 'Derain' (1967) and 'Giorgio Morandi' (1970), or subjects that validated the contemporary through historical context, as in 'Vienna Secession 1900–1970' (1971) and 'French Painting since 1900' (1969), the Academy inserted such exhibitions with greater regularity into its programme after 1966. This was possibly a reflection, as Bryan Robertson pointed out in his introduction to the 'British Sculptors '72' catalogue, of the influence of the new President, Sir Thomas Monnington, who had been elected in that year.

Given the range of sources from which exhibitions were drawn during this period, their organization had to be coordinated within the Academy. While the creation of a designated Exhibitions Department had to wait until 1968

72 Russell Westwood, *Librarian of the Royal Academy, Sidney Hutchison, at his Desk, 1953*, March 1953, photograph (RA 10/3662).

to 'Goya and his Times' (1963), and deficits of £31,302 and £37,134 experienced by 'France in the 18th century' and 'The Royal Academy Bicentenary 1768–1968' (1968 and 1968–9 respectively).

INTO THE TWENTY-FIRST CENTURY

Throughout the 1970s the loan exhibitions were often numerous, frequently reactive to external forces, and increasingly rocked by financial risk. They juddered from 'D. G. Rossetti', 'John Armstrong' and 'Bird Drawings of C. F. Tunnicliffe RA' to the ill-conceived and highly problematic 'Landscape Masterpieces from Soviet Museums', often achieving poor attendances and running regular deficits. There was, however, the occasionally more ambitious show inserted into the programme such as 'Italian Futurism' presented in 1973. Of greater significance for the future was the carefully organized exhibition of 1974 marking the centenary of the first Impressionist exhibition in Paris, and the collaboration with the Tate Gallery on the highly successful bicentennial exhibition of J. M. W. Turner (1974–5). The Turner exhibition was curated by a team of distinguished Turner scholars and accompanied by a notably scholarly catalogue. It showed some 650 works and attracted over 400,000 visitors in just under four months (November 1974–March 1975). One way forward was indicated by the novel arrangements put in place for showing 'The Genius of China', an exhibition of archaeological finds from the People's Republic of China over the winter of 1973–4. In the light of its recent financial troubles, the Academy realized that in order to mount its large, ambitious survey exhibitions it now had to turn to commercial sources of funding, in this case *The Times* and *The Sunday Times*.

Following the election of Sir Hugh Casson to the presidency in 1976, Norman Rosenthal was appointed Assistant Exhibitions Secretary in the following year. He was recruited partly in response to an article that he had written in the *Spectator* challenging the Royal Academy to a more ambitious loan exhibitions programme that would be comparable to that being vigorously pursued at the Grand Palais in Paris (where it was underwritten by the French state).[76] In the same year, an exhibitions committee was once more established, chaired by the painter Frederick Gore RA; Griselda

with the appointment of Philip James (previously at the Arts Council) as Assistant Exhibitions Secretary, responsibility for liaising with outside organizations and ensuring the delivery of individual shows fell to the Librarian, Sidney Hutchison (fig. 72). The financing of loan exhibitions extended the hybrid model already introduced during the inter-war years. The majority, however, demanded Academy financing, and apart from income from its trust funds, the primary sources of revenue remained those generated from both the summer and the winter exhibitions. This was to prove to be ever more precarious during the course of the 1950s and 1960s. Against a backdrop in which the Summer Exhibition's visitor numbers decreased by over 100,000 and its revenues halved, loan exhibition revenues could fluctuate between a surplus of £35,734, generated by 347,996 visitors

Hamilton-Baillie took on Press, Public Relations (including fund-raising) and Friends; and the present writer joined the institution in 1983, initially to establish an education department and to curate exhibitions. A new era of exhibitions was launched, marked by a programme that effectively established the Academy as a Kunsthalle that could command exceptional individual loans from home and abroad and receive fully formed exhibitions to an extent almost unprecedented at that time in London or the UK.

Over the period 1976–2016 some 310 loan exhibitions were presented within Burlington House, many small in scale and shown in spaces outside the main exhibition galleries. Some of them were drawn primarily from the Royal Academy's own collections, inaugurated after 2000 in the Print Room and, after 2003, in the Tennant Gallery,[77] while others, with some works for sale, were mounted in the Friends Room.[78] Several patterns emerge in the overall programme. After a hectic period of producing or hosting exhibitions during the 1970s, the number of loan exhibitions settled at around eight each year following the temporary inclusion of the Private Rooms as exhibition spaces after 1977, with a more sober rhythm adopted of some six or seven major loan exhibitions after the opening of the Sackler Galleries in 1991.[79] The exhibition programme aimed, over a two-year period, to represent the Old Masters, modern European art (of the nineteenth and twentieth centuries) and non-western art, as well as different media (sculpture, works on paper, architecture), a schedule interspersed with exhibitions of works by contemporary living artists who were primarily but not exclusively Royal Academicians.[80]

To fulfil this intended programme, the Academy, continuing its recognition of the grandeur of its great Main Galleries, which had informed its loan exhibitions since 1870, mounted great synoptic survey exhibitions of western art such as 'Genius of Venice' (1983–4), 'Age of Chivalry' (1987–8), 'Pop Art' (1991), 'The Great Age of British Watercolour' (1993) and 'Byzantium' (2009), as well as a sequence of four exhibitions devoted to the art of the twentieth century in Germany, Britain, Italy and the United States.[81] There were also major monographic exhibitions devoted to such artists as Reynolds, Mantegna, Frans Hals, Van Dyck and Rodin. Non-western art included 'The Great Japan Exhibition' (1982–3), 'Africa' (1995–6), 'Tibet' (1992), the 'Turks' (2005), the 'Aztecs' (2002–3) and 'China' (2005–6), as well as a sequence of four

shows devoted to the Japanese print, inaugurated with 'Hokusai' in 1991. In addition, the programme was amplified by a growing number of exhibitions drawn from private and public collections. Public collections, as directorial aspirations for new museums and extensions ballooned in the 1990s, became increasingly packaged as touring shows, and the Academy hosted several, notably from the Baltimore museums, the Museum of Fine Arts Boston, the National Museum of Budapest, the Dresden Museum, the Ny Carlsberg Glyptotek, the Maeght Foundation and the Sterling and Francine Clark Art Institute. To these may be added 'From Russia' (2008), which drew upon the four major national museums of Moscow and St Petersburg.

Among exhibitions that presented little-known periods or artists, few among the British audience had encountered the work of artists such as Odilon Redon (1995), Charlotte Salomon (1998), William Nicholson (2004), Vilhelm Hammershøi (2008) or Jean-Étienne Liotard (2015). A series of notable exhibitions, co-curated by Norman Rosenthal and Christos Joachimides, explored the art of four nations in the twentieth century, being dedicated to America, Italy, Britain and Germany, in 1985, 1987, 1989 and 1993 respectively. There were also more inclusive, ground-breaking exhibitions that challenged the accepted road to modernism, including 'Post-Impressionism: Cross-currents in European Art, 1880–1910' (1979–80) and '1900: Art at the Crossroads' (2000). The Academy also addressed photography for the first time in its history, in an extensive exhibition of some 462 prints celebrating 150 years since the invention of the medium ('The Art of Photography 1839–1989'), although this had to surmount considerable opposition from a membership still residually wary of the medium's claim to be a 'fine art'.

These more adventurous exhibitions did not pass without generating controversy within the press, which was also the case when the Academy addressed contemporary art. In order to fill gaps in the main galleries' programme caused by the cancellation of other exhibitions, the Academy presented three shows between 1981 and 1999. Put together with a necessary degree of speed, 'A New Spirit in Painting' (1981) and 'Sensation' (1997) explicitly charted new landscapes for contemporary art. The former presciently announced the return to figuration in the wake of abstraction, and the latter – in fact an exhibition drawn from a private collection (that of Charles Saatchi) – launched the YBAs (Young British

73 Anish Kapoor exhibition, installation view, Gallery III: Royal Academy of Arts, 2009.

Artists) on the international platform of the Academy's galleries. It was highly controversial on account of several of the exhibits, a factor which, when taken together with the involvement of Charles Saatchi in the commercial art market, led to the planned showing at the National Gallery of Australia in June 1999 being cancelled by its director.[82] Interestingly, far less controversy attended one of the more dramatic exhibitions of contemporary art in the early years of the twenty-first century, the retrospective of Anish Kapoor RA in 2009, which occupied the entire surface of the Main Galleries (fig. 73).

The Academy also introduced a new strand into its programme: architecture exhibitions. In the inter-war period, there had already been a gesture made towards the fact that the Academy's membership included a number of distinguished architects, but reservations about the public's ability to read conventional architecture exhibitions, their lack of popular appeal and their cost had deterred the institution from integrating this area into its regular exhibition programme.[83] It was only with the mounting of 'New Architecture: Foster Rogers Stirling' in 1986 that this issue was readdressed. While fully recognizing that architecture exhibitions can only function through surrogates for the buildings themselves, the exhibition used the galleries to communicate concepts and works through large-scale models set against vivid two-dimensional images and, in the case of James Stirling RA, a one-to-one detail of an element of his Staatsgalerie in Stuttgart.

On receipt of an endowment for architecture in 1991, funds were at last available for a programme of exhibitions without complete reliance upon commercial sponsorship. There followed a series of shows that balanced the historical and the contemporary: the neo-Palladianism of Lord Burlington and the achievements of Sir John Soane RA and

Andrea Palladio were set beside exhibitions devoted to contemporary architects, Denys Lasdun RA, Tadao Ando, Kisho Kurakawa, Arato Isozaki and Richard Rogers RA.[84] Survey exhibitions such as 'Living Bridges', which embraced a specific building type, were complemented by 'Sensing Spaces' (2014), which made no compromise to provide surrogate material but constructed 'real' buildings in the main galleries in order to engage the public in the sensory dimension of architecture.

Although some of the exhibitions organized by the Arts Council of Great Britain during the 1950s and 1960s had been partnered with other institutions, it was only when 'Post-Impressionism' in 1979 was 'exported' to the National Gallery of Art, Washington, DC, that the pattern of the Academy working with other major institutions was established. Loan exhibitions became increasingly political, and the desirability of collaborating with major museums and art galleries with significant lending power of their own was attractive to the Academy, while its own strength in this respect lay almost exclusively in the field of British art since 1750. There were also budgetary benefits to be gained from sharing costs such as shipping, curating and catalogue production, and the Academy found itself working with an array of American museums, from the Metropolitan Museum and the Guggenheim in New York to the Museum of Fine Arts, Boston and the Art Institute of Chicago, and with leading institutions throughout Europe.

SPONSORSHIP

Such international partnerships could also assist in securing financial support for exhibitions, as companies and foundations sought to raise their profiles across more than one continent. This raises the wider issue that became an unavoidable imperative within the making of the Academy's exhibitions from the 1970s onwards: the need for sponsorship. The Academy entered that decade with a deficit accumulated over three years. It was to grow throughout the 1970s because of increasing overheads, rising exhibition costs and the servicing of a mounting overdraft, all unassuaged by intermittently improving revenues from the Summer Exhibition. Despite the proposal from the auction house Sothe-

by's in 1972 to rent from 1974 to 1976 the entire main galleries for a substantial fee (which was refused because it entailed truncating the length of the Summer Exhibition),[85] and fruitless approaches to the government and the Arts Council in 1979 for regular annual core funding,[86] it was recognized in that same year, 'in view of the size of the deficit and the losses of the majority of exhibitions…that even more serious consideration should be given to the financial aspects of future exhibitions.'[87]

Although from 1979 the Academy benefited from a government indemnity to cover insurance costs,[88] sponsorship became indispensable if the institution's ambitions for its loan exhibitions were to be maintained. Having initially tested external commercial support with 'The Genius of China' in 1973–4, sponsorship became the norm. Technology firms such as Olivetti and IBM were joined by banks, oil companies and other commercial and philanthropic entities, the arrangements for which were initially on the basis of a guarantee against loss but subsequently changed to one of a straightforward grant. With exhibition costs inexorably rising, however, the financial model for the Academy to support its loan exhibitions inevitably extended to involve contributions from its Friends (founded 1977), Patrons and corporate supporters, revenue from catalogues and related merchandise (a resource already identified in the 1930s) and returns from the gate.

At the same time, the Academy was facing increasing competition as the number of venues holding loan exhibitions and, naturally, tackling the same sources of funding grew. In London alone, all the national and state-funded institutions, from the British Museum and the Tate to the Hayward Gallery (opened in 1968) and the Whitechapel Art Gallery, participated with increasing regularity. The Saatchi Gallery was joined by commercial galleries with a global reach, such as Gagosian, Pace and White Cube, in initiating loan exhibitions primarily of contemporary art. Internationally, the fight for audiences meant that subjects deemed popular and commercially advantageous were repeatedly mounted, causing potential and actual clashes of interest between 'rival' organizations and reducing the availability of key works. Through it all, the Academy generally sought to maintain a seriousness of purpose for its exhibitions while remaining committed to a visually compelling presentation.

A CLOSER LOOK

3.1

John Callcott Horsley
A Pleasant Corner

Diploma Work

CAROLINE DAKERS

A Pleasant Corner, the Diploma Work of John Callcott Horsley RA (fig. 74), offers a view of a type of house that was to become a distinctive feature of the Victorian art world in the decades after the Academy's arrival in Burlington House in 1867. This was the fashion for artists' studio-houses, which were at one and the same time homes, studios and showrooms. Horsley's sitter is positioned in the dining room of the artist's house, Willesley, near Cranbrook in Kent. The actual business of painting the picture would have been carried out in the studio that the artist had recently added to his residence under a remodelling that Horsley commissioned from an architect who became a master of the genre, Richard Norman Shaw RA. It was Shaw's first domestic work (Willesley is now known as Shaw House), but the friendship that formed between the two men led to Shaw's providing designs for Horsley's friends in the Academy, including his neighbour at Cranbrook, Thomas Webster RA, but also Edward William Cooke RA, Frederick Goodall RA and Thomas Sidney Cooper RA. It was also the start of a long involvement of Shaw with the Academy itself, which included his additions to the exhibition spaces in the years around 1885 discussed in this chapter.

From the mid-1870s Shaw designed studio-houses in London for younger artists who were as yet outside the Academy but ambitious to join, including Luke Fildes, Marcus Stone, Edwin Long, George Henry Boughton and Frank Holl.[1] Shaw went on to design for the Academy the large Refreshment Room (now the restaurant) on the ground floor; three additions to the main galleries in the form of a Watercolour Gallery (now the Large Weston Room); a 'Black and White Room' (now the Small Weston Room); and the Architecture Room (now the Academy Room) on the first floor. The former two galleries were linked to the restaurant by a sweeping staircase.

Shaw was not in fact the only architect to design houses in which artists could both work and live. In 1859 Philip Webb had designed the Red House for William Morris and Edward Burne-Jones ARA, and then houses for John Roddam Spencer-Stanhope, Valentine Prinsep RA and George Boyce. George Aitchison RA created an extraordinary Orientalist palace for Frederic Leighton PRA (now the Leighton House Museum) and a purpose-built gallery for George Frederic Watts RA. Edward Godwin was commissioned by James Whistler, while Lawrence Alma-Tadema RA devised his own Pompeian-style fantasy in

74 John Callcott Horsley RA, *A Pleasant Corner*, 1865, oil on canvas, 76.8 × 57.1 cm (RA 03/944).

St John's Wood in a building that had formerly been the house and studio of James Tissot, which he enlarged.

Most artists chose to live in London, within easy reach of the Royal Academy and (from 1877) the Grosvenor Gallery. Distinct colonies were established, notably in Kensington, St John's Wood, Hampstead and Chelsea, while the most prestigious address was Holland Park, home of Frederic, Lord Leighton. The period 1860–1900 was a golden age for British artists. Their work commanded high prices and their income increased through the sale of reproduction rights. Several became as rich as members of the aristocracy: millionaires in twenty-first-century values. Some were knighted and a few were given hereditary titles.

The sculptor Arthur George Walker RA bequeathed to the Academy several very attractive and informative paintings of the interior of his studio-house at Cedar Studios, Glebe Place, Chelsea, which had been built in 1885–6 by the sculptor/designer Conrad Dressler. *Tea in the Studio* shows a couple seated among the marbles and plasters (fig. 75), and the sculptures that we see include a rear view of Walker's Diploma Work *Grief* (1915) at the right of the picture, reflecting the fact that these houses offered the chance to display works throughout the year but also – and it was important – in advance of each year's Summer Exhibition on 'Show Sundays'.

Every spring, from the 1870s onwards, the artists held two 'Show Sundays' in their studios, just before work had to be sent in for the annual Summer Exhibition. One was for members of the Academy, the other for 'outsiders', and the timing meant that they became part of the London Season. For some artists, however, exhausted after a year of hard work,

75 Arthur George Walker RA, *Tea in the Studio*, 1932, oil on canvas, 62 × 51 cm (RA 03/1143).

the occasions were stressful. Edwin Austin Abbey RA observed: 'everybody is taking a long breath now that the agony of Show-Sunday is over and the pictures are gone in.'[2]

3.2

Frederic, Lord Leighton
St Jerome

Diploma Work

ANNETTE WICKHAM

In 1868, the year that John Everett Millais' *Souvenir of Velázquez* was accepted into the Academy's collection, his friend Frederic Leighton was elected an Academician. Both men were to be deeply involved with the Academy in its new home in Burlington House. Leighton was to dominate the institution, especially during his presidency from 1878 until his death in 1896, and he was followed in that office by Millais, although briefly (Millais died later the same year). Like Millais, Leighton chose to present a religious painting produced during a consciously pivotal phase in his career. Unlike Millais, Leighton's painting was happily accepted by the Academy and received positive comments in the press. Conversely, this work now appears to be something of an 'odd man out' in Leighton's oeuvre since it is his only finished painting of a Christian saint.

St Jerome is often depicted as an ageing ascetic in the desert, accompanied by the lion that he had tamed when he healed its paw. Leighton's *St Jerome in the Desert* adopts the less common iconography of the saint in an act of penance, kneeling in prayer at the foot of the cross, stripped to the waist and with a whip for self-flagellation discarded behind him on the ground as he raises both arms in supplication

(fig. 76). Generally, the painting owes something to Titian's depictions of the saint, but the pose is unusually expressive. *St Jerome* is rarely mentioned in the literature on Leighton, but Alison Smith has discussed it in relation to *Daedalus and Icarus* (c.1869; Faringdon Collection, Buscot Park), suggesting that the artist intended a thematic link between the two works as a contrast between Christian 'subjugation of the flesh' with 'pagan adulation of the body'.[1] In the background, the lion faces in the opposite direction from the saint, towards the fiery rays of a setting sun, a feature that could be interpreted as symbolizing the division between Christian and pagan spirituality. The sun as a vital, life-giving, but dangerous force is a recurrent theme in Leighton's work from the late 1860s onwards.[2]

When the painting was exhibited at the Academy in 1869, the critic of the *Athenaeum* specifically commented on the amount of effort exerted on it, observing that it was created 'with care at least equal to that expended by the artist on any former work', which, in Leighton's case, was always a substantial amount.[3] The *Daily News* described it as the most important of Leighton's exhibits that year, adding that, while Academicians 'have generally painted some small work of

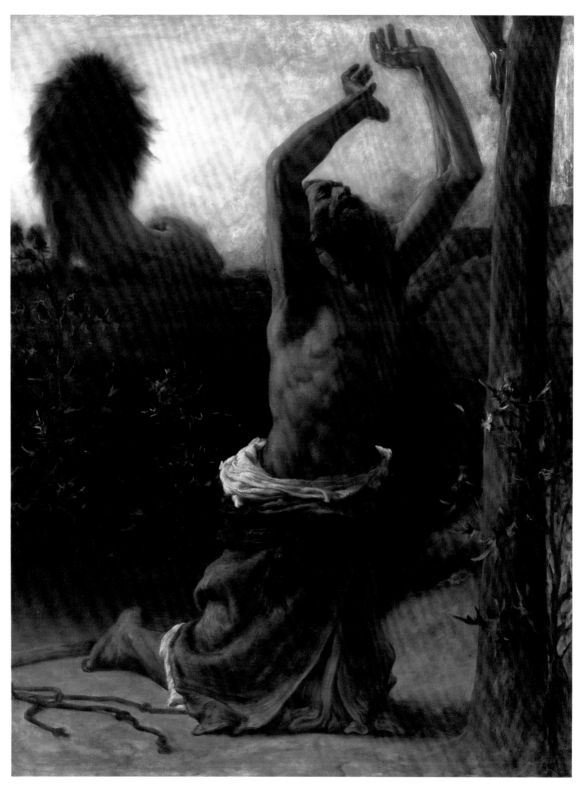

76 Frederic, Lord Leighton PRA, *St Jerome in the Desert*, 1869, oil on canvas, 184.5 × 142 cm (RA 03/1343).

minor importance' for their diploma pieces, 'Mr Leighton has…made a discreet choice in favour of his more serious and grave style.'[4] Leonée Ormond has pointed out that Leighton did not find it easy to sell his religious paintings, and suggested that this was his reason for placing *St Jerome* at the Academy;[5] Leighton may have seen his Diploma Work as an opportunity to explore a theme of this kind free from the concern of having to appeal to a buyer or patron. Indeed, Mrs Barrington, Leighton's biographer, felt that he had a particularly strong personal connection with the *St Jerome*, which she described as being one of the few works to reflect 'a side of his nature about which he was profoundly reserved'. She likened it to his *Elijah in the Wilderness* (1879; Walker Art Gallery, Liverpool), which Leighton claimed he had 'put more of himself into' than any other picture.[6]

One of Leighton's sketchbooks in the Royal Academy collection includes drawings for *St Jerome* alongside sketches for other important works of the late 1860s such as *Helios and Rhodos* (c.1868–9; untraced) and *Electra at the Tomb of Agamemnon* (1868–9; Ferens Art Gallery, Hull), demonstrating how his interest in religious art developed in tandem with his exploration of classical subjects.[7] This is also clear from Leighton's Royal Academy exhibits. In 1868 Leighton showed three scenes from Greek mythology, one portrait and the Old Testament subject *Jonathan's Token to David* (1868; Minneapolis Institute of Arts). The following year was the Academy's first exhibition at Burlington House, and Leighton, who was on the hanging committee, again showed three scenes from ancient myth, *Daedalus and Icarus*, *Electra at the Tomb of Agamemnon* and *Helios and Rhodos*, all of which were hung in relation to similar works by Albert Moore and G. F. Watts RA. The fourth work, *St Jerome*, appeared in Gallery VI along with religious paintings by Alfred Elmore RA and Edward Armitage RA.[8]

It must have appeared that this new element in Leighton's art was set to become a significant, if subsidiary, aspect of his work. Together with Millais and others, Leighton had received commissions to illustrate elements of the Dalziel brothers' illustrated Bible project, and at the time that he painted *St Jerome* he had recently completed a fresco of *Christ and the Wise and Foolish Virgins* at St Michael and All Angels, Lyndhurst, Hampshire. By the 1880s and 1890s, however, Leighton was focusing almost exclusively on classicizing themes and figures from ancient myth.

The death and funeral of Frederic, Lord Leighton

ANNETTE WICKHAM

The archive of the Academy contains photographic records of many key moments in its history. One such is a negative that records the lying-in-state of its President, Frederic, Lord Leighton, in the Octagon Room in late January 1896 (fig. 77), which was but one stage in the elaborate mourning procedure that preceded his funeral on 3 February.

It was on 25 January that Lord Leighton's long reign as 'king' of the Victorian art world had come to an end.[1] He died of a heart attack in the small and curiously stark bedroom of his otherwise opulent Kensington studio-house. Leighton had been suffering from heart disease for at least a year, a fact unknown to all but his closest friends.[2] Even when he succumbed to his final illness in the winter of 1895, Leighton gave strict instructions that his condition should not be made public. His physician, Dr E. A. Barton, left a touching account of the artist's last hours, describing how Leighton's sisters, Alexandra and Augusta, sat with him throughout, quoting lines of German poetry that they had all learned by heart as children. The only other visitors permitted to enter the room were medical staff, lawyers and two friends, Samuel Pepys Cockerell and Val Prinsep RA (whom Barton described as having 'sobbed like a boy').[3]

If Leighton's illness and death were deliberately low key and private, his funeral was, by contrast, an ostentatious affair displaying the full panoply of pomp and ceremony that characterized Victorian mourning for public figures. The Academy immediately took charge of organizing the funeral, with The Times reporting that their arrangements left 'no room for doubt' that the ceremony would be 'impressive, solemn and gravely picturesque in no common measure'.[4] Not all of the Academy's presidents had been given such grand funerals, but Leighton's was firmly in the tradition set by that of the first incumbent, Sir Joshua Reynolds, whose body had lain in state in the Life Room at Somerset House surrounded by candles and black drapes before being taken to St Paul's Cathedral in a cortège of 91 carriages, his coffin carried by ten pall-bearers, eight of whom were peers of the realm.[5]

Leighton's body was first laid out in the drawing room of his house. Several newspapers published illustrations showing the open coffin amid a crush of wreaths, paintings and sculptures.[6] A few days later, graduating to a more formal period of lying-in-state, the body in its polished oak coffin was taken to the Royal Academy. This stage was carefully orchestrated by the Academy's officials, and guests were invited to pay their respects at allotted times.[7] On entering the Octagon they would have seen Leighton's coffin covered with a crimson velvet pall and resting on a bier draped with a deep purple cloth. The artist's palette and brushes were prominently displayed on top of the coffin, while on a red velvet cushion

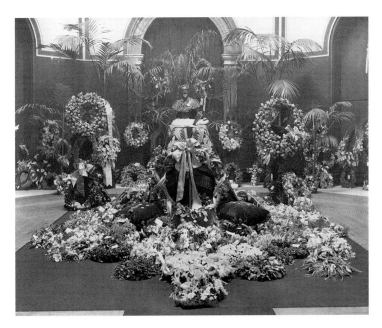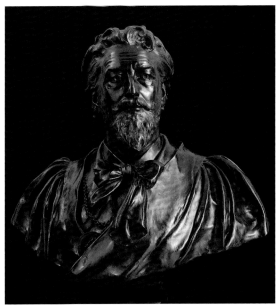

77 Frederic, Lord Leighton PRA lying in state in the Octagon Room, Royal Academy of Arts, 1896 (RA 10/1320).

78 Thomas Brock RA, *Frederic, Lord Leighton PRA*, 1892, bronze, height 83 cm (RA 03/1682).

were the medals and orders conferred on him by foreign governments and academies. The bronze portrait bust of the artist by Thomas Brock RA (fig. 78) was also placed in the room and hung with Leighton's presidential chain of office. The coffin was almost hidden among a mass of floral tributes, which included a wreath from Queen Victoria made from laurel leaves and 'immortelles' grown at her Frogmore estate.[8]

The funeral took place on Monday 3 February. At 11 o'clock, the cortège left Burlington House led by a guard of honour from the company of the Artists' Rifles, of which Leighton had been a keen member. The formation of the procession was meticulously hierarchical. The pall-bearers included Sir John Everett Millais PRA (representing the Academy and who succeeded Leighton as President), the Duke of Abercorn, the President of the Royal Society, the Principal of the Royal Academy of Music, and the Librarian of the British Museum. They were escorted by a group of eminent artists, and were followed by Leighton's family and representatives of the royal family. Next came the officials of the Royal Academy followed by the rest of the Academicians and Associate Academicians,

the institution's professors, its curators, selected students carrying wreaths and, lastly, its servants.[9]

Leighton's death was felt beyond the confines of the Academy and the art world, reflecting the elevated status of successful artists in Victorian society. Large crowds gathered at Burlington House and lined the route of the procession.[10] The Dean and clergy of St Paul's were in attendance, along with the Bishop of Stepney and the Archbishop of York (as chaplain of the Royal Academy).[11] Burial took place in the crypt, and so a stone had been removed from the pavement of the nave in order to lower the coffin down into it. At this stage of the ceremony, Leighton's sisters realized that they were unable to see the interment. Dr Barton described how he 'half carried, half bundled the old ladies down the stairs…and into the crowded body of the church' so that they could pay their last respects.[12] As a mark of gratitude, Augusta and Alexandra presented the doctor with their brother's watch and chain and, in a more morbid touch, a tumbler containing the folded handkerchief with which Barton had administered chloroform to the artist in his last moments.

MUNNINGS AND AFTER

Teaching and Exhibiting after the Second World War

PAUL MOORHOUSE

On 28 April 1949, the then President of the Royal Academy, Sir Alfred Munnings, delivered a speech at the annual dinner that mounted a premeditated, sustained and scathing attack on what he described as 'so-called modern art' (fig. 79).[1] Munnings's words have acquired notoriety, not only for the bitterness with which they were expressed, but also for the surprising range of his targets. The speech was broadcast live to a large radio audience and, with Winston Churchill at his side, the President's barbs were aimed at Picasso, Matisse and the School of Paris in general. Also singled out for criticism were others regarded as sympathetic to the 'affected juggling'[2] of which Munnings disapproved. These included the Surveyor of the King's Pictures, Sir Anthony Blunt, who was present; art experts or 'highbrows'[3] for whom Munnings evidently had little affection; London County Council, the body responsible for showing modern international sculpture in exhibitions held at Battersea Park; and the Revd

Walter Hussey, whose support (as patron and collector) for such artists as Henry Moore RA, Graham Sutherland and Stanley Spencer RA was well known. Pointedly, Munnings rounded on the members themselves for a perceived affinity with new forms of artistic expression. He declared them to be 'a body of men who are what I call shilly-shallying'.[4]

Sixty-two years later, the 243rd Royal Academy Summer Exhibition was held between June and August 2011. Continuing previous developments, the hanging committee's commitment to showing modern and contemporary art, both British and international, in strength and diversity was clear. In addition to respected senior foreign artists such as Mimmo Paladino, Per Kirkeby and Anselm Kiefer Hon. RA (all of whom were first shown at the Academy 30 years earlier in the 'New Spirit in Painting' exhibition), a generation of artists who had established their reputations in the last 15 years was also conspicuous. Among many

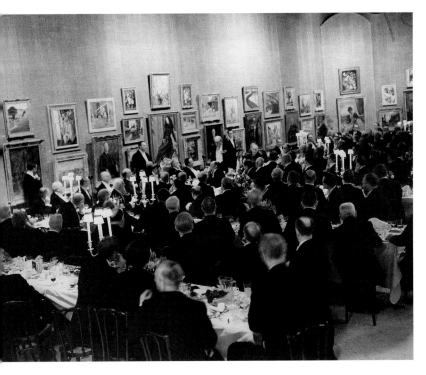

79 Keystone Press Agency, *Royal Academy of Arts Annual Dinner 1949*, 28 April 1949, photograph, 20 × 25.2 cm (RA 07/3922).

of the twenty-first century, the Academy's involvement with recent art represents nothing less than a sea-change. Resistance to progress and a contempt for any deviation from the familiar have apparently been replaced by openness and a will to engage with the new and the experimental. The transformation is remarkable, because so emphatic had Munnings's diatribe been – and it was delivered 'responding for The Academy'[5] – that long after the event it was still taken as defining the institution's relationship with the external world in general and with the art world in particular. The speech was perceived as embodying the apogee of the Academy's reactionary position within an atmosphere of change, and this historic body was subsequently perceived as having surrendered its position of influence in exchange for one of marginalization, and as struggling thereafter to regain its former pre-eminence. This was the account advanced by James Fenton, who argued, 'What nearly sank the Academy, and took decades for it to recover from, was its vision of itself as a bastion Against Modern Art.'[6]

There can be little doubt that during the second half of the twentieth century the Academy's stance in relation to modernism – as set out by Munnings – meant that its already eroded position of authority was severely tested. This was all the more noticeable in that, although far from ubiquitous, modern art was by no means unknown in Britain. It had first became a focus for critical discourse because of a flurry of important exhibitions held in London between 1910 and 1914. In addition to 'Manet and the Post-Impressionists' and the 'Second Post-Impressionist Exhibition', which were organized by Roger Fry and held, respectively, in 1910 and 1912, there were shows devoted to Cézanne and Gauguin, to drawings by Picasso, to Kandinsky and to Brancusi. The exhibition 'Twentieth Century Art: A Review of Modern Movements', mounted at the Whitechapel Gallery in 1914, explored the influence of Post-Impressionism and of Cézanne in particular upon certain British artists, notably James Dickson Innes, Vanessa Bell, Fry, Duncan Grant, Bernard Adeney, David Bomberg, Mark Gertler and Jacob Kramer. This exposure, which bore fruit in the activities of the Camden Town Group and its successor the London Group, marked the beginning of radical changes in the currency of artistic thought in Britain with which Munnings, at least, wanted nothing to do. But the Academy's post-war history can be regarded not simply, and not only, as a contest

others, Tracey Emin RA, Gavin Turk and Martin Creed were notable: artists whose work at one time might have been considered sufficiently progressive as to be beyond the pale. Throughout, the emphasis on works embracing various media was strongly evident, with photography well represented in the Central Hall and high-profile practitioners such as the American Cindy Sherman Hon. RA making a first appearance as an Honorary Academician. The inclusion of artists such as Michael Craig-Martin RA, whose previous allegiance to conceptual processes would at one time have appeared antithetical to the Academy's emphasis on traditional disciplines, also represented a highly significant development. Alongside these contemporary artistic tendencies, as ever the exhibition contained the evidence of an enduring allegiance to showing artists whose work is representational and sometimes incongruously – amateur. Notwithstanding the catholicity of this approach, the imperative to embrace a broad span of contemporary art was inescapable.

Viewed in this way, the difference between Munnings's post-war denunciation of modern art and, at the beginning

with modern art. As will be seen, the Academy's involvement with modernism was more ambivalent than might be supposed. Indeed, its present, altered position in the twenty-first century can be viewed as the outcome of a complex process of reinvention. And it took place during a period that saw radical developments not only within art but within the wider world.

THE POST-WAR ACADEMY AND THE SCHOOLS

What kind of place was the Royal Academy in 1945? In several ways, it found itself repeating a thoroughgoing review of itself and its activities that had first been forced upon it by an adverse Royal Commission report as long ago as 1863. From this distance in time, the move of the Academy to Burlington House in 1868 might be interpreted as a triumphant reflection of the Academy's central role in national life and its pre-eminence in teaching, but in reality it was overshadowed by the recent 'Report of the Royal Commissioners appointed to inquire into the Present Position of the Royal Academy ... and the Minutes of Evidence', with which the Academy was struggling to come to terms. Although the Academy, as a non-state-funded institution, consistently claimed immunity from the necessity to implement the reforms laid out in the Royal Commission's report, its membership was not immune to the harsh verdicts that this report had handed down. The move to Burlington House appears to have provided the opportunity for some of the more pressing matters to be addressed.

The quality of tuition provided by the Royal Academy Schools had engendered concern from external bodies since at least the 1830s, but from 1867, with the prospect of the move into new, dedicated quarters which permitted for the first time uninterrupted tuition throughout the year, aspects of the curriculum were questioned. Over the ensuing three years, significant changes were introduced. The first wave of reforms, spearheaded by Charles West Cope RA, Richard Redgrave RA and Richard Westmacott RA between 1867 and 1868, could be described as being more of a tinkering nature than a set of radical changes, with the exception of the introduction of a class within the Painting School that addressed the lack of competence in the basic elements of painting amongst 'junior students'. Far more sweeping were

the reforms proposed by Leighton, who, on 4 November 1869, submitted a paper to Council (on which he sat) in which were embedded suggestions for

> an improvement in the organisation of the Schools of the Royal Academy: Times of attendance; Vacations; Classes; Study of Drapery; Visitors; Modes of Study; teachers on Architecture and in sculpture and other departments of art-discipline, comprehending within its scope, the application of these studies when once passed to be under the supervision of a Committee of Education, selected from among the Members of the Royal Academy with the view of fostering and guiding the student in the practice of the more elevated directions of his art.

Leighton's proposals were passed by General Assembly on 3 January 1870, and the newly housed RA Schools thus welcomed new teaching positions in painting, modelling and architecture as well as an increase in the number of female students and the intention to introduce instruction in mural painting (fig. 80).

The Royal Commission had also been exercised about the unrepresentative nature of an institution that purported to represent nationally the interests of the fine arts but was governed by 40 self-electing Academicians. It had called for a significant expansion in the numbers of both Royal Academicians and Associate Members, as well as the introduction of a class of foreign members. While the Academy resolutely refused to increase the number of full Academicians, it agreed as early as 1866 to expand its class of Associates, although no action was actually taken until five new Associates were eventually elected in 1876. The case of widening its membership by establishing a class of 'Foreign Honorary Members' was, however, adopted in 1868. Nominations for election were made from 12 July 1869, and by the date of the election held on 15 December 1869 sixteen names had been entered into the Nomination Book of which six were elected.

In responding to criticism as it did, the Royal Academy ensured that improvements to the ways in which it functioned were congruent with its new building – and that they endured. The first thing to note from the 1945 Annual Report is that this was an institution weakened financially by the recent war. Although it maintained the appearance of having been largely unaffected by the rigours of the conflict, that was not the case. The Academy had closed the Schools

81 'A Studio in the Royal Academy Schools, 1917', in Norman Wilkinson, *A Brush with Life*, London 1969, pl. 25, 11.5 × 17.7 cm (RA 13/583).

80 Russell Westwood, *Sir Albert Richardson RA (PRA 1954–6) lecturing at Royal Academy Schools*, March 1953, photograph (RA 12/3029).

and launched a review of its teaching, abandoned its loan exhibition programme, and put its entire collection into safe keeping, off site and on. Nonetheless, we gain the impression that there was a desire if not quite to carry on business as usual, then at least to re-establish those pre-war principles and traditional practices that in some instances the war had interrupted. Reflecting this impulse, the king followed long-established protocol in receiving the President and Secretary of the Academy in audience at Buckingham Palace on 5 June. The report on the year's business was granted royal approval and diplomas were signed. As ever, the Academy's connections with the monarch remained a defining feature of its prestige and distinction.

Munnings had been elected President in March 1944, when the Keeper was Gerald Kelly RA (fig. 82), who had

taken up the position in 1943 while the Schools were temporarily closed. Although Kelly was soon replaced by Philip Connard RA (later in 1945), he was chairman of the committee that reported its findings and recommendations about the future of the Schools. Despite the break in teaching operations and also the abandonment of its loan exhibitions programme, throughout the war the Summer Exhibitions had continued unabated. This fact accords with the observation made in the Schools report that 'the Royal Academy is more and more thought of by the members themselves as an Exhibition (mainly of pictures).'[7]

The Academy's function as an exhibiting society had remained intact, but there was a suggestion that, for some members linked more closely with the Schools, the relative neglect of its teaching role was a source of irritation. The report's author, the painter A. K. Lawrence RA, observed: 'Few members today take any active interest in the Schools.'[8] In 1945 the Academy's time-honoured sense of its own position and purpose as a centre of excellence for teaching was qualified. At the end of the previous war, in 1918, during which the Schools had continued to function (fig. 81), an earlier Schools committee had reported that 'the one function that differentiates the Academy in kind from any other artistic society [is] that the Academy itself possesses a tradi-

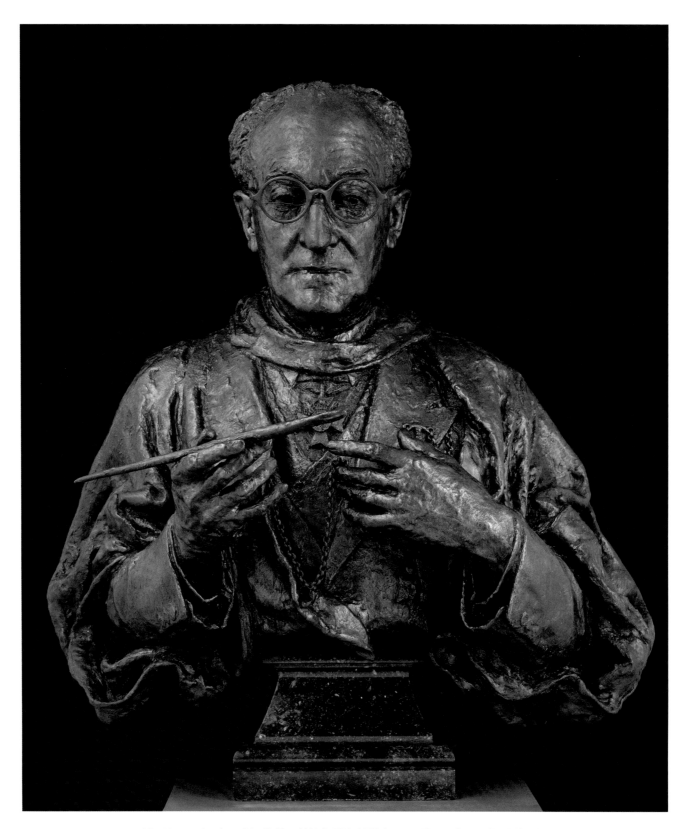

82 Maurice Lambert RA, *Sir Gerald Kelly PRA*, 1954, bronze, 68.6 × 68.6 cm (RA 03/1740).

tional prestige and commands in its Members resources of expert technical knowledge not to be found elsewhere.'[9] The post-Second World War Academy struck a very different note, and the 1945 report revealed that it no longer thought of itself as a thing apart: 'The Royal Academy Schools have come to be regarded as an education establishment very similar to new schools founded in the 70s and 80s of the last century, namely the Slade and South Kensington Schools.'[10] It also intimated that there were recent weaknesses in organization and a moving away from traditional teaching and academic principles. The suspension of several historic teaching posts lent weight to these misgivings. In 1945 the professorships of Painting, Sculpture, Architecture and Perspective were all vacant, only partly as the result of retirements that coincided with the outbreak of the war, and two (Painting and Architecture) had even lacked an incumbent since 1911.

The report's recommendations were unequivocal. In order that the special character of the Schools should be restored and maintained, there needed to be a return to those 'grounding principles which its students are advised to accept'.[11] In other words, tradition should be upheld. This ethos not only informed the Academy's teaching but represented its values as a whole. It was recommended that there should be a Keeper who would be entirely responsible for implementing this policy, supported by permanent staff as well as by members who would be invited (they had hitherto been elected) to participate as Visitors to the Schools. The central aim of the teaching would be to impart a sound technical training in the craftsmanship of the various visual arts.

Comprising a studentship of four years, the training was to include drawing and painting from the living model (fig. 83) and the Antique; pictorial composition; studies in the materials of the painter's craft, chemistry, anatomy and perspective; and an introduction to the essentials of architecture and sculpture. Within the Sculpture School, the emphasis on traditional skills was even more marked (fig. 84). Noting that 'the country is now provided with many excellent Art Schools',[12] it was felt best not to compete with such institutions, but instead to focus on the technicalities which would arise later in professional practice. Referring to the impending task of post-war rebuilding, the report on the School of Architecture was confident that 'study of the finest examples from the past'[13] would result in maintaining the Academy's distinguished position within a wider context. It asserted:

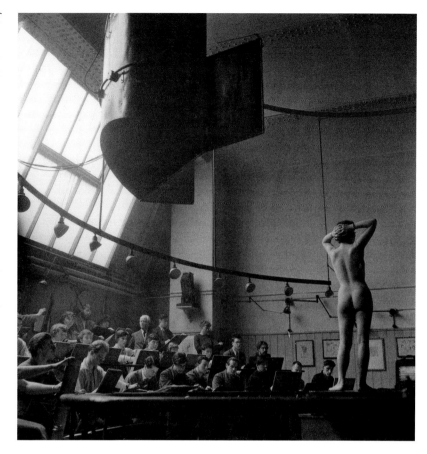

83 Russell Westwood, *Sir Henry Rushbury RA and Students, the Life Room, Royal Academy Schools, 1953*, March 1953, photograph (RA 10/3459).

'The Royal Academy as the leading Art Institution in the nation and Empire feels a special responsibility for upholding a high standard in the plans that are being made and in the work that is to be done.'[14]

If the Academy saw its future in terms of a return to order through an appeal to tradition, the evolving post-war character of the external world was more complex. Large areas of London had been devastated by enemy bombing. Indeed, for some younger artists working in the early 1950s – in particular Frank Auerbach and Leon Kossoff – the shattered urban landscape sprouted building sites that provided subjects rich in implication for the development of a personal, if unconventional, artistic vision. In contrast, the Academy had survived the war almost unscathed, and set back from Piccadilly and sequestered within the courtyard of Burlington House,

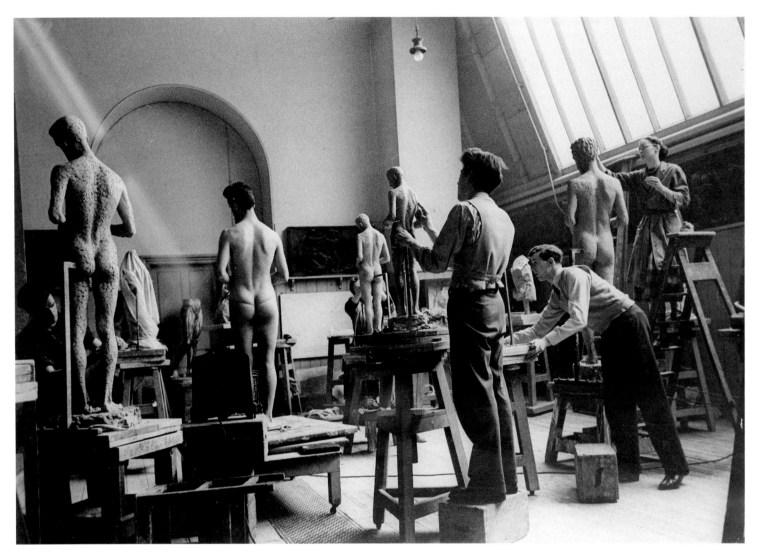

84 Russell Westwood, *Students modelling from Life, Royal Academy Schools*, March 1953, photograph (RA 12/3027).

it remained somewhat insulated against such changing vistas. Other art institutions were less fortunate. The Tate Gallery had been badly damaged and was not returned to full use until 1949, while other national collections had also closed for the duration, although while the war was in progress, the National Gallery had instituted a programme of special displays of single paintings. It also held loan exhibitions of modern British art, organized by Lillian Browse, but for five years the public's access to the permanent art collections was curtailed. In contrast, the Academy's summer exhibitions had continued, assuming a particular significance. Now that hostilities had ceased and doors began to reopen, the art world landscape changed rapidly.

In terms of the Academy's position and expectations within that wider context, the main post-war developments related to the growing visibility of what Munnings later described as 'so-called modern art'.[15] While it is difficult to define precisely the kind of art implied by Munnings's use of this term, some sense of his meaning can be suggested. In the same speech of 1949 Munnings had stated bluntly: 'If you paint a tree – for God's sake make it look like a tree, and if you paint a sky, try and make it look like a sky.'[16] For Mun-

nings, verisimilitude was important. This ethos formed part of the Academy's Schools recommendations, made in the 1945 Annual Report, which advocated that 'a very considerable time should be spent in accurate copying, the student being directed to study the actual methods of the masters.'[17] Central to this way of thinking is the principle, enshrined in the Academy's report, that 'the highest possible skill in craftsmanship [is] insisted on…excellence in craftsmanship [has] this end in view…the representation of form.'[18] Munnings's antipathy to 'modern art' would appear therefore, at some level, to equate with a deep distrust of abstraction, which he saw either as a wilful distortion of, or as an inept response to, natural appearances. With Munnings at the helm, from 1945 the Academy found itself at variance with an art world that increasingly gave credence to an alternative, progressive tendency rooted in the expressive validity of abstraction.

EXHIBITIONS AND MODERNISM

During the 1940s and 1950s the idea of 'modern art' gradually gained currency, supported by its developing presence in a variety of contexts. These included exhibitions in public galleries, displays in a flourishing network of London-based commercial spaces, publications such as the *Penguin Modern Painters* series, and stage productions, notably at the Old Vic, where sets were designed by John Minton and Michael Ayrton. A range of art schools both within London and further afield also provided opportunities for students to make contact with new concepts and styles. Although far from ubiquitous, modern art was gaining a wider audience. For example, in 1945 the National Gallery mounted an exhibition of paintings acquired by the Tate Gallery in the last three years that included Duncan Grant, Stanley Spencer RA, Mark Gertler and Matthew Smith. In November the same year, the Victoria and Albert Museum opened an exhibition of Picasso and Matisse that for many provided the first direct contact with a more extreme form of modern European painting. The exhibition provoked widespread controversy, cementing allegiances and dividing opinion. It was followed in December by an exhibition at the National Gallery devoted to Paul Klee. Although still unable to open fully, in 1946 the Tate Gallery mounted several small loan exhibitions devoted to Cézanne, Braque and Rouault. Nor

was this growing awareness confined to London. The Picasso and Matisse exhibition travelled to Glasgow, which in 1948 also held a large exhibition devoted to van Gogh.

London, however, largely remained the epicentre for the appreciation of – and, of course, resistance to – modern art, because it contained the greatest concentration of galleries in which to view the evidence of change in the visual arts. Motivated by the presence of dealers, collectors, influential gallery directors, artists, publishers, critics and students, the modernist debate was given impetus and context which, in turn, encouraged the evolution of a new infrastructure supporting modern art. The period from 1945 saw the establishment of two important organizations. The first was the Arts Council of Great Britain, which was to play an important role in purchasing modern British art as part of a mission to increase the public's accessibility to fine art. The year 1947 saw the opening of the second, the Institute of Contemporary Arts, which in February–March 1948 showed the exhibition 'Forty Years of Modern Art 1907–47' and a follow-up show, '40,000 Years of Modern Art', 20 December–29 January 1949. Significantly, the latter provided a context for the first appearance in Britain of Picasso's *Les Demoiselles d'Avignon*, one of the key paintings in the modernist canon. By 1953, the ICA's lead in introducing the latest developments was evident in its 'Opposing Forces' exhibition, which included works by the American abstract painters Jackson Pollock and Sam Francis.

In addition to these developments, older established institutions also played a significant role in advancing the modernist cause. The Contemporary Arts Society was an important patron of contemporary painting and sculpture, and its purchases were distributed to national and regional collections. After 1952, under Bryan Robertson's leadership, the Whitechapel Art Gallery played a seminal part in bringing international modern artists – from de Staël to Pollock – to the attention of a British audience. Although it had been formed in 1897 to house modern British art, since 1915 the Tate Gallery had been entrusted with the additional responsibility of forming a national collection of modern foreign art. Until 1946 it was hampered by the lack of a government grant for purchases. This changed somewhat after 1949, a year that saw important purchases of works by Matisse, Derain, Gris, Dufy, Miró, de Chirico and Schwitters. Thereafter, the evolution of the Tate's representation of modern British and

foreign art was a further incentive to the gathering body of public interest in newer modes of visual expression.

The Royal Academy viewed the support of other institutions for modern art as an aberration. Its internal view was that 'the progressive addition of foreign works to the Tate Gallery has tended to blur its original and proper purpose.'[19] During this formative post-war period, the Academy therefore energetically nailed its own colours to the mast of tradition. In 1946, while the Arts Council's exhibition 'British Painters 1939–45' included 70 works by artists such as Robert Colquhoun, Ivon Hitchens, Victor Pasmore RA, John Piper and Graham Sutherland, the Academy's first peacetime loan exhibition, 'The King's Pictures', brought together masterpieces by Holbein, Van Dyck, Reynolds, Gainsborough and Lawrence.

Such comparisons are stark, but the press was alert to what it sensed as growing opposition between the forces of tradition and progress. In January 1949 the *New Statesman and Nation* included an article entitled 'The Tate versus the Academy',[20] followed by the *Daily Telegraph*, which published an article from the Director of the Tate Gallery headed: 'Why the Tate Does Not Show its Chantrey Pictures'.[21] Both pieces were responding to the spectacle of the Academy's mounting an exhibition of all the paintings acquired for the Tate Gallery under the terms of the Chantrey Bequest (which it administered). The exhibition drew a range of responses, exciting nostalgia from some visitors (some 99,000 of them) and from others derision. As the Tate made clear, many works had been acquired despite its resistance. But among the recently acquired works that were shown were paintings and sculpture by Augustus John RA, Jacob Epstein, Laura Knight RA, Thomas Lowinsky and Henry Lamb RA. As this revealed, tradition and modernism admitted a degree of overlap that made the relation of these two forces more complex than any straightforward opposition.

The effect of Munnings's 1949 speech was, however, to present the Royal Academy as antagonistic to modern art and its supporters. While this was – and continued to be – partly true, the wider picture was less clear cut. Munnings's views upheld the Schools' desire to maintain traditional skills, but his antagonism to progressive artistic tendencies was not entirely representative of the Academy as a whole. After Munnings was succeeded by Gerald Kelly in 1949, these differences of opinion within the membership became grad-

ually, though not immediately, more apparent. In October 1950, for example, the Council denounced Munnings for seeking 'to defame the character and art of Mr Spencer, RA' by inciting a police investigation into the artist's work on grounds of alleged obscenity. By 1952, Kelly could declare, with some justification, that 'the whole policy of the Academy was much more liberal than in the past and that concessions had been made to the younger members' (fig. 85). This growing liberalism is evident if we examine the Royal Academy's activities in 1951 in the light of the key external event of that year, the Festival of Britain.

The festival was planned as a celebration of British culture, and a central element was the Arts Council's contribution to the planning of the visual art aspect. Among other initiatives, there were two main components: an exhibition 'British Painting 1925–50' and a large-scale programme of commissions titled '60 Paintings for '51'. Taken together, these projects are especially valuable in providing a snapshot of those modern British artists who commanded serious critical attention. In addition to leading established figures such as Henry Moore, Ben Nicholson, Victor Pasmore, Graham Sutherland, Ivon Hitchens and John Piper, other artists whose work had gained a following through exhibitions at such commercial galleries as the Leicester Galleries, Lefevre, the Redfern Gallery, Gimpel Fils and the Hanover Gallery were also provided with a hugely expanded audience. Many works had been acquired by the Arts Council, the British Council, the Contemporary Arts Society and the Tate Gallery, and among the artists who benefited were Francis Bacon, Edward Burra, Prunella Clough, Roy de Maistre, Lucian Freud, Duncan Grant, Josef Herman RA, Henry Lamb RA, Robert MacBryde, John Minton, Rodrigo Moynihan RA, Paul Nash, Ceri Richards, William Scott RA, Matthew Smith, Ruskin Spear RA, Gilbert Spencer RA, Keith Vaughan and Carel Weight RA.

The Royal Academy Summer Exhibition opened two days after the festival and was devised by a hanging committee that comprised six Academicians and four Associates, one of whom – Gilbert Spencer – was included in the festival. Among those selected for the Summer Exhibition, several also showed work in the festival's showcase of contemporary painting, notably de Maistre, Lamb, Lowry, Minton, Moynihan, Spear, Julian Trevelyan RA and Weight. In other words, while the positions occupied by the Academy and the festival

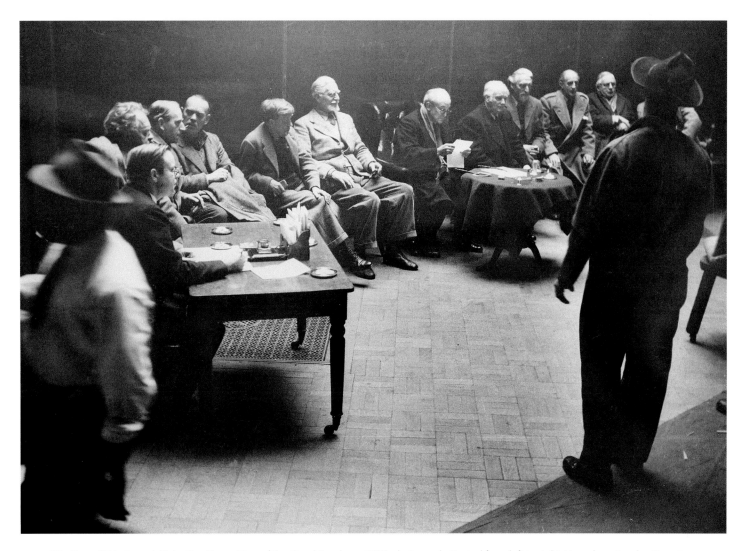

85 Russell Westwood, *Selection Committee of the Royal Academy, 1953*, photograph. Seated from left to right: Humphrey Brooke, Secretary,
Siegfried Charoux RA, J. Cosmo Clark RA, Maurice Lambert RA, Charles Cundall RA, Algernon Newton RA, Sir Gerald Kelly PRA, Sir Henry
Rushbury RA, Arnold Mason RA, John Nash RA and Steven Spurrier RA (RA 12/3028).

may appear opposed, the inclusion of some artists in both
contexts shows that the boundary between them was not
entirely rigid. Stanley Spencer, whose work had been
attacked by Munnings, showed at the Academy but declined
to be included in the festival. As the former President had
seemed to acknowledge, the Academy was more tolerant of
'modern art' than he would have liked. The catholicity of the
Academy's Summer Exhibition embraced artists of a modern
persuasion whose work could also be seen at the festival, as
well as others from different points in the artistic spectrum.

As even a small sample of names shows, the exhibitors at
Burlington House spanned artists with a broad range of
approaches: Pietro Annigoni, Robert Buhler RA, Winston
Churchill, Paul Feiler, Frederick Gore RA, Peter Greenham
RA, Sir James Gunn RA, Albert Irvin RA, Kelly, Thomas
Monnington PRA, Munnings and William Roberts RA.

A similar inference can be drawn from the Academy's
membership in the same year. Among those affiliated were
artists whose work, in subtle and complex ways, spanned both
traditional and more progressive elements, including Edward

Bawden RA, Buhler, Frank Dobson RA, Richard Eurich RA, James Fitton RA, Meredith Frampton RA, Charles Ginner ARA, Eric Kennington RA, Laura Knight, Monnington, Moynihan, John Nash RA, Dod Procter RA, Spear, Gilbert Spencer and Stanley Spencer. By the 1950s the Royal Academy was a broad church: wedded to the past, committed to tradition, but at the same time looking further afield.

DAYS OF CONFLICT

Those progressive developments in the visual arts that defined the decades of post-war Britain are an inseparable part of the Academy's subsequent history. As London consolidated its position as a great modern art capital, the Academy remained cautious about, and at times deeply critical of, such tendencies. Even so, it would be a mistake to imagine that as an institution it remained implacably opposed to modernism. Moore, Nicholson, Sutherland, Bacon, Freud, Bridget Riley and others declined to join the Academy, no doubt repelled by its continuing anti-modern broadsides while also sensing that the Academy's influence had waned. But under successive presidents the Academy remained engaged with external developments, veering between different outward-facing postures as it carried on a process of self-examination reflecting the various, constantly evolving artistic elements within its ranks.

Gerald Kelly, who served as President from 1949 to 1954, was far more sympathetic than his predecessor to art that gravitated away from strict academic principles. Although his own work was rooted in the kind of verisimilitude that Munnings admired, early personal contact with Monet, Rodin and Degas (as well as with artists who had been in the ambit of Gauguin and Matisse) had imparted a liberal outlook that others in his vicinity lacked. During Kelly's term, Stanley Spencer was re-elected after an absence of 17 years and new members or Associates included Bawden, Dobson, Eurich, Fitton (fig. 86), Greenham (fig. 87), Kennington, Moynihan and Spear. The Chantrey Bequest was also put to more adventurous use, with acquisitions for the Tate of paintings by Stanley Spencer, Edward Wadsworth ARA, Ruskin Spear RA (fig. 88), André Derain, Matthew Smith and Fitton. More eye-catching in terms of public visibility were the loan exhibitions mounted during Kelly's

86 James Fitton RA, *Indoor Garden*, 1954, oil on board, 76.3 × 46.9 cm (RA 03/615).

term. No doubt to Munnings's chagrin, these included 'L'École de Paris 1900–1950' in early 1951. While there were important historical shows, not least the 'Leonardo da Vinci Quincentenary Exhibition', for the first time exhibitions were held of the work of living British artists: Sir Frank Brangwyn in 1952 and Augustus John in 1954.

If Kelly's presidency went some way to softening the Academy's reactionary image in the eyes of those sympa-

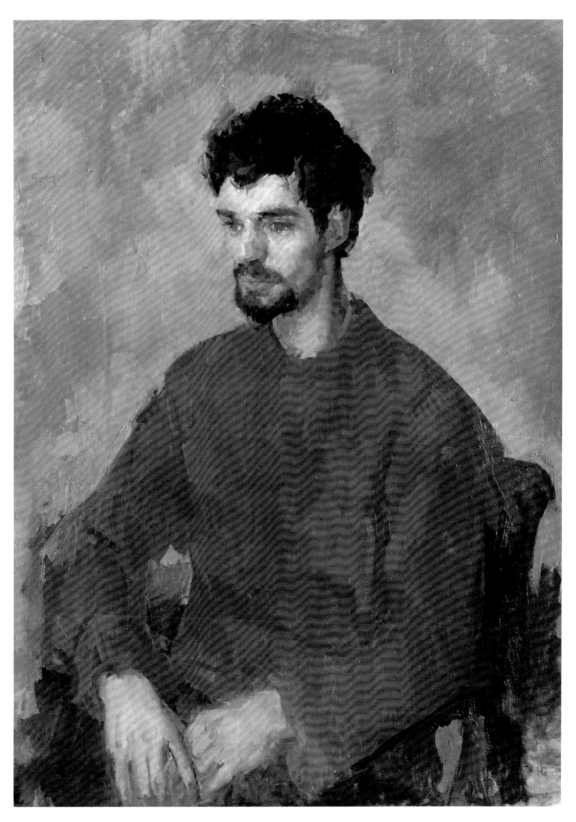

87 Peter Greenham RA, *Eric Hebborn*, *c.*1960, oil on canvas, 97 × 70.5 cm (RA 03/400).

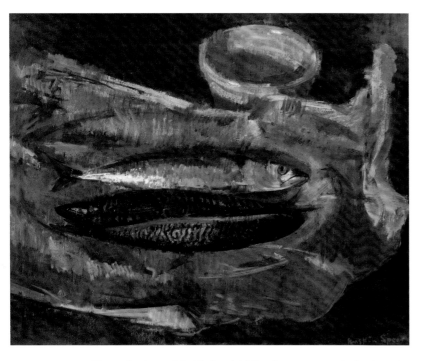

88 Ruskin Spear RA, *Mackerel*, 1943, oil on paper applied to board, 47.6 × 60.5 cm, transferred to the Royal Academy by the Trustees of the Chantrey Bequest, 2000 (RA 03/449).

thetic to change, his successor, in contrast, was even more effective in turning the clock back. Described in the *City Press* as 'an enthusiast for the art and architecture of the Georgian age',[22] Sir Albert Richardson PRA, whose two-year tenure began in 1954, seemed determined to persuade an attentive press of the Academy's enduring hostility to progress. Speaking at the Sheldonian Theatre in Oxford on 31 May 1955, he referred to the Festival of Britain and declared: 'This example of pure exhibitionism had widespread results, not only in Britain but in the Commonwealth. It is now seen that this was merely the expiring burst of a phase which failed to establish a new tradition.'[23] This observation seems particularly defiant when seen in the light of two articles that had appeared in the press in the preceding month. The first, a piece in *The Times* entitled 'The Modern Trend', noted: 'It is unlikely that the resistance to the RA common in certain quarters will ever be broken down to such a degree that the majority of our leading non-academic artists will be prepared to exhibit there.'[24] The presence in the 1955 Summer Exhibition of Annigoni's celebrated new

portrait of the queen (National Portrait Gallery), which drew vast crowds, was certainly unlikely to have persuaded the modern contingent otherwise. The second article, provocatively headed 'The Ancient Battle Joined Anew', concluded: 'The clash of opposing tendencies...the cleavage between the old Academy and its newer elements has never been so pronounced.'[25]

Although it drew up battle-lines, this last observation is also significant in identifying dissent within the Academy's ranks. Others also sensed that the institution was not entirely dominated by a bastion mentality towards modern art and that it admitted different voices. *The Times* responded to the 1955 Summer Exhibition noting: 'As is usual nowadays, a part of the Academy is given over to painting of a more "advanced" kind than is generally associated with its reputation.'[26] The difference was not, however, simply between old and new. For many observers the problem afflicting the Summer Exhibition was one of quality. Writing in the *Sunday Times*, Myfanwy Piper observed that, while the Academy 'does more and more to accept work from serious artists of the modern school', such efforts were blighted because 'a large proportion of the Royal Academy's Summer Exhibition still makes painting look like a hobby.'[27] Not for the first time would the very diversity of the Summer Exhibition act both as a door to modern art and as a deterrent. Even so, this seasonal art world event remained hugely popular, in 1955 (admittedly boosted by the presence of the Annigoni royal portrait) attracting record 250,000 visitors compared to the Tate Gallery's 145,000 in the same period.

The sheer volume of attention paid in the press to the Royal Academy's activities during this volatile period is notable. In an increasingly media-dominated world this was an important aspect of the institution's external relationships. Whether or not it remained influential within the art world, the Royal Academy continued to command huge public interest, not least as a result of its President's attacks on 'the contemporary idiom he detests', as characterized by the *Architects Journal*.[28] The perception of conflict with the modern faction was, however, beginning to stick, and there was a growing sense that this adverse publicity was damaging. In a letter written to the *Manchester Guardian*, Mervyn Levy asserted that 'to offset the enormous harm that is being wrought almost daily by these attacks, it would seem the moment is ripe for the foundation of a Royal Academy of

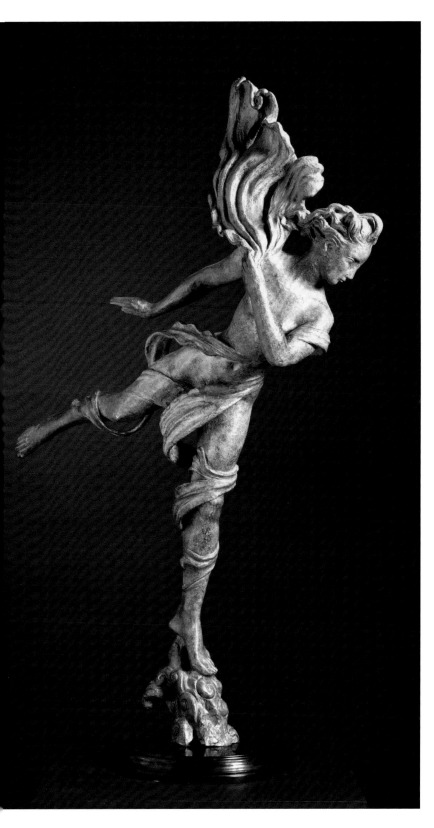

Modern Art.'[29] With the appointment of a successor to Richardson in view, more than ever the need was for a President capable of connecting the Academy with modern art in a positive way.

Charles Wheeler PRA, who served in this capacity until 1966, was the first sculptor to be elected (fig. 89), but almost immediately he became a focus for internal dissent. His defeated rival, James Fitton, commented: 'The voting was close, but senior academicians turned up in strength as I expected they would and there is still a strong leaning to the traditional at the Academy.'[30] Others were more keen to emphasize his tolerance and affinity with the new. The *Scotsman* reported that Wheeler 'though of academic outlook is very tolerant of "contemporary" work'.[31] Wheeler brought a breadth of valuable experience and external contacts. He had been a trustee of the Tate Gallery, a member of the Royal Fine Art commission, and was associated with several bodies concerned with reconciling art with public buildings and town planning. John Rothenstein, the Tate's long-standing director, was also a supporter, observing: 'He is very level headed. During his term as a trustee of the Tate many works came up for consideration which were well outside his instinctive sympathies. Yet I can't remember a case where he didn't give them fair and careful consideration.'[32] Under Richardson, there had been further Chantrey Bequest problems with the Tate Gallery. Recently, the Tate's views had been overruled by the Academy's persistence in purchasing a sculpture of Margot Fonteyn by Maurice Lambert (fig. 90). While there is in Rothenstein's tribute an intimation of Wheeler's conservatism, he also saw the new President as an ally.

Wheeler's need to pacify those conservative elements within the Academy and, at the same time, mend fences with the outside world proved a difficult balancing act. His own proclivities were made clear when, shortly before becoming President, he resigned from the Arts Council in protest at the exhibition 'Alberto Giacometti: Sculpture, Paintings, Drawings', curated by David Sylvester and held at the Arts Council Gallery. In a worrying echo of previous presidents' views, he stated: 'It is beyond the limits of intellectual tolerance. It is an

89 Sir Charles Wheeler PRA, *Ariel of the Bank*, c.1936, bronze, 106 × 76.2 cm (RA 03/1853).

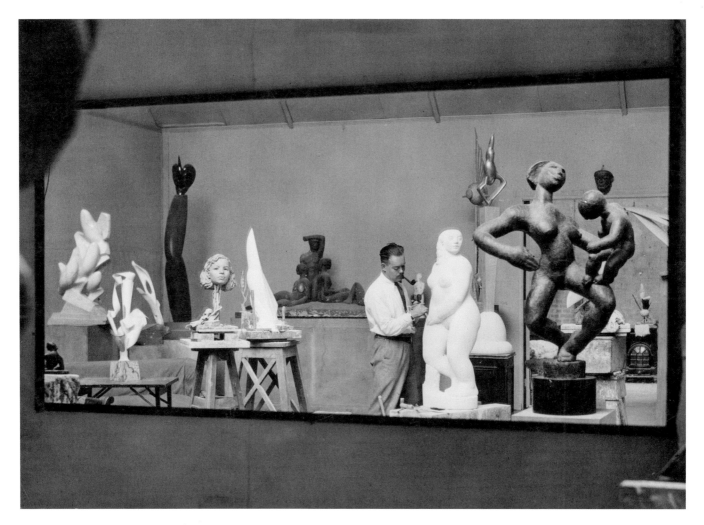

90 *Maurice Lambert RA in his Studio at Logan Place, London W8*, early 1930s, silver gelatin print, 14.4 × 19.7 cm (RA 06/4068).

extreme form of modernity.'[33] Wheeler's innate conservatism continued to rise to the surface at intervals. In May 1957 he used his first speech as President to stage a long critique of modernism. The problem, he declared, was that 'So much of "Modern Art" is estranged from nature and so much devoid of human feeling.'[34] In May 1958 the *Daily Telegraph* reported that Picasso had burst into laughter when told that the President of the Royal Academy, once again using the annual dinner as a platform for comments about modern art, had described Picasso's mural at the Unesco headquarters in Paris as '800 square feet of absurdity'.[35] Writing in the *Listener*, David Sylvester felt that it was time to expose Wheeler's reputed tolerance of modern art. 'The Establishment', he

wrote, 'seems to have decided that the best way to deal with what used to be called "modern art" is to patronise it, in both senses of the word. The new strategy, as revealed in the President's speech at the Academy dinner, is to allow that the moderns have won the right to be taken seriously but to insist that, for their own good, they need to be protected against themselves, that is against the charlatan element in their ranks.'[36] Clearly, for some, the Academy's tolerance of modern art was not without problems.

Despite these differences, during his term of office Wheeler undoubtedly laid the foundations for a rapprochement with modern art. The art world was, as he noted in 1957, 'split into two main halves. Speaking broadly, one half

91 Sandra Blow RA, *Green and Red Variations*, 1978, oil and collage on canvas, 137.2 × 121.9 cm (RA 03/818).

is "representational" and the other "abstract".' Whichever side of the split he preferred, he was at pains to point out that, under his leadership, the Summer Exhibition that year made an attempt to address the art world as it was: 'In these galleries you will find the two halves overlapping here and there.'[37] Recent trends in less academic figurative painting were also embraced. *New Chronicle* reported: 'The young painters of the "kitchen sink" school have broken into the Royal Academy in a big way this year. John Bratby has one 12 footer among his three paintings on show.'[38] Also, between 1956 and 1966 Wheeler presided over an ambitiously expanded exhibition programme that, in addition to numerous important shows, included 'Dunoyer de Segonzac' (1959),

'Sir Matthew Smith' (1960), 'Primitives to Picasso' (1962), 'Art USA Now' (1963) and 'Pierre Bonnard' (1966). Even so, there were limits. In 1959 the Tate Gallery hosted a landmark exhibition, 'The New American Painting', which brought the radical language of Abstract Expressionism on a large scale before a startled British public. At the same time, visitors to the Royal Academy could see the exhibition 'Paintings by the Rt. Hon. Winston Churchill', arguably Britain's most distinguished amateur artist. In spring 1960 Wheeler ordered John Hoyland, then a student at the Academy Schools, to take down his final examination show as it was comprised solely of abstract paintings. This episode suggested that, as Sylvester had sensed, the Academy still had some way to go (Hoyland was subsequently elected ARA 1983 and RA 1991). More than being simply tolerant of modern art, it needed to be totally committed.

By 1965, prevarication was no longer possible. Writing in *The Times*, Edward Lucie-Smith argued that 'modern art has established itself'[39] and that the 'establishment' therefore had to act. In Wheeler's penultimate year the Summer Exhibition for the first time included abstract works by Ben Nicholson, Ivon Hitchens and Sandra Blow, of whom the last went on to be elected ARA 1971 and RA 1979 (fig. 91). It also looked in a different, and even more contemporary, direction with the inclusion of *Toy Shop* by the leading Pop artist Peter Blake RA. The *Sunday Times* was convinced and expressed appreciation: 'At last the Royal Academy is taking genuine steps to alter the stuffy image of its summer show.'[40] The *Daily Mail* also joined in with an article headed 'RA Stops Snubbing the Moderns': 'The Royal Academy is confident that this will mark the turning-point in its efforts to heal the 80 year old breach between it and many of the most progressive elements of the art world.'[41] While Wheeler's presidency went some way in healing the rift with modern artists and their supporters, in other areas of the Academy's external relations it also inflicted new wounds, and ultimately his term is associated with the sale of the masterpiece by Leonardo da Vinci, *Virgin and Child with St Anne and St John the Baptist*.

The completion of the task of making peace with those progressive art world forces that Wheeler had courted fell to his successor Thomas Monnington. An abstract painter in his own right, although his Diploma Work was a decorous early landscape (fig. 92), Monnington was not only receptive to

92 Sir Thomas Monnington PRA, *Piediluco*, c.1923–6, oil on panel, 42.5 × 60.5 cm (RA 03/196).

non-figurative art; he had a genuine respect for the advances made in the cause of modernism, a curiosity about new modes of expression, and a commitment to connect the Academy with the latest developments. When he was profiled by *Art Review* in January 1967, Monnington explained his wish to step outside the precincts of Burlington House in order to travel internationally, gaining 'first-hand knowledge of what is being produced at the moment'. He set out an agenda that included fewer Old Master exhibitions and, instead, laid an increasing emphasis within the loan exhibition programme on twentieth-century developments. One statement in particular marks the contrast with his predecessor: 'Personally I would have liked the RA to organise a really large Giacometti show for example.' He added that 'an

exhibition of people of the calibre of Henry Moore, Ceri Richards, Graham Sutherland would be of tremendous interest...with our huge galleries at Burlington House we could stage a truly international show.'[42]

From the outset there was a sense of renewed purpose and fresh direction. The Annual Report for 1968 reveals the formation of a policy advisory committee to set out the Academy's future role and direction. In the section on the Schools, the Keeper Peter Greenham defined the institution's teaching policy as being 'to give the help of appropriate teachers to students of every inclination, whether abstract or figurative'.[43] That said, the Schools' long-standing insistence on life drawing remained the cornerstone of its training and it continued to be so. But reaching outwards was indeed a

theme of Monnington's approach. In addition to opening discussions with the Arts Council and the ICA, the Academy provided premises for AIR and SPACE, the independent artist-information and studio-space initiatives then being developed by Bridget Riley and Peter Sedgley.

It is, however, the loan exhibition programme, which Monnington oversaw during the period until his death in 1976, that remains among his most substantial achievements. A survey of the exhibitions devoted to twentieth-century themes mounted during this period highlights the way the Academy now assumed a new importance, addressing an audience with expectations geared to modern art. The programme included 'Derain' (1967), '50 Years Bauhaus' (1968), 'Big Paintings for Public Places' (1969), 'The London Group 1970' (1970), 'Young Contemporaries' (1970), 'Giorgio Morandi' (1970), 'British Sculptors '72' (1972), 'Futurismo 1909–19' (1973), 'Impressionism' (1974) and 'L. S. Lowry' (1976). Within a modern perspective, the breadth of different themes was impressive. The 'Bauhaus' exhibition was a significant milestone, placing contemporary ideas of modernity within an art-historical context that comprised paintings, sculpture, photographs, artefacts and reconstructions. The 'Big Paintings' exhibition took a different tack, using the large gallery spaces as a showcase for contemporary expansive canvases. The exhibitions devoted to British sculptors, 'Young Sculptors' in the Diploma Galleries in 1972 followed by 'British Sculptors '72', developed that approach, the latter using the lofty exhibition halls as a venue in which to explore recent developments in sculpture by a range of artists, from older internationally respected figures to those with emerging reputations. The 24 sculptors in 'British Sculptors '72' included Robert Adams, Kenneth Armitage RA, Hubert Dalwood ARA, Garth Evans, Phillip King PRA, Bryan Kneale RA (fig. 93), Eduardo Paolozzi RA, Carl Plackman and William Tucker. The response to this exhibition by Guy Brett in *The Times* is worth quoting at length because it seems to set a triumphant seal on a process of rehabilitation, to provide an assessment of the Academy's new position in the art world, and to point the way to future developments:

The days of conflict between progressive artists and the Royal Academy are over now. They were bitter days. For artists of Henry Moore's and Ben Nicholson's generation

93 Bryan Kneale RA, *Matrix*, 1975, steel painted with Hammerite and bronze, 60.5 × 50 × 50 cm (RA 03/1738).

the ruling body of academicians could not only heap abuse on their work but even threaten their livelihood. They still pass Burlington House on the other side of the street. But today the Academy no longer has the same kind of power, and young artists quite often find themselves in dispute with institutions like the Tate Gallery

In fact the Academy has begun to stage exhibitions of painting and sculpture of the kind that it used to deride, and to realise that it has the great asset of a suite of enormous exhibition rooms in the centre of London.[44]

If *The Times*'s assessment is to be believed, it would suggest that the Royal Academy inherited by Hugh Casson (fig. 94) when he became President in 1976 was a very different place from what it had been 30 years earlier in the aftermath of war. The antagonism with modern art had been overcome – but there had been concessions. As it now took its place alongside other organizations and institutions dedicated to the cause of progress in the visual arts, the Academy no longer enjoyed its historic position of pre-eminence. It had, however, as *The Times* pointed out, assets of great value, not least its capacity to mount exhibitions of world class. But how accurate was this assessment? Comparing its position in 1981 to that in 1951, it is illuminating to consider again the Academy's core activities – the Summer Exhibition, the membership and its teaching – in relation to the outside world.

In 1981 the hanging committee of the 213th Summer Exhibition comprised ten Academicians and four Associates. In contrast with 1951, women were now included, albeit just three individuals within a total panel of 14. The average age of the committee had barely altered: it was 58 in 1951 and 57 thirty years later. A slightly greater range of artistic approaches was now in evidence in the way the panel was constituted. Responding to post-war artistic developments, abstract painting was represented by Sandra Blow (see fig. 91) while figurative painting remained strongly in evidence in the form of Peter Coker RA, Frederick Gore, Peter Greenham (the Keeper), Ruskin Spear, Betty Swanwick RA (fig. 95) and David Tindle RA. Michael Rothenstein RA brought to bear a graphic intelligence well versed in those collage-related visual developments that had emerged in the 1960s. As for those selected, the Summer Exhibition continued to be diverse in outlook, although notably much stronger in terms of artists whose work eschewed an academic or traditional leaning. Essentially, however, the span embraced figurative painting of varying degrees of abstraction, as well as a representative sample of abstract artists. The range extended from Norman Ackroyd RA, John Lessore, Leon Vilaincour and John Wonnacott to Gillian Ayres RA, Brian Fielding, William Gear RA, Victor Pasmore and Gary Wragg. Modern sculpture was represented by Barry Flanagan RA, Janet Nathan and William Pye, among others.

94 Bernard Dunstan RA, *Sir Hugh Casson Lecturing*, 1987, oil on canvas, 27.6 × 21.1 cm (RA 03/707).

In terms of the membership, there were notable developments. In 1951 the Academy's ranks, although not closed to artists of a more modern sensibility, nevertheless included little more than a handful of those contemporary artists who qualified for inclusion in the Festival of Britain. In 1981 the modern art contingent had significantly expanded within the Academy. Saranjeet Wallia's survey *Contemporary British Artists*, published just two years earlier, lists 211 practitioners, of whom 48 were either members or Associates at the beginning of the 1980s. This is a substantially increased proportion, and while Wallia's book cannot be considered exhaustive, these figures nevertheless serve to suggest an underlying trend.

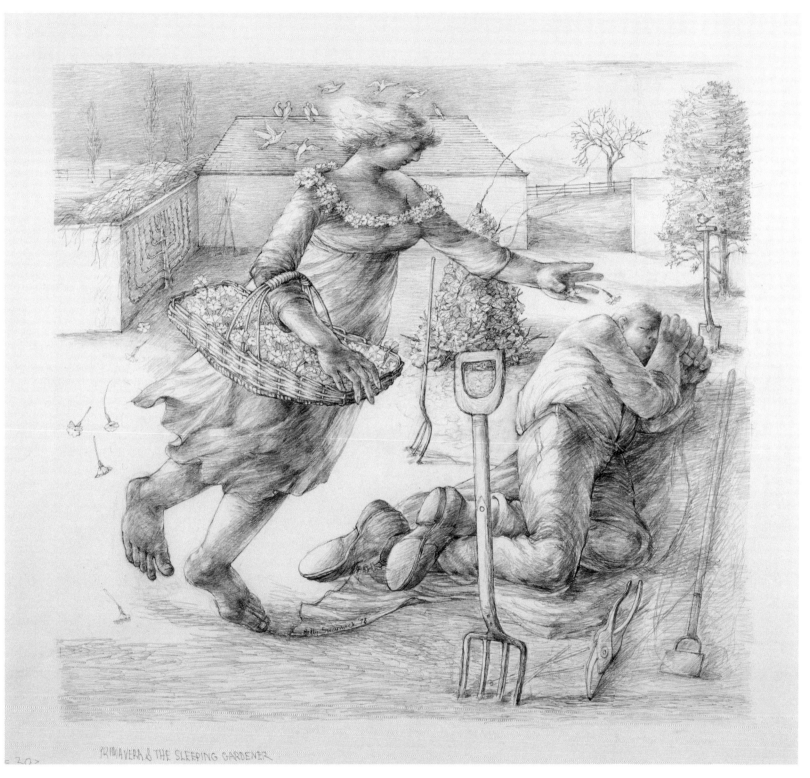

PRIMAVERA & THE SLEEPING GARDENER

95 Betty Swanwick RA, *Primavera and the Sleeping Gardener*, pencil on wove paper, 56 × 56 cm (RA 04/159).

96 Dame Elizabeth Frink RA, *Rolling Horse*, c.1976, bronze, 16.5 × 31.8 × 25.4 cm (RA 03/1724).

Then there is the question of the constitution, aims and outlook of the Schools at this time. In common with other arts schools in Britain, the RA Schools had undergone significant changes since the early 1960s when degree equivalent status courses were introduced. In 1981 the Royal Academy Schools offered three courses, all lasting three years, leading respectively to the Royal Academy Schools Postgraduate Diploma, the Diploma in Advanced Studies and, following the post-foundation course, the Royal Academy Schools Diploma. Its ethos was to provide 'training in Drawing, Painting and Sculpture for students of approved ability and promise whose aim is to become practicing [*sic*] artists'.[45]

In addition to a permanent staff comprising the Keeper, Master of the Sculpture School, Master of Carving, and professors of Architecture, Anatomy, Chemistry and Perspective, visiting teachers included the members as well as various outsiders. The latter category had by the mid-1960s already embraced a catholic outlook, avoiding any particular dogma. In 1965, for example, visiting teachers included David Sylvester, Frank Auerbach and David Oxtoby. In 1981 there were visits from Elizabeth Frink RA (fig. 96), Anthony Gross RA, Michael Kenny RA and Eduardo Paolozzi RA. Even so, the training remained essentially traditional. In 1952 the Keeper's report noted the emphasis on painting from the

nude and from still life, observing 'in all the Schools a greater sense of energy and enthusiasm than ever'.[46] Thirty years later, prizes were still being awarded for paintings of figures, landscape, still life and from Antique casts. But the outlook had changed. The art world had moved on and the ranks of contemporary artists had greatly expanded, with a resulting increase in competition. The Keeper now observed that the question of what students 'do when they leave becomes a matter of acute concern'.[47]

Viewing all these developments in relation to the wider pattern of external artistic developments, the overall picture that emerges is a complex one. The presence of many more modernist artists included in the Summer Exhibition and also represented as members does indeed suggest that the 'days of conflict' appear to have receded. When the ranks of the contemporary art world are considered more widely, however, the cause for celebration is somewhat qualified. The period from the early 1960s to the early 1980s saw a bewildering succession of movements and tendencies on an international stage. In Britain these manifestations included Pop Art; New Generation abstract sculpture; post-Situation abstract painting; the continuing presence of Frank Auerbach, Michael Andrews, Francis Bacon, Lucian Freud, Leon Kossoff and others involved with School of London figurative painting; and the rise of conceptual art, video and performance. Even this very general survey brings to the fore numerous leading British artists who continued to be absent from Burlington House: Francis Bacon, Anthony Caro (who declined election in 1990 but became Senior RA in 2004), Michael Craig-Martin (RA 2006), Gilbert and George (Gilbert Proesch and George Passmore, elected as a single Academician in 2017), Richard Hamilton, John Latham, Richard Long (RA 2001) and Bridget Riley. Taking an international perspective, the position was also ambiguous. In 1981 the Academy now counted several modern masters as Honorary Academicians, notably Balthus, Marc Chagall, Stanley Hayter, Giacomo Manzù and Joan Miró. Oskar Kokoschka Hon. RA had died in the previous year, and Willem de Kooning and Eduardo Chillida were to be appointed in 1983. But many others had no connection whatsoever.

A similar ambivalence characterized the Schools. Although it was more open to outside progressive influences, the emphasis on traditional skills was retained. In that respect it appeared more staid than, for example, its counterparts at

Saint Martin's School of Art, where, 20 years earlier, Frank Martin's leadership of the sculpture school had overturned conventional thinking. To put this in context, in the early 1980s the Academy was no less up to date in outlook than the Royal College of Art, where over half the teaching staff comprised Royal Academicians. Even so, in relation to the more progressive elements of the international avant-garde, from Arte Povera to Body Art and beyond, the Academy Schools appeared conservative.

In terms of the Academy's engagement with modern and contemporary art in an international context, the other area to be considered is the exhibitions programme. In the last 30 years there has been a steady growth in the institution's profile as a world-renowned exhibition venue. The foundations for the Academy's transformation were laid by Casson's businesslike approach to the institution's operations. Although the Academy had never enjoyed government support, in 1980 the then prime minister closed the door on any such prospect. At the Royal Academy banquet, Margaret Thatcher made the position clear: 'You cannot achieve a renaissance by simply substituting state patronage for private patronage.'[48] Under Casson's leadership, the Academy had already begun to develop a range of fund-raising initiatives that, collectively, drew the Academy out of its position of closeted 'independence' and closer to the marketplace.

Concurrent with these developments and under the successive presidencies of Hugh Casson (1976–84), Roger de Grey (1984–93), Sir Philip Dowson (1993–9), Phillip King (1999–2004) and Nicholas Grimshaw (2004–11), the Academy extended its record of mounting important historical exhibitions while deepening its commitment to contemporary art. Casson's presidency saw 'Painting in Florence 1600–1700' (1979), 'Post-Impressionism' (1979) and 'A New Spirit in Painting' (1981). Although it was financially unsuccessful, the last was a significant exhibition credited with reflecting international developments relating to painting, including the reconsideration of figuration, that were then in fruition. Upon his election as President, Roger de Grey, whose own painting was thoroughly academic (as indeed he was himself) (fig. 97), announced his support for more contemporary art at the Academy. Within two years the press was reporting that in the Summer Exhibition 'for the first time, abstract art steals the show'.[49] During the next seven years, the Academy's important survey exhibitions of twentieth-century art by

country included 'German Art' (1985), 'British Art' (1987), 'Italian Art' (1989) and 'American Art' (1993).

By the end of the 1980s a new, vibrant confidence characterized the Academy's involvement with modern art and with the art world generally. The press release for the 1989 Summer Exhibition referred to 'the largest open art exhibition in the world'.[50] The winds of change were detected by the *Sunday Telegraph*, which observed:

> The Academy seems intent on re-establishing the position of leadership which it enjoyed in the Fine Arts in the early 19th century … more and more artists are being won over. Some of those who, only a few years ago, would have disdained the Academy altogether are now lobbying to get in. Numerous familiar names from the contemporary art world such as Barry Flanagan, David Hockney, John Hoyland, Allen Jones and Ron Kitaj have already been elected, so have some of the best known architects – Norman Foster, Richard Rogers and James Stirling.[51]

In 1992 the Academy's contemporary cachet extended further afield when it began to approach foreign artists to show their work in the Summer Exhibition. This represented a radical extension of its reach and remit. Further geographical expansion followed. When he was elected President in 1995, Sir Philip Dowson inherited from Roger de Grey the process of acquisition of 6 Burlington Gardens, the location of the former Museum of Mankind (which was finally acquired in 2001). 'This', he announced in *The Times*, 'would be a centre for the visual arts in the middle of Piccadilly.'[52] More contentious was the Academy's relations with collectors of contemporary art. As if to confirm its aspirations as a major player in this field, in 1997 the 'Sensation' exhibition controversially presented works selected by Norman Rosenthal from the Saatchi Collection. It focused on the so-called YBAs (young British artists), the generation that defined contemporary art in the 1990s, and the show exposed old divisions within the Academy.[53] Tracey Emin, Damien Hirst, Sarah Lucas and Mark Quinn were among those artists whose artistic shock tactics and confrontational stance had already secured notoriety. But even these were trumped by *Myra*, a painting by Marcus Harvey in which the depiction of the convicted child murderer Myra Hindley was, for some, a bridge too far. Gillian Ayres RA

97 Sir Roger de Grey PRA, *Interior/Exterior*, 1992, oil on canvas, 137.3 × 182 cm (RA 03/1290).

and Michael Sandle RA both (temporarily) resigned, and Rosenthal commented upon his controversial selection: 'There is a slight edge between Members of the RA and me.'[54] Although there were internal repercussions, the effect was, however, to remove any lingering impression of an organization out of step with the art of its own time. Indeed, in 2000 the Academy itself confided to the *Daily Telegraph* that it 'was anxious to throw off its image as a stuffy, staid institution',[55] a furrow it has continued to plough under subsequent presidents Phillip King, Nicholas Grimshaw and Christopher Le Brun.

After 1945 the Academy had struggled to resolve those contradictions arising from its will to engage with the present while remaining deeply committed to its traditions. 'Sensation' effectively aligned the Academy with the cutting edge of contemporary art. But the underlying ambivalence of its attitude to the new is exposed when considering those works in the collection that define this period. As had been the case previously, there is a noticeable time lag between the emergence of an artistic tendency and its admission within the Academy. It took another decade for Emin, Gary Hume RA, Gillian Wearing RA and others to attain the establish-

ment recognition conferred by membership. In the meantime, the Academy's attention was focused elsewhere. It made strenuous and conspicuous progress in recruiting an earlier generation of artists that, in its formative stage, had also been beyond the pale.

This ethos of confidence in the new now permeates the Academy as a whole. As a result of the keepership of Maurice Cockrill RA, who retired in 2011 after six years in post, the Academy Schools now offer a studio-based practice across all contemporary art media and time-based ways of working. Alongside openness to experimentation, traditional skills retain their place. In addition to professors in Painting, Sculpture, Drawing and Architecture, expertise associated with materials and representation of the figure continues to be made available by professors of Chemistry and Anatomy. Recent additions to the exhibition programme reflect an involvement not only with modern art but the art of today. The GlaxoSmithKline-sponsored exhibitions of contemporary art and the *Artist's Laboratory* series both provided a platform for new developments. The membership's lack of congruity with wider contemporary practice is, however, somewhat surprising. The Arts Council Collection's report of its acquisitions in the period 1988–2002 – arguably a reasonable index of contemporary art in Britain – lists some 506 artists: a huge expansion on the profile offered above for 1981. Of these artists, only 21 are Academicians.

These figures give rise to a surprising reflection. In the twenty-first century the Royal Academy has made great progress in repositioning itself within a contemporary context; older and mid-career modern practitioners are represented in strength as members, but, paradoxically, only a relatively small proportion of younger artists presently at work are Academicians. One reason is that, while the field of contemporary art continues to expand, more than doubling in the last 30 years, the number of Academicians has remained fixed at 80 (although in practice it hovers around 100, since at the age of 75 a member becomes a Senior RA, opening up space for a new election). As never before, the Academy has the capacity to be truly representative of the art of its time in all its diversity. But in order to achieve that end it will need to decide whether to continue to confer distinction through exclusivity or, instead, to extend the horizon of its membership in order to engage more closely with the new, and it has shown distinct signs of doing just that.

One of its most startling gestures in this direction was the election on 8 December 2011 at the General Assembly of a new Professor of Drawing. Tracey Emin, who had been elected RA four years earlier, was for some a surprising choice. Her art had been associated with the perceived excesses of the YBAs, the generation of artists that defined British art in the 1990s, and seemed inimical to those core values that continued to colour the wider general public's perception of a once venerable institution. Against tradition and academic skills rooted in drawing from life and the Antique, and in opposition to the Academy's enduring 'establishment' veneer, Emin appeared to represent something closer to hubris. In particular, she was identified with one particular controversial work of art that brought her widespread recognition: *My Bed* (1998, private collection). It was first seen at the Tate Gallery in 1999, when it was a shortlisted entry for the almost equally notorious Turner Prize (established in 1984). The exhibit consisted of the artist's own bed complete with biological stains and an array of everyday objects and personal detritus. Emin's anarchic reputation was established.

In the main, the press response to her appointment was wry rather than outraged. Despite reports in the *Daily Mail* of 'uproar' at the Academy, most other newspapers were sanguine. *The Times* and the *Guardian* both registered approval, a generally positive verdict that seemed encapsulated by the reaction of Nicholas Serota, then director of Tate: 'There will be a lot of people who say, "What a lousy idea, she doesn't stand for classical drawing", but I think it's a great appointment.'[56] Other commentators went further, citing Emin's drawing skills which, while hardly classical, were nevertheless regarded as sophisticated and fundamental to her practice. Indeed, a view emerged in the pages of some broadsheets that in many respects Emin was the perfect candidate for this historic teaching role: not only was she the first woman to hold a professorship at the Royal Academy, but she was a leading contemporary artist who could be perceived as a compelling exponent of drawing as a vital form of expression, and one freed from the constraints of dry academicism.[57]

This episode and the resulting critical consensus are telling. Coming as they did at the beginning of the second decade of the twenty-first century, these developments provided confirmation of the revolution wrought not only

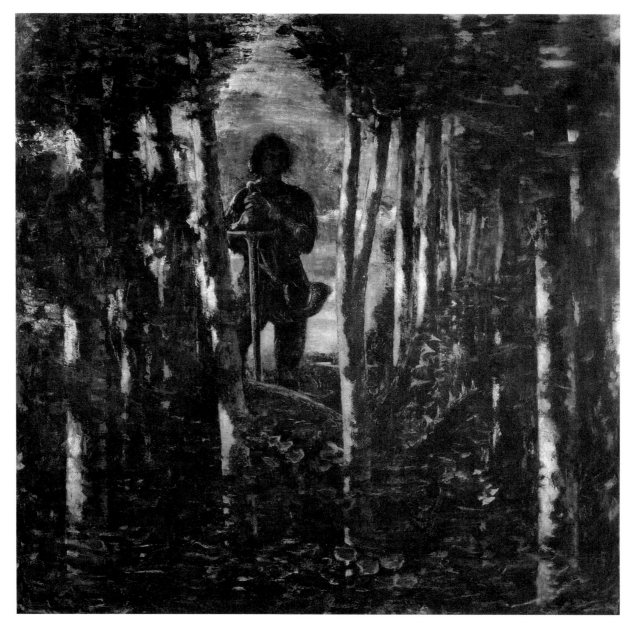

98 Christopher Le Brun, *Siegfried and Fafner, LXIII*, 1994, photogravure with etching, aquatint,
burnishing and scraping, 50.5 × 52 cm (RA 04/207).

within the Academy itself, but also in terms of the way the institution has come to be perceived. Together, both represent a sea-change that has occurred since 1945. Collectively, this period has seen a fundamental repositioning and redefining of those earlier values that defined the post-war Academy. Put simply, a bastion mentality – against modern-ism and resistant to change – has given way to a commitment to the contemporary and the new.

On the day of Emin's election, the General Assembly also elected a new president, the respected painter and printmaker Christopher Le Brun (fig. 98). Le Brun was elected RA in 1996 but had been equivocal about joining the Academy,

mindful of its continuing reputation for conservatism. He was, however, attracted by the evidence of changing attitudes within the organization and its apparent will to engage more actively with the contemporary art scene. As a former trustee of both the Tate Gallery and the National Gallery, he was well equipped to build bridges between the forces of tradition and those seeking renewal. In his own words, he is 'a believer in establishments',[58] someone willing to contribute to the process of regeneration from within. When his predecessor Nicholas Grimshaw retired, Le Brun was seen by those who supported his election as a leader who would maintain the process of change.

He made significant strides. There was an evident keenness to attract new blood from across the range of contemporary practice within Britain. The seven new RAs appointed in 2012–13 were Ron Arad, Thomas Heatherwick, Chantal Joffe, Mike Nelson, Sean Scully, Conrad Shawcross and Emma Stibbon. In the following year, the ranks were swelled by a further eight new RAs: Louisa Hutton, Neil Jeffries, Cathie Pilkington, Tim Shaw, Yinka Shonibare (fig. 99), Bob and Roberta Smith (Patrick Brill), Wolfgang Tillmans and Rebecca Warren. The imperative to extend the membership internationally continued with the election as Honorary Academicians of Marlene Dumas, who was born in South Africa and lives in the Netherlands, and the distinguished German artist Rosemarie Tröckel. Collectively, this group forms one of the largest changes in membership in the Academy's history.

At the same time, a five-year plan to transform 6 Burlington Gardens was announced. Underpinning those radical architectural developments, a new, slimmed-down management structure was introduced, intended to build a more integrated and cohesive organization. Alongside all these advances, the exhibition programme sustained an international profile with major surveys of Mexican and Australian art, while the exhibition 'Sensing Spaces: Architecture Reimagined' provided a platform for seven architectural practices from around the world. Broadening the Academy's membership, expanding its footprint in central London,

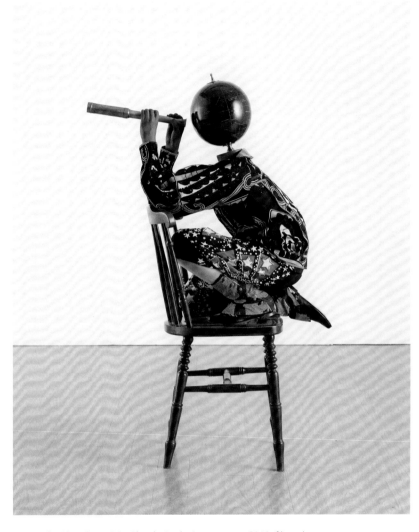

99 Yinka Shonibare RA, *Cheeky Little Astronomer*, 2013, fibreglass life-sized mannequin, dutch wax printed cotton textile, leather, resin, chair, globe and telescope, 123 × 47 × 90 cm (RA 14/2669).

restructuring the organization, and reinforcing the international reach of the exhibitions programme are conspicuous elements of Le Brun's presidency. They testify to an awareness that developing the Academy's relationship with the external world might be the key to its future.

A CLOSER LOOK

Sir Alfred Munnings
Kilkenny Horse Fair

Diploma Work

ANNETTE WICKHAM

Alfred Munnings was born in 1878 into a family of millers and farmers in Mendham, Suffolk. Life in rural East Anglia fostered his enduring fascination with horses and his love of the English landscape. At the age of 14, Munnings was apprenticed to a lithography firm but studied at Norwich School of Art in the evenings. In 1899 an accident left him blind in one eye, but this did not impede his progress as an artist. During the early 1900s Munnings attended the Académie in Antwerp and the Académie Julian in Paris, travelled with gypsies in southern England and painted with the Newlyn School of artists in Cornwall. Munnings was described by Dame Laura Knight as a man of 'irresistible charm', and he was a popular guest at parties and country houses.[1] Such contacts secured lucrative commissions for portraits of horses and their owners. These paintings, alongside Munnings's pictures of race meets, landscapes and country fairs, were well regarded in his day. Although his reputation is now enjoying a revival, for much of the recent past he was chiefly remembered for his reactionary views on art. Munnings was elected a Royal Academician in 1925, became President in 1944 and was knighted shortly afterwards. Frustrated by the protocol required by this

post, he resigned in 1949 using his last speech as President to launch a diatribe against 'modern art' and its supporters.

Munnings visited Ireland in 1922 to paint Isaac Bell, Master of the Kilkenny Foxhounds. The artist greatly enjoyed this commission and later enthused, 'What landscape and what sights I saw with Isaac Bell in that part of Ireland!'[2] One of these sights was the horse fair at Kilkenny, and Munnings's RA Diploma Work, *Kilkenny Horse Fair* (fig. 100), could easily be mistaken for a *plein-air* painting. The imposing grey horse in the centre is clearly placed for effect, but there is spontaneity in the otherwise haphazard arrangement of figures and in the fluid rendering of the fresh, cloudy sky.[3] Munnings seems, however, to have produced at least two versions of this scene in the studio. The first was exhibited at the RA in 1923, and then this second version was presented to the Academy as his Diploma Work in 1925.[4] Both were clearly based on his experiences in Ireland, but there is a striking discrepancy between the image and Munnings's description of his visit to the fair. He recalled 'a scene of hundreds of umbrellas': 'A horse fair in the rain – real rain…I still see the women beneath the umbrellas, with grey shawls over their heads as they stood selling halters. Sheets of water lying in the ground like a vast

126

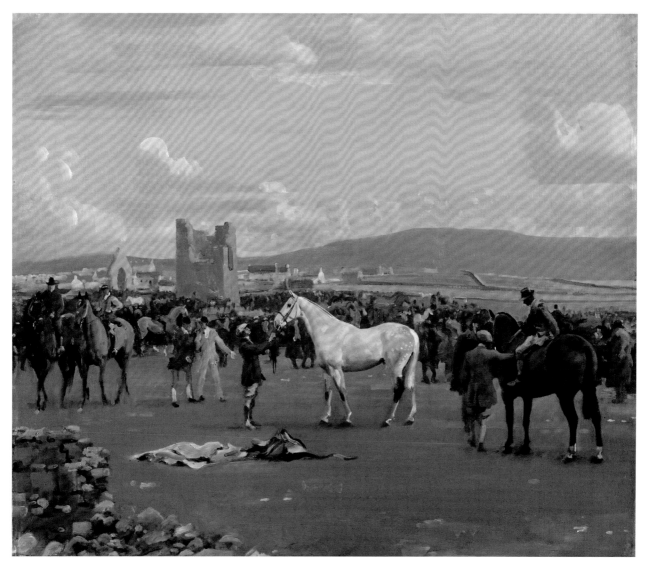

100 Sir Alfred Munnings PRA, *Kilkenny Horse Fair*, *c.*1925, oil on canvas, 64.3 × 76.9 cm (RA 03/273).

lake with shapes of crowded, shivering horses reflected in its surface, peppered with the rain.'[5]

Another passage in Munnings's memoirs corresponds more closely with the painting. Describing his final day in County Kilkenny, Munnings wrote wistfully of the 'forlorn, yet beautiful, far away stone-wall country where herds of goats were roaming', and where 'hardy, robust people' lived 'in thatched, stone cottages as they did three hundred years ago'.[6] This romanticized image of the Irish landscape clearly informs Munnings's portrayal of the horse fair, in which he fused together the elements of Irish country life that most appealed to him, editing out the troublesome rain and the instances of political unrest he observed during his travels.[7] Munnings was strongly opposed to the mechanization of agriculture and even gave lectures promoting the preservation of traditional farming methods.[8] This painting, depicting a historical custom taking place in a landscape apparently untouched by modernity, is deeply imbued with the artist's nostalgia for the pre-industrial past.

William Roberts
Combat
Diploma Work

ROBIN SIMON

William Roberts is often thought of as an 'English Cubist',[1] and his art represented everything that Sir Alfred Munnings PRA feared: the infection of British art by the dangerous, even decadent, tendencies of early twentieth-century European painting. *Combat* (fig. 101) was Roberts's Diploma Work and shows how his art was influenced by Cubism and the art of Picasso in particular, although there is a marked affinity with the kind of modified Cubism developed by Fernand Léger. Roberts himself identified his own early work as Cubist, notably the *Return of Ulysses* of about 1913 (Nottingham Castle Museum and Art Gallery).

Roberts trained at the Slade School at the same time as Stanley Spencer, Mark Gertler and David Bomberg among a brilliant generation of students immediately before the First World War. *Pace* Munnings, there is something essentially English and indeed naturalistic about *Combat* that positions Roberts more comfortably within the same figurative tradition to which Spencer belongs. That seems clear enough now from our perspective, but we should recall that Spencer was so much disliked by Munnings that, as discussed in the present chapter, the President reported him to the police for obscenity

in 1950, an action deplored by the Academicians as it was seen as an attack on one of their fellow members. Another English strand in Roberts's development was his early involvement with Vorticism (the English version of Futurism), and he appeared in both editions of the movement's short-lived magazine *Blast* (1914–15).

Roberts's immersion in the academic and classical tradition, which led to the *Return of Ulysses* and also to a number of religious compositions (of what he called 'Christian Mythology'),[2] is revealed by the compositional antecedent of *Combat*, which was another history painting of a classical subject, *Rape of the Sabines*, which he exhibited at the Academy in 1955.[3] This powerful oil was founded upon careful studies, including a pencil and watercolour study squared up for transfer to canvas.[4] In 1977 Roberts was still considering this theme of the Sabine women in a composition in which the Romans are attempting to abduct their victims on horseback.[5] It is strikingly close to *Combat*, and it seems therefore that Roberts's Diploma Work, which ostensibly just depicts a group of men and of women fighting on a beach, is a modernist interpretation of an episode in the history of ancient Rome.

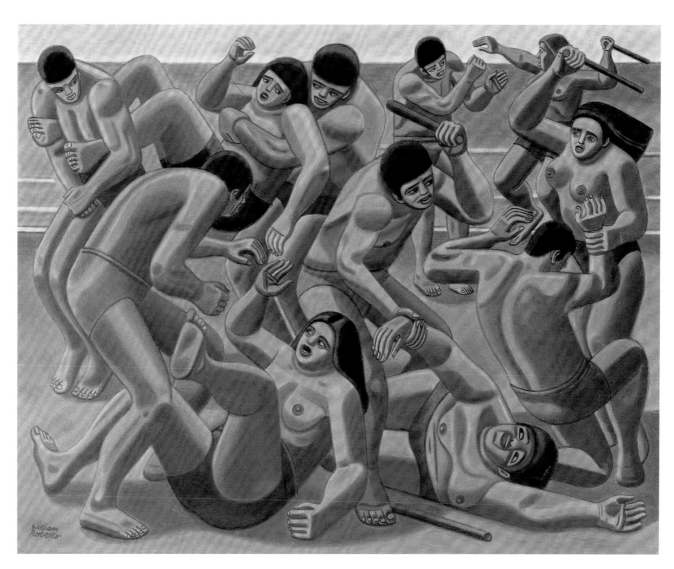

101 William Roberts RA, *Combat*, 1966, oil on canvas, 60.1 × 76.2 cm (RA 03/479).

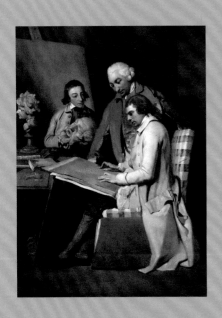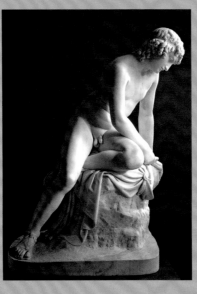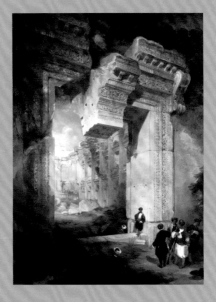

PART
TWO

WORKS OF ART

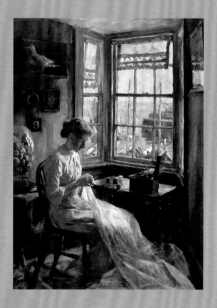
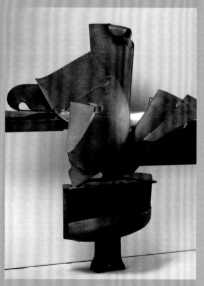
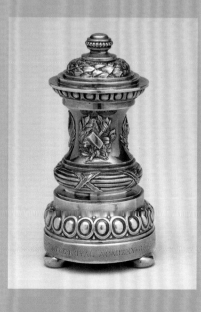
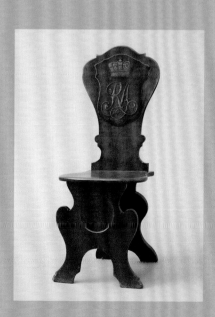

5

PANTHEONS AND PORTRAITS

ROBIN SIMON

The visitor to Burlington House will be struck by the sculptures high up on the façade (see fig. 11), without perhaps being able to recognize any individual or to read a single identifying inscription. And yet this pantheon, small in scope but great in its assertiveness, speaks of the peculiar nature of the Royal Academy. Despite its title and origins – with each current monarch as its patron – the Academy is private, but the façade sculptures make a public statement of intent. They show, from left to right, Phidias, Leonardo da Vinci, John Flaxman, Raphael, Michelangelo, Titian, Joshua Reynolds, Christopher Wren and William of Wykeham (fig. 102). The Academy clearly saw itself in an international and historical context, since we find the Academicians Reynolds and Flaxman in the company of Leonardo, Michelangelo, Raphael and Titian. Indeed, in asserting the Academy's place within the great European tradition, the longest possible view was taken, since the array also includes Phidias, the legendary sculptor, painter and architect of ancient Greece.

His presence was perhaps inevitable, given the overwhelming impact in Britain of the Elgin Marbles from the Parthenon then ascribed to him, which first went on public display in Park Lane, London, in 1807. Moreover, in 1811 the Elgin Marbles had found a home in the grounds of Burlington House, on the western side of the courtyard, where they remained until 1816 when they were moved to the British Museum, having been purchased after an enquiry that same year. They were to play a fundamental role in the training of students in the Royal Academy Schools.[1]

The Schools were integral to the Academy's purposes, and so the Academy's façade sculptures also asserted its credentials as a centre of learning through the presence of William of Wykeham, the founder of both Winchester College and New College, Oxford. He is present here also as an architect, having been involved in supervising the rebuilding of Windsor Castle for Edward III. Architecture as an aspect of the Academy's activities is more plainly represented by

102　Sculptures towards the east of façade of Burlington House, showing (left) Edward Stephens ARA, *Christopher Wren*; (right) Joseph Durham ARA, *William of Wykeham*, completed 1874, stone.

Christopher Wren, who at the same time emphasizes the Academy's claims to intellectual distinction. It is conceivable that William of Wykeham's presence was required also as a representative of the native Gothic tradition as opposed to the classical, a hint at the Academy's encompassing both sides of the 'battle of the styles' that characterized Victorian attitudes to public buildings.

The Royal Academy scheme, although so prominent and self-confident, is only one of a number of such lapidary statements to be erected in London at this time. It is possible

that the immediate inspiration – although it may simply have emerged from the same impulse – was the National Portrait Gallery, founded in 1856, which was the first institution avowedly of this kind: a 'gallery' of portraits of those considered worthy of commemoration for their role in the nation's history, with an entrance façade adorned with the busts of its three founders, Thomas Carlyle and Lords Stanhope and Macaulay, while the north side of the building was decorated with busts of famous British artists. Although the National Portrait Gallery went further than anything before, there had been many precedents, which usually took the shape of agglomerations of worthy or distinguished individuals, whether as representative of a nation, a culture, or an institution. In England, for example, there had been Peter Lely's 'Flagmen' commissioned by James, Duke of York, in 1665 (National Maritime Museum, Greenwich), and his 'Windsor Beauties' (Hampton Court Palace), probably commissioned by the Duchess of York at about the same time, which were imitated by Godfrey Kneller in his 'Hampton Court Beauties' for Mary II in 1691.

The various colleges of Oxford and Cambridge host a vast and motley array of portraits of dons reaching back over hundreds of years. In Italy the great collection of artists' self-portraits in Florence, initiated by Cardinal Leopoldo de' Medici in 1664, was once a famous feature of the ducal palace and is now ranged through the principal section of the *corridoio vasariano* that runs from the Uffizi over the River Arno to Palazzo Pitti.[2] A notable inclusion was a self-portrait by the first President of the Royal Academy in London, Joshua Reynolds, in 1775, showing him in academic robes and clutching a bundle of drawings marked 'Michelagnolo'. On its arrival in Florence this portrait was greeted with astonishing acclaim, which must have contributed to Reynolds's decision to have the first seven of his *Discourses* published in Italian (as *Delle arti del disegno*) in Florence in 1778.[3] The architect of this triumph was a fellow Academician, Johan Zoffany, then living in Florence, who had suggested to the director of the Uffizi that Reynolds might be asked to present a self-portrait. Zoffany presented his own self-portrait to Grand Duke Leopold I on 30 March 1778.[4]

Only one of these collections in Europe of portraits, monuments or memorials explicitly adopted the name of 'pantheon', although that is, in effect, what they all were: the Panthéon in Paris was invented in 1791 at the time of the Revolution as a resting place specifically for great men ('Aux grands hommes la patrie reconaissante'), although Marie Curie subsequently crept in.[5] It was housed in a former church (Ste-Geneviève) which, with peculiar though adventitious propriety, had a portico modelled upon the original Pantheon in Rome. The new institution drew inspiration from that building, one of the greatest survivals from classical antiquity. The Roman Pantheon was originally founded by Marcus Agrippa between 29 and 19 BC as a temple to 'all the gods', which is what 'pantheon' means (the dedication is the topic of arcane dispute), although what we see now is chiefly the building as remodelled after fires in the first century AD. It was further transformed in the Renaissance not only as a Christian church (it had become Santa Maria ad Martyres in the seventh century) but also in order for it to function as a resting place for the bones of famous men: hence the use of the term in its modern and secular sense. First to arrive was Raphael, the High Renaissance artist revered within all the later European art academies as a kind of godhead. In 1542, shortly after his death, a society of artists was founded as a confraternity based in the church (specifically, in the first chapel on the left). It became known as the 'Virtuosi al Pantheon', and over the succeeding centuries its members were commemorated in busts that remained in place until the nineteenth century.[6] Tombs included those of painters such as Annibale Carracci but also musicians (Arcangelo Corelli) and architects (Baldassare Peruzzi) and finally, and most expansively, the first two kings of united Italy (in 1878 and 1900).

There was a precedent in England for the Panthéon in Paris: 'Poets' Corner' in Westminster Abbey. The south transept began to assume this role in the eighteenth century, a development watched with some interest in the contemporary French press. It came about through one of those English accidents: the presence there of a monument to Geoffrey Chaucer, who had been buried in the abbey not so much because he was a great poet but because he was Clerk of the Works to the Palace of Westminster. The years around 1720, when monuments began to appear in the south transept, witnessed the assertion of an indigenous British culture to rival anything on the Continent and especially France. To the astonishment of French commentators, Westminster allowed famous women as well as men to be buried with honour in this ad hoc pantheon, and even actresses. Anne Oldfield, for

example, was placed there as early as 1730, at a time when her French counterpart, Adrienne Lecouvreur, was not allowed even to be interred in hallowed ground.[7]

The development at Westminster was reflected in a contemporary pantheon of 16 sculpted busts designed by William Kent and set up in the 1730s in the grounds of the great country house Stowe: the 'Temple of British Worthies'. It included the Black Prince, Elizabeth I, Alfred the Great, Shakespeare and Milton. In a manner characteristic of these monuments, among the busts (others are of Drake, Raleigh and Locke) is to be found the then topical but now less resonant image of one Sir John Barnard. At the time, Barnard's inclusion made sense in the context of what was intended as a statement of opposition to the prime minister, Sir Robert Walpole, and the inscription described Barnard as 'distinguished … in Parliament by an active and firm opposition to the pernicious and iniquitous Practice of Stock-jobbing'. At this distance in time, it looks merely odd.[8]

In the 1790s a pantheon of great military men began to be developed in St Paul's Cathedral, a scheme in which the Royal Academy was very much involved,[9] to the extent that it sought to ensure that its members got all the commissions, which caused something of a public outcry. Many more coherent and larger examples appeared, however, in the years around 1870, and – with one notable exception – the Royal Academy and its members played a leading role in the design of them all. By that date, Germany had Walhalla, high above the Danube outside Regensburg in Bavaria, named after the hall of fallen heroes in Norse mythology. It was devised by Ludwig I of Bavaria and built 1830–42 by Leo van Klenze in the Greek manner on a lavish scale to honour the immortals of the German-speaking world. Ludwig's interpretation of who was German was expansive (or expansionist), and Walhalla features a Flemish (British) artist, Anthony van Dyck, and a Dutch (British) monarch, William of Orange (William III). The building was recorded by J. M. W. Turner RA in a romantic watercolour of about 1840 (Tate Britain, London) when the building was still not quite complete, and subsequently in an overblown oil, *Opening of the Walhalla 1842* (Tate Britain, London). Turner exhibited this painting in the Academy in 1843, where it was generally well received, but at its subsequent exhibition in Munich in 1845 it was greeted with ridicule by a public unaccustomed to Turner's painterly excesses.

The activities of King Ludwig of Bavaria cast a long shadow on public art in Britain, and it is possible to see the purpose-built pantheons in London that were erected in the latter part of the nineteenth century as the result of the interest taken in such things by Prince Albert. He was born in Saxe-Coburg-Saalfeld within what is now modern Bavaria, and married Queen Victoria in 1840 at the very time that Walhalla was nearing completion. Albert was the driving force behind the long-drawn-out schemes for the interior decoration of the Palace of Westminster, for example, from 1841 until his death in 1861, where the key and, as it turned out, very bad decision to use fresco for the paintings was due to a decision to take the activities of Ludwig of Bavaria as a model.[10]

The sculptural and mosaic pantheons created in Britain at this period have, indeed, a rather Teutonic air about them. More generally, they are reflective of the recent growth of Great Britain's possessions into a global empire, and many were on a truly imperial scale. The biggest is, fittingly, the 'Parnassus' frieze on the Albert Memorial (1872; fig. 103), which is made up of no fewer than 169 sculpted stone figures of painters, architects, sculptors, musicians and poets, on the scale of life and international in scope. It was conceived by Sir George Gilbert Scott RA and executed in high relief by Henry Armstead RA (east and south sides) and John Birnie Philip (west and north sides) in remarkably animated and convincing compositions. Then there is the mosaic frieze on the outside of the Royal Albert Hall, masterminded by Frederick Yeames RA (1871), and the rich array on the front of the building at the back of the Royal Academy, 6 Burlington Gardens (1867–70). This building was designed as the home of the University of London, and so we find upon its façade an impressive catch-all of intellectual achievement: 22 life-size representatives of genius from Archimedes and Plato to Cicero and Galen, through to Leibniz, Linnaeus, Adam Smith, Locke and (this being the University of London) Jeremy Bentham. Milton is perched on the exterior near Bentham, although Shakespeare was only to be discovered inside, on the main staircase (his very large statue seems to have vanished).

The South Court in the Victoria and Albert Museum was created at much the same time, 1862–72, with a mosaic display of 35 artists to designs from various hands, including the Academicians Frederic Leighton, Edward Poynter and

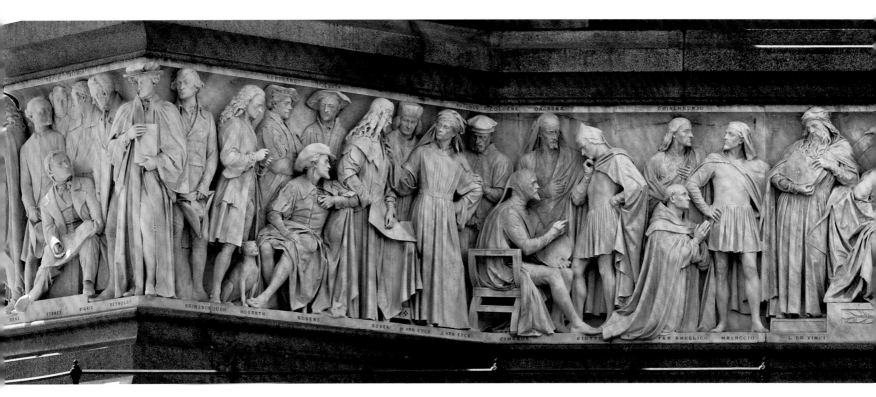

103 Henry Hugh Armstead RA, 'Parnassus' frieze on the Albert Memorial, South Kensington, London, 1872.

G. F. Watts, and was instantly dubbed 'the Kensington Valhalla'.[11] The architects commemorated in this scheme include Christopher Wren and William of Wykeham (again) but also Inigo Jones, who had appeared, as the sole representative of British art among 75 artists of all nationalities, in the great hemicycle pantheon by Paul Delaroche of 1837–42 in the École des Beaux-Arts, Paris. Delaroche's conception derived, ultimately, from the granddaddy of all painted pantheons, Raphael's *School of Athens* (1509–11; Vatican, Rome), and fills the back wall of the auditorium of the École, the ceiling of which celebrates all the European schools of art with the exception of the British School, which is simply not mentioned (a very Gallic omission, and despite the fact that Delaroche was assisted by Edward Armitage, a future RA).[12] Jones's inclusion in this picture is therefore all the more curious, as is the fact that he is also the sole British artist whose name appears in the echoing space of the immense and now vacant sculpture hall of the École that sits before the more famous auditorium. Such, perhaps, is the nature of fame, and the quirky selection at the École is

typical of what now appears to be the somewhat arbitrary character of artistic pantheons wherever they appear.[13]

On the other side of Piccadilly from the Royal Academy is the façade of the Royal Institute of Painters in Watercolour (1881–3), designed by Edward Robert Robson, who, significantly, was never an Academician. It is still handsome (despite some mutilation) but is generally ignored by passers-by, despite its palatial classical elevation stretching some 100 feet westwards from the Wren church of St James's, Piccadilly, and offers ample testimony to the esteem in which the medium of watercolour was held at the institute's foundation in 1831. Following the death of the greatest exponent of watercolour, J. M. W. Turner, in 1851, the institute became grander still. It had been founded as a direct challenge to the Royal Academy, which, despite the presence of Turner within its ranks, took from its inception one of those predictable academic positions that argued against watercolour as a medium of the most serious art.[14] In 1881–3 the institute's new headquarters was erected, in an obvious act of defiance, almost directly across the street from the Royal Academy, which had then

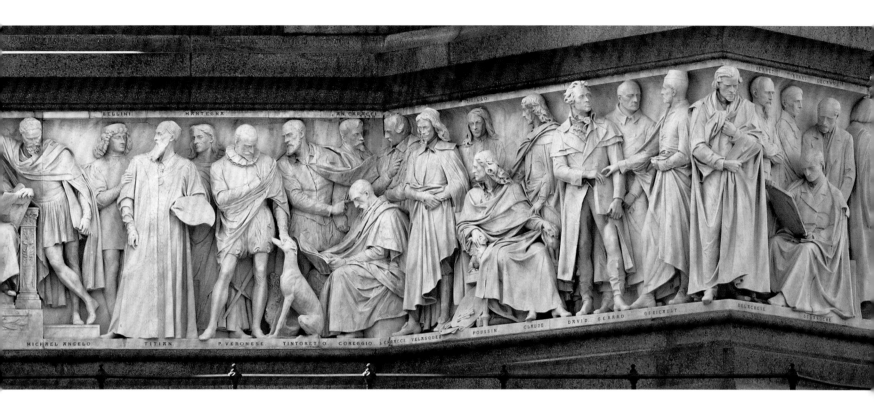

barely settled into its new home at Burlington House. And in 1885 the institute too became 'Royal' by command of Queen Victoria, who was herself, like so many of the royal family, an accomplished watercolourist. Since it now became known as the RI (Royal Institution), this mark of recognition provided a two-lettered gesture in the direction of the RA.

Here, as elsewhere, the choice of those immortals who were perceived as embodying the aspirations of the RI at one particular point in its history seems, with hindsight, surprising. All eight sculptured busts on the façade of the RI were the work of Onslow Ford, who was not yet an Academician, which was a point in his favour so far as the RI was concerned. Turner, of course, had to be represented; and so did Thomas Girtin, John Robert Cozens, David Cox Senior and Peter De Wint. But George Barret the Younger and W. H. 'Bird's Nest' Hunt now appear to have been rather stretching the point.

One of the last of these pantheons was assembled on the Cromwell Road façade of the Victoria and Albert Museum, designed 1899–1909 by Aston Webb, PRA, and here too the touch appears, from our perspective, to have been uncertain.

The choice of British artists to appear in the form of full-length sculptures began well enough with William Hogarth, Joshua Reynolds, Thomas Gainsborough and even George Romney, but with no room anywhere for Thomas Lawrence, it dipped towards absurdity with Richard Cosway. When viewed with hindsight, the hint of bathos is characteristic, although of course these curious selections tell their own story. It is unfortunate, however, that the improbable positioning side by side of Hogarth and Reynolds (both sculptures of 1905), who in life were natural opposites, is made more preposterous by the fact that the sculpture of Hogarth stands on Reynolds's plinth, while that of Reynolds is on Hogarth's (fig. 104). No one seems ever to have noticed, not even, perhaps, the sculptor of these two statues, Reuben Sheppard.[15] It is a telling comment on the genre.

All these schemes pale into insignificance compared with the plan for another kind of Valhalla on the banks of the Thames, to house all the 3,000 or so statues and wall monuments in Westminster abbey.[16] The two buildings, the new gallery and the venerable Abbey, would actually have been connected, in a project conceived as a spin-off from

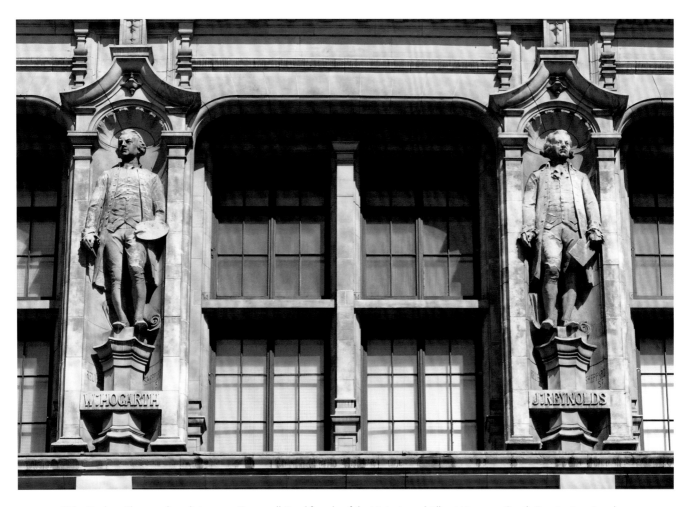

104 Reuben Sheppard, sculptures on Cromwell Road façade of the Victoria and Albert Museum, South Kensington, London,
showing (left) William Hogarth and (right) Sir Joshua Reynolds, 1905.
The statues are on the wrong plinths: Reynolds holds a palette; Hogarth holds an engraving plate.

a plan – characteristic of the period – to restore the abbey to its supposedly pristine Gothic glory. Had this thoroughly un-British scheme taken shape, the abbey, while Gothic enough, would certainly have looked abandoned.

A SELF-PERPETUATING PANTHEON

For the sculptures on the façade of Burlington House, the Royal Academy had more material to play with than its rival, the RI, although the juxtaposition of Flaxman and Michelangelo, or of Reynolds, Leonardo and Phidias, is, to

say the least, self-confident. Quite who was to be represented had been a matter of debate. In January 1873 a committee of the Royal Academy first decided on the occupants of the nine niches provided in Smirke's upper-storey design. They chose the individuals we see today, but with Giotto where Phidias now is. This recommendation went to the Council, which promptly decided that the five Italians should be replaced by five British artists: Hogarth, Turner, Gainsborough, Strange and Wilkie. This patriotic choice was in itself contrary, not only in view of the perceived opposition of Hogarth to such an institution as the Royal Academy during his lifetime, but also on account of the fraught relationship

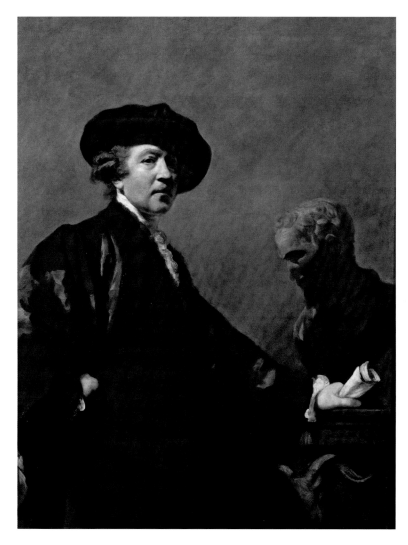

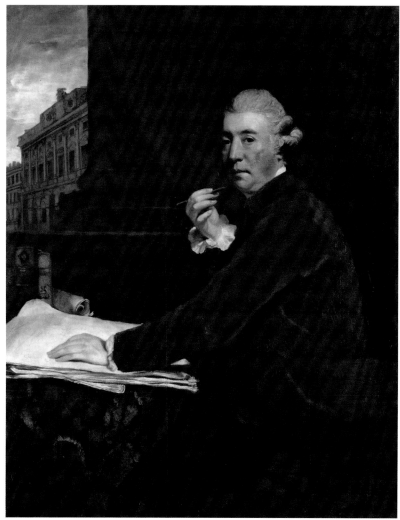

105 Sir Joshua Reynolds PRA, *Self-portrait*, 1780, oil on panel, 127 × 101.6 cm (RA 03/1394).

106 Sir Joshua Reynolds PRA, *Sir William Chambers RA*, c.1780, oil on panel, 129 × 103.2 cm (RA 03/704).

that existed between the Academy and Sir Robert Strange. Almost immediately, at the next stage of the process, the General Assembly reinstated the original selection, but substituted Phidias for Giotto, which was a little unfortunate in view of the key role of several Academicians in the rediscovery of Giotto in the late eighteenth and early nineteenth centuries, especially the Arena Chapel, Padua.[17] The execution of the work went to two Academicians, W. Calder Marshall (the figures of Michelangelo and Titian) and Henry Weekes (Flaxman and Raphael) and two ARAs, Joseph Durham, who had carved Newton, Bentham, Milton and

Harvey for 6 Burlington Gardens (Phidias and William of Wykeham), and Edward Stephens (Reynolds and Wren). They were paid in January 1874, and so the whole upper storey was complete within two years from the approval of Smirke's plans in June 1872.

Inside the building, the Academy became richer with each passing year in the range and splendour of the portraits it contained. These were, and are, principally of its own members, right from the initial presentation in 1780 by Reynolds of a self-portrait (fig. 105) and a portrait of Sir William Chambers (fig. 106), respectively showing the first

President and Treasurer of the purpose-built Academy building in New Somerset House that Chambers had designed.[18] They form a most impressive pair, pendants that were initially displayed in the Council Room,[19] with Reynolds to the left of the fireplace, Chambers to the right. Chambers, naturally enough, is seen with the Strand front of his new building in the background. Reynolds, intriguingly, depicts himself, as has always been recognized, in the manner of Rembrandt, a striking decision that reflects a life-long devotion to the master that was formed under the influence of his teacher Thomas Hudson, who, among an important collection of Old Masters, had a large number of works by Rembrandt. Yet it is an odd choice, since Reynolds's own *Discourses* were shaped to direct the Academy in the direction of the emulation not of Dutch painting but of High Renaissance Italian art. 'Painters', according to Reynolds, 'should go to the Dutch school to learn the art of painting, as they would go to a grammar-school to learn languages. They must go to Italy to learn the higher branches of knowledge.'[20] True art, it was thought, should aim at the ideal, at surpassing nature, an aspiration in direct contrast with Rembrandt's great strengths, which, as everyone acknowledged, were his naturalism and realism – two qualities that were, at the same time, held to represent his limitations.

The primacy of Italian High Renaissance art explains the presence in Reynolds's *Self-portrait* of a plaster copy of a bust by Daniele da Volterra of Michelangelo, which was a gesture in the right direction, although the choice of Michelangelo itself is a little odd, since it might have been expected that the Renaissance master included in such a manifesto portrait at this date would be Raphael, whose art Reynolds extolled in his *Discourses*. Reynolds was, however, being consistent in this choice: it is a bundle of drawings inscribed 'Michelagnolo', we recall, that features in Reynolds's Uffizi *Self-portrait*, and it is a bust of Michelangelo (indebted to Daniele, carved by Joseph Wilton RA) that sits over the entrance to the Royal Academy in Chambers's Somerset House.

One might, however, have expected Reynolds to portray himself as an artist, especially at the very heart of the Academy over which he presided, but he did not. Instead, he chose to show himself in the robes of a Doctor of Civil Law, the degree that he had recently been awarded by the University of Oxford, although these loose robes and the soft cap partly trick us into the impression that we are looking at a typical self-portrait of an artist in studio cap and painting dress. Clearly, the portrait is making a public statement about the intellectual status of the artist that the new Academy intended to assert. At the same time, however, it is, especially in its overt echoes of Rembrandt, a distinctly personal, even private, painting.

The allusion to Rembrandt hints at the contemporary practice of 'imitation', an intellectual conceit characteristic of so much thoughtful painting and writing of the eighteenth century, whereby a new work made studied reference to a major work of the past.[21] To which Rembrandt painting in particular might Reynolds be referring? It has frequently been asserted that the *Self-portrait* bears a resemblance to Rembrandt's *Aristotle contemplating a Bust of Homer* (Metropolitan Museum, New York), partly because that picture is known to have belonged to a friend of Reynolds, Sir Abraham Hume, by 1815. In fact, Reynolds could not have seen the *Aristotle* before he painted his *Self-portrait* in 1780, either in its original form or in the form of a copy or print, since none of the latter existed, and the painting itself hung, from the time of its commission directly from the artist until an earthquake of 1783, in the Ruffo family palace in the port area of Messina on the island of Sicily, which Reynolds never visited.[22] It seems instead that Reynolds, as would anyway have been more probable, was consciously referring to a self-portrait by Rembrandt, to be precise, the *Self-portrait with Two Circles* of the late 1660s (Kenwood House, London), a picture that Reynolds could have seen in Paris on his visit to the city in 1752. At that time the painting was in the collection of the comte de Vence, a collector who, as a member of the Académie royale de peinture et de sculpture, was in the habit of opening his gallery to artists.[23] Reynolds recorded that while in Paris he was in search of paintings by Rembrandt, and the comte de Vence owned more of his paintings than anyone else in France. When he painted his Royal Academy *Self-portrait*, Rembrandt's *Self-portrait with Two Circles* could also have been fresh in Reynolds's mind owing to its appearance (in reverse) in a volume of etchings by Antoine de Marcenay de Ghuy (fig. 107), either in its original edition of 1755 or the reprinted edition of 1780. The following year, 1781, Reynolds certainly studied the original painting in Brussels and left a memorable account of it.[24] Another self-portrait already in Britain may have first suggested to Reynolds that he might portray himself in

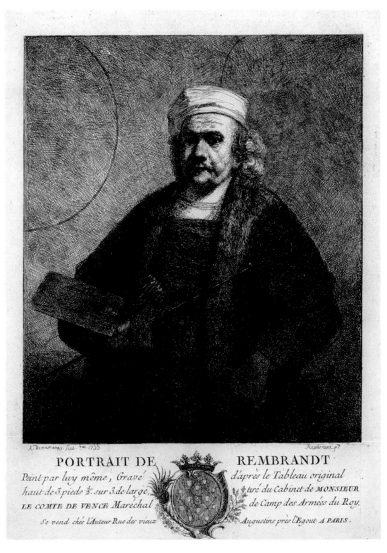

107 Antoine de Marcenay de Ghuy after Rembrandt, 'Self-portrait with Two Circles', in *Œuvre de Mr. de Marcenay de Ghuy écuyér, peintre, et graveur...*, Paris 1755, republished 1780, pl. 18, etching.

great cartoon by Leonardo da Vinci, *Virgin and Child with St Anne* (National Gallery, London), which is shown by Edward Francesco Burney in his watercolour of the Antique School at Old Somerset House (see fig. 392) amid other instructive aids (for that is how this supreme masterpiece was regarded), behind a door in the main teaching room. The only tiny exception would seem to be the portrait of the Academy's royal patron, King George III, that appeared on the medal produced by Thomas Pingo to a design by Foundation Members Giovanni Battista Cipriani and Edward Penny for presentation as student prizes.

Grand portraits were planned, however, for the new building, the north block on the Strand, and, with a sense of decorum that was natural to an eighteenth-century institution, the first to be commissioned were of the king and queen, painted in full length by Reynolds in 1779, for which he was paid his usual rate of 400 guineas.[25] This transaction – and Reynolds was not the only Academician paid for work at the new building – marks a break with the world of the St Martin's Lane Academy and its related institution, the Foundling Hospital, to which so many artists, inspired by the example of William Hogarth, had donated both their time as governors and their works of art.[26] One might even view Reynolds's insistence on a large fee with a little distaste, but that would be a mistake: although he was often suspected of being too fond of money, Reynolds was quite deliberately setting this new professional institution apart from the London academies of the past.

The Royal Academy went on to acquire portraits of each successive royal patron, the reigning monarch, each of whom has taken the duties of the position more or less seriously as individual taste or sense of duty has dictated. As seems inevitable, the paintings all take the form of full-length state portraits, such as *George IV, William IV* and *Queen Victoria* by Martin Archer Shee and the outstanding *George V* of 1928 by Sir Arthur Stockdale Cope (fig. 108). The most unusual, if not the most compelling, of the sculpted portraits must be the marble bust (1876) of Queen Victoria by her daughter Princess Louise, Duchess of Argyll, who presented it to the Academy in 1877 (fig. 109).

The princess was never an Academician, although she exhibited at the Academy, first an earlier bust of the queen in 1869 and then in 1874 a bust of General Grey. She enjoyed an unusually close relationship with her mentor Sir Joseph

relation to a sculpted bust, that by Michael Dahl painted in 1691 (National Portrait Gallery, London). Referring to the Rembrandt *Self-portrait with Two Circles* enabled Reynolds radically to reinterpret this precedent.

When the Academy moved to Old Somerset House in 1771 few, if any, portraits were acquired. There would hardly have been room for them, because the spaces occupied by the Academy were stuffed with casts and other early elements of the collection including, as now seems barely credible, the

108 Sir Arthur Stockdale Cope RA, *King George V*, 1928, oil on canvas,
261 × 159.6 cm (RA 03/1193).

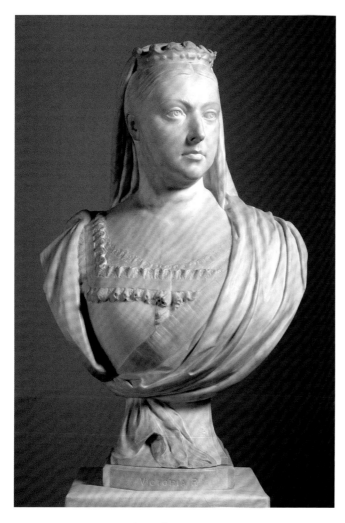

109 Princess Louise, Duchess of Argyll, *Queen Victoria*, 1876, marble, height 83.8 cm (RA 03/2435).

Edgar Boehm, Bt, who was elected to the Academy in 1882 and was much patronized by the royal family. The princess was with Boehm in his studio when he died suddenly, which gave rise to much speculation about their relationship (her husband was homosexual and they lived mostly apart); the search for the truth was long confounded by the swift destruction of Boehm's papers after his death.[27] We now know that Boehm did indeed die during sexual intercourse with the princess: she was initially trapped underneath his dead body. They had been lovers since 1869, although she had taken others and so had he.[28] The princess's chief comforter at the time of this dramatic incident was

Boehm's assistant, Alfred Gilbert ARA (RA 1892), who was a friend to both. Gilbert helped to cover up the circumstances of Boehm's death by claiming that it was he who had found the dead body upon entering the studio (fig. 110). Gilbert now succeeded Boehm as the favoured sculptor of the royal family.

Much of Boehm's own work consisted of public monuments, where Queen Victoria's insistence upon the accurate rendering of medals and uniforms gave rise to Edmund Gosse's remark that Boehm had 'sacrificed humanity to buttons'. In fact, this attention to detail was a reflection of Boehm's unusual interest in the realistic portrayal of his sitters in contemporary fashion, in reaction to the prevailing habit of neoclassical presentation. Boehm himself was quite clear about this, asserting that '[art which is] not of its time is failing in the all essential element of common sense'.[29] In successfully pressing for Boehm to be buried in St Paul's Cathedral, Princess Louise made the same point to the queen: 'he did more for modern art than any one of the day. If you remember 22 years ago it was dull heavy and bad classic, he was almost the first to introduce life and action into his

110 Joseph Parkin Mayall, 'J. E. Boehm, R.A.', in F. G. Stephens, ed., *Artists at Home Photographed by J. P. Mayall*, London 1884, photogravure, 16.5 × 21.6 cm (RA 05/4685).

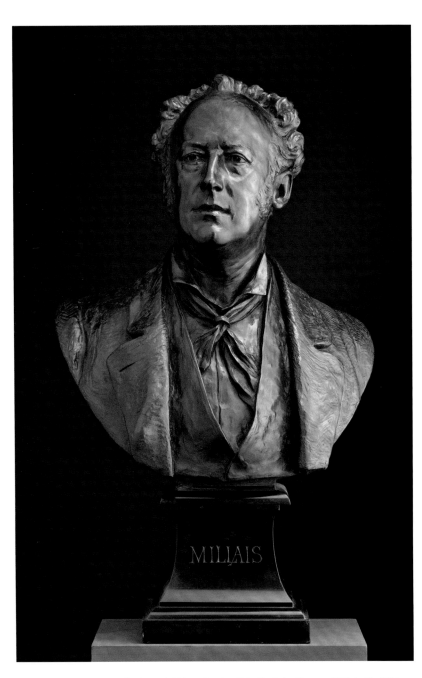

111 Sir Joseph Edgar Boehm RA, *Sir John Everett Millais, Bt, PRA,* 1881–2, bronze, height 82.5 cm (RA 03/1675).

work.'[30] An outstanding example of Boehm's approach is his Diploma Work (accepted 1882), the sensitive bust of John Everett Millais (fig. 111), which is all the more interesting since it manages effortlessly to triumph over what Millais

himself perceived as a problem: 'Artists have to wrestle today with the horrible antagonism of modern dress; no wonder, therefore, that few recent portraits look really dignified. Just imagine Vandyck's *Charles I* in a pair of check trousers!'[31]

BUILDING THE COLLECTION

Portraits in oils and marble busts had, of course, been exhibited in the earliest days, at the exhibitions that had continued at the Pall Mall house for some time after the Academy's move to Old Somerset House, and some of them were included in the new building, for example Agostino Carlini's 1773 bust of George III, which was placed on the mantelpiece in the Library. Carlini, who was also much involved in the exterior decoration of New Somerset House, for which he was well paid, donated this bust and also his acclaimed model for an equestrian statue of the king, which had been shown at the very first exhibition in 1769 (fig. 112). Other artists did not follow suit at this point in presenting work to the new institution, as might have been expected, although important portrayals of Foundation Members were exhibited during the 1770s, including J. F. Rigaud's group of Carlini, Bartolozzi and Cipriani in 1777 (National Portrait Gallery, London). Much later, admittedly, an impressive (unfinished) portrait of Cipriani was donated by Nathaniel Dance's son in 1837 (fig. 113). Rigaud's portrait group of Chambers, Wilton and Reynolds (exhibited at the Academy in 1782), however, is also in the National Portrait Gallery rather than in the Academy, even though it pointedly represented the three Foundation Members who respectively embodied the principal arts: architecture, sculpture and painting.

Rigaud's portrait of Joseph Bonomi ARA did arrive at the Royal Academy, although only through the bequest of the sitter at his death in 1808. The portrait has added significance in view of the fact that Bonomi, an architect who sometimes collaborated with Rigaud (ARA 1772, RA 1784), was the focus of trouble that led to Reynolds's temporary resignation as President in February 1790 (he had unsuccessfully championed Bonomi for the professorship of Perspective in 1789). Although Rigaud thought of himself primarily as a history painter, his portraits of the early Academicians are now the most valued aspect of his work, another key portrait being that of the architect John Yenn RA (fig. 114),

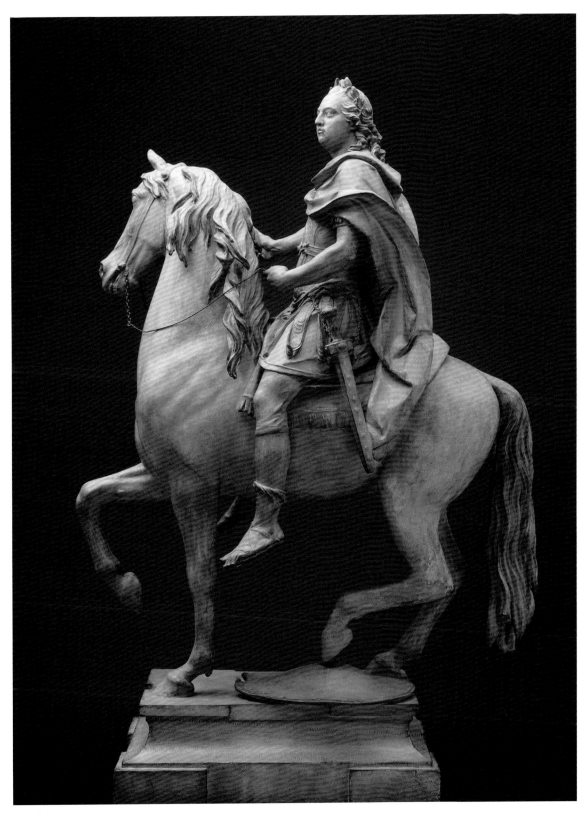

112 Agostino Carlini RA, *Model for an Equestrian Statue of King George III*, 1769, gilded plaster
with metal and string bridle, 87.6 × 38.1 × 59.7 cm (RA 03/1684).

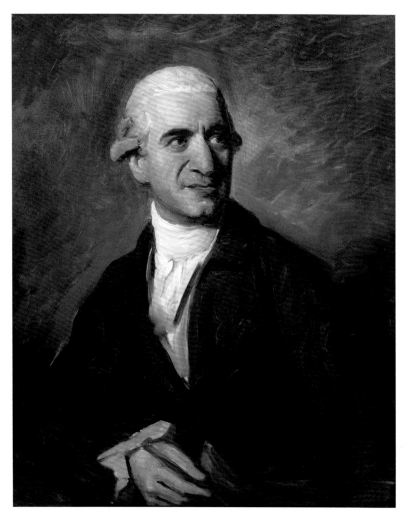

113 Nathaniel Dance RA, *Giovanni Battista Cipriani RA*, c.1768, oil on canvas, 76.2 × 63.4 cm (RA 03/206).

114 John Francis Rigaud RA, *John Yenn RA*, before 1785, oil on canvas, 76 × 64 cm (RA 03/215).

a protégé of William Chambers, to whose example Rigaud makes ample reference in this picture. Chambers's *Treatise on Civil Architecture* (1759) appears prominently behind Yenn's right arm. The giant acanthus leaves and woven basket allude to the same book where they are illustrated in the opening chapter as 'Origin of the Corinthian Capital'. Rigaud himself admitted that he seemed to find portraits of fellow artists his most sympathetic occupation, remarking in his memoirs, 'I succeed better in those works I do for Artists as I am without restraint.'[32]

Many other portraits came by way of gift and bequest, often filling gaps in the historical pantheon, as, for example,

had been the case with *Dr William Hunter* (1769) by Mason Chamberlin RA (donated by the artist in 1780–81 (fig. 115). This was of great significance, since Hunter had lectured on anatomy to the Academy from its inception. He holds a reduced version of a full-size écorché figure that appears in Zoffany's *Dr William Hunter teaching Anatomy at the Royal Academy* (c.1772; Royal College of Physicians, London), which he had had made in 1751 for his lectures at the St Martin's Lane Academy.[33]

Another link with the St Martin's Lane Academy is *John Malin* by Thomas Banks RA, also dating from about 1769 (fig. 116). Malin had been the porter at St Martin's Lane,

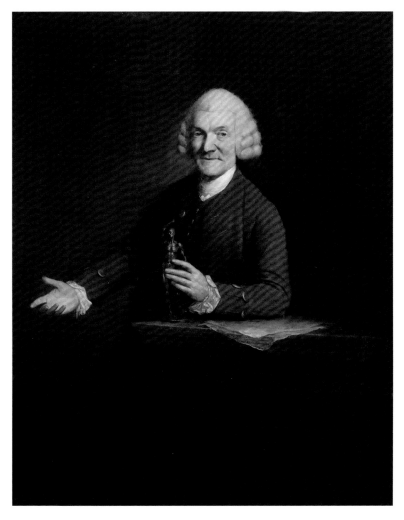

115 Mason Chamberlin RA, *Dr William Hunter*, 1769, oil on canvas, 127 × 101.6 cm (RA 03/712).

116 Thomas Banks RA, *John Malin*, c.1768–9, black and red chalk, heightened with white on laid paper on canvas, 48.5 × 37 cm (RA 04/3423).

doubling as a male model, and continued these roles at the Royal Academy: he appears, dressed in red, in the background of Zoffany's painting of the St Martin's Lane Academy (see fig. 425). The Banks drawing was joined in the collection by a miniature of Malin's wife: *Elizabeth Malin, Housekeeper at the Royal Academy* (1788) by Philip Jean, donated by the artist in 1791 (fig. 117). Reynolds's portrait of Francis Hayman RA donated in 1837[34] also recalls pre-Academy days. Hayman had been much involved in Hogarth's St Martin's Lane Academy, had been President of the Society of Artists, and played a key role in the develop-

ments that led to the founding of the Royal Academy, of which he was a Foundation Member. He was the Academy's Librarian from 1770.

The very Roman-looking marble bust of Reynolds by Giuseppe Ceracchi was created in 1778 (fig. 118), just before the North Block of New Somerset House was built. It appears as though it would have proved a suitably lapidary marker of the new era, but it only came to the Academy as a gift from Henry Labouchere MP (later 1st Lord Taunton) in 1851. An equally inspired donation was the gift in 1821 by Henry Edridge ARA of Reynolds's 1753 portrait of his

studio assistant Giuseppe Marchi (fig. 119), not only for its historical interest but also because it again shows Reynolds at his most Rembrandtesque. The splendiferous manner in which the young Marchi is painted was presumably intended to reflect the 'airs' that the young Marchi affected, which Reynolds remarked upon to the sculptor Joseph Wilton in a

(left) 117 Philip Jean, *Elizabeth Malin, Housekeeper at the Royal Academy*, 1788, miniature, 10 × 8 cm (RA 03/675).

(below left) 118 Giuseppe Ceracchi, *Sir Joshua Reynolds PRA*, 1778, marble, height 72 cm (RA 03/1686).

(below right) 119 Sir Joshua Reynolds PRA, *Giuseppe Marchi*, 1753, oil on canvas, 77.2 × 63.6 cm (RA 03/677).

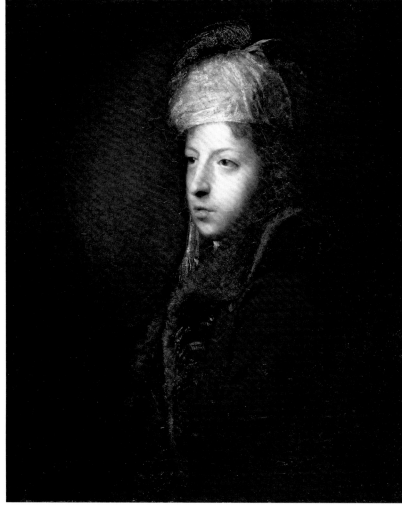

letter of 1753: 'Guseppe [*sic*] is become so intollerably proud that I fear we shall not keep long together.'[35] Marchi finally came to live in Reynolds's house in 1764 and remained until the artist's death in 1792. Joseph Wilton's portrait bust of about 1760 by Louis-François Roubiliac (see fig. 148) arrived in the Academy in 1824 as a gift from Wilton's daughter Frances (Lady Chambers).[36] The gift marked 50 years since the date of Frances's marriage, at the age of 16 in 1774, to Robert Chambers, the brilliant jurist and judge who was a close friend of Samuel Johnson and Joshua Reynolds, and also a member of The Club. She herself appears, in turn, in a portrait by Francis Hayman, *Joseph Wilton with his Wife and Daughter*, of about 1760 (National Portrait Gallery, London).[37]

Such portraits as these, in which artists appears variously as sitter and executant, reflect their intertwined relationships and the way in which filial and more generally familial piety often inspired the posthumous presentation of such works to the Royal Academy as fitting gifts. Gainsborough's younger daughter Margaret, for example, presented his late *Self-portrait* in 1808 (although it is fair to say that the Academy has spent much time over the years in extricating itself from accepting gifts that were inappropriate). Gainsborough had been a Foundation Member, although his rather fraught relationship with the Academy, especially over the way in which his paintings were exhibited at the annual exhibitions, meant that he withdrew from exhibiting for some years, first 1773–7 and then conclusively in 1784, and this painting contains no hint of his membership of the Academy. In 1799 Margaret had already presented the Academy with Gainsborough's late landscape of about 1783, *Romantic Landscape with Sheep at a Spring*.

A similar family gift in 1817 filled a real gap in the Academy's collection where the distinguished Foundation Member Francis Cotes had been hitherto poorly represented. Cotes has a claim to be Britain's greatest pastellist (or 'painter in crayons' as he would have been termed at the time), but it was only with the arrival of the portrait of his father, Robert Cotes (fig. 120), a gift from Francis's younger brother, Samuel, that the splendour of his art could begin to be appreciated within the Academy.[38]

The unusually fine portrait by Sir William Beechey RA of Paul Sandby, another Foundation Member, of about 1780 took even longer to arrive, when it was bequeathed by the sitter's descendant W. W. Sandby in 1904, together with a

120 Francis Cotes RA, *Robert Cotes*, 1757, pastel on paper, 59.5 × 44.5 cm (RA 03/672).

superlative gouache landscape of 1794, *View of Windsor Castle from the Banks of the River Thames*. The same bequest brought a study of Sandby's head by Henry Singleton, taken for the large *Royal Academicians in General Assembly* of 1795 (see fig. 146).

It could be argued that in this latter picture Singleton does not create quite so convincing a fiction as Zoffany in his ingenious arrangement in a painting that never came to the

121 Johan Zoffany RA, *Academicians of the Royal Academy*, 1772, oil on canvas, 110.1 × 147.5 cm. Royal Collection.

Academy (fig. 121).[39] This group, which includes a self-portrait in the seated figure at the far left, was shown at the Academy's exhibition in 1772, when it was bought by George III and went straight into the Royal Collection. Like the Singleton (see fig. 146), it does not record an actual event, but the invention is believable in that it shows the assembled Academicians present at the setting of the pose of a model – something they did all the time, although in much smaller numbers – and the whole scene is animated by their individ-

ual reactions and discussion. Zoffany's brilliant little oil-sketch portrait of Gainsborough now in the Tate was evidently preparatory to Gainsborough's inclusion in this painting, but Gainsborough did not appear in the final picture. Zoffany's sketch is designed in such a way that Gainsborough would have been placed at the right-hand side of the finished composition, but it may well be that Gainsborough's often strained relationship with the Academy led to his exclusion; and the same may be true of the two other Academicians

122 Charles West Cope RA, *Council of the Royal Academy selecting Pictures for the Exhibition, 1875*, 1876,
oil on canvas, 145.2 × 220 cm (RA 03/1288).

missing from the group, the Dance brothers, George and
Nathaniel. (Nathaniel Dance, like Gainsborough, refrained
from exhibiting at the Academy in 1773, the year after Zof-
fany's painting was exhibited.)

Subsequent group portraits strove to adhere more closely
to the facts than either Zoffany or Singleton and to record
actual events, notably the *Council of the Royal Academy selecting
Pictures for the Exhibition, 1875* (1876) by Charles West Cope,
who, like Zoffany, managed to insert himself into the paint-
ing (at the back left, bald-headed, in the fold of the red
screen) (fig. 122). So too did Frederick William Elwell RA in
a less animated scene that showed the Academicians at lunch,
Royal Academy Selection and Hanging Committee, 1938 (1938),
where the artist is seen at the left, brush in hand, having

vacated the seat in the foreground. The very largest of these
groups, some 20 feet (6 metres) wide, *Council of the Royal
Academy* (1908) by Hubert von Herkomer RA, did not come
to the Academy because its creator donated it to the Tate
Gallery, where it is never on view, and nor does any photo-
graph of it exist.[40]

An especially informative early portrait group, showing
John Hamilton Mortimer ARA with Joseph Wilton RA
and a student identifiable as Charles Ruben Ryley (fig.
123),[41] painted by Mortimer in the early 1760s, was pre-
sented by the writer T. Humphrey Ward in 1889. The setting
is the 3rd Duke of Richmond's Cast Gallery, which was
opened for study by the duke between 1758 and 1762 under
the supervision of Wilton, who is the elder man standing at

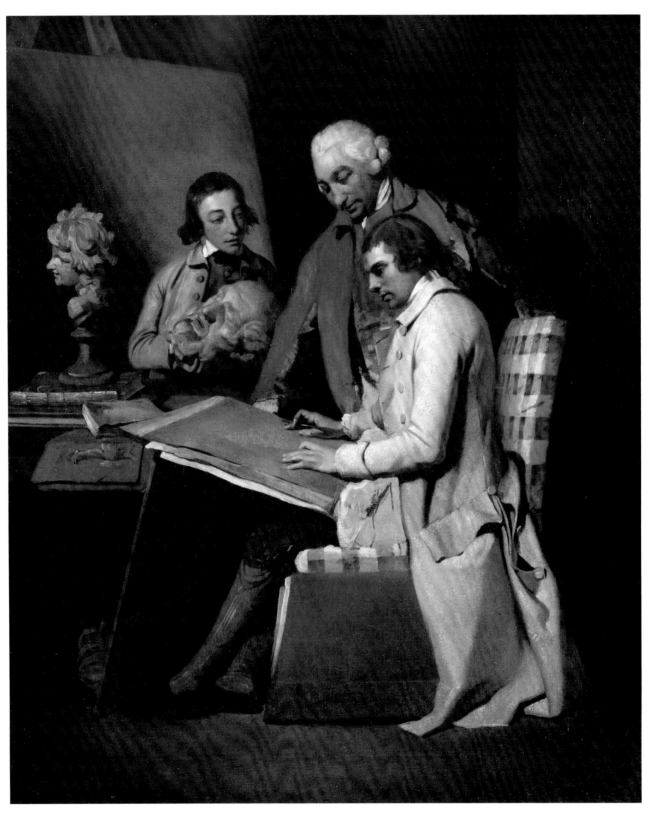

123 John Hamilton Mortimer ARA, *John Hamilton Mortimer ARA with Joseph Wilton RA and a Student (Charles Ruben Ryley)*, *c*.1760–65, oil on canvas, 76 × 63.5 cm (RA 03/970).

the seated Mortimer's shoulder. The gallery was one of several significant initiatives in the training of artists in the years immediately preceding the foundation of the Royal Academy.[42] The Academy Library contains a rather disenchanted manuscript note (see fig. 151) claiming that neither Wilton nor Giovanni Battista Cipriani, who assisted him, was ever paid by the duke and that a scheme for awarding silver medals for the best drawings was not implemented (although prizes were awarded for drawings made in the gallery by the Society of Arts). Nonetheless, the duke's gallery was attended not only by Mortimer but also, among others who were to be elected to the Royal Academy, by Matthew William Peters, Richard Cosway, Joseph Nollekens, Joseph Farington and William Hodges. The two last were pupils of Foundation Member Richard Wilson, whose landscape art was in many ways founded upon the Antique;

(left) 124 David Roberts RA, *Clarkson Stanfield*, c.1845, pen and ink on wove paper, 18.9 × 12.3 cm (RA 06/4865).

(right) 125 Clarkson Stanfield RA, *David Roberts*, c.1845, pen and ink on wove paper, 19 × 15.3 cm (RA 06/4866).

while another of Wilson's pupils, Thomas Jones, noted in his memoirs in 1762 that the duke's gallery was 'in decline' and that Wilton and Cipriani had resigned.[43]

In an enduring and endearing practice, many portraits of Academicians were made by fellow members in paint, print, pencil, stone and bronze, and also entered the collection. Some were presented by the artist, some donated later. Two especially attractive and informal 'friendship drawings' are those of David Roberts RA and Clarkson Stanfield RA (figs 124 and 125). These sketches were designed as a pair and

126 John Prescott Knight RA, *Sir Charles Lock Eastlake PRA*, 1857, oil on canvas, 91.9 × 71.5 cm (RA 03/1034).

John Opie by Prince Hoare, painted in crayons (pastel) in the 1790s, records one of the odder phenomena of the early Academy, the 'Cornish Wonder', who was presented to a gullible public, which included Reynolds on this occasion, as an untaught natural genius. Opie had, in fact, been coached in darkest Cornwall before being sprung upon the world by the polemicist John Wolcot, who wrote biting satires, not least upon the Royal Academy, under the pen name of Peter Pindar. Reynolds declared that Opie was 'like Caravaggio, but finer', which raises the question of which works by Caravaggio had been seen by the President, since Caravaggio was all but unheard of at this period and seldom if ever mentioned. Reynolds did own one painting that has since been attributed to Caravaggio, *Boy peeling Fruit*, although at the time it was thought to be by Murillo;[44] but he must surely have seen some of his paintings in Rome, and certainly knew *The Fortune-Teller* in the French royal collection.[45] Reynolds's high opinion assisted in Opie's being rapidly elected an Academician in 1787 at the age of 26, just one year after the minimum age. Martin Archer Shee PRA announced that Opie was 'in manners and appearance, as great a clown and as stupid a looking fellow as ever I set my eyes on', and there was indeed something very odd about Opie, which Hoare's rather unsettling portrait seems to reflect. Nonetheless, the history pictures that were the basis of Opie's mature success were better than many, and he ably delivered – unexpectedly – the lectures required of him as Professor of Painting in 1805–7.[46]

John Prescott Knight RA painted and presented his portrait of Sir Charles Lock Eastlake PRA (fig. 126) in 1857. Few of these acts of mutual homage among Academician portraitists can, however, match an unfinished masterpiece by the animalier artist Edwin Landseer RA, his portrait of John Gibson RA (fig. 128). Landseer's portrait of the great neoclassical sculptor, who inherited the mantle of Canova and Thorvaldsen, is a brooding study of self-absorbed genius, and although the sculptor may be wearing a cloak to protect his clothes while at work in the studio, it suggests what was referred to at the time as Gibson's neglect of his appearance and his 'utmost unconsciousness and democratic plainness of life'.[47] It was painted in about 1850 and came to the Academy by Landseer's bequest in 1874. John Gibson himself made one of the single greatest bequests in the Academy's history, of his own sculpture, casts and drawings together with what was then the gigantic sum of £32,000.

were swiftly executed at the same time in about 1845 on similar paper and in the same ink. The portrait of Stanfield also reveals that they were made within the Royal Academy, because Reynolds's portrait of William Chambers (see fig. 106) is to be glimpsed in the background, to the left of a folding screen. The sketches were given in 1912 by the portrait painter Walter William Ouless RA, two of whose impressive portraits of fellow Academicians are in the Academy collection.

Frank Holl RA had his portrait of Sir John Everett Millais PRA accepted as his Diploma Work in 1886, the year it was painted. G. F. Watts RA bequeathed his impressive portrait of *Frederic, Lord Leighton PRA* (1888), while two other examples of artists' portraits are of particular interest in showing the artist in the studio. *Thomas Faed* by John Pettie RA (fig. 129) and *John Pettie* by Arthur Stockdale Cope RA represent a sub-genre of which there are not so many examples in the Academy as one might expect, although there is an invaluable series of photographs of 25 artists, most of them in their studios, masterminded by Joseph Parkin Mayall and published in 1884.[48] These absorbing photographic images are chiefly of RAs and ARAs but include a picture of W. E. Gladstone, who was associated with the Academy as its Professor of Ancient History.

Another group of artists' portraits, including many Academicians, is a richly entertaining set of some 71 photographs by David Wilkie Wynfield taken in the early 1860s, 20 of which were published from March 1864 as *The Studio: A Collection of Photographic Portraits of Living Artists, Taken in the Style of Old Masters, by an Amateur*. All the sitters are togged out in historical costumes as characters from the past, a reflection of what was something of an obsession in the first flush of photography, as seen, for example, in the work of Julia Margaret Cameron. Photographers of this kind appear to have hoped that the newly found realism of photography might enable a more vivid recreation of the past – even, perhaps, that it might take over the role of history painting. The results, to modern eyes, appear artificial, contrived and often amusing, and indeed both the photographer and the sitters in Wynfield's series seem to have felt much the same. Some of the pictorial sources chosen from the past are neatly apt, such as the image of John 'Spanish' Phillip RA in a Spanish costume (fig. 127). The photographs were all donated to the Academy by William Frederick Yeames RA in 1911, and Wynfield's image of Yeames himself allows us to identify him as the model for one of the characters in *Whither?* by Philip Hermogenes Calderon RA (see fig. 255).

The most extensive and deliberate scheme for recording the appearance of Academicians, however, was a series of profile drawings of 53 of his fellow members begun by the architect George Dance RA in 1793, the year of the silver jubilee of the Academy's foundation. He missed only two of those then living in Britain (for reasons unknown), Mary

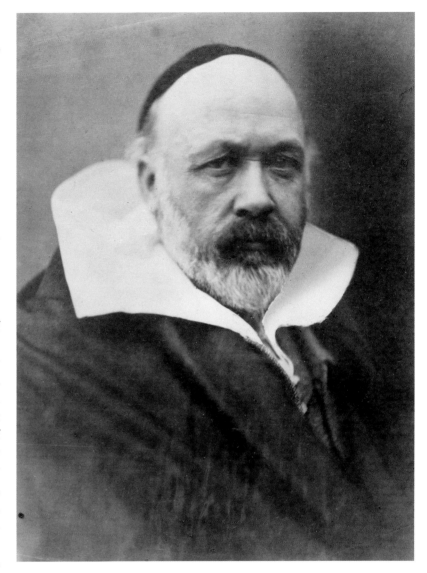

127 David Wilkie Wynfield, *John Phillip RA*, early 1860s, albumen print on mount with textured paper surface layer, 20.4 × 15.7 cm (RA 03/5750).

Moser RA and Philip Jacques de Loutherbourg RA, and only a few of his portraits do not adhere to the strict profile. The plan, which continued to be updated until 1810, was evidently to create, in emulation of Vasari's *Lives*, two or more bound volumes of these portraits accompanied by biographies written by Joseph Farington RA, whose diary is the chief source of information about it.[49] By 1797 the two men were deep in discussion about arranging and binding

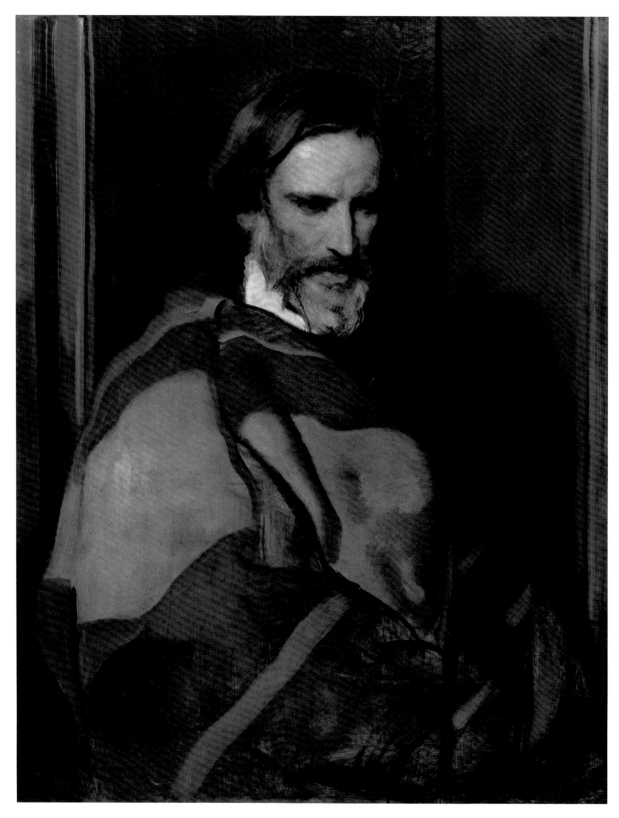

128 Sir Edwin Landseer RA, *John Gibson RA*, c.1850, oil on canvas, 92.5 × 72 cm (RA 03/1235).

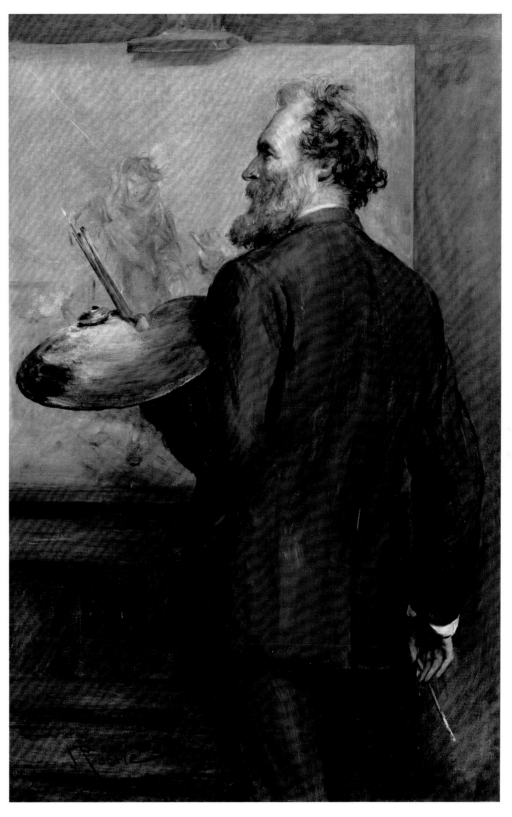

129 John Pettie RA, *Thomas Faed RA*, 1887, oil on canvas, 65.8 × 42.9 cm (RA 03/427).

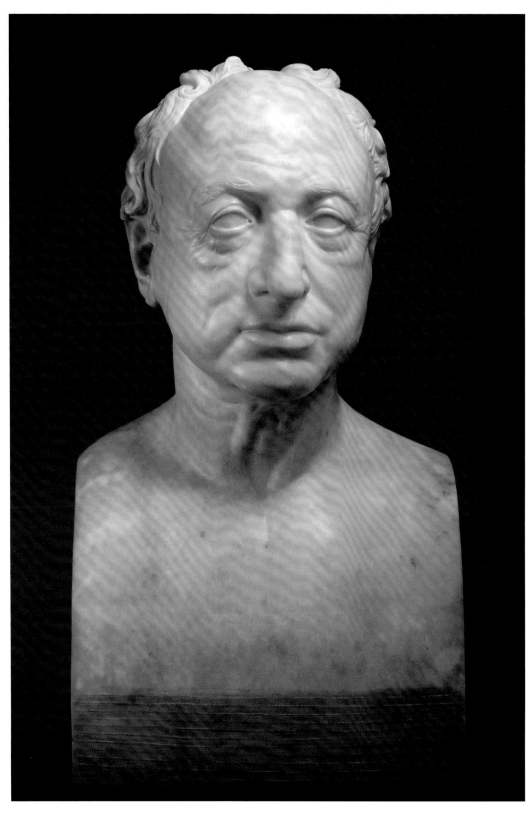

130 Charles Rossi RA, *George Dance RA*, 1827, marble, height 50 cm (RA 03/1815).

131 George Dance RA, *Joseph Farington RA*, 5 May 1793, pencil, black and pink chalk, blue and black wash, 24.5 × 19.1 cm (RA 03/3272).

does George Stubbs ARA and the Academicians J. M. W. Turner, Johan Zoffany, Benjamin West, James Barry, Joseph Nollekens, Thomas Lawrence, James Wyatt, Robert Smirke, William Chambers, John Opie and Richard Cosway. Among them, as a matter of course, is Joseph Farington (fig. 131), which is taken to a higher degree of finish than most of the other drawings. Farington may not have finished his biographies for the joint publication with Dance, but his extensive and detailed diary referred to above, which covers the period 1793–1821, has itself conferred a kind of immortality upon the members of the Royal Academy at an especially formative, even transformative, period of its existence.

A rather arch series of caricature drawings of fellow Academicians – inspired, it would seem, by the example of Dance – was attempted by the sculptor Francis Derwent Wood RA around 1919–23, many of them apparently taken at dinner. Their creator, at least, seems to have thought highly of them, and they were presented by his widow in 1945. A more fitting monument to Wood's talent is his sensitive bronze of Ambrose McEvoy ARA (1916; fig. 132), a portrait painter with a fey but distinctive manner of painting too much influenced by J. A. M. Whistler. In reference to that fact, McEvoy's friend and fellow student at the Slade, Augustus John RA, referred to his affectation of a Beardsley-like appearance (of the kind we see in this bust) as 'a perfect "arrangement in black and white"'.

the drawings, and had already looked into having them engraved. The scheme was still alive at the close of 1806, but the publication never appeared, although some of Dance's drawings of Academicians were etched by William Daniell RA, along with many of his other portrait drawings, of which well over 100 exist in various locations. George Dance himself was commemorated in a marble bust sculpted towards the very end of his life by Charles Rossi RA, who presented it as his Diploma Work in 1827, two years after Dance had died (fig. 130). Rossi had been elected RA in 1802 and ARA in 1798, at which point Dance had drawn him.

Altogether, Dance's series provides an invaluable record of the appearance of some of the most resonant names in the history of British art, let alone the Academy, including as it

SELF-PORTRAITS

Among the many self-portraits in the collection one of the more striking is that by Samuel Woodforde RA of 1805 (fig. 133), which is both romantic and quintessentially of the Regency. Today, this dramatic composition appears to eschew any signs of the artist's profession, but that is an accident of the painting's condition, since the oblong palette with brushes that he is actually holding at the right-hand side of the picture have been, as it were, sucked into the dark background and rendered nearly invisible. In the circumstances, the cloak thrown over the right shoulder lends the artist an even more swaggering air than he may originally have had in mind, since its function would have been chiefly to protect his everyday clothes while at work in the studio. The pose and the holding of palette and brushes in the

132 Francis Derwent Wood RA, *Ambrose McEvoy ARA*, 1916, bronze, height 59.7 cm (RA 03/1704).

133 Samuel Woodforde RA, *Self-portrait*, 1805, oil on canvas, 75 × 61 cm (RA 03/287).

134 Ken Howard RA, *Self-portrait*, c.1950, oil on canvas, 34.5 × 24.3 cm (RA 07/212).

presented by the artist in question. Reynolds, however, as noted above, had presented his in 1780, and this precedent may have inspired a later president, Sir Francis Grant, to donate his *Self-portrait* in 1876, although it is a rather dreary image complete with Dundreary whiskers. While the source of several self-portraits in the collection is not known (and so it is just possible that some may have been presented by the artist in question), Grant's is the sole documented exception to the Academy's evident discouragement of the presentation of self-portraits as Diploma Works – until, that is, the later twentieth century when the practice became a little more common.[50] For example, in 2007 Ken Howard RA gave an appealing self-portrait painted some 57 years earlier (fig. 134), while Sidney Nolan RA had his *Self-portrait in Youth* accepted as his Diploma Work in 1992, the year of his death. The nearest precedent for these is an odd one. The *Self-portrait* of John Hoppner RA (*c.*1800) was accepted as a Diploma Work, but it was presented by his widow shortly after his death in 1810: Hoppner had become a full Academician in 1795 but like many other members had taken his time about presenting a picture.

In various ways, then, a kind of self-perpetuating pantheon was created by the living of themselves, rather than of the distinguished dead, and on their own terms and conditions. The Royal Academy was not by any means, as the portraits in its collection attest, always prepared to wait for the verdict of posterity. In this respect, comparison can be made with one European academy of which all the Foundation Members were aware and to membership of which several had aspired, the Accademia di San Luca in Rome, which in the second half of the eighteenth century accumulated as many portraits of its members, past and present, as it could manage. Most were painted by Anton von Maron and many were copies, the whole process being designed not to interfere with the academy's steadfast resistance to the acceptance of portraiture as a qualification for election. The plan had a much earlier precedent at the Accademia del Disegno in Florence conceived by two of its founders, Giorgio Vasari and Vincenzo Borghini, in 1563. The intention was to adorn the walls of the Accademia with an array of posthumous portraits of the most famous Tuscan artists and their contemporaries, but it was never completed. The second edition of Vasari's *Lives of the Artists* was, however, illustrated with portraits of his subjects, the aim of which was explicitly to

left hand also speak of a self-portrait taken in the studio looking-glass.

Woodforde's *Self-portrait* was presented to the Academy by the artist's widow in 1860, and it is a fact that almost all the self-portraits in the collection were donated by descendants, or occasionally purchased from them, rather than being

confer immortality, making 'esteemed, clear, and eternal the names and images of those who through their virtue have merited eternal life'.[51]

BUILT-IN PORTRAITS

Within Burlington House the portraits chosen to adorn the major public spaces eventually included many incorporated into the fabric. On either side of the staircase landing, for instance, immediately before the visitor reaches what is in effect the *piano nobile* of Smirke's new galleries of 1868, are two relatively late additions of over-life-size sculptures: *Turner* by William McMillan RA of 1937 (see fig. 200) and *Gainsborough* by Thomas Brock RA, which was originally carved in stone (1906; Tate Britain, London) but cast in bronze and positioned here in 1939. By the time these two have been encountered, the visitor will already have come across *Sir Joshua Reynolds* by Alfred Drury RA outside in the courtyard, a monument erected in 1931. These three painters are the triumvirs, as it were, of the Academy's glorious past, all of them cast in the noble and proverbially enduring material of bronze. But it is interesting to reflect that these statues were put in position so late in the Academy's history, and so long after the death of each artist. Was it coincidence that they were put in place in the 1930s, at the very time that modernism was being most feverishly debated and often, within the Academy, most ferociously resisted? It was not.

Moving on past Turner and Gainsborough, the visitor arrives at the Octagon, the pivotal space around which Smirke's galleries turn. High above, below the entablature, each wall carries a roundel containing the bust of an artist. The usual suspects are there, with Reynolds and Flaxman again taking their place among Raphael, Michelangelo, Leonardo, Titian and Wren. The identification of the remaining bust is a mystery, but even allowing for the quirks of these displays, it seems highly unlikely that, as has been suggested, it represents Sir Robert Smirke, brother of the Royal Academy's architect, and indeed the head bears a resemblance to some representations of Isaac Newton.

It is less well known now that the Saloon by William Kent in the Fine Rooms contained, in a decoration by J. D. Crace of 1891, another array of artists (together with the royal patrons King George III and Queen Victoria), all of them

135 Saloon, ceiling decoration by J. D. Crace, 1891, detail with head of Sir Charles Eastlake PRA.

British, modern and Academicians, evidently chosen to complement the (chiefly) Old Masters of the past who could be seen in the Octagon (fig. 135).[52] The Saloon scheme was covered over by 1924 with plain paint, although both the paint and Crace's work have now been partially removed in attempts to discover what remains of Kent's earlier decoration at this level (a quite substantial amount), which evidently complemented his central ceiling painting of the *Marriage Banquet of Cupid and Psyche.*

These public displays, incorporated into the fabric of the building, are only the most visible manifestations of the integral significance of portraiture to the life of the Royal Academy. Once the academic barriers crumbled, which they did with astonishing speed in the early years of the nine-

136 Sir Arthur Stockdale Cope RA, *Sir Edward Poynter PRA*, 1911, oil on canvas, 110.5 × 85.1 cm (RA 03/890).

teenth century, and portraiture came to be taken every bit as seriously as history painting, the number of portraits added to the Royal Academy's collections in every medium increased. There were more and more to be seen in each annual exhibition, and more arrived to take up permanent residence with every passing death, whether in an act of remembered friendship, of family piety or by bequest, or simply as gifts from those who wished the Royal Academy well. Portraits of royalty or of famous individuals also continued to arrive, all contributing to the pantheon as the status and nature of portraiture itself began to change.

THE PORTRAIT AS A WORK OF ART

As the nineteenth century progressed, a different kind of portrait began to enter the Royal Academy collection: portrayals of individuals in which the identity of the sitter was of little or no significance. This shift reflects profound changes that were taking place, as the boundaries between the categories that shaped the formerly accepted hierarchy of works of art within the Academy began first to blur and then to fade away. The status of portraiture became correspondingly elevated as history painting lost its supremacy, a process that may be said to have begun with the presidency (1820–30) of Thomas Lawrence, who himself enjoyed a pan-European reputation as a portrait painter and whose superb but unfinished *Self-portrait* was wisely bought by the Academy from Lord Chesterfield in 1867 (see fig. 520).

Artists increasingly came to expect portraits to be accepted on their own terms, as works of art in their own right, without any regard to the old academic hierarchy. This affirmation of the status of the portrait is enshrined, so to speak, in the Diploma Work of Arthur Stockdale Cope RA, accepted in 1911, *Sir Edward Poynter PRA* (fig. 136), a majestic portrait of the President, the Academy's long-serving successor to Millais. The painting, as Cope must have known, exemplifies the artist's strengths: the sitter is portrayed hung about with his Academy medal and civil orders and yet caught in a moment of introspection. It is an image at once official and full of humanity and painted with an unerring touch in both colour and tone.

An important reason for this shift in the status of the painted or sculpted portrait is that, with the advent of pho-

tography in the middle of the nineteenth century, the portrait lost its centuries-old role as the sole means of recording the appearance of an individual. That could now easily be done with a camera. At the same time, it followed that it came to matter less that the identity of the sitter should have an intrinsic significance to the Academy as a condition of a portrait's entering the collection. Lawrence Alma-Tadema RA, for example, is represented in the collection not only by his Diploma Work – which is exactly what might be expected from that great purveyor of archaeologically researched scenes of Greek and Roman life, *Way to the Temple* (1882; see fig. 294) – but also by several portraits that reveal an impressive range, including private family subjects. Alma-Tadema's portrait of his fellow Academician and close friend Ernest Albert Waterlow, presented by Lady Waterlow in 1920 after her husband's death, is a fine instance of the tradition of Academicians portraying each other already discussed. The grand-manner portrait bust of Alma-Tadema that Onslow Ford RA presented as his Diploma Work in 1895 (fig. 137), a bust that, not surprisingly, the sitter greatly admired, falls into much the same category.[53] *A Family Group* (1896; fig. 138), however, offers an intimate view of Alma-Tadema's second wife, Laura Epps, together with her brother and sisters, while the artist himself is glimpsed reflected in a mirror in the background. The beautifully low-keyed portrait of his daughter Anna offers a similarly striking contrast to the artist's famous classical histories and is a resolutely contemporary reflection of the 'Aesthetic' taste of the time, in the clothes and in the interior of the family house.[54]

At least one self-portrait by an Academician, *Beaver Hat* by Frank Bramley RA, was disguised, as became common practice, rather teasingly by a title that suggested more a work of genre (fig. 139). It also hinted that the manner in which the most conspicuous feature of the composition, the large hat, and the bravura way in which it is painted are of more interest than the identity of the sitter. This clever work does more. The cheery expression of the artist does not conform to the usually rather solemn way in which artists choose to present themselves. Rather, in combination with the dashing brushwork and mid-to-high tonality, it hints at Bramley's affinity with historical precedent and at the work of Frans Hals in particular. Specifically, it refers to the *Laughing Cavalier* (fig. 140), the acquisition of which at auction by Lord Hertford in 1865 for a vast sum of money was a defining moment in the

137 Onslow Ford RA, *Sir Lawrence Alma-Tadema RA*, 1895, bronze, height 77 cm (RA 03/1720).

138 Sir Lawrence Alma-Tadema RA, *A Family Group*, 1896, oil on canvas, 30.5 × 27.9 cm (RA 03/408).

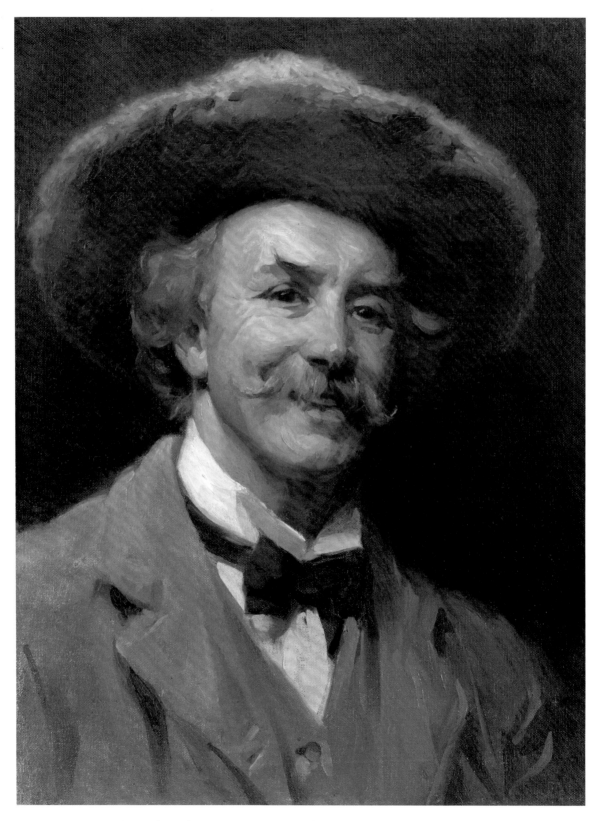

139 Frank Bramley RA, *Beaver Hat*, 1911, oil on canvas, 54.2 × 40.8 cm (RA 03/259).

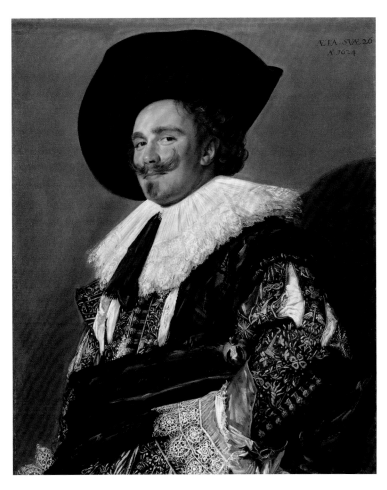

140 Frans Hals, *Laughing Cavalier*, 1624, oil on canvas, 83 × 67.3 cm. Wallace Collection, London.

revival of interest in Hals, whose reputation had sunk in the eighteenth century. In the second half of the nineteenth century, Hals's home town of Haarlem became a place of pilgrimage for young artists interested in exploring the possibilities of dramatic brushwork. They included Claude Monet (who went in 1871), Edouard Manet (1872) and John Singer Sargent RA (1878), while the *Laughing Cavalier* came to be considered the acme of painterly *sprezzatura*. During these years of growing interest in Hals, Bramley had spent three of them in Antwerp (1879–82), some miles down the coast from Haarlem. A visit to Haarlem would have been normal for any young painter at that time, but in any event Bramley knew the *Laughing Cavalier* in London, and *Beaver Hat* can be best understood in this context. Its affinities with

the *Laughing Cavalier*, in such elements as the tonality and brushwork, are confirmed by the direction of the good-humoured gaze – and, of course, those whiskers. This is a portrait that possesses a historical and international resonance while on the face of it – especially with the bow-tie – looking entirely of the Edwardian period and of England.[55]

In the twentieth century, portraits were increasingly offered as Diploma Works when the identity of the sitter was of little or no significance to the Academy (as noted above): they were not in any sense additions to the pantheon. The portrait of the literary critic and poet John Davenport by Robert Buhler RA, for example, was accepted in 1960 (fig. 141). Davenport, although interesting to Buhler as a favourite sitter (he had exhibited three portraits of him in earlier exhibitions), held no intrinsic significance for the Academy: this is not so much a portrait, more a work of art. The same is true of other Diploma Works such as the marble portrait bust of a girl, *Young Diana*, by W. Robert Colton RA (1919), as well as *Miss Ann Harcourt* (1921) by George Harcourt RA, accepted in 1926 (fig. 142) and *May sitting on the Roof Garden* (1975) by Olwyn Bowey RA (fig. 143). *A Young Man* of about 1928 by Augustus John RA (see fig. 305), accepted in 1930, has a title that disguises the fact that it is a portrait of the artist's son Robin. It is also an early instance of the offering of what might in earlier times have been considered an ineligible work for the Diploma, since it is not only modest in scale but sketchy in execution. The portrait of Ernest Marsh (*c.*1954) by Ruskin Spear RA is an outstanding instance of a Diploma Work in which the sitter has no relevance to the Academy's history: it shows the proprietor of a fish and chip shop in Hammersmith (see fig. 323).

Jane XXX by Sir Gerald Kelly PRA (see fig. 310) could hardly be more different from Augustus John's offering, and takes a high degree of finish to extremes. 'Jane' was the name that Kelly had given to his wife, Lilian Ryan, whom he married in 1920 and who had in fact been what the title suggests, an artist's model: she had first sat to Kelly in 1916. Some 50 portrait paintings of Jane by Kelly appeared in exhibitions at the Academy, each accompanied by Roman numerals to indicate the year (the 'XXX' here is for 1930). On this occasion, the contrived studio drapes that Jane wears are the focus of Kelly's interest, a challenge to his technique in depicting the contrasting textures and surfaces of silk, skin, hair, velvet and fur. The picture is defiantly splendid and,

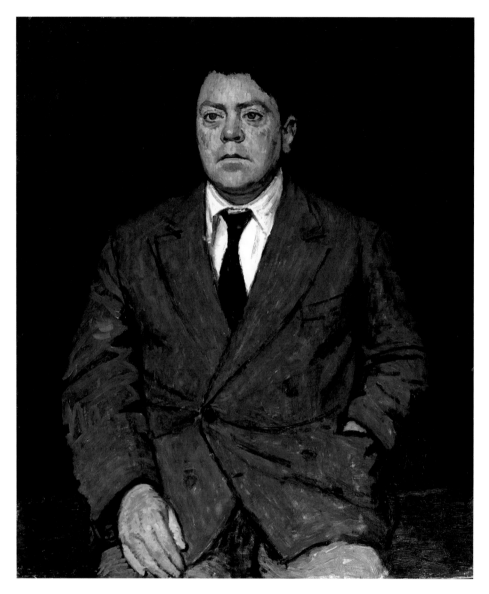

141 Robert Buhler RA, *John Davenport*, 1960, oil on board, 10.16 × 86.4 cm (RA 03/347).

apparently, resolutely indifferent to any 'modern' movement. Yet it could hardly be more evocative of its period, as is the remarkable portrait of a woman by the quirky and brilliant George Spencer Watson RA, a canvas that was discovered on the back of the artist's Diploma Work, the deeply considered portrait of his sculptor daughter, Mary (see fig. 311). The finest of all Diploma portraits of this kind, however, is probably *Pauline Waiting* by Sir James Gunn RA (see fig. 313) from the same period, painted in 1939, and showing the artist's second wife. It distils the essence of the decade but was not presented until 1961 when the hugely successful Gunn – a favourite of the royal family – was finally elected RA. For reasons unknown but quite possibly a simple matter of jealousy, Gunn had had to overcome a strange prejudice against him within the Academy, although his *Pauline in the Yellow Dress* (Harris Museum and Art Gallery, Preston) had been a sensation at an Academy exhibition, when it was hailed by the *Daily Mail* as 'the Mona Lisa of 1944'.

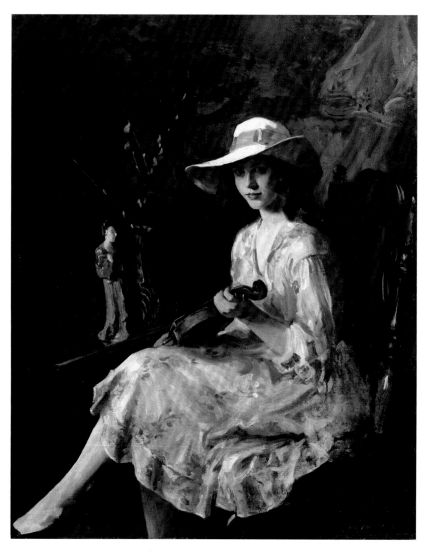

142 George Harcourt RA, *Miss Ann Harcourt*, 1921, oil on canvas, 126 × 103 cm (RA 03/824).

143 Olwyn Bowey RA, *May sitting on the Roof Garden*, 1975, oil on canvas, 125.8 × 100 cm (RA 03/855).

It would seem from these examples that the acceptance of a portrait as a Diploma Work, regardless of the importance, or lack of it, of the sitter, is a modern phenomenon, but in fact it had happened much earlier, although not frequently. Francis Grant PRA offered his portrait of *Miss Grant, the Artist's Daughter* (c.1850) and had it accepted in 1851. John Singer Sargent RA, most famous for his individual portraits, chose in 1900 to present what might in earlier times have counted as a conversation piece, a portrait group of the Curtis family that was nonetheless given the genre title of *An*

Interior in Venice (1899; see fig. 302). The Diploma Work of Sir John Lavery RA, accepted in 1921, also has the air of a conversation piece about it but, less obviously a portrait group, passes under the title *Van Dyck Room, Wilton* (c.1920; fig. 144).

Until the middle of the nineteenth century, portraiture – whether painted, sculpted or drawn – was, as we have noted, the sole means of recording the appearance of an individual. This very purpose lent any portrait a peculiar fragility. Once the identity of a sitter was lost, as so often happened, a portrait would be relegated to the status of, say,

144 Sir John Lavery RA, *Van Dyck Room, Wilton*, c.1920, oil on canvas, 63.5 × 76 cm (RA 03/254).

'A lady in red'. At that point, if a portrait was to survive at all, it necessarily came to be assessed on different grounds: as a work of art. The shift in the nature of portraiture that we have just identified is, therefore, not simply a phenomenon of more recent times, but a reflection of something inherent in the nature of portraiture itself. And the time-honoured media in which portraits have always been made show no signs of becoming obsolete, let alone of being superseded by the camera. Whatever the virtues of the camera in the matter of recording a likeness, a photograph is not, and never can be, a drawing, a marble, a bronze or an oil painting. Portraitists, who frequently use photography as an aid, are aware of this fundamental fact and so, it seems, are their customers – and the Royal Academy.

A CLOSER LOOK

5.1

Thomas Gainsborough
Self-portrait

HUGH BELSEY

In the 1780s most of the portraits Gainsborough painted were heads presented in oval slips, which took on an immediacy by posing the sitter with his head turned as though his attention had been caught by something outside the canvas. It gave the portrait a natural animation that the artist wanted also to adopt in portraits of himself. Such fluency masked the necessary technical complexities that were first noted in modern times by a former President of the Academy, Roger de Grey. Studying the late *Self-portrait* in the Royal Academy (fig. 145) from a practitioner's point of view, Grey wrote to the Librarian, 'Almost in profile it is difficult to imagine how it was painted – by a deft arrangement of mirrors catching the sideways glance of the painter to reveal the subtly described image that only a few of the great European masters can match.'[1] In another self-portrait painted at the same time, now in a private collection, the sitter gazes upwards, and here too the likeness could only have been caught by means of even greater optical gymnastics. A mirror was always to be found in a portrait painter's studio, but by using two mirrors the artist sees himself as others see him, and that would have been an important consideration for Gainsborough.

The Royal Academy's portrait was painted for Gainsborough's close friend, the viol da gamba virtuoso Carl Friedrich Abel. Abel died on 20 June 1787 'without pain, after three days sleep',[2] and the portrait was put aside unfinished. It is mentioned in almost the last letter Gainsborough wrote before his own death the following year. Animation in portraiture was of great importance to Gainsborough, and so the recipient of the letter is strictly charged that after his death 'no plaister cast, model, or likeness whatever be permitted to be taken', but he adds that he would not object to the line-engraver William Sharp making a print from the portrait intended for Abel.[3] That, however, was not to be, and it was only some 10 years later that the artist's family permitted Francesco Bartolozzi RA to make a stipple engraving of the portrait. The print sold well, and after another 10 years the artist's daughter Margaret gave the original to the Academy. Since then it has appeared in three dozen exhibitions all over the world and has become the best-known image of the artist. Looking over his shoulder, his eyebrow quizzically raised, nearly 250 years later Gainsborough is fortuitously best remembered through his own choice of self-portrait.

145 Thomas Gainsborough RA, *Self-portrait*, c.1787, oil on canvas, 77.3 × 64.5 cm RA (03/1395).

Henry Singleton
Royal Academicians in General Assembly, 1795

ROBIN SIMON

This large and impressive group by Henry Singleton (fig. 146), showing Benjamin West PRA on the President's throne, is a cunningly composed invention rather than the record of an actual gathering in the Council Room at Somerset House (a room also called the Second Room of the Antique Academy, the Assembly Room and the Lecture Room, since it served multiple functions). Nor indeed does it accurately record the appearance of the Council Room, although the portraits of the king and queen by Reynolds can be seen in their correct position at the far (east) end of the room. For example, it shows Reynolds's *Self-portrait* high up on the right-hand wall, although it was hanging in the Library, in order to draw attention to the history of the academy and the significance of its first president. Casts such as the Belvedere Torso that we see at the left were in another room, the Antique Room (also known as the First Room of the Antique Academy). The positioning of the Academicians – variously in profile, three-quarters or facing the viewer – bears no relation to the way they would have been disposed in an actual meeting.

The design and general air of activity in Singleton's group owes less to Zoffany's earlier portrait of the Academicians of the Royal Academy (see fig. 121) than to the example of John Singleton Copley RA, who was a master of crowded compositions in such contemporary history paintings as the *Death of Chatham* (National Portrait Gallery, London). Singleton acknowledges this debt within his composition because, among the few paintings on view, Copley's Diploma Work, *The Tribute Money* (see fig. 221), is conspicuous, next to Reynolds's *Self-portrait* on the side wall.

It is extraordinary to reflect that Singleton's tour de force was only painted for the purposes of an engraving to be made by Charles Bestland, a print that was published in 1802. The painting was not even exhibited until 1822 and came into the Academy's collection by way of a gift from the architect Philip Hardwick RA in 1861. It inspired several later group portraits of Academicians, including a modern photographic record where the members are said to be 'in General Assembly', disposed somewhat as if in the manner of this painting, with an attempt at similar animation, and including at least one non-Academician (fig. 147). There is some irony, however, in the fact that Singleton, the creator of one of the most famous images of the institutional life of the Academy, was never even elected ARA, despite two attempts to join, in 1807 and 1811, by which time this composition was already well known through Bestland's engraving. Moreover, Singleton

146 Henry Singleton, *Royal Academicians in General Assembly 1795*, 1795, oil on canvas, 198.1 × 259 cm (RA 03/131).

had close links with the Academy. His father died when he was young, and he was brought up by an uncle, William Singleton, who had been a pupil of Ozias Humphry RA and exhibited at the Royal Academy 1773–88, where Henry's two sisters also exhibited. He himself attended the RA Schools, winning a silver medal in 1784 and gold medal in 1788. He first exhibited at the Academy in 1784 and, despite his not being elected, continued to do so until his death.

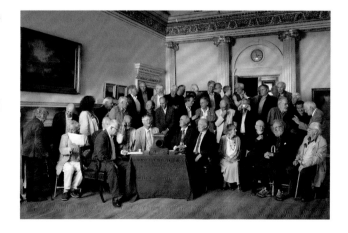

147 Dennis Toff, *Royal Academicians in General Assembly*, 28 May 2009, C-type colour print, 31.8 × 53.7 cm (RA 12/369), Photo © Dennis Toff (FRPS).

THE DOMINANCE OF SCULPTURE

Joseph Wilton to E. H. Baily

KATHERINE EUSTACE

The portrait bust of the sculptor Joseph Wilton RA of about 1760 by Louis-François Roubiliac (fig. 148) arrived in the Academy in 1824 as a gift from Wilton's daughter Frances (Lady Chambers).[1] When Wilton succeeded Agostino Carlini RA as Keeper of the Royal Academy on 5 November 1790,[2] he already had a long track record of teaching students. An immediate sense of a 'new broom' appears in the Council minutes, with fresh regulations issued about the 'Plaister' (cast) Room. The Keeper was to be responsible for student admissions and if, after a year, a student was not confirmed by Council he was to be 'discharged as incapable'; if a student was accepted, thereafter he (and it always was 'he') had free admittance for six years, while prize-winners retained student advantages for life. A list of the students admitted was compiled, and all were given a month to provide a drawing for inspection by Council. The President himself reinforced the regulations by adding that if anyone submitted work not

his own he was to be expelled. The regulations were to be pinned up in the hall for all to see.[3]

Wilton, with the architect Sir William Chambers, provided much of the energy behind the founding of the Academy. He had returned from Italy to set up a drawing school under the patronage of the Duke of Richmond, and had collected at least some plaster casts for the purpose both by purchase and by making them himself. Joseph Baretti informs us that Wilton had presented the Academy with a cast of the head of 'Sanctus Georgius', Donatello's *St George* from Orsanmichele in Florence (see fig. 440) 'moulded by himself on the Original' and also, even more remarkably, one of Donatello's 'Sanctus Johannes'. If they survive (and they are no longer in the Academy collection), these must be the earliest examples of casts after High Renaissance sculpture in Britain.[4] Perhaps disillusionment with aristocratic patronage spurred Wilton to join the less obsequious among the artists of the day in

178

founding the Academy. It was at Wilton's house, probably the one in Hedge Lane, Charing Cross, that the meetings appear to have taken place, and it was to this address that Joshua Reynolds came to be persuaded to become President.[5] Wilton was the only sculptor present at the first meeting of Council on 20 December 1768,[6] when minutes of the first General Assembly of the Academicians on 17 December were read. He was not present at the next meeting, but was at the third on 27 December at which the charitable purposes of the Academy and 'the Certificate of the Qualifications and Morals of the person recommended' were set out.[7] Thereafter Wilton was highly visible, assiduously attending meetings of Council and serving as Keeper from 1790 to 1803.

That a sculptor should have been so instrumental in the formation of the Academy is no accident. In eighteenth-century Britain sculpture was central both to the development of the nation's understanding of its identity and to concerted efforts to establish a native school of art. In an age obsessed by the classical world, sculpture was also perceived as the art form that had best survived from antiquity. Under the Hanoverians, the dynasty that succeeded to the throne in 1714, a new style of government and a new social class provided the opportunity for three émigré sculptors in particular to create a dramatic change in the appreciation of art. There was something of a vacuum in portrait painting of high quality between the death of Sir Godfrey Kneller in 1723 and the establishment of William Hogarth as a major portrait painter in the 1740s, but at just this period there was much sculpture of a high order that surpassed painting in invention, execution and technical virtuosity. George Vertue observed in 1738 that sculpture had 'of late years made greater advances [than painting] in many great and rare workes of several hands'.[8] He proceeded to list by name John Michael Rysbrack, Peter Scheemakers and Louis-François Roubiliac.[9]

There were public places in London where people could see sculpture by these masters, including Westminster Abbey. Increasingly, the abbey became a place of theatre as much as history, and the unveiling of a new monument was a metropolitan event: from Rysbrack's *Sir Isaac Newton* (1731), centre stage in the nave, and Scheemakers's icon-fixing *Shakespeare* (1741) to Roubiliac's dramatic monument to Lady Elizabeth Nightingale (1761), with its anatomically correct skeletal spectre of Death. They were followed by many masterpieces by Royal Academicians, notably those of Joseph Wilton

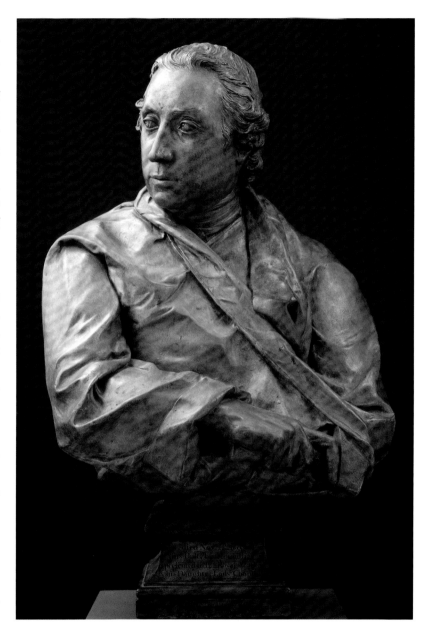

148 Louis-François Roubiliac, *Joseph Wilton RA*, c.1760, plaster, height 68.6 cm (RA 03/1817).

(*General Wolfe*, 1772), John Bacon (*Pitt the Elder*, 1779) and John Flaxman (*Earl of Mansfield*, 1793).

There were two other public places, less exalted, to see sculpture in London, one of them at Hyde Park Corner, where statuaries' yards and showrooms fronted the Great West Road and where stone, lead and plaster figures, often

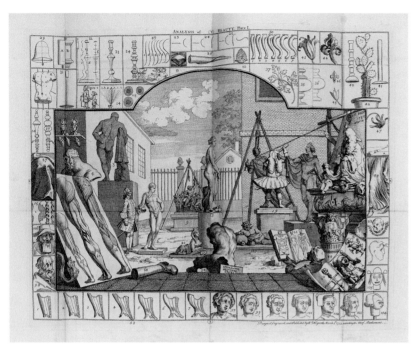

149 William Hogarth, 'A Statuary's Yard', in *The Analysis of Beauty* (1753), London 1772, pl. 1 (RA 03/2303).

brightly coloured, and exhibited out of doors, made it one of the London sights. Admittedly, the taste displayed in these 'showrooms' was not always admired, and their notoriety was even an embarrassment to the more discerning.[10] The other key place to see sculpture was the pleasure gardens at Vauxhall, where customers were treated not only to paintings by Francis Hayman, a future Foundation Member of the Academy, but also, conspicuously, to a sculpted apotheosis by Roubiliac of Handel in the guise of Orpheus, playing Apollo's lyre (1738; Victoria and Albert Museum, London), an arresting image that was far from classical.[11] Finally, less public but no less popular, were the sculptors' workshops themselves, with their displays of models, portrait busts of the celebrities of the day, and work in progress.

None of this was lost on Hogarth, whose own practice drew inspiration from sculpture not least in the sudden and dramatic change of scale in his portraiture evident in *Thomas Coram* (1740; Foundling Museum, London); in child portraiture such as the *Graham Children* (1742; National Gallery, London), where both scale and approach were radical in painting; and in his visual dialogue with the sculpted bust.[12]

Nor is it an accident that one of only two plates in Hogarth's *Analysis of Beauty* (1753), 'A Statuary's Yard' (fig. 149), is a view of what is now generally accepted as the yard of John Cheere at Hyde Park Corner. Hogarth's pictographic employment of a sculpture yard should not be taken as a mere piece of Hogarthian satire, a joke against sculptors and copyists after the Antique in particular. It is much more than that: it clearly recognizes and acknowledges the cultural shift in favour of sculpture and the three-dimensional that had taken place during Hogarth's working life.

In *The Analysis of Beauty* Hogarth rarely talks of the theory of painting and its practice: instead, almost all his examples are taken from sculpture, and exhibit a clear understanding of the Antique and its central role in the sculptural aesthetic.[13] Indeed, one of the most surprising things about the book is that it rarely refers to painterly techniques at all, and overwhelmingly takes its point of view from that of a sculptor, even when discussing 'Colouring'. Hogarth writes authoritatively of sculpture and the techniques of making moulds, plaster casting, wire measuring for ascertaining the outline of the musculature and so on: 'If the reader will follow in his imagination the most exquisite turns of the chisel in the hands of a master, when he is putting the finishing touches to a statue; he will soon be led to understand…[what] the Italians call, the little more, Il poco piu.'[14] Such an understanding and choice of examples show a close familiarity with sculptural practice: a first-hand acquaintance that he evidently obtained from conversations with sculptors such as Rysbrack, Roubiliac and Henry Cheere.

EN ROUTE TO THE ROYAL ACADEMY

Hogarth worked alongside Roubiliac at the St Martin's Lane Academy that he established in 1735. This, known as the Second St Martin's Lane Academy, to distinguish it from that run by John Vanderbank and Louis Chéron from 1720 to 1724, was the most important of the forerunners of the Royal Academy, and in it, as the role of Roubiliac attests, sculpture played a significant role, as it had done in all the earlier London academies. The provision of life classes was a priority, but drawing from casts and related prints was also practised: a drawing by Vanderbank of the *Farnese Hercules* of 1732 (fig. 150) seems to have been part of a small group of life and cast

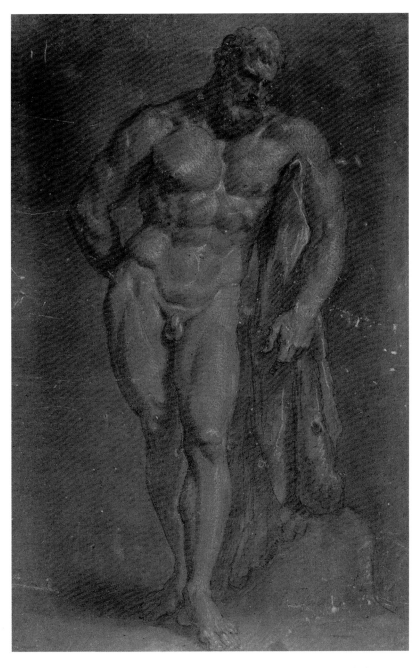

150 John Vanderbank, *Farnese Hercules*, 1732, black and white chalk, 58.1 × 39.1 cm (RA 07/3676).

drawings that came to the Royal Academy from the Second St Martin's Lane Academy. Although the drawing cannot have been created there, it exemplifies the drawing from casts that Vanderbank had encouraged in his own academy.

A drawing academy specifically devoted to the provision of casts for study was the initiative of Charles Lennox, 3rd Duke of Richmond, who opened a gallery attached to his house in Whitehall in March 1758,[15] an initiative that, from about 1758–62, was at the heart of artists' training in the years immediately preceding the foundation of the Royal Academy. The duke's gallery, 'fitted up with every convenience requisite for the accommodation of students',[16] was designed by William Chambers. In addition to a collection of about 24 major casts, there may have been as many as 105 smaller casts of individual heads from Trajan's Column, which subsequently passed to the Royal Academy, some 52 of which are still in the collection (see fig. 424).[17] The duke's cast collection was thought to have been assembled for the purpose by Wilton, made 'during the pursuit of his studies in Italy from 1750 to 1756'.[18] Recent research has, however, identified Matthew Brettingham the Younger as the procurer of many of the casts or 'jesse' or 'gesses' (plasters: Italian *gessi*), although Wilton provided some, including the *Fighting Gladiator*, which may have passed to the Royal Academy, and Michelangelo's *Bacchus*.[19]

Wilton supervised the day-to-day running of the gallery and the maintenance of its casts. He would issue admission notes for those wishing to attend, addressed 'To the Porter of the Statue Room at Richmond House', certifying that the bearer was 'above 12 years of age', a 'sober and diligent person', who had promised 'to observe the rules of the room'.[20] Students could come during the week between 9 and 11 and from 2 until 4, while Wilton and the painter Giovanni Battista Cipriani RA inspected the resulting drawings on the Saturday and gave instruction as needed. Edward Edwards ARA, himself a student there in 1759 and later Professor of Perspective of the Academy, pointed out that the attendance of Wilton and Cipriani remained unremunerated by the duke.[21] None of the premiums and medals promised by the duke was ever awarded, as is recorded in a manuscript note preserved in the Library, although this same record also lists the remarkable number of future Academicians who attended (fig. 151).

A self-portrait by John Hamilton Mortimer ARA, believed with good reason to be set in the duke's gallery (where Mortimer is known to have studied), shows him being supervised by what is generally accepted to be Joseph Wilton (assisted by a young man identifiable as Charles Ruben (or

151 Manuscript note preserved in the Royal Academy Library, with list of artists attending the Duke of Richmond's gallery: 'Joseph Nollekens, Simon Taylor,…Bellingham, Ozias Humphry,…Walsh, John Mortimer, Richard Earlom, Johnson Carr, James Gandon,… Parsons, William Peters, Edward Edwards, William Hodges, William Lawrenson,…Burgess Sr., Richard Cosway, William Parry, Thomas Jones, William Byrne,…Burgess Jr., Alexander Gressi, William Parrs, Joseph Farington, James Durno,…Terry' (FAR/4/1).

Reuben) Ryley, who was to study painting under Mortimer),[22] and lays emphasis on the discipline of drawing (see fig. 123). The setting is dark, with an easel and canvas leaning against the back wall, while the presence of a chair in a checked 'case cover' suggests valued furniture worth protecting against the wear and tear of artistic studies. Ten years later, Cipriani and Wilton were Foundation Members of the Royal Academy.

JOSEPH WILTON, EDUCATION AND 'PLAISTERS'

As Chambers's New Somerset House developed, Wilton and Carlini were engaged in its embellishment. Carlini's 1773 bust of the Academy's patron, George III, was placed on the mantelpiece in the Library (fig. 152). Wilton produced, for example, the head of Michelangelo over the main entrance to the Royal Academy and that of Isaac Newton over the

joint entrance to the Royal Society and Society of Antiquaries. He was also responsible for the colossal figures of Asia, Africa, the Americas and Europe upon the attic storey of the north block on the courtyard side of the Strand building (see fig. 22), while both men worked variously on providing keystones (fig. 153), medallions and vases emblematic of British rivers, the winds, seasons, and ornaments of official significance on the exterior.[23] Wilton also produced chimney pieces for the interiors, one of which, in its use of griffin and candelabra motifs, echoes their use in Rysbrack's Hopetoun chimney piece.[24] Another chimney piece now in the Council Room at Burlington House has sometimes been stated to be Wilton's Diploma Work (fig. 154), although this is not the case. Foundation Members such as Wilton were never required to present one, and this was expressly made for the Council Room at New Somerset House.

When the Royal Academy moved into Old Somerset House on 14 January 1771, the interior was described as 'the

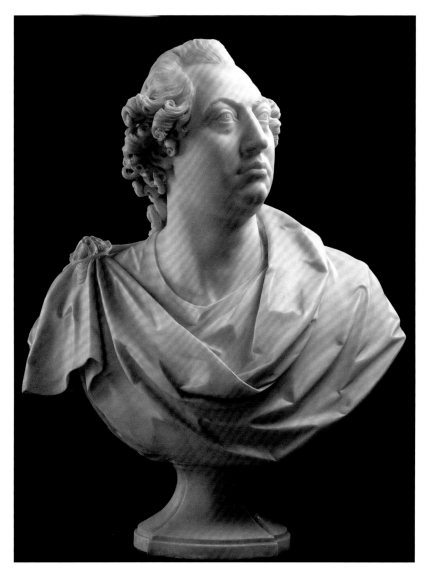

152 Agostino Carlini RA, *George III*, 1773, marble, 81 × 60 × 38 cm (RA 03/1685).

153 Agostino Carlini RA, 'Dee', keystone on Strand side of the north block of Somerset House.

most superb of any in the world' and, significantly, 'the best stocked with casts after the antique'.[25] Sculpture lay at the very heart of the training offered in the Academy's Schools. The school of design was in effect two rooms for drawing: one dedicated to drawing after the Antique, present largely in the form of plaster casts; the other to drawing from the live model. Two contemporary watercolours record the Antique Room as it was first in Old Somerset House (see fig. 392) and then as it was in New Somerset House, respectively (see

fig. 26). In Old Somerset House, the Plaister Room, as it was also called, is randomly set about with plaster casts, in marked contrast to the room in Chambers's new building, where a distinct air of considered arrangement has been introduced. In both buildings, the cast room was where students spent the first year, having been examined on their drawing or modelling ability.

All the teaching at the Academy was focused upon drawing, for neither painting nor sculpture was taught at all.

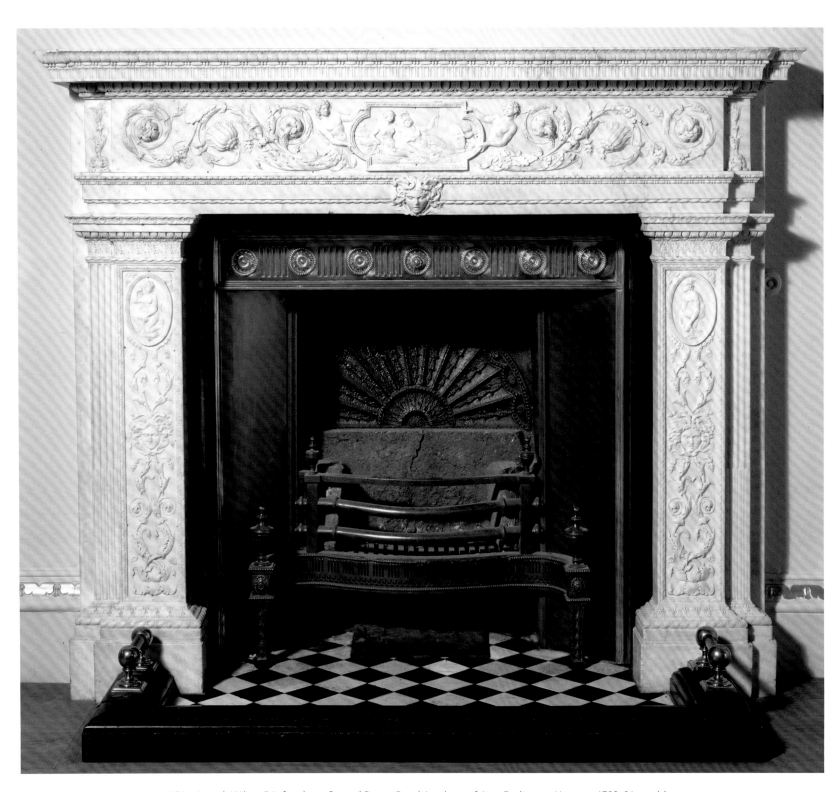

154 Joseph Wilton RA, fireplace, Council Room, Royal Academy of Arts, Burlington House, *c*.1780–86, marble,
156.2 × 193 cm (RA 03/3972).

There was not a whiff of turpentine or of drying oil in the teaching rooms of Somerset House; the clink of chisel on stone or marble was never heard. There was, however, dust, remarked upon by contemporaries, and there was gloom, as most of the teaching was done at night by candlelight (fig. 155). This in itself was a distillation of the aesthetic that antique sculpture was enhanced by chiaroscuro and dramatic lighting. There was probably a practical reason too for evening classes, since students were likely to be already gainfully employed as assistants and apprentices in studios and work-shops, although some of the regulars, like Robert Nixon, appear to have been amateurs. Similarly, the models in the life classes would often have had employment elsewhere.

At the Royal Academy, plasters were everywhere, crowding into every space, and they dominate Singleton's group por-trait of the Academicians (see fig. 146). The casts were subject to an annual inspection by the Keeper and two members of Council, the minutes of which report the regular presentation by benefactors (among them in 1802 'Ca'nover' – Antonio Canova – and Sir William Hamilton), acquisition by purchase, and arrangements for restoration and storage. Casts might eventually be 'passed for disposal' and replacement.[26] They could be trundled about on boxes equipped with handles and raised on wooden casters that are as hard and round as croquet balls, and there were frequent instructions not to move them without the Visitors' permission.

Although fragile, plasters were relatively light and, if well packed, were not especially prone to damage in transit. They made perfect presents for artists and collectors and, as we shall see, ideal diplomatic gifts. The subject of the cast col-lection took up much Council business. When, in August 1769, the collector Charles Townley presented the Academy with a cast of the *Lacedaemonian Boy* and Thomas Jenkins gave a cast of a Venus, Council resolved that letters of thanks should be sent to them. Mr Lock presented a cast of a head of an Atalanta in March 1771;[27] the Duke of Dorset was thanked in October the same year for presenting 'a Cast from a Bust of Antinous in his Collection' and again in December, when he presented a cast of 'Pythogoras' [*sic*], perhaps after the head in the Capitoline Museum, Rome.[28] Just over a year later, early in 1773, Council 'ordered the following Figures to be removed out of the Academy: The Drunken Bacchus, The Wrestler with the pot of Ointment, One of the Centaurs, The Venus, The Figure of Polypheme

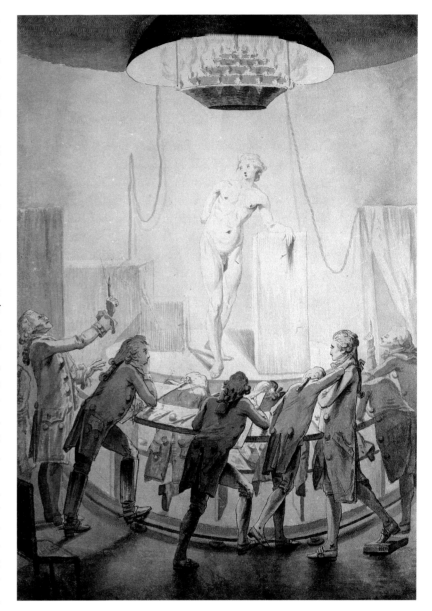

155 Elias Martin ARA, *Dr William Hunter at the Royal Academy Life Class*, c.1770, ink and wash on paper, 45.9 × 32.2 cm. Wellcome Library (no. 44427i).

and the Head of Neptune by Bernini to be put into the Case', although no reasons for this are given in the tantaliz-ingly reticent minutes. In June 1774 Council, 'leave having been already obtained from his Lordship', arranged for casts to be made from Lord Shelburne's 'Meleager, The Gladiator putting on his Sandals, & the Paris'. The gladiator putting

on his sandal, known also as the *Cincinnatus*, can be seen in Burney's views of the old and new Antique School of 1779 and 1780 mentioned above.[29]

WATERLOO AND ANTONIO CANOVA

A historical event that highlights the power of these icons of classical antiquity, and the hold they exerted on the collective imagination, is the diplomatic mission of Antonio Canova to the 1815 peace conference, the Convention of Paris, that followed the defeat of Napoleon after the Battle of Waterloo (18 June 1815).[30] Waterloo could be said to have put the Royal Academy where it wanted to be, centre stage in the life of the nation, because it brought to London the greatest living

156 Sir George Hayter, *Antonio Canova*, c.1816, graphite and wash, 18 × 11.2 cm. British Museum, London.

sculptor, a visit that boosted the standing of the Academy and of sculpture in particular.

In the wake of Napoleon's defeat in 1815, the British flocked to Paris to catch sight of the European collections that had been ransacked by the French armies over the previous two decades. The works were displayed in the Palais du Louvre, which Napoleon had renamed the Musée Napoléon (after Waterloo it became the Musée royale). There visitors saw the originals of such sculptures as the *Apollo Belvedere*, the *Venus de' Medici*, and the *Laocoön* in the Salle de l'Apollon and Salle du Laocoön. Canova (fig. 156) had been sent by Pope Pius VII to make a claim for 'la restituzione de' capi d'opera dell'arte antica e dei quadri' (the restitution of masterpieces of the Antique and of paintings), chiefly those that had been removed from Italy to Paris after the Treaty of Tolentino in 1797 in the wake of Napoleon's victories.[31] Canova was described in his appointment to the mission by the Roman Senate as the 'emulatore del Greco Scalpello, e Principe perpetuo della Romana Accademia delle Belle Arti' (the equal of [the masters of] the Greek chisel and perpetual president of the Roman Academy of Fine Arts), and was a celebrity throughout Europe. Indeed, his own works subsequently became the subject of diplomatic negotiation and purchase. The British acquired Canova's *Napoleon as Mars the Peacemaker* (1802–6; Apsley House, London), which, incidentally, took its inspiration from the *Apollo Belvedere*. It was purchased in order for it to be formally presented by a grateful nation to the victor of Waterloo, the Duke of Wellington, and Flaxman was responsible for setting it up at Apsley House in 1817.[32]

That Canova was successful in his mission was due in part to his long acquaintance with the London cultural and artistic establishment. Canova's introduction to the British delegation may have been effected by a friend of Sir Thomas Lawrence RA, Dr Granville, a physician of Italian extraction,[33] and by William Richard Hamilton (no relation to the diplomat and collector Sir William Hamilton). Canova may already have met Hamilton in 1803 when the Elgin Marbles were briefly disembarked at Civitavecchia on their journey to London, an operation overseen by Hamilton, who was then Lord Elgin's attaché. Towards the end of October 1815, as the Convention of Paris drew to a successful close, Hamilton encouraged Canova to make a visit to London, and he was possibly supported in this move by Canova's old Rome acquaintance and

friend, John Flaxman, who was now a Royal Academician and Professor of Sculpture at the Academy.

There were several possible motives for Canova's London visit on both sides. One was the prospect that Canova might undertake a public commission or two, a hope that was repeatedly foiled in the face of strong opposition from the British artistic fraternity. (Significantly, proposals for a Waterloo Memorial were brought forward to the Academy just days after Canova's subsequent departure for Rome.)[34] The chief reason, as put about in the press, was that he was to give his opinion on the Elgin Marbles, which, now Europe was at peace, were once again a subject of controversy. Canova more than fulfilled any expectations on this issue, and the *Gentleman's Magazine* reported after his departure: 'The celebrated sculptor, Canova, who lately visited this Country, on inspecting the Elgin Marbles, said they were superior in style to everything else on earth; that at Rome they had no idea of such things, and would be astonished were they to see them, that there would be a great change in the whole system of both painting and sculpture in consequence.'[35]

No sooner had Canova arrived at Brunet's Hotel, Leicester Square, than, on Friday 3 November, he was taken off by the Duke of Bedford to see the studio of a former pupil, the successful Richard Westmacott RA (he was to be knighted in 1837) (fig. 158), to visit the sights and to dine. On the Sunday, he and his brother, the Abbate Canova, like other tourists in London, went to Westminster Abbey, but making little of the monuments there, they headed for St Paul's, which was then taking shape as a kind of new pantheon, chiefly of the heroes of the wars against Napoleon.[36] Here the monuments were all contemporary and by sculptors of the Canova brothers' acquaintance, most of them Royal Academicians. They would have seen Flaxman's *Lord Howe* (1803–11) (Flaxman's *Lord Nelson*, 1818, was not yet installed; see fig. 170), Westmacott's wildly ambitious *General Abercromby* (1801; see fig. 168) was on view, as were *Captain Mosse and Captain Riou* (1802–5) and *Lord Rodney* (1810–15) by Charles Rossi RA, who had been in Rome on a Royal Academy travel scholarship 1785–8 and whose portrait of George Dance RA in the Academy collection is probably his masterpiece (see fig. 130). Here also was the recently installed *General Sir John Moore* (1810–15) by John Bacon the Younger; *Captain Richard Burgess* (1802) by Thomas Banks RA, with its direct reference to antique Roman sculpture; and the relief of *General Bowes* (c. 1811) by

157 Frederick William Smith, *Sir Francis Chantrey RA*, 1826, marble, height 55.9 cm (RA 03/1822).

the rising star Francis Chantrey (RA 1818; fig. 157).[37] On Monday, Canova called on John Bacon at 17 Newman Street, where his host insisted on drawing him as they discussed the monuments seen the day before.[38] They may well have dis

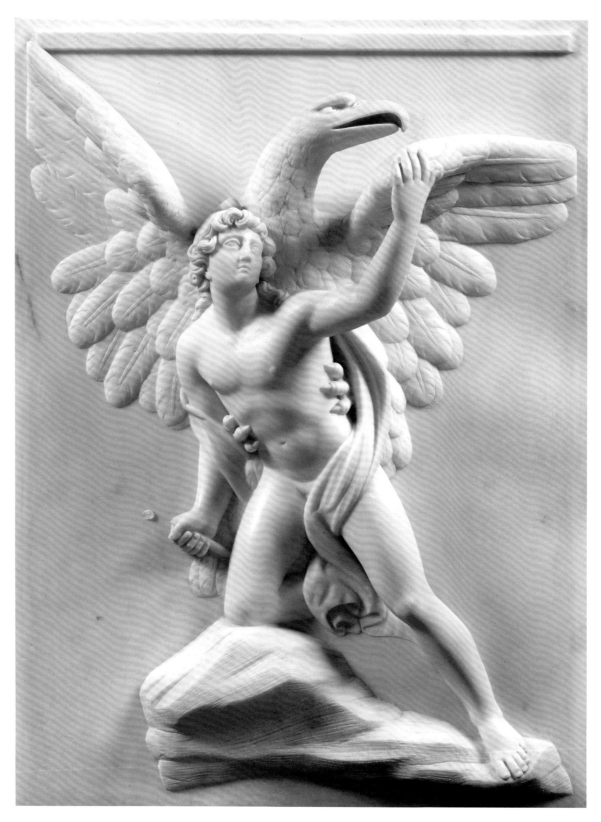

158 Sir Richard Westmacott RA, *Jupiter and Ganymede*, 1811, marble, 68.5 × 51.5 cm (RA 03/1852).

cussed the issue of the incongruities that were so obvious in St Paul's, where contemporary sculptors were presenting modern heroes naked in the Antique manner and, moreover, within an ecclesiastical setting.[39]

Canova went to see the Elgin Marbles several times at Burlington House, and while he was in London the Phygalean marbles were delivered to the British Museum. Thomas Phillips RA reported that he had 'heard from Flaxman that [Canova] is highly delighted indeed with Lord Elgin's marbles & regards us as very rich in Sculpture'.[40] A formal dinner orchestrated by the President of the Academy, Benjamin West, was arranged at Somerset House for Friday 1 December at 5 o'clock. Canova was accompanied by Hamilton and three Italians, and among the 25 Academicians present were the sculptors Nollekens, Flaxman, Rossi and Westmacott. The President proposed the toasts to Canova and to Hamilton, and Henry Fuseli RA remarked afterwards on the sculptor's 'modesty and talents'.[41]

Plaster casts were still very much on the minds of Academicians. While the most famous examples of antique sculpture from Rome were still in the Louvre, Philip Reinagle RA understood 'there have been very fine moulds taken from all the most valuable statues, so that the different academies of painting may be supplied with good casts for the Studies of their pupils'.[42] Whether or not that was the case, it had clearly been impressed on Canova that a complete set of Vatican casts for the Royal Academy would be a most acceptable gesture by way of acknowledging the efforts made by the British to see the return of the works of art to Italy, and to the Vatican in particular, under the terms of the Convention of Paris.[43] Even before Canova had left for the Continent, Flaxman moved a motion in the General Assembly on 9 December to procure a new collection of 'Casts from the Antique'. On 14 December, he and Westmacott were in attendance at a Council meeting convened specifically for this purpose and 'reported the substance of a conversation they had had with Lord Sidmouth [the Home Secretary]' on the subject, and an address to the Prince Regent was composed. It pointed out the necessity of replacing the existing casts that, after nearly half a century, were 'so discoloured and injured ... that they no longer afford the students sufficient means of improvement'. It further requested the Prince Regent's assistance in acquiring the desired 'new and perfect casts' from Rome, Florence and

Naples.[44] Canova was in an ideal position to help. The taking of casts had always been a matter of diplomacy at the highest levels, but the papacy, the jealous guardian of so many originals, was now put in the position of having to acknowledge its gratitude to Canova and to Britain. The casts after the Vatican marbles were despatched in groups to the Prince Regent, although it was understood by everyone that, as the *Notizie del Giorno* put it, they were 'per uso degli studenti' at the Royal Academy.[45] A special General Assembly was called to thank His Royal Highness for his generous gift,[46] while other groups of casts followed over the next five years.

The Academy's relations with Canova did not stop there. On his return to Rome, Canova as *principe perpetuo* of the Accademia di San Luca, saw that West, Fuseli, Flaxman, Lawrence and W. R. Hamilton were all made members of the Accademia di San Luca, and he subsequently extended the same honour to J. M. W. Turner RA.[47] In London, Canova's memory was kept alive by the publication in 1816 of Visconti's *Letter from the Chevalier Antonio Canova* by the leading publisher of the day, John Murray,[48] and by Lawrence's portrait of Canova exhibited in the annual exhibition the same year, some 14 versions of which are known.[49] In addition, Charles Long MP (who was crucial in arranging government support for many artistic projects)[50] and W. R. Hamilton ensured the agreement both of the Prince Regent and of the Royal Academy that Canova's new work should be seen at the annual exhibitions as and when it came into the country, before being dispersed to the country houses of the sculptor's patrons. When, for example, in April 1817 Lord Cawdor's *Hebe* and Sir Simon Clarke's *Terpsichore* arrived, they were offered for display at the Academy Annual Exhibition by Hamilton and were accepted.[51] In fact, Canova exhibited with the Royal Academy each year between 1816 and his death in 1822. His *Dirce* (1820–24; Royal Collection), with its clear visual reference to Canova's *Pauline Borghese as Venus Victrix* (Galleria Borghese, Rome), was left unfinished in 1822, and was subsequently bought by George IV.[52] Lawrence, who had seen the model in Rome, described it to Canova as 'the most perfect of your productions', and the sculptor dedicated a print of it to him. Moreover, Canova sent a drawing – not by himself but by another artist – of his *Sleeping Nymph* to Lawrence on 16 December 1820 that is now in the Academy (fig. 159), as is the letter in which it was enclosed.[53] On Lawrence's death in 1830 a sale of the prop-

erty of the 'Late President Of The Royal Academy' at Chris-
tie's included 'A Valuable Assemblage Of Casts, From some of
the most celebrated antique Groups and Statues, in the dif-
ferent galleries on the Continent and in this Country...[and]
the Venere Vincitrice of Canova, presented by that Sculptor
to Sir Thomas Lawrence'.[54]

THE PHENOMENON OF FLAXMAN

Throughout these encounters with Canova, one name recurs,
that of the British sculptor who enjoyed not only the highest
reputation at home but also a degree of fame in Europe that,
at this distance, remains remarkable: John Flaxman. His inter-
national reputation chiefly rests, it is true, upon his outline
illustrations to the *Odyssey* and *Iliad* (fig. 160), but in Britain
in the first part of the nineteenth century sculpture was
considered supreme as a medium. This conception was rein-
forced by the proliferation of public monuments, at a time
when Flaxman's pre-eminence as a sculptor was unchal-
lenged. Sculpture was, moreover, the quintessential medium
of neoclassicism: no Greek paintings survived and so the
artistic achievements of ancient Greece were necessarily
measured above all in the form of sculpture. As if in affirma-
tion, in 1811 the Elgin Marbles from the Parthenon arrived
in London, to be stored at Burlington House.

It is a curious fact that, just as there have been only two
presidents of the Royal Academy who have been first and
foremost sculptors, so there has only been one retrospective
exhibition at Burlington House devoted to a single Acade-
mician who falls into that category.[55] That sculptor was
Flaxman (fig. 161). There are several reasons why he might
have attracted this singular attention: he embodied in his
career the purpose of the Academy, and his reputation and
international influence were and remain synonymous with a
style and a period. In the earliest work of modern scholarship
on British sculpture, Flaxman was damned with faint praise,[56]
but since then his reputation has been celebrated many times
over. For the Royal Academy he has always been one of the
hero-figures, not quite on a par with Sir Joshua Reynolds
but, like J. M. W. Turner, head and shoulders above the rest.
Like Turner's, his career is an embodiment of the Academy's
purpose and, like Turner, his loyalty to his alma mater was
stirred but never shaken.

159 After Antonio Canova, *Sleeping Nymph, c.*1820, pencil,
14.5 × 22.2 cm (RA 09/1803).

John Flaxman's father was a successful modeller and seller
of plaster casts with roots in Yorkshire and premises in
Covent Garden. An anonymous memoir published together
with Flaxman's collected lectures three years after his death

160 Tommaso Piroli after John Flaxman RA, *Thetis calling Briareus to
the Assistance of Jupiter,* engraving, 16.8 × 24.2 cm (RA 11/2149).

(above) 161 Edward Hodges Baily RA, *John Flaxman RA. c.*1823, marble, height 54.4 cm (RA 03/3593).

(right) 162 George Romney, *Flaxman modelling the Bust of William Hayley, watched by Thomas Hayley and the Painter, c.*1795, oil on canvas, 226.1 × 144.8 cm. Yale Center for British Art, New Haven, Paul Mellon Collection.

provides details of his early youth and was perhaps written by Maria Denman, his sister-in-law, adopted daughter, executor and keeper of the flame.[57] We learn from this that Flaxman was so ill as a child that on one occasion he was laid out for dead. The affliction may have been poliomyelitis, as in a number of portraits his right arm appears shrunken, a serious handicap to the would-be sculptor. Frailty afflicted him all his life, and affected his appearance and his shortness of stature. This disability, combined with his associated determination in the face of challenge, only serves to emphasize

the strengths in drawing and modelling that characterize his work. Flaxman himself made light of his physique, lampooning himself with an obvious hump in a sketch made when he was about 20 – the pen has bitten with force into the paper in describing the hump[58] – and allowing himself to appear in a painting of the poet William Hayley by his friend George Romney that emphasizes his diminutive figure set against the god-like height of the poet and next to the colossal head of Hayley, their mutual hero, that he is working on (fig. 162).

Flaxman's appearance was clearly odd: an image of him modelling by candlelight drawn by his travelling companion in Italy, William Young Ottley, shows a slightly grotesque figure raised up and kneeling at his work.[59] Benjamin Robert Haydon, with that curious mixture of obsequiousness and spite that so irritated his contemporaries, awarded Flaxman the epithet 'the intelligent deformity'. In his attempts to be reconciled with the Royal Academy, Haydon called on the sculptor, then aged 72 and in the last year of his life, and described how 'his old, deformed, humped shoulder protruded' as he lent forward 'and his sparkling old eye and his apish mouth grinned on one side, and he rattled out of his throat, husky with coughing, a jarry, inward, hesitating hemming sound.'[60]

Flaxman seems always to have worn his hair long, and usually undressed, as Baily shows him (see fig. 161),[61] a striking aspect of his appearance that may have harked back to the radical and possibly religious politics of his youth, when such men as the Quaker Benjamin Franklin and the Unitarian Joseph Priestley, both democrats, wore theirs in this manner. There is no evidence that Flaxman was politically motivated, although he counted Thomas Banks a friend: there is a drawing by Flaxman of Banks's wife, Lavinia, playing the harp.[62] Nor was he a courtier, despite the dependence on royal favour evinced by his colleagues among the leadership of the Academy. Despite his long and distinguished career Flaxman was never knighted as, in contrast, were Thomas Lawrence and Francis Chantrey.

In Flaxman's youth, none of this seems to have hindered his progress either socially or professionally. Flaxman really does seem to have lived out the myth of the child prodigy. He may well have attended the Duke of Richmond's gallery, as there is an anecdote that when he was aged 10 he came home 'from some sort of class' (we are not told where) discouraged because John Hamilton Mortimer (who certainly attended the gallery: see fig. 123) had ridiculed his attempts at drawing a pair of eyes, comparing them to 'flounders'.[63]

If Flaxman was one of the last students at the Richmond gallery, he was among the first at the Royal Academy. He was accepted on 7 October 1769, at the age of 14, winning a silver medal within the year.[64] He continued to pass under Wilton's bust of Michelangelo on his way into the Academy for the rest of his life. He married Ann (Nancy) Denman in 1782, which provoked the remark from Reynolds, 'Oh,

then you are ruined for an artist!'[65] – the eighteenth-century equivalent of Cyril Connolly's quip, 'A pram in the hall is the enemy of promise.' Five years later the Flaxmans left for Rome, where social circles among expatriates were more fluid than in London. Flaxman moved in the city's international milieu and met many future patrons, including the Earl-Bishop of Bristol, Frederick Hervey, Thomas Hope and the Dowager Countess Spencer. Farington reported that, while Flaxman was still in Rome, he had won the commission for a monument to 'the three Captains', which 'Lady Spencer has contributed to procure…for him' (though nothing came of it and the commission went to Nollekens).[66] When Flaxman and Nancy returned to England they came not alone but in the company of the Italian wife of Richard Cosway RA, Maria, and the engraver 'young Bartlozzi [sic]'.[67] This ability to endear, engage and mix socially was to stand Flaxman in good stead in the political world of the Academy.

Flaxman's contemporary fame was established, as already noted, by the success of his drawings illustrating Homer's *Iliad* and *Odyssey* (as well as Dante's *Divine Comedy*), and their sale must have added a fillip to his annual income.[68] They were disseminated in line engravings across Europe, and according to Goethe in a commentary of 1799, they made Flaxman the 'Idol of all the Dilettanti'.[69] While in Rome in 1792, Flaxman had first been commissioned by Mrs Georgiana Hare-Naylor to draw the Homer illustrations (fig. 163), which were published the following year in Rome in two volumes in the form of line engravings by Tommaso Piroli. In a separate commission, Thomas Hope acquired the Dante drawings, again for engraving by Piroli, which he published privately in 1793.[70] In London in 1795 appeared a commission from Georgiana Hare-Naylor's cousin, the Dowager Countess Spencer, *Compositions from the Tragedies of Aeschylus Designed by Iohn Flaxman Engraved by Thomas Piroli, the Original Drawings in the Possession of the Countess Dowager Spencer.*

All these illustrations (there were many subsequent editions of all of them), with their elegant economy of line, incorporeality and spiritual romanticism, influenced such disparate artists as Blake, Goya, Géricault, Ingres, Thorvaldsen and Philipp Otto Runge,[71] and they must ultimately have had an impact on the Aesthetic movement and the British versions of Art Nouveau and Symbolism. Jean-Au-

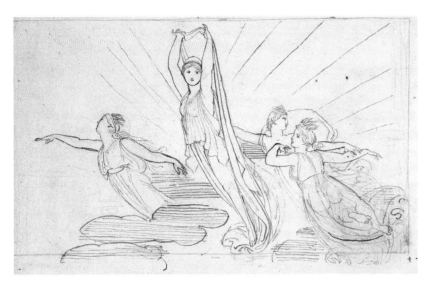
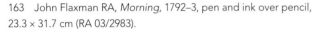

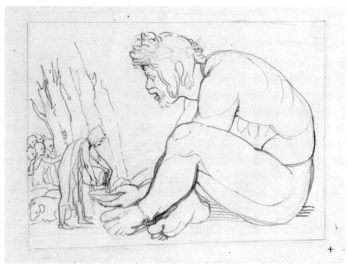

163 John Flaxman RA, *Morning*, 1792–3, pen and ink over pencil, 23.3 × 31.7 cm (RA 03/2983).

164 John Flaxman RA, *Ulysses giving Wine to Polyphemus*, 1792–3, graphite and ink, 23.8 × 29.5 cm (RA 03/1903).

guste-Dominique Ingres is said to have owned a preparatory drawing by Flaxman for *Prometheus visited by the Oceanides* that he kept in his studio,[72] and after the sculptor's death, he included him in the ambitious ceiling painting of the *Apotheosis of Homer* (1827; Louvre, Paris). Ingres's fellow Frenchman David d'Angers produced a bronze medallion portrait, *John Flaxman, Statuaire Anglais*.[73] These two works mark Flaxman as something of a nonpareil among British artists in terms of receiving French compliments.

In 1881 an entire gallery in the Academy's Winter Exhibition was dedicated to a loan from Charles Clare, a descendant of Georgiana Hare-Naylor: two large groups of Flaxman's original drawings for the published line engravings.[74] The first group contained some 65 of the pen-and-ink drawings for the *Iliad* and the *Odyssey* (fig. 164); the second consisted of 28 of the final drawings that had been announced on the title page of the Aeschylus publication of 1795 as being then in the possession of the Dowager Countess Spencer. All the drawings were bought by the Academy immediately after the exhibition.

On his return to London in the summer of 1794 Flaxman made it his business to achieve election first as an Associate (1797) and then in 1800 as a full Academician, whereupon he presented a bas-relief of *Apollo and Marpessa* as his Diploma Work, the same format that had been employed for Diploma

Works by Nollekens before him and by Richard Westmacott RA (the Younger) after him (fig. 165).[75] There may have been a sound reason for this preference for bas-reliefs, which may itself have informed teaching in the Academy, in that reliefs could be hung like pictures and were therefore much easier to display, store and handle than free-standing sculpture.

In the daily business of the Academy Flaxman was assiduous and responsible. His active engagement in the acquisition of plaster casts meant that he and Banks, with Council's authority, acquired a number at a sale of George Romney's effects in 1801.[76] Flaxman also oversaw the ordering, restoration and cataloguing of the Academy's books with the help of Josiah Taylor, the Holborn bookseller who produced the first catalogue of the Library in 1802.[77] Indeed, in his lectures, Flaxman put a clear emphasis on the importance to students of studying in the Academy Library. As a result of all his activities, Flaxman was made Professor of Sculpture in 1810, a post created specifically for him.

Flaxman took his lecturing to the students very seriously. Like Turner, he was not a natural public speaker and he could appear very solemn, although he was praised at the time for his clarity and distinct enunciation. His erudition and knowledge of his subject shone through, and his lectures were full of insights and remarkable for the sweep of periods and styles covered. Although Flaxman's name is synonymous

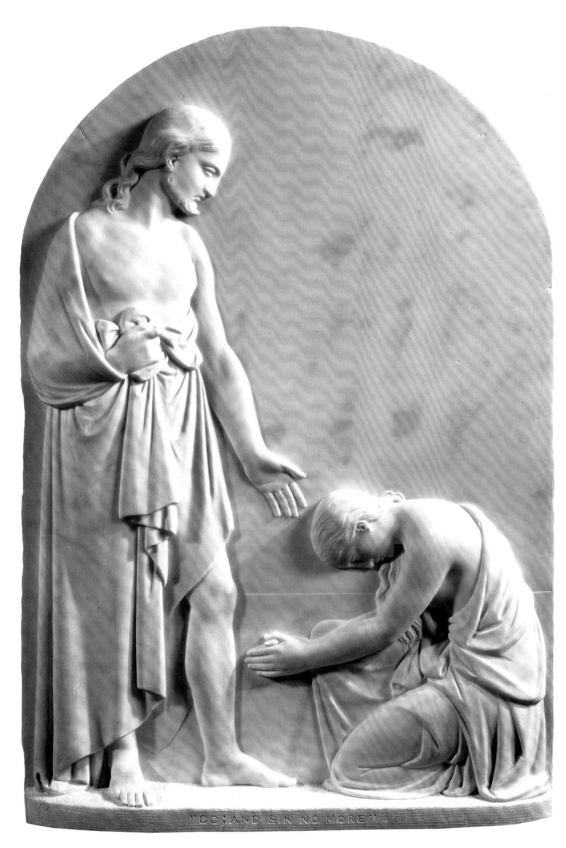

"GO; AND SIN NO MORE"

165 Richard Westmacott RA (the Younger), *'Go, and sin no more'*, 1849, marble, 99.7 × 68.9 cm (RA 03/1851).

with neoclassicism, and in this country specifically with the porcelain productions of Josiah Wedgwood, he was also influential in the reappraisal of the Italian Renaissance. He went to Italy in search of the classical ideal at an age (32) when he was already an established and respected artist. What Flaxman first encountered, however, was the late Gothic and early Renaissance art of northern Italy,[78] and of Florence in particular, as well as the work of Michelangelo, all of which had a great impact upon him.[79] His sketchbooks are full of carefully observed studies of sculpture, antique and medieval, Renaissance and even baroque, sometimes in the form of detailed records, sometimes just as notes of composition and the massing of forms. The sketchbooks evidently formed an invaluable source for the large drawings that he eventually made for teaching purposes, only one of which, it seems, can now be certainly identified (fig. 166).[80] Flaxman devoted considerable space in his Academy lectures to the work of the Pisani of the thirteenth and fourteenth centuries and of Michelangelo, the latter an interest that he shared with Thomas Lawrence, for whom he made small-scale figures of Michelangelo and Raphael (both in the Royal Academy collection). In several respects, Flaxman was well ahead of his time, and indeed he has sometimes been viewed as a proto-Pre-Raphaelite. Long before he went to Italy he had keenly studied English medieval churches and monuments, and it can be argued that this most neoclassical of sculptors played a key part in the stirrings of the Gothic Revival in Britain.

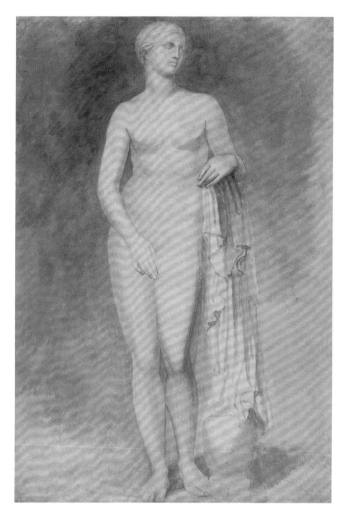

166 John Flaxman RA, *Braschi Venus*, brown wash over pencil, 73.8 × 63.8 cm (RA 13/1716).

THE SUPREMACY OF SCULPTURE

Beyond the Academy Flaxman was instrumental in raising a general awareness of the arts but with sculpture playing a central role, especially in St Paul's Cathedral as the principal site in which the nation's more recent history might be expressed and the nation's sense of its own identity and destiny affirmed. The Royal Academy, as has been stressed above, was deeply involved. An episode recorded by Farington that reveals how these things worked was the result of a visit from the sculptor Charles Rossi in 1802. Rossi, on his way to and from the meeting at the Treasury at which the commissions for the latest public monuments at St Paul's were awarded,[81] called to tell Farington of the outcome.

Charles Long, Thomas Banks, Sir Richard Payne Knight and Sir George Beaumont, he reported, had been present. The sculptors waited to be called in turn to learn the commissions they had been awarded. Flaxman won the St Paul's commission for the monument to Earl Howe (6,000 guineas) with, in Rossi's opinion, 'a very good design'. Banks was awarded the monument to Captain Westcott (4,000 guineas) (fig. 167), while Westmacott was given that to General Abercromby (6,000 guineas) (fig. 168) although, Rossi said, his sketch was 'an indifferent one'. Rossi was called in last and given the commission for the monument to Captains Mosse and Riou, to be created partly from his own (unsuccessful)

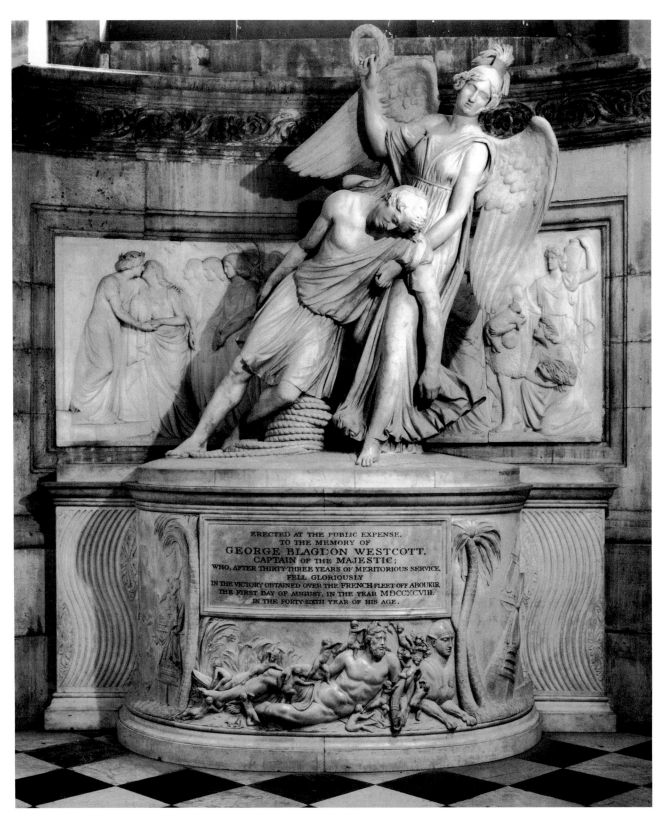

167 Thomas Banks RA, monument to Captain Westcott, 1805, marble. St Paul's Cathedral, London.

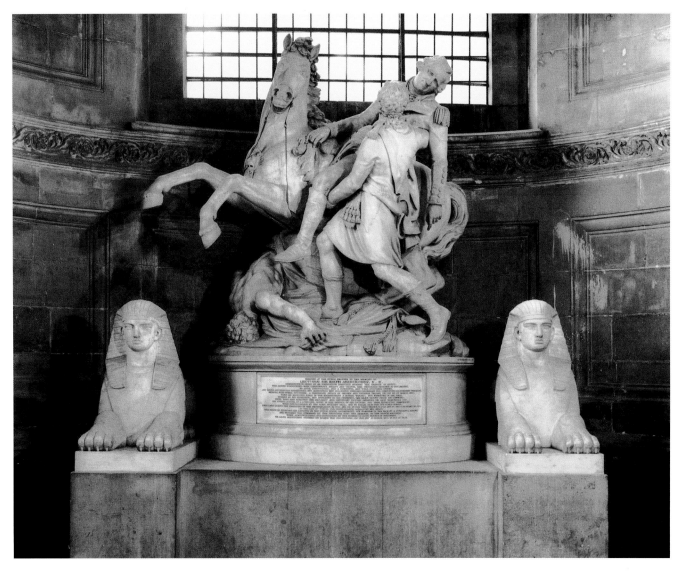

168 Sir Richard Westmacott RA, monument to General Abercromby, 1801, marble. St Paul's Cathedral, London.

design for Lord Howe's monument and partly from 'an Idea proposed by this Committee'.[82] The following year Flaxman began on his design for a monument to Sir Joshua Reynolds in St Paul's (fig. 169) (1803–13),[83] and went on to design and execute several others, including the monument to Nelson (fig. 170). This monument, which Flaxman worked on from 1808, was the public affirmation of Nelson's standing as the ultimate national hero in the pantheon. It was positioned on the cathedral's main floor following Nelson's burial in the crypt below at the state funeral in 1806, when his body was

placed in a Renaissance sarcophagus originally carved for Cardinal Wolsey, and located directly under the dome.[84]

In 1815 Council minutes reveal the Academy's central role in the plans to erect a monument to the British victory at Waterloo. The matter was offered to any member of the Royal Academy, and by June there were commissioners and two sites proposed, one in the Circus at Regent's Park and the other at the Observatory at Greenwich. Towers and columns were to be considered, while the closing date had been extended to the end of the year.[85] As early as 1799,

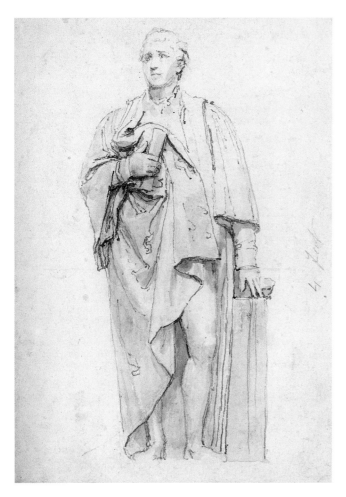

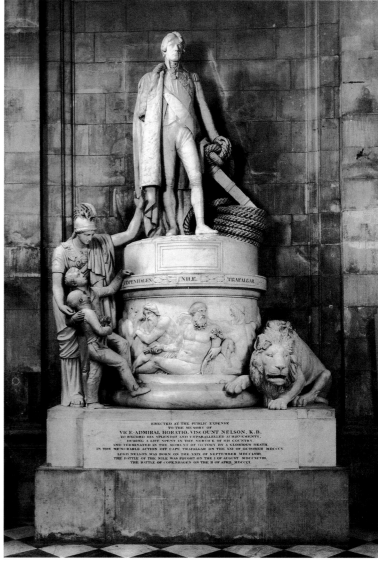

(above) 169 John Flaxman RA, design for monument to Sir Joshua Reynolds, pencil and wash on paper, 18.3 × 13.2 cm (RA 07/1317).

(right) 170 John Flaxman RA, monument to Lord Nelson, 1818, marble. St Paul's Cathedral, London.

Flaxman had worked on a number of schemes that included colossal figures of Britannia, triumphal arches, trophies and other elements. A 230-foot (70-metre) figure of Britannia, for instance, bearing the inscription 'by Divine Providence Triumphant', was proposed for Greenwich Hill as a naval monument, and in 1801 he exhibited a model for a 'statue of Britannia' in the annual exhibition.[86] Flaxman later expounded the significance of colossal figures in his lectures. As so often with such grandiose schemes, they came to nothing. It was left to Flaxman's chief disciple, Edward Hodges Baily RA, to undertake, much later, the crowning

statue of the monument that best reflected Flaxman's ideas as expressed in his lectures for the commemoration of heroes and the nation's great events: the towering monument to Nelson in Trafalgar Square (fig. 171).

Flaxman died at the end of the first quarter of the nineteenth century, but his influence reached deep into the century. Henry Weekes RA, a former assistant of Francis Chantrey RA and who idolized the work of Flaxman, succeeded him as Professor of Sculpture as late as 1868 and reiterated many of Flaxman's precepts in his own lectures.[87] It was Weekes who carved the figure of Flaxman on the

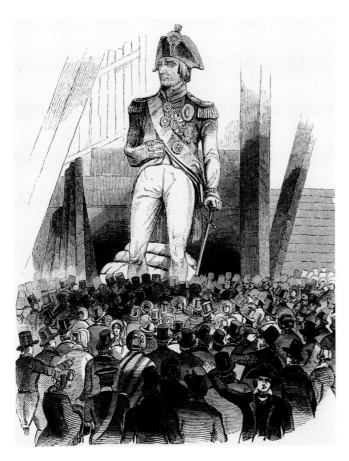

171 Statue of Nelson by E. H. Baily RA for Nelson's Column, seen while in progress, in 'Exhibition of the Nelson Statue, Charing Cross', *Illustrated London News*, 4 November 1843.

façade of the Royal Academy at Burlington House; but it is Edward Hodges Baily who exemplifies the continuation of Flaxman's extraordinary supremacy, although his own career was to be subject to a dramatic change in taste that saw his reputation collapse: his name effectively vanished from history for close on a century after his death in 1867.

THE RISE AND FALL OF EDWARD HODGES BAILY RA

The Royal Academy possesses busts by Flaxman's devoted pupil Edward Hodges Baily of his old master and also of his colleague in the Academy, the painter Thomas Stothard RA (fig. 172 and see fig. 161). The first, the bust of Flaxman, was made in about 1823 and presented by Baily as his Diploma

Work. The second, the bust of Stothard, was made in 1826 and donated by the sculptor in 1862. Two other marble versions of these busts formed part of a commission from Lawrence following Flaxman's death, as two in a quartet of representations of fellow Academicians which was completed by busts of Henry Fuseli RA (who had also recently died) and Robert Smirke RA.[88] They appear in an aquatint of Lawrence's private sitting room at 65 Russell Square, published at his death in 1830.[89] All four were dispersed at the sale of the contents of 65 Russell Square in 1830.[90] It is indicative of the importance of sculpture at this time that these busts, carved by an up-and-coming member of the next generation of Academicians, should all preside almost like Roman household gods over the private room in which Lawrence entertained visitors to breakfast or supper. Baily's bust of Flaxman was exhibited at the Academy in 1823. It was considered by J. T. Smith, who owned a cast, to be 'one of the finest busts of Flaxman extant…from the hand of Baily, the Academician, Flaxman's favourite pupil'.[91] It is the most severe form of classical presentation with its herm form and blank eyes, recalling a suitably Homeric albeit beardless type. It was engraved soon after and, becoming the prototype icon, was reproduced in a variety of media.[92]

Baily was elected ARA in 1817 and RA in 1821 when he was already held in high regard. Yet 'E. H. Baily RA' as he signed himself (always with the 'RA') and as he is now most usually styled, is not even indexed in the most recently published histories of the Royal Academy.[93] Not one of his funerary monuments is mentioned in Mrs Esdaile's pioneering *English Church Monuments 1510–1840* (1946), and Margaret Whinney, while including both Westmacotts, excluded Baily from her seminal *Sculpture in Britain 1530–1830* (1964). His reputation, like his work, fell, so to speak, into an oubliette. His prolific sculptural output – 112 funerary monuments, 60 statues, 135 busts and much more – was ignored by the next generation, and remained unregarded by generations of art historians thereafter.[94] The brief entries in older editions of the *Dictionary of National Biography* failed even to record that Baily was responsible for the statue of Nelson on top of the column in Trafalgar Square, a creation on a vast scale that has become, as was intended, an instantly recognizable symbol of London and Britain.

Yet in his time this forgotten sculptor was called 'England's Canova'. Baily's career, like that of his master Flaxman, is also

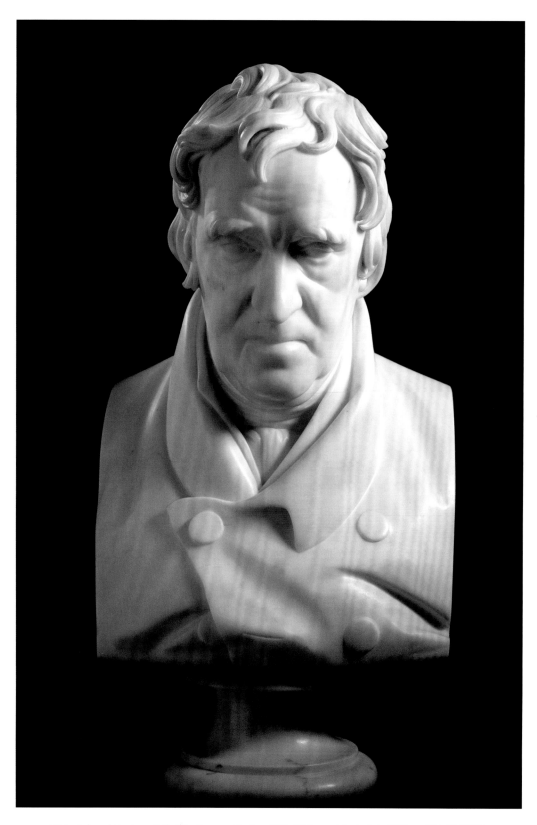

172 Edward Hodges Baily RA, *Thomas Stothard RA*, 1826, marble, height 55.9 cm (RA 03/3597).

integral to the story of the Royal Academy, and illustrates well the precepts of its foundation. He was born in Bristol, the son of William Baily, a wood carver who specialized in ships' figureheads.[95] Like many other artists he carried the Vasarian child-prodigy myth with him, for, after being 'spotted' by a Dr Leigh and given a commission to copy the line engravings in Flaxman's *Iliad*, he was encouraged to go to London. He was admitted in the Schools in 1809, the 982nd student enrolled, and among his peers were Peter de Wint, Lewis Vulliamy and Henry Wyatt.[96] He immediately distinguished himself with one of the eight silver medals awarded for 'Models' of Academy figures, in a year when only one gold medal was awarded (to James Adams). He subsequently gained several prize medals, and in 1811 he was one of three gold medallists, for his *Hercules rescuing Alcestes from Orcus*. It is probable that he was one of the young artists present in the Academy on Canova's visit in 1815.

Early in 1817 Council resolved that it would now be 'expedient...to maintain a student on the Continent', a responsibility that had lapsed while Europe had been in thrall to the French Empire. In July Council received requests from gold medallists E. H. Baily and Samuel Joseph to be considered as candidates for these travelling bursaries, and at the subsequent meeting their allowance was fixed at £130 per annum, each with £40 on setting out for travel expenses and a similar sum on return. It is possible that Baily never went to Rome, but if he did so it must have been a brief visit. However that may be, the year 1817 was momentous for Baily, because he was the only sculptor elected an Associate of the Academy in the General Assembly of 3 November. Thomas Lawrence, in a letter to Farington, when voting for Baily, declared, 'the Academy should have the support of the strongest talents.'[97] Later in the month 'Mr Edward Hodges Baily and Mr Abraham Cooper' were introduced as newly elected Associates, signed their Obligations and received their diplomas from the President. When Benjamin West died in March 1820, it left a vacancy in the body of the Academicians, and in February 1821 Baily defeated William Daniell (RA 1822), in two rounds, and was declared duly elected a full Academician, with the minutes signed by the new President, Baily's fellow Bristolian Thomas Lawrence.

A Council Meeting at the end of October 1821 recorded that Baily had offered to make *Eve at the Fountain* in marble as his Deposition (Diploma Work), and that it had been

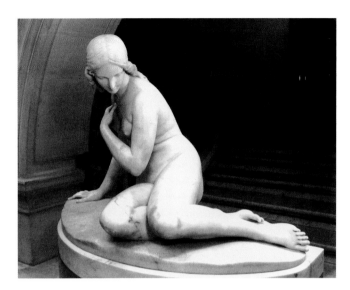

173 Edward Hodges Baily RA, *Eve at the Fountain*, 1822, marble. Bristol City Art Gallery, on loan to the Masonic St Augustine's Lodge, Bristol.

accepted.[98] Baily had exhibited a full-scale model almost certainly, as was the custom, in plaster in that year's Summer Exhibition, and he had earlier, in 1819, exhibited a 'Sketch for a figure of Eve, to be executed the size of life'. The potential acceptance of this composition in marble as a Diploma Work was incentive enough for Baily to invest in the expense and labour of transferring it from one medium to the other. Recent research has suggested that the RA Diploma Work and the marble acquired by subscription for the Bristol Institution in 1826 (fig. 173) were two versions of the same subject.[99] That Baily was later allowed to replace his original Diploma Work with another, the bust of Flaxman, might suggest that the subscription raised by the citizens of Bristol was regarded as prestigious enough a commission, coming from the second city of the land and the birthplace of both the sculptor and the President of the Royal Academy, to warrant such a rearrangement, particularly as Baily was in financial straits. Baily's manoeuvrings may indeed have formed a strategy, and the episode certainly led to further commissions such as the figure of *Justice* on Sir Robert Smirke's Council House in Bristol.[100] This would mean that the two versions of *Eve* are in fact one and the same. Baily was, however, more often than not in financial trouble, and the exchange of Diploma Works could have happened at any

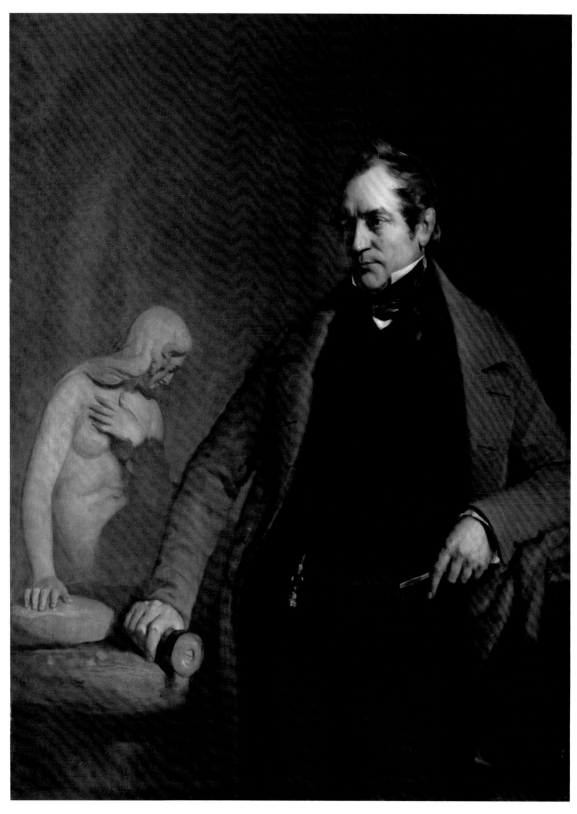

174 Thomas Mogford, *Edward Hodges Baily at Work on Eve at the Fountain*, oil on canvas,
143.5 × 112.6 cm (RA 06/4203).

time, possibly as late as 1859 when, on the point of retiring, he offered the Academy a number of busts of Academicians 'by his own hand' as well as a painting of himself by Thomas Mogford – which shows him at work on *Eve at the Fountain* (fig. 174).[101] The matter is further confused by Baily's habit of repeating his own work, as Canova had done before him, although that is in itself a sign of popular demand.

The composition for *Eve* was said to have been based on a small Roman torc in the British Museum that Baily had first used as the source for a knop to the lid of a silver gilt bottle cooler, the plaster model for which is a rare survival.[102] The classical type that provided the conceptual idea for this was well known in versions of the *Venus* or *Nymph with a Shell*.[103] Baily is said actually to have made a cast of his wife in the pose of Eve, a method that might be considered as taking the notion of perfection to its logical conclusion. In fact, this procedure was disapproved of: the avoiding of any modelling on the part of the sculptor was considered to lack aesthetic or technical merit. The sculptor also laid himself open to other criticism. Taking a life-cast from a paid model would infringe the norms under which models were accepted in the nude, for, as has been pointed out, models were held to be little better than prostitutes, even though they might be privately celebrated as courtesans.[104] His wife preferred modelling for her husband rather than having him pay other women, of whom she is reported to have been jealous.[105] This meant, however, that her husband was exposing her in the nude, albeit at two removes (carved in marble from a plaster cast), to the vulgar gaze of thousands at the exhibition. Despite all these controversial factors, the work itself gained immediate and universal fame. It was engraved in 1822, the year that it was exhibited at the Academy in marble.[106]

The influence of Baily's *Eve* casts long shadows. Almost a hundred years later, in 1913, the Danish sculptor Edvard Eriksen's *Little Mermaid*, a composition clearly based upon Baily's, was unveiled in the harbour at Copenhagen.[107] As recently as 2011, Royal Academician Cornelia Parker's *Folkestone Mermaid* was sited near the harbour of that port. Based knowingly on Eriksen's *Little Mermaid*, and cast in bronze from a life-cast – unknowingly echoing Baily – it is asserted to be specifically unidealized, and to embody 'real people with real values and fears'.[108]

Throughout his working life Baily was involved in many notable public projects, many of which have become part of

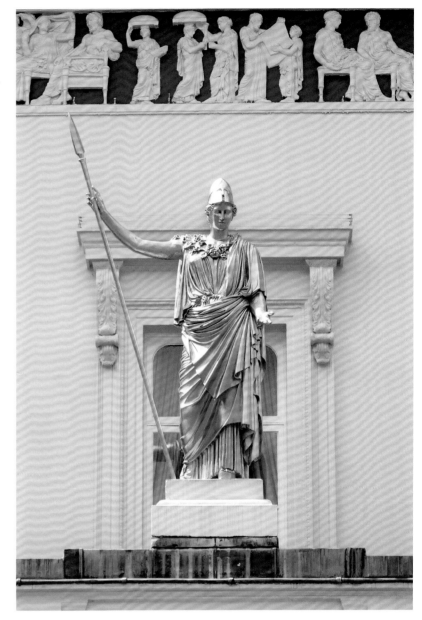

175 Edward Hodges Baily RA, *Athena*, c.1830, marble and gilding. Athenaeum façade, Pall Mall, London.

the fabric of two great cities, London and Bristol. In London his creations are familiar, from the sculptural ornament on Marble Arch (*c.*1828) and the gilded *Athena* (*c.*1830) above the entrance to the Athenaeum Club (fig. 175) to *Nelson* (1839–43) on Nelson's Column in Trafalgar Square: all silent witnesses to this long-forgotten British sculptor.

In his lifetime, however, Baily was never out of work nor out of mind. There were, for example, eight works by him in Paxton's Crystal Palace for the international Great Exhibition in Hyde Park in 1851. In the mid-1850s he was contributing historical figures to the embellishment of the Houses of Parliament: *William Murray, 1st Earl of Mansfield* (1855) suggests a nice synchronicity, since Flaxman had executed the lawyer and jurist's monument in Westminster Abbey; and *Charles James Fox* (1856), for whose brother Henry, 3rd Lord Holland, Baily had made the monument of Fox in Westminster Abbey (1845).[109] Baily was one of 14 sculptors who contributed to the grandiose quality of the Egyptian Hall for the Mansion House, City of London, with the figures of the *Morning Star* (1853–4) and the aptly named *Fate of Genius* (1856–7; destroyed).[110]

Baily's assistants considered him a fairer and better employer than Francis Chantrey,[111] a characteristic possibly acquired in the seven years Baily spent in the sympathetic environment of Flaxman's studio. These numerous assistants stayed with Baily for long periods, and went on to make names for themselves, some to become ARAs and RAs, forming a roll-call of distinguished sculptors of the mid-nineteenth century: Joseph Durham (ARA 1866), Alfred Gatley, William Calder Marshall (RA 1852), Edward Bowring Stephens (ARA 1864), William Theed Junior and Musgrave Lewthwaite Watson. Baily's work is neoclassical but he established an influential style of his own, known as ideal or 'poetic' sculpture, since it was often inspired by English poetry, exemplified by the work not only of his former assistants but also of other sculptors. Baily's style can also be seen as foreshadowing that of later sculptors associated with the Pre-Raphaelites such as Thomas Woolner RA and Lawrence Macdonald.

Like J. M. W. Turner, Baily remained engaged in Academy business throughout his life. He became an honorary retired Academician after he ceased to exhibit in 1862, and his name appears with surprising regularity in the minutes of Council and General Assembly. His willingness to help was not always appreciated. For example, in April 1837 he asked to be present at the arrangement of the sculpture for the Annual Exhibition, the last at Somerset House, but the hanging committee that year was made up of painters, and Council stressed the 'impossibility' of 'complying'. This was a periodic problem, and one that Baily was clearly not prepared to accept. Later that year he found his 'pecuniary embarrassment to be such

as to compel him to solicit the assistance of the Council'.[112] Presumably on this occasion he felt his work had not been seen to best advantage and sales had suffered in consequence. Henry William Pickersgill RA, seconded by William Etty RA, moved that he should receive £30, which was agreed unanimously.

In November 1843 Baily faced disgrace. It had been brought to the attention of Council that he had worked on student prize submissions, the reprise of an incident at the Duke of Richmond's gallery when Joseph Nollekens and John Walch were disqualified from the award of premiums for models when it emerged that Joseph Wilton had aided them a little in their manufacture.[113] Baily was invited, as was customary in such cases, to attend Council and make a statement.[114] At a special meeting convened three days later, a letter signed by Baily was read out in which the sculptor stated 'most solemnly that I have never placed a finger upon the Model of any student. Still I must own that in passing through the school I gave my advice to one & all – as to individual defects relative to the figures or proportions – This as a Member of the Academy I considered myself bound to do for general advantage – no favour can have been shown thereby, as all parties enjoyed them equally, or, should it apply, it makes all alike ineligible.' A letter from Council was drawn up, accepting Baily's denial and stating that it would proceed no further, but it gave him a solemn and severe dressing down for the 'irregularity' of his being in the Antique School while students were working on the models. It was agreed the eight students were to be admitted, with five in favour and two against, and Thomas Phillips was tasked with bringing in new regulations.

At the end of 1852 Baily suggested to the General Assembly that as a 'greater amount of skill [was] required to produce a Bas-relief as compared with a statue or group in the round', students either should present in bas-relief or else all should be in the round. Six months later Baily made another intervention, complaining by letter to Council of the placing of his sculpture in the Annual Exhibition: he had altered the positions of his sculpture, but afterwards they had been restored to the former positions. Council resolved that the arrangement of the exhibition must always be completed before the general admission of the members, and noted somewhat testily, 'Mr Baily had no right whatever to alter that arrangement, and that any complaint he might have had

to make should have been submitted to the Council in the first place.'[115]

At a meeting on 13 November 1856, Council noted the 'Will and Funds of J. M. W. Turner', by whose will a medal, to be called 'Turner's Medal', equal in value to the Royal Academy's gold medal, was to be awarded for the best landscape painting at the biennial distribution. There was to be a public competition for the design, with a best and a second best. Then Council revoked this decision, and Baily was asked to produce designs. These were thought to be unsatisfactory, and after William Dyce had produced a design for the obverse – which included a profile portrait of the late painter – a competition was again opened for the reverse, which was eventually won by Daniel Maclise RA.

Baily's financial hardship continued. In 1858 he wrote to Council setting out his reasons for relinquishing 'further Professional labours', and requesting that he be placed on the list of 'Pensioners of the Academy ... having no other resource for his future maintenance and requesting also assistance to relieve him in his present pressing difficulties'.[116] This was moved and seconded, and it was resolved that he should be placed on the Pension List from Christmas that year and be awarded a donation of £50. Nearly four years later his circumstances were as bad as ever. In April 1862 he again wrote to Council for pecuniary assistance 'being in circumstances of much difficulty', and it was resolved to forward £50 to him.[117] At the end of the year Baily wrote again, asking to be placed on the list of retired Academicians, and it was resolved that the matter should be referred to the General Assembly that he be made a candidate 'for the class of Hon[y] Retired Academicians'.[118] Letters from Baily and also from the architect C. R. Cockerell RA were read to the Assembly in December and, by a unanimous show of hands, it was agreed that both should be put on a list of Honorary Academicians.[119] Within the institution to which he cleaved throughout his life, Baily's repeated appearance in the minutes probably led to an element of impatience among fellow and younger Academicians as the years went on. Lady Eastlake's kindly way of referring to the sculptor as 'Dear old Baily' may echo her husband's private reflections on returning from yet another meeting in which Baily's troubles appeared as an agenda item.

Both Baily and his work were the subject of a number of portrait images and engravings, indicative of his contempo-

176 Maull & Polyblank, *Edward Hodges Baily RA*, 1866 or later, albumen print mounted on card, 9.1 × 5.9 cm (RA 03/3662).

rary fame. An arresting image of him by Charles Hutton Lear shows him working intently on a small model, while in an anonymous cartoon thought to be of about 1850 the sculptor is seen either in his studio or in the RA itself as a colossus among pygmies, before whom he appears to be lecturing (both National Portrait Gallery, London). Baily was among the first artists to be photographed, which he was several times in the 1860s (fig. 176). As late as 1882, the *Art-Union* produced a handsome medal by Alfred Benjamin Wyon fea-

turing Baily's portrait in profile on the obverse and his most famous work, *Eve at the Fountain*, on the reverse (Victoria and Albert Museum, London). Baily's sculpture itself proved ideal for early photographic experiments, and Henry Fox Talbot, for example, used a scale version of *Eve at the Fountain* in his prodigious early experiment of printing some 6,000 Talbotypes or 'sun-pictures' for a promotion by the *Art-Union*, which therefore became the first journal to reproduce photographs. Only some four dozen or so of these images are known to survive, Baily's *Eve at the Fountain* among them.[120] Baily's *Sabrina* (a subject from Milton's *Comus*) proved an ideal subject for a late nineteenth-century stereoscopic photograph, or 'stereograph', published by the London Stereoscopic Company (Victoria and Albert Museum, London).[121]

The cultural and social climate was changing during Baily's lifetime, which helps to account for his descent into financial difficulties and oblivion after his appearance on the *Art-Union* medal of 1882. One stylistic change was radical and profound: the Gothic was replacing the classical as a principal source of inspiration and creativity. This was a reflection of changes in religious sensibility and understanding, but there were changes too in social mores: what has generically become known as Victorian values. Notoriety for casting the body of one's wife in plaster might have been a step too far in the 1820s, largely on the grounds of technology bucking the modelling process, but by the 1840s it would have been seen as socially unacceptable as well. The pure, Canovaesque elegance of Baily's work, the apogee in both sensibility and technique of the Italian master's *carnosità*, so admired in its day, came to be regarded as derivative, effete, even decadent. Indeed, Baily's very success in representing flesh in marble may later have told against him, as may his engagement in commerce and the artisan trades. Although Baily was included in the vast 'Age of Neo-Classicism' exhibition held at the Royal Academy and the Victoria and Albert Museum in 1972, he was represented only by a design for a wine-cooler and appears in the index to the catalogue under 'Artists and Craftsmen' in the 'Furniture and Applied Art' section.[122]

Curators at the V&A might be forgiven for having treated Baily purely as a designer of silverware, because for over half

177 Edward Hodges Baily RA, *Horatio, Viscount Nelson*, 1843, granton stone. Nelson's Column, Trafalgar Square, London.

a century he modelled some of the grandest centrepieces, such as the *Montefiore Testimonial* (1842), of the kind beloved of memorial-minded plutocrats,[123] and racing cups both maritime and equine. He worked with Flaxman for Rundell Bridge and Rundell, the royal goldsmiths, and was later assistant to the great silversmith Paul Storr at their Dean Street premises. Later, when Storr went independent, Baily became his chief modeller.[124] Magnificent silver pieces produced throughout his career were regularly illustrated in the *Illustrated London News*, the *Builder* and the *Art Journal*. This form of activity may have done Baily no service, however, because by the 1850s it became 'fairly exceptional' for sculptors to be engaged in metalwork design.[125]

It seems that Baily – unlike Lawrence, or that other West Countryman Sir Humphry Davy, or indeed his fellow sculptors Joseph Wilton and Sir Francis Chantrey – never quite made it into polite society. Baily, coming from a provincial and, like the scientist Michael Faraday, a Nonconformist background, may not have sought social success. He does not seem to have courted patrons as other artists did, even such rough diamonds as Turner. Baily's failure to make anything of the opportunities of a Rome scholarship, and his wife's attitude towards female models, suggest a low-key sobriety of personal beliefs. Perennial penury and near bankruptcy, which had always been a hazard of the sculptor's profession,

came to have a social stigma, so sharply described by Dickens, Thackeray and, later, Trollope. And so, while in an earlier age a number of sculptor Academicians, William Tyler and Joseph Wilton among them, were bankrupted at different stages of their careers and survived, Baily, despite continuous and prestigious work, could not.

Today it is easy to underestimate the contemporary reputations of Flaxman and Baily, two of the Royal Academy's most successful sculptors. Baily in particular played a major role in one of the most famous monuments in the world, Nelson's Column, directly opposite the Academy's quarters (from 1837) in Wilkins's National Gallery building on Trafalgar Square. Academicians had been involved, as we have seen, in most of the public monuments to national heroes, but this was the most ambitious of them all, of granite, sandstone and bronze with sculpted reliefs and monumental lions. It had begun with a design competition in 1840 that was won, on a re-run, by the architect William Railton on condition that Baily should carve the statue of Nelson. The column was installed in 1854 although the lions, designed by Edwin Landseer RA, were not put in place until 1867, the year of Baily's death and the year before the Academy moved to Burlington House. Baily's gigantic and evocative statue on the top of the column stands as a memorial not only to a national hero but also to a forgotten stalwart of the Royal Academy (fig. 177).

A CLOSER LOOK

6.1

Thomas Banks
Falling Titan

Diploma Work

HELEN VALENTINE

In 1812 John Britton wrote of this sculpture (fig. 178): 'In form, expression, anatomical accuracy, and adaption, this statue approaches perfection: it is one of those works of art, that in a small compass, and with simplicity of parts, may be called sublime.'[1] Thomas Banks had entered the Schools in June 1769 and in the following year won the gold medal and the travelling scholarship to Rome. Sir Joshua Reynolds had pronounced him 'the first British Sculptor who had produced works of classic grace' and felt sure that 'his mind was ever dwelling on subjects worthy of an ancient Greek'.[2]

Banks returned to London in 1779 having spent seven years in Rome. He was elected ARA in 1784 and RA the following year. It was perhaps in recognition of the support he had been given by the Academy that Banks offered such an impressive and ambitious piece as his Diploma Work. Before 1786 there had been only three sculptural Diploma Works deposited by RAs: an engraved gem of *Neptune* by Edward Burch given in 1771, a small marble relief of *Cupid and Psyche* by Joseph Nollekens given 1773, and a marble bust *Sickness* by John Bacon from an element of his monument to Thomas Guy, presented in 1778.

The subject of the *Falling Titan*, or *A Falling Giant* as it has also been called, depicts the doomed attempt of an earthbound giant to reach Olympus and overthrow Jupiter by piling up great boulders, only to be crushed by the same stones. This dynamic sculpture represents the anguish and pain of the giant as he is flung down the mountain, and the presence of the huge mass of rocks bearing down on the figure greatly contributes to the drama. The immense size of the Titan is made clear by the inclusion of a tiny figure of a satyr and two goats who are seen fleeing in fear at the base of the sculpture.

The dramatically foreshortened figure of the Titan may be derived from sessions of academic drawing that Banks and Henry Fuseli shared when they were both students in Rome together. Banks's daughter, Lavinia Forster, recalled that the two young men were 'very fond of comparing figures from five points placed at random, and I have several of their sketches made in that way. It is probably that one of these first suggested to him the idea of The Fallen Titan.' These very early sketches, she claimed, were 'done while he [Thomas Banks] was in Italy; and probably he had not till then had an opportunity of executing this subject, which had for so many

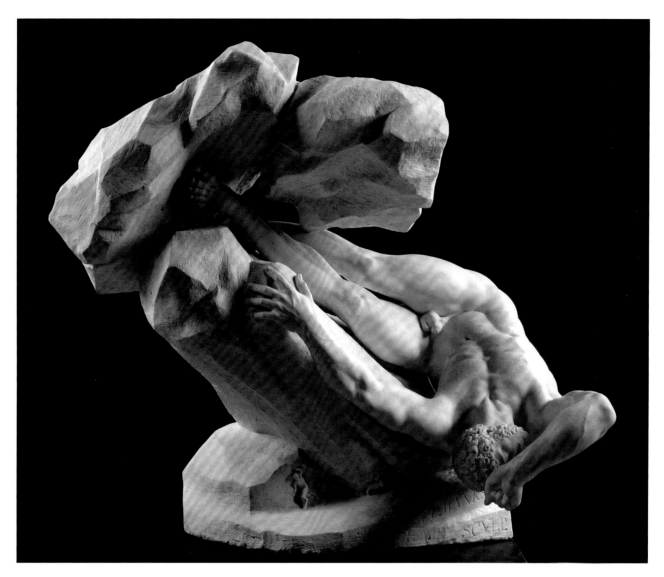

178 Thomas Banks RA, *Falling Titan*, 1786, marble, 84.5 × 90.2 × 58.4 cm (RA 03/1673).

years dwelt on his mind.'[3] To be more specific, it seems likely that the pose was derived from one that is known to have been set in the life class of the Académie de France in 1777–8.[4]

Banks's daughter also recollected that, while her father was working on the sculpture, he had said that 'he conceived the subject to exist in the block of marble, *a priori*, and that it was called forth by the sculptors hand.'[5] Nonetheless, careful preparation went into the production of the piece. In addition to sketches, Banks produced a clay model (of which a plaster cast exists in the Royal Academy collection) that with the exception of a reduced mass of boulders is faithful to the marble version. The sculpture is also significant in that it is half-life-size, this being a requirement of the *morceaux de réception* that newly elected academicians in France gave to the French Académie royale in Paris. Another factor in this choice of scale for such an ambitious piece is that anything larger might have proved too great a challenge for Banks, particularly for a sculpture that was to be presented to the Royal Academy.

John Flaxman
Apollo and Marpessa

Diploma Work

KATHERINE EUSTACE

Apollo and Marpessa was offered by John Flaxman as his Diploma Work in 1800 (fig. 179) and shown the same year at the Royal Academy exhibition. It is a consummate example of the linear composition and relief at which Flaxman excelled. It is thought to have been produced while Flaxman was in Rome (1787–94), which would account for the highly finished surface treatment so characteristic of Italian sculptors' assistants at the time. Compositional studies (in pen and ink and wash; Fitzwilliam Museum, Cambridge, and Scottish National Gallery, Edinburgh)[1] of the same uncommon subject (taken from Apollodorus) owe much to Flaxman's fascination with Athenian red-figure vases and the Meidias Hydria in particular (4th century BC, British Museum, London). Apollo, less lost in god-like aloofness than the Apollo Belvedere but kin to it nevertheless, steps down and forward in pursuit of the mortal Marpessa, with his cloak held aloft by the energy of the movement: what Flaxman described in his lecture on drapery as the 'impulse of motion', suggestive of the urgency of the moment.[2] Marpessa, while inclining backwards towards her pursuer, feigns modesty as she draws about her the 'peplos or veil … an outward female garment, like the cloak or pallium, but of a finer texture, worn by Homer's female divinities and

heroines'.[3] The relief work is higher than usual for the sculptor and, as Flaxman put it, 'allows no picturesque addition or effect of background; the story must be told, and the field occupied by the figure and acts of man.'[4] It is a good example of Flaxman's theory that drapery was 'a medium through which the human figure is intelligible'.[5]

The process involved in bringing *Apollo and Marpessa* back to London may have prompted Flaxman to engage in an area where the Academy had played a significant part from the outset: the matter of customs duty to be paid by artists and students on works of art brought back from the Continent, mostly from Florence, Rome and Naples. Earlier, the gem engraver Nathaniel Marchant ARA had instigated a bill, moved by Lord Camelford in Parliament, that British artists studying in Italy should be allowed to bring works into the country duty free. The bill was passed, and the Royal Academy undertook to oversee the business, members of Council attending at the customs house as and when they were given notice.

Under this dispensation Flaxman himself brought in works.[6] Perhaps *Apollo and Marpessa* had been the victim of some customs official's petty-mindedness because, when the matter was raised again, Flaxman went to see Benjamin West PRA to

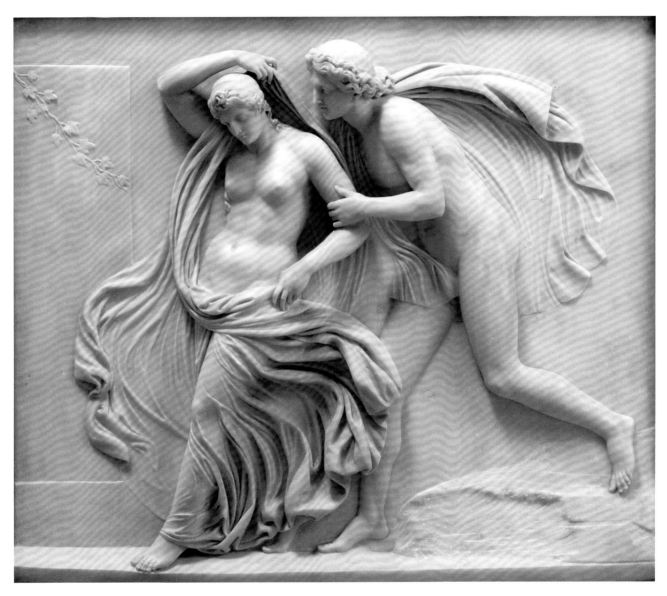

179 John Flaxman RA, *Apollo and Marpessa*, c.1790–94, marble, 48.4 × 54.8 cm (RA 03/171).

discuss it. Duty was set at 27½ per cent on sculpture and 6*d*. each on prints, and 'the expences in short are so great that artists forbear to purchase.'[7] This state of affairs was seen to be counter to the cultural ambitions of the country. The following summer Flaxman called on Joseph Farington RA to read a letter to be sent to Gavin Hamilton at Rome, stating that the Lords of the Treasury had granted permission for British artists to import, duty free, casts, prints and drawings which had been purchased for their use and study. The letter mentioned Charles Long and Farington as being responsible for obtaining the 'indulgence', although there must be a suspicion that here the self-effacing Flaxman had also been at work.

VICTORIAN AND MODERN SCULPTORS

BENEDICT READ

Histories of the Royal Academy, particularly the more recent, have been remarkably silent about the role of sculpture. Even now that the Victorian era has been rescued from ridicule and neglect, its sculpture has rarely featured, which is puzzling, all the more so in view of the fact that the two greatest bequests to the Academy, in cash and kind, were both made by sculptors in the nineteenth century: Sir Francis Chantrey RA and John Gibson RA (fig. 180 and see fig. 128).

Chantrey died in 1841 leaving approximately £150,000.[1] He had been the most successful portrait sculptor of his time in both bust and statue format from 1805 until his death and also produced a mass of church monuments. His work answered the needs of the rich and privileged classes of society, and his clients numbered many of the major personalities of his time. His portraits were particularly favoured

because he could render marble in such a way as to seem to represent living flesh. Indeed, he was a master of naturalism. By roughing up the surface against the grain, when the stone was viewed in a certain way he seemed able to suggest the pores of the skin's surface. Chantrey left a life interest in his estate to his widow, and when she finally died in January 1875 the Academy was ultimately left in possession of approximately £105,000, a vast sum. The effect of this and of the conditions attached, together with an assessment of the modern-day equivalent value, are dealt with in the course of the following account.

John Gibson died in Rome in 1866.[2] He was born in North Wales in 1790, and after early training and work in Liverpool and London he arrived in Rome in 1817, where he effectively spent the rest of his working life, setting up a

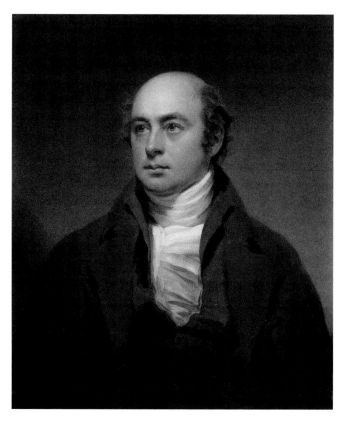

180 Charles Turner ARA after Sir Henry Raeburn RA, *Sir Francis Chantrey RA*, 1843, mezzotint, 25 × 20.9 cm (RA 06/4683).

studio that was visited by the eminences of Europe, among whom he established a flourishing clientele. Gibson produced funerary monuments and portrait statues, but his speciality was reliefs and statuary of classical subjects in neoclassical style. He was willing to produce marble replicas of many of his creations, which can be found throughout Europe. He was able to do this because, like most nineteenth-century sculptors, he retained in his studio the original plaster models of his works that clients could view, admire and, with luck, order a marble equivalent to buy.

What Gibson left the Academy principally was the collection of his plasters and drawings and the sum of £32,000.[3] Gibson's will was made initially in Rome in 1855, but an important codicil was added just before his death after consultation with the Academy. In the final document he left various bequests to relatives and friends including, for example, an annuity of £100 to his beloved brother

Solomon Gibson and a one-off gift of £200 to the author and reformer Anna Jameson. But the entirety of drawings, by himself and other artists, he left to the Academy along with the bulk of the plaster models in his Rome studio.[4] He did specify that his general executors, Sir Charles Eastlake (then PRA), Philip Hardwick (then RA Treasurer) and Gibson's close friend William Boxall RA (in lieu of J. P. Knight, RA Secretary), might allocate 13 specified plasters to such public institutions as they chose with a view to 'their being preserved and kept for public instruction'. These included the plaster *Queen Victoria Standing* and *Hunter and Dog* (fig. 181). The remaining compositions, works, plaster casts and models, whether his own or by other artists, he left in trust to the President, Treasurer and Secretary of the Academy in order that they may be 'employed or disposed of' under the direction of the Council for the development and advancement of the study of drawing and modelling. He also appointed two Roman executors, the painter Penry Williams and the sculptor Benjamin Spence.

In March 1865, however, Gibson added the codicil. It proposed a much tighter disposition of his assets. He included the marble group of *A Young Warrior Wounded Assisted by a Woman* that he had almost completed and any other marble works that remained unsold in his studio at his death. He also added the plaster models of all his works executed in marble in his lifetime, except the plasters of the marbles now assigned to the Academy (in order to avoid duplication). He then, and this was crucial, specified the bequest to the Academy of the sum of £32,000 on condition that the Academy officers provide 'sufficient and convenient space to arrange and preserve my said Works of Marble Plasters and Models' so that they might be seen by RA students and by the public. Moreover, he stipulated that the said officials 'shall hold and possess my said Works in marble models and casts upon trust so that they may be from time to time exhibited and viewed (subject to such regulations as the Council for the time being of the said Royal Academy shall deem suitable)' by the students and also by the public at the time of the Annual Exhibition. The President, Treasurer and Secretary could hold on to the money for the time being, until it was dispensed in order to fulfil the purposes of the bequest, except that none of the money could be applied either to the purchase of land or for any other purpose that could not be legally justified.

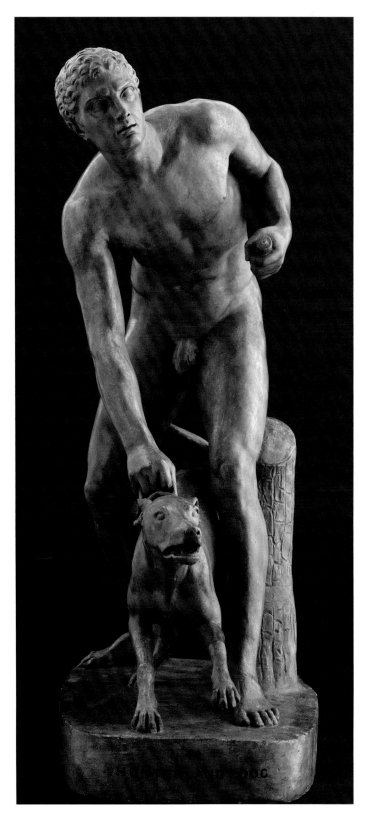

181 John Gibson RA, *Hunter and Dog*, c.1847, plaster, height
153 cm (RA 03/1727).

The will was passed for probate in London in May 1866 in favour of the surviving general executors, Hardwick and Boxall. (The sum was finally confirmed by Hardwick in June 1868 as £33,354 1s. 1d. held by the RA plus £6,896 14s. 5d. held at Drummond's Bank, a total of just over £40,250.)[5] Eastlake had died on 24 December 1865, and it is intriguing to speculate whether the firmer directives incorporated in Gibson's 1865 codicil had been influenced by his correspondence with Eastlake in November 1864.[6]

The full details of the bequest were spelled out by Gibson's friend and surviving Roman executor, Penry Williams, who like Gibson had settled permanently in Rome as a young man. (The other Rome executor, Benjamin Spence, had died by this date.) On 29 May 1867 Williams wrote to Boxall saying he had all the works and property from Gibson's studio and residence ready for sending, in three batches, totalling 77 cases. This included cases of drawings by Old Masters, others by Gibson himself and possibly some by Spence; 11 diplomas from European academies; a Star of the Legion of Honour; and a case with papers, clothes and miscellaneous items including Gibson's court dress, cocked hat, shirt with wide sleeves, cashmere shawl, travelling pouches and shoe-horns.[7] Williams was also being urged by Gibson's Roman friends to include in the bequest his unfinished last work, *Mercury and the Robber*, which Hardwick and Boxall had previously declined. It could easily be finished off, it was clear, because Harriet Hosmer had in her possession a large finished study of the group from which a carver could complete the work. At the same time, other sculptors were keen to have the studio, including a 'Mr Adams' (almost certainly John Adams, known as John Adams-Acton from 1869, who had been in Rome since 1858 and admired by Gibson),[8] and a 'Mr Cardwell' (Holme Cardwell).[9] But the landlord would not allow any subletting, which was prohibited in the lease without the consent of the landlord, who, moreover, wanted to take it back while refunding part of the rent, retaining only whatever was necessary for repairs.

In addition to these complications, there remained the problem of what to do with what was left in the studio. Might any duplicates of what was going to the Royal Academy, in

the shape of plaster statues, groups and reliefs, be presented to the Accademia di San Luca in Rome, which was complaining that Gibson had left it nothing? Williams had given various minor remains to Harriet Hosmer, but there were stands and blocks of marble which 'Baini' (Gibson's assistant?) wanted. Williams had been very stressed since Spence's death and had done no work in his own studio. A reply to Williams's letter to Boxall about all this came back by telegram: 'Do nothing wait my letter written by President [Sir Francis] Grant's desire Boxall'.

The Gibson boxes duly arrived at the Academy, but because the new galleries designed for Gibson's sculptures were not ready, the boxes were stored in part of what had been the Academy's Trafalgar Square premises. The new Gibson Galleries were ready in about April 1874,[10] by which date there had already been a question in the House of Commons, in July 1873, about the delay, which was answered effectively by the First Commissioner of Works, Acton Smee Ayrton.[11] As soon as the new galleries were complete the boxes were brought over, but 'so broken and shattered... did the plaster models prove to be when they were unpacked, that all idea of exhibiting until properly repaired was out of the question.'[12] The Academy's chief plaster expert, Domenico Brucciani, was called in to do the repairs under the supervision of William Calder Marshall RA. And there, in the Gibson Galleries, this remarkable bequest remained on display for some 80 years.

Gibson had sent Eastlake an exact plan of how his works should be arranged, but it became detached from the correspondence and so we do not know his intentions. All that does survive is a plan in Gibson's hand of how some were arranged in his Rome studio.[13] Also absent is any visual record at all of what the Gibson Galleries looked like. In later printed catalogues of the Gibson and Diploma Galleries there is at least one general plan locating the 'Gibson Gallery' in the space now occupied by the Library. These catalogues list the works, and separate volumes of selected individual illustrations were issued during the 1930s, but we know that the space was being used as storage certainly from the 1950s, and that there had been a cull in May and June 1950 when nine plaster statues, allegedly damaged, were destroyed, two by a subcommittee, seven by order of the Keeper, Henry Rushbury RA.[14] The trail of destruction can be followed in the RA Council minutes: 'Resolved that the Keeper with a

small committee consider and report with recommendations for the removal from the Academy of a number of casts and other articles in the Schools and the basement which appear to be redundant'; 'A committee should be appointed to decide on the clearance of unwanted casts from the Schools'; 'Report read of the Committee appointed... to consider the clearance of redundant property of the Academy, recommending the removal of a number of casts in the Schools, Entrance Hall and basement... The report was approved, and the Keeper was authorized to carry out its recommendations forthwith.'[15] Gibson's original plaster model for the *Tinted Venus*, of which the fingers and apple were damaged, was destined for the same fate but was rescued by Sir William Russell Flint, who gave it to 'a lady' who returned the model to the Academy after her death in 1969.[16]

Gibson's original intention, as outlined in his correspondence with Eastlake, was to follow the pattern of his great Roman contemporaries, Canova and Thorvaldsen, who had set up museums of their own works in Possagno and Copenhagen respectively. Many other such collections were set up in Europe – for example, those of David d'Angers in Angers, Christian Daniel Rauch in Berlin and Charles-Auguste Fraikin in Herenthals. There were similar collections in England such as those of John Lough and Matthew Noble, both in Newcastle-upon-Tyne, and Frederick Thrupp in Torquay. The fortunes of these self-glorifying monuments have varied. While the Rauch collection survives in part in Berlin,[17] the works of Lough and Noble were recycled in the form of hardcore for Newcastle's urban motorway in the 1960s.

The third floor of the Academy building, which, we recall, was largely paid for by Gibson, now houses the Sackler Galleries, Library and Archives. Gibson is (just) remembered by the statue of the *Wounded Warrior* on display in the Library – appropriately so, since this space was formed out of what was the Gibson Gallery proper – and five of his works are to be seen on the cornice outside the Sackler Galleries, including his Diploma Work, *Narcissus* (fig. 182). The remaining 52 or so works are either on loan or in store. (The clothes, caps and knick-knacks are on deposit at the Welsh Folk Museum in St Fagans, near Cardiff.) The surviving works have, admittedly, been superbly catalogued and their condition checked, although it is hard to resist the thought that this is the least that could be done. Unfortunately, Gibson's will in the end

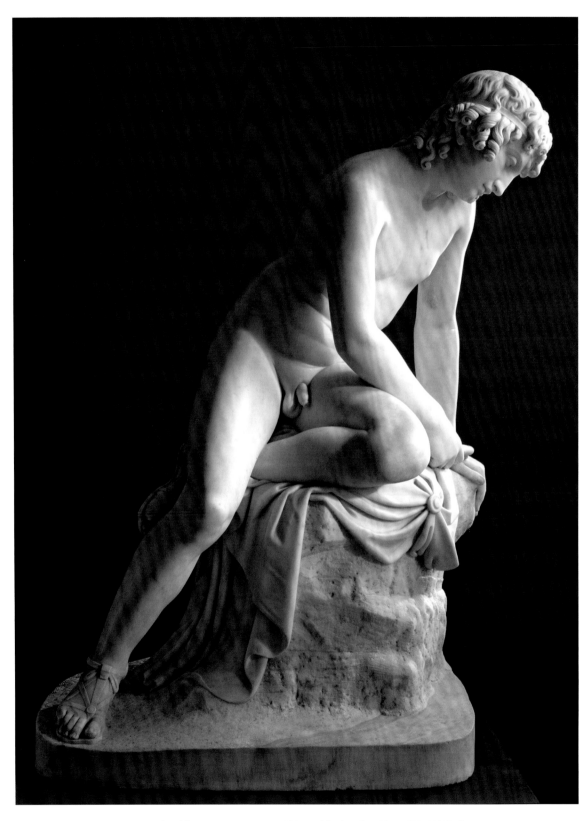

182 John Gibson RA, *Narcissus*, 1838, marble, height 108 cm (RA 03/1918).

gave control to the RA Council and so legal recourse, even if desirable, would be pointless. Nonetheless, the feeling persists that a more obvious public acknowledgement of one of the greatest benefactions the Academy ever received might be made at the site of the vanished galleries funded by Gibson's bequest.

AFTER GIBSON

Gibson's bequest is, in a way, the tip of the iceberg of sculptors' very considerable involvement in the nineteenth-century Academy. The stalwarts of mid-Victorian sculpture were elected Associates then full Academicians: E. H. Baily in 1817 (RA 1821), William Wyon in 1831 (RA 1838), Gibson 1833 (RA 1836), the younger Richard Westmacott in 1838 (RA 1849), William Calder Marshall in 1844 (RA 1852), John Henry Foley 1849 (RA 1858) and Henry Weekes 1851 (RA 1863). Some only rose to ARA: W. F. Woodington at the age of 70 in 1876, E. B. Stephens in 1864 and Joseph Durham in 1866. Fuller details of sculptors proposed for ARA are recorded from 1866,[18] and between 1866 and 1870 we find an intriguing record of successes and failures. Woodington was proposed by Weekes and George Jones RA on 11 November 1866 but not elected until April 1876. Thomas Woolner was nominated on 5 December 1866 by William Boxall and his one-time Pre-Raphaelite colleague J. E. Millais RA, elected in January 1871 and made full RA in 1874. The same day Matthew Noble was nominated by E. M. Ward and C. W. Cope, but the notes read 'deceased 1876' without his having made further progress. At the same time, C. F. Fuller was put forward by Millais and Weekes on 10 December, but he died unelected in 1875. Similarly, in December 1866 Thomas Thornycroft was nominated by Foley and Durham, but he asked for his name to be 'erased' in 1874. And so it went on, many dying before being elected. In October 1869 Alfred Elmore RA and Frederic Leighton RA honourably but vainly proposed Alfred Stevens. There were some successes: Henry Armstead was proposed by Watts and Henry Wells in 1870 and elected in 1875; Joseph Boehm was nominated by Boxall and Watts in 1870 and elected ARA in January 1878.

With the exception of the case of Woolner, we do not really have evidence of what might have gone on behind the scenes. Woolner was a founder member of the Pre-Raphaelite Brotherhood in 1848 and was always held to be – and held himself to be – a forthright, outspoken character. From surviving correspondence we can identify that he had a complex attitude towards the Academy.[19] He claimed to be ill treated by the Academy and hated by its sculptor members; he cared nothing for fancy titles and did not want his time to be taken up by Council meetings.[20] Nevertheless, he was active in lobbying to become ARA and RA. Many friends claimed he would make much more income with initials after his name, and he felt he had support from painter members, such as J. F. Lewis RA and Solomon Hart RA. He pressed his good friend and fellow Pre-Raphaelite the critic F. G. Stephens to campaign for him, mentioning also Richard Redgrave RA and Thomas Creswick RA as potential supporters. He even admitted that a minority of sculptors might be sympathetic towards him, such as, possibly, Richard Westmacott the Younger, and he clearly saw John Foley RA as a supporter, writing to Mrs Tennyson in 1859 that 'he does me the honor to think well of my efforts: he told me that for many years he had felt nothing but disgust at the way the R. Academy had treated me.'[21]

When Woolner was elected full Academician in 1874, he filled the sculptural vacancy of the man he identified as his alleged sole friend among the sculptors, Foley. He was congratulated by Lawrence Alma-Tadema RA and – significantly – by the President, Sir Francis Grant: 'Allow me to offer you my hearty congratulations on your election[.] You are <u>the</u> man I wanted.'[22] Woolner did admit to J. F. Lewis that he was gratified by 'the hearty and friendly way in which I have been welcomed by the Members' although not, of course, the sculptors, who 'looked sourly as usual'.[23]

Full members played a multiplicity of roles in the governance, exhibiting and teaching of the Academy. Between 1860 and 1880, for instance, Foley, Calder Marshall, Weekes, Patrick MacDowell RA, Baron Marochetti RA, Westmacott, Woolner and Boehm served varying terms on the Council. Calder Marshall (fig. 183) served nine years as Auditor as well as five years as Inspector of Property. Marshall was, in his way, a key representative sculptor in the running of the Academy and other roles. Born in Edinburgh in 1813, he trained in London in the studios of Chantrey and Baily and at the RA Schools. After three years in Rome he returned to England to win commissions for the Palace of Westmin

183 Joseph Parkin Mayall, 'William Calder Marshall RA in his Studio',
in F. G. Stephens, ed., *Artists at Home Photographed by J. P. Mayall*,
London 1884, photogravure, 21.8 × 16.6 cm (RA 05/4658).

would first exhibit a work in plaster, then later in marble or bronze if a successful commission had materialized. They showed large numbers of portrait busts, which were their professional staple. People would order records of themselves or of people they considered important. Sculptors would also show what were called 'Ideal Works', subjects drawn from mythology, literature and history in which the artists believed that the highest form of their art was displayed. Unfortunately, these creations were more expensive than portraiture, they were also larger and, if executed in marble or bronze, weighed a lot and took up much space.

Each year a sculptor Academician would be charged with selecting and placing the works in the galleries. Between 1860 and 1880 Foley, MacDowell and Calder Marshall fulfilled this role; in 1878 there were 18 works shown by members along with 117 by non-members.[25] In 1881, when Armstead was in charge, 18 works featured by members – though none, it was noted, by Woolner or William Woodington RA – and 113 by non-members.[26] More may have been submitted, but in evidence to the 1863 Royal Commission Foley said if such works did not get in, it was because they were not of any value.[27] We do know of one rejection that caused a stir. In 1886 when Calder Marshall was in charge, he rejected a work by Auguste Rodin, *L'Idylle*, now known as *L'Idylle d'Ixelles*. Rodin had exhibited at the Academy in 1882 and was developing critical support in London, including that of the recently elected President, Frederic Leighton. But his supporter W. E. Henley, critic and editor of the *Magazine of Art*, brought this rejection by the Academy to public attention.

So long as the Academy was sited at Trafalgar Square (1837–68) there were problems with showing sculpture (fig. 184). Sculptors and critics who gave evidence to the 1863 Royal Commission were almost unanimous on the matter. A. H. Layard MP, one-time effectively Minister of Culture (although no such post actually existed) and a person of wide cultural interest and experience, spoke clearly about it. If the Academy were to obtain the entire premises at Trafalgar Square, he observed, 'You might have good sculpture rooms, the present rooms being entirely inadequate for the purpose.'[28] Woolner, not yet vying for status at the Academy, claimed it was very difficult for sculptors to get adequate space for exhibiting as there was an overwhelming majority of painters who prevented a more equal division of space. There had been a

ster series in St Stephen's Hall of commemorative statues of great parliamentarians (as did Foley, MacDowell and other RAs); he won first prize in the competition for the national monument to the Duke of Wellington in St Paul's Cathedral in 1857 (although he did not get the commission); and his work featured in the Albert Memorial, London, as well as in the form of other public statues in London, Manchester, Bolton and Cape Town. From early in his career he won attention and commissions for a series of poetic, ideal subject pieces drawn from literature and particularly classical mythology.[24]

Exhibiting was central to the role of the Academy, and here sculptors could show their work for the benefit of critics but, more importantly, for potential patrons. Usually they

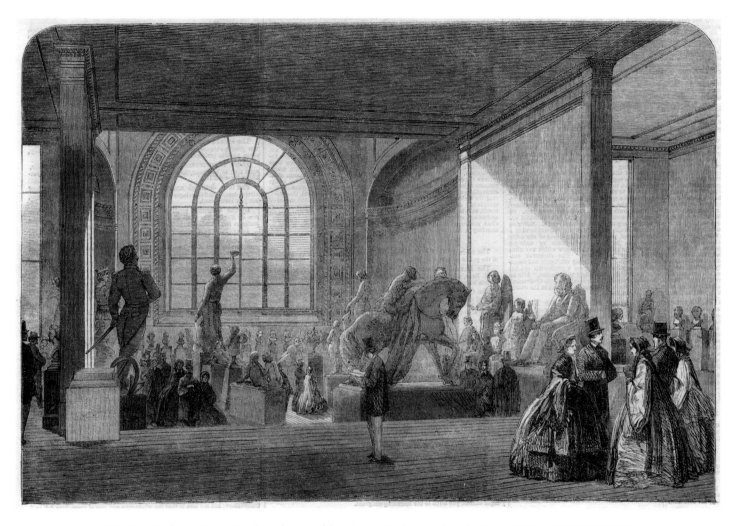

184 New Sculpture Room, Royal Academy, Trafalgar Square, in *Illustrated London News*, 18 May 1861 (RA 08/1651).

sculptors' petition about it, with which some painters had sympathized, but no solution was found. There had been some debate about showing sculptures in the painting rooms, although some thought this fatal to the effect of sculpture because of the hostile vertical light. Woolner, however, thought it was not as bad as having the sculptures standing close to each other, 'all crowded together like the trees of a forest'.[29]

The most serious complaint about the spaces for exhibiting sculpture came from John Henry Foley RA. He was one of the most respected sculptors of the High Victorian period,[30] and he considered that the space for showing sculpture at the Academy was 'bad in situation, bad in arrangement of light and bad in its general plan … For my own part, I never

care to send a work there which I set very much value upon … Mr Gibson has not exhibited at the Academy for many years and I understand will never again exhibit there until proper exhibition space shall have been provided for sculpture.'[31] It is worth noting that when a meeting was held to elect a successor to Foley after his death in 1874, Grant, who could not make the meeting, sent an urgent message to the Secretary, Frederick Eaton, asking him to inform members on his behalf that 'the dispute that had separated Foley from the Academy had been entirely removed before his final illness' and that Foley had been prevented by that illness from finishing a group that he had intended to send to the next exhibition.[32]

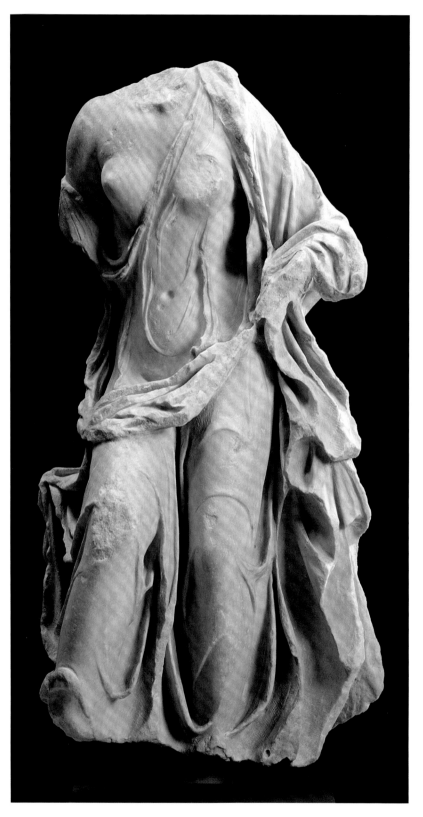

For some sculptors, their key contribution to the work of the Academy lay in teaching. Apparently at the head of this was the Professor of Sculpture, a position first occupied by Flaxman, then successively by Sir Richard Westmacott and Richard Westmacott the Younger.[33] Although the post was prestigious, in practice it only required an annual series of six lectures. The younger Westmacott was succeeded in 1868 by Henry Weekes, whom we have already come across playing a significant role in the governance of the Academy. Weekes was a major sculptor in his own right; he had been principal assistant to Chantrey and so inherited a part of the latter's immense prestige. Over more than 40 years he executed funerary monuments, portrait statues, 'ideal works' and particularly portrait busts.[34] His lectures were first published in 1880,[35] three years after his death, and are the most consistent and intelligent exposition of sculptural thinking in the Victorian period. Weekes was seriously concerned with the state of sculpture, both generally in that, as an art, it is limited and can never be popular, and specifically, at the Academy, where he states he is aware that it receives little encouragement.[36] The first half of the lectures deals with topics such as composition, beauty, taste, style, idealism and realism in sculpture; colour in sculpture; education; and portraiture. The second half is mainly a historical survey. For beauty in sculpture, Weekes advises, avoid affectation and keep things simple.[37] Do not enforce artificial rules, yet do not let the imagination run riot.[38] A crucial problem, as Weekes sees it, is the reconciliation of idealism and realism.[39] Idealizing is abstracting from nature: 'The abstract of Nature is, in fact, the essence of the abstract Art, Sculpture.'[40] But reality is necessary for us to 'identify'; moreover, the Ideal has changed, or is less poetic than of old: science has come and shifted people's understanding of the Ideal.[41] Antiquity is to some extent no longer a sufficient guide, although this did not stop Weekes presenting to the Academy in 1855 a genuine piece of antique marble sculpture, the female torso (possibly Europa), c.375–350 BC, attributed to Timotheus (fig. 185). He also enabled the Academy to purchase a cast of a figure called the 'Athlete of the Vatican' and add it to the collection of the Antique

185 Attributed to Timotheus, female torso of a figure perhaps representing Europa, mid-fourth century BC, marble, height 77 cm (RA 03/1916).

School.[42] On a practical level, Weekes deals with the use of drapery and the effects and uses of marble and bronze; he describes the best practical method of carrying out a portrait bust,[43] and we may note that his own Diploma Work was a portrait bust (fig. 186).

What does enliven Weekes's lectures, though, is his sense of humour. He compares the understanding of an antique figure cast to the way jockeys size up and define the perfect horse, and he had heard of a painter of racehorse portraits who could give a likeness of a Derby winner without having seen the horse, relying purely on descriptions of its salient points such as whether there was a spot in the middle of the forehead – 'of the horse I mean'.[44] He then goes on to describe a train of thought as proceeding over the points, with his own travelling on a loop line and on a narrower gauge: 'I have to accompany, if not guide you, past the different stations, to the terminus from where you alight.'[45] In the end, though, he noted the limits of the effectiveness of his lectures, since 'practical instruction can be carried on in the schools only, with the modelling-tool in hand, and the clay to operate upon',[46] and indeed it was the practical teaching in the Schools that formed the main body of education in sculpture.

Regularly over the years sculptors were designated to be Visitors in the Life School. Between 1860 and 1880 Foley, MacDowell, Calder Marshall, Weekes, Marochetti, Woolner, Armstead, Woodington, E. B. Stephens and Boehm acted in this capacity, with Calder Marshall by far the most frequent. In 1870 there were six sculptor attendances in the Life School out of 81 recorded, and the same year it was proposed there should be 'a competent Teacher in the technical details of Modelling in all the Schools of the Royal Academy'.[47] This was modified two years later when it was proposed there should be a Professor or Teacher of Sculpture to teach modelling to the sculpture students in a School set apart for the purpose. Weekes and Calder Marshall were asked to look into this, but it seems to have come to nothing.[48]

NEW DIRECTIONS

Beginning in the 1870s, a series of developments took place that fundamentally changed the nature of sculpture at the Academy. In the first place – though this was not exclusive to sculpture, it affected painting as well – came the opening

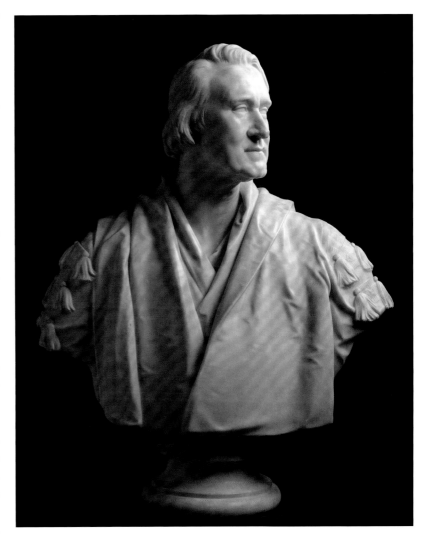

186 Henry Weekes RA, *Joseph Henry Green*, c.1863, marble, height 93 cm (RA 03/1849).

of certain private galleries that were to provide radical alternative exhibiting spaces. The Fine Art Society was founded in 1876, the Grosvenor Gallery in 1877, and the New Gallery, seceding from the Grosvenor, in 1888. There were to be important cases where sculptors regarded these spaces as being equally valid venues where their work might be seen by the public, away from the officialdom and establishment atmosphere of the Academy.

In January 1875 Lady Chantrey died, and the Academy acquired the remains of Chantrey's estate. According to the Council report for 1875, after the payment of legacy duty

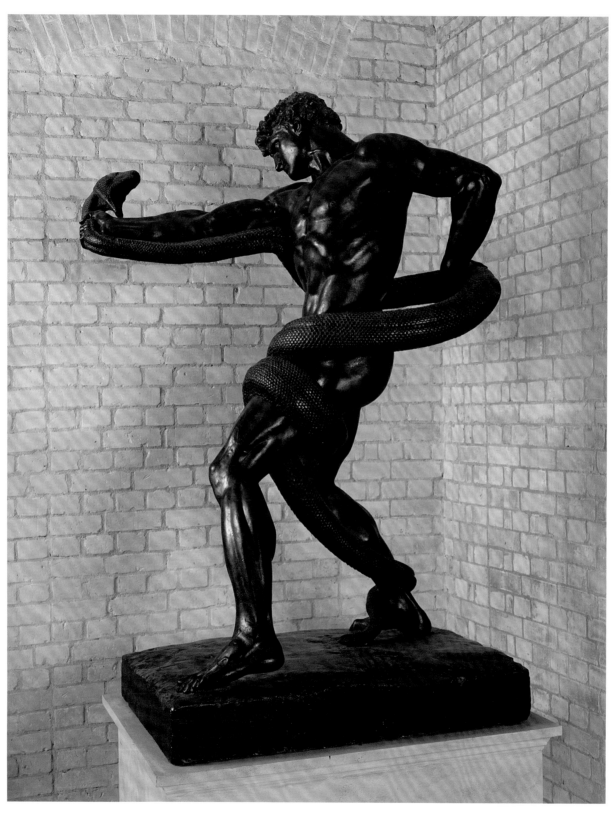

187 Frederic, Lord Leighton PRA, *Athlete struggling with a Python*, c.1877, plaster coloured to imitate bronze, height 175.5 cm (RA 03/1764).

this amounted to £105,000. It was a remarkable sum of money.[49] There were already trustees of the money, but the President and Treasurer were automatically added to the number, with the RA Secretary automatically becoming Secretary of the trust. Although there was a problem in that Grant was already a trustee, it simply meant that two ordinary trustees needed to be appointed.[50] Its function was essentially to buy works of art for the nation, to be selected from exhibits at the Royal Academy. There were to be continuing attempts to define more closely the terms of the bequest, such as, for instance, whether the trust could commission a bronze version of a sculpture when only a plaster had been exhibited;[51] and then there was the question of where the works purchased were to be exhibited. More seriously, the apparent stranglehold of the Academy on the bequest came to be challenged, but this was the largest bequest the RA received in the nineteenth century and it still exists.

The first work to be bought, in January 1877, was a posthumous purchase, a painting by William Hilton RA of 1825. The second on 26 April 1877 was a bronze statue by Frederic Leighton, *Athlete struggling with a Python*, of which the Academy also possesses the original plaster (fig. 187). This was proposed by Alfred Elmore RA, seconded by J. C. Hook RA with supporting votes from E. M. Barry RA, E. J. Poynter RA, G. D. Leslie RA and S. A. Hart RA. Henry Pickersgill RA, who was in the chair, did not vote, while Grant, Sir John Gilbert RA and Sir Giles Gilbert Scott RA were not present. There was one vote against, by Thomas Woolner, but it was not sufficient to prevent the work being purchased for £2,000.[52]

On 13 November 1878 the General Assembly met to elect a successor to Sir Francis Grant, who had died on 5 October. Remarkably (it had never happened before), every Academician plus one Honorary Retired Academician attended, and they elected Frederic Leighton as President,[53] the second major event in the history of the role of sculpture within the Academy. That may seem strange, in that Leighton had been, and was to remain, overwhelmingly a painter by profession. Nevertheless, he had just had a sculpture, the *Athlete*, selected as the second Chantrey purchase, and he was to have a major impact on sculpture at the Academy until his death in 1896, and his influence endured thereafter.[54] Some critics pointed out that there had always been a sculptural element even within Leighton's paintings,[55] and from the 1870s onwards

he had, in fact, begun to make small plaster models in order to help him settle the compositional arrangement of certain paintings. Upon seeing one of these models, the French refugee sculptor Jules Dalou (or it may have been Alphonse Legros) had suggested to Leighton that he should develop this practice in the direction of making a full-size sculpture: hence the *Athlete*.

The main means by which Leighton affected the fortunes of sculpture at the Academy was by ensuring that a new generation of members was recruited. He had already inspired young sculptors through his teaching in the Life School, where Hamo Thornycroft, for example, recorded the way, in 1872, that Leighton set the model and draped it like one of the figures from the Elgin Marbles pediment in the British Museum. In 1879, as President, Leighton seconded Thornycroft's nomination for ARA, and when he was elected in 1881 Leighton wrote to him: 'Dear Hamo, Nobody is better pleased than I to call you now my colleague' (fig. 188). In 1888, when Thornycroft was elected RA, Leighton wrote: 'Dear Hamo, Just elected at the head of the list – a splendid election which gave your professor great pleasure.'[56]

Having seen Alfred Gilbert's *Perseus Arming* in 1882, Leighton visited him that summer in Perugia and commissioned the bronze figure *Icarus* shown at the Academy in 1884. He then persuaded Gilbert to return to England and to engage with sculpture at the Academy, and by June 1883 Gilbert was lecturing at the Academy on bronze-casting. When Gilbert was nominated for ARA in 1884, he was proposed by Leighton and seconded by Leighton's great sculptural ally in the Academy, Joseph Edgar Boehm (ARA 1878, RA 1882).[57] Gilbert was finally elected RA in 1892 (fig. 189 and see fig. 215). Leighton was also instrumental in attracting to the Academy other members of the so-called 'New Sculpture' movement: Thomas Brock, who had been Foley's technical executor and helped Leighton with the technical production of the *Athlete*, ARA 1883, RA 1891; Onslow Ford, ARA 1888, RA 1895; Harry Bates, ARA 1892 (he died in 1899 before he could rise further); and George Frampton, ARA 1894, RA 1902. They were to be succeeded by Goscombe John, Alfred Drury, W. Robert Colton, Henry Pegram, Frederick William Pomeroy and Francis Derwent Wood as ARAs in the years up to 1910, chosen in preference to Thomas Nelson MacLean, Percival Ball, John Warrington Wood, Roscoe Mullins and Wallis Rowland Ingram, who

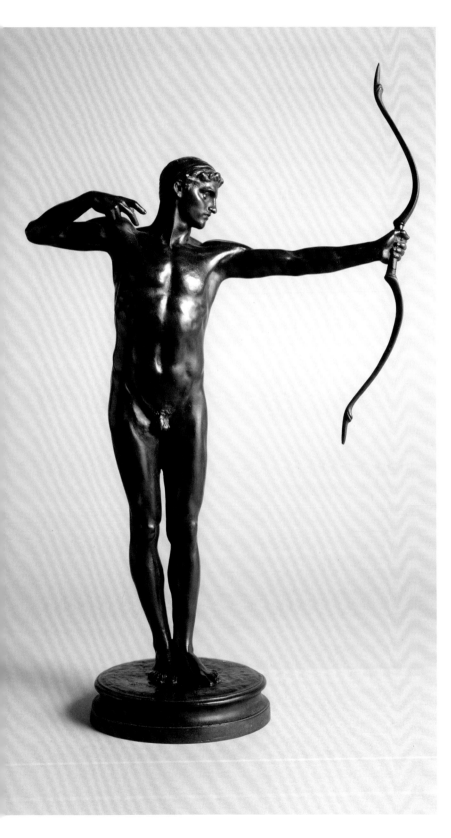

were all put forward for ARA between 1878 and 1898 without success.

Leighton was to intervene in the field of public sculpture. This was nothing new for the Academy, which had been active in this field since the 1790s, in the commissioning of public statues in St Paul's Cathedral of the secular and military great and good, followed by the parliamentary heroes in St Stephen's Hall in the Houses of Parliament from the 1840s (largely by Academicians such as Gibson, Baily, Foley, Calder Marshall and MacDowell),[58] and the Albert Memorial between 1862 and 1876 where seven out of nine sculptors were from the Academy.[59] In 1881 Leighton, with Calder Marshall and Woolner (an intriguing mixture), was able to award the commission for the statue of Rowland Hill in the City of London to Onslow Ford. In 1885, with Watts and Millais (a more congenial group of friends), he fixed for Hamo Thornycroft to land the job of the statue of General Gordon for Trafalgar Square (now on the Embankment), and he endlessly worked for Gilbert to obtain a range of commissions of varying sorts. He was, however, unsuccessful in his intervention in the Blackfriars Bridge scheme.[60] This area of Leighton's activity was criticized by sculptors whom he did not favour. Woolner, for instance, blamed his own financial problems of the 1880s on Leighton's jobbing away public commissions to his protégés,[61] as did Adrian Jones when he went to Leighton for support in replacing Wyatt's statue of Wellington at Hyde Park Corner: 'Sir Frederick replied quite frankly that "he had his own friends to look after",' he recorded.[62]

Woolner resigned as Professor of Sculpture soon after Leighton's election as PRA, claiming that he preferred giving direct practical instruction even though he is only recorded as Visitor in the School of Modelling in 1886.[63] It made for another practical problem with sculpture that Leighton had to face. For years, no professorial appointment was subsequently made, and endless appeals were made to members asking them to deliver lectures. In 1878 Boehm and E. B. Stephens ARA agreed to do so, while Armstead and Woodington declined.[64] At varying times thereafter, in a desultory way, Armstead, E. B. Stephens, Boehm, Thornycroft, Gilbert

188 Hamo Thornycroft RA, *Teucer*, 1881, bronze, height 77 cm (RA 03/2432).

189 Ralph W. Robinson, *Alfred Gilbert in his Studio, c.*1889–91, platinotype print mounted on card, 19.4 × 15 cm (RA 06/1084).

190 *Horace Montford and Modelling Class, c.*1890, photograph.

and W. B. Richmond RA all gave lectures. The 1885 lectures were 'Imitation is the means, not the end of art' by Thornycroft, and 'Bronze Casting as applied to Sculpture' by Boehm.[65] Many were given by outside experts such as, from the British Museum, Charles Thomas Newton, Keeper of Classical Sculpture, and Stuart Poole, Keeper of Coins and Medals, as well as John Henry Middleton (Slade Professor at Cambridge) on medieval sculpture in 1888. In that year Alfred Gilbert gave his first two lectures on 'The Arts immediately dependent on the Plastic Art'.[66] The continuing vacancy in the professorship seemed resolved in 1900 when Gilbert was selected and his first lectures were entitled 'A Glimpse into the Lives, Work, and Methods of the Great Masters of the 14th, 15th and 16th Centuries'. His scripts were never published, however, and we have only press reports of the lectures.[67] His lectures came to an untimely end after 1903, when he went into exile in Bruges, and he resigned from the Academy in 1908. In 1904 W. R. Colton RA gave a lecture on 'Enthusiasm in the pursuit of Sculpture', and A. S. Murray from the British Museum gave another four. Gilbert, we are told, was 'unable through illness to deliver any Lectures' (he was in Bruges).[68] Colton was nominated as Professor of Sculpture in 1906, and his first lecture as such was again on 'Enthusiasm', although the title was expanded to include 'The Rough-hewn and the Imitation of Life'; further lectures were given by Goscombe John on 'Modern Sculpture' and Richmond on Egypt and Greece.[69]

More significant for sculpture education was the setting up in 1881 of a new School called 'The School of Modelling from the Life', and in December that year Horace Montford was appointed to the post, from a list of 13 candidates, at a salary of £100 per year. Photographs exist of Montford in this role with his pupils about him (fig. 190). The 'New Sculptors', once elected, were to be regular Visitors to the School: Thornycroft, Armstead, C. B. Birch ARA, Marshall and Boehm initially, but soon joined by Brock (1883), Gilbert (1887), Ford (1890) and Frampton (1894).

As we move on past 1900 the Academy continued to take in new members, many of whom were to become central to sculpture at the RA into the post-war period: Alfred Drury, ARA 1900, RA 1913; Colton, ARA 1903, RA 1919; Henry Pegram, ARA 1904, RA 1922; F. W. Pomeroy, ARA 1906, RA 1917; Derwent Wood, ARA 1910, RA 1920; and Charles Hartwell, ARA 1915, RA 1924. Unsuccessful nom-

inees for ARA included Albert Hodge, nominated by Brock, Thornycroft and Aston Webb in 1907; Benjamin Clemens, who had multiple nominations between 1907 and 1920; and Oliver Wheatley, nominated by Brock, Drury and Pomeroy in 1907 but in 1920 confirmed (by Walter Lamb) as being in a lunatic asylum.

A final legacy of Leighton's began to materialize in 1908. On his deathbed in 1896, Leighton, having left his estate absolutely to his two sisters, managed to pass on a few suggestions to them about what they might do with the money. One was that £10,000 might be given to the Royal Academy. The sisters did this, and the Academy decided that the income should be used for placing pictures, statues and other decorative works in or near public buildings.[70] The exercise got off to a slow start. First in 1908 came a bronze lamp post for Horse Guards Parade by S. Nicholson Babb, who was proposed ARA from 1912 onwards but unsuccessful in spite of repeated attempts;[71] he gained 12 proposers in 1927 and nine, finally, in 1934.[72] The second Leighton-funded work was the only painting, *Tumult in the House of Commons 2nd March 1628* in St Stephen's Hall in the Palace of Westminster by A. C. Gow RA. This was one of the several early twentieth-century wall paintings aimed to help complete the project of artistic decoration of the Houses of Parliament that had been begun by Prince Albert and Charles Eastlake in the 1840s. Proper sculpture commissions supported by the Leighton Fund began in 1916 with payment for a further cast of Brock's portrait bust of Lord Leighton for Scarborough Town Hall in the town of Leighton's birth.[73]

Academy sculptors were also internationally involved at this time. The Venice Biennale was founded in 1895, and in its first year there was an International Committee of Patronage including Leighton, Millais, Edward Burne-Jones and Alma-Tadema from the Academy although the exhibition did not contain any British sculpture. By 1905 there were specific national artist commissioners: two painters who were joined by a sculptor, George Frampton RA, who had exhibited individually in 1897, 1901 and 1903. Seven sculptors exhibited in 1905, including the Academicians Drury, Frampton, Goscombe John, Thornycroft and Derwent Wood. Frank Brangwyn RA served as commissioner in 1907 when the sculptors represented were Frampton, Derwent Wood and the non-Academician Stirling Lee. In 1909 there was a general committee drawn from the great and the good,

assisted by an artistic subcommittee that included Frampton, and on this occasion five sculptors exhibited, all of them current or future Academicians. Derwent Wood succeeded Frampton on the subcommittee for 1910 and 1912 as the work of an ever larger number of sculptors was shown. Selection for the Biennale began to change when British participation resumed in 1922, and as varying fields of endeavour were encouraged, the prominent role of sculptor Academicians that had featured up to 1914 diminished; but what had happened bore witness to the position of sculpture as it had developed up to that period.[74]

In a way, the climax of this phase of sculpture at the Academy is represented at the turn of the new century when Queen Victoria died in 1901 and with the proposal of a memorial to her, the equivalent to that to her husband Prince Albert 40 years or so previously. Just as the Albert Memorial had been largely an Academy affair, so too was the Victoria Memorial.[75] Its architect, Aston Webb RA, was chosen from a shortlist of five, but the only sculptor in the running was Thomas Brock. Poynter played a major role in putting him forward, although Brock had been known to Victoria's successor, Edward VII, for 20 years, since the Prince of Wales, as he had then been, chaired the deliberations of five selection committees when Brock had succeeded in being awarded the commissions.

The Victoria Memorial is the central feature outside Buckingham Palace, an 'expanded field' so to speak, as wide as it is high, featuring free-standing and attached figures as well as high- and low-relief elements in both bronze (some gilded) and marble, all set amid fountains. The effect is that of a narrative that slowly reveals itself, a creation that turns out to be infinitely richer and more complex as it unfolds than could have been suspected in a sculptural complex that, at first sight, so well fulfils all the immediate purposes of a public monument. And it expands to include Brock's further large figures set against Admiralty Arch (also by Webb) at the opposite end of the Mall. It seems to have been subject to minimal control from Webb, and was largely Brock's own idea.

The significance for the Academy lay in Brock's long-standing association with the institution and the role played by sculpture within it. He had been one of Foley's executive assistants from 1874, and Foley can be regarded as the major sculptor of the High Victorian era. Brock had also been executive assistant to Leighton for his sculptures (as men-

191 Thomas Brock RA, *Model for the Tomb of Lord Leighton*, c.1897–1900, painted plaster, 52.1 × 83.8 × 31.1 cm (RA 03/1681).

tioned above) and had led the takeover of the 'New Sculptors' within the Academy (fig. 191). The memorial also features key stylistic reminiscences of the previous 40 years of British sculpture. There are, for example, clear references to the art of Alfred Gilbert in the uppermost gilded *Winged Victory* as well as recollections of two of the non Academy heroes of the movement: Alfred Stevens in *Constancy* and *Courage* immediately below *Victory*, and Jules Dalou in the figure now known as *Motherhood* facing the façade of Buck-

ingham Palace. These particular creations by Brock have been sometimes unjustly denigrated as pastiche, but it seems rather that one must credit Brock with having made a deliberate decision to commemorate here this great era of sculpture. The surroundings of the Victoria Memorial were embellished with strictly non functional allegorical gate piers that were executed between 1905 and 1908 by other Academy sculptors: *South Africa* and *West Africa* by Alfred Drury, *Canada* by Henry Pegram and *Australia* by Derwent

227

Wood. The monument was only completed in 1924, symbolically bringing to an end an especially rich and distinguished era in British sculpture in which the Royal Academy had played the central role.

TWENTIETH-CENTURY SCULPTURE UNTIL THE SECOND WORLD WAR

In December 1931 Alfred Drury's statue of Sir Joshua Reynolds was inaugurated in the courtyard of the Royal Academy in London.[76] It was appropriate in many ways: it represented the Academy's first President and was also executed by a Royal Academy sculptor who could be seen as representative of British sculpture of the previous half-century. Drury was a known admirer of two heroes of the modernizing movement of the end of the nineteenth century that had come to be known as the 'New Sculpture', Alfred Stevens and Jules Dalou. He owned a substantial collection of Stevens drawings, and had returned to Paris with Dalou when the latter's exile was remitted, working for some years as principal assistant in his studio. In suggesting itself as a testament to British sculpture of the preceding decades, the Reynolds statue can be seen as fulfilling a role similar to that of Brock's Victoria Memorial with which we closed our look at developments before the First World War.

There is a critical issue, though, in the year 1931, when the statue was finally put up (the project had been under discussion since 1914). According to modernist historians of sculpture, by 1931 modernism had arrived, and 1931–2 was indeed the date of what is possibly the first abstract sculpture produced in Britain, Barbara Hepworth's *Pierced Form* (in pink alabaster; destroyed in the Second World War). In effect, what was taking place was an overlap of sculptural ideologies, which was to continue for much of the twentieth century. It is undeniable that Henry Moore, Hepworth and other sculptors who introduced 'modern' sculpture to Britain after about 1930 never adhered to the Royal Academy. But one cannot therefore characterize the Academy as simply not being 'modernist', and the sculpture that it favoured as being therefore intrinsically unimportant. As we shall see, the Academy continued to embrace sculptor members who produced work that answered the needs of various audiences, and which in itself possessed considerable value.

Academy sculpture changed only gradually after 1914. The major figures were active until they died in turn: Colton in 1921, Brock in 1922, Pomeroy in 1924, Thornycroft in 1925, Frampton in 1928. Gilbert was to return from exile in 1932 but died in 1934. Drury lived on until 1944 but mainly took to painting in his later years; Goscombe John survived until 1952. All were involved in the provision of war memorials, which became a major activity. The Academy held a 'War Relief Exhibition' in 1915, a show that only partly involved sculpture, but Brock, Frampton, Drury and others all exhibited, as well as relative newcomers such as Bertram MacKennal (ARA 1909, RA 1922) (fig. 192), and there was a single work by Jacob Epstein. A more sculpturally focused exhibition was held at the Academy in 1919, 'War Memorials', which sculptors shared with their architectural colleagues. The Central Hall contained *Crown of Victory: Ideal Group to be placed upon a Memorial* by Colton, elected RA that year, two years before his death. In this same prominent space were works by an array of sculptors who were not necessarily Academicians, while other rooms featured a single effigy by Brock and four works by Thornycroft.[77]

The leading sculptors obtained commissions for public war memorials. Goscombe John produced the memorial to the Engine Room Heroes in Liverpool unveiled in 1916, originally intended to commemorate crew members of *RMS Titanic*, which had sunk in 1912,[78] but its remit was extended to include similar personnel caught up in the First World War. The monument is unusual in no longer being strictly academic and was criticized for that: certainly, the figures are beginning to be formalized away from strict 'truth to nature'. Frampton produced *Nurse Edith Cavell* (fig. 193) of 1920 in St Martin's Place, Westminster, a complex design that seemed to blend traditional portraiture against a structure verging on the modern and including a Symbolist grouping at the top that chimes with Frampton's work of the 1890s. Drury in his London Troops Memorial in front of the Royal Exchange in the City of London of 1920 retained realistic soldiery.[79]

New sculptors began to emerge. Charles Sargeant Jagger was nominated for ARA first in 1919 by Frampton, Pomeroy, Goscombe John and Derwent Wood, and then subsequently supported in 1925 also by Thornycroft.[80] This was not surprising. Jagger's Royal Artillery War Memorial (fig. 194), selected over a design by Sir Edwin Lutyens and Derwent Wood, struck home when unveiled in 1925 as one of the

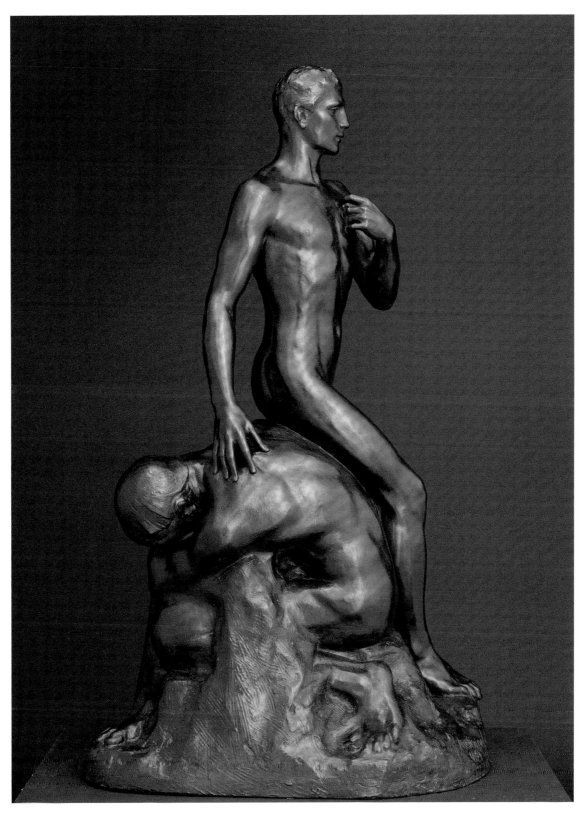

192 Bertram MacKennal RA, *Dawn of a New Age*, 1924, bronze, height 75.6 cm (RA 03/1767).

(left) 193 Sir George Frampton RA, *Nurse Edith Cavell*, 1920, white marble against a grey granite cross. St Martin's Place, London.

(above) 194 Charles Sargeant Jagger ARA, Royal Artillery War Memorial, 1925, Portland stone and bronze. Hyde Park Corner, London.

most realistic and effective memorials, especially as the artist had himself served and been wounded in the Gallipoli campaign. He had completed a considerable number of other war memorials, at Portsmouth, West Kirby, Birmingham, Brussels, Cambridge and Paddington Station, and succeeded in being elected ARA in 1926. He embarked on a series of public statues, three in New Delhi, interior and external architectural sculpture in London, but died in 1934 before becoming a full RA.[81]

Gilbert Ledward had to wait longer to become ARA, having been first nominated likewise in 1919 by Frampton, Pomeroy, Goscombe John and Derwent Wood, although it was not until 1932 that he was elected.[82] His war memorials included those in Harrogate, Blackpool and Grahamstown, South Africa, while his London masterpiece in this field was

the Guards Division Memorial (fig. 195) overlooking Horse Guards Parade in London, unveiled in 1926. Ledward had been in competition for this commission with John Tweed and Henry Poole RA, but was supported by Brock, although even the latter could not prevent the savage cutbacks inflicted on the sculptural content.[83] Ledward was to become RA in 1937 and lived until 1960.

There were other sculptors who became Academicians between the world wars, who varied in the style of their work. Alfred Turner was first nominated ARA in 1907 but was only elected in 1922, supported by Pomeroy, MacKennal and Derwent Wood, among others, becoming full RA in 1931.[84] He had produced three monuments to Queen Victoria in Delhi, Tynemouth (fig. 196) and Sheffield (which was originally erected in 1905). He executed war memorials in

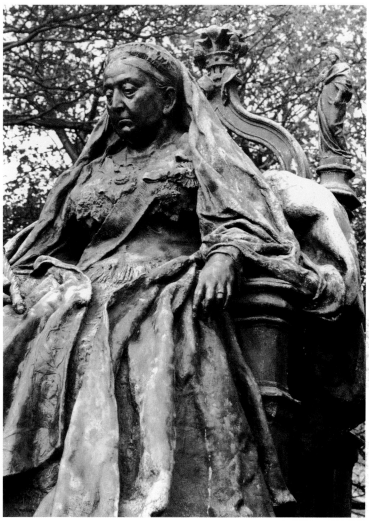

195 Gilbert Ledward RA, Guards Division Memorial, 1926, bronze statues against a Portland stone obelisk by H. Chalton Bradshaw. Horse Guards Parade, London.

196 Alfred Turner RA, *Queen Victoria*, 1902, bronze statue on Portland stone base. Tynemouth.

Northampton, Fulham, South Glamorgan, Pretoria and Jersey, but the most significant work was set on the top of Herbert Baker RA's South African War Memorial at Delville Wood in northern France, a group of *Castor and Pollux* symbolizing the two white component peoples of South Africa uniting in their military endeavour. Turner's Diploma Work for the Academy was likewise classical, *Dreams of Youth* (fig. 197), which helps to confirm the acceptability within Academy ranks of a type of classicism that may have derived originally from Harry Bates, whose assistant Turner

had been. Turner exhibited a range of poetic ideal works with Symbolist titles from early in the century, for example, *Death and Innocence* (RA 1905) and *Cycle of Life* (RA 1913) – which was akin to the much earlier work of G. F. Watts RA. Turner's fine Gothic figures of St George on the war memorials at Jersey and Kingsthorpe, Northampton, do credit to the tradition of Burne Jones, which was also revisited in Drury's *St George* Boer War memorial at Clifton College, Bristol.

It took Arthur George Walker RA, who was 13 years Turner's senior, a few years longer to be accepted within the RA

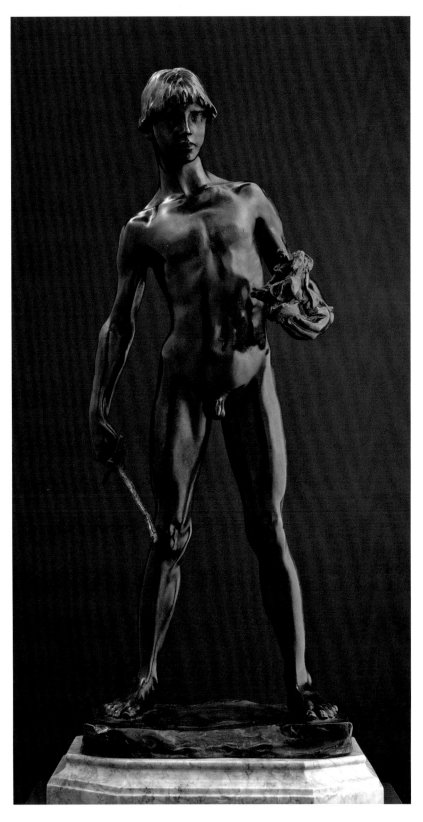

hierarchy, becoming ARA in 1925 and RA in 1936, just three years before his death aged 78.[85] Walker was a multi-media artist: he painted, worked in mosaic and was an illustrator in addition to his main field of sculpture. Walker executed war memorials at Bury St Edmunds, Derby, Hawarden and Limehouse in East London, and was responsible for the monument to Florence Nightingale in Waterloo Place, London, of 1915, the relief for which can be seen on the shelf above the door in Walker's view of his studio at Cedar Studios, Glebe Place, Chelsea (fig. 198). The setting up of this monument brought about a realignment of Crimean memorials as it joined John Bell's Guards Crimea Monument and Foley's *Sidney Herbert* – which was moved from its position in front of the War Office originally in Pall Mall. Walker also executed relief memorials to Florence Nightingale in St Paul's Cathedral and at St Thomas's Hospital, while his other major public statue was that of Emmeline Pankhurst in Victoria Tower Gardens next to the Houses of Parliament.

Walker maintained a steady production of portrait busts (as most sculptors still did at this period), but he had two other unusual areas of activity. He began to specialize in religious works, some attached to buildings, as in the case of his emblematic Symbolist figures of the *Four Evangelists* in bronze and stone on the Church of the Ark of the Covenant in Stamford Hill, north London, and some free-standing, as with two groups of the Madonna and Child at Wells and Llandaff cathedrals. Concurrently he began to make polychromatic sculptures, inspired possibly by such work by Frampton during the 1890s. His portrait bust of the Duchess of York (RA 1925) was in ivory and marble, and he brought the same approach to his ideal groups and statuettes, classical and religious, such as *Christ at the Whipping Post* shown at the Academy the same year. His Diploma Work, accepted in 1936, was *Grief*, created in 1915. In 1939 he bequeathed to the Academy a classical sculpture, *A Youthful Pan* (of c.1920) as well as three paintings he had executed of the interior of his own studio, showing works such as the plaster model for his statue of John Wesley in Bristol, a *Circe* (RA 1907) and *The Necromancer*. Walker was also a member of the Art Workers' Guild and altogether was an artist of considerable imagina-

197 Alfred Turner RA, *Dreams of Youth*, 1932 (after versions dated 1914 and 1915), bronze, height 78 cm (RA 03/2498).

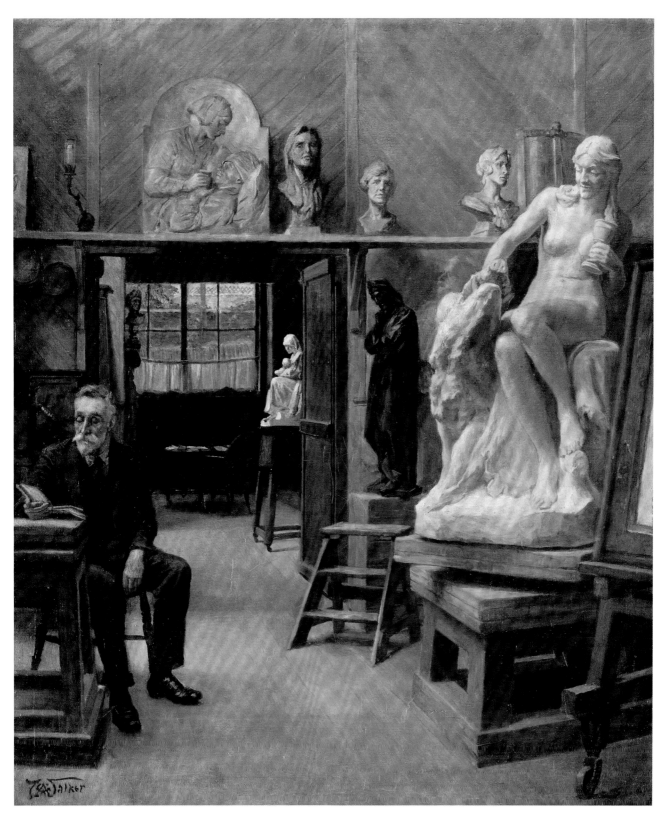

198 Arthur George Walker RA, *Cedar Studios*, c.1932, oil on canvas, 66.8 × 56 cm (RA 03/1111).

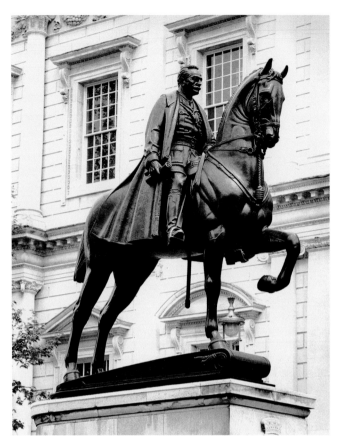

199 Alfred Hardiman RA, Earl Haig Memorial, 1937, bronze.
Whitehall, London.

tion and practice, to whose achievements the Academy eventually paid tribute.

There were many other sculptors who became part of the Academy in the period between the wars, such as Henry Poole (ARA 1920, RA 1927), Richard Garbe (ARA 1929, RA 1936), Ernest Gillick (ARA 1935) and Alfred Hardiman (ARA 1936, RA 1944). Hardiman was responsible for the controversial Earl Haig Memorial (fig. 199) in Whitehall unveiled in 1937. The work was selected in competition with William McMillan RA and Ledward, but was objected to both by the king and Haig's widow, as well as a supposedly populist press campaign. The objections boiled down to its stylization when a more naturalistic representation would have been preferred.[86] And there were others who never made it: Allan Howes was proposed variously between 1927 and 1951 with support from William Reid Dick RA, Poole,

Turner, McMillan and Ledward among the sculptors;[87] between 1937 and 1957 John Kavanagh was nominated by Ledward, Wheeler, Hardiman, Goscombe John, Arnold Machin RA and David McFall RA.[88]

There was one group of recruits, however, that was to be particularly significant both for the Academy and nationally. William Reid Dick became ARA in 1921 and RA in 1925; William McMillan, ARA 1925 and RA 1933; and finally Charles Wheeler, ARA 1934, RA 1940, PRA 1956–66.[89] The importance of this group was that, from the 1920s onwards, they were seen as embodying a style of credibly 'modern' sculpture at the Academy that was distinguished by a number of characteristics. In the first place they consciously aimed at 'truth to material' in their work with the use of unmistakably 'direct carving' in wood and marble. And they acknowledged the impact on their work of two particular European sculptors critically regarded as modern in the first 30 years of the twentieth century, the Serbian Ivan Meštrovic and Carl Milles from Sweden. A large Meštrovic exhibition was held at the Victoria and Albert Museum in 1915 when he was greeted as a wholly new force in sculpture, a worker in stone and marble. His influence upon William McMillan was detected as early as 1919, while Charles Wheeler later acknowledged the profound influence of Meštrovic on his own work. Milles was the subject of an exhibition at the Tate Gallery in 1927 when two works were acquired for the nation. In 1930 his work was cited as the source for the rising British School of sculpture, with McMillan's *Birth of Venus* mentioned as an example. Milles's idealized modern classicism is evident in the work of all three sculptors, and when Wheeler was elected ARA in 1934 the move was considered by the then President of the Royal Academy, Sir William Llewellyn, with disapproval and as being positively revolutionary. But during this decade these three sculptors began to assume a major public role in the creation of monumental and architectural works, activity that was to become more emphatically evident after 1945.

We are perhaps conditioned by a rather myopic view of art history to regard only Moore and Hepworth as the developing geniuses of the decade before the Second World War. They too developed their forms of stylized figuration at this time, but the younger Academicians were unable to take on board that ultimate shibboleth of sculpture that at the same time took abstraction on board. They retained a loyalty to their particular form of stylized modern classicism that

satisfied both them and their clientele – and the majority of critics. The Academy, it is true, had tentatively tried to encompass the proto-modernists (as usually defined), and the issue of Epstein's association with the Academy, for example, is fairly easy to understand even if it contained several complex elements. Epstein had shown at the RA in 1915 in the war exhibition mentioned above, and a tentative attempt to nominate Epstein as ARA took place in 1925, when he was nominated by Sir John Lavery RA, Charles Shannon RA and Poole, although it never came to anything. When Epstein's fragile sculptures on the British Medical Association building in the Strand were forcibly defaced in the 1930s for alleged safety reasons (the point at issue was the removal of the prominent genitalia), any contribution from the then PRA, Llewellyn, among the letters of protest in the press was noticeably absent. This has been taken to reflect the refusal of the Academy to support an artist, and it has also always been alleged that this was the reason why Moore never joined the Academy, although there is no evidence in the nominations books to indicate that he was ever proposed. A case has been made that Llewellyn felt constrained by his inability to ensure that he was acting with the support of his colleagues, and that it was simply impractical to organize that in time. It should be noted that Reid Dick was a signatory of the 1935 *Times* letter, but at the same time Llewellyn's doubts about Wheeler, already mentioned, added fuel to the debate.[90]

The other proto-modernist was Eric Gill, and here the Academy did a little better. Gill was first proposed for ARA in 1928 when nominators included Reid Dick and Poole. Further names were added in 1930, 1931, 1932 (Alfred Turner), 1933 (including Ledward and McMillan). In 1934 a message came via Reid Dick that Gill wished his name to be deleted; then in 1937 Ledward conveyed Gill's consent to going back on the list, and that year he was elected ARA with further support from Ledward (again), Wheeler and Hardiman among the sculptors. It is interesting that Reid Dick and Ledward conveyed communications from Gill: like Gill, they were both emphatically carvers, and Reid Dick had initially trained as a mason sculptor.[91]

One might perhaps note in passing those who did not get voted in between the wars. Among the more distinguished sculptors were John Tweed, who was first proposed in 1912 by luminaries such as Pomeroy, Derwent Wood and John

Singer Sargent RA among six nominators, and again later by the architect Sir Reginald Blomfield RA, Llewellyn and Frank Dicksee RA (1920). In 1927 his 12 supporters included Frampton and Hartwell but somehow to no avail, and Tweed died in 1933.[92] Other distinguished and professionally successful sculptors who failed in spite of nomination included Andrea Lucchesi, Henry Fehr, William Reynolds-Stephens, Gilbert Bayes and Albert Toft. Others less renowned suffered a similar fate, such as Ferdinand Blundstone, James Stevenson, Basil Gotto (originally nominated in 1907 by Brock, Frampton, Drury, Pomeroy and Goscombe John).[93] S. Nicholson Babb received a raft of nominations from 1912 onwards, including in 1927 Sir Frank Dicksee (who was then PRA), Hartwell, Frampton and Llewellyn; in 1934 Llewellyn again (now PRA), Turner, McMillan, Russell Flint and five others were in favour.[94]

Certain specific Academy funds for sculpture continued to be used, including the Leighton Fund.[95] As we have seen, Babb had won a commission for a lamp post in 1908, though this does not seem to have aided his progress towards membership. A replica of Brock's bust of Leighton for Scarborough Town Hall was paid for in 1916, a bronze version of Thornycroft's *Sower* (plaster, RA 1886) was commissioned for Kew Gardens in 1927. The fund was to be used exclusively for public works by or about Academicians: a bronze statue of *William Pitt, 1st Earl of Chatham* by Derwent Wood for the Houses of Parliament (1929); Drury's *Sir Joshua Reynolds* (1931); Pegram's *Hylas* in bronze for the rose garden, St John's Lodge, Regent's Park (1933); a memorial to Alfred Gilbert by Ledward and another to John Constable by Alfred Turner, both for St Paul's Cathedral in 1937, the same year in which a bronze statue of J. M. W. Turner by McMillan was put up on the main staircase of the Academy (fig. 200), followed in 1939 by a bronze statue of Gainsborough that was placed opposite on the staircase and cast from Brock's marble statue of 1906 (although that languishes in store at the Tate).[96] A sum was taken to carry out repairs to Gainsborough's tomb in Kew churchyard in 1921,[97] and in 1933 the fund was used to pay for a pair of wrought-iron electric lamp standards for the west entrance of St Paul's Cathedral, which were designed by Lutyens and Reid Dick.[98]

Meantime, the Chantrey Fund continued to flourish. There had been, it is true, criticisms from outside the Academy about its administration and choice of art, with a

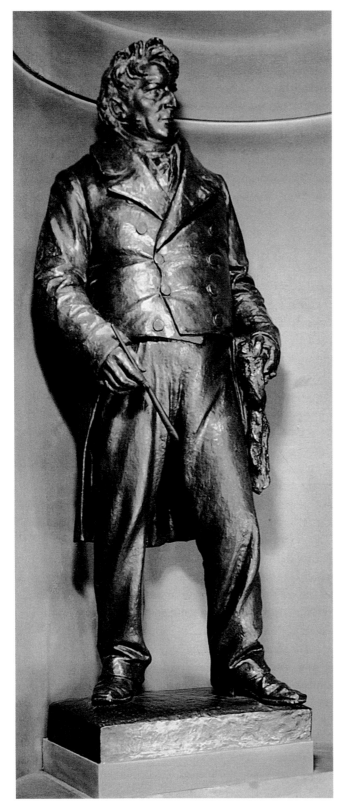

select committee of the House of Lords sitting in 1904. The Academy quite reasonably defended its independent role as defined by the terms of the bequest, though it did make an effort to expand the field of its selections. From the start, a major criticism within the Academy had been the inability of government to provide premises to exhibit the works acquired, and so they had been shown at the South Kensington Museum (renamed in 1894 the Victoria and Albert Museum) and in provincial galleries. The creation of the Tate Gallery in 1897 (initially under the National Gallery) as the National Gallery of British Art provided a natural and proper site. In 1917 the Tate acquired its own trustees, who thought it reasonable that they should have some say in the choice of Chantrey works, since they would have to house them. Eventually in 1922 it was decided to have a selection committee in which the Academy had a majority of three to two, and this committee would make its selection known to the Academy Council, which retained its legal right to make the choices.[99] There was a temporary blip in this relationship in 1927 and 1928 when the Tate representatives did not attend, but things returned to normal with the election of Llewellyn as PRA at the end of 1928.[100] The pattern of sculpture acquisitions between 1914 and 1939 was varied. There were works by RAs, ARAs, those about to become such and those who never made it. In 1914 *Dawn*, a marble statue by Hartwell (ARA 1915), was purchased for £1,100, along with the marble bust of Henry James by Derwent Wood (who had become ARA in 1910) for £100. The following year saw the purchase for £850 of *The Bather* by Albert Toft, who was proposed but never elected, and in 1916 *The Kiss* by Hamo Thornycroft, RA since 1888, was bought for £1,250. *The Critic* by C. Web Gilbert was purchased for £100 in 1917, when Web Gilbert was again proposed, although he was never elected. In 1919 *Androdus*, a bronze mask by Reid Dick, was bought for £42, a purchase supported by Thornycroft, Frampton and Pomeroy, among others. Reid Dick became ARA in 1921. In 1922 the bronze bust *Nan* by Epstein was bought for £200, which shows that the Academy was not against Epstein in principle, and it was to buy other works later through the Chantrey Fund. It might be argued this

200 William McMillan RA, *J. M. W. Turner*, 1937, bronze, height 217 cm. Royal Academy of Arts, London.

happened through the involvement of Tate representatives in preliminary discussions, although it was already the case that the purchases were a mixture of work by the established, the up-and-coming and the unknown, which was to continue throughout the period. Old habits, however, perhaps died hard, and in 1937 the carved elm *Old Horse* by William G. Simmonds was bought for £250. Simmonds never made it to Academy status, but by this date he was already represented at the Tate by a Chantrey purchase of a watercolour in 1907 and a Tate sculpture purchase from its own Lewis Fund, *Farm Team*, in 1929.[101]

AFTER 1945

Sculpture at the Royal Academy after the Second World War appears as a split personality. Initially, it seems simply to consolidate its establishment character, with leading members providing the state and royalty with official three-dimensional emblems in various fields, and the Academy elected Charles Wheeler as its first sculptor President in 1956. He retired in 1966 to be succeeded by Thomas Monnington, under whose presidency during the 1970s a gradual transformation took place. Initially a few sculptors came on board who could be construed as less establishment, more in tune with the critical avant-garde, and suddenly nearly all the leading sculptors seemed to want to belong to the Academy. A second sculptor President, Phillip King, was elected in 1999, and by the year 2000 the representation of sculptors was as truly national as it had been around 1900.

It was those three proto-modernists of the 1920s and early 1930s, Reid Dick, McMillan and Wheeler, who led the way after the war, becoming almost the 'Three Kings' of official sculpture in the later 1940s and the 1950s. To begin with, there were major public projects to be completed. In 1936 a scheme was initiated to commemorate in Trafalgar Square the two major naval heroes of the First World War, Admirals Jellicoe and Beatty, to accompany Nelson, who was, of course, already there high up on his column, created by an earlier Academician, E. H. Baily. At first, statues were envisaged but soon fountains with sculpture included were preferred. The fountain elements were designed by Lutyens (PRA from 1938), with Wheeler and McMillan to execute the sculptural elements for the west and east fountains

respectively. These were ready by 1940 but only unveiled in 1948 (figs 201 and 202), and it is suggested the sculptors nudged the memory of the authorities by showing the two component busts at the 1946 Summer Exhibition.[102] There were, though, rumblings about the commissions. In December 1945 Ernest Gillick ARA wrote to Walter Lamb saying that Llewellyn (who had retired as PRA in 1938) had told him that he, Gillick, had been robbed of one of the statue commissions after it had been unanimously decided to entrust him with the commission by the customary advisory committee. He added that he would be glad to hear of any correction to this account. It seems in fact that all decisions had been taken by Sir Philip Sassoon, the First Commissioner of Works, and Reid Dick wrote to Lamb to explain that he had been involved with Sassoon in the commissioning of the statues in 1937 and that Gillick had indeed been one of those in the running for one of the commissions. It had been decided that, because Gillick did not approve of the plan of incorporating the sculpture with Lutyens's fountains, the scheme presented insuperable difficulties and he could not be of any further help. Gillick replied saying he did not accept Reid Dick's explanation as being true or fair, and repeated Llewellyn's accusation that certain people had been working in an underhand way in a conspiracy to cheat two sculptor members of the RA of their rightful honours and rewards. Gillick later claimed that a copy of the letter from him to Lutyens that was shown to the RA Council had been altered, and that Reid Dick (specifically mentioned) had not seen to its correction.[103]

Other major commissions by the 'Three Kings' seem to have been executed without internal controversy, and the monarchy was an area where Academy sculptors, as so often in the past, provided works. Reid Dick, who had made the tomb effigies for George V and Queen Mary in 1936 (the effigy of Queen Mary remained in store until required in 1953), executed the commemorative statue of George V in Old Palace Yard beside the Houses of Parliament, which was unveiled in 1947 (fig. 203).[104] He was subsequently responsible for the commemorative bronze medallion of Queen Mary off The Mall, London, which was unveiled in 1967,[105] and of which he made a replica for Sandringham. He also made busts and plaques of George VI (RA 1944, 1957), a bust of his consort Queen Elizabeth (subsequently Queen Mother) (RA 1946), and one of Queen Elizabeth II (RA 1961). But he

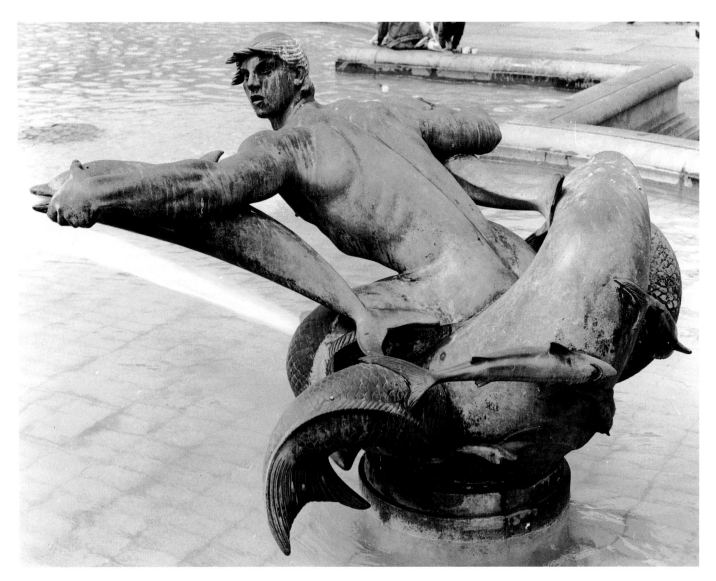

201 William McMillan RA, Trafalgar Square East Fountain, 1940 (unveiled 1948), bronze. Trafalgar Square, London.

was also responsible for non-royal statues: Franklin Delano Roosevelt in Grosvenor Square, London, of 1948, and Lady Godiva in Coventry, unveiled in 1949. Other works shown at the Academy in the post-war period consisted of straightforward busts, plaques and small ideal statues.[106]

McMillan created a statue of George VI for Carlton Gardens, London, in 1955, and *Sir Walter Raleigh* was erected in Whitehall in 1959, a statue that was transferred to Greenwich in 2001. McMillan's statue of Lord Trenchard, the 'Father of the Royal Air Force', was unveiled in front of the

Ministry of Defence off Whitehall in 1961. Other Academy sculptors had been invited to submit photographs of their work for this commission, including Maurice Lambert, Reid Dick, McMillan, Ledward and Wheeler, but Reid Dick and Wheeler excused themselves.[107] McMillan's statue of the airmen Alcock and Brown was put up at Heathrow Airport in 1954.

Wheeler made a statue of George VI for Vancouver in 1957–8, which is to all intents and purposes a replica of McMillan's statue. He went on to do four portrait busts of

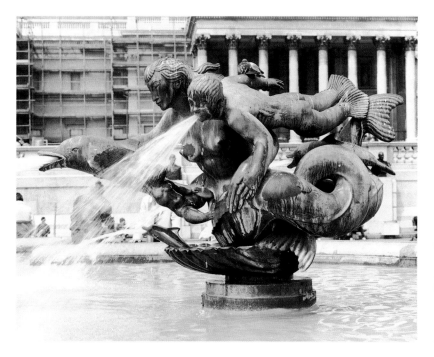

(above) 202 Sir Charles Wheeler PRA, Trafalgar Square West Fountain, 1940 (unveiled 1948), bronze. Trafalgar Square, London.

(right) 203 Sir William Reid Dick RA, *George V*, 1947, Portland stone. Old Palace Yard, Westminster, London.

Queen Elizabeth II between 1962 and 1964 and a bust of Princess Alexandra in 1968, but his crucial post-war public sculpture work was initially in the field of naval war memorials: at Chatham (1946–52), which included two figures by McMillan; Portsmouth (1948–53); Plymouth (1948–54); and that at Tower Hill in London, dedicated to the Merchant Marine, 1952–5. These all incorporated substantial figure work as well as decorative features. He was also responsible for the sculpture elements at the war memorials at Halfaya-Sollum in Egypt (1945–7), Tobruk in Libya (1945–51) and the colossal gilt-bronze eagle on top of Worthington's war memorial at Valletta, Malta, unveiled in 1954.[108] These were in addition to statues of John Cabot (Bristol, 1951), Thomas Paine (Thetford, 1963–4) and Lady Wulfruna in Wheeler's hometown of Wolverhampton (1972–4), as well as other busts, architectural sculpture, statuettes, medallions and panels. His work for the Navy had started as early as 1944, with seven busts of various naval figures, including some for the Admiralty.

In view of the status of Wheeler's patronage, it was not that surprising he was elected the first sculptor President of the Royal Academy in 1956. Sculptors had been approached in the past, among them Sir Richard Westmacott in 1850,[109] although he gave way to Eastlake; Sir Edwin Landseer, who was an occasional sculptor; and then Leighton, who was the classic painter-sculptor, elected PRA in 1878. Wheeler, however, was known not just for his friendly personality, which was in such stark contrast to that of his immediate predecessors, the combative Alfred Munnings and the austere Gerald Kelly; he was also known for his skills as an art politician and for his diplomacy, which was accompanied by a

would do what I could to encourage the showing in our galleries of works of all persuasions as long as they were good examples of their kind…I was intent upon a policy of tolerance on a wide front. I meant to attach particular importance to the rigorous protection of freedom of expression though I might hate its form.'[110] Some progress was made, and abstract work was first shown in 1958, but it took time and also the gradual accession to Academy membership of artists of a less traditional outlook.

In the meantime, there were other Academy sculptors who fulfilled prominent public roles. James Woodford (ARA 1937, RA 1945) executed decorative sculpture for the new headquarters of the Royal Institute of British Architects in Portland Place, London, in 1934, including two monumental bronze doors weighing one and a half tons each, followed by 18 sculpted roundels for the bronze doors of Norwich Town Hall in 1938. For the coronation ceremony of Elizabeth II in 1953 he executed ten plaster sculptures, each 6 feet (1.8 metres) high, of the Queen's Beasts for the entrance to Westminster Abbey and in 1956 reproduced them in stone for Kew Gardens. Outside London, he executed the landmark bronze statue of Robin Hood for the exterior of the castle in his hometown of Nottingham.

A number of one-time avant-garde sculptors began to come on stream with the Academy from the 1940s. Frank Dobson (ARA 1942, RA 1953) had appeared decidedly 'modern' in the 1920s with works such as *Pigeon Boy* (1920; Courtauld Institute, London) and the *Man Child* (1921; Tate Britain, London), unequivocally in worked stone and where the modelling was formalized towards oriental or Modiglianesque leanings. Further formalization and material consciousness is apparent in the polished brass bust of Osbert Sitwell of 1922 (Tate Britain, London). After visiting Paris, Dobson developed a distinctive Maillolesque style of formalized female nudes, his *Cornucopia* (1925–7; University of Hull Art Gallery) was greeted by Clive Bell as 'the finest piece of sculpture by an Englishman since…I don't know when'.[111] These features of Dobson's development can be discerned in his Diploma Work, *Study for the Head of 'Pax'* of 1933 (fig. 204). He pursued a successful career in portraiture and teaching and once in the Academy played a prominent role in its activities.

Maurice Lambert (ARA 1941, RA 1952) had been active in the 1920s, executing works in a range of materials such as

204 Frank Dobson RA, *Study for the Head of 'Pax'*, 1933, bronze, height 50 cm (RA 03/1712).

robust determination. His candidacy was supported by the architect Edward Maufe RA, who was the current Treasurer. Wheeler was clear about his intentions. He wanted somehow to create for the Academy a middle way between out-and-out conservatism and the rampant forces of modernism. He saw it as his duty to carry on the established traditions of the Academy but also to mould it to the new conditions of the middle of the twentieth century: 'I decided, therefore, that I

205 Maurice Lambert RA, *Carving in Paros Marble*, c.1937, marble, 45.1 × 78.2 cm (RA 03/1739).

marble (fig. 205), alabaster, African hardwood, Portland stone and metal, sometimes in combination.[112] These could often be stylized, verging on abstraction, equivalent to Moore or Hepworth at the time, but the move of those two sculptors towards total abstraction led to Lambert's withdrawal from experimentation. He went on to become an extremely competent provider of public work – for example, a statue of Viscount Nuffield for Guy's Hospital, London (1949) and an equestrian statue of George V for Adelaide (1950) – and he

also produced a range of portrait busts, among them those of William Walton, J. B. Priestley, Sir Gerald Kelly and Sir Henry Rushbury. Perhaps Lambert had always been an Academy man at heart – he had worked under Derwent Wood from 1918 to 1923, giving him help with the Machine Gun Corps Memorial, and he served as Master of the RA Sculpture School from 1950 to 1958.

John Skeaping (ARA 1950, RA 1959) had been both close associate and husband of Barbara Hepworth from 1925,

although they separated in 1931 and divorced in 1933.[113] From the start, Skeaping was as committed to direct carving as Hepworth or anyone else. His immense *Horse* of 1933 (Tate Britain, London, 1.8 × 3.8 m) made from mahogany and pyinkado woods is a stunning demonstration of truth to material. Skeaping though, like others, resisted the move to abstraction. He continued to produce animal sculptures, sometimes carved, often in bronze, until the end of his life, fitting in well with the Academy's sculptural agenda of the time. A contrast in Academy post-war sculpture terms was David McFall (ARA 1955, RA 1963).[114] He had ended his studies at the City and Guilds School, that is to say, at a much more craft-oriented institution, and he had early experience working as assistant to Eric Gill in 1939 and also Epstein at various points between 1944 and 1958. He certainly assisted with Epstein's TUC Memorial of 1956–7. McFall was active as a portrait sculptor but also executed public works, including statues of Winston Churchill at Woodford Green (bronze, 1959; see Diploma Work, bust of Winston Churchill, RA 1958), Lord Balfour in the Palace of Westminster (limestone, 1962), the memorial to Sir Gerald Kelly PRA in St Paul's Cathedral, London (1973), and a bronze statue of the *Son of Man* outside Canterbury Cathedral of 1988. He also executed architectural sculpture, for example, statues of St Bride and St Paul in St Bride's Church, Fleet Street (1957), and stone friezes for the extension to the Institute of Chartered Accountants in London of 1969, where the original reliefs had been done by Hamo Thornycroft. McFall's ARA nomination had been initiated from 1945 by Academicians such as Dobson, Ledward, Reid Dick, Woodford, Lambert and Wheeler, who by now were all familiar figures.

Sculpture in the post-war Academy was enriched by a particular group of sculptors who had fled Central Europe under Nazi rule. They were not necessarily Jewish, although some were; they were not necessarily 'degenerate', that is abstract or expressionist; what perhaps did unite them was a spirit of artistic independence that refused to accept that the state could dictate the last word in art for all artists. These artists shared a commitment to a form of twentieth-century classically based figuration which was common in Europe from the 1920s if not earlier. We have already noted the inspiration from the Swedish Carl Milles in the cases of McMillan and Wheeler, but there were other protoypes: in France Maillol, Bernard, Despiau; in Germany and Austria a host of followers of Adolf von Hildebrand such as Kolbe, Scheibe and Müllner: Ledward was certainly familiar with Hildebrand's work.[115] Siegfried Charoux (ARA 1949, RA 1956) had practised in Vienna and executed public monuments there: his Lessing Memorial unveiled in 1935 was destroyed by the Nazis for its seeming unconventionality.[116] He arrived in England in 1935 and his *Youth: Standing Boy* was acquired by the Tate in 1948 under the Chantrey Bequest. He went on to execute various public works in this country (fig. 206). Uli Nimptsch (ARA 1958, RA 1967) trained in Berlin and worked in Rome and Paris before coming to London in 1939 (his wife was Jewish).[117] He developed a career in public sculpture and a successful line in portrait busts of celebrities such as Paul Oppé (1949) and Sir Mortimer Wheeler (1969). Georg Ehrlich (ARA 1962) trained as a sculptor in Vienna and had a successful career in Austria, but with the fascist putsch in 1938, being already in London he decided to stay.[118] He built up a successful career with works acquired by various public collections. Willi Soukop (ARA 1963, RA 1969) was of mixed Czech and Austrian parentage and trained in Vienna.[119] In 1934 he was invited to England where, apart from a period of internment during the Second World War, he built up an extremely successful career as teacher of sculpture at schools and art colleges, including Chelsea (1947–72), and he was Master of the Academy Sculpture School from 1969 to 1982. He executed a large number of works in public locations, especially for schools, and he was responsible for the portrait relief memorials to two PRAs in St Paul's Cathedral: Thomas Monnington and Charles Wheeler.

A major field of activity in post-war art for Academy sculptors was their participation in the public sculpture exhibitions held in London.[120] They often shared these exhibitions and the organizational roles they involved with dedicated members of the then seeming avant-garde as well as with entrenched members of the various artistic bureaucracies. The first of these exhibitions was held at Battersea Park in 1948 when Wheeler and Dobson were on the organizing committee along with Henry Moore and the directors of the National and Tate galleries. Sculptors represented included Reid Dick, Charoux, Hardiman and Ledward, together with Moore, Hepworth and Epstein; Zadkine, Matisse, Laurens and Lipchitz represented European modernism, while Rodin, Despiau and Maillol were also shown.

206 Siegfried Charoux RA, *The Friends*, c.1956, bronze and wood, height 68.5 cm (RA 03/1691).

In 1951 there were two parallel exhibitions, at Battersea Park and on the South Bank site of the Festival of Britain. The Battersea Park show was organized by the Arts Council and the London County Council. Holding the fort for the Academy on its advisory committee was Charoux (replacing Ledward, who had first been invited but subsequently

resigned),[121] pitted against Barbara Hepworth and Peter Gregory (treasurer of the Institute of Contemporary Arts), with a number of possible neutrals or even wild cards such as Epstein, F. E. McWilliam RA, Sir Eric Maclagan (one-time director of the V&A, now chairman of the Fine Art Committee of the British Council, which was already championing advanced British art abroad), John Rothenstein from the Tate Gallery, and Philip James from the Arts Council (ostensibly neutral but a close friend of Henry Moore). Of the 44 works selected, 12 were identifiable to some degree or another with the Academy: those by Charoux, Dobson, Ehrlich, Gill, Hardiman, Lambert, Ledward, Nimptsch, Skeaping, Soukop, Havard Thomas and Wheeler. Moore and Hepworth led the way for the moderns, accompanied by Reg Butler, Lynn Chadwick (Senior RA 2001) and Bernard Meadows (the latter three soon to be catapulted to critical fame by the British Council at the Venice Biennale of 1952), and an assortment of reputable moderns from abroad such as Arp, Bill, Calder and Giacometti; and so honours were, perhaps, even. The spread of sculpture on the South Bank site was immense and varied, including works by Nimptsch, Charoux, McFall and Lambert, while present also were the creations of Adams, Butler, Chadwick, Meadows, Eduardo Paolozzi (ARA 1972, RA 1979, Senior RA 1999), Moore and Hepworth (twice) along with the productions of a large number of other sculptors, some 30 in all.

Other Battersea Park exhibitions were to follow, often displaying a similar balancing trick. An intriguingly analogous exhibition was held by the London County Council at Holland Park in 1957 entitled 'Sculpture 1850 and 1950', which set out to compare and contrast sculpture of the mid-Victorian era with that of the mid-twentieth century. At that time Victorian sculpture was critically, so to speak, invisible, but the selectors were fortunate to engage the services of Rupert Gunnis, who had published his *Dictionary of British Sculptors 1660–1851* in 1953. To him must be credited the selection of significant Victorian works, largely drawn from the Royal Collection, the Academy and the Tate, which was displayed in the Orangery. The contemporary works were selected by various bodies and their representatives: Charoux and Gunnis for the Royal Academy; Philip James and John Piper for the Arts Council; John Rothenstein and Charles Wheeler for the Royal Society of British Sculptors; and Lynn Chadwick and H. D. Molesworth,

Keeper of Sculpture at the Victoria and Albert Museum, for the Institute of Contemporary Arts. The Academicians represented were Charoux, Dobson, Durst, Ledward, McFall, Skeaping and Wheeler alongside a clutch of sympathisers and future members: Robert Clatworthy (ARA 1968, RA 1973, Senior RA 2003), Edward Folkard, Elizabeth Frink (ARA 1971, RA 1977), T. B. Huxley-Jones, McWilliam and Benno Schotz. But the moderns were not to be outnumbered. Here were Moore and Hepworth, and the young 'Geometry of Fear' sculptors of the 1952 Venice Biennale: Robert Adams, Kenneth Armitage (Senior RA 1994), Butler, Chadwick and Bernard Meadows. Identifiably modernist young sculptors included Hubert Dalwood (ARA 1976), John Hoskin, Peter King, Leslie Thornton and Austin Wright. Epstein was also present with an Expressionist bronze bust while Arthur Fleischmann, with his perspex *Lot's Wife*, was a reminder of the Central European migration. The introduction to the catalogue is perhaps the most intriguing element of the whole enterprise. It was written by Wheeler, by then PRA, and attempts a balanced account of sculpture of the past as well as the present. He found the Victorian sculpture 'sentimental' and wondered whether it might have given rise to abstraction, and was prepared to admit that contemporary sculpture reflected the age in being 'rough, agitated, nervous, even tortuous', 'searching and seeking' as the 'inheritors of cataclysms'. There were hopeful signs, he thought, even though charlatans might rush in. It was for the viewer to choose.[122]

If we jump 30 years in the sculptural membership of the Academy, the battle lines (almost) of the 1950s referred to above were beginning to vanish, and today most leading sculptors are members of the Academy, for which there is a very good reason, involving the personality and work of the sculptor Bryan Kneale (ARA 1970, RA 1974). Kneale trained as a painter at the RA Schools between 1948 and 1952, winning a Rome Scholarship in 1949. In 1960 he turned to sculpture in metal of an emphatic abstract nature, and in 1963–4 became sculpture teacher at the Royal College of Art. He maintained friendly relations with a number of Academicians and in 1970 became ARA. At this time there was still a reluctance on the part of contemporary, abstract, non-academic sculptors to be involved with the Academy, where the only truly abstract practitioners were Robert Clatworthy and Ralph Brown (ARAs 1968) and Geoffrey

Clarke (ARA the same year as Kneale, 1970). There was an awareness within the Academy this was not a satisfactory state of affairs, and Kneale became involved in discussions with, among others, the then PRA Thomas Monnington to see if it could be remedied. Kneale explained that his contemporaries were really opposed to the spaces for exhibiting, featuring as they did a range of encrusted cornices and patterned wall hangings. If, however, he were to be allowed to construct some white gallery space he would see what he could do. The result was the breakthrough 1972 Winter Exhibition at the Royal Academy, 'British Sculptors '72'. Of the 24 participants four were already ARAs (those already mentioned) and nine more were to become Academicians or Associates: Eduardo Paolozzi, George Fullard (ARA 1973), Hubert Dalwood, Phillip King (ARA 1977, RA 1988, PRA 1999–2004) (fig. 207), Michael Sandle (ARA 1982, RA 1989, with a break, 1997–2004, owing to his resignation), Kenneth Draper (ARA 1990, RA 1991), William Tucker (RA 1992), Kenneth Armitage and Nigel Hall (RA 2003). This was not a bad haul, all told. Clarke, Armitage and Paolozzi had all been part of the 1952 Venice Biennale so-called 'Geometry of Fear' show, while Clarke and Paolozzi had both entered for the allegedly shocking 'Unknown Political Prisoner' competition in 1955; and Phillip King had played a prominent role in the development of the revolutionary teaching at St Martin's School of Art in the 1960s. Anthony Caro (election declined 1990, Senior RA 2004) was asked to join in but declined; however, King's exhibited work *Sculpture 1971* he renamed *Academy Piece*. The Academy thus became a highly satisfactory gathering place for the major sculptors of our time, including Richard Wilson (b. 1953, RA 2006; fig. 208).[123] The current sculptor membership of the Academy amounts to 23 full members and five Associates, plus six Senior RAs, a total well beyond the 14 sculptors required by the constitution, and seven of this number are women, again well in excess of previous practice.

Whatever the changes in the nature of the Academy personnel in the post-war era, certain earlier opportunities did not fade away. In 1948 Ledward wrote to Walter Lamb, the Secretary, pointing out that a large sum of money had accumulated in the Leighton Fund and that it might be appropriate, in what looked likely to be forthcoming times of austerity, to use some of it for a small fountain in a London square with the aim of encouraging local authorities to follow suit.

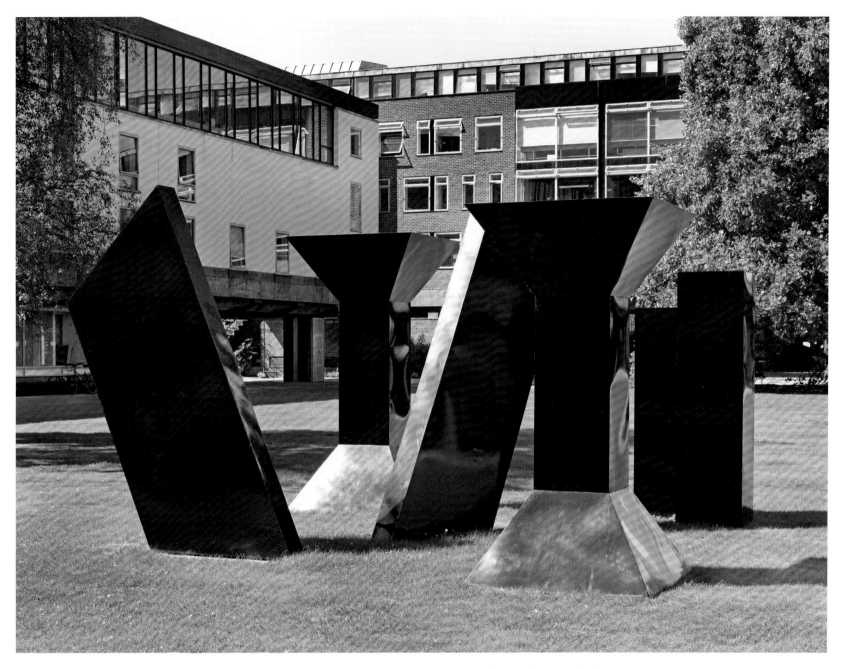

207　Phillip King PRA, *Span*, 1967, painted steel, 250 × 540 × 480 cm. University of Cambridge, Faculty of Economics, Sidgwick site.

Chelsea Borough Council was, indeed, persuaded to place a fountain in Sloane Square. Ledward was careful to say he was not interested in such a scheme, and that it should not be confined to Academicians but open to public competition, but the commission was restricted to RAs and Ledward landed the job, his popular Venus Fountain being unveiled in 1953 (fig. 209).[124] The Leighton Fund was also to be used for the series of commemorative relief medallion portraits of Academy presidents to be placed in the crypt of St Paul's Cathedral. Willi Soukop produced the medallions to Thomas

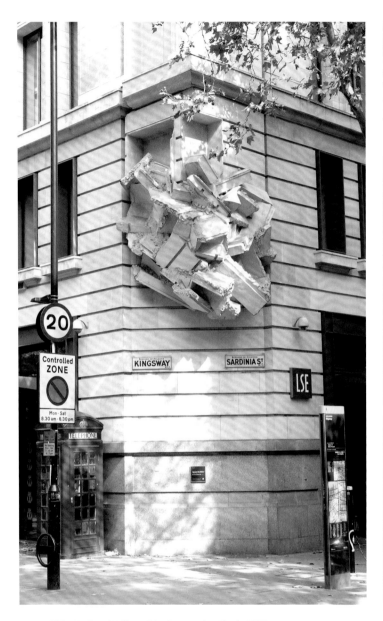

208 Richard Wilson RA, *Square the Block*, 2009, stone. London School of Economics, London.

209 Gilbert Ledward RA, Venus Fountain, 1953, bronze. Sloane Square, London.

Monnington and Charles Wheeler, and David McFall those to Albert Richardson (1965) and Gerald Kelly (1973).

By far the greater sculptors' bequest was the Chantrey Fund, which continued throughout the pre-war and post-war periods to acquire paintings and sculptures for the nation, often with controversy attached. The problem remained the Academy's perfectly legal exclusive right to the fund, and

it resisted critical and legal pressure to compromise its long defended independence. An accompanying problem was with the deposit of the works: they were acquired ostensibly for the National Gallery, but its relevant subsidiary, the Tate Gallery, became the National Gallery of British Art in 1954. This had its own curators, and increasingly during the 1940s and 1950s they had formed their own distinctive views on what

was significant as contemporary art. The Academy had set up two subcommittees of three painters and three sculptors to advise the Council selectors on what they might choose, but it seems not to have been until 1956, when the Chantrey committee bought Lambert's life-size bronze statue of Dame Margot Fonteyn, that the Tate trustees finally refused to accept a Chantrey purchase.[125] The Tate did so again in 1981 when it declined to accept Clatworthy's *Seated Figure*.[126]

This was not to say the Academy necessarily made poor acquisitions. Many, it is true, were by Academicians or soon-to-be Academicians. For example, on 1 May 1947 the Chantrey committee bought *Spring* by Arnold Machin (ARA 1947, RA 1956) for £1,000; on 29 April 1948 they bought Charoux's *Youth* for £1,000. In both cases, Munnings (then PRA) voted against, but Wheeler and Richard Garbe RA in favour.[127] An Epstein followed in 1953, a Gaudier-Brzeska in 1957. *Relief: Lovers III, 1969* by Ralph Brown RA was bought for £240 in April 1971 despite the opposition of Maxwell Fry RA and Sir Thomas Monnington PRA, and the same day Dobson's *Man Child* (1921) was bought for £2,750 at the suggestion of the Tate Gallery: Uli Nimptsch voted against.[128] In 1972 two works by Elisabeth Frink were refused by the selection committee.[129]

The situation with the Tate clearly needed resolution, and a meeting was held between Hugh Casson PRA and Alan Bowness, director of the Tate Gallery, who already knew each other. It was agreed there would be a preliminary meeting between two Academy representatives and two from the Tate, who would go round the Summer Exhibition in order to find suitable purchases, which would then go forward to the official selectors. There were other problems with the Chantrey Bequest, notably those works that were still in limbo because a location for them had never been decided. It was agreed that they would be distributed among provincial public galleries.

Remarkably, over 170 years since Chantrey's death, his bequest is still active. In 2012 the charity had six trustees, the President and Treasurer of the RA *ex officio* (as they have been since 1877) and others representing the Academy and the Tate. The Council still appoints a selection committee consisting of three RAs and three Tate representatives, and works still have to be shown first at the Summer Exhibition.[130]

In concluding an account of sculpture at the Royal Academy since 1840, one might note that one of its greatest bequests, from a sculptor, is still (just) alive in spite of what the financial experts have done to try and kill it off. And one might add, rather sadly, that the Academy seems to make no public effort to pay tribute to one of its greatest benefactors. But then, however generous he was, Chantrey was a sculptor and so, the cynic might ask, what do you expect?

A CLOSER LOOK

7.1

Henry Hugh Armstead
Three drawings for a sculpture

ROBIN SIMON

The Royal Academy collections includes many drawings by sculptors, a specialized group that is of particular interest. No fewer than 900 are by Henry Armstead RA, of which seven relate to designs of *c*.1880 for his tomb effigy of Bishop Ollivant in Llandaff Cathedral. The three illustrated here (figs 210–12) reflect the sculptor's painstaking approach in recording different views of the bishop's head and the appearance of the finished tomb, while others demonstrate his concern to depict the correct ecclesiastical dress. Armstead exhibited a sculpture of 'The Late Bishop Ollivant; for Llandaff' at the Royal Academy Summer Exhibition in 1887. Ollivant, who had been Regius Professor of Divinity at Cambridge 1843–9, was described as 'tall and spare, with features said by many to resemble those of the Duke of Wellington'. Sir Nikolaus Pevsner described the tomb at Llandaff as 'spectacularly treated', referring to 'Armstead's grandiose recumbent effigy', while the present volume in the series observes that 'the sculptor has made the most of the leonine head and the lawn sleeves.'[1]

A number of Armstead's other drawings in the Academy collection were also made for carvings and fittings at Llandaff Cathedral, including the Doctors of the Church in the sanctuary, during its restoration by the architects John Prichard and J. P. Seddon in the second half of the nineteenth century.[2] It was a major project, most of which took place during Ollivant's time as bishop (1849–82). The restored cathedral featured work by several Pre-Raphaelites, including Dante Gabriel Rossetti (triptych, *Seed of David*, originally for Prichard and Seddon's high altar), Sir Edward Burne-Jones ARA (porcelain panels, *Six Days of Creation*, stained glass), Thomas Wollner RA (pulpit panel, Chapter House), William Morris (stained glass) and Ford Madox Brown, whose *St Elizabeth with the Infant Baptist* is in the east window of the south aisle.[3] The Academy's continuing involvement in the sculptural adornment of Llandaff Cathedral is represented by a dramatic monument to Bishop Richard Lewis by Goscombe John RA (1909) in the sanctuary and a *Madonna and Child* by A. G. Walker RA on the altar of the Lady Chapel (1934). After being severely damaged in an air raid in 1941, the cathedral was again restored, this time under the architect George Pace, with work commissioned from many artists, resulting, most notably, in the *Majestas* by Jacob Epstein of 1957 that dominates the interior of the cathedral. The acceptance of this dramatic design meant that a projected *Last Judgement* by Sir Stanley Spencer RA was abandoned.

248

(above) 210 Henry Hugh Armstead RA, *Profile of Bishop Ollivant*, c.1880, pencil, 12 × 17.4 cm (RA 04/2290).

(below left) 211 Henry Hugh Armstead RA, *Rt Revd Alfred Ollivant, Bishop of Llandaff (1798–1882)*, c.1880, pencil, 15.6 × 17.6 cm (RA 04/2291).

(below right) 212 Henry Hugh Armstead RA, *Study for the Tomb Effigy of Bishop Ollivant*, c.1880, pencil, 25 × 15.5 cm (RA 04/2286).

Sir George Frampton
Lamia

HELEN VALENTINE

'I cannot recall anything quite like this…I had been in the sculpture gallery some minutes before my eye fell on this strange and fascinating Lamia. Imagine a life-size face of extraordinary beauty, mysterious and sad, carved in ivory that in a minute becomes flesh to the eye…She makes an absolute silence in the room; whoever turns his head in passing stops and remains as one enchanted.'[1] Such is the power of the sculpture that Sir George Frampton RA created of this mysterious femme fatale (fig. 213). His protagonist, shaped from polychromatic materials, is not the monster from Greek mythology who preyed on children but the Lamia of John Keats's eponymous poem (1819): a beautiful serpent-like creature who assumes female form in order to win the love of the mortal Lycius. When her true nature is exposed at their wedding, she changes back into a serpent and vanishes, and her husband dies. The bust depicts the dramatic moment when Lamia is exposed for what she is, and Keats describes first the charged atmosphere when:

> By faint degrees, voice, lute, and pleasure ceased;
> A deadly silence step by step increased,
> Until it seem'd a horrid presence there,
> And not a man but felt the terror in his hair. (ll. 265–8)

He then describes through Lycius's eyes the physical transformation

> "Begone, foul dream!" he cried, gazing again
> In the bride's face, where now no azure vein
> Wander'd on fair-spaced temples; no soft bloom
> Misted the cheek; no passion to illume
> The deep-recessed vision – all was blight;
> Lamia, no longer fair, there sat a deadly white.
> (Part II, ll. 271–6)

The use of ivory for the face perfectly depicts her 'deadly white' demeanour, and on the back and sides of the neck, incised in the bronze, are the scales of a snake's skin as she starts her change back to serpent form (fig. 214). Frampton also decorated the costume of Lamia with an elaborate pendant and used semi-precious stones that have an obvious symbolic significance. The pendant has a small figure of a boy beneath a large opal that is elaborately caged in bronze. Further opals adorn the headdress and also surround the figure in the pendant. Foliage leads down to a spherical crystal held in a setting reminiscent of roots. Opals are symbolic of shifting passions and ill fortune, and crystal balls are associated with witchcraft and fortune-telling.

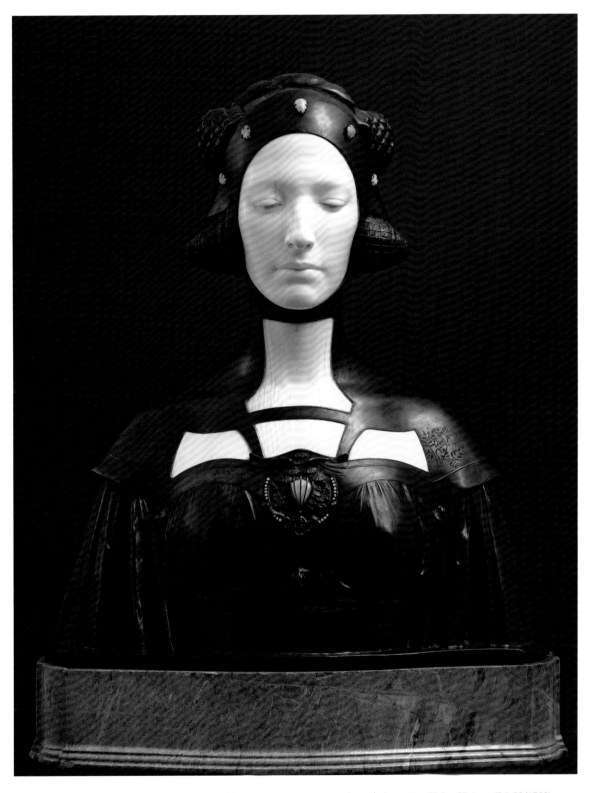

213 Sir George Frampton RA, *Lamia*, 1899–1900, ivory, bronze, opals and glass, 61 × 55.3 × 25.4 cm (RA 03/1723)

214 Sir George Frampton RA, *Lamia*, view from the back.

The use of ivory at this period was increasing and was particularly favoured by late nineteenth-century Symbolists in France and Belgium. Frampton probably used African ivory, which was widely available from the Belgian colony in the Congo. The chest and neck sections are four separate pieces of ivory, but the face is one large piece that would have been moulded once the ivory was softened, and a plaster model of the face mould still exists in the Victoria and Albert Museum.[2] The encasing of the ivory within the severe bronze headdress and strapped cape reflects Lamia's own life as a prisoner of her own fate.

According to an article in the *Studio* in 1899, Frampton originally intended to enrich this sculpture further with 'an ornamental network of gold about the throat and forehead' and proposed that the 'sleeves and drapery are to be of silver, embellished with mother-of-pearl and coloured enamels.'[3] Although he ultimately omitted these additional decorations, there are faint traces of gilding around the edges of the bronze chest sections. It is possible that the model for this work was the artist's wife, Christabel Cockerell, a painter whom the sculptor met when they were both studying in the Royal Academy Schools. Christabel also modelled for other sculptures by Frampton including *Mysteriarch* (1893–4, Walker Art Gallery, Liverpool).[4]

Frampton's work in the 1890s appears to be closer to contemporary French and Belgian artists than to that of his British colleagues. The combination of materials in works by Symbolists, such as Charles Van der Stappen's *Sphinx Mystérieux*, which is made of silver and ivory (1897, Musées Royaux d'Art et d'Histoire, Brussels), were an important precedent. Frampton had previously exhibited sculptures such as the polychromed plaster *Mysteriarch* bust in the first exhibition of the Belgian avant-garde exhibiting body 'La Libre Esthétique' in Brussels in 1894, where the critic Roger Marx had already identified Frampton as 'a sculptor-decorator obsessed with dream and mysticism'.[5] He also exhibited in the Venice Biennale of 1897 and the first Vienna Secession in 1898, and increasingly incorporated elements of the decorative arts into his sculpture as a way of expressing Symbolist ideas. *Lamia* is the culmination of this fusion of technique and ideology into a masterpiece of Symbolist sculpture, in which the combination of life-size scale, the uncanny resemblance of ivory to deathlike flesh, and the mythology of the femme fatale all work to create a vision that arrests us 'as one enchanted'.

Sir Alfred Gilbert
Victory
Diploma Work

ROBIN SIMON

This is a bronze version of the original sketch for the figure that perches on top of the orb held by the queen in the Queen Victoria Jubilee Memorial in the Great Hall at Winchester Castle executed by Sir Alfred Gilbert RA in 1887 (fig. 215). The sketch for this memorial was exhibited by Gilbert at the Academy exhibition the following year (1888), and he presented this bronze as his Diploma Work in 1893. In itself, the Queen Victoria Jubilee Memorial is as brilliant and eccentric as anything created by this extravagantly inventive sculptor, and it was described by no less a towering figure than Rodin to be 'the finest thing of its kind in modern times'. Rodin also asserted that Gilbert was not just the equal of Benvenuto Cellini but 'better than that, better than that'. Many versions of this bronze exist, some with minor variations, because Gilbert was in the habit of presenting them to friends and acquaintances including, for example, the great actor Sir Henry Irving, whose high-quality version of *c*.1891 was acquired by the Victoria and Albert Museum after his death in 1905 on the advice of Thomas Brock RA (V&A 1050-1905). *Victory* evidently possessed a particular significance for Gilbert, and he is seen holding the figure in

the commemorative portrait bust of 1936 by Albert Toft in the Academy collection.

The Academy also owns a sketch by Gilbert for another, different, figure on the Jubilee Memorial, which was cast in bronze within the Academy at some point after 1936, as well as a bronze of the sketch model for the figure of Eros on the Shaftesbury Memorial at Piccadilly Circus. Other works by Gilbert in the Academy collection include both the plaster and bronze of his portrait bust of G. F. Watts RA of 1889, the bronze having also been made within the Academy (in 1939); and four plaster modelli for the tomb of the Duke of Connaught (St George's Chapel, Windsor).

Gilbert's relationship with the Academy was so fraught, however, that in 1908 he was obliged to resign his membership, at a date when he was attempting to survive in exile in Bruges after he had been declared bankrupt in 1901. After returning to Britain after the First World War, he triumphantly demonstrated his undiminished brilliance with the astonishing Queen Alexandra Memorial of 1932 (opposite St James's Palace), and he was rewarded with election as Senior RA the same year.

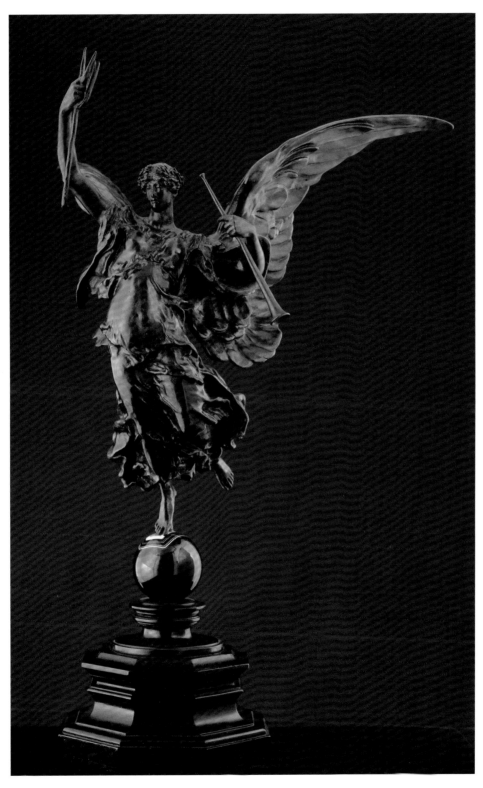

215 Sir Alfred Gilbert RA, *Victory*, c.1887, bronze, height 28.6 cm (RA 03/1917).

FROM HISTORY TO GENRE

SIMON POË

For many years after the Royal Academy was founded in 1768, it remained the rule that, upon election, members – whatever their specialism – were encouraged to present what was called a 'history' as the required Diploma Work. 'History' simply meant the depiction of an action, but it had to be an interpretation of a specific text, as a kind of guarantee of authenticity. The texts were usually biblical or epic (preferably classical), but the more specific the better, so that most histories were drawn from just one or two lines, which were often quoted upon any engraved reproduction. History, it was still considered, was the highest kind of art within a hierarchy that had been formally established by the Académie royale de peinture et de sculpture in Paris in the middle of the seventeenth century, although it had been commonly accepted since the Renaissance in Italy. Ranked below history were portraiture, genre (scenes of everyday life), then landscape, and so on down through the depiction of animals to still-life.

There was considerable sensitivity about the inadequate showing in the field of history on the part of British artists as the eighteenth century progressed. It was confronted by William Hogarth not only in history paintings but also in his development of portraits in which the distinction between portrait and history was deliberately unclear. *David Garrick as Richard III* (1745; Walker Art Gallery, Liverpool) is Hogarth's most distinguished creation in this respect.[1] He was followed by Joshua Reynolds in many ingenious compositions, such as his portrait group of the Montgomery sisters, *Three Ladies adorning a Term of Hymen* (1773; Tate Britain, London), that drew heavily upon Old Masters and sources in the Antique.[2] By the date of the latter portrait, the perceived problem had if anything become more pressing, since the annual exhibitions of the Royal Academy were by now well under way, and portraits often formed the most plentiful category of works on view.

216 Sir Thomas Lawrence PRA, *Gipsy Girl*, 1794, oil on canvas, 91.5 × 71.1 cm (RA 03/411).

If portraits might increasingly be lent an air of history painting, the line between history and genre at the Royal Academy was blurred right from the beginning. So it was that in 1794 Thomas Lawrence presented as his Diploma Work not a history painting but a 'fancy picture', the *Gipsy Girl* (fig. 216), although this was even more complicated since it was modelled upon, without quite being a portrait of,

Maria (or Marie) Siddons. She was one of the two daughters of the great actress Sarah Siddons, with both of whom Lawrence was simultaneously romantically, and messily, involved.[3] The fiction here is that this darkly enticing girl, who has unaccountably forgotten her blouse, has stolen the chicken that she holds since, although it is difficult now to perceive, an angry farmer is giving chase in the background.

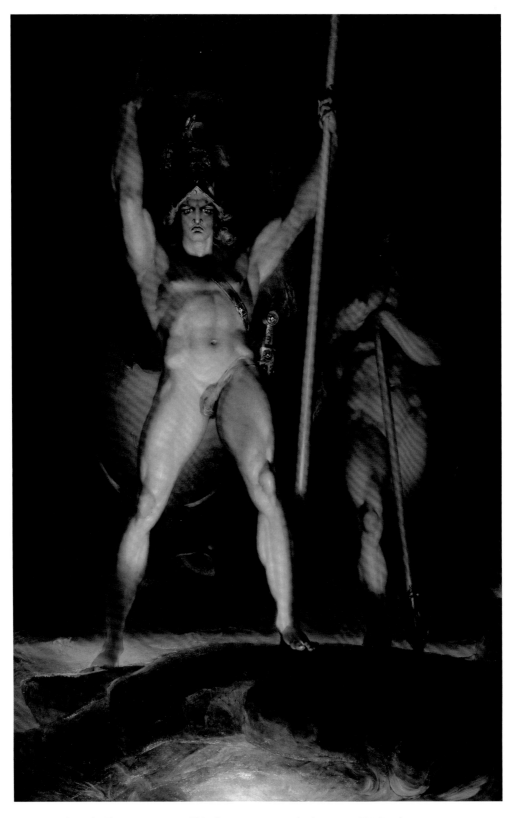

217 Sir Thomas Lawrence PRA, *Satan summoning his Legions*, 1796–7, oil on canvas,
432.8 × 274.3 cm (RA 03/1094).

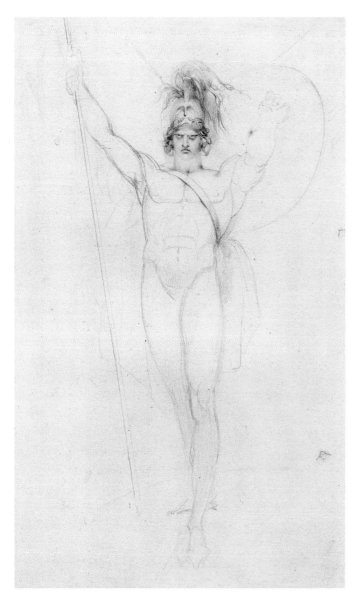

218 Sir Thomas Lawrence PRA, *Preparatory Drawing for 'Satan summoning his Legions'*, c.1796–7, pencil, 32.5 × 9.3 cm (RA 09/1936).

Book 1. Lawrence took just one line (l. 330), when Satan rouses his forces for battle with the words, 'Awake, arise, or be for ever fallen.'

Lawrence's painting tells us much about how a history might be put together. For example, a preparatory drawing in the Academy collection (fig. 218) shows how Lawrence, who was still only 25, was influenced in his initial thoughts by the example of his fellow Academician Henry Fuseli, whose *Thor battering the Midgard Serpent* had recently been presented to the Academy as a Diploma Work (fig. 219), a picture that shares a similar heightened Gothic intensity. Lawrence's Satan holds his shield in his left arm in the drawing, but in the painting it is on his shoulders, as described in an earlier part of the passage in *Paradise Lost* (ll. 283–8).

Lawrence's drawing was probably studied from the live model, which was good academic practice, and we may note the gentlemanly positioning of the feet at right angles in accordance with current notions of correct deportment.[4] But the use of a model is more evident in the torso of the finished painting, and for a good reason. It was modelled upon the body of the bare-fist boxer John Jackson, who had just conquered Daniel Mendoza in 1795 to become champion of England, which he did by holding Mendoza's hair with one fist and beating him to a pulp with the other. The head, however, was studied from that of the actor John Philip Kemble, who provided an appropriate facial expression. A history was supposed to rise from the particular to the ideal, and so it is not easy to identify Kemble's rather icy classical features in the painting. Meanwhile, the profile of the figure writhing at Satan's feet was initially modelled upon Kemble's sister, Sarah Siddons, although Lawrence had second thoughts about this and obscured any resemblance. This touch of delicacy was probably just as well since it was at precisely this time, around 1797, that Lawrence was romantically entangled with her daughters.

Lawrence lamented that the rest of his career, which was crowned with great European success in portraiture, had never lived up to his *Satan*, although we may feel free to differ, as did the contemporary critic who wrote:

The frequency with which we have been annually compelled to notice the daring folly of our callous Artistes, in assuming the baton of an historical Painter, before they had even a common knowledge of the human anatomy,

It was only much later that Lawrence's scrupulous exercise in academic history painting, *Satan summoning his Legions* (fig. 217), painted in 1796–7, entered the collection, as a commemorative gift from his friend Samuel Woodburn in 1837. This composition was based, as was desirable, upon a specific text, the same source in fact from which Thomas Banks's *Falling Titan* is more loosely derived, Milton's *Paradise Lost*,

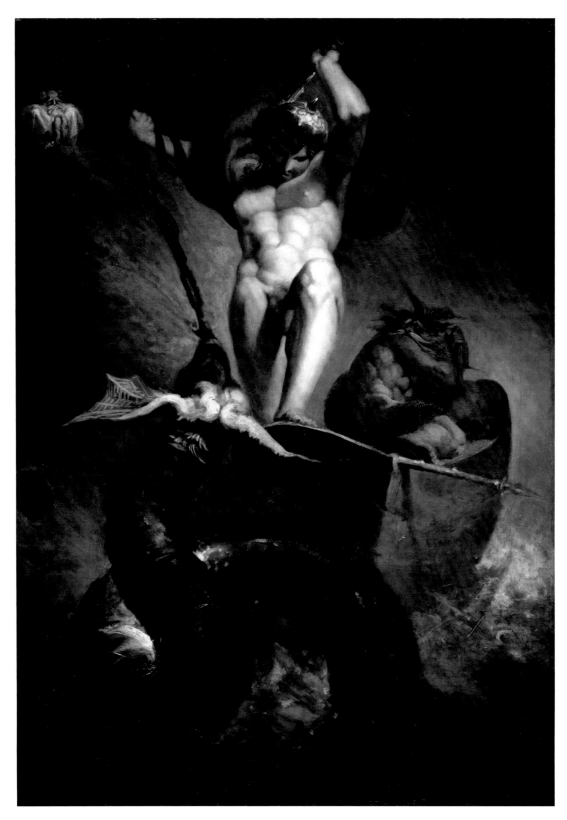

219 Henry Fuseli RA, *Thor battering the Midgard Serpent*, 1790, oil on canvas, 133 × 94.6 cm (RA 03/995).

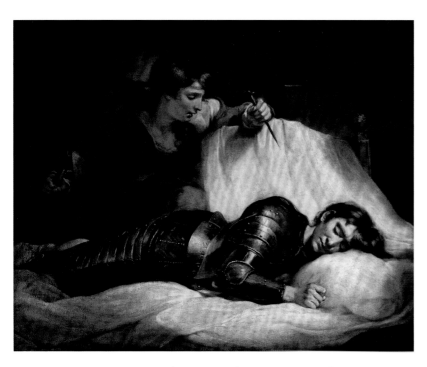

220 James Northcote RA, *Jael and Sisera*, 1787, oil on canvas, 124.5 × 155 cm (RA 03/881).

has filled us with regret, yet it appears, that no warning can refrain their lunacy, nor any admonition amend their manners: – before *Michel Angelo*, or *Rafaelle*, attempted to walk in this path of sublimity, they added the force of incalculable and unremitting study to the purest and strongest endowments, and even then they took up the pencil tremblingly, well knowing the complicated difficulties of the pursuit.

'But fools rush in, when angels fear to tread.'

The picture is a *melange*, made up of the worst parts of the divine *Bonarotti* [*sic*], and the extravagant *Goltzius*: the figure of Satan is colossal and very ill drawn: the body is so disproportioned to the extremities, that it appears all legs and arms, and might, at a distance, be mistaken for a sign of the spread eagle. The colouring has as little analogy to truth as the *contour*, for it is so ordered that it conveys an idea of a mad German baker, dancing naked in a conflagration of his own treacle! – but the liberties taken with his Infernal Majesty, are so numerous, so various, and so insulting, that we are amazed the ecclesiastic orders do not interfere in behalf of an old friend.[5]

Lawrence's composition does, however, attain a level of heightened drama that is absent from many of the history paintings dutifully presented to the Academy in the years around 1800, although the *Sixth Trumpet Soundeth* of 1804 by Henry Howard RA struck a similar note of Fuselian melodrama. More characteristic are the subdued *Rape of Ganymede* by William Hilton RA of about 1806 and *Vertumnus and Pomona* by William Hamilton RA of about 1789, while the positively genteel telling of the brutal biblical episode of Jael and Sisera by James Northcote in 1787 (fig. 220) is all the odder for showing the Old Testament victim in seventeenth-century armour. Anachronisms of this kind were soon to become outdated in the light of a movement in both painting and the theatre towards greater historical and archaeological accuracy, but they had been accepted within the eighteenth century without comment, as, for example, when David Garrick played Macbeth not in plaid but in Georgian court costume.[6]

The most dignified of the Academy's history paintings is *The Tribute Money* by John Singleton Copley RA (fig. 221), which is of particular interest in that the artist deliberately returned to the New Testament for this Diploma Work (accepted in 1782). By this date Copley was more famous for painting contemporary history in dramatic compositions such as the *Death of Chatham* (1781; National Portrait Gallery, London) and for the entrepreneurial acumen with which he exploited them. Copley would place one of these very large canvases on show in the manner of a theatrical production, for which he charged admission – in the case of the *Death of Chatham* at the Great Room, Spring Gardens (which was close to the present Admiralty Arch). Copley's development of the depiction of contemporary events in large-scale history paintings had been anticipated by two fellow Academicians in particular, Edward Penny and Benjamin West, who both painted the *Death of General Wolfe*, Penny in 1763 and West in 1770; but neither rose to the heights of Copley, who remains the exception among British artists as a technically near-faultless master of vast historical compositions.

The truth is that history had always been an aspiration more than an achievement within the Academy, as it had been throughout the years that saw the emergence of the British School in the first part of the eighteenth century. But it remained, even as the shadow of a shadow, to haunt the Royal Academy for many years to come: for example, Charles

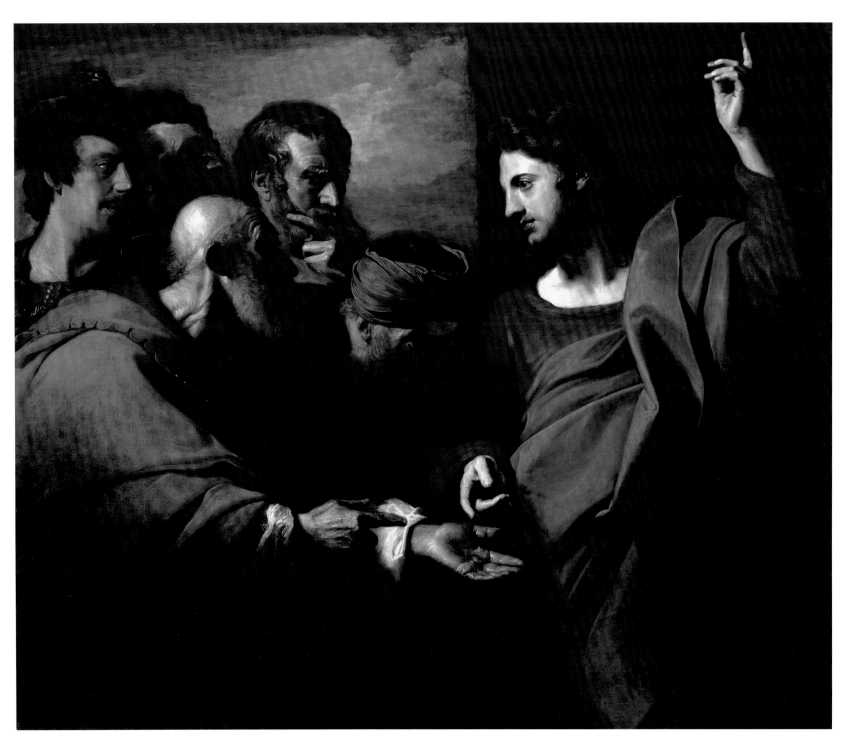

221 John Singleton Copley RA, *The Tribute Money*, 1782, oil on canvas, 128.3 × 153.7 cm (RA 03/994).

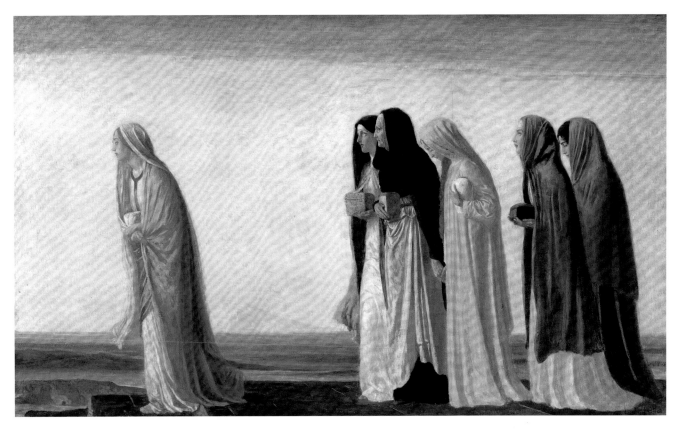

222 Charles Anning Bell RA, *Women going to the Sepulchre*, 1912, oil on canvas, 76 × 127 cm (RA 03/482).

Eastlake PRA presented *Hagar and Ishmael* in 1830, Frederic Leighton PRA *St Jerome* in 1869, Charles Anning Bell RA *Women going to the Sepulchre* in 1912 (fig. 222); even Walter Sickert RA attempted to present a *Lady Macbeth* (now Royal Shakespeare Company Collection) but was asked to offer something more 'representative'. As recently as 1992, Sonia Lawson RA presented *Tobias and the Angel*.

The failure of histories to take hold in Britain was only partly due to the continued supremacy of portrait painting. More significantly, and largely during the presidency of Lawrence (1820–30), it was shouldered aside by the astonishing rise of genre, which increasingly took upon itself, especially in the Victorian period, the moral burden that had previously been borne by histories. The brilliant inventions of David Wilkie RA especially dealt history a heavy, if not quite mortal, blow. His paintings, notably *Chelsea Pensioners receiving the London Gazette Extraordinary of Thursday, June 22d, 1815, announcing the Battle of Waterloo!!!* (exhibited RA 1822;

Apsley House, London) were often related to actual contemporary events.[7] They were, in a sense, histories, and yet they were fictions, original to the artist and not drawn, like a history, from a revered textual source of the past. Nonetheless, the process by which they were composed was akin to the preparation of a history, as is amply attested by the presence of many of Wilkie's preparatory studies in the Academy collection.

After the first decades of the nineteenth century the curious amalgams of the kind that we see in Northcote's *Jael and Sisera* were replaced, as noted above, by attempts at a more faithful recreation of the past. In literature this movement was exemplified in the Romantic novels of Sir Walter Scott that were set within what seemed to be accurately depicted former times, and which were hugely popular throughout Europe. Episodes drawn from Scott, but also from Shakespeare, who was likewise so appealing to the Romantic imagination (he had been disapproved of by Euro-

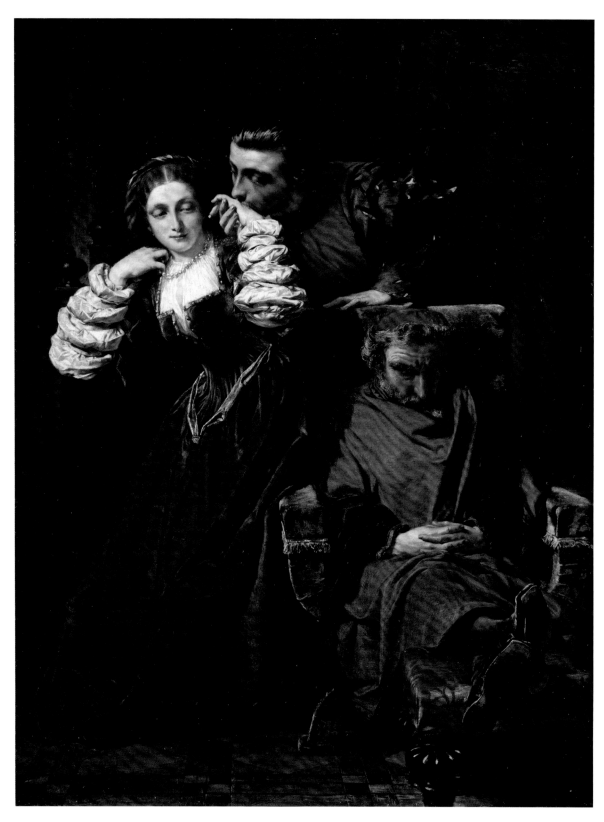

223 Alfred Elmore RA, *A Scene from Two Gentlemen of Verona*, 1857, oil on canvas, 70.1 × 53.9 cm (RA 03/1014).

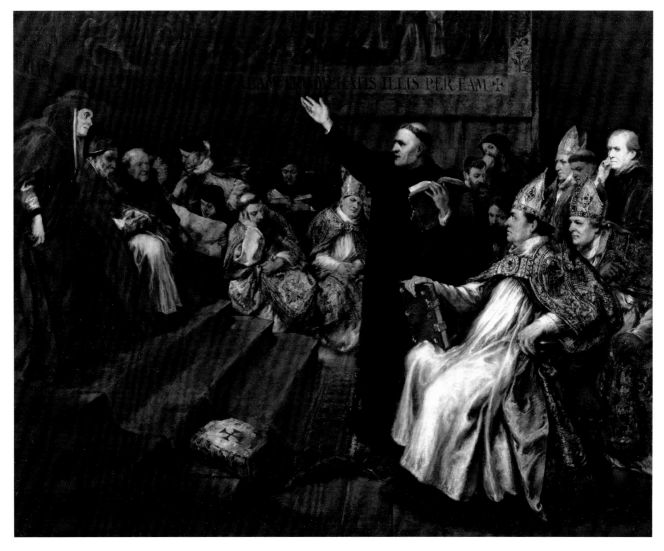

224 Sir John Gilbert RA, *A Convocation of Clergy*, 1870, oil on canvas, 122.5 × 152.3 cm (RA 03/812).

pean thinkers in the eighteenth century), were now to be seen in exhibitions in London and on the Continent. In many cases these works, which appear to be scenes of historical genre, were very close to histories, since they might interpret just a few lines in one of Scott's novels or Shakespeare's plays: *A Scene from Two Gentlemen of Verona* by Alfred Elmore RA (fig. 223) is a case in point, since it is founded upon just two lines – 'This love of theirs myself have often seen / Haply, when they have judged me fast asleep' (I, 3) – and these lines were quoted in the catalogue when the painting was exhibited in 1858.

More prevalent, however, indeed overwhelmingly so, was a new species of composition, not so much of history as historicizing genre. These are imaginary scenes invented by the artist, but interpreted with an often painstaking attention to the reproduction of the past. Some themes proved more popular than others: anything involving Cavaliers and Roundheads, for instance, but also scheming cardinals and naughty priests, while lutes were a favourite prop. The Academy has its fair share of all of them: for example, *A Convocation of Clergy* (1870) by Sir John Gilbert RA (fig. 224). When, as in the case of the splendid *Lute Player* (1899) by Edwin Austin Abbey RA,

it offered the excuse to paint in a rich approximation of Venetian Renaissance colour, so much the better. The early years of the nineteenth century, however, belonged to genre painting and David Wilkie.

DAVID WILKIE AND THE 'NEW' GENRE

The breakdown of the accepted hierarchy of art was an aspect of what is still sometimes regarded as the Romantic 'revolution', which in Kenneth Clark's words was 'a rebellion against the static conformity of the eighteenth century'.[8] In this sense, at least, David Wilkie was both a Romantic and a revolutionary, and certainly the rise of genre painting and Wilkie's primacy in that context were recognized at the time: 'The class of pictures which now employs the largest number of artists, and is most sought after and best paid, combining some of the qualities of historical painting with still life – what is called *genre*-painting', observed Tom Taylor in 1853. He went on to say that '[it] may almost be said to have been founded by Wilkie.'[9]

Of course, there had been genre painting before Wilkie, but he pioneered a new, hybrid genre that took on some of the subjects, the ambition and the reach of history painting, accreting to it not least its moral function.[10] Wilkie firmly set his inventions in the mundane world, not that of mythical figures or heroes of the past, yet relating the everyday to dramatic events of contemporary history which, in particular, were amply supplied by the Napoleonic Wars, as exemplified in *Chelsea Pensioners* discussed above.

In 1810 the Prince Regent had bought the *Village Choristers* from Edward Bird (ARA 1812, RA 1815), and he commissioned Wilkie to paint a companion piece. This was *Blind Man's Buff* (1812, RA 1813; Royal Collection). As if to confirm Wilkie's ascendancy over his supposed rival, in 1813 the prince commissioned a further painting, *Penny Wedding* (1818, RA 1819; Royal Collection), which Wilkie finally delivered in 1818, the probable date of a study for the composition in the Academy collection (fig. 225). *Reading of a Will* (1820; Neue Pinakothek, Munich) was the result of a commission from the King of Bavaria, although the Prince Regent wanted it too. 'To have monarchs contending for your works is but a just tribute to their unequalled excellence,' observed Sir Thomas Lawrence PRA, who helped to

225 Sir David Wilkie RA, *Study for the 'Penny Wedding'*, c.1818, pencil and watercolour, 13.1 × 7.8 cm (RA 03/6970).

226 Sir David Wilkie RA, *Study of a Man with One Leg*, by 1841, pencil and ink, 7.8 × 4.9 cm (RA 03/6990).

mediate between the would-be owners, 'but it is a new distinction for the arts in our time.'[11] In 1816 Wilkie acquired another great patron when, on 17 August, the Duke of Wellington called personally at Wilkie's house in Kensington to commission a picture, the *Chelsea Pensioners*. It was an honour of which Wilkie and his family were almost painfully conscious: 'The sensation this event occasioned quite unhinged us for the rest of the day', he told Haydon in a letter. *Chelsea Pensioners* was a turning-point in Wilkie's career. The duke took the closest interest in its creation, choosing what he liked and disliked from sketches prepared by the artist. Wilkie recorded that he and the duke quickly worked out the concept for the painting at their first meeting, when the duke suggested

> that the subject should be a parcel of old soldiers assembled together on their seats at the door of a public-house chewing tobacco and talking over their old stories. He thought they might be in any uniform, and that it should

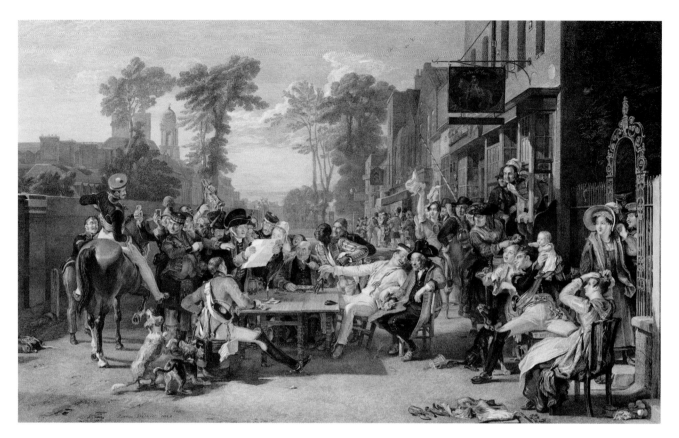

227 John Burnet after Sir David Wilkie RA, *Chelsea Pensioners reading the Gazette of the Battle of Waterloo*, 1822, etching and engraving, 43.8 × 71.9 cm (RA 06/5703).

be at some public-house in the King's Road, Chelsea. I said this would make a most beautiful picture, and that it only wanted some story or a principal incident to connect the figures together: he said perhaps playing at skittles would do or any other game. When I proposed that one might be reading a newspaper aloud to the rest, and that in making a sketch of it many other incidents would occur, in this he perfectly agreed, and said I might send the sketch to him when he was abroad.[12]

The duke later decided that there should also be 'more soldiers of the present day … the Duke agreed that the man reading should be a pensioner … He wished that the piper may be put in, also the old man with the wooden leg' (fig. 226).

The composition became familiar to millions through its reproduction in etching and engraving, of which an example

was presented to the Academy by the artist in 1831 (fig. 227). It is probably the composition in which the 'new' genre and the new sort of history painting that Wilkie developed along-side it are united in the most perfect equipoise.

If, on the one hand, Wilkie's work supplanted, to some degree, formal history painting, Wilkie also reacted, on the other, against the elegant and sentimental tradition of genre painting that, although it continued to be strongly repre-sented on the walls of the Royal Academy, had begun to look somewhat passé and formulaic. This line of genre can be traced back through the fancy pictures of Thomas Gainsbor-ough RA to the work of the Spanish painter Bartolomé Esteban Murillo, who, although he is best known for religious art, also produced lively, realist portraits of flower girls, street urchins and beggars such as the *Two Peasant Boys* (late 1660s) at Dulwich Picture Gallery. Gainsborough made several inspired copies of individual canvases by Murillo, whose

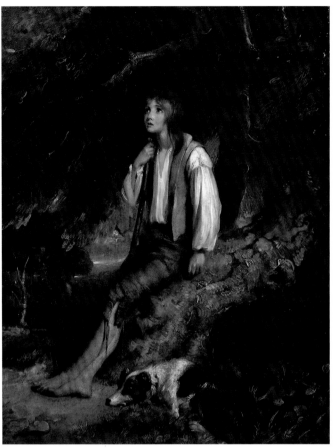

228 Henry Robinson after Thomas Gainsborough RA, *Young Cottagers*, 1828, line engraving on steel, 9.8 × 8 cm (RA 06/5687).

229 Richard Westall RA, *A Peasant Boy*, c.1794, oil on canvas, 91.1 × 71 cm (RA 03/963).

influence and popularity in Britain were at their height during the eighteenth century.[13] According to Sir Joshua Reynolds PRA in his 14th Discourse: 'In his fancy-pictures, when [Gainsborough] had fixed on his object of imitation, whether it was the mean and vulgar form of a wood-cutter, or a child of an interesting character, as he did not attempt to raise the one, so neither did he lose any of the natural grace and elegance of the other; such a grace, and such an elegance, as are more frequently found in cottages than in courts.'[14]

The Royal Academy's collection includes an engraving by Henry Robinson (1828) after Gainsborough's *Young Cottagers* (1787; fig. 228). The print was reproduced in *The Anniversary*, an anthology of poetry and prose published in 1829 by Allan Cunningham (later to be Wilkie's first biographer), accompanying an essay in which he compared paintings of children by

Reynolds and Gainsborough. 'There is a rustic grace and untamed wildness about the children of the latter', he suggested, 'which speak of the country and of neglected toilettes. They are the true unsophisticated offspring of nature, running unchecked among woods as natural as themselves.'[15] This discovery of 'grace and elegance' in the children of the poor was as flattering to the sensibility of the connoisseur as it was patronizing to the subjects, who were unlikely ever to see themselves portrayed. Just how prevalent this kind of work was can be gauged from the titles of some Diploma Works presented to the Royal Academy around the turn of the century. Francis Wheatley RA and Richard Westall RA both presented paintings entitled *A Peasant Boy*, Wheatley in 1791 and Westall in 1794 (fig. 229), while William Redmore Bigg RA offered *Cottagers* (1814; fig. 230). William Owen RA

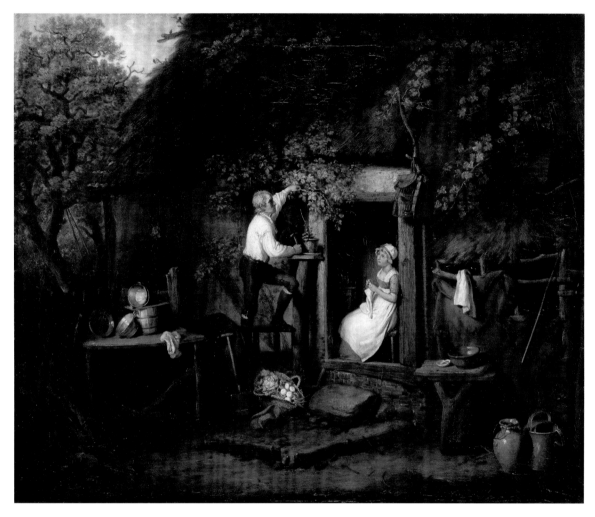

230 William Redmore Bigg RA, *Cottagers*, 1814, oil on canvas, 76.9 × 92.2 cm (RA 03/582).

offered *Boy with a Kitten* as his Diploma Work in 1807, and Henry Thomson presented the Academy with Owen's *Cottage Children* (*c.*1804–14) in 1827. This particular kind of senti-mental genre painting continued to attract distinguished practitioners, notably Henry Raeburn RA, whose very beautiful *Boy and Rabbit* (*c.*1814) is a jewel of the Royal Acad-emy's collection (fig. 231), but when David Wilkie erupted onto the walls of the Academy in 1806 it had been with a strikingly different sort of picture, the *Village Politicians* (1806, collection of the Earl of Mansfield). Wilkie shows the patrons of a rural inn, their passions roused by a combination of whisky and the *Edinburgh Gazetteer* (a short-lived radical paper of the 1790s to which Burns was a contributor). With

it, Wilkie enjoyed overnight success: like Lord Byron a few years later, he 'awoke one morning and found himself famous'. Further commissions followed: *Blind Fiddler* (Tate Britain, London) for Sir George Beaumont, *Card Players* (private collection) for the Duke of Gloucester, and *Rent Day* (private collection) for the Earl of Mulgrave – paintings that were, in turn, the sensations of the exhibitions of 1807, 1808 and 1809.

Wilkie was elected ARA in November 1809 just before he reached the age of 24, the minimum officially required by its statutes. The *Village Politicians* drew comparisons with the work of Teniers, and we are told that after he had arrived in London 'during the season when the galleries were open, [Wilkie] was to be seen at Cleveland House, Grosvenor

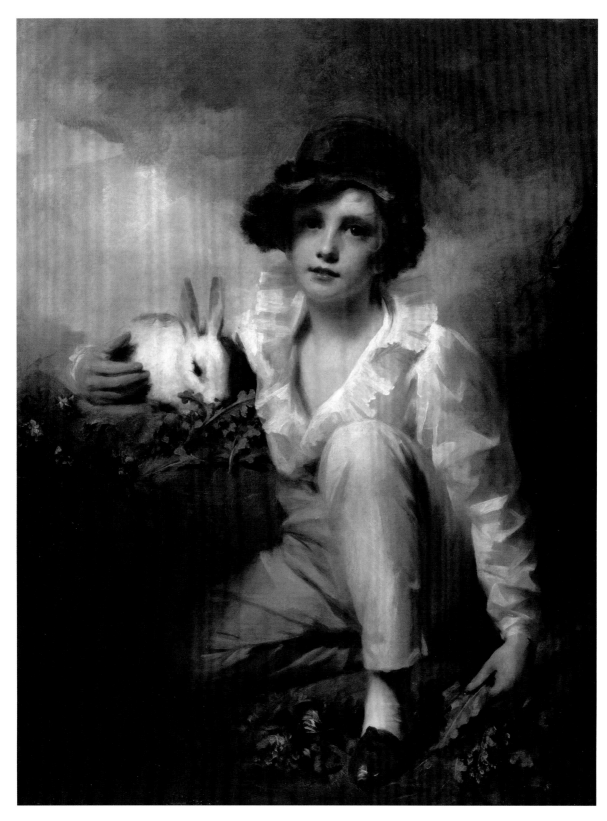

231 Sir Henry Raeburn RA, *Boy and Rabbit*, *c.*1814, oil on canvas, 103 × 79.3 cm (RA 03/703).

House, and other collections of pictures, everywhere peering into the works of the Dutch and Flemish schools.'[16] By the following year, when he exhibited the *Blind Fiddler* at the Academy, Wilkie was routinely being referred to as 'our British Teniers',[17] and his *Card Players* clearly refers to Teniers's *Two Men playing Cards in the Kitchen of an Inn* (*c.*1635–40; National Gallery, London).

Genre paintings were small enough to hang in the homes of buyers from an expanding middle class. 'Art here has flourished from the demands of those who love it as a home delight,' remarked Richard Redgrave RA in 1863, 'therefore our pictures are small, and suited to private houses.'[18] History painting no longer paid well (in fact, it had hardly ever done so), and its more stubborn practitioners suffered as a result. James Barry RA – whom Cunningham therefore called 'perverse' – 'chose to hunger and thirst in the great cause of epic art',[19] and his addiction to painting histories was shared by Wilkie's friend, Benjamin Robert Haydon, of whose efforts Wilkie remarked, 'it would be of great advantage to Haydon to paint small, from the much greater demand there would be for his pictures.'[20]

In his own day, Wilkie was compared with William Hogarth, an artist whom he admired. His compositions are indebted to Hogarth's, and they share an attention to eloquent gesture and facial expression. Wilkie's precision in this regard is partly due to his habit of working always from the live model, as attested by the drawings in the Royal Academy's collections (fig. 232), but it has been plausibly suggested that his acute sensitivity to the inner life of his characters, as manifested in the attitude of their bodies and the expression of their faces, may also owe something to his own 'thin skin' and his personal experience of depression and anxiety.[21] During the summer of 1809, before he was elected ARA, 'an illness, brought on by close study and those doubts and fears to which the sensitive are exposed…pressed sorely on Wilkie',[22] and for a month 'he seems to have given his pencil a complete holiday.'[23] Directly after his election he began to be canvassed as to whether he wanted to be considered immediately for full membership of the Academy, and received contradictory advice as to whether or not he should submit a small painting he had just begun for that year's exhibition. He had hoped to show an ambitious picture, the *Alehouse Door*, but did not get it finished in time. In the event, he submitted a small painting, the *Wardrobe Ransacked*

232 Sir David Wilkie RA, *A Man leaning on the Back of a Chair*, by 1841, pen and ink, 8.4 × 6.1 cm (RA 03/7019).

(now lost; a first version, 1810, Sotheby's, London, 7 July 2011, lot 324), which showed an old man teasing a girl by putting on her cap and shawl, but was asked to withdraw it. His friends were unnecessarily concerned at the time also by the fancied challenge to his pre-eminence mounted by Edward Bird RA, an up-and-coming genre painter, who was offering *Village Choristers rehearsing* (1810; Royal Collection) and was already being touted as 'the next Wilkie'. Bird indeed went on to be elected RA in 1815 when his Diploma Work was, confusingly a history painting almost too much in the academic mould, *Proclaiming Joash King* (fig. 233).

Following the death of Sir Francis Bourgeois RA on 8 January 1811 and the consequent vacancy in the membership, Wilkie was elected RA, scarcely 15 months after he had

233 Edward Bird RA, *Proclaiming Joash King*, c.1815, oil on panel, 64.1 × 92.8 cm (RA 03/1088).

become an Associate. The rapidity of his promotion was well deserved, of course, but it would be naive to imagine that it provoked no envious resentment within the Academy. Indeed, there was resentment on both sides. It is hardly likely that Wilkie soon forgot his humiliation over the *Wardrobe Ransacked*, and Cunningham's tone was not untinged with irony when he suggested that Wilkie 'looked up to the Royal Academy with something of the reverence of a son, obeyed all its rules, listened to all its maxims, treasured up its counsels in his heart, practised them in his life, believed that its members rivalled the prime ones of the earth, and that the chair of the president outshone the thrones of Ormez [*sic*] or of Ind'.[24] Wilkie's next move, a solo exhibition of his work shown at 87 Pall Mall between 1 May and 2 June 1812, as he admitted in a letter to his sister, 'is giving great offence to some of my

brethren of the Royal Academy, which I am doing all that I can to pacify'.[25] The exhibition included both versions of the *Wardrobe Ransacked* and also the *Alehouse Door* – now completed, retitled the *Village Holiday* (1811; Tate Britain, London), and sold to John Julius Angerstein – as well as the unfinished *Blind Man's Buff*, a recent commission from the Prince Regent. These important paintings were never shown at the Royal Academy. Given his declared wish to pacify his fellow Academicians, it seems extraordinary that Wilkie chose to send only the sketches for these compositions to the Annual Exhibition, which coincided with his one-man show.

Cunningham suggests that Wilkie's Diploma Work, *Boys digging for Rats* (fig. 234), which he worked on during 1811 and completed and delivered in 1812, was very much a placatory gesture towards the Academy. It is certainly a won-

272

234 Sir David Wilkie RA, *Boys digging for Rats*, 1812, oil on board, 36.4 × 30.4 cm (RA 03/1379).

derful painting. A frozen moment in the midst of furious activity, it shows four boys and their dogs poised to catch and kill the cornered rodents as they burst from their hole. The bravura brushwork in the painting of the big boy with the spade, the perfect balance between the red of his shirt and the yellow of the waistcoat of the kneeling boy with the stick, the skilful depiction of the muscular white terrier scrabbling at the rathole in the foreground: all are masterly. At the same time, anything less like the grace and elegance 'more frequently found in cottages than in courts' or, equally, anything further from the dignity of 'the high historic' it would be difficult to imagine. It may have been placatory but it was also uncompromising.

'INTIMATE ROMANTIC' GENRE AND SOCIAL REALIST GENRE

Notwithstanding the quality of painting such as Wilkie's, Britain's primary contribution to the Romantic movement was literary and its undoubted international star was Sir Walter Scott. He began his career as a poet but took to prose when he saw himself outclassed by Lord Byron, and his novel *Waverley, or 'Tis Sixty Years Since* of 1814 was a sensation throughout Europe. In no time, 'he [Scott] was *the* European novelist, as Byron was *the* poet, and a later generation of novelists, Balzac, Dumas, and the Russians among them, were to look back to him as to a father.'[26] Scott's work gave readers a new way of understanding the past and transformed the ways in which the past might be represented. Some people found this new historical sensibility ridiculous. 'There was', one commentator has suggested, 'a sceptical spirit of counter-romance among the cultivated: we find it in *Northanger Abbey*, we have traces of it in Peacock's *Maid Marian*.'[27] After the publication of Scott's *Marmion* in 1808, an incredulous *Edinburgh Review* observed: 'Fine ladies and gentlemen now talk of donjons, keeps, tabards, scutcheons, caps of maintenance, portcullises, wimples, and I know not what beside';[28] and in 'The Four Ages of Poetry' (first published in Charles Ollier's *Literary Miscellany* in 1821), the satirist Thomas Love Peacock scoffed that 'Mr Scott digs up the poachers and cattle-stealers of the ancient border,' while 'Lord Byron cruises for thieves and pirates on the shores of the Morea and among the Greek Islands.' Peacock went on:

235 Richard Parks Bonington, *A Scene from Sir Walter Scott's 'Kenilworth'*, c.1821, watercolour, 9.6 × 7.4 cm (RA 03/6581).

A poet in our times is a semi-barbarian in a civilised community. He lives in the days that are past. His ideas, thoughts, feelings, associations, are all with barbarous manners, obsolete customs, and exploded superstitions. The march of his intellect is like that of a crab, backward. The brighter the light diffused around him by the progress of reason, the thicker is the darkness of antiquated barbarism, in which he buries himself like a mole.[29]

These were, however, rare voices of dissent in the face of Scott's overwhelming popularity. Part of Scott's hold over the reader lies in that fact that, even while he is chronicling great lives and events, the novels are, paradoxically, intimately told. Many of his protagonists are the 'little' people whose lives and deeds are unrecorded in history. The books showed

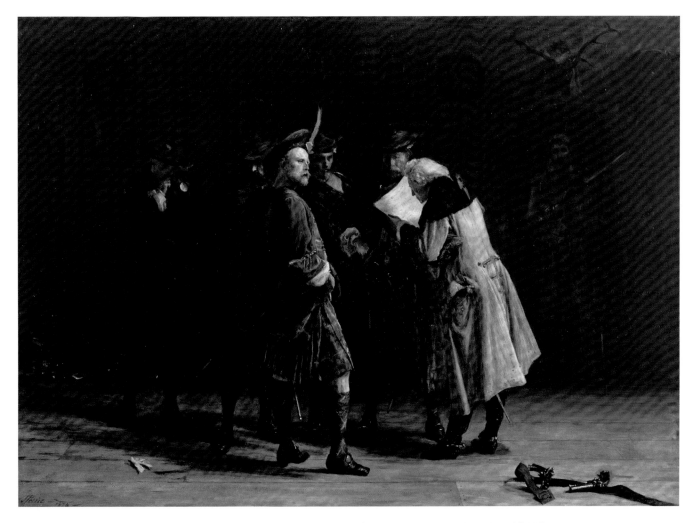

236 John Pettie RA, *Jacobites, 1745*, 1874, oil on canvas, 90.8 × 127.3 cm (RA 03/1362).

history as it appeared from below, as it were, and in Scott's hands, as in Wilkie's, 'history became human'.[30] Indeed, Scott acknowledged his kinship with 'our Wilkie' on terms of equality, and sometimes referred to his paintings for short-hand descriptions. Of an interior, for example, Scott said it was one 'which [Wilkie] alone could have painted, with that exquisite feeling of nature that characterises his enchanting productions'.[31]

Roy Strong has demonstrated how Scott's pervasive influence stretched beyond the literary and has identified a new subdivision of history painting, the 'Intimate Romantic', the emergence of which was a direct result of Scott's example: 'paintings which take as their subject-matter per-sonal, domestic glimpses of earlier ages, the great of the past caught informally or even, beyond this, the past painted purely for itself as an enchanted idyll. Through this the past was able to inspire the brushes not only of history painters but also of the exponents of genre.'[32]

Just such an episode is to be seen in a little watercolour sketch in the Royal Academy collection by Richard Parks Bonington (fig. 235). Generally, though, anything to do with Scottish history came to enjoy an extraordinary fascination. Bonnie Prince Charlie and his followers were popular underdogs, and the subjects of *Jacobites, 1745* (1874) by John Pettie RA might have stepped straight out of the pages of *Waverley* (fig. 236).

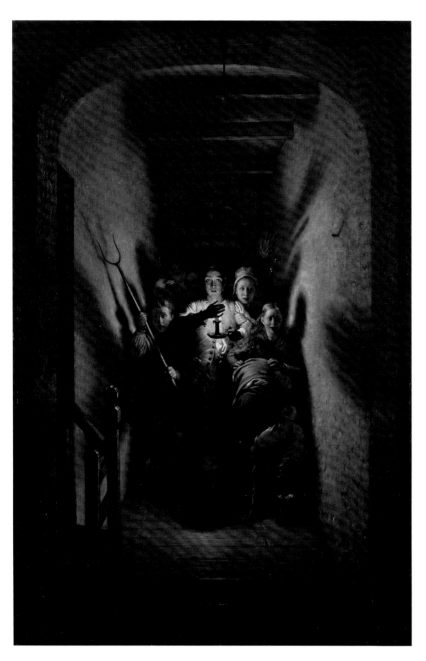

237 Charles West Cope RA, *Night Alarm: The Advance!*, 1871, oil on canvas, 150.2 × 99.6 cm (RA 03/1287).

Shakespeare, as noted above, was also 'rediscovered' by the Romantics and became as popular a source of inspiration as Scott, although no particular distinction was made between his history plays and actual historical documents, even while Victorian artists were paying ever more scrupulous attention

to details of costume and architecture. *Elizabeth Woodville in her Sanctuary* (c.1855) by Edward Matthew Ward RA is very much an essay in the Intimate Romantic and revolves around a topic of contemporary international fascination, the fate of the Princes in the Tower, which derived at several removes from Shakespeare's *Richard III.*[33] Other examples of the genre in the Academy collection include *Abelard in his Study* (1833) by Gilbert Stuart Newton RA; Herbert's *St Gregory teaching his Chant* (1845); *The Bribe* (1857) by Frederick Richard Pickersgill RA; and the mysterious *Whither?* (1867) by Philip Hermogenes Calderon RA. One of the cleverest is the *Night Alarm: The Advance!* (1871) by Charles West Cope RA, which undercuts the genre. We see a household roused in terror – by the antics of their two cats, now only dimly discernible in the foreground owing to the deterioration of the pigments (fig. 237).

The evolution of genre painting was partly a response to the requirements of a new picture-buying public, a new town-dwelling middle class, who had been uprooted from their ancestral village homes as the war, urbanization and industrialization rapidly transformed the face of Britain. Intimate Romantic paintings can be seen as part of a national effort to recoup a sense of identity by recourse to a shared past. A visual equivalent of the conventional 'Whig' history, they present the past as a reassuring pageant and progress in a positive, romantic light. There was a desire for an art that told simple stories and spoke comfortably of things that seemed unchanging, and a wish to inhabit a 'countryside of the mind...ancient, slow-moving, stable, cosy, and "spiritual"'.[34] Painters wishing to sell to this escapist market discovered, as Samuel and Richard Redgrave observed, 'that pictures to suit the English taste must be ...cheerful and decorative'.[35] No one wanted to be reminded of the much grimmer reality of life in the villages, from which the rural poor were being driven to migrate to the urban centres in ever-increasing numbers.

Artists catering to these requirements included William Collins RA, who was Wilkie's close friend and named his son, the novelist Wilkie Collins, in his honour.[36] William Collins's Diploma Work, *Young Anglers* (1820), shows two boys fishing against a background of thatched cottages and immemorial oaks. The *Early Lesson* (1846), the Diploma Work of Thomas Webster RA, shows an elderly lady dozing while her grandson does his reading practice in a brick-floored cottage interior. A medicine bottle and spoon on the

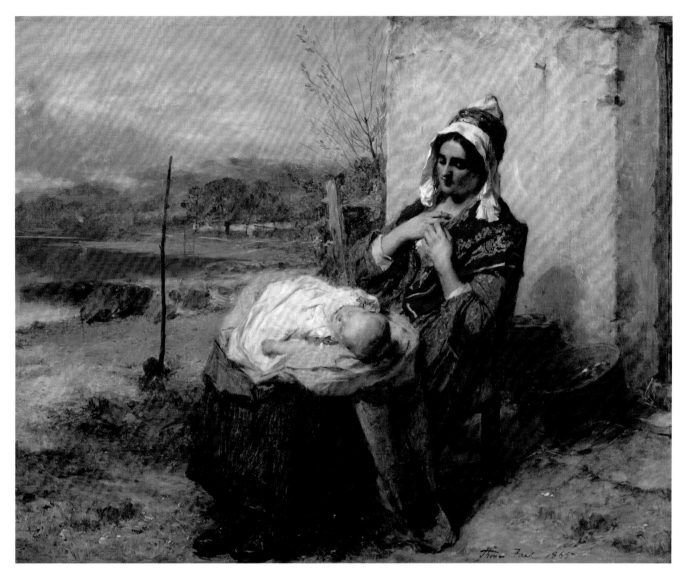

238 Thomas Faed RA, *Ere Care Begins*, 1865, oil on canvas, 60.5 × 75 cm (RA 03/645).

dresser emphasize the healthfulness of the scene. Similarly, the Diploma Work of Thomas Faed RA, *Ere Care Begins* (fig. 238), shows a mother seated at her cottage door cradling a newborn child. Although its title hints that the baby on her knee might have a hard life to look forward to, the painting is as essentially reassuring as the other examples cited.

Not everyone was satisfied, though, with art that was 'cheerful and decorative'. In her novel *Middlemarch*, written during 1869–71 but set in the period 1830–32, George Eliot had Dorothea Casaubon admit to her uncle, 'I did not like

the pictures here … I used to come from the village with all that dirt and coarse ugliness like a pain within me, and the simpering pictures in the drawing-room seemed to me like a wicked attempt to find delight in what is false, while we don't mind how hard the truth is for the neighbours outside our walls.'[37] During the 'hungry forties' some genre artists began to use the until then essentially conservative form as a vehicle for social comment and the demand for change. Though the great Reform Act of 1832 had enfranchised many of the new picture buyers, the resulting Parliament – even after general

elections in 1832, 1834 and 1837 – still seemed to Thomas Carlyle to be failing the people. In his essay *Chartism* (1839) he listed the trivial-seeming matters, 'Smithfield cattle, and Dog-carts, – all manner of questions and subjects', that had preoccupied MPs while the condition of the people had continued to deteriorate. He coined a phrase to describe what he believed they really ought to be thinking about: 'Surely Honourable Members ought to speak of the Condition-of-England question too.'[38] Some writers – including Benjamin Disraeli (who suggested that Britain was in reality 'two nations…the rich and the poor'),[39] Elizabeth Gaskell, Charlotte Brontë, Charles Kingsley and Charles Dickens – attempted to address Carlyle's question in a series of what have been dubbed 'Condition-of-England' novels. Predating most of these were two poems by Thomas Hood that caught the imagination and attracted the sympathy of the public. In 'The Song of the Shirt' (1843) Hood wrote of a poor woman hand-sewing shirts for starvation wages. 'It is not linen you're wearing out,' he assured his readers, 'but human creatures' lives!' In 'The Bridge of Sighs' (1844) he described 'one more unfortunate' – a 'fallen woman' who has drowned herself – pulled from the river at Waterloo Bridge.[40] Two artists, Richard Redgrave RA (co-author with his brother Samuel of *A Century of British Painters*, from which we quoted above) and George Frederic Watts RA, took subjects from Hood and led the way in representing the Condition of England in paint.

After 1867, when within the space of a year he was elected ARA and then quickly a full member, Watts became a committed 'Visitor' in the Schools. He was not yet an Academician when, between 1848 and 1850, he painted his four great (large-scale) social-realist pictures, *Found Drowned* (1848–50), *Under the Dry Arch* (1849–50), *Song of the Shirt* (1850) and *Irish Famine* (1850), all in the Watts Gallery, Compton, Surrey. These harrowing paintings have been contrasted with 'the sentimentalised genre depictions that graced the walls of the Royal Academy'.[41] *Under the Dry Arch* shows a homeless old pauper woman freezing in the inadequate shelter of Blackfriars Bridge, the dome of St Paul's looming uselessly in the background. *Song of the Shirt* takes its title from Hood's poem. With *Irish Famine* Watts rose to a challenge that most artists ducked, and addressed the worst humanitarian disaster of the age, as a result of which, between 1845 and 1852, a million people starved and a million more were forced to

emigrate. *Found Drowned* may refer to Hood's *Bridge of Sighs* (certainly they share a subject), and when it was exhibited at the Grosvenor Gallery more than 30 years after it was painted it was felt still to be too 'near the knuckle'. Doubts were expressed at the time whether 'elaborately crafted oil paintings, destined to decorate the houses of the wealthy' were 'appropriate vehicles for social commentary',[42] and sure enough Watts's paintings remained unsold.

Redgrave, however, managed to express social comment in terms that did not alienate potential purchasers, and he can be seen, after Wilkie, as the second key Academician in the 'triumph' of genre, precisely because he so successfully adapted it to a new and wholly unexpected purpose. The originator of what we might call 'social-realist genre', Redgrave subverted the cosy conventions of genre painting in order to surprise his audience with uncomfortable truths about contemporary life. He was, at the same time, a moderate and a reformer rather than a revolutionary. The resolve of Edward Burne-Jones to remain outside the Academy only flickered briefly in 1885 when he allowed himself to be elected ARA, and he resigned in 1893. In 1853 he had declared that he was fighting a 'crusade and Holy Warfare against the age'.[43] Redgrave would never have said anything of the sort. His daughter admitted that though he 'longed to fight for the oppressed and to help the weak', he 'could do it only with his brush'.[44] In 1848 – the 'year of revolutions' – at the time of the great Chartist demonstration, he signed up as a special constable and remembered later how he and his companions had waited anxiously all day long 'for the coming of the rabble',[45] which was hardly the behaviour, or the language, of a radical. He was a compassionate man, but also a pillar of the establishment. Both characteristics were reflected in his career as an artist, educator and curator.

Redgrave remembered how, in 1829, his sister Jane had 'pined over the duties of a governess away from home, caught typhoid fever, and was brought back only to die amongst us',[46] an unhappy memory that must have informed the *Poor Teacher* (Shipley Art Gallery, Gateshead). Redgrave's *The Sempstress* (Tate Britain, London), shown to acclaim at the Royal Academy in 1844, appeared only a year after the publication of Hood's *Song of the Shirt*. His fellow painter Paul Falconer Poole, not yet an Academician (ARA 1846, RA 1861), wrote to congratulate him: 'If any circumstance could

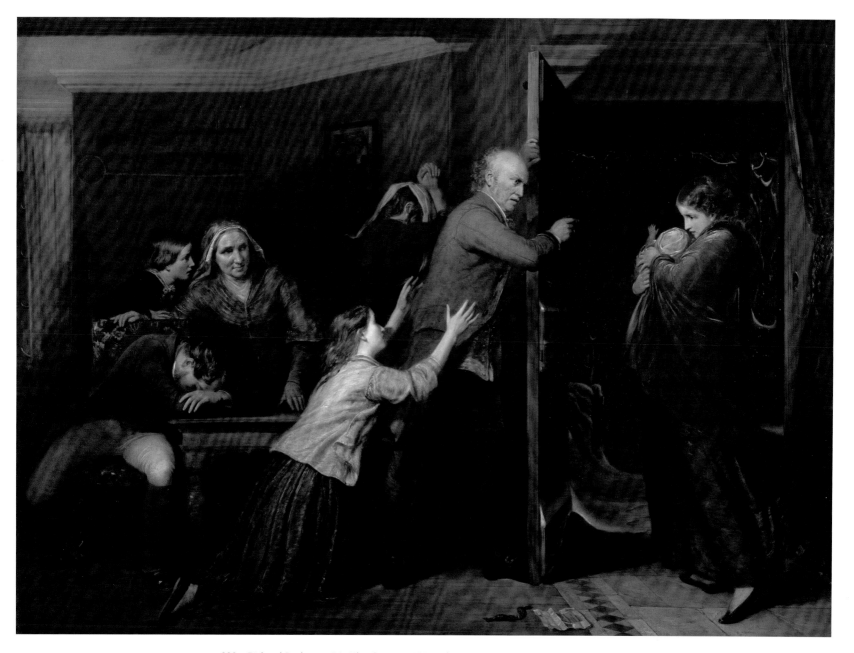

239 Richard Redgrave RA, *The Outcast*, 1851, oil on canvas, 78.4 × 107.1 cm (RA 03/720).

make me wage war against the present social arrangements, and make us go down shirtless to our graves,' he wrote, 'it is the contemplation of this truthful and wonderful picture.'[47]

Redgrave was elected ARA in 1840 and RA 10 years later, during which time, as his daughter says, 'He was solely known as a painter of *genre*.'[48] His Diploma Work, *The Outcast*

(1851; fig. 239), shows a young girl holding a baby, wrapped in a shawl but not shod for the snow that lies outside the door, being evicted (from a farmhouse, judging by the equipment hanging on the wall) by an elderly man. We presume that this is a daughter of the house being cast out by her father. He is angry-faced and implacable, holding the

front door open while gesturing peremptorily into the darkness. There is a letter and what may be a purse lying on the floor where someone has dropped them. Five other figures are clustered on the left-hand side of the picture. A young man sits on an embroidered chair, his head cradled in his arms on a small table. An older woman rests her right hand on the back of the chair and leans forward over the table, an unreadable expression on her face, to watch the departing girl. Behind her, an adolescent girl also watches with tears in her eyes. Behind the elderly man, her hands still clasped in futile entreaty, a young woman hides her face against the wall. In the foreground, her yellow jacket the picture's brightest highlight, another young woman kneels on the floor, her hands outstretched towards the girl with the baby. The old man is looking at the young mother, but she and the girl in the yellow jacket are gazing straight at one another, their eye contact the central emotional axis of the composition and the last thing that is going to be broken in this tragic scene of rupture and bereavement.

Powerful though the painting undoubtedly is, there is something that a modern audience will find 'stagey' about the postures of the figures in it. This may be because Redgrave has painted them according to a convention from the theatre of his day. A 'situation', as Edward Mayhew explained in his treatise *Stage Effect* (1840), was a 'strong point in a play likely to command applause; where the action is wrought to a climax, where the actors strike attitudes, and form what they call "a picture", during the exhibition of which a pause takes place; after which the action is renewed'.[49] According to Mayhew, Victorian melodrama was constructed around a sequence of such 'pictures', and *The Outcast* undoubtedly has a melodramatic quality. The traffic was not all in one direction; theatre also borrowed from the visual arts. The creation of *tableaux vivants* also became a popular parlour entertainment, and handbooks were published with suggested themes and instructions for poses and settings, detailing how they could be achieved at home.[50]

Several interpretations of *The Outcast* have been advanced.[51] One suggestion is that it might illustrate a dramatic incident from George Crabbe's *The Borough* (1810).[52] An episode in this long poem concerns a young woman called Ellen Orford, who is thrown out of the family home after she falls pregnant by a lover who is her social superior and who abandons her to marry another. Redgrave had already

derived one painting from the poem – unequivocally entitled *Ellen Orford* – which he showed at the RA in 1838. He remembered that, when room could not be found for it 'on the line', Wilkie removed one of his own works so that it could be accommodated in that prime position.[53] But perhaps there is no definitive explanation. Redgrave elicits our sympathy for the girl with his depiction of her sweet face and of the intense, motherly protectiveness of the embrace in which she clutches her child. After that, the painting's very ambiguity (its range of possible scenarios, which we are impelled to discuss, inwardly or with one another) constitutes a rhetorical device to make us think longer and harder about its message.

From the beginning, Redgrave was obliged to support his career as a painter with other paid work, at first as a drawing master. He joined the staff of the Government School of Design in 1847 (which then occupied the Royal Academy's recently vacated rooms at Somerset House) and was a pioneer of art education in this country. Edward Poynter PRA called him 'the author of the most perfect system of national art instruction ever devised'.[54] He was involved in the development of what is now the Victoria and Albert Museum (which started life as the teaching collection of the School of Design) and was instrumental in acquiring John Sheepshanks's collection for the museum in 1856.[55] There, and in his capacity as Surveyor of Crown Pictures, a post he held from 1857 until his retirement in 1880, he showed himself to be an outstanding curator. He was also a diligent officer of the Royal Academy, serving several terms on Council and acting as a member of Frederic Leighton's committee for the reform of education within the Academy. He was commemorated by his friend Charles West Cope in the *Council of the Royal Academy selecting Pictures for the Exhibition, 1875* (see fig. 122).

William Mulready RA, like Wilkie, stretched the genre tradition that he inherited almost to bursting. He was one of Holman Hunt's teachers in the life class at the Royal Academy Schools; his own life drawings, of which the Royal Academy has a collection, are exquisite, and his work exhibits many of the characteristics we recognize in Pre-Raphaelite painting. He painted with a fine stipple of translucent paint on a white ground long before the Pre-Raphaelites adopted the technique. His colour is rich and his handling sharp. His attention to detail in the painting of objects such

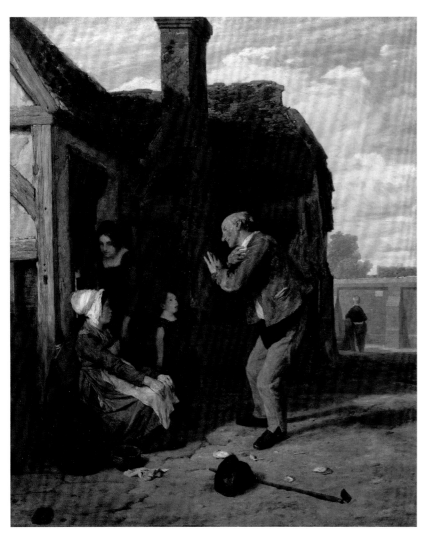

240 William Mulready RA, *Village Buffoon*, 1816, oil on canvas, 76.3 × 63.6 cm (RA 03/1333).

as the sewing basket in his portrait of the Countess of Dartmouth (1827–8; private collection) anticipates their practice. He began his career as an illustrator and then as a painter of landscape, but after Wilkie's success with the *Blind Fiddler* in 1807 and seeing the widening disparity between the prices that their work could fetch, he too began to paint genre. He was elected ARA in November 1815 and RA the following February, and his Diploma Work was the *Village Buffoon* (fig. 240). While acknowledging the almost Michelangelesque monumentality of the figures in a painting such as *The Sonnet* (1839; Victoria and Albert Museum, London), the curator of

the exhibition marking Mulready's bicentenary also pointed out his debt to 'fancy pictures by Gainsborough' and to 'early cottage subjects'.[56]

EXOTIC GENRE

Opportunities to travel abroad during the Napoleonic Wars had been extremely limited. (Byron managed it, but he was a peer of the realm, wore an army officer's uniform he wasn't really entitled to – 'I have a most superb uniform ...indispensable in travelling'[57] – and was able to take passage on Royal Navy vessels.) As a result, early pictures by artists who came to maturity during that time have a home-grown quality about them. Genre paintings of this period can seem parochial, not merely in their choice of subjects – as, for instance, in Wilkie's *Village Politicians* and *Village Holiday* and in Mulready's *Village Buffoon*, beside many other pictures with 'village' in the title – but in their nature. They seem to be 'of the earth, earthy' and rooted deep in British soil. Like some British people, however, once wartime restrictions had been lifted, exponents of genre demonstrated an unexpected versatility and a prodigious appetite for foreign travel, even if some artists remained satisfied with the landscapes and the subjects they knew best. Mulready, for instance, never stepped off British soil. Others, however, took the parlance of the parish pump and adapted it for international discourse.

In 1814, after sending in *The Refusal* (RA 1814; Victoria and Albert Museum, London) and *Letter of Introduction* (RA 1814; Scottish National Gallery, Edinburgh) to the Academy, and before peace had even been signed, Wilkie hastened to Paris accompanied by his friend Benjamin Robert Haydon. 'This being our first entrance into a foreign country', Wilkie wrote to his sister, 'we were greatly struck with everything we saw.'[58] As soon as they had landed at Dieppe, he began to notice details and to respond to this new environment as material for art: 'The dresses of the women have the greatest variety of colours, and are in this respect very picturesque. The apartments within, and the spaciousness of the houses without, present at every view complete compositions for pictures.'[59] They also seized every opportunity that presented itself to look at paintings. At the Louvre Wilkie was most impressed by the *Wedding at Cana* (1563) by Paolo Veronese and by the *Marie de Médicis* series by

Rubens. On 6 June he wrote to his sister: 'Went to the Palais de Luxembourg to see the gallery of Rubens; on entering, I was not at first struck with the look of the pictures, but after comparing them with what I had seen before, they grew upon me amazingly, and before I left the room, I could not help being convinced that, with all his faults, Rubens is one of the greatest painters that ever existed.'[60]

Like his fellow nationals, the Scots engineers, soldiers and explorers who were the shock troops of British imperialism, Wilkie found a destiny not merely beyond his birthplace at Cults, but far beyond the London he had conquered so quickly and so completely. He revisited Paris in 1821, but in 1825 he suffered another recurrence of nervous trouble that had incapacitated him in 1810–11. A severe breakdown left him quite unable to work and he departed on a longer continental tour. After receiving medical treatment in the French capital, he travelled on to Italy. He wintered there, spent the summer of 1826 in Germany (where he witnessed the *tableau vivant* mentioned above), visited Vienna, and returned to Italy for another winter. During December Wilkie began, at last, to paint again. *Pifferari playing Hymns to the Madonna* (1827, RA 1829; fig. 241) gives an early hint of a transformation in his work that was beginning at this time. Wilkie's travels thus far had been on fairly well trodden paths, but the next year, having spent the summer in Switzerland, he decided to move on to Spain, then barely known to anyone in Britain and as late as 1872 still 'a virtual *terra incognita* to foreigners'.[61] In 1843, when George Borrow published *The Bible in Spain*, he called it a 'land of wonder and mystery'.[62] The *Handbook for Travellers in Spain and Readers at Home* by the art connoisseur Richard Ford was published by John Murray in 1845.

Wilkie's journals and letters are full of the pictures he saw and the impression they made on him. After his arrival in Spain 'his chief desire was to see, examine, and study the works of Murillo and Velasquez, both natives of Seville, and thither he resolved to bend his steps.'[63] When he reached Madrid in October 1827 and saw the work of Velázquez, Wilkie's first impression was that his work resembled 'Teniers on a large scale'.[64] Sir Robert Peel, then home secretary, asked Wilkie to keep an eye out for Old Master paintings that might be acquired for his collection,[65] and the two were in regular contact throughout his travels. He arranged a subscription, on behalf of the Academy, to a series of 'litho-

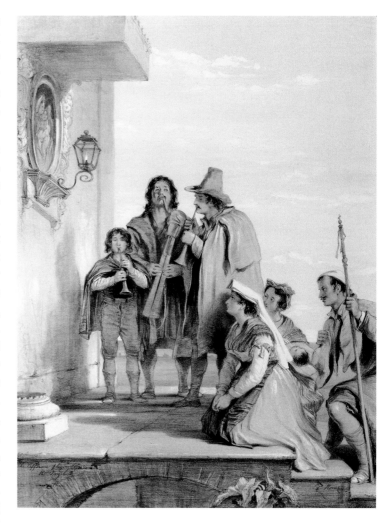

241 Joseph Nash after Sir David Wilkie RA, *Pifferari playing Hymns to the Madonna*, 1827, lithograph, 39.7 × 30.3 cm (RA 15/2432).

graphic prints of the leading pictures of the different schools of the Museum and Academy of Madrid, and in the Convent of the Escurial',[66] a bound volume of which is in the library of the Royal Academy. He also gathered information for colleagues in London. 'I wish much that I knew what is the information about Spanish painting which you most wish to have', he wrote to Thomas Phillips RA, 'particularly should it be in reference to your views as professor of painting.'[67] 'To our English tastes it is unnecessary to advocate the style of Velasquez,' he wrote to Lawrence from the Prado on 12 November: 'I know not if the remark be new, but we appear as if identified with him; and while I am in the two galleries

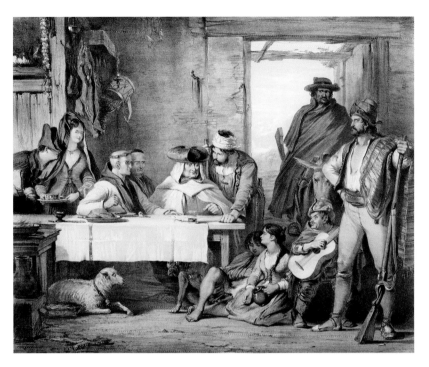

242 Joseph Nash after Sir David Wilkie RA, *Spanish Posada or Guerilla Council of War*, 1827, lithograph, 32.7 × 39.6 cm (RA 15/2457).

at the Museum, half filled with his works, I can almost fancy myself among English pictures. Sir Joshua, Romney, and Raeburn, whether from imitation or instinct, seem powerfully imbued with his style, and some of our own time, even to our landscape painters, seem to possess the same affinity.'[68]

In Spain Wilkie started work on a series of remarkable paintings. On his return to London the first three of these – the *Spanish Posada* (fig. 242), the *Defence of Saragossa* and the *Guerrilla's Departure* (all RA 1829) – even in their unfinished condition so impressed the king that as soon as he saw them they were earmarked for the Royal Collection, and Wilkie was pleased that the king noticed their resemblance 'to Rembrandt, to Murillo, and Velasquez'.[69] A fourth, the *Guerrilla's Return to his Family* (RA 1830), projected but not yet begun, was commissioned and also entered the Royal Collection.[70] They reveal Wilkie as almost a different artist from the one who created *Chelsea Pensioners*. 'All appear to remark a change,' Wilkie wrote, 'and they say for the better, in the colouring and larger style of execution. I wish to prove that I have not seen Italy and Spain for nothing.'[71] He had

emerged from his illness, after all his researches in the galleries of Europe, a fully fledged European Romantic. All British painters, according to the 'distinguished foreigner', quoted but not named by Cunningham at around this time, seemed 'standing still, save Wilkie'.[72] Cunningham felt that Wilkie had 'dipped his brush' in 'the historic style',[73] but the old hierarchical categories were losing purchase. These pictures are history paintings in that they are set 20 years in the past and represent momentous events, but, on the other hand, they are small in scale and depict the actions of common people. Viewed in a European context, and according to a continental chronology, they recall the struggle of Alfred de Musset's pair of baffled provincials to keep up with the pace of change in Paris. His 'Lettres de Dupuis et Cotonet' were published in 1836 in the *Revue des Deux Mondes*: 'During 1831 and the year after, aware that the historical style had fallen into disfavour and Romanticism had come out on top, we realised that everyone had started talking about *le genre intime*. But try as we might, we could never work out exactly what *le genre intime* might be.'[74]

In fact, the subject of Wilkie's pictures – the guerrilla (or 'little war') of the Spanish people against the French invaders – is a precise analogue of their 'genre' character. With their small size, their informality and their bravado, they stand in exactly the same relation to traditional history painting as did the Spanish guerrilla forces to the ponderous legions of the French. Form and content could not be more perfectly in tune with one another. They have a 'Jack the giant-killer' feel about them that it is hard to believe Wilkie did not intend. It may even have reflected his own mixed feelings about the Royal Academy.

Three artists in particular, linked both stylistically and by bonds of friendship, form a second wave of British genre painters in Spain. John Phillip RA was born in poverty in Aberdeen, but his obvious talent secured him a patron who paid for his training at the Royal Academy. While there he was a member of 'the clique', a group of young painters that included Richard Dadd, Augustus Egg RA, Alfred Elmore RA, William Powell Frith RA, Henry Nelson O'Neil ARA and Edward Matthew Ward RA, who were united by their admiration for the work of both Hogarth and Wilkie. Like Wilkie's, Phillip's early work was mostly Scottish genre scenes. His *Scotch Fair* (1848; Aberdeen Art Gallery and Museum), for instance, is clearly indebted to Wilkie's *Pitlessie*

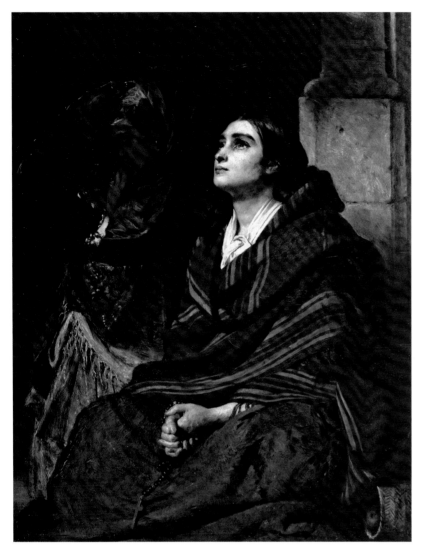

243 John Phillip RA, *Prayer*, 1859, oil on canvas, 74.5 × 59.1 cm (RA 03/1073).

244 John Phillip RA after Diego Velázquez, *Las Meninas* (c.1656), 1862, oil on canvas, 185 × 148 cm (RA 03/1097).

Fair (1804; Scottish National Gallery, Edinburgh). In 1851, after he had been advised to travel to southern Europe for his health, Phillip headed for Spain. From that time onwards his subject matter, 'the gay, guitar-twanging, castanet-playing, bolero-dancing, carnival-keeping, cigarette-smoking life of Seville',[75] was drawn so entirely from the country that he is still remembered by the nickname 'Spanish' Phillip. He was also attracted by the rituals and mysteries of Spanish Roman Catholicism, which is reflected in his Diploma Work, *Prayer* (1859; fig. 243), and also in the painting he

considered his masterpiece, *La Gloria: A Spanish Wake* (1864; Scottish National Gallery, Edinburgh). Phillip was especially determined to understand the art of Velázquez, and the Royal Academy also has his very fine copy of a detail of Velázquez's *Las Meninas* (1862; fig. 244).

Edwin Longsden Long RA studied at Leigh's School of Art in London in 1846 with John Bagnold Burgess RA and Philip Hermogenes Calderon RA (who was half-Spanish). According to the *Art Journal*, in 1857 Long 'made the acquaintance of John Phillip, and the two journeyed to Spain to sit at the feet

245 Edwin Longsden Long RA after Diego Velázquez, *Las Hilanderas* (1657), c.1857, oil on canvas, 127.5 × 163.7 cm (RA 03/822).

ofVelasquez'.[76] The copy Long made ofVelázquez's *Las Hilan-deras* (fig. 245) was probably painted during this trip and was given to the RA in 1943 by his one-time student Sir George Clausen RA. Long remained close to Phillip and specialized for many years in Spanish genre subjects, of which the first to be shown at the Royal Academy was *Bravo el Toro!* (1859). In *The Suppliants: Expulsion of the Gypsies from Spain* (RA 1872; Royal Holloway College, London) we see him beginning to outgrow the influence of Phillip and move towards a less genre-inflected style of history painting.

Burgess, his friend from Leigh's, accompanied Long on a visit to Spain in 1858, one result of which was *A Castilian Almsgiving* (RA 1859), the first in a long line of Spanish genre subjects. The closeness, both social and stylistic, between Phillip, Long and Burgess can be illustrated with an anecdote. The collector Sir Merton Russell Cotes saw a painting, *Dialogus Diversus* (1873; private collection), which shows two Spanish priests arguing a point of theology, which was advertised as having been painted by Edwin Long, but about which he had suspicions:

It is a very beautiful picture, but, as I said, I felt certain, knowing his works so well, that it had been painted by my old friend John Phillip, RA. It was agreed, therefore, that before I purchased it, it should be submitted to Mr Long ...After examining it, he declared that it was a work painted by himself, and quite genuine ... He remarked that it had never occurred to him, but now that it was mentioned, he realised that it was marvellously like Phillip's work.[77]

Comparison of Long's *Dialogus Diversus* with Burgess's Diploma Work, the *Freedom of the Press* (1889; fig. 246), which also shows two Spanish priests, one reading aloud from a newspaper and the other exclaiming in horror, seems to indicate that the pairs of priests have been painted from the same two models. Either Burgess (who visited Spain every year from 1858 to 1888) used studies made with Long in Spain many years before to prepare his Diploma Work, or he actually presented the Academy with a painting he had had on his hands for a long time (a not unknown practice). His magnum opus is *Licensing the Beggars in Spain* (RA 1877; Royal Holloway College, London). Although the practice of licensing beggars was still current in Spain – and Burgess made his painting from contemporary studies of mendicants in Seville being examined for their licences – the magistrate in *Licensing the Beggars* is in eighteenth-century dress. The picture therefore makes clear the appeal of Spain to artists as 'living history' but also highlights Burgess's interest in low life. The same critic who observed the 'guitar-twanging' tendency in John Phillip's work also noted 'the rough, ragged, dirty, sheep-skin-clad, parched-up peasantry, gypsies, and *contrabandistas* of the Sierra Morena, with the surroundings of the low *venta* and *posada*, such as John B. Burgess chiefly delights in'.[78]

Spain was, literally and metaphorically, a staging post en route to the eastern Mediterranean, and the Moorish buildings of Andalusia were for Wilkie, Disraeli, Long and many other early travellers an introduction to the Orient, which became such a passion among painters of landscape and genre in the second half of the nineteenth century. Another Scot, David Roberts RA, later better known as an Orientalist, first visited Spain in 1832–33 on Wilkie's advice. After being accepted as an ARA in 1838, Roberts headed east and travelled throughout the Middle East during 1838–9. He was elected a full Academician soon after his return and gave the *Gateway to the Great Temple at Baalbec* (1841) to the

246 John Bagnold Burgess RA, *Freedom of the Press*, 1889, oil on canvas, 59.5 × 49.5 cm (RA 03/1337).

Academy as his Diploma Work (fig. 247). Roberts's figures are always carefully observed, but they are not the main focus of his attention: his primary interest was always in the view. The same could not be said of John Frederick Lewis RA, whom Wilkie had bumped into at Constantinople. Lewis presented as his Diploma Work in 1865 the *Door of a Café in Cairo* (1865), a meticulously observed masterpiece in terms of detail and light, which uncompromisingly asserted his status as one of the great exponents of Orientalist genre (fig. 248).

John Frederick Lewis lived in Spain between 1832 and 1834 and in Cairo 1841–50. Edwin Long's career followed

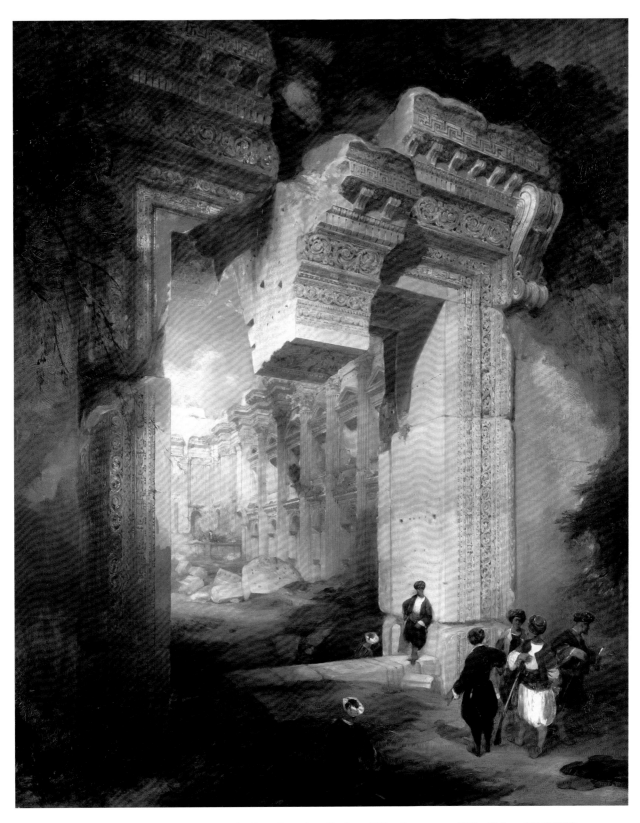

247 David Roberts RA, *Gateway to the Great Temple at Baalbec*, 1841, oil on canvas, 75.8 × 61.8 cm (RA 03/842).

248 John Frederick Lewis RA, *Door of a Café in Cairo*, 1865, oil on canvas, 76.2 × 53.4 cm (RA 03/1006).

249 Frederick Goodall RA, *Song of the Nubian Slave*, 1863,
oil on canvas, 71.2 × 92 cm (RA 03/841).

the same eastward path, and the title of his Diploma Work, *Nouzhatoul-âouadat* (1881), uses the French spelling of the Arabic for 'the Delight of the Home'. Henry William Pickersgill RA came from an earlier generation. He was the uncle of Frederick Richard Pickersgill RA, whose *The Bribe* we have already mentioned. His Diploma Work was the *Oriental Love Letter* (1824). The early genre paintings of another traveller to the Middle East, Frederick Goodall RA,

show Wilkie's influence. He travelled during the 1850s in the Crimea, Morocco, Spain, Portugal and Italy, and lived in Cairo in 1858–9. His Diploma Work is the *Song of the Nubian Slave* (1863; fig. 249).

The 'triumph of genre' at the Royal Academy and outside its walls occurred in the context of momentous events and forces: the Romantic movement, the Napoleonic Wars, the Industrial Revolution, urbanization, the expansion of the middle class, changes in patronage, and the erosion of the certainties and hierarchies of the eighteenth century. But even in the midst of such powerful forces, individuals can still sometimes have an effect. It is not given to many artists to take history by the scruff of the neck, give it a good shake, and send it off on a different path, but it may be that David Wilkie RA was one of those unusual people. On his way home from the Middle East, having fallen ill in Alexandria, Wilkie died and was buried at sea near Gibraltar on 1 June 1841. The event was magnificently commemorated by his friend and fellow Academician J. M. W. Turner in the painting *Peace – Burial at Sea* (RA 1842; Tate Gallery, London), in which the outward urge, the restless, centrifugal energy that had characterized Wilkie's career, is perceived as having resolved itself in a lambent apotheosis followed by stillness and quiet. When he was criticized for the mournful darkness of the sails, Turner replied, 'I only wish I had any colour to make them blacker.' It is a splendid tribute, but it is ironic that the champion of genre, the man who, more than any other painter, was responsible for dismantling the old artistic hierarchies, should be memorialized at last by what is, when all is said and done, a history painting.

A CLOSER LOOK

Histories and portraits in the early exhibitions

MATTHEW HARGRAVES

The Royal Academy's earliest exhibitions were in direct competition with those of the Free Society of Artists (FSA) and the Society of Artists of Great Britain (SAGB) (fig. 250), and it was not until the mid-1770s that critics, and even Britain's artists themselves, considered the Academy exhibitions to be pre-eminent. By the close of the 1770s these exhibitions had effectively eliminated all competition and appeared to vindicate the Academy's claim that royal patronage, selective membership and its Schools were the best means to cultivate the fine arts in Britain.

It was understood that the Royal Academy would best serve the nation by fostering a native school of history painters, a plan encouraged by the king himself. This aim endured and was built, so to speak, into its first purposely designed home in the north block of Chambers's New Somerset House, where the ceilings were adorned with allegorical paintings by Angelica Kauffman RA and Benjamin West PRA (figs 251, 252) and Sir Joshua Reynolds PRA (*Theory*, 1779–80). A lingering adherence to the age-old artistic hierarchy is reflected in the fact that the canvases of Kauffman and West were successively removed and reinstated as the Academy took up its various residences, and they are now to be seen in the entrance hall of Burlington House.

The chief rivalry in the early years of the Academy was between Reynolds, principally a portrait painter and its first

250 After George Michael Moser RA or Christopher Seton, *Arms, or Common Seal of the Incorporated Society of Artists of Great Britain*, line engraving, 15.3 × 10.1 cm (RA 09/1510).

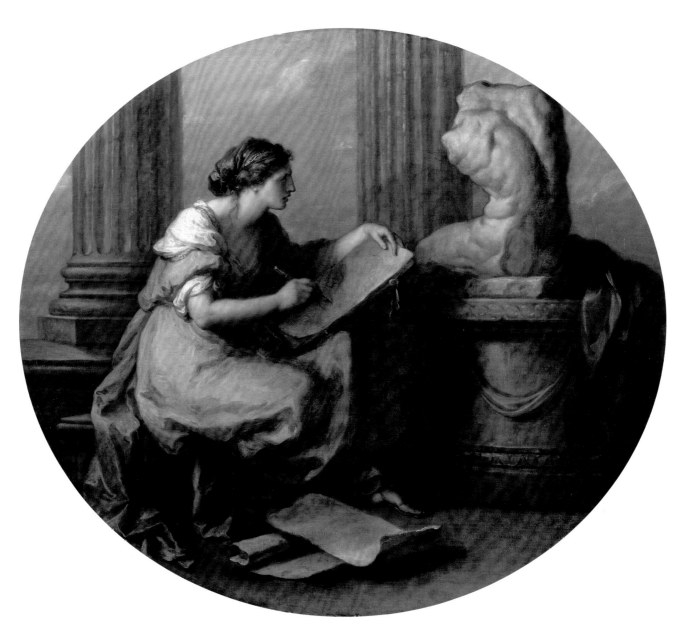

251 Angelica Kauffman RA, *Design*, 1778–80, oil on canvas, 130 × 150.3 cm (RA 03/1129).

President, and Benjamin West, the leading history painter who succeeded Reynolds as President, a rivalry that lasted for a decade and was amply documented in the contemporary press. West received a laudatory notice in the *Public Advertiser* on 27 May 1769 for his *Departure of Regulus from Rome* (1769; Royal Collection), a painting commissioned by the king before the Academy's foundation but conveniently finished in time for its first exhibition. Meanwhile, the *Public Advertiser*'s critic went on to assert that Reynolds was the leading painter of his generation for having rescued taste from the falsities of Sir Godfrey Kneller's style, although his specialism, portraiture, was declared subordinate to the kind of history painting practised by West. 'Portrait-Painting has had it's [sic] Day … the Superiority of History Painting, over Works of every Kind, is now universally acknowledged.' Thus, it was deemed by some that the hierarchy of genres inherent

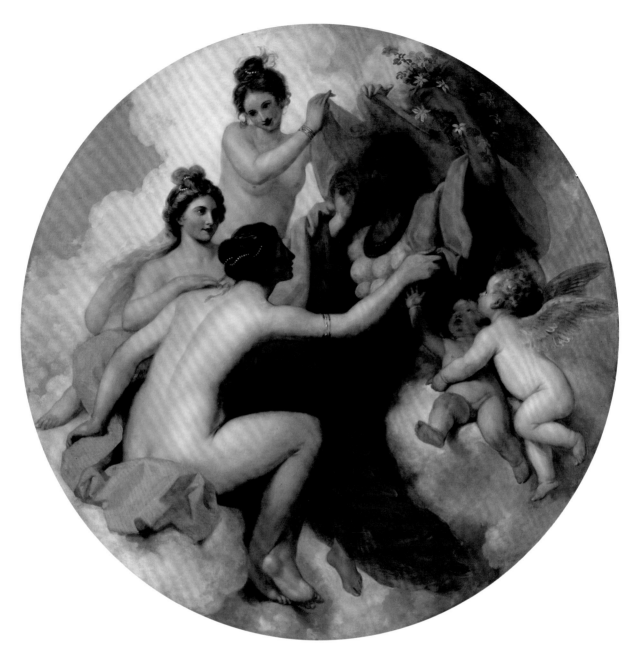

252 Benjamin West PRA, *Graces unveiling Nature*, c.1779, oil on canvas, diameter 152.4 cm (RA 03/1127).

in the academic project was not reflected in the hierarchy of the institution itself, a circumstance that became a point of critical comment throughout the 1770s.

As the gulf widened between the Academy and SAGB, the two chief exhibiting societies, historical art became a key point of reference when comparing their relative merits. For some

critics, the SAGB's lack of commitment to history painting became a badge of honour, while the history paintings at the Academy were branded un-English. In the *Middlesex Journal* 'Paul Varnish' fulminated against 'the mean, slavish and selfish arts practised by the Foreign Academy in Pall Mall', the membership of which was 'mostly foreigners . . . and some of

them Papists'.[1] But it was the rivalry between Reynolds and West that continued to fascinate the critics. The *Morning Chronicle* gave them significant attention in 1773, while singling out Stubbs and Wright for the SAGB, and exploited Reynolds's deficiencies in history painting, the genre most prized by his own institution. 'Fabius Pictor' criticized Reynolds's *Ugolino* and advised him to stick to portraiture, arguing that 'the painting of history is new and strange to you' and that foreign critics would see Reynolds's histories as 'the rude disorderly abortions of an unstudied man, of a portrait painter, who, quitting the confined track where he was calculated to move in safety, had ridiculously bewildered himself in unknown regions'.[2] The taste for histories was such that in 1774 the critic for the *London Chronicle* commented on the historical works of three Academicians only – Reynolds, John Francis Rigaud and West – since everything else in its exhibition was 'either portraits, landscapes, views, or, if they contain anything historical, are founded upon recent and well-known incidents' and so did 'not stand in need of any illustration'.[3]

By 1775, however, the Academy's exhibition was considered to have triumphed over its rival. 'Mundanus', writing in the *Morning Chronicle*, was a lone voice in arguing the contrary, protesting that he had seen much comment on the exhibition 'but not one word upon that of the Society of Artists', which, he asserted, 'was not destitute of merit'.[4] But it is telling that even he went on to single out the Academy for its unequalled achievement in both portraiture and historical art, while giving the laurels for nurturing the best of contemporary landscape to the SAGB. Reynolds's portrait of *Archbishop Richard Robinson* (1771–5; Musée des Beaux-Arts, Bordeaux) was considered finer than anything seen since Van Dyck, and one critic commented, 'In the line of historical Portraits, Sir Joshua Reynolds seems to stand unrival'd.'[5]

It was this combination of portraiture and history as developed by Reynolds that effectively ended the controversy over the superiority of the one over the other in the hierarchy of art.[6] Moreover, at the same time, the Academy was praised for nurturing the previously under-represented field of pure history painting, as the *Public Advertiser* remarked with satisfaction, noting Kauffman and West in particular: 'It has long been a Matter of *Complaint* in this Country, that there is very little Encouragement for Historical painting...However well-founded the above-mentioned Complaint might be some Years ago, yet it is certainly not so at Present.'[7] This he attributed above all to the blessings of the king's academic project, arguing that 'ROYAL PATRONAGE AND PROTECTION has set an Example of Encouragement to the Rich and Great; so that at present when Artists arise in the historical Line (of such acknowledged merit as Mr. West and Signora *Angelica*) there can be no doubt of their being fully employed and amply rewarded.'[8]

Augustus Egg
Night before Naseby
Diploma Work

ANDREW SANDERS

The Diploma Work of Augustus Leopold Egg RA, the *Night before Naseby* (fig. 253), shows Oliver Cromwell rapt in prayer on the eve of his decisive victory over Charles I's army in June 1645. It has a significant place in the career of Augustus Egg and also within the context of a general Victorian fascination with the highly divisive politics of seventeenth-century England. Egg's moral distaste for the corrupt nature of Restoration England is evident in his well-known *Life and Death of Buckingham* (1855; Yale Center for British Art, New Haven). His prayerful Cromwell is seen in a far more favourable light, which may well reflect the opinions of his close friend Charles Dickens, who emphatically told Victorian children, 'If you want to know the real worth of Oliver Cromwell you can hardly do better than compare England under him, with England under CHARLES THE SECOND.'[1] Egg may also have been acquainted with Thomas Babington Macaulay's definitive and much reprinted *Edinburgh Review* essay on Milton of 1825. For Macaulay the Civil War period was 'one of the most memorable eras in the history of mankind', and he asserted that it had proved to be 'the very crisis of the conflict between Oromasdes and Arimenes, liberty and despotism, reason and prejudice'.[2]

This crisis was, to Macaulay, a Zoroastrian battle between light and darkness which had been fought 'for no single nation, for no single land', but which had first proclaimed 'those mighty principles which have since worked their way into the depths of the American forests... and which, from one end of Europe to the other, have kindled an unquenchable fire in the hearts of the oppressed, and loosed the knees of the oppressors with an unwonted fear'.[3] According to Macaulay, the central figure in this critical period, Oliver Cromwell, did not lose 'by comparison with Washington or Bolivar', and despot though he may have become, the simple choice open to his contemporaries had been not between Cromwell and liberty, 'but between Cromwell and the Stuarts'.[4] A devout Cromwell had been one of Thomas Carlyle's heroes in the celebrated lecture series published as *On Heroes, Hero Worship and the Heroic in History* (1841). It was Carlyle's further act of homage, *Oliver Cromwell's Letters and Speeches* of 1846 that was to inspire Ford Madox Brown's painting of the young, meditative, Bible-reading man of destiny: *St Ives, AD 1630, Cromwell on his Farm* (first conceived 1853–6; Lady Lever Art Gallery, Port Sunlight).

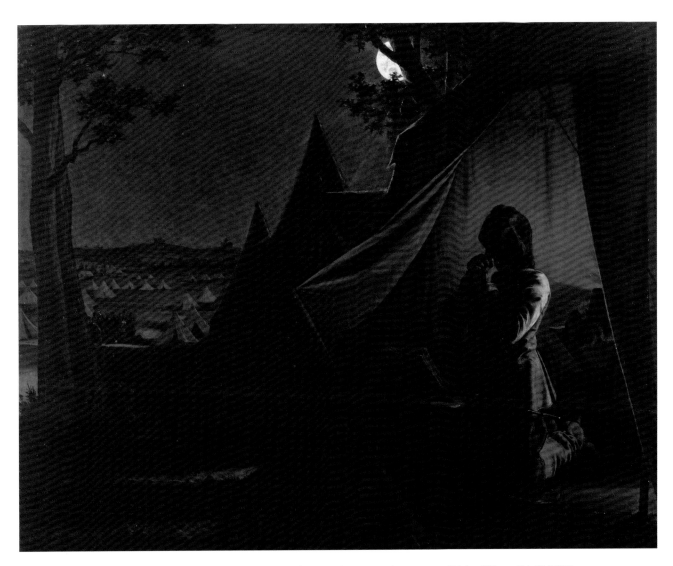

253 Augustus Leopold Egg RA, *Night before Naseby*, 1859, oil on canvas, 101.6 × 127 cm (RA 03/1291).

Augustus Egg became a Royal Academician in 1860, the year after he had painted the *Night before Naseby*, which he presented as his Diploma Work in 1863. Some 20 years earlier, the young artist, while a student at the Royal Academy Schools, had been painted by his friend and close artistic associate, Richard Dadd (Yale Center for British Art, New Haven). Either Dadd or Egg himself had resolved that he should be portrayed as a Cromwellian soldier wearing a Puritanical steeple hat, a red-brown jerkin with broad linen collar and a breastplate. Another friend, William Bell Scott, later recalled seeing a portrait of Egg 'in a tall conical brown hat, like a Puritan, his complexion being almost colourless'.[5] It is possible that Dadd was seeking to give his subject a Rembrandtesque *gravitas*, but it is much more likely that the two would-be radical young artists were drawn to the Cromwellian period, and that they were seeking to express an enthusiasm for the principles of what was still commonly referred to as 'the Great Rebellion'. What is certain is that Egg remained particularly attracted to seventeenth-century history throughout his career as an artist described in an obituary notice in the *Mirror* as 'among the best we have in *quasi-historical figure-subjects*'.[6]

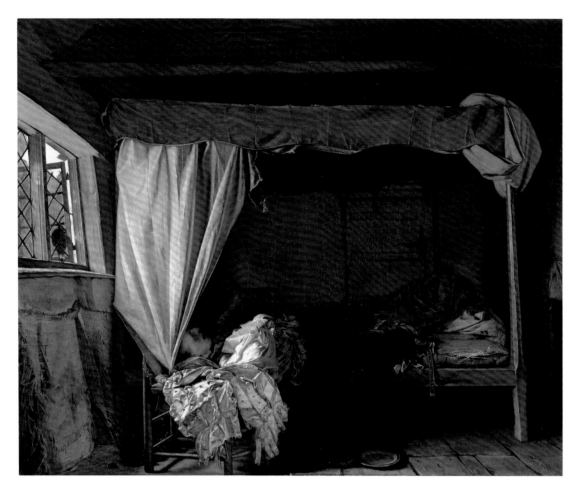

254 Augustus Leopold Egg RA, *The Death of Buckingham*, exhibited 1855, oil on canvas, 74.9 × 91.4 cm.
Yale Center for British Art, New Haven, Paul Mellon Collection.

These subjects were drawn from history proper, from poetry, and also from contemporary historical fiction. Egg's starkly instructive pictures – the *Life of Buckingham* and the *Death of Buckingham* (Yale Center for British Art, New Haven) – were painted in 1857 and 1858 respectively (fig. 254). Both were closely based on lines from Alexander Pope's third 'Moral Essay', the *Epistle to Bathurst* of 1733. There are also two fine paintings drawn from incidents in Thackeray's *Henry Esmond* of 1852: *Beatrix Knighting Esmond* (Tate Britain, London) and *Esmond Returns after the Battle of Wynendael* (Walker Art Gallery, Liverpool), both 1857. In the great 'Art Treasures of the United Kingdom' exhibition held at Manchester in 1857, Egg both helped to select the Modern Masters section and showed two of his own recent pictures, the *Buckingham*

Rebuffed of 1846 (private collection, Hollywood) and *Pepys's Introduction to Nell Gwynn* (Museum of New Mexico, Santa Fe). Also in 1852 Egg had finished *Charles I raising his Standard at Nottingham* (Walker Art Gallery, Liverpool) as a direct comment on a key event in the English Civil War.

Despite Egg's own attitude of adulation, Oliver Cromwell's reputation remained ambiguous to many Victorians. He was as loathed and feared by pious royalists and Irishmen as he was honoured and revered by pious Nonconformists and radicals. Manchester, a city long associated with religious dissent, included a head of Cromwell among the stone effigies of monarchs that decorated its new Assize Courts of 1859–64. A marble bust of the Lord Protector by Matthew Noble was prominently displayed in the sculpture gallery of its new town

hall, and as a direct affront to the new Anglican Bishop of Manchester, a statue of Cromwell was erected close to the cathedral in 1875. Even though Macaulay exerted great influence over the seventeenth-century subjects in the murals decorating the lobbies of the Houses of Commons and Lords in the Palace of Westminster, it is significant that they include no representation of Cromwell, although both Charles I and Charles II appear, and the statue of Cromwell by Hamo Thornycroft RA that now stands outside the palace was only erected – after much debate and much vocal dissent from the Irish Nationalist Party – in 1896. The contentious issue of the location of the statue contributed directly to the resignation of the already beleaguered Lord Rosebery as prime minister – and it was Rosebery who ended up footing the bill. The statue shows Cromwell with a drawn sword in his right hand and a closed Bible in his left, and was finally unveiled at an early hour by the sculptor himself with only five witnesses present, one of whom was the duty policeman.[7] It stands at a safe distance from any public footpath.

We can glimpse something of the radical edge that was associated by mid-Victorians with the Cromwellian regime in Thomas Hughes's novel *Tom Brown at Oxford* (1861), the sequel to *Tom Brown's Schooldays*. Having left Rugby, Tom Brown has proceeded to St Ambrose's College at Oxford, from which in the 1640s 'the plate had gone without a murmur into Charles the First's war-chest.' Despite the traditions into which he was born, and which are evidently upheld by his college, Tom's political opinions undergo a sea change at Oxford, moving steadily from an unthinking inherited high Toryism to an ultra-Liberalism that earns him the soubriquet 'Chartist Brown'. Tom is taking the socio-moral teachings of Dr Arnold to an extreme. The engraving of George III that had hung over the mantelpiece in Tom's college rooms is replaced in his third year by the head of John Milton and a hunting print with a facsimile of Magna Carta. A highly telling seal is set on this new decorative scheme with a reproduction of the death warrant of Charles I. When his Tory father visits him, Tom vacillates as to whether or not to remove the offensive engraving but resolves that it should stay in place despite the 'devout hope that his father might not see it'. Squire Brown, whose early recollections include 'the news of the beheading of Louis XVI, and the doings of the reign of terror', does, of course, notice the engraving, and is so offended by it that Tom takes it out of its frame and burns it, while protesting that he

'would not give up his honest convictions, or pretend that they were changed, or even shaken'. Ultimately, Tom Brown's radical, republican phase proves transient, but he emerges from it with a distinctly socialistic tinge to his 'honest convictions' that closely resemble those of his 'muscular Christian' creator.

We cannot precisely determine the extent of Egg's political liberalism and whether or not it rivalled Tom Brown's radical sympathy with the Cromwellian revolution of the 1640s and 1650s. The *Night before Naseby* suggests, however, that the artist possessed an uncritical admiration for the most prominent 'muscular Christian' in English history. This is not a representation of a regicide, nor does it show us a politician, let alone a potential tyrant. Egg offers us a static but nonetheless dramatic picture of an unarmed soldier at prayer. Half of the canvas is occupied by Cromwell's illuminated tent, the other half by a moonlit view of the Parliamentary encampment. We are probably meant to be reminded of that other famous scene of a night before battle, Act V scene 2 of Shakespeare's *Richard III*, so memorably represented, with David Garrick as the king, by William Hogarth in 1745 (Walker Art Gallery, Liverpool).[8] Hogarth's accursed king wakes in the middle of a nightmare that foretells his bloody end. Egg's Cromwell, in contrast, more resembles Shakespeare's Richmond (whose tent is not shown by Hogarth),[9] a prayerful man who addresses himself to a divine captain before sleep, asking that his army might be rendered 'ministers of Chastisement' whose victory will be sanctified by heaven. Egg's Cromwell is on his knees before an open Bible set upon a folding camp-stool where it appears to be supported by the general's sword. Thus, the instrument of 'chastisement' is shown as the prop to the justifying and incentivizing moral text, rather than vice versa. The man of action is shown not in physical action but in spiritual engagement. Egg, like Ford Madox Brown after him, may deliberately be giving us a picture of Cromwell preparing for greatness rather than a triumphant Cromwell who, having assumed greatness, has tyranny in his grasp. Therein lies the painting's subtly ambiguous message. The man of destiny is first and foremost a man of prayer. No Victorian Tory could properly have been morally offended by Egg's *Night before Naseby*, although many a mid-century Dissenter and radicalized Tom Brown might well have been morally, and perhaps politically, reassured by it.

Philip Hermogenes Calderon
Whither?

Diploma Work

ROBIN SIMON

Whither? was accepted in 1867 as the Diploma Work of Philip Hermogenes Calderon RA (fig. 255). He was the leading figure in a group of artists, most of them Academicians, who were known, from the location of their houses in north London, as the St John's Wood Clique (and to distinguish the group from the earlier 'Clique' *tout court* of the late 1830s established by Augustus Leopold Egg RA and his friends). Other Academicians in the group were Henry Stacy Marks, Frederick Goodall, George Adolphus Storey and William Frederick Yeames, who, as we can see from the photograph by David Wilkie Wynfield (fig. 256), sat for the male figure in Calderon's haunting composition. These artists wanted to initiate a new kind of historical genre that was described by the critic Tom Taylor as 'the home life of past times'.[1] The kind of thing they were aiming at is exemplified by the most famous of the 'Cavaliers and Roundheads' paintings that were so popular at this time, Yeames's endlessly reproduced *And When Did You Last See Your Father?* (1878; Walker Art Gallery, Liverpool).

The St John's Wood Clique was especially interested in the Tudor and Stuart periods. In the summer of 1867, for inspiration and because of its historical associations, Calderon rented Hever Castle, the home of Anne Boleyn.

Here he was joined by several of his fellow members, and here Calderon evidently painted this picture. A play by his famous ancestor, a near contemporary of Shakespeare, Pedro Calderón de la Barca, would have been a natural focus of interest to Calderon.[2] It may well be, therefore, that this picture was inspired by – even if it does not precisely interpret – a scene in *The Mayor of Zalamea* (1651), one of Calderón de la Barca's most enduring plays, which had recently been translated by Edward FitzGerald.[3] The play is still sometimes to be seen in production and in the twentieth century was adapted several times as a film (German silent, 1920; Spanish, 1955; East German, 1956). Act III scene 1 begins with a soliloquy by the dishonoured Isabel in which she asks: 'Whither can I go? Ah! Whither?' (in FitzGerald's 'free' translation, 'What shall I do? Whither turn my tottering feet?'). She then discovers her imprisoned father, the hero of the play, Pedro Crespo, whom she sets free, and he leads her home. The reversed sword in Pedro's hand may be a reference to his decision, in this tortured tale of honour and dishonour, not to take his daughter's life, even though she implores him to do so, in order to save the honour of them both. She says, 'revive your dead honour in the blood of her

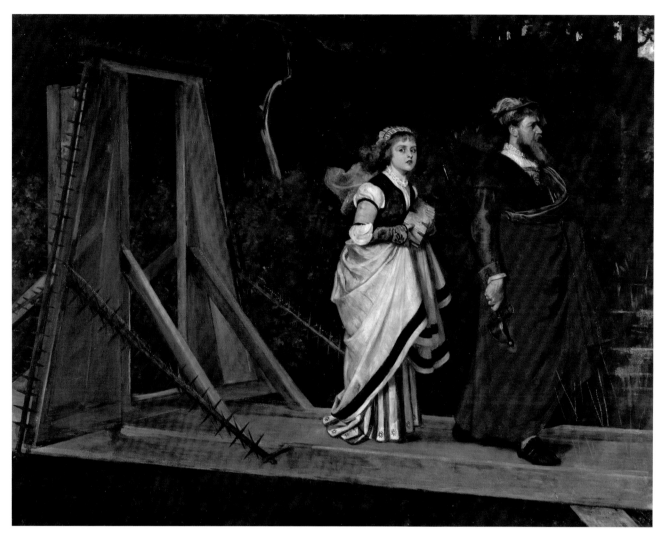

255 Philip Hermogenes Calderon RA, *Whither?*, 1867, oil on canvas, 86.9 × 119 cm (RA 03/848).

256 David Wilkie Wynfield, *William Frederick Yeames*, 1860s, albumen print mounted on paper, 21.5 × 16.4 cm (RA 03/5040).

you gave life to,' but he replies, 'Rise, Isabel; rise, my child…Come, we will home, my Isabel, lean on me…Come my girl! Courage!'

Philip Hermogenes Calderon became Keeper of the Royal Academy in 1887. Within the St John's Wood Clique he was known as 'the Fiend' for his habit of dressing up as Mephistopheles, for which his black hair and beard were appropriate, and he was notorious for his loud singing. His Spanish father, Juan, had trained for the priesthood but became a

Protestant and left Spain, first for France – Philip was born at Poitiers – and then London in 1845, where he became Professor of Spanish Literature at King's College. This was a position that must have encouraged an interest in the plays of Calderón de la Barca, and indeed Philip's own fifth son, George Leslie, became a playwright. His third son, William Frank, was an animal painter who presented a fine écorché horse to the Royal Academy in 1919.

LANDSCAPE

WILLIAM VAUGHAN

Landscape painting as a genre rose to prominence in this country at much the same time as the Royal Academy was founded. During the first century of its existence a substantial number of landscape painters were Academicians, and their practice was profoundly affected by this association. The two artists most frequently thought of as Britain's leading landscapists, J. M. W. Turner RA and John Constable RA, were both deeply committed to the Academy, regarding it as central to the nation's artistic life. For later generations the relationship changed, and fewer of the major landscapists were Academicians. Yet landscape continued to have a prominent part in the Annual Exhibition, and specialists in the genre found themselves more welcome in the institution than they had been initially. This remains the case today, when many distinguished practitioners are associated with the Academy.

When the Academy was founded, the role of landscape within the institution was problematic, even though the Foundation Members included Richard Wilson and Paul Sandby. From the start it set out to promote the status of the fine arts in this country through instruction and the exhibition of exemplary contemporary work. A central part of this project was the maintenance of an artistic hierarchy that had become codified during the Renaissance. According to this, as has already been discussed, the noblest form of art was the type commonly referred to as 'history painting'. This involved the depiction of allegorical, historical and devotional subjects in an idealized manner on a grand scale. The main focus in such works was the depiction of the human form: mastery of figure drawing was the central concern of the Academy, and much of the instruction given to students was aimed at achieving it. Landscape had little relevance to such an endeavour, and it was classified within the academic hierarchy as a 'lesser' genre, as was portraiture followed by animal painting, comic subjects and still-life. Although landscape painters were allowed into the Academy, they were not

normally given a prominent place in its activities, and it is significant that until the twentieth century no landscape painter was elected President. As a result, landscapists often felt marginalized and complained that it was harder for them to become elected Academicians than history or even portrait painters. This was felt particularly by Constable, who had to wait until he was 53 before becoming elected a full Academician. In 1828, when he had been beaten in election to RA by William Etty, a painter with a penchant for bacchanalian themes, Constable complained that the Academy preferred the 'shaggy posteriors of a satyr to the moral feeling of landscape'.[1]

The lowly status of landscape could, however, partially be redeemed by showing proper deference to the principles of historical painting. The one form of the genre that did have some status in academic eyes represented historical or mythological themes in an idealized, usually classical, setting. Acceptable models were provided by the great classical landscape painters who had been dominant in Rome in the seventeenth century, especially the French artists Nicolas Poussin and Claude Lorrain. While Poussin offered a paradigm of learning and intellectual rigour, Claude enchanted the viewer through the sheer beauty of his uplifting scenery, and his glades and vistas were believed to be authentic records of the 'classic' terrain of Rome and its surrounds. By the mid-eighteenth century many works by Claude were in aristocratic collections in Britain. Those not able to have access to these paintings could study the artist's compositions through the many engravings after his works that were published at the time (fig. 257).

The academic view of landscape was set out in the *Discourses* of Sir Joshua Reynolds, the Academy's first President, lectures delivered originally to its students in which he sought to establish the main principles of art. Central to his conception was the practice of what Reynolds called 'the Great Stile'. Reynolds makes it clear in his Fourth Discourse, which treats this subject, that while landscape is inferior to history, it can nevertheless be improved through emulation of the latter. There is a 'superior' form of landscape that does not just copy nature, but selects and improves it according to an ideal model. Reynolds sees Claude as producing such work and contrasts Claude to the Dutch painters, whom he sees simply as producing low and limited models of everyday nature. 'Claude Lorraine', Reynolds pronounced, 'was convinced

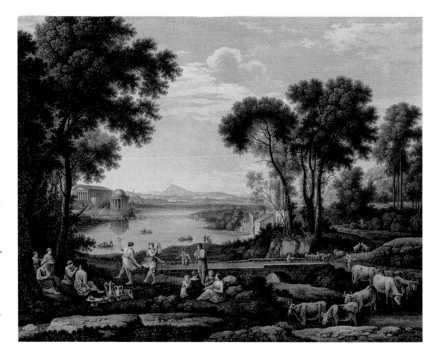

257 François Vivares after Claude Lorrain, *Landscape with Dancing Figures*, 1766, etching, 44.7 × 57.9 cm (RA 05/2303).

that taking nature as he found it seldom produced beauty. His pictures are a composition of the various draughts which he has previously made from various beautiful scenes and prospects.' He then went on to stress that this should be the model for landscape painters, as it was essentially the same process of selection adopted by the history painter: 'That the practice of Claude Lorraine, in respect to his choice, is to be adopted by landscape painters, in opposition to that of the Flemish and Dutch schools, there can be no doubt, as its truth is founded upon the same principle as that by which the historical painter acquires perfect form.'[2]

The art of Claude did indeed remain a model for landscape painters in Britain during the late eighteenth and early nineteenth centuries, but it could hardly be a precise guide on all occasions for a number of practical and aesthetic reasons. On the practical side there might be mentioned the issue of the painter's clientele. Whatever the Academy recommended, artists still had to produce work they could sell and which addressed the interests of their audience. Undoubtedly, the most popular form of landscape painting was 'view painting', which was essentially the representation

of celebrated or well-loved places. Reynolds might look down his nose at the Dutch for doing 'mere portraits' of places, but that is what most people wanted. The problem for the landscape painter here was essentially no different from that facing the figure painter, as Reynolds well knew. However much he might have praised history painting at the lectern, his own main occupation was portraiture, a far more profitable undertaking. And while the Academy might maintain a superior stance against what a later Professor of Painting, Henry Fuseli, was to dismiss as 'the tame delineation of a given spot',[3] it admitted such pictures in their legions into the Annual Exhibition. Here again we meet the problem of the conflict between idealism and commerce that runs through the Academy's history.

It early became evident that the revenues generated by the Annual Exhibition (through ticket and catalogue sales) were crucial to its survival, and so while the 'Great Stile' had always to be given pride of place on such occasions, other more popular practices were also countenanced. To this should be added the fact that, from the start, the notion that landscape painting was at its noblest when transcribing some ideal form was not universally accepted. There were other social, moral and intellectual purposes for landscape. In the days before the camera the attentive transcription of appearances had a vital documentary role. The later eighteenth century was an age of increasing scientific enquiry, and landscape painters played their part in exploring new ways of understanding nature. The naturalistic paintings of Constable are a prime example of achievement in this area.

LANDSCAPE IN BRITAIN BEFORE THE ACADEMY

The taste for landscape flourished in Britain before the founding of the Academy. Already in the seventeenth century there was a well-established clientele for such work, particularly among the aristocracy and merchant classes. For the most part this taste was serviced by continental artists. Dutch landscapes and seascapes were the most available and popular. In the eighteenth century the growth of classical taste shifted preferences south. The growing habit of the Grand Tour among the aristocracy – itself a reflection of the mounting wealth of the country – led to the increasing importation of works by Claude and other masters whose practice was

centred upon Rome, the ultimate goal of almost all Grand Tourists. The same experience also led to the increased popularity of the landscaped garden where returning aristocrats might reshape their country estates to mimic the glades of a Claudian composition and provide recollections of the scenery around Rome. Although in one sense an imitation, it pioneered a whole new direction in landscape gardening, and it was for this reason that the particular kind of informal setting that resulted became known on the Continent as the 'English garden'. It can be said to have been the first original move by the English in landscape and was a prelude to the establishment of an indigenous school of landscape painting in the later eighteenth century.

Prior to this there had been imitators in Britain of continental landscape painting – artists such as Samuel Scott, who followed the Dutch manner, and George Lambert, who emulated the Italians. But although they were fine painters, neither established a new direction. To some extent this was due to the lack of public support for their ventures. Their careers might have been different, indeed, had the Academy already existed in their day.

THE FIRST LANDSCAPE ACADEMICIANS: WILSON, GAINSBOROUGH AND SANDBY

The situation was different for Richard Wilson, who is often referred to as the 'father of British landscape'. He was one of the three landscape specialists among the founders of the Academy in 1768, the others being Thomas Gainsborough and Paul Sandby. By that time he had established himself as a master of the kind of classicizing landscape that Reynolds was to hold up as a model in his *Discourses* (fig. 258). Wilson was the son of a Welsh clergyman with connections among the gentry and aristocracy. After training in London and working as a portrait painter, he had travelled to Venice in 1750 and thence to Rome in 1751, where he stayed until 1757. It was in Rome that he developed as a landscape painter. He was much influenced by French and Italian painters there, two of whom, Joseph Vernet and Francesco Zuccarelli RA (himself a Foundation Member of the Royal Academy), encouraged him to specialize in landscape. He made spirited sketches, including a small study of a volcano in eruption (fig. 259), countless studies, sets of presentation

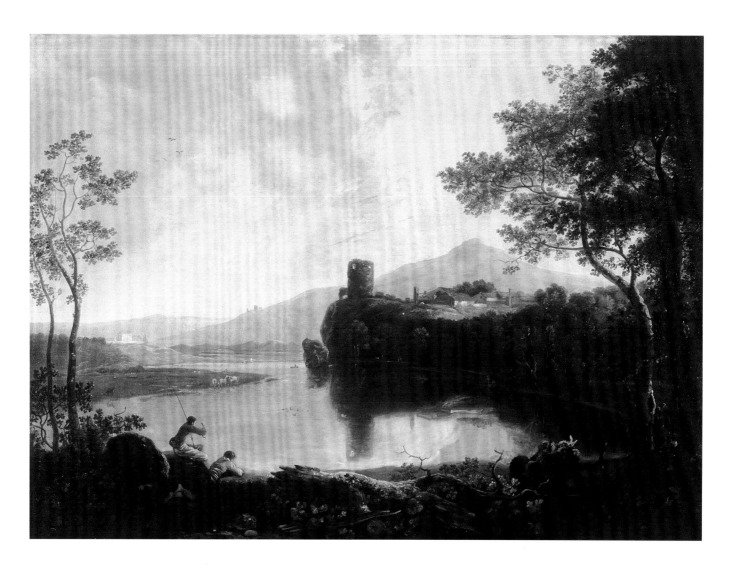

drawings and some oils. He also made valuable contacts among the British 'milordi' who became his patrons while in Italy and after his return to Britain.

Contemporaries saw Wilson as a successor to Claude in his mastery of light and of composition, but above all it was his determination often to paint faithful interpretations of specific locations that gave his work such authority. On

(above) 258 Richard Wilson RA, *Dolbadarn Castle, c* 1760, oil on canvas, 85.5 × 131.4 cm. Amgueddfa Cymru – National Museum of Wales (NMW A 72).

(left) 259 Richard Wilson RA, *Landscape with a Volcano, probably Vesuvius,* 1756, chalk, 9.6 × 9.8 cm (RA 03/1876).

returning to England in 1757 he initially established his credentials as a painter of historical landscape, with his exhibition in London at the Society of Artists in 1760 of his grandiose *Destruction of the Children of Niobe* (Yale Center for British Art, New Haven). He also gained wide employment producing memorable views of local scenery and estates for wealthy patrons, and in a sense he could be seen as claiming the local topography for the ideal vision, in much the same way as the landscape garden redesigned terrain. To this day there is debate about these fine works. To some he can be seen as the first discoverer of the beauty of native landscape, especially that of Wales, the land of his birth; to others he can be seen as the imposer of an aristocratic aesthetic on indigenous identity.[4] For painters in Britain, however, at the time and subsequently, he represented a new standard of the ideal and offered a new perception of light that was an inspiration and a challenge.

Given Wilson's status and authority by 1768, it is no surprise that he was selected to be a founding member of the Academy. Yet, sadly, his work was already falling out of favour by that point in his career and his income dwindled. In 1772 he was appointed Librarian at the Academy on a salary of £50 a year – an act that had a whiff of charity about it. Unfortunately, he seems not to have enjoyed the respect of Reynolds, who perhaps felt the older artist was past his best.

260 Thomas Gainsborough RA, *Wooded Landscape*, late 1740s, pencil, 12 × 18.2 cm (RA 03/1883).

There is a story that at one artist's banquet where Wilson was present Reynolds proposed a toast to Gainsborough as 'the first landscape painter of Europe'. Wilson promptly responded by hailing Gainsborough as 'the greatest portrait painter of Europe'.[5] Reynolds may well have remembered this gibe in his Fourteenth Discourse, which was a eulogy to the recently deceased Gainsborough. Reynolds praised Gainsborough for staying within his limits as a master of nature and contrasted it to the kind of landscape painter who 'pompously' includes classical references in his work. The inference is that he had Wilson in mind. For, while Reynolds encouraged the aspiration towards the ideal, he also maintained that those not capable of achieving this did best to cultivate their limited resources at a lower level.

Despite Gainsborough's towering success as a portraitist, he always maintained that landscape was his first love. He wrote once to his friend William Jackson professing to be 'sick of Portraits' and wishing he could take his viola da gamba off to 'some sweet Village' where he could paint landscapes and 'enjoy the fag End of Life in quietness & ease'.[6] In his early life he had formed a fine landscape style on Dutch seventeenth-century models, but had been forced into portraiture because of a lack of commissions. Throughout his life he studied nature when he could. He was a superlative draughtsman, and his often rapid sketches capture forms in nature with the most exciting sensitivity and vivacity (fig. 260). As a young student Constable – a great admirer of such work – declared, 'I fancy I see Gainsborough under every hedge and hollow tree.'[7] In later life the affluence brought by success enabled Gainsborough to take the time off from portraiture increasingly to practise landscape. Here the Academy can be said to have played an important role, because he was able to display his fine late landscapes at the Annual Exhibitions. In contrast to Wilson (as Reynolds observed) they were not full of classical references, but nor were they paintings of specific locations; rather, they were evocations of an indigenous Arcadia. Gainsborough showed lyrical scenes of peasants returning from market or setting off to work, although rarely, if ever, actually working. Such pictures conjured up the classic urban dream of retirement and can be said to have fuelled a nostalgia that has guided responses to nature in this country ever since. Gainsborough himself was from a small country town and yearned to escape the city. As the effects of industrialization grew in the early

nineteenth century his landscapes rose in popularity, and he was more admired for them at that time than for his portraits. As well as celebrating country life Gainsborough was also a pioneer in the exploration of the wilder parts of Britain. His *Romantic Landscape with Sheep at a Spring* (c.1783) shows an imagined mountain scene based on a visit he had made to the Lake District. This area – soon to become popularized through the poetry of Wordsworth – was already attracting travellers who sought to immerse themselves in the elemental. Gainsborough's work with its lowering atmospherics was formed for poetic reverie.

Gainsborough's focus on indigenous scenery also brought into play another key consideration in the rise of landscape in this country. This is the association of landscape with national identity. The idea that the British character could be epitomized in representation of the natural terrain was strengthened in the early nineteenth century, when the country was at war with France. It could be argued that it has remained a persistent theme ever since.

While both Wilson and Gainsborough can be said to have offered idealizations of nature, albeit of a different kind and to a very differing degree, the third major landscapist to be a Foundation Member of the Academy came from an alto-gether different tradition. Paul Sandby represented the practical side of picture-making. He was employed as a draughtsman at the Board of Ordnance, involved first and foremost in mapping exercises which included the making of a survey of the Scottish Highlands following the 1745 rebellion. In this he was following closely the career of his elder brother Thomas, an architect and draughtsman who worked for the Duke of Cumberland. Paul's superlative skill at topography was widely recognized, and Gainsborough once recommended him as the master of 'real Views from Nature in this Country' while turning down such work himself.[8] Sandby's habitual direct sketching led him to master the technique of watercolour, so well adapted to rapid notation and the capture of subtle atmospheric effects. Often he used these studies as the basis for fanciful as well as observed landscapes (fig. 261). He is often cited as the 'founder' of the practice of watercolour in this country, a reputation that is rather ironic considering the relatively low view that the Academy entertained of the medium in the early nineteenth century. By the time of Sandby's death, in fact, a significant group of watercolourists had established an alternative institution to support their work, the Society of Painters in Water Colours (1804).

261 Paul Sandby RA, *Ruins in a Landscape*, n.d., pencil and watercolour, 17.2 × 23.3 cm (RA 03/1544).

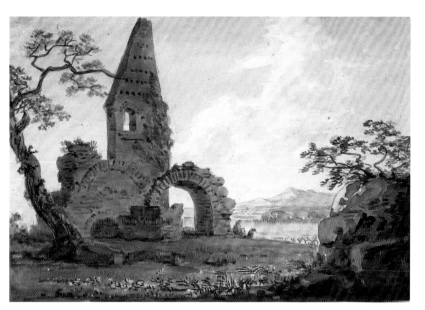

TRAVEL AND TOPOGRAPHY

Sandby's topographical work signals a growing importance in picture-making for practical purposes. As has already been mentioned, in the age before the photograph, the manual topographical record had a unique position as a technical aid to science, commerce and power. Sandby's own early work had been related to the need to chart the Scottish Highlands as an aid to controlling insurrection. The later eighteenth century was one of massively expanding British colonial ventures that led to the establishment of an empire, but which were also driven by commercial and scientific interests. Many artists were involved (as Thomas Sandby had been in the Duke of Cumberland's military ventures) in recording such journeys. Often, as well as providing valuable records, such artists would turn the experiences to advantage in setting up their reputations as painters of more elevated work. One such was William Hodges RA, a pupil of Richard Wilson, whose career was made when he was selected to accompany Captain

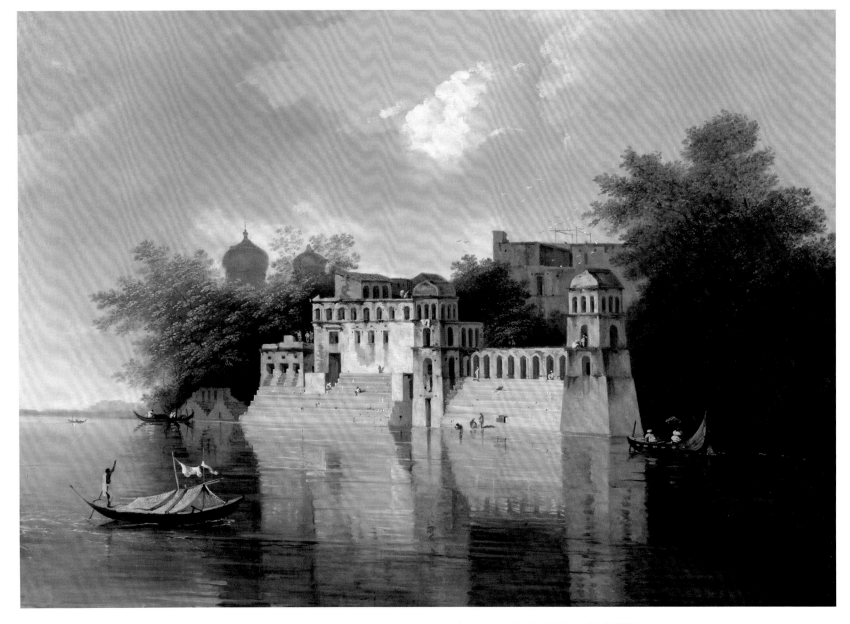

262　William Hodges RA, *Ghauts at Benares*, 1787, oil on canvas, 91.5 × 130.8 cm (RA 03/210).

Cook on his second journey to the Pacific (1772–5). It was Hodges's task to record the topographical and ethnographic phenomena encountered on the journey, and he did so in vivid studies that remain valuable records. He also brought his skills as a trained landscape painter to interpret these new lands. Most successful was his representation of Tahiti as an island paradise, feeding the view already entertained by western travellers of life there as easeful, even sybaritic. Hodges's representation of Tahiti as an Arcadia was so successful that, on his return to England, the Admiralty paid him a salary to complete a series of set-piece large oil paintings showing the South Seas in a dramatic and idyllic light.

Many of Hodges's compositions were successfully exhibited at the Academy, and he became ARA (1786) and shortly

thereafter RA (1787). Meanwhile, he was taken to India by Warren Hastings, as the first trained western landscape painter to make such a journey, and he presented an Indian scene to the Academy in 1787 as his Diploma Work (fig. 262). Hodges had accompanied Warren Hastings to Benares in 1781, and in this picture he showed the view of the 'ghauts' lining the western bank of the Ganges that enabled ceremonial bathing. Hodges has given the whole scene an exotic appeal, with a few Indians performing their rituals in an ancient and picturesque structure viewed against a mysterious, shadowy landscape.

THE PICTURESQUE

By the time that Hodges came to produce this work topographical views had been given a new dimension through the development of the vogue for the Picturesque, the literal meaning of which is 'like a picture'. Its precise application was (and is) much debated, but the main point was that it both reflected and encouraged a new form of travel in which tourists journeyed not just to experience new towns and cultures, but also to contemplate natural scenery and judge it aesthetically. It has often been remarked that the popularity of this movement answered the requirements of a new leisure class, the affluent bourgeoisie, who by the later eighteenth century were in a position to take regular holidays – a privilege that had previously only been available to the upper classes. Such people were not, on the whole, able to take the years out of their life required to make the Grand Tour to Italy favoured by the aristocrat. In addition, towards the end of the eighteenth century access to the Continent was difficult because of the French Revolution and its aftermath, which must have encouraged a fresh examination of what travel at home might offer. Nor, indeed, did the well-off middle class always have the kind of educational and cultural background that would be necessary in order to gain maximum benefit from making the Grand Tour. But they did have time to take a few weeks off to visit a British area of natural beauty such as, say, the River Wye or the Lake District. Most members of this new class were town dwellers, and readily bought into the myth of the pure natural beauty of the countryside as well as to its patriotic associations. To a great extent, this taste for the Picturesque was fuelled by travel writing, in itself a sign of a

newly literate market, and a field pioneered by the Revd William Gilpin. He was the elder brother of the artist Sawrey Gilpin RA and an amateur artist himself, and made tours of the countryside, noting the 'picturesque' sites and making sketches of them. Eventually, as these records grew and were privately circulated, Gilpin was 'persuaded' by friends to publish them, when they became best sellers.

The Royal Academy Library does not possess many examples of such literature, which is not in itself surprising, since these books were aimed at an amateur market. In a similar manner, the Academy Library has very little representation of the voluminous publication of drawing manuals and the like that, throughout the nineteenth century, instructed amateurs on how to draw – largely by reference to landscape. The one example of Gilpin's work that is in the Academy Library was purchased recently, in 2006, and shows fine aquatints after his work. One is of a mountainous scene that exemplifies the characteristics that Gilpin described as 'picturesque' (fig. 263). In order to meet this expectation, the landscape needed to offer a pleasing contrast of forms and an accompanying tonal contrast. It was a tenet of the Picturesque that irregularity was admired: the opposite of mechanistic straightness or contrived smoothness, seeming to indicate what was natural, as opposed to the machine-made and manufactured that was

263 Samuel Alken after William Gilpin, *Landscape*, 1794, aquatint, etching and colour washes, 17.4 × 26.1 cm (RA 06/1135).

264 Thomas Rowlandson, 'Doctor Syntax Loses his Way', in
W. Combe, *The Tour of Doctor Syntax in Search of the Picturesque*,
London 1812, pl. 2, hand-coloured etching with aquatint,
11.4 × 19.7 cm (RA 06/4367).

crossroads, wondering which of two unpromising directions to take to find his pictorial Eldorado (fig. 264).

Interestingly, *Dr Syntax* was published by Rudolph Ackermann, the printmaker and publisher who made a fortune producing 'picturesque' guidebooks and instruction manuals for amateurs, and so for him, it would seem, making fun of the Picturesque was, in the end, just part of the ongoing business.

For landscape painters the taste for the Picturesque offered great opportunities. A huge number of them made their living by travelling to sites renowned for their picturesqueness, which they would then turn into pictures to be sold at exhibition or to be exploited as the basis for illustrations in travel books. This might seem to be a lowly trade, yet it started the career of many of the most accomplished painters of the time, including J. M. W. Turner.

J. M. W. TURNER RA

increasingly such a feature of daily life. Gilpin recommended much irregularity in the foreground, to be contrasted with a distant smoothness, and thought that the Alps, for example, were not picturesque because of the jagged nature of the aiguilles that surmounted them.

Such 'rules' for picturesque landscape might perhaps strike us as comic or even absurd, and by the early nineteenth century they were already thought so by many. They are the object of satire by Jane Austen in *Sense and Sensibility*, for example, while one of the most popular spoofs of the day was the illustrated picaresque venture, *The Tour of Dr Syntax in Search of the Picturesque* (1812). This was a collaborative effort by the author William Combe and the illustrator Thomas Rowlandson, one of the most gifted draughtsmen of the age, and also one with a taste for mischief. He had been sacked as a student at the Academy, allegedly for firing at the nude female model with a peashooter. He was lazy and pleasure-loving, and his rapid and fluent drawing manner made him much in demand among the printmakers of the day. Dr Syntax, a kind of artistic Don Quixote, is a schoolmaster convinced he can make a fortune by making 'picturesque' views of famous beauty spots, and so he ventures forth into the countryside and meets all kinds of disasters as a result of his efforts. In the page illustrated here he pauses at a

Born in 1775, Turner came to maturity in the 1790s, when the Picturesque movement was well under way. Coming from a lowly background – the son of a barber in Covent Garden – he had to earn his living from an early age. View painting was the obvious choice, and he received training in an architect's office while simultaneously attending the Royal Academy Schools. This was not an unusual arrangement. The Schools, high-mindedly, taught drawing and composition through study of the live figure and the Antique. They did not at that time teach painting and certainly not watercolour, the medium which Turner, like most topographers of the time, used as the stock in trade method of depicting views.

Turner's attitude towards the Academy was always deeply supportive, and he was aware of how much he owed his career to it. For a start, its instruction in those days was free to all who demonstrated ability, which meant that a person from Turner's relatively poor background could afford to study there. In addition, the Annual Exhibition offered a place for an unknown to show his work, and Turner had his work accepted for exhibition when he was only 15. He continued to exhibit there for the rest of his life. The success of his early works was such that he was offered Academy membership at the earliest possible age, being made an Associate in 1799 and a full Academician in 1801, when he was

only 26. This 'fast-tracking' of an artist of exceptional ability showed the academic system at its most effective. Yet it should be remembered that Turner only succeeded because he had shown himself amenable to the adoption of the Academy's principles.

As his Diploma Work demonstrates (fig. 265), Turner had developed as an oil painter by the time of his election. Based on Dolbadarn Castle in Snowdonia (which he had visited in the 1790s), the composition aims to achieve a dramatic, awe-inspiring effect. As such it contrasts interestingly with Richard Wilson's view of Dolbadarn. Wilson sought to provide an elevated view of his native scenery. He sets the gaunt tower of Dolbadarn in a landscape that might have been designed by Claude, and while he shows the tower as a forbidding silhouette, he counterpoints this with a gleaming vista of Snowdon behind and frames the whole with elegant trees and foreground figures at ease. Turner, in contrast, homes in on the subject. He chooses a vertical format for his picture to enhance the tall shape of the tower (the elevation of which he exaggerates). The mountains behind offer no relief. They are equally gloomy and threatening. As such the picture can be seen as an essay in the fashionable concept of the Sublime – that sense of overpowering effect defined by Edmund Burke in his famous essay of 1757, *A Philosophical Enquiry into the Origin of Our Ideas of the Sublime and the Beautiful*, the Sublime itself being perceived as the most extreme kind of aesthetic experience. Turner further embellishes the scene with an appropriate subject. As the verses that accompanied the work when it was exhibited at the Academy in 1800 make clear, Turner was aware of the grim history of the tower, in which the Welsh prince Owain Goch was imprisoned from 1255 to 1277. As if to symbolize this, he has the figure of a naked captive cowering in the foreground. This is not a literal reconstruction of the past, as the tower is shown as it was when Turner saw it rather than as it had been in the thirteenth century, and the aim was rather to heighten the sensation of fear with thoughts of loss of liberty. These in their turn were highly topical: Turner painted this picture during the Napoleonic Wars, at a time when anxieties about invasion were high. In his evocation of mood and range of associations Turner shows himself to be a true exponent of Romantic landscape.

Watercolour painting, as has already been mentioned, was considered by the Academy to be an inferior technique –

simply a form of coloured drawing. It has always been regarded as significant that Turner's main rival as a watercolourist, Thomas Girtin, was rejected when he applied for membership of the Academy, but, unlike Turner, Girtin had remained a watercolour specialist and had not complemented this work with oil painting and therefore never offered an oil to the Academy as proof of his abilities. It was not just the acceptance of the technique of 'proper' painting that endeared Turner to the Academicians, however; it was also that he showed a willingness to take on landscape in its 'highest' form, to follow Reynolds's recommendation of treating landscape in an ideal manner and as though it was a kind of poetry.

Poetry itself was a genuine passion for Turner. Although uncertain in his own use of language (he may have been dyslexic), he was a voracious reader and attempted throughout his life the creation and completion of an epic poem that he entitled 'Fallacies of Hope', frequently using extracts from it to accompany his exhibited works. The classical notion of 'Ut pictura poesis' (a poem is like a picture) had been invoked by Reynolds to encourage painters to approach their subjects poetically. It has often been remarked that the age that shows the great flowering of landscape painting in Britain was also the one in which a new and more intense form a nature poetry rose to prominence – as can be seen in the works of Wordsworth and Coleridge. Turner did not make much use of the work of his contemporaries, however, with the exception of Byron, although he drew on poetry in his exhibited works from early on. In 1798 – the first year, incidentally, that the Academy allowed the quotation of poems to be entered into the exhibition catalogue – Turner exhibited a view in the Lake District accompanied by a quotation from Milton's *Paradise Lost*, describing mist rising (*Morning amongst the Coniston Fells, Cumberland*, 1798; Tate Britain, London). He accompanied his Diploma Work with some lines (believed to be his own) reflecting both on the awesome scenery and the fate of the medieval Welsh prince Owain Goch.

Such a demonstration of intent was a prelude to the great artistic journey in which Turner explored new intellectual heights for the genre of landscape, and it is unthinkable that such an ambition would have been pursued without the stimulus of the Academy. This is not to say that Turner's work was always approved by the institution – far from it; but it had set the terms for such an undertaking. Furthermore, the fact

265 J. M. W. Turner RA, *Dolbadarn ('Dolbadern') Castle*, 1800, oil on canvas, 119.4 × 90.2 cm (RA 03/1383).

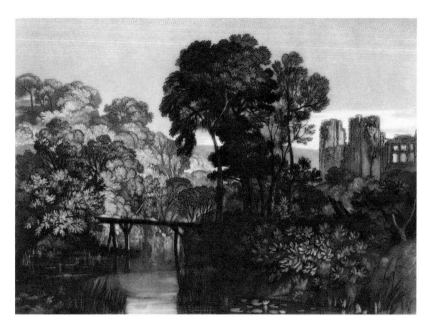

266 J. M. W. Turner RA, 'Berry Pomeroy Castle' (c.1815), in *Liber Studiorum*, London 1806–19, etching and mezzotint, 19.3 × 27 cm (RA 03/3312).

(fig. 266), but it was also intended as a statement on the potential of landscape and an encouragement to others to continue his own explorations.

Turner was honoured by the Academy – yet only to a degree. It is noticeable that he was never made the President, despite his evident willingness to assume that office. To some extent this was because he was regarded as too eccentric a person to occupy a post that has always required considerable diplomatic skills – added to which is the fact that there were only two occasions when he might seriously have been considered and on one of those he would have been standing against Sir Thomas Lawrence (PRA 1820–30). But it might also be because he was a landscape painter. Turner might have done all he could to persuade the Academy to believe that landscape could be put on an equal footing with historical painting. By the time of his death, too, precisely this argument had been made in *Modern Painters* (1843–60), the first great work of his admirer John Ruskin. But it would take some further changes in the art world before the Academicians could bring themselves to abandon the concept of the primacy of the figure.

Turner's continued support of the Academy can be seen in his bequest. In his will he left a substantial sum to the Academy for educational and charitable purposes, but it is also interesting to note that that he left the collection of his own work to the nation (substantially housed at Tate Britain). Perhaps he felt that the Academy's position as a private rather than a public institution meant that it was not ultimately the best place to house a donation he wished to survive in perpetuity, although he may also have been sensitive to the Academy's long-established fear of becoming a 'museum'.

that Turner had been made an Academician in 1801 meant that he had the right to exhibit whatever he liked without any of his works having to be judged by the exhibition jury. This gave him a unique opportunity for free expression, leading to results of which we all are the beneficiaries.

At one level, Turner was a rugged individualist going his own way. On the other hand, he had a strong sense of artistic community and wished to communicate with and encourage his fellows. There are many stories from students at the Academy about the support he would give, in his own strange way, when they were struggling, and it was his desire to communicate that led him to apply to become Professor of Perspective at the Academy in 1807. Landscape was not taught at the time, and perspective was the skill nearest to it. The lectures were not a success because of Turner's poor delivery, but he had more success with a purely visual form of didacticism. This was the publication of mezzotint designs after his works, the *Liber Studiorum* (1806–19), issued as a series, and demonstrating his interpretation of all the varieties of landscape composition and subjects. It was certainly an advertisement of his amazing range, from imitations of the Claudian ideal to the most dramatic of sublime landscapes

JOHN CONSTABLE RA

John Constable is seen today very much as the counterpart to Turner in the great period of British landscape. They were close in age but were very different painters. Constable represented the kind of landscape that focuses on the familiar, the everyday, while Turner ranged in all directions. Constable never painted historical landscape, but kept to scenes he had experienced, and his subject matter was chiefly drawn from places he knew intimately. Prime among these were his native Suffolk village, East Bergholt, and the Stour Valley.

Other favoured places – Salisbury, Brighton, Hampstead – all had personal associations. Above all, at least in modern times, Constable has become a talisman for what is often thought of as 'authentic' painting, epitomized by the brilliant and direct *plein-air* oil studies that he made.

Yet in their lifetime the contrast between Constable and Turner was not so often made, largely because Constable was, until the very last years of his life, much the less well known of the two. Unlike Turner, Constable had been a slow starter as an artist – partly because of parental opposition – and he was already over 20 when he enrolled at the Academy Schools. Indeed, he was first accepted for exhibition in the same year that Turner was made a full Academician, and Constable did not become an Associate until 1819, when he was 43. He was not elected a full Academician until 1829 when he was 53, at a date that, he bitterly considered, was far too late to be of any use to him. Yet despite this he was as dedicated as Turner to the Academy and its principles. His manner of painting, too, owes more to the academic tradition than might at first be supposed.

Constable is legendary as the artist who rejected convention to paint simply what he saw. His comment, 'there is room enough for a natural *peinture*' – made after he had seen his work on exhibition in the Academy for the first time – has been taken as a battle cry for pictorial truth in opposition to convention. Yet despite this, Constable was deeply committed to the art of the Old Masters, which he studied closely.[9] He was well aware that there was no simple 'naive' vision, and that 'natural *peinture*' had, in effect, to be learned. Like Turner, his approach to painting was essentially intellectual. Like Turner, too, he owed this approach to the Academy. He was a constant reader of the *Discourses* of Reynolds, and in his last years he delivered a distinguished series of lectures himself on the history of landscape.

Even Constable's habitual naturalistic practice – the making of direct, outside, *plein-air* oil sketches – was sanctioned by academic tradition. At one time he was believed to have been an innovator in this area, but in fact *plein-air* oil painting goes back to the seventeenth century and may even have been practised by Claude. It was certainly used by Richard Wilson,[10] who may have been the key figure for introducing the habit into this country, and his student, Thomas Jones, was one of the most original British practitioners in the eighteenth century. The main virtue of painting outdoors in oils – as opposed to simply sketching, say, in pencil or chalk or even watercolour – was that it necessitated transcribing the experience of natural light and colour through the medium habitually used for finished pictures. Traditional studio techniques had stressed the achievement of tonal subtleties in oil by means of layers and glazes – methods that took months to execute and could only be practised effectively under controlled studio conditions. Painting in oils out of doors meant, in contrast, that layering of paint was highly restricted and that more emphasis was put on setting tones and colours side by side and using descriptive gestural strokes. It encouraged a new sense of immediacy in the art. Constable seems to have found the practice conducive to a particularly passionate engagement with his subject, and it is for this reason that nowadays it is usually felt to be the most attractive part of his art.

Constable certainly sought to bring the vividness and directness of *plein-air* painting into his finished practice. But, with some exceptions, he did not paint his 'finished' works out of doors. There were practical reasons for this. He was working before the days of collapsible paint tubes (an invention of 1841), and although bladders to contain the mixed oil paint could be used, the colours had to be laboriously prepared and were liable to dry out. It was not possible to roam the countryside with a set of pre-prepared paints in tubes in the way that the Impressionists were later able to do. But there was more than this to Constable's habit of completing pictures in the studio. Despite all his talk of 'a natural *peinture*', he still ultimately thought of a 'proper' painting as being a controlled composition bringing out the full import and grandeur of the scene. In this sense he remained true to the academic notion of the 'big picture'. As he himself commented, it was only after he had moved into painting truly grand-scale works – what he referred to as his 'six-footers' – that he was made an Associate of the Academy. 'I do not consider myself at work unless I am before a six-foot canvas', he remarked.[11]

His main series was of views along the River Stour – the river that ran through East Bergholt and was the principle avenue of wealth for his family: his father was a miller who used the river both to power his mills and to send their produce down to Ipswich in barges, where it would be shipped to the London market, and so Constable could be said to have been continuing a family tradition by seeking to make a living out of the Stour. This series of Stour views

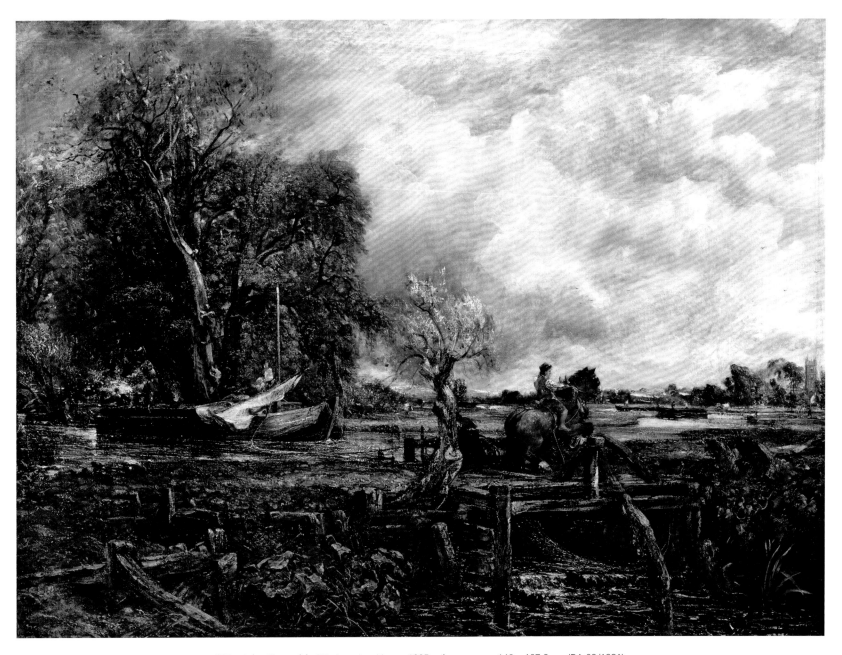

267 John Constable RA, *Leaping Horse*, 1825, oil on canvas, 142 × 187.3 cm (RA 03/1391).

started with the *White Horse* in 1819 (Frick Collection, New York), which gained him his Associateship. It ended with the *Leaping Horse* (fig. 267), now one of the ornaments of the Academy's collection although the reason for its being there is somewhat fortuitous, since it arrived as part of a bequest from a Mrs Dawkins – of whom nothing is known – in 1889.

Nevertheless, it stands as a telling witness to Constable's desire to produce 'a natural *peinture*' that might rival the claims of historical art. The 'incident' that forms the theme of the picture is a barge horse leaping over a barrier on the tow-path of the Stour. While in one sense an everyday occurrence, Constable has taken care to show the horse

leaping in a heroic pose familiar from monumental sculpture. He has, furthermore, depicted dramatic weather conditions that not only demonstrate his mastery of atmospherics but are also in themselves appropriately heroic. But there was a problem for Constable. However magnificent such work might be, it was difficult to sell. His earlier 'canal scenes' had mostly been bought by his close friend Archdeacon Fisher, but Fisher's funds were running low and he could not afford the *Leaping Horse*.

Unlike Turner, Constable had not supplemented his academically ambitious art with a profitable sideline as a topographer, and moreover he was a married man with a growing family. The canal scene series was abandoned, and Constable attempted work with more 'eye-salve' as he put it, notably *The Cornfield* (1826) now in the National Gallery. Ironically, this was the first work by Constable to enter the national collection. It soon became the focus of his popularity and was also partly responsible for the growth of the myth of him as a simple-minded country boy who just painted nature as he saw it. He himself, in contrast, had wished to be remembered by the deeply complex and troubled representation of *Salisbury Cathedral from the Meadows* (1831), which shows the ancient structure threatened (or having just been threatened) by a storm. He had not painted this picture by the time that he was elected a full Academician in 1829, and the picture he selected as his Diploma Work, *A Boat passing a Lock* (fig. 268), is significant because it gives an unusual prominence to the human form. Centre stage is a muscular figure working the lock sluice, in a pose based on an Academy model study. It was Constable's way of showing that his landscape was capable of 'historical' grandeur even when representing the contemporary and the everyday.

LANDSCAPE OUTSIDE THE ACADEMY

The collection of the Royal Academy houses fine examples of works by Britain's two leading landscape painters of the early nineteenth century, but it is interesting to note that many other major landscapists from the period are not represented, the reason for which lies in the artistic conflicts of the early nineteenth century. It has already been mentioned that watercolour painters – who had increased greatly in number due to the growing popular taste for landscape in the later

eighteenth century – felt that their genre was not well suited to the Academy, which itself considered their medium as only of secondary importance. Their works tended to be hung in the smaller, lesser rooms when exhibited. This might seem quite understandable given its usual use for small-scale work and its relative delicacy, but it also implied a lowliness of status – as did the exclusion of watercolourists from the ranks of the Academicians. As a result the independent Society of Painters in Water Colours was established in 1804, which is where such major figures as John Sell Cotman, David Cox and Samuel Prout displayed their work. The society was joined by a rival, the New Society for Painters in Water Colours, in 1831: both flourished as exhibiting bodies in the Victorian period and both were eventually granted royal charters.[12]

The watercolour societies were not the only rivals to the Academy at the time. In 1805 the British Institution had been established by a group of connoisseurs. This held annual exhibitions of Old Master paintings, an implied critique of the Academy's inability or reluctance to provide access to paintings of this kind. Almost from the beginning the BI supplemented this exhibition with an annual show of contemporary artists which in the early nineteenth century rivalled the Academy's exhibition in status, becoming a natural alternative site for young ambitious artists, and also for those discontented with the Academy. A leading example of the latter was the dramatic landscapist John Martin. Martin specialized in a kind of megalomaniacal historical sublime – largely sensational views of biblical catastrophes and the like – that were hugely popular. But the Academicians saw him as a rather vulgar artist and he fell out with them. In the 1820s the Academy attempted to field a rival in the form of the Irish artist Francis Danby – but this strategy backfired when the artist had to leave the country on account of a marriage scandal. Eventually, bridges were rebuilt with Martin – partly because he was widely admired by royalty abroad and by Prince Albert in Britain. Martin returned to exhibiting in the Academy but was never elected an Academician, and the Academy possesses his work only in engraved form – notably the magnificent mezzotints that he made of Milton's *Paradise Lost* (fig. 269). An odder case is the landscapist John Linnell, who had been a brilliant Academy student, winning several prizes. He went on to produce ground-breaking pictures of modern life scenes such as *Kensington Gravel Pits* (Tate Britain,

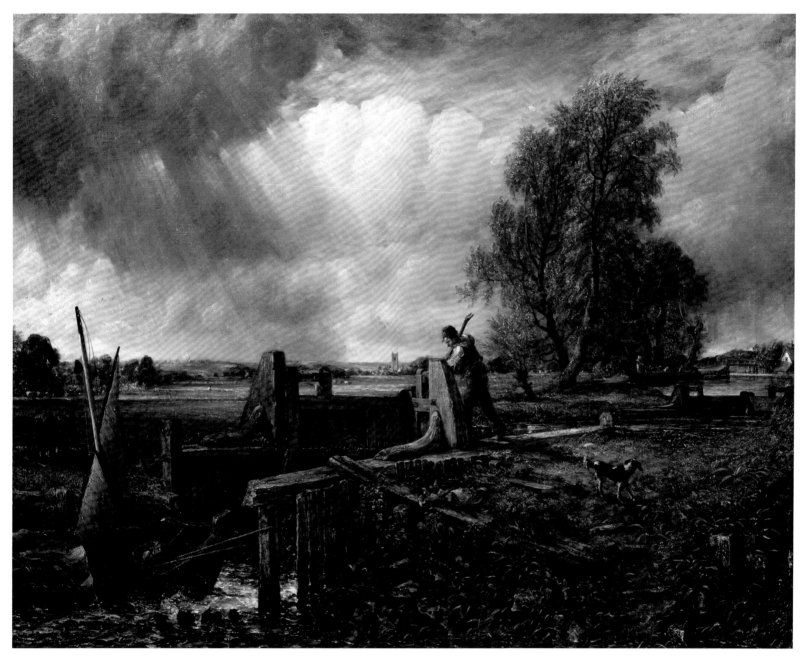

268 John Constable RA, *A Boat passing a Lock*, 1826, oil on canvas, 101.6 × 127 cm (RA 03/923).

London), exhibited at the British Institution in 1813. Yet, despite applying for membership for over 20 years, Linnell was never elected to the Academy. He himself believed he had been blackballed by Constable, who, he thought, was spreading rumours about financial irregularities and could, of course, have been seen as a rival in painting modern landscapes. Despite this, Linnell continued to send his works to the Academy for exhibition and became in later life the most popular and financially successful landscape painter in the country. When he was old, the Academy finally approached

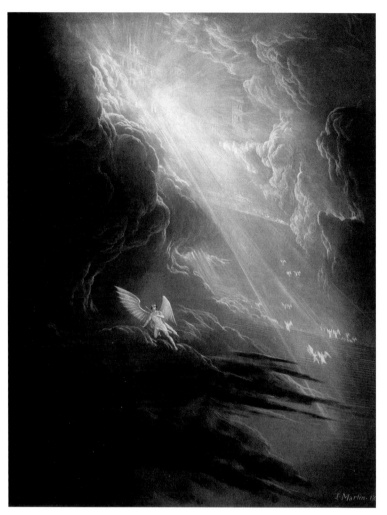

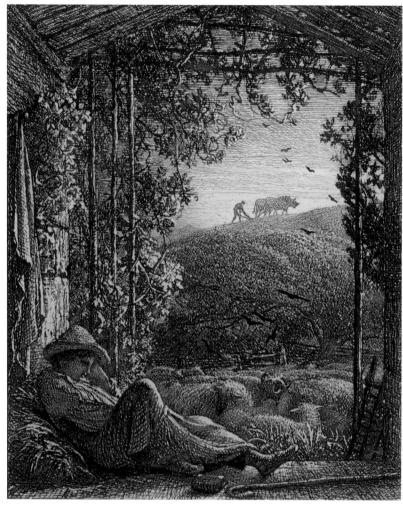

269 John Martin, *Satan viewing the Ascent to Heaven*, 1824, mezzotint on steel, 19.6 × 15.3 cm (RA 04/224).

270 Samuel Palmer, 'Sleeping Shepherd', in *Etchings for the Art-Union of London by the Etching Club*, London 1857, pl. 5, etching, 9.4 × 7.8 cm (RA 06/567).

Linnell to become a member, but he rejected the overture angrily as being made too late.

Perhaps the best-known landscapist of the period not to become an Academician was Linnell's son-in-law, Samuel Palmer, which is not so surprising since his high reputation came only after his death, although Palmer had had his work accepted by the Academy when he was just 14.[13] He might have had a promising career there had he not developed his own highly individualistic visionary style – what he referred to once as his 'wonted outrageousness'.[14] Nevertheless, the Academy seems to have been relatively tolerant of Palmer's

eccentric manner and accepted much of his work for show. On one occasion a reviewer suggested that Palmer should show himself in person at the Academy so that people could see what manner of person might produce such strangeness.[15] The main problem for Palmer, however, was that he could not sell his work of this kind. In the mid-1830s he adopted a more conventional manner, but clearly felt that he was not making enough mark at the Academy to warrant election. In 1843 he adopted the alternative route of joining the Old Watercolour Society and becoming a watercolour specialist. Palmer always regretted this move to some extent, describ-

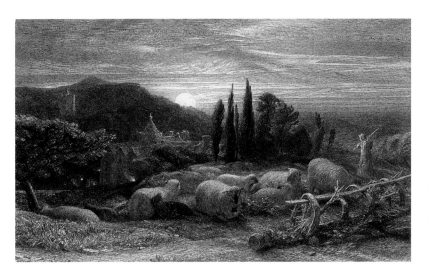

271 Samuel Palmer, 'Rising Moon', in *Etchings for the Art-Union of London by the Etching Club*, London 1857, pl. 5, etching, 11.6 × 19.2 cm (RA 06/569).

ing himself once as a watercolourist 'by accident'.[16] It was a more decisive move than it might be now, since in those days it was not possible to stand for election at the Academy if you were a member of another exhibiting society. There are no paintings by Palmer in the Academy collection, yet there are two fine examples of his work that got in, so to speak, by the back door. In 1850 Palmer joined the Etching Club, and two etchings came into the Academy's Library via the publication that it produced in 1857. Most of the members of the Etching Club were Academicians, and this is presumably why the volume came to the Academy.

In Palmer's etchings something of the poetic force of his earlier visionary works remains. One, the *Sleeping Shepherd* (fig. 270), harks back to a theme he first developed when working in the country at Shoreham. The other, *Rising Moon* (fig. 271), shows more of the wistful melancholy of his late style. From a technical point of view it is an absolute tour de force. It shows the most subtle effects of glimmering, low light – achieved through a complex web of hatchings and a sophisticated use of 'stopping out' processes when etching the plate: Palmer was criticized by some contemporaries for 'false' etching. His laborious method seems to go against the fashion for rapid sketch-like effects of the kind mastered by Whistler, but Palmer argued etching was appropriate for both approaches – citing Rembrandt as his authority, a point

that would readily be conceded today – and his melancholy late pastorals turned out to be highly influential among printmakers of the twentieth century, particularly Graham Sutherland and the neo-Romantics.

LATER ROMANTICS AND THE VICTORIANS

The Academy continued to provide a haven for dramatic and lyrical landscapes. One of the most successful producers of the former was Clarkson Stanfield, an erstwhile sailor and self-taught scene-painter, who was elected ARA in 1832 and RA in 1835, chiefly it seems on account of the patronage of William IV. His most popular dramatic sea piece was a wrecked ship at sea called *The Abandoned* (present whereabouts unknown),[17] but his Diploma Work for the Academy, *On the Scheldt* (fig. 272), shows his skill in uniting the drama of the sea with vivid atmospherics, a skill that caused Ruskin to pronounce him 'the leader of our English Realists'.[18]

Such powerful scenes were counterpointed by a continuation of the gentler rural idyll. One of the most appealing and consistent producers of such work was Thomas Creswick RA, whose Diploma Work shows an artist (possibly himself) observing a simple rustic scene (fig. 273). Such tranquil pastorals offer an interesting contrast to Palmer's darker vision.

The topographical tradition of painting distant and exotic lands continued to flourish as well. A leading exponent, David Roberts RA, was a former collaborator of Stanfield's in scene painting. A worthy successor as a traveller to William Hodges, he was the first British artist to specialize in painting the Near East and helped develop the 'Orientalist' interest in the 'land of the Bible' that later brought the Pre-Raphaelite Holman Hunt to the Holy Land. Roberts's Diploma Work shows a dramatic gateway of the ruined Great Temple at Baalbec (see fig. 247), a site that he had seen on his first tour of the region in 1839. Roberts has included diminutive figures in local costume to emphasize the scale and exotic nature of the scene.

In the Academy there was not much support for more radical types of landscape. The mounting interest in realistic landscape seen in the works of the Pre-Raphaelite Brotherhood certainly found exhibition space in the Academy, but it led to few Academicians among its practitioners and this type of landscape does not appear in the Academy's collec-

272 Clarkson Stanfield RA, *On the Scheldt near Leiskenshoeck: A Squally Day*, 1837, oil on canvas, 96.6 × 130.2 cm (RA 03/1366).

tion. Partly this was to do with the choice of the artists, for by the 1860s the Academy was appealing less and less to avant-garde artists. With the exception of Sir John Everett Millais PRA, none of the leading Pre-Raphaelites pursued their career through the Academy. This was also the case with the leaders of the Aesthetic movement. J. M. W. Whistler, for example, showed his early modern-life subjects and views at the Academy until 1861, when his *Symphony in White No. 1* (National Gallery of Art, Washington, DC) was rejected, and his later career took place outside. Alternative exhibiting spaces and societies, such as the Grosvenor Gallery and the New English Art Club emerged to provide niche sites for avant-garde artists. Furthermore, the rise of the dealer as an agent for the modern artist made exhibition in annual general shows such as the Academy less critical for success.

NATURALISM, FRENCH AND ENGLISH

While Pre-Raphaelite landscape does not figure in the Academy's collection, there is some record of some of the more vivid forms of naturalism that accompanied it. A prime

273 Thomas Creswick RA, *Landscape with Artist resting beside a Road*, c.1851, oil on canvas, 71 × 91.5 cm (RA 03/574).

example is the work of the Academician James Clarke Hook RA. His Diploma Work, *Gathering Limpets* (fig. 274), is typical of the brightly painted sea pieces that he concentrated on in his later life.

While the Naturalist tradition was certainly challenged by the Aesthetic movement, with its doctrine of 'art for art's sake', it was also being called into question by a quite different technical development. The emergence of photography in the early Victorian period raised the question of painting's traditional dependence on mimesis as its justification. To be sure, the relatively limited scope of early photographs meant

that the challenge was at first limited, but growing sophistication meant that by the 1880s photography could show mastery of compositional forms and claim to get a closer purchase not just on resemblances but also on recording the daily activities of people. None shows this more clearly than the great photographer P. H. Emerson, the founder of 'Pictorialism', whose superb records of Norfolk rural life can rival the finest forms of realist painting for their sense of authenticity and in their emotional range (fig. 275). It was almost as though Emerson was throwing down the gauntlet to the fine artist, and he had recently made strong claim for photogra-

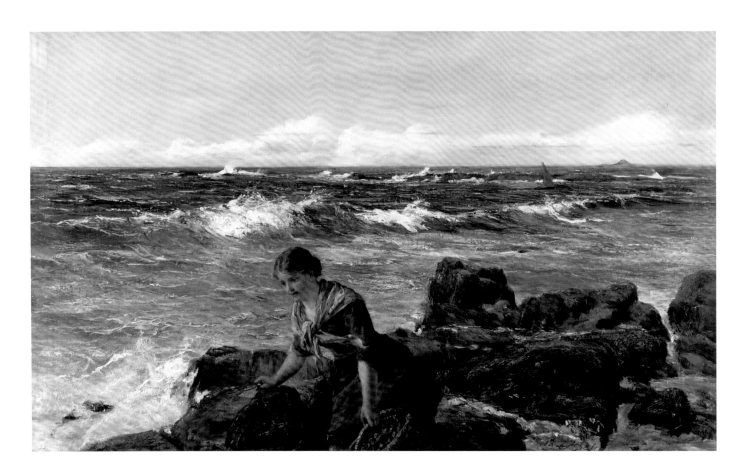

274 James Clarke Hook RA, *Gathering Limpets*, 1886, oil on canvas, 50.8 × 85.1 cm (RA 03/1024).

275 P. H. Emerson, *A Stiff Pull*, 1890, photogravure mounted on paper, 28.8 × 20.6 cm (RA 03/3153).

phy as an art. In doing so he stressed that the photograph should be a direct record of observation, and he made it a point of honour that his pictures were printed as taken, rather than being rendered 'artistic' through the use of retouching or multiple negatives – as had become the practice at the time. Emerson set a standard followed by the leading photographers of the twentieth century, making his work known through publications such as *Life and Landscape on the Norfolk Broads* (1886), *Pictures of East Anglian Life* (1888) and, most challengingly, *Naturalistic Photography for Students of the Art* (1889). It is a telling indication of Emerson's ambitions for photography as an art that he should have presented a volume of his work to the Academy in 1890, but despite this it was to be some decades before photography became admitted as an art form in the Summer Exhibition.

Emerson's intervention came at a time when there was much excitement about the impact of French Naturalist painting in this country. Emerson himself was a particular admirer of such pictures – especially those of Jules Bastien-

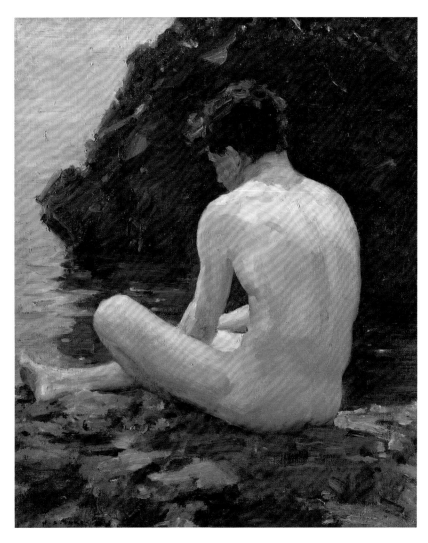

276 Henry Scott Tuke RA, *July Sun*, 1913, oil on canvas, 53.4 × 43.5 cm (RA 03/710).

Lepage, who exhibited some works at the Academy and rather more at the Grosvenor Gallery. The main response to French Naturalism – and increasingly to the Impressionist movement, which predated and then ran parallel with it – can be found in Britain among artists working outside the Academy tradition, particularly those associated with Whistler and, later, Walter Sickert RA. One branch of this tendency, associated with the New English Art Club founded in 1885 (with which Whistler exhibited in 1888), increasingly found a home in the Academy. This was the group of painters who became known as the Newlyn School, after the Cornish

fishing village in which many of them settled. Their self-proclaimed leader was Stanhope Forbes RA, who continued to promote Newlyn for the rest of his life. Forbes combined the new tonal painting of the French Naturalists and some sense of the loose painterly handling of international Naturalist painters such as John Singer Sargent RA and Anders Zorn (and perhaps even a touch of Impressionism) with the narrative traditions of British modern-life painting. Such features became a byword of the school, although individuals varied greatly in the way they applied them. One of the finest, Henry Scott Tuke RA, specialized in painting young boys, often nude, in glittering sunlight, presenting a somewhat wistful image of innocent Arcadia (fig. 276).

The impact of Newlyn in the Academy was long lasting. It could almost be seen as providing the 'default mode' for academic painters of landscape and daily life in the first half of the twentieth century. Increasingly after 1900 the Academy distanced itself from the more extreme experimentations of the avant-garde, seeking instead to remain a haven for sound traditional painting. This tendency reached its apogee in the career of Alfred Munnings, a largely self-taught artist closely associated with Newlyn painters who became a superlative master of horses, and also of a sparkling impressionistic style – evident in his Diploma Work, *Kilkenny Fair*.

The Naturalist tradition also continued to flourish among other artists associated with Newlyn in their early years. A notable case was Dame Laura Knight RA – one of the first women to be elected a full Academician since the eighteenth century. Her Diploma Work, *Misty Sunrise* (fig. 277) is a record of the Malvern area where she and her husband settled in the 1930s. In her autobiography she talked of observing 'the first rays of the sun rising over the Bredon Hill to dry up the floating strands of mist hiding the flatter country to the west'.[19]

BEING BRITISH AND GOING MODERN

While resisting the extreme manifestations of the avant-garde, the Academy in the twentieth century was often sympathetic to artists who incorporated aspects of modernity into their work. Thus, while there is little to be found in the collection relating to Cubism, Vorticism or the modernism

277 Dame Laura Knight RA, *Misty Sunrise*, 1956, oil on canvas, 76 × 96 cm (RA 03/1161).

that was later to become associated with St Ives in Cornwall, there are examples of works by artists who engaged with the contemporary in more subtle ways. In the 1930s the landscape painter Paul Nash talked of the problem of reconciling 'being British' with 'wishing to be modern'.[20] The concern to 'be British' reflects an ongoing concern about national identity, which became increasingly intense in the interwar years. As there had been in the Napoleonic period, there was a fear of invasion, a concern that frequently emerged in the

discussion of landscape, which itself could be considered as embodying the nation's character. The combining of modernity and Englishness can be found in the work of Nash's brother John Nash RA, whose view of *The Lake, Little Horkesley Hall* (fig. 278) involves an angular pattern of barren branches that introduces a modernist accent into a finely observed natural scene.

Much of the landscape and view painting that emerged in the Academy from the 1920s onwards seems to engage with

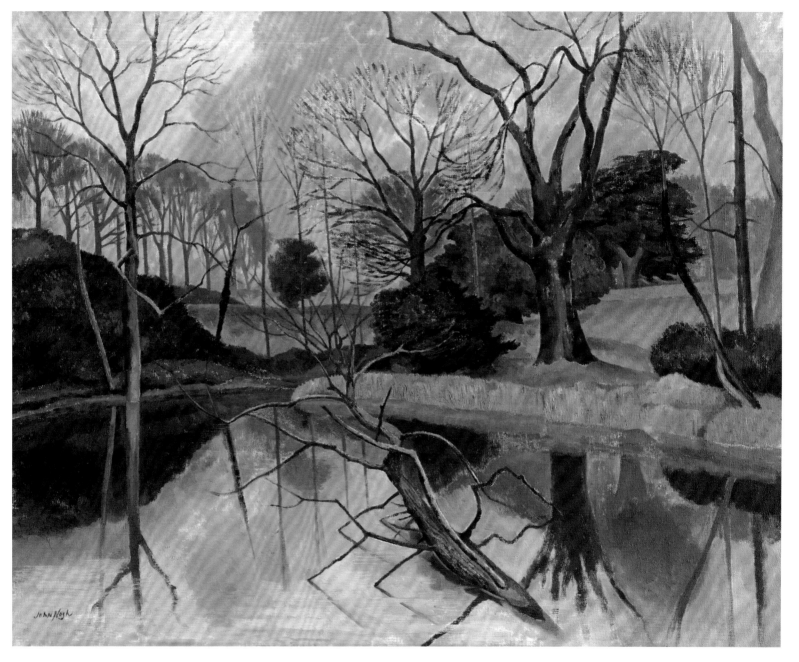

278 John Nash RA, *The Lake, Little Horkesley Hall*, c.1958, oil on canvas, 60.6 × 76 cm (RA 03/1007).

this dialogue between tradition and modernity. A sense of indigenous authenticity plays a part in the work of L. S. Lowry RA, one of the most celebrated and popular of twentieth-century Academicians. Lowry's urban views of his native Salford are the stuff of legend and have led to his being seen as the true yet sympathetic recorder of the gritty life of the industrial north. It is as well to remember, however, that the 'simplicity' of his style was deliberately assumed. Lowry was a trained artist, and he intentionally gave his pictures a naive look by leaving out shadows and simplifying

279 L. S. Lowry RA, *Station Approach*, 1962, oil on board, 40.7 × 50.9 cm (RA 03/416).

shapes. *Station Approach* (fig. 279), his Diploma Work, records the old Exchange Station in Manchester's city centre. Despite claiming that 'I only paint what I see, you know', Lowry has taken liberties with the scene here, particularly with the statue of Oliver Cromwell in the foreground.[21]

Lowry's interpreting of Manchester forms an interesting contrast with another individualistic painter of the urban scene, Algernon Newton. Newton was based in London, a member of the family that founded the famous Winsor & Newton paint business in the previous century. He turned his back on modern methods and developed a meticulous tech-

nique based on the Old Masters, such as the eighteenth-century Venetian view painter Canaletto. Yet despite this, there is nothing old-fashioned about the mood of his work. His *Regent's Canal, Paddington* (1930; fig. 280) is a gaunt and silent scene. Canal transport was rapidly becoming obsolete at the time, a process hastened by the current economic depression, and Newton communicates a sense of abandonment, accompanied by an air of the uncanny that has affinities with the contemporary Surrealist movement.

Surrealism seems to have encouraged other academic artists to explore the psychological dimensions of landscape. Richard

280 Algernon Newton RA, *Regent's Canal, Paddington*, 1930, oil on canvas, 182.8 × 274.6 cm (RA 03/1207).

Eurich RA pursued a kind of 'landscape of memory' in which the scenes from his childhood were redescribed with dramatic effects. He was particularly fond of the sea, and a representation of Dunkirk led to his being employed as a war artist in the Second World War, specializing in naval subjects. His fine Diploma Work, *Mariner's Return* of 1953 (fig. 281), was painted when he was living near the Solent and Southampton docks. It presents a kind of panoramic 'seagull's view' of a ship returning to port, with townsfolk rushing forward in excitement, a nostalgic image of community. The slightly naïve and detailed style is also used to evoke a sense of childhood.

A very different reminiscence of childhood haunts the scenes of Carel Weight RA, who was brought up partly by foster parents in west London and remained acutely aware of the gulf between poverty and affluence in the suburban world. His detailed yet subtly distorted views of unkempt gardens are often peopled with mysterious or supernatural occurrences, as in the *Departing Angel* (fig. 282). It is not surprising to learn that he was an admirer of the work of Stanley Spencer RA and Edvard Munch.

The growth of interest in imaginative approaches to landscape also led to a reconsideration of the British Romantic

281 Richard Eurich RA, *Mariner's Return*, 1953, oil on canvas, 63.5 × 76 cm (RA 03/603).

tradition that became known as neo-Romanticism. A fine example of such work is provided by the watercolour of *Lindsell Church, Essex* by Edward Bawden RA (fig. 283), evoking the atmosphere of a stormy day with occasional shafts of light breaking through the clouds onto a medieval building. Lindsell is near Great Bardfield, Essex, where the artist lived, and its church provided the focus for a series of watercolours, drawings and prints that he produced in the late 1950s. After the First World War, Great Bardfield had become an artist's colony, and similar views of the same site were also painted by other local artists, including John Aldridge RA, whose *Pant Valley, Summer 1960* provides a

remarkable example of sober and assured observational paint-ing of the Essex countryside (fig. 284). Aldridge taught at the Slade School of Art under William Coldstream and was a key figure in the revival of interest in observed, realist art, an interest shared by Ruskin Spear RA. In Spear's case the Euston Road School's concern for the objective depiction of urban life was a particular inspiration. Yet the scenes he painted were often viewed from unusual angles, perhaps because he was confined to a wheelchair as a result of child-hood polio. Spear was born in Hammersmith and focused much on west London, as in his *Old Lyric Theatre Hammer-smith, 1943* (fig. 285). Viewed across hoardings with splendidly

282 Carol Weight RA, *Departing Angel*, 1961, oil on canvas, 91.5 × 91.5 cm (RA 03/1370).

283 Edward Bawden RA, *Lindsell Church, Essex*, 1956, pen and ink with watercolour, 46.8 × 57.4 cm (RA 06/5256).

284 John Aldridge RA, *Pant Valley, Summer 1960*, 1963, oil on canvas, 63.5 × 91.7 cm (RA 03/419).

285 Ruskin Spear RA, *Old Lyric Theatre Hammersmith, 1943*, 1979, oil on board, 80.2 × 99.4 cm (RA 03/1365).

garish adverts, this is a nostalgic recollection of the popular culture of a departed age, perhaps influenced by the more recent flourishing of Pop Art.

It may have been inevitable, given the Academy's location and the bias of the art world, that London-based artists should have been so prominent there. But it is far from a rule, and one of the finest regional landscapists to have practised in the later twentieth century is represented in the collection by an impressive and characteristic work. Kyffin Williams RA was the most prominent Welsh artist of the twentieth century, and the most distinctive interpreter of the landscape of Wales. Certainly, nobody evokes more powerfully the sombre landscape of his native Anglesey and Gwynedd, and *Dafydd Williams on the Mountain* depicts a hill farmer from the Gwynant Valley in Snowdonia (fig. 286). The artist described the sitter as 'a slight man, bent from walking up hills and with the sandy hair that made him look like one of the foxes that lived on the mountain behind the farm'. Williams has painted the farmer as he thought of him, because 'in some strange way' he had become 'part of the ridges, the

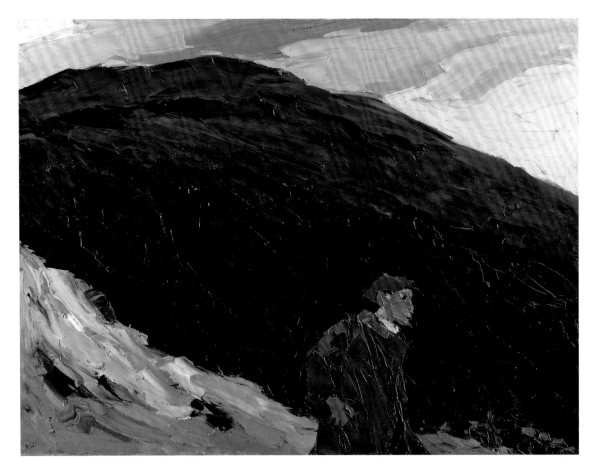

286 Kyffin Williams RA, *Dafydd Williams on the Mountain*, 1969, oil on canvas, 91.5 × 121.8 cm (RA 03/584).

screes and the cliffs',[22] and indeed he seems like a character from one of the poems of R. S. Thomas, whose subject matter was often drawn from his experience of the same part of the country.

AFTER MODERNISM

The pictures discussed above show the richly varied rural and urban scenes that have been produced in connection with the Academy in the twentieth century. Much of it was collected when the Academy was viewed with deep suspicion by the modernist avant-garde. But times have changed, and in recent decades there has been an increasing rapprochement between the rival factions. The passing of the heyday of modernism and its replacement by the variety of

postmodern practices – and now those of the emerging digital age – have led to the welcoming of a plurality of voices in which the old mingle with the new. It is fitting therefore to end this survey of landscape in the Academy with the most celebrated of modern artists, David Hockney RA, who has contributed a monumental landscape painting to the Academy as his Diploma Work (fig. 287). Coming to celebrity as a leading figure in the Pop movement, Hockney has explored his own rich vein of modernity and brought British art into a truly international dimension – something that can be symbolized by the theme of his diploma picture – a study for his monumental panoramic project engaging the American landmark, the Grand Canyon. This undertaking looks both backwards and forwards, drawing on the Romantic obsession with the Sublime and engaging with new spatial concepts using up-to-date technology.

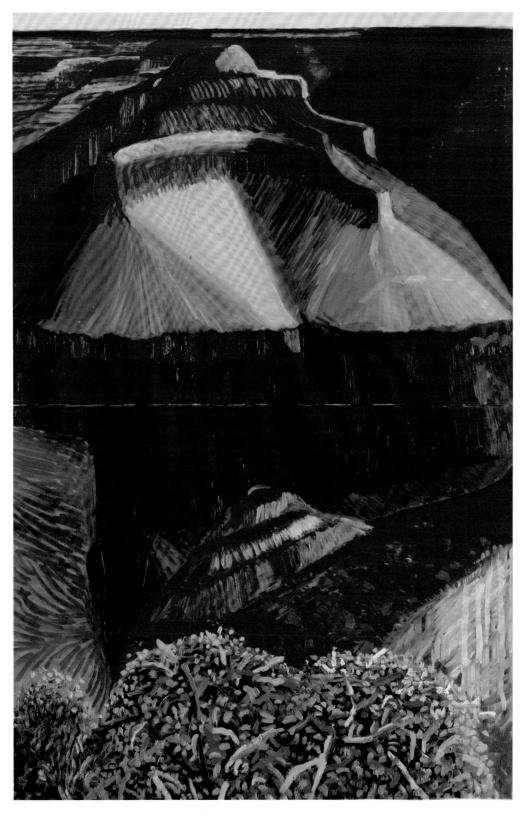

281 David Hockney RA, *Double Study for 'A Closer Grand Canyon'*, 1998, oil on canvas, 181.6 × 121.3 cm (RA 03/891).

A CLOSER LOOK

Thomas Gainsborough
Romantic Landscape with Sheep at a Spring

ROBIN SIMON

This magnificent landscape (fig. 288) was presented to the Academy by Gainsborough's younger daughter, Margaret, in 1799.[1] Gainsborough did not travel much, but this painting represents a dramatic shift in his landscapes as a result of a visit to the Lake District immediately following the Academy's Annual Exhibition of 1783, the year in which he also made his sole trip to the Continent, visiting Antwerp July–September.

The painting is one of two landscapes made at this time that drew inspiration from the Lake District, the other being *Pastoral Landscape (Rocky Mountain Valley with a Shepherd, Sheep and Goats)* in the Philadelphia Museum of Art.[2] Neither painting depicts a particular place. In both Gainsborough shows rocky cliffs and distant mountains bathed in an evening light, and introduces shepherds and sheep. The painting in Philadelphia is more symmetrical, with a distant mountain in the centre framed on both sides by cliffs and woods that rise from the riverbank. In the Academy's picture the scale of the mountain range is diminished, while the rocky cliffs in the foreground are more striking and craggy and the peacefully flowing river is absent.

The process whereby this transformation was achieved appears to be recorded in a rare surviving compositional drawing also in the Academy's collection (fig. 289). It seems that, initially, Gainsborough intended to retain the centrally placed mountain that we see in the Philadelphia painting, but omitted it in the finished painting in favour of a lower mountain range crowned with wispy clouds. In effect, Gainsborough shifted the landscape aesthetic in these two paintings away from the beautiful and picturesque in the direction of the sublime.

Gainsborough is always thought of as a quintessentially British artist, but his refusal throughout his middle and later years to depict specific locations identifies him as closer to the European academic tradition that preferred ideal landscape compositions and consciously avoided topographical accuracy. John Constable RA and J. M. W. Turner RA, in contrast, both followed Richard Wilson RA in interpreting particular places. Subsequently, the success of Constable's *Hay Wain* at the Paris Salon in 1824 ultimately determined the future direction of landscape painting on the Continent in favour of a similar preference for the interpretation of particular places.

By the time he painted *Romantic Landscape with Sheep at a Spring*, Gainsborough had gained a profound understanding

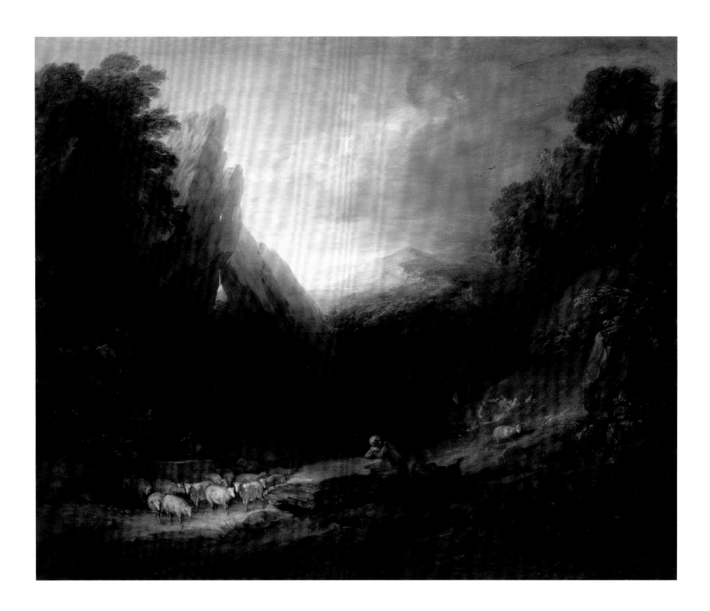

of light, tone and colour, and his subtle deployment of purples and greens – colours that are in complementary opposition – subliminally reinforces the marked contrast in light and shade that more obviously lends the picture its dramatic impact.

(above) 288 Thomas Gainsborough RA, *Romantic Landscape with Sheep at a Spring*, c.1783, oil on canvas, 153.7 × 186.7 cm (RA 03/1396)

(right) 289 Thomas Gainsborough RA, *Mountainous Wooded Landscape with Figures and Sheep*, c.1783, black and white chalk with black ink, 17.6 × 21.4 cm (RA 12/930).

John Constable's oil sketches

WILLIAM VAUGHAN

The three sketches reproduced here are from different periods in the life of John Constable RA. The first (fig. 290) is of a favourite subject near his village, his father's Flatford Mill. It is more of a compositional sketch, and eventually this design was to emerge as *Scene on a Navigable River*, exhibited at the Academy in 1817 (Tate Britain, London). As oil takes time to dry, it is hard to do much overpainting when working directly. Here Constable has conceived his forms as blocks of colour placed side by side – a very modern effect.

The second (fig. 291) is a cloud study made when he was resident in Hampstead in north London. Constable's cloud studies are some of his most celebrated works. He made them to gain a closer understanding of atmospherics, and they reflect a new scientific interest in such phenomena: clouds had recently been classified into distinct types by the meteorologist Luke Howard. The third study (fig. 292), made when Constable was staying in Brighton in 1825, shows a highly transient effect – a cloudburst of rain over the sea – captured with rapid, vigorous brushstrokes.

Constable was a continual and obsessive sketcher who considered such work to be a form of exercise and a means of gathering information rather than something to exhibit and sell. The sketches therefore remained in his studio, and are only in the Academy collection now because they were given by his daughter Isobel, by which time they had been framed, suggesting that they had acquired the status of publicly exhibitable works of art in their own right.

Constable's reputation as a pioneer of naturalistic painting rests on his habitual painting of the scenes that he knew best, particularly those of his native East Bergholt in the Stour Valley in Suffolk. While most of his finished works were produced in the studio, these were built up from studies he made directly out of doors, particularly those made using oil paints such as the sketches we see here. Constable was not the first artist to make direct *plein-air* studies in this medium – the habit had been practised since the seventeenth century – but he pursued it to a quite unusual degree for his day and took more pains than most to use the results of this practice as the guide for his finished work.

Oil painting out of doors was more difficult then than it is now, as noted in the present chapter, and most of Constable's oil sketches were painted within a short walk from his place of residence. The paintings themselves are outstanding for their freshness and immediacy, and also for a variety of treatment more extensive than that in his finished work. It seems that in the fever of working directly from nature, Constable allowed a more intuitive side to emerge, and it is noticeable that he concentrates more on capturing mood and atmosphere than on recording detail.

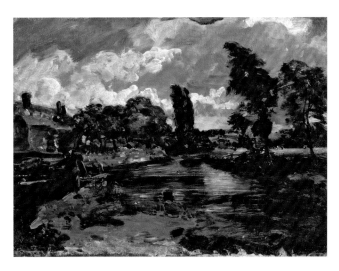

(left) 290 John Constable RA, *Flatford Mill from a Lock on the Stour*, c.1811, oil on paper laid on canvas, 26 × 35.5 cm (RA 03/1393).

(right) 291 John Constable RA, *Cloud Study, Hampstead, 11 September 1821*, oil on paper laid on board, 24.1 × 29.9 cm (RA 03/455).

(below) 292 John Constable RA, *Rainstorm over Sea*, c.1824–8, oil on paper laid on canvas, 23.5 × 32.6 cm (RA 03/1390).

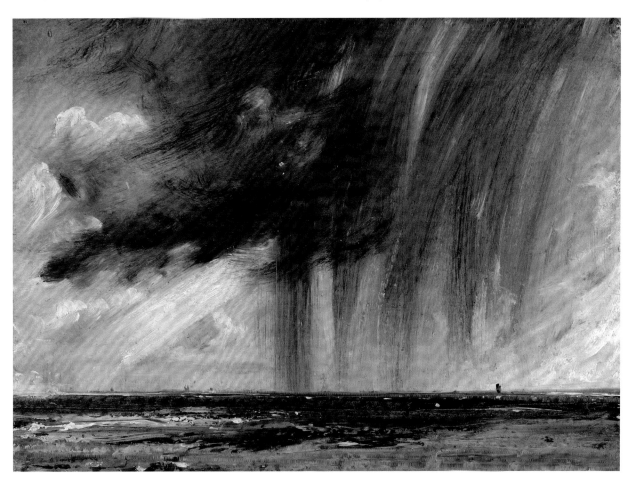

10

THE EMBATTLED TRADITION

JAMES FOX

In the spring of 1938 Frederick Elwell RA started work on a large painting of a group of Royal Academicians (fig. 293). It was the latest in a long line of group portraits of Academicians that had started in the eighteenth century, and it depicted the selection and hanging committee taking lunch after selecting the contents of that year's Summer Exhibition.[1] The committee members look relatively relaxed, but the decisions they had just made were to prove deeply controversial. Their rejection on this occasion of a portrait of T. S. Eliot by Wyndham Lewis, in particular, triggered a national furore, and seemed to confirm that the Royal Academy was still embarrassingly out of touch with modern art. The view was even shared by some of its own members and, in protest against the portrait's rejection, Augustus John did what Walter Sickert and Stanley Spencer had done three years earlier: he resigned his membership from the Academy, claiming that it was being ruled by a 'junta of deadly conservatism'.[2]

In Elwell's painting the Royal Academy may not be deadly, but it is certainly conservative. He represents the institution as an exclusive gentleman's club, a place where old men gather to smoke cigars and drink claret, and indeed the committee was then, as it still is, fortified with 'beef tea' during its deliberations. Moreover, his picture, the surface of which is as placid and polished as the gleaming tableware it depicts, contains no reference to the cultural and political upheavals that were taking place around it in the late 1930s. There is no trace of the abstractionist tendencies that were flourishing in British painting and sculpture at the time; no engagement with the continental ideas that had arrived in London with the French Surrealists and German émigrés; and no allusion to the growing political tensions in Europe that were already troubling many artists. Not one of these external influences is allowed through the panelled doors of Elwell's dining room; the men inside are the cultural firewall, the stubborn stewards of an insular but embattled tradition.

293 Frederick Elwell RA, *RA Selection and Hanging Committee 1938*, 1938, oil on canvas, 118 × 144.5 cm (RA 03/1320).

When Elwell deposited his picture at the Royal Academy's Diploma Gallery in 1939, it joined a collection that appeared as old-fashioned as his sitters.[3] By that stage modern art and 'modern life' had been raging for at least half a century, yet the Academy's pictures from the period seem to belong to another, older age. Among them were highly finished histor-icist tableaux such as the *Way to the Temple* by Sir Lawrence Alma-Tadema RA (fig. 294), escapist fantasies such as *A Mermaid* by William Waterhouse RA (fig. 296), pre-industrial landscapes such as the *Autumn Morning* of George Vicat Cole RA (fig. 295), hieratic state portraits such as *King George V* by Arthur Cope RA, and wilfully archaic allegories such as *Vanity* by Frank Cadogan Cowper RA (fig. 297), an artist who apparently wore 'higher collars than any other man in

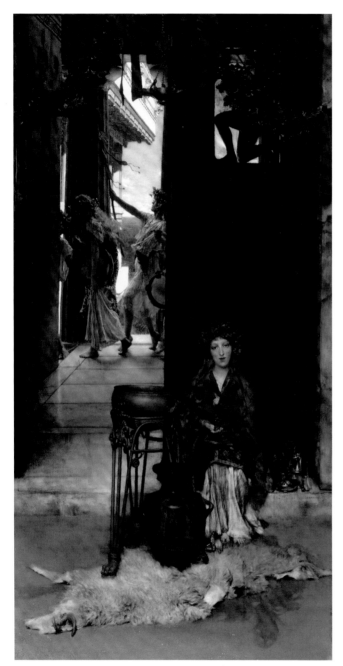

(left) 294 Sir Lawrence Alma-Tadema RA, *Way to the Temple*, 1882, oil on canvas, 101.5 × 52 cm (RA 03/1021).

(above) 295 George Vicat Cole RA, *Autumn Morning*, 1891, oil on canvas, 81.5 × 132.8 cm (RA 03/1351).

the country'.[4] Formal, finished and utterly respectful of genre conventions, these paintings revealed little or no interest in the realities of their own time.

If any one artist embodied this insular academic tradition it was Sir Frank Dicksee PRA, and this was not least because he devoted his entire career to the institution. Dicksee had

trained at the Royal Academy Schools as a teenager, was made ARA in his twenties, RA in his thirties, and at the end of his life became the thirteenth President of the Royal Academy – a position he used publicly to denounce the 'worship of ugliness' in the 'modern art' of his time.[5] In the Academy collection is his unforgettable Diploma Work, which he completed in 1892. *Startled* (fig. 298) depicts two naked female bathers who have been surprised by an oncoming boat. The *mise en scène* may seem faintly ludicrous today, but Dicksee – who painted it specifically for his election – considered the picture a blueprint for contemporary art: it was carefully planned and highly finished; its figures were derived from classical models; its setting was based on a detailed observation of nature; and its goals were truth, beauty and sincerity of feeling.[6] Dicksee's painting, like the many others in the collection, suggests that the Royal Academy was too stuck in the past to respond to the present. And yet, by 1892 this had already started to happen.

Closer examination of the collection reveals that by the end of the nineteenth century the Academy was not just aware of the advanced artistic developments of the period: it was actively engaging with them. In the 1880s modern French art (in the form of Naturalism as practised by Jules

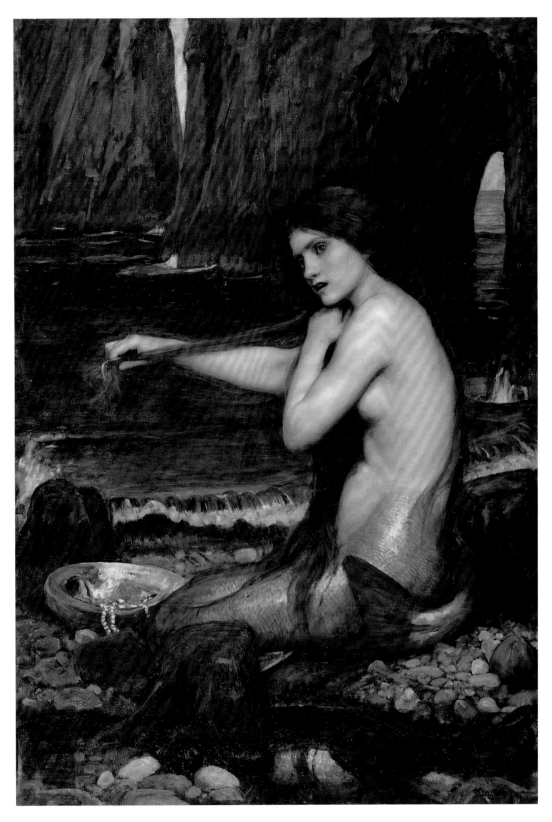

296 J. W. Waterhouse RA, *A Mermaid*, 1900, oil on canvas, 96.5 × 66.6 cm (RA 03/805).

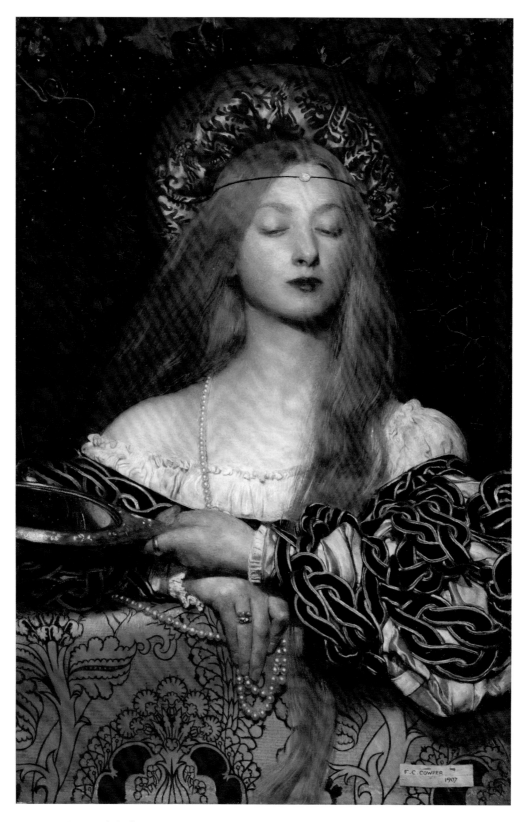

297 Frank Cadogan Cowper RA, *Vanity*, 1907, oil on canvas, 57.1 × 38.1 cm (RA 03/1013).

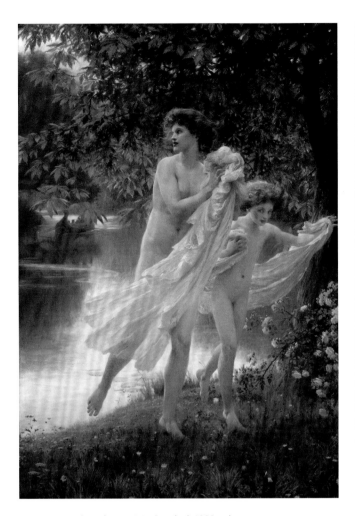

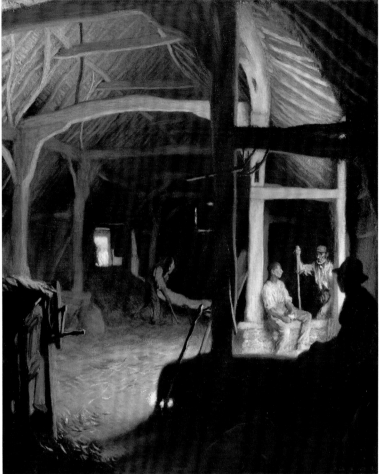

298 Sir Frank Dicksee PRA, *Startled*, 1892, oil on canvas, 97.8 × 67.3 cm (RA 03/1039).

299 George Clausen RA, *Interior of an Old Barn*, 1908, oil on canvas, 91.6 × 76.6 cm (RA 03/1233).

Bastien-Lepage) became increasingly influential in Britain, and in 1885 its supporters formed the New English Art Club in order to promote it.[7] The organization was conceived as a democratic and progressive alternative to the Royal Academy, and contemporaries viewed the two institutions as 'diametrically opposed' in almost every way.[8] Nevertheless, under the presidency of Lord Leighton (1878–96) the Academy consciously sought a rapprochement with its more modern counterpart. In the late 1880s the Academy started hanging work by New English Art Club members at its summer exhibitions; it chose to purchase their paintings for the nation through the Chantrey Bequest; and in the 1890s it even made three of the New English Art Club's

most celebrated founder-members Associates: Stanhope Forbes (1892), George Clausen (1895) and Henry Herbert La Thangue (1898). La Thangue's arrival was particularly surprising: only 10 years earlier he had described the Academy's election policy as 'the diseased root from which other evils grow'.[9]

By the second decade of the twentieth century, Clausen, Forbes and La Thangue were all Academicians, and their Diploma pictures were some of the first progressive paintings to enter the collection. The new members had all previously worked in France, and their submissions reveal an enthusiastic deployment of modern French methods. Clausen's *Interior of an Old Barn* (fig. 299) is an almost entirely tonal response to

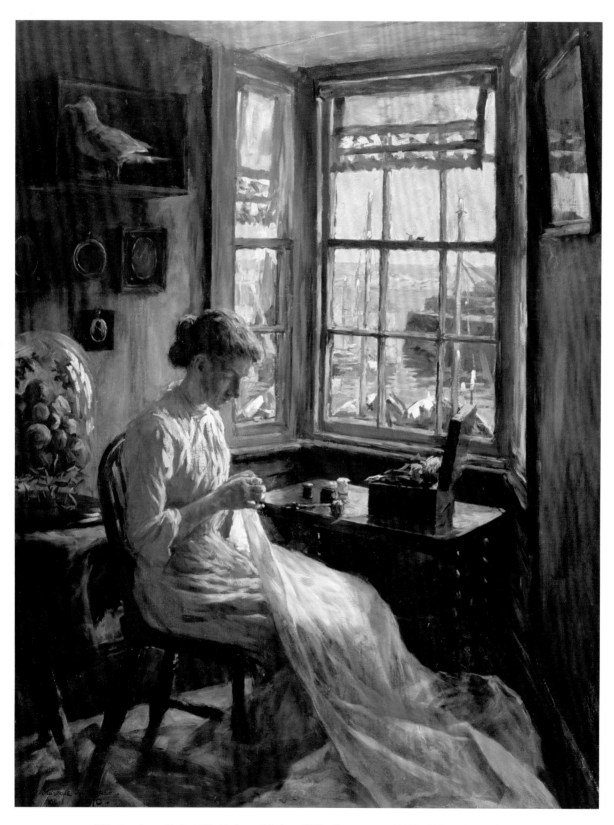

300 Stanhope Forbes RA, *Harbour Window*, 1910, oil on canvas, 112.5 × 86.7 cm (RA 03/251).

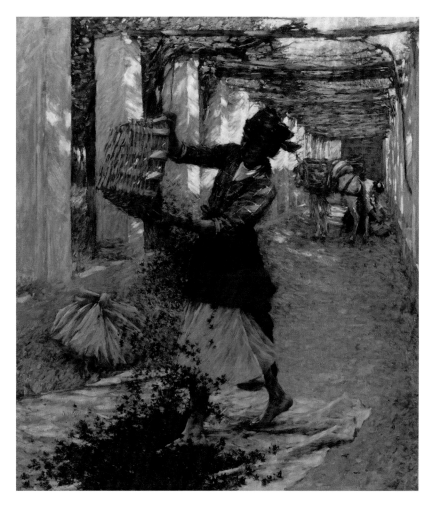

301 Henry Herbert La Thangue RA, *Violets for Perfume*, c.1913, oil on canvas, 109 × 95 cm (RA 03/811).

its subject; Forbes's *Harbour Window* (fig. 300) features in its background the vivid colour *taches* of Impressionist plein-air-ism; and La Thangue's *Violets for Perfume* (fig. 301) combines dappled sunlight and expansive brushwork with rich crimson and pure violet, where the prominence of the violet is perhaps no coincidence, since contemporaries regularly identified the colour with Impressionism.[10] The new Diploma Works were admittedly less radical than their Impressionist prototypes: the high-keyed colours never threaten the contours that contain them; the gestural brushwork never destabilizes their careful compositions; and the sentimental rural subjects remain essentially Victorian in spirit. But while it is easy to denigrate this 'anglicized Impressionism' as a lacklustre compromise, it

was an important compromise, because it proved that the Royal Academy was opening up to modern art.[11]

One of the first artists at the Royal Academy to forge a genuinely successful compromise between academic tradi-tions and progressive methods was John Singer Sargent RA. The Academy owns one of his most memorable experiments along these lines, although the picture's presence in the col-lection is owed to an unlikely set of circumstances. After Sargent was elected RA in January 1897 (itself evidence that the institution was becoming more receptive to new cosmo-politan styles), he obtained permission to defer presentation of a permanent Diploma Work until he had a fitting specimen to hand.[12] In the meantime he began work on a group portrait of the Curtis family, with whom he had stayed as a guest at the Palazzo Barbaro in Venice during the summer of 1898. The picture was intended as a gift of thanks to Mrs Curtis, but she declined it because she considered the likenesses to be unflat-tering. Sargent, however, was so fond of the painting that in 1900 – following critical acclaim at that year's Summer Exhi-bition – he offered it to the Academy as his Diploma Work.

The painting, which was renamed *An Interior in Venice* (fig. 302), flawlessly fused a traditional subject with a modern method. The picture is essentially a conversation piece, a genre with which the Royal Academy had a long and fruitful connection. Yet, despite the stately framework of the compo-sition, Sargent's approach was wilfully unconventional. He plunged the room into a disorientating darkness, and deline-ated its forms with such reckless brushwork that even the usually perceptive James McNeill Whistler could only discern 'smudge everywhere'.[13] More perplexing still was Sargent's unorthodox depiction of the Curtis family: Daniel Curtis, the elderly owner of the palazzo, is uncomfortably cropped at the right side of the picture; next to him Mrs Curtis sits awk-wardly, the harsh light emphasizing her ageing features; while in the background their son Ralph leans indecorously against a console table and his wife stoops to pour her own tea. Sargent may here have returned to a grand old genre, but his protagonists, as the *Spectator* noted, were 'ordinary modern people'.[14] And while it may have been too modern for Mrs Curtis, it was evidently not too modern for the Academy: the Council unanimously accepted the painting, which today is one of the treasures of the collection.[15]

Sargent's painting demonstrated that by 1900 the Royal Academy's taste could be surprisingly progressive, given

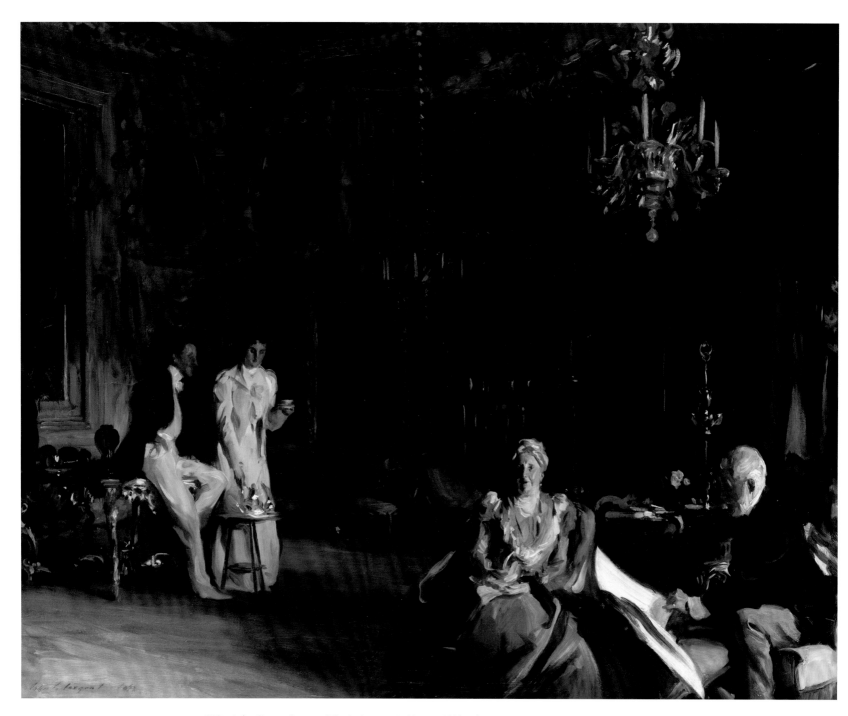

302 John Singer Sargent RA, *An Interior in Venice*, 1899, oil on canvas, 66 × 83.5 cm (RA 03/1387).

303 Arthur Hacker RA, *Wet Night at Piccadilly Circus*, 1910, oil on canvas, 71 × 91.5 cm (RA 03/1019).

the right circumstances. It was 10 years later, however, that the first thoroughly modern picture entered the collection. In 1910 Arthur Hacker RA submitted *Wet Night in Picca-dilly Circus* (fig. 303) as his Diploma Work.[16] The painting represents the eastern side of the intersection on a rainy evening, with the statue of *Eros* on the left and the London Pavilion Theatre in the centre. Nocturnal London had been a popular subject with artists since Whistler's nocturnes of the 1870s, but Hacker transformed this conventional theme into a highly unconventional image. He chose not to focus on the quaint effects of moonlight and river reflections, but on the dazzling chromatic consequences of electric lighting,

rushing crowds and smoking motorcars.[17] Moreover, he did so with an audacious gestural style, capturing the city's vertiginous energy with flares of white, brown and yellow impasto. Here, all traces of 'anglicized Impressionism' are gone: Hacker's forms have been dissolved into a near-abstract cloud of light and colour – even his signature seems to disappear into the mist.

When critics first encountered Hacker's painting at the Summer Exhibition of 1911 they were understandably perplexed. Never before had they seen at Burlington House a picture that combined such 'contemporary' subject matter with such 'violently romantic colour'.[18] They sought prece-

345

304 Charles Sims RA, *Clio and the Children*, 1913–15, oil on canvas, 114.3 × 182.9 cm (RA 03/1215).

dents for the unusual exhibit in the work of Turner, Whistler and the French Impressionists.[19] Yet in its urban, even technological, iconography and its vividly dematerializing style, Hacker's painting arguably had more in common with the Futurist artworks of his own time than those of the decades before it.[20] And while it may not be quite so revolutionary as some pictures painted on the Continent in the same year, it was radical enough to reveal a profound transformation in the Royal Academy's aesthetic tolerance. Twenty years earlier Hacker's picture would never have made it into the Summer Exhibition, let alone the Academy's exclusive Diploma Gallery.

If at the start of the century the Royal Academy persuaded some people that it was opening up to modern art and modern life, the First World War reminded them that deep down it was still out of touch. The institution was criticized

throughout the conflict for failing (where others had succeeded) to address what was evidently an epoch-defining event. While unproven artists went to the front line and compellingly captured the 'bitter truth' of mechanized warfare,[21] the 'old men' of the Academy – who had 'never been nearer to Spion Kop or Arras than St John's Wood' – were condemned for painting battles as though they were still living through the Napoleonic Wars.[22] Yet these allegations were not entirely correct. The collection at Burlington House contains just one picture that directly responded to the First World War, and it alone proves that Academicians could also express the conflict's unprecedented consequences.

Charles Sims RA, like Frank Dicksee before him, was a Royal Academy thoroughbred. He had been educated at its Schools, was made ARA at the age of 35, and believed pas-

sionately in the English traditions for which the institution stood. It was no surprise then that, when he was made RA, his Diploma Work celebrated tradition itself being handed down from one generation to the next. *Clio and the Children* (fig. 304) showed the muse of history reading her scroll to a group of listening youths in the West Sussex countryside. The picture, which had been painted in 1913, a year before the outbreak of war, was unapologetically Arcadian, but the ensuing conflict shattered Sims's optimistic outlook. His son was killed in action in 1915, and later that year, before his picture was sent to the Diploma Gallery, he made some dramatic alterations: Clio now slumped in her chair, and pools of blood blotted out the words on her scroll. If she was dead, Sims's faith in the peaceful continuity of traditions had perished with her.[23] His amended picture may not have represented soldiers, sailors and battlefields, but it was as stark a representation of the disasters of war as anything to come out of the conflict.

The war had altered Charles Sims's attitude to art as well as life, and in the post-war period he abandoned his traditional training and started painting pictures that were as modern as anything ever produced by an Academician.[24] He was not alone: contrary to popular perception, the war emboldened rather than undermined the Royal Academy's nascent exploration of new tendencies. War exhibitions had brought younger artists into the previously closed confines of Burlington House – a process that the *Daily Express* described as the 'rebels in the fortress' – and in the 1920s the Academy tried to forge a lasting reconciliation with them.[25] Its intentions were first signalled in April 1921 when it made one of the most notorious anti-establishment artists, Augustus John, an Associate. On hearing the news, John wrote: 'Had I not been a Slade student? Was I not a member of the New English Art Club? Did I not march in the front ranks of the insurgents? The answer to these questions is "yes". But had I cultivated the Royal Academy in any way? Had I ever submitted a single work to the Selection Committee?... History answers "no". Without even blowing my trumpet the walls of Jericho had fallen!'[26]

The Academy's seduction of Augustus John culminated nine years later when it made him an Academician. He submitted as his Diploma Work a portrait of his son Robin (fig. 305). Modest, incidental and seemingly hurried, the painting is by no means the artist's most memorable effort,

305 Augustus John RA, *A Young Man*, c.1928, oil on canvas, 61 × 46.5 cm (RA 03/252).

but in its stubborn informality it probably represented the collection's most radical departure yet from the Academy's traditional expectations of finish.

Augustus John was not the only rebel to storm the fortress in the 1920s. Hot on his heels was the equally rebellious, if not quite so young, Walter Sickert, an influential and combative figure who had been at the centre of progressive developments in British painting since the end of the nineteenth century. It therefore surprised many when he was made ARA in 1924 and RA 10 years later. Sickert's Diploma Work, however, originated from much earlier in his career. It was one of a number of paintings of Santa Maria della Salute that he made, or made preparations for, in Venice in the first half of 1901 (fig. 306), and while it did not represent him at his most daring, it was still a surprising addition to the Acad-

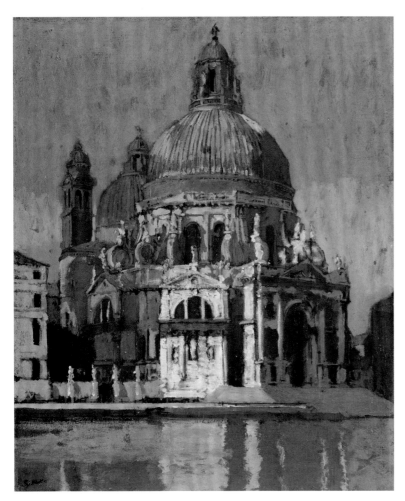

306 Walter Sickert RA, *Santa Maria della Salute, Venice*, c.1901, oil on canvas, 56 × 46 cm (RA 03/257).

emy's collection. The picture was small, obstinately ordinary, and even bore the traces of squaring-up beneath its final coats of paint – irrefutable evidence of highly unacademic working methods.[27] Yet the picture itself was not the point; as with Augustus John, it was the gesture that counted: the Royal Academy had tamed two of the biggest beasts of modern British art, and hung their paintings like trophies in its Diploma Gallery.

Other additions to the Diploma Gallery confirm that the Academy's post-war liberalism was not merely skin-deep. In the 1920s a number of British-based Impressionists (notably Mark Fisher and John Lavery) gave works to the collection, as did more unconventional names like Charles Ricketts and

Glyn Philpot. And while traditional pictures may still have dominated the Academy's holdings, unorthodox ones became ever more common, which was not to everyone's liking. Among them were eccentric religious paintings such as *The Message* by Maurice Greiffenhagen RA (fig. 307) and kaleidoscopic genre pictures such as the *Market Stall* by Sir Frank Brangwyn RA (fig. 308). In their dazzling, almost decorative, use of high-keyed colour, both seemed to have absorbed the bolder lessons of modern French painting. Indeed, French methods were so ubiquitous in the decade that even the Diploma Work of that high priest of English cultural conservatism, Sir Alfred Munnings PRA, *Kilkenny Horse Fair* (see fig. 100), betrayed in its dappled surface an unmistakable debt to Impressionist practice. The most celebrated picture to

307 Maurice Greiffenhagen RA, *The Message*, 1923, oil on canvas, 95.2 × 85.1 cm (RA 03/657).

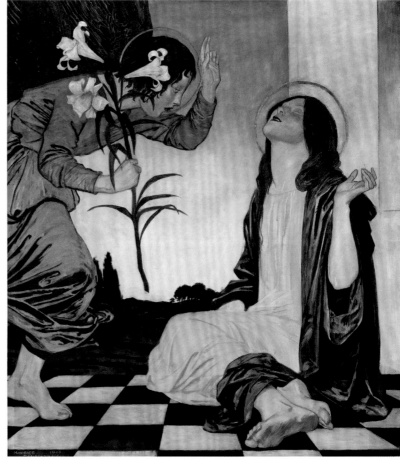

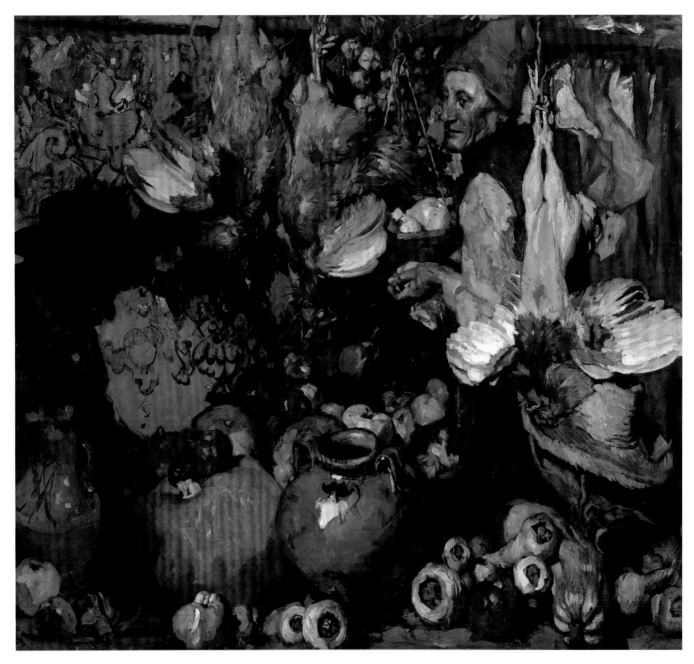

308 Sir Frank Brangwyn RA, *Market Stall*, 1919, oil on canvas, 146 x 160 cm (RA 03/715)

enter the Academy's collection in the 1920s, on the other hand, was modern in a very different way.

Sir William Orpen RA had exhibited regularly at the Academy since 1908, but *Le Chef de l'Hôtel Chatham* (fig. 309) was his first picture to join its permanent collection. He had conceived it in Paris where, as an official artist to the British Peace Delegation, he was tasked with painting the diplomats who were negotiating the post-war settlement.[20] This picture, however, did not portray the politicians with whom Orpen spent the days, but the chef of the hotel in

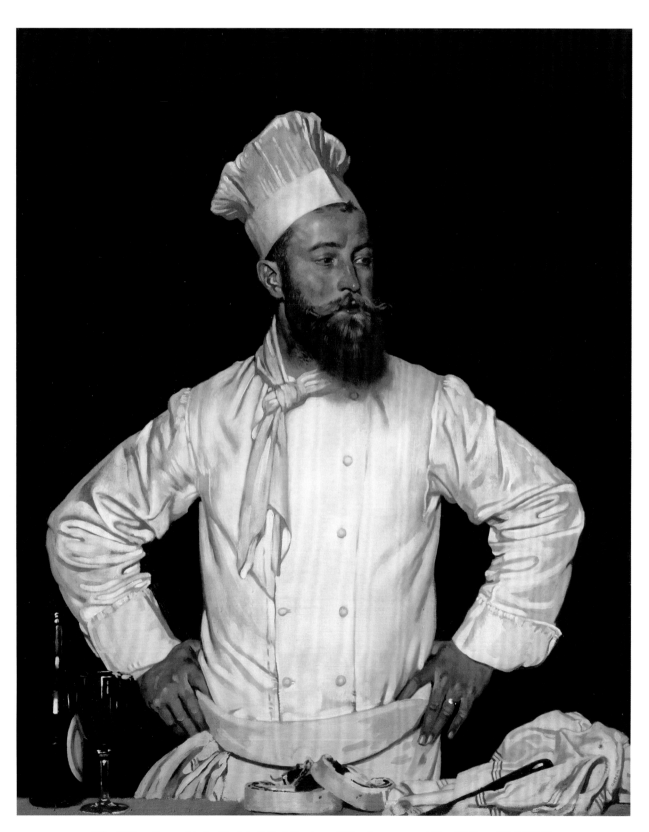

309 William Orpen RA, *Le Chef de l'Hôtel Chatham*, 1921, oil on canvas, 127 × 102.5 cm (RA 03/1237).

which he spent the nights. Orpen's chef stands imperiously in his kitchen, as two chops and a bottle of wine surround him like saintly attributes. It is an austere, almost archaic portrait, betraying the artist's huge debt to the works of Diego Velázquez and Edouard Manet. But when it appeared in the Summer Exhibition of 1921 it instantly captured the public's imagination. It was named the 'picture of the year', was reproduced widely in the press, and even secured its eponymous chef a remunerative new job in London.[29] Critics concluded that its success was above all due to its modern, democratic subject. Frank Rutter wrote:

> We have been told that he cooked chops amazingly well, but I can't believe Orpen painted him merely in gratitude for their succulency. Why did [the chef] appeal so irresistibly to Orpen? I will hazard a guess; it was because of his rich, full humanity, because he was 'a very man' as many of the politicians and great persons, let me whisper, never were nor will be ... That is why this Orpen portrait, though the style of painting be as old as Hals or Moroni, is yet of the twentieth century. Humanity is always new.[30]

The appeal of the painting was such that the Royal Academy chose to purchase it for the nation through the Chantrey Bequest.[31] A price of £735 had been agreed upon when it was discovered that Francis Chantrey's will had stipulated that artworks could only be purchased if they were 'entirely executed within the shores of Great Britain'.[32] Orpen insisted that the painting, if not its sitter, had met those standards, but sufficient doubts were raised and the acquisition had to be abandoned. Orpen subsequently deposited the picture as his Diploma Work in 1921. It remains telling proof that artworks did not need to be modernist in order to be modern, and did not need to discard traditions in order to engage a wider audience.

If the Royal Academy had made important progress in the 1920s, the institution squandered its gains in the decade that followed. It was in the 1930s that two of its most exciting new recruits, Augustus John and Walter Sickert, resigned their memberships in protest against the Academy's renewed conservatism. That conservatism was only highlighted by the innovations that were taking place elsewhere in British art at the same time.[33] Yet while many British artists spent the decade exploring the possibilities of abstraction, Surrealism and social realism, the Academy acquired pictures that seemed

as stubbornly reactionary as ever. Its holdings from the 1930s include the same aristocratic genre paintings (*Sir Richard Sykes, 7th Baronet of Sledmere* by Simon Elwes RA), mythological fantasies (*Persephone* by A. K. Lawrence RA) and Constablian landscapes (*English Landscape* by Reginald Brundrit RA) that had dominated the collections half a century earlier. Nevertheless, from this otherwise quiet decade there emerged at least one notable trend: a taste for elegant, complex and unmistakably modern portraits of women.

In the collection at Burlington House are almost a dozen paintings of women from the 1930s. The earliest is the exquisite portrait by Gerald Kelly of his wife, Lilian Ryan, which he submitted as his Diploma Work in 1930 (fig. 310). Renaming her 'Jane', Kelly painted his wife as many as 50 times throughout his career, exhibiting the portraits nearly every year at the Academy's summer exhibitions. The reason for the repetition, he claimed, was simple: 'I paint her because I think nobody has a prettier wife than I.'[34] Not all the Academy's women, however, were as placid as Kelly's spouse. In the portrait by George Watson RA of his daughter Mary (fig. 311), the frontal pose, bobbed hair and defiant expression lent his sitter as robust a personality as Orpen's chef; while the *Ophelia* of Gerald Brockhurst RA (fig. 312) reveals his model interpreting the role with a sexual energy that still seems risqué today. Yet in spite of their differences, all three pictures possess a glamorous swagger and economical design that is unthinkable without the posters, advertisements and celebrity imagery of their day.

The most familiar picture of this type, however, was made by Sir James Gunn RA. Gunn painted *Pauline Waiting* (fig. 313) in 1939, although the picture did not enter the collection until he became an Academician 22 years later. At the time of painting it, Gunn was said to charge more for a portrait than any other exhibitor at the Royal Academy.[35] It is not difficult to see why. The picture, which depicts his wife waiting in the lobby of Claridge's Hotel in London, is painted with the graceful precision that Gunn made his own and that patrons found hard to resist. Gunn's obsessive desire to capture the contemporary scene in all its vividness is revealed in his sketchbooks, where every last detail – from the waiters' livery to the design of the background music stand – is recorded, annotated and replicated.[36] The Academy's picture may not be as famous as Gunn's later *Pauline in the Yellow Dress* (Harris Museum & Art Gallery, Preston) – which was dubbed the

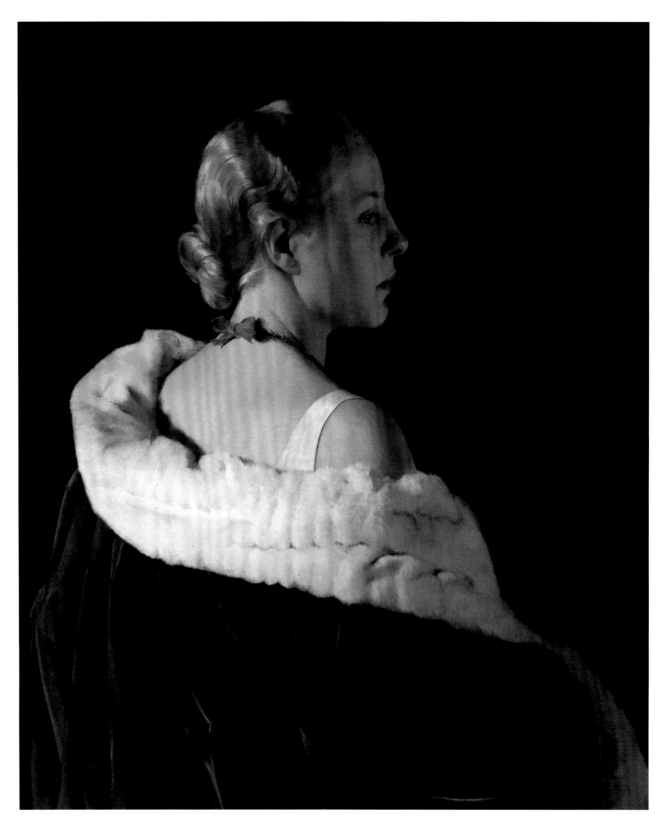

310 Sir Gerald Kelly PRA, *Jane XXX*, 1930, oil on canvas, 75 × 63.5 cm (RA 03/253).

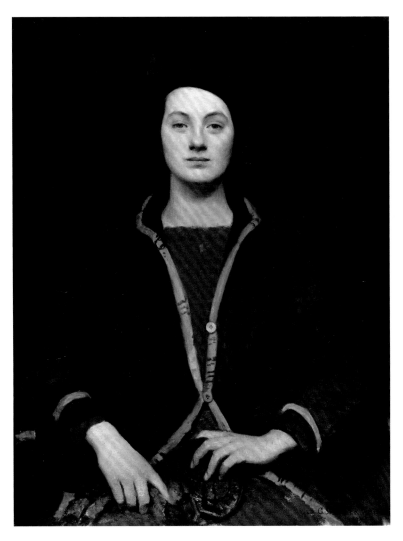

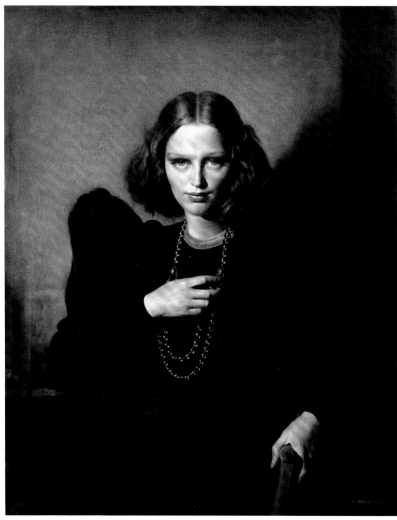

311 George Spencer Watson RA, *Mary*, 1932, oil on canvas, 91.5 × 71.3 cm (RA 03/1040).

312 Gerald Brockhurst RA, *Ophelia*, 1937, oil on canvas, 102 × 81 cm (RA 03/1323).

'Mona Lisa of 1944' – but it is equally enigmatic, with the artist brilliantly exploiting the suspense of his sitter's impending assignation.[37]

If there was one artist at the Royal Academy who painted with even greater precision than Gunn, it was Meredith Frampton R A. From 1920 Frampton had regularly submitted his meticulous portraits to the summer exhibitions, with each of them taking the best part of a year to complete. His Diploma Work, however, was one of his few still-lifes (fig. 314). It consists of a group of ostensibly unrelated objects in a coastal landscape. At its centre is a Roman bust; a classical

stone vase filled with flowers and a partially unwound tape measure sit atop a marble plinth, while behind them stand a large pile of masonry and three tree trunks.[38] It is without doubt a heterogeneous group, but Frampton's fastidious approach ensured that it is never for a moment unconvincing. His composition contains visual riffs, rhymes and reflections that bind its contents together. Animate echoes inanimate, squares interact with circles, and forms proliferate like leitmotifs: even the small shape of the bust's eyes recurs in the bark of the shortest tree, at the centre of the tape measure and in the soil inside the vase. The unity of Frampton's artwork is

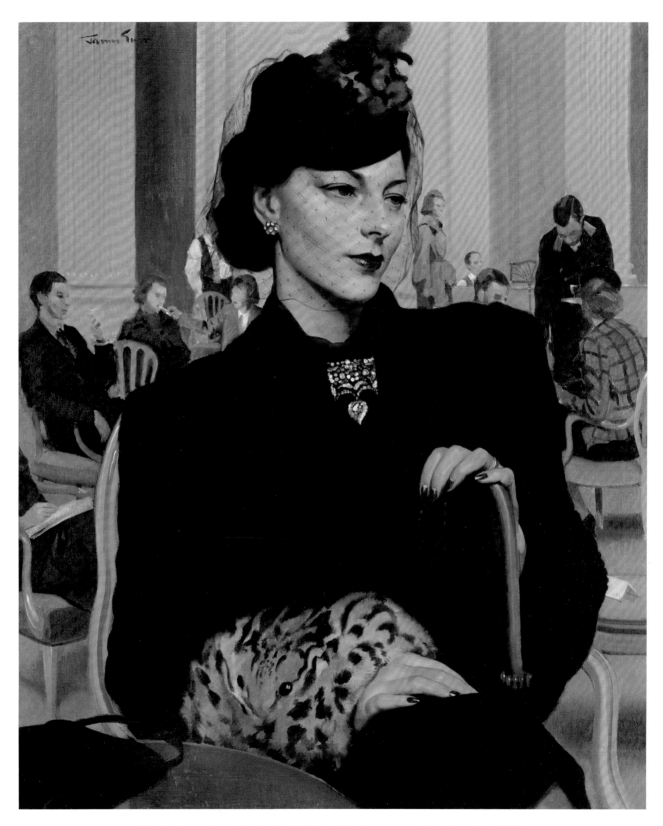

313 Sir James Gunn RA, *Pauline Waiting*, 1939, oil on canvas, 76 × 64 cm (RA 03/503).

314 Meredith Frampton RA, *Still-life*, 1932, oil on canvas,
123 × 81.9 cm (RA 03/955).

made yet more plausible by his painting technique. Working slowly with a small brush on a fine weave canvas, he was able to produce subtle modulations of light and extraordinary degrees of detail that captured each of his objects with hyper-real clarity.

Nevertheless, to concentrate on Frampton's technique is to ignore his picture's powerful psychological impact. Its mood is unsettling, even sinister – and this is not only because the sculpted face in the foreground wears a porten-tous frown. Nearly everything in the painting is disfigured: the bust is chipped, the vase is broken, the masonry is in

fragments, and at least two of the trees have been cut down. The atmosphere of danger and disintegration is reinforced by the plants: some of the flowers are dying in the vase, and at the bottom right Frampton included a stinging nettle and a thistle – a warning, perhaps, about getting too close. The picture may be a meditation on life and death, creation and destruction, and it certainly seems to belong to the northern European *vanitas* tradition. Yet it is also very much of its own age, and it has an unmistakable affinity with what Surrealist painters were producing at the same time. The juxtaposition of incongruous elements, the uncanny aura of inanimate objects, and the depiction of unreal scenes in hyperrealistic ways were all being employed by Salvador Dalí, René Magritte and Giorgio de Chirico. But it is perhaps unwise to describe Frampton's work as either traditional or modern. Like many of the finest pictures in the collection, it is both.

In spite of its implicit modernity, Frampton's painting represented the Academy's holdings at their most formal. At the other end of the spectrum were its works on paper. Unlike Diploma Works, the drawings at Burlington House were rarely intended for public display, and most of them entered the collection as gifts or bequests from artists and their families.[39] They therefore possess an informality that is not normally associated with the Academy's output. The institution owns casual preparatory sketches by George Clausen RA and Laura Knight RA, atmospheric pastel studies by Edward Stott ARA, and witty caricatures of Academicians that Francis Derwent Wood RA made on scraps of paper at annual banquets. The most popular drawing in the collection is a small pen and ink study of a cat, made by F. Ernest Jackson RA in the 1920s (fig. 315). Jackson taught drawing at the Royal Academy Schools in the interwar years and was highly regarded by his peers: Gerald Kelly considered him to be 'one of the greatest draughtsmen England ever had'.[40] Kelly, a remarkable draughtsman in his own right, may have been overstating the case, but Jackson's drawing is expertly economical, with the artist deftly exploiting the interplay between white card and black ink to capture the texture, pattern and movement of the cat's fur.

Frank Brangwyn RA, a prolific and versatile artist, produced more than 12,000 artworks in a range of media through his long career, but he believed that his 'bundles and piles of sketchbooks' contained his best work.[41] The Academy is therefore fortunate that towards the end of his life Brang-

315 F. Ernest Jackson RA, *Study of a Cat viewed from the Back,* *c.*1920–30, pen and ink over pencil on card, 29 × 24.4 cm (RA 07/860).

316 Sir Frank Brangwyn RA, *A. H. Mackmurdo, 1 May 1945,* 1952, red chalk on cream laid paper, *c.*50.3 × *c.*65 cm (RA 03/34).

wyn presented a number of paintings and drawings, while the sketchbooks followed in a bequest. Brangwyn had no formal training, and always retained an intuitive attitude towards drawing. In 1949 he wrote to budding draughtsmen: 'Every individual sees a thing in his own way. Show us how *you* see it. If we don't see it like that – blame it on us.'[42] His sketchbooks corroborate those unpretentious principles. Most remarkable was his omnivorous consumption of found imagery. The pages of his albums are filled with photographs, postcards and newspaper cuttings – many of which Brangwyn squared up, copied and deployed in larger works. This was hardly the austere approach to draughtsmanship taught in the Royal Academy Schools: indeed, it seems to have more in common with the techniques of Francis Bacon than the practices of the famous Life Room.

Brangwyn's most impressive drawing in the collection is rather more conventional. It is a portrait of the Arts and Crafts architect and designer Arthur Heygate Mackmurdo (fig. 316). The two men were old friends (it was Mackmurdo who discovered Brangwyn and helped establish his reputation), but this drawing was prompted by Mackmurdo's death

in March 1942. Brangwyn was deeply affected by the loss of his friend, and in 1945 he decided to make a posthumous portrait of him in red chalk. He based the likeness on a photograph that, though now lost, was probably taken in May 1939 when the two men were together.[43] Brangwyn demonstrated remarkable control of the medium, far removed from the cavalier spontaneity of his other works on paper. Particularly impressive was the way that he painstakingly captured the play of light on Mackmurdo's wrinkled face. The precision is a sign of the image's importance to Brangwyn, and he evidently made it as a deeply personal memento of his dead friend. In 1952, however, he presented it with his other works to the Royal Academy, declaring that Mackmurdo would 'be pleased to be amongst the many that he knew'.[44]

When Brangwyn donated his works to the Royal Academy in 1952, he was adding to a collection that had grown quickly and often surprisingly over the previous half century. This survey has offered a brief introduction to its contents, but has also argued that they are in no way representative of what some have called an embattled tradition. The paintings and drawings at Burlington House may not have been the most

radical artworks of their era, but this did not mean that they ignored or rejected modern art and modern life. On the contrary, the collection proves that the Academy's artists were actively engaging with both of them throughout the period. Their responses were not immediate, and they were rarely dramatic. Rather, modern styles, subjects and attitudes were gradually acknowledged, absorbed and incorporated into existing traditions and frameworks. The visual evidence suggests that, in the 50 years before 1945, the Royal Academy was not so much an embattled tradition as an adapting tradition. And if its collections do not correspond to wider perceptions about the institution's identity, it is only because, as *The Times* observed in 1928, 'the Royal Academy stands for much more than what it actually contains.'[45]

A CLOSER LOOK

10.1

Sir Stanley Spencer
The Dustbin, Cookham

ROBIN SIMON

The relationship of Sir Stanley Spencer RA with the Royal Academy was rather fraught, and this late painting (fig. 317) is related to the difficulties that he had encountered many years earlier, soon after being elected ARA in 1932. For the artist, the subject of this picture had a more profound meaning than might be suspected. In 1935 two of the five paintings Spencer had submitted to the Summer Exhibition were withdrawn by the hanging committee, and Spencer resigned from the Academy, only rejoining it first as ARA then RA in 1950, at the invitation of the newly elected President, Sir Gerald Kelly. This was all the more pointed, since that year the eccentric outgoing President, Sir Alfred Munnings, had initiated an obscenity prosecution against Spencer, focused upon some drawings of a decade or so earlier (from a series of some 100, known as the *Scrapbook Drawings*) that Munnings had seen in an exhibition. Kelly had defended Spencer in the ensuing fracas.

One of the two paintings rejected in 1935 was *St Francis and the Birds* (Tate Britain, London). It shows the artist's father in his dressing gown and slippers as an equivalent of the saint's habit and sandals of a friar, and surrounded not by the birds of the field but by domestic chickens and ducks. The other was *The Dustman* (also known as *The Lovers*) (Laing Art Gallery, Newcastle-upon-Tyne) featuring a resurrected dustman and his wife. The composition includes some of the rubbish of their earthly existence. Spencer wrote of that painting:

I feel, in this Dustman picture, that it is like watching and experiencing the inside of a sexual experience. They are all in a state of anticipation and gratitude to each other. They are each to the other, and all to any one of them, as peaceful as the privacy of a lavatory. I cannot feel anything is Heaven where there is any forced exclusion of any sexual desire…The picture is to express a joy of life through intimacy. All the signs and tokens of home life, such as the cabbage leaves and teapot which I have so much loved that I have had them resurrected from the dustbin because they are reminders of home life and peace, and are worthy of being adored as the dustman is. I only like to paint what makes me feel happy. As a child I was always looking on rubbish heaps and dustbins with a feeling of wonder. I like to feel that, while in life things like pots and brushes and clothes etc may cease to be used, they will in some way be reinstated, and in this Dustman picture I try to express something of this wish and need I feel for things to be restored. That is the feeling that makes the children take out the broken teapot and empty jam tin.[1]

317 Sir Stanley Spencer RA, *The Dustbin, Cookham*, 1956, oil on canvas, 76.8 × 51.3 cm (RA 03/197).

The Royal Academy bought *The Dustbin, Cookham* from the artist in 1956, a painting made from a drawing created some 29 years earlier for the month of September in an almanac published by Chatto & Windus (1927). Its acquisition by the institution that had slighted the same artist over another painting related to this theme, which was so close to his heart, seems likely to have offered him what might now be called 'closure'

In a letter to Gwen Raverat, Spencer wrote from his home village of Cookham: 'Dust bins are looking up; to-day (Tuesday) is the day the dust cart comes round + all the dust bins of each house are placed by their gate or on the edge of the pavement, + I note that every body has their own ideas about dust bins, just as I have mine.'[2]

ABSTRACTION TO ABSTRACT

The Collections after 1945

PAUL MOORHOUSE

As with any great art collection, the works that comprise it can be seen as the lifeblood of the host institution. They supply an intimate and immediate record not only of changing values and taste but of something deeper: the pulse of life within an organization. This principle is enshrined in the constitution of the Royal Academy. Those artists who are invited to become members are required to submit an example of their work – a Diploma Work – 'approved of by the then sitting Council of the Academy'.[1] As a result, there is a close relationship between those values present in the work of art submitted and those attitudes manifest in approving and admitting a work to the collection. In many cases, a work may be offered and accepted years after its creation. But this in itself may be significant, signalling that moment of convergence between an artist and the Academy, a point of accord that may have taken years to arrive.

In this way, the Royal Academy's collection embodies the artistic life within its walls, its outlook on the external art world and, in consequence, its own history. This is the premise of the discussion here, in which selected works are offered as points of illumination within a period that witnessed complex changes. At the heart of these developments two radical patterns of growth are apparent. The first is the gradual and progressive absorption of works of art that evince a growing abstraction, that is to say a movement away from naturalistic depiction and towards visual expression that embraces non-literal means. The second has been, in terms of the Academy's adherence to academic principles, more testing. The acceptance of abstract art – works that exist on their own terms and without reference to recognizable objects – is, to an even greater extent, the evidence of fundamental change. In particular, it reveals the more open relationship with wider

artistic values that was to become increasingly characteristic of the Academy after 1945.

AUSTERITY

During the 1930s modernist ideas fed by an influx of émigré artists fleeing from a darkening European political situation took root within small but forward-looking circles of British artists. Paul Nash, Edward Wadsworth ARA and Edward Burra developed a form of figurative abstraction that inclined towards the influence of Surrealism, while Barbara Hepworth and Ben Nicholson explored an alternative route informed by the example of Constructivist abstract art. While hardly inexorable, such developments were both profound and progressive. And for many, as the country confronted a much-altered post-war situation, art that dispensed with outworn ideals and sought new forms of expression seemed truer to the world as it now appeared.

For others, visual art that dispensed with academic skills in drawing and rendering appearances naturalistically marked a break not only with the past but with the great traditions of art history. Alfred Munnings, who had been appointed President of the Royal Academy in 1944, viewed such traditions as forming the very foundation of the institution over which he presided. There is also a sense that, in Munnings's deep aversion and hostility to modern art, there was a mistrust, perhaps deepened by the recent war, of movements and modern art 'isms' that emanated from abroad. For Munnings, as for others of a similarly conservative cast of mind, new forms of artistic expression were not only destabilizing at a time when there was a need to rebuild confidence. Worse than that, modern art was perceived as being foreign in its origins, and to espouse it seemed an unforgiveable betrayal.

In 1946, two years into Munnings's term as President, the Academy exhibited a plaster bust of its singular figurehead (fig. 318). The bust was sculpted by Edwin Whitney-Smith, who was not an Academician but, at 66, both senior and deeply traditional in approach, and it enshrined the face that Munnings, on behalf of the Academy, wished to present to the world. In 1918 Munnings's predecessors had reported that the Academy possessed 'a traditional prestige'.[2] Whitney-Smith's portrait, created in the wake of the Second World War, seems founded on similar principles. This is an effigy

318 Edwin Whitney-Smith, *Sir Alfred Munnings, PRA*, 1946, bronze, height 57.8 cm (RA 03/3756).

that is remarkable for the extent to which it disdains to make any concession to recent changes in the language of portraiture. It is a world away, for example, from the exploration of the expressive rendering of form that we can see in the work of Jacob Epstein, and instead draws on nineteenth-century traditions, emphasizing the dignity of the sitter and the prestige of office. The eye is drawn to the President's medal, worn over the left breast like a shield of honour. This presents a man at once defensive and defiant who, in addition to his official position, was a self-appointed scourge of modern art. Like Munnings himself, 'responding for the Academy'[3] as he did in his notorious declamatory outburst in 1949, this

319 Robert Buhler RA, *Green Park*, 1947, oil on canvas,
61.1 × 76.3 cm (RA 03/1154).

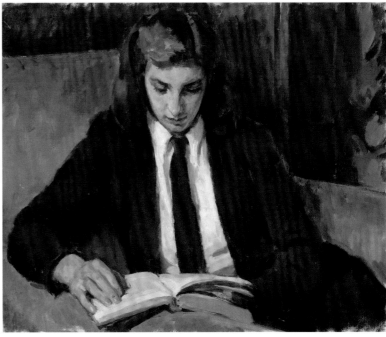

320 Henry Lamb RA, *Henrietta Reading*, 1949, oil on canvas,
50.8 × 61 cm (RA 03/894).

austere image makes no distinction between the individual and the institution.

Because he was so closely identified with the Academy in this way, Munnings's antagonism to modernism especially alienated many artists of a more progressive outlook. This is ironic, as Munnings's views were far from representative of the institution as a whole. Robert Buhler exemplifies those many artists within the Academy's ranks whose work, while eschewing the extremer modernist tendencies of, for example, Francis Bacon or Henry Moore, and while remaining essentially naturalistic, nevertheless demonstrates a subtle movement beyond strict academic principles. Buhler's painting *Green Park* (fig. 319) was exhibited at the Academy in 1947. It presents a scene close to the precincts of Burlington House: a view of the park as seen from the balcony of 94 Piccadilly, then home to the Naval and Military Club. The snow-coloured ground is a familiar trope of Impressionist painting, as is Buhler's engagement with the resulting light effects. The painting is, however, distinctive in other respects. The subdued, grey illumination of the scene is peculiarly English and, with the presence of the London bus in the foreground, is associ-

ated with an urban setting. The figures that move silently across the middle distance seem enveloped in a kind of torpor. In contrast to the celebratory radiance of French Impressionism, Buhler has advanced into local terrain. The painting surveys a cityscape with an objective eye. But, at the same time, it touches on the deeper context: post-war London, the spirit of which seems both frozen yet impelled to continue.

Two portraits created shortly afterwards, by Henry Lamb and Arnold Mason, express a similar sensibility. Both artists were appointed ARA in the same year, 1940, and both paintings were completed in 1949. Lamb's portrait of his daughter *Henrietta Reading* (fig. 320) is, like the Buhler, naturalistic in treatment and seems the product of an objective, unsentimental realism. The sitter is presented in a private moment, quietly occupying the world evoked by the book whose pages she touches. The composition is unified by a suppression of detail, its enveloping brown tonality and, like the Buhler, an enlivening, central accent of red which here describes Henrietta's tie. By these understated means, Lamb creates a portrait that is at once intimate yet, through its emphasis on pictorial essentials, satisfying as an image in

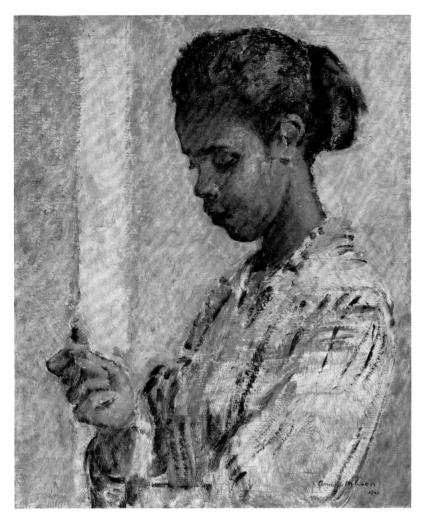

321 Arnold Mason RA, *Brown Study*, 1949, oil on canvas, 61.5 × 51.3 cm (RA 03/858).

terms of colour and shape. This engagement with elements that are both descriptive and formal has an affinity with, yet stops short of, the modernist imperative towards more radical abstraction. The same sympathy enlivens Arnold Mason's *Brown Study* (fig. 321). The title refers both to the sitter's being lost in thought and to the sitter's ethnicity, but it also alludes to concerns of a more purely pictorial nature. A black girl contemplates a yellow flower. The painting is rendered with sfumato brushwork; passages of description are softened, blended and drawn into a surface that flickers with small expressive accents provided by touches of colour and texture. It was presented as a Diploma Work in 1951, two years after

Munnings had stepped down as President, and the painting has a chromatic and tactile sensuality that alludes, quietly but insistently, to the future.

A DECADE OF CHANGE

With hindsight it is possible to view the radical developments that occurred in British art during the 1950s as among the most profound during a century defined by change. This was a decade that saw new forms of realism sweep aside the romantic, visionary ideals of the preceding generation. The bitter experience of conflict and the stark austerity of the ensuing peace exposed areas of human experience that called for alternative means of expressing the reality of the present. Two lines of response emerged. The first, which is principally associated with Francis Bacon, Frank Auerbach, Michael Andrews RA, Lucian Freud and Leon Kossoff, was rooted in the creation of forms of representation forged from an intense emphasis on subjective expression. Reality was, as it were, to be abstracted from inner experience. The other line of response was championed by the Marxist critic John Berger. Realism, for Berger, placed art at the service of politics. By depicting the lives and living conditions of the working class, so-called 'Kitchen Sink' artists such as John Bratby RA, Jack Smith, Derrick Greaves and Edward Middleditch RA articulated a social responsibility.

Alongside the struggle between these alternative realist positions, the decade also saw the rise of new forms of sculpture and abstract painting. In 1952 Reg Butler, Lynn Chadwick RA, Kenneth Armitage and others exhibited disturbing, abstracted images in which human and animal forms were ambiguously enmeshed. The anxiety and uncertainty of a world capable of mass annihilation found a visual language described memorably by Herbert Read as 'the geometry of fear'.[4] In painting, following the moment when in 1948 Victor Pasmore RA 'turned abstract',[5] by the end of the 1950s a generation of artists had expunged naturalistic representation entirely. An immersion in colour, shape and abstract mark-making seemed to promise liberating possibilities denied by a continued involvement with drawing from the Antique. The imperative for experiment revealed by all these artistic currents defines a tipping point in British art, a period when modernism attained a new, persuasive visibility.

322 Maria Elena Vieira da Silva Hon. RA, *Pervenche*, 1959, oil on canvas, 81 × 100 cm (RA 03/1373).

Despite these winds of change, throughout the 1950s the Royal Academy remained resolute in presenting itself as the guardian of tradition. With the exception of Bratby, who was elected ARA in 1959, none of the artists named above was admitted to the Academy during this period. This is not to suggest that the Academy was immune to the rise and influence of modern art, but under the successive presidencies of Gerald Kelly, A. E. Richardson and Charles Wheeler the institution waxed and waned: outwardly receptive – although sometimes less so – but essentially cautious. This prevaricating stance is reflected in the works in the collection belonging to the 1950s.

Seen as a whole, the collection demonstrates an overwhelming bias towards figurative painting and sculpture in which there is an evident allegiance to traditional approaches, tempered by an affecting sympathy for subtle abstraction. Edward Le Bas RA, William Dring RA, Norman Hepple RA and Roger de Grey PRA all manifest a restrained objectivity grounded in the discipline of the closely observed subject. An isolated instance of abstract painting, *Pervenche*, an exemplary canvas of 1959 by Maria Elena Vieira da Silva Hon. RA, is an addition to the collection made at a much later date (1993) (fig. 322). The figurative work is focused in three main areas: portraiture, still-life and landscape. Within these respective genres there are, however, several works that demonstrate an affinity with tradition while reflecting an effective involvement with contemporary developments. *Ernest Marsh* by Ruskin Spear of about 1954 (fig. 323) can be seen in relation to the social realist tendency noted earlier that saw a progressive involvement with subjects connected with working-class life. The portrait, a Diploma Work presented in the year that Spear was elected RA, depicts a man who worked in a fish and chip shop in King Street in west London. At the time it was painted, Spear was teaching at the Royal College of Art and was also president of the London Group. He was influenced by Sickert and was early immersed in the Camden Town Group and the depiction of the ordinary and everyday. His presence at the Academy forms a bridge with the revival of interest in the 1950s in the unidealized reality of street life, in domestic existence and down-to-earth characters. As is shown by his slightly later painting *Man in a Pub*, probably painted in the 1960s, Spear found inspiration in the pubs, shops and snooker halls that he frequented in Hammersmith, Fulham and Chiswick, among other places. Both paintings are striking examples of Spear's ability to find a surprising and touching vitality in the commonplace.

A similar sensibility informs two works that demonstrate a close engagement with the Kitchen Sink ethos of depicting subjects that move deliberately from the familiar to the banal. *Sheep Carcases on a Bench* by Peter Coker RA of 1955 (fig. 324) was exhibited in January 1956 in the artist's first one-man exhibition held at the Zwemmer Gallery in London. This striking image, one of 32 paintings shown, half of which were studies of carcases, was based on drawings made in a butcher's shop in Leytonstone to which Coker was granted access on

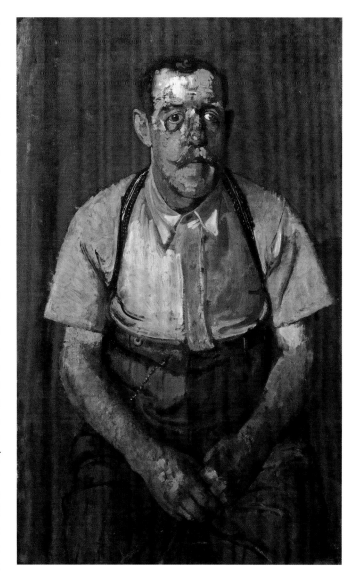

323 Ruskin Spear RA, *Ernest Marsh*, c.1954, oil on canvas, 104.4 × 64.7 cm (RA 03/644).

Wednesday afternoons, when it was closed. Tellingly, the painting confronts the Academy's devotion to the Life Room with a motif of dead flesh found in a shop. The artist was elected RA in 1972, and the painting is another instance of a Diploma Work that illuminates the period in which it was created, having been presented nearly two decades after its creation. Like the Coker, *Still-life with Check Table Cloth* by John Bratby RA of about 1960 (fig. 325) exemplifies a moment in British art when drawing and painting from life

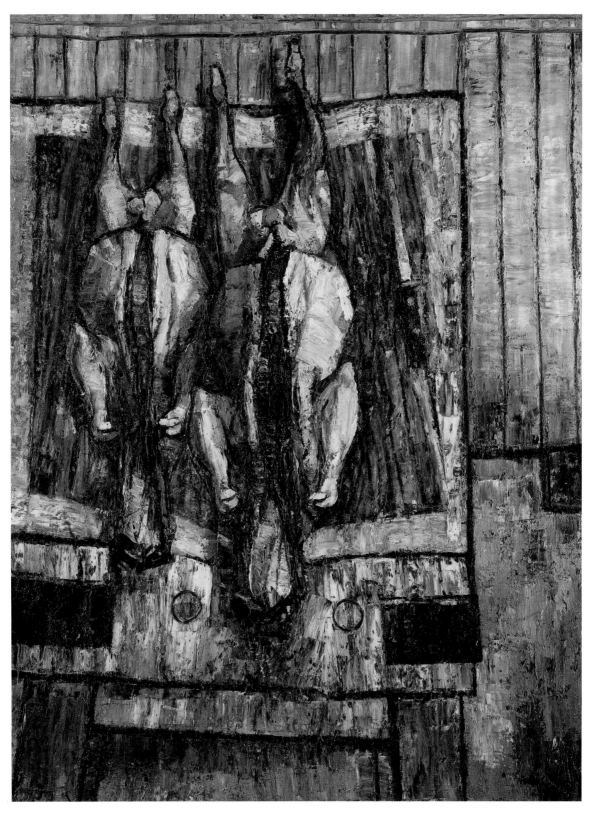

324 Peter Coker RA, *Sheep Carcases on a Bench*, 1955, oil on board, 152.5 × 115 cm (RA 03/1074).

325 John Bratby RA, *Still-life with Check Table Cloth*, c.1960, oil on board, 27.1 × 47.7 cm (RA 03/705).

meant turning away from the human form and the Antique cast and replacing these traditional subjects with the detritus of everyday life. In this case Bratby preserved the remains of a meal, finding formal and expressive significance in an arrangement of plates, bottles, a pan and other kitchen objects.

Alongside these notable instances of gritty urban realism, the Academy also harbours the compelling evidence of another, alternative line of development during the same period. An older generation of artists that includes Stanley Spencer RA, John Aldridge RA, John Nash RA and Richard Eurich RA continued an involvement with a kind of realism in which observed or remembered scenes are permeated by an atmosphere of imaginative invention and transformation. Spencer's *Farm Gate* of 1951 (fig. 326) depicts the artist and his first wife, Hilda, opening the gate of Ovey's Farm in Cookham, a place familiar to the artist from childhood. Based on memory, the scene incorporates an unusually high viewpoint, a severe confining perspective, and the artist's

characteristic expressive simplification of human form. The resulting vignette has the intimacy and oddness of a dream, vividly recalled but imperfectly understood. In terms of its subject *The Dustbin, Cookham* of 1956 has an ostensible connection with Coker's and Bratby's calculated use of banal motifs, but, like the *Farm Gate*, Spencer's abstracted and strangely purified description of the subject lends it an otherworldly quality quite removed from social realism.

A similarly heightened but enigmatic clarity pervades Aldridge's *Leyden* of about 1954 (fig. 327). Aldridge first exhibited at the Academy in 1948 and was elected ARA in 1954 and RA in 1963. He had previously shown with Ben Nicholson and other members of the Seven and Five Society. Some intimation of Nicholson's insistence on an extreme, reductive, non-representational purity of form can be discerned in the sharp, precise lines and proportions that underpin Aldridge's townscape. The result is to invest the scene with an idealized formal rigour that lifts it above

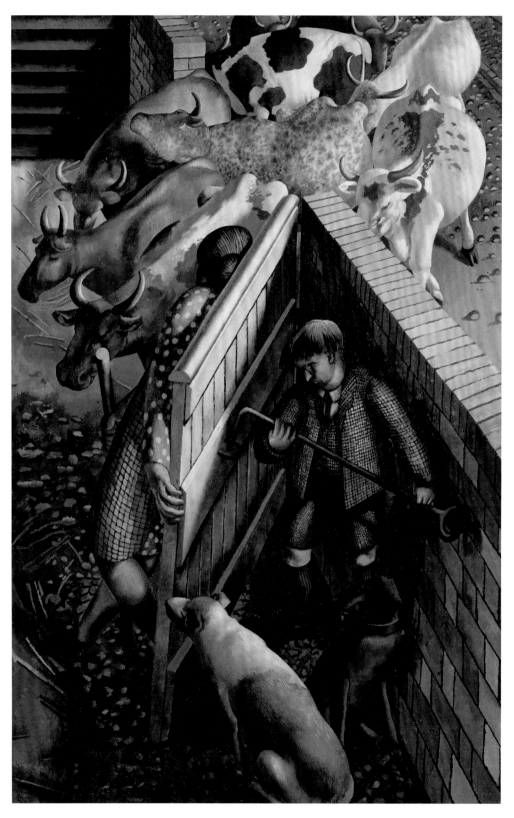

326　Sir Stanley Spencer RA, *Farm Gate*, 1951, oil on canvas, 91.5 × 58.5 cm (RA 03/198).

327 John Aldridge RA, *Leyden*, c.1954, oil on panel, 67.2 × 82.4 cm (RA 03/1164)

328 Richard Eurich RA, *Queen of the Sea, 1911*, 1954, oil on canvas, 122 × 182.8 cm (RA 03/1180).

observed reality. John Nash applied a related sensibility to a landscape subject, the *Lake, Little Horkesley Hall*, in about 1958 (see fig. 278). Nash became an RA in 1951, and this is one of several of his paintings held in the Academy's collection. In this work, Nash expunges all superfluous detail, abstracting a taut and highly clarified formal design. But, in contrast to the Aldridge, which possesses a seamless – if unnatural – calm, Nash's jagged branches and ambiguous reflected forms invest the scene with a brooding tension.

This elision of description and imaginative, formal transformation finds its most extreme expression in two paintings by Richard Eurich RA, *Mariner's Return* of 1953 (see fig. 281) and *Queen of the Sea, 1911* of 1954 (fig. 328). Like Spencer, as has already been discussed, Eurich drew on memory in order to create a simplified and abstracted setting which he then

embellished with a mass of invented incidental details: a plaque below the window reads 'Richard Eurich stayed here, 1911'. In a curious way, the painting is suggestive of the Academy's own position in the 1950s: a somewhat isolated vantage point in which past and present are held in a state of disorientating suspense.

DIVERSE FIGURATION

If the 1950s was the decade that saw modern art emerge as a visible alternative to those traditional or academic approaches generally identified with the Royal Academy, the succeeding period witnessed a veritable explosion of new and self-consciously modern artistic styles. In addition to the kind of

expressive figuration that continued to be championed by Francis Bacon, Lucian Freud, Frank Auerbach and others, a new 'cool' or more impersonal form of realism emerged in the form of 'Pop Art'. This phenomenon was associated mainly with a group of young artists then studying at the Royal College of Art, notably Derek Boshier, Patrick Caulfield RA, David Hockney RA, Allen Jones RA, R. B. Kitaj RA and Peter Phillips. The early 1960s saw the arrival of an opposite, if in some ways related, tendency in the form of large-scale, brightly coloured and entirely abstract painting associated with the 'Situation Group'. Its exponents included Gillian Ayres RA, Bernard Cohen, Robyn Denny, John Hoyland RA and William Turnbull. This insistently non-figurative painting had a no less compelling corollary in sculpture, centred on St Martin's where the teaching of Anthony Caro RA provided a luminous source of inspiration. A new, completely abstract, constructed sculpture posed a radical alternative to the medium's traditional allegiance to depicting the human figure. If this were not enough, other extreme manifestations of modernism appeared around the same time, not least those perceptual, optical and kinetic forms of art associated with Bridget Riley, Peter Sedgeley and Liliane Lijn.

As a media-dominated general public could not fail to notice, modern art had arrived. By 1966 its presence was irresistible. In April that year, *Time* magazine trumpeted on its front cover: 'London: The Swinging City'. No longer either able or willing to ignore these developments, the Royal Academy summer exhibitions became much more diverse and far less restrained in terms of the work on display. By the late 1950s, Kitchen Sink realism had found a place, as had abstract painting. Ten years later, paintings by older non-figurative painters such as Ben Nicholson and Ivon Hitchens were hung with those by leading exponents of Pop such as Peter Blake RA. Under Sir Thomas Monnington, who succeeded Sir Charles Wheeler as President in 1966, the Academy's exhibition programme also embraced modernism. But the Academy's collection of works during this period ploughs a somewhat different furrow. None of these eye-catching emergent tendencies is represented in any depth, and abstract art, in particular, is absent. Instead, figurative painting remains conspicuous but now assumes an impressive diversity in terms of the different approaches manifested. From the intensely observed, objective realism of *Still-life with Henbane* by Patrick Symons RA (fig. 329) to

329 Patrick Symons RA, *Still-life with Henbane*, c.1960, oil and pencil on canvas, 92.5 × 57.5 cm (RA 03/867).

the enigmatic, imaginative abstraction of the *Promotion No. 1* (1969) by Leonard Rosoman RA (fig. 330), the Academy's collection presents figurative painting as a vital, multifaceted genre that continued to reinvent itself even while modernism moved to centre stage.

330 Leonard Rosoman RA, *Promotion No. 1*, 1969, acrylic on canvas, 122 × 122 cm (RA 03/431).

Symons's still-life is a bravura example of the inspiration that many British contemporary artists continued to find in the art of the past. As with many of his works, the composition was determined according to geometric principles and proportions employed during the Renaissance. According to the artist, the painting is a 'golden rectangle', the ancient proportion often called the Golden Section or Golden Ratio (if a square is removed from this picture field, then the remaining shape retains the same aspect ratio as the whole). In this instance, the Golden Rectangle encloses a meticulously rendered botanical subject (a lifelong interest), a naturally dried specimen of a plant – henbane – that the artist had found near Beachy Head. It is set against a backdrop formed by a drawing of the painting *Virgin of the Rocks*, attributed to Leonardo in the National Gallery, London, that Symons had made on the wall of his studio. Here, the

Golden Rectangle, within which is contained both a plant and an image of human and spiritual perfection (in the Christ Child), may ultimately refer to the observations and theories of Adolf Zeising, who asserted that the Golden Ratio exists in natural forms: specifically, in the stems and leaves of plants. Zeising went on to describe it as a 'universal law in which is contained the ground-principle of all formative striving for beauty and completeness in the realms of both nature and art, and which permeates, as a paramount spiritual ideal, all structures, forms and proportions…[and] finds its fullest realization, however, in the human form'.[6] Le Corbusier had developed similar ideas in the twentieth century (which he applied to the proportions of buildings).

Combining geometry, botany and history within a meticulously rendered and predetermined formal structure, Symons's painting encapsulates the artist's fascination with the illusion of space while asserting the pictorial rigour of his means. Other works by Symons adopted variants on mathematical relationships calculated in terms of their aesthetic significance, and this particular work, although essentially traditional in terms of subject and execution, engages with contemporary concerns about abstract relationships. Although it shares a similar, botanical, subject with the Symons, the still-life *Through the Looking Glass* by Jean Cooke RA (fig. 331), which was also painted in 1960, demonstrates an entirely different sensibility. Cooke, who was married to John Bratby, approached her floral motif in a spirit of informality, receptive to the impressions received during the painting process. Like Symons, Cooke shared a passion for plants, in this case pansies, and she has recorded that she treated each as she would a portrait. The result has a playful metaphorical quality arising from its ostensible, purely literal subject. In some ways, this elision of description and imagination is a strand that connects many of the figurative painters active during this period and subsequently represented in the Academy's collection. For example, the *Departing Angel* (1961) by Carel Weight RA (see fig. 282) is a strange, enigmatic evocation of urban life in which there is an inexplicable metaphysical occurrence. A young woman sits among her potted plants in the patio area of her townhouse. Unremarkable in itself, this realistically rendered situation is tipped towards the extraordinary by the apparition of a semi-transparent, ghostly figure tiptoeing out of the picture. Similarly, Weight's Diploma Work, *The Silence*, a rendering of

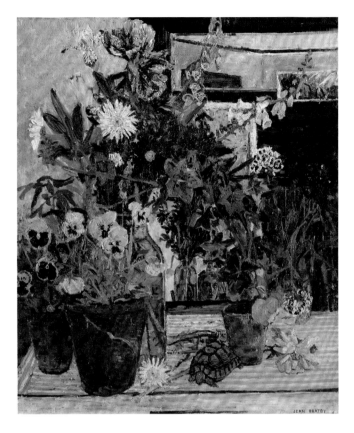

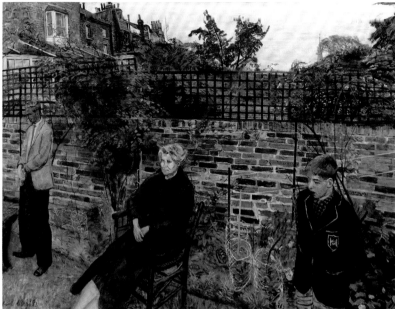

(left) 331 Jean Cooke RA, *Through the Looking Glass*, 1960, oil on canvas, 60.8 × 50.8 cm (RA 03/269).

(above) 332 Carel Weight RA, *The Silence*, 1965, oil on board, 91.5 × 122 cm (RA 03/200).

the silence observed on Remembrance Sunday and set in the artist's Wandsworth garden, is a haunting meditation on loneliness; and indeed the three models used were painted separately and never met (fig. 332).

Observation and visionary invention are themes deeply embedded in British art. The capacity to develop a pictorial tension from the opposition – or marriage – of these elements is characteristic of painters such as Weight, but it also underpins the work of a diverse range of other artists including L. S. Lowry RA, Rosoman, Robert Medley RA and John Bellany RA, all of whom are represented. Lowry was elected RA in 1962 at the age of 74. His Diploma Work, *Station Approach* (1962) (see fig. 279), is one of several paintings in the collection that have the character of reality refracted, as it were, though the lens of an inward eye, as if arising from some deeply digested and transformed memory. Whether industrial townscapes or portraits, Lowry's images have an emblematic quality that penetrates beneath incidentals to the essence of his subject. In *Station Approach*, the view is that of the road leading to Manchester's Exchange Station

from Victoria Road (the station no longer exists, having been closed in 1969 and subsequently demolished). But these topographical details have been manipulated, incorporating imaginary landmarks and populated by teeming figures flowing from some unconscious spring.

The self-portrait by John Bellany RA (1966; fig. 333) goes further, deep-mining the recesses of buried feeling and recall. The subject is the artist himself, but the surrounding area, a blackened space that frames the figure, introduces an element of sinister containment. The artist is seen against a backdrop of sky, but this is hemmed in by a void. Birds fly overhead but seem oddly isolated. In common with Bellany's work at this time, the image has a claustrophobic ambiguity, as if the painter is haunted by the spectres of his own imagination. Leonard Rosoman's *Promotion No. 1* (1969) employs related elements. A figurative vignette comprising two seated figures is blocked in on three sides by dark rectangles: a large horizontal shape at the top supported by narrower verticals at either side. This arrangement suggests a stage set, as if the curtains and screen have been withdrawn to reveal a dramatic

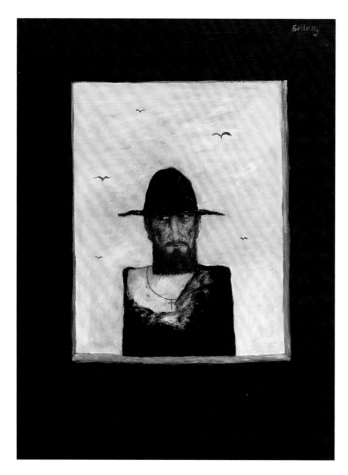

(left) 333 John Bellany RA, *Self-portrait*, 1966, oil on board, 121 × 91 cm (RA 03/1086).

(above) 334 Robert Medley RA, *Rough Field*, 1962, oil on canvas, 99 × 114.3 cm (RA 03/462).

tableau. Indeed, the theatrical character of this work relates to its subject, which derives from a scene in John Osborne's play, *A Patriot for Me* (1965). Here, as with all these works, an appearance of reality is enmeshed with the evidence of the work's own artistic production. In the *Rough Field* by Robert Medley RA (1962; fig. 334) this abstracting process is overt. Literal description has been subsumed by a surface of gestural marks expressive of movement and energy. The 'field' of the title is at once a reference to the observed motif and to the actual activity within the painting itself.

While abstract sculpture of the period is not represented in the collection, the Academy's acceptance of abstraction, and its progressive embrace of non-literal forms of expression, are demonstrated by the presence of *Meditation* by Willi Soukop RA, a sculpture of about 1969 (fig. 335). Here, naturalistic representation is informed by softened and simplified lines and shapes that draw the depicted head into a new,

pictorial, reality. Medley's and Soukop's respective advances in painting and sculpture – anathema to Munnings – reveal the extent to which, in two decades, the Academy had succeeded, if not in fully aligning itself with the avant-garde, at least in reaching towards the central tenets of modernism.

THE PERSISTENCE OF REPRESENTATION

The 1970s is generally regarded as the decade when painting and to some extent sculpture were vanquished by the avant-garde. Conceptual art, which placed a premium on ideas rather than their physical realization on canvas or as fabricated objects, held sway. Gilbert and George RA presented themselves as works of art in the form of 'living sculptures'; Richard Long RA created impermanent, cerebral structures relating to walks made in the landscape; the installation *An*

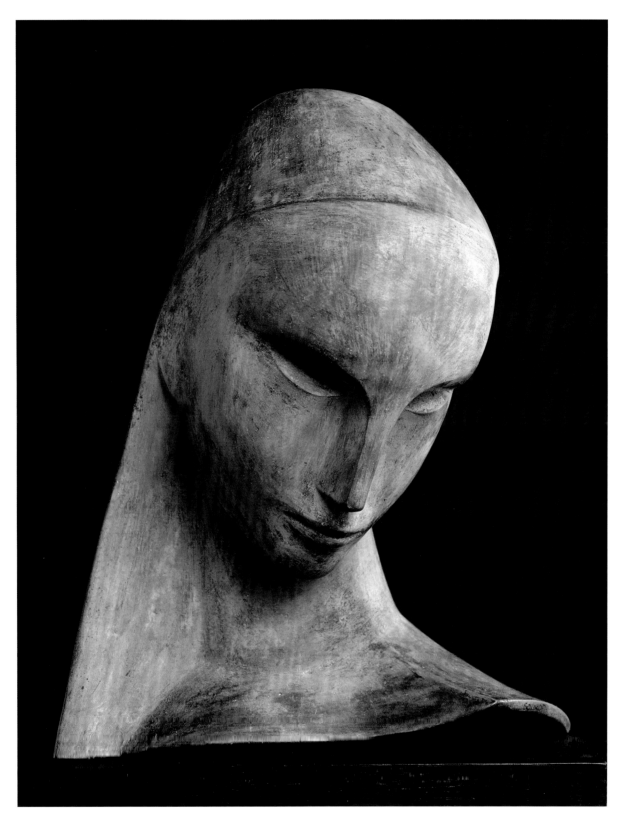

335 Willi Soukop RA, *Meditation*, *c.*1969, terracotta, height 38 cm (RA 03/1824).

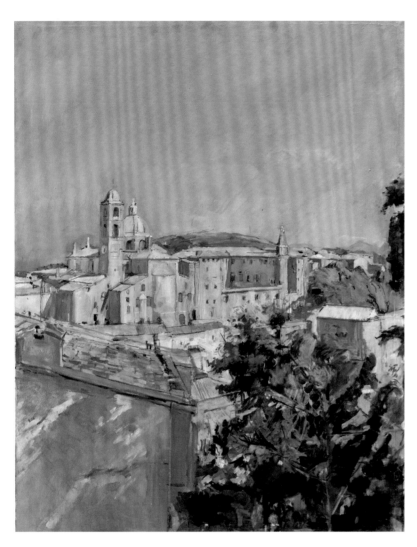

336 Anthony Eyton RA, *Urbino III*, 1974, oil on canvas, 118.5 × 93.7 cm (RA 03/1158).

Oak Tree by Michael Craig-Martin RA advanced a glass of water, a shelf and an accompanying text as evidence of the artist's transformative activity. Text, the human body, photography, video and performance were new vehicles for meaning. Painting and sculpture, meanwhile, were sidelined. While this account of what happened to painting and sculpture is to some extent true, at least in identifying the emergence of radical alternative approaches to making art, it is hardly accurate. As the Royal Academy's collection of works produced in the 1970s demonstrates, painting and sculpture may have slipped from the critical limelight, but

nevertheless they not only continued but flourished, as both genres persisted in exploring the principles and conventions of representation.

At one end of the figurative spectrum, artists such as Anthony Eyton RA demonstrated the enduring vitality of painting that engages with the complexities of recording appearances. Eschewing self-conscious pictorial devices, his art confronts nature directly, probing its ever-changing face and seeking analogous structures with which to fix and signify visual sensation. *Urbino III* (1974; fig. 336) exemplifies Eyton's celebratory vision. This way of working draws on Cézanne's interrogation of appearance but pulls back from the earlier master's fragmentation of form. Instead, as this painting shows, Eyton's is a more generalized view, in which detail is suffused within the play of light on different surfaces – stone, sky, vegetation – producing a radiant encapsulation of observation and perception.

Lawrence Gowing RA evinces in his *Still-life: Vanitas* of about 1979 (fig. 337) a related fascination with recording the impression made by the world on the eye and mind. But Gowing's is a more deeply analytical view that probes both the ambiguities of sight and the corresponding challenge of finding a pictorial language that signifies the fugitive nature of vision. Gowing was a writer and teacher as well as a painter, and his painting uses a traditional *vanitas* motif, a skull on a tabletop, as the basis for probing a specific perceptual issue. Gowing was aware that, because of the binocular nature of vision produced by two eyes arranged laterally, perceived images are sharper at the top of the field of sight, while the sides appear less certain. This visual characteristic, which is infrequently expressed in art, is the subject of Gowing's painting. The artist presents an arrangement of objects the horizontal edges of which – the top of the skull and the traversing line of the table – appear more definite that their vertical extremities. This pictorial rendering of the data processed by the eye transcends the skull motif's conventional significance as a reminder of the transitory nature of life. It serves, in addition, as a compelling manifestation of the elusive nature of appearance.

Three other paintings also of the late 1970s provide further evidence of the surprising range of pictorial invention that characterizes painting during this supposedly dormant period. The first is *The Artist* (1976; fig. 338), a self-portrait by Anthony Green, who was elected RA in 1977 and had

337 Lawrence Gowing RA, *Still-life: Vanitas*, c.1979, oil on canvas, 51 × 76 cm (RA 03/1357).

338 Anthony Green RA, *The Artist*, 1976, oil on board, 265 × 370 cm (RA 04/2138).

339 Eileen Agar RA, *Collective Unconscious*, 1977–8, acrylic on canvas, 105 × 102 cm (RA 03/346).

340 Michael Kidner RA, *Relay*, 1978, oil on canvas, 192 × 131.5 cm (RA 08/904).

a retrospective exhibition at the Royal Academy in the following year. In common with Green's art in general, this shaped canvas uses complex perspectival devices and compressed formal arrangements to evoke the experience of habitable space. Here, the artist himself is presented at centre stage as if appearing before an audience, a device that neatly captures the relationship of creator, subject and viewer that stands behind all Green's work. The second, *Collective Unconscious* (1977–8; fig. 339) by Eileen Agar RA, pushes beyond figurative representation. Despite its appearance, the image is not entirely abstract but incorporates highly abstracted

shapes derived from a range of natural elements, including molluscs, shells, sea anemones, seaweed and fossils. These forms are, however, combined with geometric, non-representational patterned areas. As such, the painting brings together separate modes, the abstracted and the abstract. It evokes the seen and, on the other hand, incorporates shapes and colours that are expressive without representing other things. The resulting hybrid stands at the edge of recognition. The third, *Relay* (1978; fig. 340) by Michael Kidner RA, goes beyond iconic representation, banishing resemblance completely and employing a language purely of form. This

341 Michael Kenny RA, *Cruxifixx*, 1976, plaster, wood, aluminium, glass, found objects (plumb line and bob, glass jar), 201 × 252 × 203 cm (RA 04/586).

342 Geoffrey Clarke RA, *Above Eye-level*, 1976, aluminium mounted on wooden backboard, 44.8 × 28.9 cm (RA 03/1694).

entirely abstract painting arises from principles that are essentially Constructivist; rational, systematic, concerned with colour, shape, structure and the relation of different elements, it transcends personal, autographic expression in seeking a reality that exists on its own terms, independent of recognizable objects.

The admission of abstract works into the RA collection is significant, signalling a development beyond that long-standing adherence to 'the representation of form',[7] a principle that the Academy continued to place at the centre of its teaching in 1945. Instead, abstract art engaged directly with form, transcending issues of resemblance and imitation. This is not to suggest, however, that an abstract language was incapable of conveying meaning. As works by two sculptors, Michael Kenny RA and Geoffrey Clarke RA, both amply demonstrate, during the 1970s abstract sculpture made significant advances in bringing metaphor within its armoury of expression. *Cruxifixx* (1976; fig. 341) by Kenny is a wooden construction that pares down its subject to non literal essentials. Clarke's *Above Eye-level* (fig. 342) was made in the same year and presents a ladder like element beneath a circular shape enclosing a cross. Neither sculpture is descriptive in a literal

way, yet each implies a human presence: the Kenny with its T-shaped outstretched members; the Clarke with its ascending steps. Both works proceed from non-representational elements the arrangement of which moves *towards* – rather than *from* – significance, evoking instead of depicting.

PAINTING ASCENDANT

In 1981 the Royal Academy mounted an exhibition that has since been seen as defining an important moment in late twentieth-century art. 'A New Spirit in Painting' brought together the work of 38 painters. They included non-living or senior artists with established reputations such as Pablo Picasso, Balthus Hon. RA and Francis Bacon. There were also important representatives of a later, mid-career generation, notably Cy Twombly Hon. RA, Frank Auerbach and Gerhard Richter, as well as younger artists such as Bruce McLean, Julian Schnabel and Rainer Fetting. As this list of examples suggests, the international perspective was impressive, with America, Britain, France, Germany and Italy all represented. The thesis of the exhibition was no less compelling. Christos Joachimides, who was one of the exhibition's organizers, explained that, in reaction to the 'self-defeating' pre-eminence of Minimalism and conceptual art in the 1970s, 'artist's studios are full of paint pots again and an abandoned easel in an art school has become a rare sight. Wherever you look in Europe or America you find artists who have rediscovered the sheer joy of painting.'[8]

The exhibition was not a financial success but made a valuable point, restoring painting to critical esteem. The Academy also benefited from hosting an exhibition with real contemporary relevance. For many within the Academy, however, the exhibition's claim to have given a platform for a 'new concern with painting'[9] must have rung hollow. As its membership, schools and collection all demonstrated, within the precincts of Burlington House, painting had never relinquished its prime importance. Indeed, beyond the glare of the critical spotlight, and alongside more advanced developments, the reality was that throughout the 1970s painting had continued. Indeed, the principle that was said to underpin the revival of painting – 'a certain subjective vision'[10] – can be seen to apply equally to the painting of the preceding decade held in the Academy's collection. That said, the

343 Stephen Farthing RA, *The Understudy*, 1983, oil and beeswax on cotton duck, 170 × 241.2 cm (RA 03/1293).

emphasis now given by the exhibition to its artists' concern with the creation of 'personal worlds',[11] while hardly new, is an effective frame for considering the RA's collection of paintings made in the 1980s.

The Understudy (1983) by Stephen Farthing RA (fig. 343) exemplifies the taste for a kind of imaginative anarchy that underpins much figurative painting during this period. In common with his prize-winning debut work, *Louis XV Rigaud*, which was exhibited at the 'John Moores Liverpool Exhibition 10' in 1976, Farthing subjects his chosen motifs to a process of unsettling deconstruction. Whether derived from a historic portrait such as Rigaud's or relating to a traditional genre – an interior – as with *The Understudy*, such images deliberately shatter expectations connected with value or perception. *The Understudy* does this overtly. As implied by the punning title, it presents a view of a furnished and carpeted room as if seen from below, with the architectural elements of floor and walls having been removed. The result conveys an impression of reality suspended, as it were, between the familiar and the impossible.

During the 1980s, two artists (already referred to above) associated with the emergence of Pop Art two decades earlier were elected to the Academy. R. B. Kitaj became ARA in

(left) 344 R. B. Kitaj RA, *Bather (Wanda)*, 1984–6, oil and pencil on canvas, 152.5 × 61.8 cm (RA 03/357).

(above) 345 Allen Jones RA, *Spice Island*, 1986, monoprint, 108 × 154.4 cm (RA 04/2365).

1984 and Allen Jones was made RA in 1986. Both are represented by paintings of the figure, a shared preoccupation, in which naturalistic representation has been transformed by the vibrant application of resonant colour. As with Farthing, the pictures of Kitaj and Jones have an idiosyncratic treatment of a familiar subject that draws the viewer into a private world. In *Bather (Wanda)* (fig. 344) Kitaj depicts a standing female; Jones's *Spice Island* (fig. 345) shows figures standing and reclining in a natural setting. In each case, the motif is abstracted, yielding to an emphasis on painterly mark-making that animates the surface and draws attention to itself as evidence of the artist's presence. Both evoke a realm of the senses: tactile, chromatically intense, physical and erotic. Highly abstracted colour also makes visible the interior universe that is the subject of the art of Craigie Aitchison RA. In his case, however, the world he evokes, though sensual, has a spiritual, indeed religious, significance. His *Crucifixion* (1988–9; fig. 346) presents the crucified figure of Christ, seen from afar, within a darkened landscape. Devoid of naturalistic detail, the setting is, however, one of feeling rather than topography: a private, imagined repository of emotion.

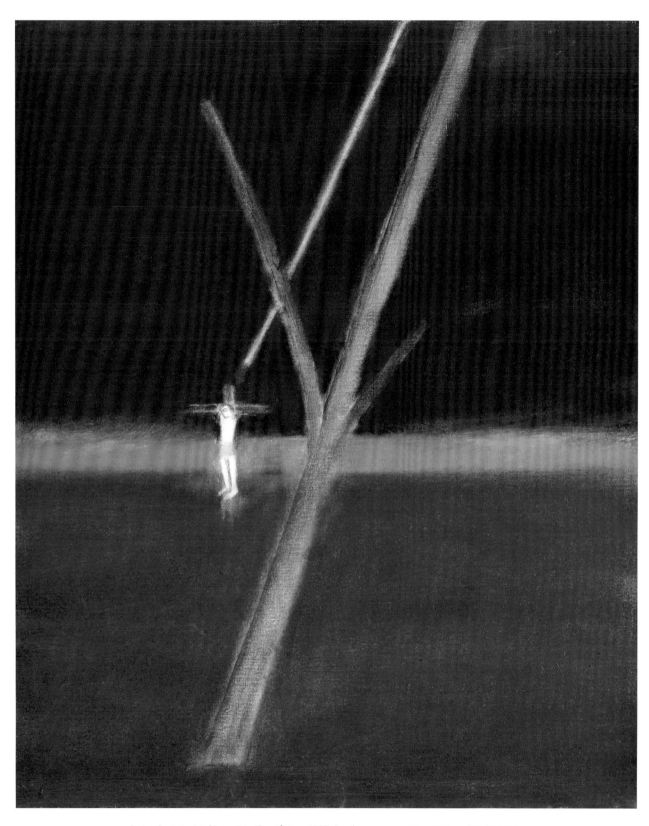

346 Craigie Aitchison RA, *Crucifixion*, 1988–9, oil on canvas, 61 × 48.2 cm (RA 03/424).

347 John Hoyland RA, *Taking a Dive 23.2.85*, 1985, acrylic on cotton duck, 154 × 170 cm (RA 03/589).

348 Albert Irvin RA, *Blue Anchor*, 1989, acrylic on canvas, 213 × 305 cm (RA 03/1296).

It could be argued that painting is uniquely well suited to the creation of a personal, intimate world. Plastic and directly responsive to both touch and thought, paint gives form to experience and desire immediately. Within that process, painting that dispenses with representation takes this endeavour a step further, enabling the painter to create an entirely subjective domain and to inhabit it simultaneously. Within the Academy's collection, large-scale paintings by John Hoyland and Albert Irvin RA represent this abstract tendency with extreme aplomb. Hoyland's *Taking a Dive 23.2.85* (1985; fig. 347) belongs to a particular phase within the artist's development. During the 1960s and 1970s Hoyland was mainly concerned with creating a virtual space that was populated, at first, by vast, stained rectangles of colour, but subsequently by thickly impastoed blocks of multicoloured pigment. From the early 1980s, Hoyland invested this activity with more allusive significance. His paintings appeared as strange containers or places that he filled with the progeny of fantasy – a complete, living universe of invented forms

animated by desire. Irvin's *Blue Anchor* (1989; fig. 348) is no less an imagined space. In Irvin's case, however, the circles, chevrons, lines and other abstract shapes are the traces of the artist's movements through a virtual context analogous to reality. The circumlocutions, encounters, reversals and resolutions of colour and form all echo experiences in life, but are here stripped of particularity, as if concentrated into a numinous essence.

TIME PRESENT AND TIME PAST

The 1990s saw the Academy elect several senior British artists whose affinity with earlier manifestations of modern art had previously been a source of mutual alienation. Barry Flanagan RA was elected R.A in 1991. His Diploma Work, *Unicorn and Oak Tree* (fig. 349), is a characteristic late creation that, following the artist's former engagement with sculpture made from stuffed sacking, cloth, rope and other unconven-

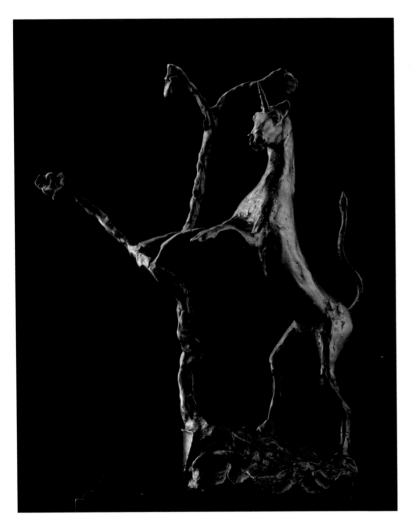

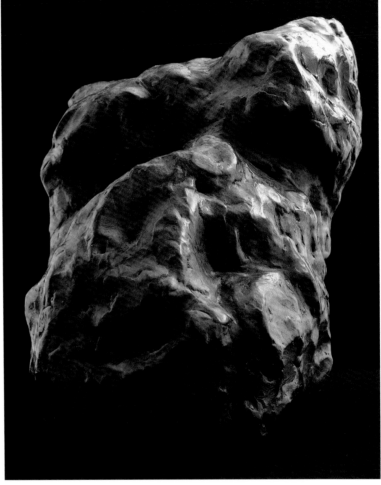

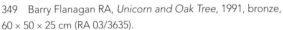
349 Barry Flanagan RA, *Unicorn and Oak Tree*, 1991, bronze, 60 × 50 × 25 cm (RA 03/3635).

350 William Tucker RA, *Study for a Mother Goddess*, 1992, bronze, 22 × 23 × 17 cm (RA 03/1830).

tional elements, marked a return to figurative imagery, albeit of a fantastic nature. Here, working in clay cast in bronze, the artist fashioned a mythical creature, a unicorn, rearing within the skeletal branches of a gnarled tree. This ensemble provides an impression of vitality, the unicorn seeming an embodiment of life that is at once physical and imaginative. As with much of Flanagan's figurative imagery, the motif suggests the artist's own creative processes in the way that inert matter is invested with metaphysical significance. The sculpture was part of Flanagan's competition entry for a proposed fountain in Parliament Square, a project that failed to materialize.

Study for a Mother Goddess by William Tucker RA (fig. 350) is, like the Flanagan, evidence of the capacity of a sculptor, having achieved authority with unconventional methods, going on to reinvent his approach. Tucker was one of the leading figures within the New Generation group of sculptors whose compelling engagement with constructed abstract sculpture and new materials during the 1960s defined the experimental energy of that time. As his work demonstrates, Tucker subsequently reverted to conventional materials involving plaster and bronze, as well as to a renewed concern with the human figure. But the language he evolved invested massive, amorphous shapes with a subtle impression of imma-

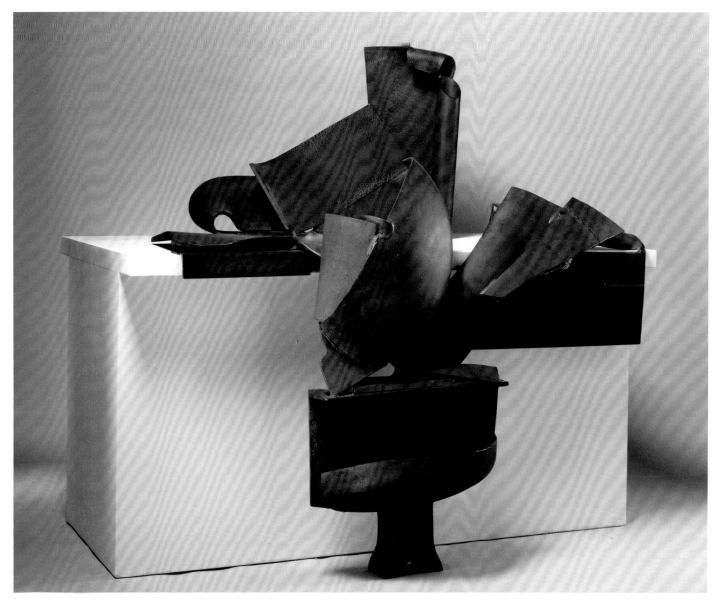

351 Sir Anthony Caro RA, *Cascade Series 'Mouchoir'*, 1990, steel (rusted and waxed), 139.5 × 139.5 × 111.5 cm (RA 05/1782).

nent life. At once intensely physical and yet suggestive, Tucker's sculpture reaches back to Rodin while adventuring into a contemporary world of allusion and metaphor.

Anthony Caro, whose innovations during the early 1960s inspired students at St Martin's such as Tucker, is also represented in the RA's collection of works from the 1990s. Caro was not, however, to join the Academy until 2004, and *Mouchoir*, which belongs to the 1990 *Cascade* series, was

added retrospectively (fig. 351). The sculpture exemplifies a distinctive way of working that Caro evolved in 1966 and made his own. His celebrated earlier break with sculpture presented on a plinth defined his abstract constructions as existing on their own terms in the real world. From the mid 1960s he solved the problem of how to present smaller sculptures, which needed to be seen at waist height, without returning to the imaginative space that would be implied by

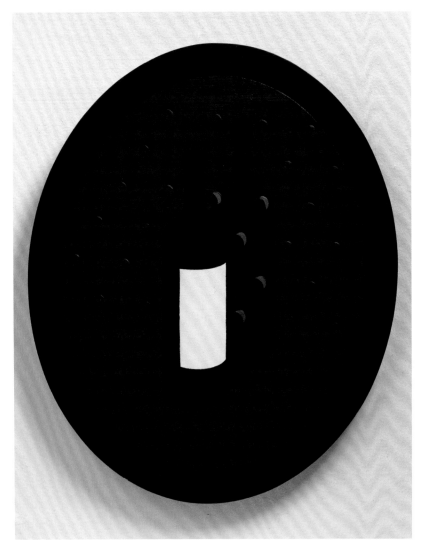

352 Patrick Caulfield RA, *Moroccan Red*, 1997, acrylic on canvas, 51.6 × 41.7 cm (RA 03/227).

in the early 1960s, even though neither claimed an affiliation with that movement. Caulfield's subject matter, which mainly focused on still-life and the depiction of interiors, stood at a remove from Pop's preoccupation with the more sensational aspects of the mass media. For a time Hockney's depiction of Typhoo tea packets had an affinity with the fascination with consumer products evinced by Pop, but his autobiographical, indeed deeply personal, motifs also seemed idiosyncratic. Caulfield's *Moroccan Red* (1997; fig. 352) and Hockney's *Double Study for 'A Closer Grand Canyon'* (1998; see fig. 287) are both works from each artist's maturity. Caulfield's still-life is a typically highly resolved composition, at once a simple yet subtle meditation on shadow-play and abstracted representation. The Hockney expands into the complexities of evoking the vast grandeur of a magisterial topographical motif.

A BROAD CHURCH

As the Royal Academy entered the new millennium, its collections revealed changes in the preceding 50 years the extent of which were unparalleled in the institution's history. From a position of embattled antagonism to those artists and tendencies that challenged orthodoxy, it had redefined itself as a forum in which a surprising range of artistic outlooks, some contradictory, were not only embraced but coexisted, joined in debate. At the core of these developments, the abstracted and the abstract – artistic values that had been regarded with suspicion or excluded entirely – now stood as twin pillars of expression and artistic vitality. Concurrent with this advance, artists who previously had regarded the Academy as irrelevant now accepted the mantle of membership. Significantly, those drawn to the fold included many senior international figures from disparate backgrounds, including Georg Baselitz to Cindy Sherman, who became Honorary Academicians.

Even within those figurative and non-figurative tendencies, which now stand side by side, a rich diversity is apparent. This is particularly true of the abstract persuasion. Since 2000 there has been an impressive expansion in the ranks of those artists whose work eschews literal representation. Tess Jaray RA, Ian McKeever RA and Basil Beattie RA reveal markedly different approaches while remaining wedded to a language of pure shape and colour. As *How*

using an elevated plinth. Situated instead on a table-like form, *Mouchoir* tumbles from that surface, into the viewer's space, and touches the ground. Its presence is thus maintained as a purely abstract, expressive cascade of shapes that has its own, self-contained reality.

Alongside the collection's holdings of exemplary works by distinguished sculptors, the 1990s are also represented by submissions marking the membership of leading senior painters. Patrick Caulfield and David Hockney are both closely associated with the emergence of Pop Art in Britain

353 Tess Jaray RA, *How Strange*, 2010, oil on linen, 143 × 115 cm (RA 10/3678).

354 Ian McKeever RA, *Sentinel X*, 2003, oil and acrylic on canvas, 225 × 125 cm (RA 04/3675).

Strange shows (fig. 353), Jaray's images remain rooted in an ethos that is essentially perceptual and non-autographic, arising from the deliberate arrangement of interrelated visual elements. A refined formal structure, such as that advanced by *How Strange*, involves the viewer in an active, subjective dialogue. As a result, their experience of space, distance and the relation of different elements is subtly activated. McKeever's sensitively nuanced paintings occupy a different universe. *Sentinel X* (2003; fig. 354) belongs to a body of work in which the process of painting is foregrounded, an activity in which control and discovery are held in a fine balance. At once abstract and yet arising from observed phenomena, an ambiguous intimation of light and shadow assumes a biomorphic character, a feat of transformation in which the sublime – that sense of transcendent nature – is implied.

Beattie's paintings are no less impressed with an insistent subjectivity. In contrast to Jaray and McKeever, however, Beattie's empiricism is neither perceptual nor metaphysical. Instead, in paintings such as *Never Before* (2001; fig. 355), simple abstract shapes are realized with an extreme painterly

355 Basil Beattie RA, *Never Before*, 2001, oil and wax on flax, 254 × 304.8 × 7.6 cm (RA 07/3134).

attack. Often – as here – Beattie allows the raw canvas to stand as a ground. This accentuates the impression of immediacy and of imagery summoned, as it were, from the dark recesses of cognition. In this instance, an ascent of rectangles resembles steps, poised precariously. As in Beattie's work as a whole, abstract form resonates expressively and is charged with metaphorical significance. Here as elsewhere in Beattie's iconography, shapes that seem strangely architectural – steps

but also doors, windows and tunnels – suggest routes or points of access to a realm of unconscious experience.

Within the figurative trajectory, the range of approaches is similarly broad. Tony Bevan, who was elected RA in 2007, shares with Beattie a confidence in autographic mark-making as the most effective vehicle for profound personal expression. *Head and Neck* (2007; fig. 356), in common with much of Bevan's work, arises from the artist's engagement with his

356 Tony Bevan RA, *Head and Neck*, 2007, acrylic on canvas, 90.6 × 74.1 cm (RA 07/5148).

357 James Hunkin, *Tony Bevan RA*, May 2007, silver gelatin print, 30 × 24 cm (RA 07/3192).

own image. Its source is Bevan's head and features, photographed or as seen in a hand-held mirror, an appearance that was transcribed as a drawing. This graphic image was then transferred to canvas and, in the process of its recreation, underwent transformation. Abstracted marks, vectors and scar-like passages of description underpinned the creation of an effigy rooted in the principle of physiognomic perception: a container or equivalent for psychological states was thus revealed. Bevan takes the self-portrait motif as the starting point in a process of self-interrogation, but the graphic elements of his composition have not been drained of expression, rather the reverse; and anyway it would be an impossibility, since all visual elements and their arrangements may be viewed in terms of their expressive character. This rich am-

bivalence, in which an unmistakably 'modern' image powerfully recalls the ancient tradition of self-portraits, is representative of the to–fro flux of past and present that has always marked the Royal Academy. Indeed, the Academy commissioned from James Hunkin (b. 1958) between 1995 and 2011 a total of over 80 photographs of Academicians that recall the many older photographs of artists in their studios (see figs 90, 110, 176, 183, 189). Among the artists recorded through the Academy's initiative was Tony Bevan, photographed by Hunkin in 2007 (fig. 357), the same year as *Head and Neck*.

The work of Gary Hume RA, who in 1988 graduated from Goldsmith's College, asserts the autonomous, impersonal nature of the image even when it too is founded upon observation of the human figure. His painting based on an

358 Gary Hume RA, *American Tan XXVIII 1*, 2008, gloss paint on aluminium, 160 × 200 cm (RA 08/2363).

359 Tracey Emin RA, *Trying to Find You 1*, 2007, acrylic on canvas, 21 × 29.8 cm (RA 09/2877).

image of an American cheerleader, *American Tan XXVIII 1* (2008; fig. 358), for example, is so abstracted as to lose obvious contact with its original significance and to invite other, disparate, levels of interpretation.

The passage of Tracey Emin RA from enfant terrible to the Academy's Professor of Drawing is discussed elsewhere. Appropriately, she is represented in the collection by a painting in which drawing serves as a vehicle for subject matter that is nakedly confessional – literally so. In common with her work in general, the motif derives from a personal history, mined and unearthed, in which sexuality, vulnera-

bility and uncertainty are raw materials. In *Trying to Find You 1* (2007; fig. 359) Emin presents a female figure, kneeling as if in supplication although the context is not specified. This submissive image articulates human fragility with raw frankness. Joining the Academy's collection after 60 remarkable years of change, the Emin drawing attests the catholicity that had become the institution's defining strength: the Academy as a broad church, embodying graphic and painterly vitality but also revelatory as well as inscrutable abstraction, together with the autonomy and poetic resonance of the abstract.

A CLOSER LOOK

11.1

Lynn Chadwick
Teddy Boy and Girl

Diploma Work

ROBIN SIMON

Teddy Boy and Girl (fig. 360) rocketed Lynn Chadwick RA to fame when it was exhibited at the 28th Venice Biennale in 1956. He won the International Sculpture Prize despite competition from the older and more famous Alberto Giacometti, who was widely expected to be recognized for a lifetime's achievement. Clearly, Chadwick's sculpture resonated with the mood of the times, with its ingenious exploitation of the new fashion among the young for Edwardian era revival clothing (hence the term 'Teddy boy'), which was topped off by duck-arse hair for men (the beehive for women was yet to be created). The long drapes of the male jacket were invariably worn with a cigarette and drainpipe trousers (extremely narrow and tapered), with a comb tucked up one sleeve, as easy to slip into the hand as a flick-knife, although a folding 'flick-comb' was an option. The comb could also, demanding a more choreographed movement, be kept in the back pocket, but either way it was essential for the constant recombing and setting of the thickly Brylcreemed hair.

Some of these elements are reflected in Chadwick's modelling of the rectangular (definitely not 'square') male figure, while the triangular female retains a residual hair-do and ribbed skirt. There is no place for the thick-soled brothel-creepers that Teddy boys affected: rather, both figures teeter on what at this stage might be the girl's stiletto heels, although similar spiky supports for the figure became a cliché (or signature) of Chadwick's subsequent work. The composition manages to convey, in the uncomfortable and aggressive relationship between the two figures, the edgy world of the Teddy boy and the 1950s coffee bar, where violence was only a misdirected glance away.

Chadwick's prize was a personal triumph, but it was also important for the future of the British Council's promotion of art that was responding to modernism, since its choice of Chadwick for the Biennale had been widely criticized. Although Chadwick gained international recognition by winning the prize, in Britain his work continued to be treated with suspicion or outright hostility. In 1958, for example, when he was commissioned to create a work (*Stranger*, or *Watcher*) marking the return crossing of the Atlantic by an airship in 1919, to be placed at London Airport, it was blocked by the House of Lords. The prototype was characterized by Lord Brabazon as looking like 'a diseased haddock', and the scheme was abandoned.

360 Lynn Chadwick RA, *Teddy Boy and Girl* 1955 (2002 casting), bronze,
190 × 70 × 58 cm (RA 03/1687).

Colin Hayes
Landscape in Northern India

PAUL MOORHOUSE

This luminous painting (fig. 361) belongs to the final phase of Colin Hayes's long and distinguished career. With its closely observed tonal values, harmonious colour and clear structure, it evinces pictorial concerns that were evident at the outset and became central to his subsequent artistic development. Hayes was born in London in 1919 and studied at Westminster School and Christ Church, Oxford. It was only after being invalided out of the army in 1945, following injuries received while serving during the war in the Western Desert, that he received a training in art, first at Bath School of Art and later at the Ruskin School of Drawing, Oxford. Indeed, drawing was to be the foundation of Hayes's practice. Never one to opt for easy solutions, Hayes believed that in order fully to understand a subject it was necessary to draw it. Through an active visual engagement with the observed motif, and with eye and mind working in harness, the artist came to an appreciation of the motif's essential features. An intense process of looking laid the foundation for seeing, enabling the formation of drawings and paintings rendered with both precision and economy.

These were values and principles that Hayes communicated to one of his first students, Bridget Riley, whom he instructed after taking up the position of Head of Painting at Cheltenham Ladies College, where Riley was a pupil, in 1947. The instruction that Riley received, not least Hayes's emphasis on visual scrutiny and the creation of equivalent pictorial structures, was the bedrock for her later abstract painting. For his part, Hayes remained true to a process in which observation led inexorably to progressive abstraction, while never abandoning description. His mature work is characterized by formal rigour complemented by flat areas of sensuous colour. In those respects, Hayes's artistic affinities are apparent. In addition to Rembrandt and Sickert, Hayes greatly admired Renoir, Matisse and Bonnard, and from the example of these various masters, he forged a personal language in which the disposition of shapes and carefully judged chromatic relationships achieve a satisfying balance.

In 1949 Hayes joined an influential group of teachers at the Royal College of Art, among them Ruskin Spear ARA (RA 1954) and John Minton; its students at one time or another included Frank Auerbach, David Hockney, Bridget Riley and Richard Smith. Following the end of the war, Hayes exhibited regularly at the New Grafton Gallery and with frequent submissions to the Royal Academy's Summer Exhibition. Elected ARA in 1963 and RA 1970, he belonged to a generation of younger Academicians that included Leonard Rosoman and Frederick Gore. During the 1960s, they initiated the process of

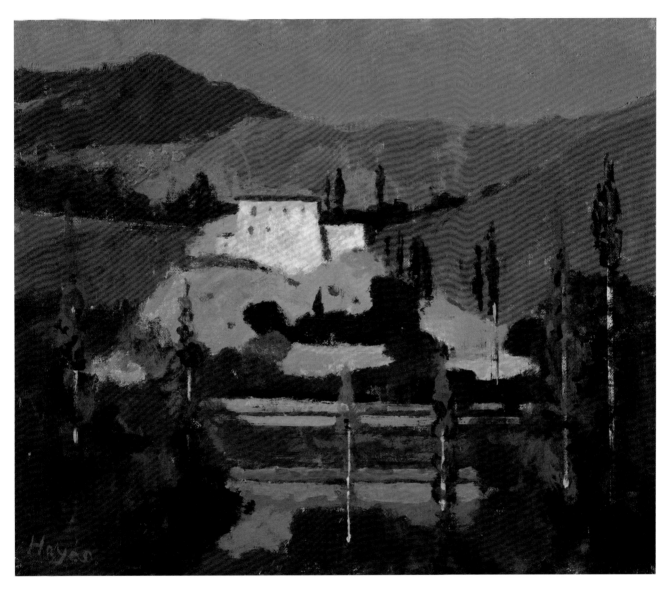

361 Colin Hayes RA, *Landscape in Northern India, c.*1993, oil on board, 25.7 × 30.4 cm (RA 03/1032).

modernization at the Royal Academy that eventually gained momentum and led to permanent change. In later life, Hayes's travels to Greece and, as in this case, India nourished a feeling for rich colour that was finely balanced between pictorial autonomy and literal representation. As this painting shows, that balance was rooted nevertheless in the principle of forming a clear idea of the subject. This manifested a depth of understanding that always transcended mere illustration.

SILVER

PHILIPPA GLANVILLE

From the earliest days, dinners of the Royal Academy, which from 1787 were catering for more than 100 distinguished diners, have attracted public interest and press reports. In April 1778 Horace Walpole sourly commented that he was not about to attend: 'I shall not leave my little hill for the dinner at the Royal Academy on Thursday, only to figure the next day in the newspapers in the list of the Maecenases [*sic*] of the world.'[1] The glamour of the anniversary dinner was recalled, however, by an American diplomat who was not only astonished by the English obsession with dinners but also admired the ubiquitous presence of silver gleaming against white damask:

> Yesterday the Royal Academy gave their anniversary dinner at Somerset House. It was the fiftieth celebration…I had the satisfaction to see, as his successor in the chair, my venerable countryman Benjamin West. There were present, the royal academicians, a large collection of

the nobility, many of the cabinet ministers, the Lord Chancellor, the Bishops of London and Salisbury, artists and others, high in the walks of genius and taste; the foreign ambassadors and an array of private gentlemen. Five of the rooms had their walls hung with paintings. There were more than four hundred…We dined in the principal exhibition room…Dinner was served at six. Until past seven, we had the sun through skylights. Afterwards, there fell gradually from above light from numerous shaded lamps in hanging circles.[2]

The Academy was following a well-trodden path in this pattern of frequent dinners, which could take the form both of large annual set-piece events and of smaller club gatherings. The dinners given by the Foundling Hospital, the Society of Artists, and the Royal Society are all well documented, emphasizing the significance of conviviality as a key element in the smooth functioning of cultural society. Spe-

362 Sir Nicholas Grimshaw PRA, model of Waterloo International Terminal, 2011, silver, 18.8 × 56 × 21.1 cm (RA 11/3664).

cialist caterers set up dinners for the Academy at so much a head, with an extra allowance for dessert, for the porters' beer, bread and cheese, and for hothouse fruit out of season. As Holger Hoock has analysed, dinners mattered to the institutions, clubs and academies of Georgian London.[3] Disparaging remarks made by present-day art historians about the tedious and repetitive descriptions of Academy dinners in Joseph Farington RA's diary fail to grasp the significance of those carefully plotted occasions, with their nuances of who was invited or – more importantly – excluded, how many attended and of what rank or distinction, who sat by whom, and how the occasion was assessed afterwards.[4]

The plate, given from the earliest years by Academicians serving by rotation on the Council, was intended to dignify more intimate occasions. These were the dinners made up of the group of 10 serving Academicians (chaired by the President) who managed the institution's affairs, to which

occasional guests were invited. Politely, but firmly, the Academician's duty was made plain: 'It is expected, that every Academician, when he arrives at the Honour of being of the Council, do deposit five shillings and threepence, and afterwards make a Handsome Present to the Academy of a piece of Plate for the use of the Council and his Name shall be engraved thereon and transmitted.'[5] This agreeable custom of presenting gifts designed to ornament the collective life of the Academy, although not observed regularly, continued well into the twentieth century. Sir Nicholas Grimshaw (PRA 2004–11) recently revived this practice. his President's gift of 2011 was a silver centrepiece in the form of a model of part of the Waterloo International Terminal that his firm had designed (it was opened in 1993) and inscribed with the names of Academician and external members of Council during his presidency (fig. 362). This tradition explains, however, the little-known but intriguing

assemblage of tableware, ranging in date from the 1760s to the 1960s. The historian of the Academy, its former Secretary, Sidney Hutchison, observed, 'It has no outstanding items of great rarity but it does provide a creditable assortment of tableware which is frequently in use.'[6]

Although the tables are no longer laid with any of the 37 polygonal plates or the old flatware, and the candlesticks given in 1771 no longer reflect the flicker of flames, the Academy's plate is still a working collection. Michael O'Halloran, at the time of writing the chief Red Collar (as the security guards are known from the collars that they have worn since the 1790s), described recently his pride in his traditional role of selecting decorative silver for the tables for varnishing day lunches, for the selection committee lunches, and for formal dinners. He also observes the ancient ritual of obtaining a signed receipt when his colleagues in various departments request historic items of silver for occasional use.

Although it was regularly in use until about 20 years ago, the plate has been well cared for by the Academy's officers. Few losses are recorded, apart from a couple of table forks from the set given by Francis Chantrey RA in 1819, or missing teaspoons noted in the 1850s, and others said to be missing since varnishing day luncheon 1968. This compares well with the plate belonging to the Crown, which was regularly issued by the Jewel House for diplomatic occasions until the early nineteenth century and from which spoons and forks often vanished. One very large loss of teaspoons, for example, occurred in February 1805, when George III gave his German Ball at Windsor. At this glamorous occasion, which was central to his strategy to persuade the British establishment to support a military campaign against Napoleon, who had invaded the Electorate of Hanover in 1803, tables glittered with the spectacular Hanover silver. Inevitably, it seems, the silver teaspoons, engraved with the royal monogram and identifiable as from Hanover, were regarded as providing delightful souvenirs.

Marking membership with a gift of something of perceived value and shared collective purpose is an ancient and deeply rooted tradition, and one that continues to thrive. In this spirit, Dame Laura Knight RA left to the Academy in 1970 the silver platter that she had been given by the Society of Women Artists 34 years earlier. There is probably a particular significance in her choice of this platter, since she herself was the first woman to be elected as full Academician since

Mary Moser RA and Angelica Kauffman RA at the Academy's foundation. Material memory, allied to hospitality, has been a powerful driver in English society for many centuries. This impulse, alongside the custom of a 'fine', in the form of silver at the time of entry to the senior ranks of a private society, still flourishes in Oxford and Cambridge colleges, in City livery companies and in military units. Typically, men (usually) of wildly differing financial and social status came together in a collective world and, aspiring to live within that magic circle at shared expense, each did as well as he could.

Since the donors of plate to the Royal Academy are known (their names are engraved on the various items as demanded by Council), it is possible to assess who chose to give what, within a fairly modest range of items. Unlike the livery companies of London or the Mansion House, there are no spectacular (and costly) centrepieces, apart from the handsome one designed by Henry Armstead RA, commemorating the centenary of the foundation (fig. 363), which was commissioned at collective expense and thereafter graced the annual dinners at Burlington House from 1872. Indeed, the silver was not the vehicle chosen for egotistical display by Academicians. Apart from small sauce tureens and a delicate pierced bread basket given by J. F. Rigaud RA in 1779 (fig. 364), the sole Sheffield-marked item among the early gifts, there are few larger or heavier items of tableware. There are not many candlesticks, apart from an elegant neoclassical pair weighing 51 ounces together, which Dr Hunter, Professor of Anatomy, gave in 1771. They are complemented by four identical ones given by Joseph Wilton RA, Benjamin West PRA, Paul Sandby RA and G. B. Cipriani RA, making up a dignified set for lighting a dinner table of 12. It was more than a century before more arrived: a pair in 1891 marked for 1775. Another four arrived in the 1920s, again of late eighteenth-century date, by the distinguished neoclassical silversmiths Smith and Sharp. The focus of the collection was on accumulating plates, flatware of an increasing variety, salts and other condiment vessels. Over time the choices changed and widened, reflecting the evolving dining patterns of London society.

Despite Britain's economic troubles during the French and American wars, the 50 years from the Academy's foundation were notable for the lavishness of the tableware available in London and its competitive display on English tables. In 1785 the German traveller Johann Wilhelm von

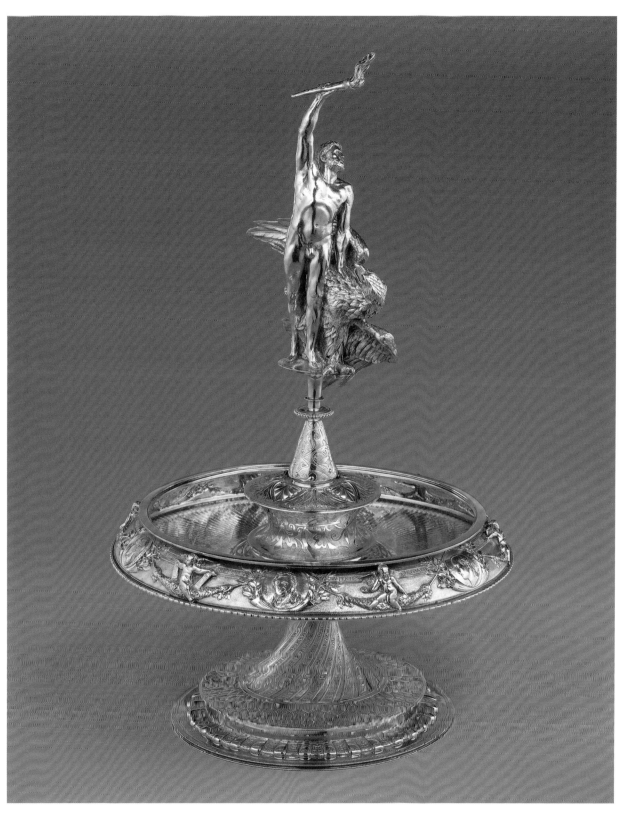

363 Henry Hugh Armstead RA, centrepiece, designed by Armstead 1872, made by Hancocks & Co. 1872, silver, 48 × 30.5 × 30.5 cm (RA 03/5421).

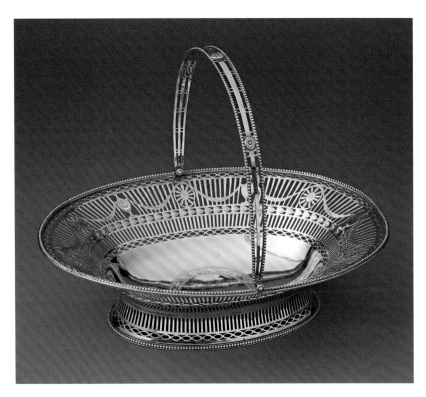

364 J. T. Younge & Co., bread basket, 1779, silver, 23.4 × 26.1 cm (RA 03/5700).

Archenholz observed, 'Nothing can be more superb than the silversmiths shops. In looking at the prodigious quantity of plate piled high and exposed there, one can only form a proper idea of the riches of a nation.'[7]

Although several Academicians such as Thomas Stothard, John Flaxman, John Yenn, Sir William Chambers himself and, later, E. H. Baily were distinguished as designers of silver for London's internationally known silver manufacturers, their collective familiarity with the upper end of the late eighteenth-century and Regency silver world had no impact on the look of the Council silver. The energetic Stothard, who was renowned as a versatile designer of plate, devised some of the most admired objects sold by Rundell and Bridge, the showy royal goldsmiths on Ludgate Hill, whose emporium was part of the tourist trail until its closure early in the 1840s. One of their memorable designs for flatware was Stothard's richly encrusted diestruck *Stag Hunt*, associated with Paul Storr's workshop, which was a wholly owned subsidiary of Rundells, although nothing showing this flam-

boyant Regency taste was ever chosen for the Council table. Was this the reflection of a personal and collective discomfort about being associated with commercial design?

After a lull in the 1830s and 1840s, for some reason the Council silver collection for dining was growing in the 1850s. Newly purchased flatware, acquired between 1850 and 1859, would have enabled rather larger groups to dine together. Although this has been explained as supplying the dinners of the Royal Academy Club (originally the Academy Club, revived in 1847), that reasoning cannot be correct because the dinners were catered at the Thatched House Tavern or at the Crown and Sceptre at Greenwich, or in Richmond, and in any case did not involve more than 20 or so diners, according to a small red account book in the Library.

Individualism and personal preferences in plate design appear intermittently at the Academy from the mid-nineteenth century onwards, as a symptom of a widespread rejection of the excesses of contemporary design. A few drawings for silver preserved in the collections show that there were exceptions to the convention of Academicians not designing tableware for the institution's use. In the 1850s, to take one example, Sir Robert Smirke RA made a sketch for a silver caster for the Academy, which was apparently never realized. The Armstead centrepiece referred to above, designed by the sculptor himself, owed at least its overall form and central band to widely admired designs for silver for the Tudor court by Hans Holbein, a reflection of contemporary aesthetics. Armstead's drawings for this centrepiece are in the Academy collection (fig. 365).

In the middle decade of the nineteenth century a campaign was initiated to acquire antique silver, focusing on late eighteenth- or early nineteenth-century forks and spoons, as disdain about the look of contemporary tableware fed a demand for older tableware. In 1850 Sir Charles Eastlake PRA was in keeping with the spirit of the times in giving a set of shell-handled old flatware, which had been sold by the London retailers J. and A. Savory in 1837. The name of Richard Redgrave RA appears on a set of table forks hall-marked 30 years earlier (1822) by the London spoon-makers Eley and Fearn. Redgrave was a designer of silver for Henry Cole's reforming Summerly Art Manufactures, and criticized contemporary silver design for being 'overloaded with imitation of textures…[and] laborious littleness'.[8] Did this assessment colour his choice of second-hand forks, or was he

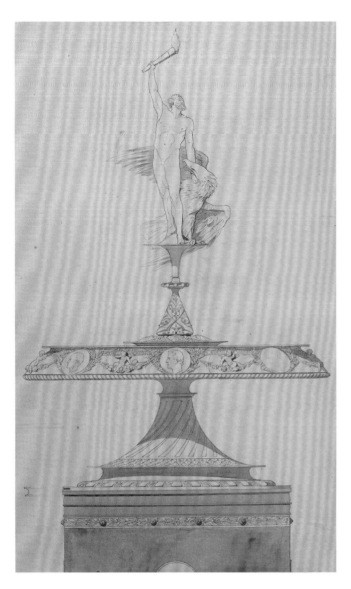

365 Henry Hugh Armstead RA, *Drawing for Centrepiece* (see fig. 363), 1872, pencil, pen and ink and watercolour on card, 56.2 × 40 cm (RA 04/3698).

merely contributing to the Secretary's campaign to equip the Academy with more old flatware, of a kind sold by weight at auction or by silver dealers and which was therefore less expensive?

There had always been an active market in second-hand silver, sold at little above its value by weight and available at goldsmiths, auctions, pawnbrokers and bric-a-brac shops. But the aesthetes' self-conscious seeking out of old silver, as being

more virtuous, simpler and more pleasing in design than the commercial products of the later nineteenth century, suited Royal Academicians, and perhaps at the prompting of successive secretaries the purchasing of simple old flatware, linked directly by its hallmarks or style to the origins of the Academy, was an obvious strategy. The fact that it was better value for money was due in part at least to the fact that it avoided the manufacturers' premium on new goods. As recently as 1972, indeed, we can see the habit continuing, as the dessert spoons acquired at that date and engraved with the name of Peter Coker (RA 1972) had been made more than a century and a half before: they are hallmarked for 1809.

As connoisseurship grew and the knowledge of how to read hallmarks became widely shared (the first publication of English hallmarks on antique plate was in the 1860s), the Academicians' choice of giving silver of an earlier date, or even from the founding years of the Academy, was more fully informed. In 1897, for example, John Singer Sargent RA selected an elegant neoclassical mustard pot, marked by the royal goldsmith Thomas Heming (fig. 366) and later adapted as a jam pot, with a notch cut in its rim. Sargent also had his name engraved on plate of the standard form of flatware, which was thus part of the sequence of donors stretching back to the foundation, although this order was organized by the Secretary. A distinct pattern of antiquarianism emerges. In 1880 Sir William Quiller Orchardson RA gave a bright-cut teapot of 1790–91 accompanied by a spoon tray of 1796, which offered a near-enough match in date and style. Sir Reginald Blomfield RA's gift of a teapot in 1914 again harked back to the early nineteenth century, for it bears the London hallmark for 1808. Sir John Lavery RA's choice in 1924 for his gift was a pair of sauceboats marked for 1774 by the fashionable Panton Street retailers Parker and Wakelin (fig. 367). In 1937 Frank Cadogan Cowper RA gave a cruet stand made in the 1780s, and in 1951 John Nash gave six dessert spoons, marked for Newcastle in the 1850s.

Oddly, the Academy owns very few silver drinking vessels, which are so typical of other masculine societies in early modern Britain such as regiments and livery companies. The exceptions are the two small fluted cups bequeathed by Francis Cotes RA that arrived in 1775, and were no doubt intended for toasts after dinner. They would have been filled with wine at the sideboard for the President and his favoured partner in the toast, to whom they would then be presented

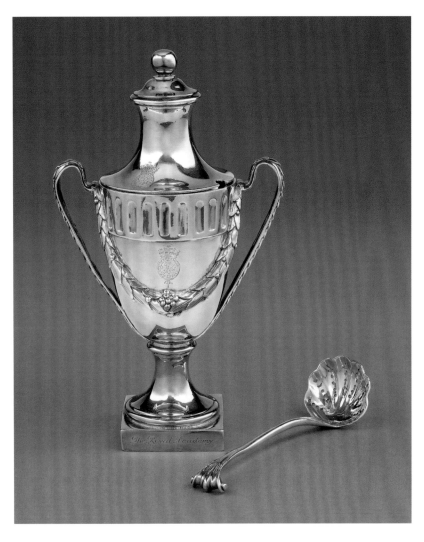

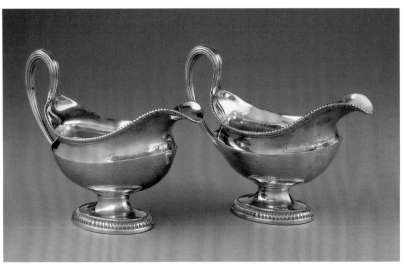

on the two waiters or salvers, which were themselves given by Francesco Bartolozzi RA and Mason Chamberlin RA in the early 1770s. George Dance RA's four circular stands intended for glass wine bottles or decanters, each labelled with a silver bottle ticket to identify their contents, would have then been moved along the table to fill up the glasses of others at the dinner. Presumably, as was the case at the dinners of the Dean and Chapter of Westminster Abbey in the later eighteenth century, the caterer provided stoneware mugs and glasses as part of the cost per head of the dinner, with a charge for those broken during the evening. Punch also featured as a standard after-dinner refreshment, and a curvaceous silver punch ladle, marked for 1783 with a delicate whalebone handle, was given by Edmund Garvey RA in 1787.

A large and handsome presentation cup, standing eight inches (20 centimetres) tall and made to the design of John Bacon RA in 1780, incorporates impressions of the gold and silver medals awarded by George III to students in the Royal Academy Schools. This commission may mark the move from Pall Mall to Somerset House that took place in that year. An exception in every sense to this pattern is an even larger two-handled presentation cup and cover, marked as made by Paul Storr in 1800, which is of especial interest on account of its intimate connections with the Academy (fig. 368). It is of the kind that was called a 'Fifty pound cup' and cost a total of £69 17s. 10d., including an engraved red leather case. It was designed by Benjamin West PRA 1799–1800 and presented to Margaret Gainsborough, according to the inscription upon it, as 'a token of respect to the abilities of her Father Thos Gainsbrough Esqr R.A.' (she had just donated her father's *Romantic Landscape with Sheep by a Spring*). In 1965 the cup was given back to the Academy by Margaret Gainsborough Gardiner, a descendant of Gainsborough's nephew.

Turning to the silver tableware, from the first large but plain tablespoon, we notice that each piece is engraved with

366 Thomas Heming, mustard pot, lid and spoon, silver,
13.2 × 12.5 × 6.7 cm, 6.8 × 6.5 × 6.5 cm and 12.6 × 4.2 cm, presented by John Singer Sargent RA 1897 (RA 03/5703, 03/5704, 03/5705).

367 Parker and Wakelin, two sauceboats, 1774–5, silver,
14.4 × 18.7 × 9.2 cm and 14.3 × 20 × 8.9 cm, given by Sir John Lavery 1924 (RA 03/5626, 03/5625).

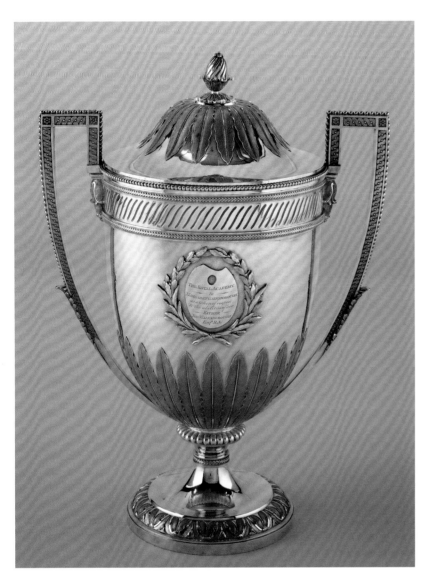

368 Paul Storr, presentation cup and cover, 1799–1800, silver, height 40.6 cm (RA 03/5956).

the name of the donor and date of donation, as well as the elegant laurel roundel of the Academy. The shaped plates, which weigh around 19½ ounces (550 grammes), bear a longer inscription, 'for the use of the President and Council'. By immediately adopting the practice of identifying original donors, the Academy secured a reminder of their generosity while also providing a useful means of checking the return of each precious item to store at the end of a dinner. The practice also had the more significant purpose of reinforcing,

at every social encounter, the assembled Academicians' delicious sense of their own history and of belonging to a continuing tradition.

Although the custom of giving a piece of plate (almost all for dining, with the exception of the first president's standish, given in 1769) was initiated in the first years after the foundation of the Academy, this requirement seems not to have been formally recorded until it was spelled out in a document dated 1799.[9] The reverse of the 1799 document has, however, a draft note of defaulters and of early donors, whose names stretch back to 1779, with facetious and hyperbolic comments about their gifts. These were largely standard tablespoons, but they are described variously as 'shining', 'elegant', 'incomparable', 'exquisite', 'brilliant' and 'for Green peas'. The neoclassical candlesticks were qualified as 'pompous'. This early list is headed by the 'superb' inkstand for the use of the President that had belonged to Sir Joshua Reynolds PRA (fig. 369), while Bartolozzi's waiter or salver is described as 'superexcellent', along with the Treasurer's 'elegant Nest of Cruets'. This joking language may echo the term 'Handsome' cited in the 1799 document, but no doubt was in use far earlier. The terms of praise reflect, in fact, the puffing language adopted in advertisements for silver in contemporary newspapers, such as, for instance, the Foster Lane wholesaler Thomas Daniel's vocabulary used to advertise his 'fashionable … finest … elegant … genteelest' stock of silverwares in the 1780s.

At five shillings and sixpence, the original contribution for silver was presumably calculated as the cost of the dinner at a contract price. By coincidence, it is similar to the entry fine, anciently called 'spoon silver', in the livery companies and city corporations. This sum would not have paid for even a single tablespoon in the late eighteenth century: the spoons given in the early years weigh a solid two and a half ounces (71 grammes) each, when silver was valued at five shillings and ninepence three farthings an ounce (as recorded in Matthew Boulton's trade ledgers in 1776–8).[10] And so the entry fine was far too small an amount to have paid for later acquisitions, such as sets of table forks. Just as the cost of the dinners increased over time, particularly during the Napoleonic Wars, so presumably the expected gift of silver, or cash in lieu, also increased. Unfortunately, it has not proved possible to trace any purchases by specific members. The 'Gentlemen's Ledger' of the Panton Street silver retailers

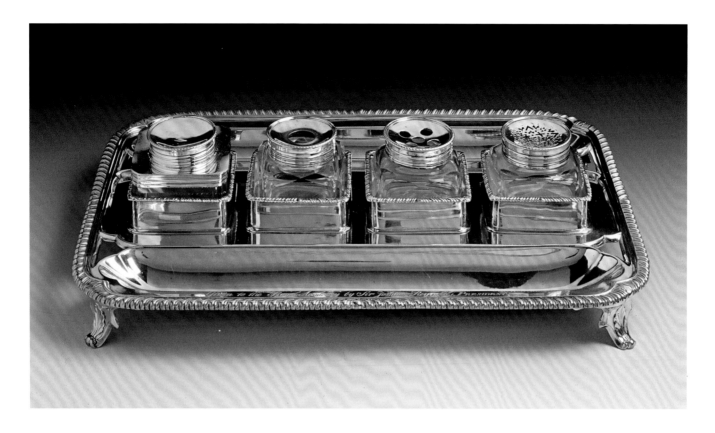

369 Parker and Wakelin, Sir Joshua Reynolds's inkstand, 1769, silver, length 36.8 cm, inscribed 'Given to the Royal Academy by Sir Joshua Reynolds, President' (RA 03/5185).

370 John Parker and Edward Wakelin, pair of sauceboats, 1764–5, silver, 16.9 × 22.7 × 10.2 cm and 16.4 × 22.7 × 10 cm, given by Nathaniel Dance RA 1772 (RA 03/5250 and 03/5251).

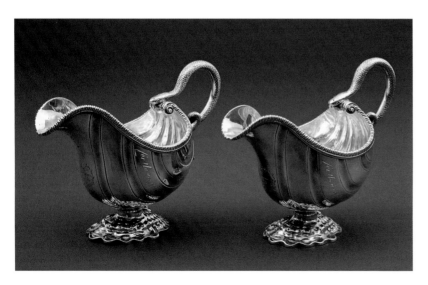

Parker and Wakelin, suppliers of the President's inkstand and of Nathaniel Dance RA's sauceboats (fig. 370), where both men had accounts, do not record payments for these items.[11]

The pattern of the Council's eating habits, as revealed through the silver as it accumulated, has several idiosyncrasies. No doubt, as royal servants the artists considered themselves worthy of silver tableware, but although it might have reflected the gentlemanly status they now enjoyed as Academicians, they chose not to align themselves with the lavish provision made for high-status employees in the royal household and among the aristocracy. When the 3rd Duke of Portland lived at Burlington House (he died in 1809), his upper servants ate every day in the Steward's Room with their own silver flatware, serving spoons and drinking vessels. In the first 50 years of the Academy, many of the artists enjoyed visits to the country houses of their aristocratic patrons, and so the grand dining style would have been familiar to them.

In the 1760s dining required several changes of plates, whether English or French style, since a choice of dishes was offered. It was calculated that, for a grand dinner for 24, 12

dozen plates would be required. This explains the presence of multiples of plates and flatware at the Royal Academy, even though they were initially intended only for use by the Council.

Although there are some personal choices, it is clear that successive secretaries, from Francis Milner Newton RA onwards, directed the Academicians' choices in order to build up specific elements for laying a handsome table, which explains the preponderance of shaped polygonal plates, 16 at least of which were acquired between 1788 and 1811, at the expense of James Northcote RA, William Hodges RA, James Wyatt RA and John Flaxman RA. They are heavier than the standard plate of the 1760s (at around 19 ounces or 540 grammes) and they bear various London silversmiths' marks. Some at least were purchased over a long period from the retailer E. B. Thomas at 153 New Bond Street, as stamped on the reverse. The curvaceous shape of these plates was no longer current on fashionable tables by 1800 but was already an established element of the Academy's history, and plates of this distinctive shape continued to be commissioned well into the twentieth century: for example, the name of Giles

Gilbert Scott RA appears on one of a series of plates bought in the mid-1920s.

By 1780, when the Academy moved to Somerset House from Pall Mall, the Council enjoyed a decent but unshowy assemblage, no doubt guided by Newton. Sauceboats hallmarked for 1766 and sold by the fashionable retailers Parker and Wakelin are engraved with Nathaniel Dance's name and the date 1772, while Sir William Chambers's five-bottle cruet stand entered the collection at about the same time. A set of four modest pierced salts with blue-glass liners, a standard design typical of the London firm of Hennell, was built up over a four-year period, and is recorded as given by Edward Burch RA, Richard Wilson RA, Joseph Nollekens RA and James Barry RA between 1771 and 1775.

Campaigns to build up sets of fashionable flatware can be detected in response to a more refined approach to the dining table. For example, in 1802 the simple equipment of spoons, plates, sauceboats, cruets and candlesticks that had been assembled by 1800 was extended by a pair of fish slices, the gift of Charles Rossi RA (fig. 371). Apart from sets of a dozen table forks, arriving from 1819, including dessert forks and

371　Robert Eley, fish slices, 1798–9, silver, 29.5 × 6.6 cm and 30.5 × 6.9 cm, given by Charles Rossi 1802 (RA 03/4877 and RA 03/4879).

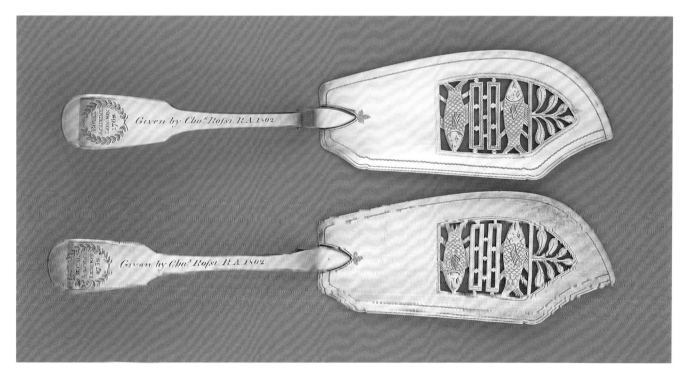

later dessert spoons, there was another innovation. Dinners became notably more decorous from the early nineteenth century onwards, and more diverse flatware, including teaspoons, sugar tongs and a teapot (presented in 1834), suggests a post-dinner custom of taking non-alcoholic drinks as well.

Although dining history glamorizes and simplifies dining practice conditioned by a mid-nineteenth-century bourgeois viewpoint, the picture is more complex. Tools for eating varied over time and place, as they do today. When the Academy first began, folding knives were clearly recognized as an adjunct to eating, particularly in France. In 1769 Joseph Baretti, the Royal Academy's short-sighted Italian-born Secretary for Foreign Correspondence, who was accosted at night in the Haymarket by prostitutes and then attacked, actually killed his attacker, a certain Evan Morgan, with his pocket knife. Its blade was protected with a silver sheath and the whole folded into a shagreen case. 'I wear it', he told the court at his trial for murder, 'to carve fruit and sweetmeats … It is a general custom in France, not to put knives on the table, so that even ladies wear them in their pockets for general use.' A witness testified: 'The outside is silver, the inside is steel, to cut a little bit of bread with.' The witnesses in Baretti's defence included Dr Johnson, Professor of Ancient Literature at the Academy; Oliver Goldsmith, its Professor of Ancient History; and the President, Sir Joshua Reynolds, who said that it was club night at the Academy and they were wondering where Baretti was, since he had not arrived, when they heard of the incident. Baretti was acquitted of both murder and manslaughter, since he carried the knife as an eating tool, not a weapon, and had acted in self-defence.[12]

Initially, the Academicians were echoing a widespread British practice in eating merely with large silver spoons, of the size we would call tablespoons, and in the institution's first half-century those at the Council dinners seem to have managed without forks. Perhaps the caterer supplied steel-tined ones with horn handles, or Sheffield-plated forks, with matching base-metal knives. At any rate, no silver forks were acquired until the set of twelve presented by Chantrey in 1819. This quirk may have sprung from a spirit of self-conscious simplicity and patriotism. Although aristocratic families had been accustomed to eating with matching sets of knives, forks and spoons from the late seventeenth century onwards, with gilded flatware for dessert, and even special knives for fruit and cheese, a practice shared by the wealthier livery companies in the City, there is a curious lack at lower social levels of table forks until the 1820s, as though the usual English practice was to eat with a knife and spoon only.

This phenomenon, at a time when different parts of society adopted forks, is rarely discussed by food historians, but can be confirmed from trade and other records. Quite apart from the need to learn the skill of politely manipulating fork and knife together, forks were troublesome and costly to make, and far fewer were in use than the ubiquitous silver spoon. At the Old Bailey Sessions, for example, out of some 3,000 cases of theft in London only a small proportion concerned a fork, in contrast with 300 in which spoons were mentioned. In 1787–8 the Dublin assay office marked four times as many tablespoons as forks, and 15 times as many dessert spoons as forks. No forks at all were marked at the Chester office. In Birmingham only two spoon-makers and no fork-makers registered marks between 1773 and 1800 (in a list of 120 names of silversmiths). Matthew Boulton in Birmingham had a reputation far larger, where flatware was concerned, than his capacity to manufacture. He sold a mere 12 silver forks to the trade in 1780, and supplied account customers with French plated spoons from Sheffield. Exeter assay office records for 1755–73 and 1780–84 also list no forks, other than the occasional mention of 'Sallad Forks' for serving.

From the 1820s, silver table forks became less expensive and were more widely used by the middle classes, which fits in with the advice given in contemporary books on behaviour. 'Agogos' (W. C. Day), in *Hints on Etiquette and the Usages of Society with a Glance at Bad Habits*, commented in 1834: 'At every respectable table you will find silver forks.' In the 1850s sets of a dozen table and dessert forks became a frequent acquisition in the Royal Academy, and it is noticeable that the names of H. W. Pickersgill (RA 1826), David Roberts (RA 1841), Sir Charles Barry (RA 1842), Thomas Creswick (RA 1851), George Doo (RA 1857), Alfred Elmore (RA 1857) and John Foley (RA 1858) all appear on these sets, in gifts presumably made in response to the Secretary's policy.

Between 1768 and the 1820s the Royal Academy gradually built up its silver for the Council dinners from single spoons, salts and candlesticks to a complete equipage that included vessels for tea drinking. But attitudes were changing. By the mid-nineteenth century, the Academy's assemblage was reflecting new practices at the table as well as changing attitudes to the design and associations of the tableware itself.

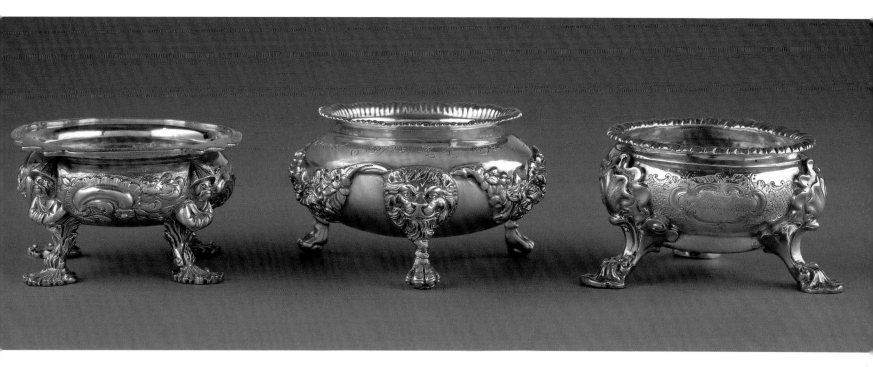

372 (left) Rebecca Emes and Edward Barnard, one of a set of four silver footed salts, 1817, 5.3 cm × 10.4 cm (diameter), given by Aston Webb PRA 1904 (RA 03/5265); (centre) George Lambert, one of a set of four silver-gilt footed salts, 1897–8, 5.8 cm × 11 cm (diameter), given by Ernest Crofts RA 1898 (RA 03/5257); (right) Daniel and Charles Houle, one of a set of four silver footed salts, 1860, 5.6 cm × 9.2 cm (diameter), given by Sydney Smirke RA 1860 (RA 03/5260).

Old plate became increasingly admired, as a reflection of the current distaste for 'Birmingham-bright' contemporary products and a preference for patinated surfaces. This reaction against the modern grew even stronger later in the century, and was reflected in the attitude of Charles Lock Eastlake, nephew of Sir Charles, in his *Hints on Household Taste* (1868), which was an essential guide for the aesthetically minded consumer. Eastlake announced, 'I have neither desired nor attempted in the following pages to do more than show my readers how they may furnish their houses in accordance with a sense of the picturesque,' while cautiously adding that his advice would be offered in such a way that it 'shall not interfere with modern notions of comfort and convenience',[13] This popular standard work, which went into four editions by 1887, rejected commercial silver and recommended seeking out simpler forms of antique plate and rummaging in the brokers' shops in Hanway and Wardour streets.

From 1869 until 1919 the Burlington Fine Arts Club held its exhibitions of antiques and works of art at its building in Savile Row, directly behind the Academy, and so there were opportunities to see and discuss antique plate with social equals close to home. Presumably these aesthetic attitudes conditioned Sydney Smirke RA's choice of rococo-revival lion-mask salts in 1860 (fig. 372: right), made to a design associated with Paul de Lamerie's output in the 1740s yet still in production in the early nineteenth century. Forty years later, two more Academicians chose to present similar salts of rococo design, although by different manufacturers: Ernest Crofts RA in 1897 (fig. 372: centre) and Aston Webb PRA in 1904 (fig. 372: left). Webb's salts, the closest to the original mid-eighteenth-century design and perhaps created from old casting patterns, had been made in 1817 by the large London manufacturers Emes and Barnard.

By 1861 the tableware had been augmented so that there was enough silver for more than just the Council dinners, although the plates and flatware were never sufficient for the formal public occasions hosted by the Academy. An inventory of the plate, with weights, taken that year concludes

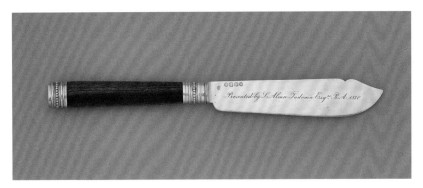
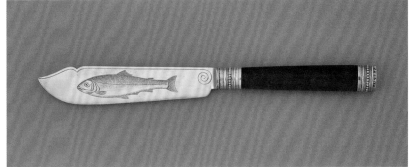

373a and b One of a set of twelve fish knives with silver-gilt blades and green-stained handles, 1879, 22.5 × 2.5 × 1.2 cm, gift of Lawrence Alma-Tadema RA (RA 03/4546).

with the latest arrival, Thomas Creswick RA's gift of a modest four-ounce (113-gramme) cheese scoop (he had already given a set of forks in 1852), at which time the table silver now weighed more than 1,300 ounces (37 kilogrammes). Although this would have seemed modest to an eighteenth-century secretary of state, for example, who had a personal allowance from the king's Jewel House of a thousand ounces, or an ambassador, whose allocation until 1820 was more than eight thousand ounces, it suited the established traditions of the Academy, which was shortly to travel to its present home in Burlington House, in 1868–9.

From the 1840s manufacturers had been promoting distinctive knives and forks for eating fish, although some social uncertainty hovered around their acceptability, since old families continued to eat fish with a fork and a piece of bread. Again the Council was slow to adopt this novelty. An echo of this ambiguous attitude may explain Edward Armitage RA's gift of fish knives, without forks. Sir Lawrence Alma-Tadema RA also gave 12 distinctive fish knives, without forks, with gilt blades engraved with fish and green-stained handles (fig. 373). His engraved name has the additional honorific 'Esqre', which is unusual, if not unique, among the tableware.

In the later nineteenth and early twentieth centuries the distinctive preferences of certain artist-donors become evident, their choice of gifts driven by self-image and aesthetic values. The 1890s saw exhibitions of Arts and Crafts silver, notably in the 1893 exhibition at the New Gallery of 'modern artistic silverware'. Gilbert Marks, who was well known for his chased floral Arts and Crafts silver, made a fruit bowl on a stand chosen by George Aitchison RA in

1897. In the same year George Henry Boughton RA gave a rather unsuccessful, self-consciously hand-raised, lumpy toast rack. Another later example of the Arts and Crafts spirit, albeit with a Nordic twist, is the large ladle given by Lady von Herkomer after her husband's death in 1914. Today this has a curiously dead surface almost recalling aluminium (it is silver, but was no doubt darkened originally with oxydization and later cleaned chemically), although the most striking element is the burnished silver statuette perched incongruously on top of the long verdigris-ornamented handle.

Historicism continued to play a role too, in the form of specially created designs that recalled past styles. Richard Norman Shaw RA, for example, designed a biscuit barrel in a Baltic mid-seventeenth-century style, with three feet and floral chasing (fig. 374), which recalls the York- or Hull-marked historic silver that was becoming known through exhibitions at the South Kensington Museum; and Solomon J. Solomon RA gave a Chester-marked steeple cup in Jacobean style in 1906. An architect known for his designs of church plate, G. F. Bodley RA, consciously commissioned a medievalizing cruet by the well-known art metalworker Carl Krall. In 1912 the painter Arthur Hacker RA chose to present a pair of pepper grinders in an aggressive knobbly design, devised by Sir W. Goscombe John RA, with relief trophies for each group of Academicians – sculptors, engravers, painters and architects – the whole evoking a kind of Tudorbethan monumentality (fig. 375).

Although some of the silver is deployed for the pleasure of Council members during the selection of the Summer Exhibition, the range of the plate belonging to the Academy is

almost unknown to the outside world. In 1969 the distinguished Victoria and Albert Museum curator Charles Oman wrote an article, 'Plate and Prestige', in *Apollo* magazine, about the Academy's silver to mark the institution's 200th anniversary. With characteristic acuity he summarized its early history, emphasizing the importance of plate in establishing prestige ('A well-furnished dinner table was almost essential for an aspiring public body'), and quoted the 1799 document that is the sole record of the requirement. The choice of illustrations, from Joshua Reynolds's inkstand to a rosewater bowl made by A. R. Emerson in 1953, the coronation year, and given by Edward Maufe RA, ignored the eclectic nineteenth- or early twentieth-century acquisitions, apart from the spectacular Armstead-designed centrepiece of

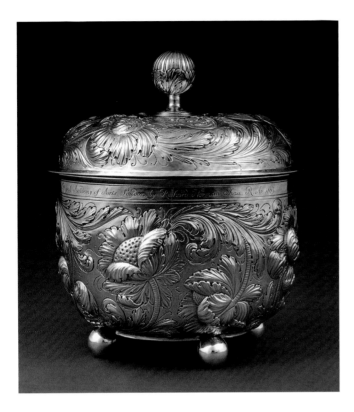

(left) 374 Biscuit barrel presented by Richard Norman Shaw RA, 1883, silver, 27 × 24 cm (RA 03/5200).

(below) 375a and b Pepper mills (two of a set of four) given by Arthur Hacker RA, 1912, silver, 12.7 × 6.8 cm each (03/5815, 03/5816, 03/5817, 03/5818).

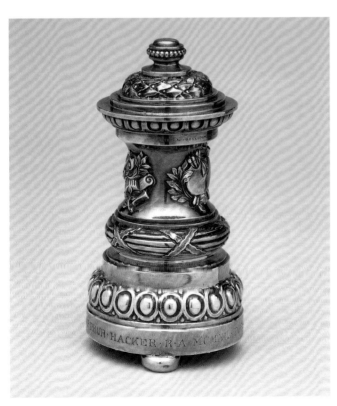

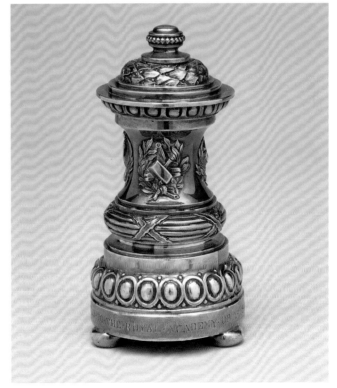

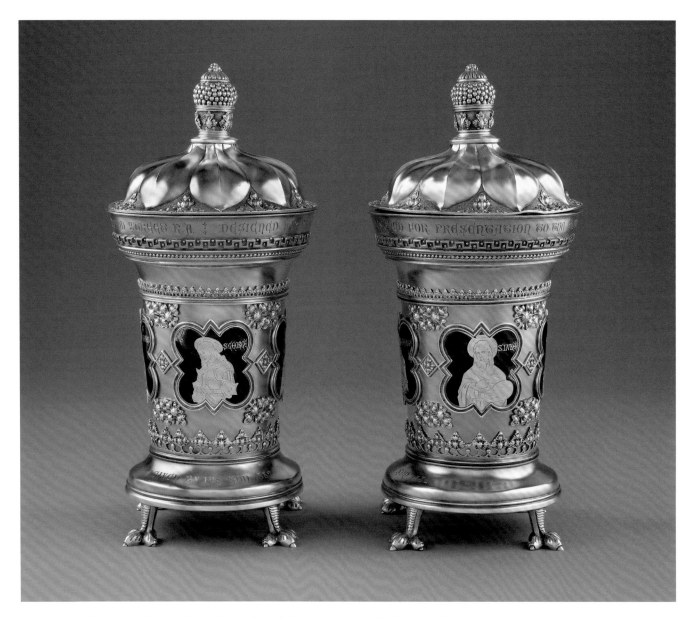

376 Designed by George Edmund Street RA, made by S. Smith & Son, two tall gilt salts (of four), Tudor revival, with enamels of the Evangelists, 1881–2, silver gilt and enamel, given by Street's son 1882, 13 × 6 cm (RA 03/5663, 03/5664, 03/5665, 03/5666).

1872, and G. E. Street RA's massive and flashy salts in the manner of late fifteenth-century Germanic beakers, depicting four saints in *champlevé* enamel, and called 'Vases' in a later inventory (fig. 376).

Fashions in silver scholarship evolve, however, and something of little interest to Charles Oman that intrigues us today is why the Academy acquired what it did when it did.

Unfortunately, there is almost nothing in the archive to explain those choices, and little has emerged about why, for example, in 1818 J. M. W. Turner gave six dessert spoons. By that date, 50 years after its foundation, the Academy was well stocked with tablespoons, and was about to acquire table forks. These two decisions, taken together, indicate a refinement in dining customs in response to growing public

exposure. Although the Council dinners were private affairs for a dozen diners and guests, huge publicity was given to the prestigious annual dinners, particularly after the Napoleonic Wars, when life became easier and taxes on food and drink dropped. As it happens, however, little silver was added in the 1820s and 1830s, which may reflect the slowing down in the rate at which artists might proceed to full election as Academicians during that period.

Ways of eating and attitudes to the necessary equipment for consuming food alter according to circumstances. In almost every respect a ceremonious catered dinner today differs from a private family supper. Collective sentiment and an established tradition can also be powerful drivers. The Royal Academy silver, accumulated as a result of both personal taste and institutional decisions over almost 250 years, also reflects changes in emphasis on the British table, from the Regency adoption of silver table forks to the emphasis on dessert and smoking rituals in the 1880s, which had become a major aspect of dining, although seldom, if ever, today. Sir Edgar Boehm RA's bear cigar lighter, with a honeypot as a reservoir for oil, was a typical picturesque joke, devised for wheeling along the table at the dessert stage. In a similar spirit, Murray Marks, although not himself an Academician, gave a humidor of aromatic wood, with its silver mount inscribed with a Shakespearean quotation in praise of the sweet herb tobacco. And there is an attractive cigar box with lid by H. G. Murphy given by Algernon Talmage RA in 1933 (fig. 377). Times change.

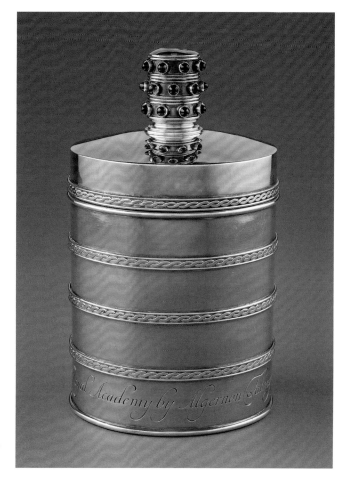

377 Henry George Murphy, cigar box with lid, 1933, silver, 17.5 × 10.5 cm, given by Algernon Talmage RA 1933 (RA 03/5736).

A CLOSER LOOK

Sir Joshua Reynolds's tea caddy

ROBIN SIMON

The amiable practice of donating gifts of silver to complement the social life of the Academy is exemplified by the presentation of Sir Joshua Reynolds's tea caddy (fig. 378) by a group of Academicians on 10 December 1898. In doing so they commemorated, of course, not only their first President but also themselves at a point when they were members of Council, as the inscription on the underside of the lid attests, while the date of the presentation, 10 December, marks the 130th anniversary of the Instrument of Foundation. The tea caddy was originally presented by 'M. B.' to Reynolds in that same year of the Academy's foundation, 1768, as recorded on its silver lock plate. Caddies were locked at this period in view of the relative expense of tea in order to prevent servants helping themselves to either the leaves or the silver, which includes, in addition to the lids of the glass containers for tea and sugar, six spoons, a sugar tongs and spoon-shaped strainer.

The inscription beneath the lid reads: 'This Tea Caddy, once belonging to Joshua Reynolds PRA, was purchased and given to the Royal Academy by Sir Edward J. Poynter PRA, Sir W. B. Richmond KCB, George H. Boughton, Hamo Thornycroft, Henry H. Armstead, Alfred Waterhouse, Ernest Crofts, Thomas G. Jackson, John S. Sargent, Frederick Goodall, Walter W. Ouless, Council for 1898, and Fred A.

Eaton, Secretary 10 Dec. 1898.' The inscription on the lock plate reads: 'M. B. to J. R. 1768'.

The Archive contains a number of documents tracing the tea caddy's arrival in the Academy. The most interesting of them is the letter of the initial approach from Mr Archer to the President, Sir Edward Poynter:[1]

[Dated 22 October 1898.
To Edward Poynter from James Archer][2]

Dear Sir,
I have in my possession the tea caddy that once belonged to Sir Joshua Reynolds, which was presented to him by the poet Beattie the author of the 'Essay on Truth'. It was given to my wife some good many years ago by Sir Theodore & Lady Martin; the hard hand of necessity is on me just now & I can see no other way of raising the money that I require than by parting with it. When I showed it to Sir John Millais he exclaimed at once 'The Academy should have that!' but you can imagine Sir Edward that it is very hard to me the idea of parting with what [to] a Painter must be so precious.

It is a black shagreen silver mounted casket having a richly ornamental lock on which was engraved the initials 'M.B. to J.R. 1768'. Inside there are 3 silver mounted crystal goblets

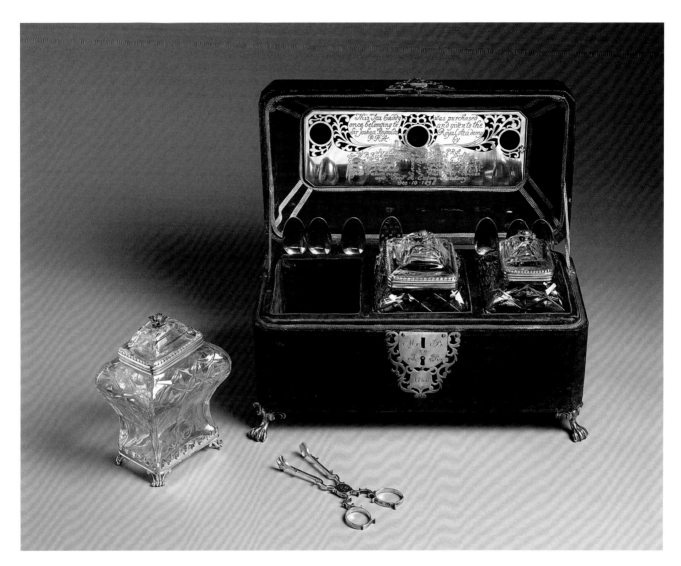

378 Tea caddy set presented to Sir Joshua Reynolds PRA by 'M.B.' in 1768, silver in a lined case, 20 × 31 × 17 cm, donated to the Royal Academy 10 December 1898 by a group of Royal Academicians (RA 03/4895).

for the tea & I presume sugar, as there is a pretty little pair of sugar tongs along with the 6 teaspoons & a perforated one that I suppose they poured the tea through.

Sir Theodore Martin told me when he got it that the full number of teaspoons was deficient & he got others made to complete the set There is also within the velvet lining of the lid a parchment of an old writing giving a short statement of the history of the casket & how much it was valued by Sir J.R. If the Academy think they would like to possess this

tea-caddy I would be willing to part with it for 100 pds. (though 'willing' is not exactly the proper word.)

I beg Sir Edward
Yours faithfully & respectfully
 James Archer

The Council minutes for 1 November 1898 record that this offer was initially turned down, only for the tea caddy to be purchased shortly afterwards by the group mentioned above.

13

FURNITURE

SIMON JERVIS

In the Life Room of the Royal Academy Schools, erected to the design of Sydney Smirke RA in the late 1860s, are two tiers of curved benches with, in front, a broad rail with a shelf for drawing implements below, on which drawing boards can be rested (fig. 379). The ensemble is believed to have been transferred to Burlington House in 1869, having previously been at New Somerset House from about 1781 and subsequently, from 1837, in the National Gallery building on Trafalgar Square. It appears in Thomas Rowlandson's *A Life Class at the Royal Academy* of 1811 (see fig. 405) and his *Drawing from Life at the Royal Academy* (Somerset House) (see fig. 25). In Johan Zoffany RA's *Academicians of the Royal Academy* exhibited in 1772 (see fig. 121), something similar is to be seen. The composition is set within a nondescript room that may have been in the Pall Mall house belonging to the bookseller Richard Dalton, the kings's librarian, which was the first home of the infant Academy from 1768, although it might possibly be a room in Old Somerset House, whither

the Schools and Library moved in 1771. In any event, sections of what appear to be rails very like the kind in Zoffany's painting are also to be seen in Edward Francesco Burney's watercolour of the Antique School in New Somerset House (see fig. 26). Zoffany's earlier unfinished *A Life Class at St Martin's Lane Academy*, painted in 1761–2 (see fig. 425), depicts similar fitments, and since in 1767 the St Martin's Lane subscribers had agreed for the transport of 'their furniture, anatomical figures, busts, statues, & c.' to Pall Mall,[1] it is not impossible that elements in the present Life Room date back to 1735, when William Hogarth established the second St Martin's Lane Academy in St Peter's Court. They may thus be, in Royal Academy terms, prehistoric relics.

In 1787 a carpenter, George Neale, was paid 9s. 9d. 'To fixing up seats in the Model Academy',[2] which could refer to the benches. Burney indicates that, in about 1779, in Old Somerset House these rails were being used in front of individual boxes on which the students perched. A few years

379 Marcus Leith RA, *Benches in the Life Room, Royal Academy of Arts, London*, 2010, photograph (RA 10/4109).

after the move into Chambers's New Somerset House, which was in 1780, these benches were presumably created to provide a more permanent seating while still using the old rails that supported the drawing boards and lamps – lamps that appear identical in Zoffany's painting of the St Martin's Lane Academy and Burney's watercolour. Burney's drawing of the Antique School in New Somerset House, however, predates the making of the benches, and here again are the sections of rails, with lamps, behind which students are seated

on boxes. In Zoffany's *Academicians* the only visible seats – behind sections of those rails with lamps – are examples of the same simple wooden boxes, on which Zoffany himself and his crony Francis Hayman are sitting. A teaching studio in an academy is not a place for fancy furniture.[3]

It is worth recalling two features that were so central to the Life Room: its main lamp and its stove. The lamp is prominent, indeed central, in Zoffany's *Academicians*, and may be the same as that shown in Elias Martin ARA's *Picture*

380 Students at work in the Antique School showing casts on movable bases fitted with iron handles.
The Lady's Pictorial, 19 February 1916.

of the Royal Plaister Academy (see fig. 427). As early as 1771 'Buhl' was paid £1 4s. for altering the lamp following the Council's resolution on 19 May 'that Mr Richards's Improvement of the Lamp be adopted & that he be desired to order & superintend the making of it'.[4] Evidently this did not prove satisfactory, and the Council resolved in 1773 'that the Lamp be altered according to the Directions of the Council & Visitors under the inspection of the Keeper'.[5] The stove was equally a preoccupation: on 15 October 1772, 'Several of the Visitors having complained that the stove in the living Academy does not give Heat enough. Order'd that Mr Moser be desir'd to speak to Mr Jackson about it', and on 6 November, 'Mr Moser reported that Mr Jackson had seen the stove and would make a new one.'[6]

Furniture that certainly survives from the premodern (in the art-historical sense) period includes two rudimentary

wheeled stands, one rectangular for the cast of a horse, the other square for the life model. In 1788 the carpenter, George Neale, just mentioned, charged a day's labour, three shillings, 'To Repairing platform in model academy and fixing Castors [*sic*] to ditto'; the eighteen brass casters cost ten shillings.[7] And distributed round the Schools and in stores is a handsome series of square or rectangular plinths for plaster casts, usually with boldly moulded bases and often cornices, some with casters, and many with beefy iron handles on their sides (fig. 380).[8] Once again George Neale's 1788 account is relevant, charging £1 9s.: 'To a new pedestal with 4 Strong Castors and 2 Iron handels to ditto'.[9] Oak graining, or an indeterminate dark brown or black, are regular finishes, although one pedestal, for the Medici Venus, has a black base and *verde antico* marbling. Several bear labels or inscriptions, and it may thus be learned that the Prince Regent presented the casts of

the *Germanicus* from the Louvre and the *Belvedere Torso* from the Vatican (in 1816) and 'Sir F. Leighton P.R.A.' that of the *Hermes* from Olympia. There are also some columnar bases, one for a cast of the *Capitoline Cupid and Psyche*, evidently for the Schools, another, with a black base and a dark red 'porphyry' drum, possibly for a showier location.

Otherwise, there is little furniture directly associated with the Schools. One touching exception is a low oak chest, of about 1850, with seven drawers and a 'Wellington' locking device, which bears much evidence of long use, including old paper labels inscribed with such legends as 'Willow charcoal' in fine Italic calligraphy that itself recalls the vanished Arts and Crafts world of the master penman and typographer Edward Johnston. There are still easels in the Schools, but they are of no obvious antiquity. A proxy for such 'native' practical furniture is provided by the easels associated with celebrated painters which have inevitably gravitated to the Academy. Pride of place goes to an easel said to have been given to Sir Joshua Reynolds PRA by the poet and divine William Mason, in recognition of Reynolds's generosity in annotating his 1783 verse translation of Dufresnoy's *L'art de peinture* (fig. 381). Of handsomely carved mahogany, it was included in the 1821 sale of the possessions of Lady Inchiquin, Marchioness of Thomond, Sir Joshua's niece and heiress,[10] and was later presented to the Academy by Sir Francis Grant PRA. Other easels include one given by Sir Edwin Landseer RA to his friend, the painter James Ward RA, which passed to John Ward Knowles, stained-glass manufacturer and painter in York, whose son presented it to the Academy in 1931; an easel that had belonged to the watercolourist Myles Birket Foster RWS, who was not an Academician, which had been presented to Agnews in 1958 by his grandson, Captain Lancelot Glasson, and passed from Agnews to the Academy in 1971;[11] and two easels that had been used by Dante Gabriel Rossetti, who was emphatically not an Academician. The first of them was given in 1937 by Mrs Penryn Milsted, daughter of the art dealer and friend of Rossetti, Murray Marks, while the second was purchased at the Kelmscott sale in 1939 (following May Morris's death in 1938) by the artists Edward (né Scott-Snell) Godwin and his

381 Three-legged mahogany easel with profile medallion of Sir Joshua Reynolds, *c*.1783, 188 × 94 × 92 cm (RA 04/1341).

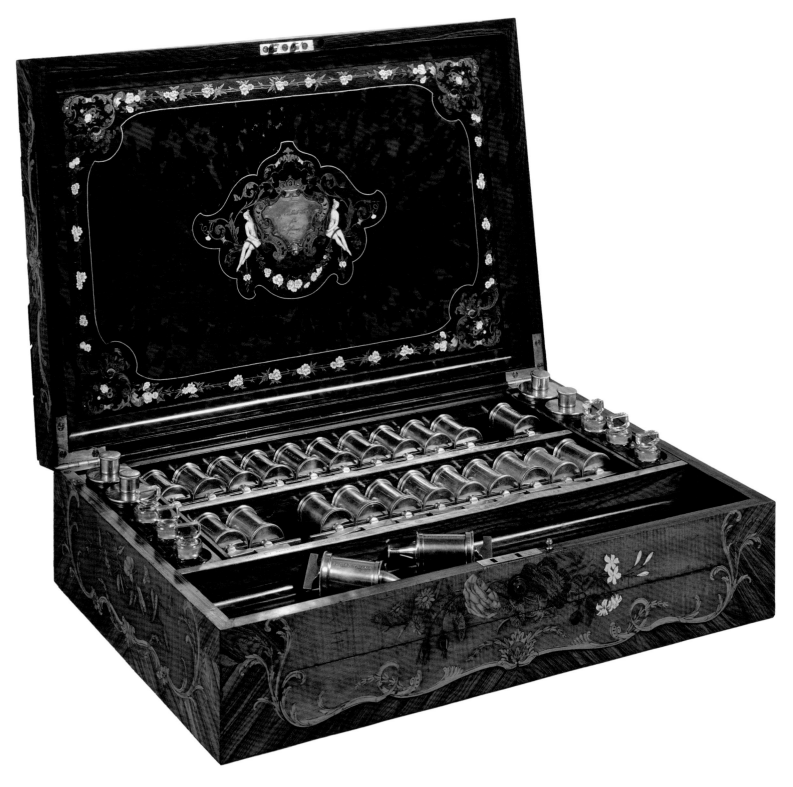

382 Queen Victoria's painting box, *c*.1837, inlaid wood and fitted interior including 24 silver-plated syringes for oil colours with silver-plated strips below to mark each place, 15 × 58.5 × 38 cm (RA 03/2530).

wife Stephanie (née Allfree) Godwin, who were tenants at Kelmscott from 1940 to about 1945. It was presented to the Academy by Mrs Godwin in 1957.[12]

A larger category of practical equipment is made up of painting or drawing boxes, many of which have accumulated in the Academy. Some are small, modest, functional objects, but a few are worth singling out, such as a neat mahogany box that belonged to the miniature painter William Grimaldi, incorporating a palette, drawer and lectern. Another is a rosewood paintbox with Winsor & Newton colours in trays and a drawer that was used by William Etty RA, and another mahogany example, incorporating an elaborate and ingenious folding slope covered in green baize, which was that of another miniaturist, Sir William Ross RA, a great favourite of Queen Victoria. These pale, however, before two boxes which belonged to the queen herself.

The first, for watercolours and still containing Ackermann watercolour blocks, was given to the Academy by the queen's artistic fourth daughter, the sculptor Princess Louise, Duchess of Argyll, in about 1900. It is a handsome rosewood object, probably dating from about 1845, inlaid with borders and blocks of stylized foliage in mother-of-pearl. The second, for oil paints, was given by Edward VII in 1906 and is of exceptional quality and interest (fig. 382), not least on technical grounds, as its fittings include not only two palettes and bottles for turpentine, linseed oil, and 'mastich' and copal varnish, but also 24 silver-plated syringes inscribed with the names of colours, all fitted into two neat rows with silver-plated strips below, similarly engraved to ensure that the syringes are replaced in the correct position after use. In 1824 James Harris of Plymouth was awarded a silver medal by the Society of Arts for a 'syringe for the purpose of preserving oil paint', endorsed by Sir Thomas Lawrence PRA, William Collins RA, and John King of Dartmouth. Harris's syringes were superseded by Winsor & Newton's glass tubes, patented in 1840, themselves rapidly replaced by the screw-top collapsible metal tubes patented in 1841 by the American painter John Goffe Rand.[13] The queen's box is thus unlikely to be later than 1840. It bears the inscription 'To My Beloved Victoria from Her Affectionate Mother' – that is, Princess Victoria of Saxe-Coburg-Saalfeld, Duchess of Kent, herself an accomplished artist – and may date from about 1834 when the future queen, then approaching her 15th birthday, first attempted oils.[14] The box is equally remarkable for its

decorative treatment. Inside the lid it is veneered in tortoiseshell with floral borders and the central inscribed cartouche in silver, brass, copper, ivory and abalone shell, a rich combination evoking Boulle prototypes, while its exterior is clad on top, back and sides in very fine floral marquetry in rococo cartouches. The front incorporates a drawer with a lower edge shaped to the outline of a rococo cartouche the top of which extends on to the front of the lid. Attribution of such work is a risky business, but both style and quality strongly suggest that the box was executed by the leading specialist Robert Blake, 'cabinet inlayer and buhl manufacturer' of 8 Stephen Street, Tottenham Court Road.[15]

In contrast to this special treasure is a miscellany of pleasant mid- to late nineteenth-century portfolio stands, one in oak and a couple in mahogany (one bequeathed by Carel Weight RA), and a big mahogany portfolio cabinet, nearly 10 feet long, with glazed doors to ends and sides and drawers in its frieze. This last piece, which long did duty as storage and work surface in the mount-cutting and framing work shop off the picture store, is just the sort of solid useful object that should populate a long-established institution. A big glazed bookcase in the Schools, with an acanthus frieze, now painted black but once oak-grained, is said plausibly to have come from the Academy's rooms in William Wilkins RA's National Gallery, which was built 1834–8. There is also an ebonized vitrine on a similar scale for the display and protection of skeletons, human and animal, that probably post-dates the replacement of the skeleton collection in 1876–8 and was perhaps designed by Richard Norman Shaw RA (fig. 383). A decent Victorian mahogany roll-top desk with twin pedestals and a solid dining table with heavily reeded legs, also mahogany, in the Secretary's office are further objects in this miscellaneous category, which also comprises, a little surprisingly, a simple Victorian mahogany dressing-table mirror, perhaps of about 1850, and a mahogany wash-hand stand of the same ilk, stamped by an obscure London maker, 'TURURTT'. Also marked and unprovenanced is a large mahogany arm-chair with turned front legs stamped under its front seat 'HOLLAND & SONS', the greatest London furniture firm, who signed thus from 1843.

The furniture firms employed by the Royal Academy in its earlier years include Montellier (£13 16s. 0d. on upholstery in 1769);[16] Arbuckle, upholder (£18 10s. 2½d., also in 1769);[17] Ayliffe and Webb (upholstery, £1 16s. 0d. in 1771, a

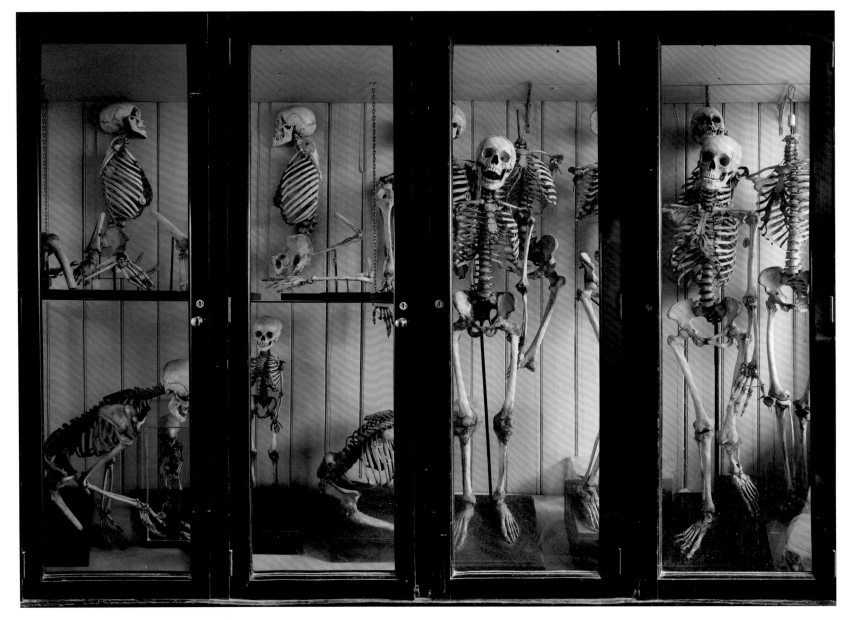

383 Attributed to Richard Norman Shaw RA, skeleton cupboard in the Schools, wood and glass, 254 × 333 × 65 cm (RA 17/1066).

floor cloth, 5s., in 1772, and matting, £2 0s. 9d., in the same year);[18] and George Seddon & Sons, 'Cabinet Makers and Upholders, Also Manufacturers of British Cast Large Plate Glass', first noted in 1785 and employed in most years up to 1795.[19] The one detailed Seddon bill, covering 1785 to 1788, with a total of £12 3s. 6d., includes one large item, 'A Mahogany frame to support Books', which cost £8 10s. 0d.

in July 1786, and a few small items, among them, in 1785, 'Beating & Cleaning a large Turkey Carpet 4s.', which proved to have been charged in error, being work done for the Royal Society, the Academy's neighbours at Somerset House. Seddons, however, were involved in a flurry of prosaic activity from April 1788, occasioned by the Annual Exhibition: 'Porterage of Green Baize Covers to Somerset place 2

384 Ottoman, one of 17, supplied in 1868, semicircular ends with buttoned upholstery and mahogany-carved lions' feet.

Workmen laying down the Baize in the Exhibition Room & Room adjoining & covering stand for Figures & Rails in the Hall & pay place & 4 Benches with new Baize and 4 Stands with Do. Where the Drawings are & new Baize to a Picture £1.8.0'. Such activity no doubt complemented 'Carpenters Work done at the Royal Academy by George Neale', charged for that same April, including 'To taking Down Seats and taking in pictures and fixing up and taking Down Ditto 106 days £15.18.0', a substantial sum.[20]

For a century the Annual Exhibition constituted the Academy's principal public face, but to judge from the Seddon account just cited and the somewhat rudimentary benches, probably temporary and apparently covered in green baize, shown in Edward Burney's 1784 drawing of the exhibition[21] and in the 1808 aquatint after Pugin and Rowlandson from Rudolph Ackermann's *Microcosm of London*, its furnishings were basic. After, however, the move to Burlington House in 1869 and the initiation of the Winter Exhibition in 1870, along with the opening of the Diploma and Gibson Galleries in 1874–8, all designed by Smirke, with the Gibson Galleries being completed by E. M. Barry RA, there was a need for more permanent seating. It is possible that a battered pew-like bench in the Schools could be a survivor of a seating scheme dating from early in this phase. Something more substantial is visible in the view of the new Great Room published in the *Illustrated London News* in July 1869, but not clearly delineated. This was probably one of no fewer than 17 large rectangular, semicircular-ended ottomans with buttoned upholstery on their seats and central backs, and lions' feet carved in mahogany (fig. 384), supplied in 1868 and shown in early twentieth-century photographs and in a 1939 drawing of varnishing day by Feliks Topolski RA.[22] Probably slightly later are a pair of big mahogany benches, upholstered in buttoned red leather, with end uprights nicely carved with a band of guilloche enclosing rosettes terminated by a semicircular acroterion.[23] Three large back-to-back benches with ebonized frames, with 'RA' in gilt letters on their back rails, may be contemporary. A very large – over 11 feet (3.4 metres) long, mahogany bench in the Schools, with a continuously dished wooden seat and back, is of the same basic pattern as a slightly shorter bench with curved ends, upholstered in buttoned black leather, that was made to fit the bottom of the Norman Shaw stairs, which were completed in 1885. Another object for public use is a battered wheel-

385 Chair marked 'Treasurer', rush-bottomed with ladder-back, one of a set, originally of 40 similar, c.1771 (RA 04/1060).

chair converted from a square-backed late nineteenth-century armchair, with shallow-buttoned red leather upholstery, a sliding footrest and, across its back rail, the gilt inscription 'ROYAL ACADEMY OF ARTS'.

The Academy's lectures were less accessible than the Summer Exhibition, but were open to distinguished (male) visitors and thus formed an element of its public presence. In 1771 the Council 'Took into consideration the Seats at the Lectures' and 'Resolved, that forty Chairs be placed, & out of these, twelve to be allotted for Strangers of Distinction & be marked with the Letter V. The rest with the Letters R.A. That

two Benches (with a Back-Rail) to hold vi each be provided for the associates and marked with the letter A. That these Benches be placed behind the Seats for the Strangers' and 'That the Treasurer sit on the right hand of the President, the Keeper on his right and the Secretary on the left Hand of the President'.[24] In 1914 George Dunlop Leslie RA, whose memory went back at least to 1854 when he entered the Royal Academy Schools in Trafalgar Square, wrote: 'I recollect a number of old rush-bottomed chairs which used to be placed on lecture nights in front of the students' seats, for the exclusive use of members. On the backs of some of these chairs were painted the words, "The President", "The Keeper", "The Secretary", "The Treasurer", but in my time I hardly saw any of the officials seated on them except the Keeper.'[25] Despite Leslie's having intruded the definite article into his titles, the chairs he describes must be those that survive in some quantity, including one labelled 'TREASURER' (fig. 385), which are clearly of eighteenth-century date. Their ladder-back form goes back to at least 1625 when a similar chair was illustrated by Hendrik Hondius in his *Instruction en la Science de Perspective*;[26] later, more elaborate, late seventeenth-century versions are in the First State Room at Boughton.[27]

Examples of what may have been the Academy's chairs can be glimpsed in Zoffany's painting of *William Hunter giving a Lecture on the Muscles at the Royal Academy* of 1772–3 (Royal College of Physicians, London). Another is clearly shown in Henry Singleton's sketch for his group portrait of the Royal Academicians in General Assembly (British Museum, London), which establishes these chairs as rare eighteenth-century documents of this form.[28] They may be those supplied in 1771, in which case it is plausible to attribute them to Ayliffe and Webb, who, as noted above, were working for the Academy at this date and specialized in turned chairs; or, less likely (since we can see examples in the Zoffany painting of Hunter), they may be part of a new set purchased when the Academy moved into their new rooms at Somerset House in 1780.

What was supplied to these new rooms, or rather to their ground floor entrance hall, was a set of oak hall chairs, of the typical *sgabello* form, painted on their backs with a nicely shaded crown and RA monogram, of which seven survive. George Scharf depicted one of these in his 1836 watercolour of the entrance hall (see fig. 24) and in his preliminary study

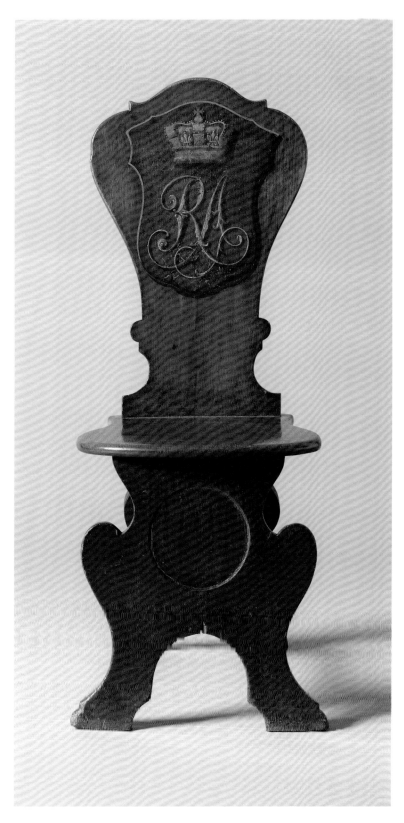

for that picture. Scharf attributed the painting of the motif on the chair back to 'Mr Catton, one of the first Royl [sic] Academicians…originally a Herald painter'.[29] They are now to be seen in the Library (fig. 386). Charles Catton RA was the leading coach painter in London, who worked on a design for George III's State Coach in 1760 and was appointed a Foundation Member in 1768.[30] In 1766–7 he worked for Sir William Chambers on a ceiling in Lord Clive's house in Berkeley Square, and Chambers owned paintings by Catton to the end of his life.[31] There are numerous payments to 'Catton Painter' in the Academy's accounts from 1777 onwards, for such substantial sums as '£7.15.9' (1777), '£10.3.3' (1778) and '£22.2.2' (1781), which leaves little doubt that Scharf's attribution was correct.[32]

Handsome as these hall chairs are, they do not qualify as state furniture. Indeed, the only object falling unequivocally into that category is the President's throne. This is shown, identifiably, both in Singleton's finished group portrait of the Academicians of 1795 (and in his preliminary drawing datable c.1793 (British Museum, London) and in Benjamin West PRA's 1793 self-portrait as President (fig. 387) and so must have been in existence by that date (fig. 388). Its attenuated gilt frame is surmounted by a carved and gilt cartouche in the form of a palette, with a maul stick and brushes, a pair of dividers and a chisel (representing painting, architecture and sculpture), red leather upholstery, a seat rail with a carved trophy in its centre, and tapering fluted legs. Its form is very unusual, roughly corresponding to the French *bergère à joues*, although the 'joues' are vestigial. It is difficult to imagine this having been produced under Chambers's aegis,[33] and it may be that it was commissioned by West on his election to the presidency in 1792. The throne is *sui generis*, but it is worth mentioning in its context a group (not a set, although nearly matching) of eight curvilinear gilt armchairs in a long-lived Louis XV pattern which, although much regilded, appear to be of late eighteenth-century date,[34] and also a set of five mahogany dining chairs in a post-'Chippendale' pattern, but with triple splats, neatly carved with neoclassical paterae, and having black leather seats with two rows of gilt nails. The latter pattern is comparable to the 'Three Upright Baluster Splat'

386 Hall chair painted by Charles Catton RA, eighteenth century, oak, 100 × 38.5 × 49 cm (RA 04/2251).

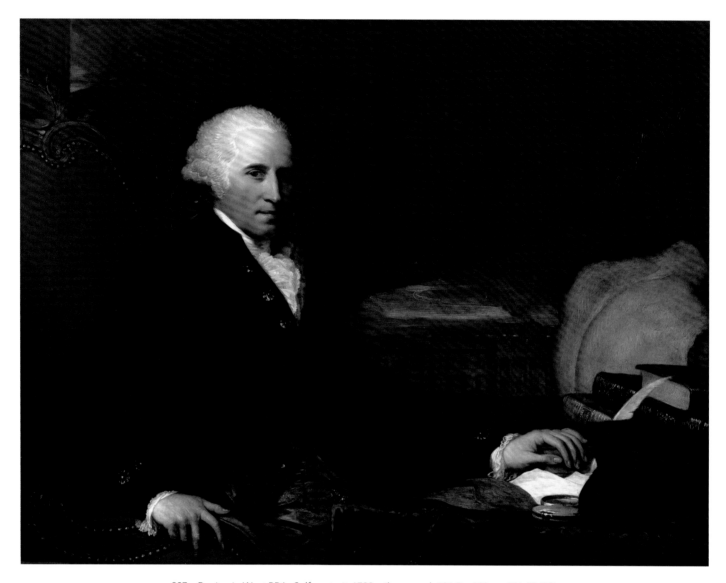

387 Benjamin West PRA, *Self-portrait*, 1793, oil on panel, 101.5 × 132 cm (RA 03/28).

design adopted by Gillows in 1779.[35] It is just possible that these two groups, stylistically complementary, may have been supplied in the late eighteenth century to afford the comfort and elegance appropriate, respectively, to a drawing room and to dining. But they may have arrived independently later.

Two sets of neat mahogany 'Parlour Chairs' with wide curved back rails, upholstered seats and turned front legs with lappets, their design reminiscent of patterns shown in Thomas King's *Modern Style of Cabinet Work Exemplified* of 1829 and still current in William Smee & Sons of Finsbury Pavement's catalogue of about 1850,[36] now serve as occasional chairs in the Madejski (Fine) Rooms. They may well have been acquired for public use during the 30 years from 1838 when the Academy was housed in the east wing of William Wilkins's National Gallery.

In 1885 Richard Norman Shaw RA converted what had been Lord Burlington's state bedroom, subsequently a state dining room and a refreshment room, into the Academy's General Assembly Room, the location for the private meetings of its governing body, a role it still fulfils; it is surveyed by

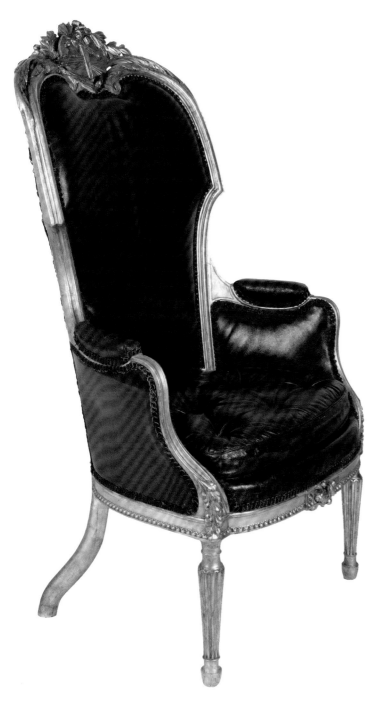

388a and b President's throne (a), perhaps commissioned by Benjamin West upon his election in 1792, gilt frame surmounted by a carved and gilt cartouche (b) in the form of a palette, with a maul stick and brushes, a pair of dividers and a chisel (representing painting, architecture and sculpture) with red leather upholstery, a seat rail with a carved trophy in its centre, and tapering fluted legs, 138 × 76 × 80 cm (RA 04/1065).

a built-in wall clock designed in 1931 by Sir Edwin Lutyens RA, who paid for half its cost. The room is dominated by a massive Victorian mahogany dining table, some 22 feet (6.7 metres) long, with six Brobdingnagian turned legs. Around the walls and the table are part of an extensive set of stylish klismos-legged chairs and armchairs, the central back rails of which are elegantly formed as fluted U-shaped drapes. The set also comprises four sofas. Although the style is 'Regency', it appears that the chairs were supplied a few years after the move to Burlington House in 1867, for they were first illustrated in Charles West Cope RA's *Council of the Royal Academy selecting Pictures for the Exhibition, 1875* and are thus a precocious example of the 'Regency Revival' (see fig. 122).[37] One is stamped 'BERTRAM & SON DEAN ST OXFORD ST W', a well-known Victorian firm founded by William Bertram in 1839 and disbanded in 1909.[38] This revival was re-revived when, in 1971, 30 reproduction armchairs were made, subscribed for by Academicians and Associates as well as, in the case of four, by the widow of Sir Howard Robertson RA, all of whose names are recorded in gilt lettering on the back seat rail of the appropriate chair. Before its recent restoration some other pieces had accumulated in the General Assembly Room, including a late eighteenth-century mahogany sideboard decorated with elaborate stringing but lacking its brass gallery, and a substantial Chippendale revival mahogany sideboard table with an open fretwork apron. Albeit pleasant enough, they hardly matched its regained splendours and have been consigned to store.

The Academy also possesses an accumulation of clocks. A couple of watchman's clocks in mahogany cases may be part of the original Burlington House fittings of about 1868, and a small mahogany-framed wall clock in the Library and another, larger, in store, along with a mahogany mantel clock on a scrolled base, could be of the same vintage. More recent arrivals include a small mantel clock with a case of ebonized and burr wood, presented by Sir Robin Darwin RA in 1972, and another, of black and grey marble with floral inlay, given by Laura Valentine and Colin McKenzie in 2004. A brass lantern clock, late seventeenth century in style and made by the substantial Victorian firm 'John Walker 230 Regent Street London', is inscribed 'Presented by Sir Hamo Thornycroft, R. A. 1890'. A grander benefaction was a long-case regulator clock veneered in mahogany, its silvered dial inscribed 'Viner, 235 Regent St. London', presented by the architect E. Vincent Harris RA in 1968.[39] Charles Edward Viner, a superior maker, traded at the address given from 1836 to 1855.

We may add some further objects with personal or particular associations in addition to those mentioned earlier. The Academy possesses two sitter's chairs associated with Sir Thomas Lawrence PRA, one bequeathed in 1891 by the Revd J. R. Bloxam DD, the painter's nephew, and the other presented in 1946 by the distinguished choir director Sir Sydney H. Nicholson MVO, who had inherited it from his grandfather Archibald Keightley, who had been Lawrence's executor. One of these interesting survivals is a straightforward square-backed caned mahogany armchair, with a reeded frame, turned legs and arm supports, and loose buttoned leather cushions to seat and back, probably of about 1810.[40]

Sir Joshua Reynolds's easel has already been noted, but the Academy also possesses two painting tables associated with the first President. One, presented by Mrs E. M. Fraser in 1954, was said to have come from the collection of General Francis Edward Gwyn, whose wife, Mary née Horneck, was a close friend of Reynolds and of others in his set, notably Oliver Goldsmith.[41] It is a neatly detailed but relatively plain example of the type called by Ince and Mayhew in their *Universal System of Houshold Furniture* (1754) 'Writing and Reading Tables', with a rising top, candle-stands and a fitted pull-out drawer which its front legs split to support. The second also has a rising top inlaid with a shell, but is formed as a Pembroke table. While the associations of these tables with Reynolds are not as watertight as could be wished,

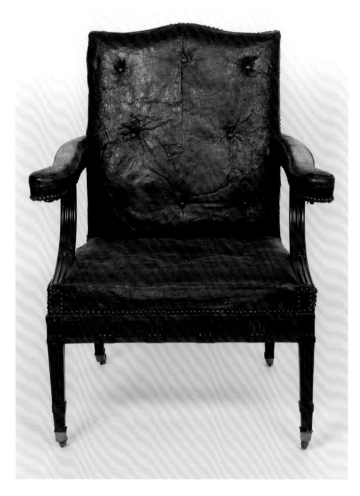

389 Sitter's chair of Sir Joshua Reynolds PRA, *c.*1762, mahogany with double-nailed and buttoned leather upholstery, with neoclassical chair-rail, fluted triglyphs, armrests and square tapering legs, 103 × 75 × 75 cm (RA 04/1067).

those of the final object to be mentioned, Reynolds's sitter's chair (fig. 389), are impeccable. In January 1794, less than two years after his death, it was presented by his niece, Mary Palmer, and her husband, by then Lord and Lady Inchiquin, to James Barry RA, who acknowledged the gift in fulsome terms.[42] On Barry's death the chair was inherited by his biographer, Dr Edward Fryer, at whose posthumous sale in 1826 it was spotted by the engraver, writer and antiquary John Thomas Smith, and purchased by him for Sir Thomas Lawrence. On Lawrence's death in 1830 it passed to his suc-

cessor as President, Sir Martin Archer Shee, and at his sale it was bought by the third of this succession of presidents, Sir Charles Lock Eastlake, followed by two more, Sir Francis Grant and Sir Frederic (later Lord) Leighton, who gave it to the Academy in 1879.[43]

At first glance Reynolds's sitter's chair looks like a typical, though good quality, mid-eighteenth century mahogany piece, with double-nailed and buttoned leather upholstery, of the type known, misleadingly, as a 'Gainsborough' armchair, but which was called by Thomas Chippendale in *The Gentleman and Cabinet-Maker's Director* (1754) a 'French Chair'. What makes it special is the neoclassical detailing of its chair-rail, with fluted triglyphs, with its armrests and square tapering legs also fluted. The chair is first noted in Reynolds's 1762 seated portrait of *Emma, Countess of Mount Edgcumbe* (private collection) and is particularly conspicuous in his unfinished portrait of 1766, *Lord Rockingham and Edmund Burke* (Fitzwilliam Museum, Cambridge). A stool or bench of the same pattern is shown in *Mrs James Paine and the Misses Paine* (Lady

Lever Art Gallery, Port Sunlight), also of 1766, and a small sofa in his *Mrs Baldwin* of 1762 (Compton Verney). The Doric detailing is precocious for what must have been a suite of seat furniture of the early 1760s. John Harris has suggested that Sir William Chambers may have been responsible for the design of the suite, and also for that of the octagonal painting room and library that Reynolds added to his Leicester Square house in about 1760.[44] It is pertinent that a table with a 'Dorick Entablature, with its Triglyphs and Metopes, supported by two Cariatides', the metopes embellished by wreaths and crossed palms, is shown in a plate, dated 1760, for the third (1762) edition of Chippendale's *Director*, a response, no doubt, to early neoclassical stirrings, quite possibly stimulated by Chambers's example.[45] Whoever its designer, Reynolds's chair – perhaps he, like Chambers, reckoned himself 'a Very pretty Connoisseur in furniture'[46] – is a high point on which to conclude this account of an assemblage of distinctly varying quality, but of considerable interest in the context of the Academy's history.

A CLOSER LOOK

13.1

Frames:

Joseph Nollekens, *Cupid and Psyche*

MARYANNE STEVENS

The very first Diploma Work to enter the Royal Academy's collection, on 1 February 1773, was a bas-relief presented within an elegant neoclassical two-toned gilt frame: *Cupid and Psyche* by the recently elected sculptor Joseph Nollekens RA (fig. 390).[1] This must have influenced the Council when, just a few months later, James Barry RA presented his *Medea making her Incantation after the Murder of her Children* (lost) without a frame. No requirement to provide a frame had been made until this point, but the President and Council now declared that it was 'Resolved, that all Pictures, Bas reliefs or any other Performance that may be given by any Academician for their Admission must have a Frame. Order'd That Mr Barry be acquainted that a frame is wanting for his Picture.'[2] The decision over Barry's picture meant that the frame for every subsequent Diploma Work has been fully documented, is associated with a specific Academician, and has a terminal date for its execution provided by the record of acceptance in the Council minutes.

If books in a house can be said to furnish a room, frames are certainly part of the furniture. Proof of this observation can be found in Joseph Baretti's *Guide through the Royal Academy* (1781), which reveals that, at that date, four paintings were hanging in the Council Room but that there were also empty frames on the walls ready to receive pictures:

The *second Room* of the Academy of the Antique, intended also for the general Meetings of the Academicians, or Council, is more splendidly furnished than the first. The Walls of it are hung round with *Frames*, that are in time to contain Pictures by the Academicians. Only four of them are as yet filled up with *Portraits*, which tell very plain by whom they are made, and whom they represent. *Sir Joshua's* hand needs no Nomenclature, when his Originals are known to the Beholder.[3]

This perhaps surprising observation is confirmed by *A Candid Review of the Exhibition . . . of the Royal Academy MDCCLXXX* by 'An Artist' in 1780 (p. 11): 'In the end of the Room fronting the door we are struck with two noble pictures of *their Majesties* . . . These pictures are to remain in the room, and we hear that the frames, which are disposed around, are to be filled.'[4]

There are some 1,000 Diploma Works in the collection, and partly because framing was not appropriate for all, 440 of them were presented framed.[5] In all these cases, the frames, most of them commissioned from professional frame-makers, probably reflect the taste of the individual artist. When J. M. W. Turner RA deposited his Diploma Work, *Dolbadern*

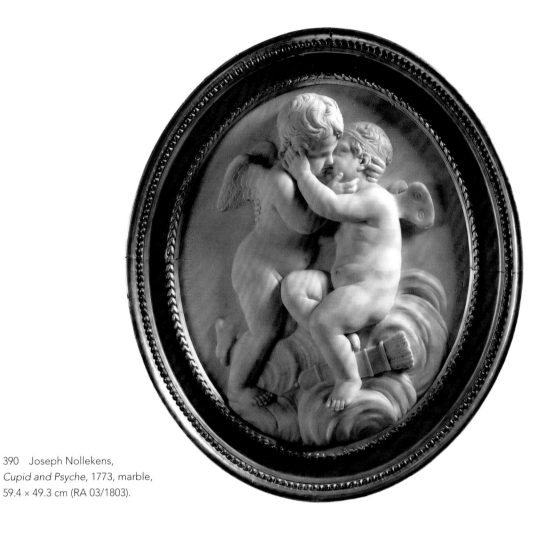

390 Joseph Nollekens,
Cupid and Psyche, 1773, marble,
59.4 × 49.3 cm (RA 03/1803).

[*sic*] *Castle* (1800), in 1802 (see fig. 265), he chose an elegant Maratta frame, whereas Henry Scott Tuke RA picked a restrained Edwardian frame for *A Bathing Group* (1914; RA 03/258). A few Academicians designed their own frames, as in the case of Lawrence Alma-Tadema's (*Way to the Temple* (1882; see fig. 294) and G. F. Watts RA's *My punishment is greater than I can bear* (a.1067; RA 03/1313), while John Flaxman undertook both the design and execution of the austere, deep grey neoclassical frame that encloses his bas-relief *Apollo and Marpessa* (c.1790–94; see fig. 179).

The Royal Academy's frame collection also contains significant historical examples beyond the Diploma Works: for example, several paintings by Watts that have frames made to his own distinct design.[6] In the small number of cases when non-Diploma Works were either reframed or provided with a second frame, the date at which this was undertaken is an indicator of changing taste. For example, when Constable's *Leaping Horse* (1825; see fig. 267) was to be exhibited at the 1908 Empire Exhibition in London, it was decided to provide it with a brand-new modified 'Watts' frame rather than a replica of its 1820s Regency-style frame. Other notable frames include those on some of the Academy's 25 copies after original works by Old Masters, fine late eighteenth- and early nineteenth-century designs that include a set of Maratta frames adorning the copies by Giuseppe Cades and Stefano Tofanelli after the Raphael Stanze in the Vatican. In the twentieth century, however, a growing tendency to eliminate the perceived barrier that a frame erects between the work of art and the space it inhabits led to a relaxation of the 1773 resolution, although the exigencies of exhibition and transport mean that, in consultation with the member, such works are often provided with frames.

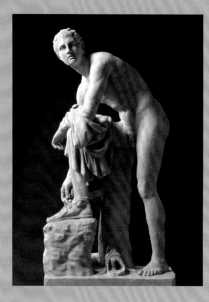
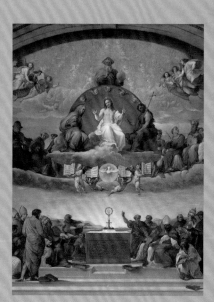

THE ARTS OF INSTRUCTION

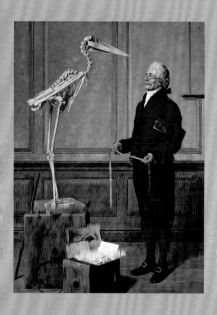

14

THE SCHOOLS AND
THE PRACTICE OF ART

ANNETTE WICKHAM

The *Cambridge Magazine* reported in 1769, the 'chief end' of the Royal Academy was 'the establishment of schools of design under proper regulations; where students may receive such instruction as may be met with in foreign academies and have long wanted…in this country'.[1] As the first official fine art school in Britain, its foundation marked the culmination of a century of debate. In his presidential *Discourses* Sir Joshua Reynolds PRA set out the theoretical framework for the new Academy's pedagogic mission: to raise both the technical quality and intellectual scope of British art by equipping artists with the skills to paint, sculpt or design in the 'grand manner'. To this end the Academy self-consciously modelled itself on the European academic tradition, and accordingly brought together under one roof the study of plaster casts after classical and Renaissance sculpture and the study of anatomy and life drawing. Practical instruction was complemented by lectures on anatomy, painting, perspective and architecture and, from 1810, sculpture, although lectures were not always delivered as planned: George Dance RA, for instance, failed to give a single lecture as Professor of Architecture 1798–1805. All students could attend these talks, and they also had access to the Academy's Library. More controversially, the Academy was both exclusive and hierarchical. Unlike its predecessors in Britain, tuition was offered free of charge, but in order to enrol, students had to meet a required standard and then follow a fixed progress, from first studying plaster casts, then attending the life class and then (from 1816) the School of Painting; ivory tickets were issued from 1800 to identify the students and which school they were in (fig. 391).[2]

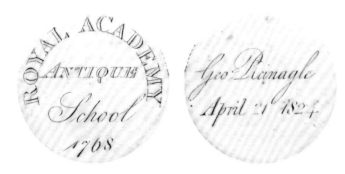

391 Ticket to the Antique School belonging to Philip Reinagle RA issued 21 April 1824, ivory, diameter 5.2 cm (RA 03/4004).

The founding aims of the Academy are well known, but how did these principles translate into the practicalities of day-to-day teaching? Surprisingly, the early records of the institution provide sparse evidence, as the founding Academicians put very little in writing about their plans. The Instrument of Foundation, drafted by Sir William Chambers RA and the king, defines the general structure of the Schools and the responsibilities of its staff, but gives no details of any curriculum or recommended teaching methods.[3] Nonetheless, by taking into account surviving examples of work by both students and teachers, contemporary descriptions of student life and the evidence to be found in the institution's records, it is possible to reconstruct a sense of what was offered. This process also reveals some intriguing – perhaps unexpected – insights into the decisions made by Reynolds, the Foundation Members and their successors.

THE 'ANTIQUE'

The stated purpose of the Schools was to teach the 'arts of design', but its structure clearly shows that the study of the human body was the principal focus and that this was to be approached exclusively through the prism of the classical ideal. All students, including those intending to become architects, began their training in the Antique School (also known as the Plaster, or 'Plaister' Academy), where they drew plaster casts chiefly of ancient Greek and Roman sculptures until permitted to attend the life class (fig. 392). Indeed, aspiring artists were expected to have begun this pursuit

before attending the Academy, as entry was by submitting a drawing of a sculpture or cast (or, for architects, a drawing of a building). If this was approved, they became 'probationers' and were allowed to draw in the Schools for a number of months. They were officially enrolled at the end of this period if their work passed muster, and were thereafter eligible for the medals that were awarded for the various kinds of training. Prizes offered by the Schools reflected the hierarchy of genres set out by Reynolds in his *Discourses*. The lesser, silver, prizes were for drawings and models after casts, from the life or of buildings; while the gold prize, only open to students who had reached the life class, was awarded for a painting or relief of a historical subject or an original architectural design.

In the early period, the new institution's rapidly growing collection of casts after celebrated classical sculptures symbolized its prestige and intellectual gravitas. In his *Discourses*, Reynolds endorsed the study of casts, arguing that the 'reiterated experience' of drawing them was key to understanding the essence of human form and 'the real simplicity of nature'. He insisted that this practice taught students judiciously to 'correct' the defects and idiosyncrasies of a specific model through their knowledge of idealized figures.[4] The system, it should be said, also had more prosaic advantages. Unlike models, plaster casts did not move, they could be drawn for hours on end, and they did not require payment. This helped to ensure that students honed their drawing skills, acquiring a mastery of line as well as of light and shade at an early stage. In 1895 George Richmond (ARA 1856, RA 1866) presented a drawing of the Apollo Belvedere made in November 1824 and an earlier drawing of the Belvedere Torso that he had kept because they had marked his transition from probationer to full student of the Academy (fig. 393).[5]

Presiding over the students in the Antique School was the 'Keeper'. The Academy's Instrument of Foundation specified that this should be 'an able Painter of History, Sculptor or other Artist, properly qualified', who, as well as managing the Academy's servants and looking after the collections, would advise and instruct the students and keep order.[6] The first Keeper was George Michael Moser RA, a Swiss enameller and gold-chaser with extensive teaching experience at forerunners of the Royal Academy such as the Duke of Richmond's sculpture gallery and the St Martin's Lane Academy.[7] Following Moser in this post were two sculptors, Agostino Carlini RA and Joseph Wilton RA, but the most influential

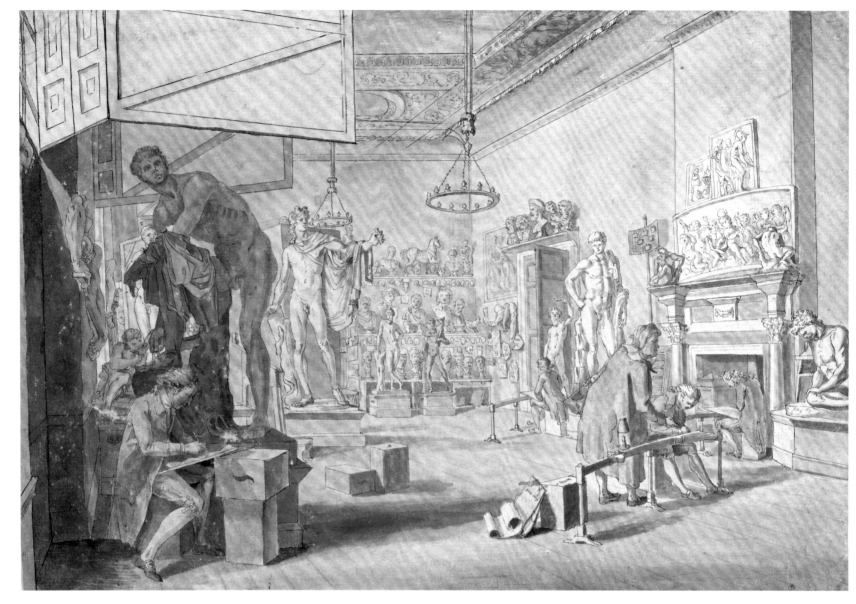

392 E. F. Burney, *Antique School at Old Somerset House*, 1779, watercolour and pen and ink, 33.5 × 48.5 cm (RA 03/7485).

incumbent in the early period was his compatriot, the 'mad Swiss' history painter, Henry Fuseli RA. Students recalled his exuberant and eccentric character but noted that he often left them to continue with their work undisturbed, a habit they praised as 'wise neglect' (fig. 394).[8]

The Keeper would set out specific casts to be drawn each week and the students chose their own seats, which were simply boxes (see fig. 392). They were supposed to keep the same place for the week, which led to perennial complaints about the students acting 'like a mob' to secure the best places.[9] George Richmond is said to have perched atop a precarious tower of five boxes to get a good view of the Apollo Belvedere.[10] The Antique School was open in term time from Monday to Saturday (9:00 am to 3:00 pm), with a two-hour evening session added from March 1769. This suggests that students might spend up to 40 hours on each

393 George Richmond RA, *Belvedere Torso*, August 1823, pencil and chalk, 34.5 × 40.8 cm (RA 07/3675).

394 George Dance RA, *Henry Fuseli*, 2 June 1793, pencil and chalk, 25.2 × 19 cm (RA 03/3271).

drawing, but it would be wrong to assume that this was a requirement or even the norm. Attendance at the Schools was recorded but not enforced, and students could come and go as they pleased,[11] arrangements that remained largely unchanged from the time of foundation until the latter half of the nineteenth century.

A belief in the primacy of drawing is fundamental to the tradition of art academies, and it is often stated that the Royal Academy only taught drawing until the opening of the School of Painting in 1816, but that is not strictly true. While drawing was certainly the staple diet of most students, those intending to become painters were allowed to model in clay in both schools from the outset, and painting was permitted in the life class at certain times. More significantly, the Royal Academy Schools also rejected certain elements of the established academic method of teaching drawing. At most continental academies, students began by copying drawings or prints of parts of the figure – noses, eyes, feet, hands, heads and so on – examples of which were available in books devoted to the subject. They then progressed to drawing casts of these parts before tackling prints and then casts of the whole figure. Only after successfully completing this process were they permitted to draw from live models.[12] At the Academy Schools, the initial stage of this method was jettisoned and students went straight to drawing the casts.[13] This was partly because the Academy considered itself above teaching the basics of drawing but there seems to have been more to the issue. The deliberate rejection of this and other conventions reveals a fundamental tension at the heart of the institution. Reynolds and the founding Academicians wanted

to emulate the perceived professionalism of continental academies but, at the same time, had a palpable fear of the mannerism they felt had 'infected' many of these schools.[14] While arguing that academic rules should not be viewed as the 'fetters of genius', Reynolds also believed that the chief advantage of the new institution was that it 'had nothing to unlearn'.[15] He was particularly ambivalent about the practice of copying, describing the 'drudgery' of imitating without selecting as a 'very erroneous method'.[16] Copying drawings, whether by Old Masters or living Royal Academicians, seems to have been identified as the stage at which the rot set in, and it was avoided altogether.

Cutting out the stage of copying prints and drawings meant that the Academy had surprisingly little in the way of a study collection until much later in the nineteenth century. The few drawings available in the Library early on were mostly gifts, including figures taken by James Nevay from Michelangelo's *Last Judgement* and, possibly, a drawing of the Farnese Hercules by John Vanderbank (see fig. 150).[17] Apart from architects' Diploma Works, the Academy initially made no concerted effort to acquire drawings.[18] Leonardo's famous cartoon of the *Virgin and Child with St Anne* (National Gallery, London) was at Old Somerset House by 1779, although how it came to the Academy is not certainly known. The Academy also passed up several opportunities to acquire major collections of Old Master drawings, including those assembled by two of its own presidents, Joshua Reynolds and Thomas Lawrence. The latter, in particular, was of such range and quality that it has passed into the mythology of collecting. Prints and illustrated books were collected as exemplars, but again there seems to have been no requirement for students to copy them in a systematic way. William Blake (a student at the RA Schools from 1779), for one, was unmoved by the efforts of Moser to steer him away from the works of Raphael and Michelangelo towards those of Charles Le Brun and Rubens.[19] This attitude gradually changed, and from the mid-nineteenth century onwards the Academy began to buy drawings specifically for the Schools, notably a group of life studies by William Mulready RA.[20] A residual wariness of the use of drawings in teaching remained, and in the 1870s the Academy opted to invest not in originals but in state-of-the-art facsimiles of important collections of drawings.[21]

It was also official policy not to acquire student drawings, not even those by prize-winners. Fortunately, many exam-ples survive in museums and gallery collections around the UK and abroad. Artists and their families often retained the drawings produced for admission to the Academy as mementoes, and a small number of these works have found their way to its collections, including two by Richmond, who presented them to his alma mater in 1895. Forming a collection of prize-winners' drawings was proposed on several occasions from the mid-nineteenth century onwards, but only one remains in the holdings today (see below, The 'Life').[22]

The examples of student drawings that do survive offer some insight into practices in the Schools and how they developed over time.[23] Those from the Antique School suggest that, despite the later stereotype of academic drawing, the creation of highly finished studies of casts was not especially encouraged: if anything, at least up until the 1830s, that kind of work was likely to be criticized. Fuseli was even said to have struck through drawings that he thought had been laboured over with a 'neegling tooch'. In 1826 Sir Thomas Lawrence used his presidential Discourse to warn against 'too exclusive attention to fineness of finish and relief' at the expense of 'general proportion and character'.[24] This is demonstrated by students' drawings from the early 1800s, which are broadly drawn and emphasize dramatic contrasts of light and shade, a practice deliberately encouraged by the way the casts were lit in the evening (fig. 395). Most studies are in black and white chalk, but some are drawn on toned paper. Others use coloured chalks, a technique more often associated with life drawing.[25] Over time, the style of drawing encouraged at the Academy became tighter and brought to a higher degree of finish (fig. 396). During the presidency of the American neoclassical painter Benjamin West, further prizes for drawings of casts had been added to encourage interest in this area and prevent students 'rushing impatiently to the School of the Living Model'.[26] Minor modifications to the rules were also aimed at encouraging greater attention to detail and anatomical correctness. From 1814 onwards, probationers had to produce labelled anatomical diagrams as well as a drawing of a cast, and students progressing to the life class had to produce 'drawings as large as nature of a hand & foot' in addition to a study of a whole figure or group.[27] A detail from the Laocoön drawn by Sir Edwin Landseer RA is an example of just such a drawing and is inscribed 'for admission to the Life' (fig. 397).

395 Formerly attributed to Johan Zoffany RA, *Antique School of the Royal Academy at New Somerset House*, 1780–83, oil on canvas, 110.8 × 164.3 cm (RA 03/846).

During the mid-nineteenth century there was a growing influence from the many private art schools that young artists attended before and sometimes after, enrolling at the Academy. John Everett Millais (ARA 1853, RA 1863, PRA 1896) and William Powell Frith (ARA 1845, RA 1853), for example, both attended the drawing school run by Henry Sass in Bloomsbury, Millais from the age of nine. Sass relied on a very 'severe' version of the academic system originally

rejected by the Academy, and students began by copying their master's outline drawings (what was called 'from the flat') over and over again until, as Frith recalled, he 'could be induced to place the long desired "Bene" [good/well done] at the bottom of them': just this inscription can be seen at the bottom right of a drawing by Millais (fig. 194).[20] Sass also insisted that students draw with Italian chalk on white paper, and his bugbear was the 'stump' (a piece of rag, leather or

396 Student's study of *Laocoön* signed by the Keeper, Charles Landseer RA,
black chalk on laid paper, 70 × 45.5 cm (RA 05/1223).

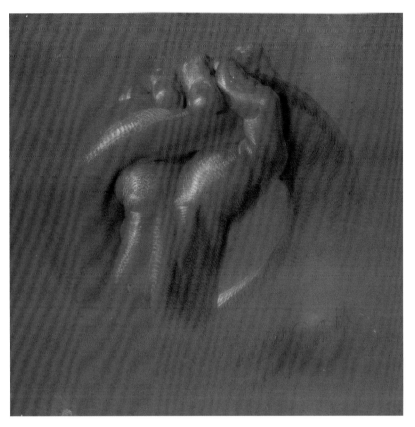

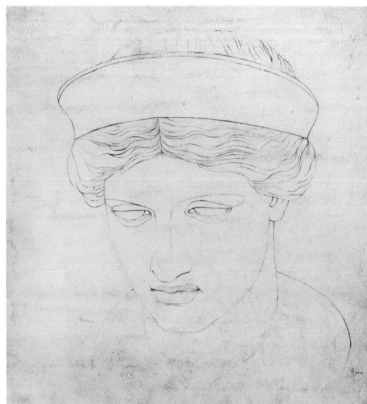

397 Sir Edwin Landseer RA, *Chalk Study of the Hand of Laocoön*, c.1818, black and white chalk, 37.8 × 35.8 cm (RA 07/4244).

398 Sir John Everett Millais PRA, *Head of Juno*, c.1838, pencil, 35 × 32.5 cm (RA 02/230, verso).

tightly rolled paper used to smudge the medium as a shortcut to creating areas of shading), which he strictly forbade.[29] The student who, like Millais, subsequently enrolled at the Academy found there a more relaxed attitude to materials and techniques, and he, its youngest-ever student at 11 years of age, soon abandoned Sass's methods, using the stump for shading and creating highlights by taking out chalk marks with bread. William Holman Hunt recalled meeting the young Millais in the British Museum in 1843 and being told: 'I like white paper just now. You see I sketch the lines in with charcoal, and when I go over with chalk I rub in the whole with wash leather, take out the lights with bread and work up the shadows till its finished. Another student during the 1840s, the sculptor J. L. Tupper, was surprised by the variety of techniques in use and noted that his peers used 'all sorts of paper' even though the Keeper recommended that they draw on white, the practice to which Millais refers (fig. 399).[30]

Tupper was also disappointed by the lack of guidance and teaching offered in the Antique School. He was not alone, and in response to growing external criticism of the Schools and internal concern about standards, the Academy set up a succession of committees charged with improving their 'efficiency' and 'utility' from 1800 onwards.[31] The institution's educational activities were also scrutinized by a series of government select committees.[32] The ensuing reforms were, however, fairly minimal. In the Antique School they focused on making the entry requirements for the Life School more rigorous, yet there were few changes to teaching arrangements, apart from the appointment of a Curator in 1871 to assist the Keeper in maintaining order and to instruct the sculpture students.[33] Despite the fact that most students had studied elsewhere before enrolling, these changes meant that they tended to spend longer in the Antique School.[34] Initially, there was no specified period in each school, but by the

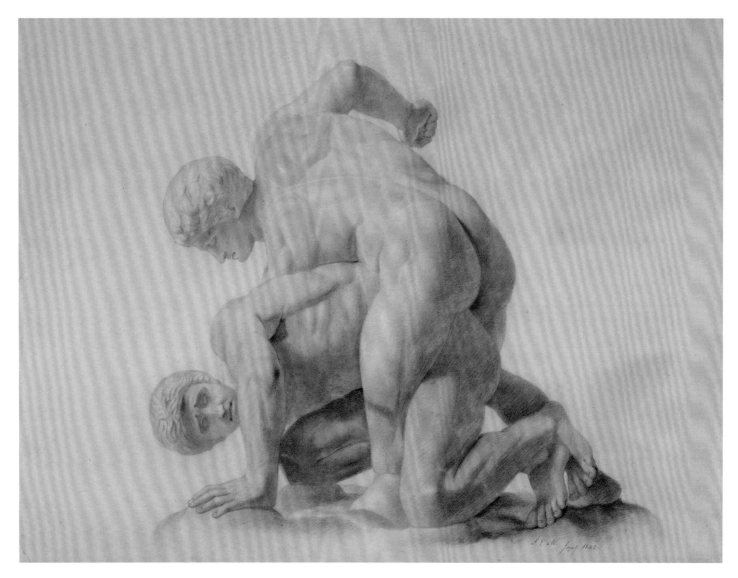

399 Sir John Everett Millais PRA, *The Pancrastinae*, January 1842, pencil and chalk, 49 × 63.2 cm (RA 02/265).

1840s students could be spending several years in studying the Antique, which inevitably led to a growing sense of dissatisfaction and frustration. Later in the century, the course in the 'Lower School' officially became three years, by which time, the *Magazine of Art* observed in 1887, the students tended to 'get frisky'.[35] Ironically, by the end of the nineteenth century aspects of the system that the Academy had originally rejected crept back in, and students had to draw heads and hands and so on before they could draw the whole figure (fig. 400). In his comical illustrated pamphlet *Royal Academy Antics* (1890), the illustrator and satirist Harry Furniss took a potshot at such tired teaching methods:

Why do we not make the introduction of Art more attractive to the boy? A cold, meaningless scroll is first placed in front of him…next a head, a hand, a foot…a sort of mutilated corpse in plaster of Paris and about as cheering to be stippled, cross-hatched and worked up for months. By the time he sees the art student's life is not a happy one; he finds relief in throwing lumps of bread at the heads of

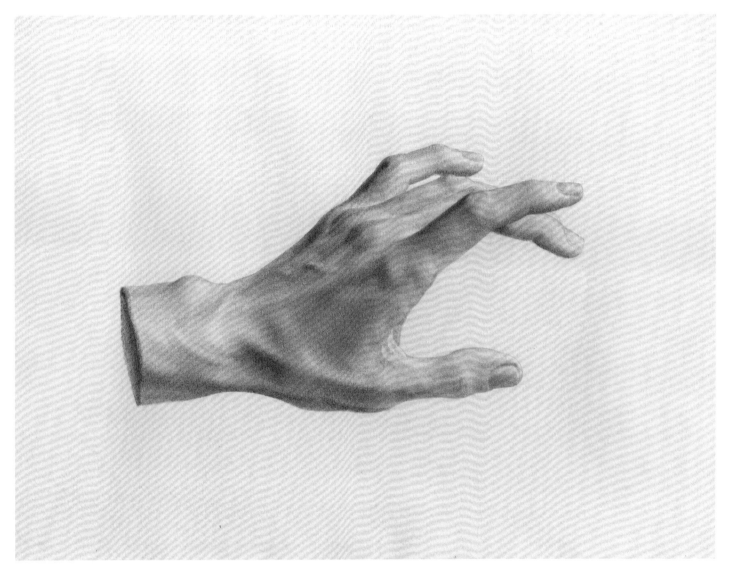

400 Margaret E. Wilson, *Study of a Cast of a Hand*, c.1912, black chalk on wove paper, 26.8 × 35.2 cm (RA 09/1525).

other students and a little extra excitement when he hits his Professor by mistake.[36]

The plaster casts that had once symbolized the lofty ambitions of the institution now became emblematic of all the perceived failings of the academic system. The Academy was fairly slow to respond to this situation, and until the turn of the twentieth century it was still necessary to produce a drawing of a cast (or, alternatively, a model of one for sculpture students) in order to gain a place. In 1903 the Academy

finally acknowledged that this arrangement was off-putting to 'advanced students...either from unwillingness to go through a second course of the antique, or because the bent of his talent does not lie in that direction'. As a result, drawing plaster casts ceased to be compulsory and the importance of this discipline steadily dwindled in favour of life drawing and other pursuits, a process accelerated by the social and cultural changes brought about by the First World War.

Nevertheless, the aura of the Antique remained important. In 1969, 200 years after the foundation of the Schools, the

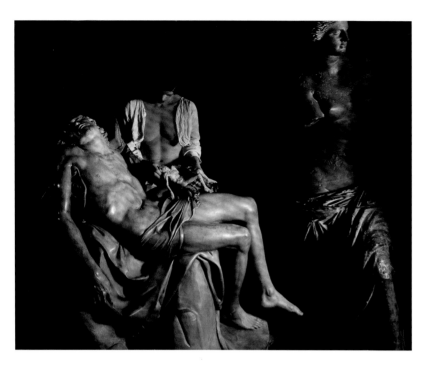

401 Liane Lang, *Ars Moriendi*, 2006, C-type photographic print,
118.6 × 148 cm (RA 06/5698).

Keeper, Peter Greenham RA, jokingly referred to the 'double rank' of plaster casts still installed in the Schools as 'the army of unalterable law',[38] and prizes for drawings after casts were still being awarded as late as the 1980s. The Academy's historic collection of casts has remained largely in place. Their presence has certainly added to the unique atmosphere of the Schools, and they continue to be a source of inspiration to students, albeit in a different way. *Ars Moriendi*, produced by Liane Lang during her final year as a student, is part of a series that attempts to consider the cast from a contemporary point of view (fig. 401). Using reconfigurations which draw out the cast's qualities of gesture and sensuality, the artist aims to animate them away from their academic confines.

THE 'LIFE'

Once students had successfully demonstrated their proficiency in drawing plaster casts, they were admitted to the 'Life', or the 'School of Living Models' as it was originally known, where they drew male and female nude models.[39]

From the outset, arrangements differed from those in the Antique School, and following academic tradition, teaching was conducted not by the Keeper but by a succession of 'Visitors' (the term was derived from the *visitatori* of the Accademia di Belle Arti in Florence). These were nine Academicians elected periodically to teach in rotation, taking turns of one month each over the year. But while the Académie royale in Paris, for instance, had an administrative structure with a specific committee to oversee its school, the Academy's version of the Visitor system created a fundamental dilemma over who was in charge. The Keeper, in theory, had administrative power over the Schools as a whole but, in effect, the Visitors were autonomous. This led to several conflicts between the Keeper and certain Visitors in the 1770s. When the issue was put before the Council in both 1772 and 1775, it was confirmed that the Visitor was in charge of the life class and that the Keeper should not even 'presume to enter the room whilst the Visitor is setting the model, nor shall they give any instructions or orders whatsoever'.[40]

This decision effectively left the life class without any consistent direction, leading to a great variety in the quality of teaching and also several flashpoints of recurring debate. The Visitor always set the pose of the model, but the approach to teaching ranged from that of William Etty RA and Mulready, who habitually drew alongside the students and corrected their work, to Landseer, who, according to Frith, sat back and read *Oliver Twist*.[41] The Visitor system became enshrined, but its mercurial nature made it the focus of persistent external criticism from the 1830s onwards.[42] In response, the Academy became more entrenched and clung to its original core structure and values. Although the Academicians agreed to overhaul teaching arrangements in 1864 (in response to recommendations of the 1863 Royal Commission) and appointed a Curator to assist with the class, Visitors were still teaching the life class well into the early twentieth century, and it was not until the 1930s that they were largely replaced by permanent teachers. The purpose of the Visitor system was to guard against the adoption of particular mannerisms, to preclude the students from being indoctrinated in one particular style. It was also an opportunity for them to meet the various Academicians and learn from their techniques.

Inevitably, students did emulate influential teachers and the system produced some interesting results. As with the Antique School, these works were deliberately not collected initially,

but some examples found their way back to the Academy, notably some drawings by Mulready mentioned above that were bought by it in 1864 shortly after his death, when the Council felt 'assured that they could not place before the Students of the Life School finer examples to guide them in their study' (fig. 402).[43] Stephen Francis Rigaud, son of John Francis Rigaud RA, attended the Schools in the 1790s and left a detailed account of the different approaches of the Visitors at this time. He observed that James Barry RA drew on coarse brown paper in pen and ink 'making a bold clever sketch...with coarse materials that cost him nothing' (fig. 403).[44] He also described Francesco Bartolozzi RA and Giovanni Battista Cipriani RA using 'fine strokes' and white chalk for highlights, while Richard Cosway RA drew in red and black chalks on white paper. Rigaud claimed that Fuseli, however, did not draw the figure himself but that he would draw on the students' work, although some surviving sketches by Fuseli suggest that he did indeed draw directly from the model in the life class.[45] Rigaud remarked on Thomas Stothard RA's 'clever spirited sketches of the model in pen and ink, seen from different points of view'. Stothard was not known for his life drawings outside the Academy but developed his own particular approach in the life class. He would make small studies in a sketchbook, sometimes moving around the room to make rapid drawings of the same figure from different angles, sometimes concentrating on outline, and at other times focusing on the contrast of light and shade (fig. 404).

As noted above, the Royal Academy is said to have taught only drawing in the early years, but there is an intriguing reference in the Instrument of Foundation indicating that the teaching of painting was originally envisaged as part of the curriculum in the life class. It states, 'There shall be a Summer Academy of living Models to paint after, also of Laymen with Draperies, both antient & modern, Plaister Figures, Bas reliefs, Models & Designs of Fruits, Flowers, Ornaments, &c.'[46] In practice, painting in the class appears to have been controversial at times, and rules regarding permission to paint changed quite frequently. In an etching by Thomas Rowlandson a man towards the left-hand side is shown standing at an easel wearing an apron and seems to be

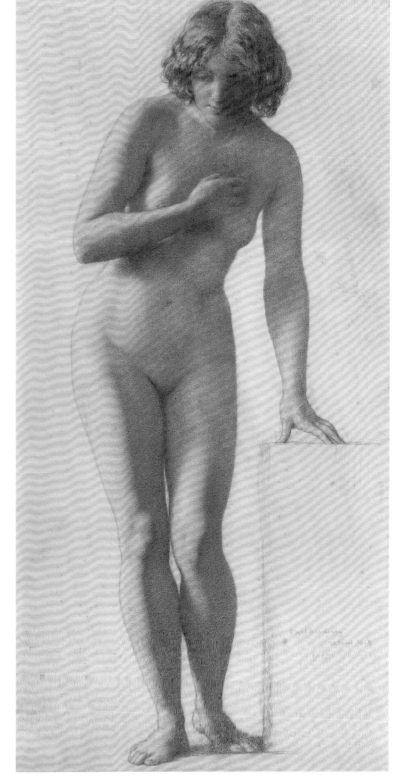

402 William Mulready RA, *Standing Female Nude*, 26 June 1858, black and red chalk, 55.7 × 28.1 cm (RA 03/114).

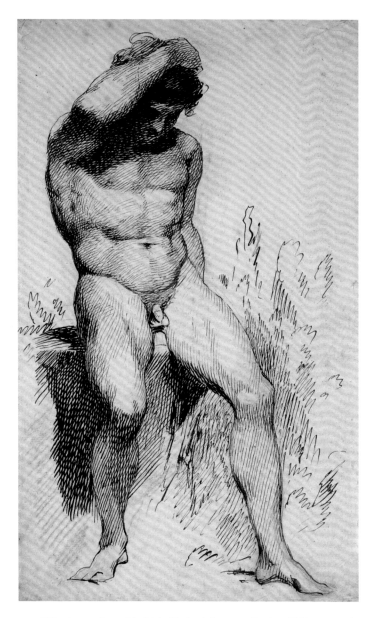

403 James Barry RA, *Male Nude sitting on a Rock*, c.1790s, pen and ink over black chalk on laid paper, 51.6 × 31.9 cm (RA 04/496).

404 Thomas Stothard RA, *Sketches of a reclining Male Nude*, c.1800, pen and ink on laid paper, 16 × 9.3 cm (RA 05/3146).

painting (fig. 405).[47] While access to the School of Painting itself, where students could paint copies of works by the Old Masters on loan from Dulwich College, became progressively more open, permission to paint in the life class was reserved for advanced students.[48] Among many similar statements is that of the Keeper William Hilton RA, who in 1834 congratulated one of the students on not having been 'seduced into

the practice of painting instead of drawing'.[49] Contemporary references suggest that painting the nude by lamplight was particularly frowned upon. Etty – an artist whose devotion to life drawing was the subject of ridicule – favoured this method, on account of the 'glorious effect' of the contrast between the dark room and 'the Figure immediately under the gaslight' (fig 406).[50] As Etty's work and other examples

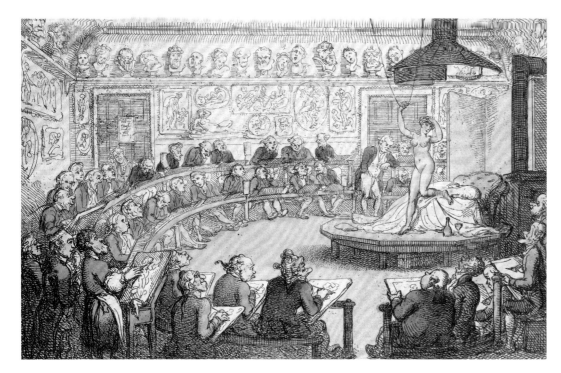

405 Thomas Rowlandson, *A Life Class at the Royal Academy*, 1811, hand-coloured etching, 15 × 22 cm (RA 03/6176).

406 William Etty RA, *Study of Female Nude*, 1820–30s, oil on card on canvas, 49 × 64 cm (RA 03/1223).

clearly show, the Schools provided 'Men and Women of different characters' as models.[51] The presence of nude female models was another deviation from continental academic practice and stemmed from the tradition of life classes in England that, throughout the eighteenth century, usually included models of both sexes. William Hogarth had even joked that it helped to sell subscriptions to his St Martin's Lane Academy.[52] Wary of any possible impropriety, it was stipulated that students must be aged 20 or be married before they were allowed to attend the life class when the female model was present.[53] Records reveal that there was some cause for concern, and the caricaturist Thomas Rowlandson, for example, was nearly expelled for firing a peashooter at the female model. James Northcote RA also observed that, while students were generally absorbed in their work during the class, as the session drew to an end 'the figure seemed almost like something coming to life again ... and students sometimes watched the women out, though they were not of a very attractive appearance, as none but those who were past their prime would sit.'[54] In the early days the male

models included the Academy's porters – among them, John Malin (see fig. 116) and Samuel Strowger – but many were soldiers, athletes or boxers on account of their physiques. The women, by contrast, were viewed with a certain amount of suspicion and frequently assumed to be prostitutes. An insalubrious eighteenth-century publication, *Nocturnal Revels*, suggests, however, that male Academy models might also find work in the demi-monde, describing a tableau at a brothel featuring six of 'the most athletic and well proportioned young men ... some of them Royal Academic figures'.[55]

During the eighteenth century, moral concern was mainly for the welfare of the young male students who might be 'lured into a course of dissipation and ruined' by associating with the women who sat as life models.[56] This switched around into the reverse of the nineteenth century and by the 1870s and 1880s campaigners such as John Callcott Horsley RA were trying to persuade the Academy to stop drawing from the female nude altogether, claiming that it was degrading and exploitative.[57] The practice was defended by numerous artists, including G. F. Watts RA, who subsequently

445

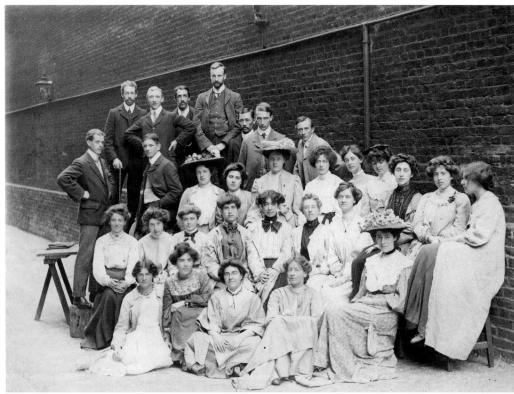

407 G. F. Watts RA, *Studies of Female Nude viewed from the Back*, black and white chalk, *c*.1860, 74 × 56.7 cm (RA 04/64).

408 Women and men students at the Royal Academy Schools, 1906, photograph, 16.2 × 21.3 cm (RA 08/2755).

bequeathed to the Academy in 1904 a large group of his own life drawings, which he called the 'grammar' of his art. Moreover, he vigorously defended drawing from the nude model: 'If the human form is not to be studied, painted and sculptured there will be an end to art. Prudery is one of the worst forms of indecency' (fig. 407).[58]

These issues were further complicated by the admission of female students from 1860,[59] a major change that occurred when the Academy accepted the drawing of a probationer signed L. Herford, unaware that the 'L' was for Laura. The Academicians subsequently found, to their surprise, that there never had been any written rule excluding women from the Schools and were forced to admit Laura Herford as a student. The women were not at first on equal footing with their male counterparts and were confined to the Antique School. They were subsequently allowed to draw only draped models, with one student complaining of being expected to

believe that people had 'head, arms and feet apparently linked together by clothes'.[60] After persistent campaigning, the women were permitted to draw the female nude (in separate classes from the men) and, from 1893, also the male, albeit clothed with a very involved form of drapery consisting of 'ordinary bathing drawers, and a cloth of light material 9ft long by 3ft wide … wound around the loins … passed between the legs and tucked in over the waistband'[61] (fig. 408).

In contrast to the Antique, which had lost its pre-eminent status by the early twentieth century, the 'Life' remained central to the course. Although there was briefly a renewed enthusiasm for the Visitor system in the early 1900s (it was seen as a unique advantage of the Academy), it eventually gave way, as we have noted, to the employment of permanent teachers. Life drawing remained an important component of the course well into the 1990s, although it ceased to be compulsory. The Academy retains its historic life room, and the

409 Michael Landy RA, *Norman Rosenthal*, 2008, pencil on paper, 70 × 50 cm (RA 09/774).

practice of drawing more generally continues to be a core interest at the Schools, as demonstrated by the creation of the Eranda Professorship of Drawing in 2000, with Christopher Le Brun PRA as the first incumbent, while recent successors include Tracey Emin RA and Michael Landy RA (fig. 409).

CHANGES IN PRACTICE

The original curriculum was intentionally limited, a fact that was poorly understood by many subsequent generations of both students and commentators. The purpose appears to have been to follow academic tradition in providing painters, sculptors, engravers and architects with the same grounding in drawing and theory, while allowing them time to practise their chosen art externally with a master.[62] That they were certainly expected to learn to paint, sculpt and design while attending the Academy is evident from the range of prizes on offer – the gold prize being for a painting or relief of a histor-

ical subject or an original architectural design. Although these arrangements were based on the continental academic model as it stood in 1768, the Royal Academy did not subsequently keep pace with all developments among its European counterparts, and in Paris, for instance, in the latter part of the nineteenth century a prize was awarded for painting the human figure. The Academy has a study in oils of a male nude of 1876 by Pascale Adolphe Jean Dagnan-Bouveret Hon. RA, who won that prize in Paris in that year (fig. 410). In practice, the system put in place did not develop in quite the way that had been expected. Until 1870 it remained a necessity for architecture students to attach themselves to the office of an established practitioner, but prospective painters, sculptors and engravers followed various different paths, and many of them were, to all intents and purposes, teaching themselves.[63]

During the nineteenth century, the Academy did very gradually begin to expand its curriculum. The first significant change came in 1816 when the School of Painting was opened at Somerset House. It was overseen by the Keeper, but teaching was again provided by Visitors who varied greatly in their approach. By the middle of the nineteenth century the Academy had also opened a Painting School which, confusingly, was specifically for painting drapery and head studies. The process of diversification and specialization continued, with Frederic Leighton RA (later Lord Leighton PRA) and others attempting to establish a fuller and more rigorous curriculum in line with contemporary continental methods.[64] This was partly aimed at helping the Academy compete with the appeal of new art schools in the UK, including those at South Kensington (1853) and the Slade (1871), as well as the academies and ateliers of Paris and other European cities. By the end of the century, the studentship had been officially divided into three years in the 'Lower' and three (shortly afterwards reduced to two) in the 'Upper' School. Students could begin painting in the Lower School and were offered separate classes in sculpture and architecture, lectures in chemistry as well as extra prizes and travelling scholarships.[66] Change was a slow process, however, and by the time these reforms came to fruition they were already somewhat outdated. They also met with resistance from more traditional Academicians including G. D. Leslie RA, who claimed that there had been a gradual decline in standards since the 'female invasion' and the introduction of 'foreign ideals', the latter stemming from the presidency of Leighton

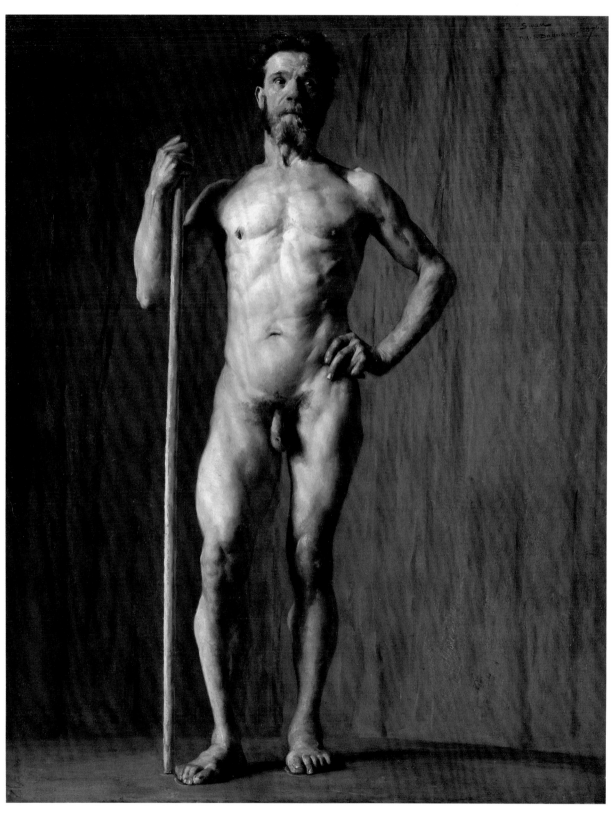

410 Pascale Adolphe Jean Dagnan-Bouveret Hon. RA, *Academic Study of a Male Nude*, 1876, oil on canvas, 82.5 × 65 cm (RA 03/1135).

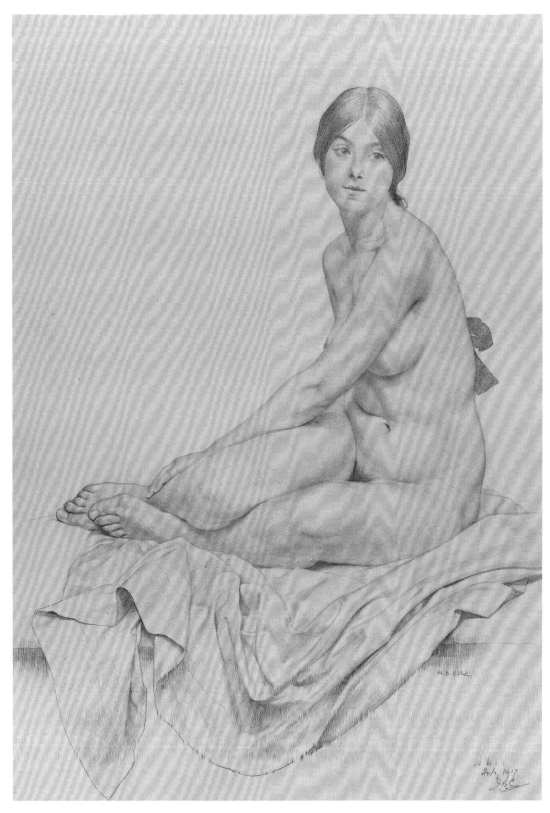

411 Winifred Broughton Edge, *Life Drawing of a seated Female Nude*, July 1917, pencil on paper,
56.4 × 38.4 cm (RA 10/4587).

(who had trained in Germany, Italy and France) and the keepership of Philip Hermogenes Calderon RA.[66]

Further changes were made around the beginning of the twentieth century, at a time when the 'female invasion' was in the process of becoming an unalterable fact (fig. 411). By now the Academy had also come formally to accept that most students had already attended an art school before applying, and so it began scaling down preliminary classes and study of the Antique.[67] By 1927, Sir George Clausen RA, then Director of the Schools, could look back with nostalgia to the days before the First World War when, for a short time at least, the institution was run along very clear and efficient lines: 'The old system ... was perfect of its kind. Attendance was enforced, lectures were regularly given ... each school – painting, drawing, sculpture and architecture – had its Curator ... the system was too rigid. But it worked without much difficulty.'[68]

During the First World War there had been an attempt to incorporate the Academy Schools into the national university system as a 'final', or higher, college of art, but although the proposal was given serious consideration, it was eventually dropped.[69] There was certainly a sense that the Schools were moving towards being officially recognized as an advanced school, but the Academicians, in the absence of government enthusiasm, chose to continue as an independent institution rather than be co-opted into the national system. The Keeper during the mid-twentieth-century period was Sir Henry Rushbury RA (1949–64), who was praised for giving 'every student a sense of importance' and putting the Schools on a par with the Slade and the Royal College of Art, when they had previously been seen as a 'poor relation' in comparison.[70] Unlike its rivals, though, the Academy's independent status meant that it was able to opt out when the whole nature of art education in Britain was overhauled in the aftermath of the first Coldstream Report of 1960.[71] The Keeper during this period of flux, Peter Greenham RA (1964–85), was unimpressed by the state system's promotion of theoretical inquiry above technical skill, complaining that 'under the

412 Julie Born Schwarz, still from *Love has no reason*, 2014, HD video with sound (RA 15/4213).

panoply of BAs and postgraduate diplomas and tutorials and seminars and theses the standard of drawing has declined to such an extent that the student who has not been to an art school may draw better than a postgraduate.'[72] That is not to say that he resisted change in itself. From 1968, the official policy of the Schools was 'to give the help of appropriate teachers to students of every inclination, whether abstract or figurative', although all students still had to complete at least one term of life drawing.[73]

Having remained outside the mainstream of the UK art education system, the Schools were viewed as rather idiosyncratic and old-fashioned. Yet a sense of the laissez-faire attitude intentionally instilled at the Academy's foundation lived on, and students followed different paths according to their individual interests, some traditional, others more progressive. Following Greenham as Keeper were Norman Adams RA and Leonard McComb RA, who encouraged this diversity while overseeing the gradual transformation of the Schools. In the 1990s, with the spotlight on Young British Artists and the ground-breaking contemporary exhibition 'Sensation' mounted at the Royal Academy, the process of moderniza-

tion was accelerated, particularly under Brendan Neiland RA from 1998 and his successor Maurice Cockrill RA (2004–11).

At the time of writing, the course is a three-year postgraduate diploma through which students can explore all media and a diverse range of approaches, and the Academy collections gained its first artwork in film in 2014 (fig. 412). The historic connection between the Schools and the collections has continued, with students encouraged to engage with the Academy's holdings both old and new, and through the annual Keeper's Purchase Prize established in 2006, the collection now acquires one work annually by a student from the Schools Show each year. In addition to having individual studio spaces, the students benefit from a variety of lectures, artist talks, critiques and tutorials given by leading contemporary artists, Academicians, writers and theorists. The Schools have continued to evolve with the appointment of the first female Keeper, Eileen Cooper RA, in 2011, who was succeeded by Rebecca Salter RA in 2017, and also the first female Curator and Head of the Schools, Eliza Bonham-Carter (from 2006).

A CLOSER LOOK

14.1

A sketchbook in the Schools

ANNETTE WICKHAM

These lively sketches (figs 413–16) by an unidentified artist, but possibly Edward Francis (Francisco/Francesco) Burney, provide a glimpse of life at the Royal Academy Schools in the 1770s, which Burney entered in 1777, having enrolled the previous year (he left in about 1780). It was the hope of Sir Joshua Reynolds PRA that students would learn from each other as well as from the Academicians in the 'atmosphere of floating knowledge' that the Schools intended to foster.[1] In the early period, however, the age of students ranged from 14 up to 35, and the atmosphere was often boisterous. James Elmes was not alone in complaining of students 'playing at leap frog…spouting water, breaking fingers off the Apollo, pelting one another with modeller's clay and crusts of bread, roasting potatoes in the stove, teizing [sic] the Keeper by imitating casts'.[2]

This sketchbook was given to the Academy by John Postle Heseltine, a painter and collector of prints and drawings and a trustee of the National Gallery, to which he donated a number of Dutch and German paintings. He believed the drawings of Academy students in the sketchbook to be the work of Thomas Gainsborough RA, although that attribution is not feasible. A connection with the Schools is clear, and the inscriptions under some of the drawings appear correctly to identify the sitters by name, almost all of whom were young artists enrolled at the Schools in the mid- to late 1770s, in particular Richard Corbould and Thomas Stowers. It is very likely that the artist was himself a student at the Schools in the late 1770s. Almost all the portrait sketches are drawn in pen and ink outline over pencil with shading in grey wash, and some of the sketches show the sitters drawing or painting.

In addition to the portrait sketches the book also contains a set of rapidly drawn but accomplished pencil sketches of a theatrical subject, perhaps *King Lear*, and of scenes depicting musical entertainment, which are probably by another hand. Further drawings in the book appear to be after, or based upon, contemporary portraits, and although some of them resemble portraits by Gainsborough, none of them has yet been clearly identified. There are also some less accomplished pencil drawings, perhaps made by a child.

Sketchbook of drawings in the Schools, late 1770s, sketches illustrated here pencil, pen and wash, 19.6 × 15.8 cm.

(top left) 413 *Man sitting on a Chair* (09/1708).

(top right) 414 *Seated Man asleep at a Table* (09/1731).

(bottom left) 415 *Man in a Tricorn Hat, resting on a Cane*, inscribed 'Thornton' (09/1697).

(bottom right) 416 *Man standing with his Left Foot on a Sketching Box*, inscribed 'Alexander' (09/1701).

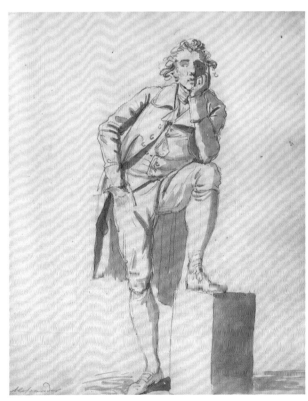

High Renaissance masterpieces:
Michelangelo, Leonardo and Rosso

ROBIN SIMON

Michelangelo's Taddei Tondo (fig. 417) is probably the most important Italian High Renaissance sculpture in Britain. It is all the more remarkable, therefore, that it should have come to the Academy as an aid to the instruction of students. Sir George Beaumont bequeathed it to the Royal Academy very deliberately, since many of the key paintings in his collection had been donated to form the nascent National Gallery in 1824. Beaumont had bought the Tondo in Rome in 1822, for a very large sum, from Napoleon's former head of looting in Italy, the engraver and painter Jean-Baptiste Wicar. Beaumont was assisted by the great sculptor Antonio Canova, as he wrote in a letter to Sir Thomas Lawrence PRA: 'You may be sure I was made to pay for this, & but for the assistance of our excellent Friend Canova probably I should not have succeeded at any rate.'[1]

The Tondo may have been commissioned by Taddeo Taddei from Michelangelo, for the purposes of private devotion. Although it remained with the Taddei family in Florence until the early eighteenth century, it then passed to their relations the Quaratesi, from whom Wicar obtained it, perhaps in 1812 but possibly much earlier.[2] If Wicar did in fact buy it from the Quaratesi, it would have been, in accordance with his usual practice, at a knock-down price; but Wicar was quite capable of simple confiscation, and indeed he had officially exercised that power on behalf of the *directoire* and Napoleon.

After the fall of Napoleon in 1814, Wicar found himself willing and able to assist in the vast task of returning to Italy those same works that he had busied himself in removing. His fortunes varied with those he served in turn: the monarchy, the Revolution, the Terror, the Republic, the Directory, the Empire, and the various monarchies in Italy and Spain invented by Napoleon – until, despite having won the admiration of Pope Pius VII in 1820, in 1823 Wicar finally ran out of protectors.[3] In the business of restoring stolen works of art to Italy, Wicar worked alongside Antonio Canova, who was ultimately in charge of the whole operation. Canova was in London 1815–16, and so it was natural that he should subsequently have acted as a go-between during Beaumont's efforts at extricating the Taddei Tondo from Wicar (Beaumont and Canova had met in Rome in the winter of 1821), at the time when the luck of that supple operator was beginning to run out. Canova supervised the packing of the Tondo, which was addressed to Beaumont's London house at 34 Grosvenor Square.

With Beaumont's remarkable purchase, the Tondo was now studied by Academicians in London, where it was first drawn in 1823 by David Wilkie RA (fig. 418), who wrote to Beaumont:

454

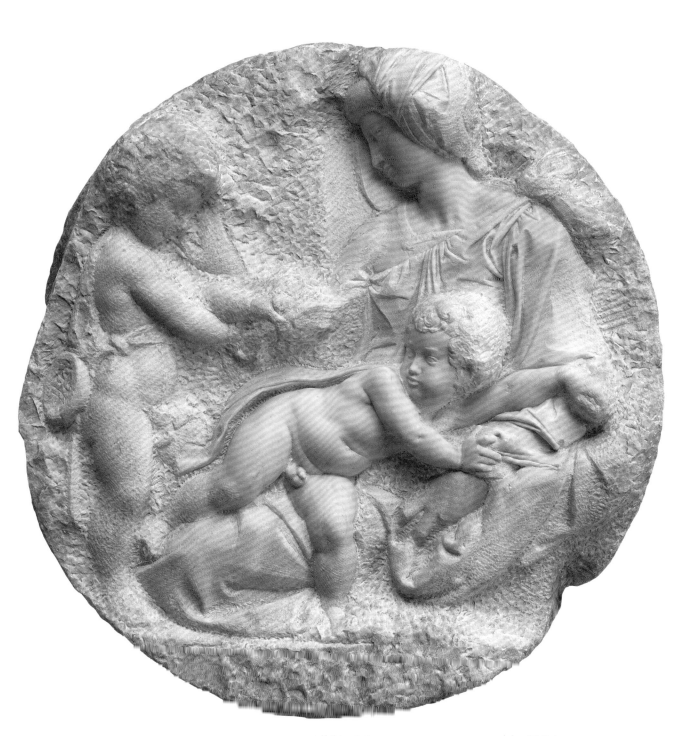

117 Michelangelo Buonarotti, *Virgin and Child with the infant St John* (Taddei Tondo), c.1504–5, marble relief, diameter 106.8 cm (RA 03/1774)

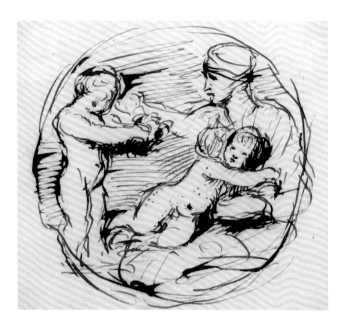

418 David Wilkie RA, sketch of Taddei Tondo, 1823, pen and brown ink, *c*.13 × 13 cm (RA 04/2432).

419 John Constable RA, sketch of Taddei Tondo, 1 July 1830, pen and brown ink, 11.5 × 12.7 cm (RA 04/205).

'Your important acquisition of the basso-relievo of Michael Angelo is still the chief talk of all our artists. It is indeed a great addition to our stock of art, and is the only work that has appeared in this northern latitude to justify the great reputation of its author.'[4] Immediately after it entered the Royal Academy's collection in 1830, it was drawn by John Constable RA (fig. 419), who wrote a letter to the *Athenaeum* (3 July 1830) remarking on its lighting: 'showing the more finished parts to advantage, and causing those less perfect to become masses of shadow, having at a distance all the effect of a rich picture in chiaroscuro'.

THE LEONARDO CARTOON

One of the two greatest treasures that the Royal Academy has owned can be dimly discerned, to the side of the far doorway, in the background of Edward Burney's watercolour of the Antique School at Old Somerset House (fig. 420): Leonardo da Vinci's cartoon of the *Virgin and Child with St Anne*. In 1962 it was put up for sale by the Academy at £800,000, at which point it was displayed by the National Gallery, for which it was eventually acquired as the result of a public appeal. A related

but not identical composition in oil is in the Louvre, a painting that may have been begun in 1499, and the cartoon is often dated to much the same period.[5] The absence of any pricking or of incised lines indicates that it was never actually used as a cartoon: that is to say, for transferring the composition on to a surface for painting. It was evidently preserved as a work of art in its own right.

What was this supreme masterpiece doing on the side wall of a drawing school? Quite simply, like the Taddei Tondo, it was a teaching aid. Although Leonardo's reputation rose to new heights in the nineteenth century, he had always been held in high esteem, and in March 1801 Henry Fuseli RA referred to him in the second of his lectures in fulsome terms: 'Such was the dawn of modern art, when Lionardo [*sic*] da Vinci broke forth with a splendour which distanced former excellence: made up of all the elements that constitute the essence of genius…all ear, all eye, all grasp; painter, poet, sculptor, anatomist, architect, engineer, chemist, machinist, musician, man of science.'[6]

It is not known how the Leonardo cartoon came into the Academy's collection. It had been in a Milanese collection in the seventeenth century, and was then in the Sagredo family collection in Venice in the eighteenth before being acquired in

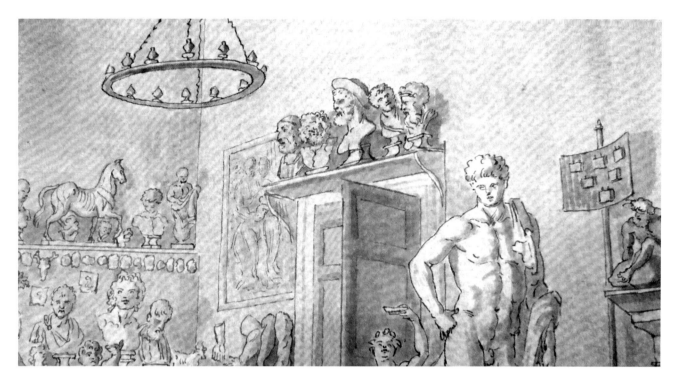

420 E. F. Burney, *Antique School at Old Somerset House*, detail, 1779, watercolour and pen and ink, 33.5 × 48.5 cm (RA 03/7485).

1763 by the English collector Robert Fullarton Udny, whose brother John, a compulsive collector and dealer, was consul in Venice from 1761. In 1763 John suffered a financial disaster, from which he was able to extricate himself through the sale of his collection, and this is the year in which the cartoon passed into the collection of his brother Robert. The Leonardo cartoon was listed in the Royal Academy's inventory of 1791, but Burney's watercolour shows us that it was already in the collection in 1779. Robert Udny was of an ancient Scottish family but gained a fortune as a West India sugar merchant and had a London townhouse in South Audley Street. He was a notable scholar and antiquarian, a Fellow of the Society of Antiquaries and of the Royal Society. Udny was in Italy 1769–70 when he was painted by Pompeo Batoni (sold by a descendant, Christie's, London, 6 July 2006, lot 39) and again in 1775 in Rome. This plate and Piranesi's celebrated publication *Vasi, candelabri...* (2 vols, 1778) are dedicated to Robert Udny and another to his first wife, Maria Hougham. In about 1780 Udny employed Robert Adam to build a picture gallery on to a house he had just bought in Teddington, on the corner of Kingston Lane and the High Street (demolished 1826). Udny is

known to have patronized Edward Edwards RA, who was one of the very first students at the Academy Schools (from 30 January 1769). By the time Edwards became teacher of perspective at the Academy in 1788, the cartoon was already there, and it seems probable that Udny had donated it. After his death in 1802, the Royal Academy was offered the chance to buy Robert Udny's collection, but the offer was 'declined'.[7]

LEDA AND THE SWAN ATTRIBUTED TO ROSSO FIORENTINO

The third High Renaissance masterpiece owned by the Royal Academy, the oldest drawing still in the collection, was long thought to be from the hand of Michelangelo, and to be the cartoon for a painting of this erotic subject that he made for Alfonso d'Este, Duke of Ferrara, 1529–30 (fig. 421).[1] The duke's envoy, when he arrived in Florence to collect that painting, annoyed Michelangelo, who as a result gave both the painting and the cartoon for it to his pupil Antonio Mini, who took them to Lyons, where he had three copies made. Mini then

457

421 Attributed to Rosso Fiorentino, after Michelangelo Buonarotti, *Leda and the Swan*, *c*.1538, black chalk on paper, 174.5 × 253.8 cm (RA 04/282).

took both the original painting and its cartoon to the court of François I of France at Fontainebleau in 1531, intending to sell the painting to the king,[9] and it was soon afterwards recorded in the French royal collection.

Rosso's drawing is on a very large scale, that of a cartoon, in fact, created for a picture that was itself described as a *quadrone* – a big picture – and it may well have been traced directly from Michelangelo's original cartoon. Rosso was in the perfect position to execute this because he was working at Fontainebleau in the 1530s, and in 1532 he had actually been employed to make a large and heavy frame for Michelangelo's painting (which was in tempera on panel). The drawing is especially significant as the record of a lost cartoon by Michelangelo, although copies of his lost painting survive,

among them one by Rubens (Fogg Art Museum, Harvard University).

The present drawing was acquired in Florence from the Vecchietti family in the early 1770s by William Lock the Elder, who had it shipped to London in 1773, and at the time the drawing was presented to the Academy by his son it was still thought to be by Michelangelo. Despite the attempts of Lawrence to persuade the younger Lock to sell him the picture, he gave it to the Academy, where it was put on display in the Schools as another aid to instruction. In 1877 two Academicians, John Rogers Herbert and John Callcott Horsley ('Clothes Horsley' as *Punch* dubbed him on account of his prudish antagonism to the nude), tried to have the drawing thrown out of the collection on the grounds that it was

corrupting of morality. It survived, unlike Michelangelo's original painting, which had been destroyed in a similarly prudish way apparently by des Noyers, Louis XIII's minister of state, 'par principe de conscience', in the seventeenth century, perhaps on the orders of the queen, Anne of Austria.[10] That painting had, however, already been much copied. One copy, held at the time to be by Michelangelo, was bought by the Hon. John Spencer in 1746 and passed to Sir Joshua Reynolds 'by the favour of the present Earl Spencer', according to the catalogue of the sale by James Christie of Reynolds's collection in 1795, when it sold to Lord Berwick for 71 guineas.

It was subsequently sold at auction by Peter Gann in 1812, still as by Michelangelo (12 June 1812, lot 17). Another copy of the painting was donated to the National Gallery in 1838 by the Duke of Northumberland, and so was therefore in the same building in Trafalgar Square as the Academy's copy of the cartoon. Like the drawing, this copy of the lost painting was thought almost too hot to handle. The duke stipulated that it should not be put on public display, and so it remained hidden from view in the director's office. Meanwhile, Rosso's copy of the original cartoon was still available to students in the Academy Schools.

The Society for Photographing
Relics of Old London

PAT EATON

With the advent of photography, the Academy began to acquire photographs, as it did books, prints, drawings, casts and copies, as a research aid to students. One such set of images recorded the ancient buildings that were vanishing from London, the work of the Society for Photographing Relics of Old London. It had been formed as a consequence of a number of letters in *The Times* pleading for the preservation of various architectural features threatened by redevelopment and demolition. One such letter was written by Alfred Marks,[1] a company secretary and brother of the painter Henry Stacy Marks RA. Marks announced that in order to retain a record of an old London inn prior to its destruction, 'a few gentlemen' had commissioned photography of the Oxford Arms, a galleried building near St Paul's Cathedral, which was about to be demolished to make way for the expansion of the Old Bailey (fig. 422).[2] Encouraged by the enthusiasm with which this photographic campaign was received, and with support from George Henry Birch, president of the Architectural Association, the painter Henry Wallis and Henry Stacy Marks, the society decided to publish an annual photographic record of buildings under threat, a series that was issued 1875–86. Each instalment was priced at one guinea, and from 1881 onwards Alfred Marks, the society's honorary secretary, wrote a descriptive text providing a historical background to each of the buildings.

The Society was one of the first organisations to use photography to survey and record architecture threatened with urban change. In Scotland, in 1868, the Glasgow City Improvement Trust had employed the photographer Thomas Annan to document the city's old 'closes', and in 1875 James Burgoyne provided photographs of existing streets (and slums) for the Birmingham Improvement Scheme. Both of these were municipal schemes, their purpose being to produce images of contemporary living conditions rather than architectural records. In 1886 the Society for Photographing Relics of Old London, however, referred to its work as a 'record',[3] and although the urgency of securing negatives sometimes prevented a strict classification of subjects, the society seems to have considered its aims carefully. Architecture was to remain pre-eminent in each image in the series, whether recording an individual structure or the juxtaposition of civil and ecclesiastical buildings.

Initially, the society employed Alfred and John Bool as its photographers, although Henry Dixon & Son printed the Bools' negatives. In 1879 Dixon and his son Thomas James took over photography, and, with one exception, they

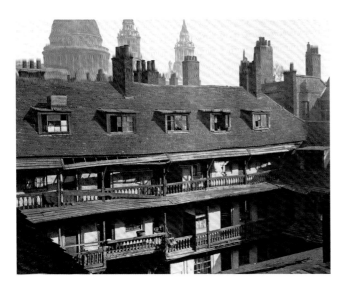

422 Alfred and John Bool, *Galleries of the Oxford Arms, Warwick Lane, looking from Warwick Lane*, c.1875, carbon print mounted on card, 18 × 22.6 cm (RA 06/74).

423 Henry Dixon & Son, *Shop, Macclesfield Street, Soho*, c.1883, carbon print mounted on card, 18 × 22.7 cm (RA 06/277).

continued as the photographers for the remainder of the project. Perhaps the onset of commercially available gelatine dry plates had some bearing on this change. By 1879 it can be assumed that Henry Dixon had some experience of the new plates as he is credited with writing an article in that year enthusiastically praising their advantages.[4] As their portability and sensitive emulsion would have aided the photography of interiors, it is probably no coincidence that, a year after Dixon & Son took over, the society began to include interior views with the publication of a series of photographs of Charterhouse. The number of photographs per issue also rose from 6 to 12.

The society's photographers created views within the 'picturesque' aesthetic that was to remain popular in British photography well into the twentieth century. On a few occasions, views would include domestic objects and posed figures. This is more often the case, it seems, in the photographs of the humbler kinds of building, such as inn yards and shops (fig. 423). A balance, however, had to be carefully negotiated between the need to create an accurate, informative record and an image that also invited contemplation. If the society was conscious of criticism of some of the photographs when they were exhibited by the Architectural Association as being of no practical use to architects, they would have been delighted when, on 26 September 1882, a reviewer in *The Times* remarked, 'The prints combine the accuracy of such [photographic] work – an accuracy hardly to be attained in the most careful drawing – with the charm of thorough and artistic treatment.'[5]

The photographs that Dixon & Son produced for the society's subscribers were carbon prints, a process that, unlike others of the time, does not suffer from fading. The society hoped its photographs would appeal to people of antiquarian tastes and, particularly for professional reasons, to architects. It is also very likely that they would have been of great interest to painters, as they provide a rich source of authentic detail that could be used in historical recreations of English urban scenery. Many of the photographs show examples of Tudor or Stuart architecture, a period that, in the mid-nineteenth century, was often considered to be the most romantic in English history and provided subject matter for a number of Academicians. It is therefore not surprising that, in 1880, the historical genre painter Solomon Hart RA, in his last few months as the Academy's Librarian, purchased 48 of the society's photographs. In subsequent years the new Librarian, John Evan Hodgson RA, who was also a historical genre painter,[6] completed the purchase of the full series of 120 photographs.

15

THE CAST COLLECTION

MARTIN POSTLE

The study of classical statuary, often in the form of plaster casts moulded from carefully selected marble or bronze paradigms, formed the bedrock of artistic training and theory in the European academy from the sixteenth century. A repertoire of well-known statues was held to show the human body in its most perfect form, and so the study of them was central to the academic pursuit of the ideal. Plaster casts were much sought after by academies, and their acquisition required not only a serious investment of financial resources but also diplomatic skills and assiduous networking. By the time the Royal Academy was founded, casts taken from important collections of antique statuary, not least those found in the statue court of the Belvedere belonging to the Vatican, had been disseminated throughout Europe. Among the most urgent tasks facing the new institution was the assembling of a cast collection, one that would be worthy of its aims and ambitions and put the Academy on a par with its European counterparts.

During the first 100 years of its existence, the Academy assembled the largest and most wide-ranging collection of antique and Renaissance plaster casts in Europe. Today, apart from those casts on display in the Academy Schools and others dotted around its public spaces, the bulk of the collection remains hidden from view, consigned to off-site storerooms. The issue is not simply one of neglect: far from it. As we shall see, the Royal Academy has always had a serious commitment to its cast collection, in terms of both its preservation and conservation, even though, because of its primary function as a teaching resource, it has at times undergone rough treatment through frequent movement and manhandling. Yet, unlike so many other collections of casts in art schools and academies in Britain and abroad, the Royal Academy's collection has managed to survive. To some extent its existence is bound up with the innate conservatism of the Academy. Even when studying from plaster casts was deemed unfashionable or disdained, there was no move,

apart from two episodes, to offload, despoil or even to destroy them, as was the case in many art schools.[1] And in recent years the Royal Academy has become increasingly aware of the importance of its cast collection, and has embarked upon a programme of cataloguing and conservation. It is also, at the time of writing, the intention to enhance the display of casts beyond the Schools, demonstrating the power of their presence throughout the buildings.

PRELUDE: THE DUKE OF RICHMOND'S GALLERY

In Britain the replication of antique marble statues and bas-reliefs in plaster of Paris was pioneered from the late 1730s by the sculptor John Cheere from his yard at Hyde Park Corner, where he manufactured casts both painted off-white to resemble marble and gilded to look like bronze.[2] These casts served a primarily decorative purpose in private town and country houses. The first significant collection of plaster casts assembled specifically for educational purposes, and an important precursor to the Royal Academy, was at the 3rd Duke of Richmond's gallery in Whitehall.[3] As Horace Walpole remarked in a letter to Sir Horace Mann on 9 February 1758: 'I was pleased yesterday with a very grand seigneurial design of the Duke of Richmond, who has collected a great many fine casts of the best antique statues, has placed them in a large room in his garden, and designs to throw it open to encourage drawing.'[4] The directors of the Duke of Richmond's gallery were the sculptor Joseph Wilton RA and the Italian painter and designer Giovanni Battista Cipriani RA. Wilton selected and arranged the casts and wrote the prospectus.[5] The gallery, which opened its doors to artists on 6 March 1758, contained 22 plaster casts made from statues in Rome and Florence, together with smaller plaster busts, statuettes and reliefs. It included notable figures, such as the *Apollo Belvedere*, the *Venus de' Medici* and the *Dancing Faun*. Some casts were supplied by the architect Matthew Brettingham the Younger, who had imported statues and moulds for producing casts from Italy. Others came from Wilton's own studio, since Wilton had himself carved marble copies of various antique statues. Casts were also made from statues in English private collections, notably a Pythagoras or *Demosthenes*, acquired by John Frederick Sackville, 3rd Duke of Dorset, in Rome (now in the Glyptotek, Copenhagen) and

424 Cast of head of older, clean-shaven Roman legionary or auxiliary, plaster, 15.1 × 15.4 × 5 cm (RA 10/3296).

a *Discobolus* belonging to William Lock, a prominent connoisseur and collector, who had travelled in Italy with Richard Wilson RA in the 1750s.

Despite its lofty ambitions the Duke of Richmond's gallery was short-lived, and by 1762 Thomas Jones, who had studied there, reported that 'this noble Institution was now on the Decline.'[6] Wilton and Cipriani resigned their posts, and by 1767 the gallery was unsupervised. Within a year or two, as the artist Edward Edwards observed, 'the foundation of the Royal Academy rendered it useless.'[7] Between 1778 and 1782 the gallery was dismantled and the casts mothballed. They were finally sold off at Christie's on 18 July 1820. Some casts came to the Royal Academy, including the *Fighting Gladiator* and over 100 medallion reliefs from the Column of Trajan in Rome (fig. 424).[8]

EARLY YEARS: BEQUESTS OF THE ST MARTIN'S LANE ACADEMY AND THE ROYAL ACADEMY

During the 1760s the St Martin's Lane Academy, the precursor to the Royal Academy, functioned principally as a life class, as represented in Johan Zoffany RA's painting of

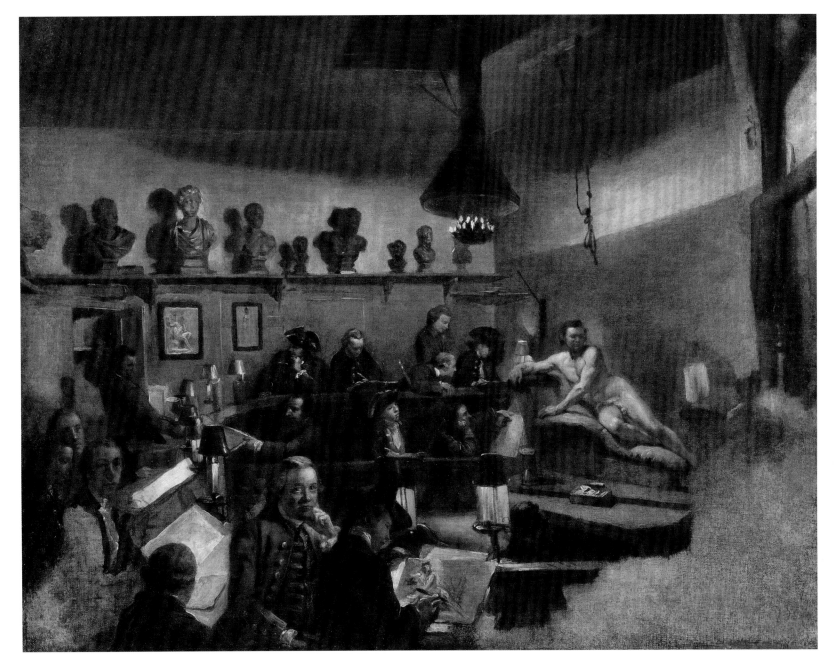

425 Johan Zoffany RA, *A Life Class at St Martin's Lane Academy*, 1761–2, oil on canvas, 50.5 × 66 cm (RA 03/621).

1761–2 (fig. 425). Several small plaster casts were evidently available to students, as indicated by their presence on a shelf on the back wall in Zoffany's painting. Some of these casts made their way into the Royal Academy's collection, including a bust of Commodus as a youth, a cast of which is still in the Academy (fig. 426), as well as a bust of Caracalla and a head of the *Laöcoon*, both of which are mentioned by Joseph Baretti in 1781 as being in the collection.[9]

The earliest visual record of the casts available for study at the Royal Academy is a fascinating painting by the Swedish

426　After a Roman sculpture, *Commodus as a Youth*, plaster, height 72 cm. (RA 03/1463).

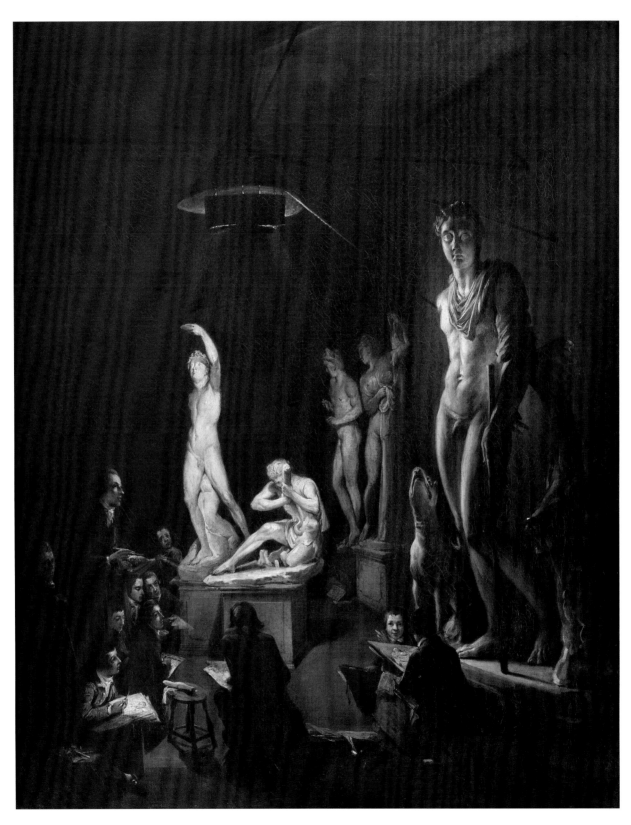

427 Elias Martin ARA, *A Picture of the Royal Plaister Academy*, 1770, oil on canvas. Royal Academy of Fine Arts, Stockholm.

artist Elias Martin. He had been a student in the Academy Schools since 3 November 1769 and in 1770 exhibited *A Picture of the Royal Plaister Academy* (fig. 427); shortly afterwards Martin was elected ARA (27 August 1770). Here five plaster casts are represented (left to right): Jacopo Sansovino's *Bacchus*, two boys fighting over a game of knucklebones (also known as the 'Knucklebone Players', or 'The Cannibal', on account of its appearance, only partially preserved), *Mercury*, the *Callipygian Venus*, and *Meleager* with the dog and boar's head. Joseph Baretti mentions all five casts in his guide, although it would appear that none featured in Martin's painting has survived in the Academy. Nor is it certain when the Academy acquired these important casts.

The original statue of Sansovino's *Bacchus*, then in Florence and now housed in the city's Museo Nazionale del Bargello, had been seriously damaged in a fire of 1762, and Baretti was under the impression that it had been destroyed, thus making the Royal Academy's cast all the more precious.[10] The original statue of the two boys fighting over a game of knucklebones (British Museum, London) had been acquired from the Barberini Palace, Rome, by the dealer Thomas Jenkins in 1767, who had sold it the following year to Charles Townley, from whom the Academy acquired its cast.[11] *Mercury*, which had been in the Uffizi Gallery, Florence, since 1734 had during the eighteenth century been replicated in plaster and as a bronze statue in the Farnese Collection, a mould of which had been imported to England by Matthew Brettingham the Younger.[12] It is possible therefore that the Royal Academy's cast was also derived from Brettingham's mould. The *Callipygian Venus* (Museo Nazionale, Naples) was at that time in the Palazzo Farnese, Rome. Plaster casts of the statue – which Baretti 'reckoned very fine, especially about the parts' – were made for a number of English collectors, Matthew Brettingham supplying from his mould a cast for the Earl of Leicester, at Holkham Hall, Norfolk, and also, perhaps, this cast.[13] The original statue of *Meleager* (Musei Vaticani, Rome), was purchased in 1770 by Pope Clement XIV. Since the sixteenth century it had been among the most admired antique statues in Rome. As a result plaster casts of the figure were eagerly sought after by European academies. A cast of *Meleager* was also acquired via Matthew Brettingham the Younger for Kedleston Hall, Derbyshire, during the 1750s, and the Royal Academy cast possibly derived from the same mould.[14]

In addition to the visual evidence supplied by Martin's painting, representations of other early acquisitions of plaster casts are to be found in Zoffany's wonderfully idiosyncratic painting, *Academicians of the Royal Academy*, exhibited in 1772 (see fig. 121). The setting of Zoffany's painting is indeterminate and may have been partly imaginary,[15] but the casts all appear to have been in the Academy's collection, and the painting provides a unique record of some of its more significant holdings at that time (fig. 428). Beginning at the extreme left, and moving to the right, we see, raised up on a shelf, three casts. The identity of the small female bust at the extreme left is uncertain.[16] The white plaster bust is a head from the *Niobe Group*, which was transferred from the Villa Medici, Rome, to the Uffizi, Florence, in 1770, where it remains.[17] Next is a cast of an *Infant Hercules*, which can be identified probably as Caracalla in the guise of the Infant Hercules, now in the Capitoline Museum, Rome.[18] Suspended on the back wall at the left is a small unidentified cast of a bearded head. On the shelf directly below are six casts, some of which are still to be found in the Academy's collection. The first is the bust of Commodus as a youth mentioned above. The unidentified white plaster cinerary urn is similar to, but not identical with, one presently in the collection.[19] Next is a standing female figure, the Mattei *Ceres*, the original of which was acquired by the pope in 1770 from Don Giuseppe Mattei and placed in the Museo Pio-Clementino.[20] Matthew Brettingham the Younger had made a cast from it, and it may have been from his mould that the Royal Academy acquired its own cast (fig. 429).[21] In the centre is Giambologna's *Mercury*, which, according to Baretti, was taken from the version of the bronze statue then in the Villa Medici, Rome, and now in the Museo Nazionale del Bargello, Florence.[22] The cast is no longer in the Academy's collection. To the right is a white plaster bust of Niobe, a later version of which is in the collection (fig. 430). At the right-hand side is a bust of a bearded male, possibly Jupiter. On the wall below the shelf, in the centre, is a rectangular relief sculpture depicting warriors, a cast taken from a marble relief, now in San Nilo Abbey, Grottaferrata, south-east of Rome. This relatively obscure relief had gained attention owing to its inclusion in Johann Joachim Winckelmann's *Monumenti antichi inediti* published in 1767.[23] To either side are reliefs of putti from François Duquesnoy's tomb of Ferdinand van den Eynden in S Maria dell'Anima, Rome (1633–40).[24] Finally, in

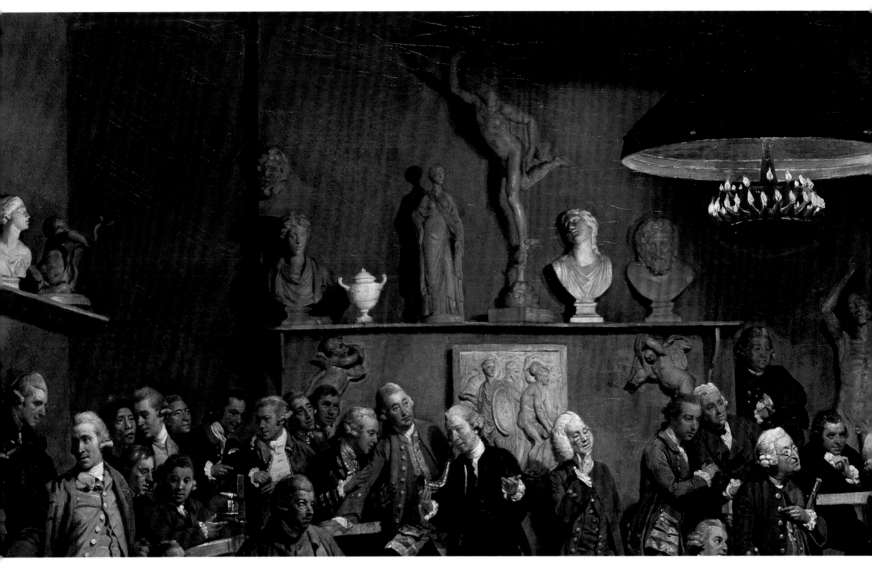

428 Johan Zoffany RA, *Academicians of the Royal Academy*, detail of fig. 121 showing casts.

the right foreground of Zoffany's painting (see fig. 121), lying on the floor beneath the cane positioned so suggestively by the artist Richard Cosway RA, is a sculpted female torso. It would appear to be a cast of the torso of Venus excavated only recently at Porta d'Anzio, which had been acquired by William Lock from Thomas Jenkins. According to Baretti, who described the cast of the torso after it had been installed at New Somerset House in 1780, Lock's original marble torso, displayed at his house in Portman Square, was restored by Joseph Wilton 'in his usual masterly manner, and made

again into a whole statue'. This cast was therefore apparently made prior to Wilton's restoration.[25]

EARLY ACQUISITIONS, 1769–1780

During the 1770s the sculptors Joseph Wilton and Joseph Nollekens played prominent roles in brokering the acquisition of new casts for the Royal Academy's cast collection through their international network of influential patrons,

468

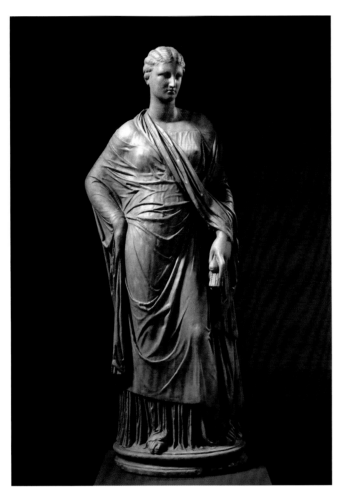

429 After a Roman copy of a Greek original, Mattei *Ceres*, plaster, height 109 cm (RA 03/1472).

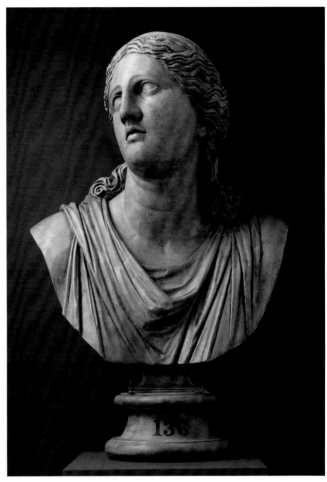

430 After a Roman copy of a Greek original, *Head of Niobe from the Niobe Group*, plaster, height 89 cm (RA 03/1516).

collectors and cast-makers. Wilton, in addition to his experience with the Duke of Richmond's gallery, had worked in Rome in the early 1750s making casts of antique statues, along with Matthew Brettingham the Younger, while in the following decade Nollekens had also been in Rome, where he gained employment in the workshop of the renowned sculptor Bartolomeo Cavaceppi, restoring classical statues and making casts. Among the earliest acquisitions of casts recorded by the Royal Academy in Council minutes were gifts by British collectors, art dealers and artists based in Italy. In August 1769 the Council reported two gifts of casts from Charles Townley and Thomas Jenkins; 'a Cast of the Lacedemonian Boy' from Townley and 'a Cast of Venus' from Jenkins. Although we cannot be certain, the former cast was probably of two boys fighting over a game of knucklebones, the sculpture mentioned above that was also known as 'The Cannibal', which Townley had acquired in 1768 during his Grand Tour from Jenkins, who in turn had purchased it from the Barberini Collection. The cast of Venus was also made from a statue formerly in the Barberini Collection, although it was subsequently known as the 'Jenkins Venus', after he had acquired it in 1762 from Gavin Hamilton and sold it on for a vast sum a few years later to William Weddell for his sculpture gallery at Newby Hall, Yorkshire.[20] Jenkins's gift of the cast to the Royal Academy at this early period in its history surely signalled his desire to assert the primacy of his

Among early donors to the cast collection was the Scottish artist, antiquary and dealer, Colin Morison, then based in Rome. In March 1770 the Council reported that they had received from Morison 'a Cast of the Torso & a Cast of a Bust of Alexander'.[28] The original head of the so-called *Dying Alexander* was then, as now, in the Uffizi Gallery, Florence. The 'Torso' was the celebrated *Belvedere Torso*, also called, as Baretti notes in his *Guide*, 'Hercules' or the 'Torso of Michelangelo…because Michelangelo termed it His School, thinking it the very best remain [*sic*] of Greek Sculpture that the World could show'.[29] The *Belvedere Torso* sent by Morison from Italy was one of two owned by the Royal Academy by around 1780, Baretti noting that the principal cast was then displayed in the 'Second Room of the Academy of the Antique', while the other, which he describes as a 'duplicate' of the former, was in the Entrance Hall.[30] In his biography of Nollekens, John Thomas Smith states that the sculptor had presented to the Royal Academy 'a fine cast of the Torso, having brought it from Rome for that purpose'.[31] Although no date is given, it would appear to have been around the time that Morison presented his, Nollekens having left Rome in October 1770. Assuming that they were separate acquisitions, we cannot know which was regarded as the principal cast and which the duplicate, but since Nollekens had been employed in Rome in the workshop of Cavaceppi his cast would certainly have been a very good one. In March 1771 the Council acknowledged the receipt of a cast from William Lock, whose gift was a head of Atalanta. According to Baretti, Atalanta was moulded from a copy in the French royal collection (now Louvre) made by Pierre Lepautre of the ancient statue when it was in the Mazarin Collection.[32] Lock was a close friend of Joseph Wilton and had collections at his home in Portman Square and Norbury Park, Surrey, and as we have seen had already presented the Academy with a cast of the *Discobolus* as well as the cast of the torso of Venus that we see in Zoffany's *Academicians*.[33]

In March 1769 Joshua Reynolds had written to Sir William Hamilton, then British ambassador to the court of Naples, with a detailed account of the structure of the newly founded Academy.[34] The following summer, he wrote to Hamilton once more, thanking him for the gift of two casts, a 'Bas-relievo of Fiamingo' and an 'Apollo' that had just arrived at the Royal Academy, noting that 'they have been so long on their passage that we have but just now receiv'd

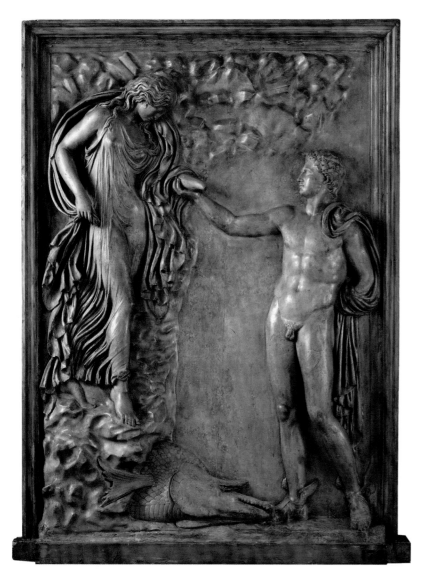

431 After a Roman sculpture, *Perseus and Andromeda*, plaster, height 172.3 cm (RA 03/2018).

Venus over the more celebrated *Venus de' Medici*. Although the Royal Academy still has a cast of the *Venus de' Medici*, Jenkins's cast has not survived and nor, apparently, has the cast made from Townley's boys fighting. Over the next few decades Townley gave further casts made from his collection to the Academy, including a torso of Venus, a bust of Hercules, a 'Head of Diomedes' and a cast of a relief panel depicting Perseus and Andromeda, the original of which is in the Capitoline Museum, Rome (fig. 431).[27]

them'.[35] The bas-relief was the *Concert of Angels* by the seventeenth-century Flemish sculptor François Duquesnoy ('il Fiammingo') from the Filomarino altar in the church of SS Apostoli, Naples, while the 'Apollo' was presumably a cast of the *Apollo Belvedere*. The original statue of the *Apollo Belvedere* was at that time in the Vatican's Belvedere statue court, but, as Baretti pointed out, the Royal Academy's cast, 'to say the truth, is none of the best, as it was formed, not on the Original, but on another cast'. He also noted that by then the Academy possessed a duplicate.[36] Reynolds reported to Hamilton in the same letter of 1770 that both casts were 'ordered by his Majesty' to be placed in Somerset House, the new home of the Royal Academy Schools, during the summer. Although neither cast has survived, both are visible in Edward Burney's watercolour of the Antique School at Old Somerset House (see fig. 392): the *Apollo* left of centre and Duquesnoy's bas-relief situated directly over the fireplace at the right.[37] On the move to New Somerset House, as Baretti recorded, the *Concert* was placed in the entrance hall.[38] Further gifts of casts were made by William Hamilton to the Royal Academy in the 1770s and in 1803.[39]

Among other titled donors and benefactors during the earlier 1770s were the 3rd Duke of Dorset and William Petty, 2nd Earl of Shelburne (later 1st Marquess of Lansdowne). In October 1771 the Duke of Dorset presented a cast of a bust of Antinous from his collection.[40] The original bust was shortly afterwards sold by the Duke of Dorset to Charles Townley, and is now in the British Museum.[41] The bust, which depicted Antinous as Dionysus, with a wreath of vine leaves, was, as Baretti commented, similar to another bust of Antinous acquired by the Royal Academy from the collection of Lord Shelburne (fig. 432), the original of which is now in the Fitzwilliam Museum, Cambridge.[42] In addition to the bust of Antinous, the Council recorded, in December 1771, the presentation by the Duke of Dorset of 'a Cast of Pythagoras' (fig. 433).[43] The original statue, now known as *Demosthenes*, had been acquired by Lord Sackville in Rome and is now in the collection of the Ny Carlsberg Glyptotek, Copenhagen. In 1788 Reynolds wrote to the sculptor John Bacon RA suggesting that his statue of Samuel Johnson, then intended for Westminster Abbey, should be 'near naked in the manner of Pythagoras [*sic*] which we have a cast in the Royal Academy'.[44] Bacon's statue was eventually placed in the crossing of St Paul's Cathedral.

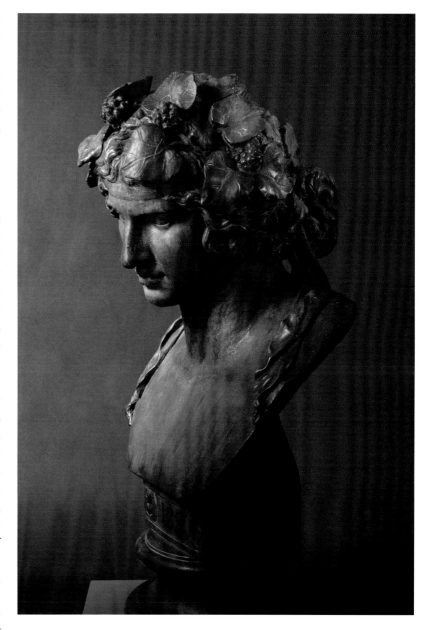

432 After a Roman sculpture, *Antinous as Bacchus*, plaster, height 81 cm (RA 03/1471).

In June 1774 the Royal Academy gained permission from the Earl of Shelburne to make casts from three of his most celebrated antique statues, recently discovered in Rome by Gavin Hamilton.[45] They were described as 'The Meleager, The Gladiator putting on his Sandals, & the Paris'. The 'Gladiator', or *Cincinnatus* (fig. 434) as it is also known, was

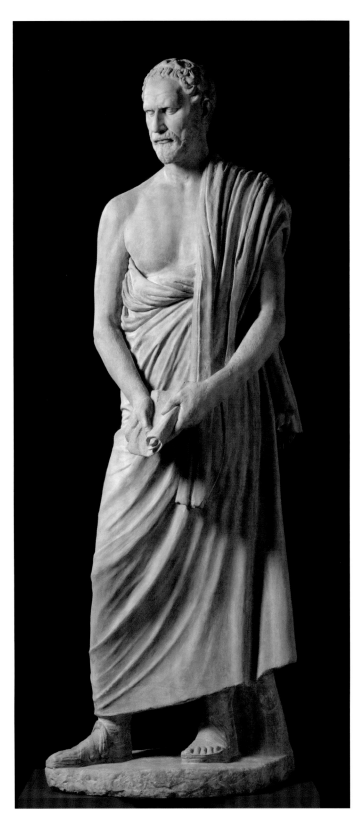

excavated by Hamilton from Hadrian's Villa, and sold by him in 1772 to Lord Shelburne, who displayed it with other classical statues in the dining room of Lansdowne House, Berkeley Square.[46] Although in poorer condition than the statue already in the French royal collection and the plaster cast made from it in the French Academy in Rome, Shelburne's *Cincinnatus* had the advantage of having its original head. 'Meleager' was a quite separate figure from the one depicted in Elias Martin's painting (with the hound and boar's head, see fig. 427), and was a version of the *Belvedere Antinous* (Musei Vaticani, Rome), excavated by Hamilton at Tor Colombaro. The 'Paris', like *Cincinnatus*, was excavated from Hadrian's Villa, and featured a standing youth in a Phrygian cap, with crossed legs. It is now in the collection of the Louvre, Paris. Of the casts made for the Royal Academy from these statues only the *Cincinnatus* has survived: it is among the oldest in the collection.

The majority of casts acquired by the Royal Academy during the early years were from antique statues, busts and bas-reliefs, but in 1773 it acquired casts of the celebrated 'Gates of Paradise' by Lorenzo Ghiberti: the bronze door panels from the Baptistery, Florence (fig. 435). Although we cannot be certain, it would appear likely that these casts were acquired through the agency of the antiquarian and dealer Richard Dalton (the king's librarian) and the artist Thomas Patch, who was then resident in Florence. Patch had a close interest in Ghiberti's door panels having recently made a series of engravings of them, which were incorporated into a book, *Libro della seconda, e terza porta di bronzo della Chiesa di S. Giovanni Batista [sic] di Firenze 1403. 23. novembre*, published by Patch and the Italian engraver Ferdinando Gregori.[47] The scale of the doors clearly presented a challenge in terms of their accommodation in the Academy. As the Council noted, 'Resolved, that the disposing of the Casts of the Gates of the Baptistry of St John at Florence, by Lorenzo Ghiberti, be left to Mr Moser (with this restriction, that they be placed at the End of the Lecture-Room but not to be higher than the top of the Door. That the Outer Border be placed in the Hall.'[48] By around 1780 'the Pannels of the three doors' were hanging on the walls of the first room of the Antique

433 After an original by Polyeuctus?, *Demosthenes*, plaster, height 198 cm (RA 03/1492).

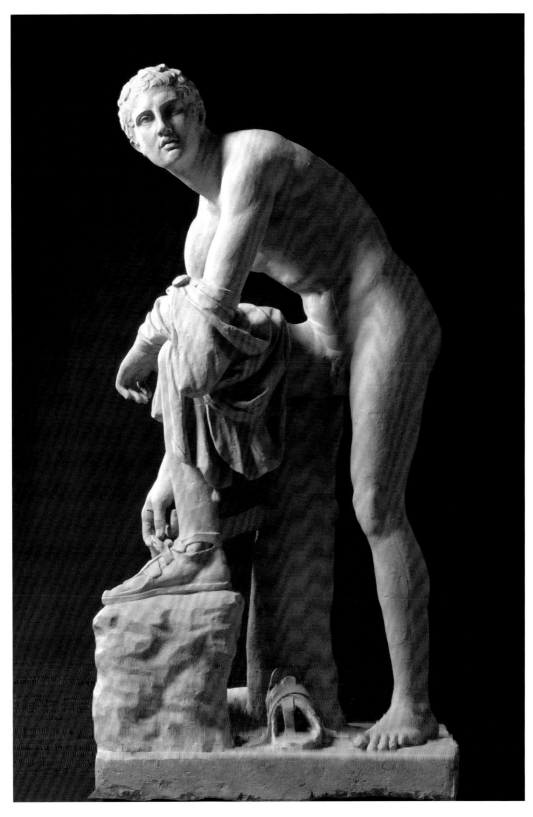

434　After a Roman copy of a Greek original, *Cincinnatus*, plaster, height 162 cm (RA 03/1488).

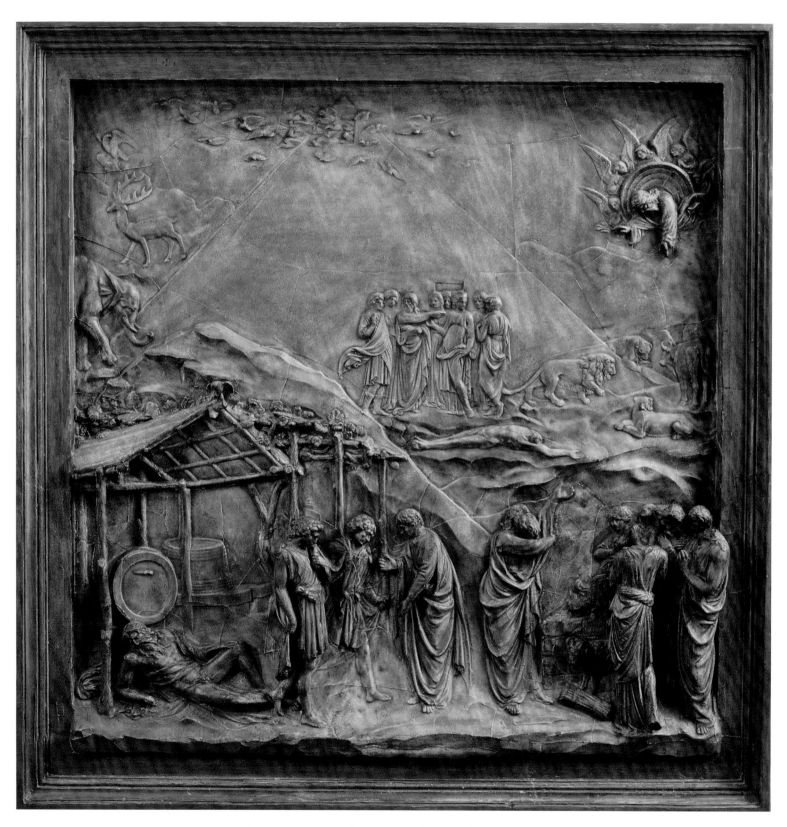

435 After Lorenzo Ghiberti, *Story of Noah*, plaster, height 92 cm (RA 03/1966).

436 After a marble in the Capitoline Museum, Rome, *Sleeping Endymion*, plaster, height 169 cm (RA 03/2016).

Academy at New Somerset House, as Baretti noted, and they can be seen in E. F. Burney's drawing of the *Antique School at New Somerset House, c.*1780 (see fig. 26).[49]

By the mid-1770s, as well as accepting donations of casts, the Royal Academy was committed also to their purchase. In January 1774 the Council recommended the purchase of a 'Figure of Comedy' for £8 8s. and a 'Boy' by Duquesnoy.[50] 'Comedy' can probably be identified as the plaster replica of Thalia, which had been moulded from the statue belonging to Lord Anson at Shugborough Hall, Staffordshire.[51] Anson's collection of classical statues had been acquired in a job lot from a bankrupt merchant in Livorno in 1766, and restored by the sculptor Peter Scheemakers.[52] The 'Boy' was probably the Duquesnoy cast described by Baretti as the 'Adolescentus, or Little Boy', since the 'Puellus; that is a child', in the entrance hall at New Somerset House, also by Duquesnoy was, he noted, 'a present of Sir William Hamilton to the Royal Academy'.[53]

In the later 1770s the Royal Academy received further gifts of casts, including in 1777 a bas-relief of the *Sleeping Endymion*, from the marble sculpture in the Capitoline Museum, Rome, presented by Clotworthy Upton, 1st Baron Templetown (fig. 436).[54] A few years later, at New Somerset House, it was placed on the wall of the staircase, between the mezzanine and the principal floor, evidently fulfilling a primarily decorative function.[55] Also at this time, William Hoare RA, who had trained in Rome during the 1730s, presented 'an Allegorical Bas-relief (said to be of Michelangelo)', 'a Cast of the Head of the Tiber on the Trajan Column' and 'the cast of a Vestal sacrificing'; while 'Mr Harris', probably the eminent grammarian James 'Hermes' Harris, was thanked for his gift of 'a Cast of a Pallas'.[56] This cast may be identified with the bust of Pallas of Velletri in the Academy's collection (fig. 437), which is based upon the marble bust excavated in the Villa of Licinius Murena in Tusculum in 1770 (Glyptothek, Munich). Also of relevance in the collection is a drawing of the bust by James Barry RA, probably made when he was a Visitor in the Academy Schools sometime between its acquisition and his expulsion from the Academy in 1799 (fig. 438). The colossal statue of Pallas Velletri, now in the Louvre, was not discovered

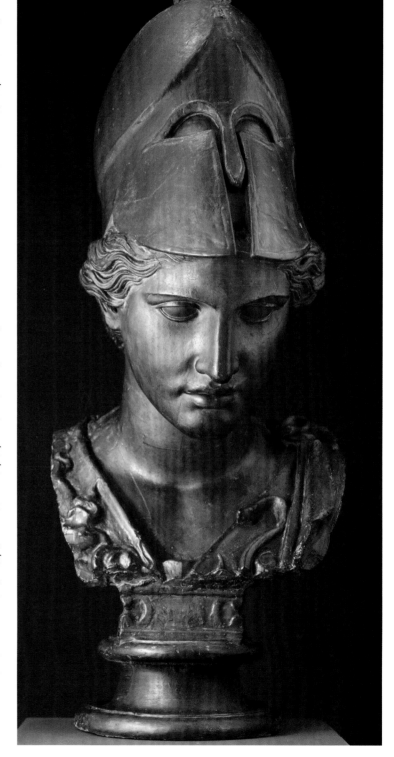

437 After a Roman copy of a Greek original, *Pallas of Velletri*, plaster, height 98.5 cm (RA 03/1465).

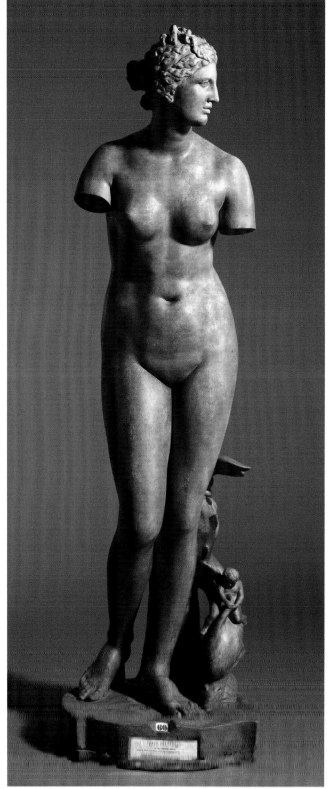

(above) 438 James Barry RA, *Two Studies of Pallas of Velletri*, 1782–1806, pen, ink and wash over red chalk, 16.4 × 17.4 cm (RA 03/2050).

(right) 439 After an unknown copy of an original attributed to Cleomenes, *Venus de' Medici*, plaster, height 165 cm (RA 03/1481).

until 1797, but the Royal Academy, as we shall see, also acquired a cast of this statue in due course.

Although the king was the patron of the Royal Academy, the first royal gift of plaster casts was not received until 1779, when the Duke of Gloucester presented a cast of the *Venus de' Medici* (fig. 439) and the reclining figure of *Justice* from the tomb of Pope Paul II, in St Peter's, Rome, by the Renaissance sculptor Guglielmo della Porta.[57] William Henry, Duke of Gloucester, younger brother of George III, made the first of three visits to Italy in 1771–2. Baretti mentions that the cast of the *Venus* had been presented to the duke, presumably following his first trip, by Abbot Filippo Farsetti, who had assembled a formidable collection of casts that were displayed in a dedicated museum in Farsetti's Venetian palazzo, many of them made from celebrated statues in Rome through the

permission of Pope Benedict IV.[58] The Academy's cast of the *Venus* shows the statue without arms, which were remade for the original marble after its arrival in Florence from Rome in 1677.[59] The *Justice* was also presumably made from a cast belonging to Farsetti.

On its foundation the Royal Academy had established a strict set of rules for the 'Plaister Academy', as follows:

> There shall be Weekly, set out in the Great Room, One or more Plaister Figures by the Keeper, for the Students to draw after, and no Student shall presume to move the said Figures out of the Places where they have been set by the Keeper, without his leave first obtained for that Purpose. When any Student hath taken possession of a Place in the Plaister Academy, he shall not be removed out of it, till the Week in which he hath taken it is expired. The Plaister Academy shall be open every Day (Sunday and Vacation times excepted) from Nine in the Morning till Three in the Afternoon.[60]

In order to control the lighting, large improved screens had been erected in addition to the window shutters. Several of the major casts already mentioned are visible in Burney's drawing (see fig. 392), as well as others of unknown provenance. Helpfully, Burney provided on the verso of his drawing a key identifying the plaster casts and other objects in the room, including 'Lamps for lighting the figures in Winter' and 'the Door of Mr Mosers little Room': a reference to the Keeper of the Schools, George Michael Moser RA, who stands in the foreground of Burney's drawing in a large blue coat and turban instructing a student.[61] Prominent also in the foreground at the left of the drawing is *Cincinnatus*. Directly behind can be glimpsed the group of the boys fighting over a game of knucklebones and *Meleager*. In the centre of the room is the *Apollo Belvedere* and, to the right at the back of the room, *Paris*, from the statue belonging to Lord Shelburne, and the *Faun with Kid*. By the door is a cast of the *Bacchus* by Jacopo Sansovino, immediately behind the larger cast of the *Belvedere Antinous*. Over the fireplace is Duquesnoy's relief sculpture, the so-called *Concert of Angels*, and above it are casts of two relief sculptures featuring the triumph of Marcus Aurelius and a group of warriors (which had also featured in Zoffany's painting of the Academicians).[62] At the extreme right, partly cropped at the edge of the drawing, is the *Dying Gaul*.

In Burney's second drawing of the Antique School, following the move to William Chambers RA's New Somerset House in 1780 (see fig. 26), the students are given greater prominence. Burney shows some of the same casts that featured in the previous drawing (see fig. 392), notably the *Cincinnatus* and *Dying Gaul* to the left and the *Meleager* to the right. Beyond the *Dying Gaul* is the *Seated Nymph* or *Nymph alla Spina*, with Ghiberti's Baptistery door panels either side of the door. Beyond the door are *Bacchus*, *Demosthenes* and the *Venus de' Medici*. In the niche to the left at the rear of the room, just visible is *Cupid and Psyche*, and also at the rear, to the right of the central recess, the *Capitoline Antinous*. In the right foreground is the *Uffizi Mercury*, and behind, to the left, the towering figure of *Meleager*.

THE MOVE TO NEW SOMERSET HOUSE

The move of the Royal Academy to New Somerset House in 1780 afforded the opportunity to make a new arrangement of the cast collection, for study and for decorative purposes. In acknowledgement of its enhanced public profile, the Academy published *A Guide through the Royal Academy* by its Secretary of Foreign Correspondence, Giuseppe ('Joseph') Baretti, which included a thorough room-by-room account of the cast collection. As Baretti himself admitted, a description of the cast collection was particularly challenging because casts were 'so often moved for the convenience of the students', but he hoped that, since most of them at that time had names written on them, 'the Reader will find without difficulty such information as he may require.'[63] Baretti also provided a fascinating insight into the character, condition and provenance of the cast collection at this watershed in the Academy's early history. Baretti noted that casts were contained in several apartments at Somerset House, principally in the entrance hall and the 'Academy of living Models' on the ground floor, and on the first floor in the 'Academy of the Antique', 'consisting of two spacious rooms filled with fine Casts of the most celebrated Remains of ancient Sculpture still existing at Rome, Florence, and elsewhere'.[64] The 'Academy of the living Models' contained a number of significant casts no longer in the collection, including that colossal reclining figure of *Justice* already referred to and Giambologna's *Mercury* that we noted in

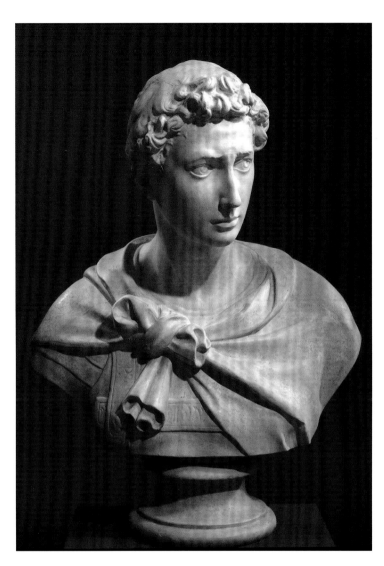

440 After Donatello, bust from the full-length statue of St George at Orsanmichele, Florence, plaster, height 75 cm (RA 03/1441).

presented by Louis XV to Frederick II of Prussia, the cast being a present from Pigalle 'to the Royal Academy as soon as founded'.[66] Since Joseph Wilton had trained under Pigalle in Paris during the 1740s, it is probable that he was the conduit for the gift.

As indicated by Baretti, the most important casts in the Academy's collection were situated appropriately in the two apartments that comprised the Academy of the Antique. In the first apartment Baretti noted, as mentioned above, of the *Apollo Belvedere* that it was a cast of a cast. Of the *Discobolus* and *Cincinnatus* Baretti recorded that they had been cast from statues belonging respectively to William Lock and Lord Shelburne. Lock's *Discobolus*, one of several versions then in existence, had been acquired from the sculptor and restorer Bartolomeo Cavaceppi.[67] The second apartment, used also for Council and General Assembly meetings, was 'more splendidly furnished than the first'. Casts in this room included the fighting boys from the statue in the collection of Charles Townley, the 'Torso of Michelangelo', the *Venus de' Medici* and the so-called *Jenkins Venus*. The room also contained the celebrated group of the *Laocoön and his Sons*, which dominates Henry Singleton's portrait of the *Royal Academicians in General Assembly 1795* (see fig. 146). Although it is not known when or by what means the Royal Academy acquired this cast of *Laocoön*, Baretti did reveal that it 'was sadly broken when carried hither; but Mr. Wilton set it to rights with a great deal of care and patience.'[68] It was to be replaced with a new cast in 1816, one of several presented by the Prince Regent, which incorporated restorations made to *Laocoön* by Canova earlier the same year following the statue's return from Paris to Rome. It is still in the Academy's collection.

Although the Royal Academy had by 1780 assembled an impressive array of casts, it continued to accrue further pieces regularly and opportunistically throughout the following decades. In 1783, on the recommendation of the sculptors Agostini Carlini RA, Nollekens and Bacon, the Academy acquired 'Casts, Models &c.' from the collection of George Moser, who had died earlier that year. Although the items were not listed, the sum laid out, £136 10s., indicates that it was a substantial collection. In March 1789 the Academy recorded the purchase of 'Heads of Castor and Pollux' from Charles Harris, presumably the sculptor of church monuments and plaster cast maker who operated in the Strand.[69] These colossal heads were moulded from the celebrated

Zoffany's *Academicians*.[65] In the same room was a bust of St George from Donatello's full-length statue in Orsanmichele, Florence, presented by Joseph Wilton, and 'moulded by himself on the Original', presumably during his sojourn there 1751–5. Although Wilton's cast is no longer in the Royal Academy, it is quite likely that a later cast acquired from the commercial cast makers (and consultants to the Academy) Brucciani & Co. in the nineteenth century (fig. 440) was itself made from Wilton's cast. Of particular interest was a cast of the statue of Venus by Jean-Baptiste Pigalle

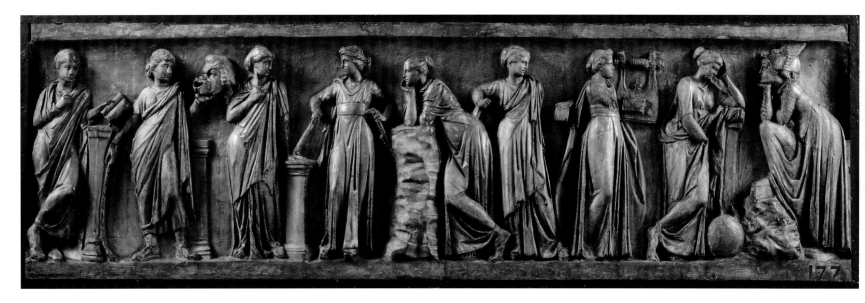

441 After a Roman sculpture, front panel of *Sarcophagus of the Muses*, plaster, 67 × 212 cm (RA 03/1957).

group of *The Horse-tamers* in the Piazza del Quirinale, Rome, and which were in the eighteenth century identified as representing either Alexander with his horse Bucephalus or the twin gods Castor and Pollux.

In 1790 the Academy made one of its most significant cast purchases, when the Council resolved in August 'that the President be empowered to make an Agreement for the Cast of the Farnese Hercules – the whole Expense to the placing of it in the Royal Academy not exceeding Seventy five guineas'.[70] The original statue, as well as being greatly admired, was very large and difficult both to cast and to transport. The opportunity to acquire a cast arose presumably when the statue was transferred from the Palazzo Farnese to the Roman workshop of Carlo Albacini for restoration, which included the attachment of the original legs, before being moved to Naples.[71] In September 1791 the Royal Academy received from Joseph Bonomi RA a bill for £108, for the reimbursement of transport costs for the cast from Rome.[72] Over a year later, in December 1792, the Academicians met to consider the positioning of the *Farnese Hercules*. According to James Barry, the meeting was held at Somerset House 'in the ground floor, under the coach-way into the square, where the statue was loosely put together, and set up in the place where Sir William Chambers wished it to remain'.[73] Despite Barry's plea that the acquisition of the

Farnese Hercules should be used as an opportunity to completely reorganize the display of the casts on the ground floor in a new and more publicly accessible space, 'the matter ended without further discussion; and, leaving poor Hercules to screen himself as well as he could from cold and damps, we went up stairs.'[74] The cast was placed in the stairwell of the entrance hall, flanked by casts of the *Furietti Centaurs* (see fig. 24). The *Centaurs*, which are now again at Somerset House in the entrance hall of the Courtauld Institute (on what was in the eighteenth century the Royal Society and Society of Antiquaries side, towards the east), had been acquired by 1780, when Baretti recorded their presence on the first floor vestibule landing of the Royal Academy. They were one of a series of pairs cast in Rome from black marble statues by Bartolomeo Cavaceppi, the first pair having been brought to England in 1765 by Nollekens for Thomas Anson's Shugborough Hall.[75]

THE EARLY NINETEENTH CENTURY

In the spring of 1801 Thomas Banks and John Flaxman RA purchased over a dozen casts on behalf of the Royal Academy from the collection of the artist George Romney, who had retired in poor health to Cumbria, where he died the

following year.[76] The casts were part of a large collection assembled by Romney and contained in a sculpture gallery at his house in Hampstead.[77] Flaxman had known Romney since his youth, initially through Romney's acquaintance with his father, who ran a plaster figure-making business in London.[78] During the early 1790s, when he was based in Italy, Flaxman had been instrumental in assisting Romney to form his cast collection, organizing the manufacture of casts as well as arranging for their payment and transport to England.[79] The casts now selected by the Academy included a panel of a Roman sarcophagus with nine Muses (fig. 441).[80] Also chosen was a bust of Apollo, the so-called *Apollo Giustiniani* (fig. 442), the marble original being then in the Giustiniani Collection, Rome, and now in the British Museum.[81] Other acquisitions included a statue of the twins Castor and Pollux, possibly made from the plaster in the French Academy in Rome, or from a marble copy made from the group in Italy by Nollekens;[82] *Urania* ('Oerrania'), the muse of astronomy, possibly from the marble statue in the Vatican Museum; the lower limbs of a colossal figure (identified as Eumolpus); and a cast of the so-called 'Gaddi Torso', the original marble statue having been sold by the Gaddi family to Leopold I, Grand Duke of Tuscany, in 1778.

During the early years of the nineteenth century new cast acquisitions continued to trickle into the Academy as, for example, in March 1803 when it was noted that Sir William Hamilton intended to present a cast from an antique bas-relief.[83] In May 1810 the Council minutes recorded that John Flaxman 'stated that he had purchased for the Academy, a cast in plaister from the Venus of the Capitol for fifteen Guineas'.[84] Also in 1810 the gem engraver Nathaniel March- ant RA, who was experienced in the importing of plaster casts from Italy, was given permission to purchase on behalf of the Academy a cast of the celebrated *Barberini Faun*, also known as *Bacchus*, the *Drunken Faun* or *Sleeping Faun*.[85] At this time the statue was still in the possession of the Bar- berini family, although it was acquired shortly afterwards by Crown Prince Ludwig of Bavaria, who installed it in the Glyptothek in Munich, where it remains today. While it was greatly admired, casts of the Faun were scarce, owing to the reluctance of the Barberini family to permit its duplication.[86] A few years later, Marchant himself bequeathed three casts of classical busts, 'Apollo on my staircase Laocoon & Homer'. They were, Marchant noted, 'The very first casts from the

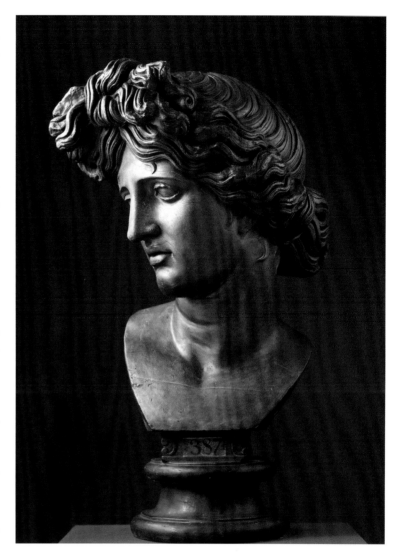

442 After a Roman copy of a Greek original, *Apollo Giustiniani*, plaster, height 66 cm (RA 03/1464).

originals and I particularly request and desire that they may not be painted over with any colour but be suffered to remain as they are now.'[87] A bust of Homer and a bust of Laocoön still in the Academy's collection may relate to Marchant's gift.[88] In 1811 the Academy purchased a 'Cast of the Venus from the Townley Collection.[89] This was the celebrated life-size semi-draped figure known today as the *Townley Venus*, which had been smuggled out of Italy in 1775 by Gavin Hamilton in two pieces in order to avoid detection by the authorities, and sold to Charles Townley.[90] Following

Townley's death in 1805, the statue, along with the rest of his collection, was sold to the British Museum, from where the Royal Academy presumably obtained its cast.

Although the cast collection continued to grow, its students looked further afield for opportunities to make drawings from classical statuary, notably the British Museum. In 1808 it was inundated with requests by Royal Academy students to draw in the newly opened Townley Gallery. As a result the Trustees of the British Museum, which had formed a subcommittee to deliberate upon the regulation of access, wrote to the President and Council of the Academy offering to admit students between 10 a.m. and 4 p.m. on every Friday, and every day during August and September, except Saturday.[91] In 1810, presumably in response to the access that students had gained to the British Museum, Flaxman, together with Henry Howard RA and John Yenn RA, reported to the Council that the cast collection should be expanded through the acquisition of 'molds in the possession of Lord Elgin, from the Towneley, the French, and the Neapolitan Museums'. They also enumerated the existing collection, which currently held over 250 casts, listing '70 statues; 122 busts; 50 small bassi relievi & 12 large fragments; besides 105 pieces from the Trajan column; 2 marbles from the frieze of the Parthenon; 5 ornamental fragments in marble; 19 architectural casts & a variety of small figures, hands, feet, etc'.[92] Flaxman, as ever alert to the need to augment the collection, had already the same year presented a cast of the *Capitoline Venus*, coinciding with his appointment as Professor of Sculpture.[93] Even so, in 1813 the Royal Academy approved the acquisition of another cast of the *Capitoline Venus* on the grounds that the one presented by Flaxman had already been damaged.[94]

While the Academicians themselves articulated their disquiet at the shortcomings of the cast collection, by now the Academy was attracting criticism from beyond its ranks. In a chapter of his book, *Epochs of the Arts* (1813), Prince Hoare, who had himself been a student at the Academy Schools, noted that 'few degrees of inadequacy will be found to exceed those of the provisions for study in the Royal Academy', adding that the scanty supply of casts was 'crowded into so narrow a space, that it is difficult for the students even to obtain a proper view of them'.[95] As a result of increasing external criticism as well as internal dissent, in 1814 it was decided to revise existing laws relating to the running of

the Schools, including regulations relating to the Antique School.[96] That summer an inventory and report were commissioned upon the condition of plaster casts in the Academy, and carried out by the sculptor Richard Westmacott RA (the Elder; knighted 1837) and the painter David Wilkie RA. The report, issued in November 1814, made for worrying reading:

> The Statues, Busts, Antique Fragments, &c have been found with the few exceptions subjoin to correspond with the Inventory, but the numbers to several being worn have with difficulty been traced & it is therefore suggested to the Council that they be painted & not affixed, & that they should run in succession through the whole & not by reference to any particular room, which would allow the casts to be removed for the accommodation of the Students without disturbing the Catalogue. Several of the Statues most in use in the Antique Academy being, from paint & smoke so much injured as in a great measure to be unintelligible to the Student, it is recommended to the Council, a facility of obtaining others from France now presenting itself, that Casts from the following be procured The Warrior of Agasias / Torso / Apollino / Venus de' Medici. The Pedestals to most of the Statues in the Antique Academy from age or use are unsafe & require immediate attention.[97]

The unsatisfactory condition of the Royal Academy's existing casts, and the attendant issue of keeping track of them, led to a major new initiative spearheaded by Westmacott and Flaxman. In 1796 Flaxman had presented a paper to the Council requesting that 'Casts, Prints and Drawings purchased Abroad by British Artists for their Study and Improvement; may be imported Duty Free; on being so attested by the Royal Academy'. Flaxman's intention had been to extend the suspension of import duties already approved a few years earlier on works of art made by British artists abroad.[98] The Treasury had duly agreed, although the Royal Academy had not taken advantage of the exemption. Now, on 9 December 1815, Flaxman proposed at a meeting of the General Assembly that new casts from the Antique should be procured, the intention being to secure them from Rome. Shortly afterwards it was proposed at a meeting of the Council to write to the Prince Regent via the Home Secretary, Lord Sidmouth, with whom the matter had already been discussed by Flaxman and Westmacott. The resulting

letter to the Prince Regent stated, 'The Casts from the Antique Statues & Groupes in the Possession of the Royal Academy are become so much discoloured & otherwise injured in the course of nearly half a Century, that they no longer afford the students sufficient means of improvement.' They therefore petitioned the Prince 'to afford your gracious aid and protection to their efforts for obtaining new & perfect Casts from some of the fine Antiques in Rome Naples & Florence, by allowing them a free conveyance to London in some of his Majesty's vessels, & by such other facilities as your Royal Highness in your wisdom & goodness may direct for the advantage of the Royal Academy.'[99]

In January 1816 Sidmouth replied, agreeing to the proposal.[100] Seven months later, at a Council meeting in August 1816, Benjamin West PRA reported that the government minister, Charles Long, had provided him with a list of 26 casts from the marble statues in the pope's museum which were about to be sent to the Prince Regent '& which his Royal Highness is graciously pleased to present to the Royal Academy and that Mr Long had further in command from His Royal Highness to intimate to the President that if Casts from any other of the fine antiques in Rome shoul'd be consider'd desirable for the School of the Royal Academy His Royal Highness would on their being specified, use his influence to obtain them'.[101] These 26 casts included some of the most revered objects in the collection: the *Belvedere Torso*, the *Belvedere Antinous*, the *Laocoön*, *Meleager*, the *Dying Gladiator* and the *Capitoline Venus*.[102] The further 'wish list' of 21 statues presented by the Academy to Charles Long contained other iconic objects.

The casts on the second wish list were also carefully considered and included a number of iconic works that had not hitherto been available, notably the *Apollo Belvedere*, *Cleopatra* (or *Sleeping Ariadne*), *Cupid and Psyche*, all of which had been taken by the French in 1798 and only recently returned to Rome. Also included were the *Barberini Faun* ('Fauno de' Barberini – la paarte antica') and two versions of the *Discobolus*, one of which ('Discobolo del Palazzo Massimo') was taken from a marble excavated in 1781, then in the possession of the Massimo family at the Palazzo Massimo delle Colonne. The other was based upon a marble acquired by Gavin Hamilton ('trovato da Hamilton') and sold to Lord Shelburne in 1792, indicating that the cast was taken from an existing mould rather than the original, which was already in

England.[103] Also included on the list was *Paetus and Arria* ('Gruppo d'Amore e Antigone – detto Paeto e Arria'), the *Amazon* from the Villa Mattei and statues then housed in the casino at Villa Ludovisi in Rome, the seated figure of Mars ('Marte sedente – de Villa Ludovisi'), a colossal head known as the *Juno Ludovisi* (now in the Palazzo Altemps, Museo Nazionale Romano, Rome), *Papirius* ('Athra e Teseo, volgamente detto Paperio colla madre'), and *Pan and Apollo* ('Gruppo di Pane con un giovane').[104]

Several months later, in November 1816, the Academy reported that the Prince Regent had granted permission for the Academicians to view for the purpose of selection a group of casts at Carlton House. The selection, including large figures, busts, bas-reliefs and '20 casts from nature', as well as assorted legs, feet and hands, was duly made by the President, Benjamin West, and members of the Council.[105] Shortly afterwards the Academy wrote to Frederick Watson, assistant secretary to the Prince Regent at Carlton House:

> The Collection of Casts which y. R.H. has been pleased to present to the Royal Academy has replaced those objects of Study in the school of the Antique which in the lapse of nearly half a century had become materially injured & has afforded us several new & valuable specimens from the finest periods of Art: – Y. R.H's liberality has renovated the Schools of Design of the Royal Academy & provided it with a better stock of appropriate example than it has hitherto ever possessed.[106]

In order to accommodate the new collection of casts, a number of existing casts deemed surplus to requirement were removed and sold to James Cockaine, 'the Moulder in the employ of the Academy', for the sum of £28.[107]

While the Prince Regent was the principal conduit for the supply of casts in 1816, other offers were forthcoming. In June of that year the banker John Dean Paul, who was also an amateur artist, contacted the Academy concerning the fabrication of a cast from an antique torso in his possession. His consent, he stated, relied 'as point of honour on its being confined to the Academy, as it would not be agreeable to me to have them multiplied. Wherever they like to send a Person to take the Cast I will afford him every facility here.' The Academy returned thanks to Paul, 'assuring him that the mould shall be kept in the Academy, & no other Cast be taken without his express order; acquainting him also that a

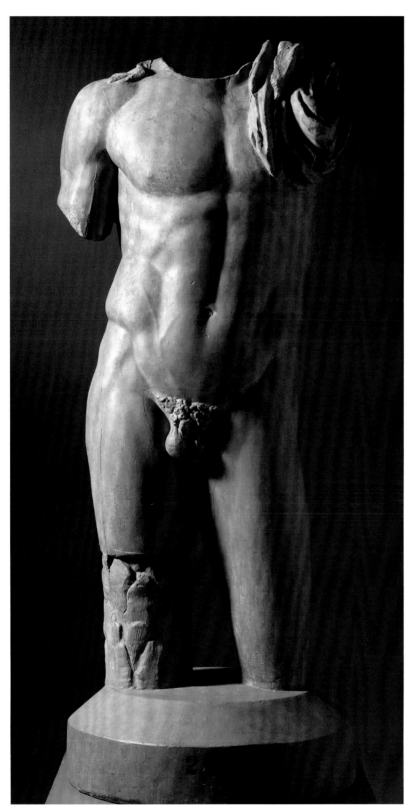

Cast for himself will be at his service if he should desire to possess one'.[108] The acquisition was clearly significant, not least since it was to be unique to the Academy. The identity of the torso remains uncertain. There is, however, still in the collection a rather fine cast of a torso (fig. 443) which – although it has been posited as a gift from the Prince Regent – may possibly relate to John Dean Paul's gift.

The Prince Regent's assistance in adding to the collection continued through 1817. In January that year it was confirmed at the meeting of the Council that a list of further casts desired by the Academy – apparently the second list referred to above – had been presented by Charles Long to the prince and that he in turn had instructed Long to 'write to Signor Canova at Rome requesting that the Casts contained in the said List might be transmitted to him'. As Long informed the Academicians, he had lately received a letter from Canova 'in which he acquaints me that he is authorised by the Pope to obtain The Casts accordingly and to transmit them to the Prince Regent subject however to the observation contained in a note enclosed in his letter and which I am commanded to forward to you for the Information of the Members of the Royal Academy'.[109] As Canova's note indicated, the provision of casts was subject to what was to be made available to him.[110] Long confirmed in the same letter that upon receipt of the casts it was the intention of the prince to present them to the Royal Academy.

In the spring of 1815 the Academy had turned down the offer of a cast of the *Barberini Faun* from the Italian art dealer Angelo Bonelli 'imported by him at great expense, etc, for the sum of £100'.[111] Now, in August 1817, Charles Long wrote to Benjamin West informing him that the prince had, in addition to those casts already requested by the Academy, arranged for Canova to send the Academy a cast of the *Barberini Faun*, 'as fine a Cast as could be obtain'd'. The cast, reported Long, had arrived at London's docks packed in two crates. The Academy duly sent Thomas Phillips RA and William Mulready RA to retrieve them. Although the *Barberini Faun* was shipped duty free, the Academy was nonetheless compelled to pay £30 for additional freight charges in order to release the crates from customs.[112]

443 After an unknown marble original, *Male Torso*, plaster, height 140 cm (RA 03/1473).

Canova's pivotal role in the provision of casts to the Royal Academy and the wider role of the provision of casts in the context of international diplomatic relations has been explored extensively by Christopher Johns in his seminal study of Canova and the international politics of patronage.[113] Suffice it to say here that Canova, a professed Anglophile, had been familiar with members of the British artistic community in Rome since the 1780s, notably John Flaxman, whom he greatly admired. While Flaxman was clearly the driving force in canvassing Canova's support for the project, Sir Thomas Lawrence PRA also claimed responsibility for gaining the confidence of the Prince Regent. As he told a friend later: 'It is a solid gratification to me (although I have never before mentioned it but to one friend) the fine and extensive Collection of Casts presented to it [the Academy] by His Majesty, was secur'd to it chiefly by my means; in my private Intercourse, with which I was honor'd by him.'[114] In fact, the presentation of casts from statues in the papal collection to the Prince Regent was ultimately in recognition of his political support for the return of looted works of art from France, although without doubt both Flaxman and Lawrence were key players in instigating the gift, with Canova bringing it to fruition.

Among the most significant political interventions made by Canova during his visit to England was his advocacy of the Elgin Marbles before the parliamentary committee debating their purchase by the government.[115] The Marbles, acquired by Lord Elgin in Athens between 1801 and 1805, had courted controversy over their aesthetic and historic significance. Championed notably by the artist Benjamin Robert Haydon, they were dismissed by others, including the British art establishment's leading connoisseur, Richard Payne Knight.[116] Canova's support for the supremacy of the Elgin Marbles above any other examples of classical Greek sculpture proved influential, and in 1816 they were acquired by the British Museum. The same year, in November, the Council of the Royal Academy reported that two original fragments from the frieze of the Parthenon, purchased in Athens in 1765 by the Society of Dilettanti in the course of its first Ionian expedition, and loaned to the Royal Academy in 1784, should now be transferred to the British Museum.[117]

By this time, the Academy had begun to show interest in acquiring casts of the Elgin Marbles. In November 1815 the sculptor William Theed the Elder RA, recommended the purchase of a cast 'from Mr Lawrence's restoration of a Horse's Head in Lord Elgin's collection of Antiques', which was the horse of Selene from the east pediment of the Parthenon.[118] In May 1816 the Council agreed to the purchase of a cast of the reclining river god Ilissos and 'one of a fragment of the Frieze of the Parthenon already moulded'.[119] And among the casts selected by the Academicians in November 1816 from those viewed at Carlton House were also nine unidentified bas-reliefs from the Parthenon. Over the ensuing years and decades, the Academy gathered together an extensive collection of casts from the Elgin Marbles, including by 1869 a total of 20 panels from the frieze of the Parthenon, mostly from the north side. In 1820 Sir Richard Westmacott presented three casts of Metopes from the Parthenon 'as a small mark of his good wishes to the Royal Academy'.[120] Other significant acquisitions included a second cast of the *Theseus*, as well as the imposing figures of *Aphrodite and Dione* from the east pediment of the Parthenon. In addition to the Elgin Marbles, the Academy procured casts from other Greek sculptures in the British Museum. In 1816 Henry Fuseli RA and William Theed suggested that since the Trustees of the British Museum had commissioned casts of their recently acquired Bassae frieze, or 'Phigaleian marbles', the Royal Academy should also request a set.[121] The British Museum duly agreed, the Academy footing the bill for Richard Westmacott to oversee the production of the casts.[122] In all 23 reliefs were acquired, of which 16 are still in the collection (fig. 444).

While the casts procured from Rome through the agency of the Prince Regent had been received by 1817, further royal gifts followed in the wake of international post-war diplomacy. In 1819 Charles Long informed the Academy that the prince had 'lately received as a present from the Grand Duke of Tuscany some very fine casts of the Groupe of Niobe', and it was his 'intention of placing them in your hands for the Benefit of the Students of the RA'.[123] The casts, based upon the original sculptures in Florence, were presented to the prince in exchange for casts of the Elgin Marbles.[124] Among other diplomatic gifts of casts passed on to the Academy by the prince over the next few years was a large standing figure, the *Pallas of Velletri*, the original statue having been sequestered by the French from Rome in 1798 and which remains in the Louvre, a cast of one of the classical bronze horses from the basilica of St Mark's, Venice, returned to the city from French possession in 1815; and 'ten Casts of

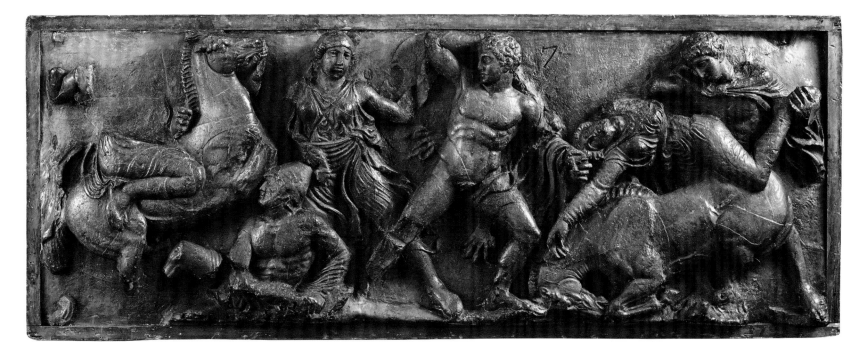

444 After the frieze slab of *Herakles and Hippolyte* from Temple of Apollo at Bassae, plaster, 72 × 186 cm (RA 03/1947).

Statues from the Antique brought from Berlin, called the family of Lycomedes'.[125] By now the matter of storage space to accommodate these imposing objects had become a pressing issue, and in the spring of 1820 the architect Robert Smirke RA was tasked to procure a warehouse or vault to store various cases of casts forwarded to the Academy by the secretary to the Admiralty, John Wilson Croker, 'in pursuance of His Majesty's commands'.[126]

By the mid-1820s, in order to monitor the cast collection and carry out regular inspections, the Academy began to keep a register, although records of only a few years survive.[127] Frustratingly, the registers identify the majority of casts by number only, and comments are restricted for the most part to the listing of broken legs, hands, arms and fingers, and the whereabouts of objects scattered throughout the building, in the hall, Library, Life Room, vaults and cellar. The report for 1828, compiled by Francis Chantrey RA and Charles Robert Leslie RA, noted that the casts were 'generally in as good a state of preservation as can reasonably be expected'. They also recommended that those casts 'more or less injured' should be repaired immediately. At the same time they remarked that they had not been able to make a complete

inspection because of 'want of arrangements' and the inaccuracy of numbering in the printed list.[128] The total number of casts by this time probably numbered 688, since a line is drawn beneath the last one mentioned, 'Canova's head', and the fact that the penultimate cast, a 'Dead Christ', was evidently that presented by Richard Cook RA in March 1828, taken from Michelangelo's *Pietà* in St Peter's, Rome, omitting the figure of the Virgin.[129]

Since its foundation the Royal Academy had employed a series of plaster cast-makers both to produce casts and to carry out repairs to its collection, evidently under the direction and management of sculptors from within the Academy's ranks. During the 1770s and 1780s this work was carried out by James Hoskins, who also worked as foreman to John Cheere at his sculpture yard at Hyde Park Corner, together with his business partners Samuel Euclid Oliver and Benjamin Grant.[130] Early in 1791, upon the death of Hoskins, two candidates put themselves forward for the post of 'Moulder & Caster in Plaister, to the Royal Academy': Benjamin Grant and Antonio Sartini, who operated a plaster figure shop in New Compton Street, Soho.[131] A ballot was held, and Sartini, who won by five votes to two, was duly appointed.[132] By the

late 1820s the role of plaster moulder at the Academy, or *formatore* as it came to be called, was performed by William Pink, who also worked variously as a coal dealer and green-grocer, before cornering the market in making casts for the British Museum in 1839 on the recommendation of the Royal Academy.[133] And it was Pink who, in October 1836, was given the responsibility for 'removing, repairing, & painting the Casts' upon their transfer, along with the rest of the Academy's belongings, from Somerset House to its new home in Trafalgar Square.[134]

MOVING FROM SOMERSET HOUSE TO TRAFALGAR SQUARE

In 1837 the Royal Academy moved into the premises it shared with the National Gallery in Trafalgar Square. As the plan by William Wilkins RA of 1836 indicates (see fig. 30), the cast collection was contained on the ground floor in a dedicated 'Hall of Casts' beyond the Academy's entrance hall in the east wing, as well as in four 'Saloons for the Exhibition of Casts from the Antique' in the National Gallery's west wing. Already in December 1836, in anticipation of the move, the Keeper was authorized 'to have such figures painted as may be required to decorate the Hall of Casts'.[135] At the same time the Council resolved that 'the Farnese Hercules be placed in the Hall where it now stands', that is, in the Academy's entrance hall.[136] The following spring there was a flurry of correspondence between the Council and Wilkins in order to persuade him to erect a 'substantial wall' behind the *Hercules* in order to prevent access to the Academy's entrance hall from the central hall of the National Gallery, prior to the annual exhibition.[137] Despite its public profile, the Academy was clearly intent on protecting its privacy.

Following the move to Trafalgar Square the Royal Academy continued steadily to improve the range and quality of its cast collection. Already in 1830 it had invested £250 in the purchase of a significant collection of classical architectural casts from the collection of Sir Thomas Lawrence, who had purchased them a few years earlier for £500 from the archi-tect John Sanders, with a view to finding a home for them at the Royal Academy.[138] Owing to lack of space at Somerset House, however, the architectural casts were put on long-term loan to the British Museum. Even so, in order to make

casts of this kind available to the Academy's architecture students, in November 1837 Charles Cockerell, who had been made RA the previous year, proposed the purchase of yet more architectural casts.[139] Over the next few months Cockerell, aided by Robert Smirke, made a number of pur-chases, Cockerell himself presenting the Academy with a cast from one of the capitals of the Pantheon in Rome, the original of which was then in the British Museum, among six that had been acquired by Charles Townley as a result of the Pantheon interior's having been remodelled in 1747.[140] In March 1838 Cockerell and Smirke produced a bill for £66 3s. for architectural cast purchases. They were thanked accordingly 'for the trouble they have taken in the purchase of the above Casts & to those Gentlemen & Sir Jeffrey Wyat-tville for their liberality in offering to present so many of them to the School'.[141] Jeffry Wyatville (as he styled himself), né Wyatt (RA 1824), was knighted by George IV in 1828 in recognition of his work on Windsor Castle. In 1844 the architectural casts purchased from Lawrence were eventually returned to the Academy, where they joined another collec-tion of architectural casts presented by William Wilkins, which were in 1854 'conveniently arranged in the library'.[142]

Over the ensuing decades Academicians and supporters continued to augment the cast collection through donations. In 1840 Philip Hardwick RA (then ARA) presented a cast of one of the metopes from the Parthenon, while his elder brother, John, a leading London magistrate, gave a cast of the 'Venus of Melos', or *Venus de Milo*, which had been excavated by a French naval officer on the island of Milos in 1820 and transferred to the Louvre.[143] Thomas Lawrence had obtained a cast of the *Venus de Milo* by 1830, and it can be seen in an engraving of the cast collection in his private sitting room in Russell Square, although none of these casts found their way to the Academy. In 1842 J. M. W. Turner RA, a close friend of Hardwick, in whose father's architectural office he had worked briefly as a youth, presented a cast of the *Belvedere Torso* to the Academy.[144] Although, as we have seen, the Academy had acquired two casts of the *Torso* by 1780, and a third via the Prince Regent in 1816, a new cast was clearly not regarded as surplus to requirements, and may have been acquired as a replacement for the older casts or to increase opportunities for study. Certainly, the *Torso* held a special place in Turner's affection since he had made a highly worked drawing of the cast in the Royal Academy Schools in the

early 1790s, perhaps as a presentation piece.[145] Among gifts presented in the 1850s were a 'Cast of a portion of the Monti Caballo [*sic*] statue by Phidias' and a 'Cast of an Archaic Statue of a young Athlete', donated by the ageing Sir Richard Westmacott in 1851, the former cast being taken from one of the celebrated Quirinal *Horse Tamers* that Westmacott had used as the model for his colossal bronze statue of Achilles at Hyde Park Corner in the early 1820s.[146] In addition to casts, in 1855 the Royal Academy received a 'fragment of ancient sculpture brought to this country by Sir Pulteney Malcolm, from one of the Greek islands'. The marble sculpture, a female torso, possibly Europa, was presented by the portrait sculptor Henry Weekes RA.[147] Sir Pulteney Malcolm, a distinguished naval officer, had himself previously presented the so-called 'Pashley Sarcophagus' from Crete to the Fitzwilliam Museum, Cambridge. The female torso was the first and only original piece of antique statuary to enter the collection of the Royal Academy.

In 1851 moves were made to improve the display of casts, the Council resolving in October that the Keeper, Charles Landseer RA, assisted by the Treasurer, Philip Hardwick, should determine 'the best means of putting together and exhibiting the Bas-reliefs of the Ghiberti Gates'.[148] This was the year of the Great Exhibition, and given the huge appetite for displays, it was not surprising that the Academy sought to improve its credentials as a space for public exhibition by promoting its cast collection. It is also worth noting that it was to be another 16 years until the South Kensington Museum acquired its electrotype casts of Ghiberti's Baptistery doors, in 1867.

At Trafalgar Square regular inspections of the casts continued to be made by a committee appointed by Sir Richard Westmacott and the architect John Deering, and in 1849 they reported that they 'were found to be in good order'.[149] Towards the end of 1853, a detailed report was submitted following an inspection by the sculptor William Calder Marshall RA and the landscape painter Thomas Creswick RA. It gave cause for concern, including comments that 'some of the Statues in the School and in the Halls are considerably injured, especially those which require to be frequently removed either into the Schools, or during the time of exhibition'. The *Barberini Faun*, in particular, had been 'injured' since being placed in the Antique School. Some small statues in the closet and hall were 'more interesting as curiosities

than as works of art', and it was decided to place a selection on a lower shelf, while others were to be consigned to the cellar or destroyed. An inspection of casts already placed in the cellar revealed duplicates, such as the *Fighting Gladiator*, the head of the 'Monte Cavallo Achilles' and the 'Hermaphrodite'. It was suggested that these casts be presented 'to some Educational Institution' or exchanged for other works. Finally, not only was there a 'great deficiency of hands and feet for students to study', but 'the casts in the Life School are in a very dirty state', and the School itself was in great need of painting and cleaning.[150] The report of 1853 told a familiar story. The cast collection was not simply an expanding asset, but a considerable financial and curatorial responsibility that demanded constant care and consolidation, repair and replacement. During the 1840s William Pink continued to attend to the welfare of the cast collection,[151] although the role of *formatore* was evidently taken on during the 1850s by a 'Mr Johnson', who in turn was succeeded in December 1858 by Domenico Brucciani, who had approached the Academy about the post at the beginning of the year.[152]

With the arrival of Domenico Brucciani the process of cast acquisition at the Academy became more streamlined and businesslike as he steadily cornered the market in the manufacture and sale of casts to a range of art institutions. He was born in Barga, Italy, and came to England with his father, Vincenzo, and joined the plaster cast-making business run by his uncle Luigi (Lewis) Brucciani.[153] In 1852 Domenico Brucciani, now established as the head of the company, was appointed as an instructor in moulding and casting at the School of Design at the National Art Training School. Brucciani already described himself in the 1851 Census as 'Professor of Modelling in Clay'. And in the Census of 1861 he was recorded as a 'Plaster Figure Manufacturer Employing 25 Men & 5 Boys'.[154] A few years later, in 1864, Brucciani's primacy was confirmed with the establishment of a 100-foot (30-metre) long gallery, the Galleria delle Belle Arti, in Russell Street, Covent Garden, which included Byzantine, Gothic and Renaissance casts, as well as Greek and Roman objects.[155] In addition to his work for the Royal Academy, Brucciani was employed in producing casts for the British Museum and the South Kensington Museum (now the Victoria and Albert Museum). From the time of his appointment Brucciani, who by then had a virtual monopoly on cast production and supply, provided the majority of casts to

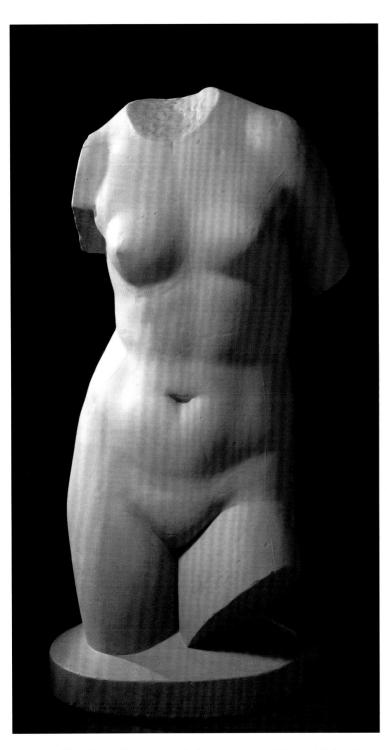

445 After a Roman copy of a Greek original, *Richmond Aphrodite*, plaster, height 91.9 cm (RA 03/1007)

the Academy, and among them were the *Borghese Gladiator*, a bust of Hermes and the so-called *Richmond Aphrodite* (fig. 445), which was the torso referred to earlier in connection with its appearance in Zoffany's *Academicians*.[156] It had been sold by William Lock to the Duke of Richmond and in 1820 went to the British Museum, where Brucciani took his cast. As newly discovered classical sculptures emerged, so Brucciani supplied the Academy with the requisite cast, notably the so-called *Esquiline Venus* excavated on the site of the Horti Lamiani on the Esquiline Hill, Rome, in 1874 and subsequently transferred to the Capitoline Museums.[157]

Through a combination of business acumen and opportunism Brucciani effectively embedded his own enterprise within the heart of the Royal Academy, supplying casts for the institution, making casts from existing works in the collection for his own use, and even working alongside the Academy's Registrar, Henry Eyre, on a catalogue of the casts, wherein 'the numbers for reference be cut or inlaid in the statues or plinths wherever practicable to prevent loss or defacement'.[158]

Although Domenico Brucciani died in 1880, his legacy was carried on by Brucciani & Co., which continued to operate until the business was taken over by the Board of Education in 1922, and rebranded as the 'Department for the Sale of Casts', administered by the Victoria and Albert Museum. It eventually closed in 1951 when it was no longer financially viable owing to a steady post-war decline of interest within art schools in the acquisition of casts. Indeed, it was not long before many of these same art schools began disposing of their cast collections, some even holding sessions in which students gleefully smashed them, urged on by the staff.[159] But in 1868, after the Royal Academy had moved to Burlington House and relocated its cast collection there in the Cast Corridor, it was evidently business as usual. In July that year, Frederic Leighton, then in his late thirties, who had just been elected RA (PRA 1878–96), brought the Council's attention to 'the present very dilapidated state of the casts employed as objects of study'. As a result it was recommended that a subcommittee be formed to inspect the casts and report on their condition. The Academicians Leighton, G. F. Watts, Daniel Maclise, Alfred Elmore and William Calder Marshall were duly appointed to the task.[160]

A CLOSER LOOK

15.1

Architectural casts

JULIA LENAGHAN

The Royal Academy has a significant collection of plaster casts chiefly taken from buildings, historically referred to as 'architectural casts' (fig. 446).[1] The collection is one of the oldest of its kind in the United Kingdom and had a didactic function for most of the nineteenth century.[2] Until recently the most thorough documentation of the collection was a set of 25 photographs taken by Bedford Lemere & Co., specialists in architectural photography, in 1876 (fig. 447).

The Academy had gathered a relatively small number of such casts in the eighteenth century, and the majority of the collection was acquired in the nineteenth century, mainly 1810–70. The earliest reference to these casts is in the Council minutes of 1810 citing 19 'architectural casts', 105 items described as 'objects from the Column of Trajan', and 50 'reliefs'.[3] The 105 objects from the Column of Trajan are particularly interesting, as almost half are still in the Academy's collection, and the number corresponds perfectly to the number of such pieces recorded in the teaching gallery of the 3rd Duke of Richmond in 1782.[4]

The boom in acquisition was related to the important expansion of the British Museum, which corresponded in large part to the new exploration of Greece and to the availability of the collection of Sir Thomas Lawrence PRA.[5] Between 1805 and 1816 the British Museum obtained at minimal cost the best English collection of ancient marbles,

the Townley collection (1805); purchased the 23 slabs from the cella of the Temple of Bassae (1814);[6] and received from the British government Lord Elgin's collection of mainly Athenian marbles (1816). Casts from all of these collections entered the Academy collection shortly thereafter. In 1816 Richard Westmacott the Elder RA directed the acquisition of the Bassae reliefs, and 16 of the panels are still in the collection. Of the Elgin collection, there are currently in the RA 31 casts from various parts of the Parthenon, a handful of others from the Erechtheion, and one from the monastery at Daphne. The casts from the Parthenon were acquired between 1820 and 1869. From the Townley collection, there are at least eight objects. Casts from objects in the Elgin and Townley collections may have entered the Academy when Sir Robert Smirke RA and C. R. Cockerell RA were given funds in 1837 to purchase architectural casts so as to enhance the collection.[7] Equally, some casts, especially some of those after the Erechtheion, may have been part of the architect William Wilkins RA's collection, given in 1854.[8] Interest in architectural casts in the earlier part of the nineteenth century was focused on classical – that is to say, Greek and Roman – antiquity: it included Renaissance works only because they reflected the classical aesthetic.[9] Later in the century, 1870, a gift from the architect Sydney Smirke RA brought the collection up to date, reflecting the tendencies

446 Wall at the Schools, from left to right and top to bottom: Medici panel; Todi pilaster; Santa Maria del Popolo pilaster; archivolt Arch of Septimius Severus; rosette; Vatican Biga; rosette from frieze in Vatican (RA 12/5336).

447 Bedford Lemere & Co., photograph of plaster casts of the frieze from the Temple of Neptune, Capitol, quadriga of Vatican, capital from Erechtheion, two panels of festoons and other fragments, 1876 (RA 08/3227).

of the Gothic Revival,[10] and in the Council minutes Smirke's gift is noted as casts from York and Lichfield cathedrals. Two extant casts in the collection, however, are labelled as coming from objects in the Temple Church in London – where Smirke had worked. Most of the medieval casts are now missing, but three of the Bedford Lemere photographs are mainly devoted to them.

The Academy's collection of architectural casts has value not only as a record of the significance of casts in the history of the Academy's activities but also for the study of the original objects. Some of the original objects of which the Academy has casts are now lost or destroyed: for example, elements of Trajan's Column, a frieze from the Palatine Hill (fig. 448), and another from the Temple Church in London.

448 After what may be a lost frieze from Aula Regia, Domitian's Palace, Palatine Hill, Rome, mounted over a cast of scrolls and flowers, plaster, 67.5 × 97 cm (RA 03/1967).

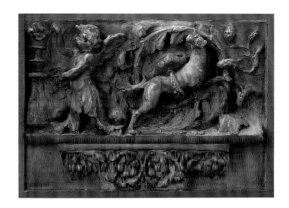

16

COPIES

JONATHAN YARKER

One of the most important paintings in the Royal Academy collection, from a historical point of view, is a copy: a full-size copy by Giovanni Pietro Rizzoli, known as Giampietrino, of the *Last Supper* by Leonardo da Vinci in the refectory of Santa Maria delle Grazie, Milan. From its inception, however, the Academy had a most uncomfortable relationship with copying. Copying prints and sometimes drawings was not entirely disapproved of in the Schools, although the principal training was taken up by drawing plaster casts of antique sculptures; but copying Old Master paintings was another matter. This was in marked contrast with academies on the Continent where replication of the most celebrated paintings as a means of instruction was an established activity: until late in the nineteenth century the completion of such copies was a requirement of recipients of the Prix de Rome.[1] Sir Joshua Reynolds PRA, in his Second Discourse, specifically attacked the practice, stating: 'I consider general copying as a delusive kind of industry; the Student satisfies himself with the appearance of doing something; he falls into the dangerous habit of imitating without selecting, and labouring without any determined object as it requires no effort of the mind.'[2]

This situation, where students lacked an opportunity to familiarize themselves at first hand with the Old Masters, obtained for the first decades of the Academy's existence and was compounded by its reluctance to acquire a collection of paintings that might have offered suitable models for replication. This was odd, since it contradicted what Reynolds set forth in his First Discourse where he stated that 'the principal advantage of an Academy [is that]…beside furnishing able men to direct the Student, it will be a repository for the great examples of the Art.' He went further, and proposed that 'by studying these authentick models, that idea of excellence which is the result of the accumulated experience of past ages, may be at once acquired.'[3] Yet from 1769 until 1800 only Leonardo's cartoon of the *Virgin and Child with St Anne*

and St John the Baptist, now in the National Gallery, entered the Royal Academy's collection. Despite frequent offers of paintings – and indeed whole collections, including that of Reynolds himself in 1791 – successive generations of Academicians failed to fulfil Reynolds's wish.[4] The first significant acquisitions were, ironically, copies, which in most cases were donated to the Academy for their instructive potential, and so it is rewarding to trace the accumulation of such copies during the first half of the nineteenth century and to examine the corresponding changing attitudes towards copying itself. It culminated in the foundation of the Painting School and the institution of two premiums awarded for copying in 1816.

There is an apparent inconsistency between Reynolds's animadversion against copying on the one hand and his desire for students of the Academy to 'imitate' Old Masters on the other. But for Reynolds – and by extension the Academy for its first few decades – imitation was deemed a creative process, while copying was merely mechanical. Henry Fuseli RA succinctly articulated the distinction in his lecture on design:

> The two words *copy* and *imitation*...[are] essentially different in their operation, as well as their meaning. An eye geometrically just, with a hand implicitly obedient, is the requisite of the former, without all choice, without selection, amendment, or omission; whilst choice, directed by judgment and taste, constitutes the essence of imitation, and raises the humble copyist to the noble rank of an artist.[5]

In the syllabus sketched by Reynolds in his *Discourses*, the student, by close study of 'authentick models', would learn the mechanics of composition and secrets of colouring. In turn he was expected to quote, or borrow inventively, individual features: a thought, figure or pose from the Old Masters in his own works, a procedure modelled upon the training laid down in the Académie royale de peinture et de sculpture in Paris.

It was any suggestion of the merely mechanical that Academicians were eager to avoid. As a result, in common with other exhibiting societies in London during the eighteenth century notably the Society for the Encouragement of Arts, Manufactures and Commerce the Academy prohibited the showing of copies. In the rules for contributors to

the first annual exhibition it was clearly stated: 'No Picture copied from a picture or print, a drawing from a drawing; a Medal from a Medal, a chasing from a chasing; a model from a model, or any other species of sculpture, or any copy be admitted in the Exhibition.'[6] There is evidence to suggest that this was taken extremely seriously. In 1771 the Council minutes record a discussion regarding a miniature by Jeremiah Meyer RA after Reynolds's portrait of the Marquess of Granby 'being a copy and contrary to the Rules of the Academy'; it was only admitted following the intervention of George III, the minutes specifically recording that it was 'not to be considered as a precedent in respect to the admission of copies'.[7] There are other examples of copies being allowed into the Annual Exhibition, which suggests that, early in its life at least, the rules were still fluid. For example, in 1773 the Scottish painter James Nevay dispatched from Rome five black-chalk drawings of figures from Michelangelo's *Last Judgement*. The Council minutes record the gift of these drawings in June, and they were then included in the exhibition the same year.[8]

The prohibition against the exhibition of copies of any form remained in force until the nineteenth century, but from 1800 copies began to enter the Academy's collection as teaching aids, the year in which arrived a set of full-scale copies painted 1729–31 by Sir James Thornhill of the seven tapestry cartoons by Raphael (Royal Collection, on loan to the Victoria and Albert Museum) (fig. 449). The set was presented in 1800 by Francis Russell, 5th Duke of Bedford, having been removed from the duke's London residence, Bedford House, which was pulled down the same year to make way for Bedford Place.[9] The copies of the cartoons had been purchased on behalf of the 4th Duke of Bedford by the painter Isaac Whood for £210 at the posthumous sale of Thornhill's collection in 1737.[10]

Despite having been the principal furnishing of a dedicated gallery at Bedford House, the copies seem clearly not to have begun life as decorative works. For British painters in the eighteenth century, the Raphael Cartoons occupied a central position as exemplary models, especially in early training. Jonathan Richardson referred to the cartoons throughout his 1715 *Theory of Painting*, a text designed to instruct British artists in the rules of continental painting. But the originals themselves were housed at Hampton Court and largely inaccessible to painters, particularly young artists

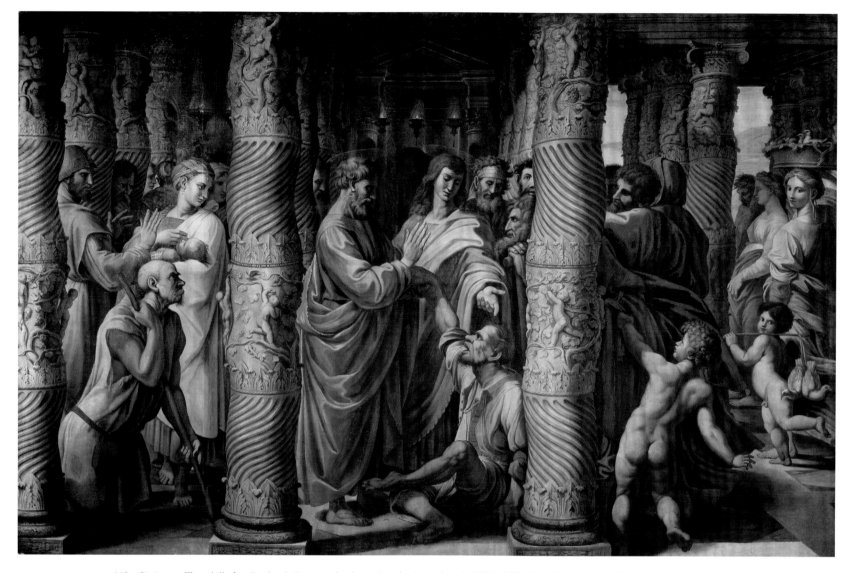

449 Sir James Thornhill after Raphael, *Peter and John curing the Lame Man* (c.1516), 1729–31, oil on canvas, 348 × 538.5 cm (RA 03/1102).

who may have benefited from studying them. Thornhill was a neighbour of Richardson's and fellow director of the Great Queen Street Academy, and championed several schemes for painting academies in London; it seems likely that he made this set of copies as instructive material for the students at one of the schemes in which he was involved.[11]

We can date the Royal Academy copies very precisely, as the antiquarian George Vertue recorded Thornhill at work on them in Hampton Court in 1729, commenting that they were 'of the same magnitude of the Originals. with all the justness and excellence. Possibly imitable in the originals. omitting all the accidental defects by time or repairs. Or working after.'[12] In 1718 the Great Queen Street Academy had moved into Thornhill's own house in Covent Garden (he had taken over the governorship from Sir Godfrey Kneller on 29 October 1716), and four years later Thornhill founded the 'free school' for young artists, as William Hogarth, who studied there, remembered: 'in place he built at the back of his own house in the piazza now next the playhouse and furnish'd [tickets] gratis to all that require

admition [sic].'[13] Thornhill's fascination with the Raphael Cartoons is therefore to be understood in the context of his ongoing concern for artistic education: 'For Thornhill, copying Raphael was a self-appointed task; in doing so, he can be seen to have consciously positioned himself as the doyen of an incipient "British School" and to have assumed the role of aesthetic broker.'[14] By the time of his death in 1734, Thornhill had painted three sets of copies from the tapestry cartoons, and had also made 200 traced details and an album of 162 pen studies.[15] Vertue, in his obituary notice of Thornhill, noted that he 'had made remarks on the Cartons of Raphael Urbin (& critisisimes) very curiously obser'vd whilst he was copying them at Hampton Court...these sheets not long before his death he had revised & etched with a design to publish them and a book of the heads hands & feet...for the use of students in the Art of painting & sculpture.'[16] Thornhill was clearly attempting to reconcile the technical and theoretical, with a practical drawing book and analysis of the cartoons. The presence of both the full- and half-size copies in the posthumous sale of Thornhill's collection is further confirmation that they were never intended to perform a merely decorative purpose.[17]

The Duke of Bedford's gift of the copies to the Royal Academy in 1800 turned out, however, to be almost more trouble than it was worth. The Academy had to employ the frame-maker David Ross 'to examine those parts of the Frames, which prove to be fixtures, that the Cartoons were placed in, at Bedford House'.[18] Ross informed the Council that the stucco of the frames 'must be liable to damage & broken in removing', while valuing the work at £159 together with a similar estimate for reassembling them with new frames in the Academy. The Council demurred, and it was left for the architect John Yenn RA '[to propose] enclosing them at the upper end of the Room [presumably the Great Room in Somerset House] by a Partition to fix the Pictures against'.[19] This could only ever have been a temporary arrangement, and in March 1804 Robert Smirke RA suggested that the copies be 'rolled up, & deposited in some convenient place'.[20] They were unrolled again after the foundation of the Painting School in 1816 and before 1830 could be seen on display once more in the Great Room, at which date three are visible above the audience in George Scharf's lithotint of Richard Westmacott RA lecturing, (fig. 450).[21] Also visible in Scharf's print is Giampietrino's copy of

the *Last Supper* and another copy of an Old Master painting that entered the Academy's collection at the beginning of the nineteenth century, the *Descent from the Cross* after Sir Peter Paul Rubens by Guy Head, along with *The Visitation* and the *Presentation in the Temple* – original panels forming one of Rubens's two great triptychs in Antwerp Cathedral. Guy Head had enrolled in the Royal Academy drawing schools in April 1778 and lived on the Continent from 1787, eventually returning to Britain in 1799. Like most artists based in Rome, Head found copying more profitable than painting his own compositions, although a number of lifeless neoclassical subject paintings by him do survive.[22]

Head's collection was first offered in the form of a private contract sale in 1801, entitled 'Accurate copies from some of the most distinguished works in Europe' sold at 'No. 4 Duke Street'.[23] The three most valuable lots were the copies after Rubens, and the catalogue specifically stated that they 'have become of infinite Importance; the Originals being nearly destroyed in their removal to Paris [by Napoleon]'. The catalogue also proclaimed that they were 'traced from the Originals; and are the only Copies that were ever taken of the same size'. Copying by tracing was an invasive but surprisingly common procedure in the eighteenth century, when thin sheets of oiled cloth called *voiles* were placed against the surface of the picture and, in the case of larger compositions, often fixed with nails, and the composition traced upon them. For paintings as large as those of Rubens the whole business would have necessitated the erection of scaffolding. The elaborate nature of this procedure and the accuracy of it ought to have made Head's copies all the more significant, as the organizers of the sale evidently thought, but the paintings failed to find any buyers and they were subsequently consigned to auction at Christie's in 1802 by Head's widow.[24] Success followed, and a priced copy of the catalogue in Christie's archive reveals that Henry Hope purchased them for the substantial sum of £420. In 1794 Hope, cousin of the patron and collector Thomas Hope, had fled to Amsterdam before the French occupation of Haarlem and thereafter had brought to England the greater part of the family's art collection. Head's sale records four copies after paintings in that collection, including Reynolds's *Hope Nursing Love* and *Nymph and Cupid*, as well as Rubens's *Woman Taken in Adultery* (now in Brussels).[25] Nine days after the 1802 auction, Hope offered the paintings to the Royal

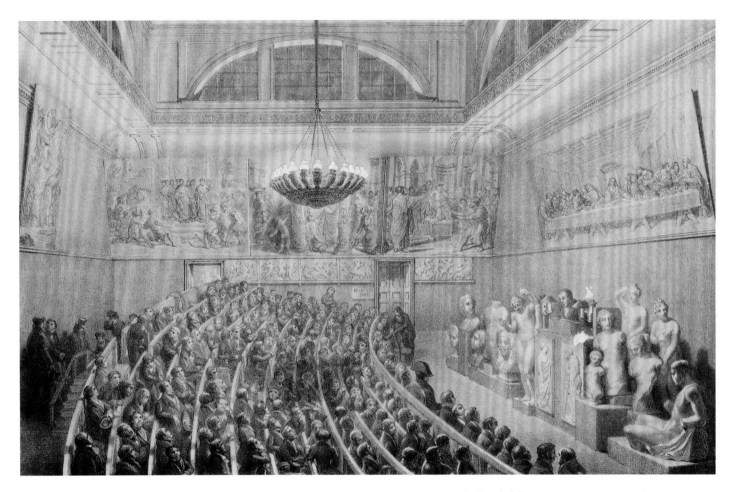

450　George Johann Scharf, *Richard Westmacott lecturing at Somerset House in 1830*, chalk-style lithotint, 20 × 31.6 cm (RA 04/2743).

Academicians in London, who accepted unanimously.[26] By 1918 the apparently unrelated Sir Theodore Hope had presented the Academy with another Head copy of a Rubens, the dramatic *Fall of the Damned* (original in Alte Pinakothek, Munich) (fig. 451), one of the most frequently copied of all the master's compositions.

The arrival of copies from 1800 onwards is instructive. Britain was effectively cut off from the Continent by the Napoleonic Wars, and the 'Grand Tour', the educative trip to Rome deemed essential for both artists and patrons, became impossible; the Academy itself was forced to suspend its Rome Travelling Scholarship that had first been awarded in 1774. This isolation gave a new cultural weight to those collections that had been assembled abroad during the previous decades, and copies, such as those by Head, that had been made of paintings that were no longer accessible or, even worse, feared destroyed by the French assumed a new importance. The Academy had also recently been savaged in print by its Professor of Painting, James Barry RA, for being 'too ill supplied with materials for observations', and he added that 'the miserable beggarly state of its library and collection of antique vestiges' was a situation that required immediate attention.[27] Barry offered a specific critique of the absence of paintings from which students could copy.[28] In September 1801 the Library was reordered and a librarian employed to catalogue the books and replace any that were found to be wanting. In May 1801 the sculptors Thomas Banks RA and John Flaxman RA were commissioned to augment the cast collection, and acquired 16 from the posthumous auction of the contents of George Romney's studio.[29] They included

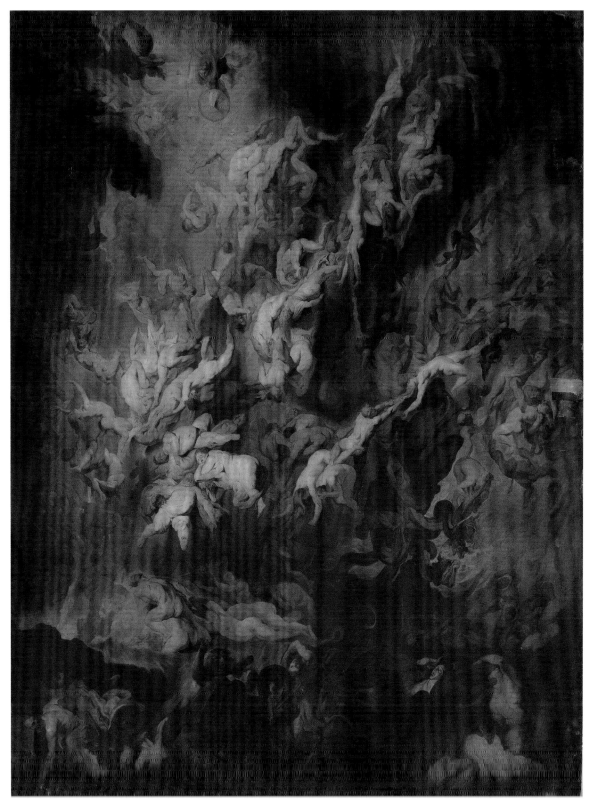

451 Guy Head after Peter Paul Rubens, *Fall of the Damned* (*c.*1620), before 1799, oil on canvas, 288.5 × 215.5 cm (RA 10/1032).

casts of sculptures originally in Italy that, like the Rubens paintings in Antwerp, had since been seized by the French and taken to Paris. All this attention was accompanied by the publication of the Academy's proceedings by Prince Hoare, and the first volume of his *Extracts from a Correspondence with the Academies of Vienna & St. Petersburg* (1802) proudly announced the gift of the Head copies.[30]

The second campaign of collecting came after 1816, following the foundation of the Painting School, and it is worth pausing to consider the Academy's shifting attitude towards copying. As in 1800, change was in part a reaction to events rather than an example of organic growth. In 1813 the Academy's authority came under renewed attack by one of its own members when Prince Hoare, who had been its Honorary Foreign Secretary from 1799, published an invective on the poor facilities provided for students, complaining that 'in the present state of the Institution, it would almost appear that it is by a kind of *misnomer*, rather than by a just assumption, that the term *Painting* has been included in its title; since not a single original Picture is to be found in its Schools'.[31] This was a reiteration of Barry's critique and given practical weight by the recent establishment of a rival organization, the British Institution, founded in 1805, which essentially provided students with the practical environment lacking at the Academy.

The British Institution was established by a group of connoisseurs and collectors when a resolution of the opening meeting proclaimed that such an organization for the promotion of painting would 'upon a great & general scale … tend to encourage & reward the talents of artists of the united Kingdom'.[32] This was to be achieved initially by holding exhibitions of contemporary art and awarding premiums, and once it had acquired premises on Pall Mall, the 'BI' annual exhibition became a popular alternative to those at the Academy (even if the visitor numbers never quite compared: from 1806 to 1810, for example, visitors to the Academy numbered about 60,000 a year, rising to around 85,000 in the 1820s, when the BI attracted some 20,000). Moreover, in 1806 the British Institution decided to open a painting school and to borrow a number of pictures by 'Ancient Masters' for 'the Study of Rising Artists'.[33] By 1812 it had decided to mount exhibitions of Old Masters and to offer painters the opportunity to work from the pictures exhibited in the gallery.[34] The rules for copying (which also forbade copying on the original scale, in order to avoid confusion either deliberate or accidental) attempted to prevent literal repetition, suggesting instead a freer response in terms that closely echo the remarks of Fuseli and Reynolds above: 'They wish him [the student] to catch the spirit rather than to trace the lines; and to set his mind, rather than his hands, to work upon this occasion.'[35]

In fact, the Academy supported the British Institution from its inception: it was agreed that a work initially shown at the latter could not also be exhibited at the former. There was an overlap of personnel between the two organizations, and, for example, the Academy lent four pictures to the exhibition devoted to Reynolds in 1813, which was followed by an exhibition in 1814 featuring Hogarth, Richard Wilson RA, Thomas Gainsborough RA and Johan Zoffany RA. But undoubtedly the presence of an organization in London apparently fulfilling, in part, Reynolds's founding principle of being 'a repository for the great examples of the Art' from which students could study 'authentick models' prompted the Academy to consider opening a similar establishment.

The immediate stimulus for the foundation of the Painting School was an offer from Dulwich College to lend paintings to the Academy. In 1811 Sir Francis Bourgeois RA had died, leaving the outstanding collection of paintings he had assembled with his friend, the dealer Noel Desenfans, to Dulwich College. Bourgeois, with Desenfans as the *éminence grise*, had been instrumental in expelling James Barry after his critique of the Academy in 1799 and was a key member of the 'court' party in the internecine struggles of 1803 that saw James Wyatt PRA briefly replace Benjamin West PRA as President.[36] In December 1815, soon after the completion of Soane's gallery at Dulwich, the Council minutes record a letter sent to Dulwich containing the rules for the new painting school, which they 'have been induced to establish by the liberal offer of the Master, Warden & fellows of Dulwich College'.[37] The offer was for a number of paintings, not exceeding six, from the collection to be used for copying at Somerset House each year. The following January the first six paintings were chosen to hang in the Great Room over the winter: *Mars and Venus* by Rubens together with the picture that had been framed as its pendant by Desenfans, Van Dyck's *Madonna and Child*; Poussin's *Rest on the Flight into Egypt*; Rembrandt's *Girl at a Window*; a landscape by Aelbert Cuyp; and the *Nativity* by Annibale Carracci.[38]

The two things the Royal Academy offered over the British Institution were stressed in a letter of thanks to the staff at Dulwich that began: 'His Royal Highness the Prince Regent has been recently pleased to sanction the establishment of a School of Painting in the Royal Academy with professors to superintend & instruct the Students & Premiums to excite their exertions.'[39] The annual premiums are listed in the 1828 laws of the Academy as: 'Two Silver Medals will be given for the best Copies made in the School of Painting…the first Medal shall be accompanied by a Copy of the Lectures of Professor Barry, Opie, and Fuseli.'[40] The project in turn became more ambitious when the Prince Regent was asked for the loan of one of the original Raphael Cartoons: 'Conceiving that such an opportunity of studying the Cartoons of Raffaelle as will be afforded in this school under the inspection of its professors has perhaps never occurr'd before.'[41] As the original cartoons had hitherto already been lent to the British Institution, the Academy was keen to stress the advantage of professional instruction. This intention is neatly adumbrated by John Bligh, 4th Earl of Darnley, in his letter agreeing to the loan of Titian's *Venus and Adonis*, now in the Metropolitan Museum of Art, New York: 'I am indeed persuaded that nothing will tend more effectually to form & improve the Taste or more usefully to direct the hand of the young English artist than a careful study of the peculiar excellencies of the great Italian Masters.' George Wyndham, 3rd Earl of Egremont, having declined the loan of his Claude because it was already promised to the British Institution, added, 'I am very glad to find that the academy are going to take the direction of the arts into their own hands.'[42] But the Academy's apparent volte-face, rejecting Reynolds's disapproval of copying, was not universally appreciated. Writing on 15 July 1819, the collector and designer Thomas Hope declined the loan of a painting from his house in Duchess Street with the words: 'I should think nothing more conduced to the advancement of painting than the constant study of the living model – the celebrated Old Masters arrived at the excellence they attained, not by copying their predecessors – for they had none worth copying – but by the unremitting study of nature herself.'[43]

The diarist Joseph Farington RA offers a varied picture of the Painting School's success. In January 1816, on the one hand, he reported a conversation with the painter Thomas Phillips RA. 'He has attended the School of Painting at the Academy, as Visitor, there being 6 pictures recd. From Dulwich College for the purpose of being copied. He said only three artists had attended and of them seldom more than one at a time. He remarked that they confined their studies to pictures by Rubens, Vandyke, and Rembrandt, and left Carrach, and N. Poussin unnoticed.'[44] But, equally, that December Farington was able to report, following a visit to the Painting School himself, that he 'found several Young men there who had been copying pictures, also Wilkie & Ward & Frearson, the Deputy Keeper, who told me that He attends daily to superintend the Students from 9o Clock in the morning till four – Wilkie said he meant to make a small study in Oil from the *Bacchus and Ariadne* by Titian – and Ward meant to copy parts of the Cartoon of the *Death of Ananias* which was very well placed to be seen to advantage.'[45] The deputy keeper was John Frearson, who later the same year was forced to bar C. G. Christmas and the sons of Edwin Landseer RA from copying because they had touched the Raphael Cartoons.[46] The copy by David Wilkie RA of Titian's *Bacchus and Ariadne* survives, as do a number of other pictures that were made in the Painting School, giving a sense of its popularity among both established Academicians and students. In 1818 William Etty RA recorded copying Damiano Mazzo's *Rape of Ganymede* then in the Angerstein Collection; and in 1820 William Hilton RA, who had been appointed Visitor of the Painting School, completed a fine, full-size copy of Van Dyck's *Samson and Delilah* from Dulwich, which is now in the Victoria and Albert Museum.[47]

This second period of collecting on the part of the Academy that had been prompted by the opening of the Painting School led to some striking acquisitions. In January 1819 the Council minutes record: 'Mr Turner moved that a copy from Raffaelle's School of Athens lately in the possession of S. Woodeforde Esq: R.A be purchased of the sum of fifty pounds for the painting School of the Royal Academy.'[48] The painting is probably an eighteenth-century copy purchased by Samuel Woodforde RA during his period of study in Italy (1786–9) under the patronage of Richard Colt Hoare. Then, in June 1821, as we have seen, the General Assembly unanimously agreed to purchase the copy of Leonardo Da Vinci's *Last Supper*. This copy duly took centre stage, as can be seen in Schart's lithotint mentioned above, being placed above the lectern in the Great Room at Somerset House during the Academy lectures,[49] and made significant appear-

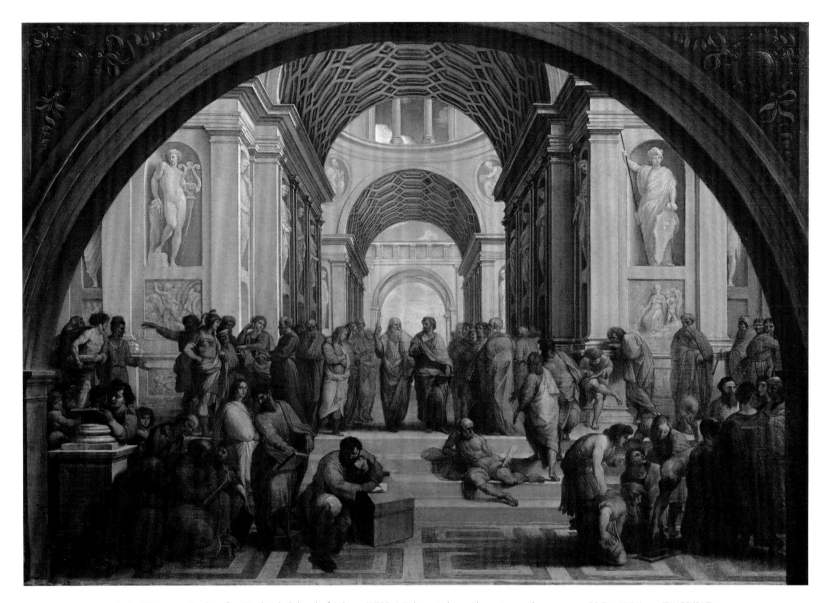

452 Giuseppe Cades after Raphael, *School of Athens* (1509–11), late eighteenth century, oil on canvas, 83.5 × 119.4 cm (RA 03/815).

ances within the lecture texts themselves. The Leonardo copy became the subject of Fuseli's eleventh lecture, for instance, which was entitled 'On the prevailing method of treating the history of painting, with observations on the picture of Lionardo [*sic*] da Vinci of "The Last Supper"',[50] and also of Henry Howard RA's fourth lecture on colour. Reading the published lectures of Fuseli and those of his successors, Thomas Phillips and Henry Howard, it becomes apparent that the arrangement of the Academy's collection

of copies in the Great Room during the winter became a de facto syllabus. Thus, Howard could observe, 'The copy above me from "The Last Supper" exhibits portions of very refined and beautiful colour, which may be fairly supposed to have belonged to the original in at least an equal degree; possibly some passages in the copy may have been executed by Lionardo [*sic*] himself', while Phillips deployed the Raphael Cartoons and Head's copies after Rubens, as well as the *Last Supper*, to inform his texts.[51]

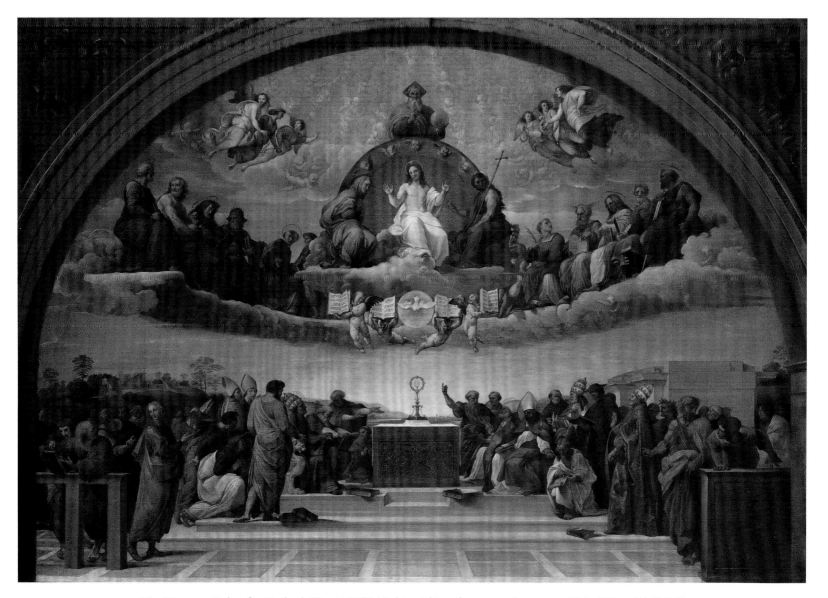

453 Giuseppe Cades after Raphael, *Disputà* (1510–11), late eighteenth century, oil on canvas, 79.5 × 113 cm (RA 03/678).

This motivation accounts for the only other significant subsequent acquisition of copies by the Academy.[52] In 1812 Farington reported a conversation with Benjamin West about a series of reduced copies of Raphael's frescos from the Stanze in the Vatican then in the collection of Francis Basset, Lord de Dunstanville. West noted that 'were those copies brought to the Royal Academy and well commented upon more wd. be learnt by the Students than from all other works that he could mention. He said that justice had never been done in one respect to the merit of Raphael. The critics had never allowed him to possess superior knowledge of what was necessary to produce a fine general effect.'[53] The copies, which had been acquired by Basset in Italy in 1788 from the engraver Giovanni Volpato, had been made by three painters, Giuseppe Cades, Bernadino Nocchi and Stefano Tofanelli, in preparation for Volpato's celebrated series of engravings of Raphael's frescos (figs 453–4).[54] West's desire that they should become part of the apparatus of the Painting School

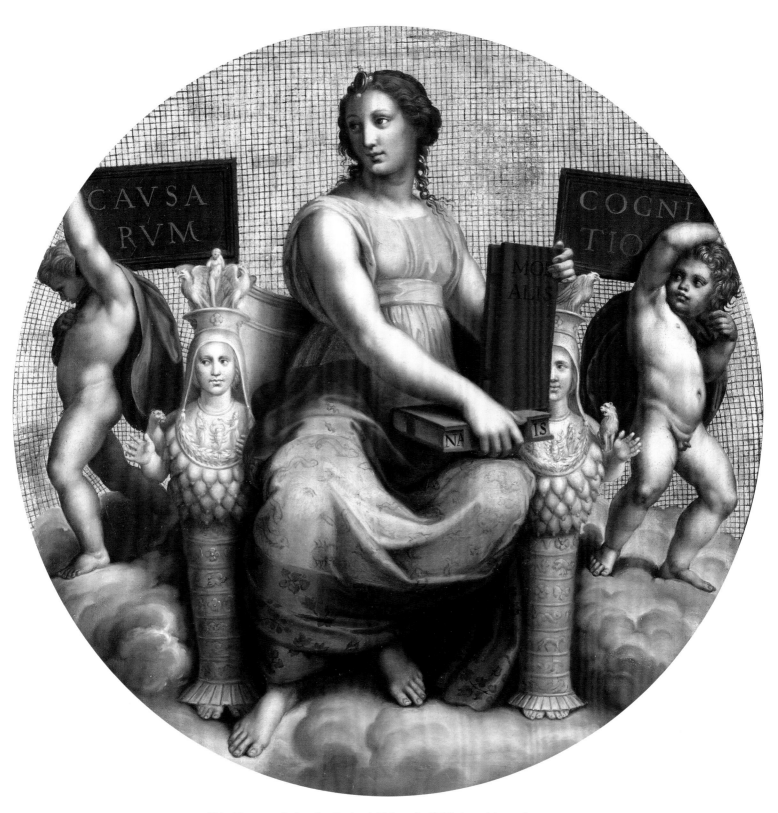

454　Giuseppe Cades after Raphael, *Philosophy* (1508), late eighteenth century, oil on canvas, diameter 49 cm (RA 03/1183).

was eventually fulfilled when Basset's daughter, Frances, gave them to the Academy in 1842.[33] But by the time of this donation the Academy had moved from Somerset House to the new National Gallery building in Trafalgar Square and had, for the first time, a permanent collection of Old Masters adjacent to the Schools. It was this move that, in effect, ended the Academy's active accumulation of copies.

Long after the period discussed here, however, copying remained central to the practice of most young artists, and there is significant evidence that, whether or not it was officially encouraged, copying took place within the Academy itself and was encouraged by certain acquisitions. In the case of James Nevay's drawings of figures from Michelangelo mentioned above, which were placed in the Library after going on exhibition, drawn copies after them of individual figures were made by both William Blake and J. M. W. Turner RA when they were students in the Schools. Despite the importance of copying in the education of most artists, and indeed the early aspiration, as enunciated by Reynolds himself in his First Discourse, for the Academy to become a 'repository for the great examples of the Art', throughout the latter part of the eighteenth century it had failed to offer adequate models for its students in the form of a collection of Old Masters. That the Academy did put together a collection of copies in the first decades of the nineteenth century was largely a matter of reaction to events, in particular to specific attacks by members of the Academy itself: those of James Barry in 1798 and Prince Hoare in 1813. This attitude to collecting largely explains both the nebulous nature of the body of copies in the Royal Academy's collection today, and also the fact that it has never hitherto been systematically discussed.

A CLOSER LOOK

Giampietrino's copy of Leonardo da Vinci's *Last Supper*

ROBIN SIMON

Leonardo's original *Last Supper* was executed c.1495–8 not in true fresco but in tempera and oil paint on dry plaster on a wall of the Refectory of Santa Maria delle Grazie, Milan (fig. 456). It has suffered greatly over time and is now a shadow of what it once was. The copy by Giampietrino, however, was made as early as c.1520 and is considered the most reliable record of the original appearance of one of the legendary masterpieces of European painting (fig. 455). Giampietrino was in Leonardo's workshop when the *Last Supper* was being painted and may even have assisted his master.[1] His copy was bought by the Academy for the immense price of 600 guineas on 23 June 1821, at which time it was attributed to Leonardo's principal pupil, Marco d'Oggiono.[2] It is instructive that in the Council minutes, which are usually frustratingly silent on the motivation for any acquisition, it was observed that 'the Council having since inspected the Picture…[is] of opinion that the possession of such a work would be of essential benefit to the schools of the academy.'[3] In 1825 Henry Fuseli RA, in his capacity as Professor of Painting, was able to deliver his eleventh lecture in front of this painting. The earlier provenance of the painting is not known apart from the fact that by the seventeenth century it was in the Refectory of the Certosa in Pavia. Giampietrino's copy is almost the same size as the original but lacks the top third of Leonardo's composition.[4] It does, however, show many details that are not now visible in the original, such as the salt cellar overturned by Judas as his fist tightens about the purse of money in his right hand (which is also no longer visible). Christ's feet and those of the Apostles to either side, which we can clearly see in Giampietrino's record, were lost from Leonardo's composition when an extra door was inserted in the refectory wall. The saturated oil colours of Giampietrino differ in effect from how Leonardo's must have appeared even before they faded, but they do allow us to see colours and combinations that are now either weaker or altogether missing: for example, the red and white combination in the clothes of St Simon, seated at the extreme right, and the green of St James seated two away from the left of Christ. The copy also offers us a clearer appreciation than is now possible in front of the original of the great variety of expression and gesture in the Apostles' reaction to Christ's announcement that one of them will betray him.

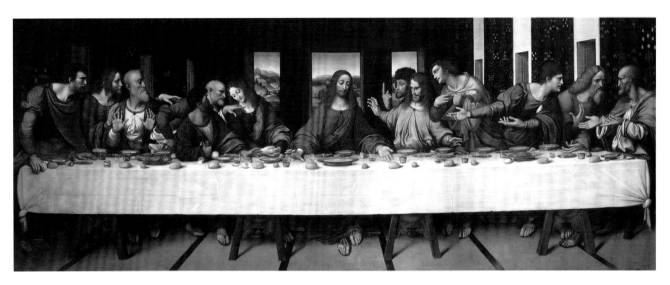

455 Giovanni Pietro Rizzoli, called Giampietrino, after Leonardo da Vinci's *Last Supper*, c.1520, oil on canvas, 302 × 785 cm (RA 03/1230).

456 Leonardo da Vinci, *Last Supper*, c.1495–8, fresco, Refectory of Santa Maria delle Grazie, Milan.

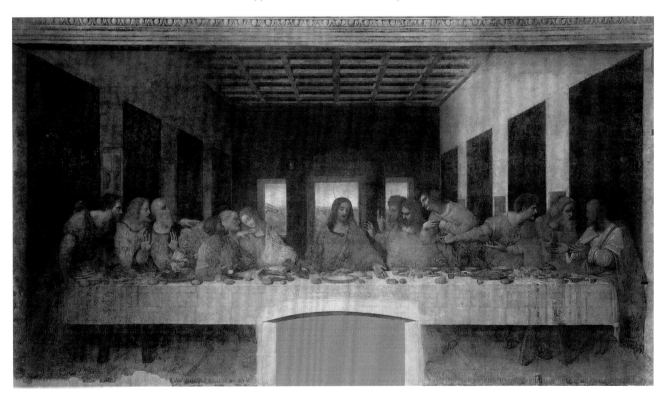

17

ANATOMICAL STUDIES

ANNETTE WICKHAM

'I suppose you have seen accounts upon the newspapers of the Jews which were hung for robbing a house and murdering a servant man in it. We had the body of one of them at the Academy for Dr Hunter to read his lectures on…We had two lectures on it because they might have the body fresh to cast a plaster anatomical figure…placed in the Academy to be drawn from.'[1] This grisly event was described by the young Royal Academy student James Northcote in a letter to his brother in 1771. Such displays, macabre as they may seem, were not uncommon in the early years of the Royal Academy and demonstrated the new institution's commitment to providing anatomical training for artists, emulating the practices of Old Masters such as Leonardo da Vinci. This aim was pursued with particular vigour by the first Professor of Anatomy, William Hunter. He was perfectly suited to the task, being a pioneering anatomist and physician as well as an art collector and a friend of many artists including Sir Joshua Reynolds PRA and James Barry RA. Hunter took his duties

at the Royal Academy very seriously, offering thorough practical instruction as well as observations on the utility of anatomical knowledge as applied to art.[2] His first lecture series at the Academy Schools in 1769 was typical of this approach, being divided between lessons on the human skeleton and actual dissections demonstrating the workings of the muscles.

Finding specimens to dissect was not straightforward, however. The only bodies legally available at this time were those of executed criminals whose sentences specified that their corpses be given up for dissection.[3] By the nineteenth century the supply of bodies was insufficient, leading many anatomists to rely on the services of the notorious 'resurrection-men' who robbed graves for profit. When Hunter managed to obtain a cadaver for the Royal Academy through the official channels, therefore, he had to make optimum use of it. In the case recorded by Northcote, for instance, the body of the hanged felon was partially dissected over the

course of two lectures to the students. After that, the entire skin and certain layers of muscle were removed and a plaster cast made to create an écorché figure (from the French for flayed) that would serve as a permanent teaching aid. The striking polychrome plaster cast still in the Royal Academy collections today is almost certainly the one produced on this occasion (fig. 457). When an actual corpse could not be found, Hunter used écorchés for teaching, explaining that he preferred the 'veridical representation' of a real body in contrast with the 'tawdry', 'incorrect' and 'ridiculous' effects of the wax anatomical models that were popular at the time.[4] The preservation of a small but important group of écorché figures at the Royal Academy reflects Hunter's significant contribution as well as the impact of this legacy on future generations of Royal Academicians and students.

Hunter oversaw the creation of several écorchés specifically for artists, including at least two bespoke figures made specifically for the Academy. An écorché that he had already produced for the Society of Artists also made its way to the Academy by the early 1770s.[5] This no longer exists, but it became famous at the time and is recorded in two paintings by Johan Zoffany RA that show William Hunter teaching at the Academy, *Dr William Hunter teaching Anatomy at the Royal Academy* (*c.*1772; Royal College of Physicians, London) and *Academicians of the Royal Academy* (1772; see fig. 121). Smaller versions of the figure were also cast in bronze, and Dr Hunter is shown holding one of these in Mason Chamberlin RA's portrait of him of 1769 (see fig. 115).

The first of the two écorchés directly associated with Hunter that survive in the Royal Academy is the polychrome figure mentioned in James Northcote's letter. It differs considerably from the Society of Artists' écorché that Hunter holds in his portrait by Chamberlin, although it has a similar contrapposto stance. The coloured paintwork and areas of deep dissection show different layers of muscle and bone to produce a particularly powerful, naturalistic effect. Doubts have been raised over whether Northcote's letter can securely be linked to the polychrome figure, but as Martin Postle has shown, such qualms are settled by Abraham Rees's *Cyclopedia* of 1819, which provides a clear description of the écorché,

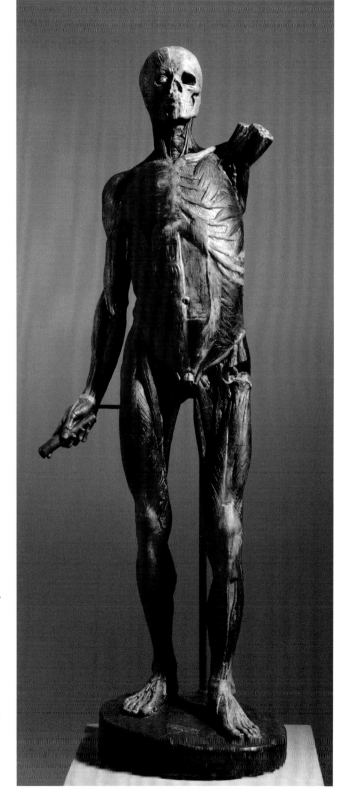

457 Polychrome écorché figure, probably 1771, painted plaster cast, 171.5 × 61 × 47.5 cm (RA 03/1435).

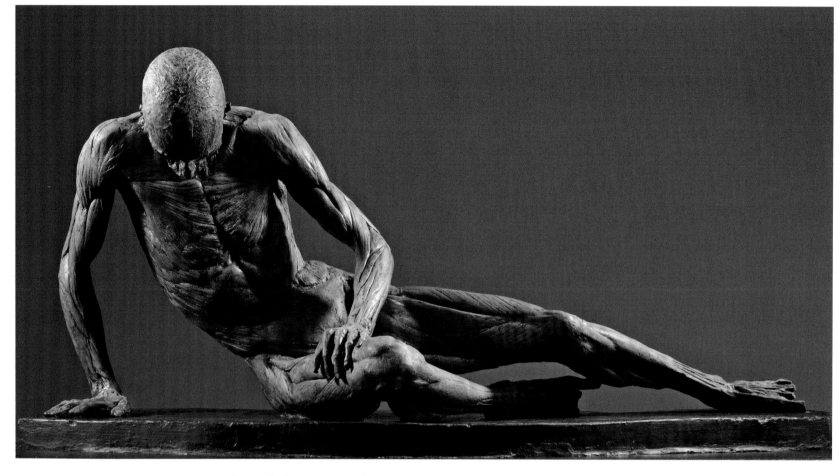

458 William Pink after Agostino Carlini RA, *Smugglerius*, 1776, plaster, 75.5 × 148.6 cm (RA 03/1436).

adding that it was made by Hunter.[7] Conservation work carried out in the 1990s further revealed a hidden and removable circular section in the abdomen of the cast designed to show the internal organs.[8] This level of detail indicates that the cast was the work of a meticulous and knowledgeable physician, strongly indicating the involvement of Hunter. Such an approach corresponds closely with the professor's beliefs as explained in surviving notes for his lectures. Hunter argued that artists should follow nature as closely as possible and took issue with the idea that art which was too lifelike could be an 'object…of horror'. Ridiculing this notion, he added: 'when a statuary [sculptor] has but good information that young men have made serious attempts on his Vestal it will be time enough to say that the resemblance is too perfect.'[9]

The second écorché produced by Hunter for the Academy goes by the mock Latin nickname it was given by students in the eighteenth century: *Smugglerius* (fig. 458). The original was made in 1776, but the present cast is a replica made in 1834 by William Pink, the Academy's *formatore*. *Smugglerius* and the *Anatomical Crucifixion* discussed below are the best-known anatomical casts in the Academy collections, owing to the fact that their striking poses respectively mimic classical sculpture and the work of the Old Masters.

Attempts at establishing the identity of the man whose body was immortalized as *Smugglerius* have given rise to some debate.[10] The key piece of evidence is a letter from the young art student John Deare to his father dated 1 May 1776.[11] He wrote: 'I have seen two men hanged, and one with his breast cut open at Surgeons' Hall. The other being a fine subject,

they took him to the Royal Academy, and covered him with plaster of Paris, after they had put him in the position of the Dying Gladiator [also known as the Dying Gaul].' There were only two double executions at Tyburn in London during the spring of 1776, that of Samuel Whitlow and James Langar on 12 April and that of Benjamin Harley and Thomas Henman (also spelt variously as Hendman and Headman) on 27 May.[12] Joan Smith and Dr Jeanne Cannizzo, carrying out research for an exhibition in Edinburgh, identified Langar as the most likely candidate because the date of his execution preceded that on Deare's letter and because, as a soldier, he was more likely to have had an impressive physique than Whitlow, a servant.[13] Professor Tim Hitchcock has since argued, however, that Harley and Henman should not be ruled out because it was usual for people to finish letters some weeks after starting them during the eighteenth century. He also points out that Harley and Henman's sentences specified that they were to be dissected after execution and, crucially, that they were a pair of smugglers who murdered a revenue officer, a widely reported fact that highlights the gallows humour of the écorché's classical nickname.[14]

On its arrival at the Royal Academy, the body – whichever one it was – was flayed by William Hunter, but it was the Italian sculptor Agostino Carlini RA, a Foundation Member, who determined the pose, which does indeed imitate that of the *Dying Gladiator/Gaul*, one of the most admired examples of classical sculpture.[15] In comparison with Hunter's polychrome cast, this écorché is more clearly a collaboration between sculptor and scientist, and it highlights some significant differences of opinion regarding the place of anatomy in the academic canon. Unsurprisingly, Hunter was firmly convinced of the value of anatomical study for artists, and his fundamental belief in empirical observation led him so far as to question whether there was much point in students spending long hours drawing from static plaster casts after classical sculptures, although this practice formed the bedrock of the Academy course.[16] Scholars have therefore linked the overtly classicizing and slightly less visceral appearance of *Smugglerius* with Carlini's adherence to Reynolds's theories on the relationship between nature and the Antique. Although the Academy's founding President officially approved of anatomical training for students, he was somewhat ambivalent about the extent to which artists should pursue this discipline. Throughout his *Discourses* he returns time and again to his

theory that the essential purpose of studying nature is in order to be able to 'correct' individual quirks and generalize towards the ideal.[17] Carlini's choice of pose for this écorché both validates the study of anatomy as a means of achieving a literally – deeper understanding of a classical masterpiece, while at the same time it imbues the gruesome figure with a greater sense of elegance and propriety.

Despite his divergence from Reynoldsian orthodoxy, William Hunter's methods and attitudes had a profound effect.[18] This became evident in artists' practices and in a growing concern for naturalism. Less directly, Hunter's influence can also be felt in the development of a stylized aesthetic derived from the pronounced musculature of écorché figures and anatomical illustrations (fig. 459).[19] Dissection itself, however, remained a controversial practice, and a lingering distaste for anatomical study in polite society was shared by numerous artists and critics.

Differing opinions within the Academy regarding the value of anatomy in artists' training became more apparent after the death of Hunter in 1783. The next professor, John Sheldon, proved a much less dynamic presence, and he was often absent through illness. At this time a group of students, including Benjamin Robert Haydon, John Constable, David Wilkie and Andrew Robertson, took matters into their own hands and arranged to attend anatomical demonstrations and dissections elsewhere.[20] Following Sheldon's death in 1808, the Academicians passed up the opportunity to appoint 'the Painter anatomist' Sir Charles Bell.[21] To the great disappointment of Haydon and others, they chose instead Sir Anthony Carlisle, a man who had publicly questioned the relevance of anatomical study for artists and who was described in the *Examiner* as 'incapable of ... [the] ... tasteful application of his science to painting'.[22] Eminent though he was as a physician, Carlisle became known at the Academy not for his medical expertise but for his showmanship. His lectures were delivered in full court dress, usually accompanied by a 'novelty'. These included a display of naked guardsmen, performing Indian acrobats and a human brain that was passed around the audience on a dinner plate. Spectacles of this type inevitably drew a crowd, and on at least one occasion the police were said to have been called to keep the peace.[23]

It is significant that the most famous, and probably the only, écorché produced for the Royal Academy after William Hunter's time was made not by the Professor of Anatomy

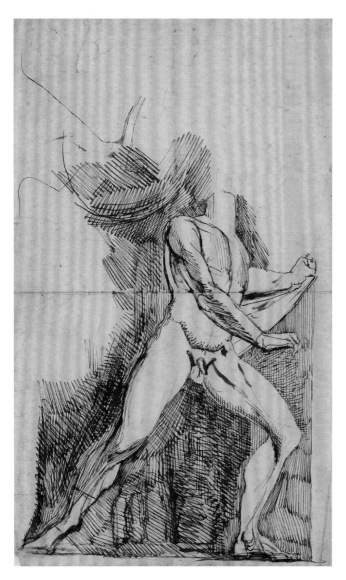

459 Henry Fuseli RA, *Standing Male Nude in the Pose of the Dioscuri*, pen and ink on paper, 32 × 20 cm (RA 07/5161, verso).

but by an external surgeon directed by a group of artists. The *Anatomical Crucifixion* (fig. 460) was carried out to settle an artistic debate between three Academicians: history painter Benjamin West, sculptor Thomas Banks and painter Richard Cosway. They believed that most portrayals of the Crucifixion were anatomically incorrect, given that artists painted either from a corpse or from a living model, neither of which would truly show the external effects on the body caused by this manner of execution. They concluded that – short of

actually crucifying someone or stabbing a model on a cross (as various anecdotes claimed that Michelangelo or Caravaggio had done) – the only way to test this theory was to crucify a fresh corpse while it was still warm.

In this case the identity of the man who was flayed is well documented.[24] In 1801 the three artists approached the surgeon Joseph Constantine Carpue for his help in finding a suitable subject. On 2 October that year an opportunity arose when Carpue was called to Chelsea Hospital. One of the pensioners, an old Irishman named James Legg, had argued with a colleague. He later burst into the other man's room carrying two loaded pistols and demanding a duel. His opponent refused and threw the pistol to the ground, at which point Legg shot him in the chest, killing him instantly. A newspaper report of Legg's trial described him as having the 'extremely decent and venerable' appearance of a man of 'about 80 years of age'.[25] Despite his advanced years and a defence of insanity, Legg was found guilty and sentenced to be hanged on 2 November. The judge specified that his body was afterwards to be dissected, which allowed Carpue and the Academicians to carry out their experiment.[26]

Carpue recalled the occasion: 'A building was erected near the place of the execution; a cross provided. The subject was nailed on the cross; the cross suspended…the body, being warm, fell into the position that a dead body must fall into …When cool, a cast was made, under the direction of Mr Banks, and when the mob was dispersed it was removed to my theatre.'[27] There Carpue flayed the cadaver and Thomas Banks made the écorché cast. The Academicians are reported to have been pleased with the results of their experiment, concluding that most artists had used dead bodies as models for the figure of the crucified Christ.[28] It was observed that the effect on Legg's corpse was to raise the bones of the chest, to sink the abdomen and generally to elongate the body. The hands, in particular, displayed the effects of bearing the body's weight, leading Benjamin West to exclaim that it made him feel that he had 'never before seen the human hand'.[29]

The striking 'before and after' casts generated considerable public interest, and crowds gathered to see them in Banks's London studio. Although West, the serving President, had instigated the production of the figures, it was not an official Academy venture. Banks nevertheless sent both casts to the Schools in 1802; although they remained there for only 20 years.[30] An *Art-Union* article of 1845, based on Carpue's

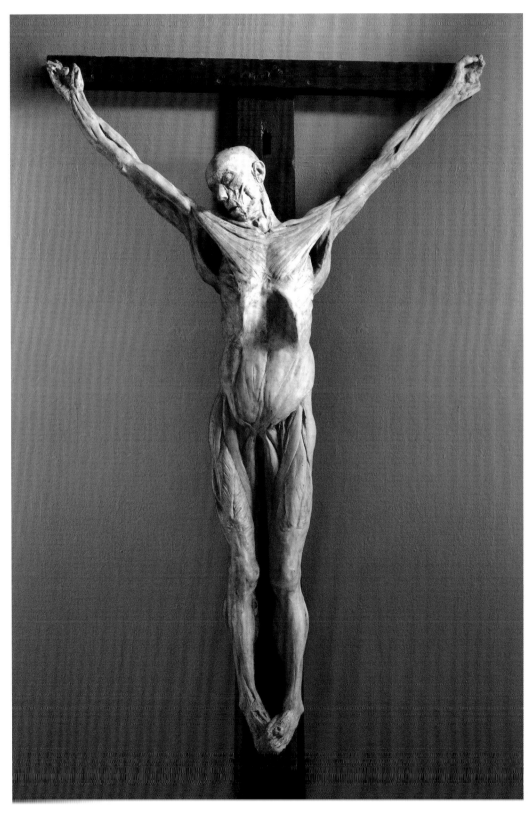

460 Thomas Banks RA, anatomical crucifixion of James Legg, 1801, plaster and wood,
231.5 × 141 × 34 cm (RA 03/1438).

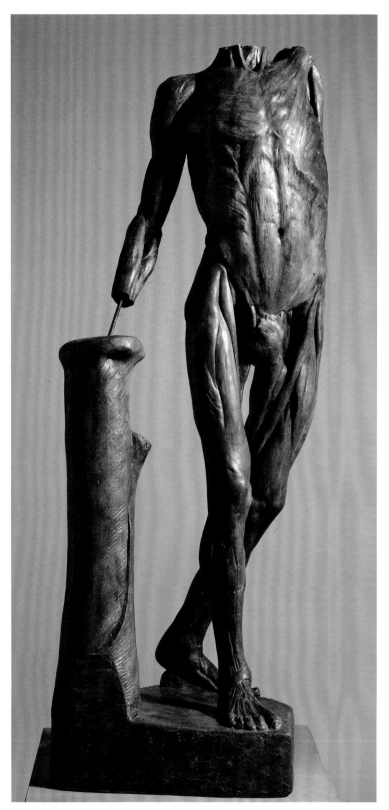

recollections, castigated the Royal Academy for removing the crucified figures in order to make room for George IV's donation of casts after classical sculptures.[31] This was a rather a long time after the casts had arrived, and in fact the Academy's archives suggest that it was Carpue himself who had earlier requested their removal. In 1822 the Council minutes record that he asked permission to place the casts in his own anatomical museum, promising that they would still be accessible to students and members of the Academy.[32] The surgeon later lent both casts to the sculptor William Behnes, in whose studio they could be viewed in 1845.[33] Carpue's indignation with the Academy might be explained by his claim that he offered the crucified figures back to the Academy at this juncture but was apparently refused. He subsequently bequeathed the casts to St George's Hospital, London, where they hung in the dissecting room of the medical school before being returned to the Royal Academy in the late nineteenth century.[34] The écorché still hangs in the Life Room of the Schools, but its unflayed pair is untraced.[35]

In addition to the three écorchés made specifically for the Royal Academy are several examples that were bought by or given to the Academy during the eighteenth and nineteenth centuries. *Standing Headless Male Écorché Figure* (fig. 461) is thought to be the oldest écorché in the Academy collections. Apart from the missing head and left arm, it is identical to one in the École nationale supérieure des beaux-arts in Paris, which was traditionally attributed to the French sculptor Edmé Bouchardon (although this identification has since been challenged).[36] The écorché may have come from the collection of the Royal Academy's predecessor, the St Martin's Lane Academy, for there is a reference in 1767 to the transfer of some of their 'casts, anatomical figures ... and other goods' to the rooms in Pall Mall that briefly later served as the Schools prior to their relocation to apartments in Old Somerset House in 1771.[37] Alternatively, it has been suggested that, because the Academy appears to have had the Society of Artists' écorché from an early date, this example may be a later acquisition.[38] Indeed, a reference to the purchase of an anatomical cast from Paris in the RA Council minutes of 1847 could possibly refer to *Standing Headless Male Écorché Figure*.[39]

461 After Edmé Bouchardon, *Standing Headless Male Écorché Figure*, mid-eighteenth century, plaster, 147 × 68 × 60 cm (RA 03/1444).

The R.A. also owns two partial casts after a celebrated anatomical figure by the French sculptor Jean-Antoine Houdon. Houdon's original is a standing male, full length with right arm extended horizontally, and the Academy partial casts are of torso and legs only and head and torso only, respectively. While studying at the Académie de France in Rome between 1764 and 1768, Houdon developed an intense interest in anatomy and produced an *Écorché au bras tendu* in 1767 as a preparatory study for a *St John the Baptist* originally conceived as one of a pair of enormous marble sculptures, the other being *St Bruno*, commissioned in 1766 for S. Maria degli Angeli, Rome. Only one life-size plaster version (1766–7) of this final sculpture of the Baptist survives (Galleria Borghese, Rome), painted white, which was discovered in the storeroom of the Museo Nazionale, Rome, in 1921. It is now thought that the marble was never made, and, indeed, only a plaster – 315 cm high, compared with the Borghese plaster of 160 cm (excluding its base) – was placed in S. Maria degli Angeli. The marble *St Bruno* survives, but the plaster Baptist was destroyed in June 1894 when it fell and broke.

Houdon's study for *St John the Baptist* was reproduced as a cast, and soon became known throughout Europe. A ubiquitous item in art academies, it has been described as 'the outstanding and most admired anatomical model in the history of sculpture'.[40] Unlike the examples discussed above, however, Houdon's 'écorché' is in fact an anatomical sculpture rather than a cast of a flayed corpse.[41] It was based on an extensive study of anatomy that Houdon undertook at the hospital of San Luigi dei Francesi with its surgeon M. Séguier, but Houdon pointedly recorded that he had deliberately improved upon nature: 'I had done this work to teach artists, which is the reason for the correction of the design…Surgeons, as skilled as they may be, are not artists, and artists are not surgeons. In my view, the skilled surgeon must study after nature, as defective as one may find it to be…But we artists must study it differently. It is nature in all her nobility, her perfect state of health, that we are looking for, or if not, we are nothing but wretched imitators.'[42]

The date of the Academy's acquisition of the two casts after Houdon is not known,[43] although it may be significant that Johan Zoffany, nominated RA by King George III in 1769, who was in Italy from 1772, conspicuously included the popular small version of Houdon's famous écorché in the background of his *Self portrait* of 1778 (Uffizi, Florence).[44]

By the late nineteenth century, greater access to illustrated books on anatomy and to public demonstrations meant that the heyday of the écorché was over, although such figures were still valued as part of the apparatus of an artist's training. The miniature figure known as the *Écorché à la Colonne*, for example, was produced by the Victorian cast manufacturers Brucciani and appears in their published catalogues around the turn of the twentieth century, listed simply as 'Anatomical (French)'. It is thought to derive from a model made by the French sculptor Eugène Caudron.[45]

ANIMAL ÉCORCHÉS

Given the Academy's original mission to equip its students with the means to paint or sculpt in the 'Grand Manner', the study of human anatomy was of paramount importance. A knowledge of animal anatomy was also useful, however, and the anatomical collections included animal examples from the very early days of the institution. In 1773 there is a reference to the acquisition of 'casts of lyons' made by 'Messrs Hopkins and Oliver',[46] and in 1780 Joseph Baretti described a miniature cast of a flayed horse on one of the mantelpieces in the Council Room, 'the Original of which, a bronze in great esteem, is to be seen in the Villa Mattei at Rome, supposed to have belonged to some ancient school of anatomy'.[47] This no longer exists in the collection, but it can be seen in E. F. Burney's watercolour of the Antique School at Old Somerset House (see fig. 392). The Academy still retains écorchés of a Bengal tiger, a leopard and a horse.[48] The leopard, also traditionally described as a panther, is very similar to one depicted by George Stubbs ARA in his preparatory studies for *A Comparative Anatomical Exposition of the Human Body with that of a Tiger and a Common Fowl* (1804–6). For this reason, Stubbs is thought to have made, or been involved in making, the écorché.[49] A late addition to this collection in 1920 was the *Anatomical Lion* (1897) by Briton Rivière RA, presented by his widow. Like Houdon's figure, this is a sculpture rather than a true écorché, and it was said to have taken Rivière years to complete.[50]

Dominating the Life Room of the Royal Academy Schools is an écorché horse traditionally known as 'Copenhagen' after the Duke of Wellington's celebrated charger (fig. 462). This seems to have been merely a nickname, as Copen

462 Marcus Leith, photograph of the Life Room, Royal Academy Schools, 2010 (RA 10/4112).

hagen died in 1836 and was buried intact on the duke's estate at Stratfield Saye, Berkshire.[51] The actual origin of the écorché horse is unknown, but it was presented to the Academy in 1919 by the artist son of Philip Hermogenes Calderon RA, William Frank Calderon, who from 1894 ran the School of Animal Painting in Baker Street, London, that boasted a 'unique' collection of casts and anatomical drawings.[52]

SKELETONS

While écorchés were important in helping students to understand the form and movement of the body, the skeleton demonstrated its essential structure. As Benjamin Robert Haydon put it, the skeleton can be considered as the 'basis of all design'.[53] There is a skeleton in Zoffany's painting *Dr William Hunter teaching Anatomy at the Royal Academy*, which may have belonged to Hunter, while the Academy provided the Professor of Anatomy and the students with a skeleton

from at least the 1780s.[54] From 1814 probationers hoping to enrol in the Antique Academy were required to hand in 'outline drawings of an anatomical figure and skeleton not less than two feet high with lists and references on each drawing of the several muscles, tendons and bones'.[55] It was John Marshall, however, Professor of Anatomy 1873–91, who revived the tradition of acquiring anatomical examples for teaching and who assembled the large collection of skeletons that can still be seen in the Schools today (see fig. 383).

On his appointment in 1873, Marshall immediately set about improving students' access to anatomical training, and he successfully applied to London University for their admission to anatomical demonstrations and dissections.[56] He also persuaded Council to give him funds to acquire skeletons and preparations of dissected muscles. Marshall described this as an 'art anatomy' collection, but his approach was firmly rooted in nineteenth-century scientific theory. His correspondence with the Academy reveals an overriding interest in comparative anatomy: on 20 September 1887 he

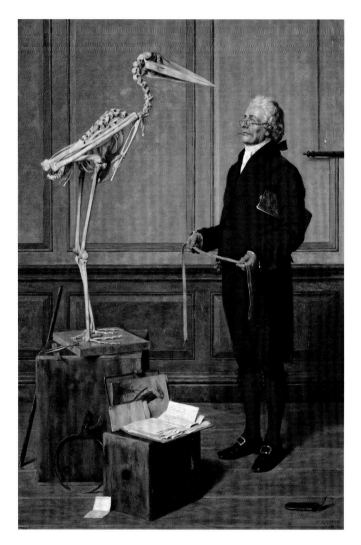

463 Henry Stacy Marks RA, *Science is Measurement*, 1879, oil on canvas, 91.5 × 61 cm (RA 03/702).

presented a 'specimen of a Torso Skeleton (Human)', a 'cast of a Chinese Woman's foot taken from a Cemetery' and 'two casts of a Chimpanzee's foot and hand'. On 13 December 1887 he wrote that the Anatomical Museum 'is now absolutely unique', requiring only 'a dissection of the face & perhaps a few National Skulls to make it perfect'.[57]

The impulse to record, categorize and compare is also evident in Henry Stacy Marks RA's Diploma Work *Science is Measurement* (fig. 463). The title derives from the dictum of Victorian physicist William Thompson, later Lord Kelvin, who considered measurement to be the foundation of all

scientific inquiry. The painting depicts a scientist approaching the skeleton of a large bird with a tape measure in order to record its dimensions in the open notebook at his feet. Scattered around him are other tools of measurement including a wooden yardstick, a needle compass and calipers. Marks implicitly draws a comparison between the processes of observation employed by artists and scientists, and highlights the importance of comparative anatomy between humans and other species, an undertaking recently promoted through the dissemination of Charles Darwin's evolutionary theory.

BOOKS AND WORKS ON PAPER

The Academy's anatomical collections extend beyond écorchés and specimens, and an important collection of books on the subject had been assembled by 1802, bringing together illustrated volumes of seminal works such as those of Vesalius (fig. 464) and Albinus as well as more recent publications such as the works of Peter Camper published in 1794.[58] The Academy continued to acquire books on anatomy: for example, Juan de Valverde de Amusco, *Historia de la composicion del cuerpo humano* (1556; fig. 465), Jean-Galbert Salvage's *Anatomie du gladiateur combattant, applicable aux beaux Arts* (1812) and Robert Knox's *Manual of Artistic Anatomy* (1852).[59] Important contributions such as John Bell's *Engravings explaining the Anatomy of the Bones, Muscles and Joints* (1794) were, however, overlooked at the time of publication and were only acquired towards the end of the nineteenth century.[60] Bell's approach to anatomy may not have found favour at the Academy, since he portrayed unmistakably dead bodies carved up on the slab rather than following the Renaissance convention of depicting animated flayed figures in classical poses.

The Academy also built up a considerable collection of anatomical drawings that, in some cases, were purchased because of their connection with a member. In 1885, for instance, Council bought a copy of *Anatomical Studies of the Bones and Muscles for the Use of Artists from Drawings by the late John Flaxman R.A. Engraved by Henry Landseer with two additional plates and explanatory notes by William Robertson* (1833). Bound into this volume, which originally belonged to Sir Francis Chantrey RA, were 19 anatomical drawings by Flaxman (fig. 466) from which the plates were engraved. Flaxman was more famous for his outline illustrations to

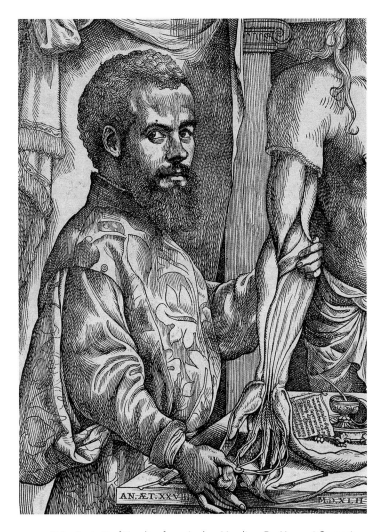

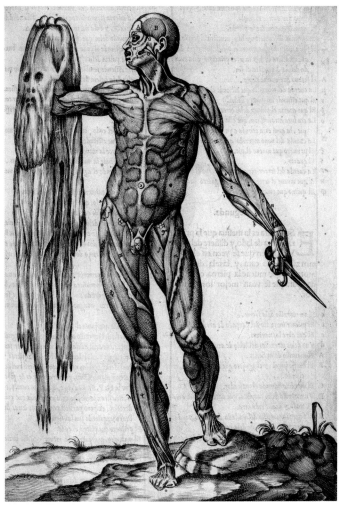

464 Portrait of Vesalius from Andrea Vesalius, *De Humani Corporis Fabrica*, Basle 1555. RA 03/2867.

465 Attributed to Gaspar Becerra, flayed man holding his own skin, in Juan de Valverde de Amusco, *Historia de la composicion del cuerpo humano*, Rome 1556 (RA 03/6654).

Homer, Aeschylus and Dante, and he made these anatomical studies for his own use. William Robertson wrote, in the preface to the book in which they were published, that they were intended to show 'the exemplification of his [Flaxman's] labours; the secret of his processes; and all that need be urged on the young Student is to follow in the Master's steps.' He added that these are the drawings of a man 'who had made the laws of muscular action his most particular and successful study, and whose skill as a draughtsman enabled him to give the most expressive character of nature to his transcripts from the dissected limb'.[61]

Some of the most significant additions to the anatomical collection were gifts, presumably prompted by the Academy's high reputation for anatomical teaching that had been established by William Hunter. In 1771 John Belchier presented a copy of William Cheselden's *Osteographia* (1733). Belchier had assisted Cheselden on the project and is to be seen in the frontispiece helping to set up a long wooden camera obscura aimed at a skeleton, which is hanging upside down in order to appear the right way up to the recording artist (fig. 467). Belchier also gave a near-complete set of 168 original drawings for its plates, which were made under Cheselden's direc-

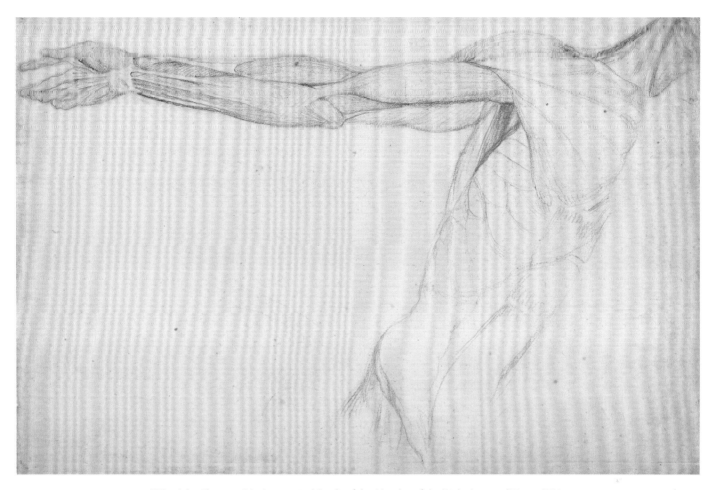

466 John Flaxman RA, *Anatomical Study of the Muscles of the Right Arm and Torso*, 1780s,
pencil and red chalk on laid paper, 29 × 44 cm (RA 07/1598).

tion by Jacob Schijnvoet and Gerard Vandergucht (fig. 468). A thorough study of the human skeletal system, the *Osteographia* was one of the most comprehensive publications of its kind to date. In his preface, Cheselden stated that every bone in the human body was included, 'delineated as large as life, and again reduced to lesser scales, in order to shew them united to one another'.[62]

In 1879 the Academy also received George Stubbs's outstanding drawings for *Anatomy of the Horse* (1766) through the bequest of Charles Landseer RA. This encompassed a full set of finished studies for the engraved plates as well as an important group of working drawings. The most unlikely addition to the anatomical collections, but also one of the most interesting, is a set of drawings by the history painter Benjamin

Robert Haydon, who famously lambasted the institution at every possible opportunity. These studies were also part of a gift, the Stretton Bequest, that came to the Academy in 1949 and mostly consisted of drawings by Academicians. Despite Haydon's antipathy, it is entirely fitting that these drawings should form part of the collections because he had made them while attending the Schools.

Haydon aspired to be a history painter from a young age and was hugely enthusiastic about the prospect of studying at the Academy. He read Reynolds's *Discourses* before enrolling and wrote that it 'made my whole frame convulse with the thought of being a great painter...I thought only of LONDON – Sir Joshua – Drawing – Dissection and High Art'.[63] Initially, the Schools met his high expectations, but he

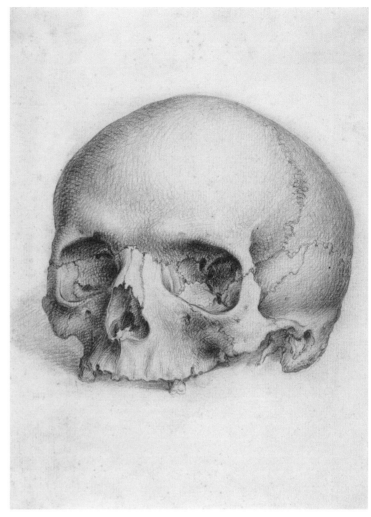

467 Title page to William Cheselden, *Osteographia*, London 1733 (RA 07/520).

468 Gerard Vandergucht, *A Human Skull viewed from the Front, for Cheselden's 'Osteographia'*, by 1733, pencil on paper, 23 × 17 cm (RA 03/6846).

quickly became disappointed by the lack of instruction offered in anatomy. By this date the professor, John Sheldon, was ill and frequently absent.

The 88 drawings by Haydon fall into three categories, each marking a stage in his study of anatomy. The first group is made up of drawings after illustrations in seminal texts such as the *Tables* of Albinus.[64] The second was made from specimens at Plymouth Hospital, where the artist's father was a patient. The last group contains visual records of dissections in which the artist participated (fig. 469).[65] The experience he

gained from such studies led him to return to some of his earlier drawings in order to correct them.

Haydon assembled these drawings in an album that he used to instruct his own students, who included the three Landseer brothers, Charles, Thomas and Edwin. In deliberate opposition to the tuition at the Academy Schools, Haydon's pupils undertook a lengthy course in dissection before progressing to draw from the Elgin Marbles and the Raphael Cartoons. He was proud to declare that while 'the authorities' considered this system 'inconsistent with their dignity', his students

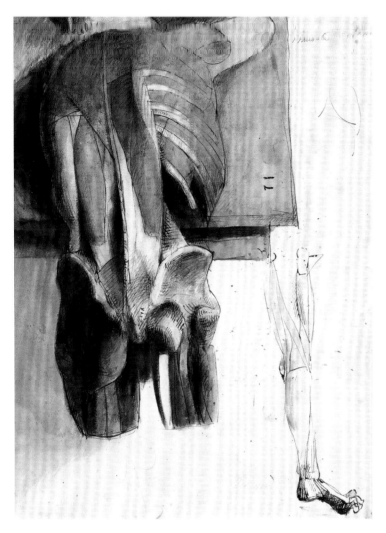

(left) 469 Benjamin Robert Haydon, *Anatomical Drawing of the Muscles and Bones of a Cadaver viewed from the Back*, December 1805, pen and ink, 44 × 32.7 cm (RA 02/313).

(above) 470 Robert Buhler RA, *Anatomy Lesson or the Death of Art Schools*, c.1968, pen and ink on card, 24.4 × 39 cm (RA 11/554).

were busy 'making capital drawings…hanging over a putrid carcass, dissecting and drawing for twelve and fifteen hours a day at a time of year when surgeons generally give up'.[66] In a handwritten note on the cover of the anatomy album, Haydon wrote that anatomy had been the foundation of 'genius' in each of his students, adding: 'This is I think visible in the whole school / Each pupil has formed pupils – they others – + the whole / system will imperceptibly undergo reform silent + / evident, + irresistible / London Aug 26th 1841 B R Haydon.'[67]

Haydon took issue with the lack of practical instruction in anatomy provided by the Royal Academy and accused the institution of only paying lip service to its founding ideals, but the legacy of William Hunter ensured that, at the very least, this subject always remained part of the curriculum. The survival of so much of the Academy's anatomical collections intact and *in situ* is also a direct result of the institution's continuing independence from the state higher education system. When fine art courses in the United Kingdom were overhauled in the 1960s, many colleges abandoned traditional disciplines such as perspective, anatomy and the study of plaster casts in order to conform to the academic requirements of the new Diploma of Art and Design or 'Dip AD'. The physical apparatus assembled for teaching these subjects was often jettisoned at the same time or subsumed into museum collections. Robert Buhler RA's pastiche of Rembrandt's *Anatomy Lesson of Dr Nicolaes Tulp* (1632) is inscribed on the recto with 'DIP–AD' and on the verso 'Death of Art Schools' (fig. 470). It humorously refers to the Old Masters and the tradition of anatomical study, and suggests that the art schools, including the prestigious Royal College of Art – where Buhler himself taught – were being dismembered like a cadaver on the slab. Nonetheless, although the level of anatomical training on offer at the Royal Academy fluctuated over the years, the institution avoided the fate of other art schools. In addition to retaining its sizeable collection of écorchés, skeletons, anatomical books and drawings, the professorship of anatomy survives to this day.

A CLOSER LOOK

George Stubbs's drawings for
The Anatomy of the Horse

ANNETTE WICKHAM

George Stubbs ARA is celebrated for his majestic portraits of thoroughbred horses such as *Whistlejacket* (1762; National Gallery, London). Underpinning the power of such works was the artist's unrivalled knowledge of equine anatomy, honed through the painstaking and physically gruelling practice of dissection. Between 1756 and 1758 Stubbs rented a barn at Horkstow, Lincolnshire, where he devoted 18 months to investigating the musculo-skeletal structure of the horse. With only the assistance of Mary Spencer, who was his companion and (probably) common-law wife, Stubbs undertook the whole process himself. His method began with the grisly procedure of bleeding the horse to death by making an incision in the jugular vein to ensure that the body was otherwise undamaged. He then suspended the carcass from the roof on a tackle he had devised, in order to enable him to place the animal in a natural, standing position. Starting at the abdomen, the artist then gradually stripped back layers of muscle, making a detailed drawing at each stage as the dissection progressed.[1]

The aim was to produce a book, *The Anatomy of the Horse*, published in 1766, which was the first of its kind since the sixteenth century. Forty-two of the artist's drawings for this remarkable project survive, and all are held in the Royal Academy collections. They fall naturally into two groups: 24 working drawings (figs 471 and 472) and 18 finished studies. The former are Stubbs's visual records of specific dissections, some of which focus on small details of the animal's anatomy, while others are more robust depictions of the whole animal. They are drawn in pencil with touches of chalk and ink, and are meticulously observed. The sheets are inscribed with the Latin terms for different muscles and bones, together with observations on how the different parts of the body fit together and information about the animal being dissected. On one drawing, for example, Stubbs recorded that the template for the skeleton was 'taken from an old mare about 13 hands high'.[2]

In contrast, Stubbs's finished studies – intended for engraving – are finely wrought drawings in pencil (fig. 473), one for each of the published plates. They do not record the dissection of a particular horse, but are a synthesis of work on numerous specimens. While this approach indicates the artist's commitment to the scientific principles of the Enlightenment, it also reflects the practical challenges he faced. Putrefaction and the risk of disease obliged Stubbs to work from 'a great number of horses', each carcass lasting no more than six or seven weeks.[3]

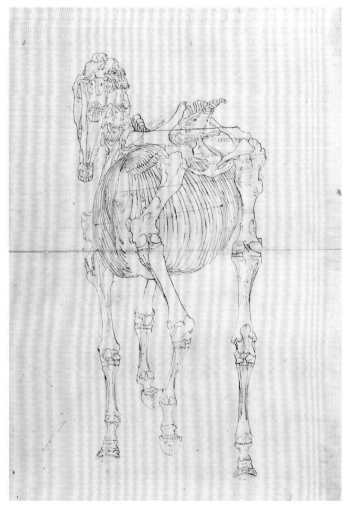
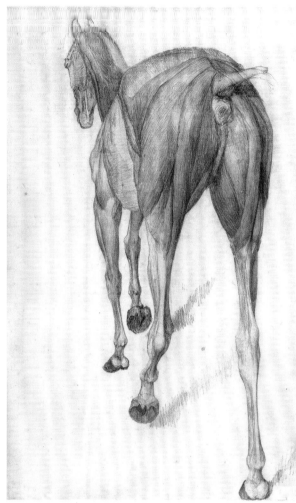

471 George Stubbs ARA, *Measured Working Drawing for the 'Third Anatomical Table of the Skeleton of the Horse'*, 1756–8,
pen and brown ink, 36.7 × 25 cm (RA 03/1587).

472 George Stubbs ARA, *Working Drawing for the 'Twelfth Anatomical Table of the Muscles…of the Horse'*, 1756–8,
pencil, black and red chalk, 47.7 × 29.6 cm (RA 03/5727).

When Stubbs's *Anatomy of the Horse* was published in 1766, it was acclaimed by both artists and anatomists. Stubbs could surely have sold his drawings for the book but chose to keep them for his own reference. After his death they passed to Mary Spencer, and it was certainly not the artist's wish that they should go to the Royal Academy: Stubbs's relationship with the institution had been fraught. Although he was elected a full member in 1781, his refusal to give a Diploma Work caused much consternation and ensured that he remained an Associate, with little involvement in Academy affairs. Stubbs's

work was, however, enormously influential, the only precedent for which was Carlo Ruini's *Anatomia del Cavallo* (1598), and at some point after the death of Mary Spencer, the drawings were bought by Sir Edwin Landseer RA from the London dealer Colnaghi.[4] Although Landseer himself was best known for his anthropomorphic paintings of dogs, as a young boy he had been obsessed with horses and was a keen anatomist.[5] Together with his older brothers he received instruction from the history painter Benjamin Robert Haydon, who believed that all artists should practise dissection, and so, inspired by

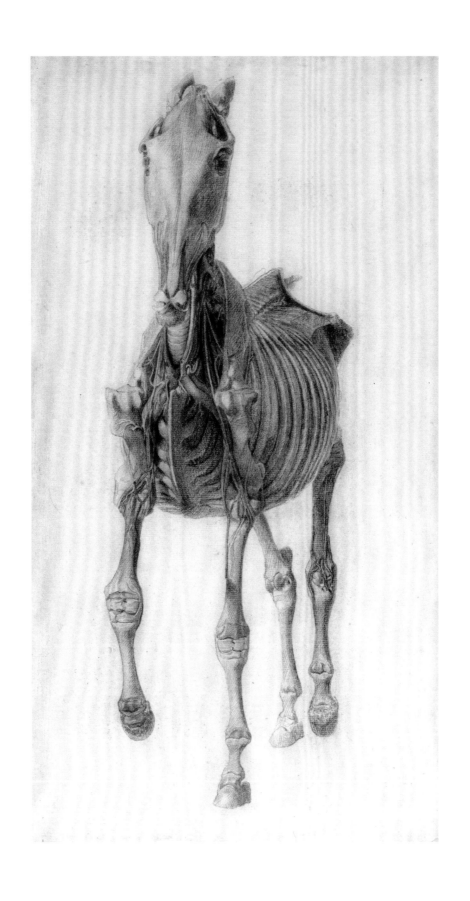

Haydon's example, Landseer produced striking écorché drawings of dogs, cats and horses.

When Landseer died in 1873 the Stubbs drawings went to auction along with other effects of the artist, but Charles Landseer RA, Edwin's brother, promptly bought them back. As the longest-serving Keeper of the RA Schools, Charles Landseer was deeply committed to its pedagogic mission and must have had this in mind when he subsequently bequeathed these works to the Academy, together with £10,000 to fund four scholarships. In 1879 Stubbs's drawings were enthusiastically accepted, and a selection of 18 examples was put on display at Burlington House; but in December 1880 they were placed with Stubbs's 'other works in the Library for the more convenient reference of the Students'.[6]

After they had once been divided for display, the drawings seem to have remained in two groups, and at some point 24 of them were put away in a drawer and forgotten about until their chance rediscovery by the Librarian, Constance Anne Parker, in 1963.[7] The two groups of drawings were reunited that year, and they have now been inventoried, catalogued, photographed and conserved.

473 George Stubbs ARA, Finished Study for the 'Tenth Anatomical Table of the Muscles…of the Horse', 1756–6, pencil, 35.5 × 19.3 cm (RA 03/3271)

18

THE ACADEMICIANS' LIBRARY

The First One Hundred Years

NICK SAVAGE

In 1799 James Barry RA first publicly complained about what he called 'the contracted, beggarly state of our Academical Library':

> At least now, after more than five and twenty years' establishment of our Institution, one might have expected that our Library would have been filled with whatever could be useful, and that the Professor might in his night-gown and slippers have an opportunity of examining them conveniently … However, let us go on with patience, and make the most we can of our wretched situation.[1]

Subsequently, its reputed meagreness, inaccessibility and irrelevance came to be seen, especially by the Academy's nineteenth-century critics, as incontrovertible proof of the institution's failure to meet its obligations as custodian of the nation's premier school of fine art. F. G. Stephens, for example, complained in 1862, 'How empty of all use this strange library

is.'[2] As a result, W. T. Whitley's assertion that it 'was in reality a very poor affair, and remained so long after the foundation of the Royal Academy',[3] not only has never been questioned, but also has had the unfortunate effect of obscuring the need to examine critically the history of the oldest institutional fine art library in Britain. This chapter will set out the historical evidence that survives concerning the formation, contents and growth of the Academy's Library up to the watershed of its removal to Burlington House in January 1875. Only in the light of such evidence is it possible to understand the respective roles of the Council and Librarian in the Library's development, the nature of its pedagogic function within the institution, and the criteria that might have determined at any particular moment the selection or rejection of specific books or types of book as suitable to place on its shelves.

The Library owes its origin to Clause 20 of the Academy's Instrument of Foundation, which states:

There shall be a Library of Books of Architecture, Sculpture, Painting and all the Sciences relating thereto, also Prints of Bas reliefs, Vases, Trophies, Ornaments, Dresses, ancient & modern Customs & ceremonies, Instruments of War & Arts, Utensils of Sacrifice, & all other Things useful to Students in the Arts, which Library shall be open one Day in Every Week to all Students properly qualified. One of the Members of the Council shall attend in the room during the whole Time it is open, to keep Order, & to see that no Damage be done to the Books, and he shall be paid 10/6d for his Attendance. No Books shall under any Pretence be suffered to be taken out of the Library. But every Academician shall have free ingress at all seasonable Times of the Day, to consult the Books & to make Designs or Sketches from them.

As a brief for creating a library for the use of artists, this may seem 'absurdly detailed',[4] but the evident desire to spell out what subjects the library of a 'royal academy' should cover and the manner in which it should be run is a clear reminder that, unlike nearly every other aspect of the new institution's proposed activities, the formal establishment of such a library was uncharted territory. There is little doubt that the creation of a library by royal command was intended to distance this version of an academy from its British predecessors and, in particular, to avoid the 'democratical' disorder for which the Incorporated Society of Artists had become both notorious and odious in the eyes of the king. Indeed, it is not too far fetched to see the 'Rules & Orders for the Library' drafted by the Council on 28 February 1769, with its requirement that the Academicians take turns to keep order and the books in their proper places, as a figuring of their wider responsibility as the king's representatives to conduct his institution in an orderly and decorous manner.[5]

GIFTS AND BEQUESTS

In contrast to the bureaucratic checks and balances enshrined in the Academy's 'Instrument of Foundation', which had been distilled from hard lessons of the past, assembling a library looked forward to the benefits of what the Foundation Members collectively hoped to achieve. Particularly during its early years, each addition to the shelves carried a

charge of optimism for the future success of the institution, building the confidence and belief in its permanence that can still be sensed today. It is not surprising therefore that as early as 7 January 1769 Sir Joshua Reynolds PRA set the tone by presenting copies of two standard works on the triumphal columns of Trajan and Marcus Aurelius in Rome.[6] Reynolds's example did not go unheeded in that, at probably the same time, three other Foundation Members serving on the first Council also donated equally significant books. Thus, the sculptor Joseph Wilton RA, a key player in the secession that had led to the founding of the Academy, gave a copy of Charles Le Brun's *La Grande Galerie de Versailles* (1752); Nathaniel Hone RA, a well-heeled Irishman who was later to become a major thorn in Reynolds's side, followed suit by presenting a copy of Rubens's *La Gallerie du Palais du Luxembourg* (1710);[7] and Francis Cotes RA, fashionable portrait painter to the king and one of the original petitioners for royal involvement in the new institution, trumped them both by donating a copy of the second (and best) edition of Vesalius's *De Humani Corporis Fabrica* (1555), one of the most influential and important scientific books ever printed and certainly the most valuable gift of a single book ever made to the Academy's Library (see fig. 464).

No mention of Reynolds's gift or of those of his fellow Council members appears in the minutes of their meetings, and we know of them only from inscriptions in the books themselves.[8] A possible explanation for this omission is the sheer volume of business that Council faced during the first year of the Academy's existence. As, however, all gifts of books from whatever source begin to be recorded in Council minutes from 30 January 1769 onwards, it is probable that, like Reynolds's, these donations were received before that date.[9] The same is probably true of a similarly unrecorded gift of a small number of duplicates from George III's collection, including three that were evidently carefully chosen as key literary sources for the depiction of ancient classical myths in history painting: George II's subscriber's copy of Alexander Pope's translation of Homer's *Odyssey* (1725–6); Jacob Tonson's illustrated edition of John Dryden's translation of *The Works of Virgil* (1697), in a calf binding bearing the royal arms of George II; and a copy of the 1637 edition of Blaise de Vigenère's French translation of the *Eicones* of Philostratus the Athenian with George III's engraved bookplate pasted to the verso of the title page (fig. 474).[10]

474 George III's bookplate, in Blaise de Vigenère, *Les images ou tableaux de platte peinture des deus Philostrates*, Paris 1637 (RA 03/2922).

The historical significance of a gift to an institution lies not just in what it materially consists of, but also in its timing, what it reveals of the donor's understanding of the purpose of the institution, and the claim to appropriateness that his or her gift inherently makes. Such gifts were rarely so obvious a demand to be noticed as Robert Adam's presentation of a resplendently bound copy of his own book on Diocletian's Palace at Split (1764), and this claim is often most interesting when a gift seems for some reason slightly to miss the mark.[11] It is worth considering, for instance, why Samuel Johnson,

the Academy's honorary Professor of Ancient Literature and Reynolds's closest friend, presented not a single work from his own pen to the Academy but in 1772 gave instead a copy of the 1758 edition of the Royal Danish Academy's charter[12] and, in June of the following year, Henri Testelin's *Sentimens des plus habiles peintres sur la pratique de la peinture et de la sculpture* (1696). Well intentioned as these gifts no doubt were, and useful as they would have been when the constitution of an English royal academy was under discussion, to proffer them half a decade later implied that artists' academies on the Continent were still better managed there than over here. The possibility that Johnson was aware of this implication is heightened by the fact that on both occasions he pretended that the books in question were gifts from Robert Levett, his lodger.[13]

However much Council's formal acceptance of gifts of books may appear to have been a merely administrative process, and however low the bar may seem to have been set, it served to confirm a particular book's appropriateness to the Academy's needs and self-image. And although Dr Johnson had no need of it himself, the value of this imprimatur was not lost on less eminent authors. The closer their acquaintance with the institution, the better chance such authors had of judging the appropriateness of their presentations correctly. It is revealing, for example, to compare the reception of Thomas Major ARA's perfectly timed gift of a copy of *The Ruins of Paestum, otherwise Posidonia, in Magna Graecia* (1768) in January 1769 with the fate of the advance copy of C. F. Viel de Saint Maux's *Lettres sur l'architecture des anciens et celle des modernes* (1787) that its author sent to the Academy in July 1785.[14] As one of the foremost exponents of landscape engraving in the country, and in reality the engraver, editor and publisher rather than author of the book that bore his name, Thomas Major intended his gift to the newly founded Academy first and foremost as a demonstration of what he considered the recent improvement in the standard of engraving in England, a point which he is at great pains to stress in his preface. That his book was accepted as such, and not as the archaeologically accurate survey which in formal terms it claimed to be, is evident from where it was shelved in the Library. This was not where one might have expected, alongside the copy of Robert Adam's *Ruins... at Spalatro* received at the same Council meeting on 11 January 1769, nor beside J.-D. Le Roy's *Les*

ruines des plus beaux monuments de la Grèce (2nd edn 1770, first published 1758) and the two celebrated archaeological surveys that Major had taken as his model, Robert Wood's *Ruins of Palmyra* (1753) and *Ruins of Balbec* (1757); instead, it was placed in a quite different bookcase alongside Bonaventura van Overbeke's *Les restes de l'ancienne Rome* (1709) and similar books in which ancient buildings are depicted in a pictorial rather than archaeological fashion.[15] This accurate and perceptive assessment of Major's book on Paestum, informed as it must have been by Council's knowledge of both the peculiar circumstances of its production and the reputation of its 'author', stands in sharp contrast to the difficulty they had in knowing what to do with two volumes of advanced architectural theory sent to them by an unknown Frenchman in 1785:

[8 July 1785] Mons. Viel de St Maux having presented two Books of or on Architecture, Resolved that Sir Wm. Chambers be desired to peruse them & report thereupon.

[31 December 1785] Sir Wm. Chambers reported that he had read the Book referred to him. Ordered that Mr. Barretti be desired to write a Letter of Thanks.[16]

This is one of very few occasions when discussion of the presentation of a book leaves any trace in Council minutes, and may have been a consequence of its author wanting more positive evidence of the Academy's approval of his work than its mere acceptance as a gift. Be that as it may, and regardless of the tenor of Chambers's report (which is not known but was probably pretty negative), the outcome of Council's deliberations in this case may be deduced from the fact that Viel de Saint Maux's gift does not appear in any extant catalogue of the Academy's Library.[17]

Viel de Saint Maux's book is by no means the only instance where the omission of an author's gift from the catalogue raises the possibility that there was some specific reason for not placing it on the shelves. On at least 10 other occasions between 1770 and 1864 a decision of this kind seems to have been taken, affecting books as diverse as Joseph Fratrel's *La cire alliée avec l'huile ou la peinture à l'huile-cire, trouvée à Manheim par. M. Charles baron de Taubenheim* (1770); Richard Payne Knight's *An Account of the Remains of the Worship of Priapus* (1786); Jacob Schnebbelie's *The Antiquaries*

Museum (1791); William Wood's *An Essay on National and Sepulchral Monuments* (1808); L. J. Le Clerc Dupuy's *Fragmens d'un mémoire inédit sur…les causes de l'excellence de la sculpture antique, et quels seroient les moyens d'y parvenir* (1815); W. J. White's *Sketches of Characters…illustrative of…Norfolk, Cambridgeshire, and Middlesex* (1818); Sir Charles Wheatstone's *Contributions to the Physiology of Vision: on some Remarkable, and hitherto Unobserved, Phenomena of Binocular Vision* (1838); T. Wharton Jones's *On the Invention of Stereoscopic Glasses for Single Pictures* (1860); César Daly's *Des concours pour les monuments publics* (1860); and Ludovico Cadorin's *Studii teorici e pratici di architettura e di ornato* (1863).[18]

This is not the place to attempt to identify precisely what may have been objectionable about these books in the eyes of the Academy's Council at the time of their presentation other than to point out that the range of topics they cover offers a rich field for investigation into contemporary differences of opinion on such matters as the relevance of recent experiments in chemistry and optical science to artists' current practice; the proper role of the state in the dispensation of public patronage of the fine arts; the value or otherwise to artists of antiquarianism and connoisseurship pursued for its own sake; and the pitfalls of engaging in the precise delineation of mundane subjects unconnected to higher artistic goals or, conversely, of attempting to attain the latter by adherence to the precepts of a prescriptive course, theory or system. Had these books been considered merely irrelevant, there is little doubt they would have been allowed to sleep peacefully on the shelves alongside the Earl of Dudley's *Letters to the Bishop of Llandaff* (1840) and the earliest English edition of a Chinese text, Sir George Staunton's *Ta Tsing Leu Lee: Being the Fundamental Laws of China* (1810).[19] Sadly, this did not prove to be the case with the three volumes of calotypes presented by David Octavius Hill and Robert Adamson in 1849 – the purpose of which exactly paralleled Thomas Major's 80 years earlier, but unlike his championing of the cause of engraving, failed to result in the creation of a category of membership of the Academy that would recognize the art of photography in even the half-hearted way that associateship had done for engravers.[20]

One might have expected that gifts of books from the Academicians themselves would not have needed the acceptance of Council, in the same way that their work was automatically hung in the Annual Exhibition. Although in

practice such acceptance was hardly likely to be withheld, where presentations by members were concerned the choice of a particular book to give always, to some degree, echoed Reynolds's original 'founding' gift to the Library in that it revealed its donor's relationship to and understanding of the Academy at a particular moment. Occasionally, the point of making the gift is overtly stated in the traditional manner by means of a presentation inscription. Usually dismissed as more or less empty forms of words, these inscriptions are in fact valuable clues for understanding the true purpose of Academicians' gifts. Take, for instance, this inscription written by the Professor of Architecture Sir John Soane RA in a copy of his *Designs for Public and Private Buildings* (1828) (fig. 475): 'To the President and the rest of the Academicians of the Royal Academy, This volume is presented, with sentiments of Gratitude & profound respect, by the Author formerly a travelling Student of the Royal Academy Lincolns Inn fields, 22 April 1828.'

It is instructive to compare this inscription with the way in which C. R. Cockerell RA, soon to succeed Soane as professor, inscribed an offprint of his contribution to the fourth volume of a new edition of James Stuart and Nicholas Revett's *Antiquities of Athens* (1830): 'For the use of the Students in architecture of the Royal Academy – respectfully from the Author.'

What is striking here is how careful Cockerell and Soane were to address their exact peers within the institution. Thus, as a recently elected ARA, Cockerell addressed the Academy's student body, while Soane, as the senior architect member of the Academy and leader of the profession at large, offered his book directly to his equals. In each case the gift of a book served to affirm and memorialize the donor's specific relationship to the Academy at the time – one that was just starting as far as Cockerell was concerned, but that for Soane stretched back almost 60 years to his days as a prize-winning student in the Schools.

In cases where a member's ties to the Academy were particularly strong, it is worth considering why a certain book was given and not another. For example, it is clear that both Soane and, before him, Chambers were selective about which of their books they considered to be appropriate for the Academy. Despite its dedication to George III, the notoriety of Chambers's *Dissertation on Oriental Gardening* (1772) meant that this was not a work he would have wished to see placed

475 Half-title with presentation inscription by Sir John Soane RA, *Designs for Public and Private Buildings*, London 1828 (RA 06/4160).

on the Library's shelves alongside Volumes I and II of 'Chambers's Works'.[21] Twenty years later, Soane was to follow Chambers's example by choosing carefully what books to give to the Academy and when. As a former student, Soane had successfully solicited the Academy's subscription for a copy of his *Plans, Elevations and Sections of Buildings* (1788) of executed designs for country houses (this being the precise moment in his career when he was most in need of the Academy's imprimatur to help consolidate his reputation); 40 years later, as the doyen of the profession and a senior Academician, it was clearly far more appropriate to donate his *Designs for Public and Private Buildings* than expect the Academy to purchase it. And finally, towards the end of his

long life, he sent the Academy a copy of the definitive edition of the *Description of the House and Museum on the North Side of Lincoln's-Inn Fields, the Residence of John Soane* (1835), inscribed 'To the President and the Members of the Royal Academy from the Author, with his best wishes', a form of greeting one would expect between professional peers who were now longstanding friends. On the other hand, for reasons that reflect a clear judgement both of his·own interests and the needs of the institution, Soane never gave the Academy his juvenile *Designs in Architecture* (1778), nor his pattern book of picturesque *Sketches in Architecture containing Plans and Elevations of Cottages, Villas and other Useful Buildings* (1793).[22]

Occasional apparently random gifts of out-of-print volumes for the Library could equally well serve to highlight a particular member's involvement in the institution at a particular moment. Council's acceptance of Henry Thomson RA's gift on 28 December 1827 of a copy of Domenico de' Rossi's *Gemme antichi figurate* (1707–9) and Simon Thomassin's *Recueil des statues…et autres ornements de Versailles* (1724) marked, therefore, his retirement as Keeper of the Academy Schools a few days earlier. The trigger for William Etty RA's presentation on 19 July 1841 of a copy of the first edition of Moses Harris's *Natural System of Colours…(c.1769–76)* – a book of legendary rarity that Etty had specially bound for the Academy in best-quality red morocco – was probably Charles Eastlake PRA's English translation of J. W. von Goethe's *Theory of Colours* (1840), a copy of which Eastlake had presented to the Council on 27 May 1840. A further connection for Etty and for most Council members at the time would have been a lecture 12 years earlier by the Academy's former Professor of Painting Thomas Phillips RA, in which Harris's book had been discussed at some length.[23] Similarly, J. M. W. Turner RA's gift of a copy of *Le rime di Michelagnolo Buonarroti* (1817) – the only book he ever gave to the Library – is not as eccentric as it might seem, since the occasion he chose was at the end of a long and tiresome Council meeting on 18 March 1846 at which he had borne once again the irksome responsibility of standing in for the ailing President, Sir Martin Archer Shee PRA.[24]

As is the case with gifts from non-members, the more involved with the institution a member was, the greater the likelihood that there would be an occasion and reason to give something appropriate. It is not surprising, therefore, that the only Academicians to donate books more than once

– John Flaxman RA in 1799 and 1818 and Charles Eastlake four times between 1840 and 1844 – did so during periods when they were taking, or were about to take, a particular interest in the Library, in Flaxman's case as a member of Council in 1801–2, and in Eastlake's as Librarian from 13 July 1842 to 18 December 1844. Conversely, associate members especially (both ARAs and Associate Engravers) always ran a greater risk of missing the mark, not least because they did not serve on Council and therefore had no opportunity of taking part in discussions over the approval of purchases or acceptance of gifts for the Library. Indeed, the reception given to the very first book to be given by an ARA (or indeed by any elected member) – Valentine Green ARA's *Review of the Polite Arts in France…compared with their Present State in England…* (1782), a copy of which was received at a Council meeting on 17 February 1783 – was probably one of the reasons why James Barry (who was serving on Council at the time) not long afterwards presented a copy of his *Account of a Series of Pictures in the Great Room of the Society of Arts, Manufactures, and Commerce, at the Adelphi* (1783).[25]

As an ARA domiciled in Sweden, the landscape painter and etcher Elias Martin had even less chance than Green of striking the right note with Admiral Count Ehrensvärd's rather odd account of a recent grand tour, *Resa til Italien* (1786), a book illustrated with hand-coloured etchings after the author's sketches that Martin sent to the Academy (probably via Chambers) in 1787 (Martin came to England the following year for his second extended stay, which is presumably no coincidence).[26] Another pitfall – into which both Edward Edwards RA and James Ward RA fell – was to assume that the Academy would be as interested as everyone else in topical depictions of newsworthy subjects such as the damage wrought by a recent tornado, or portraits of celebrated 'fasting women' who were reputed to have eaten no food for many years. There could, of course, be no question of Council refusing Edwards's presentation of a copy of his *Short Account of the Hurricane, that happened at Roehampton-Lane…on the Fifteenth of October, 1780…* (1781) or of James Ward's *Some Account of Mary Thomas of Tanyralt, Merionethshire…and of Ann Moore, 'The fasting woman of Tutbury'* (1813), but they were destined to make at best an awkward appearance on the shelves.[27]

Although gifts are revealing of different attitudes towards, perceptions of and relationships to the Academy at a particu-

lar moment, they accounted for only 12 per cent of the Library's growth between 1769 and 1802. By the time the first printed catalogue was ready for the press in the spring of 1802, it held 557 printed books, 11 bound albums (including two assembled from published suites of engravings), 2,000 plaster impressions of intaglio gems published by Philipp Daniel Lippert 1767–76, and a portfolio containing 17 loose engravings and a set of James Barry's etchings of his paintings in the Great Room of the Society of Arts at the Adelphi.[28] Out of this total, 69 items were gifts, including, in addition to those noted above, a large album of topographical engravings presented by William Seward in 1794; the first number only of M. F. Quadal's *Variety of Tame and Wild Animals* (1793) given by Benjamin West PRA on 12 July 1793; an album of drawings by Gerard Vandergucht and Jacob Schijnvoet for William Cheselden's *Osteographia* (1733) donated by his pupil, the surgeon John Belchier, on 25 October 1771; and a bound collection of original designs by John Wood the Elder of Bath for the Bristol Exchange (1741–3) given by Prince Hoare in 1800.

Of the 104 printed books, nine albums of Old Master Italian engravings collected by George Cumberland, two manuscripts and a small number of loose prints that are recorded as additions to the Library in the second printed catalogue of 1821–2, the proportion of gifts (33) to purchases increased significantly to just under a third, nearly all from non-members (21) or institutions (6).[29] Of the additional 206 printed books, 13 print albums, three loose prints and one manuscript recorded in the 1841 edition of the Library catalogue, roughly the same proportion was made up of gifts (68).[30] In 1835 the Academy had also received a bequest of books and prints from Prince Hoare, its unusually active and independently minded Secretary for Foreign Correspondence who had died on 22 December 1834. Although no contemporary list has been traced, on the basis of annotations in the books themselves by George Jones RA, the Academy's Librarian at the time, and internal evidence such as the inclusion in some of the albums of amateur sketches by Mary Hoare, 18 books and nine albums are identifiable today as deriving from this bequest (fig. 476).

By the time the fourth edition of the catalogue came off the press in the summer of 1864, it recorded a further 449 additions: 416 printed books, 18 more albums of prints, nine portfolios of loose prints, four folders or albums of photo-

476 Ornamental vase designed and etched by Jacques-François Saly, in *Vasa inventa atq. studii causa delin. et incisa D.V.C. Iacobus Saly*, [Rome] 1746, pl. 26, etching, 18.5 × 12.2 cm (16/1472).

graphs, one more manuscript, and an album of life drawings by the former Librarian Thomas Stothard RA. Of these additions 68 books came via Sir Augustus Wall Callcott RA's bequest in 1845, consisting mainly of historical works on artists' techniques and materials and fairly recent biographies of continental artists from the library of his wife, the pioneer artist-historian Maria Callcott. Apart from this group and one straggler from the Prince Hoare bequest, there were 120 gifts amounting to roughly 26 per cent of the total, the great

majority coming once again from non-members (86) and institutions (17).

This fourth edition of the catalogue somewhat inflates the number of print albums added to the Library since, unlike previous editions, it lists for the first time (with frustratingly imprecise descriptions) albums and portfolios of prints that may well pre-date 1841, including, for example, nine albums of 'British School' prints.[31] The origins of this latter collection can be traced to an order of Council in November 1822, that 'All the loose prints, the works of members, [were] to be inserted in an album.'[32] David Wilkie RA's gift in January 1820 of a 'series of engravings made from his paintings by J. Burnet and A. Raimbach' may well have sparked the realization – and the recent expenditure on George Cumberland's Old Master print collection would have brought it home – that the Academy had so far neglected to preserve and celebrate the achievements of its painter members in any permanent or tangible way. When, therefore, an album 'into which 64 Engravings presented by Members from their own works & those of other Members of the R. Academy' was produced at a subsequent Council meeting on 21 December 1822, it was resolved to announce at the next General Assembly:

> The President & Council having taken into consideration that the Library, though much extended in its collection of Engravings from the Old Masters has remained very deficient in those of the English School & being of the opinion that a comprehensive collection of this class would be highly creditable to the Royal Academy & its members & useful to the Students, they have completed one Volume which they have the Satisfaction of laying before the General Assembly, by whom they hope to be joined in recommending that the Members individually would be pleased to favour the Academy with an impression of every Engraving from their own Works of which they may approve.[33]

PURCHASES

'The manner in which the Academy has waited on Providence for the means of enlarging its collection of prints, and graciously received gifts while it made few purchases (we believe none at all), may account for the smallness thereof.

As to books, the list … is … not of a larger number than most private persons get together who have a taste for reading.'[34]

This scathing dismissal of the Academy Library in September 1862 by F. G. Stephens, art editor of influential literary magazine the *Athenaeum* and a founder member of the Pre-Raphaelite Brotherhood, was based above all on his disillusioned memories of the Academy as a student in the 1840s. For him it was depressingly obvious that the Library was still as 'empty of all use' as it had been then. Certainly, visually it can have changed little: the books were still sitting on the shelves in exactly the same places as they had been since it moved to the Trafalgar Square building in 1838; it would have been difficult to tell from the much interpolated catalogue what, how many, and even probably where the books were that had been added since it was printed in 1841; and the octogenarian Librarian H. W. Pickersgill RA no doubt treated his venomous visitor with every bit of the resigned courtesy that comes across in his 'Librarian's Report' to Council in 1863: 'Though the attendance of the Students, so far as regards numbers, has not been satisfactory, yet I have much pleasure in bearing testimony to the gentlemanly conduct of those who have visited the Library. I have assisted them in their researches to the extent of my ability, and always received their respectful acknowledgement of my attention.'[35]

Before the year was out, however, Pickersgill was to be succeeded by the historical genre painter Solomon Alexander Hart RA, who had long coveted his post and was destined to enlarge and modernize the Library so thoroughly as in effect to create an entirely new one. To recover any sense of this earlier Library, of which Pickersgill was the last dignified if ineffectual custodian, it is necessary to return to the circumstances of its original formation in 1769.

The earliest information we have regarding the implementation of Clause 20 of the Academy's Instrument of Foundation appears in a well-known letter Reynolds wrote to Sir William Hamilton in Naples on 28 March 1769. Having described in some detail the progress that had been made in establishing the new Academy, Reynolds concludes his letter as follows: 'The King interests himself very much in our success he has given an unlimited power to the Tresurer [sic] to draw on his Privy Purse for whatever mony [sic] shall be wanted for the Academy we have already expended some hundred pounds in purchasing books relating to the Arts. If

you should think it proper to mention to the King of Naples the establishment of a Royal Academy he would probably make a present of the Antiquities of Herculaneum'.[36]

So far as the Library is concerned there are three striking aspects to Reynolds's choice of words. The first thing to note is the urgent priority that had evidently been given to stocking it, a task which, unlike the obvious need to ensure that the Antique Academy and Life School were properly equipped for the students to work in, was hardly essential to getting the new institution off the ground. The second is the way in which Reynolds illustrates George III's financial support by referring specifically to purchases for the Library, and the third is that what sounds like an exaggerated boast about expenditure on books is fully borne out by the evidence of the accounts, which show that four London booksellers had already been paid a total of £97 in the first quarter of 1769.[37] Given that, since his accession to the throne in 1760, George III had been deeply engaged in collecting both individual books and whole libraries in order to restock the depleted shelves of the old royal library, it is hard not to detect the direct influence of the king here, not least because the creation of a library in *his* Academy would act as a permanent reminder of the royal munificence that had established the institution. By the time the Academy celebrated its first anniversary on 10 December 1769, the astonishing sum of £290 7s. 6d. – the equivalent in today's money of £38,900 – had been spent solely on books for its Library.[38] Over the next 30 years only in 1774, 1780 and 1786–8 did expenditure on books exceed £45 per annum, the average yearly amount being less than £20.[39] What these figures show is that not only was a sizeable library created with remarkable speed within a year of the Academy's foundation, but that even as late as 1802 this core collection probably still accounted for approximately 55 per cent of its total holdings. Housed at first in a second-floor room at 125 Pall Mall with 'paper and shelves running the whole length of the north side',[40] it may indeed have already included most if not all of the 298 books recorded in the 1802 printed catalogue for which there is no evidence of an acquisition date later than 1769.[41] It is also clear that the king's appointment of Francis Hayman RA to the new post of Librarian to the Royal Academy on 1 October 1770 needs to be understood not as marking its birth but rather establishing the essential shape of the Library, and that as a consequence his responsibilities were essentially custodial in terms of the books and pedagogic in relation to the students who came to consult them. Historians of the Academy from William Sandby RA onwards have consistently misread this to mean that the post was a sinecure created for Hayman (who suffered from intense gout) so 'that he might enjoy its emoluments, small as they were, in consequence of his bodily infirmities which in the evening of his life pressed heavily upon him'.[42]

Although Hayman was serving on Council the year he was appointed Librarian, he was not expected to continue the previous year's intense programme of book buying, which by midsummer 1770 had tailed dramatically off to a mere £3 12s. for the preceding quarter and only £16 11s. for the year to date. What this meant was that any future development of the Library in terms of acquisitions or use lay firmly in the hands of the Council and that the Librarian had no control over either except insofar as he might be able to influence members of Council at a particular moment. While this did not make the job a sinecure – running a library, keeping the books in their proper places, the catalogue up to date and readers in line was no easy task, as Hayman's successor, Richard Wilson RA, famously discovered[43] – it ensured the preservation of the Library, which, by the time of the Academy's first anniversary on 10 December 1769, had come to symbolize the king's preservation and protection of the institution itself.[44] It was no accident therefore that, like the Treasurer, the new 'Librarian to the Royal Academy' was appointed directly by the king rather than, like the President, Secretary and Keeper, being elected into office by ballot by the Academicians. As Hayman was by now of the wrong generation to have any immediate personal influence at court, there can be little doubt that he owed his appointment principally to the recommendation of the king's closest advisor in all matters relating to the Academy, Sir William Chambers RA.

As Treasurer, Chambers had no remit to get involved in the Library, but his influence is not surprising. He was the author of what was widely considered the best modern treatise on architecture and a highly cultured architect. His continental training and eminent friends abroad lent great authority to his opinions, and, last but not least, he was the king's most trusted representative within the institution. His influence and to some degree interference in the running of the Academy Library can be detected right up until his death in 1796.[45]

Chambers's most intense involvement in the Library – when he had the most opportunity to take a leading part in its formation – arose as a direct consequence of his period of service on both the 1769 and 1770 Councils. He is unlikely, however, to have been able to dictate what was suitable for the Library unless it fell within the field of his own expertise as an architect. There was probably also some tension with George Michael Moser RA over custodial responsibility for the Library, arising from the fact that Clause VII of the 'Instrument of Foundation' stated that the Keeper's 'Business shall be to keep the Royal Academy with the Models, Casts, Books & other Moveables belonging thereto'. A small sign of this tension can be detected in a Council resolution requiring the Keeper as of 9 December 1769 'to mark the names of benefactors directly on to their presents', in that this almost certainly related particularly to books.[46] It was perhaps not quite a turf war, but Moser may have had some justification for feeling that he had lost territory as a result of Hayman's appointment. It would explain why Council subsequently decided that the Keeper and Librarian should each have two keys to the bookcases.[47] As an ex-officio attendee on Council the Keeper had a permanent opportunity, if he so chose, to put forward proposals for book purchases, enabling Moser, for instance, to pop out on 21 April 1774 to John Bell's Circulating Library bookshop on the Strand and buy a copy of Gavin Hamilton's recently published *Schola Italica Picturae* (1773) (fig. 477).[48]

By the same token Chambers was able to use the perpetual nature of his ex-officio position as Treasurer not just to influence discussion of book purchases in Council, but to do so in an accumulative way that rotating members of Council could never match. It also enabled him on occasion to take shortcuts. While Chambers could well have argued that the four guineas he paid the Marquis de Voyer d'Argenson, a long-standing and intimate friend, for a copy of the first edition of Colen Campbell's *Vitruvius Britannicus* (1715–25) represented good value, it is hard to believe the thought did not cross some people's minds that it was a bit odd for the Royal Academy to buy its copy of the bible of English neo-Palladian architecture from a French army general.[49] Less easy to justify, had Chambers been required to do so, was the complicated arrangement he came to in May 1774 with his architect friend Julien-David Le Roy, whereby he accepted a miscellaneous parcel of mainly civil engineering

477 John Bell, invoice for a copy of Gavin Hamilton, *Schola Italica Picturae* (1773), bought by George Michael Moser RA for the Royal Academy 21 April 1774 (RA 03/2289).

books for the Academy in lieu of payment for the copies of his *Dissertation sur le jardinage de l'orient* (1772) and *Discours servant d'explication, par Tan Chet-Qua de Quang-Cheou-Fou* (1773) that Le Roy had undertaken to sell on his behalf in Paris.[50] Nor was this the first time that Chambers had exchanged copies of his own books with Le Roy for books to sell on to the Academy. As Robin Middleton has recently pointed out, it was thanks to Thomas Major's book-couriering trips to Paris on Chambers's behalf in September and October 1772 that the Academy acquired its copies of P. M. Paciaudi and E. A. Petitot's *Descrizione delle feste celebrate in Parma per le nozze del Infante Ferdinando di Borbone con l'archi-*

Cavaliere della Quadriglia azzurra

478 Tommaso Baratti after Giuliano Zuliani, 'Cavaliere della
quadriglia azzurra', in Ennemond Alexandre Petitot, *Descrizione delle
feste celebrate in Parma per le nozze del Infante Ferdinando di
Borbone con l'archiduchessa d'Austria Maria Amalia*, Parma 1769,
etching (RA 03/2248).

duchessa d'Austria Maria Amalia (1769) (fig. 478) and the
'première partie' of Pierre Contant d'Ivry's *Oeuvres d'architec-
ture* (1769).[51]

Chambers's early involvement in the Library needs to be
seen against the backdrop of a probably quite deep frustration
at the lack of any platform in the Academy for his pedagogic
and intellectual ambitions. That he had wanted and expected
to be appointed to the post of Professor of Architecture is
apparent from Reynolds's mistaken reference to him as such

as late as 28 March 1769.[52] His attempt in 1770 and 1771 to
draft a series of Academy discourses on architecture that
would parallel those delivered by Reynolds on painting ran
into the ground. And, to make matters worse, he had no
opportunity to teach in the Academy Schools in the way that
painter and sculptor Academicians could when elected to the
annual roster of 'Visitors' to the Life Room. It is not surpris-
ing therefore that Chambers's unrealized pedagogic instincts
should have found a focus in the Library, and given his con-
stant overriding concern that the Academy should not
deviate in any way from its original objectives and constitu-
tion, that this was expressed in a controlling protectiveness of
the knowledge and wisdom enshrined in the books on its
shelves, especially in relation to architecture.[53] A striking
illustration of this attitude in the case of a specific book is the
way even such a landmark publication as the first volume of
James Stuart and Nicholas Revett's *Antiquities of Athens*
(1762) was not acquired for the Library until just after
Chambers had published his objections to Greek Revival
taste as 'a caution to stragglers' in the third edition of his
Treatise on Civil Architecture...(1791).[54] Another more subtle
but illuminating example of Chambers's controlling instinct
is the counter-intuitive way in which, having agreed (perhaps
against his better judgement) that the Academy should sub-
scribe to an expensive coloured copy of George Richardson's
first publication, *A Book of Ceilings composed in the Style of the
Antique Grotesque* (1776) (fig. 479) – a work that exemplified
everything he disliked about the current taste in interior
decoration made fashionable by Richardson's former master,
Robert Adam – Chambers seems to have insisted that the
Academy subscribe to virtually every other book that Rich-
ardson published thereafter.[55] Since no other contemporary
architectural or ornamental pattern books were purchased
during Chambers's lifetime, one suspects that he may have
seen Richardson's publications as removing the need to
acquire any similar books (a flood of which had continued to
appear on the market since the 1750s), especially in light of
the fact that Moser, for instance, might well have argued that
this kind of material provided useful models and sources for
student painters and sculptors.[56] It may explain why in Sep-
tember 1777 the Academy subscribed to the first two
numbers of Michelangelo Pergolesi's engravings of 'a great
variety of Original Designs of Vases, Figures, Medallions,
Friezes, Pilasters, Pannels and other ornaments in the Etrus-

479 Design for a hall ceiling, in George Richardson, *A Book of Ceilings composed in the Style of the Antique Grotesque*, London 1776, pl. XXXIII, hand-coloured etching (RA 06/4725).

can and grotesque style' (1777–85), but then changed its mind and cancelled the subscription.[57]

Chambers's influence on the Library ran deeper, however, than merely helping to determine whether or not a particular type of architectural book should be acquired. Following

Hayman's death on 2 February 1776, he was once again in a position to make a private recommendation to the king concerning a suitable successor. Whether or not he did so we do not know, but the perception of his opportunity to do so is clear from a Council resolution 15 years later: 'Resolved, That it be recommended to Sir William Chambers to take the first opportunity of acquainting His Majesty, that the place of the Librarian is now vacant by Mr. Wilton having been elected Keeper.'[58]

By then three librarians – Richard Wilson RA, Samuel Wale RA and Joseph Wilton RA – had come and gone. It is telling that of these three only Wilton, Chambers's close friend and long-standing professional colleague, succeeded in having any impact on the Library. Although Wilson had overseen a trickle of books onto the shelves during his tenure from 5 February 1776 until the summer of 1781, the only significant identifiable purchases had been a subscription to George Richardson's new edition of Cesare Ripa's *Iconologia*; the buying of a copy of the 1763 revised edition of the 'Cabinet de Crozat' for 12 guineas in August 1777 and of Joachim von Sandrart's *L'Academia Tedesca...*(1675–9) for 11 guineas in 1779; and a flurry of books ordered from Molini later that year and paid for in January 1780.[59] The last order probably included a set of the Comte du Buffon's *Histoire Naturelle...*(27 vols, 1749–80), freshly bound in full calf and gilt-stamped with the royal arms, presumably in time to make a good appearance in the splendour of the Library's purpose-built apartment in New Somerset House. Here the books were no doubt beautifully arrayed in glazed bookcases resplendent beneath Reynolds's ceiling painting *Theory* (1779–80), surrounded by G. B. Cipriani RA's cove decorations representing the subject matter of all art – Nature, History, Allegory and Fable – and presided over by Agostino Carlini RA's marble bust of the Academy's founder and protector, George III.[60]

Paradoxically, it was just at this point, when the Academy and Library with it had come of age, that things began to go wrong. The first blow came in the summer of 1781 when Council 'resolved that the Librarian [Richard Wilson RA] on account of his ill state of health be indulged with a Deputy', and appointed Moser 'to officiate for him, with an Allowance out of his Sallary of fifteen Pounds pr Ann: for the same'.[61] Although this must have hit poor Wilson hard, it no doubt seemed a sensible move at the time. Unfortunately,

however, it set a precedent that was later to have damaging consequences. A second, more immediate problem, however, was money, since it is clear from the accounts that once the cushion of the royal Privy Purse could no longer be relied upon, expenditure on the Library plummeted. Indeed, over the next four years, and throughout Samuel Wale's tenure of the post from 14 June 1782 until his death on 7 February 1786, there is no record of any expenditure whatsoever on books apart from £7 5s. 6d. paid on 24 August 1782 to 'Millar', which was probably a payment to the binder John Miller of 16 St Martin's Lane; a mysterious 12 guineas paid in 1783 to Joseph Baretti, the Academy's Secretary for Foreign Correspondence (it may have been to cover the cost of sending out complimentary copies of his *Guide through the Royal Academy* [1781]); and £3 13s. 6d. paid in 1784 to an unnamed recipient, which was probably for the copy of John and Andrew van Rymsdyk's *Museum Britannicum* (1778) that Council had resolved to purchase on 7 January that year.[62]

With the appointment of Joseph Wilton as Librarian on 17 February 1786, this dire situation was transformed overnight. By the end of Wilton's first year £89 1s. 6d. had been spent on books, an annual expenditure unprecedented since 1769. In January 1787 the Academy purchased a set of 'the late Mr. Hogarth's Works' selected by a committee of the associate engravers, for which the artist's widow, Jane Hogarth, was paid 100 guineas and granted an annuity of £40 on the king's recommendation.[63] Despite this unprecedented expense, in February the same year the Academy also subscribed to a copy of William Hodges's *Select Views in India...*(1787–8) at a cost of 18 guineas, this being the first time that it had ever publicly supported a member's published work through subscription.[64] And in April 1788 Wilton pressed home his advantage by placing a very large order with Francesco Sastres for 21 recently published Italian art and architecture and illustrated books costing a staggering £82 6s., including volumes 1–7 of Giorgio Bonelli's *Hortus Romanus...*(1772–84) priced at £22 1s. (fig. 480).[65] In October that year, however, when Wilton went back to Council for approval to buy four more books from Sastres, his request must have provoked some discussion since, unusually for this period, details of his proposed purchases were recorded in the minutes of the meeting.[66] Nonetheless, by the end of 1788 the year's total expenditure on books had reached a record-

480 Probably Maddalena Bouchard after Cesare Ubertini, 'Convolvulus major', in Giorgio Bonelli et al., *Hortus Romanus*, Rome 1772–84, vol. I, pl. 17, hand-coloured etching (RA 12/534).

breaking £153 16s., a figure that was not to be surpassed until 1820.[67] Not surprisingly, 1789 saw a retrenchment, the only major outlay being six guineas for the first volume of Richard Gough's *Sepulchral Monuments in Great Britain* (1786), approval for which is once again recorded in Council minutes, and

subscriptions to C. M. Metz's *Imitations of Ancient and Modern Drawings* (1789), John Soane's *Plans, Elevations, and Sections of Buildings* (1788), and Francesco Sastres's magazine *Il Mercurio Italico: The Italian Mercury* (1789–90), at a combined cost of £6 16s. 6d.[68] Wilton's last gasp proved to be the purchase in January 1790 of a copy of R. C. Alberts's edition of Jan Blaeu's monumental *Nouveau théâtre du Piémont et de la Savoye* (1725), since on 24 September that year his election as Keeper marked the end of his tenure as Librarian.[69] In his four and a half years Wilton had had more impact on the Library than all previous librarians put together and demonstrated above all that the key to any progress depended entirely on what influence could be brought to bear on Council.[70]

At this crucial juncture Chambers did something quite odd. Instead of acting as quickly as he done in February 1786 to smooth the way for Wilton's appointment within 10 days of Wale's death, he let things drift – in fact for so long that, despite Council's resolution in February 1791 urgently requesting him to speak about the matter to the king, the post remained vacant for at least another year. There was no obvious excuse for this in that the king had recovered from his first bout of insanity by March 1789, and although Reynolds's eyesight was failing, the fracas that had provoked the President's temporary resignation from the Academy in February 1790 had long since died down. The most likely explanation is that Chambers, who would have recalled the precedent of Moser's deputizing for Wilson in 1781–2, was hoping that a way could be found for Wilton to combine the two posts, and that the longer he left it the more likely it was that this would happen by default, given that Wilton was presumably continuing to attend to his duties in the Library throughout the interregnum. If this was the case, the wording of Council's resolution conveyed a note of distinct irritation at Chambers's tactic. What broke the deadlock was almost certainly Reynolds's death on 25 February 1792, in the aftermath of which it was obviously important for the Academy to be seen to function properly and in accordance with its own rules.

The appointment of Dominic Serres RA as Wilton's successor on 27 March 1792 owed more to the fact that he had been Marine Painter to George III since 1780 than to any claim to 'abilities and assiduity in promoting the arts [that] had long rendered him conspicuous'.[71] It is difficult to avoid the suspicion here that Chambers had simply switched tactics

and ensured that the new Librarian was not someone likely to be in a position to exert much influence on Council. As a result, book purchases during Serres's 19-month tenure were relatively modest when compared to Wilton's, amounting to £20 9s. in 1792 and only £7 12s. 3d. in 1793, the most notable being George Stubbs RA's *Anatomy of the Horse* (1766) and Richardson's *New Designs in Architecture…* (1792) bought direct from the authors for 5 and 3 guineas respectively, and subscriptions to John and Josiah Boydell's *History of the River Thames* (1794–6), Thomas Malton the Younger's *Picturesque Tour through the Cities of London and Westminster* (1792–1801), James Malton's *A Picturesque and Descriptive View of Dublin* (1794) and John Chamberlaine's *Imitations of Original Drawings by Hans Holbein* (1792–1800). The emphasis on architecture and architectural topography evident in all but the first and last of these books almost certainly betrays Chambers's influence over their purchase. Nor can there be much doubt that he was behind the Academy's decision to subscribe to J. C. Murphy's *Plans, Elevations, Sections, and Views of the Church of Batalha…* (1795), a pioneering analysis of Gothic architecture that the author justified in the light of Chambers's recent praise of the style for having 'a lightness…to which the ancients never arrived, and which the moderns comprehend and imitate with difficulty'.[72]

A more surprising acquisition perhaps was Edward Burch RA's *Catalogue of One Hundred Proofs from Gems, Engraved in England* (1795).[73] When exactly it was decided to subscribe to this work is uncertain, although its timing may well be connected to a meeting on 18 October 1793, when Burch appears to have held the deciding vote in a stand-off between the painter and architect members on Council over whether the Academy should subscribe to a copy of J. C. R. de Saint-Non's *Voyage pittoresque ou description du Royaume de Naples et de Sicile* (1781–6).[74] Given Chambers's by now public disapproval of anything that encouraged pursuit of the *ignis fatuus* of Greek Revival architecture, it can be taken as read that he would have considered Saint-Non's picturesque account of the ancient Greek temples at Segesta and Agrigento (for instance) to be an unsuitable acquisition for the Academy Library.[75] Burch's unpremeditated reward was not long in coming, for when, three weeks later, Serres died on 6 November it was almost certainly on Chambers's recommendation that the king appointed Burch as Librarian.[76] In the meantime, however, a storm was brewing in the form of

John Singleton Copley RA, who was famous for bearing a grudge and evidently furious at the way Chambers and his allies had vetoed Saint-Non's book.[77] Determined no doubt to find some way of retaliating, before the meeting was over on 18 October he requested permission 'to have a copy of the Catalogue of the Books in the Academy. – Which was Allowed; – but to be done at his own expence, the copy to be taken in the Academy, & at convenient times'.

Whether or not 'convenient times' were found is not known, but the immediate upshot for Burch was to find himself facing the classic librarian's nightmare. Copley fired his first salvo at the General Assembly meeting on 10 December 1793 (at which Burch was not present):

> Mr. Copley requested of the President that before the Business of the Day took place he might be permitted to call the attention of the Assembly to an act he had long wish'd for an opportunity of pointing out, which was the placing in the Library of the Royal Academy, the First Volume of a Work entitled – A Philosophical and Critical History of the Fine Arts, &c. By the Rev: Robert Anthony Bromley B:D:, which work was subscribed to, for the Academy – but he had such objections, he would make a Motion, – & accordingly did – that the first Volume be removed from the Library, – & that the Subscription be withdrawn. Mr. Opie seconded the Motion. A long debate took place, in which several difficulties arose, & some objections on the propriety of proceeding too precipitately. And Mr. Tyler moved, that the Motion be postponed, to a future Day. And as several Gentlemen declared, they had not read Mr. Bromley's Book, Mr Copley agreed to suspend the determination of his Motion, to the next General Assembly.[78]

Two months, and two General Assembly meetings later, Copley renewed his attack:

> Mr. Copley then brought on his Motion, which he desired he might be permitted to make some little variation in, & now states as follows, viz: That, Mr. Bromley's History of the Arts, shall be removed from the Library of the Royal Academy. Which was seconded by Mr. Opie. Sir William Chambers, (Treasurer of the Academy,) immediately got up, & informed the President, that he protested against the proceeding on the above Motion, it not having been

brought on in a regular manner, according to the established laws of the Academy. After a very long debate, it was resolved that the President should put the Question on Mr. Copley's Motion, & at twice, viz: Aye, – & No. to be signified by holding up Hands. – which being done, there appeared for Ayes 5. – Noes 10. Then, another long conversation took place, some of the Gentlemen declaring they had not Voted, not knowing the Question was put. Some were for putting the Question again, & to be decided by a Ballot, which others would not agree too [*sic*] – after some altercation, The President proposed to take the sense of the Assembly, whether or no, they should Ballot a second time; – which was agreed to, & he accordingly put that Question: when there appeared Ayes 11. – Noes 14.[79]

Both Chambers and Burch (who was attending for the first time as Librarian) must have fervently hoped that this was the end of the matter, but at the next General Assembly ten days later, Henry Fuseli RA hijacked the agenda, complaining bitterly of 'some Aspersions, in parts of a Letter he had received from Mr. Bromley'. This stirred up yet another 'long debate' that was brought to a close only when William Tyler RA, seconded by Robert Smirke RA, successfully moved 'That it be recommended to the Council That the Subscription for the remainding [*sic*] Volumes of Mr. Bromley's History of the Arts, be discontinued'. While this compromise may have placated the opposition, for Chambers it represented a major defeat, particularly when the crucial words 'That it be recommended to the Council' were later deleted by order of the General Assembly on 1 December 1794.[80]

Contrary to appearances, this was not a storm in a teacup about a book in a bookcase, but rather the first round of a power struggle between Council and General Assembly that was to emerge after Chambers's death two years later and steadily intensify to the point of bringing the Academy to the brink of self-destruction in 1803. For Burch, the whole episode must have been a bruising experience, since he cannot but have been aware that, with Chambers's power waning and General Assembly on the warpath, he had little or no chance of bringing any influence to bear on Council. Following Chambers's death on 8 March 1796, the office of Treasurer was made accountable to trustee Academicians responsible for managing the assets and property of the

Academy, which included, of course, the Library. As a result a 'Committee of Inspection' was appointed 'consisting of not less than Two of the Council [who] shall Once in every Year, with the assistance of the Librarian, examine the state of the Books, Prints, &c. in the Library; & report such improvements as may be necessary'.[81] One might have thought that this would have had an immediately beneficial effect, but oddly it was in these five years following Chambers's death that the Library reached what is probably the lowest point in its history. Burch's ill-health is usually blamed, but the real problem was that an annual inspection of the books could be no substitute for the kind of engagement with the Library that Chambers's constant presence on Council had provided for good or ill over the past three decades.

By June 1799, when John Flaxman presented copies of his *Compositions from the Tragedies of Aeschylus* (1795), *The Iliad of Homer* (1795), and *Letter to the Committee for Raising the Naval Pillar* (1799), the poor state of the Library must have been plain to see. At the end of the year the king 'signified his pleasure that in case Mr. Burch is prevented by indisposition attending his duty in the Library of the Academy, that Mr. Sandby do attend for him'. Unfortunately, Paul Sandby RA had just finished serving on that year's Council; otherwise he might have been able to do more to address the Library's problems than merely cover for its absentee Librarian. Instead, another year passed before salvation arrived in the form of a newly elected Academician on Council who cared about and understood the importance of the Library. As one of the earliest students to train in the Schools, John Flaxman would have had memories of the Library in its first formative years, and as an artist whose work was now hugely admired throughout Europe, he was (as Chambers had been) in a uniquely strong position to take the lead on what needed to be done to restore it to a condition worthy of the Academy. Not surprisingly, therefore, in response to a Council resolution of 2 July 1801, that 'Mr Flaxman, who had offered, be requested to enquire for a proper Person to put [the Library] in Order, & prepare a Catalogue for the use of the Members', his proposals went rather further than Council had originally envisaged:

Mr Flaxman having examined the state of the Library of the Royal Academy, had drawn up the following, which he read…viz: Upon examination of the Library, according

to the Order of Council it appeared, that the whole should be cleaned, the order of arrangement restored & that such Books as are in want of it, should be Bound, that a correct Catalogue should be Written, Printed, & copies given to the Members of the Academy; that the new Books purchased in future shall be added in M:S: to the Catalogue kept in the Library. That Mr. Taylor Bookseller of Holborn be employed for these purposes, – if approved by the Council.[82]

Flaxman then read out a long list not only of 'Books wanting, to compleat the Sets already in the Library' but also of 'Books essentially useful in the Arts, therefore necessary to be added to the Collection'. Although only one book on the latter list – an English translation of B. S. Albinus's *Tabulae Sceleti et Muscolorum Corporis Humani* (Tables of the Skeleton and Muscles of the Human Body, 1749) – seems to have been acquired at the time, Flaxman's recommendations flagged up the crucial point that improving the state of the Library was not just a matter of restoring it to order. As a result, when Josiah Taylor presented his final bill of £122 17s. for compiling and printing 250 copies of the new catalogue of the Library and putting the Library back into shape, it came in at almost five times his original estimate.[83] It was due largely to the number of 'Volumes wanting to compleat such Works that are imperfect – new Binding some – & Prints – & repairing, &c. &c.'. Taylor's bill also included the cost of buying at auction on the Academy's behalf a copy of Giambattista Visconti's catalogue of the Museo Pio-Clementino, which Flaxman had described at a Council meeting on 17 June 1802 as 'a very scarce Work…not in the Library of the Royal Academy, never having before appeared in England, but would be brought to the Hammer the next Day'. The enthusiasm of Council's approval of 'so inestimable an acquisition' can be detected in the slightly ungrammatical wording of their resolution that 'The possessing it was unanimously wished, & …that Mr. Taylor be impowered to purchase'.[84] Flaxman rounded off this *annus mirabilis* for the Library by securing approval for the purchase of Vivant Denon's *Voyage dans la basse et la haute Égypte…* (1802), Alexandre Lenoir's *Musée des monuments français…* (1800–6), and George Stubbs's *Comparative Anatomical Exposition of the Structure of the Human Body…* (1803–5); getting West to promise to buy on his forthcoming trip to Paris a 'work now publishing' of prize-

winning designs by students of the Académie d'architec-ture;[85] introducing a library accessions register in which 'all Articles for the Library [were] to be entered...by the Librar-ian when received...to be produced occasionally, in the Council'; and, last but not least, obtaining agreement that the Librarian's annual salary be raised from £50 to £60 and the hours of his attendance altered from 9 a.m.–3 p.m. to 10 a.m.–4 p.m. (presumably to co-ordinate better with Academy Schools's timetable – a perennial problem that remained essentially unsolved until the Library moved to Burlington House and was open six days a week).[86]

Over the next 20 years Flaxman's initiative bore piecemeal fruit for the Library through the periodic efforts of a handful of Academicians such as Henry Fuseli as the Keeper in 1811 and 1818, the architect Robert Smirke and the sculptor Richard Westmacott RA (the Elder) as Council members in 1812–13 and 1813–14, and Flaxman once again in 1810 (coin-ciding with his appointment as the Academy's first Professor of Sculpture) and as a member of Council in 1818–19. No one, however, turned the Library into quite such a demon-stration of their political power within the Academy as Joseph Farington RA during his term on Council in 1804–5. Riding high after the resolution of the constitutional crisis of 1803 in favour of his inner circle of like-minded members, Farington celebrated by indulging in a monumental spending spree on books for the Library. In February 1804 he prepared the way by selling the Academy a copy of his *Views of the Lakes &c. in Cumberland and Westmorland* (1789) for £7, two numbers of Philipp André's *Specimens of Polyautography* (1803) for 1 guinea, six numbers of Volume 2 of Thomas Hearne's *Antiq-uities of Great Britain* (1807) for £7 10s., a copy of John Smith's *Select Views in Italy* (1792–6) for £7 12s.[87] Then, in August the following year, he moved (seconded by Philippe Jacques de Loutherbourg RA) 'that Mr. Daniell's Publications (com-pleat) of Views in India be purchased, to be deposited in the Library of the Royal Academy'.[88] What the minutes of the meeting failed to record about this purchase of the original folio edition of Thomas and William Daniell's *Oriental Scenery* (1795–1807) was its huge cost, which the accounts reveal to have been an astounding £134 14s.[89] After that, it is hardly surprising that almost nothing was bought for the Library for more than four years, and when Josiah Taylor sent in 'some Books of Architecture' that were said to have been ordered by Ozias Humphry RA in January 1808, Council demanded

that 'Mr. Humphry must explain as all Orders come from the President and Council.'[90]

The hit-or-miss manner in which the Academy made purchases for the Library during this period probably accounts for some rather anomalous oversights in its acqui-sition of contemporary publications, perhaps the most remarkable being its failure to subscribe to J. M. W. Turner's *Liber Studiorum* (1807–19).[91] Burch's absenteeism prevented the obtaining of many of the books that Flaxman had rec-ommended and that had been agreed for purchase in March 1810, and although the baton of Deputy Librarian had passed seamlessly to J. F. Rigaud RA when Paul Sandby died in 1809, and to Thomas Stothard RA when Rigaud in turn died the following year, by the time Burch himself died on 11 February 1814, the Committee of Inspection for the Library had to report once again that 'the Catalogue is defective & several cases from their insufficient size to contain the large Folio books are in a disordered state & without reference.'[92]

By now Thomas Stothard had taken on full responsibility for the Library that he had been caretaking as a deputy for the past four years, and finally, for the first time in its history, the Academy had the benefit of a Librarian (in post 1814–34) who was born for the job. As one of the most prolific and gifted book illustrators this country has ever produced, Stothard had a natural feeling and affinity for books, understanding and appreciating them as physical objects. It is this sensitivity to the different shapes and sizes and colours of books that makes his visual inventory of the shelves in 1814–15 such an appealing document (fig. 481).[93] Stothard was also a prodigiously hard worker, extremely conscientious, and well liked and respected by his fellow Academicians. In addition, he was blessed with good health and a settled home life, and all in all a greater contrast to poor old Burch could hardly be imagined. Over the next five years Stothard slowly but surely set about improving the 'infrastructure' of the Library, not only in terms of the physical condition of books and their accommodation, but also in how they were arranged, catalogued and found. One should not be fooled by the Committee of Inspection's consistently negative reports on the state of the Library in 1814–17, since it is quite apparent from the sudden volte-face of the 1818 report ('in excellent order...only one book was missing') that the Librarian was well aware of how effec-

4 shelf

Garrard's Documents respecting the Act
for securing the Copy-right of new Models in } 2 - 4 - 1
Sculpture, 38 Geo. 3. 1798, MS. folio ——

Sir Jos Reynold's Works, 2 Vols. 4º. large Pap, 2 - 4 - 2

Fuseli's Lectures on painting, 4º ——1801— 2 - 4 - 3

Mengs Opera, 4º ——— Parma 1780 - 2 - 4 - 4

D'Ankerville, Recherches sur les Arts de } 2 - 4 - 5
la Greece, 3 vols. 4º. —— Lond. 1785 }

Wood's Designs for the Exchange at Bristol, } 2 - 4 - 6
folio

Richardson's designs for ~~Vases~~, 4º. — 2 - 4 - 7

Portraits des grandes Hommes, 4º. 2 - 4 - 8

Vasi, Vedute di Roma, 10 Books in 2 vols. folio Rom. 1747 2 - 5 - 1

Flaxmans Tragedies of Æschylus folio ——— 2 - 5 - 2

——— Iliad of Homer — folio — 2 - 5 - 3

Smith's Turkish Dresses, folio ——— 2 - 5 - 4

Metz's Imitations of drawings by Parmegiana —— 2 - 5 - 5

——— Polidori 2 - 5 - 6

Wilson's Twelve Views in Italy, 4º —— 2 - 5 - 7

Hearne's Views ~~of~~ Antiquities in England, } 2 - 5 - 8
vol. i. folio ——— 1786 }

Malton, T. Tour of London, folio ——— 2 - 5 - 9

Boydell's History of Rivers. London 1794 2 - 5 - 10

X Hearns Views removed to Case 5 - 5

181 Thomas Stothard RA, diagram of the arrangement of books in the Library of the Royal Academy ('Case 2, Shelves 4 & 5'), 1814–15, manuscript and pen, wash and watercolour (RA 06/2696).

tive a lever these reports could be in applying pressure on Council to address specific problems. In December 1814, for example, Stothard not only got the additional bookcase that, as Deputy Librarian, he had pleaded in vain for the previous year, but in a little twist of the kind that reveals the Academy working at its best, persuaded one of the inspectors that year – the architect Robert Smirke – to design it for him.[94] It is not known whether he was as successful in obtaining the 'small press' that the inspectors also recommended to remove creases from misfolded plates, 'without the necessity of sending the Books out of the Academy'. A considerable flow of books must, however, have already been sent out for repair because in November 1814 the Academy's booksellers Cadell & Davies submitted a binding bill of £80 11s. 6d., and they were to charge a further £129 for similar work carried out between August 1817 and March 1818.[95]

Stothard's toughest challenge was the dire state of the catalogue. In a fixed-location library the catalogue acts as the primary finding tool, and any logic to the original ordering of the books on the shelves will always tend to be compromised by the arrival of new volumes. Since its installation in New Somerset House in 1780, the Academy Library had had to find space for 187 additional folio volumes, 121 quartos and 155 octavos. A similar problem of integration arises in relation to a printed catalogue, especially one that predates consistent use of authors' surnames to identify titles and alphabetize catalogue entries. By 1814, up to 124 new titles had been added since 1802, and it is clear that well before Stothard's offer to act as Burch's deputy was accepted by Council on 19 December 1810, there had been concern that the catalogue was already in urgent need of revision.[96] It is not certain when it first dawned on Stothard that what was really needed was not so much a revision of the catalogue as an entire rearrangement of the Library. By the summer of 1815, however, he had obviously fed this idea to the Committee of Inspection, who reported to Council that they considered 'the great desideration in the Library to be a more systematic arrangement of its contents, both for the convenience of the Students & of future Inspectors'.[97]

The practical purpose of Stothard's 1814–15 visual inventory of the shelves becomes apparent in the light of his need to plan how this rearrangement would work in physical terms. Although there are no scale bars, it is clear that his sketches of the individual books as they were currently

arranged are drawn in correct proportion to one another, so that he could compose his proposed new arrangement shelf by shelf. It was to prove a long-drawn-out process because, at the point when the new catalogue was finally ready to go to press in September 1818, Stothard seems to have realized that his reorganization of the shelves did not allow enough room for future expansion.[98] Following Council's approval of 'a new arrangement of the Books in the Library' on 15 December, his request for the installation of 'additional bookcases' the following January was presumably agreed to, although it was not until February a year later that the revised catalogue was once again ready for printing.[99] Despite Council's resolution on 14 February 1820, however, that '250 Copies of the Catalogue of the Library, as newly arranged by the Librarian be immediately printed', it did not finally take place until July 1822.[100]

PRINTS IN THE LIBRARY

The reasons for this further delay are not hard to fathom. After the long drought brought on by Farington's extravagance, from the autumn of 1810 onwards the Academy's expenditure on books recovered to a more reasonable equilibrium of around £50–£60 each year.[101] Between 1819 and 1820, however, it leapt dramatically from £79 13s. 6d. to £189 18s. 6d., and remained at the historically high figure of £98 16s. in 1821. Faced with the need to incorporate a large influx of new books, it is hardly surprising Stothard postponed printing the new catalogue for as long as he could. It was also precisely during this period, when he was trying to complete his new catalogue, that an issue seems to have arisen over whether and how to include loose prints. In a way that is common in committee meetings, Council's response on 31 July 1818 to the news that the 'Librarian has prepared with great care & Intelligence a more complete Catalogue of the books in the Library' had a sting in its tail in the form of a resolution that he 'be requested to make out a List of such loose Prints as are in the Library & lay it before the Council'.[102] The fact that Stothard was able to comply with Council's request in little over a month suggests that either there were not that many loose prints in the library, or – and this is much more likely – there were a great deal, in which case he must of necessity have made a selection of

what he considered the most important. In fact, prompted as they obviously were by the imminence of the revised catalogue, it is more than likely that Council envisaged an update of the listing of the contents of the portfolio that had formed an appendix to the 1802 edition.[103]

At first sight, the prints contained in this portfolio seem a random miscellany: plates I–IV of Giovanni Volpato's series of large engravings of Raphael's celebrated frescoes in the Vatican Stanze (*School of Athens*, *Disputation of the Sacrament*, *Expulsion of Heliodorus* and *Conversion of Attila*, 1775–84); plates I–IV of Anton Mengs's recreation of ancient Roman wall paintings in the recently excavated so-called Villa Negroni engraved by Angelo Campanella (1778–9); Rubens's *Mucius Scaevola before Porsenna* engraved by Jakob Schmutzer (1776); a mezzotint of M. F. Quadal's painting of the life room at the Vienna Academy engraved by Johann Jacobé (1790); *Fall of the Damned* engraved by Jonas Suyderhoef after Rubens (1641); Van Dyck's *Pembroke Family* (1740) and Holbein's *Henry VIII granting the Charter to the Barber-surgeons* (1736), both engraved by Bernard Baron; Anker Smith's engraving of Leonardo's cartoon of the *Virgin and Child with St Anne and St John the Baptist* (1789); Francesco Bartolozzi's engraving of J. F. Rigaud's Royal Academy Diploma Work, *Samson breaking his Bands* (1799); James Barry's etchings of his paintings in the Great Room of the Society of Arts (1792); Guido Reni's *Liberality and Modesty* engraved by Sir Robert Strange (1755); and, lastly, Mengs's *Noli me tangere* at All Souls College, Oxford, Poussin's *Holy Family*, and portraits of the Bishop of London (after Robert Edge Pine) and Earl of Chatham (after a bust by Joseph Wilton), all four of which were engraved by the former Royal Academy gold-medal-winning student John Keyse Sherwin published between 1778 and 1784.

This apparently motley collection – the only prints in the Academy's collection deemed worthy of being separately listed in the catalogue – is far from random. In the first place, it is striking that only one – Suyderhoef's *Fall of the Damned* – does not date from the eighteenth century, and only the pair by Baron and Strange's print after Reni date from earlier than 1775. Second, taken as a group, there can be little doubt that these prints had been selected by someone – Francesco Bartolozzi is a prime candidate – as exemplary of the best engravings of modern times. We may no longer agree with or understand the basis of this judgement, but every one of these prints was

deemed in its day to have brought honour and glory to the engraver's art.[104]

Nothing could be further from the truth than to imagine that engravers were 'kept out' of the Academy because the painter Academicians did not appreciate the value of print-making. How well (and profitably) their work is reproduced has always been of paramount importance for visual artists, and even architects sometimes set more store by how beautifully their buildings are represented than how well they function. This natural concern for the artistic integrity of the original work translates within the context of the Academy into a pedagogic worry that older prints especially failed to do justice to the paintings, drawings and sculpture they claimed to reproduce. A particularly revealing instance of this can be seen in a celebrated encounter between William Blake and George Moser RA recorded by Blake:

> I was once looking over the Prints from Rafael & Michael Angelo in the Library of the Royal Academy. Moser came to me & said: 'You should not Study these old Hard, Stiff & Dry, Unfinish'd Works of Art – Stay a little & I will shew you what you should Study.' He then went & took down Le Brun's & Rubens's Galleries. How I did secretly Rage! I also spoke my Mind…I said to Moser, 'These things that you call Finish'd are not Even Begun; how can they then be Finish'd? The Man who does not know The Beginning never can know the End of Art.'[105]

It should be remembered that Blake was looking with the eye of a professional engraver and that the 'finish' that he objected to was as characteristic of the engravings of Le Brun's *Grand Galerie de Versailles* and Rubens's *Galerie du Palais du Luxembourg* as it was of the paintings that they reproduced.[106] What Moser objected to, on the other hand, was not that Blake was looking at the works of Raphael and Michelangelo per se – that would have been ridiculous – but that he was doing so through the lens of what he considered to be bad engravings. In fact, the incident only really makes sense as a disagreement between master and student about different qualities in engraving as much as painting, although Moser would have been wiser not to have chosen prints after Blake's bête noire Rubens with which to make his point. When, almost 40 years after this episode, Stothard laid before Council his list of the loose prints in the Library, there was evidently still a deficiency of what were deemed to be good

engravings after Michelangelo, since at the same meeting Flaxman was immediately asked to obtain some more from the print dealers Colnaghi & Co.[107]

Two years later, in the autumn of 1820, the Academy bought a major collection of early Old Master Italian engravings from William Blake's friend George Cumberland, which was to prove by far the largest and most important purchase of prints in the Academy's history.[108] The nine albums in which this collection was arranged, so as to illustrate the history of engraving 'from the earliest practice of the art in Italy to 1549', no longer exist, although fortunately their contents are known from a catalogue that Cumberland subsequently published to highlight 'the utility of collecting the best works of the ancient engravers of the Italian school'.[109] This was the only systematically organized collection of prints that the Academy ever purchased, and it is clear that the Academicians' purpose in buying it was rather different from what Cumberland's had been in assembling it.[110] Particularly revealing of this different perspective is the fact that no copy of Cumberland's catalogue was acquired until January 1839, almost 12 years after its publication.[111] Equally symptomatic was the recommendation of a Committee of Inspection in 1832 that 'the Cumberland Collection of early engravings is to be considered incomplete & might from time to time receive additions'. The point of such additions, however, was not to fill in gaps in the history of engraving, but to obtain a better and fuller representation of the work of Italian Renaissance artists in general. Thus, the committee also recommended that 'as the Prints accumulate they might perhaps be arranged according to the Masters, as it would be desirable to see the works of M. Angelo, Raffaelle, Coreggio, Titian &c. together.' Although a few scrappy print folders do survive in the collection, labelled simply 'Titian', 'Correggio', 'Durer' or 'Tiepolo', etc., there is no evidence that its recommendation was ever acted upon, nor that any attempt was made to follow its advice that 'even in their present state a catalogue of the contents of each Portfolio should be pasted in the beginning or at the back of each.'[112] It is a remarkable fact that, apart from the 'British School' collection and a single album containing what were considered particularly important prints after the Old Masters, the Academy never managed to organize its print collection into anything other than a series of miscellaneous bundles – a condition in which it has largely remained to this day.[113]

The arrival of the Cumberland albums in the autumn of 1820 stimulated not only gifts by members but also purchases of other prints over the next two years: for example, at Richard Cosway RA's sale in February 1822, from the dealer Francis Collins in July the same year, and direct from engravers such as Charles Bestland, whose large stipple etching of Henry Singleton's *Royal Academicians in General Assembly* was finally acquired by the Academy some 20 years after its original publication in 1802.[114] In July 1823 Council even went so far as to give Stothard £25 to spend on prints as he saw fit.[115]

Financial storm clouds were gathering, however, not just for the Academy but for the whole country, with the result that during the two-year banking crisis of 1824–5 only two payments were made for books, amounting to £5. Nonetheless, despite further calls for retrenchment in 1829 and 1832, the average annual spend on books stayed above the £50 mark until 1833, with highs of £159 18s. 4d. and £133 3s. 6d. in 1826 and 1828, respectively. As a result, several landmark publications were obtained during this period virtually straight from the press, such as the original edition of J. B. L. G. Seroux d'Agincourt's monumental *Histoire de l'art par les monuments* (1811–23), Francesco Inghirami's multi-volume *Monumenti Etruschi* (1821–6) and, through David Wilkie's enthusiastic help, José de Madrazo's superb *Colección litografica de cuadros del rey de España el señor Don Ferdinando VII* (1826–32).[116] There can be little doubt that Stothard's rearrangement and expansion of the Library encouraged Council both to invest in new books and, thanks to a suggestion of the Committee of Inspection in December 1832, to lay the foundations of a collection of antiquarian sources for the history of costume that in later years, under Solomon Hart's aegis especially, was to become one of the Library's most distinctive strengths. So it was that in October 1833, at the very reasonable price of £2 12s. 6d., the Council resolved to purchase 'The Acts of Maximilian and a History of Brabant, containing above 260 prints of Costume'.[117] It is equally certain that Stothard should be given the credit for being the first to point the Library in this fruitful direction, since it was surely his appreciation of the importance of historical visual reference, for literary illustration as well as genre painting, that led him to create new categories in the 1821–2 catalogue for 'Poetry' and 'Dresses, Manners, & Ceremonies'. In a way that is uniquely appropriate to the Academy, Stothard lives

on today in the Library he did so much to restore to life in the shape of 17 large albums of engravings of his work compiled by two former students, Richard Westmacott RA (the Younger) and W. E. Frost RA, which stand in honour of his 20 years as the Academy's first true Librarian.[118]

TRAFALGAR SQUARE

In his way 'Captain' George Jones RA, who succeeded as Librarian on 22 July 1834, was as perfectly suited to the job as Stothard had been, but for very different reasons and to very different effect. For a former military officer who so idealized the Duke of Wellington that he is said to have consciously mimicked his hero's appearance and speech, books were quite clearly first and foremost troops to be kept in line. And although there was a poetical soul beneath the crusty exterior – he and Turner were genuinely good friends – he had exactly the right qualities to project manage the billeting of the Academy Library in its new quarters in Trafalgar Square. Unfortunately, Jones was also extremely reactionary in his opinions, which would not have been a problem but for the fact that the Academy's 30 years of bad neighbourliness with the National Gallery coincided with a period of embattled defensiveness against what it deemed to be unwarranted government threats to its independence and autonomy. Just as happened in the internecine struggles of the 1790s and early 1800s, and was to happen again through much of the twentieth century, the Library came to be seen as the perfect symbol of the values of the institution, for both its critics and its defenders. Of Jones's four successors in the space of 24 years, William Collins RA, Sir Charles Lock Eastlake PRA, Thomas Uwins RA and H. W. Pickersgill RA, only Uwins and Eastlake had any real chance of pointing the Library in a new direction. Uwins made a big splash in his first few months by purchasing in April 1845 what is today

one of the Library's greatest treasures, a set of the *Recueil Jullienne* engravings after Watteau (1726–8).[119] Sadly, he did not live up to this promising start, lost the confidence of Council in 1853, and had to be temporarily relieved of his duties by the Keeper, 'Captain' Jones, in February 1855. Eastlake, on the other hand, could have been the best Librarian the Academy ever had. In the two and a half years of his tenure from 13 July 1842 to 18 December 1844, for the first time one can see signs of someone in the Academy taking an objective interest in the history of the institution and the era in which it was founded. Unfortunately, Eastlake had too many other irons in the fire, and although in February 1844 Council approved his 'Plan for increasing and improving the collection of Books & Prints', there is little evidence he got very far in implementing it, apart from possibly creating a historical framework for the British School print albums and purchasing, on 29 March 1843 and 27 March 1844, a total of 100 prints after Benjamin West, Thomas Gainsborough RA, Richard Wilson and Johan Zoffany RA.[120]

Another lost opportunity, over which the Academy had more control, was its failure to appoint Solomon Hart as Uwins's successor in January 1856. Hart had stepped into the breach when Uwins resigned in November 1855 and was bitterly disappointed not to get the job. As there was no love lost between him and the Keeper, he probably had some justification in thinking that Jones had worked to block his appointment. For Hart, the thirteenth Librarian, it was clear that the Academy had to decide what it wanted: a library that looked to the future and offered its students a window on the world, or one that looked to the past and reflected only the institution's image of itself. When, in the New Year of 1875, its new Library opened to readers for the first time in Burlington House, Hart was in no doubt which one he himself wanted, and he was to prove more successful in showing the Academy how to realize his vision than any other Librarian before or since.

A CLOSER LOOK

Benjamin Robert Haydon's *Vasari* that had belonged to Joshua Reynolds

ROBERT HARDING

'Not being able to get my Vasari out of the Pawn broker's yet, the odd volume I have of Sir Joshua's Vasari is a great consolation.' So wrote the troubled, turbulent and serially bankrupt history painter Benjamin Robert Haydon, the man who caused more trouble to the Royal Academy in the early nineteenth century than everyone else combined, on 19 October 1827, in the million-word *Diary* which charts his course between palaces and debtors' prisons and his descent into depression and eventual suicide in 1846.[1] The book to which he was referring is this odd Volume II of the expanded second (and first illustrated) edition of Giorgio Vasari's *Lives of the Most Excellent Painters, Sculptors, and Architects*.[2]

The book was purchased by Haydon for a particular reason and as an act of homage: it had formerly been owned by his fellow Devonian Sir Joshua Reynolds PRA. Haydon was born in 1786 and so too young to have met Reynolds, but he attended Plympton Free Grammar School where Reynolds's father had been Master and Reynolds a pupil. Haydon wrote on the flyleaf, 'This belonged to Reynolds. Northcote told me the name was his sister's writing – I bought it at Whitmore & Fenn's – also bought a great many of Sir Joshua's Books' and it bears the 'SR/IR' ink stamp usually found on Reynolds's prints

and drawings. It also has many pencil markings in the margins, noted by Haydon's ink inscription on the front paste-down 'all the pencil marks are Sir Joshua's BRH', while the title page has his own signature and stamp 'B.R.H.' (fig. 482).

Since its first publication in 1550, Vasari's *Lives* has been the pre-eminent and unrivalled contemporary resource for Renaissance art historians. It has overwhelmed his own reputation, considerable though it was in his day, as painter and architect. Through his often first-hand anecdotal biographies Vasari, a Tuscan himself, established the concept of Florence as the heart and soul of the Renaissance. Indeed, so seminal was his work that even the word *Rinascimento* (Renaissance) owes its first appearance in print to him.

> I took up Vasari and read Titian's life. A man like Vasari, who knew them all, recording their very words, saying 'I called on Titian in 1566, &c., &c.' is so self evident & delightful that I dreamt all night about the Venetians & Titian & colours & Pictures (Haydon, *Diary*, 10 October 1823).

> Read Vasari's life of Raphael through, till the tears came into my eyes (Haydon, *Diary*, 23 September 1827).

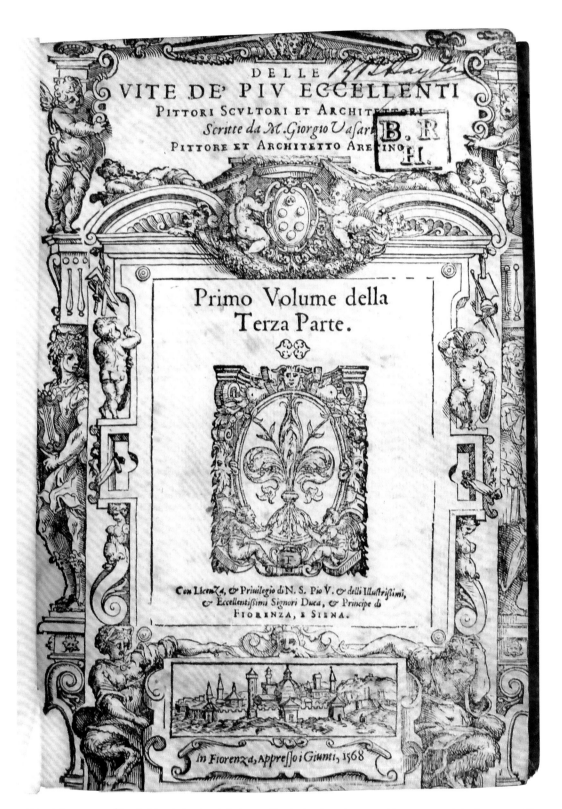

DELLE
VITE DE' PIV ECCELLENTI
PITTORI SCVLTORI ET ARCHITETTORI
Scritte da M. Giorgio Vasari
PITTORE ET ARCHITETTO ARETINO

B. R.
H.

Primo Volume della
Terza Parte.

Con Licenza, & Priuilegio di N. S. Pio V. & delli Illustrißimi,
& Eccellentißimi Signori Duca, & Principe di
FIORENZA, E SIENA.

In Fiorenza, Appreßo i Giunti, 1568.

482 Title page to Giorgio Vasari, *Le vite de' piu eccellenti pittori, scultori, e architettori...*, vol. 2, Florence 1568.
Sir Joshua Reynolds's copy, purchased by Benjamin Robert Haydon (RA 06/3766)

Robert Adam
Spalatro

ROBERT HARDING

The spectacular red morocco special binding, with palmette border and royal arms in a central oval, was designed by Robert Adam for his book on the classical remains at Split on the coast in modern-day Croatia (fig. 483).[1] He presented the volume to the newly founded Royal Academy (of which Adam was never to be a member) on 11 January 1769, accompanied by a letter (which is tipped into the volume) to the Treasurer, William Chambers RA: 'Mr Adam presents his Compliments to Mr. Chambers & sends him a Copy of The Ruins of Dioclesians palace at Spalatro which he begs Mr Chambers will do him the Honour to present to the Royal Academy & Beg their Acceptance of it, and of his Sincere wishes for the prosperity of so Great & so Usefull an Institution. Lower Grosr Street. 11th January 1769.'

While on the Grand Tour in Italy in the summer of 1757 the young Scottish architect Robert Adam, accompanied by the French artist Charles-Louis Clérisseau and two draughtsmen, made a five-week diversion to the ruins of the fortress-palace that the Emperor Diocletian had built for his retirement at Aspalathos in Dalmatia (modern-day Split, then known as Spalatro). Here, he was struck by the thought that the ruins were of a domestic, albeit palatial, rather than public nature. As such, he considered, they might have more relevance to modern architecture than the remains of other surviving Roman edifices, and he conceived a project worthy of his ambition: to transform himself from an obscure Edinburgh architect to a London-based figure of national and international renown. He decided to publish a volume recording the ruins of Spalatro that would emulate such works as Robert Wood's *Ruins of Palmyra* (1753). Adam saw his work not only as a work of pure architectural/archaeological record but, influenced by the example of other artists such as Giovanni Battista Piranesi, also as a work of landscape scenery. Clérisseau therefore presented the ruins in atmospheric and realistic compositions that had figures added in London by Paul Sandby RA, himself a Foundation Member of the Academy. The prints were made by the best Italian engravers Adam could find: Francesco Bartolozzi RA, another Foundation Member (fig. 484), Paolo Santini, Domenico Cunego and Francesco Zucchi.

On 17 January 1760 Adam, describing himself as 'Member of the Academy of St Luke at Rome, of the Institute at Bologna, and of the Imperial Academy of Arts at Florence',[2] advertised 'Proposals' for his work, inviting subscribers for copies at three guineas in sheets. The 61 plates were engraved in Venice under the supervision of Clérisseau and

483 Binding to Robert Adam, *Ruins of the Palace of the Emperor Diocletian at Spalatro in Dalmatia*, London 1764, red morocco, special binding, designed by Adam, with palmette border and royal arms in central oval (RA 05/3754).

484 Francesco Bartolozzi RA, frontispiece to Robert Adam, *Ruins of the Palace of the Emperor Diocletian at Spalatro in Dalmatia*, London 1764, engraving, 43.3 × 33 cm (RA 16/638).

Adam's brother James. The completed work was published in December 1763, although dated 1764 on the title page (Adam by now describing himself as 'F.R.S. and F.S.A. Architect to their Majesties'), with a glittering list of subscribers including many of Adam's current and future patrons.

The magnificent neoclassical binding seen here was devised by Adam for a number of presentation and subscribers' copies, as had been the case with the recently published *Antiquities of Athens* by James 'Athenian' Stuart and Nicholas

Revett (1762). There were three grades of design in a variety of coloured leathers: one with a simple gilt palmette border (a pencil sketch in Sir John Soane's Museum seems to be the original design); a second with the royal arms, either hexagonal or oval (as seen here); and a third with an elaborate frame of scrolls, flowers and allegorical figures. Adam's investment must have been considerable, and he cannot have measured the publication's success in commercial terms but rather in its immeasurably enhancing his reputation.

18.3

Count Ehrensvärd
Resa til Italien

ROBERT HARDING

This first edition of the account of Count Carl August Ehrensvärd of his travels in Italy was privately printed by the Swedish royal printer, Elsa Foug.[1] It is rare and this seems to be the only copy in the UK. It is of particular interest because the etching and colouring after Ehrensvärd's drawings was carried out by one of the Academy's first students who was also one of the first ARAs, the young Swedish artist Elias Martin (fig. 485), whose presentation of this volume to the Academy was recorded on 31 December 1787.[2] Having briefly studied in Paris, Martin arrived in London in 1768 and enrolled as a student in the Academy Schools on 3 November 1769. On 27 August 1770, no doubt through the influence of the Academy's first Treasurer, the Swedish-born Sir William Chambers RA, Martin was elected ARA. He was a regular exhibitor at the Academy (1769–74, 1777, 1779–80 and 1790), including, in 1770, *A Picture of the Royal Plaister Academy*, a dramatic lamp-lit view of the original cast gallery at 125 Pall Mall (see fig. 427). A Martin drawing of 1769–70 records a life class at the same location, with students receiving instruction from the Academy's first Professor of Anatomy, Dr William Hunter.[3]

Martin returned to Sweden in 1780, where he became a member of the Royal Swedish Academy (founded 1775) and Professor of Landscape Painting and was drawing master to the young Ehrensvärd, who was to become general admiral of the Swedish navy. Martin came back to England in 1788, living first in Bath for three years and then in London.[4] He last exhibited in 1790, although he did not finally return to Sweden until 1797. The Council minutes reveal, however, that the Academy had completely lost track of him by 23 October 1832, unaware that he was now dead, when it introduced a new rule that loss of contact with any member for 10 years would make that place vacant, given, they argued, the example of Elias Martin, of whose existence they mistakenly stated there had been no proof 'for sixty years'.[5]

As a landscape artist Martin was influenced by Richard Wilson RA, Joseph Wright of Derby ARA, Paul Sandby RA and Alexander Cozens. No doubt he imparted these influences to his pupil, and some of the colour-washed etchings in the *Resa til Italien* (Journey to Italy) show an interest in clouds and the effects of light and shade in an almost impressionistic form, including *Clouds in the Alps* (p. 3), *The Eye Loves a Wide View* (p. 6) and the *View of Isola Bella, Lake Maggiore* (p. 27).

In addition to his career as a naval officer, Count Ehrensvärd was a critic, antiquary, amateur architect and artist with a taste for caricature and mild pornography. He spent the years

485 Elias Martin ARA after Count Carl August Ehrensvärd, 'View of Isola Bella', in Admiral Count Carl August Ehrensvärd, *Resa til Italien 1780, 1781, 1782: Skriven I Stralsund*, Stockholm 1786, etching and watercolour, 13 × 10.2 cm (RA 03/6046).

486 Elias Martin ARA after Count Carl August Ehrensvärd, 'Italian Street Seller', in Admiral Count Carl August Ehrensvärd, *Resa til Italien 1780, 1781, 1782: Skriven I Stralsund*, Stockholm 1786, etching and watercolour, 12.5 × 10.1 cm (RA 03/6051).

1780–82 on a Grand Tour to Italy, travelling from Stralsund via Paris, Milan, Terracina and Rome to Sicily, and from Sicily via Montecassino, Bologna, Milan, Venice and Vienna back to Stralsund. Ehrensvärd's charming *Resa til Italien* has been frequently reprinted since 1812 and has become a minor classic in Sweden, but has not been translated other than into Italian

(1969). It is consciously unlike other Grand Tour guidebooks. The text is short, as the author acknowledges, but deliberately so. He is interested in picturesque costumes (fig. 486) and national characteristics, searching for likenesses of the ancient Romans and Greeks in the southern Italians. He almost wholly excludes the usual descriptions of classical ruins and art.

19

MEDALS

PHILIP ATTWOOD

The Royal Academy's collection of medals and medal-related objects comprises slightly fewer than 250 pieces, acquired piecemeal over the years of the institution's existence. No stated policy appears to have shaped the way in which their numbers have grown, but many of the acquisitions have tended to fall into fairly well-defined groups, which give the collection a certain coherence. Principal among these groups have been the various medals issued by the Academy itself, along with some of the tools with which those medals have been produced; medals won by artists associated with the Academy; medals, orders and decorations awarded to eminent Royal Academicians; medals relating to the arts issued by other bodies or commissioned by individuals; and a few medal-related works by Academicians. Within the collection are a number of pieces particularly important for their personal associations or for their place within the Academy's history, or as works of art in their own right.

The Academy has used medals as prizes for students at the Schools since its foundation. The earliest were the gold and silver medals designed jointly by Giovanni Battista Cipriani RA and Edward Penny RA and produced by Thomas Pingo, with the head of George III on their obverses and the *Belvedere Torso* and *Minerva directing a Youth to the Temple of Fame* on their respective reverses (figs 487 and 488). With the accession of George IV in 1820, an obverse showing the new king by William Wyon RA was introduced (fig. 489) along with a reverse of figures of Painting, Sculpture and Architecture after a design by Thomas Stothard RA for the gold medal and a new version of the *Belvedere Torso* for the silver, both also by Wyon. Under William IV and Queen Victoria the reverses remained unchanged (fig. 490), while the same artist engraved the portraits. Thomas Brock RA provided the portraits of Edward VII and George V and, for the gold medal, a new reverse of the three allegorical figures; a new

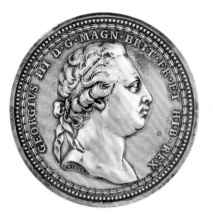
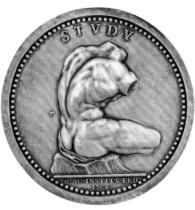

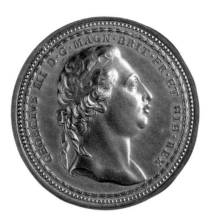
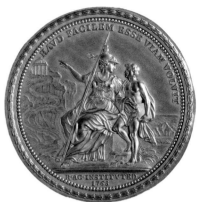

487 Thomas Pingo after G. B Cipriani RA and Edward Penny RA, version in silver of Royal Academy Schools gold medal, George III on obverse, *Belvedere Torso* on reverse, *c.*1817, diameter 5.3 cm (RA 03/4307).

488 Thomas Pingo after G. B Cipriani RA and Edward Penny RA, Royal Academy Schools silver medal, George III on obverse, *Minerva directing a Youth* on reverse, *c.*1770, diameter 5.3 cm (RA 03/4304).

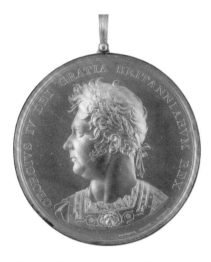

489 William Wyon RA, Royal Academy gold medal, George IV on obverse, 1820, diameter 7 cm (RA 16/2759).

490 William Wyon RA, Queen Victoria and *Belvedere Torso*, reverse, *c.*1840, metal dies, diameter 4.5 cm (RA 04/1754 and 04/1757).

version of the *Torso* was also introduced. With Edward VIII indicating that the royal portrait should appear only on medals distributed by the king, Ernest Gillick ARA and Mary Gillick produced a prize medal that combined a historicizing portrait of George III on the obverse (fig. 491) with a reverse consisting of a laurel wreath and an inscription. This design continued to be used for the gold, silver and bronze medals during succeeding reigns, until medals ceased to be awarded systematically as prizes in the early 1980s.[1] Two other medals have been awarded to students: one of

these, made by Leonard Wyon after designs by Daniel Maclise RA, was issued according to the terms of Turner's will and first presented in 1857 (figs 492 and 493);[2] the other, for which William Wyon's head of Victoria was used, was funded by Edward Armitage RA in 1877.[3]

The changing nature of the medal presentation ceremony over the years is noted by George Dunlop Leslie RA, who, in nostalgic and condescending mode, compares the late nineteenth-century prize-givings under Leighton with those of the 1810s and 1850s: 'A full share of the prizes,

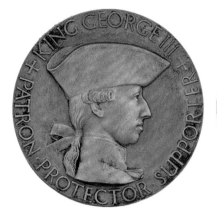
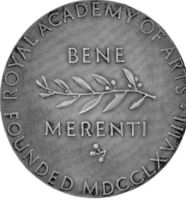
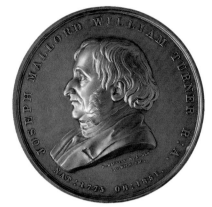

491 Ernest Gillick ARA and Mary Gillick, Royal Academy prize medal, George III on obverse, 1949, silver, diameter 5.5 cm (RA 06/1203).

492 Leonard Charles Wyon, Turner medal as executed after designs by Daniel Maclise RA, c.1859, bronze, diameter 5.5 cm (RA 08/3413).

including occasionally even the gold medal itself, fell to the lot of the female students; and the applause was loud and long as the young ladies, in pretty evening dresses, received their medals, with smiles and blushes, from the hands of the illustrious President, who addressed a few gracious congrat-

ulatory words to each. How time has changed this annual gathering since the days when my father received his two medals from the hands of Fuseli in Somerset House, or even since my own day, when the unemotional and placid Eastlake handed the medals one after another to young men with

493a and b Two drawings by Daniel Maclise RA for the Turner medal, 1858, pencil on card, diameter 17.5 cm
(obverse RA 08/2788, reverse RA 08/2805).

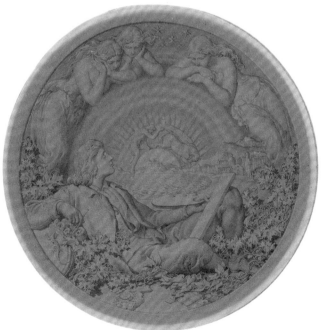

494a and b Edward Hodges Baily RA, models for the Turner medal, c.1857, plaster, diameter 3.1 cm each (RA 09/2586).

rough and rather long hair, dressed in their ordinary daily coats, who, as they retired to their seats amidst boisterous applause, received violent smacks on the back from their fellow students!'[4]

The collection includes a large number of these medals, along with various studies and other objects relating to their production. From the eighteenth century, a group of lead squeezes of the George III obverse, Minerva reverse and decorative edge of Pingo's medal would have served to show the Academy what the artist was intending for the original gold medal. The collection also includes the obverse and reverse dies for this medal. For William Wyon's replacement medal, a sheet of studies by Stothard for the three figures shows his original intention.[5] Wyon's work is represented by dies for his Queen Victoria obverse and the silver medal's *Belvedere Torso* reverse.

The complex story of securing suitable designs for the Turner medal is illustrated by various works. For this medal the Council first resolved to hold a public competition, but after a few months it revoked this decision and gave the task to the sculptor Edward Hodges Baily RA. His two plaster models (fig. 494) are now in the collection, but neither found approval from the Council, and so designs were instead sought from the general body of Academicians. When this resulted in one response only, a request went out to the painters William Mulready RA, William Dyce RA and Daniel Maclise RA. Finished drawings by both Dyce (fig. 495) and Maclise are in the Royal Academy's collection.

Dyce's design seems to have little to do with either Turner or landscape, although it has been suggested that it refers to a specific passage in Ruskin's *Modern Painters*, and it was Maclise who won the vote of General Assembly. The dies by Leonard Wyon for both sides of the medal remain in the collection.[6] There is also what appears to be a trial strike for the reverse of the Armitage medal.

The many prize medals that found their way into the collection include a large number of these Academy medals, as well as those presented by other art schools and the (Royal) Society of Arts. The interim arrangements that the Academy made following the death of George IV are indicated by a uniface example of Wyon's *Belvedere Torso* medal, to the back of which a paper has been glued explaining: 'This Medal will be exchanged in due course for one with the King's head on it. Notice will be given in the Schools as soon as the new medals are ready.' Some groups of medals allow the early progress of the artists concerned to be reconstructed. An example is provided by the six medals awarded to Henry Le Jeune ARA in 1837–41, which were subsequently placed in a frame. The earliest is a silver medal for drawing from the Antique, won in 1837 (fig. 496); in the following year he was awarded another silver medal for drawing from life; and in 1839 yet another for a copy made in the Painting School. That year he also won the silver palette award of the Society of Arts for copying a figure in Indian ink. Two years later, in 1841, he was presented with yet another silver Royal Academy medal, for a drawing from life, and a gold medal for a historical painting. Le Jeune went on to become drawing master and curator at the Academy, and was elected Associate in 1863.

Several medals within the collection hint at future greatness: there is the silver medal awarded to Sydney Smirke RA in 1817 for a drawing from a public building, and another silver one awarded to the sculptor Allan Gairdner Wyon in 1909 for four models from life. The achievement of women is represented by such examples as the four Schools medals awarded to Cecilia Frances Forbes-Robertson in 1920–21[7] and the two won by Winifred Turner in 1925.[8] The story is continued into the 1930s and 1940s through medals won by Hermione Hammond, who is perhaps now best known for her paintings of war-ravaged London, and Joanna Jill Crockford (subsequently known as Jill Walker), who in the 1950s settled in Barbados, where she continued to paint.

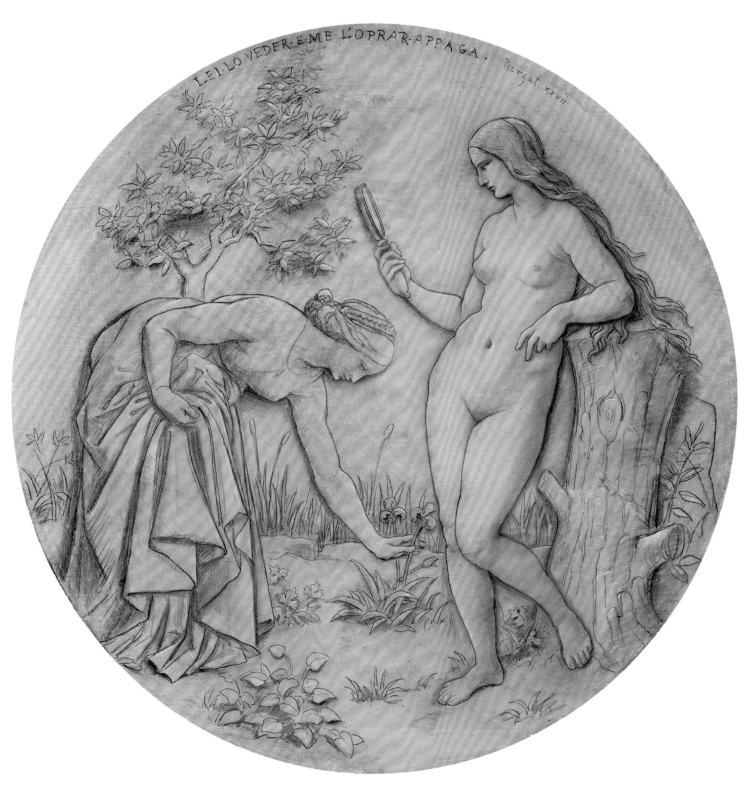

495 William Dyce RA, design for the reverse of the Turner medal, 1858, pencil, chalk and charcoal over gouache on paper, diameter 50 cm (RA 03/152).

496 Royal Academy silver medal for drawing from the Antique presented to Henry Le Jeune ARA, 9 December 1837, diameter 5.5 cm (RA 04/671).

497 W. Wyon and G. G. Adams, bronze juror's medal of the sculptor John Gibson RA for the 1851 Great Exhibition, diameter 6.3 cm (RA 03/5023).

Other medals reflect the eminence attained by many Academicians. The engraver Samuel Cousins RA, whose Society of Arts silver palette and Isis medal, awarded in 1813 and 1814 respectively, both have a place within the collection, is represented also by his Grande médaille d'honneur from the Paris Exposition Universelle of 1855, his Légion d'honneur, and a bronze medal awarded at the Vienna World Exhibition of 1873. The juror's medal of the sculptor John Gibson for the 1851 Great Exhibition (fig. 497) and a medal bearing Prince Albert's portrait and presented to Gibson for services rendered are also included. The many medals and

decorations awarded to Sir Lawrence Alma-Tadema RA range from an 1862 gold medal from Amsterdam (fig. 498) through various medals won at British and international exhibitions, and also the Légion d'honneur, to the Royal Institute of British Architects gold medal awarded in 1906.[9] Even greater success attended Frederic, Lord Leighton, PRA, whose many awards include the gold medal he won at the Paris Salon in 1859, gold medals from Paris in 1878 and Melbourne in 1880, his gold RIBA medal awarded in 1894 (fig. 499) and decorations from Germany and France.[10] In the portrait by G. F. Watts RA (1888) and presented by him to

498 Gold medal awarded to Sir Lawrence Alma-Tadema at Amsterdam, 1862, diameter 4.6 cm (RA 04/2632).

499 Gold medal awarded by the Royal Institute of British Architects to Frederic, Lord Leighton PRA, 1894, diameter 5.7 cm (RA 04/2633).

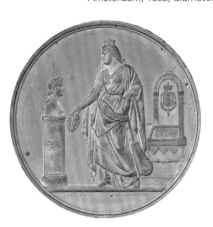

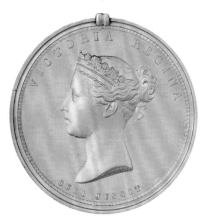
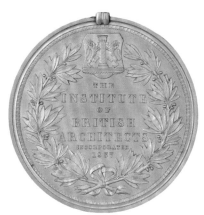

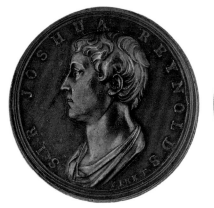
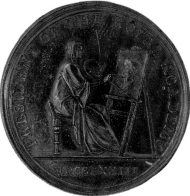
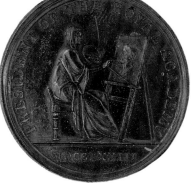
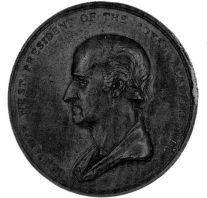

500 John Kirk, medal showing Sir Joshua Reynolds PRA as an ancient Roman (obverse) and an allegorical figure of Painting (reverse), 1773, bronze, diameter 3 cm (RA 04/2606).

501 George Mills, medal commemorating death of Benjamin West PRA, 1820, bronze, diameter 4.1 cm (RA 03/4410).

the collection, Leighton is shown wearing another important piece from the collection: the Academy's presidential gold medal and chain, presented by George IV in 1820.[11] With the king's bust on its obverse and an inscription on the reverse, it can also be seen in the portrait by John Prescott Knight RA of Charles Lock Eastlake PRA of 1857 (see fig. 126), presented to the Academy by the artist in the same year, and in that by Sir Arthur Stockdale Cope RA, *Sir Edward Poynter PRA*, accepted as the artist's Diploma Work in 1911 (see fig. 136). It is still called into service on formal occasions.

A wide range of commemorative medals, principally from the nineteenth and twentieth centuries, have been added piecemeal to the collection over the years, although it cannot be said that the institution itself has been very active in initiating commemorative medals of its own. The medal it commissioned to celebrate its twenty-fifth anniversary in 1793 was engraved by Thomas Pingo,[12] but a proposed medal for the fiftieth anniversary was never produced, although the collection includes three drawings for it by John Flaxman RA.[13] There are, however, a number of commemorative medals that have close associations with prominent Academicians, as, for example, the medal of 1773 by John Kirk (fig. 500) portraying Reynolds as an ancient Roman, with its reverse of an allegorical figure of Painting seated at her easel.[14] Three variants of a medal engraved by George Mills for Benjamin West PRA are included. Produced initially as a tribute, the reverse inscription of

the earliest is dated 1815 and reads: 'BENJAMIN WEST AGED SEVENTY SEVEN IN THE FULL POSSESSION OF HIS POWERS AND HIS GLORY MDCCCXV'. A second indicates that West went on to use the medal as a personal gift, for its reverse inscription reads: 'THE PRESIDENT REQUESTS RICHARD COSWAY ESQ ROYAL ACADEMICIAN WILL HONOR HIM BY ACCEPTING THIS MEDAL AS A TOKEN OF HIS GREAT RESPECT'.[15] After West's death in 1820, Mills combined the same portrait with yet another reverse inscription (fig. 501). This reflects his own very personal feelings: 'INSCRIBED BY G MILLS IN GRATEFUL REMEMBRANCE OF THE PATERNAL SOLICITUDE FRIENDLY ADMONITIONS AND THE GREAT AND EXCELLENT EXAMPLE OF HIS FIRST PATRON BENJAMIN WEST PRA WHO DIED MARCH MDCCCXX AGED LXXXII'. West's successor, Sir Thomas Lawrence PRA, is represented by two medals by Scipio Clint (fig. 502); one of them, unusually, has a portrait bust on both sides, one of which is taken from Edward Hodges Baily's posthumous bust.[16]

Other commemorative medals within the collection have a broader connection with the arts. The many examples of the medals issued by the Art Union of London reflect the close association between that body and the Academy. While some Art Union prize-winners were allowed to select works from the Summer Exhibitions, others received medals showing a British artist or architect on their obverse and an example of his work on their reverse; taken together, these

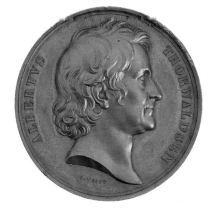

502 Scipio Clint, medal commemorating Sir Thomas Lawrence PRA, 1830, bronze, diameter 4.1 cm (RA 03/4413).

503 Karl Voigt, medal in honour of Bertel Thorvaldsen, 1837, bronze, diameter 4.5 cm (RA 03/4406).

medals act as a celebration of British artistic greatness over two and a half centuries.[17] Other works commemorating or celebrating some of the artistic exemplars placed before nineteenth-century students include the medal by Giovanni Antonio Santarelli of Michelangelo, the *Canova* by Giuseppe Girometti of 1823, and the *Thorvaldsen* by Karl Voigt of 1837 (fig. 503). Many others have a less obvious relevance to the functions and status of the Academy, such as the seven medals of Pope Pius VI in two leather cases bequeathed by the gem-engraver Nathaniel Marchant RA.

The collection also contains a small number of important works by Academicians. William Wyon, the only medal engraver to have been elected an RA (1838), is represented not only by his Academy student prize medals but also by other works, including a framed and glazed design for a botanical medal and, like this design also part of his Diploma Work, a design for an anatomical medal, also glazed and set in a wooden frame (fig. 504), with a portrait of William Cheselden, author of *Osteographia or The Anatomy of Bones* (1733) on the obverse. The latter design was used by St

504 William Wyon RA, design for a medal for anatomy, two silvered impressions, 29 October 1838, diameter 7.8 cm (RA 04/602).

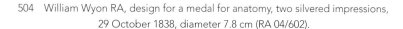

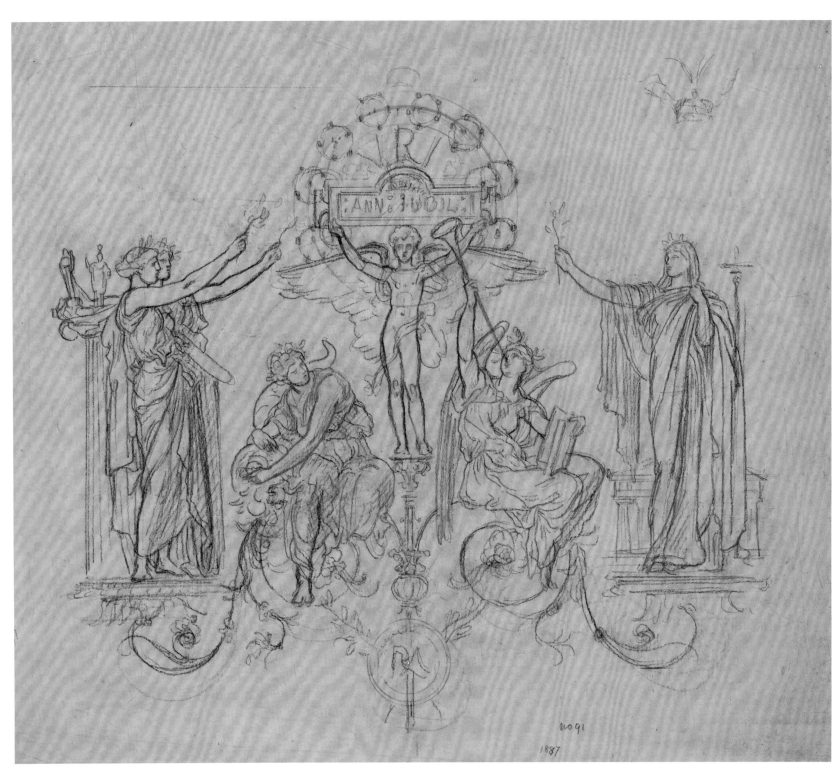

505 Frederic, Lord Leighton PRA, design for the reverse of the official medal celebrating Queen Victoria's golden jubilee, by 1887, pencil on tracing paper, 29.5 × 21.9 cm (RA 04/1116).

506 Frederic, Lord Leighton PRA, official medal celebrating
Queen Victoria's golden jubilee, reverse, 1887, plaster,
diameter 4.7 cm (RA 06/2746).

507 George Taylor Friend RA, *Easter*, uniface medal dedicated to
Alfred Turner RA, perhaps after a design by Eric Gill, 1934, silver,
diameter 6 cm (RA 05/5012).

Thomas's Hospital as an award.[18] There are also two examples of Wyon's Primrose medal for Manchester School of Design, with a female figure, winged youth and girl on one side and a portrait of Raphael on the other.[19] Leighton engaged in medal work on one occasion, producing the reverse of the official medal celebrating Queen Victoria's golden jubilee (figs 505 and 506); a group of three large plaster models, including one presented by the painter Val Prinsep RA, and two moulds remain in the collection.[20] From more recent times, six plaster reliefs by Eduardo Paolozzi RA relate to a medal the sculptor produced for the National Galleries of Scotland.[21] Finally, not by an Academician but presented to one, is a rare uniface medal entitled *Easter* by the engraver George Taylor Friend (fig. 507). It has been suggested that Eric Gill was responsible for the design, which shows Christ and the three Marys. Incised into the reverse of the example in the Academy's collection is the dedication, 'To Alfred Turner RA from GTF 1934'.[22]

A CLOSER LOOK

Edward Burch
Neptune
Diploma Work

ROBIN SIMON

Edward Burch RA is a remarkable instance of the catholic nature of the early membership of the Royal Academy and of its links with the second St Martin's Lane Academy. In 1769 he resigned from the Society of Artists (of which he was a director) to join those colleagues and friends who had just founded the Royal Academy, becoming ARA in 1770 and RA in 1771. He was a gem-engraver who enjoyed a European reputation, and the Academicians insisted that his Diploma Work should be a 'specimen of his abilities in Material in which he works', although initially he had offered a wax model of Neptune.[1] What is of particular interest is that both that wax figure and that on the final *Neptune* intaglio (fig. 508) were derived from a wax model of a famous écorché of a standing figure by Michael Henry Spang (Hunterian Museum, Glasgow, CRE SPANG) exhibited at the Society of Artists in 1761. Spang modelled the wax figure at the St Martin's Lane Academy after a now-lost full-size écorché cast made by William Hunter from the body of a hanged criminal in about 1760.[2] That écorché can be seen in Johan Zoffany RA's *Dr William Hunter teaching Anatomy at the Royal Academy* of c.1772 (Royal College of Physicians, London) and his *Academicians of the Royal Academy* of much the same date (see fig. 121). In 1767 it had

been taken from the St Martin's Lane Academy to what was to become the Royal Academy's first home at 125 Pall Mall, along with 'anatomical figures, bustoes, statues, lamps and other effects'.[3]

Burch had joined the St Martin's Lane Academy in about 1750, and Hunter's lectures there on anatomy had a profound effect upon him.[4] Spang's wax model reveals that Hunter had determined to have reduced bronzes cast after his full-size écorché, and an example can be seen in the 1769 portrait of Hunter by Mason Chamberlin RA (see fig. 115). Following Spang's early death, the making of these bronzes was chiefly entrusted to Burch (fig. 509), although a 'Cast of an Anatomy figure, after Spang' by Albert Pars was awarded a premium at the Society of Artists in 1767.[5] The artist James Paine had one with him in Italy in 1768 when he described it as 'a little Anatomycal figure in bronze, by Spang, from a model he made in wax, from nature of a finely proportioned Man executed at the Gallows – and dissected by Dr. Hunter for the Artists',[6] which implies that some casts at least were made by Spang himself. Paine reported that his little bronze was much admired in Paris and Rome, and the precision and portability of the écorché in this form spread Hunter's fame throughout Europe.

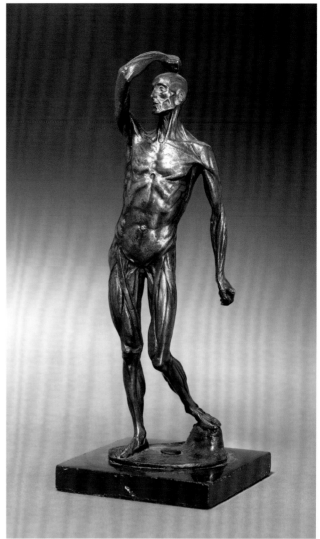

508 Edward Burch RA, *Neptune*, 1771, intaglio, cut in cornelian and set in gold and cast plaster, 6.6 × 4 × 5 cm (RA 03/3595).

509 Edward Burch after Michael Henry Spang, *Écorché Figure*, c.1767, bronze, height 23.8 cm (excluding base). Yale Center for British Art, New Haven, Paul Mellon Collection.

The Danish sculptor Michael Spang was well known in London as one of the stone carvers working for Robert Adam and as a teacher of drawing to, for example, Joseph Nollekens RA,[7] and it is interesting to note that his widow received a pension from the Academy until her death in 1785.[8] Further evidence of the Academy's charitable support of those associated with the institution lies in the fact that, like Richard Wilson RA before him, when Burch fell upon hard

times he was made Librarian, in 1794. The year before that he was the subject of one of the series of portraits of Academicians by George Dance RA, a drawing of 16 March 1793 that, unusually, is inscribed with his profession, 'Gem Engraver', which suggests that Burch's reputation had much diminished by that date, no doubt as the result of the fact that his eyesight had begun to fade after the 1770s. He died in poverty.

PART
FOUR

THE ARCHIVE

THE MEMORY OF THE ACADEMY

MARK POMEROY

Late in January 1809 Thomas Lawrence RA (later PRA) wrote to his friend and supporter Joseph Farington RA about an imminent election at the Royal Academy. Of the many candidates only one raised significant comment, the gem-engraver Nathaniel Marchant ARA (fig. 510), an old man in a hurry whose pushy self-advocacy had riled some of the Academicians. Lawrence summarized the situation in semi-hysterical style he reserved for his closest friends:

Upon my honor I tell you truth when I say that I have not seen one Person who has promis'd to support him who is not ashamed of doing it. Our Friend of whose worth we think equally Smirke (and I know he cannot be hurt that I mention it) is most thoroughly so. Rossi has only the most thorough contempt for him as an Artist and a Man and engaged to vote for him because he thought Westmacott would be push'd. Flaxman confesses his present Imbecility but promis'd him years ago and cannot now say

to him 'your talents have decay'd and I can no longer support you' (hinting at the same time that he has heard he is not quite harmless but rather a little mischievous) and therefore Flaxman votes for him! Sir Francis Bourgeois and Soane openly because they apprehend Robert Smirke [Jr.] would be push'd and that Marchant's name would divide the interest. Nollekens thinks his own Men can copy the Antique as faithfully and have therefore as great a Right! West (who with all his Weakness you must acknowledge feels for art, and knows its claims) nothing could be more disgraceful to the Academy than his election. Westall has the same disgust of it. Hoppner it is said the same, Phillips the same, Owen the same. Thompson [sic] (sent to me upon the subject by our true Friend Smirke) I need not tell you the same. Others whose Names in this hurry I cannot, need not put down have the same feeling. Oh my good & valuable Friend think of, feel for the Character of the Academy; for its first purpose; for

510 George Dance RA, *Nathaniel Marchant ARA*, 8 February 1794,
pencil with black and pink chalk, 25.3 × 19.2 cm (RA 03/3261).

the Advancement of Art and Character of Artists; not let this Committee of Taste, after their Dinners of Laughter at the drivelling Absurdity of the Man hold him up to the amusement of their Friends as a true specimen of a Royal Academician.[1]

Even allowing for overstatement the letter provides a valuable account of the fervid politics consuming the Academy in this period. It becomes doubly important when one considers that not one of the opinions, prejudices, obligations or betrayals that Lawrence records is entered into the Academy's official record. The Assembly minutes state the names of the competitors, the votes apportioned and the Academicians who attended: the unvarnished fact of the election, nothing more.[2]

Marchant was fully aware of how he was regarded. Farington records him as present on the night of his election, 'at the bottom of the stairs of the Academy. Lawrence among others spoke to him as He passed Him after the Election, on which Marchant cried out "*Oh! you are my enemy*".'[3] As well he might, and Marchant was to make good on Flaxman's claim of mischievousness. In 1816 the Academy received a letter from his executors. Marchant had bequeathed 'several Diplomas & the letters which render me credit as an Artist... particularly requesting that they will be pleased to keep & preserve the same in remembrance of me as one of their Body'. Marchant was determined to have the last word and guaranteed that he would do so through the agency of an archive. The little tin-gilt box full of honours was promptly forgotten but it was preserved.[4] The Marchant diplomas were the first personal archive accepted by the Royal Academy. They characterize much of what makes the Academy's archives so intriguing, blending aspects of status, character, memory and forgetting. It is part of the wonder of the Royal Academy that both sides of this story, the official and the unofficial, can be studied under one roof.

Despite their relatively modest size (although they contain some 600,000 records) the archives created by and in the custody of the Royal Academy embody the institution's history at every level, from the international to the national and the mundane, and support continuing scholarship of great diversity. The archives are stored in an elegant purpose-built repository on the second floor of Burlington House and comprise the records of the Academy itself (that is to say, the minute books, ledgers, day books, letters, memoranda and reports), those of several other artistic institutions, and collections of papers compiled by many Academicians. The material as a whole covers the period 1750 to the present day and grows as the Academy continues its work. Nothing displays this vibrant, active heritage more fully than the Roll of Obligation (figs 511 and 512), a document created in December 1768, holding the signature of every Academician since that date and which continues to perform a ritualized function on an Academician's introduction to membership.[5] It is the most totemic aspect of an archive that has developed continuously, almost organically, over nearly 250 years, memorializing and characterizing the institution it serves.

Archives contain the essence of the personality of an institution; the founding documents, in particular, can endure for

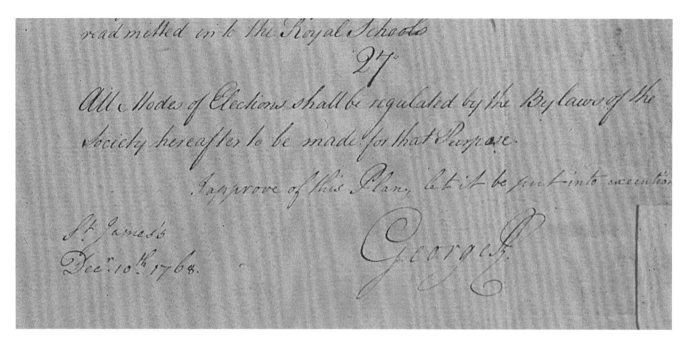

513 Royal Academy Instrument of Foundation, signature of George III, 1768 (RAA/IF).

centuries, articulating its purpose and acting as a focus for policy. The Royal Academy was born when George III scribbled, 'I approve of this Plan, let it be put into execution,' at the foot of a large, though un-showy, document since entitled the 'Instrument of Foundation' (fig. 513; see also fig. 5). It consists of a preamble and 27 clauses laying out the Academy's constitution and core purpose, making it similar to any number of founding documents preserved in archives the world over: a formal document, full of simple statements, expressed with certainty. The Instrument, however, inhabits a shadowy terrain as it is not the end result of a normal legal process. Although characterized as a 'royal instrument' (which, in 1768, placed the document within a raging debate on the royal prerogative), it was nothing more than a private scheme carrying the king's support.[6] Its equivocal status has led to periodic stress in the management of the Academy, in its relations to external authorities and in its claims to accommodation. Over the course of the nineteenth century the Academy was subjected to repeated parliamentary attention, resulting in two full enquiries. At the heart of each investigation was a question of authority: what was the Royal Academy? Was it a public body or a narrow and private club? The Instrument of Foundation was not fit to provide an answer, leaving the Royal Commis-

sion of 1863 to seek opinions. Speaking as an Academician, Richard Westmacott responded, 'When we wish not to be interfered with, we are private; when we want anything from the public we are public.'[7] Although possibly accurate this was not a helpful contribution, and the Royal Commission concluded that 'the position of the Academy would be far better defined and far more satisfactory, if instead of the present Instrument of 1768, it rested on a Royal Charter.'[8]

George III had provided the Academy's predecessor, the Society of Artists, with just such a charter in 1765, and this was to have been a great leap forward in the organization of British artists.[9] But that charter failed. The constitution it supported was immediately challenged, causing the artists who had framed it to secede and plot the birth of the Royal Academy. In this sense the Academy's Instrument can be looked upon as Plan B, and once the king signed the Instrument it became literally unwarrantable to seek a new royal charter.[10]

The assiduity with which the Academicians cultivated George III and his successors becomes fully understandable in the light of this ethereal constitutional basis. The personal support of a sovereign can be withdrawn at any time, Instrument or no, and to incur his or her displeasure would be

disastrous. The sense of panic that characterized much of the Academy's institutional politics in the 1790s and early 1800s was a product of the absolute necessity of retaining the king's support.[11] The Academy's special relationship with the sovereign, as underwritten by the Instrument, acted as a shield in the early years and has since provided just enough cover for the Academy to ward off most sorts of external control. When Sir Francis Grant PRA triumphantly secured from the government a 999-year lease for Burlington House in 1867, he finally eased anxieties over permanent accommodation, an issue that had acted as a constant reminder of the Academy's shaky claims for support.[12] The Instrument of Foundation, this strange and ill-defined document, endures as the platform upon which the constitution of the Academy is based.[13] It does so primarily because it has aided the preservation of the Academy's most jealously guarded treasure: its independence.

Tucked away in the Instrument of Foundation, between clauses defining professorships and the Annual Exhibition, is this: '15. There shall be a Porter of the Royal Academy, whose Sallary shall be 25 Pounds a Year; he shall have a Room in the Royal Academy, & receive his Orders from the Keeper or Secretary.' The Porters were responsible for security, keeping order, managing daily traffic, administering the submission of works to the Annual Exhibition and regulating the visiting public. They also routinely worked as life models in the Schools. For many years the Porters, together with the Sweeper (swiftly retitled Housekeeper), formed the entirety of the Academy's staff. Despite this centrality to the institutional life of the Academy, these figures are ordinarily absent from published histories, appearing, if at all, as supporting characters in a memoirist's witty anecdote. But the archive preserves their memory, revealing the crucial role they played in the functioning of the Academy and which they may have played in its creation.

The first Porter was John Malin (see fig. 116). He was married to Elizabeth, and they had a son named Benjamin. John had worked at the St Martin's Lane Academy for many years, and it is supposed that he owed this connection through a chance encounter with Louis-François Roubiliac.[14] Less widely recognized is the role that the Malins played in the life of the Society of Artists, the records of which are preserved in the Academy archives. Indeed, John Malin worked for the society even before its formal creation,

supervising at the first exhibition of 1760,[15] and he had long been known to the artists from the St Martin's Lane Academy where he had fulfilled the same dual role of porter and model. He can be seen in the background of Johan Zoffany RA's painting of the St Martin's Lane Academy (see fig. 425). Malin was routinely used as the messenger of the society, was placed on a salary of £20 per annum in 1767 and allowed the cost of a new Laud hat every year on St Luke's Day, which suggests that he officiated at the artists' feast.[16] At a directors' meeting held on 15 March 1769, a full three months after Malin's appointment as Porter to the Academy, he asked to retire from the society because of age and illness.[17] On his death shortly afterwards, the Royal Academy voted to pay for his funeral expenses, 'in consideration of his long and faithful services'.[18]

Recounting these events raises questions concerning the nature of the Academy's secession from the Society of Artists. These are reinforced when it becomes clear that the Academy also took over the employment of Elizabeth Malin and John Withers, who since 1761 had worked for the society, tending the exhibitions.[19] The Academy appears to have lured away its entire staff, dealing a significant blow to its continuity, over and above the matter of the secession of so many of its artist members.

Elizabeth Malin (see fig. 117) became the first Housekeeper of the Royal Academy. Her role within the institution is thrown into sharp focus by the survival of bills and receipts for 1788 (fig. 514).[20] The Housekeeper was responsible for the general expenses incurred through the running of the Schools. As she was illiterate, the Keeper, Agostino Carlini RA, wrote up the bills in his admittedly poor English. Through the minutiae of such records it is possible to determine the type of oil used to light the Schools, the amount of bread provided to students for the purposes of erasing, the quantity of beer, rum or shrub provided to the models for their refreshment and, most significantly, the names of the male models working in the Life School and the amount paid to the anonymous 'Woman'.[21] Without these humble scraps of financial record the quotidian mechanism of the Life Schools would remain obscured. Through evidence provided by the Academy's records the Housekeeper emerges from the shadows not merely as a servant, but as a woman at the heart of the almost exclusively male Academy, its exhibition and its Schools.

514 Example of a bill of Elizabeth Malin, housekeeper of the Royal Academy, 1788 (RAA/TRE/2/1/2).

which may throw their reliability in doubt or at least raise acute problems of interpretation of the evidence. Archivists commonly refer to minute books as the 'backbone' of an institutional archive, since they form an unbroken narrative of both policy and activity. Their formal nature and procedural language can lull the reader into regarding them with an evidential respect, whereas they should more properly be subjected to a continual critique.

When placed next to the early minutes of similar societies, the minutes of the Royal Academy are surprisingly coherent, not to say pompous. They are robed in the authority of weighty reverse-calf tomes, nearly 400 pages in extent.[22] This physical presence suggests great ambition, and the manner in which the minutes are entered shows equal confidence. Many mid-eighteenth-century societies display a more haphazard developmental process. Often the first period of a society's life was not documented at all, until it was decided to enter the more formal territory of recorded existence.[23] In other cases a basic record was kept, only for it to be more carefully structured as the society matured. It is through this accretion of processes and business formulae that administrative history is normally traced.[24] In contrast, the Royal Academy appears to have sprung like Aphrodite fully formed, but this is misleading, as its developmental phase was completed before the Academy was even created.

The first Secretary of the Academy was the painter Francis Milner Newton (fig. 515).[25] Newton had ample prior experience of this type of role as the amanuensis of every significant development towards the institutionalization of British artistic life from as early as 1752. In 1759 Newton acted as secretary for the artists who met at the Turk's Head to organize the first exhibition of contemporary art. This group became the Society of Artists of Great Britain, the early minutes of which display the groping developmental process comparable to that found in the records of other associations.[26] The language is terse and exact, with the precise focus that was to characterize Newton's writing for the rest of his career, but the terms of debate at the Society of Artists' meetings were hammered out over time and minuted to form the core of the society's laws.[27] These regulations chime closely with the practice observed at the Royal Academy, where at first the rules were not explicitly stated, providing another indication of the continuity of administration between the Royal Academy and the Society of Artists. The

Records enable the historian to reach beyond the partial anecdote of memory to a more dispassionate account, since their very existence is due to the necessities of business. But it is often not possible to know all the purposes lying behind the creation of a record, which can lead to challenges of interpretation. The minutes of the Academy's Council and General Assembly provide many instances of this difficulty,

515 George Dance RA, *Francis Milner Newton, RA*, 5 May 1793, pencil with pink chalk and blue and black wash, 25.1 × 19.1 cm (RA 03/2659).

516 George Dance RA, *John Inigo Richards RA*, 11 March 1793, pencil with black and pink chalk, 25.3 × 18.6 cm (RA 03/3267).

Academy's minutes record no wrangling over procedure but then, perhaps, Newton chose not to mention it. The power of the minutes lies in their character as the official record, and as such they should be beyond all disputation. Consequently, they are frequently at the centre of it.

The career of Newton's successor, John Inigo Richards (William Hogarth's godson) (fig. 516), was to coincide with one of the most destructive periods in the Academy's history, of which Joseph Farington RA's diary provides a detailed personal account. He records long and fractious disputes at meetings that are not necessarily reflected in Richards's minutes. On 27 December 1803 Farington wrote, 'At noon called on West, who informed me that at the Council last night the whole evening till one oClock was occupied by the discussion of a Narrative & Resolutions proposed by

Soane.'[28] Of this Richards records precisely nothing but eight men sitting in a room, 'Decr. 26th 1803. Adjournment. Present: – The President, The Secretary, J. S. Copley, J. M. W. Turner, The Treasurer, Jno. Soane, Chas. Rossi Esqrs. & Sr. Fran. Bourgeois. No Business done. Adjourned.'[29]

In 1803 the Academy was close to self-destruction, involving a bitter dispute between the General Assembly and Council members who had been suspended.[30] In such an atmosphere the responsibility of being record-keeper is onerous. Academicians brought Richards's impartiality into question, and he was charged with controlling the record for the benefit of a faction.[31] Under this sort of pressure it is little wonder that Farington had cause to characterize him as a 'surly brute'.[32] In May 1803 relations between the Council and the General Assembly broke down completely, and vio-

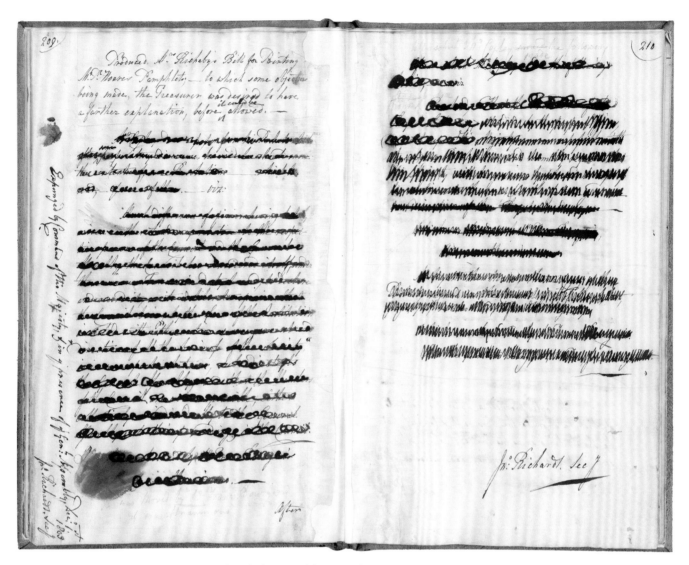

517 The 'Black Page' of the Council minutes, 1803 (RAA/PC/1/3).

lence spilled over on to the pages of the minute books as competing visions attempted to control the narrative (fig. 517).[33] This extreme crisis is rare, but the pressure visited upon this one element of the archive leaves the marks of many competing visions, outlooks and narratives. Far from being a manifesto of corporate blandness, the minutes exhibit all of the contradictions that one would expect from a body as heterogeneous as the Royal Academy.

The Academicians understood the power held within the minute books, and they have always been treated with extraordinary secrecy. Until the modern era, any suggestion

that an external authority should have access to the minutes was always firmly rebuffed. In 1860 William Sandby became the first outsider to be given access, and this was not repeated until William T. Whitley nearly 70 years later.[34] The minutes are now open to all researchers and are the lens through which historians most commonly seek evidence of the Academy and its members.[35] Very gradually, the account becomes more inclusive, even verbose. In a process that has taken decades, patterns of debate start to be recorded, personal opinions entered. The entries for the 1890s are garrulous when placed next to those of the 1790s; those for the

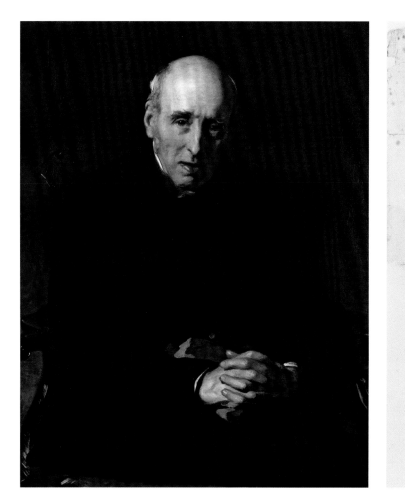

518 John Prescott Knight RA, *Thomas Vaughan*, 1852, oil on canvas, 92 × 71 cm (RA 03/1072).

519 Premiums notices to students, 1771 (RAA/SEC/22/1).

1990s appear almost as stream of consciousness by comparison. By the late twentieth century this process reached its logical end-point when it was suggested that meetings should be tape-recorded.[36] If ever taken, this decision would mark a definitive closure of the book first opened in 1768 by Francis Milner Newton.

Part of the great value of an archive is that it allows study of these processes of change. The nineteenth century saw huge growth in the production and consumption of culture. It also witnessed the advance of a modern civic state into new areas of society, such as fine art. The Royal Academy reacted in various ways to these developments, most of them resulting in the growth of its activities, administration and staff. First mention of an assistant to the Secretary comes as early as 1797, but it was not until 1822 that a permanent position of Clerk was instituted.[37] The first, Thomas Vaughan (fig. 518), was a recent ex-student, and it is thanks to Vaughan that the archive gained a monumental series of scrapbooks holding series of memoranda and ephemera (fig. 519).[38] Vaughan's successor, Henry James Eyre, made a significant and enduring impact on the structure of the Academy's administration. The records of this period are remarkably complete and are his enduring legacy. Eyre had not been a student at the Academy, and there is little to suggest that he had trained as an artist.[39] His arrival coincides with a dramatic improvement in the quality of record-keeping, and it

is clear that Eyre's work brought him into close contact with what was already being referred to as the Academy's archive. In the preface to his history of the Academy William Sandby recorded his gratitude 'to the Registrar, who afforded me every needful facility in obtaining access to, and explanation of, the documents in his charge'.[40] The Royal Commission of 1863 demanded that the Academy provide detailed statistical submissions concerning its activities. Eyre undertook this labour (to all appearances he did so with glee), which resulted in indexes to the minutes of Council and General Assembly that are even now of great utility.[41] More than that, he drafted a simple catalogue of the surviving letters and memoranda in the archive.[42] Eyre was a superlative administrator and actively lobbied Council for the creation of the post of Registrar.[43] The Registrar's role was 'to superintend & carry out under the orders of the Secretary the business of the office in all its departments'.[44] From 1870 this included the organizational apparatus supporting the Winter Loan Exhibition of works by Old Masters. Although the Academy has grown dramatically since Eyre's day, the administration that he established endures in work performed by a staff structure that would have left him awed by its size and horrified by its expense. Records produced by these departments flow towards the archive which, thanks to Eyre's protean efforts, has grown seamlessly with the Academy for 150 years.

These official papers alone would ensure the importance of the Academy's archive for historians of British art and culture. But when combined with the perspectives added by deposited private archives it becomes something remarkable. The Academy possesses major collections of artists' papers, originating from famous names such as Thomas Gainsborough RA and Sir Joshua Reynolds PRA to lesser-known figures such as Ozias Humphry RA and Arthur Middleton Todd RA, while substantial deposits in more recent times include the papers of Sir George Clausen RA and John Ward RA. These personal archives are the written residue of busy lives and are formed of letters, journals, accounts and memoranda. Very rarely does such material come directly from the artist, and this has important consequences for its value as historical evidence.

Archivists tend to analyse and structure the material under their charge in terms of the principles of provenance and original order.[45] Provenance compels the archivist to identify the boundaries of an archive according to its point of crea-

tion and interdicts the mingling of material with different creators. Happily, almost all the deposited archives received by the Royal Academy have been treated with this principle in mind, thus preserving their integrity. An archive's original order is that in which it was left by the creator, and in this the Academy has been less fortunate. Problems most commonly result from the good intentions of executors or curious relatives, and it is rare for an archive to be received into institutional custody unmolested. The letters of Thomas Lawrence form the largest private archive in the Academy, and it provides a fine example of the sort of thing that can occur. At the end of the last of the five main volumes of manuscripts, tucked away, is some bad poetry:

In that delicate form, while a pulse should remain,
Of that mind, but one ray be preserv'd,
That throb, would thy power undiminished retain,
That glance, be with reverence reserved –
Unnoticed – unknown – my devotion I'd prove,
Till thy last emanations expire;
As faithful, when cold e'en the embers of love,
As when cherished and blest by its Fire![46]

Among the two and a half thousand manuscripts of the Lawrence papers, this is almost the only hint relating to his disastrous entanglement with the two daughters of Sarah Siddons: 'Marie' or Maria (see fig. 216) and Sally.[47] Both women subsequently died of consumption (Maria in 1798 and Sally in 1803), and a glimpse of Lawrence's disturbed state of mind at this time appears in William Godwin's letter to him of February 1796,[48] while in a letter to his brother, William, Lawrence writes that Maria Siddons's illness causes him to be half-distracted.[49] This nerviness and insecurity comes out frequently in Lawrence's papers, even when he was being fêted as the most successful portrait artist in Europe. In a letter of 25 November 1818 Lawrence writes of the tension of the sitting: 'The suspense, the waiting is a nervous thing…that first quarter of an hour of agitation and doubt in spite of all previous determination…But Mrs Siddons said she could never yet face an audience without something of apprehension and I must therefore be well content to endure this weakness.'[50]

Lawrence's friendship with Sarah Siddons is a constant theme in the correspondence. They were introduced on Lawrence's first arrival in London in 1788 and were in

contact for the rest of his life. A note from Sarah thanking Lawrence on 23 December 1824 for his praise for Reynolds's portrait of *Mrs Siddons as the Tragic Muse* in his *Discourse* indicates the extent to which they kept in touch.[51] Tantalizing glimpses are shown of Lawrence's friendships with women, an aspect of his life about which little has been confirmed but upon which some light is shed by the occasional fragments or drafts of letters in this collection. Mrs Jens (Isabella) Wolff, who separated from her husband, the Danish consul in London, also featured prominently in Lawrence's emotional life, as shown in his musings on her character on 30 September 1810, calling her 'the most perfect personality'.[52] Another female friend, Elizabeth Croft, censored these letters, as shown in a note of 30 September 1829 in which Lawrence pours out his feelings on the death of Mrs Wolff, 'his closest friend'.[53]

In fact, though, there is little enough in the archive to hint that Lawrence had any sort of private life at all. Even in the year of his death one putative biographer cried off the task explaining, 'The materials which I could obtain most miserably disappointed me & after writing reams of letters to individuals & consuming whole days in calling on them I found that all they could tell me about Sir Thos. might be included in a nutshell.'[54] His successor hinted at being unable to access certain caches of documents and muttered darkly, if in true biographical tradition, of 'efforts of some friends of Sir T.L. to induce him to garble papers'.[55]

The letters now at the Academy were gathered and bound in 1830–31 by Lawrence's assiduous executor, Archibald Keightley, with the assistance of Elizabeth Croft. In 1939 the archive was donated to the Academy, and in the interim very little appears to have altered. But the damage had already been done. Letters addressed to Croft and Elizabeth Wolff in a smaller volume, known as the 'Keepsake', display evidence of heavy editing, and it is likely that many letters were written on the understanding that they would be destroyed on Lawrence's death.[56] A suggestion of scandal had swirled around Lawrence for most of his life, without ever settling upon him definitively. It is probable that, on account of the celebrity of the deceased and under the immense workload imposed by the estate, Keightley and Croft decided that any

sensitive letters should be burnt. This is impossible to confirm, there being no conclusive evidence, and this evidential void is the true consequence of undocumented destruction within archives. It not only robs the historian of sources but diminishes the remaining material.

Destruction is not the only danger where papers are concerned, because original order is fragile and when disrupted is often irreparably damaged. Another major set of artist's papers, created by George Richmond RA, was heavily reorganized by a previous owner before coming to the Academy. The sad result is that bundles of documents, previously arranged and tied together by the creator, detailing epistolary careers, friendships and loves, have been broken and scattered. Although many letters are dated and can be arranged, others are not, and it may be that the original order within the bundles carried its own logic apart from the merely chronological. To some extent the archive is now like a shattered vase with no possibility of a perfect mend.[57]

These are the often inescapable consequences of accepting archives from external sources, but it should in no way discourage the researcher. The archivist is charged with preserving archival structure and with passing on the knowledge of an archive's history to the research public. In this manner an archive is able to speak for itself while yet bearing the scars of its journey into the Elysian Fields of the museum repository. The Richmond family papers remain a stupendous resource for the study of an artist's life in the Victorian era, just as are the letters of Thomas Lawrence for the Regency and the letters of Ozias Humphry for the reign of George III. In addition to their own many merits, these archives resonate to the insistent drumbeat of that of the Royal Academy itself, an institution prone to bouts of introspection even as it instinctively and intermittently reaches out. The Royal Academy's archive is inclusive in a way that few institutional archives can ever hope to be, finding a place even for those for whom membership would be anathema: 'Dear Roger de Grey, Thank you very much for offering to make me an Academician, but I am afraid I must _refuse_. I belong to nothing and feel I am too old to start now, but thank you _very_ much for the suggestion. With all very best wishes, yrs. sincerely, Francis Bacon.'[58]

A CLOSER LOOK

Sir Thomas Lawrence PRA
in the archive

PAT HARDY

Sir Thomas Lawrence (fig. 520) was elected the third President of the Royal Academy in 1820, following Sir Joshua Reynolds and Benjamin West, which put him in an unenviable position. He had to formulate a distinctive strategy to ensure that he remained the pre-eminent portrait painter in his own lifetime while maintaining the status and prestige of the office of the presidency itself. He was President for 10 years, and he succeeded in both these objectives.

Lawrence's recording of his art was not, however, anything like so successful. He left no sitter-book (unlike Joshua Reynolds, whose sitter-books are in the Academy's archive) or list of portraits, and so it has been difficult correctly to attribute his works, which are widely scattered and chiefly in private collections. Numerous unfinished portraits left in Lawrence's studio on his death in 1830 had to be handed over to the sitters or their families, together with 430 objects that had been used as accessories in the portraits. Nor was his very large collection of Old Master drawings kept intact. On 10 May 1830 Christie's held the first of a series of sales of the contents of Lawrence's house in 65 Russell Square, London, the interior of which is recorded in an aquatint presented to the Academy by Mary Keightley, the daughter of Lawrence's executor, Archibald Keightley, who published the print (. 521). The

Christie's catalogues reveal the wide-ranging nature of Lawrence's book collection, prints, paintings and drawings. The sales took place partly to satisfy the estate debt left on Lawrence's death, but particularly because four named beneficiaries declined, in turn, the collection of 4,300 sheets and seven albums of Old Master drawings offered them at a price of £18,000.

Lawrence appears to have given no thought to his posthumous reputation nor to how biographies of him might be written. He left no diary or journal, and so attention has focused on his correspondence, which, however, was itself not kept in good order. By the time of his death, a large amount of correspondence had piled up at 65 Russell Square, which Archibald Keightley worked through. In addition to ordering the correspondence, Keightley's legal training meant that he could not resist adding surmised dates, and he sometimes relegated drafts or scribbled notes to a status of lesser importance. He also put out a call for recipients of Lawrence's letters to return them to him, so that a biography of Lawrence could be commissioned.

Much archival material had been lost in Lawrence's move to Russell Square in 1814, and much appears to have been mislaid after his death, some of it only known from publication

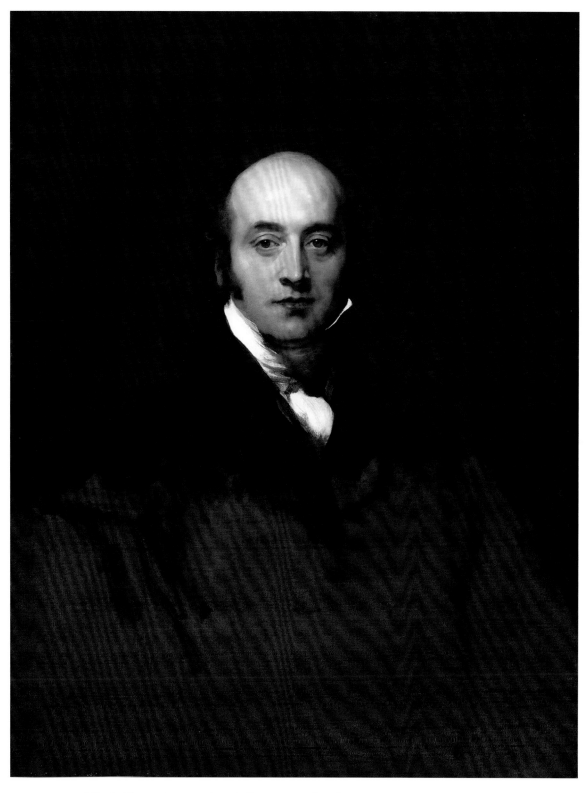

520 Sir Thomas Lawrence PRA, *Self-portrait*, c.1825, oil on canvas, 91 × 71.4 cm (RA 03/950).

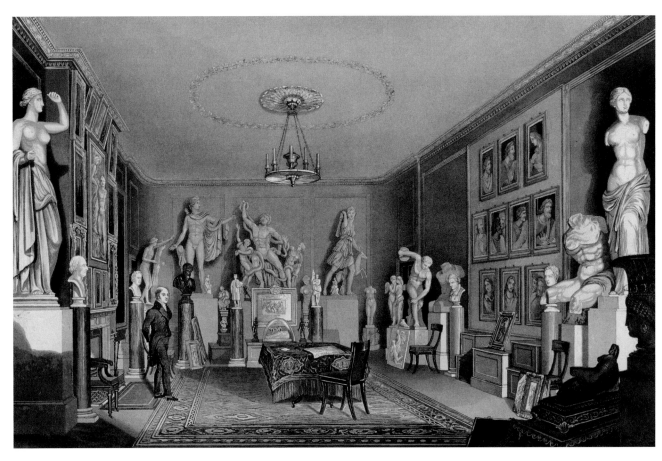

521 *Private Sitting Room of Sir Thos. Lawrence*, 1830, aquatint and etching, 24 × 37 cm (RA 03/5973).

in works such as D. E. Williams's *Life and Letters of Thomas Lawrence* (1831). In addition, Lawrence (or his friends acting on his instructions) seems to have destroyed or censored letters that he sent, which has again made a coherent record difficult to construct. Of what does remain, a large proportion has been preserved in the Royal Academy archive, which lends it a particular significance.[1] This correspondence was collected by Keightley and comprises five volumes of material, two index volumes, one small scrapbook and 20 loose letters, all of which were donated by Keightley's daughter Mary in 1839. It forms the major part of the approximately 2,000 Lawrence items in the Academy archive. The archive also holds 19 relevant items from the Angerstein family that were purchased by the Royal Academy at auction in 1996, and material deposited in 1997 by Kenneth Garlick, Lawrence's principal researcher, which he had purchased from a bookseller in the 1950s.

One of the most revealing periods is 1818–19 when Lawrence was on the Continent, having been commissioned by the Prince Regent to paint European heads of state and their ministers in the aftermath of the victory of the Allies at Waterloo in 1815 and the final defeat of Napoleon. Lawrence was demonstrably at the peak of his powers, but, characteristically, in these private moments he reveals himself to have been at the same time self-doubting, intellectually curious, preternaturally observant and perceptive. He was usually chary of revealing his inner life, but the novelty of his experiences in France, Austria and Italy, the excitement and his sense of history make Lawrence uncharacteristically self-revelatory in these letters to friends in London.

Reading the correspondence as a whole and correlating it with Farington's diary,[2] it is clear that Lawrence, in this key period immediately before he became President, was using

these despatches to consolidate his image as a celebrity artist. He was not writing lengthy letters solely in order to keep in touch with friends: he was acting as his own publicity agent. In a letter to Robert Smirke RA, for example, on 25 November 1818, sent from Aix-la-Chapelle,[3] after the usual flowery niceties Lawrence quickly gets to the heart of the matter, namely some British press reports he has just read criticizing his portrait of *Tsar Alexander I of Russia* (Windsor Castle). Lawrence expands on the wonderful reception afforded this particular portrait by the sitter, his family, the suite of officers 'and the general applause of all acquainted with his person'. He emphasizes that 'the literal truth is that you have never seen a portrait by me more faithful in likeness to the best moment of the Original' and describes the gracious expressions of pleasure of Emperor Alexander, the friendly pressure of his hand, the liberal commissions that flowed from the portrait in the form of copies of several other portraits, and the splendid ring that the tsar gave him, all of which conclusively prove in Lawrence's opinion 'the favourable impression' that this portrait had made.

Here is an ambitious Lawrence determined to demolish any suggestion that his work was not duly appreciated, working to ensure that the correct view is put to the audience at home in London. He was, however, careful to camouflage his motives in a long letter that has many side turnings and parentheses and expressions of friendship. This use of correspondence appears frequently from the 1790s until Lawrence's death, and it is such letters that reveal why Lawrence, despite the low opinions of subsequent biographers – and despite the grudging acceptance of his work from the 1790s by many artists such as Henry Fuseli RA and Benjamin Haydon, who were quick to point out his defects – was so successful. He was one of the youngest artists to be elected to the Royal Academy, first as Associate in 1791, second as full Academician in 1795, and finally as President in 1820.

Lawrence's fragile financial position, the subject of much speculation, is constantly raised in the letters, but nothing emerges to explain his perennial lack of funds. Very early in Lawrence's career Lord Cremorne urges him 'not to get into engagements that will embarrass you'.[4] Thomas Coutts of Coutts Bank constantly asks for clarification of Lawrence's finances from 1804, at that point rather optimistically saying they can clear Lawrence of debt within two years.[5] In 1807 Lawrence prepared a list of his debts (totalling £17,655 19*s.*) with amounts listed against the web of bankers, Angerstein, Coutts and Baring, with whom he had become so entangled.[6] He was never to be free from debt throughout his life.

What does, however, become clear is Lawrence's quest for perfection in his work, slowing down production through numerous sittings, and a frequent inability to finish portraits is illustrated from an early age. In a letter to John Hunter of 20 June 1788 Lawrence asked for a further sitting: the picture was finished, Lawrence states, 'except for the hands which require some little study from the life to make them perfect'.[7] But Lawrence's working practices, his tastes, his day-to-day routines, the texture of his life, come alive best in the correspondence with Joseph Farington RA. The friendship of the two Academicians forms the bedrock of Lawrence's career and is typified in a long letter by Lawrence written on 26 April 1811 in which he muses on the nature of friendship.[8] Reading this letter in conjunction with Farington's diary, the date becomes significant: it was the day after the last varnishing day at the Royal Academy when Lawrence had time for reflection. Farington had recently given Lawrence several pieces of advice, such as raising his prices to 300 guineas for a whole-length; whether he should continue as the King's Painter; how Lawrence should structure his debts; and how Lawrence should continue to strive against succumbing to the 'metally glittering vicious practise',[9] a cloaked reference to a habit of heavy gambling that, it would seem, ruined Lawrence's finances.

20.2

The Royal Academy Roll of Obligation and James Barry's expulsion

ROBIN SIMON

This book began with the expulsion of the Foundation Members of the Royal Academy from the Society of Artists as recorded in its papers preserved in the Academy archive. It concludes with the more notorious of the only two expulsions from the Academy that have taken place, that of James Barry on 15 April 1799.[1] It is recorded in the Roll of Obligation, which has been signed by every Academician upon election from 1768 until the present day (see figs 511 and 512), and was authorized by the signature of King George III (fig. 522).

The cause of the expulsion was Barry's publication in 1798 of *A Letter to the Dilettanti Society, Respecting the Obtention of certain Matters essentially necessary for the Improvement of Public Taste, and for accomplishing the Original Views of the Royal Academy of Great Britain*, which was written, as it states on the title page, when Barry was 'Professor of Painting to the Royal Academy'. The book was chiefly intended to be an argument for the establishment of a national collection of Old Masters, and Barry actually uses the term 'National Gallery'. It is full of perceptive remarks about painting, the dangers of 'restoration' and cleaning, and the need in the Academy for more and better plaster casts of statues (which

was shortly to be addressed) and for a worthier library (he talks of 'the miserly beggarly state of the library'). There are copious quotations from his own lectures at the Academy but, as he warmed up, his text became more aggressive and indiscreet, revealing an embarrassing amount about the inner workings of the Academy, all spiked with barbed comments about individuals. The book concludes with an appeal to the Society of Dilettanti to create a national gallery since, Barry makes clear, he considers that the Academy will make no effort to do so.

Barry's fellow Academicians were furious. Joseph Wilton RA, a Foundation Member, was still very much alive and took on the task of drawing the attention of Council to several passages in the book as evidence that Barry should not be allowed to continue as an Academician. After his expulsion, which required two meetings of General Assembly and the approval of the sovereign, Barry predictably published a riposte the same year. It took the form of a second edition of the original book with a large appendix in which he went over all the arguments in painful, even obsessive, detail. It is only one irony among many in this story that a copy of this second

522 Royal Academy Roll of Obligation (detail), expulsion of James Barry, authorized by the signature of George III (RAA/GA/10).

edition is in the Academy Library. Another is that the very first purchase of drawings by the Academy, on 12 December 1844, was of some examples by Barry (see fig. 403). Perhaps the richest irony of all, however, is that after his death on 22 February 1806 Barry's body first lay in state in the Society of Artists but then, on 14 March, after a grand funeral procession, was buried in St Paul's Cathedral, next to the Royal Academy's first President, Sir Joshua Reynolds.

APPENDIX

TRANSCRIPTION OF
THE INSTRUMENT OF FOUNDATION

MARK POMEROY

The Royal Academy's founding text, which equates in both purpose and endurance to a constitution, is a very strange document indeed. Its form and language bear no relation to the sort of standard diplomatic found in deeds, contracts, charters and other types of legal guarantees. It is little more than a scheme, a set of rules defining the operation of a members' society, an art school and an exhibition. As such it is very inward-looking. The only external authority mentioned is the person of the king, and the sole part of the document carrying legal weight is the phrase, 'I approve of this Plan, let it be put into execution', in the hand of and signed by George III. By providing his backing the king transformed a mere plan for an academy, one of many that had floated around London for years, into an instrument of the Royal Will; consequently, it has always been known as the Instrument of Foundation.

In structure the document could barely be more simple. A preamble provides some context, a type of mission statement and formally announces the full extent of the king's involvement. The rest comprises the plan itself, in 27 clauses. The first

17 lay out a clear basis for the operation of the Royal Academy and can be divided into four sections: composition and election of the membership (1–3), governance and officials (4–8), operation and staffing of the Academy Schools (9–16), regulations for the Annual Exhibition (17).

The remaining 10 clauses are arranged less logically and are suggestive of intense debate among the framers between their initial audience with the king on 28 November 1768 and the signing of the instrument on 10 December. Clauses concerning life classes and the Library display a marked specificity of content, perhaps evidence of diverging opinions over curriculum. The text finally turns again to matters of governance, framing a relationship that has since formed the seat of the Academy's politics – the co-dependency of Council and General Assembly.

Clause 4 states without qualification that the Council has 'the Entire Direction, and Management of all the Business of the Society', and mentions 'the General Body' only in relation to censure of the conduct of officers or members. However,

584

clause 21 announces that a general meeting be held annually 'to do any other Business relative to the Society'. This is a clear contradiction that is only partially tidied away through Council's power to 'frame new Laws' (clause 22) and Assembly's to 'Confirm' them.

Deliberations over the relative power of Council and General Assembly were doubtless to the fore as the draft neared completion. All those involved knew that systemic weaknesses in the constitution of the Society of Artists, as embodied in its royal charter, had allowed open conflict between the directorate and the general membership, conflict which had now brought them to the point of creating a rival society. The need to avoid this potential source of tension is largely responsible for elements of clauses 4 and 5 defining the limited membership of the Royal Academy and the enforced annual rotation of Council by election precedence, which guaranteed a democratic basis to executive involvement.

Even so, the poor drafting of clause 21 in relation to clause 4 has revealed itself at moments when the Council's agenda has been in stark variance to the feeling of the wider membership. The most well-known example of this was in 1803, when the General Assembly asserted its constitutional primacy over the Council, a reading of the text that was negatived personally by George III. But there have been many occasions when a strong Assembly has taken on an agenda substantially wider than is the apparent intention of the Instrument of Foundation.

Despite the fudge over Council and Assembly it has proved to be remarkably resilient. Its fundamental inadequacy as a legal document proved to be, for many years, its hidden strength. When challenged by external forces such as Parliament and government, the Academy argued repeatedly that it was founded by George III alone, in his personal capacity, precluding the right of any other body to interfere in its affairs. This would not have been the case had the Academy been granted a royal charter. The Instrument of Foundation allowed the Academy to accrue the prestige of a national institution while retaining a remarkable independence. However, the growing complexities of institutional governance in the late twentieth century proved that it was no longer sufficient. In 2007 a rigorous process of review resulted in a transformed constitutional framework that, while enshrining its status as the Academy's constitution, augmented it with modern protections brought by a Memorandum and Articles of Association. On 2 July 2007 the Royal Academy became incorporated as a Company Limited by Guarantee.

The Instrument of Foundation has been transcribed and published many times, appearing as an appendix in the Royal Commission report of 1863, and the official histories by J. E. Hodgson and F. A. Eaton (1905), W. R. M. Lamb (1951) and S. C. Hutchison (1986). The exactitude of these published versions is variable. The following text is a new transcription by Mark Pomeroy and Helena Bonett. It adheres faithfully to the spelling, syntax and capitalization of the original.

INSTRUMENT OF FOUNDATION OF THE ROYAL ACADEMY
OF ARTS IN LONDON

RAA/IF

INSTRUMENT OF FOUNDATION

10 December 1768

[1 sheet, imperial]

sub-fonds

Whereas Sundry Persons Resident in this Metropolis, Eminent Professors of Painting, Sculpture, and Architecture, have most humbly represented by Memorial unto the King, that, they are desirous of Establishing a Society for promoting the Arts of Design, and earnestly soliciting his Majesty's Patronage and Assistance in carrying this their Plan into Execution, and Whereas its great Utility hath been fully and clearly demonstrated, his Majesty therefore, desirous of Encouraging every useful Undertaking, doth hereby Institute and Establish the said Society under the Name, & Title, of the Royal Academy of Arts in London, Graciously declaring himself the Patron, Protector, and Supporter thereof, and Commanding that it be Established under the Forms and Regulations herein after mentioned, which have been most humbly laid before his Majesty and received his Royal Approbation and Assent.

1^{mo}

The said Society shall consist of Forty Members only, who shall be called Academicians of the Royal Academy they shall all of them be Artists by Profession at the Time of their Admission, that is to say, Painters, Sculptors, or Architects Men of fair moral Characters, of high Reputation in their several Professions, at least five and twenty Years of Age, resident in Great Britain, and not Members of any other Society of Artists established in London.

2^{ndo}

It is his Majesty's Pleasure that the following Forty Persons be the Original Members of the said Society. Vizt.

Joshua Reynolds	G. Michael Moser
Benjamin West	Samuel Wale
Thomas Sandby	Peter Toms
Francis Cotes	Angelica Kauffman
John Baker	Richard Yeo
Mason Chamberlain	Mary Moser
John Gwynn	Wm. Chambers
Thomas Gainsborough	Joseph Wilton
J Baptist Cipriani	George Barret
Jeremiah Meyer	Edward Penny
Francis Milner Newton	Augustino Carlini
Paul Sandby	Francis Hayman
Francesco Bartolozzi	Domenic Serres
Charles Catton	John Richards
Nathaniel Hone	Francis Zuccharelli
William Tyler	George Dance.
Nathaniel Dance	William Hoare.
Richard Wilson	Johan Zoffany.

3^{o}

After the first Institution, all Vacancies of Academicians shall be filled by Election from amongst the Exhibitors in the Royal Academy, the Names of the Candidates for Admission, shall be put up in the Academy three Months before the Day of Election, of which Day, timely Notice shall be given in Writing to all the Academicians, each Candidate shall on the Day of Election have at least Thirty Suffrages in his Favour, to be duly elected, and he shall not receive his Letter of Admission, till he hath deposited in the Royal Academy, to remain there, a Picture, Bas relief or other Specimen of his Abilities approved of by the then sitting Council of the Academy.

4^{to}

For the Government of the Society, there shall be annually elected, A President, & eight other Persons, who shall form a Council, which shall have the Entire Direction, and Management of all the Business of the Society, and all the Officers & Servants thereof shall be Subservient to the said Council, which shall have Power to Reform all Abuses, to Censure such as are deficient in their Duty, and (with the Consent of the General Body, and the King's Permission first obtained for that Purpose) to Suspend or entirely Remove from their Employments, such as shall be found guilty of any great Offences. The Council shall meet as often as the Business of the Society shall require it. Every Member shall be Punctual to the Hour of Appointment under the Penalty of a Fine at the Option of the Council, & at each Meeting the attending Members shall

receive forty-five Shillings, to be Equally divided amongst them in which Division however the Secretary shall not be comprehended.

5^{to}

The Seats in the Council shall go by Succession, to all the Members of the Society, excepting the Secretary, who shall always belong thereto. Four of the Council shall be voted out every Year, and these shall not reoccupy their Seats in the Council, till all the Rest have Served, neither the President, nor Secretary shall have any Vote, either in the Council, or General Assembly, excepting the Suffrages be equal, in which Case, the President shall have the casting Vote.

6^{to}

There shall be a Secretary of the Royal Academy, Elected by Ballot from amongst the Academicians, and approved of by the King, his business shall be to keep the Minutes of the Council, to write Letters & send Summonses &^{ca}. he shall attend at the Exhibition, assist in disposing the Performances, make out the Catalogues &^{ca}. he shall also when the Keeper of the Academy is indisposed, take upon himself the Care of the Academy, and the Inspection of the Schools of Design, for which he shall be properly qualified his Sallary shall be Sixty Pounds a Year, and he shall continue in Office during his Majesty's Pleasure.

7^{mo}

There shall be a Keeper of the Royal Academy, Elected by Ballot from amongst the Academicians, he shall be an able Painter of History, Sculptor or other Artist properly qualified. His Business shall be to keep the Royal Academy with the Models, Casts, Books & other Moveables belonging thereto, to attend regularly the Schools of Design during the Sittings of the Students, to preserve Order amongst them, and to give them such Advice & Instruction, as they shall require, he shall have the immediate Direction of all the Servants of the Academy, shall regulate all things relating to the Schools, & with the Assistance of the Visitors provide the living Models &^{ca}. He shall attend at the Exhibition, assist in disposing the Performances & be constantly at Hand to preserve Order & Decorum His Sallary shall be one Hundred Pounds a Year, he shall have a

convenient Apartment allotted him in the Royal Academy, where he shall constantly reside, & he shall continue in Office during the King's Pleasure.

8^o

There shall be a Treasurer of the Royal Academy, who, as the King is graciously pleased to pay all Deficiencies, shall be appointed by his Majesty from amongst the Academicians, that he may have a Person in whom he places full Confidence, in an Office where his Interest is concerned. And his Majesty doth hereby nominate & appoint William Chambers Esquire Architect of his Works, to be Treasurer of the Royal Academy of Arts, which Office he shall hold, together with the Emoluments thereof, from the Date of these Presents & during his Majesty's Pleasure. His Business shall be to receive the Rents and Profits of the Academy, to pay its Expenses, to superintend Repairs of the Buildings & Alterations, to Examine all Bills, & to conclude all Bargains, he shall once in Every Quarter lay a fair State of his Accounts before the Council, & when they have passed Examination & been approved there, he shall lay them before the Keeper of his Majesty's Privy Purse to be by him finally audited & the Deficiencies paid, his Sallary shall be Sixty Pounds a Year.

9^o

That the Schools of Design may be under the Direction of the Ablest Artists, there shall be Elected Annually from amongst the Academicians nine Persons, who shall be called Visitors, they shall be Painters of History, able Sculptors, or other Persons properly qualified, their Business shall be to attend the Schools by Rotation, each a Month, to set the Figures, to examine the Performances of the Students, to Advise & Instruct them, to endeavour to form their Taste, & turn their Attention towards that Branch of the Arts, for which they shall seem to have the aptest Disposition. These Officers shall be approved of by the King, they shall be paid out of the Treasury ten Shillings & sixpence for each Time of attending which shall be at least two Hours, & shall be Subject to a Fine of ten Shillings & sixpence, whenever they neglect to attend, unless, they appoint a Proxy from amongst the Visitors for the Time being, in which Case he shall be entitled to the Reward. At every Election of Visitors four of the old Visitors shall be declared non-Eligible.

10^{mo}

There shall be a Professor of Anatomy, who shall read Annually Six public Lectures, in the Schools, adapted to the Arts of Design his Sallary shall be Thirty Pounds a Year, & he shall continue in Office during the King's Pleasure.

11°

There shall be a Professor of Architecture, who shall read Annually Six Public Lectures, calculated to form the Taste of the Students to Instruct them in the Laws and Principles of Composition, to point out to them the Beauties or Faults of celebrated Productions, to fit them for an unprejudiced Study of Books, & for a critical Examination of Structures, his Sallary shall be Thirty Pounds a Year and he shall continue in Office during the King's Pleasure.

12°

There shall be a Professor of Painting who shall read Annually Six Lectures, calculated to Instruct the Students in the Principles of Composition, to form their Taste of Design & colouring, to strengthen their Judgement, to point out to them the Beauties & Imperfections of celebrated Works of Art, & the Particular Excellencies or Defects of great Masters and finally to lead them into the Readiest, & most efficatious Paths of Study. his Sallary shall be Thirty Pounds a Year, and he shall continue in Office during the King's Pleasure.

13°

There shall be a Professor of Perspective, and Geometry, who shall read Six public Lectures Annually in the Schools, in which all the useful Propositions of Geometry, together with the Principles of Lineal & Aerial Perspective, & also the Projection of Shadows, Reflecions & Refractions shall be clearly & fully illustrated, he shall particularly confine himself to the quickest, easiest, & most exact Methods of Operation. He shall continue in Office during the King's Pleasure & his Sallary shall be Thirty Pounds a Year.

14°

The Lectures of all the Professors shall be laid before the Council for its Approbation, which shall be obtained in Writing,

before they can be read in the public Schools. All these Professors shall be Elected by Ballot, the three last from amongst the Academicians.

15°

There shall be a Porter of the Royal Academy whose Sallary shall be 25 Pounds a Year, he shall have a Room in the Royal Academy, & receive his Orders from the Keeper or Secretary.

16°

There shall be a Sweeper of the Royal Academy whose Sallary shall be 10L a Year.

17°

There shall be an Annual Exhibition of Paintings, Sculptures & Designs, which shall be open to all Artists of distinguished Merit, it shall continue for the Public one Month, & be under the Regulations expressed in the By laws of the Society hereafter to be made. Of the Profits arising therefrom Two Hundred Pounds shall be given to indigent Artists or their Families, and the Remainder shall be employed in the Support of the Institution. All Academicians till they have attained the Age of Sixty shall be obliged to Exhibit at least one Performance, under a Penalty of five Pounds to be paid into the Treasury of the Academy, unless they can Show sufficient Cause for their Omission but after that Age they shall be exempt from all Duty.

18°

There shall be a Winter Academy of living Models, Men & Women of different Characters, under the Regulations expressed in the By laws of the Society hereafter to be made, free to all Students who shall be qualified to receive Advantage from such Studies.

19°

There shall be a Summer Academy of living Models to paint after, also of Laymen with Draperies, both antient & modern, Plaister Figures, Bas reliefs, Models & Designs of Fruits, Flowers, Ornaments, &^{ca}. free to all Students qualified to receive Advantage from such Studies & under the Regulations expressed in the By Laws of the Society hereafter to be made.

20$^{\text{mo}}$

There shall be a Library of Books of Architecture, Sculpture, Painting and all the Sciences relating thereto, also Prints of Bas reliefs, Vases, Trophies, Ornaments, Dresses ancient & modern Customs & Ceremonies, Instruments of War & Arts, Utensils of Sacrifice, & all other Things useful to Students in the Arts, which Library shall be open one Day in Every Week to all Students properly qualified. One of the Members of the Council shall attend in the Room during the whole Time it is open, to keep Order, & to see that no Damage be done to the Books, & he shall be paid 10/6$^{\text{d}}$. for his Attendance. No Books shall under any Pretence be suffered to be taken out of the Library. But every Academician shall have free ingress at all seasonable Times of the Day, to consult the Books & to make Designs or Sketches from them.

21$^{\text{mo}}$

There shall be annually one General Meeting of the whole Body or more if requisite, to Elect the Council & Visitors to Confirm new Laws & Regulations, to Hear Complaints & redress Grievances if there be any, and to do any other Business relative to the Society.

22$^{\text{mo}}$

The Council shall frame new Laws & Regulations but they shall have no force, till ratified by the Consent of the General Assembly and the Approbation of the King.

23$^{\circ}$

Though it may not be for the Benefit of the Institution absolutely to prohibit Pluralities, yet they are as much as possible to be avoided, that his Majesty's Gracious Intention may be comply'd with, by dividing as nearly as possible the Emoluments of the Institution amongst all its Members.

24$^{\circ}$

If any Member of the Society shall by any means become obnoxious it may be put to the Ballot in the General Assembly whether he shall be expelled, & if there be found a Majority for Expulsion, he shall be expelled provided his Majesty's Permission be first obtained for that Purpose.

25$^{\circ}$

No Student shall be admitted into the Schools till he hath satisfied the Keeper of the Academy, the Visitor & Council for the Time being of his Abilities, which being done, he shall receive his Letter of Admission, signed by the Secretary of the Academy certifying that he is admitted a Student in the Royal Schools.

26$^{\circ}$

If any Student be guilty of improper Behaviour in the Schools or doth not quietly submit to the Rules & Orders Established for their Regulation it shall be in the Power of the Council upon Complaint being first made by the Keeper of the Academy, to Expel, Reprimand, or Rusticate him for a certain Time, but if he be once Expelled he shall never be readmitted in to the Royal Schools.

27$^{\circ}$

All Modes of Elections shall be regulated by the By laws of the Society hereafter to be made for that Purpose.

I approve of this Plan, let it be put into execution
George R.

S$^{\text{t}}$. James's
Dec$^{\text{r}}$. 10$^{\text{th}}$. 1768.

NOTES

Full publication details are given at the first mention in each chapter. Subsequent references to the same source are indicated by the author (or short title where there is no author) and date.

Royal Academy archival references are given in full at the first mention in each chapter, with shortened versions for subsequent mentions. Royal Academy collection inventory numbers are indicated by RA 00/0000.

References to the *Oxford Dictionary of National Biography* (ed. H. C. G. Matthew and Brian Harrison, Oxford 2004) are abbreviated as *ODNB* throughout.

INTRODUCTION

1 RA Archives, Instrument of Foundation, Clause III, RAA/IF. Foundation Members themselves did not have to present anything. A Diploma Work is so called because on acceptance of the proffered work by Council the Academy would present the artist with a diploma, signed by the monarch, entitling the addition of the initials 'RA' after the name. Approval of a Diploma Work was not always forthcoming, and there are several instances of artists being requested to present a different work from that offered. Walter Sickert, for example, was asked in 1934 for something 'more representative' than his *Lady Macbeth* now in the Royal Shakespeare Company Collection (RA Archives, Council Minutes, 20 March 1934, RAA/PC/1/26); and in 1911 Frank Bramley was asked for a painting 'more representative of his work as a figure painter' (Council Minutes, 7 November 1911, RAA/PC/1/22).

2 The existence of the Royal Academy collections website, and of the World Wide Web in general, has done away with the need for much information that has taken up space in previous histories of the institution, such as biographies, the make-up of various committees, membership details, professorships, holders of office, and accounts of internal politics. These details feature largely in, for example, William Sandby, *The History of the Royal Academy from its Foundation in 1768 to the Present Time, with biographical notices of all the members*, 2 vols, London 1862; J. E. Hodgson and Frederick A. Eaton, *The Royal Academy and its Members 1768–1830*, London 1905; and Sidney C. Hutchison, *The History of the Royal Academy, 1768–1986*, London 1986 (first published as *The History of the Royal Academy, 1768–1968*, London 1968). The politics of the earlier history of the Academy have been studied by Holger Hoock, *The King's Artists: The Royal Academy of Arts and British Culture 1760–1840*, Oxford 2003; while a broader, more personal, view was taken by James Fenton, *School of Genius: A History of the Royal Academy of Arts*, London 2006. The earlier history of the Academy's exhibitions, which have always been such a fundamental feature of its activities, have been examined in David H. Solkin, ed., *Art on the Line: The Royal Academy Exhibitions at Somerset House, 1780–1836*, exh. cat., New Haven and London 2001. The earliest days of the Academy are traced in Charles Saumarez Smith, *The Company of Artists: The Origins of the Royal Academy of Arts in London*, London 2012. The catalogues

of three exhibitions drawn from its collections also contain many insights: MaryAnne Stevens, ed., *The Edwardians and After: The Royal Academy 1900–1950*, London 1988; Helen Valentine, ed., *Art in the Age of Queen Victoria: Treasures from the Royal Academy of Arts Permanent Collection*, London 1999; MaryAnne Stevens, ed., *Genius and Ambition: The Royal Academy of Arts London, 1768–1918*, London 2014. Architecture within the Royal Academy, which is discussed at many points in the present book, has been the subject of a study by Neil Bingham, *Masterworks: Architecture at the Royal Academy of Arts*, London 2011. That book took as its focus the Diploma Works of architect Academicians. See also an earlier work by Neil Bingham, 'Architecture at the Royal Academy Schools 1768–1836', in N. Bingham, ed., *The Education of the Architect: Proceedings of the 22nd Annual Symposium of the Architectural Historians of Great Britain*, London 1993. The architecture of Burlington House and its estate is the subject of a book by Nick Savage to be published in 2018. It covers the history from the 1680s onwards, including the latest interventions by David Chipperfield. Here architecture is chiefly discussed in relation to the Academy's successive homes since its foundation and in relation to its exhibitions.

I IN SEARCH OF A ROYAL ACADEMY

1 Its satellite, the Académie de France in Rome, was founded in 1666: J. Delaplanche, *350 anni di creatività: Gli artisti dell'Accademia di Francia a Roma da Luigi XIV ai nostri giorni*, Milan 2016.

2 The records of the Society of Artists came to the Royal Academy in 1836 and are held in the archive. Strange wrote a sour account of these battles: *The Conduct of the Royal Academicians while Members of the Incorporated Society of Artists of Great Britain*, London 1771. The standard history is Matthew Hargraves, *Candidates for Fame: The Society of Artists of Great Britain, 1760–1791*, New Haven and London 2006. For a summary see Matthew Hargraves, 'Society of Artists of Great Britain', *ODNB*.

3 In January 1769 the RA made an attempt to disguise the personal antipathies that that led to Strange's exclusion by creating a category of six Engraver Associates of the RA, but engravers did not become full Academicians until 1853. The account here of Strange is chiefly drawn from James Dennistoun, *Memoirs of Sir Robert Strange, Knt., Engraver ... and of his Brother-in-Law Andrew Lumisden ...*, 2 vols, London 1855. See also Timothy Clayton, 'Sir Robert Strange', *ODNB*. Bartolozzi's status as a painter was, in a sense, corroborated

by the Committee on the Polite Arts (of the Society for the Encouragement of the Arts) when it invited him to be one of the artists (together with Jean-Etienne Liotard) to test Charles Pache's pastels in late 1772, prior to Pache's being granted funds to establish their manufacture in London in April 1773 (at the time, the medium of pastel was described as 'painting in crayons').

4 He appears, for example, amusingly, in John Hayes, ed., *The Letters of Thomas Gainsborough*, New Haven and London 2001, pp. 167–8.

5 Dalton, who trained as draughtsman and painter, with a period under Agostino Masucci in Rome, is a complex character: see John Sunderland, 'Richard Dalton', *ODNB*.

6 Michael Wynne, 'Members from Great Britain and Ireland of the Florentine Accademia del Disegno, 1700–1850', *Burlington Magazine*, CXXXII (August 1990), pp. 535–8. The Florence academy did, however, teach, and two Foundation Members of the Royal Academy trained there, Francesco Bartolozzi and Giovanni Battista Cipriani, both of whom went on to be elected at Florence as members in the more professional category, *di merito*.

7 Dennistoun 1855, vol. 2, p. 16.

8 Several art schools were set up in Scotland from 1729 onwards, in particular the Foulis Academy in Glasgow, founded by the Foulis brothers in 1753 and running until 1775, which offered a European-style training. In Ireland, the state-sponsored Dublin Society drawing schools also predate the founding of the Royal Academy, but initially their main objective was to promote the quality of manufacturing rather than to train fine artists.

9 Henry Emlyn, *A Proposition for a New Order in Architecture ...*, London 1781, p. XIV, fig. 4.

10 Anthony Ashley Cooper, Earl of Shaftesbury, 'Letter concerning Design', in *Characteristicks of Men, Manners, Opinions, Times*, 3 vols, London 1732. Original spelling and capitalization have been preserved throughout. For the history of academies in England, see Ilaria Bignamini, 'George Vertue, Art Historian, and Art Institutions in London, 1689–1768', *Walpole Society*, LIV (1988), pp. 1–148. She misunderstood this passage. Bignamini (pp. 25–6ff) took Shaftesbury's reference to mean that the proposal for a royal academy that had been put forward in England in 1698 was still actively being considered at the time that he wrote, 1712, and moreover that Shaftesbury had always been involved in that proposal. On the contrary, in the passage more fully quoted above, Shaftesbury says, 'As for other Academys, such as those for Painting, Sculpture or Architecture [all of which were in existence in France] we have

not so much as heard of the Proposal': that is, we have not heard anything about them. Shaftesbury, it follows, was not, contrary to Bignamini's interpretation, involved in any plans for an academy, let alone with Closterman, as she asserts. See also K. Downes, 'The Publication of Shaftesbury's Letter concerning Design', *Architectural History*, XXVII (1984), pp. 519–23.

11 Narcissus Luttrell, *A Brief Historical Relation of State Affairs from September 1678 to April 1714*, 6 vols, Oxford 1857, IV, pp. 343–4, cited Bignamini 1988, p. 25.

12 One result was a plan for a Trianon at Thames Ditton, which was to be joined to Hampton Court by an appropriately lengthy avenue. John Harris, 'The Hampton Court Trianon Designs of William and John Talman', *Journal of the Warburg and Courtauld Institutes*, XXIII (1960), pp. 139–49.

13 For Thornhill's copies of the cartoons, see Arline Meyer, *Apostles in England: Sir James Thornhill and the Legacy of Raphael's Tapestry Cartoons*, exh. cat., Columbia University, New York 1996.

14 In 1735 Vleughels took the opportunity to get back at Richardson in print, in the introduction to his translation of Lodovico Dolci's *Dialogo della pittura* (1557), *Dialogue sur la peinture* (Florence 1735). See Robin Simon, *Hogarth, France and British Art: The Rise of the Arts in Eighteenth-century Britain*, London 2007, pp. 256ff.

15 Meyer 1996, p. 32, n. 66, and pp. 32ff. Simon Thurley, *Hampton Court: A Social and Architectural History*, New Haven and London 2003, p. 186.

16 For many of the details here, see Bignamini 1988, pp. 61ff.

17 Simon 2007, pp. 15ff.

18 In 1718 he relocated it to a room attached to his house in Covent Garden.

19 John Ireland, *A Supplement to Hogarth Illustrated ...*, 2nd edn, London 1804, pp. 61–2. For the original manuscript, see M. Kitson, 'Hogarth's "Apology for Painters"', *Walpole Society*, XLI (1966–8), pp. 46–111.

20 R.B. Paulson, *Hogarth*, 3 vols, Cambridge 1991–3, III, pp. 309–10.

21 Vertue II, *Walpole Society*, XX (1931–2), pp. 150–55.

22 William Hauptman, 'Before Somerset House: The Royal Academy in Pall Mall', *The British Art Journal*, XVII, 1 (2016), pp. 22–42 (quote on p. 25).

23 See the chapters on casts and furniture.

A CLOSER LOOK 1.1

1 RA Archives, Instrument of Foundation, 1768, RAA/IF; reprinted in Sidney C. Hutchison, *The History of the Royal Academy, 1768–1986*, 2nd edn, London 1986, p. 245.

2 See Holger Hoock, *The King's Artists: The Royal Academy of Arts and the Politics of British Culture 1760–1840*, Oxford 2003, especially pp. 127–45.

A CLOSER LOOK 1.2

1 RA Archives, RAA/TRE/1/1. 'An Account of the Income and Expenses of the Royal Academy from its First Institution, January 1st 1769, to December 31st 1795 both inclusive; Compiled from the copy of the general account delivered by Sir William Chambers, the late Treasurer to the Council July 10th 1795, and from original Bills and Receipts and other vouchers now in the custody of the Secretary by George Dance and William Tyler, the Committee appointed by the same Council to inspect and report upon the same.' With the initiation of the Annual Report in 1860, the accounts of the Royal Academy were published annually. A summary of the financial situation for the period 1769 to 1859 was provided in the 1860 Annual Report as 'Appendix No. 3' (p. 54), over the name of the then Treasurer, Philip Hardwick RA.

A CLOSER LOOK 1.3

1 See Introduction.

2 RA Archives, Council Minutes, 20 March 1865, RAA/PC/1/12. It was common for Academicians at this time to leave a work as a 'temporary' offering in order to comply with the institution's regulations while buying more time to produce their Diploma Work.

3 Ibid., 4 July 1864 and 26 November 1864.

4 W. R. Sickert, 'The Royal Academicians', Chapter 4 in S. Potter, *Sense of Humour*, London 1954, pp. 137–41, and M. H. Spielmann, *Millais and his Works*, Edinburgh and London 1898, p. 79.

5 F. T. Palgrave, 'English Pictures in 1865', *Fortnightly Review*, no. 6 (August 1865), p. 670.

6 W. R. Sickert, 'The Royal Academicians', in Potter 1954, p. 140.

7 Cited from a review of the section on British painting at the Paris Exposition Universelle in 1867, *Art Journal*, November 1867, p. 247.

8 Philippe Burty, 'Exposition de la Royal Academy', *Gazette des Beaux Arts*, May 1865, p. 560, and *The Times*, 8 May 1865, p. 167.

2 THE BUILDINGS

1 At the suggestion of the architect Ian Ritchie. The fountain forms part of the redesign of the courtyard by Sir Michael Hopkins RA, which was dedicated by Her Majesty Queen Elizabeth II on 22 May 2002.

2 Simon Thurley, *Somerset House: The Palace of England's Queens, 1551–1692*, London 2009, p. 31.

3 The Office of Works records are in the National Archives, E351/3243 for 1607–9; E351/3244 for 1609–10; E351/3245 for 1610–11; E351/3246 for 1611–12.

4 Thurley 2009, p. 37, marks the bedchamber 'P' as the queen's withdrawing room, and labels these rooms as being on the ground floor. The queen's bedchamber was the third in her suite of rooms facing the river, and although it was approached from ground level in the courtyard, it was on the upper floor of the river front owing to the steep fall in the ground.

5 R. Needham and A. Webster, *Somerset House*, New York 1905, p. 94.

6 National Archives, E351/3269 for 1635–6; E351/3270 for 1636–7; E351/3271 for 1637–8.

7 Jerry Brotton, *The Sale of the Late King's Goods: Charles I and his Art Collections*, London 2006; Needham and Webster 1905, p. 131.

8 *European Magazine*, August 1802, quoted by Needham and Webster 1905, pp. 92–3.

9 RA Archives, Council Minutes, 7 January 1771, RAA/PC/1/1. A drawing by the young John Soane when at the Royal Academy Schools is inscribed 'Front next the Thames of the Royal Academy from actual Measurements 1770' (Sir John Soane's Museum, London, 74/2/2).

10 Thurley 2009, p. 37, shows these marked as R, S and T.

11 Richard Stephens, 'Four Letters by Sir Joshua Reynolds', *The British Art Journal*, X, 2 (Winter 2009), pp. 58–9; Julia King, 'An Ambassador's House in Essex', *Georgian Group Journal*, 1997, pp. 117–29.

12 'An Act for Settling Buckingham House with the Appurtenances thereof upon the Queen in case she shall survive his Majesty in lieu of his Majesty's Palace of Somerset House, for enabling the Lords Commissioners of the Treasury to sell and dispose of Ely House in Houlborn, and for applying the money to arise by the sale thereof in erecting and establishing public offices at Somerset House, and for embanking certain parts of the River Thames lying within the bounds of the Manor of the Savoy, and for other purposes herein mentioned.' L. M. Bates, *Somerset House: Four Hundred Years of History*, London 1967, p. 108.

13 The east wing was added by Robert Smirke 1830–35 for King's College, and the west wing by James Pennethorne 1851–61 for the Inland Revenue.

14 The other government offices included the Legacy Office, the Lottery Office, and the offices of the Duchies of Cornwall and Lancaster. Joseph Baretti (*A Guide through the Royal Academy*, London 1781, p. 4) lists them.

15 Chambers had spent his early life in Sweden, and his title was given him by the Swedish king.

16 Baretti 1781, p. 17.

17 Edward Croft-Murray, 'Decorative Paintings for Lord Burlington & the Royal Academy', *Apollo*, January 1969, pp. 18–19.

18 Baretti 1781, p. 15.

19 Ibid., p. 31.

20 Letter to William Mason, 19 May 1780. W. S. Lewis, ed., *Correspondence of Horace Walpole*, 48 vols, New Haven 1937–83, xxix, p. 33 and n. 10.

21 Its space at Somerset House was under pressure from an expanding government bureaucracy.

22 Council Minutes, 28 June 1834, RAA/PC/1/8.

23 Ibid., 1 November 1834.

24 Wilkins's evidence, printed in the *Report of the Select Committee on Arts & their Connexion with Manufactures*, London 1836, p. 123, section 1392. Lord Aberdeen was chairman of the Trustees of the National Gallery.

25 These rights of way were closed in the 1880s and the spaces converted into additional entrances.

26 Wilkins's evidence, in *Report 1836*, p. 101, sections 1197, 1207.

27 The early proposal for the Public Record Office also to share the building was dropped.

28 J. Mordaunt Crook and M. H. Port, eds, *The History of the King's Works, Volume VI: 1792–1851*, London 1973, p. 463.

29 Wilkins's drawings for the National Gallery are in the National Archives, Works 33/909–63.

30 Mordaunt Crook and Port 1973, p. 467.

31 Evidence of T. C. Hofland, in *Report 1836*, pp. 105–6, sections 1357, 1263.

32 Although students had access to the Library.

33 Wilkins's 1833 plan of the basement shows a kitchen, scullery, cellar and wine cellar, as well as a large bedroom for 'women servants' and a room for a footman; there was a water closet on both floors. National Archives, Works 33/920.

34 Sidney C. Hutchison, *The History of the Royal Academy 1768–1968*, London 1968, p. 103.

35 Wilkins 1833 basement plan. National Archives, Works 33/920.

36 'Resolved that the unfinished marble by Michelangelo be placed over the chimney in the library' (Council Minutes, 24 December 1836).

37 'Mr Edge to fit up the new building for the conveyance of gas, to 23 different places ... for £308' (ibid., 1 February 1837).

38 'A farewell dinner will take place at Somerset House on the occasion of removing the establishment to Trafalgar Square on Saturday next' (ibid., 12 December 1836).

39 Geoffrey Tyack, *Sir James Pennethorne and the Making of Victorian London*, Cambridge 1992, p. 202.

40 Letter from William Cowper, First Commissioner, to Sir Charles Eastlake, dated 5 June 1865. National Gallery Archives, NG5/168/5.

41 Once the barracks and workhouse were demolished, the rights of way closed, and their sites had become available, it was able to expand northwards into magnificent new galleries designed by E. M. Barry RA.

42 Robert Latham and William Matthews, eds, *The Diary of Samuel Pepys*, 11 vols, London 1971–82, VI, p. 39: 20 February 1665.

43 J. Kip and L. Knyff, *Britannia Illustrata*, London 1707.

44 For a detailed description by Walter Ison of Burlington House and its development, see *Survey of London, XXXII: Parish of St James's Westminster, Part II: North of Piccadilly*, London 1963, pp. 309–429.

45 The 41 hearths probably included the pavilions. *Survey* 1963, p. 392.

46 Annabel Ricketts, *The English Country House Chapel*, Reading 2007, p. 155.

47 Two drawings attributed to Jean-Claude Nattes in the London Metropolitan Archive show the top floor. SC/PZ/WE/01/352 shows a small servant's bedroom, and SC/PZ/WE/01/353 shows the large central space in the northern range. Neither of these spaces appears to have been altered very much since the house was built.

48 'Here I ... standing by a candle that was brought for sealing of a letter, do set my periwigg a-fire; which made such an odd noise, nobody could tell what it was till they saw the flame, my back being to the candle': Pepys, *Diary*, 28 September 1668, in Latham and Matthews 1971–82, IX, pp. 321–2.

49 Possibly the first changes to the house were made in his minority by his mother, Juliana. *Survey* 1963, p. 395.

50 Horace Walpole, *Anecdotes of Painting in England*, vol. IV, London 1771, p. 109.

51 Burlington paid Pellegrini £200 and Ricci £700 for their work. The dating of their work is problematic (see *Survey* 1963, p. 394); but see George Knox, 'Antonio Pellegrini and Marco Ricci at Burlington House and Narford Hall', *Burlington Magazine*, CXXX (November 1988), pp. 846–63, who dates the paintings to 1709–10.

52 Sir James Thornhill refers to payments by Burlington of £200 to Pellegrini and £700 to Sebastiano Ricci. Tim Knox, 'Report on the Decorative History of the Private Rooms of Burlington House', 2 vols, internal report, Royal Academy 1998, II, p. 13.

53 The notion that substantial amounts of the Kent decoration survived, justifying the destruction of the Crace scheme in order to recover it, proved incorrect, and now only fragments of either exist.

54 Croft-Murray 1969, pp. 11–15.

55 For instance, Benjamin West arranged for some of his friends to view them. The admission note is in the National Art Library (Victoria and Albert Museum, London), 86.WW.1.

56 The Hon. Charles's elder brother, although he died in 1812, had a son who succeeded his grandfather as 2nd Earl of Burlington in 1834 (and through quirks of inheritance eventually became 7th Duke of Devonshire). At the time of the negotiations over Burlington House he was Chancellor of the University of London.

57 Transcript of original letter in Council Minutes, 5 June 1865, RAA/PC/1/12.

58 Ibid., 30 July 1866.

59 'The President recommended that if required by the government it would be advisable for the Academy to offer a considerable sum, say £30,000 or £20,000, to purchase the interest now held by the Royal Society in the building of Burlington House' (ibid., 3 July 1866).

60 Ibid., 4 February 1867.

61 Letter to Banks and Barry dated 11 March 1867. RA Archives, Letters from Sir Francis Grant, MIS/6R/6. I am grateful to Mark Pomeroy for providing me with transcripts of Grant's correspondence.

62 Approved by the Council in March 1867 (ibid.).

63 Sir Albert Richardson, 'A Painter's Views on Architecture', *Country Life*, 5 July 1962, p. 14.

64 Some of Smirke's designs are in the Royal Institute of British Architects Drawings Collection, SC95/18/1–10 and SA23/4.

65 J. Mordaunt Crook, *Seven Victorian Architects*, London 1976, p. 65.

66 Nikolaus Pevsner and Simon Bradley, *Buildings of England, London 6: Westminster*, London and New Haven 2003, p. 488.

67 The sculptors were Calder-Marshall, Durham, Stephens and Weekes. The position of the sculptures was approved by the General Assembly on 25 February 1872. Council Minutes, 4 March 1872, RAA/PC/1/13.

68 Gallery VI was intended for sculpture and was not originally top-lit until the 1880s, but had side windows.

69 Plan of upper floor by Norman Shaw RA, 1883. RA Archives, Exhibition Notices, RAA/SEC/22/6.

70 R. Phené Spiers, *Architectural Review*, XVI (1904), p. 206.

71 Ingrid Roscoe, Emma Hardy and M. G. Sullivan, *A Biographical Dictionary of Sculptors in Britain 1660–1851*, New Haven and London 2009, p. 523.

72 The contractors for the new building were Messrs Jackson & Shaw, who were paid £2,000 in 1867 for the foundations. Council Minutes, 2 July 1867.

73 Council Minutes, 4 June 1870.

74 Letter from Sir Francis Grant to Banks and Barry, 20 June 1867. Letters from Sir Francis Grant, MIS/GR/18.

A CLOSER LOOK 2.1

1 Sir John Soane's Museum, drawer 42, set 2, no. 11. I am grateful to Stephen Astley, curator of the museum, for the information he provided. The account here is drawn from the author's larger study of the Pall Mall residence of the Royal Academy: William Hauptman, 'Before Somerset House: The Royal Academy in Pall Mall', *The British Art Journal*, XVII, 1 (2016), pp. 22–42.

A CLOSER LOOK 2.2

1 *The Works of Sir Joshua Reynolds ... To which is prefixed an Account of the Life and Writings of the Author*, 2nd edn, 3 vols, London 1798, I, p. xxxii. There is a good account of Burke's influence on Reynolds in Frederick Hilles, *The Literary Career of Sir Joshua Reynolds*, Cambridge 1936, pp. 137–40.

2 Recent scholarship has concentrated much more on Reynolds's art than on his ideas. In writing this essay, I am indebted to Ian McIntyre, *Joshua Reynolds: The Life and Times of the First President of the Royal Academy*, London 2003, and Mark Hallett, *Reynolds: Portraiture in Action*, London and New Haven 2014, but more to Hilles 1936, and Frederick Hilles, ed., *Portraits by Sir Joshua Reynolds*, New York and London 1952.

3 The Literary Club has not been much written about, apart from *Annals of The Club 1769–1914*, London 1914, which contains original source material; Lewis P. Curtis and Herman W. Liebert, *Esto Perpetua: The Club of Dr. Johnson and his Friends, 1764–1784*, Hamden, Conn. 1963; and, more recently, Pat Rogers, 'Samuel Johnson and his Friends: The Clubbable and the Unclubbable', *New Rambler: Journal of the Johnson Society of London*, 2011–12, pp. 25–48, and Charles Saumarez Smith et al., *New Annals of the Club*, London 2014.

4 For this moment in the Academy's history, see Charles Saumarez Smith, *The Company of Artists: The Origins of the Royal Academy of Arts in London*, London 2012, p. 66.

A CLOSER LOOK 2.3

1 See N. Bingham, *Samuel Ware and the Creation of the Great Staircase at Burlington House, Piccadilly, London*, exh. cat., London 2008.

3 BURLINGTON HOUSE

1 Plan of the upper floor of Burlington House by Richard Norman Shaw RA, 1883, RA Archives, Exhibition Notices, RAA/SEC/22/6.

2 The scheme was approved by General Assembly, 20 July 1899: the cost was not to exceed £2,200. Structural defects demanding rectification, however, brought the final cost to £3,578 1s. 7d. RA Archives, Annual Report 1899, p. 9, and Annual Report 1900, p. 6, RAA/PC/10.

3 RA Archives, Sir Francis Grant PRA, 'Correspondence relative to the new site for the Royal Academy of Arts on the Burlington House Estate', letter from Grant to Lord Derby, 8 August 1866, RAA/PRA/2/1.

4 Ibid., Grant to General Grey, end July 1866.

5 Ibid.

6 The Academy was eager to demonstrate to the Royal Commission of 1863 that it had already begun to address the meagre number of no more than 20 Associates at any one time initially instituted on 11 December 1769, Annual Report 1863, p. 8; this limit was removed on 31 July 1866 and the number increased to 30 on 5 December 1879.

7 RA Archives, General Assembly Minutes, 18 March 1869, RAA/GA/1/7.

8 William Powell Frith, *My Autobiography and Reminiscences*, 2 vols, New York 1888, I, p. 441.

9 RA Archives, Sir Roger de Grey, papers relating to the building, RAA/PRA/10/54.

10 An additional gallery had been added to Sidney Smirke's original suite of two Diploma Galleries and the Gibson Gallery by Richard Norman Shaw RA in 1885, but this has been set at approximately 3 feet (1 metre) above the Smirke galleries.

11 Sir Roger de Grey, New Diploma Galleries, papers and correspondence, RAA/PRA/10/55.

12 Photocopy in author's possession of a currently unlocated original document.

13 For a comprehensive set of concept drawings, plans and elevations, see Foster Associates London Archive 356; for J. T. Cadbury-Brown RA's intervention to ensure natural top lighting in the new galleries, see his note to Roger de Grey PRA, RAA/PRA/10/55.

14 Sir Roger de Grey, New Diploma Galleries.

15 See ibid., notably letters from Leonard Manasseh RA to the President, 4 February 1987, and note from Philip Powell RA to the President, 30 October 1988.

16 The final cost of the Sackler Galleries was reported to have been £5,257,000: Sir Roger de Grey, Sackler Galleries, RAA/PRA/10/58.

17 Robert Maxwell, 'Norman Foster – The Sackler Galleries', first published in *Casabella*, October 1991, reprinted in *Sweet Disorder and the Carefully Careless: Theory and Criticism in Architecture*, Princeton 1993.

18 For documents outlining the brief and the initial estimated costs of the new Library, see Sir Roger de Grey, papers relating to the building.

19 RA Archives, uncatalogued file: Secretary, schedule 1, file 16 – Library 1986–9.

20 See RA 09/3262, RA 09/3263, RA 09/3264.

21 See 'Proposal for the Move of the Library to the Gibson Gallery' and related documents (as note 19 above).

22 'The Print Room: Summary of the brief and diagram showing public and staff access floors', RA 09/3251.

23 See RA 09/3251, RA 09/3252, RA 09/3254 and RA 10/1075.

24 Photocopy in author's possession of unlocated original document.

25 Annual Report 2002, pp. 5, 16; the Archive Room, subsequently named 'The Dame Jillian Sackler Archive Room', opened on time and within budget.

26 See *Survey of London XXXII: Parish of St James's Westminster, Part II, North of Piccadilly*, London 1963, pp. 435–41.

27 The Royal Academy possesses an impressive model of the Hopkins Architects scheme: *Model for the Development of Burlington Gardens with Burlington House*, 1997, Diploma Work accepted 9 June 2009; RA 09/2578.

28 For the Academy's loan exhibitions in relation to modernism, see Chapter 4.

29 The British Institution loan exhibitions were presaged by the short-lived 'English School', an exhibiting society founded in London in 1802 by two artists and the young technologist George Field. The 'English School' provided space for selling displays of primarily contemporary works of art, but also presented works by members of the British School and recently deceased artists lent by major collectors. See J. Gage, '"The British School" and the British School', *Towards a Modern Art World*, ed. Brian Allen, New Haven and London 1995, pp. 109–20.

30 Nicholas Tromans, 'Museum or Market: The British Institution', *Governing Cultures: Art Institutions in Victorian England*, ed P. Barlow and C. Trodd, Aldershot 2000, pp. 44–55. For a more extensive discussion of the history of loan exhibitions, see F. Haskell, *The Ephemeral Museum: Old Master Paintings and the Rise of the Art Exhibition*, New Haven and London 2000.

31 For example, one gallery was hung chronologically in 1848 with, for the first time, labels bearing the artist's name, title and date of each work, a practice that was subsequently adopted by the National Gallery when it rehung its galleries in 1855.

32 Annual Report 1866, pp. 60–61.

33 Annual Report 1868, p. 9; the Royal Academy had agreed to lend some works to this exhibition. At Manchester an astonishing 16,000 works had been on display.

34 Established 1866, dissolved 1952; it had its origins in the Fine Arts Club, formed in 1856.

35 Annual Report 1869, pp. 7–8.

36 Ibid., p. 8.

37 Ibid., pp. 5–10. It should be noted that as early as 1802 the Academy's Library had begun to acquire prints after works by leading artists of the British School (see Chapter 17).

38 Letter to S. A. Hart RA, 12 November 1869. RA Archives, Uncatalogued letters concerning early winter exhibitions, acc. 796.

39 Catalogues of all loan exhibitions from 1870 to 1939 have been digitized and are available online, in some cases accompanied by illustrations of works included in each exhibition. See also Lea Schleiffenbaum, 'The First Loan Exhibition at the Royal Academy of Arts, Burlington House, London, 1870', *The British Art Journal*, XIV, 3 (2015), pp. 68–74.

40 Its powers to deliver the first loan exhibition were invested in the committee by Council, 20 October 1869.

41 Letter from Courtney Boyle to S. P. Hart RA, 14 December 1869. Uncatalogued letters.

42 The usual explanation for refusal of such an offer was that 'arrangements were too far advanced'; see letter from S. A. Hart RA to Mrs Adolphus Clark, 27 November 1869, ibid.

43 Letter from S. A. Hart RA to Thomas Agnew, 10 November 1869, ibid.

44 Letter from Royal Academy to the Burlington Fine Arts Club, 19 November 1869, responded to by the latter on 30 November 1869, ibid.

45 A look at the floor plan in Schleiffenbaum 2015, p. 70, pl. 2, shows how this arrangement made sense.

46 45 and 29 respectively.

47 Annual Report 1870, p. 9.

48 The three recipient charities were the Artists' Orphanage (£500), the General Benevolent Fund (£160) and the Female Artists' Fund (£50).

49 The Times, 3 January 1870.

50 The Times, 2 January 1870.

51 Reported by the Athenaeum on 5 February: Schleiffenbaum 2015, p. 73.

52 Annual Report 1870, p. 9.

53 See C. Newell, The Grosvenor Gallery Exhibitions, Cambridge 1995; S. P. Casteras and C. Denney, eds, The Grosvenor Gallery: A Palace of Art in Victorian England, exh. cat., New Haven and London 1996; and C. Denney, At the Temple of Art: The Grosvenor Gallery, 1877–1890, Madison, N.J. 2000.

54 Devoted to, respectively, G. F. Watts RA (1882), Lawrence Alma-Tadema RA (1883), Joshua Reynolds PRA (1884), Thomas Gainsborough RA (1885) and J. E. Millais RA (1886).

55 See C. E. Hallé, Notes on a Painter's Life, London 1909. These solo exhibitions were devoted to E. Burne-Jones ARA (1893), G. F. Watts RA (1896), D. G. Rossetti (1897) and W. B. Richmond RA (1900).

56 See A. G. Temple, Guildhall Memories, London 1919.

57 See C. Lowe, Four National Exhibitions in London and their Organiser, London 1892.

58 For example, Holbein in 1871 (Dresden), Rubens in 1877 (Antwerp), Rembrandt in 1898 (Amsterdam), Cranach in 1899 (Dresden) and Van Dyck in 1900 (Antwerp).

59 The Times, 5 January 1880. The Royal Academy showed 500 sheets, the Grosvenor Gallery 1,100.

60 Annual Report 1891, pp. 11–12, 22–3.

61 The Times, 30 December 1893.

62 Since the 1880s, the National Gallery had been circulating exhibitions of British painting to regional museums, but it was barred from lending Old Masters for exhibition both within

and beyond the United Kingdom. The recently established National Gallery of Ireland was under no such restrictions, and lent for the first time to the Royal Academy's Winter Exhibition of 1882.

63 The attribution is that of Sacha Llewellyn: personal communication to Robin Simon, 16 November 2016. A signed and inscribed study of the composition, labelled on the reverse with title and the artist's name and address, oil on board, 27.9 × 95.3 cm, was with Darnley Fine Art, London, November 2016.

64 1918 included exhibitions under the auspices of the Imperial War Museum and one which included pictures commissioned by the Australian War Artists' Commission; 1919 had two exhibitions devoted to war memorials, one general and one to Canadian war memorials.

65 Rent was set at £100, but increased to £150 in 1920.

66 None of these exhibitions was very popular. For example, 'Exhibition of Works by [Thirty-six] Recently Deceased Members of the Royal Academy' (1922) attracted a mere 6,426 visitors, and 'Commemorative Exhibition of Works by Late Members' (1933) 40,000.

67 See note 56 above.

68 Haskell 2000, p. 105.

69 'Introduction', 'Exhibition of Flemish and Belgian Art 1300 to 1900', 1927.

70 'Exhibition of British Primitive Paintings (from the Twelfth to the Early Sixteenth Century) with some Related Manuscripts, Figure Embroidery and Alabaster Carvings', October–November 1923.

71 The pattern of exhibitions devoted to the fine and decorative arts was interrupted twice during this period: 'British Art in Industry' (1935), mounted with financial support from the Royal Society of Arts, and 'British Architecture' (1937), which attracted a mere 8,850 visitors over eight weeks and led the Academy to conclude that 'the general public in this country take little interest in the technical side of Architecture' (Annual Report 1937, p. 13).

72 Apart from the appeal of the subject matter and the exceptional quality of loans, visitor numbers were also driven up by a more professional approach to press and marketing introduced in 1933 by the appointment of the energetic Australian-born Alleyne Clarice Zandor (1893–1958) as a dedicated manager of publicity.

73 'Royal Academy Planning Committee: Exhibition of Designs for Reconstruction of London after the War', 14 October–28 November 1942. This was followed by the London County Council's more radical and 'modernist' proposals,

which were presented, also at Burlington House, in an exhibition, 'London County Council: County of London Plan Exhibition', 3–28 November 1943.

74 'Exhibition of Works from the Paul Oppé Collection: English Watercolours and Old Master Drawings'.

75 Annual Report 1951, p. 11.

76 Norman Rosenthal, 'The Future of the RA', Spectator, 1 January 1977, pp. 46–7.

77 With restricted space for display of the Academy's collections within Burlington House, these two spaces, subsequently extended to include the Council Room, permitted regular focus on specific areas of their holdings, ranging over different media and including both the fine arts and architecture, as well as celebrating important donations and providing complementary displays in conjunction with loan exhibitions.

78 Capitalizing on 'found' space within Burlington House, the ramp leading to the restaurant ('The Architecture Space') was appropriated by the architecture programme in 2004 for small, highly focused and often challenging architectural exhibitions, both thematic and of individual practitioners.

79 The Sackler Galleries removed the need to press the Private Rooms into temporary exhibition service, making it possible to undertake their comprehensive restoration in 2003. Reopened as the Fine Rooms, they served as a window on to the Academy's permanent collection and provided much needed income-generating spaces from functions.

80 This facet of the programme was reinforced with the introduction in 2010 of the series of 'Artists / Laboratory' exhibitions, in which an individual member was invited to explore specific issues within their creative production; the series was inaugurated by Ian McKeever RA, followed by Stephen Farthing RA.

81 Shown in 1985, 1987, 1989 and 1993, respectively.

82 It went to Berlin 1998–9 and Brooklyn 1999–2000 (where it fully lived up to its controversial reputation).

83 See note 71 above.

84 Exhibitions held in 1997, 2004, 1993, 1995 (in association with the Royal Institute of British Architects and presented at the headquarters in Portman Place) and 2013, respectively.

85 Annual Report 1972, p. 9.

86 Annual Report 1978–9, p. 8. The Academy also approached Westminster City Council for complete relief of rates (ibid., p. 9) and the Department of the Environment for the repairs and maintenance of Burlington House, which

was turned down by the Rt Hon. Michael Heseltine MP. Ibid., p. 9; letter dated 14 June 1979, Sir Roger de Grey, Papers relating to the building.

87 Annual Report 1979, p. 3.

88 Usually only available to national museums and galleries, the scheme was extended, exceptionally, in 1979 to the Royal Academy, in order to cover the high value of works lent to 'Post-Impressionism: Cross-currents in European Art, 1880–1910'. The Royal Academy, despite being a private institution, has benefited from the scheme ever since.

A CLOSER LOOK 3.1

1 All subsequently Academicians.

2 For the quotation here, see Caroline Dakers, *The Holland Park Circle*, London 1999, p. 238.

A CLOSER LOOK 3.2

1 Alison Smith, ed., *Exposed: The Victorian Nude*, exh. cat., Tate Britain, London 2001, cat. 37, p. 103.

2 Stephen Jones in *Frederic Leighton 1830–1896*, exh. cat., Royal Academy of Arts, London 1996, cat. 59–60, p. 165.

3 'Fine Arts: The Royal Academy', *Athenaeum*, 8 May 1869, p. 610.

4 'The Royal Academy Exhibition', *Daily News* 22 May 1869.

5 Leonée Ormond, 'Leighton and the Subject Picture', in *Frederic Leighton 1830–1896*, pp. 69–80 (quote on p. 76).

6 Mrs Russell Barrington, *The Life, Letters and Work of Frederic Leighton*, 2 vols, London 1906, II, p. 188.

7 The sketchbook is in the Royal Academy Collection (RA 06/1780).

8 Christopher Newall in *Frederic Leighton 1830–1896*, cat. 57, p. 162.

A CLOSER LOOK 3.3

1 Leighton is described as 'king' of the Victorian art world by Leonée Ormond, 'Leighton and the Royal Academy', in *Frederic Leighton 1830–1896*, exh. cat., Royal Academy of Arts, London 1996, p. 18.

2 Most reports of Leighton's death acknowledged that he had been suffering from an 'affectation of the heart', but many nevertheless described his death as 'unexpected' or 'a shock',

including *The Times* (27 January 1896) and the *Daily Telegraph* (27 January 1896). His death being brought about by 'a chill' was reported in the *Lloyds Weekly Register* (26 January 1896) and the *Illustrated London News* (1 February 1896), among other publications.

3 RA Archives, Leighton papers, LEI/48.

4 *The Times*, 3 February 1896.

5 Martin Postle, 'Reynolds, Sir Joshua (1723–1792)', *ODNB*. See also the *Daily Telegraph*, 28 January 1896.

6 Illustrations showing Leighton lying in state in his studio were published in the *Daily Graphic* (28 January 1896), the *News of the World* (2 February 1896) and the *Minute* (4 February 1896). These and many more contemporary press cuttings are in a scrapbook in the Leighton papers, LEI/47.

7 Leighton papers, LEI/44.

8 Mrs Russell Barrington, *The Life, Letters and Work of Frederic Leighton*, 2 vols, London 1906, II, pp. 336–8, and *The Times*, 3 February 1896.

9 *The Times*, 3 February 1896.

10 *Country Gentleman*, 8 February 1896.

11 RA Archives, Order of service for the funeral of Lord Leighton, RAA/SEC/10/53/4, and Leighton papers, LEI/47.

12 Leighton papers, LEI/48.

4 MUNNINGS AND AFTER

1 Sir Alfred James Munnings, *The Finish*, London 1952, p. 145. He published the speech, preceded by an apologia, in his book *An Artist's Life*, London 1950. It can be heard in the British Library Sound Archive: C1398/0095 C3.

2 Munnings 1952, p. 145.

3 Ibid.

4 Ibid.

5 Ibid.

6 James Fenton, *School of Genius: A History of the Royal Academy of Arts*, London 2006, p. 23.

7 Recorded in RA Archives, Annual Report 1945, p. 33, RAA/PC/10.

8 Ibid.

9 Quoted ibid., p. 28.

10 Ibid., 1945, p. 33.

11 Ibid.

12 Ibid., p. 37.

13 Ibid., p. 41.

14 Ibid., p. 40.

15 Munnings 1952, p. 145.

16 Ibid.

17 Annual Report 1945, p. 34.

18 Ibid., p. 36.

19 Ibid., p. 16.

20 Raymond Mortimer, 'The Tate versus the Academy', *New Statesman and Nation*, 15 January 1949. See Chapter 2 for exhibitions at the Academy in the twentieth century.

21 John Rothenstein, 'Why the Tate Does Not Show its Chantrey Pictures', *Daily Telegraph*, 20 January 1949.

22 *City Press*, 11 March 1955.

23 Reported in *Oxford Mail*, 1 June 1955.

24 *The Times*, 30 April 1955.

25 T. W. Earp, 'The Ancient Battle Joined Anew', unidentified cutting in RA Archives presumably from the *Daily Telegraph*, of which Earp was the art critic.

26 *The Times*, 30 April 1955.

27 Myfanwy Piper, 'The Royal Academy', *Sunday Times*, 1 May 1955.

28 *Architects Journal*, 5 May 1955.

29 Mervyn Levy, *Manchester Guardian*, 19 May 1956.

30 Quoted in *Scotsman*, 12 December 1956.

31 Ibid.

32 *Everybody's*, 12 January 1957.

33 Quoted in *Daily Express*, 1 July 1955.

34 The full text of the speech was published in the *Studio*, CLIV, 774 (September 1957), pp. 74–5, 83.

35 'Picasso Jibe at PRA', *Daily Telegraph*, 1 May 1958.

36 David Sylvester, 'Round the London Galleries', *Listener*, 15 May 1958.

37 *Studio*, September 1957, p. 74.

38 *New Chronicle*, 3 May 1957.

39 Edward Lucie-Smith, 'Art and the Mass Audience', *The Times*, 23 March 1965.

40 'Pop Goes the Academy', *Sunday Times*, 4 April 1965.

41 Richard Walter, 'RA Stops Snubbing the Moderns', *Daily Mail*, 31 March 1965.

42 Barrie Stuart-Penrose, 'Profile: Monnington', *Arts Review*, 7 January 1967.

43 Annual Report 1968, pp. 32–3.

44 Guy Brett, 'Sculpture at RA: New and Dispiriting', *The Times*, 7 January 1972.

45 RA Library, The 213th Royal Academy of Arts Summer Exhibition, list of works, 1981.

46 Annual Report 1952, p. 33.

47 Annual Report 1980–81, p. 26.

48 Quoted in James Naughtie, 'Thatcher Draws Line at "State Art"', *Scotsman*, 28 May 1980.

49 Sarah Jane Checkland, 'Quality in Abstract', *Sunday Today*, 8 June 1986.

50 RA Archives, Fay Ballard, RA press release, Summer Exhibition, 1989, RAA/PRE/2.

51 *Sunday Telegraph*, 25 June 1989.

52 *The Times*, 11 February 1996.

53 Quoted in *Sunday Telegraph*, 21 September 1997.

54 Quoted by Lucinda Bredin, 'Meltdown at the Academy', *Daily Telegraph*, 27 September 1997.

55 Quoted in *Daily Telegraph*, 3 May 2000.

56 Quoted in ibid., 14 December 2011.

57 Fiona Rae RA was appointed Professor of Painting a little later the same day.

58 Quoted from a conversation between Christopher Le Brun and the author, 31 March 2015.

A CLOSER LOOK 4.1

1 Dame Laura Knight, *Oil Paint and Grease Paint*, London, 1936, pp. 171–2.

2 Sir Alfred Munnings, *The Second Burst*, Suffolk, 1951, p. 139.

3 The grey horse is probably based on one from Isaac Bell's stables that Munnings painted while in Ireland (see ibid., opposite p. 137) and later acquired himself. He wrote, 'Were I to enumerate all the pictures in which that grey has appeared, I should need many pages' (ibid., p. 141).

4 This version was exhibited at the RA in 1926; see Angela Jarman, ed., *Royal Academy Exhibitors 1905–1970*, 6 vols, Wakefield 1973–82, III, p. 198. Another version of the Kilkenny Horse Fair, dated 1922 and probably the one exhibited at the RA in 1923, went on sale at Sotheby's, New York (2 November 2001) and at Christie's, London (21 May 2004).

5 Munnings 1951, p. 140.

6 Ibid. p. 142.

7 Munnings visited Ireland during an eventful phase in the country's history, following the War of Independence but before the declaration of the Irish Free State. In his autobiography, the artist mentions Waterford Races being run by 'young Sinn Feiners' and also strike action by members of the same party disrupting the cattle fair in Kilkenny town; see ibid., pp. 140–41.

8 Jean Goodman, 'Munnings, Sir Alfred James (1878–1959)', *ODNB*.

A CLOSER LOOK 4.2

1 William Roberts, *In Defence of English Cubists*, London 1974; Andrew Gibbon Williams, *William Roberts: An English Cubist*, London 2004.

2 William Roberts, 'A Reply to my Biographer Sir John Rothenstein' (London 1957), quoted in John David Roberts, ed., *William Roberts: Five Posthumous Essays and Other Writings*, Valencia 1990, p. 159.

3 With Bonham's, London, 18 November 2015.

4 Formerly with the Sheen Gallery, Richmond, London.

5 Christie's, London, 12 November 1987.

5 PANTHEONS AND PORTRAITS

1 See, for example, Ian Jenkins, *Archaeologists and Aesthetes*, London, 1992, esp. ch. 2, 'The Museum as a Drawing School', pp. 30ff. The Academy owns three plaster casts after the Elgin Marbles made at this time.

2 Giovanna Giusti and Maria Sframeli, eds, *Artists' Self-portraits from the Uffizi*, exh. cat., Milan 2007, pp. 22ff.

3 Martin Postle, *Joshua Reynolds: The Creation of Celebrity*, exh. cat., London 2005, p. 80; Giusti and Sframeli 2007, cat. 20. The translation of Reynolds's *Discourses* into Italian was made by Joseph Baretti, Secretary for Foreign Correspondence at the Royal Academy, whose work was not acknowledged in the Italian publication edited by Luigi Siries. See G. Baretti, *Lettera scritta da Giuseppe Baretti a Luigi Siries a Firenze*, London [1778], copy addressed in MS by Baretti and mailed by him to the director of the Uffizi, Giuseppe Pelli, dated 13 December 1778: Yale Center for British Art, New Haven, MS Reynolds 60. The Yale Center also has Pelli's copy of the Reynolds volume (ND497.R4 A3516 1778).

4 Robin Simon in Martin Postle, ed., *Johan Zoffany RA: Society Observed*, exh. cat., New Haven and London 2011, cat. 59.

5 The only other woman there, Sophie Berthelot, simply happened to have been buried with her husband.

6 See Ilaria Bignamini, 'Art Institutions in London 1689–1768: A Study of Clubs and Academies', *Walpole Society*, LIV (1988), pp. 19–148 (quote on p. 22, n. 6). The confraternity is now the Pontificia Insigne Academia di Belle Arti e Letteratura dei Virtuosi al Pantheon.

7 The contrasting posthumous fate of Lecouvreur and Oldfield ('Ophils'), inter alia, in the monuments ('temple de mémoire') of France and England was the subject of one of Voltaire's finest poems, *La mort de Mademoiselle Lecouvreur*:

Le sublime Dryden, et le sage Addison,
Et la charmante Ophils, et l'immortel Newton,
Ont part au temple de mémoire:
Et Lecouvreur à Londre aurait eu des tombeaux
Parmi les beaux-esprits, les rois, et les héros.

Robin Simon, *Hogarth, France and British Art: The Rise of the Arts in Eighteenth-Century Britain*, London 2007, p. 132, see n. 27. A later monument to an actress in the abbey is that is to Hannah Pritchard, although it was moved to the triforium in the 1930s in order to make room for the bust of Dr Johnson.

8 David Bridgewater has pointed out that Jean Dassier was producing medals of a set of British worthies at the same time that Rysbrack and Scheemakers were working on the Stowe Worthies and that, moreover, he had earlier (1723–4) produced portrait medallions of the great men of France, *Les hommes illustres du siècle de Louis XIV*, advertised in the *Mercure de France* in 1723. These portraits were themselves derived from the engraved pantheon of Charles Perrault, *Hommes illustres qui ont paru en France pendant ce siècle* (Paris, 1696–1700). In the event, only eight of Dassier's British worthies appeared. His son, Jacques-Antoine, produced 12 medals of his own set of British worthies, advertised in 1741. See David Bridgwater blog, *Bath, Art and Architecture*, http://bathartandarchitecture.blogspot.co.uk/search?q=dassier, accessed 2 December 2015.

9 See Holger Hoock, *Empires of the Imagination: Politics, War and the Arts in the British World*, London 2010, pp. 134ff.

10 Another of Ludwig's buildings, the Neue Pinakothek, Munich, was once adorned on its exterior by a spectacular display of frescoes of modern artists, sculptors and architects that was destroyed in the Second World War. They were painted by the director of the gallery, Wilhelm von Kaulbach. For the tribulations of a fresco painter working on the British scheme, see Nancy Langham, 'John Rogers Herbert (1810–90) and the New Palace of Westminster', *The British Art Journal*, XI, 3 (Spring 2011), pp. 48–56. See also Emma L. Winter, 'German Fresco Painting and the New Houses of Parliament at Westminster, 1834–1851', *Historical Journal*, XLVII, 2 (2004), pp. 291–329.

11 See Julius Bryant, *Designing the V&A: The Museum as a Work of Art (1857–1909)*, London 2017.

12 Francis Wey observed in the 1850s, on a visit to the National Gallery in London, that William Hogarth was 'the only incontestable glory of a non-existent school'. Francis Wey, *A Frenchman Sees the English in the '50s*, trans. Valérie Pirie, London 1935, p. 24; quoted in Giles Waterfield, *The People's Galleries: Art Museums and Exhibitions in Britain, 1800–1914*, New Haven and London 2015, p. 33. A hemicycle along the lines of that by Delaroche was proposed for the lecture theatre in the V&A and designed (although never executed) by Sir Edward Poynter PRA: Bryant 2017, p. 74, fig. 71.

13 The Parnassus frieze on the Royal Albert Memorial, for example, has such now-surprising inclusions among the musicians as Étienne Méhul and André Grétry.

14 Watercolours were included in the annual exhibitions, but an artist only working in the medium could not qualify for membership of the Academy.

15 No record has been found of these sculptures having been taken down and wrongly repositioned, although that would seem the obvious explanation for such a muddle, and it may well have happened. It does not alter the point that no one has hitherto noticed. Sheppard, an elusive figure, exhibited at the RA 1906–14, at which point he stopped working as a sculptor and became a commercial traveller. He was then out of work in the post-war depression. He was the brother of the well-known Irish sculptor Oliver Sheppard, who was working in Dublin with the architect of the V&A, Aston Webb, at the time that Reuben was commissioned to create his two statues in London. Reuben had been admitted as a National Scholar to the National Art Training School, South Kensington, in 1894, where his brother had been 1888–91. See John Turpin, *Oliver Sheppard 1865–1941: Symbolist Sculptor of the Irish Cultural Revival*, Dublin 2000.

16 For Pearson's schemes of 1888–92, see Anthony Quiney, *John Loughborough Pearson*, New Haven and London 1979, pp. 211–13.

17 See Robin Simon, '"A Giotto conviene far ritorno": The Arena Chapel, the British, a Futurist, and the Reputation of Giotto (*c*.1267–1337)', *The British Art Journal*, XVI, 2 (2015), pp. 3–17.

18 David Mannings (the subject pictures catalogued by Martin Postle), *Sir Joshua Reynolds: A Complete Catalogue of his Paintings*, 2 vols, New Haven and London 2000 (=Mannings and Postle 2000), cats 21, 346.

19 Joseph Baretti, *A Guide through the Royal Academy*, London 1781, p. 25.

20 E. Malone, ed., *The Works of Sir Joshua Reynolds…*, 2 vols, London 1797, II ('A Journey to Flanders and Holland, in the Year MDCCLXXXI'), p. 86.

21 On imitation see Simon 2007, esp. pp. 153ff.

22 Robin Simon, 'The Trouble with Rembrandt: British and Dutch Portraiture in the Eighteenth Century', in Paul Williamson, ed., *The New Potato Eaters: Van Gogh in Nuenen 1883–1885*, Cambridge and Stockholm 2015, pp. 94–105.

23 Ibid., where the relationship between the two self-portraits is discussed. The young Fragonard, for example, copied Rembrandt's *Self-portrait with Two Circles* in the 1750s (n. 25);

Ernst van der Wetering, *A Corpus of Rembrandt Paintings IV: Self-portraits*, Dordrecht 2005, pp. 567–8, fig. 4 (drawing); Julius Bryant, *Kenwood: Paintings in the Iveagh Bequest*, New Haven and London 2003, p. 74, fig. 6 (painting).

24 Edmond Malone, ed., *The Works of Sir Joshua Reynolds*, 2 vols, London 1797, II, p. 14. In 1975 the Royal Academy bought a copy by Reynolds of Rembrandt's *Lady with a Fan* (Westminster Collection) from Mrs Egerton Cooper. Martin Postle observes (personal communication) that the dating of this Reynolds copy to *c*.1746 is correct: 'It is quite small and on panel and I have seen nothing comparable by Joshua Reynolds at this early period.' It is not listed in Mannings and Postle 2000.

25 Mannings and Postle 2000, cats 717, 718.

26 Simon 2007, e.g. pp. 182ff.

27 See Mark Stocker, 'Sir (Joseph) Edgar Boehm', *ODNB*. The studio in question was at The Avenue, Fulham.

28 The princess had a surprising number of affairs, one of them with Edwin Lutyens PRA, whose own marriage was unsatisfactory. The key to the facts about Boehm's death is another of his lovers, Catherine Walters ('Skittles'), better known as one of the lovers of Princess Louise's brother 'Bertie', the future Edward VII. Skittles told all to Wilfrid Scawen Blunt – another of her lovers. Blunt's diaries containing the facts are at the Fitzwilliam Museum, Cambridge. See Lucinda Hawksley, *The Mystery of Princess Louise: Queen Victoria's Rebellious Daughter*, London 2013, ch. 22, especially pp. 105–7; 239–48. Skittles had the details from the royal doctor Sir Francis Laking. Hawksley also found that the papers concerning the artistic tutors of Princess Louise (Boehm, Edward Corbould and Mary Thorneycroft) held by the National Gallery, London, had been, she was told, 'appropriated by the Royal Archives' (ibid., p. 105).

29 Quoted by Mark Stocker, 'Sir (Joseph) Edgar Boehm', *ODNB*.

30 Quoted in Hawksley 2013, p. 247.

31 Quoted by John Guille Millais, *The Life and Letters of Sir John Everett Millais, President of the Royal Academy*, 2 vols, London 1900, II, p. 354.

32 Stephen Francis Dutilh Rigaud, 'Facts and Recollections of the XVIIth Century in a Memoir of John Francis Rigaud Esq., R.A.', ed. William L. Pressly, *Walpole Society*, L (1984), p. 70.

33 For Hunter's early role in the Royal Academy, see MaryAnne Stevens in Martin Postle, ed., *Johan Zoffany RA: Society Observed*, exh. cat., New Haven and London 2011, cat. 46. The reduced bronze that Hunter holds was cast by Edward Burch. See D. Bilbey, with M. Trusted, *British*

Sculpture 1470 to 2000: A Concise Catalogue of the Collection at the Victoria and Albert Museum, London 2002, cat. 78; M. Kemp, ed., *Dr William Hunter at the Royal Academy of Arts*, Glasgow 1975, pp. 15–17, 28. The original wax model of this reduced figure survives in the Hunterian Museum, Glasgow. It was made by a Danish sculptor, Michael Henrik Spang, who, among other things, worked for Louis-François Roubiliac and taught drawing to Joseph Nollekens, and whose widow received a Royal Academy pension until her death in 1785.

34 By 'J. E. Taylor', correspondent of Tom Taylor, 1865 (National Portrait Galley archive, London), when living in Manchester.

35 The letter was published by Martin Postle in 'An Early Unpublished Letter by Sir Joshua Reynolds', *Apollo*, CXLI, 400 (1995), pp. 11–18: see Mannings and Postle 2000, cat. 1219.

36 A bronze was made from this plaster, within the RA, in 1928.

37 There can be little question that this is of Joseph Wilton and not of the obscure Benjamin Carter. The features of the man resemble those in Roubiliac's bust, and Frances was a little over one year old at this date, like the baby in the portrait.

38 Reproduced in colour for the first time by Neil Jeffares, 'Francis Cotes (1726–1770)', *The British Art Journal*, XVI, 3 (2015–16), pp. 68–73, pl. 1. In 1818 this pastel was recorded as hanging in the Council Room of the Academy in Somerset House 'close by the portrait of Sir Joshua Reynolds': obituary of Robert Cotes, *Gentleman's Magazine*, March 1818, p. 276.

39 Postle 2011, cat. 44.

40 A photogravure, one example at least signed by artist and sitters, was printed in Munich, apparently at the time of the painting's presentation to the Tate (Bonham's, London, 29 March 1990, lot 171).

41 The identification of Ryley was made by Matthew Payne and James Payne, *Regarding Thomas Rowlandson 1757–1827: His Life, Art & Acquaintance*, London 2010, p. 35, figs 9, 12. Ryley was a student at the RA Schools from 1769 and later worked as an engraver, although he studied painting under Mortimer. His work was collected by J. M. W. Turner: Ian Warrell, 'A Checklist of Erotic Sketches in the Turner Bequest', *The British Art Journal*, IV, 1 (Spring 2003), pp. 15–46 (quote on p. 16).

42 John Kenworthy-Browne, 'The Duke of Richmond's Gallery in Whitehall', *The British Art Journal*, X, 1 (2009), pp. 40–49.

43 'Memoirs of Thomas Jones', *Walpole Society*, XXXII (1951), p. 8. The gifted but short-lived Johnson Carr, another pupil of Wilson, also attended.

44 Ishizuka Tokyo Collection (Christie's, 20 January 2015, lot 16, unsold); *Burlington Magazine*, LXXXVII (1945), Editorial, 'Sir Joshua Reynolds' Collection of Pictures – II', pp. 210–17, 'Morillio' 'A peasant boy' (p. 217).

45 Mannings and Postle 2000, p. 529. This picture was mentioned as the reference in a report by the Royal Academy correspondent of the *Morning Post* (13 May 1777, p. 4): J. Chu, 'Joshua Reynolds and Fancy Painting in the 1770s', in L. Davis and M. Hallett, eds, *Joshua Reynolds: Experiments in Paint*, exh. cat., Wallace Collection, London 2015, pp. 86–99 (see p. 94). The writer of the press report was no doubt informed by Reynolds.

46 Published as *Lectures on Painting...*, London 1809.

47 The phrase belongs to the American writer William Dean Howells, quoted in *Encyclopaedia Britannica* (1911).

48 *Artists at Home Photographed by J.P. Mayall, and Reproduced in Facsimile by Photo-Engraving on Copper Plates. Edited, with Biographical Notices and Descriptions, by F. G. Stephens*, London 1884.

49 K. Garlick, A. Mackintyre and K. Cave, eds, *The Diary of Joseph Farington*, 17 vols, New Haven and London 1978–98.

50 Sir Henry Raeburn RA had his *Self-portrait* rejected as a Diploma Work, and it was replaced by *Boy with a Rabbit*.

51 Giusti and Sframeli 2007, p. 22. The quotation is from a letter from Marcello Adriani to Vasari (see p. 22, n. 6).

52 The coving contained these individuals, among which only Eastlake's portrait survives: clockwise from the northwest corner, *North cove* Victoria, Landseer, [missing, but perhaps Chantrey], Chambers, George III; *East cove* Reynolds, Gainsborough, [not identifiable but with the letters 'WE S', and so perhaps West]; *South cove* Lawrence, Flaxman, Shee, Wilkie, Eastlake; *West cove* Grant, Turner, Leighton. Information courtesy MaryAnne Stevens and Alexandra Burnett.

53 In exchange for a copy of the bronze for himself, Alma-Tadema painted a portrait of Ford's daughter.

54 Both these latter paintings were bought from Anna Alma-Tadema in 1944.

55 Millais, for one, referred to Hals as 'Frank Hals', which may have prompted Frank Bramley to portray himself in this way.

A CLOSER LOOK 5.1

1 Royal Academy Library, collection files.

2 A letter to the Revd Sir Henry Bate-Dudley: John Hayes, *The Letters of Thomas Gainsborough*, New Haven and London 2001, p. 164, no. 101.

3 Dated 15 June 1788: ibid., p. 175, no. 109.

6 THE DOMINANCE OF SCULPTURE

1 A bronze was made from this plaster, within the RA, in 1928.

2 RA Archives, Council Minutes, 5 November 1790, RAA/PC/1/2.

3 Ibid., 19 November 1790.

4 J. Baretti, *A Guide to the Royal Academy*, London 1781, p. 14. The *St George* now in the collection has a provenance to the nineteenth century and was made by D. Brucciani & Co. (London), RA 03/1441.

5 K. Garlick, A. Mackintyre and K. Cave, eds, *The Diary of Joseph Farington*, 17 vols, New Haven and London 1978–98, VI, p. 2469; quoted in J. Fenton, *School of Genius: A History of the Royal Academy of Arts*, London 2006, p. 95.

6 It was also recorded that the housekeeper Elizabeth Malin was to be allowed £5 for an assistant and that 'there be no Female Model for the present'; Council Minutes, 20 December 1768, RAA/PC/1/1.

7 Ibid., 27 December 1768.

8 Vertue III, *Walpole Society*, XXII (1948–50), p. 85.

9 For these sculptors, see K. Eustace et al., *Michael Rysbrack Sculptor 1694–1770*, exh. cat., Bristol 1982; I. Roscoe, 'Peter Scheemakers', *Walpole Society*, LXI (1999), pp. 163–304; and M. Baker and D. Bindman, *Roubiliac and the Eighteenth Century Monument: Sculpture as Theatre*, New Haven and London 1995.

10 J. Ralph, *A Critical Review of the Publick Buildings, Statues and Ornaments in, and about London and Westminster*, London 1734, quoted in M. Baker, *Figured in Marble: The Making and Viewing of Eighteenth-Century Sculpture*, London 2000, p. 121.

11 Robin Simon, *Hogarth, France and British Art: The Rise of the Arts in Eighteenth-Century Britain*, London 2007, pp. 183–4.

12 K. Eustace, 'The Key is Locke, Hogarth, Rysbrack and the Foundling Hospital', *The British Art Journal*, VII, 2 (Autumn 2006), pp. 34–49; Simon 2007, ch. 10, 'Hogarth, Sculpture and the Paragone'.

13 Simon 2007.

14 William Hogarth, *The Analysis of Beauty*, ed. Joseph Burke, Oxford 1955, p. 81.

15 For a full account, see J. Kenworthy-Browne, 'The Duke of Richmond's Gallery in Whitehall', *The British Art Journal*, X, 1 (2009), pp. 40–49. Appendices provide transcriptions of documents relating to the expenses of the gallery, West Sussex Records Office, Goodwood Archives (230). J. M. Kelly, *The Society of Dilettanti: Archaeology and Identity in the British Enlightenment*, New Haven and London 2009, pp. 175–6.

16 E. Edwards, *Anecdotes of Painters who have resided or been born in England*, London 1808, p. xvi.

17 Edwards lists the principal casts and mentions that '[to] these were added a great number of casts from the Trajan column': Edwards 1808, pp. xvii–xviii.

18 R. Dossie, *Memoirs of Agriculture*, vol. III, London 1782, Article XV, p. 446 (provides a list of the statues and other items after the Antique, p. 444).

19 Kenworthy-Browne 2009, p. 43.

20 Edwards transcribed his own certificate: Edwards 1808, footnote. The original is RA Archives, JU/2/84.

21 Edwards suggested their attendance at the school was for 'several months' only: Edwards 1808, p. xvi.

22 M. and J. Payne, *Regarding Thomas Rowlandson 1757–1827: His Life, Art & Acquaintance*, London 2010, p. 35, fig. 12 (and see p. 27, fig. 9).

23 See Susan Jenkins, 'The External Sculptural Decoration of Somerset House and the Documentary Sources', *The British Art Journal*, II, 2 (Winter 2000–01), pp. 22–8, which includes details of payments to the sculptors from the contemporary accounts in the National Archives, PRO A03/1244 (pp. 27–8).

24 Ingrid Roscoe, Emma Hardy and M. G. Sullivan, *A Biographical Dictionary of Sculptors in Britain 1660–1851*, New Haven and London 2009 (=Roscoe 2009); J. Coutu, 'Joseph Wilton', *ODNB*; K. Eustace, 'Robert Adam, Charles-Louis Clérisseau, Michael Rysbrack and the Hopetoun Chimneypiece', *Burlington Magazine*, CXXXIX (November 1997), pp. 743–52.

25 Quoted in C. Saumarez Smith, *The Company of Artists: The Origins of the Royal Academy of Arts in London*, London 2012, p. 163.

26 Old casts were sold to Cockayne 'the Moulder in the Employ of the Academy' for £28, Mazzoni 'the Figure Moulder' having offered £25: Council Minutes, 20 December 1816, RAA/PC/1/5.

27 Council Minutes, 9 August 1769 and 25 March 1771, RAA/PC/1/1.

28 At the same meeting acknowledgement was made of the gift from William Hamilton of a cast of a bas-relief. The minute taker left a

space but the subject was never supplied: ibid., 18 December 1771. This may be a late official note, for Reynolds had personally thanked Sir William Hamilton for 'a Bas-relievo of Fiamingo' which he was unacquainted with 'and the only thing of the kind that we have which make it a very acceptable present', and also an Apollo on 24 June 1770: quoted in Saumarez Smith 2012, p. 159.

29 Council Minutes, 4 January 1773 and 11 June 1774, RAA/PC/1/1. The earliest and most famous version of the *Cincinnatus* had been acquired by Louis XIV. Lord Shelburne (later 1st Marquess of Lansdowne) acquired his in 1772, the statue having been recently excavated by Gavin Hamilton at Hadrian's Villa. It is now in the Ny Carlsberg Glyptothek, Copenhagen: F. Haskell and N. Penny, *Taste and the Antique: The Lure of Classical Sculpture 1500–1900*, New Haven and London 1981, pp. 182–4.

30 For a full account of Canova's mission to Paris and subsequent visit to London, see K. Eustace, '"Questa Scabrosa Missione": Canova in Paris and London in 1815', in K. Eustace, ed., *Canova: Ideal Heads*, exh. cat., Oxford 1997, pp. 9–38.

31 See Eustace 1997, pp. 9–38, n. 5.

32 Flaxman, through W. R. Hamilton's correspondence with the Italian sculptor, was given detailed instructions as to the figure's alignment: S. Jenkins, 'Arthur Wellesley, First Duke of Wellington, Apsley House and Canova's *Napoleon as Mars the Peacemaker*', *Sculpture Journal*, XIX, 1 (2010), pp. 115–21.

33 He accompanied Canova everywhere, and was invited to all the receptions.

34 Council Minutes, 14 December 1815, RAA/PC/1/5.

35 *Gentleman's Magazine*, December 1815, p. 624.

36 See, for example, H. Hoock, *Empires of the Imagination: Politics, War and the Arts in the British World*, London 2010, pp. 134ff. This development was overseen and any funding approved by a committee of taste under the chairmanship of Charles Long MP (subsequently 1st Lord Farnborough).

37 For illustrations see M. Whinney, *Sculpture in Britain 1530–1830*, Harmondsworth 1964, pls 140, 142, 158, 159, 160, 161b, 162b, 163a.

38 Bacon notebook, private collection, cited in T. Clifford, A. Weston Lewis et al., *The Three Graces, Antonio Canova*, exh. cat., Edinburgh 1995, p. 14 and fig. 10.

39 See, for example, Hoock 2010, pp. 167–8, drawing attention to the incongruity of Thomas Banks's monument to Captain Burgess (1798–1802) where the naked deceased is being presented with a sword by a draped female figure with, between them, a 'phallic cannon' and 'balls on the ground' (p. 168, pl. 23).

40 Thomas Phillips to Dawson Turner, 10 November 1815, Dawson Turner Papers, Trinity College, Cambridge.

41 The seating plan is recorded in Farington's diary: Garlick, Mackintyre and Cave 1978–98, XIII, pp. 4743–4 (1 December 1815).

42 Thomas Harvey to Dawson Turner, Norwich, 18 November 1815, Dawson Turner Papers, Trinity College, Cambridge.

43 Canova's private gesture of acknowledgement and gratitude was his presentation of an *Ideal Head* to each of the main characters responsible for the success of his mission to Paris: Eustace 1997, cats 1–4.

44 At the Council meeting on 10 January 1816, the reply from Sidmouth to Flaxman and Westmacott was read out; the Prince Regent had agreed and the Lords Commissioners of the Admiralty and His Majesty's Consuls in the different parts of Italy would be instructed 'to afford all the facilities & assistance in their power towards the accomplishment of its object'; Council Minutes, 10 January 1816, RAA/PC/1/5.

45 *Notizie del Giorno*, Rome, 24 September 1818, no. 38; quoted in Eustace 1997, p. 28, n. 165.

46 It is intriguing to speculate that the engineering by Canova of the Prince Regent's surprisingly thoughtful gift to the Academy was related to him having made a decisive extra payment in 1815 to Canova in order to enable the sculptor to complete the Stuart dynasty's monument in St Peter's, Rome. The Prince Regent gave 50,000 francs when it looked as though the project would never otherwise be finished, although it had been commissioned in 1810. The first design and the contract are in Stella Rudolph, 'Il monumento Stuart del Canova: Un committente dimenticato e il primo pensiero ritrovato', *Antologia di belle arti*, XVI (1980), pp. 46 and 49–51 respectively.

47 *Gentleman's Magazine*, November 1816, p. 452. Letter of thanks for his recommendation from Turner to Canova, 27 December 1819, quoted in full in J. Gage, ed., *Collected Correspondence of J. M. W. Turner*, Oxford 1980, no. 86, pp. 80–81. Although Hamilton was not an artist, there had always been a category in the Accademia for distinguished lay members.

48 RA Library, Ennio Quirino Visconti, *A Letter from the Chevalier Antonio Canova…*, London 1816, RA 05/1762.

49 K. Garlick notes lent to the author in 1997.

50 See note 36 above.

51 Council Minutes, 15 April 1817, RAA/PC/1/5.

52 H. Honour in *The Age of Neo-Classicism*, exh. cat., Arts Council of Great Britain, London 1972, cat. 329, p. 213; http://www.royalcollection.org.uk/collection/2042/dirce, accessed 17 May 2013.

53 Letter of 16 December 1820 (RA Archives, Sir Thomas Lawrence, Letters and Papers, RA/LAW/3/242): '[I have] had a little drawing made from the Sleeping Nymph, and, in compliance with your request, I inclose it in this letter. I must, however, declare, that it will afford you but a poor idea of my work, of which it is certainly not an accurate representation; but I knew of no one who could execute a design in the masterly and graceful style which is so peculiarly yours. However, your fancy will supply the defects of the drawing. I do not say this to exalt the merit of my work; but merely for the sake of being sincere with you, and to give you to understand, that the little outline sketch might have been better, and more faithful to the original.'

54 Christie's, London, 6 July 1830; interleaved copy of sale catalogue, RA 06/2970.

55 D. Bindman, ed., *John Flaxman, RA*, exh. cat., London 1979. A Winter Exhibition in 1881 included 'a collection of drawings' by Flaxman which were given their own gallery. Of 182 catalogue entries, many of them made up of more than one item, the bulk belonged to University College London and the Royal Academy. The occasion of the exhibition must have been the purchase in the previous year of 65 drawings from the *Iliad* and the *Odyssey* from J. R. Clayton, descendant of Mrs Hare-Naylor (née Georgiana Shipley and mother of Augustus Hare) who had originally commissioned them from Flaxman in Italy in 1792. The biggest private lender was F. T. Palgrave, who had inherited from his mother, a daughter of Dawson Turner of Yarmouth. A Winter Exhibition in 1927 was dedicated to the work of Hamo Thornycroft and Francis Derwent Wood.

56 Whinney 1964, pp. 183–95 (quote on p. 195).

57 J. Flaxman, *Lectures on Sculpture by John Flaxman, Esq. R.A.*, London 1829. It includes the last lecture, Lecture X on 'Modern Sculpture', which was never delivered.

58 John Flaxman, inscribed 'J. Flaxman's reception by Sir Ed. Hales at St Stephens – sketch'd by himself', 1775, Oppé Collection, Tate Britain, London, T10248, illustrated in David Irwin, *John Flaxman 1755–1826: Sculptor, Illustrator, Designer*, London 1979, p. 2, fig. 2.

59 British Museum, London, 1885,0509,1575. Illustrated in H. Brigstocke, E. Marchand and A.

E. Wright, 'John Flaxman and William Ottley in Italy', *Walpole Society*, LXXII (2010), frontispiece.

60 At the time Flaxman was carving *St Michael overcoming Satan* for Lord Egremont (1826, National Trust, Petworth, Sussex). B. R. Haydon, *The Autobiography and Journals of Benjamin Robert Haydon*, London 1950, pp. 411–12; quoted in Fenton 2006, p. 182.

61 In a portrait of 1792 by Guy Head, it appears long but dressed: National Portrait Gallery, London (NPG 877).

62 *Exhibition of Works by the Old Masters and by Deceased Masters of the British School including a Collection of Drawings by John Flaxman, R.A.*, exh. cat., Royal Academy Winter Exhibition, London 1881, cat. 61.

63 Anonymous memoir, Flaxman 1829, p. xiii.

64 S. C. Hutchison, 'The Royal Academy Schools 1768–1830', *Walpole Society*, XXXVIII (1960–62), pp. 123–91 (medal listed p. 134, no. 54).

65 Anonymous memoir, Flaxman 1829, p. xv. Nancy's brother Thomas became one of Flaxman's assistants.

66 Garlick, Mackintyre and Cave 1978–98, I, p. 274 (13 December 1794). The monument to Captains Bayne, Blair and Lord Robert Manners (killed 1782, monument 1784–93) by Nollekens in Westminster Abbey was one of the earliest of the Peninsula Campaign commemorations.

67 Garlick, Mackintyre and Cave 1978–98, I, pp. 259–60 (15 November 1794). Gaetano Stefano Bartolozzi was the son of the RA Foundation Member Francesco Bartolozzi. He went to Italy on several occasions with consignments of this father's prints.

68 See entries under 'Eschylus' in E. Croft-Murray, 'An Account-book of John Flaxman, RA (B.M., Add. MSS. 39.784', *Walpole Society*, XXVIII (1939–40).

69 Irwin 1979, pp. 67, 225, n. 1.

70 For an account of the complex history of the commissions and their numerous and often pirated editions, see S. Symmons, 'Flaxman and the Continent', and D. W. Dörrbecker, 'A Survey of Engravings after Flaxman's Outline Compositions 1793–1845', in Bindman 1979, pp. 152–3 and 184–5; and D. Bindman, ed., *John Flaxman 1755–1826: Master of the Purest Line*, exh. cat., London 2003, cats 4, 45, 46, 47, p. 56.

71 S. Symmons, 'Flaxman and the Continent', 'Themes and Variations' and 'France and Spain'; Bjarne Jørnæs, 'Denmark'; and H. Hohl and S. Symmons, 'Germany'; all in Bindman 1979, pp. 152–5, 156–63 and 164–7, 169–74, and 175–81.

72 *Age of Neo-Classicism* 1972, p. 235.

73 D'Angers met Flaxman in London in 1816, but the portrait is thought to date from after 1826 and probably 1828; Bindman 1979, cat. 179; Bindman 2003, cat. 21.

74 *Age of Neo-Classicism* 1972, cats 570, 576. Most of them were included in the 1881 Winter Exhibition Catalogue (see note 55).

75 Council Minutes, 19 February 1800, RAA/PC/1/3.

76 Referred to in Fenton 2006, p. 23. While he was in Rome, Flaxman had collected and shipped these for Romney.

77 Council Minutes, 2 July 1801, 25 September 1801, 7 August 1802, RAA/PC/1/3; H. Hoock, *The King's Artists: The Royal Academy of Arts and the Politics of British Culture 1760–1840*, Oxford 2003, p. 49.

78 Several Royal Academicians, including Flaxman, William Hilton, Thomas Phillips, David Wilkie, Charles Eastlake and (through his wife Maria) Augustus Wall Callcott, were, around 1800, among the first to recognize the significance of Giotto's decoration of the Arena Chapel, Padua. See Robin Simon, '"A Giotto conviene far ritorno": The Arena Chapel, the British, a Futurist, and the Reputation of Giotto (*c*.1267–1337)', *The British Art Journal*, XVI, 2 (2015), pp. 3–17.

79 Brigstocke et al. 2010.

80 The relevant sketchbooks are: Yale Center for British Art, New Haven (B1975.3.468), and Victoria and Albert Museum, London (E.442-1937 & 2790); see Brigstocke et al. 2010. It is probable that the lithographic prints illustrating the lectures, printed at the end of Flaxman 1829, were related to the teaching drawings (the Braschi Venus, as the Venus of Cnidos, appears, for example, as pl. 22). They are all credited as 'printed' by Charles Joseph Hullmandel after different artists, however, none of them Flaxman. Some drawings in the Kunsthalle, Hamburg, are clearly related to the illustrations for the lectures, but their size does not suggest they were actually used for the purposes of teaching: see Bindman 1979, pp. 133–4.

81 These were government Treasury funds and commissions awarded following the guidance of the committee of taste chaired by Charles Long MP: see above.

82 Garlick, Mackintyre and Cave 1978–98, V, p. 1781 (entry following 24 May 1802). See Whinney 1964, pls 158–64.

83 Flaxman recorded a part payment of the £1,150 on 1 September 1808, and further sums in 1810 and 1813. Croft-Murray 1939–40, p. 92.

84 Roscoe 2009. For an account of the maritime monuments, see Takeshi Nakamura, 'The Commemoration of Nelson and Trafalgar in St Paul's Cathedral', *East Asian Journal of British History*, 2 (2012), pp. 1–22.

85 Council Minutes, 7 June 1816, RAA/PC/1/5.

86 J. Physick, *Designs for English Sculpture 1680–1860*, London 1969, p. 165, fig. 129. The design with the inscription is in the Victoria and Albert Museum, London (E.950-1965). Flaxman's *Letter to the Committee*, December 1799, illustrated by William Blake: Physick 1969, pp. 168–9. The 1801 'statue of Britannia' was no. 1037 in the Annual Exhibition and is probably the model now in Sir John Soane's Museum. Physick 1969, pp. 168–9.

87 S. Beattie, *The New Sculpture*, New Haven and London 1983, pp. 28–30.

88 The *Fuseli* was exhibited in 1824 (NPG 6376), *Stothard* in 1826 and *Smirke* in 1828 (NPG plaster 4525); Roscoe 2009.

89 Lucy Peltz has suggested that the print may have been published by Lawrence's executor Archibald Keightley as an advertising device for the sale of Lawrence's distinguished collection of Old Master drawings: A. C. Albinson, P. Funnell and L. Peltz, eds, *Thomas Lawrence: Regency Power and Brilliance*, exh. cat., New Haven and London 2010, cat. 28.

90 A. Kader, 'Four Marble Busts of Artists by Edward Hodges Baily', *Antologia di Belle Arti*, no. 52–5 (1996), pp. 177–182. *Thomas Stothard* was bought by Samuel Woodburn; *Flaxman* and *Smirke* were purchased by Sir Charles Merrick Burrell.

91 Quoted in Kader 1996.

92 A stipple engraving by James Thomson was published by Asperne, London, 1 October 1825, while 'in the possession of Sir Thos. Lawrence', Victoria and Albert Museum, London (E.1109-1945). It was reproduced in Coade stone; British Museum, London (1909,1201.484); J. T. Smith owned a 'Model' or 'Plaster' 'by Bayley' which was sold at his death, Elgood & Ward, London, 23 April 1833 (lot 15).

93 Fenton, 2006; Hoock 2003; E. H. Baily is mentioned in the latter, but only in a footnote (p. 293, n. 141).

94 The tide changed with the publication of Ben Read's ground-breaking *Victorian Sculpture*, New Haven and London 1982. Thereafter entries appeared in the *Grove Dictionary of Art* (K. Eustace) and the *ODNB* (K. Eustace). He is studied in two unpublished theses: E. Knowles, '"The Most Brilliant Genius That Ever Lived..."?: Edward Hodges Baily 1788–1867', BA thesis, University of Leicester 1994; and M. Greenwood, 'Victorian Ideal Sculpture 1830–1880', PhD thesis, University of London 1999.

95 Katharine Eustace, 'Edward Hodges Baily', *ODNB*.

96 The age given is 21, which would mean he was born in 1788, whereas it appears he had an older brother also christened Edward (but not Hodges) in 1788, who must have died in infancy. Edward Hodges Baily was baptized in 1791, which suggests he was 19 when he entered the Schools. Ibid.; Hutchison 1960–62, p. 165.

97 RA Archives, Sir Thomas Lawrence to Joseph Farington, 3 November 1817, RA/LAW/2/230.

98 Council Minutes, 31 October 1821, RAA/PC/1/6.

99 C. Jordan, '"The very spirit of purity and chastity": *Eve at the Fountain* by Edward Hodges Baily', *Sculpture Journal*, XV, 1 (2006), pp. 19–35.

100 Douglas Merritt and Francis Greenacre, with K. Eustace, *Public Sculpture of Bristol*, Liverpool 2010, pp. 105–6.

101 Council Minutes, 11 January 1859, RAA/PC/1/11. I am grateful to Annette Wickham for advising me that it is not known when the exchange took place.

102 Bottle cooler, 1828–9, silver gilt, height 57.8 cm, for Rundle and Bridge, Royal Collections; reproduced in Jordan 2006, pp. 19–35, fig. 2. The plaster is in Bristol City Museums and Art Gallery.

103 In the Louvre from about 1811. Charles Townley owned a version now in the British Museum, replicas from which were reproduced in Coade stone. Haskell and Penny 1981, pp. 280–82.

104 M. Postle, 'Naked Civil Servants: The Professional Life Model in British Art and Society', in J. Desmarais, M. Postle and W. Vaughan, eds, *Model and Supermodel: The Artist's Model in British Culture*, Manchester 2006, pp. 9–25.

105 See Joseph Riddel Collection, British Library, London, Add. MS 38678, quoted in Jordan 2006 (see esp. p. 23).

106 *Eve at the Fountain*, engraved by T. March, 1822, V&A E.371-1941.

107 The bronze was commissioned by the Danish patron Carl Jacobsen, who owned a marble version of *Eve at the Fountain*, and who in 1909 had seen Hans Beck's ballet based on Hans Christian Anderson's *Little Mermaid*. The prima ballerina Ellen Price refused to pose naked, and so the head alone is modelled on the dancer, while the body is that of the sculptor's wife: Jordan 2006.

108 'Cornelia Parker, Folkestone Triennial Permanent Collection', *Art Quarterly*, Spring 2013, p. 73.

109 J. Physick and J. Whitlock Blundell, *Westminster Abbey: The Monuments*, London 1989, no 1.

110 Read 1982, p. 206; P. Ward-Jackson, *Public Sculpture of the City of London*, Liverpool 2003, pp. 243, 245–6, 249–50 (illus.).

111 Read 1982, pp. 69–70.

112 Council Minutes, 14 April 1837, 12 December 1837, RAA/PC/1/8.

113 Kenworthy-Browne 2009. Not that premiums, as it transpired, ever were awarded.

114 Council Minutes, 22 November 1843, RAA/PC/1/9.

115 Council Minutes, 26 May 1853, RAA/PC/1/11.

116 Council Minutes, 18 December 1858, RAA/PC/1/11.

117 Council Minutes, 9 April 1862, RAA/PC/1/12.

118 Ibid., 11 November 1862.

119 General Assembly Minutes, 1 December 1862, RAA/GA/1/6, p. 132.

120 See the *1846 Art Union Fox Talbot Research Project* online, www.1846artunion.org. The original article about Talbot, 'The Talbotype–Sun Pictures', is in *Art-Union*, 8 (June 1846), pp. 143–5.

121 For *Sabrina* see Jordan 2006, figs 9, 10.

122 V&A E.104-1964. *Age of Neo-Classicism* 1972, cat. 1553, and related silverware by Paul Storr, cat. 1747. At the time of the exhibition Baily's sculpture in the V&A collections was consigned to a store at Bethnal Green, where in the early 1980s the present author saw *Eve Listening to the Voice* (Royal Academy 1842) sadly grimy and damaged (V&A 468-1875). Even now Baily's very large plaster *Marius sitting amid the Ruins of Carthage*, exhibited at the Royal Academy in 1833, remains in store (V&A 8126-1862).

123 A silver centrepiece modelled by Baily to designs by Sir George Hayter RA for Mortimer & Hunt, and presented to Sir Moses Montefiore in gratitude for his part in protecting the Jews of Damascus and Rhodes in 1840. *Illustrated London News*, 4 March 1843. Twenty-eight designs for the Montefiore piece are in an album, V&A E.252-1990.

124 Yet Baily is not mentioned once in N. M. Penzer, *Paul Storr: The Last of the Goldsmiths*, London 1954.

125 Read 1982, p. 310.

A CLOSER LOOK 6.1

1 John Britton, ed., *The Fine Arts of the English School*, London 1812, p. 22.

2 Julius Bryant, *Thomas Banks 1735–1805: Britain's First Modern Sculptor*, exh. cat., Sir John Soane's Museum, London 2005, p. 7. Quoted in A. Cunningham, *The Lives of the Most Eminent British Painters, Sculptors and Architects*, 5 vols, London 1830, III, p. 86.

3 Mrs Forster's letter to Allan Cunningham, 1 March 1830, *Builder*, XXI, 5 (3 January 1863); quoted in C. F. Bell, ed., *Annals of Thomas Banks, Sculptor, Royal Academician, with some Letters from Sir Thomas Lawrence, P.R.A., to Banks' Daughter*, Cambridge 1938, p. 68.

4 Robin Simon, personal communication. He notes the striking similarity between the *Falling Titan* and the oil study called *Hector* by Jacques-Louis David of 1778 (musée Fabre, Montpellier); the related drawing by David of similar date (private collection); and François-Xavier Fabre's *La mort d'Abel* of 1790 (musée Fabre, Montpellier). He also suggests that this same source may lie behind Fuseli's *Titan Prometheus freed by Hercules* (private collection, ex Christie's, London; drawing, British Museum, London, 1885,0314.199) as well as his famous *Nightmare* (Detroit Institute of Arts), both of 1781. For the David and Fabre works, see Jérôme Delaplanche, *350 ans de Création: Les artistes de l'Académie de France à Rome de Louis XIV à nos jours*, Rome 2016, p. 59, pl. 4; cats 43, 46.

5 Bell 1938, p. 68.

6 J. T. Smith, *Nollekens and his Times*, ed. Wilfred Whitten, 2 vols, London 1920, II, p. 125.

A CLOSER LOOK 6.2

1 David Irwin, *John Flaxman 1755–1826: Sculptor, Illustrator, Designer*, London 1979, pp. 169–71, pls 233, 234.

2 J. Flaxman, *Lectures on Sculpture by John Flaxman, Esq. R.A.*, London 1829, Lecture VIII 'Drapery', p. 246.

3 Ibid., pp. 252–3.

4 Ibid., Lecture VI 'Composition', p. 176.

5 Ibid., Lecture VIII 'Drapery', p. 237.

6 H. Hoock, *The King's Artists: The Royal Academy of Arts and the Politics of British Culture 1760–1840*, Oxford, Oxford University Press 2003, p. 242.

7 K. Garlick, A. Mackintyre and K. Cave, eds, *The Diary of Joseph Farington*, 17 vols, New Haven and London 1978–98, II, pp. 421–2 (3 December 1795).

7 VICTORIAN AND MODERN SCULPTORS

1 Timothy Stevens, 'Sir Francis Chantrey', *ODNB*; Ingrid Roscoe, Emma Hardy and M. G. Sullivan, *A Biographical Dictionary of Sculp-*

tors in Britain 1660–1851, New Haven and London 2009 – see http://liberty.henry-moore.org/henrymoore/.

2 Emma Hardy, 'John Gibson', in Roscoe et al. 2009; see also Lady Eastlake, ed., Life of John Gibson, R.A., Sculptor, London 1870, and T. Matthews, The Biography of John Gibson, R.A., Sculptor, Rome, London 1911.

3 RA Archives, Sir Charles Lock Eastlake, Correspondence relating to the Gibson Bequest, RAA/PRA/1/1. It is notoriously difficult to assess such a sum in modern terms, but it perhaps equates to £1.4 million.

4 Anna Frasca-Rath and Annette Wickham, John Gibson RA: A British Sculptor in Rome, exh. cat., London 2016. Anna Frasca-Rath, John Gibson: Die Canova Rezeption in Großbritannien, Vienna 2017.

5 RA Archives, Annual Report 1868, p. 12, RAA/PC/10. Perhaps equivalent to over £1,839,460.

6 Eastlake, Correspondence relating to the Gibson Bequest.

7 RA Archives, Papers relating to the estate of John Gibson RA, GI/4/59–66; Annual Report 1879, p. 56.

8 S. E. Fryer, revised Anne MacPhee, 'John Adams-Acton', ODNB.

9 Roscoe et al. 2009, p. 194.

10 Annual Report 1874, p. 5.

11 Hansard, HC (series 3), vol. 217, cols 493–4.

12 Annual Report 1874, p. 5.

13 RA Archives, John Gibson RA, Lists of sculpture, c.1850, GI/3/75.

14 RA Library committee meeting 2 April 1997 listed Gibson sculptures destroyed by order of subcommittee of Council 1950 (two plaster statues), and by the Keeper between May and June 1950 (seven plaster statues). Information on old Royal Academy catalogue cards.

15 RA Archives, Council Minutes, 24 November 1949, 3 January 1950, 14 March 1950, respectively, RAA/PC/1/28.

16 An old Royal Academy catalogue card notes of the Tinted Venus, 'Fingers and apple damaged; thought to have been destroyed by order of the Keeper, May 1950 [but] Sir William Russell Flint rescued it and lent the statue to Mrs Elizabeth Underwood…At her demise in 1969 it was returned to the R.A.'

17 P. Bloch, Bildwerke 1780–1910: Skulpturen-Galerie und Nationale-Galerie Berlin, Berlin 1990 pp. 93–139.

18 RA Archives, Nomination book for Associateship 1866–1907, RAA/GA/11/2/1.

19 A. Woolner, Thomas Woolner R.A. Sculptor and Poet: His Life in Letters, London 1917.

20 Ibid., p. 300.

21 Ibid., p. 168.

22 Bodleian Library, Oxford, MS. Eng. lett. d. 292, p. 125.

23 Woolner 1917, p 302.

24 See Emma Hardy, 'William Calder Marshall', in Roscoe et al. 2009.

25 Annual Report 1878, pp. 30, 31.

26 Annual Report 1881, p. 31.

27 Report of the Commissioners Appointed to Inquire into the Present Position of the Royal Academy in relation to the Fine Arts, together with the Minutes of Evidence Presented to both Houses of Parliament by Command of Her Majesty, London 1863, para. 2029.

28 Ibid., para. 3340.

29 Ibid., paras 2382–91.

30 Emma Hardy, 'John Henry Foley', in Roscoe et al. 2009; Benedict Read, Victorian Sculpture, New Haven and London 1982; Paula Murphy, Nineteenth-Century Irish Sculpture: Native Genius Reaffirmed, New Haven and London 2010.

31 Report of the Commissioners 1863, paras 2021–5.

32 RA Archives, Correspondence of and relating to Sir Francis Grant, RAA/SEC/10/33/1.

33 W. R. M. Lamb, The Royal Academy: A Short History of its Foundation and Development, London 1951, p. 166.

34 Emma Hardy, 'Henry Weekes', in Roscoe et al. 2009.

35 H. Weekes, Lectures on Art, with a Short Sketch of the Author's Life, London 1880.

36 Weekes 1880, pp. 43, 68, 174.

37 Ibid., pp. 75, 108, 113, 137.

38 Ibid., p. 35.

39 Ibid., Lecture VI.

40 Ibid., p. 139

41 Ibid., p. 146.

42 Annual Report 1871, p. 11.

43 Weekes 1880, pp. 61, 62, 219ff.

44 Ibid., p. 79.

45 Ibid., p. 111.

46 Ibid., p. 134.

47 Annual Report 1870, pp. 15, 32.

48 Annual Report 1872, p. 12.

49 Perhaps the equivalent today of £4,800,000.

50 Annual Report 1875, p. 11.

51 Read 1982, p. 294.

52 RA Archives, Chantrey Bequest purchase ledgers, RAA/PC/12/1, p. 2.

53 Annual Report 1878, p. 7.

54 Benedict Read and Alexander Kader, Leighton and his Sculptural Legacy: British Sculpture 1875–1930, London 1996.

55 Alred Lys Baldry, Leighton, London 1908, pp. 75–6.

56 Benedict Read, 'Leighton and Sculpture', in Frederic Leighton, exh. cat., Royal Academy of Arts, London 1996, p. 86.

57 Boehm shared with Leighton a cosmopolitan European background, having been born in Hungary, then studying in Austria, Italy and France before settling in England in the 1860s.

58 Read 1982, pp. 82–4.

59 Benedict Read in David Cannadine and Jacqueline Riding, eds, The Houses of Parliament: History, Art, Architecture, London 2000, p. 268.

60 Philip Ward-Jackson, Public Sculpture of the City of London, Liverpool 2003, pp. xxiv, 40–41.

61 Letter to F. G. Stephens, 11 April 1885 – Bodleian Library, Oxford, MS. Don. e. 80, fol. 137.

62 Adrian Jones, Memoirs of a Soldier Artist, London 1933, pp. 82–4.

63 Annual Report 1886, p. 31.

64 Annual Report 1878, p. 20.

65 Annual Report 1885, p. 49.

66 Annual Report 1888, p. 43.

67 Richard Dorment, Alfred Gilbert, New Haven and London 1985, pp. 210–11.

68 Annual Report 1904, p. 14.

69 Annual Report 1906, p. 45.

70 Lamb 1951, p. 57.

71 Nomination book for Associateship 1907–27, RAA/GA/11/2/2, p. 44.

72 Nomination book for Associateship 1927–38, RAA/GA/11/2/3, p. 19.

73 Lamb 1951, p. 191.

74 Sophie Bowness and Clive Philpot, eds, Britain at the Venice Biennale 1895–1995, London 1995.

75 Philip Ward-Jackson, Public Sculpture of Historic Westminster, 2 vols, Liverpool 2011, I, pp. 123–33.

76 Ibid., pp. 14–15.

77 See War Memorials Exhibition 1919, exh. cat., Royal Academy of Arts, London 1919.

78 Terry Cavanagh, Public Sculpture of Liverpool, Liverpool 1997, pp. 137–9.

79 Ward-Jackson 2003, pp. 334–6.

80 Nomination book for Associateship 1907–27, p. 107.

81 Ward-Jackson 2011, I, pp. 96–100; A. Compton, ed., Charles Sargeant Jagger: War and Peace Sculpture, exh. cat., Imperial War Museum, London 1985; A. Compton, The Sculpture of Charles Sargeant Jagger, Farnham 2004.

82 Nomination book for Associateship 1907–27, p. 108; ibid. 1927–38, p. 41.

83 Ward-Jackson 2011, I, pp. 74–7.

84 Nicholas Penny, *Alfred and Winifred Turner*, exh. cat., Ashmolean Museum, Oxford 1988; see also *Mapping the Practice and Profession of Sculpture in Britain and Ireland 1851–1951*, University of Glasgow History of Art and HATII, online database, sculpture.gla.ac.uk (hereafter *Mapping* online); John Christian, ed., *The Last Romantics: Romantic Tradition in British Art: Burne-Jones to Stanley Spencer*, exh. cat., Barbican Art Gallery, London 1989, p. 149. Nomination book for Associateship 1907–27, p. 177.

85 Christian 1989, pp. 145–6; Nomination book for Associateship 1907–27, p. 10.

86 N. Watkins, *A Kick in the Teeth*, Henry Moore Institute Essays on Sculpture, 57, Leeds n.d.

87 Nomination book for Associateship 1927–38, p. 143; ibid. 1932–54, RAA/GA/11/2/4, p. 31.

88 Ibid. 1927–38, p. 241; ibid. 1932–54, pp. 98, 157; ibid. 1954–76, RAA/BA/11/2/5, p. 40.

89 See Benedict Read, 'Introduction', *Sculpture in Britain between the Wars*, exh. cat., Fine Art Society, London 1986, pp. 15–18; Dennis Wardlesworth, *William Reid Dick, Sculptor*, Farnham 2013; for McMillan, see Nicholas Usherwood, 'William McMillan', *ODNB*; Sarah Crellin, *The Sculpture of Charles Wheeler*, Farnham 2012.

90 For full details see Sarah Crellin, 'Let There Be History: Epstein's BMA House Sculptures', in Penelope Curtis and Keith Wilson, eds, *Modern British Sculpture*, exh. cat., Royal Academy, London 2011, pp. 36–42. The incident triggered the resignation of Walter Sickert from the Academy.

91 Wardlesworth 2013, pp. 13–14.

92 Nomination book for Associateship 1927–38, p. 15.

93 Ibid., p. 4.

94 Ibid., p. 19.

95 Lamb 1951, pp. 191–2.

96 Frederick Brock, *Thomas Brock: Forgotten Sculptor of the Victoria Memorial*, ed. John Sankey, Bloomington, Ind. 2012, p. 153.

97 Council Minutes, 22 November 1921, RAA/PC/1/24.

98 Lamb 1951, p. 191.

99 See W. R. M. Lamb in *Exhibition of the Chantrey Collection*, exh. cat., Royal Academy of Arts, London 1949.

100 See Judith Collins and Robin Hamlyn, eds, *'Within These Shores': A Selection of Works from the Chantrey Bequest 1883–1985*, exh. cat., London 1989, p. 26.

101 *Mapping* online.

102 Ward-Jackson 2011, I, pp. 300–03.

103 RA Archives, Correspondence relating to Ernest Gillick, RAA/SEC/4/55/1–7.

104 Ward-Jackson 2011, I, pp. 160–63.

105 Ibid., pp. 143–4.

106 For Reid Dick see Wardlesworth 2013.

107 Ward-Jackson 2011, I, pp. 363–5.

108 Crellin 2012, pp. 163, 166, 172.

109 Marie Busco, *Sir Richard Westmacott, Sculptor*, Cambridge Studies in the History of Art, Cambridge 1995, p. 31.

110 Charles Wheeler, *High Relief: The Autobiography of Sir Charles Wheeler, Sculptor*, Feltham 1968, p. 74.

111 See Neville Jason, 'Frank Dobson', *ODNB*. Clive Bell quoted in Ian Chilvers, *The Oxford Dictionary of Art and Artists*, Oxford 2009, 'Frank Dobson', p. 180.

112 For Lambert see Hans Fletcher, revised Vanessa Nicolson, 'Maurice Lambert', *ODNB*.

113 Neville Jason, 'John Skeaping', *ODNB*; John Skeaping, *Drawn From Life: An Autobiography*, London 1977.

114 *Mapping* online.

115 Catherine Moriarty, *The Sculpture of Gilbert Ledward*, Much Hadham and Aldershot 2003, p. 62.

116 Hans Kurt Gross, 'Siegfried Charoux', *ODNB*.

117 David Fraser Jenkins, 'Uli Nimptsch', *ODNB*.

118 Douglas Hall, 'Georg Ehrlich', *ODNB*.

119 *Mapping* online.

120 See Margaret Garlake, *New Art, New World: British Art in Postwar Society*, New Haven and London 1998. The various individual exhibitions were usually accompanied by a catalogue.

121 Moriarty 2003, pp. 87–9.

122 *Sculpture 1850–1950*, 4th London County Council open-air exhibition, Holland Park, exh. cat., London 1957, n.p.

123 Personal communication of Bryan Kneale, Phillip King and Michael Sandle; and see *British Sculptors '72*, exh. cat., Royal Academy, London 1972, especially the introduction by Bryan Robertson.

124 Moriarty 2003, pp. 90–92, 122.

125 Collins and Hamlyn 1989, p. 26.

126 Chantrey Bequest purchase ledgers, RAA/PC/12/2, p. 140.

127 Ibid., pp. 117, 121.

128 Chantrey Bequest purchase ledgers, RAA/PC/12/3, p. 25.

129 Ibid., pp. 41, 45.

130 Income from investments, already significantly diminished, amounted to just over £12,000 in both 2007 and 2008 but declined considerably after the 2008 crash. Personal communication of Alan Bowness and Paul Huxley RA while RA Treasurer; Charity Commission website.

A CLOSER LOOK 7.1

1 John Newman, *Glamorgan*, vol. III in *The Buildings of Wales*, ed. Bridget Cherry, London 1995, p. 251.

2 Armstead also carved the 'fine reliefs' (ibid., p. 254) on the Prichard-designed tomb of Herny Thomas in the north aisle (after 1863).

3 The window is by Morris & Co. (among several others, notably two in the north aisle): the Christ and the Zacharias are by Morris himself.

A CLOSER LOOK 7.2

1 E.H. in *Pilot*, I (1900), p. 450, quoted in Susan Beattie, *The New Sculpture*, New Haven and London 1983, pp. 161, 258.

2 Victoria and Albert Museum, A.14-1991.

3 Aymer Valance, 'British Decorative Art in 1899, and the Arts and Crafts Exhibition, Part I', *Studio*, XVIII (October 1899), p. 50.

4 The likeness of Lamia to Christabel Cockerell was noted by Katherine Faulkner after studying family photographs in the Frampton archive. Katherine Faulkner, 'George Frampton: New Sculpture and Art Nouveau', in *Art Nouveau Sculpture: Obrist and his Contemporaries; Papers and Proceedings*, Leeds 2010, p. 12, n. 31.

5 Roger Marx, 'La Libre Esthétique', *La Revue Encyclopédique*, 1 November 1894, pp. 475–8, quoted in Beattie 1983, p. 158.

8 FROM HISTORY TO GENRE

1 For Hogarth and history painting and *Garrick as Richard III* in particular, see Robin Simon, *Hogarth, France and British Art: The Rise of the Arts in Eighteenth-Century Britain*, London 2007, chs 5, 6, 11.

2 See Mark Hallett, *Reynolds: Portraiture in Action*, New Haven and London 2014.

3 Kenneth Garlick, in his magisterial account, accepted that Maria had sat for the *Gipsy Girl*; see *Sir Thomas Lawrence: A Complete Catalogue of the Oil Paintings*, Oxford 1989, cat. 717.

4 This would have been the pose naturally adopted by the model, as can be seen in other drawings of the period. But perhaps Lawrence was thinking of Edgar in *King Lear* (III, 4): 'The Prince of Darkness is a gentleman.' It was a familiar notion. In the finished painting this anachronism was abandoned.

5 RA Archives, A.P., 'Royal Academy: Twenty-Ninth Exhibition' [1797], in *Royal Academy Critiques*, vol. II, p. 10, no. 170: '*Satan calling his*

legions. T. LAWRENCE, R.A.', CR1/2, I am grateful to Helen Valentine for drawing my attention to this passage.

6 Johan Zoffany RA, *David Garrick and Mrs Pritchard in Macbeth*, 1768, Garrick Club, London.

7 This is the original title. See illustration of the engraving after it (see fig. 227).

8 Kenneth Clark, *The Romantic Rebellion: Romantic versus Classic Art*, London 1973, p. 20.

9 Tom Taylor, *Life of Benjamin Robert Haydon, Historical Painter, from his Autobiography and Journals*, 3 vols, London 1853, III, p. 358. This phenomenon and its ramifications is the subject, notably, of David H. Solkin, *Painting out of the Ordinary: Modernity and the Art of Everyday Life in Early Nineteenth-Century Britain*, New Haven and London 2008.

10 Solkin 2008, for example, p. 37.

11 Allan Cunningham, *The Life of Sir David Wilkie: With his Journals, Tours, and Critical Remarks on Works of Art; and a Selection from his Correspondence*, 3 vols, London 1843, II, p. 37.

12 Taylor 1853, I, p. 324.

13 Martin Postle, *Angels and Urchins: The Fancy Picture in 18th-Century British Art*, exh. cat., Djanogly Art Gallery, Nottingham 1998, pp. 10–11.

14 Sir Joshua Reynolds, *Fifteen Discourses delivered in the Royal Academy* [1769–90], London n.d., p. 234.

15 Allan Cunningham, *The Anniversary: or, Poetry and Prose for MDCCCXXIX*, London 1829, p. 315.

16 Burnet 1848, pp. 108, 114.

17 Harry Mount, 'Our British Teniers: David Wilkie and the Heritage of Netherlandish Art', in Nicholas Tromans, *David Wilkie: Painter of Everyday Life*, exh. cat., Dulwich Picture Gallery, London 2002, pp. 30–39 (quote on p. 30).

18 Richard Redgrave, *Inventory of the Pictures, Drawings, Etchings, &c in the British Fine Arts Collections deposited in the New Gallery, South Kensington: Being for the Most Part the Gift of John Sheepshanks, Esq, and Mrs Ellison*, London 1863, p. 3.

19 Cunningham 1843, I, p. 270.

20 Ibid., p. 272.

21 Tromans 2007, pp. 85–6.

22 Cunningham 1843, I, pp. 239–40.

23 Ibid., p. 242.

24 Ibid., p. 330. The reference, moreover, is to the throne of Satan in Book II of Milton's *Paradise Lost*, which carries some interesting overtones: 'High on a Throne of royal State, / That far outshone the Wealth of Ormus or of Ind.../ Satan exalted sate...'

25 Cunningham 1843, I, p. 346.

26 Walter Allen, *The English Novel: A Short Critical History* (1954), London 1958, p. 108.

27 John Buchan, *Sir Walter Scott*, London, Toronto, Melbourne and Sydney 1932, p. 129.

28 Ibid., p. 85.

29 Thomas Love Peacock, 'The Four Ages of Poetry', in H. F. B. Brett-Smith, ed., *Essays on Poetry*, Boston and New York 1921, pp. 15, 16.

30 Roy Strong, *Painting the Past: The Victorian Painter and British History*, rev. edn, London 2004, p. 39.

31 In his third novel, *The Antiquary* (1816): Cunningham 1843, III, pp. 20–21.

32 Strong 2004, p. 9. See also Andrew Sanders, *In the Olden Time: Victorians and the British Past*, New Haven and London 2013.

33 The two most famous paintings of this subject are Paul Delaroche, the *Children of Edward* of 1830 (Musée du Louvre, Paris) and John Everett Millais RA in 1878 (the *Two Princes Edward and Richard in the Tower*, Royal Holloway College, London). See Robin Simon, 'Shakespeare in Art', *London Art History Society Review*, 2016, pp. 5–7, illustrated pp. 6–7, fig. 5.

34 Martin J. Wiener, *English Culture and the Decline of the Industrial Spirit, 1850–1980*, London 1992, p. 6.

35 Samuel and Richard Redgrave, *A Century of British Painters* (1866), London 1947, p. 288.

36 His other son was the Pre-Raphaelite painter Charles Allston Collins, named after the American landscape painter Washington Allston.

37 George Eliot, *Middlemarch: A Study of Provincial Life* (1871–2), Edinburgh and London 1892, ch. 39.

38 Thomas Carlyle, *Chartism*, London 1839, ch. 1.

39 Benjamin Disraeli, *Sybil, or The Two Nations* (3 vols, 1845), London 1871, pp. 76–7.

40 Thomas Hood, *The Poetical Works*, first series, London n.d, p. 184 (quote on p. 1).

41 Mark Bills and Barbara Bryant, *G. F. Watts: Victorian Visionary*, New Haven and London 2008, p. 115.

42 Tromans 2002, p. 10.

43 Georgiana Burne-Jones, *Memorials of Edward Burne-Jones*, 2 vols, London 1904, I, p. 84.

44 Frances Margaret Redgrave, *Richard Redgrave, CB RA: A Memoir*, London 1891, p. 43.

45 Ibid., p. 58.

46 Ibid., p. 26.

47 Ibid., p. 45.

48 Ibid., p. 47.

49 Edward Mayhew, *Stage Effect: or, The Principles which command Dramatic Success in the Theatre*, London 1840, p. 44.

50 See James H. Head, *Home Pastimes; or Tableaux Vivants*, Boston, Mass. 1860.

51 Susan P. Casteras and Ronald Parkinson, eds, *Richard Redgrave, 1804–1888*, New Haven and London 1988, p. 136; Christopher Wood, *Victorian Painting*, Boston, New York and London 1999, p. 51.

52 Julian Treuherz, *Hard Times: Social Realism in Victorian Art*, London 1987, p. 26.

53 Redgrave 1947, p. 312.

54 Redgrave 1891, p. 336.

55 Richard Redgrave, *An Address on the Gift of the Sheepshanks Collection, with a View to the Formation of a National Gallery of British Art*, London 1857.

56 Marcia Pointon, *William Mulready, 1786–1863*, exh. cat., London 1986, p. 165.

57 Thomas Moore, *Letters and Journals of Lord Byron: With Notices of his Life*, Paris 1830, p. 69.

58 Cunningham 1843, I, p. 395.

59 Ibid., p. 390.

60 Ibid., p. 400.

61 Piers Brendon, *Thomas Cook: 150 Years of Popular Tourism*, London 1991, p. 169.

62 George Borrow, *The Bible in Spain: or, The Journeys, Adventures, and Imprisonments of an Englishman in an Attempt to Circulate the Scriptures in the Peninsula* (1843), London 1906, p. 1.

63 Cunningham 1843, II, pp. 459–60.

64 Ibid., p. 486.

65 Ibid., p. 429.

66 Ibid., p. 468.

67 Ibid., p. 505.

68 Ibid., p. 472.

69 Cunningham 1843, III, p. 11.

70 I am grateful to Desmond Shawe-Taylor, Surveyor of The Queen's Pictures, for the opportunity to see these paintings at Buckingham Palace.

71 Cunningham 1843, III, p. 13.

72 Ibid., p. 6.

73 Ibid., p. 2.

74 Alfred de Musset, 'Lettres de Dupuis et Cotonet', in *Oeuvres complètes de Alfred de Musset*, 10 vols, Paris 1866, IX, pp. 194–292 (quote on p. 211). 'De 1831 à l'année suivante, voyant le genre historique discrédité, et le romantisme toujours en vie, nous pensâmes que c'était le genre intime dont on parlait fort. Mais quelque peine que nous ayons prise, nous n'avons jamais pu découvrir ce que c'était que le genre intime.' Translation by Simon Poë.

75 Wilfred Meynell, ed., *The Modern School of Art*, 4 vols, London, Paris, New York and Melbourne n.d., II, p. 57.

76 *Art Journal*, 1908, p. 175.

77 Sir Merton Russell-Cotes, *Home and Abroad: An Autobiography of an Octogenarian*, 2 vols, Bournemouth 1921, II, pp. 708–9.

78 Meynell n.d., II, p. 57.

A CLOSER LOOK 8.1

1 *Middlesex Journal*, 28 April–1 May, 1770, p. 1.

2 *Morning Chronicle, and London Advertiser*, 30 April, 1773, p. 2.

3 *London Chronicle*, 10–12 May 1774, p. 453.

4 *Morning Chronicle*, 28 April 28 1775, p. 2.

5 *Public Advertiser*, 28 April 1775, p. 2.

6 Reynolds's achievement is amply studied in Mark Hallett, *Reynolds: Portraiture in Action*, New Haven and London 2014.

7 *Public Advertiser*, 2 May 1774, p. 2.

8 Ibid.

A CLOSER LOOK 8.2

1 Charles Dickens, *A Child's History of England* (1852–4), London 1914, p. 295.

2 Thomas Babington Macaulay, 'Milton', *Edinburgh Review*, August 1825; reprinted in *Critical and Historical Essays*, 8th edn, 3 vols, London 1854, I, pp. 30.

3 Ibid., p. 31.

4 Ibid., p. 46.

5 See Patricia Allderidge, *The Late Richard Dadd 1817–1886*, exh. cat., Tate Gallery, London 1974, p. 56.

6 Quoted in n. 9 in Graham Storey, ed., *The Letters of Charles Dickens* (Pilgrim Edition), vol. 10, 1862–1864, Oxford 1998, p. 237.

7 For Thornycroft's statue, see Elfrida Manning, *Marble and Bronze: The Art and Life of Hamo Thornycroft*, London 1982, pp. 128–31. For other Victorian representations of Cromwell, see Andrew Sanders, *In the Olden Time: Victorians and the British Past*, London 2013, pp. 107–23.

8 Although the scene is from Colley Cibber's radically adapted version of the play: Robin Simon, *Hogarth, France and British Art: The Rise of the Arts in Eighteenth-Century Britain*, London 2007, esp. ch. 6. Hogarth's engraving cites Act V scene 7 of this version, as further adapted by Garrick.

9 Because Cibber replaced Shakespeare's two tents at either side of the stage with one, in keeping with classical principles. Egg will have seen the Cibber version on the stage, since it was the only version played until 1877, but would have read Shakespeare's text.

A CLOSER LOOK 8.3

1 Quoted by David Cast, 'Philip Hermogenes Calderon', *ODNB*.

2 Goethe considered Calderón superior to Shakespeare in the construction of his plays.

3 Edward FitzGerald, the famous translator of the *Rubáiyát of Omar Khayyam*, published *Six Dramas of Calderon Freely Translated* in 1853, which includes *The Mayor of Zalamea*. In 1865, just two years before Calderon painted *Whither?*, FitzGerald, by now famous for the *Rubáiyát* (1859), published translations of two more plays by Calderón.

9 LANDSCAPE

1 Quoted, for example, in Graham Reynolds, *Constable: The Natural Painter* (1965), London 1976, p. 110.

2 Sir Joshua Reynolds, *Discourses on Art*, ed. Robert R. Wark, London 1966, Fourth Discourse, pp. 65–6.

3 Henry Fuseli, *The Life and Writings of Henry Fuseli*, ed. John Knowles, 3 vols, London 1831, II, p. 217.

4 See Martin Postle and Robin Simon, eds, *Richard Wilson and the Transformation of European Landscape Painting*, exh. cat., New Haven and London 2014, and David J. Solkin, *Richard Wilson: The Landscape of Reaction*, London and New Haven 1982 (respectively).

5 See Martin Postle in Postle and Simon 2014, p. 147, n. 102.

6 John Hayes, ed., *The Letters of Thomas Gainsborough*, New Haven and London 2001, Letter 40, p. 68.

7 R. B. Beckett, ed., *John Constable's Correspondence*, 6 vols, London/Ipswich, 1962–8, vol. 2 (*Early Friends and Maria Bicknell (Mrs. Constable)*, Ipswich, 1964), p. 16.

8 Hayes 2001, Letter 25, p. 30.

9 Mark Evans, ed., *John Constable: The Making of a Painter*, exh. cat., London 2014.

10 See Postle and Simon 2014, cats 57, 58, 121, and pp. 5–8.

11 Letter to Archdeacon Fisher, 23 October 1821, in C. R. Leslie, *Life and Letters of John Constable R.A.* (1843), London 1896, p. 103.

12 The 'New' became the Royal Institute of Painters in Water Colours in 1885; the original society of 1804 became the Royal Society of Painters in Water Colours in 1881.

13 William Vaughan, *Samuel Palmer: Shadows on the Wall*, New Haven and London 2015.

14 A. H. Palmer, ed., *The Life and Letters of Samuel Palmer, Painter and Etcher*, London 1892, p. 178 (letter to John Linnell, 17 May 1829).

15 *European Magazine*, new series, I, 1 (September 1825), p. 85.

16 Raymond Lister, ed., *The Letters of Samuel Palmer*, Oxford 1974, p. 820.

17 Formerly in the Northbrook Collection. See T. S. R. Boase, *English Art, 1800–1870*, Oxford 1959, pl. 66a.

18 John Ruskin, *Modern Painters*, rev. edn, 5 vols, London 1888, I, p. 119.

19 Laura Knight, *The Magic of a Line: The Autobiography of Laura Knight, D.B.E., R.A.*, London 1965, p. 309.

20 Paul Nash, *Room and Book*, London 1932, p. 7.

21 Quoted in Michael Howard, *Lowry: A Visionary Artist*, Salford 2000.

22 Kyffin Williams, *Portraits*, Ceredigion 1996, p. 124.

A CLOSER LOOK 9.1

1 She gave the late *Self-portrait*, RA 03/1395, in 1808.

2 Oil on canvas, 102.6 × 128 cm, *c*.1783, Philadelphia Museum of Art, M1928-1-9.

10 THE EMBATTLED TRADITION

1 The first was Johan Zoffany's *Academicians of the Royal Academy*, 1771–2, Royal Collection.

2 Quoted in M. Holroyd, *Augustus John: The New Biography*, London 1996, p. 477.

3 The Royal Academy accepted the picture as Elwell's Diploma Work on 11 April 1939. RA Archives, Council Minutes, 11 April 1939, RAA/PC/1/27.

4 'Mr. F. Cadogan Cowper: Subject Pictures and Portraits', *The Times*, 20 November 1958, p. 16.

5 'Art of To-Day: Sir Frank Dicksee on the Cult of Ugliness', *The Times*, 27 September 1928, p. 10.

6 Dicksee's theory of art is best expressed in the two discourses he gave to students at the Royal Academy in 1925 and 1927: Sir Frank Dicksee, *Discourse delivered to the Students of the Royal Academy on the Distribution of Prizes, December 10, 1925*, London 1925; *Discourse…December 10, 1927*, London 1927.

7 See K. McConkey, *The New English: A History of the New English Art Club*, London 2006.

8 'The Case for Modern Painting by a Modern Painter, IV – The Royal Academy and the New English Art Club', *Burlington Magazine*, XI (July 1907), p. 204.

9 H. H. La Thangue, 'A National Art-Exhibition', *Magazine of Art*, X (January 1887), p. 30.

10 See O. Reutersvärd, 'The "Violettomania" of the Impressionists', *Journal of Aesthetics and Art Criticism*, IX (December 1950), pp. 106–10.

11 The term 'anglicized Impressionism' is used in A. Brighton, '"Where are the Boys of the Old Brigade?": The Post-War Decline of British Traditionalist Painting', *Oxford Art Journal*, IV (July 1981), p. 36.

12 In July 1897 he temporarily deposited a portrait of the violinist Johannes Wolff (now in the Fogg Art Museum, Cambridge, Mass.) at Burlington House. Council Minutes, 27 July 1897, RAA/PC/1/20.

13 *The Whistler Journal*, ed. E. R. and J. Pennell, Philadelphia 1921, p. 39.

14 H. S., 'Art: The Academy – III', *Spectator*, LXXXIV (26 May 1900), p. 742.

15 RA Archives, Annual Report 1900, p. 54, RAA/PC/10.

16 For more on Hacker, see A. L. Baldry, 'The Paintings of Arthur Hacker, RA', *Studio*, LVI (1912), pp. 175–83.

17 It was perhaps no coincidence that in the same year as Hacker's picture Piccadilly Circus installed its first electric advertisements.

18 *The Times*, 8 May 1911, p. 10.

19 See *The Times*, 28 September 1954, p. 2.

20 The painting has particularly striking affinities with Umberto Boccioni's *Riot in the Galleria* (Pinacoteca di Brera, Milan) and Giacomo Balla's *Street Light* (Museum of Modern Art, New York), both dated to 1909.

21 'Bitter truth' is the artist Paul Nash's term. For more, see R. Cork, *A Bitter Truth: Avant-Garde Art and the Great War*, New Haven and London, 1994.

22 C. H. Collins Baker, 'Royal Academy Again', *Saturday Review*, CXXIII (12 May 1917), p. 429. For more on academic responses to the First World War, see P. Harrington, 'Early Paintings of the Great War', *Imperial War Museum Review*, VII (1992), pp. 46–54.

23 C. Sims, *Picture Making: Technique and Inspiration*, London 1934, p. 119.

24 For a discussion, see D. Peters Corbett, *The Modernity of English Art 1914–30*, Manchester 1997, pp. 200–08.

25 J. L. McQ., 'Rebels in the Fortress', *Daily Express*, 3 January 1919, p. 4.

26 Quoted in Holroyd 1996, p. 475.

27 For more on the picture and its context, see W. Baron, *Sickert: Paintings and Drawings*, New Haven and London 2006, pp. 268–9.

28 See W. Orpen, *An Onlooker in France 1917–1919*, London 1921, pp. 98–120.

29 Orpen's sitter took up a new position as the chef for the grillroom at the Royal Palace Hotel in London. *American Art News*, 11 June 1921, p. 1

30 F. Rutter, *Some Contemporary Artists*, London 1922, pp. 103–4.

31 Funds for the Chantrey Bequest were received under the will of Sir Francis Chantrey in 1875, after the death of his widow.

32 Annual Report 1921, p. 68.

33 For a discussion, see C. Harrison, *English Art and Modernism, 1900–1939*, London 1981, pp. 231–93.

34 Quoted in F. Davis, 'Sir Gerald Kelly – The RA's Television Pioneer', *Art and Antiques Weekly*, IV (5 February 1972), pp. 10–11.

35 'Sir James Gunn: Obituary', *The Times*, 1 January 1965, p. 12.

36 There are old photographs from a sketch-book by Gunn in the RA collections: Object History File (the sketchbook is owned by the artist's descendants).

37 '"A Mona Lisa of 1944" is Academy Picture of the Year', *Daily Mail*, 29 April 1944, p. 3.

38 Frampton had collected most of these objects from home. The vase and masonry had been left at his family house by its previous occupants in 1908; the bust belonged to his father (the sculptor George Frampton), and the tape measure was owned by the artist himself. R. Morphet, *Meredith Frampton*, London 1982, p. 56. See also Harriet Judd, ed., *The Mythic Method: Classicism in British Art 1920–1950*, exh. cat., Chichester 2016.

39 See *Driven to Draw: Twentieth-Century Drawings and Sketchbooks from the Royal Academy's Collection*, exh. cat., Royal Academy of Arts, London 2011.

40 Quoted in J. G. P. Delaney, *F. Ernest Jackson and his School*, Oxford 2000, p. 6.

41 Quoted in P. V. Bradshaw, ed., *Come Sketching*, London and New York 1949, p. 13.

42 Quoted ibid., p. 14.

43 Brangwyn's assistant Kenneth Center made a portrait painting of Mackmurdo based on what seems to be the same photographic source.

44 F. Brangwyn to E. Pugh, 11 December 1951, William Morris Gallery archive, London, Brangwyn–Pugh Correspondence, ref. J610-758.

45 *The Times*, 5 May 1928, p. 13.

A CLOSER LOOK 10.1

1 Letter from Sir Stanley Spencer RA to Hilda Carline, n.d., Tate Archive, London, TGA 733.3.74.

2 Letter from Spencer to Gwen Raverat, 20 December 1932, Tate Archive, London, TGA 8216.3.

11 ABSTRACTION TO ABSTRACT

1 Quoted in Sidney Hutchison, *The History of the Royal Academy 1768–1986*, London 1986, p. 26.

2 Quoted in RA Archives, Annual Report 1945, p. 28, RAA/PC/10.

3 Sir Alfred James Munnings, *The Finish*, London 1952, p. 145.

4 Herbert Read, 'New Aspects of British Sculpture', in *XXVI Venice Biennale*, exh. cat., Venice 1952.

5 Quoted by Norbert Lynton in 'Introduction', *British Painting 40–49*, exh. cat., Arts Council, London 1966. As Lynton points out, 'The phrase itself belongs to the decade.'

6 Translated in Richard Padovan, *Proportion: Science, Philosophy, Architecture*, London 1999, p. 306 (from Adolf Zeising, *Neue Lehre von den Proportionen des menschlichen Körpers...*, Leipzig 1854, p. v).

7 Annual Report 1945, p. 36.

8 Christos Joachimedes, 'A New Spirit in Painting', in *A New Spirit in Painting*, exh. cat., Royal Academy, London 1981, p. 14.

9 Ibid.

10 Ibid.

11 Ibid.

12 SILVER

1 Letter to the Revd William Mason, 18 April 1778, in W. S. Lewis, ed., *The Yale Edition of Horace Walpole's Correspondence*, 48 vols, New Haven 1937–83, XXVIII, p. 385.

2 Richard Rush, on 3 May 1818: quoted in P. Ziegler, ed., *A Residence at the Court of London*, London and Melbourne 1987.

3 Holger Hoock, *The Kings' Artists: The Royal Academy of Arts and the Politics of British Culture 1760–1840*, Oxford 2003.

4 K. Garlick, A. Mackintyre and K. Cave, eds, *The Diary of Joseph Farington*, 17 vols, New Haven and London 1978–98.

5 RA Archives, List of donations of plate c.1770–1800, RAA/SEC/1/39.

6 Sidney C. Hutchison, *The History of the Royal Academy 1768–1968*, London 1968, p. 231.

7 Quoted in John Brewer, *The Pleasures of the Imagination* (1997), Oxford 2013, p. 34.

8 Gilbert R. Redgrave, ed., *A Manual of Design Compiled from the Writings and Addresses of Richard Redgrave R.A.*, London 1890, p. 124.

9 List of donations of plate.

10 Boulton & Watt Archive and Matthew Boulton Papers, Birmingham Central Library:

microfilm reel collections (Adam Matthew Publications), MBP 114, MBP 115, 'Boulton and Fothergill Journal, Soho, 1776–1778'.

11 The 'Gentlemen's Ledger' for this period has been published by Helen Clifford, *Silver in London: The Parker and Wakelin Partnership 1760–1776*, New Haven and London 2004.

12 The court proceeding can be found at www.oldbaileyonline.org, reference number t17691018-9.

13 Charles Lock Eastlake, *Hints on Household Taste* (1868), 2nd edn, London 1869, p. vii.

A CLOSER LOOK 12.1

1 RA Archives, acc. 1999/2, letters removed from Sir Joshua Reynolds's tea caddy.

2 From internal evidence, it must be the painter James Archer RSA.

13 FURNITURE

1 Sir Robert Strange, *An Inquiry into the Rise and Establishment of the Royal Academy of Arts*, London 1775, pp. 73–4.

2 1788 account of 'Carpenters Work done at the Royal Academy by George Neale' in RA Archives, Bills, receipts and quarterly statements of expenditure 1788, RAA/TRE/2/1/2.

3 Similar boxes, nowadays bare, white and bright, are still to be seen in the Royal Academy Schools.

4 John Buhl (RA Archives, Quarterly expenditure and annual balance sheets 1768–95, RAA/TRE/1/1) was involved in the furnishing of Lansdowne House for Lord Shelburne, also in 1771 (Geoffrey Beard and Christopher Gilbert, *Dictionary of English Furniture Makers 1660–1840*, Leeds 1986, p. 125); RA Archives, Council Minutes, 19 May 1771, RAA/PC/1/1.

5 Council Minutes, 4 January 1773.

6 Ibid., 15 October 1772, 6 November 1772.

7 As n. 2 above.

8 MaryAnne Stevens (personal communication) recalls seeing very similar plinths in the Real Academia de Bellas Artes de S. Fernando in Madrid, founded in 1752. The late Clive Wainwright surmised of the plinths with casters that those plinths with cornices were of the eighteenth century and those without cornices of the nineteenth: ibid.

9 As n. 2 above.

10 Christie's, London, 26 May 1821, lot 54.

11 This was Lancelot Myles Glasson, whose *Young Rower*, now in Rochdale Art Gallery, was

Picture of the Year when shown at the Academy in 1932, creating more of a frisson than his languorous *Repose*, purchased by Brighton Museum and Art Gallery in 1929.

12 For Marks see G. C. Williamson, *Murray Marks and his Friends*, London 1919. In 1947 the Godwins published a romanticized life of Morris, *Warrior Bard: The Life of William Morris*.

13 Robin Simon, *The Portrait in Britain and America, with a Biographical Dictionary of Portrait Painters 1680–1914*, Oxford and Boston, Mass. 1987, p. 222. Rand exhibited at the Royal Academy in 1840, and prints and copies after his lost portrait of the Duke of Sussex are in the Royal Collection.

14 Jane Roberts, *Royal Artists*, London 1987, p. 88, pl. 25, and p. 108.

15 Compare a labelled tray illustrated by Christopher Gilbert, *Pictorial Dictionary of Marked London Furniture 1700–1840*, Leeds 1996, p. 112, pl. 131.

16 Joseph Montellier was listed as a cabinet-maker at Castle Street, Oxford Street, from 1784 to 1793 (Quarterly expenditure and annual balance sheets 1768–95; Beard and Gilbert 1986, p. 616).

17 Charles Arbuckle, St Albans Street, Pall Mall, a close neighbour and a Fellow of the Society of Arts and Manufactures (Quarterly expenditure and annual balance sheets 1768–95; Beard and Gilbert 1986, p. 16).

18 Thomas Ayliffe was 'Turner in Ordinary to his Majesty' from 1762 and in partnership with Webb (possibly Henry Webb of Hammersmith, Beard and Gilbert 1986, p. 953) from 1767: their main business was chair-making and a later partner, John Gee, also became Turner in Ordinary (Quarterly expenditure and annual balance sheets 1768–95; Beard and Gilbert 1986, pp. 27, 334).

19 Seddons of Aldersgate Street were the largest firm in London (RA Archives, Bills, receipts and quarterly statements of expenditure 1788, and Annual accounts of Sir William Chambers, RAA/2/1/1; Beard and Gilbert 1986, pp. 793–8).

20 See n. 2 above for reference.

21 British Museum, London, 1904, 0101.1.

22 Tate Britain, London, N05137.

23 One is in the President's Corridor, the other in store.

24 Council Minutes, 10 January 1771.

25 George Dunlop Leslie RA, *The Inner Life of the Royal Academy*, London 1914, p. 15.

26 The Hague, 1625, illus. Simon Jervis, *Printed Furniture Designs before 1650*, Leeds 1974, pl. 312.

27 Illus. Earl of Dalkeith, *Boughton: The English Versailles*, Derby 2006, p. 35.

28 Mary Webster, *Johan Zoffany*, New Haven and London 2011, p. 397; Edward Croft-Murray, 'A Drawing of the Royal Academy by Henry Singleton', *British Museum Quarterly*, IX, 4 (1935), pp. 106–9. The chairs are less visible in the completed painting. For Singleton's painting see Chapter 5, A Closer Look 2.

29 Both finished watercolour (1900,0725.12) and study (1862,0614.194) are in the British Museum, London. The full inscription on the latter reads: 'Mr Catton, one of the first Royl [*sic*] Academicians painted these Crowns and letters of the Baks [*sic*] of the Chairs, he was originally a Herald painter I copied this from a chair at Somerset house, shortly before their removal to the New Building in Trafalgar Square. 1836.'

30 Edward Croft-Murray, *Decorative Painting in England 1537–1837*, vol. II, *The Eighteenth and Early Nineteenth Century*, London 1970, pp. 183–4.

31 John Harris, *Sir William Chambers*, London 1970, pp. 75, 177, 179 and 216.

32 Annual accounts of Sir William Chambers.

33 It is certainly a far cry from Chambers's pioneering neoclassical president's chair for the Royal Society of Arts, designed in 1759 (illus. Harris 1970, pl. 181).

34 They are upholstered in tattered pink striped tabaret, which may be evidence of early nineteenth-century recovering. Two further gilt armchairs of the same basic style, but with their backs overstuffed with no gilt frame visible, are covered in a plain modern pink material.

35 Susan Stuart, *Gillows of Lancaster and London*, 2 vols, Woodbridge 2008, I, pp. 134, 176–7.

36 Edward Joy, *Pictorial Dictionary of British 19th Century Furniture Design*, Woodbridge 1977, e.g. pp. 216, 221. Some chairs in one set, that with deeper lappets, are stamped 'TW' on their seat rails.

37 RA 03/1288. They appear later in Sir Herbert von Herkomer RA, *Council of the Royal Academy* (1908; Tate Britain, London, N02481) and in Frederick William Elwell RA, *Royal Academy Selection and Hanging Committee* (1938; RA 03/1320), which shows the committee at lunch in the General Assembly Room, with armchairs from the set in use.

38 Beard and Gilbert 1986, p. 68; stock sold at Christie's, London, 4–5 March 1909.

39 Harris had a particular interest in furniture stimulated by the fact that his wife, Ethel née Maule, was a member of the family of the great cabinet-making firm Lamb of Manchester (personal communication, 1967).

40 A modern label on the back seat rail records: 'Restored by Rural Industries Bureau, Wimbledon, London, Sept. 1963'. Perhaps this

is when somewhat crude strips of mahogany were nailed round the seat. Although the R.I.B.'s advisor was Ralph Edwards, the then doyen of furniture historians, their work did not always match up to modern conservation standards: witness their treatment of furniture at Knole.

41 Reynolds's portrait of Mary Horneck, shown at the Royal Academy in 1775, was presented to the National Trust for Cliveden by Hon. David Astor in 1994 (NT 766137).

42 Dr Edward Fryer, *The Works of James Barry, Esq.*, 2 vols, London 1809, I, pp. 281–2.

43 Council Minutes, 2 April 1879, RAA/PC/1/16.

44 John Harris, 'Early Neo-Classical Furniture', *Furniture History*, II (1966), p. 5; Harris 1970, p. 223.

45 Elizabeth White, *Pictorial Dictionary of British 18th Century Furniture Design*, Woodbridge 1990, p. 267.

46 William Chambers to Lord Melbourne, 14 August 1773, Letter Book, British Library, London, Add. MS 41133, p. 107, cited in Nicholas Goodison, 'William Chambers's Furniture Designs', *Furniture History*, XXVI (1990), p. 68.

A CLOSER LOOK 13.1

1 Paul Mitchell and Lynne Roberts have kindly commented that the frame is inspired by Louis XVI and Italian neoclassical examples, the latter being something that Nollekens could have seen in Italy 1762–70, and that he is unlikely to have carved it himself.

2 RA Archives, Council Minutes, 11 June 1773, RAA/PC/1/1.

3 Joseph Baretti, *Guide through the Royal Academy*, London 1781, p. 25. The four Reynolds portraits that Baretti says were so instantly recognizable were the half-length *Self-portrait* and *Sir William Chambers* and the full-lengths of King George III and Queen Charlotte.

4 This report is noted by Mark Hallett, *Reynolds: Portraiture in Action*, New Haven and London 2014, pp. 344–5. The report also notes the presence of John Singleton Copley's *Samuel and Eli* painted in 1780 but now at the Wadsworth Atheneum, Hartford, Conn.

5 These comprise 307 paintings, 8 bas-relief sculptures and 125 architectural drawings and other works on paper.

6 He made two donations, 1886 and 1888.

14 THE SCHOOLS AND THE PRACTICE OF ART

1 'Institution of the Royal Academy of Arts', in *The Cambridge Magazine or Universal Repository of Arts, Sciences and Belles Lettres for the Year 1769*, London 1769, pp. 28–9.

2 Income from the exhibitions was intended in part to support the Schools, and apart from a brief period (1979–80), the Academy has always provided free tuition, which at times was controversial. In 1799 James Barry, for instance, suggested that some boys went to the Schools 'because their parents could not give £20 for their learning a trade': see K. Garlick, A. Mackintyre and K. Cave, eds, *The Diary of Joseph Farington*, 17 vols, New Haven and London 1978–98, IV, p. 1124 (1–3 January 1799).

3 Their letter of 28 November 1768 requesting the support of King George III only states their intention to establish a 'society to promote the arts of design', incorporating 'a well-regulated School or Academy of Design'. RA Archives, General Assembly Minutes, transcribed in RAA/GA/1/1, pp. 2–3. Charles Saumarez Smith, *The Company of Artists: The Origins of the Royal Academy of Arts in London*, London 2012, p. 64, and Holger Hoock, *The King's Artists*, Oxford 2003, pp. 23, 26–7; see also 'The King's Artists', Tennant Gallery exhibition guide, Royal Academy, London 2012, p. 2.

4 Sir Joshua Reynolds, *Discourses on Art*, ed. R. Wark, New York 1966, Discourse III, pp. 45, 49.

5 A rather damaged and discoloured drawing of the Venus de' Medici by the teenaged William Mulready (RA 02/635) of *c*.1800 can be usefully compared with a very similar drawing made in the Schools by the young J. M. W. Turner of *c*.1792 (Tate Britain, London, D00060), a reflection of the continuity of the training at this date.

6 RA Archives, Instrument of Foundation, 10 December 1768, Clause VII, RAA/IF.

7 He was also one of the artists who had actively campaigned for a formal academy to be set up in London prior to the foundation of the RA.

8 See Tom Taylor, ed., *Life of Benjamin Robert Haydon, Historical Painter…*, 3 vols, London 1853, I, p. 33; and Tom Taylor, ed., *Autobiographical Recollections by the Late Charles Robert Leslie R.A.*, 2 vols, London 1860, I, p. 37.

9 Garlick, Mackintyre and Cave 1978–98, I, p. 281 (22–8 December 1794): 'Hamilton says the life Academy requires regulation: but the Plaister Academy much more. The Students act like a mob, in endeavouring to get places.' See also 'Recollections of Fuseli' in the *Polytechnic Journal*, 1840, pp. 122–3.

10 A. M. W. Sterling, ed., *The Richmond Papers from the Correspondence and Manuscripts of George Richmond R.A. and his Son Sir William Richmond R.A., K.C.B.*, London 1926, pp. 9–10.

11 Sir Charles Eastlake confirmed that this was still the case as late as 1863: 'He [the student] is free to attend or not, as he likes.' See *Report of the Commissioners on the Present Position of the Royal Academy in relation to the Fine Arts with Minutes of Evidence, Appendix, Index and Observations of the Members of the Royal Academy on the Report, 1863–1864*, London 1863, no. 594, p. 67, Sir C. L. Eastlake (20 February 1863). Similarly, see 'Glimpses of Artist-Life: The Royal Academy Schools', *Magazine of Art*, December 1887, pp. 55–62; p. 59 suggests that this laissez-faire attitude persisted, noting that 'there are two distinct…sets of students in the Academy – those who work and those who don't.'

12 This methodical approach was recommended, for instance, by the influential German theorist Johann Georg Sulzer in his *Allegemeine Theorie der Bildenden Kunste* (General Theory of the Fine Arts, 1792); see Nikolaus Pevsner, *Academies of Art Past and Present*, New York 1973, p. 172.

13 There are examples of RA student drawings of casts of parts of the figure (e.g. B. R. Haydon, RA 02/392 and RA 02/424), and fragmentary casts can be seen in depictions of the Antique School, but there is no indication that there was any systematic approach requiring the students to begin by drawing them for any particular length of time.

14 Reynolds 1966, Discourse I, p. 18. The word 'mannerism' itself is never used, but what Reynolds describes is what we would now understand as such. He writes of students being distracted from attaining 'real excellence' by 'falacious mastery' and attempting to imitate 'dazzling excellencies which they will find no great labour in attaining'.

15 Ibid., Discourse I, p. 16.

16 Ibid., Discourse II, p. 29.

17 James Nevay presented his drawings after the *Last Judgement* to the Royal Academy in 1773. There is no record for the acquisition of the Vanderbank drawing, but it is one of a small group in the collection of drawings of life and cast studies that predate the foundation of the Academy and were all produced by artists connected with the St Martin's Lane Academy (G. M. Moser, Francis Hayman and Allan Ramsay).

18 The first recorded purchase was a 'number of original drawings by James Barry' acquired for the price of 5 guineas in 1844; see RA Archives, Council Minutes, 12 November 1844, RAA/PC/1/10. This possibly refers to the drawings 04/495 and 04/496.

19 G. Keynes, ed., *The Complete Writings of William Blake*, Oxford 1966, p. 449.

20 The drawings were purchased at Christie's in 1864 for £447: Council Minutes, 16 May 1864, RAA/PC/1/12.

21 The albums of autotypes were purchased in 1878 for £300: RA Archives, Annual Report 1877, p. 57, RAA/PC/10. There was further discussion on the subject in 1888 when the Keeper, Philip Calderon RA, complained that the autotypes were kept in the Library in bound volumes. He requested that some 'fine drawings' be bought specifically for the Schools, but Council's response was to offer further facsimiles; see Annual Report 1888, p. 31, and Annual Report 1889, p. 14. Also, Henry Nelson O'Neil ARA offered to donate one of his own life drawings for the Schools, suggesting that other members be encouraged to do the same, but his proposal was rejected: Council Minutes, 29 May 1871, RAA/PC/1/13.

22 See, for instance, Council Minutes, 20 May 1852, RAA/PC/1/10, and Annual Report 1887, p. 47. A collection was assembled in the late nineteenth century, but it was an ill-fated project as the drawings were first affected by damp (Council Minutes, 9 December 1870, RAA/PC/1/13), some were later stolen (see Annual Report 1886), and it is possible that the remainder were eventually given back to the artists or otherwise disposed of.

23 Drawings made at the Academy by students can be found in numerous collections including those of Tate Britain, the British Museum, the Fitzwilliam Museum and the Victoria and Albert Museum.

24 Fuseli's comment is from an article in the *Polytechnic Journal* of 1840, quoted in I. Bignamini and M. Postle, *The Artist's Model: Its Role in British Art from Lely to Etty*, exh. cat., Nottingham 1991, cats 60a, 60b. Thomas Lawrence's comment is from *The Times*, 12 December 1826.

25 For instance, J. M. W. Turner's chalk study of the Belvedere Torso, Victoria and Albert Museum, London, inventory no. 9261.

26 Prince Hoare, *Academic Annals of Painting, Sculpture and Architecture*, London 1805, p. 182.

27 General Assembly Minutes, 15 April 1814, RAA/GA/1/3.

28 W. P. Frith, *My Autobiography and Reminiscences*, 3 vols, London 1887, I, p. 35. Frith continued to attend Sass's Academy after enrolling at the Royal Academy: see pp. 50–52.

29 Ibid., p. 36.

30 William Holman Hunt, *Pre-Raphaelitism and the Pre-Raphaelite Brotherhood*, 2 vols, London 1905, II, p. 37. J. L. Tupper, 'Extracts from the Diary of an Artist', No. VII, *Crayon*, III, 2 (February 1856), pp. 43–5.

31 An article in the *Art-Union* (1 August 1848, pp. 233–6), for instance, denounced the Academy as 'more a School in *name* than in *fact*' that operated no more than the 'shadow of a system'. The first Schools committee was set up in 1800 and relegated several students back to the Antique Academy because their drawings were not deemed good enough; see General Assembly Minutes, 27 March 1800, RAA/GA/1/2. There were numerous similar enterprises; see, for instance, Council Minutes, Report of the Schools Committee, 24 January 1851, RAA/PC/1/10.

32 Specifically, the 1835 Select Committee on Art and Manufactures and the 1863 Royal Commission on the Royal Academy. See Gordon Fyfe, 'Auditing the RA: Official Discourse and the Nineteenth Royal Academy', in *Art, Power and Modernity*, Leicester 2001, ch. 4.

33 Council Minutes, Report of the Schools Committee, 24 January 1851.

34 For at least the first 100 years there was no stipulation on how long students had to spend in the Antique School, and the average was about a year. Some spent much longer and this became increasingly common.

35 'Glimpses of Artist-Life: The Royal Academy Schools' 1887, p. 59.

36 Harry Furniss, *Royal Academy Antics*, London, Paris and Melbourne 1890, p. 35.

37 Annual Report 1903, Appendix 14, Papers relating to the Proposed Changes in the School Laws, p. 77.

38 Annual Report 1969, Keeper's Report, pp. 34–5.

39 In order to move up to the life class students needed to have their drawings of casts approved by the Keeper and the Visitor (see General Assembly Minutes, 2 January 1769, RAA/GA/1/1) and later also by the Council.

40 See Council Minutes, 6 November 1772 and 30 December 1775, RAA/PC/1/1, the latter relating to a dispute between G. B. Cipriani, as Visitor, and Moser.

41 Numerous students described Etty and Mulready drawing with the students, and the latter mentioned it himself in a statement reproduced in the *Report of the Commissioners appointed to inquire into the Present Position of the Royal Academy…and the Minutes of Evidence*, London 1863, p. 173. For Etty see G. D. Leslie, *The Inner Life of the Royal Academy*, London 1914, p. 25. W. P. Frith recalled Sir Edwin Landseer as Visitor being berated by his father, the printmaker John Landseer, for reading instead of drawing with the students: Frith 1887, pp. 60–61.

42 The enquiries of 1835 and 1863 (mentioned above) were particularly critical of the Visitor system. Opponents of the method such as Benjamin Robert Haydon and William Holman Hunt described it as useless and absurd. W. P. Frith admitted that it often caused 'confusion and bewilderment' (Frith 1887, p. 229). Others, including Sir Martin Archer Shee and J. E. Millais, defended the tradition.

43 Annual Report 1865, p. 8.

44 William L. Pressly, ed., 'Facts and Recollections of the XVIIIth Century in a Memoir of John Francis Rigaud Esq. RA by Stephen Francis Dutilh Rigaud', *Walpole Society*, L (1984), pp. 1–164. There is a drawing by J. M. W. Turner (Tate Britain, London, D00198) that is so similar to Barry's that it appears to have been made in the same life class, i.e. when Barry was Visitor, which he was in 1794 and 1795.

45 Pressly 1984. Fuseli's drawings made while acting as Visitor in the life class, including some that apparently match studies made by Turner as a student, are identified in Bignamini and Postle 1991, cats 60a, 60b.

46 Instrument of Foundation, Clause XIX.

47 A sense of confusion over this is evident in the diary of John Green Waller, an RA student in the 1830s: Lynn Robert Matteson, 'The Academy Diary of John Green Waller, F.S.A.', *Walpole Society*, LXVI (2004), pp. 219–29 (see pp. 225–6).

48 Council Minutes, 23 December 1817, RAA/PC/1/5. It was decided that any student could present the Keeper with a specimen of his painting in order to join the School of Painting. Conversely, painting in the life class was more closely monitored. See Royal Academy of Arts, *Laws Relating to the Schools, the Library and the Students*, London 1862. Martin Postle points out that from that date onwards on average only a quarter of the students of the yearly intake in the life class were permitted to paint: M. Postle and W. Vaughan, *The Artist's Model from Etty to Spencer*, London 1999, pp. 9–10.

49 Matteson 2004, p. 225 (27 August 1834).

50 Alexander Gilchrist, *The Life of William Etty, R. A.*, 2 vols, London 1855, II, p. 59.

51 Instrument of Foundation, Clause XVII. Female models were employed from March 1769 onwards, initially for three nights every other week: Council Minutes, 17 March 1769, RAA/PC/1/1, and General Assembly Minutes, 25 March 1769, RAA/GA/1/1. See also Council Minutes, 20 May 1769, noting that the female model be paid half a guinea each time she sits. The male models were paid five shillings a week and an extra one shilling for each night they sat (Council Minutes, 7 January 1769).

52 For Hogarth and further discussion of this issue, see Susan Owens, *The Art of Drawing: British Masters and Methods since 1600*, London 2013, p. 48, and also Bignamini and Postle 1991, pp. 13–14, 20.

53 Council Minutes, 17 March 1769. Rules regarding admittance to, and behaviour during, the class were constantly reiterated: for instance, Council Minutes, 14 March 1771. This continued into the nineteenth century: see, e.g., RA Archives, Schools committee report for 1874, Clause i, RAA/PC/6/2. There was also moral concern over the nudity of the casts at an early date; see *Morning Post and Daily Advertiser*, 15 May 1780, and Martin Postle, 'Covered in Ignominy: Scenes of Outrage at Somerset House', *Country Life*, 14 June 1990.

54 James Northcote cited in James Fenton, *School of Genius: A History of the Royal Academy of Arts*, London 2006, pp. 146–7.

55 *Nocturnal Revels: or, The History of King's Place and other Modern Nunneries*, 2 vols, London 1779, II, p. 25 (with thanks to Hallie Rubenhold for this reference).

56 Northcote cited in Fenton 2006, pp. 146–7.

57 This issue is covered at length in Alison Smith, ed., *Exposed: The Victorian Nude*, exh. cat., Tate Britain, London 2006, and also in Postle and Vaughan 1999, ch. 1. References in the RA Archives indicate that the campaign against life drawing began to gather momentum from the 1860s. See General Assembly Minutes, 10 December 1864, RAA/GA/1/6, reporting Edwin Landseer's suggestion that there should be 'some means of rendering the study of the nude model less offensive to decency and morality'. There had been previous accusations of immorality surrounding the nudity of both casts and life models (see note 53), but the practice was defended by early Academicians, including James Barry in his *An Enquiry into the Real and Imaginary Obstructions to the Acquisition of the Arts in England*, London 1775.

58 The drawings are from Watts's bequest to the Academy in 1904. Watts's statement appears in Mary Seton Watts, *George Frederic Watts: The Annals of an Artist's Life*, 3 vols, London 1912, III, pp. 28–9.

59 Women artists had campaigned for admission to the RA Schools during the 1850s, gaining some support in the art press; see the *Athenaeum*, 30 April 1859. An overview of women's access to art education in the UK during this period is given by Kyriaki Hadjiafxendi and Patricia Zakreski, eds, *Crafting the Woman Professional in the Long Nineteenth Century: Artistry and Industry in Britain*, Farnham 2013.

60 Gertrude Massey quoted in Charlotte Yeldham, *Women Artists in Nineteenth-Century France and England*, New York and London 1984, pp. 34–5.

61 Annual Report 1894, p. 18, RAA/PC/10; see also Helen Valentine and Annette Wickham, 'The Royal Academy Schools 1768–1918', in MaryAnne Stevens, ed., *Genius and Ambition: The Royal Academy of Arts, London, 1768–1914*, London 2014, pp. 39–41.

62 In the nineteenth century Sir Charles Eastlake explained, 'There never was a time when there was much teaching, in the ordinary sense of the word, at the Royal Academy…the great object of the Academy was to enlarge the boundaries of art and its founders were particularly cautious not to defeat that object by too precise rules in the teaching of art itself…I find that freedom in no other academy, and it is so striking in the history of our own.' See note 11.

63 Initially, architecture students who had passed through the Antique School needed only to attend lectures and the Library (RA Archives, Royal Book, 21 December 1772, RAA/GA/7/1). Some painters and sculptors formally attached themselves to the studio of an established artist: for example, James Northcote with Joshua Reynolds. Those who came from an artistic or artisanal family, such as J. F. Lewis RA and John Flaxman RA, naturally continued to work and train with their relatives. George Cumberland was perhaps unusual in being registered as an apprentice at the Royal Exchange Assurance Office at the same time that he studied at the RA Schools, but many students occupied themselves in producing works for sale and giving art lessons to amateurs.

64 See Rafael Cardoso Denis, 'From Burlington House to the Peckham Road: Leighton and the Polarities of Victorian Art and Design Education', in T. Barringer and E. Prettejohn, eds, *Frederic Leighton: Antiquity, Renaissance, Modernity*, New Haven and London 1999, pp. 247–65 (pp. 248–56 on the RA Schools).

65 Changes included the appointment of specialist teachers in sculpture and architecture, and the addition of classes specifically for drawing head studies, for painting monochrome studies of casts, for painting in oils and for mural painting. In 1871 a Professor of Chemistry was appointed. An upper age limit of 23, and 25 for sculptors, was imposed (although it was later changed), and the probationary period was shortened to three months. The evolution of these changes can be traced in the Annual Reports for the 1870s and 1880s, especially 1873, Appendix 6, and 1881, pp. 15–19.

66 G. D. Leslie, *The Inner Life of the Royal Academy*, London 1914, pp. 48–9, 53–4.

67 Annual Report 1903, Appendix 14, p. 77.

68 Annual Report 1927, Director's Report, pp. 39–41.

69 RA Archives, 'Report of a Committee consisting of the President, the Keeper, the Treasurer, Sir Thomas Brock, Messrs. Cope, Solomon, and Blomfield, appointed by the Council, July 2, 1914, to consider the possible co-operation of the Royal Academy with the State in the development of a Final School of Fine Art', February 1915, RAA/PC/6/3/1. With thanks to Helena Bonett, who gave a paper on this proposal for a seminar at the Academy in 2012.

70 This assessment is from the first Keeper's report by Peter Greenham, 10 August 1965, published in the Annual Report 1964, pp. 34–5. The 'poor relation' comment is from his second Keeper's report, July 1966, Annual Report 1965, pp. 39–41.

71 The National Advisory Council on Art Education under the chairmanship of Sir William Coldstream delivered its first report in 1960 and a second in 1970.

72 Annual Report 1976–7, Keeper's report, pp. 32–4.

73 Annual Report 1968, Keeper's report, pp. 32–3.

A CLOSER LOOK 14.1

1 Sir Joshua Reynolds, *Discourses on Art*, ed. Robert Wark, New Haven and London 1997, First Discourse, p. 16.

2 James Elmes, *Annals of the Fine Arts*, II (1818), p. 359.

A CLOSER LOOK 14.2

1 RA Archives, Lawrence papers, 14 May 1822, RA/LAW/4/20.

2 He was in Florence (and other Italian cities, including Rome) in the late 1790s and settled in Rome in 1801. The details of the provenance of the Tondo and Wicar's acquisition of it are not clear. Some notes about it in the Lawrence papers in the Royal Academy Archives (RA/LAW/4/21), written in French on early nineteenth-century Florentine paper, are discussed by Alison Cole in *Michelangelo: The Taddei Tondo*, London 2017, pp. 36–40. They state that the Tondo 'was made for Taddeo Taddei…from whose house it came directly having been acquired by…[Le Chevalier] Wicar in 1812 in Florence in the house itself of Taddeo Taddei'. That cannot have been the case, since both the relevant houses owned by the

Taddei (in via de' Ginori, Florence) in the time of Taddeo had ceased to be theirs by 1564, as Cole explains. Their other houses and possessions in Florence passed to Quaratesi cousins in 1729. Although it is possible that the Tondo was in one of these Quaratesi houses at the time of Wicar's acquisition, which might be imaginatively interpreted as 'the house itself of Taddeo Taddei', the notes may be more in the nature of a memorandum for a dealer's 'pitch' than an accurate record, as the repeated assertions about the house suggest. Giving the date '1812' for the acquisition may itself have been a matter of convenience: at the earlier period, around 1800, Wicar should have made it over to the French state and not kept it.

3 *Traits de génie*, exh. cat., Palais des Beaux-Arts de Lille, Lille 2013: Cordélia Hattori, 'Biographie Jean-Baptiste Wicar'. In fact, Wicar recovered, as might be expected, and in 1824 he even regained half his first collection of Old Master drawings that had been stolen as long ago as 1799.

4 Wilkie to Beaumont, 12 January 1823, in Allan Cunningham, *The Life of Sir David Wilkie…*, 3 vols, London 1843, II, p. 97.

5 Luke Syson, ed., *Leonardo da Vinci: Painter at the Court of Milan*, exh. cat., London 2011, cat. 86.

6 *Lectures on Painting, Delivered at the Royal Academy March 1801, by Henri Fuseli, P: P…*, London 1801, p. 58.

7 See Chapter 16, note 4. Udny's collection had been specially visited, for example, in 1796 by William Hayley, Jeremiah Meyer RA and George Romney (who had been close to Udny's brother in Florence and Venice in 1775). Todd Jerome Magreta, 'George Romney's Late Group Portraits at Abbot Hall and Yale', *The British Art Journal*, VIII, 2 (Autumn 2007), pp. 58–66.

8 Annette Wickham, 'Thomas Lawrence and the Royal Academy's Cartoon of "Leda and the Swan" after Michelangelo', *Burlington Magazine*, CLII (May 2010), pp. 297–302.

9 Hugo Chapman, *Michelangelo Drawings: Closer to the Master*, exh. cat., British Museum, London 2006, pp. 185ff.

10 See Janet Cox-Rearick, *The Collection of Francis I: Royal Treasures*, New York 1996, pp. 237–40.

A CLOSER LOOK 14.3

1 Alfred Marks had a scholarly interest in the collections of the Royal Academy: in June 1882 he delivered a paper to the Royal Society of Literature 'On the St. Anne of Leonardo da Vinci'. Apart from Alfred Marks, the identities of

the members of the Society for Photographing Relics of Old London are unknown.

2 Kenneth E. Foote, 'Relics of Old London: Photographs of a Changing Victorian City', *History of Photography*, XI, 2 (April–June 1987), p. 133.

3 Alfred Marks, Society for Photographing Relics of Old London descriptive letterpress for nos 109 to 120, 1886, Collection of the Royal Academy of Arts, London.

4 Lynne MacNab, *Henry Dixon's London: Photographs of a Changing City 1863–1893*, exhibition leaflet, Guildhall Library Print Room, London 1999.

5 Quoted in subscription leaflet, Society for Photographing Relics of Old London, 1884, Collection of the Royal Academy of Arts, London.

6 In his first report as Librarian, Hodgson refers to the acquisition of photographs and their use to all artists engaged in historical work. RA Archives, Annual Report 1882, RAA/PC/10. Hodgson was depicted in the photographic portrait by David Wilkie Wynfield (*c*.1860, 03/5748) in a Jacobethan ruff.

15 THE CAST COLLECTION

1 Nine plasters of Gibson statues were destroyed by order of Council and the Keeper May–June 1950 (see ch. 7), and there was a move to dispose of them during the keepership of Brendan Neiland (1998–2004).

2 Timothy Clifford, 'The Plaster Shops of the Rococo and Neo-classical Era in Britain', *Journal of the History of Collections*, IV, 1 (1992), p. 40; Timothy Clifford and Terry Friedman, *The Man at Hyde Park Corner: Sculpture by John Cheere, 1709–1787*, exh. cat., Temple Newsam, Leeds, and Marble Hill House, Twickenham, Leeds 1974, pp. 10–13.

3 See John Kenworthy-Browne, 'The Duke of Richmond's Gallery in Whitehall', *The British Art Journal*, X, 1 (2009), pp. 40–49. See also Joan Coutu, 'The 3rd Duke of Richmond and his Sculpture Gallery in Whitehall: Munificence Worthy of a Prince', in *Then and Now: Collecting and Classicism in Eighteenth-Century England*, Montreal and Kingston 2015, ch. 6, pp. 93–126.

4 Horace Walpole, *Correspondence*, cited in Kenworthy-Browne 2009, p. 41.

5 See Kenworthy-Browne 2009, appendix II, p. 48.

6 Quoted ibid., p. 44.

7 Ibid.

8 The Royal Academy presently owns 52 casts of heads in the form of medallions, and has

owned as many as 113. Of these, 105 may have come from the Duke of Richmond's collection, while eight came from Sir Thomas Lawrence. See ibid., p. 46, where the absence from the sale of the *Fighting Gladiator* is noted. See also J. Coutu, '"A very grand and seigneurial design": The Duke of Richmond's Academy in Whitehall', *The British Art Journal*, I, 2 (Spring 2000), p. 48, who cites a description of the duke's gallery by Robert Dossie which, among other things, records that 105 casts from Trajan's Column were affixed to the wall behind the entrance. See also 'A Closer Look' at the end of this chapter.

9 Joseph Baretti, *A Guide through the Royal Academy*, London 1781, pp. 10, 12.

10 Ibid., pp. 19–20.

11 See ibid., p. 27, under 'Astragalizontes'. For Townley's gift see RA Archives, Council Minutes, 9 August 1769, RAA/PC/1/1. See also Adriano Ayminino and Anne Varick Lauder, *Drawn from the Antique: Artists and the Classical Ideal*, exh. cat., Sir John Soane's Museum, London 2015, p. 195.

12 See Francis Haskell and Nicholas Penny, *Taste and the Antique: The Lure of Classical Sculpture 1500–1900*, New Haven and London 1981, pp. 2, 67.

13 Ibid., p. 318.

14 Ibid., p. 264. National Trust inventory number 109007.

15 See MaryAnne Stevens in Martin Postle, ed., *Johan Zoffany RA: Society Observed*, exh. cat., New Haven and London 2011, pp. 219–21, cat. 44.

16 It may possibly be identified with a bust of Susanna by François Duquesnoy, the terracotta of which belonged to William Lock. See Baretti 1781, p. 14.

17 Haskell and Penny 1981, p. 274.

18 Baretti (1781, p. 11) refers to three casts of the *Infant Hercules*, but these would all appear to have been based upon the standing figure in black marble then in the Villa Medici and now in the Capitoline Museum, Rome.

19 Cast of cinerary urn inscribed for 'L. Rasticanus Eu.odes[?] by mother Rasticana', RA 04/545.

20 Haskell and Penny 1981, p. 181.

21 Ibid., p. 182.

22 Baretti 1781, p. 12.

23 Aymonino and Lauder 2015, pp. 194–5, fig. 7 and n. 15.

24 I am grateful to Adriano Aymonino for this identification. For Duquesnoy's fame as a 'classical sculptor' in the seventeenth and eighteenth centuries, see M. Boudon-Mauchel, *François du Quesnoy 1597–1643*, Paris 2005, pp. 175–200.

25 Baretti 1781, p. 15. The statue was sold by Lock to the Duke of Richmond in 1790, and

burnt in a fire the following year at Goodwood House. It was once more restored by Wilton, and acquired by the British Museum in 1820. It is now once again a torso, Wilton's restoration having been removed. British Museum, Department of Greek and Roman Antiquities, 1821,0101.1.

26 For the gifts from Townley and Jenkins, see Council Minutes, 9 August 1769. Baretti (1781, p. 29) stated that Jenkins had sold the statue for £3,000. It was sold at Christie's, London, 13 June 2002 (lot 112) by the owners of Newby Hall. It was purchased by Sheikh Saud al-Thani of Qatar.

27 Council Minutes, 3 November 1792, RAA/PC/1/2: 'Mr Nollekens produced a Cast in Plaister of the Head of Diomedes from the Original in the possession of Mr Townley, by whom he was desired to present it to the President & Council for the use of the Royal Academy.' The marble bust, now identified as a bearded companion of Ulysses, is in the British Museum, London, 1805,0703.86. For Hercules see Baretti 1781, p. 22. For *Perseus and Andromeda* see Council Minutes, 7 February 1794.

28 Council Minutes, 17 March 1770, RAA/PC/1/1.

29 Baretti 1781, p. 28.

30 Ibid., pp. 28 and 9, respectively.

31 John Thomas Smith, *Nollekens and his Times: Comprehending a Life of that Celebrated Sculptor*, 2 vols, London 1828, I, p. 15.

32 'Mr Lock having presented a cast of a Head of an Atalanta to the Academy. Resolved that a Letter of thanks be wrote to him by the Sec.'. Council Minutes, 25 March 1771, RAA/PC/1/1. See also Baretti 1781, p. 10.

33 See Baretti 1781, pp. 15, 20–21.

34 John Ingamells and John Edgcumbe, eds, *The Letters of Sir Joshua Reynolds*, New Haven and London 2000, pp. 26–8.

35 Ibid., p. 32. See also Council Minutes, 17 March 1770, RAA/PC/1/1, noting that a letter of thanks should be sent to 'the Hon. Mr. Hamilton for his gift', although the objects in question are not specified.

36 Baretti 1781, pp. 19 and 9, respectively.

37 Edward Francis Burney entered the Schools of the Royal Academy in 1776. This drawing is usually dated to 1779, although it may have been made earlier.

38 Baretti 1781, p. 9.

39 In December 1771 Hamilton was thanked for the 'present of a Bas-relief', Council Minutes, 18 December 1771, RAA/PC/1/1. See also ibid., 26 March 1803, RAA/PC/1/3.

40 Ibid., 25 October 1771, RAA/PC/1/1.

41 British Museum, London, 1805,0703.97.

42 Baretti 1781, p. 27.

43 Council Minutes, 18 December 1771, RAA/PC/1/1.

44 Ingamells and Edgcumbe 2000, p. 192, and n. 1.

45 Council Minutes, 11 June 1774, RAA/PC/1/1.

46 Shelburne, who became Marquess of Lansdowne in 1784, had in 1765 bought the unfinished Lansdowne House (designed by Robert Adam) from Lord Bute. The original statues were sold in 1930. The dining room was thereafter acquired by the Metropolitan Museum, New York, and its niches filled with plaster casts.

47 An entry in the Royal Academy's Account book for August 1772 states: 'To paid of Dalton patches dr: on him for plaisters of the Academy 50 [sic]', RA Archives, Annual accounts of Sir William Chambers, RAA/TRE/2/1/1. The book of 34 plates is in the RA Library, RA 04/3184 (English title 'Account of the second and third Gate of S. Iohn [sic] in Florence …'). It was published serially 1772–4. Flaxman moved its purchase in August 1810 (Council Minutes, 13 August 1810, RAA/PC/1/4). See also Steffi Roettgen, 'Abbild und Urbild im Dialog: Zur Abformung van Ghibertis "Porta di mezzo"', in Wojciech Marcinkowski, *Plaster Casts of the Works of Art: History of Collections, Conservation, Exhibition Practice; Materials from the Conference in the National Museum, Krakow, 25 May 2010*, Cracow 2010, pp. 64–93.

48 Council Minutes, 22 October 1773, RAA/PC/1/1.

49 Baretti 1781, p. 24. They were also mentioned by Reynolds in his 10th Discourse of December 1780, which was dedicated to sculpture. See Sir Joshua Reynolds, *Discourses on Art*, ed. Robert Wark, New Haven and London 1975, p. 186.

50 Council Minutes, 17 January 1774, RAA/PC/1/1 ('il Fiamingo').

51 Baretti 1781, p. 28.

52 Thalia and a statue of Adonis were admired particularly by Thomas Pennant. See Thomas Pennant, *The Journey from Chester to London*, London 1811, p. 92.

53 Baretti 1781, pp. 9–10, 23.

54 See Henry Stuart Jones, *A Catalogue of the Ancient Sculptures preserved in the Municipal Collections of Rome, I: The Sculptures of the Museo Capitolino*, Oxford 1912, pp. 219–20, no. 92.

55 Baretti 1781, p. 16.

56 Council Minutes, 30 September 1777, RAA/PC/1/1. Alternatively, but less probably, 'Mr Harris' may have been Moses Harris, who dedicated his book *The Natural History of Colours* (n.d.), published between 1769 and c.1776, to Sir

Joshua Reynolds. A copy of Harris's book is in the Royal Academy Library, RA 03/5967.

57 Council Minutes, 10 May 1779, RAA/PC/1/1.

58 Farsetti's collection was subsequently acquired by the Hermitage. See the exhibition 'A Glorious Collection of Works of Sculpture: The Farsetti Collection in Italy and in Russia', 28 February–21 May 2006, State Hermitage Museum, St Petersburg, www.hermitagemuseum.org (accessed 28 April 2017).

59 Haskell and Penny 1981, p. 326.

60 Sydney C. Hutchison, *The Royal Academy of Arts, 1768–1968*, London 1968, p. 49.

61 See Aymonino and Lauder 2015, p. 192, cat. 25, where the inscription on the verso is reprinted.

62 Aymonino and Lauder 2015, p. 194, figs 6 and 7.

63 Baretti 1781, p. 9.

64 Ibid., p. 18.

65 Ibid., pp. 11–12.

66 Ibid., p. 14.

67 Ibid., pp. 20–21.

68 Ibid., p. 28. Haskell and Penny point out the scarcity of complete casts of *Laocoön* owing to the difficulty of casting the complex sculpture and of transportation. They also note the existence of a marble copy of the head alone of Laocoön by Wilton, which is in the Victoria and Albert Museum, London (A.84-1949), made in 1758 when Wilton was involved in the Duke of Richmond's gallery. See Haskell and Penny 1981, p. 244.

69 Council Minutes, 31 March 1789, RAA/PC/1/2. For Charles Harris see Clifford 1992, pp. 56–7; Ingrid Roscoe, Emma Hardy and M. G. Sullivan, *A Biographical Dictionary of Sculptors in Britain 1660–1851*, New Haven and London 2009, pp. 577–8.

70 Council Minutes, 19 August 1790, RAA/PC/1/2.

71 See Haskell and Penny 1981, pp. 229–30.

72 RA Archives, Receipt of Joseph Bonomi, 8 September 1791, RAA/SEC/1/50.

73 James Barry, *A Letter to the Dilettanti Society, Respecting the Obtention of certain Matters essentially necessary for the Improvement of Public Taste, and for accomplishing the Original Views of the Royal Academy of Great Britain* (London 1798), in *The Works of James Barry, Esq., Historical Painter*, 2 vols, London 1809, II, p. 490.

74 Ibid., II, p. 495.

75 George Thomas Nozlopy and Fiona Waterhouse, *Public Sculpture of Staffordshire and the Black Country*, Liverpool 2005, pp. 108–9.

76 Council Minutes, 22 May 1801, RAA/PC/1/3. A total of £68 10s. 3d. was paid for the

'purchase, & expense of carriage & Servants; for removing them to the Academy'.

77 John Romney, *Memoirs of the Life and Works of George Romney*, London 1830, pp. 230–34.

78 John Flaxman the Elder operated a plaster figure shop in New Street, Covent Garden, and later in the Strand. See Clifford 1992, pp. 53–4; Roscoe, Hardy and Sullivan 2009, pp. 440–42.

79 David Irwin, *John Flaxman, 1755–1826: Sculptor, Illustrator, Designer*, London 1979, p. 46; Romney 1830, pp. 230–31.

80 In 1830 the Royal Academy acquired another copy of the same cast from the collection of Thomas Lawrence: see RA 03/1957.

81 Acquired 1865.

82 The original marble statue was acquired by Philip V of Spain in 1724, and is now in the Prado, Madrid. Nollekens's marble copy, dated 1767, was made for Thomas Anson at Shugborough Hall, Staffordshire. It is now in the Victoria and Albert Museum, London (A.59–1940).

83 Council Minutes, 26 March 1803, RAA/PC/1/3.

84 Ibid., 29 May 1810, RAA/PC/1/4.

85 'Mr Flaxman moved that Mr Marchant be empowered to purchase for the Academy a Cast of the Barberini Faun – Seconded by Mr Howard & passed unanimously': Council Minutes, 17 November 1810, RAA/PC/1/4.

86 Haskell and Penny 1981, p. 204.

87 RA Archives, Letter from the executors of Nathaniel Marchant to the Royal Academy, 10 May 1816, RAA/SEC/2/102/3. For acknowledgement of the gifts by the Academy, see Council Minutes, 7 June 1816, RAA/PC/1/5.

88 The bust of Homer is 03/1512; the *Laocoön*, which is badly damaged and awaits conservation, is 03/1501.

89 Council Minutes, 21 July 1813, RAA/PC/1/5.

90 The *Townley Venus*, British Museum, London, 1805,0703.15. See B. F. Cook, *The Townley Marbles*, London 1985, pp. 23–4, fig. 22.

91 Council Minutes, 18 February 1808, RAA/PC/1/4.

92 Ibid., 17 November 1810.

93 See Rhodri Windsor Liscombe, 'The "diffusion of knowledge and taste": John Flaxman and the Improvement of the Study Facilities at the Royal Academy', *Walpole Society*, LIII (1987), p. 230.

94 Ibid., p. 231.

95 Prince Hoare, *Epochs of the Arts, including Hints on the Use and Progress of Painting and Sculpture in Great Britain*, London 1813, pp. 183–4.

96 Council Minutes, 18 February 1814, RAA/PC/1/5.

97 'Report upon examination of the Plaister Casts Antique Fragments &c existing in the Royal Academy, August 1814', ibid., 12 November 1814.

98 Liscombe 1987, p. 229, and p. 236, n. 18.

99 Council Minutes, 14 December 1815, RAA/PC/1/5.

100 Ibid., 10 January 1816, noting Lord Sidmouth's reply dated 6 January.

101 Ibid., 2 August 1816.

102 For the complete list in the Royal Academy Minute Book, 'Nota dei Gesse destinate di far partire per Londra al Principe Regente', see ibid., 2 August 1816.

103 For *Discobolus* and a version, see Haskell and Penny 1981, pp. 199–202. Also Viccy Coltman, *Classical Sculpture and the Culture of Collecting in Britain since 1760*, Oxford 2009, pp. 96–100.

104 Council Minutes, 2 August 1816, RAA/PC/1/5.

105 See ibid., 27 November 1816, for a full list of casts viewed at Carlton House and selected by the Royal Academicians.

106 Ibid., 29 November 1816.

107 For the list of casts to be disposed, see ibid.

108 Ibid., 15 June 1816.

109 Long's letter to the Royal Academy, dated 31 December 1816, was presented at the Council Meeting held on 15 January 1817. See ibid.

110 For Canova's MS note see RA Archives, Paper by Antonio Canova 1817, RAA/SEC/1/38.

111 Council Minutes, 20 April 1815, RAA/PC/1/5; ibid., 26 April 1815.

112 Ibid., 13 August 1817.

113 Christopher M. S. Johns, *Antonio Canova and the Politics of Patronage in Revolutionary and Napoleonic Europe*, Berkeley 1998, especially ch. 6, '"That Illustrious and Generous Nation": Canova and the British', pp. 145–70.

114 RA Archives, Thomas Lawrence MS letter to Amelia Angerstein, 1821, ANG/3/1–2.

115 Johns 1998, p. 156.

116 See Frank J. Messman, 'Richard Payne Knight and the Elgin Marbles Controversy', *British Journal of Aesthetics*, XIII, 1 (1973), pp. 69–75.

117 Council Minutes, 2 July 1784, RAA/PC/1/1. For the transfer of the fragments to the British Museum, see Council Minutes, 16 November 1816, RAA/PC/1/5.

118 Ibid., 17 November 1815.

119 Ibid., 25 May 1816.

120 Council Minutes, 18 March 1820, RAA/PC/1/6.

121 Ibid., 16 November 1816, RAA/PC/1/5.

122 Ibid., 20 December 1816, 15 January 1817.

123 Ibid., 26 March 1819, RAA/PC/1/6.

124 Haskell and Penny 1981, p. 277.

125 See ibid., p. 285, for the acquisition of Pallas and its mention by Flaxman in his lectures. Council Minutes, 18 May 1820, RAA/PC/1/6: 'His Majesty had been pleased to present to the Academy a Cast in plaster from one of the Venetian Bronze horses.' For Winckelmann's commentary on this group, see *Johann Winckelmann on Art, Architecture, and Archaeology*, trans. with an intro. and notes by David Carter, Woodbridge and Rochester, N.Y., 2013, p. 159.

126 Council Minutes, 21 April 1820, RAA/PC/1/6. See also ibid., 10 April 1813: letter from Croker, commanded by His Majesty 'to forward to the Royal Academy several cases of Casts recently arrived from Italy'.

127 'Inspection of Casts of the Royal Academy'. There are four inspection reports in the Royal Academy's collection for 1826, 1828, 1829, and an unidentified year, possibly 1827; see acc. 2341. It was not until 1872 that routine reports were written on the cast collection. These became a regular index to the annual reports from 1877 onwards.

128 'Royal Academy Inspection of Casts' for 1828, Acc. 2341. The printed schedule has a list of casts by number, 1–800, annotated, accompanied by a handwritten report. The first surviving report, dated 9 October 1826, was made by Thomas Phillips and Alfred Edward Chalon. A report dated 7 August 1829 was made by J. M. W. Turner and the sculptor Charles Rossi.

129 Council Minutes, 24 March 1828, RAA/PC/1/7. The landscape and mythological painter Richard Cook had been elected an Academician in 1822. He had married 'a lady with fortune, which enabled him to entertain liberally his brother artists'. L. A. Fagan, 'Cook, Richard (1784–1857)', rev. Annette Peach, *ODNB*.

130 See Council Minutes, 2 July 1773, RAA/PC/1/1, for Hoskins and Oliver, and Bills, receipts and quarterly statements of expenditure 1788, RAA/TRE/2/1/2, for James Hoskings's [*sic*] bill to RA for work done in 1788. See also Clifford 1992, pp. 58–60.

131 Council Minutes, 18 February 1791, RAA/PC/1/2. See also Clifford 1992, pp. 62–3.

132 Council Minutes, 18 February 1791, RAA/PC/1/2.

133 See www.npg.org.uk (British bronze sculpture founders and plaster figure makers, 1800–1980), accessed 17 June 2015. See also Ian Jenkins, 'Acquisition and Supply of Casts of the Parthenon Sculptures by the British Museum, 1835–1939', *Annual of the British School at Athens*, LXXXV (1990), p. 105.

134 Council Minutes, 20 October 1836, RAA/PC/1/6. For Pink see also ibid., 22 July 1829, RAA/PC/1/7; ibid., 23 October 1841, RAA/PC/1/9; ibid., 27 January 1844.

135 Ibid., 12 December 1836, RAA/PC/1/8.

136 Ibid., 24 December 1836.

137 Ibid., 1 March 1837; ibid., 18 March 1837.

138 Julia Lenaghan, 'The Cast Collection of John Sanders, Architect, at the Royal Academy', *Journal of the History of Collections*, XXVI, 2 (2014), p. 195.

139 Council Minutes, 16 November 1837, RAA/PC/1/8; ibid., 29 November 1837.

140 Ibid., 5 December 1837. The British Museum capital is 1805,0703.278.

141 Council Minutes, 23 March 1838, RAA/PC/1/8.

142 'Read a letter from the Trustees of the British Museum inquiring if the Academy is willing to receive back the Architectural Casts formerly in the Collection of Sir Thos. Lawrence which were presented to the B. Museum some years since. Resolved that the Trustees be informed that the Academy will be happy to have the Collection again': Council Minutes, 21 February 1844, RAA/PC/1/9. For the arrangement of Wilkins's casts in the Library, see ibid., 11 November 1854, RAA/PC/1/11.

143 Ibid., 6 November 1840, RAA/PC/1/9. The Royal Academy had previously acquired a cast of the *Venus de Milo* in 1822; see ibid., 22 April 1816, RAA/PC/1/6.

144 Ibid., 8 October 1842, RAA/PC/1/9.

145 Ilaria Bignamini and Martin Postle, *The Artist's Model: Its Role in British Art from Lely to Etty*, exh. cat., Nottingham 1991, cat. 18, p. 51; Martin Postle, 'Naked Authority? Reproducing Antique Statuary in the English Academy, from Lely to Haydon', in Anthony Hughes and Erich Ranfft, eds, *Sculpture and its Reproductions*, London 1997, pp. 91–3; Aymonino and Lauder 2015, cat. 27, pp. 199–203.

146 Council Minutes, 2 August 1851, RAA/PC/1/10.

147 Ibid., 3 November 1855, RAA/PC/1/11. For the female torso, see RA 03/1916.

148 Ibid., 25 October 1851, RAA/PC/1/10.

149 Ibid., 14 August 1849; ibid., 23 October 1849.

150 Ibid., 24 December 1853, RAA/PC/1/11.

151 For Pink's repair bills see ibid., 23 October 1841, RAA/PC/1/9; ibid., 27 January 1844.

152 For Brucciani's letter to the RA, see Correspondence from Domenico Brucciani, 4 January 1858, RAA/SEC/2/31/1. For Brucciani's appointment, see Council Minutes, 18 December 1858, RAA/PC/1/11.

153 For a detailed account of the Brucciani family's biography and business, see 'British Bronze Sculpture Founders and Plaster Figure Makers, 1800–1980 – B', www.npg.org.uk (British bronze sculpture founders and plaster figure makers, 1800–1980), accessed 20 January 2016. See also Rebecca Wade, 'The Production and Display of Domenico Brucciani's Plaster Cast of Hubert Le Sueur's Equestrian Statue of Charles I', *Sculpture Journal*, XXIII, 2, http://dx.doi.org/10.3828/sj.2014.24, accessed 20 January 2016.

154 'Domenico Brucciani', *Mapping the Practice and Profession of Sculpture in Britain and Ireland 1851–1951*, University of Glasgow History of Art and HATII, online database 2011, sculpture.gla.ac.uk; accessed 21 April 2017. http://sculpture.gla.ac.uk/view/person.php?id=msib4_1245162866, accessed 9 July 2015.

155 Haskell and Penny 1981, p. 117.

156 The *Borghese Gladiator* is RA 03/1485; the bust of Hermes RA 03/1517.

157 RA 03/1466.

158 Council Minutes, 22 December 1862, RAA/PC/1/12. See also ibid., 23 November 1868, where Brucciani was given permission to take a cast from the Academy's cast of the *Ludovisi Mars*.

159 Personal communication of the late John Ward RA (and others).

160 Council Minutes, 13 July 1869, RAA/PC/1/13.

A CLOSER LOOK 15.1

1 The collection currently includes just under 500 objects of varying size and subject, many of them on the RA website.

2 Sir John Soane's Museum has a similar collection of similar date. The Victoria and Albert Museum has probably a larger collection, of later date.

3 RA Archives, Council Minutes, 17 November 1810, RAA/PC/1/4.

4 J. Kenworthy-Browne, 'The Duke of Richmond's Gallery in Whitehall', *The British Art Journal*, X, 1 (2009), p. 48, appendix III. J. Coutu, '"A very grand and seigneurial design": The Duke of Richmond's Academy in Whitehall', *The British Art Journal*, I, 2 (Spring 2000), p. 48, n. 9.

5 Lawrence had arranged in his will that should the Academy purchase his collection of casts, it could be acquired for £250, considerably less than he had spent.

6 Temple found by Karl Haller von Hallerstein and C. R. Cockerell RA in 1811. For a primary source description of the find, see B.

C. Madigan with F. Cooper, *The Temple of Apollo Bassitas II: The Sculpture*, Princeton 1992, p. 123, appendix B.

7 Council Minutes, 29 November 1837, RAA/PC/1/8.

8 Ibid., 11 November 1854, RAA/PC/1/11. See this chapter for other purchases, including that from the collection of Sir Thomas Lawrence PRA.

9 For example, the RA possesses casts of pilasters and other panels from fifteenth-century tomb monuments in Santa Maria del Popolo, Rome, and from the Vatican storerooms. The casts of Ghiberti's bronze doors for the Bapistery of the Duomo in Florence are a slightly different type of acquisition, one more motivated by desire for masterpieces of sculpture.

10 Council Minutes, 24 March 1870, RAA/PC/1/13.

16 COPIES

1 P. Duro, 'The Lure of Rome: The Academic Copy and the *Académie de France* in the Nineteenth Century', in R. Cardoso Denis and C. Trodd, eds, *Art and the Academy in the Nineteenth Century*, Manchester 2000. J. Delaplanche, *350 anni di creatività: Gli artisti dell'Accademia di Francia a Roma da Luigi XIV ai nostri giorni*, exh. cat., Milan 2016.

2 Sir Joshua Reynolds, *Discourses on Art*, ed. R. Wark, New Haven and London 1988, p. 29.

3 Reynolds 1988, p. 15.

4 For Reynolds's attempts to have the Academy purchase his collection, see James Northcote, *The Life of Sir Joshua Reynolds*, London 1819, p. 278. Reynolds recorded his own disappointment at the failure: 'If the expense was thought too much for a Royal Academy it may well be thought too great for an individual to bear, It becomes therefore necessary that the public or that part [that] take a pleasure in Picture[s] pay the expense.' Frederick W. Hilles, *The Literary Career of Sir Joshua Reynolds*, Cambridge 1936, pp. 184–5. Several years later the Academy was offered the collection of Robert Udny. RA Archives, Council Minutes, 10 April 1802, RAA/PC/1/3: 'Considered the letter from the Executors of the late Rob. Udny esq. offering the purchase of his collection of pictures by the Royal Academy. Resolved that it is the opinion of the President & Council, that the purchase by the Royal Academy must be declined, and that a proper answer given.'

5 Henry Fuseli, *Lectures on Painting: Delivered at the Royal Academy, by Henry Fuseli, P.P.…Second Series*, London 1830, 'Seventh Lecture: On Design',

pp. 4–5. Fuseli was closely echoing the observations of Johann Joachim Winckelmann, whose work Fuseli had published in translation in 1765, *Reflections on the Painting and Sculpture of the Greeks: With Instructions for the Connoisseur, and an Essay on Grace in Works of Art*, for example, p. 256: 'To original ideas, we oppose copied, not imitated ones.'

6 Council Minutes (in the draft rules of the Academy), 7 January 1769, RAA/PC/1/1.

7 Ibid., 13 April 1771: 'Mr Meyer having sent an Enamel of the late Marquis of Grandby [*sic*] after a picture painted by Sir Joshua Reynolds being a copy and contrary to the Rules of the Academy. But his Majesty having signified his intention that it should be exhibited resolved that it be accordingly reviewed, but not to be considered as a precedent in respect to the admission of copies.'

8 See Algernon Graves, ed., *The Royal Academy of Arts: A Complete Dictionary of Contributors and their Work from its Foundation in 1769 to 1904*, 8 vols, London 1905–6, IV, p. 349.

9 Council Minutes, 10 May 1800, RAA/PC/1/3: 'The President informed the council that the Duke of Bedford had presented the Royal Academy his set of cartoons, copied by Sir Jas. Thornhill from the Original of Raphael, now in Windsor Castle.'

10 Whood's account survives at Woburn Abbey, Bedfordshire, LOC28-16-1-1, NMR 2/34/1: 'February 28, 1734, Recd then of His grace the D of Bedford by the hand of Mr Isaac Whood Two hundred and ten pounds. In full for the Large Cartoons got in Sir J Thornhills sale from Chr Cock.' The reverse of the bill: 'Feby 28th 1734, Christr Cock his receipt for money Paid him for the Cartoons £210.0.0.'

11 See Arline Meyer, *Apostles in England: Sir James Thornhill and the Legacy of Raphael's Tapestry Cartoons*, New York 1996, especially pp. 34–40, 46–52. For early interest in the cartoons and their continuing significance in the context of plans for academies in England and the training of artists (especially in relation to the French Academy), and also for Thornhill's visit to Paris in 1717 *inter alia* to look at 'Academys of all sorts', see Robin Simon, *Hogarth, France and British Art: The Rise of the Arts in Eighteenth-Century Britain*, London 2007, pp. 14–17, 61, 156–7.

12 'Pictures there as large as the originals. and also the heads many drawn on paper. By himself very well. Also a small sett of coppyes.' Vertue VI, *Walpole Society*, XXX (1948–50), p. 30.

13 London, National Art Library, MSL/1961/1455, p. 95.

14 Meyer 1996, p. 35.

15 Ibid., pp. 43–5.

16 Vertue III, *Walpole Society*, XXII (1933–4), p. 70.

17 *A Catalogue of the Intire Collection belonging to Sir James Thornhill, Late Principal History Painter to His Majesty … His last Elaborate works, from the Cartoons of Raphael at Hampton Court … at Mr Cock's in the Great Piazza, Covent Garden*, London 1735, lots 98, 101.

18 Council Minutes, 19 May 1800, RAA/PC/1/3.

19 Ibid., 3 February 1801.

20 Ibid., 10 March 1804.

21 C. R. Leslie recorded Benjamin West giving a discourse on the theory of colour using a 'board painted with a *globe* and a *rainbow*. From these he illustrated what he conceived to be the principle on which the composition of the colours in Raphael's Cartoons was conducted, large copies of which, by Thornhill, were hanging round the room.' William Dunlap, *A History of the Rise and Progress of the Arts of Design in the United States*, New York 1834, p. 71.

22 For Head, see Nancy L. Pressly, 'Guy Head and his Echo flying from Narcissus: A British Artist in Rome in the 1790s', *Bulletin of the Detroit Institute of Arts*, LX, 3–4 (1982), pp. 69–79. Head is perhaps best remembered for his impressive portrait of Lord Nelson of 1798–1800 (National Portrait Gallery, London).

23 *Catalogue of Pictures consisting of Fine Originals of the Italian and Flemish schools. Accurate copies from some of the most distinguished works in Europe: As well as Originals and studies by Mr. Head. Collected and painted during a residence of sixteen years on the continent … at his house, No. 4 Duke Street, St. James's. 27th April, 1801.*

24 *A Catalogue of the Valuable Collection of accurate Copies, from the works of the most celebrated masters, in the principal Galleries and Private collections in Italy and Germany, executed with great spirit, uremitted diligence, and infinite merit; As also, three capital original pictures, by the most ingenious artist, the late Mr Guy Head, deceased, during his sixteen years on the Continent … Which, by orders of the executrix will be sold by auction, by Mr. Christie, Saturday March, 13th, 1802.*

25 *A Catalogue of the Valuable Collection of accurate Copies … March, 13th, 1802'*, lots 185, 221, 230, 234.

26 Council Minutes, 20 March 1802, RAA/PC/1/3.

27 James Barry, *A Letter to the Dilettanti Society, Respecting the Obtention of Certain Matters Essentially Necessary for the Improvement of Public Taste, and for Accomplishing the Original Views of the Royal Academy of Great Britain*, London 1798, p. 7.

28 Ibid., p. 8.

29 Council Minutes, 22 May 1801, RAA/PC/1/3. Flaxman's attempts to provide casts for the Royal Academy Schools continued after he was elected Professor of Sculpture in 1811, and he succeeded in considerably expanding the Academy's holdings. See R. W. Liscombe, 'The "Diffusion of Knowledge and Taste": John Flaxman and the Improvement of the Study Facilities at the Royal Academy', *Walpole Society*, LIII (1987), pp. 226–38. A catalogue of the Library was prepared in 1802 and circulated among Academicians. I am grateful to Nick Savage for drawing this to my attention.

30 'Henry Hope, Esq. has presented to the Academy copies from Rubens, by Mr. Guy Head, of the following pictures: The Descent from the cross, St. Simon in the Temple, The Visitation of Elizabeth and Mary.' Prince Hoare, *Extracts from a Correspondence with the Academies of Vienna & St. Petersburg …*, London 1802, p. 10.

31 Ibid., pp. 183–5.

32 London, National Art Library, R.C.V.II.f.2. Minutes of the 'British Institution for Promoting the Fine Arts in the United Kingdom', 30 May 1805.

33 T. Smith, *Recollections of the British Institution with some Account of the Means Employed for that Purpose and Biographical Notices of the Artists who have received Premiums*, London 1860, p. 40.

34 Ibid., pp. 41–3.

35 British Institution, *An Account of all the Pictures Exhibited in the Rooms of the British Institution, from 1813 to 1823, belonging to the Nobility and Gentry of England: With Remarks, Critical and Explanatory*, London 1824, p. 18. This was consolidated by the awarding of premiums of £100 for 'the best original picture, prepared in point of subject & manner to be a companion to either of such pictures.' National Art Library, R.C.V.II.f.189.

36 1805–6. For Bourgeois see Giles Waterfield, '"That White-Faced Man": Sir Francis Bourgeois, 1756–1811', *Turner Studies*, IX (Winter 1989), pp. 36–48.

37 Council Minutes, 19 December 1815, RAA/PC/1/5. For a further account, see K. Garlick, A. Mackintyre and K. Cave, eds, *The Diary of Joseph Farington*, 17 vols, New Haven and London 1978–98, XIII, p. 4743 (19 December 1815). The gallery itself at Dulwich did not in fact open until 1817.

38 Council Minutes, 10 January 1816, RAA/PC/1/5.

39 Ibid., 12 July 1816.

40 *Royal Academy of Arts in London, Laws relating to the schools, the library, and the students*, London 1828, sect. IV, Premiums, p. 16.

41 Council Minutes, 15 June 1816.

42 Ibid., 2 August 1816. This was the *Landscape with Jacob and Laban* by Claude at Petworth House, West Sussex. It was included in the British Institution exhibition in 1816.

43 Ibid., 29 July 1819, RAA/PC/1/6.

44 Garlick, Mackintyre and Cave 1978–98, XIV, pp. 4768–9.

45 Ibid., p. 4944. Farington adds: 'Wilkie told me today that having recd. A letter from Sir G, Beaumont, he answered it yesterday, and informed him of the Academy having obtained a *Cartoon* & other pictures for the Painting School, adding that to the example set by the British Institution, the Academy owe this valuable addition to their establishment, which before limited the studies of the youth sent there to drawing only.'

46 Landseer's sons and Christmas were all members of Benjamin Robert Haydon's 'Academy'. Haydon, an ambitious history painter, had established his drawing school 'to communicate my system to other young men, and endeavoured to establish a better and more regular system of instruction than ever the Academy afforded'. In practice this meant a great deal of time devoted to copying at both the Painting School and British Institution. See F. Cummings, 'B. R. Haydon and his School', *Journal of the Warburg and Courtauld Institutes*, XXVI, 3/4 (1963), pp. 367–80.

47 A. Gilchrist, *Life of William Etty, RA*, 2 vols, London 1855, I, p. 79.

48 Council Minutes, 12 January 1819, RAA/PC/1/6.

49 See, for example, the drawing by Edward Bell of *Mr Green lecturing at the Royal Academy* of about 1825 in the British Museum, London.

50 Fuseli 1830.

51 Frank Howard, ed., *A Course of Lectures on Painting, delivered at the Royal Academy of Fine Arts, delivered by Henry Howard*, London 1848, p. 147; and Thomas Phillips, *Lectures on the History and Principles of Painting*, 2 vols, London 1833.

52 Although other copies entered the collection throughout the nineteenth century: for example, the daughters of Henry Howard RA presented a copy of Titian's *Venus Blindfolding Cupid*.

53 Garlick, Mackintyre and Cave 1978–98, XI, p. 4140.

54 See Jonathan Yarker, 'Raphael at the Royal Academy: Giovanni Volpato's *modelli* of the Vatican *Stanze* Rediscovered', *Artibus et historiae*, XXXVII 74 (2016), pp. 273–82.

55 'Read a letter from Sir A W Callcott communicating to the President & Council the intention of Lady Bassett to present to the R. Academy a series of seven pictures from Raf-

faelle.' Council Minutes, 15 March 1842, RAA/PC/1/9. The paintings are recorded arriving in April: 'The Keeper reported that he had received seventeen paintings in oil from the works of Raffaelle in the Vatican, presented to the academy by Lady Bassett. Ordered that the secretary returned thanks to Lady Bassett.' Ibid., 6 April 1842.

A CLOSER LOOK 16.1

1 Luke Syson, ed., *Leonardo da Vinci, Painter at the Court of Milan*, London 2011, cat. 84.

2 RA Archives, Council Minutes, 23 June 1821, RAA/PC/1/6. It was bought from 'H. Fraville'.

3 Ibid., 11 June 1821. The decision to purchase was made on 14 June: ibid., 14 June 1821; General Assembly Minutes, 14 June 1821, RAA/GA/1/3.

4 Its original height is not known; the original canvas only reaches the top of the windows: Syson 2011, p. 279, n. 13.

17 ANATOMICAL STUDIES

1 RA Archives, letter from James Northcote to Samuel Northcote, 19 December 1771, NOR/6. See also Martin Postle, 'Flayed for Art: The Écorché Figure in the English Art Academy', *The British Art Journal*, V, 1 (2004), pp. 55–63 (quote on p. 58).

2 Martin Kemp, *Dr William Hunter at the Royal Academy of Arts*, Glasgow 1975, p. 38.

3 This remained the case until the passing of the Anatomy Act of 1832.

4 William Hunter quoted in Simon Chaplin, 'John Hunter and the "Museum Oeconomy" 1750–1800', PhD thesis, King's College, London, 2009, pp. 129–30.

5 As mentioned by William's brother, John Hunter, in an annotated copy of S. F. Simmons's 1783 biography of William Hunter in Glasgow University Special Collections, Sp Coll Hunterian Add.q13, pp. 16–17.

6 Postle 2004, p. 59 and n. 41. The description in Rees's *Cyclopedia* is in the Anatomy section, vol. II: 'another muscular figure, prepared by Dr Hunter, one side only of which has the skin, fat & taken off, that a comparison may be made with the other side of the figure, in which it may be seen how much thicker some parts of the human body are covered than others' Doubts were raised by L. P. Amerson, Jr, 'Catalogue des moulages conservés à la Royal Academy à Londres', in B. Venot, ed., *L'Écorché* (Expérience Pedagogique à l'École

Regionale des Beaux Arts de Rouen), no. 3 (1976), pp. 19–21. Amerson connects RA 03/1435 (see fig. 457) with a reference to a coloured anatomical figure purchased by the Academy for five guineas in 1801, but, as Postle suggests, a cast such as 03/1435 would have cost much more, noting that the new cast of *Smugglerius* cost 35 guineas in 1834.

8 Postle 2004, p. 59, and Jehanine Mauduech, 'The Écorché', *Conservation News*, no. 47 (March 1992), pp. 21–2.

9 William Hunter quoted in Kemp 1975, p. 38.

10 This has centred on another nineteenth-century cast of Smugglerius at the Edinburgh College of Art. Research carried out on this version by Joan Smith and Dr Jeanne Cannizzo informed a display, 'Smugglerius Unveiled', at Edinburgh College of Art, 19 July–7 August 2010, which was accompanied by an informative leaflet.

11 T. Smith, *Nollekens and his Times: Comprehending a Life of that Celebrated Sculptor and Memoirs of Several Contemporary Artists*, 2 vols, London 1828, II, pp. 305–6.

12 See Professor Tim Hitchcock's comments on http://www.executedtoday.com/tag/smugglerius/.

13 See note 10 above.

14 Full reports of the trial, including details of the sentence for Harley and Henman, appeared in several newspapers. See, for example, *Morning Post and Daily Advertiser*, 25 May 1776. Hitchcock's arguments are to be found at http://www.executedtoday.com/tag/smugglerius/.

15 Joseph Baretti, *A Guide through the Royal Academy*, London 1781, p. 24. Francis Haskell and Nicholas Penny, *Taste and the Antique: The Lure of Classical Sculpture 1500–1900*, New Haven and London 1981, pp. 225–7.

16 Hunter quoted in Kemp 1975, p. 44. Hunter suggested that studying from plaster casts and 'academical figures' in static poses led to artists being unable convincingly to portray the human body in action.

17 Postle 2004, p. 58. See also Nicholas Penny, *Reynolds*, exh. cat., Royal Academy, London 1986, p. 337, no. 168.

18 Martin Kemp, 'True to their Natures: Sir Joshua Reynolds and Dr William Hunter at the Royal Academy of Arts', *Notes and Records of the Royal Society of London*, XLVI, 1 (January 1992), pp. 82 and 87.

19 Postle 2004, p. 60.

20 Ibid. and Tom Taylor, *Life of Benjamin Robert Haydon, Historical Painter, from his Autobiography and Journals*, 3 vols, London 1853, I, p. 43. Haydon records some of the students who

accompanied him in an inscription on a title sheet for the anatomical album RA 07/2467.

21 Bell was described thus by Benjamin Robert Haydon in March 1810. See W. Bissell Pope, ed., *The Diary of Benjamin Robert Haydon*, 5 vols, Cambridge, Mass. 1960, I, p. 130.

22 *Examiner*, 16 October 1808.

23 Thomas Landseer, ed., *The Life and Letters of William Bewick*, 2 vols, London 1871, I, pp. 141–2.

24 Full accounts of the anatomical crucifixion and the contemporary sources are given in Postle 2004, pp. 61–2. Julius Bryant, 'Thomas Banks's Anatomical Crucifixion: A Tale of Death and Dissection', *Apollo*, June 1991, pp. 409–11, and Ilaria Bignamini and Martin Postle, *The Artist's Model: Its Role in British Art from Lely to Etty*, exh. cat., Nottingham 1991, cat. 91, pp. 96–7.

25 *Caledonian Mercury*, 5 November 1801. In a postscript about Legg's execution the same article gives his precise age as 78.

26 Ibid.

27 'Obituary: Joseph Constantine Carpue, F.R.S.', *Lancet*, 7 February 1846, pp. 166–8 (quote on p. 167).

28 'Experimental Cast: The Cast taken from the Body of James Legg, Chelsea Pensioner, executed in the year 1801', *Art-Union*, no. 76 (1 January 1845), p. 14.

29 Ibid.

30 RA Archives, letter from Thomas Banks to the President and Council, 22 July 1802, RAA/SEC/2/5/7. Banks states that he and Cosway 'attended the Operation of Moulding casting & dissecting it ... Mr Cosway myself and other members of the Royal Academy being of opinion that such casts might be useful to the Students of the Royal Academy & also to the professor of Anatomy at the time of his giving his lectures ... With this view principally they were done & sent & plac'd were [sic] they are for the approbation of the Council.' There are further references to the casts in RAA/SEC/2/5/8, 8 December 1802, and in the Council Minutes, 7 August 1802, RAA/PC/1/3.

31 'Experimental Cast' 1845.

32 Council Minutes, 30 December 1822, RAA/PC/1/6, and General Assembly Minutes, 10 February 1823, RAA/GA/1/3.

33 'Experimental Cast' 1845.

34 'Carpue au Grand Guignol or How Gruesome Can You Get?', *St George's Hospital Gazette*, XLVIII (1963), p. 40. The article quotes from an earlier piece in the same journal, which stated that the casts were returned to the Royal Academy in about 1890.

35 In September 1917 the écorché cast was on display in the RA Schools where it was damaged by a Zeppelin bomb. This is mentioned in the Council Minutes for 7 November 1918, RAA/PC/1/24. Martin Postle suggests that the unflayed cast may have been destroyed in the same incident: Postle 2004, p. 63, n. 63.

36 Postle 2004, p. 57.

37 Ibid.

38 Bignamini and Postle 1991, cat. 78, pp. 88–9.

39 Council Minutes, 19 October 1847, RAA/PC/1/10. They state that 'Messrs McCracken be instructed by Mr Herbert to procure an anatomical figure from Paris, recommended by him to be purchased by the Royal Academy'.

40 H. H. Arnason, *The Sculptures of Houdon*, Oxford 1975, p. 14. For the history of Houdon's écorché and the figure of the Baptist that derived from it, see Anne L. Poulet, *Jean-Antoine Houdon: Sculptor of the Enlightenment*, exh. cat., Chicago 2003, pp. 63ff. and cats 1, 2, 3.

41 Houdon's plaster of his initial sculpted écorché is in the Académie de France, Rome, and was prepared at the behest of the director, Charles Natoire: J. Delaplanche, *350 anni di creatività: Gli artisti dell'Accademia di Francia a Roma da Luigi XIV ai nostri giorni*, exh. cat., Milan 2016, cat. 22.

42 Poulet 2003, p. 64. The statement is the epitome of aesthetic theory as exemplified in the French academy and reflected in London in the *Discourses* of Joshua Reynolds (noted above in relation to Hunter's écorchés).

43 In 1859 the Royal Academy started publishing Annual Reports that record most acquisitions. The Houdon casts were probably acquired before this date.

44 See Robin Simon in Martin Postle, ed., *Johan Zoffany: Society Observed*, exh. cat., New Haven and London 2011, cat. 59, pp. 237–9.

45 Domenico Brucciani, *Catalogue of Casts for Schools*, London 1906, no. 2271, 'Anatomical (French)'.

46 Council Minutes, 7 July 1773, RAA/PC/1/1.

47 Baretti 1781, p. 25. A cast of a flayed horse is also mentioned in the Council Minutes of 7 July 1773 as being offered to the RA, but it was not accepted.

48 The tiger (RA 03/1496), which has also been described as a lion, is possibly the same cast acquired in 1857. This is noted in the Council Minutes, 30 June 1857, RAA/PC/1/11: 'Ordered that the Treasurer do pay to Mr Julius Franz of Berlin the sum of 105 Malers for a cast of an anatomical Bengal Tiger'. Also in the collections is a modern cast made in 1990 after an eighteenth-century écorché leopard/panther (RA 03/3726).

49 The RA écorché leopard is very similar to the animal depicted in five of Stubbs's preparatory drawings at the Yale Center for British Art, New Haven, Paul Mellon Collection (B1980.1.94-98).

50 'The Royal Academy, 1897', *Art Journal*, 1897, p. 184.

51 The duke was apparently concerned to keep the horse's body intact and is said to have reacted angrily on finding that one of the animal's hooves had been removed: F. Lawley, 'Two Famous War Chargers', *Baily's Magazine of Sports and Pastimes*, LXVI (1896), pp. 337–9.

52 Tessa Mackenzie, ed., *The Art Schools of London*, London 1896. Frank Calderon was his father's third son. He exhibited at the RA and had a Hampstead studio (*Westminster Budget*, 2 February 1894, p. 14). He wrote the copiously illustrated *Painting and Anatomy of Animals*, London (n.d.), subsequently many times republished as *Animal Painting and Anatomy*, London (facsimile 1975). His school was subsequently housed at 9 St Mary Abbott's Place, London W8 (at the time of writing extant but under threat of demolition).

53 Benjamin Robert Haydon, *Lectures on Painting and Design*, London 1844, Lecture II, p. 53.

54 There are various early references to skeletons. For example, Thomas Banks RA was refused permission to borrow one from the Academy Schools: see Council Minutes, 16 December 1785, RAA/PC/1/2. A new skeleton was purchased in 1806 because the original one was in a dilapidated state: see Council Minutes, 8 March 1806, RAA/PC/1/3. Skeletons were subsequently bought or presented in 1819, 1837 and 1863.

55 General Assembly Minutes, 15 April 1814, RAA/GA/1/3. There is an example of one such drawing by W. E. Frost in the Victoria and Albert Museum, London (E.424-1948).

56 RA Archives, Annual Report 1873, p. 17, RAA/PC/10.

57 RA Archives, Correspondence between Marshall and the Royal Academy, RAA/KEE/11. Marshall gave funds 1874–6 to purchase skeletons. The skeletons, from the Royal College of Physicians, were articulated on stands and displayed in the Schools in specially built cases to form an 'anatomical museum' that survives in place.

58 Andreas Vesalius, *De Humani Corporis Fabrica Libri Septem*, 1555, presented to the Royal Academy by Francis Cotes RA before 1770, RA 03/2867. Bernhard Siegfried Albinus, *Tabulae Sceleti et Musculorum Corporis Humanae*, 1749, acquired by 1802, RA 03/2844. Petrus Camper, *The Works of the Late Professor Camper ... in Two Books ...*, translated from the Dutch by T. Cogan, M.D., London 1794, RA 03/2855.

59 RA 04/2119, acquired by 1821, and 07/2051, presented by the publisher in 1852, respectively.

60 RA 03/6639: this copy is listed in the 'Catalogue of Books Added to the Library between 1877 and 1900', 1901, p. 19.

61 *Anatomical Studies of the Bones and Muscles for the Use of Artists from Drawings by the late John Flaxman R.A. Engraved by Henry Landseer with two additional plates and explanatory notes by William Robertson*, London 1833, Preface.

62 William Cheselden, *Osteographia or the Anatomy of the Bones*, London 1733, Preface, 'To the Reader'.

63 Taylor 1853, I, pp. 19–20.

64 Bernhard Siegfried Albinus, *Tabulae Sceleti et Musculorum Corporis Humani*, Leiden 1747, published in the original Latin by John and Paul Knapton in 1749 and also translated into English by them as *Tables of the Skeleton and Muscles of the Human Body*, London 1749.

65 Haydon describes dissecting with a surgeon in Hatton Garden, London, see Taylor 1853, I, p. 39. But he is also likely to have dissected at Charles Bell's anatomy theatre where his own students later studied: see Frederick Cummings, 'B. R. Haydon and his School', *Journal of the Courtauld and Warburg Institutes*, XXVI (1963), p. 370.

66 Haydon contributing to 'Announcements of Works in Hand: Intelligence relative to the Fine Arts', *Annals of the Fine Arts*, III, 9 (1819), p. 330.

67 Inscription on title sheet of the anatomical album, RA 07/2467.

A CLOSER LOOK 17.1

1 A full analysis of Stubbs's project is provided in Judy Egerton, *George Stubbs, Painter: Catalogue Raisonné*, New Haven and London 2007, pp. 31–5.

2 RA 03/1589.

3 George Stubbs quoted in Egerton 2007, pp. 32–3.

4 Susan Owens, '"Ecorché" Drawings by Edwin Landseer', *Burlington Magazine*, CLIV (May 2012), p. 340.

5 Over 200 juvenile drawings by Sir Edwin Landseer are in the Royal Academy collections, a third of which depict horses.

6 RA Archives, Annual Report, 1880, appendix 8, Report of the Inspectors of the Property (29 December 1880), p. 49, RAA/PC/10. See also Council Minutes, 31 December 1880, RAA/PC/1/17.

7 Council Minutes, 12 February 1963, RAA/PC/1/40, records the discovery of 'a portfolio in the Library ... hitherto unrecorded ... It was appar-

ent that the original bequest of Stubbs drawings by Charles Landseer R.A. in 1879 was larger than had been supposed.'

18 THE ACADEMICIANS' LIBRARY

1 James Barry, *A Letter to the Dilettanti Society, Respecting the Obtention of certain Matters essentially necessary for the Improvement of Public Taste*, 2nd edn, London 1799, pp. 227–8.

2 [F. G. Stephens], 'Fine Arts: The Royal Academy', *Athenaeum*, no. 1821 (20 September 1862), p. 377.

3 W. T. Whitley, *Artists and their Friends in England, 1700–1799*, 2 vols, London and Boston 1928, I, p. 276.

4 Charles Saumarez Smith, *The Company of Artists: The Origins of the Royal Academy of Arts in London*, London 2012, p. 100.

5 RA Archives, Council Minutes, 28 February 1769, RAA/PC/1/1.

6 Pietro Santi Bartoli, *Colonna Trajana...*, Rome [1751], RA 03/2155; P. S. Bartoli, *Columna cochlis M. Aurelio Antonino Augusto...*, Rome 1704, RA 03/2153. Bound with: *Stylobates Columnae Antoninae Nuper e Ruderibus Campi Martii Erutae ...*, Rome 1708, RA 03/2151.

7 As with many illustrated books in the RA Library, the illustrations in this volume are separately catalogued but see, for example, RA 06/2935. By a strange coincidence it was precisely these two books that were to make William Blake so angry when the Keeper of the Academy, George Moser RA, pointed them out to him one day in the Library as a better model for a student to follow than prints after Michelangelo (see below). This incident took place during the period when Moser was deputizing for the Librarian Richard Wilson RA – between 29 June 1781 and 14 June 1782. The Le Brun and Rubens volumes are listed next to each other in the first printed catalogue (*A Catalogue of the Library in the Royal Academy*, London, [London] 1802, p. 4).

8 These inscriptions are in the same hand (possibly that of Francis Hayman) and take the form 'Given by ... to the Royal Academy'. Only those in the two books that Reynolds gave are dated.

9 It was probably only after books presented by non-members started to arrive that it was thought expedient to begin to keep a formal record of the acceptance of gifts for the Library.

10 The Hon. Lady Roberts, former Librarian of the Royal Collection at Windsor, has kindly confirmed that there is no record in the Royal Archives of any donation of books to the Acad-

emy during George III's reign. The person most likely to have played a part in brokering a donation was George III's librarian, Richard Dalton, possibly during the period when he was busy amalgamating the scattered remnants of the old Royal Library (which George II had presented to the British Museum in 1757) in order to create a new personal library for the king at Buckingham House. Dalton's appointment to the honorary post of 'Antiquarian to the Academy' was announced at a General Assembly meeting on 26 February 1770, RAA/GA/1/1.

11 Adam presented his book via Sir William Chambers RA on 11 January 1769 (gift recorded Council Minutes 30 January 1769). His decision to use a simplified variant of his red morocco 'royal' presentation binding for the Academy's copy was an acknowledgement of the king's direct support of the institution. An example of the more elaborately tooled version of this 'royal' binding, which Adam reserved for presentation to members of the royal family, is in the British Library, London (137.h.10).

12 *Fundation for det Kongelig Danske Skildre-Bildhugger- og Bygnings-Academie i Kiöbenhavn. = Fondation de l'Academie Royale Danoise de Peinture, Sculpture, et Architecture etablie a Copenhague*, [Copenhagen] 1758.

13 Council Minutes, 11 June 1772; ibid., 23 October 1773.

14 It was never placed on the Library shelves: see below.

15 Robert Wood's *Palmyra* and *Balbec*, both editions of Le Roy's *Les ruines des plus beaux monuments de la Grèce* and Adam's *Spalatro* were shelved beside each other in Case 18 (Nos 10–14); Major's *Paestum* was shelved in Case 13 (No. 15) adjacent to Overbeke's *Les restes* and close to books of engravings by Jean Barbault, G.-P.-M. Dumont, and J. C. R. de Saint Non (see *Catalogue of the Library in the Royal Academy*, pp. 10–11, 13, 15).

16 Council Minutes 8 July 1785; ibid., 31 December 1785, RAA/PC/1/2.

17 The RA Library's present copy was acquired in 2014.

18 None of these titles is present in the RA Library today, apart from Fratrel's *La cire alliée avec l'huile*, a copy of which was among the books bequeathed by Sir Augustus Wall Callcott in 1845.

19 Edward Copleston, Bishop of Llandaff, was the Academy's honorary Professor of Ancient Literature from 1831 until his death in 1849. His gift of the Earl of Dudley's *Letters* was received in 1840 (Council Minutes, 26 February 1840, RAA/PC/1/9). Sir George Thomas Staunton was the Academy's Secretary for Foreign Correspondence from 1839 until his death in 1859; his

pioneering translation of the Great Qing Legal Code was received on the same day as the Bishop of Llandaff's book.

20 D. O. Hill and R. Adamson, 'Portraits, Groups, Landscapes, Buildings, etc.', Edinburgh 1843–8 [calotypes, mounted and arranged in 3 vols, folio]. On 17 February 1849 it was reported at Council that Hill had offered to present 'a perfect collection of his Calotype works to the Library, should the Council be willing to incur the expense of mounting, &c.' Council agreed to this condition, and three volumes of 'Calotype Pictures' were formally received on 19 December 1849 (Council Minutes, RAA/PC/1/10). This collection was sold to the National Portrait Gallery in London via an anonymous benefactor in 1973.

21 The Academy's copy of the 1768 (i.e. current) edition of Chambers's *Treatise on Civil Architecture* is in a contemporary mottled calf binding that matches that of a second volume containing copies of his *Designs for Chinese Buildings* (1757; RA 03/2521) and *Plans, Elevations, Sections, and Perspective Views of … Buildings at Kew* (1763; RA 03/2522); the original spine labels of both volumes read: CHAMBERS' WORKS VOL. I. (II.). An entry recording payments for books in Dance & Tyler's facsimile of Chambers's annual accounts (RA Archives, RAA/TRE/2/1/1) during the Lady Day quarter of 1769 reads 'William Chambers £1.1.0'. It is just possible that this was a nominal payment to Chambers for supplying a specially bound copy of his collected works.

22 Although the rumour that Soane 'bought up all the copies [of his *Designs*] that he could & tried to suppress the work' is unfounded, there is evidence that 'he may well have wanted to forget his juvenile effort' (see E. Harris and N. Savage, *British Architectural Books and Writers 1556–1785*, Cambridge 1990, p. 428). The copies of the second editions of Chambers's *Dissertation* (1773) and Soane's *Sketches* (1798) currently in the RA Library are recent acquisitions.

23 See Thomas Phillips RA, *Lectures on the History and Principles of Painting*, London 1833, Lecture VIII: 'Colouring'. This lecture was delivered in 1829. The fact that Moses Harris's book was dedicated to Sir Joshua Reynolds, who must therefore have known of it, raises a question as to why no copy was acquired by the Academy either at the time of its original publication (*c.*1769–76) or later, when a second edition appeared in 1811.

24 Council Minutes, 18 March 1846, RAA/PC/1/10; Andrew Wilton, *Turner in his Time*, London 1978, p. 230.

25 Council Minutes, 17 February 1783, RAA/PC/1/1. Ironically, Green's pamphlet survives in

the RA Library today, whereas the copy of Barry's *Account* that he presented (possibly as a riposte) later that year (ibid., 10 July 1783) does not, having almost certainly been removed from the Library, along with his other writings, following his expulsion from the Academy on 15 April 1799. Interestingly, the set of etchings of his paintings in the Adelphi was allowed to remain – it had been his *words* that offended, not his art.

26 'Mr Elias Martin having presented a Vol. of Travels by Count Ehrensward – Order'd that a letter of thanks be sent him.' Ibid., 31 December 1787, RAA/PC/1/2.

27 Edwards presented his book on 8 July 1785 (ibid.). It may have subsequently helped to support his candidacy for the position of Teacher of Perspective in the Academy Schools after Samuel Wale's death in February 1786. Ward's book was accepted at a Council meeting in January 1814 (ibid., 7 January 1814, RAA/PC/1/5) and placed in a drawer ('Case 16 – –') along with Thomas Tomkins's *The Beauties of Writing Exemplified* (1808; RA 04/3208) presented by the author in 1810 (ibid., 30 March 1810, RAA/PC/1/4); a copy of vol. 2 only of James Lewis's *Original Designs in Architecture* (1797; RA 03/2647) presented by the author in 1797 (ibid., 26 August 1797, RAA/PC/1/2); the first number (only?) of John Chamberlaine's *Imitations of Original Designs by Leonardo da Vinci* (1797; RA 03/2466), paid for in the Lady Day quarter of 1798 (RA Archives, Quarterly expenditure and annual balance sheets, RAA/TRE/1/2); the first and second numbers only (of three published) of the atlas volume of George Stubbs's *A Comparative Anatomical Exposition of the Structure of the Human Body* (1803–5; see RA 03/1654), subscribed for in the Midsummer quarter of 1802 (RAA/TRE/1/2); and Nos 1–8 only of vol. IV of J. C. R. de Saint-Non's *Voyage pittoresque ou description des royaumes de Naples et de Sicile* (1781–6); Council had refused to sanction the purchase of any further numbers of the latter work (see Council Minutes, 18 October 1793, RAA/PC/1/2).

28 No catalogue of any library may be treated as complete. While no omissions from the 1802 catalogue have been identified, the three subsequent editions privately printed for distribution to members in 1821 (actually 1822), 1841 and 1864 all had demonstrable omissions, as did (less excusably) the formally published catalogue of 1877 and its supplement of 1901.

29 The two manuscripts were Sir Humphry Davy's 'Dissertation on the Colours of the Ancients', presented by Sir Joseph Banks in 1815 (Council Minutes, 11 April 1815, RAA/PC/1/5), and George Garrard's 'Documents respecting the Act for securing the Copyright in Sculpture',

presented by the author in 1814 (ibid., 7 June 1814).

30 The manuscript was Giulio Mancini's 'Alcune considerationi appartenenti alla pittura', presented by William Dyce RA in 1839 (ibid., 27 November 1839, RAA/PC/1/9).

31 Although Council had resolved as long ago as 31 December 1777 'that a Collection be made of the best Prints that shall be published in England from this time forward', no evidence survives to identify the acquisition of any newly published single prints before the purchase in November 1791 of Johann Jacobe's mezzotint of M. F. Quadal's painting of the Life Class at the Vienna Academy (published 1790); see Annual accounts of Sir William Chambers, RAA/TRE/2/1/1: November 1791 – 'Quadal a Proof print £4.4s.'. This print no longer survives in the RA Collection, although an outline drawing identifying Quadal's fellow Academicians does (RA 03/4357). An entry in the Academy's accounts for 1780 reading 'Major Engraver £9 9s.' may perhaps refer to a purchase of prints by (or at least sold by) Thomas Major (see RAA/TRE/2/1/1: November 1780).

32 Council Minutes, 29 November 1822, RAA/PC/1/6.

33 Council Minutes, 21 December 1822, RAA/PC/1/6.

34 [F. G. Stephens], 'Fine Arts: The Royal Academy', *Athenaeum*, no. 1821 (20 September 1862), p. 377.

35 RA Archives, 'Librarian's Report', in Annual report 1863, p. 25, RAA/PC/10.

36 John Ingamells and John Edgcumbe, eds, *The Letters of Sir Joshua Reynolds*, New Haven and London 2000, pp. 27–8. Reynolds had probably been told by Peter Molini (whose appointment by the king as 'foreign Bookseller to the Royal Academy' had been announced at a Council meeting on 30 January 1769) that the *Antichità d'Ercolano* and its *Catalogo* by O. A. Baiardi were unavailable in the trade despite the fact that he had advertised a set as 'expected soon to arrive' as long ago as 1765 (see *A Catalogue of Latin, French and Italian Books … to be sold cheap … by P. Molini*, [London] 1765, [p. 3]). There is no record of a copy having been received as a gift from the Neapolitan court. The Library's present copy (RA 03/1990) was probably purchased sometime between 1771 and 1779 as it includes the second volume of the *Bronzi* published in 1771 but lacks the fifth volume of the *Pitture* published in 1779.

37 RAA/TRE/2/1/1, Lady Day quarter [1 January–25 March] 1769. The booksellers were Thomas Cadell [the elder] and David Wilson in the Strand; Henry Webley at the Bible & Crown in Holborn; and Thomas Davies in Covent Garden,

whose appointment by the king as 'Bookseller to the Royal Academy' had been announced at a Council meeting on 30 January 1769.

38 This sum included a total of £122 19s. for foreign books supplied by Molini in the latter half of the year.

39 For the quarterly expenditure on books 1769–95, see RAA/TRE/2/1/1; for 1796–1867, see RAA/TRE/1/2–4.

40 W. Hauptman, 'Before Somerset House: The Royal Academy in Pall Mall', *The British Art Journal*, XVII, 1 (2016), p. 31. According to a plan (see fig. 16) attached to a letter by Reynolds to Lord Hertford dated 14 January 1772, the Library was by then located in Anne of Denmark's former drawing room (measuring 32 × 23 ft 4 in.) on the main floor of the south-east corner of Somerset House overlooking the garden (Derbyshire Record Office, D3155M/C5263; published in Richard Stephens, 'Four Letters by Sir Joshua Reynolds', *The British Art Journal*, X, 2 (Winter 2009), pp. 58–9. Stephens has helpfully established that it was this room 'next to the Lecture Room' that Reynolds reported to Council on 28 April 1771 as already 'order'd...to be appropriated to the Use of the Royal Academy' (Council Minutes, RAA, PC/1/1).

41 Of the 380 titles recorded in the 1802 printed catalogue for which no date of acquisition is known, 62 were published after 1769, and 20 are in a uniform mottled calf 'Royal Academy' binding stamped with the royal arms, the earliest probable use of which was for a copy of the second edition of J.-D. Le Roy's *Les ruines des plus beaux monuments de la Grèce* (1770) referred to above, which was presented by the author via William Chambers on 26 November 1769 (Council Minutes, 15 December 1769).

42 W. Sandby, *The History of the Royal Academy of Arts*, 2 vols, London 1862, I, pp. 94–5; Sandby's misreading (which interestingly is contemporaneous with Stephens's strictures in the *Athenaeum*) probably derives from the wording of Hayman's appointment: 'His Majesty having thought fit to establish a Place of Librarian to the Royal Academy with a Sallary of fifty Pounds per An: and it being his Gracious Intention that the said Place should always be held by some Academician whose Abilities and Assiduity in pro[moting] the Arts had long rendered him Conspicuous He had now appointed Francs Hayman Esq R.A....' (Council Minutes, 1 October 1770). While the word 'long' implied that the holder might well be aged, this was not in itself a qualification, but referred in Hayman's case to the fact that his appointment was 'just recognition from the organisation that he had fought to establish over the previous two decades'

(B. Allen, *Francis Hayman*, New Haven and London 1987, p. 9).

43 An account of John Bannister's comic impersonation of Wilson as Librarian is quoted by Whitley 1928, I, pp. 276–7.

44 The king's financial support of the Academy began to become explicit within the Library at about this time through the stamping of the royal arms on newly bound books. These are not found on any books known to have been acquired after 1781, presumably because from that year the Academy was financially independent.

45 Horace Walpole described Chambers's *Treatise on Civil Architecture* (1759) as 'the most sensible book and the most exempt from prejudices that ever was written on that science': H. Walpole, *Anecdotes of Painting in England*, ed. R. N. Wornum, 3 vols, London 1888, I, p. xiv.

46 Council Minutes, 9 December 1769, RAA/PC/1/1. See note 5 above.

47 Ibid., 1 November 1771. The second key could be lent 'to any of the Academicians, to be returned the same day', which no doubt explains Barry's complaint that he couldn't visit the Library in his 'night gown and slippers'.

48 RA Archives, Receipted bill of Bell's Circulating Library, 2 July 1774, RAA/SEC/1/24. This is the earliest bookseller's bill to survive in the RA Archives.

49 'June 1769 By Cash rec'd of Marquis de Voyer for 3 Vols. Vitr. Britan. £4.4.0.' (RAA/TRE/1/1). Copies of the [1751?] reprint of *Vitruvius Britannicus* were still plentiful in the trade to judge from a bookseller's announcement in the *Public Advertiser* on 16 and 18 June 1774 offering sets 'on fine Imperial Paper...Price 5£ 5s unbound 6£ 6s the three volumes neatly half-bound and lettered': Harris and Savage 1990, p. 147.

50 RAA/TRE/1/1: '21 May [1774] Wm. Chambers Bill for Books from Paris £23.3s.' See also the undated entry in RAA/TRE/2/1/1 listing by title 'Various books from Paris' to a total value of £14 16s. – a discrepancy that suggests that this list is incomplete. The eight books that are identified were René Aubert de Vertot, *Histoire des Chevaliers Hospitaliers...*, Paris 1726 (£0.10.0) (RA 04/2919); Cornelis Jansz Meijer, *L'arte di rendere i fiumi navigabili...*, Rome 1696 (£1.8.0) (RA 03/2664); Domenico Fontana, *Della trasportatione dell'Obelisco Vaticano...*, Rome 1590 (£1.13.0) (RA 03/2575); Carlo Fontana, *Templum Vaticanum...*, Rome 1694 (£3.3.0) (RA 03/2576); Carlo Fontana, *Utilissimo trattato dell'acque correnti...*, Rome 1696 [bound with the same author's *Antio e sua antichità dalla porta di S. Giovanni ai Volsci*, Rome 1710, and *Discorso sopra l'antico Monte Citatorio situato nel Campo Marzio*,

Rome 1708] (£1.3.0) (RA 03/2579); Jean Barbault, *Recueil de divers monumens anciens...*, Rome 1770 (£1.12.0) (RA 03/2099); Anthony van Dyck, *Iconographie ou vies des hommes illustres du XVIIe siècle* (Amsterdam 1759; RA 03/2910); and David Teniers [the Elder], *Le grand cabinet des tableaux de l'Archi-duc Leopold-Guillaume*, Amsterdam 1755 (£5.7.0 for the two works) (RA 03/2459). The prices that Chambers charged the Academy were probably based on his own valuations. I would like to thank Robin Middleton for throwing new light on Chambers's book dealing in Paris during this period (see Julien-David Le Roy, *The Ruins of the Most Beautiful Monuments of Greece*, ed. R. Middleton, Getty Research Institute Texts & Documents series, Los Angeles 2004, pp. 125–7).

51 Le Roy 2004, p. 126. See also RAA/TRE/1/1: 'Oct. [1772] to petitot's Festivals £2.15 Contants Ar. £2.2s.' Chambers's disappointment with the latter work ensured that the 'deuxième partie' was not acquired.

52 Reynolds to William Hamilton, 28 March 1769: 'we have four Professors Mr. Penny of Painting Mr. Chambers of Architecture Mr Wale of Geometry and Perspective and Dr. Hunter of Anatomy.' Ingamells and Edgcumbe 2000, p. 27. Thomas Sandby RA was elected first Professor of Architecture in 1768.

53 That Chambers had a clear sense of the pedagogic function of the Library is apparent from the fact that only students of architecture were absolutely required 'to attend the Library & Lectures, more particularly those on Architecture and Perspective' as a condition for retaining their studentship and eligibility to compete for the annual premiums (see Council Minutes, 23 December 1771, RAA/PC/1/1).

54 W. Chambers, *Treatise on Civil Architecture...*, 3rd edn, London 1791, p. 26; Council Minutes, 31 December 1791, RAA/PC/1/2. Interestingly, another landmark book that one would have expected to have been long present in the Academy Library – George Stubbs's *Anatomy of the Horse*, London 1766 (RA 03/2857) – was also resolved to be purchased at this meeting. In the case of Stubbs's book the decision may have been prompted by the acquisition of 'a horse's head' for the Schools the previous month (see RAA/TRE/1/1: 'Nov. [1791] Expenses of a horse's head £11:8:9').

55 Only two of George Richardson's nine architectural publications were not acquired by the Academy, namely *Capitals of Columns and Friezes Measured from the Antique* (1793) and *A New Book of Ornaments in the Antique Style* (1796). Significantly, these were the only instances when Richardson was not publishing on his

own account but working for a publisher: I. & J. Taylor in 1793 and T. Simpson and Darling & Thompson in 1796. This probably made his books more acceptable to the Academy in that they were not seen as publisher's confections over which an author and/or artist had no control.

56 For a chronological index of titles and editions of architectural books published in Britain during this period, see Harris and Savage 1990, pp. 522–9.

57 RAA/TRE/1/1: 'Sept. [1777] Pergolesi 2nd. No. 5s.'; '25 March [1778] Pergolesi 1st. Number omitted 5s.'. These two initial numbers of Pergolesi's series are recorded in the 1802 printed catalogue but omitted in all subsequent editions. They are not present in the RA Library today.

58 Council Minutes, 18 February 1791, RAA/PC/1/2.

59 RAA/TRE/1/1: '21 Aug. [1777] To Basan for 2 books Collection of Prints £12:12s'; '[undated 1779] Paid for Books Sandrart £11:11s.'; '10 Jan. [1780] Molini for Books £45: 4s. 11 Oct. Molini £7: 14s.'

60 Joseph Baretti, *A Guide through the Royal Academy*, London 1781, p. 16. Although no visual record is known to exist of the Academy's Library when it was in situ at New Somerset House or Trafalgar Square, it is possible to reconstruct the three different shelf arrangements of the books from 1802 onwards.

61 Council Minutes, 29 June 1781, RAA/PC/1/1.

62 Ibid., 7 January 1784.

63 Ibid., 22 January 1787, RAA/PC/1/2; RAA/TRE/1/1: '1 Feb. [1787] Mrs. Hogarth £105.' This set of 137 prints by Hogarth is still mounted in two eighteenth-century albums (03/2287, 03/2288), each with a contemporary MS list of their contents attached to the front paste-down.

64 RAA/TRE/1/1: '1 Feb. [1787] Hodges £9 9s.' Hodges was paid a further £9 9s. on 12 November 1788 for the second volume of his 'Views' and £2 2s. for the first number of his abortive 'Antiquities'.

65 RAA/TRE/2/1/2. Sastres's invoice is dated 19 April 1788 and was made out to Sir William Chambers 'for books sent to Mr. Wilton for the Royal Academy'.

66 Council Minutes, 10 October 1788, RAA/PC/1/2; RAA/TRE/2/1/2. Sastres's second bill totalling £35 3s. is headed 'Books ordered by Mr. Wilton for the use of the Royal Academy Novr 3d. 1788'. It was settled by Chambers on 26 December 1788 and included £6 6s. 0d. for a copy of a late edition of G. F. Costa's *Le delicie*

della Brenta (Venice *c.*1760; RA 03/2549), which had been 'omitted by mistake in the last bill'. According to Sastres 6d. customs duty had been charged on each of its 140 plates, which if correct amounted to £3 10s.

67 RAA/TRE/1/1: '9 May [1788] Paid Sastres for Books £82: 6s.; [13] July [1788] Millar [John Miller] £11: 19: 9 [for binding]; 12 Nov. [1788] Hodges Views £11: 11s.; Boydel prints £1: 12s. [customs] Charges; Basan for 16 Numbrs. [of Pierre Blin's *Portraits des grands hommes, femmes illustres, et sujets mémorables de France, graves et imprimés en couleurs*, Paris 1786–8] £5: 5s [03/2371]; Millar [John Miller] Books £5: 18: 9 [for binding]; Sastres £35: 3: 6d'. The original bills relating to all these payments survive in the RA Archives.

68 Council Minutes, 19 March 1789, RAA/PC/1/2; RAA/TRE/1/1: '[1789] Monuments in Britain £6: 6s.; Subscriptn to Metz £2: 2s.; Nov. Sastres £2: 2s. Soanes to Taylor £2: 12s. 6d'.

69 RAA/TRE/1/1: 'Jan. [1790] Theatre of Savoy & Antique Vases £7: 11s.' The second item was a copy of Charles Errard's *Recueil de divers vases antiques*, Paris? *c.*1680? (RA 03/2552).

70 Although Chambers would have been Wilton's principal ally on Council by virtue of his role as Treasurer, it was fortunate for them both that they had happened to serve together as members by rotation in 1786.

71 See note 39 above. Even Samuel Wale had had a better claim to this qualification for the post in that he had put in 14 years' service as the Academy's Professor of Perspective.

72 RAA/TRE/1/1: '25 March [1793] Murphy £1: 10s.' W. Chambers, *A Treatise on Civil Architecture*, 3rd edn, London 1791, p. 24.

73 RAA/TRE/1/1: '[probably November–December 1793] Burch Subsn. £1: 11s: 6; Burch Subscriptn. £1: 11s: 6'. This publication consisted of a hinged case containing 100 paste impressions of intaglio gems and a quarto printed catalogue.

74 Council Minutes, 18 October 1793, RAA/PC/1/2: 'The Views in Naples, & Sicily, were again laid before the Council, to be reconsider'd – & purchased, for the use of the Academy. The Question was put. – & Negativ'd.' This is the only known occasion when disagreement over a proposed book purchase is apparent in the minutes of a Council meeting. Apart from Chambers the architect members at this meeting were the Academy's Professor of Architecture, Thomas Sandby RA, and Chambers's long-time protégé and assistant, John Yenn RA. It would appear, therefore, that it was Burch's decision to break ranks with the painters J. S. Copley RA and Ozias Humphry RA that swung the vote. The three other members of Council – Francis

Wheatley RA, John Webber RA and Francesco Bartolozzi RA – were not present at this meeting.

75 Eight numbers of the fourth volume of Saint-Non's book are recorded in the 1802 and 1821–22 printed catalogues but omitted in all subsequent editions. They are not present in the RA Library today. The plates that Chambers was most likely to have found objectionable in this volume were a 'Table comparative des Temples, des Théâtres & de quelques autres Édifices antiques de Sicile', and plans, elevations and sections of the 'Temple de la Concorde à Agrigente' and 'Temple de Segreste en Sicile'.

76 It is a measure of how little control the Academicians had over the process that Burch's appointment as Librarian was never formally recorded in either the Council or General Assembly minute books and its exact date is not known. His attendance in this capacity at the meeting of General Assembly on 10 February 1794 may well have been the first that many members had heard about it.

77 For evidence of antagonism between Copley and West dating back to 1785, see Whitley 1928, II, pp. 47–8.

78 General Assembly Minutes, 10 December 1793, RAA/GA/1/1.

79 Ibid., 10 February 1794.

80 Ibid., 20 February 1794.

81 Council Minutes, 17 December 1796, RAA/PC/1/2.

82 Ibid., 31 December 1799, RAA/PC/1/3; ibid., 2 July 1801; ibid., 1 September 1801.

83 Ibid., 7 August 1802.

84 G. Visconti, *Il Museo Pio-Clementino...*, 7 vols, Rome 1782–1807 (RA 04/3185); Council Minutes, 17 June 1802. The seventh volume was resolved to be purchased on 12 November 1814 (Council Minutes, RAA/PC/1/5).

85 *Projets d'architecture...*(Paris 1802–6; RA 04/3194). The Academy's copy consists of the first eight cahiers only. This was all that had been published at the time of its purchase, for which West was reimbursed £2 5s. on 4 March 1803 (Council Minutes, RAA/PC/1/3). Sir Thomas Lawrence undertook to try to obtain the remainder of the work in 1820 but to no avail (see ibid., 29 December 1820, RAA/PC/1/6).

86 Council Minutes, 7 August 1802, RAA/PC/1/3; ibid., 12 November 1802; ibid., 19 July 1802; ibid., 31 December 1802; ibid., 27 November 1802. No Library accessions register survives from this period.

87 Ibid., 20 February 1804; ibid., 28 February 1804; RAA/TRE/1/2: 'Paid Joseph Farington Esqr. R.A. for the following books...' (Lady Day quarter 1804). Farington charged 18s. for binding

the Academy's copy of the *Lakes* even though it lacked its title page. André's *Specimens of Polyautography* (the earliest known artists' lithographs) may have been a present from the publisher intended for the Academy. Only the first number exists in the RA Library today.

88 Council Minutes, 1 August 1805, RAA/PC/1/3.

89 RAA/TRE/1/2: 'Paid Thomas Daniell Esqr. R.A. for his Views in India £134.14.0'.

90 Council Minutes, 27 January 1808, RAA/PC/1/4. The only payments for books recorded in this period are £29 16s. 0d. to Thomas Daniell for the fourth series of *Oriental Scenery*, 1807 (RAA/TRE/1/2: Midsummer quarter 1808) (see RA 04/3193); £27 to Henry Fuseli for J. C. Lavater's *Essays on Physiognomy*, 1789–98, the illustrations of which were after Fuseli, which was approved by Council on 13 December 1808 (Council Minutes) (see RA 06/2252); and £15 4s. 6d. to Josiah Taylor for the first part of John Carter's *The Ancient Architecture of England*, 1795 (RA 04/3192), and volume I only of John Britton's *The Architectural Antiquities of Great Britain*, 1807 (RA 04/3369), which Council reluctantly agreed to purchase on 27 February 1808 (Council Minutes) after Ozias Humphry had sent in an apology on 22 February 1808; for Council's objection on 27 January 1808, see ibid.

91 A complete set of the published plates was eventually bought from Colnaghi's in 1869 for £125 (Council Minutes, 18 February 1869, RAA/PC/1/13). In 1938 A. A. Allen presented his collection of about 500 proof impressions of the *Liber* plates (see RA 03/4132) to the Academy in honour of Sir Frank Short.

92 Council Minutes, 12 November 1814, RAA/PC/1/5: 'Report upon the state of the Library of the Royal Academy, August 1814'. The inspectors were James Ward and Robert Smirke Junior [the architect].

93 RA Archives, Thomas Stothard's catalogue of books in the Library 1815, RAA/LIB/1/1/1.

94 Council Minutes, 7 December 1814, RAA/PC/1/5.

95 Ibid., 12 November 1814; ibid., 13 March 1818.

96 The Committee of Inspection reported in 1810 that 140 books had been added since the printing of the catalogue (ibid., 17 November 1810, RAA/PC/1/4). This figure seems to have been based on the number of physical volumes rather than titles.

97 Ibid., 1 August 1815, RAA/PC/1/5: 'Report on the State of the Library ... July 25, 1815'.

98 Ibid., 3 September 1818, RAA/PC/1/6.

99 Ibid., 15 December 1818; ibid., 20 January 1819; ibid., 14 February 1820.

100 The Academy's printer, Buchanan McMillan, presented his bill of £27 5s. 6d. for printing '250 catalogues of the Library' on 29 July 1822 (ibid., 29 July 1822). Only one copy is known to have survived (RA 04/3159).

101 See RAA/TRE/1/2. The excessively low followed by exceptionally high expenditure in 1811–12 and 1817–18 are clearly anomalies arising from uneven distribution of payments between accounting periods.

102 Council Minutes, 31 July 1818, RAA/PC/1/6.

103 Ibid., 3 September 1818.

104 *Catalogue of the Library in the Royal Academy*, p. 27: 'Prints in the Portfolio Case 3 Shelf 2 No. 3'. Bernard Baron's prints may have been included as a foil to highlight the improvement in English engraving since the first half of the century. The strong representation of Sherwin's work was undoubtedly intended to demonstrate the even greater advances that had occurred since the foundation of the Academy. At some point before 1840 the four prints of Raphael's Vatican frescoes, the four Villa Negroni wall paintings, Smith's engraving of the Academy's Leonardo cartoon and Baron's engraving of Henry VIII were pasted into an elephant folio album, along with engravings of Michelangelo's Sistine Chapel prophets and sibyls by Giovanni Volpato and Domenico Cunego and some spectacular modern prints after Raphael by Raffaello Morghen, Auguste Desnoyers, Giuseppe Longhi and Antonio Ricciani. Later in the nineteenth century or early twentieth this very large album was rebound in half morocco and lettered on the spine 'Prints After Michael Angelo etc.' (RA 14/4610).

105 Geoffrey Keynes, ed., *The Complete Writings of William Blake*, London 1966, p. 449.

106 By an odd coincidence, the two books that Moser took off the shelf were those that Joseph Wilton and Nathaniel Hone RA had presented to the Academy in 1769 (see note 5 above). This incident probably took place during the period that Moser was deputizing for the Librarian, Richard Wilson.

107 Council Minutes, 3 September 1818, RAA/PC/1/6. At a subsequent Council meeting on 17 November 1818, Flaxman duly 'produced 15 Engravings from M. Angelo which were order'd to be purchased for the Library' (ibid.). It has not been possible from the evidence available in the RA Archives to establish what prints these were. Since no separate payment to Colnaghi appears in the Academy's financial records at this time, Flaxman's purchase may perhaps have been included in a later bill 'for books' costing £64 13s. (RAA/TRE/1/3, Midsummer quarter 1819).

108 For the Academy's negotiations with Cumberland regarding the purchase of his collection for two instalments of £300, see Council Minutes, 2 August 1820, RAA/PC/1/6; ibid., 1 September 1820; ibid., 20 October 1820. To judge from the minutes of the meeting on 2 August, the decision to purchase the collection had already been taken and the question under discussion was how to agree a fair price. Earlier in the same meeting exhibition receipts amounting to £4,650 14s. had been reported, which no doubt helped the mood. The Cumberland Collection was broken up and sold through P. & D. Colnaghi & Co. in the 1970s.

109 G. Cumberland, *An Essay on the Utility of Collecting the Best Works of the Ancient Engravers of the Italian School...*, London 1827 (RA 05/2772).

110 A possible exception is a mid-eighteenth-century album of trial proofs of 'Estampes diverses' by Jean Mariette, arranged hierarchically from engraved initials and small book illustrations through to large-scale separately published prints of history paintings. This album was acquired sometime before 1802 and may have been intended to exemplify the professional education of an engraver, since it includes student work undertaken by Mariette in the 1680s as a pupil in the studio of his brother-in-law, J. B. Corneille.

111 Council Minutes, 22 December 1832, RAA/PC/1/8: 'Resolved that the Catalogue publish'd of Mr. Cumberland's Collection of Prints be immediately purchased for the Library'; ibid., 30 January 1839, RAA/PC/1/9: 'Produced a copy of Cumberland's Critical Catalogue of Prints, price £2 (formerly ordered by the Council) – which was directed to be paid.'

112 Ibid., 22 December 1832, RAA/PC/1/8.

113 A last-ditch attempt in February 1859 to make 'a careful classification and arrangement of the prints' was abandoned after Pickersgill reported to Council 'that the amount of the labour & expense ... was so much greater than the Council had anticipated' (ibid., 12 July 1858, RAA/PC/1/11; ibid., 7 February 1859; ibid., 22 March 1859).

114 Ibid., 8 February 1822, RAA/PC/1/6; ibid., 8 March 1822; ibid., 29 July 1822; ibid., 26 October 1822; ibid., 11 February 1823.

115 Ibid., 8 July 1823. The figure had been £50 but was later reduced to £25.

116 Ibid., 16 February 1826, RAA/PC/1/7; ibid., 30 October 1827; ibid., 6 December 1827. Wilkie subscribed to the last mentioned work on the Academy's behalf.

117 Ibid., 22 October 1833, RAA/PC/1/8. The books referred to are Marx Treitz-Saurwein's *Der Weiss Kunig* (1775) with sixteenth-century

woodcuts by Hans Burgkmair printed from the original blocks, and Adriaan van Baarland's *Ducum Brabantiae Chronica* (1600). They were purchased from J. F. Setchell (RAA/TRE/1/3, Michaelmas quarter 1833). Henry Howard, the Secretary of the Academy and a member of the 1832 Committee of Inspection, may well have been the instigator of this purchase since he had been responsible for the Academy's acquiring a copy of Treitz-Saurwein's companion work *Kaiser Maximilians I. Triumph* (1796) in 1817 (Council Minutes, 15 August 1817, RAA/PC/1/5) (RA 06/1441).

118 Five albums were purchased by Eastlake for £73 at the sale of Westmacott's library and offered to Council for purchase by the Academy in 1857 (Council Minutes, 23 July 1857, RAA/PC/1/11). Twelve more albums were presented by a sister of W. E. Frost in 1906.

119 *Figures de différents caractères, de paysages, & d'études dessinées d'après nature par Antoine Watteau.* Ibid., 16 April 1845, RAA/PC/1/10. The Academy's copy, for which Uwins was reimbursed 47 guineas, had belonged to Andrew Geddes ARA.

120 Ibid., 29 March 1843, RAA/PC/1/9; ibid., 21 February 1844; ibid., 27 March 1844.

A CLOSER LOOK 18.1

1 Willard Bissell Pope, ed., *The Diary of Benjamin Robert Haydon*, 5 vols, Cambridge, Mass. 1960–63, III, p. 229.

2 Giorgio Vasari, *Le vite de' più eccellenti pittori, scultori, e architettori…*, vol. 2 (*Primo volume delle terza parte*), Florence, 1568. Second (first illustrated) edn, quarto. Eighteenth-century mottled calf (rebacked in twentieth century). RA 06/3766. Sir Joshua Reynolds's copy. Purchased by Benjamin Robert Haydon. Title page inscribed in ink 'BR Haydon'. The paste-down carries a newspaper cutting, a letter from Haydon to the editor of the *Morning Chronicle* lamenting and explaining his imprisonment for debt, inscribed in ink '1836'. Signature 'J. H. Smith, Caradoc Lodge, Church Stretton'. Bequeathed in 1949 by Gilbert Bakewell Stretton together with his collection, which included many drawings by Haydon and Philip Reinagle and works by his own father, John Halphead Smith.

A CLOSER LOOK 18.2

1 Robert Adam, *Ruins of the Palace of the Emperor Diocletian at Spalatro in Dalmatia*, London 1764. Large Folio. 61 engraved plates (RA 05/

3754). Red morocco, special binding, designed by Adam, with palmette border and royal arms in central oval. Presented by Robert Adam to the RA in 1769 (RA Archives, Council Minutes, 11 January 1769, RAA/PC/1/1), with an autograph letter from Adam to the Treasurer Sir William Chambers RA.

2 See Chapter 1 for Robert Strange's similar honours.

A CLOSER LOOK 18.3

1 Admiral Count Carl August Ehrensvärd, *Resa til Italien 1780, 1781, 1782: Skriven I Stralsund.* Stockholm 1786. Quarto. Eighteenth-century mottled calf, gilt borders on upper and lower boards, with 27 outline etched plates hand-coloured with watercolour washes by Elias Martin ARA after sketches by Ehrensvärd. The plates are unsigned, but the first plate has been inscribed in ink, 'Count Ehrenswärd invt.' and 'E. Martin. the Associate, sculpt.' and the remainder 'A.E.' and 'E.M.' Presented by Elias Martin ARA: RA Archives, Council Minutes, 31 December 1787, RAA/PC/1/2.

2 Ibid. Most of the original drawings are in the Royal Academy of Arts, Stockholm, and in the Swedish National Museum.

3 Wellcome Library, London, no. 44427i.

4 Mikael Ahlund, 'Joseph Wright of Derby in a Northern Light, Swedish Comparisons and Connections: Pehr Hilleström & Elias Martin', *The British Art Journal*, X, 3 (2011), pp. 33–40. Pl. 3 is a drawing of Martin by Johan Tobias Sergel, *Elias Martin in London* (1779, pencil, ink and wash, 20 × 24.8 cm, Nationalmuseum, Stockholm, NMH 625/1875; Sergel is at the left). In Bath, Martin lived first in Trim Street, while two wash drawings on the art market inscribed 'Elias Martin No. 6 London Road' subsequently place him at that address: www.artoftheprint.com (accessed 20 November 2016). I am grateful to Robin Simon for bringing this to my attention.

5 Council Minutes, 23 October 1832, RAA/PC/1/7.

19 MEDALS

1 For the Academy's prize medals, see Sidney C. Hutchison, *History of the Royal Academy 1768–1968*, London 1968, pp. 52, 93, 99, 105, 154, 178; L. Brown, *A Catalogue of British Historical Medals*, vol. I, London 1980, pp. 30–31, nos 132–3; p. 354, nos 1464–5; L. Brown, *A Catalogue of British Historical Medals*, vol. II, London 1987, pp. 12–13, nos

1794–5; p. 396, no. 3389; L. Brown, *A Catalogue of British Historical Medals*, vol. III, London 1995, pp. 77–8, nos 4017–18. For Pingo's medals, see also Christopher Eimer, *The Pingo Family and Medal Making in 18th-Century Britain*, London 1998, p. 57, nos 42, 43; p. 85, nos 212–15. Eimer reproduces an engraving of what appears to be an unadopted design for a Royal Academy medal, pp. 85–6, no. 216. For Brock's model for the reverse of the gold medal, see Philip Attwood, 'Three Recent Acquisitions by the British Museum', *Medal*, 12 (1988), pp. 34–5. The models for the Gillicks' medal were exhibited at the 1938 Royal Academy Summer Exhibition as joint works. According to a note written by the British Museum curator Joan Martin in the 1960s and accompanying an example of the medal in the museum's collection, the portrait, although ostensibly of George III, is 'modelled from the butcher boy who delivered to Mrs Gillick at the time the medal was in process'. For the awarding of Academy prize medals, see G. D. Leslie, *The Inner Life of the Royal Academy*, London 1914, and Hutchison 1968, pp. 52, 56, 91, 110, 119.

2 Hutchison 1968, p. 117.

3 Ibid., p. 134.

4 Leslie 1914, p. 55. Leslie returns to this theme on pp. 214–15.

5 Timothy Clifford, 'Thomas Stothard, RA, and the British Neo-Classical Medal', in Mark Jones, ed., *Designs on Posterity: Drawings for Medals*, London 1994, p. 141, no. 10.

6 For the drawings by Dyce and Maclise and a study by Dyce now in the Fitzwilliam Museum, see Luke Syson in Jones 1994, pp. 260–63. For Maclise's design, see also *Daniel Maclise 1806–1870*, exh. cat., Arts Council of Great Britain, London 1972, p. 119, no. 127; Nancy Weston, *Daniel Maclise: Irish Artist in Victorian London*, Dublin 2001, p. 244; for Wyon's involvement, Philip Attwood, *Hard at Work: The Diary of Leonard Wyon 1853–1867*, London 2014.

7 There is a painting of Cecilia as a child by her mother, Janine Forbes-Robertson, in Nottingham Castle Museum. She was a niece of the actor Johnston Forbes-Robertson, who enrolled in the RA Schools in 1870 (see his portrait of Samuel Phelps, 1876, Garrick Club, London). Some of Cecilia's prize-winning drawings are recorded in photographs of *c.*1920 in the RA Archives (RAA/LIB/10/3/1, RAA/LIB/10/3/2, RAA/LIB/10/3/3).

8 For Turner, see *Alfred and Winifred Turner*, exh. cat., Ashmolean Museum, Oxford 1988, pp. 32–9, 46–8.

9 Presented in 1921 by the artist's daughter, Laurence Alma-Tadema, along with his easel

and paintboxes; see RA Archives, Annual Report 1921, p. 66, RAA/PC/10. The medals are discussed in W. Roberts, 'Medals Awarded to Artists, as Illustrated by Sir Lawrence Alma-Tadema's Collection', *Magazine of Art*, 1900, pp. 342–7.

10 Presented in 1922; see Annual Report 1922, p. 70.

11 Hutchison 1968, p. 96.

12 Ibid., p. 75.

13 Luke Syson, in Jones 1994, pp. 256–9.

14 Brown 1980, p. 40, no. 177.

15 For Mills's medals of West, see ibid., pp. 205–6, nos 862–5; p. 255, no. 1055.

16 Ibid., p. 350, no. 1448. The reverse of the other consists of an inscription recording the dates of Lawrence's birth, election as President, and death; ibid., p. 351, no. 1449.

17 G. K. Beaulah, 'The Medals of the Art Union of London', *British Numismatic Journal*, 36 (1967), pp. 179–85.

18 Mark Jones, 'The Life and Work of William Wyon', in *La medaglia neoclassica in Italia e in Europa: Atti del Quarto Convegno Internazionale di Studio sulla Storia della Medaglia 20–23 giugno 1981*, ed. Domenico Cerroni-Cadorsi, Udine 1984, pp. 121, 132; Moira Rudolf Hanley, 'Cheselden, Mead, Solly and Bristowe: Medals of St Thomas' Hospital Medical School', *Medal*, 30 (1997), pp. 46–51.

19 Wyon's great rival, Benedetto Pistrucci, is represented by his official medal for Queen Victoria's inauguration in 1837; Brown 1987, p. 14, no. 1801.

20 One of these plasters is reproduced in Mark Stocker, 'Frederic Leighton and Queen Victoria's Jubilee Commemorative Medal of 1887', *Medal*, 50 (2007), pp. 30–35, where a sequence of letters from Leighton to Boehm is transcribed, revealing Leighton's debt to the sculptor concerning practical matters. See also Brown 1987, p. 361, no. 3219.

21 Complete plasters of both sides of the medal were presented by the artist to the Fitzwilliam Museum in 1995. These plasters and the medal are reproduced in *Medal*, 34 (1999), pp. 125–7.

22 I am grateful to Joe Cribb for his comments on this piece. The gold and silver one kilo medals by Tom Phillips RA and Sir Anthony Caro RA for the 2012 Olympics in London did not enter the RA collection.

A CLOSER LOOK 19.1

1 RA Archives, Council Minutes, 19 March 1771 and 25 May 1771, RAA/PC/1/1. My thanks to Katherine Eustace for this information.

2 Martin Postle, 'Flayed for Art: The Écorché Figure in the English Art Academy', *The British Art Journal*, V, 1 (2004), p. 57.

3 William Hauptman, 'Before Somerset House: The Royal Academy in Pall Mall', *The British Art Journal*, XVII, 1 (2016), p. 25.

4 Gertrud Seidmann, 'Edward Burch', *ODNB*.

5 D. Bilbey, with M. Trusted, *British Sculpture 1470 to 2000: A Concise Catalogue of the Collection at the Victoria and Albert Museum*, London 2002, cat. 78.

6 Martin Kemp, 'Bicentenary Celebrations of Dr William Hunter (1718–1783) Glasgow University', *Burlington Magazine*, CXXV (June 1983), pp. 380–83. See also Peter Black, ed., *'My Highest Pleasures': William Hunter's Art Collection*, London 2007, pp. 92–100; Anne Dulau Beveridge, 'The Anatomist and the Artists: Hunter's Involvement', in E. Geoffrey Hancock, Nick Pearce and Mungo Campbell, eds, *William Hunter's World: The Art and Science of Eighteenth-Century Collecting*, Farnham, 2015, pp. 81–95.

7 J. T. Smith, *Nollekens and his Times*, 2 vols, London 1828, II, p. 11.

8 A list of contributors to the relief of Mrs Spang in 1763 is in the RA Archives, SA/26/3, as is the indenture of their son, Henry (SA/33/9).

20 THE MEMORY OF THE ACADEMY

1 RA Archives, Sir Thomas Lawrence PRA letters and papers, RA/LAW/1/206 (31 January 1809).

2 RA Archives, General Assembly Minutes, 10 February 1809, RAA/GA/1/2. Marchant received 22, Augustus Wall Callcott 6, Richard Westmacott 3, Joseph Gandy 1. The meeting was also notable as the election was to fill the place left vacant by the death of Angelica Kauffman. Mary Lloyd (née Moser) made a rare appearance.

3 K. Garlick, A. Mackintyre and K. Cave, eds, *The Diary of Joseph Farington*, 17 vols, New Haven and London 1978–98, IX, p. 3398 (21 February 1809).

4 RA Archives, acc. 2004/13, Diplomas and letters of Nathaniel Marchant, 1772–99. The box was rediscovered in 2001 during an audit of the sculpture stores undertaken as part of the project to catalogue the Academy's collections. Designed specifically to hold the diploma of the Royal Academy of Vienna (which is present), the contents include other letters and diplomas. On top of the documents was a scrap of paper with 'For the Royal Acdy.' written in pencil.

5 The Roll is formed of four large vellum sheets, the first of which begins with the obli-

gation, a version of which was drafted for the Society of Artists in 1765. It asks little of the signatories other than that they obey the laws of the Academy and do honour unto it. All members have subscribed their names. At the head stands Sir Joshua Reynolds, who signed on 14 December 1768.

6 RA Archives, RAA/IF, dated 10 December 1768. The Instrument of Foundation bears some similarity to a plan published by the Society of Musicians in 1738. During the 1760s the Society of Musicians met in the Turk's Head, which was also the venue for the meetings of the Society of Artists.

7 *Report of the Commissioners Appointed to Inquire into the Present Position of the Royal Academy*, London 1863, p. 210.

8 *Report of the Commissioners* 1863, p. vii.

9 Matthew Hargraves, *Candidates for Fame*, New Haven and London 2005, p. 51. The original charter has recently (2015) been found in the sculpture store at the Academy. The papers of the Society of Artists have been preserved in the Academy archives since 1836 (RA Archives, SA).

10 John Pye argued that the Instrument negated most of this previous charter at a stroke: *Patronage of British Art: An Historical Sketch*, London 1845, p. 134. In evidence delivered to the Select Committee of 1836 Henry Howard RA refuted a claim that the Academy was offered a charter by George IV, 'a charter was neither offered nor desired': *Report of the Select Committee on Arts*, London 1836, p. 177.

11 Holger Hoock, *The King's Artists*, Oxford 2003, ch. 6 and passim. Today, among organizations benefiting from the patronage of the queen, the Academy is unique in proclaiming Her Majesty 'Patron, Protector and Supporter'.

12 RA Archives, Lease to Burlington House, 7 March 1867, RAA/TRU/1.

13 It has recently been shored up by a Memorandum and Articles of Association, stating that the Royal Academy is a company limited by guarantee under the Companies Acts of 1985 and 1989.

14 W. T. Whitley, *Artists and their Friends in England, 1700–1799*, 2 vols, London and Boston 1928, I, pp. 183–4.

15 SA/1, 15 May 1760, 'Mr. Newton reported that he had paid...John Malin 10s 6d.'

16 SA/3, 1 September 1767.

17 SA/10.

18 General Assembly Minutes, 11 August 1769, RAA/GA/1/1. There is no official response to the news of Malin's death in the records of the society.

19 SA/1, 12 June 1761.

20 RA Archives, Bills, receipts and quarterly statements of expenditure 1788, RAA/TRE/2/1/2.

21 Shrub was a type of early cocktail composed of concentrated orange or lemon juice and rum. The average retail price of a quart of porter in 1788 was 3½d., meaning approximately a pint a night was allowed to models (P. Mathias, *The Brewing Industry in England*, Cambridge 1959, p. 546). The Schools were getting through one to one and a half loaves a night, suggesting this was being used by students for erasing purposes rather than eating: T. R. Gourvish, 'A Note on Bread Prices in London and Glasgow, 1788–1815', *Journal of Economic History*, XXX, 4 (December 1970), p. 855.

22 The early volumes of minutes were re-bound into reverse-calf sometime in the nineteenth century. The representation of the Secretary in Henry Singleton's *Royal Academicians in General Assembly 1795* (see fig. 146) suggests a vellum binding for the early minutes, rather like that used for the first volume of directors' minutes of the Society of Artists (SA/10).

23 J. M. Kelly, *The Society of Dilettanti*, New Haven and London 2009, p. 4. The Dilettanti Society, for one, met for three years before records began. The early minutes of the Royal Society of Musicians were lost altogether, if they ever existed. The earliest minutes extant are for 1785, and even these bear evidence of having been retrospectively entered into the book.

24 Royal Society of Arts Archive, RSA/AD/MA/100/12/01/01, 19 February 1755: 'The Secretary was desired to consult with Mr Goodchild about providing proper Books for entring the Minutes keeping the Accts. and Registering all affairs relating to the society.'

25 Existing biographies assert that Newton was born 31 January 1720, but the baptismal register for St Andrew's, Holborn, states clearly that Newton was 'Born ye. 10th Bapt ye. 31st [January 1728]'. Newton signs as Secretary a notice of the 'Academy for Painting, Sculpture &c', placed in the *Daily Advertiser* of 20 March 1752. This relates to the life class more normally known as the St Martin's Lane Academy.

26 P. J. Willetts, *Catalogue of the Manuscripts of the Society of Antiquaries of London*, Oxford 2000, MS 265.

27 SA/1, 23 June 1761.

28 Garlick, Mackintyre and Cave 1978–98, VI, p. 2205. The account of the debate continues at length.

29 RA Archives, Council Minutes, 26 December 1803, RAA/PC/1/3. Further notes were scrawled through on the order of a subse-quent Council. In their place is the terse phrase given above.

30 The Attorney General Spencer Perceval gave his opinion, in response to questions put to him, concerning the interpretation of the laws governing the Academy, and his personal annotations can be seen in the interleaved copy of *Abstract of the Instrument of Institution and Laws of the Royal Academy of Arts in London* (London 1797) in the Academy Library.

31 Hoock 2003, p. 50. The minutes of Council in particular have been repeatedly called into question at times of extreme stress. Newton's impartiality was questioned as early as 1767, when the Society of Artists began to implode (SA/3). More recently, the minutes became a battleground during the secretaryships of Humphrey Brooke (1952–68) and David Gordon (1996–2003).

32 Garlick, Mackintyre and Cave 1978–98, X, p. 3609.

33 Hoock 2003, p. 197.

34 Council Minutes, 5 April 1860, RAA/PC/1/11. The resultant works are William Sandby, *A History of the Royal Academy from its Foundation...*, London 1862, and Whitley, 1928. Whitley went so far as to claim, 'I am the first modern writer who has been allowed to search and quote from the records.'

35 A closure period of 30 years remains in place to protect the privacy of individuals and enable good governance.

36 General Assembly Minutes, 22 October 1969, RAA/GA/1/12. This first proposal arose from A. K. Lawrence, a maverick among the membership. His motion was defeated easily. The question has arisen since, usually at times of great stress.

37 Council Minutes, 10 July 1797, RAA/PC/1/2. Ibid., 15 February 1811, RAA/PC/1/4.

38 RA Archives, Secretary's scrapbooks, RAA/SEC/22. Holding material dating from as early as 1771, the most significant series of volumes concerns the regulation and awarding of the School Premiums, with another holding printed memoranda circulated to the membership. The latter series continues to the present day.

39 Eyre did produce exquisite diagrams of the Summer Exhibition hangs of 1851–4 (RA Archives, Records of the Summer Exhibition, RAA/SEC/23/1).

40 Sandby 1862, p. viii.

41 RA Archives, Reference Books c.1850–1965, RAA/SEC/20.

42 RA Archives, Records of the Registry, RAA/REG/4. These finding aids are of major importance as they reveal just how much of the pre-1860 correspondence has subsequently been lost. Items recorded include letters from 'Soan J., candidate for silver medal', 'West B.,...rejecting the inadmissibility of Hagar & Ishmael' and 'Reynolds, Sir J., respecting Mrs. Hogarth's pension'. Circumstantial evidence suggests that many letters and memoranda covering the period 1769–1860 were mislaid or destroyed subsequent to the arrival of the Royal Academy at Burlington House.

43 Council Minutes, 7 March 1862, RAA/PC/1/12. Eyre even asked for the title of Assistant Secretary.

44 Ibid., 5 August 1884, RAA/PC/1/18.

45 The most succinct definitions of these principles is by the International Standard for Archival Description (ISAD(G)). See www.ica.org/en/isadg-general-international-standard-archival-description-second-edition.

46 RA/LAW/5/537, 'For Marie'.

47 An account of the affair with Maria can be found in *An Artist's Love Story*, ed. O. G. Knapp, London 1904. The source material for this book is now to be found in Cambridge University Library, Dept of Manuscripts, GB 012 MS.Add.6445.

48 RA/LAW/1/76.

49 RA/LAW/1.

50 RA/LAW/2/319.

51 RA/LAW/4/248.

52 RA/LAW/9/61.

53 RA/LAW/9/55.

54 RA/LAW/5/523, Thomas Campbell to Elizabeth Croft, 8 October 1830.

55 D. E. Williams, *The Life and Correspondence of Sir Thomas Lawrence*, 2 vols, London 1831, I, p. xiv.

56 RA/LAW/9/55 includes an annotation 'do not destroy this'. The letters in the Keepsake remain emotional and deeply personal despite the excisions, and frequently Lawrence signs off as 'Lauro'.

57 RA Archives, General correspondence of George Richmond, c.1826–96, GRI/3.

58 RA Archives, Members' correspondence 1984–7, 26 October 1985, RAA/PRA/10/6.

A CLOSER LOOK 20.1

1 For Lawrence see Kenneth Garlick, *Sir Thomas Lawrence: A Complete Catalogue of the Oil Paintings*, Oxford 1989; Michael Levey, *Sir Thomas Lawrence*, New Haven and London 2005; C. Albinson, P. Funnell and L. Peltz, eds, *Sir Thomas Lawrence: Regency, Power and Brilliance*, exh. cat., New Haven and London 2010.

2 K. Garlick, A. Mackintyre and K. Cave, eds, *The Diary of Joseph Farington*, 17 vols, New Haven and London 1978–98.

3 RA Archives, RA/LAW/2/339.
4 RA/LAW/1/47.
5 RA/LAW/1/113; RA/LAW/1/1144.
6 RA/LAW/1/143.

7 RA/LAW/1/17.
8 RA/LAW/1/268/2.
9 Garlick, Mackintyre and Cave 1978–98, XI, pp. 3877–8 (15 February 1811).

A CLOSER LOOK 20.2

1 The other Academician to have been expelled was Brendan Neiland in May 2005.

SELECT BIBLIOGRAPHY

Albinson, C., P. Funnell and L. Peltz, eds, *Sir Thomas Lawrence: Regency, Power and Brilliance*, exh. cat., New Haven and London 2010

Attwood, Philip, *Hard at Work: The Diary of Leonard Wyon 1853–1867*, London 2014

Baker, M., and D. Bindman, *Roubiliac and the Eighteenth Century Monument: Sculpture as Theatre*, New Haven and London 1995

Baretti, Joseph, *Guide through the Royal Academy*, London 1781

Baron, W., *Sickert: Paintings and Drawings*, New Haven and London 2006

Barringer, T., and E. Prettejohn, eds, *Frederic Leighton: Antiquity, Renaissance, Modernity*, New Haven and London 1999

Barrington, Mrs Russell, *The Life, Letters and Work of Frederic Leighton*, 2 vols, London 1906

Barry, James, *An Enquiry into the Real and Imaginary Obstructions to the Acquisition of the Arts in England*, London 1775

——, *A Letter to the Dilettanti Society, Respecting the Obtention of Certain Matters Essentially Necessary for the Improvement of Public Taste, and for Accomplishing the Original Views of the Royal Academy of Great Britain*, London 1798

Bates, L. M., *Somerset House: Four Hundred Years of History*, London 1967

Beattie, S., *The New Sculpture*, New Haven and London 1983

Beckett, R. B., ed., *John Constable's Correspondence*, 6 vols, London / Ipswich, 1962–8

Bignamini, Ilaria. 'Art Institutions in London 1689–1768: A Study of Clubs and Academies', *Walpole Society*, LIV (1988), pp. 19–148

——, and M. Postle, *The Artist's Model: Its Role in British Art from Lely to Etty*, exh. cat., Nottingham 1991

Bills, Mark, and Barbara Bryant, *G. F. Watts: Victorian Visionary*, New Haven and London 2008

Bindman, D. ed., *John Flaxman, RA*, exh. cat., London 1979

Bingham, Neil, 'Architecture at the Royal Academy Schools 1768–1836', in N. Bingham, ed., *The Education of the Architect: Proceedings of the 22nd Annual Symposium of the Architectural Historians of Great Britain*, London 1993

——, *Samuel Ware and the Creation of the Great Staircase at Burlington House, Piccadilly, London*, exh. cat., London 2008

——, *Masterworks: Architecture at the Royal Academy of Arts*, London 2011

Black, Peter ed., *'My Highest Pleasures': William Hunter's Art Collection*, London 2007

Bowness, Sophie, and Clive Philpot, eds, *Britain at the Venice Biennale 1895–1995*, London 1995

British Institution, *An Account of all the Pictures Exhibited in the Rooms of the British Institution, from 1813 to 1823, belonging to the Nobility and Gentry of England: With Remarks, Critical and Explanatory*, London 1824

Brown, L., *A Catalogue of British Historical Medals*, 3 vols, London 1980–1995

Bryant, Julius, *Thomas Banks 1735–1805: Britain's First Modern Sculptor*, exh. cat., Sir John Soane's Museum, London 2005

——, *Designing the V&A: The Museum as a Work of Art (1857–1909)*, London 2017

Casteras, Susan P., and C. Denney, eds, *The Grosvenor Gallery: A Palace of Art in Victorian England*, exh. cat., New Haven and London 1996

——, and Ronald Parkinson, eds, *Richard Redgrave, 1804–1888*, New Haven and London 1988

Cavanagh, Terry, *Public Sculpture of Liverpool*, Liverpool 1997

Cole, Alison, *Michelangelo: The Taddei Tondo*, London 2017

Compton, A., *The Sculpture of Charles Sargeant Jagger*, Farnham 2004

Cunningham, A., *The Lives of the Most Eminent British Painters, Sculptors and Architects*, 5 vols, London 1830

——, *The Life of Sir David Wilkie: With his Journals, Tours, and Critical Remarks on Works of Art; and a Selection from his Correspondence*, 3 vols, London 1843

Dakers, Caroline, *The Holland Park Circle*, London 1999

Denis R. Cardoso, and C. Trodd, eds, *Art and the Academy in the Nineteenth Century*, Manchester 2000

Desmarais, J., M. Postle and W. Vaughan, eds, *Model and Supermodel: The Artist's Model in British Culture*, Manchester 2006

Eastlake, Lady, ed., *Life of John Gibson, R.A., Sculptor*, London 1870

Edwards, E., *Anecdotes of Painters who have resided or been born in England*, London 1808

Egerton, Judy, *George Stubbs, Painter: Catalogue Raisonné*, New Haven and London 2007

Evans, Mark, ed., *John Constable: The Making of a Painter*, exh. cat., London 2014

Fenton, James, *School of Genius: A History of the Royal Academy of Arts*, London 2006

Frasca-Rath, Anna, and Annette Wickham, *John Gibson RA: A British Sculptor in Rome*, exh. cat., London 2016

Frith, W. P., *My Autobiography and Reminiscences*, 3 vols, London 1887

Garlick, Kenneth, *Sir Thomas Lawrence: A Complete Catalogue of the Oil Paintings*, Oxford 1989

——, A. Mackintyre and K. Cave, eds, *The Diary of Joseph Farington*, 17 vols, New Haven and London 1978–98

Graves, Algernon, ed., *The Royal Academy of Arts: A Complete Dictionary of Contributors and their Work from its Foundation in 1769 to 1904*, 8 vols, London 1905–6

Hadjiafxendi, Kyriaki, and Patricia Zakreski, eds, *Crafting the Woman Professional in the Long Nineteenth Century: Artistry and Industry in Britain*, Farnham 2013

Hallett, Mark, *Reynolds: Portraiture in Action*, London and New Haven 2014

Hargraves, Matthew, *Candidates for Fame: The Society of Artists of Great Britain, 1760–1791*, New Haven and London 2006

Harris, John, *Sir William Chambers*, London 1970

Haskell, Francis, and Nicholas Penny, *Taste and the Antique: The Lure of Classical Sculpture 1500–1900*, New Haven and London 1981

Hauptman, William, 'Before Somerset House: The Royal Academy in Pall Mall', *The British Art Journal*, XVII, 1 (2016), pp. 22–4

Hayes, John, *The Letters of Thomas Gainsborough*, New Haven and London 2001

Hodgson, J. E., and Frederick A. Eaton, *The Royal Academy and its Members 1768–1830*, London 1905

Hogarth, William, *The Analysis of Beauty*, ed. Joseph Burke, Oxford 1955

Hoock, Holger, *The King's Artists: The Royal Academy of Arts and British Culture 1760–1840*, Oxford 2003

——, *Empires of the Imagination: Politics, War and the Arts in the British World*, London 2010

Hunt, William Holman, *Pre-Raphaelitism and the Pre-Raphaelite Brotherhood*, 2 vols, London 1905

Hutchison, Sidney C., 'The Royal Academy Schools 1768–1830', *Walpole Society*, XXXVIII (1960–62), pp. 123–91

——, *The History of the Royal Academy, 1768–1986*, London 1986 (first published as *The History of the Royal Academy, 1768–1968*, London 1968)

Ingamells, John, and John Edgcumbe, eds, *The Letters of Sir Joshua Reynolds*, New Haven and London 2000

Irwin, David, *John Flaxman 1755–1826: Sculptor, Illustrator, Designer*, London 1979

Jenkins, Susan, 'The External Sculptural Decoration of Somerset House and the Documentary Sources', *The British Art Journal*, II, 2 (Winter 2000–01), pp. 22–8

Jervis, Simon, *Printed Furniture Designs before 1650*, Leeds 1974

Jones, Mark, ed., *Designs on Posterity: Drawings for Medals*, London 1994

Judd, Harriet, ed., *The Mythic Method: Classicism in British Art 1920–1950*, exh. cat., Chichester 2016

Kelly, J. M., *The Society of Dilettanti*, New Haven and London 2009

Kemp, Martin, *Dr William Hunter at the Royal Academy of Arts*, Glasgow 1975

Kenworthy-Browne, J., 'The Duke of Richmond's Gallery in Whitehall', *The British Art Journal*, X, 1 (2009), pp. 40–49

Knight, Laura, *The Magic of a Line: The Autobiography of Laura Knight, D.B.E., R.A.*, London 1965

Leslie, C. R., *Life and Letters of John Constable R.A.* (1843), London 1896

Leslie, G. D., *The Inner Life of the Royal Academy*, London 1914

Levey, Michael, *Sir Thomas Lawrence*, New Haven and London 2005

Lewis, W. S., ed., *The Yale Edition of Horace Walpole's Correspondence*, 48 vols, New Haven 1937–83

Lister, Raymond, ed., *The Letters of Samuel Palmer*, Oxford 1974

Mackenzie, Tessa, ed., *The Art Schools of London*, London 1896

Mannings, David (the subject pictures catalogued by Martin Postle), *Sir Joshua Reynolds: A Complete Catalogue of his Paintings*, 2 vols, New Haven and London 2000

Matthew, H. C. G., and Brian Harrison, eds, *Oxford Dictionary of National Biography*, Oxford 2004

Matthews, T., *The Biography of John Gibson, R.A., Sculptor, Rome*, London 1911

McConkey, K., *The New English: A History of the New English Art Club*, London 2006

McIntyre, Ian, *Joshua Reynolds: The Life and Times of the First President of the Royal Academy*, London 2003

Merritt, Douglas, and Francis Greenacre, with K. Eustace, *Public Sculpture of Bristol*, Liverpool 2010

Meyer, Arline, *Apostles in England: Sir James Thornhill and the Legacy of Raphael's Tapestry Cartoons*, exh. cat., Columbia University, New York 1996

Millais, John Guille, *The Life and Letters of Sir John Everett Millais, President of the Royal Academy*, 2 vols, London 1900

Moriarty, Catherine, *The Sculpture of Gilbert Ledward*, Much Hadham and Aldershot 2003

Morphet, R., *Meredith Frampton*, London 1982

Newell, C., *The Grosvenor Gallery Exhibitions*, Cambridge 1995

Northcote, James, *The Life of Sir Joshua Reynolds*, London 1819

Payne, Matthew, and James Payne, *Regarding Thomas Rowlandson 1757–1827: His Life, Art & Acquaintance*, London 2010

Physick, J., and J. Whitlock Blundell, *Westminster Abbey: The Monuments*, London 1989

Pope, Willard Bissell, ed., *The Diary of Benjamin Robert Haydon*, 5 vols, Cambridge, Mass. 1960–63

Postle, Martin, *Angels and Urchins: The Fancy Picture in 18th-Century British Art*, exh. cat., Djanogly Art Gallery, Nottingham 1998

——, 'Flayed for Art: The Écorché Figure in the English Art Academy', *The British Art Journal*, V, 1 (2004), pp. 55–63

——, *Joshua Reynolds: The Creation of Celebrity*, exh. cat., London 2005

—— (ed.), *Johan Zoffany RA: Society Observed*, exh. cat., New Haven and London 2011

——, and Robin Simon, eds, *Richard Wilson and the Transformation of European Landscape Painting*, exh. cat., New Haven and London 2014

Read, Benedict, *Victorian Sculpture*, New Haven and London 1982

Redgrave, Samuel, and Richard Redgrave, *A Century of British Painters* (1866), London 1947

Reynolds, Sir Joshua, *Discourses on Art*, ed. Robert R. Wark, London 1966

Romney, John, *Memoirs of the Life and Works of George Romney*, London 1830

Roscoe, Ingrid, Emma Hardy and M. G. Sullivan, *A Biographical Dictionary of Sculptors in Britain 1660–1851*, New Haven and London 2009

Royal Commission, *Report of the Commissioners Appointed to Inquire into the Present Position of the Royal Academy*, London 1863

Sandby, William, *The History of the Royal Academy from its Foundation in 1768 to the Present Time, with biographical notices of all the members*, 2 vols, London 1862

Sanders, Andrew, *In the Olden Time: Victorians and the British Past*, New Haven and London 2013

Schleiffenbaum, Lea, 'The First Loan Exhibition at the Royal Academy of Arts, Burlington House, London, 1870', *The British Art Journal*, XIV, 3 (2015), pp. 68–7

Simon, Robin, *The Portrait in Britain and America, with a Biographical Dictionary of Portrait Painters 1680–1914*, Oxford and Boston, Mass. 1987

——, *Hogarth, France and British Art: The Rise of the Arts in Eighteenth-century Britain*, London 2007

Smith, Alison ed., *Exposed: The Victorian Nude*, exh. cat., Tate Britain, London 2006

Smith, Charles Saumarez, *The Company of Artists: The Origins of the Royal Academy of Arts in London*, London 2012

Smith, J. T., *Nollekens and his Times*, ed. Wilfred Whitten, 2 vols, London 1920

Smith, T., *Recollections of the British Institution with some Account of the Means Employed for that Purpose and Biographical Notices of the Artists who have received Premiums*, London 1860

Solkin, David H., ed., *Art on the Line: The Royal Academy Exhibitions at Somerset House, 1780–1836*, exh. cat., New Haven and London 2001

——, *Painting out of the Ordinary: Modernity and the Art of Everyday Life in Early Nineteenth-Century Britain*, New Haven and London 2008

Stephens, F. G., *Artists at Home Photographed by J.P. Mayall, and Reproduced in Facsimile by Photo-Engraving on Copper Plates. Edited, with Biographical Notices and Descriptions*, London 1884

Stephens, Richard, 'Four Letters by Sir Joshua Reynolds', *The British Art Journal*, X, 2 (Winter 2009), pp. 58–9

Stevens, MaryAnne, ed., *The Edwardians and After: The Royal Academy 1900–1950*, London 1988

—— (ed.), *Genius and Ambition: The Royal Academy of Arts London, 1768–1918*, London 2014

Strange, Robert, *The Conduct of the Royal Academicians while Members of the Incorporated Society of Artists of Great Britain*, London 1771.

Syson, Luke, ed., *Leonardo da Vinci: Painter at the Court of Milan*, exh. cat., London 2011

Taylor, Tom, ed., *Life of Benjamin Robert Haydon, Historical Painter…*, 2 vols, London 1853

—— (ed.), *Autobiographical Recollections by the Late Charles Robert Leslie R.A.*, 2 vols, London 1860

Thurley, Simon, *Somerset House: The Palace of England's Queens, 1551–1692*, London 2009

Treuherz, Julian, *Hard Times: Social Realism in Victorian Art*, London 1987 Fuseli, Henry, *The Life and Writings of Henry Fuseli*, ed. John Knowles, 3 vols, London 1831

Tromans, Nicholas, 'Museum or Market: The British Institution', *Governing Cultures: Art Institutions in Victorian England*, ed P. Barlow and C. Trodd, Aldershot 2000, pp. 44–55

Tyack, Geoffrey, *Sir James Pennethorne and the Making of Victorian London*, Cambridge 1992

Valentine, Helen, ed., *Art in the Age of Queen Victoria: Treasures from the Royal Academy of Arts Permanent Collection*, London 1999

Walpole, H., *Anecdotes of Painting in England*, ed. R. N. Wornum, 3 vols, London 1888

Ward-Jackson, Philip, *Public Sculpture of Historic Westminster*, 2 vols, Liverpool 2011

Waterfield, Giles, *The People's Galleries: Art Museums and Exhibitions in Britain, 1800–1914*, New Haven and London 2015

Watts, Mary Seton, *George Frederic Watts: The Annals of an Artist's Life*, 3 vols, London 1912

Webster, Mary, *Johan Zoffany*, New Haven and London 2011

Wheeler, Charles, *High Relief: The Autobiography of Sir Charles Wheeler, Sculptor*, Feltham 1968

Whinney, M., *Sculpture in Britain 1530–1830*, Harmondsworth 1964

Whitley, W. T., *Artists and their Friends in England, 1700–1799*, 2 vols, London and Boston 1928

Yeldham, Charlotte, *Women Artists in Nineteenth-Century France and England*, New York and London 1984

PHOTOGRAPH CREDITS

INDEX

Zinkheisen, Doris Clare: *People of London* 82, *83*
Zoffany, Johan, RA 6, 75, 134, 146, 159, *437*, 498
 Library purchase of prints after 545
 Academicians of the Royal Academy 147, 149–51, *150*,
 176, 414, 415–16, 562
 depiction of casts in RA collection 467–8, *468*,
 478, 479, 489, 507

*Dr William Hunter teaching Anatomy at the Royal
 Academy* 146, 507, 514, 562
A Life Class at St Martin's Lane Academy 414, 415,
 463–4, *464*, 571
Self-portrait 513
*William Hunter giving a Lecture on the Muscles at
 the Royal Academy* 422

Zorn, Anders 321
Zuccarelli, Francesco, RA 302–3
Zucchi, Francesco 548